RODIN'S ART

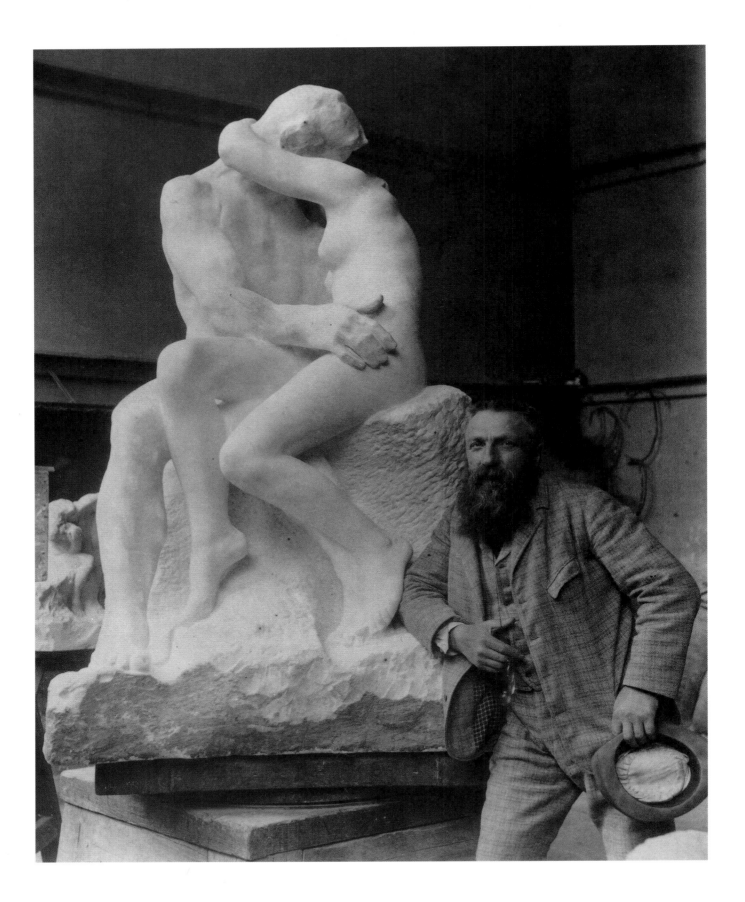

Rodin's Art

*The Rodin Collection
of the Iris & B. Gerald Cantor Center
for Visual Arts at Stanford University*

ALBERT E. ELSEN

with ROSALYN FRANKEL JAMISON

EDITED BY BERNARD BARRYTE
WITH PHOTOGRAPHY BY FRANK WING

THE IRIS & B. GERALD CANTOR CENTER FOR VISUAL ARTS AT STANFORD UNIVERSITY
IN ASSOCIATION WITH OXFORD UNIVERSITY PRESS 2003

OXFORD
UNIVERSITY PRESS

Auckland Bangkok Buenos Aires Cape Town
Chennai Dar es Salaam Dehli Hong Kong Istanbul Karachi
Kolkata Kuala Lumpur Madrid Melbourne Mexico City Mumbai
Nairobi São Paulo Shanghai Taipei Tokyo Toronto

Copyright © 2003 by Oxford University Press, Inc.
and the Board of Trustees of the Leland Stanford Junior University and the Estate of Albert Elsen

Published by Oxford University Press, Inc.
198 Madison Avenue, New York, New York

Library of Congress Cataloging-in-Publication Data

Elsen, Albert Edward, 1927–
Rodin's art : the Iris & B. Gerald Cantor Collection at Stanford University / by Albert E.
Elsen with Rosalyn Frankel Jamison; edited by Bernard Barryte; photography by Frank Wing.
 p. cm.
 "The Iris and B. Gerald Cantor Center for Visual Arts at Stanford University in
association with Oxford University Press."
Includes bibliographical references and index.
ISBN 0-19-513380-3 (cloth); ISBN 0-19-513381-1 (paper)
1. Rodin, Auguste, 1840-1917—Catalogs. 2. Sculpture—California—Palo
Alto—Catalogs. 3. Sculpture—Private Collections—California—Palo Alto—Catalogs. 4.
Cantor, B. Gerald, 1916—Art collections—Catalogs. 5 Cantor, Iris—Art
Collections—Catalogs. 6 Iris & B. Gerald Cantor Center for Visual Arts at Stanford
University—Catalogs. I. Rodin, Auguste, 1840-1917. II. Jamison, Rosalyn Frankel. III.
Barryte, Bernard. IV. Iris & B. Gerald Cantor Center for Visual Arts at Stanford
University. V. Title.

NB553.R7 A4 2002
730'.92—dc21 2001036139

Publication of this volume is made possible by a generous grant from The Iris and B. Gerald Cantor Foundation.

9 8 7 6 5 4 3 2 1

Printed in Hong Kong on acid-free paper

The way in which the artist arrives at his goal
is the secret of his own existence.
It is the measure of his own vision.

Auguste Rodin

The art of the sculptor is made of strength,
exactitude, and will. In order to express life,
to render nature, one must will and will with
all the strength of the heart and brain.

Auguste Rodin

CONTENTS

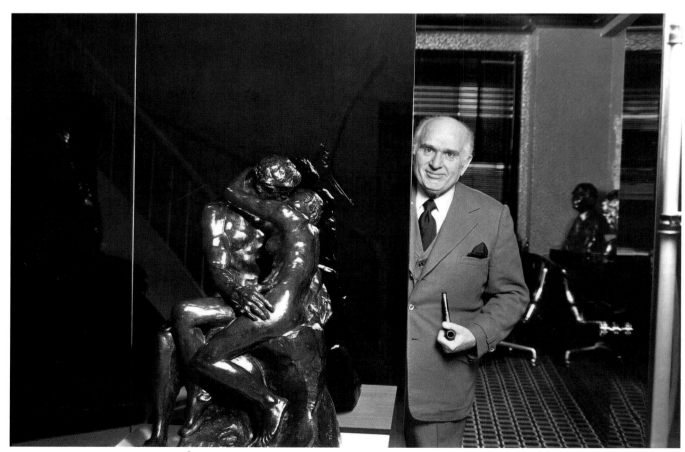

Fig. 1. B. Gerald
Cantor, art
collector, with his
cast of *The Kiss*,
New York, 1981.

FOUNDATION FOREWORD

Without question, Stanford University is the home of the greatest concentration of Auguste Rodin's work outside his estate in Paris. The product of an ardent friendship between the munificent patron B. Gerald Cantor (1916–1996; fig. 1) and Stanford professor Albert Elsen (1927–1995), this unparalleled Rodin study center benefits Stanford's students, the San Francisco Bay Area community, and the world at large in a distinctly educational way. Mr. Cantor and Professor Elsen worked for years to tailor the content of the collection so that it spanned all periods of Rodin's approximately fifty years of creative production and so that comparisons could be made between the same works figures executed in both plaster and bronze, between reductions and enlargements, and between the work of different foundries. This catalogue records the totality of Cantor's gifts of sculpture, drawings, prints, photographs, and documents associated with Rodin, which was accompanied by the donor's personal Rodin reference library (now in the Art and Architecture Library, Stanford University).

A zealous collector, Mr. Cantor eagerly shared his Rodins with the public. He also sought to clarify common misconceptions about what qualifies as an original in bronze editions and to instill an appreciation of the value of the posthumous cast. Mr. Cantor chose Stanford as the recipient of his gifts because the university setting allowed Rodin's work to be exhibited in terms of connoisseurship. He was confident the university would use the collection in the teaching of art history and that its presence would be an intellectual inspiration. In 1969 he set his plan in motion by creating a research fund to support academic study of Rodin under Professor Elsen, an endeavor that not only produced numerous important Rodin exhibitions and publications but also many scholars who hold positions in museums today.

The majority of the art was given in 1974, when Mr. Cantor had been collecting for almost thirty years. At the time the gift was hailed as one of the largest donations of sculpture ever received by a museum from a private collector. It prompted donations to Stanford from other collectors, and Mr. Cantor also made additional gifts in succeeding years. In 1977 he was joined in his philanthropic pursuits by his wife, Iris, who now serves as Chairman and President of the board of Directors of the Iris and B. Gerald Cantor Foundation (fig. 2). The couple shared a strong belief that the greatest pleasure to be derived from art comes in making it possible for others to learn from it. B. Gerald Cantor's comments of record on philanthropy were most often simply put: "Why not give it while you're alive and can see people enjoy it?"

Placing Rodin sculpture in public spaces has been a persistent undertaking of the Cantors as evidenced by the numerous sculpture gardens and galleries that bear their name around the country. Twenty monumental bronzes were chosen specifically for the one-acre B. Gerald Cantor Rodin Sculpture Garden at Stanford, which was conceived in the 1970s and opened officially in May 1985. Many of Rodin's best-loved sculptures are included, notably *The Gates of Hell, Adam, Eve, The Three Shades,* monumental heads of two of the Burghers of Calais, and *The Walking Man.* The Garden's design was inspired by the Bagatelle Gardens in the Bois de Boulogne in Paris as well as by that city's Sculpture Salon of 1898 in the now-destroyed Galerie des Machines, with its freestanding colonnade, cypress trees, grass, and gravel walks. Stanford's Garden is unique in that it has no fences or walls, and Professor Elsen once noted that its beauty is its sole protection, for it is open to the world 24 hours a day throughout the year. Since its inception it has been host to numerous public and private events; Al

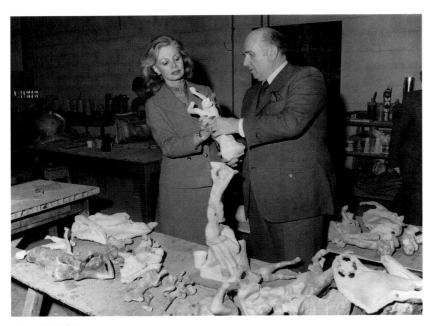

Fig. 2. Iris and B. Gerald Cantor at Rodin's home in Meudon, outside Paris.

Seligman on those details of the building that required her approval. The renovation by the architectural firm of Polshek and Partners resulted in the subtle blend of a historic building with a contemporary addition. It opened in January 1999 as the Iris & B. Gerald Cantor Center for Visual Arts. An important university and community resource, it offers new and renovated galleries in a facility that includes teaching spaces, thus providing an enriched environment for learning.

The Cantors established the Iris and B. Gerald Cantor Foundation in 1978 with two primary goals: first, to support the arts, particularly to encourage public access, appreciation, and understanding of Rodin's work; and second, to benefit biomedical research, with a particular emphasis on health-care initiatives for women. Iris Cantor has said that she likes to think of the work she and her husband did together as supporting body and soul.

Elsen himself was both married and eulogized there.

One year before Professor Elsen's unexpected death in February 1995, the Cantors pledged major support toward an ambitious fund-raising campaign to reconstruct and expand the Stanford University Museum of Art, which had been damaged by an earthquake in 1906 and further devastated by the calamity of the Loma Prieta earthquake on 17 October 1989. Mr. Cantor, who was in poor health, felt this was the right custodial gesture toward maintaining the museum that would be the home for his beloved Rodins. Sadly, he passed away less than a year after the construction began. With devotion to the commitment she and her husband had made, Iris Cantor stepped in to consult with museum director Thomas K.

With the completion of this catalogue, a daunting project begun by Professor Elsen and completed by his capable successors and colleagues at Stanford University, comprehensive documentation of this Rodin study collection now exists for reference, research, and the enjoyment of those who share the Cantors' love of Rodin in the future. The Cantor Foundation is immensely grateful to all the many contributors to the book, who have helped us take a giant step toward furthering our mission.

RACHAEL BLACKBURN
Director,
Kemper Museum of Contemporary Art
and
Executive Director,
Iris and B. Gerald Cantor Foundation, 1998–2000

DIRECTOR'S FOREWORD

Auguste Rodin was the most celebrated European artist of his day; today he is one of a handful of artists who have become household names. This catalogue offers a detailed examination of the Cantor Center's Rodin collection, the majority of which was donated by Iris and B. Gerald Cantor and their foundations. Although some critics have been unmoved or decried the emotional depth of Rodin's work as mere melodrama, the artist's popular acclaim is paralleled by other criteria of greatness. He created works that so perfectly embody particular ideas that it has become almost impossible to conceive of these abstractions in any form other than as Rodin modeled them. *The Kiss*, for example, has become virtually synonymous with the concept of romantic passion, and *The Thinker* offers such a convincing depiction of rumination that Rodin's image has become a universal, if overused, symbol for this idea. Rodin's legacy, important also for its formal innovation—particularly as it relates to the partial figure—continues to influence artists, and his work has provided the raw material for countless art historians. Our bibliography cites only some of the books and articles by biographers, journalists, poets, critics, psychologists, and art historians who have discussed the creations of Rodin's prodigious imagination. Among these writings, this volume is somewhat unusual. It takes the form of a collection catalogue, but because the collection itself was developed with the express purpose of illustrating the breadth of Rodin's accomplishment, the entries guide our eyes in the minute and exciting exploration of each object, and in combination they offer a broad perspective that encompasses essential elements of this artist's creative process.

The power of Rodin's artistry, its enduring capacity to stir the imagination and the emotions, inspired the lifelong enthusiasm of two remarkable men without whom this publication would not exist. The fascination shared by B. Gerald Cantor, a financier, philanthropist, and collector, and Albert Elsen, a Stanford professor who devoted most of his career to the study of Rodin, greatly benefited this university (fig. 3). Taking advantage of a provision in Rodin's will and a decision of the French government that authorizes the Musée Rodin to produce up to 12 bronze casts from each of the works the sculptor bequeathed to France, Cantor augmented historic casts with posthumous examples and eventually donated almost all the items catalogued here together with materials that offer insight into the sculptor's life and studio practice. Conceived as a magnificent educational tool under Elsen's guidance, the collection surveys the artist's development throughout his long and prolific career. It features examples of Rodin's less-familiar private commissions, figures created simply as the sculptor "thought with his hands," as well as sculptures that document the evolution and resolution of such monumental public works as *The Burghers of Calais, Monument to Honoré de Balzac,* and *The Gates of Hell,* many of which are available for public enjoyment night and day in the B. Gerald Cantor Rodin Sculpture Garden and elsewhere on the Stanford campus.

In addition to creating a collection that offers a microcosm of Rodin's work, the two men, philanthropist and scholar, intended to illuminate the magnitude of Rodin's accomplishment in a comprehensive study of the valuable resource they had developed. Unfortunately Cantor and Elsen both passed away before this second phase of their collaboration could be concluded. The professor, however, left a massive manuscript—or set of manuscripts on which he had periodically worked for at least 15 years—into which was compressed a lifetime of observation and study. Rosalyn Frankel Jamison, a Rodin

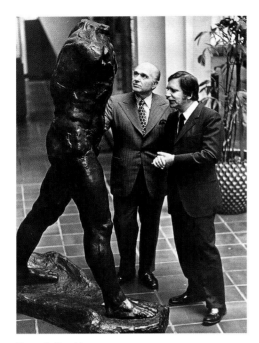

Fig. 3. B. Gerald Cantor and Albert Elsen discuss *The Walking Man*.

scholar and former student of Elsen who was working with him in the final phase of the catalogue, accepted responsibility for preparing the manuscript for publication. She integrated several drafts, assembled the illustrations, and selectively updated the literature. She is to be commended for her fortitude and thanked for the diligence, intelligence, and thoroughness demonstrated throughout this process.

The end result of all these efforts is a volume that does more than merely document a collection. Elsen observed the conventions of this genre, describing the history of each sculpture, analyzing its role within a larger project and its significance in the evolution of the sculptor's art. In addition he stressed the physicality of each piece, renewing our pleasure in seeing even the most frequently reproduced of Rodin's sculptures. Considering the nuances of each surface, Elsen enhances our appreciation for the vocabulary of line, void, and volume that Rodin manipulated as he struggled to imbue the forms he modeled with an expressive intensity that continues to intrigue audiences throughout the world.

It is a pleasure to express our gratitude to all those who contributed to this publication. In particular, our debt to the Cantors is immeasurable. They donated the major portion of the museum's Rodin collection, supported research by Albert E. Elsen and several of his students, which is incorporated in this volume, and, finally, gave generous support for this publication itself. In addition to Rosalyn Frankel Jamison, we would also like to thank our structural editors, Mitch Tuchman and Kathleen Preciado, who were given the unavoidable task of reducing an unwieldy manuscript to manageable size and who maintained respect for the author's intention and tone. Bernard Barryte, chief curator, represented the museum in all facets of production and contributed in a variety of ways to the content and character of this volume. Finally, we would like to thank our copublisher, Oxford University Press, for helping the Center make this information widely accessible and in a notably handsome form.

All museums have a responsibility to teach, but as a university art museum the Iris & B. Gerald Cantor Center for Visual Arts has a special educational mandate. In offering this catalogue to the public, we believe that we are fulfilling the aspirations of both benefactor and scholar, who also shared a passionate belief in the importance of this mission.

THOMAS K. SELIGMAN
John and Jill Freidenrich Director

PREFACE

Rodin has been well served in the literature. The reader will not find here a biography of Rodin, as his life has been thoroughly chronicled and interpreted not only by Judith Cladel's writings but in more recent times by those of Frederic V. Grunfeld and most especially Ruth Mirolli Butler. There also exist the excellent museum catalogues of Rodin's art with informative introductory essays by Athena Spear for the Cleveland Museum of Art; John Tancock for the Philadelphia Museum of Art's Rodin Museum; Jacques de Caso and Patricia Sanders for the California Palace of the Legion of Honor, San Francisco; Joan Vita Miller and Gary Marotta for the Metropolitan Museum of Art, New York; and Lynne Ambrosini and Michelle Facos for the Brooklyn Museum. More recent catalogues include those by Anne-Birgitte Fonsmark for the Ny Carlsberg Glyptotek, Copenhagen, and Mary Levkoff for the Los Angeles County Museum of Art.

The Musée Rodin curators Nicole Barbier, Alain Beausire, Claudie Judrin, Antoinette Le Normand-Romain, and Hélène Pinet have been publishing indispensable catalogues of Rodin's drawings, correspondence, exhibitions, bronzes, and works in stone. The best analysis of the drawings came from Kirk Varnedoe, the first Cantor Fellow at Stanford. J. A. Schmoll gen. Eisenwerth published in Germany many major studies of individual works and Rodin's relation to ancient art. The 1903 essay by Rainer Maria Rilke and that of 1963 by Leo Steinberg remain classics of interpretation. Catherine Lampert's 1986 *Rodin: Sculpture and Drawings* exhibition is the best attempt to show Rodin's art as a whole.

Through the extraordinary generosity of B. Gerald Cantor it was possible (until the 1989 Loma Prieta earthquake, which closed the Stanford University Art Museum but not the sculpture garden and campus display) to show the largest and most important collection of Rodin's art in the world outside the Musée Rodin in Paris. Following the museum's temporary closing in 1989, most of the collection was lent to other institutions or put in storage. Even during these difficult times Cantor continued to enlarge Stanford's holdings. No question but that nature's devastation delayed the writing and publication of this catalogue.

The intellectual justification for this book is given in the Introduction. Having for many years taught from, written about, and curated this great collection, the author found in preparing this catalogue the opportunity for a close reading of Rodin's art in terms of what the sculptor actually made as a revelation of his artistic intelligence. At times extensive formal analysis may try some reader's patience, but we are here concerned with how Rodin thought with his hands. What follows includes not just entries on individual pieces containing reflections on their meaning and critical reception but also extended essays on *The Gates of Hell, The Burghers of Calais,* and the *Monument to Honoré de Balzac.* Not only are these heroic projects strongly represented in the Cantor collection, they are three of the artist's most important commissions, and in this author's view substantial treatment is needed beyond what has been published.

The entries are grouped by themes because of the dating problems that a strict chronology would have presented and because this grouping allows the reader to comprehend Rodin's thinking as a patriot, a portraitist, an advocate of artists and writers, and an explorer of the nature of creativity, and to appreciate deeply his thinking about works made for himself in less than life-size sculptures and partial figures. Within

< XIII >

broad categories the entries are mostly ordered chronologically, with an occasional departure to allow the juxtaposition of thematically related works. Frank Wing's intelligent and sensitive photographs of works in the Stanford collection are supplemented by photographs taken by others, including historical photographs taken under Rodin's direction to give the reader a sense of how the artist wanted us to see his art.

ALBERT E. ELSEN
Walter A. Haas Professor of Art History
(1927–1995)

ACKNOWLEDGMENTS

When he began to give Rodin's art to Stanford in 1974, B. Gerald Cantor included among his motives the education of the public about the art of this great sculptor. Consistent with his intention, the funding for the research and publication of this catalogue was made possible by Cantor's foundation. The late Vera Green, who for many years served as Cantor's curator, was a true friend and excellent source of information. More recently Joan Inciardi and Susan Sawyers have admirably continued this tradition of support.

In 1975, when Monique Laurent became director of the Musée Rodin, scholars and scholarship were finally welcomed to that institution, and Rodin studies began to thrive. Her successor, Jacques Vilain, has seen to it that the museum continually welcomes scholars. The Musée Rodin's own staff has proved exemplary in publishing, and the research of many others, including myself, owes much to the genial cooperation and information provided by Nicole Barbier, Alain Beausire, Claudie Judrin, Antoinette Le Normand-Romain, Hélène Marraud, Guillaume Papazoglou, and Hélène Pinet.

Over the years Ruth Butler has been a wise and sympathetic counselor and critic, sharing fully the material and ideas that have made her one of the most perceptive Rodin scholars and Rodin's most important biographer. Anne Pingeot is one of the main reasons that the Musée d'Orsay archive is among the best places in Paris for a scholar of nineteenth-century art to work.

Since the beginnings of the Rodin collection, the support of the staff of the Stanford University Museum of Art (now the Iris & B. Gerald Cantor Center for Visual Arts) has been indispensable. Lorenz Eitner, the former director (1963–89), was always a keen critic; Betsy Fryberger, a discriminating curator of prints and drawings; and Susan Roberts-Manganelli, a patient, good-humored, and always helpful registrar. Special gratitude is due Frank Kommer for his personal support during difficult times and his extraordinary professional work, which included helping oversee the building and installation of the B. Gerald Cantor Rodin Sculpture Garden and sculptures elsewhere on campus. Jeff Fairbairn is remembered fondly for his skill, conscientiousness, and enthusiasm displayed while working for years on the interior installations. Lately come to our enterprise is Tom Seligman, the current museum director, who has brought to this project a refreshing energy and can-do optimism.

Much is owed to Alex Ross, who as head of Stanford's Art and Architecture Library made sure that new and difficult-to-obtain older materials were at our disposal quickly. Amanda Bowen, his former assistant, was a model of bibliographic alertness. Formerly on the art department staff and now at the Center as associate director of external relations, Mona Duggan cheerfully and expertly kept expenses in order, and Liz Martin was a whiz at bringing the author into the twentieth century electronically. Concerning my faculty colleagues, I warmly remember Jody Maxmin's joyfully supplying citations and photocopying essays on Greek art and John Freccero's reading of *The Gates of Hell* in terms of his vast knowledge of Dante. For more than fifteen years the sculptor Richard Randell fully shared his knowledge and insights into the technical aspects of bronze casting. From the medical school faculty I learned about Rodin's use of anatomy from Drs. Robert Chase, William Fielder, and Amy Ladd.

Many Stanford art history graduate students past and present contributed to the cataloguing work. In particular credit should be given to Gerard Koskovich for his meticulous recording of physical and bibliographic information on most of the pieces and his research in

France on the monuments to Claude Lorrain and Jules Bastien-Lepage. Much important biographical information was gathered by JoAnne Paradise, and Jo Ortel was among those who did careful preliminary preparation of the computer disks for the entries. Margherita Andreotti contributed the entry on *Bellona*.

Not enough good can be said of the museum's many inspiring docents, led by Judy Amsbaugh (who also generously and carefully reviewed page proofs), Marilyn Fogel, Boots Liddle, and Eugenie Taylor, among others. For years they not only interpreted Rodin with intelligence and exuberance to people of all ages and backgrounds, but their questions and comments constantly obliged me to refocus on particular sculptures as well as Rodin at large.

My appreciation is extended to Grant Barnes, former senior editor at the Stanford University Press, and his successor, Norris Pope, who offered important input in the early stages of reviewing the manuscript.

Finally and most important has been the writing, editing, and critical assistance of Rosalyn Frankel Jamison. This catalogue would still be in the writing without her contributions. We look forward to the eventual publication of her exceptional thesis on Victor Hugo's influence on Rodin, which will rank her with the most important Rodin scholars.

ALBERT E. ELSEN
(1927–1995)

This catalogue culminates a critical period in the expansion of the museum's collection and facility owing to the generosity of Iris and B. Gerald Cantor. This exciting growth sustained Albert Elsen's intense commitment through the years of writing. It was a privilege to work with him on this project, to contribute entries, to read and comment on the manuscript, and to participate in preparing it for publication.

Although I am immensely saddened that Albert Elsen's death in 1995 prevented him from seeing the catalogue in its final form, I have taken heart that at the time of his death he had experienced the satisfaction of overseeing the growth of the collection, the inauguration of the museum's Rodin rotunda, the arrival of *The Gates of Hell*, and the opening of the sculpture garden. Moreover, he had also by and large completed his first draft of this catalogue, in which he wished to convey the sum of his knowledge, insights, and connoisseurship about Rodin's work based on his lifelong study of the artist. Elsen and I also had completed the major part of our dialogue about the manuscript. The main arguments in the catalogue entries fundamentally reflect his research and points of view, incorporating refinements and clarifications I added based on our discussions and on subsequent research. I have aimed to reflect his intent accurately and take responsibility for any unintended departures from it. The entries that I researched and authored entirely are so designated. Limits on time and space in the catalogue preclude an essay on the historical photographs which are included as an appendix to this volume.

Given the dual misfortune of B. Gerald Cantor's death occurring roughly a year after Elsen's, I have worked with a special determination for this catalogue to serve as an apt tribute to both. First and foremost I would like to express my most profound gratitude to Iris and the late B. Gerald Cantor for their generosity, both in creating the Stanford Rodin collection and for providing unwavering support for the project of cataloguing the collection. I also want to thank former Executive Director Rachel Blackburn and her successor, Judith Sobol, for continuing the splendid tradition of cooperation between the Cantor Foundation and Stanford University's Cantor Arts Center.

I would also like to acknowledge the assistance of many people on whose knowledge and experience I have drawn, especially in the absence of Elsen's guidance. Ruth Butler, professor emerita at the University of Massachusetts, Amherst, generously offered critical advice at key points as did June Hargrove, professor at the University of Maryland. I also thank Daniel Rosenfeld, Academy Professor, Pennsylvania Academy of the Fine Arts, Philadelphia; Stephen McGough, former director of the Crocker Art Museum, Sacramento; and Steven Wander, former chair of the art department at the University of California, Irvine, for helpful suggestions. I thank Mary Levkoff, curator of European sculpture at the Los Angeles County Museum of Art, for providing information.

I would also like to express my appreciation to Bernard Barryte, chief curator, for his editorial contributions, which included updating documentation on the

collection, compiling the Appendix, preparing the text for editors and publisher, and seeing the book to press. Beyond those already acknowledged by Albert Elsen, I would like to thank Carol Osborne, former associate director, for advice in the early stages, and Dolores Kincaid, assistant registrar, for her care in providing and clarifying collection data, and Alicja Egbert for assistance in securing permissions to reproduce illustrations.

I especially appreciate the invaluable assistance of the Iris and B. Gerald Cantor Foundation in Los Angeles and wish to add to the preceding acknowledgments my thanks to Susan Sawyers, Danna Freedy, who secured numerous illustration photographs, and Joel Melchor, who carefully verified credit lines and assisted with numerous queries.

At the Musée Rodin, I wish to offer special thanks to Antoinette Le Normand-Romain, who generously contributed the entry on *The Hero*, Hélène Pinet, who provided valuable information regarding the Center's historic photographs, Jérome Blay, for information concerning provenance, and Anne-Marie Barrère, for help in obtaining photographs.

On behalf of the Iris & B. Gerald Cantor Center for Visual Arts I again thank Athena Tacha Spear for photographs of Balzac studies, several of which are included in the updated Balzac essay in the current volume.

At the Stanford University Art and Architecture Library I share Albert Elsen's debt to Alex Ross, head librarian, and also wish to thank his colleagues Peter Blank, Linda Trefflinger, and Arturo Villaseñor for their invaluable help with a wide range of bibliographic questions and library services. Kathryn Wayne, the fine arts librarian at the University of California, Berkeley, was also very helpful.

As structural editors of the manuscript, Mitch Tuchman and later Kathleen Preciado have been extremely helpful, conscientious, patient, and thorough. Oxford's copy editor, Roberta P. Scheer, has also intervened to ensure consistency and clarity.

At Stanford's Department of Art and Art History I would like to thank Susan Lewis and Wanda Corn for their helpful suggestions and Liz Martin for her technical advice concerning the drafts on disk as well as for her cheerful and resourceful assistance with the myriad questions that arose in the course of the project. I also wish to express gratitude to my friend and retired colleague Lucile Golson of the University of Southern California, who was most generous and helpful with numerous art historical questions and matters of French translation. I wish also to express my appreciation to the members of the Elsen family for their support and cooperation throughout the project.

Finally, Bernard Barryte joins me in extending thanks to our respective families for their patience and support during the long process of preparing this manuscript.

ROSALYN FRANKEL JAMISON

NOTES TO THE READER: Works of art are by Auguste Rodin unless otherwise noted. Illustrated works are in the collection of the Iris & B. Gerald Cantor Center for Visual Arts at Stanford University unless otherwise noted. Dimensions are given in inches followed by centimeters in parentheses; height before width, before depth. Measurements of collateral works are provided when available, based on information from the indicated source. An object belonging to the Cantor Center is identified by either catalogue number or appendix number, for example, cat. no. 69 or A69; references to sculptures belonging to the Musée Rodin, Paris, are indicated by an "S" number. Photographs of Cantor Center works are by Frank Wing unless otherwise noted.

RODIN'S ART

Two Genuine Articles: A Memoir of Albert Elsen and B. Gerald Cantor

KIRK VARNEDOE

Chief Curator of Paintings and Sculpture, Museum of Modern Art, New York

Few graduate students are so lucky as to find a mentor, a project, and a patron all in one shot. I was. As a green, unfocused enthusiast of early modern art and Rodin in particular, I arrived at Stanford in September 1968 with the vague intention of getting an M.A. in art history while savoring California in the late 1960s. By June 1969 I was on my way to Paris, armed with a thesis topic courtesy of Albert Elsen, a plane ticket and a new Nikon courtesy of B. Gerald Cantor, and an already feverish focus on what would be one of the most intense learning experiences of my life. In retrospect, I look on that suddenly propelled trajectory, and that raw student's accelerated mutation into aspiring scholar, as just one of the first "particle effects" of educational and cultural enrichment that radiated into the world from the collision and partial fusion, during that six-month period, of Elsen and Cantor, two fundamental forces of nature (and culture) if ever there were such. Al's personal reminiscences in this volume ("B. Gerald Cantor and the Stanford Rodin Collection") give the basic outlines of that encounter but discreetly leave out the shading of emotion and personality that were so crucial to the two men's initial antagonism and to their eventual bond of synergy and friendship, from which Stanford was to profit so immensely. Now that both men are gone, I feel that I can, in the spirit of love and gratitude I bear for both, fill in the picture a little more.

Al's autumn 1968 television review of the showing of the Cantor collection in San Francisco would have, if criticism were calories, melted directly off those bronzes the buffed wax polish he found so offensive. As the first American scholar to work seriously on Rodin and the man most responsible for creating a new scholarly interest in the artist as a modern innovator (after years in which the sculpture had been dismissed as so much Vic-

torian bathos), Elsen had been titanically frustrated by Cécile Goldscheider, the director of Paris's Musée Rodin and gatekeeper of its immense but then unplumbed archive of letters, clippings, drawings, and sculptural studies. Though he did not know Cantor personally, Elsen knew that his collection had been formed through the Musée Rodin, and a goodly portion of the anger vented in the review was doubtless aimed, consciously or unconsciously, at the collaboration with his nemesis in Paris, which he saw as reinforcing with the cash of patronage Goldscheider's obstructive policies in the scholarly domain.

Bernie Cantor's initial reaction to this assault apparently matched Elsen's anger and raised it; he was said to be consulting his lawyers about possible suit for libel, Al reported with the ill-concealed satisfaction of a man who was always happiest when pugnacious in the furtherance of a righteous cause. And when the cooler head of Bernie's curator, Ellen Landis, prevailed with the argument that the collector had ultimately more to gain from working with Elsen than from battling him, Al decided to up the ante yet another notch: he responded to their "dove of peace" overture with a quasi demand that, as a kind of precondition to a discussion of cooperation, Cantor should "do something right for Rodin," by giving a grant to support a summer's research in Paris for his student, intent on studying the sculptor's drawings. I have always guessed that Bernie, to his great credit, found that cheekiness more congenial than alien, and sensed then—correctly—that he and the fellow he had run up against shared not only a real love for Rodin but a basic kind of moxie. In any event, he graciously complied; and so began my doctoral pursuit, as an initial drop of glue in the bonding of these two very willful and fervently committed men. But more importantly, from this unpromis-

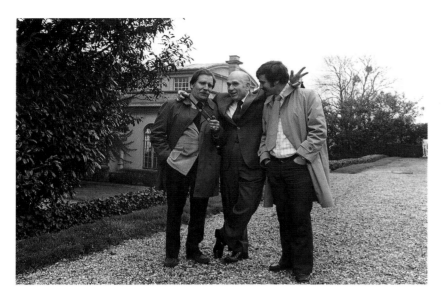

Fig. 4. B. Gerald Cantor (center) with Albert Elsen (left), and Kirk Varnedoe at Meudon, 1977.

suit to sap the feisty, often argumentative pleasure they took in art and in getting big things, like the eight-ton casting of *The Gates of Hell* or record-setting acts of philanthropy, done right. Both were in their way idealists and perfectionists, yet both were blessed with a leavening sense of pragmatism and a thick-skinned and cold-eyed—if not always tolerant or accepting—sense of the way the world worked. They goaded each other, infuriated each other, and enjoyed each other, developing ties of affection and respect that helped them get over their chronic disagreements and transcended the business they had to do together as Maecenas and mentor. Al shared with me his preoccupying worries over Bernie's health problems, and eventually I witnessed the intense sense of grief and abandoned loneliness that enshrouded Bernie as he sat, nearly blind from the diabetes that plagued his last years, in the B. Gerald Cantor Rodin Sculpture Garden, hearing Al eulogized after his sudden and unexpected death in 1995. In the plane returning to Los Angeles that evening, he wept as he held close to his eyes treasured photographs of the two of them kibitzing together at foundries, in museums, and at Stanford.

ing overture of animosities began the important program of Cantor Fellows at Stanford and a great relation of friendship and mutual respect that was to shape the activities of both the collector and the professor in the years ahead and to lead eventually to Iris and Bernie Cantor's tremendous donations to the university. Perhaps still more miraculously, Bernie was eventually able to get Al to speak civilly to Cécile Goldscheider, while Al was able, with Bernie's support, to convince French cultural officials to modernize and open up the Musée Rodin, allowing for a new surge in his own scholarship and empowering younger researchers worldwide.

I was privileged to see Bernie and Al form and then deepen their friendship in some memorable places: over a desk scattered with loose tobacco and pipe paraphernalia; in an office perpetually carpeted in the floor-to-ceiling photographic clutter of work in progress at Stanford; in a wide plush command center of investment finance in Los Angeles, as remarkable for the Rodin bronzes by the exercise bike as for the kingpin in his corduroy jumpsuit; or in the ultimate connoisseur's candy store of the reserve storerooms of Rodin's former home in Meudon, outside Paris, with hoards of plaster and clay studies overbrimming every shelf (fig. 4). Whatever the setting, it was clear that these two boys from the Bronx always found themselves back at home with each other. Neither had mellowed in the California sun, nor had either allowed the rarefied air of high finance or elevated aesthetic pur-

More than a quarter century had then gone by since the heady, conflict-ridden, and often confusing months of the late 1960s, when these two men first came together in the mutual cause of the artist who so moved both their passions to possess and to understand. Their meeting had initially sent me off, then, to try to distinguish true from false—for my doctoral project was to establish criteria for separating authentic Rodin drawings from the numerous forgeries that plagued his reputation. In such matters, I found, one learns the most by comparing; and the broader one's base of comparison, the more telling become the unique qualities of the authentic, original items amid the common run of approximations, falsifications, and partial efforts. Similarly years of study, and of life, have only reinforced my immense sense of personal gratitude that I was privileged at a particular time to know and come under the fertile influence of not one, nor even two separate, but a matched pair of human originals, each individually, and more so together, a special force in the life of Stanford and its students, Rodin studies, and late twentieth-century American cultural life writ large.

B. Gerald Cantor
and the Stanford Rodin Collection

In the United States several collectors have made great contributions to the public's awareness of Rodin. Thomas F. Ryan began the Rodin collection at the Metropolitan Museum of Art by providing the funds for the purchase of 32 sculptures. Mrs. John Simpson donated her small but important collection to the National Gallery of Art. Alma de Bretteville Spreckels gave the California Palace of the Legion of Honor its more than 70 Rodins, and with her husband she provided the building itself. Jules Mastbaum built and filled the Rodin Museum of Philadelphia. By his reckoning B. Gerald Cantor and his wife, Iris, have acquired roughly 750 Rodin sculptures, more than any other collector by far, and given more than 450 works to 70 institutions around the world. The Cantors more than doubled the Rodin holdings of the Metropolitan Museum of Art, for example. As recipient of the largest number of their donations and promised gifts, Stanford University has been the primary beneficiary of the Cantors' generosity to the extent that the university now possesses the second largest and most important Rodin collection in the world after the Musée Rodin in Paris.

The Collector

Born in 1916, B. Gerald Cantor was the founder, president, and chairman of the board of Cantor Fitzgerald Incorporated, an international securities firm and innovator in securities brokerage technology. In 1972 his firm originated screen bond brokerage (up-to-the-minute market information displayed on monitors) in the United States, and in 1983 it became the first corporation to offer worldwide screen bond brokerage services in United States government securities.

Nothing in Cantor's family background or education in New York encouraged his collecting. He was not even sure that his mother ever took him to museums. The courses he remembered at New York University were those in business. His first purchase of a Rodin sculpture was in 1947 from a Madison Avenue gallery that displayed it in a window. It was a reduction in bronze of *The Hand of God*, the marble version of which he had seen at the Metropolitan Museum of Art in 1945 after his discharge from the army. He had just begun his business, and the cast cost the equivalent of two months' rent for his apartment. Although he changed his place of business many times, that sculpture always accompanied him. It was not until a trip to Paris in the late 1950s, when he went to the Musée Rodin and talked about the sculptor with Edith Lionne, a member of the staff, that he started to buy works in any number. To begin with they were small. His business was always capital intensive, and until it was well established, he had no thought of collecting seriously. Some early purchases he gave as gifts. These gestures of personal friendship and later his donations to museums explain his buying many casts of the same work; and this in turn contributed to the rumor that Cantor was trying to corner the market. Unusual among major collectors is that after a few early sales, Cantor neither sold nor traded from his Rodin collection. When he deaccessioned, it was in the form of donations to museums.

Cantor recalled that his decision to become an ardent Rodin collector occurred in the mid-1960s, when he was drawing up his will and designating various sculptures for friends. He decided then that he would like to share the art he had acquired and give it away during his lifetime. His taste in Rodin's art was always the bronzes, not the carvings or drawings. Romantic themes and whole

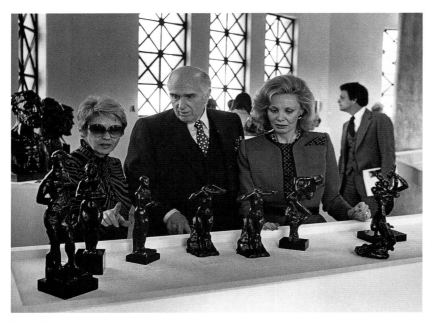

Fig. 5. Iris and B. Gerald Cantor (right), with Vera Green (left), former curator of Cantor's collection, attending the dedication of the Rodin rotunda, Stanford Museum (now Iris & B. Gerald Cantor Center for Visual Arts at Stanford University), 10 April 1981.

figures were his early instinctive interest. In time he came to admire and covet the studies for major monuments and the partial figures and hands.

There was no collector who served Cantor as a model, despite his service as a trustee of the Los Angeles County Museum of Art and the Metropolitan Museum of Art, where he had extensive contact with some of the most prominent collectors in those cities. Cantor's readings on Rodin began with Ludwig Goldscheider's 1949 book, *Rodin* (London: Phaidon), Georges Grappe's 1944 catalogue of the Musée Rodin, and my book, *Rodin*, which accompanied the 1963 Museum of Modern Art exhibition. Today these books anchor a substantial and well-used library on the artist. With regard to his acquisitions Cantor always sought lifetime casts when available and of fine quality, and the success of his business made them affordable. Cantor relied in part on his curators to alert him to objects in the auction and gallery market. There were a few dealers and galleries, notably the late Charles Feingarten and the Dominion Gallery in Toronto, who brought important works to his attention.

In the late 1960s Cantor set aside a room in his Beverly Hills office as a gallery in which to display almost 100 small bronzes. In 1981 he opened the B. G. Cantor Sculpture Center, a 4,000–square-foot gallery on the 105th floor of the now destroyed One World Trade Center, to which he had relocated his New York office. There he installed 100 works from his collection—and made

the *Guinness Book of Records* as the highest institution of its kind. Several Rodin exhibitions were mounted, but in 1987 Cantor decided to donate most of the works to the Metropolitan Museum of Art and Brooklyn Museum of Art (as well as to Stanford) because it had become awkward to accommodate the large numbers of visitors, and his company needed the gallery space for expansion. Cantor also wished to honor two great museums in the city where he and Iris were born.[1]

A turning point in Cantor's views about what he would do with his collection came in 1967, when the Los Angeles County Museum of Art exhibited many of his bronzes in *Homage to Rodin: The Collection of B. Gerald Cantor*. The pleasure it gave him to mingle anonymously with the crowds and overhear their enthusiastic reactions to Rodin's work shaped his personal mission as a collector-educator. It was Sidney Brody and Henry Rogers, fellow trustees of the Los Angeles museum, who suggested one day at lunch that he might circulate his bronzes to numerous museums. When *Homage to Rodin* toured four American cities—Houston, Brooklyn, Richmond, and San Francisco—Cantor initiated the practice of giving a Rodin bronze to each museum that hosted his collection. The Los Angeles County Museum of Art has benefited frequently from the Cantors' generosity, receiving dozens of works by Rodin and other nineteenth-century artists, a sculpture garden, gallery, and outdoor plaza.[2]

The record of Cantor's exhibitions and donations of art over a 20–year period is staggering, unmatched, it seems safe to say, by that of any other collector. For this program he relied for many years on his curator, the late Vera Green (fig. 5). Not only did he circulate groups of Rodin sculptures, but he toured three of Rodin's greatest works—*The Thinker, The Gates of Hell*, and *The Burghers of Calais*—as single-sculpture shows.[3]

Cantor and the Musée Rodin

From the then newly opened Musée Rodin, Jules Mastbaum in the early 1920s commissioned posthumous casts of all the bronzes in the Philadelphia museum collection that today bears Rodin's name. Mastbaum also agreed to restore Rodin's home and build a new pavilion at Meudon to properly house all of Rodin's plasters, which previously were stored in the artist's temporary pavilion built for the Paris exposition of 1900 and then moved to

Meudon at its close. Mastbaum died before his museum was opened and the new pavilion built, but his widow honored her husband's pledge.

Cantor is the second American to become best friend to the Musée Rodin.[4] Although the museum is part of the French Réunion des musées nationaux, it was a condition of its founding in 1916 that it be self-supporting, and that was an important reason that Rodin assigned to the state all rights of reproduction of his art. Under its first curator, Léonce Bénédite, the museum's casting of Rodin's art began even before the artist's death in 1917. (Rodin retained the right to cast for himself while he was alive.) When Cantor came into contact with the Musée Rodin in the late 1950s, its records and vast archives had not been put in order and were not accessible to scholars; its casting policies were not clear, at least to outsiders; and the physical conditions—a kind of genteel decrepitude—and irrational display of the art in the Hôtel Biron, where Rodin had lived before it became a museum, had been deplored by generations of visitors, who kept returning, however, because of the power of Rodin's art. Since 1975 the improvement of the Musée Rodin in all these areas is due not only to the professionalism of directors Monique Laurent and Jacques Vilain, her successor, but to Cantor's patronage in the form of substantial acquisitions of Musée Rodin casts and personal advice.

In the late 1950s Cantor met Cécile Goldscheider, then secretary to Marcel Aubert, the museum's curator. It was she whom Cantor credits with first tutoring him in Rodin's art and the mysteries of the bronze-casting process. She opened his mind to the torsos and hands and showed him the great collection of plasters at Meudon, those on public view and those in the vast reserve. It was through Goldscheider that Cantor in the 1960s obtained many small sculptures as well as three large works: *The Thinker, Monument to Honoré de Balzac,* and *The Walking Man.* When he saw that the museum's casts were neither numbered nor dated—certificates were issued instead—he successfully urged numbering the casts with the size of each edition. When Cantor requested bronze casts from certain plasters, often he was successful, but sometimes he was not. (The final decision, which lay with the museum's administration [*conseil d'administration*], seems to have been based less on whether a work was intended for casting and more on whether an edition would be salable.) As his connois-

seurship increased, Cantor pointed out to Goldscheider that the Musée Rodin was sometimes accepting inferior castings. When she told him of the problem of finding good foundries, Cantor proposed buying one for the museum, but the offer was declined, presumably because the government did not want to compete with private founders. When Cantor acquired at auction Rodin plasters once owned by Antony Roux, he returned to the Musée Rodin the exclusive rights to their reproduction given by the artist to their first owner. He also gave the museum plasters not in its inventory.[5] Perhaps his most significant contribution to Rodin scholarship was his encouraging the new Musée Rodin administration in 1975 to open its great archives to scholars. Rodin research, especially my own, was thereby given a dramatically new and fruitful life.

In 1974 Cantor began to think about commissioning a cast of *The Gates of Hell.* He knew that the Musée Rodin would only consent to such a commission if the cast went to an institution. Cantor also knew that the planned 1981 presentation by the National Gallery of Art in Washington, D.C., of the largest Rodin exhibition ever held, *Rodin Rediscovered,* would include works from his own collection. From 1975 until 1977 he negotiated with the Musée Rodin for the cast of the portal with the understanding that it would be finished in time for the *Rodin Rediscovered* exhibition and then be given to Stanford. Iris Cantor had the idea of making a documentary film of this historic casting at the foundry of the Fondation Coubertin, for it would be the first of *The Gates of Hell* to be created by the lost-wax process as Rodin had wanted.[6]

During a visit to Meudon with Monique Laurent and Jean Chatelain many years ago, Cantor noticed a private home being erected on the boundary of the museum's property, encroaching on the distance required next to a historic site. The despairing museum officials told him nothing could be done, but Cantor's response was quick and simple, "I'll buy and give it to the museum"—and with a couple of phone calls that's precisely what he did.

Cantor and Stanford

The idea of assembling a very large concentration of Rodin's art to form a national study center for the artist grew out of Cantor's experience with having so many

OPPOSITE PAGE
Top: Fig. 6. John
Tweed, *Profile
Portrait of
Auguste Rodin*
(A57).

Bottom: Fig. 7.
Edward
Steichen,
*Balzac—Toward
the Light,
Midnight*
(A162).

works on display in his Beverly Hills office in 1970. He wanted the art handled more professionally and made more easily accessible to the greatest number of people. Stanford came to interest him through his long association with Peter Bing and his family. In the early 1970s Bing was a member of the Stanford board of trustees and in 1975 assumed its presidency. In 1973 Cantor visited Stanford for the first time to be present at the opening of the university museum's *Rodin and Balzac* exhibition, which consisted of sculptures he lent and whose catalogue his company published to accompany the show as it toured. In 1989 Cantor recalled, "Upon my first visit to Stanford I had an immediate affinity with the place; it had everything, a beautiful nineteenth-century building with a rotunda, which dates from Rodin's lifetime, and large exterior space for a sculpture garden, which I paced off with my good friend Peter Bing. It had a built-in Rodin scholar of worldwide reputation in Professor Elsen, who since then has become a very good friend. Furthermore, I wanted my collection to be exposed not only to the public but to students and Rodin scholars. In short, I wanted it to function not only as a museum but also as a study center."

Rodin worked by daylight, and all his large pieces were intended for the outdoors. Stanford afforded ideal viewing conditions for these, but Cantor was also impressed by the spaciousness and natural light in the adjoining rotunda, where smaller works could be installed (see fig. 5). He was assured that the collection would not gather dust in storerooms, that as much of it as possible would be displayed at all times, and that it would be taught from and researched. This pragmatic man knew that for museums to successfully educate they must first inspire and that what he was giving would be inspirational to people of all ages. With Bing, Cantor liked to prowl the campus, looking for sculpture sites. It was his idea to place around the campus and not just in the sculpture garden many of Rodin's life-size works, such as four figures from *The Burghers of Calais* in the Quad and one in the History Corner Courtyard,[7] *The Thinker* to the west of Meyer Library, and the *Monumental Bust of Victor Hugo* in the lobby of Green Library. The addition of these works to the existing campus collection of modern sculptures has given Stanford one of the premier university collections of modern outdoor art in the world.

Quite apart from the impressive number of his gifts, what has separated Cantor from most other benefactors of university art collections has been his willingness to subsidize exhibitions, establish the ongoing Rodin Research Fund at Stanford, and underwrite publications by museum and independent Rodin scholars such as Ruth Butler. From the time of the fund's establishment in 1969, the Cantor Fellows have produced several doctoral dissertations and publications on Rodin's art: Kirk Varnedoe's thesis on the drawings of Rodin and his forgers, Mary Jo McNamara's study of *The Burghers of Calais*, Marion Hare's dissertation on Rodin's portraits after 1880, Rosalyn Frankel Jamison's study of the influence of Victor Hugo on Rodin's *Gates of Hell*, and Daniel Rosenfeld's study of Rodin's more than 300 carvings in stone.[8]

When Cantor gave Stanford 89 Rodin sculptures in 1974, it made news nationally because it represented the largest sculpture donation to a university art museum. Following that, he doubled the size of the sculpture collection and added gifts of books on and illustrated by the artist, drawings, prints, photographs taken under the sculptor's direction, and documents. To what was already the largest concentration of Rodin outdoor sculptures, Cantor in 1992 added as part of another of his substantial donations to the university the majestic, life-size *Three Shades*,[9] while many previous loans were converted to gifts. Understanding the importance of showing the Rodin collection in the context of his contemporaries, Cantor also gave Stanford works by such artists as Emile-Antoine Bourdelle (1861–1929), Jean-Baptiste Carpeaux (1827–1875), Albert-Ernest Carrier-Belleuse (1824–1887).

Cantor's passion for educating the public in all aspects of Rodin's art accounts for the unique character of Stanford's collection quite apart from its size. From its inception the informing principle was to illustrate Rodin's growth and range as an artist, the diverse media in which he worked, and how he worked. Thus the collection represents the "confections," or commercially attractive works, the artist made to support himself in the 1870s and 1880s as well as his serious artistic audacities represented by *The Gates of Hell* and the *Monument to Honoré de Balzac*. The Stanford collection is the only one to display side by side the same subjects by Rodin in more than one medium. Cantor was eager to obtain Rodin's plasters for the Stanford collection not only for their artistic and educational value but to prevent their being recast by private owners. He also acquired certain works in their original as well as enlarged or reduced sizes, such as *Flying Figure* and the nude study for *Jean d'Aire*, so that

students could examine the resulting effects. Rare is the collector who would commission all the casting states of the lost-wax process by which a bronze was made, but Cantor gave Stanford these didactic objects to display. To further the education of the public and collectors in the connoisseurship of Rodin bronze casts, Cantor donated a poorly patinated posthumous cast of the *Mask of the Man with the Broken Nose* that could be compared with the brilliantly finished lifetime cast of *Bellona*.[10]

The university's Rodin collection has not been determined exclusively by its major benefactor's taste. At the time of his first large donation I was invited to select the 89 sculptures from a longer list of works he intended not only for Stanford but for the Los Angeles County Museum of Art as well. There have been times when he did not agree with my recommendations for acquisitions, and Stanford declined some works by other artists that he offered. Many of his donations, such as the *Head of Charles Baudelaire* and *Avarice and Lust*, were of subjects that Cantor would not have acquired for his personal collection but which he realized were important for our mutual educational objectives.[11]

As a donor Cantor was always very businesslike. As others who benefited from his largesse to their institutions could testify, his gifts never required flattery, only our crediting the source and carrying out our promises concerning how the art would be used. It is a measure of the man that Cantor felt this was sufficient compensation for all that he did for Stanford.

Other Rodin Donors

Stanford began its Rodin collection before 1974. The first gift was the wax *Head of Mrs. Russell* from Mr. and Mrs. William Janss in 1968, given in honor of my joining the faculty that year. In 1970 Cantor made his first donation, *Flying Figure*. Cyril Magnin gave the beautiful old cast of the bust of Victor Hugo in 1971. A good friend of the museum was the late Charles Feingarten, this country's most important Rodin dealer in the 1970s, who encouraged clients such as Janss and Magnin to donate to Stanford and from whom Cantor also acquired important Rodins. His widow, Gail Wiley Feingarten, a Stanford alumna, gave us the profile portrait of Rodin by John Tweed (1869–1933; fig. 6). Funds from the William R. Rubin Foundation were used in 1974 to purchase the three great moonlit photographs of Rodin's

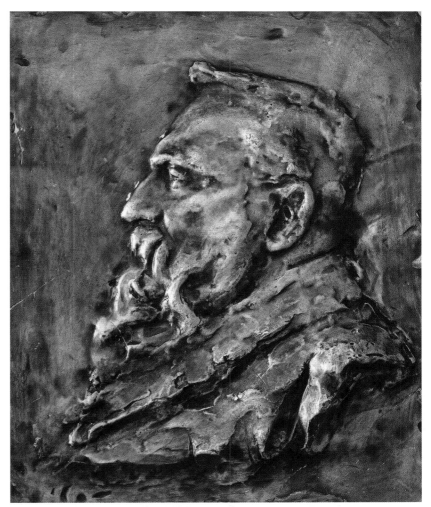

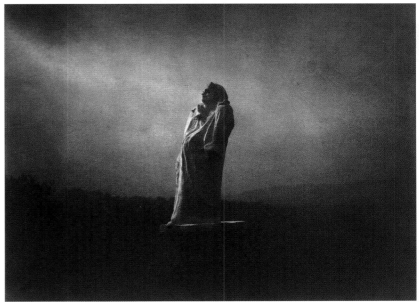

Balzac by Edward Steichen (1879–1973; figs. 7, 333–34). Far from discouraging gifts of Rodin's art by others, Cantor encouraged additional donors. The day the *New York Times* announced Cantor's 1974 gift of sculptures, for example, Madame Lascelle de Basily, the owner of two glazed porcelain reliefs, *Springtime* and *Composition with Putti*, stored for years in the Hoover Institution, read the story, changed her mind about giving them to a friend, and donated them to our collection instead.

One afternoon in 1972 an elderly woman came to the museum with a small box. In it was a beautiful old cast of *Head of Hanako*. It had belonged to the visitor's companion, who had just died, and the sculpture was lent to Stanford for safekeeping. A few years later it was given in honor of Alice F. Schott because the museum's growing collection "looked like the right home for it." In 1982 a grant from John K. and Josephine Pike, Stanford alumni, and the Fluor Foundation made it possible to publish the first edition of *The Rodin Journal*. From the Ahmanson Trust came the important *Torso of a Young Woman* in 1981. Three years later Dr. and Mrs. Harold Torbert gave *Small Torso*. The Rodin sculptures, prints, old photographs, and drawing given by my former wife and me were in large part expressions of gratitude to Iris and Bernie Cantor.

NOTES

1. Much of the information in this essay is derived from a formal interview with B. Gerald Cantor conducted by the author on August 20, 1987, the text of which was given to the Archives of American Art. The Brooklyn Museum, of which Iris Cantor is a trustee, received 58 Rodin sculptures, $3.5 million for a new auditorium, and a $1 million endowment to underwrite scholarly publications devoted to the museum's collections and major special exhibitions.
2. On these gifts, see Levkoff 1994.
3. For ten years *The Thinker* was displayed in museums throughout the United States and Japan before it was installed at Stanford in 1988. The sculpture's itinerary is revealing not only of its international appeal but also of Cantor's concern that it be shown for the first time in cities that had never seen the actual sculpture before. The legacy of exhibition is sustained by the Iris and B. Gerald Cantor Foundation, which in 1998–2000 sponsored *The Thinker*'s exhibition at Rockefeller Center, New York, the White House, and the North Carolina Museum of Art, Raleigh, as well as a monographic exhibition devoted to the sculptor's *Monument to Victor Hugo* and other traveling exhibitions.
4. The French government recognized Cantor's many contributions by making him an officer of the Order of Arts and Letters in 1984 and giving him a plaster cast of Rodin's *Hand of God*.
5. They were *Mask of the Man with the Broken Nose, Glaucus*, and *Prayer*.
6. Iris Cantor coproduced *Rodin's "Gates of Hell,"* which has won numerous awards. Important to Bernie Cantor was the pleasure the documentary film gave Jean Bernard, director of the Fondation Coubertin, and his staff to have this historic and dramatic enterprise so beautifully and accurately recorded. A second film, produced in Japan, documents the casting of *The Gates of Hell* completed in 1994 for the Shizuoka Prefectural Museum of Art.
7. All six burghers were installed together in Memorial Court in June 1998 (see fig. 56).
8. A few days after his appointment as director of the National Gallery of Art in 1969, J. Carter Brown visited my office during the dedication of the Cummings Art Building. Lining the walls he saw hundreds of photographs of Rodin drawings put there by Kirk Varnedoe, who shared the office while working on his dissertation. From that visit, Varnedoe's dissertation became the source of the exhibition *Rodin Drawings, True and False* at the National Gallery and the Solomon R. Guggenheim Museum in 1971–72. Mary Jo McNamara's dissertation was published as the catalogue for a traveling exhibition sponsored by the Cantor Fitzgerald Corporation in 1977, and she defended her paper in the museum amid the studies of *The Burghers*. Another Cantor Fellow was JoAnne Culler Paradise, whose dissertation of 1982 on the critic Gustave Geffroy grew out of her Rodin studies. Rosalyn Frankel Jamison conducted the oral defense of her dissertation on a sunny day in 1986 in front of *The Gates of Hell*. Essays by Cantor Fellows Stephen McGough and Steven Wander appeared in the catalogue *Rodin and Balzac* in 1973. The catalogue of *Rodin Rediscovered* contained contributions by Jamison, Paradise, and Varnedoe as well as Cantor Fellow Daniel Rosenfeld, and the Cantor Rodin Research Fund supported my own planning and research for the exhibition. Cantor provided the funds for a film on Rodin's *Balzac* made by Marilyn Waterman, a Stanford graduate student in the department of communications. The Cantor Fitzgerald Foundation provided subventions for my books *"The Gates of Hell" by Auguste Rodin* (Stanford University Press, 1985), *Rodin's "Thinker" and the Dilemmas of Modern Public Sculpture* (Yale University Press, 1985), and this catalogue.
9. The group was placed in the B. Gerald Cantor Rodin Sculpture Garden in June 1998.
10. In the sculpture garden the two versions of *Fallen Caryatid* exemplify the differences in quality of bronze, fidelity to modeling, chasing, and patina of two famous foundries—Coubertin and Susse—with the Coubertin cast being exemplary. When the cast of *Adam* was first installed in the garden under brilliant sunshine, the poor quality of its painted finish became apparent; Cantor had it repatinated by one of the best *patineurs* in France.

11. At my request his purchase and donation of Octave Mirbeau's book *Le jardin des supplices*, illustrated by Rodin, made possible an exhibition of Rodin's influence on the art of Henri Matisse. Cantor's gift of an early sketch of *Ugolino and His Sons* gave the museum a precious example of Rodin's drawing at the time he began *The Gates of Hell*. The purchase at auction and subsequent donation of many historic photographs of Rodin sculptures (described in the Appendix of this catalogue) allow museum visitors to see how Rodin wanted his art to be viewed.

Introduction

In addition to being a catalogue of a major collection, this book is about the way Rodin thought as an artist and how his artistic mentality was the basis of his modernity. Essential to understanding Rodin's mentality or vision of what sculpture could be are the questions he asked of art, not just the art of others but his own. Having had only the beginnings of a traditional art education in the 1850s, when he became an artist early in the 1860s, he knew nevertheless the theories or premises on which sculpture was based. He learned the rules and, as Pablo Picasso would later point out, that art's power is manifested in their breaking. Having been denied admission to the École des beaux-arts before he was twenty, Rodin spent almost 20 years practicing and testing the old assumptions as he struggled to make a living working for others. Then, in midlife, he began to question these assumptions more extensively and provide powerful alternatives to them. To cite the most important example that mirrors his modernity, when Rodin came to art in the mid-nineteenth century, sculpture was defined in academic texts as the "palpable selective imitation of nature."[1] By the time he died in the early twentieth century, sculpture had been redefined by Rodin's deeds and own words as the art of the "hole and the lump."[2] How did this come about?

The abundant literature on Rodin as a person and as an artist tells us his genius was not evident in his parents. Denied a higher formal artistic education, Rodin became brilliantly self-educated in art's history thanks to print reproductions, libraries, museums, and rail travel around France and Italy, which allowed him to directly confront sculpture from the great periods of Western art. His self-education comprised exposure to greatness in the original, such as extensive visits to the Gothic cathedrals and reading the works of great writers, not commentaries on them, so that his early mentors included Dante, Victor Hugo, and Charles Baudelaire, as well as Michelangelo and Donatello. The liberal and artistically enlightened government of the Third Republic honored him with important commissions and many acquisitions that helped secure his reputation. It gave him the money to try out his alternatives to professional models in stationary, repertorial poses, which led to artistic audacities that were freed from the kind of censorship that plagued the Second Empire. Starting in the 1880s, a constantly growing cohort of gifted and influential critics and writers on art explained Rodin to the art world, defended his daring against waves of negative criticism, and helped him sustain self-confidence after defeats.[3] (Nothing so sustained Rodin's belief in himself, however, as much as work itself.) Through exhibitions in Paris and other European cities, dealers and curators gave the sculptor crucial public exposure. From the 1880s a growing international clientele seconded Rodin's importance by an astonishing number of acquisitions.[4] An international press and photography made it possible for Rodin to be the first artist in history to experience genuine worldwide fame.

Pivotal to our understanding of Rodin's art itself, however, is something not inevitably or totally explained by external influences. I share Ernst Gombrich's view that art is not necessarily related to other developments of a particular era and is neither totally nor consistently the product of social, economic, and political conditions or the spirit of a time.[5] As if anticipating Gombrich, Rodin pointed out, "I know very well that one must fight, for one is often in contradiction to the spirit of the age."[6] Crucial to his art but not the literature on it is Rodin's questioning mentality, which was neither inherited nor acquired in the classroom. It is the core of his genius.[7] More specifically, it is a certain type of question that sets this artist apart from other sculptors of his era.

OPPOSITE PAGE
Fig. 8. Gertrude Käsebier, *Rodin with "Bust of Baron d'Estournelles de Constant"* (A77).

‹ 13 ›

Rodin may not have had a single theoretical cell in his brain, for as he put it, "I understand nothing of theories."[8] He had to learn and know things from personal study and practice, which in turn convinced him that the making of art could not be done or imparted by formulas or "studio recipes." From his early twenties Rodin began to pose the most dangerous questions to the status quo in any field: What if? and Why not? With long-established institutions dogma or doctrine can be offered in answer to the question Why? At the École des beaux-arts in the 1850s, for example, a student might ask, "Why make art?" and be told, "To perpetuate beauty." At the same time a novice studying for the priesthood in the Catholic Church might ask, "Why are we here?" and be given the response, "To know and honor God." But What if? presupposes that the questioner concedes the possibility of an *alternative*. Modern art is rich in examples of how the posing of this interrogatory changed history's course and took painting and sculpture where they had never gone before. Consider the impact of even a few of the questions posed by artists of Rodin's generation: Paul Cézanne, Edgar Degas, and Claude Monet. What if one painted outdoors rather than in the studio and based one's work on sensations of light and color rather than drawing? Why not base art on modern life directly experienced? Suppose there is no subject other than the expressive properties of the elements of art.[9]

"The way in which the artist arrives at his goal is the secret of his own existence. It is the measure of his own vision."[10] Unvoiced by Rodin were the personal characteristics that contributed to the separation of his vision from that of most sculptors of his generation. He showed an unusual aptitude for analysis, fostered by a rigorously inquisitive mind that helped him form his own goals and establish the precedent for modern sculptors to redefine sculpture for themselves. Both traits were seconded by extraordinary talent, skill, and mastery of craft, tenacity, courage in adversity, and stamina—all of which were necessary to achieving his objectives. With the possible exception of Michelangelo, no previous sculptor offered more important alternatives to sculpture as it had been than Rodin. He may not have been the first or alone in posing a certain challenge, but it is the broad and rich spectrum of Rodin's queries that is historically distinctive. Crucial to understanding his way of thinking artistically is knowing what his questions addressed and what were the resulting alternatives.

Nature

If there is a single work or artistic talisman in which Rodin early posed the basic questions and gave the personal answers that guided his art for the rest of his life, it is *Mask of the Man with the Broken Nose* (cat. no. 125). With one of his earliest sculptures Rodin had begun to ask, What if, instead of looking at nature in terms of art, one looked at art in terms of nature? Why not trust in instinct rather than idealism? Having been taught modeling at the École impériale de dessin (or Petite école) by copying reliefs and working from a few prescribed views of the model, Rodin's early portrait of his father, Jean-Baptiste Rodin (cat. no. 123), shows that he had asked himself, Why not study the subject in the round, in terms of its successive contours when viewed from all angles? He extended this query to the full-scale figure in *The Age of Bronze* (cat. nos. 1–3). The results of what came to be known as his profile method of modeling convinced him that this was the way to bring art closer to life. His ethic of what constituted both truth and the well-made in sculpture early came to be based on what he called *le model*é, which he understood as the exact fitting together and interaction of planes seen from all angles. Also established was a new democratizing of the human body for art. Rodin asked and successfully answered the question, What happens if we do not restrict our focus to the front of the human body but make sculptures that have no front or back? Witness *Fallen Caryatid* (cat. nos. 56–57). With that attitude Rodin was to show that it was possible to make a back or hand as expressive as a face.

Broadening Beauty

The choice of a broken-faced model rendered with a pathologist's accuracy was Rodin's challenge to the selective imitation of nature or conventional notions of beauty, as he made no attempt to cosmetically improve his model. Effectively he had asked, What if there was no such thing as ugliness in nature, only bad sculpture? What if beauty in sculpture was a matter of good modeling rather than beautiful models. Why not go against convention and dare to be ugly? Hence *Old Woman* (cat. no. 51).

When he could afford it, as when he received the commission for *The Gates of Hell* (cat. no. 37), Rodin asked, What if one does not work from professional models in traditional art poses but lets unprofessional, naked mod-

els move freely about the studio, watched by the artist for a particularly spontaneous, expressive movement or natural attitude? The figures in *The Gates of Hell* are unthinkable without this practice. Countless Rodin figures without historical postural precedent, such as *Despair* and *The Martyr* (cat. nos. 69–73), resulted.

Movement and Gravity

And then there was the subject of movement itself. To Rodin the concern of his contemporaries for sculptural stability produced work that appeared to suffer from inertia. Analyzing figural movement, he concluded that it consisted of a changing equilibrium between volumes and that there was "a central point around which the volumes are placed and expand."[11] Instead of conceiving a figure from the feet upward, Rodin asked, What if one began with and made the torso the pivot of movement and of the whole figure? Hence *Torso of a Man* and *The Walking Man* (cat. nos. 173–74). What if, instead of showing a subject at the end of a movement that often made a figure seem static, one showed in the same sculpture a succession or summary of movements? But how to convey a sense of a fluidity in a body that was actually a static object? Rodin answered with the alternative to anatomical correctness by proposing the new notion of what was artistically correct or what looked right. The École insisted that to maintain a sense of stability in a moving figure the head had to be plumb, or vertically aligned with the weight-bearing leg. Rodin countered with, What if the head is aligned with the interval between the legs, and so *Saint John the Baptist Preaching* (1878; fig. 446). Meditating on how a figure in sculpture was expected to adhere to the pull of the earth, Rodin came to ask, What if the figures could be as free of gravity in sculpture as they are in painting? How else to explain *Spirit of Eternal Repose* (cat. nos. 98–100) and *Half-Length Torso of a Woman* (cat. no. 74)? It was while working on *The Gates of Hell* that Rodin may have pondered the tyranny of gravity over sculpture, leading to a self-interrogatory, What if I change the orientation of a well-made figure without adjusting anatomy in its new relation to gravity? *The Falling Man* (cat. no. 64) in three orientations, *The Martyr* (cat. nos. 72–73), and other figures from *The Gates of Hell* were the answer. Rodin had discovered that exactitude was not artistic truth.

Continuous Drawing

One of Rodin's most important innovations, continuous drawing, involved his quest to render human movement in art more faithfully and resulted from questioning the limits of drawing as they had been taught to him. He had been instructed to memorize movements, noting the position of the figure's flexible joints in space, to draw with his finger in the air the outline of a distant, moving person. He came awake to what every artist who draws from the model has always known: After looking at the subject, the artist must look down to draw on paper, thereby breaking visual contact with the subject. To maintain direct contact with what inspired him, in the mid-1890s Rodin asked himself, Why not draw continuously on the paper while not taking one's eyes off the moving model? What if the proportions are wrong? The contours will be right, and the artist will have won a new intimacy with his model and drawing. The same method was adapted for sculpture in his series of dance movements (cat. nos. 171–72).

Mixing Genders

Rodin's liberation from gravity's tyranny over sculpture was accompanied by his liberation from gender consistency in a single figure. Rodin was not the first artist to be unbound by the dictum of making a single sculpture from a single model. Where he departed from his predecessors, going back to the celebrated Greek artist Xeuxis who chose the best parts from models of the same gender for a painting, was his proposition that if the best available parts for a sculpture are not of the same sex, why not use them anyway? As with other aspects of anatomical correctness, Rodin insisted that what counted was that which seemed to make sense visually, or what he chose to call the "decorative" in, say, his *Aesculapius* (cat. no. 169) and *Orpheus* (cat. no. 96) or *Meditation* (cat. nos. 61–62). Just as Rodin democratized the notion of beauty, so too did he enlarge the range of anatomical probability in sculpture.

Cubism

And then there was Rodin's "cubism." With the lesson of his abbreviated academic background and the need for

discipline in mind, Rodin was concerned about how to control the flood of spontaneous movements he sought for sculpture without diminishing the appearance of being natural. What if one imagined the evolving figure within a transparent cube?[12] That would prevent forms and gestures from flying off into space. In single figures like *The Thinker* (cat. no. 38) and *Balzac* (cat. no. 112) or groups like *The Burghers of Calais*, the imagined cube became Rodin's compositional coordinate system. Whether or not his figures achieved harmony within the cube, rather than by mutuality or intertwining of limbs, became Rodin's criterion of success. The sculptor concluded, "It is the rightness of the cube, not appearances, that is the mistress of things."[13] In many of his small compositions, especially those in which figures having disparate origins were joined, Rodin showed how to achieve more dynamic compositions. The unorthodox pairing of figures after *The Kiss* (cat. nos. 48–49) presupposed his view that in composing why not just rely on good modeling of the figures and on a fruitful friction caused by their points of contact as in *Avarice and Lust* (cat. nos. 66–67), *The Three Shades* (cat. nos. 43–44), and *Triton and Siren* (cat. no. 149)?

Questioning the Unquestionable: Art as a Continuum

It is a trait of genius to question the unquestionable by seeing beginnings where others see only conclusions. Rodin reasoned, if "nothing is arrested or finished in nature," what if one discarded the notion of a finished work of art? As false to Rodin as the public's expectation for finish was its demand for elegance and perfection. He countered that what was important was for the sculptor to achieve "solidity" and "life" through the right relationships of his planes.[14] If not finish, why not sculptural completeness to interrupt, if not halt, work on a sculpture? As it did for Picasso, to finish meant death to Rodin. Even before the painter, the sculptor effectively asked, Why not open art to the artist's processes of thought and give more time for the purely intuitive? Why not consider a sculpture as only a possibility, a stage, something to continually change as the artist changes. Hence the many studies over the years for the *Monument to Honoré de Balzac* (cat. nos. 102–12) and the *Bust of Georges Clemenceau* (cat. no. 145) and the presence of so many anatomically unaccountable touches in his other portraits, especially that of *Baudelaire* (cat. no. 101).

As Rodin always felt the need for more time to reflect on his work, he also asked, Why not consider the salon and art gallery as extensions of the studio, in which works still in progress would be shown? Rejecting perfection as well as finish, he posed and answered a question of great importance to younger sculptors like Henri Matisse: What if the étude were given the status of a finished sculpture and exhibited? Genius often loves frugality, and Rodin did not let a good sculptural idea go to waste, as when he tried the *Mask of the Man with the Broken Nose* on entire figures and used the same basic face for three of his burghers of Calais.[15]

Rodin's lifelong interrogations of art, in sum, caused him to successfully challenge the very foundations of nineteenth-century sculpture. Denied was the proposition that art could be transmitted by theory; truth and beauty were relativized; the concepts of finish and perfection were rejected. Additionally he upset expectations about decorum in the conduct of the artist with his work and sculpture's very subject. On many levels Rodin made public what previously had been considered private. Instance the way he demystified the artist's studio for the public. Being a natural teacher, not only did he encourage thousands of visitors, including writers, to his studio, but he was the first artist to ask questions about the potential of photography for educating the public about art: What if by means of photography the public could see the hard work of art, the phases a sculpture goes through in its making, the changes an artist must make. And for himself, What if one used photographs, not just for publicity but as part of the creative process, analogous to a plaster study or as a stage in the sculpture's creation, even drawing ideas on the print?[16]

Rodin's liberal views on changing notions of human privacy extended to questions about how to personalize his art. In assessing the shortcomings of his earlier work, by the 1890s he had decided that while it was "adroit," it was "too thin and dry." He knew what was missing and in effect asked himself, What if I put more of myself, my temperament and feelings, into my art? To do this, and to be modern, what if he exaggerated or amplified forms and sacrificed the detail to "general geometry" or to win "the great line," as epitomized in the *Balzac*?[17] To personalize his art, he also explored art as a continuum with life. And in his themes he chose to explore his own deep interest in the mysteries of artistic creation. He focused on the subject of creation in multiple ways: depicting creation themes from religion and mythology, producing many portraits of and

monuments to history's great artists, writers, and thinkers, and investigating his own creative process in terms of his most private emotions and sexuality.

Modernizing the Monument

By 1880 Rodin had set his thematic life course. For this tireless inquisitor it was logical to ask, What if sculptural form were given not to the rendering of heroes and heroines but to humanity's fears and frustrations, the internal lives and hidden conflicts of ordinary people as they manifest themselves in the naked body? Why not make his own and others' passionate natures and sexuality more explicitly sculpture's subject? Thereby *The Gates of Hell*. Rodin's originality as an artist nowhere expressed itself more dramatically than in the results of his rethinking of the public monument. *The Gates of Hell* was a government commission, and Rodin saw it as a monument to art and artists inasmuch as the portal was originally intended to front a museum of decorative art. Nowhere in earlier history had an artist taken as big a gamble with his career as did Rodin on this work. As he began the work as an illustration of Dante's *Divine Comedy* in the format of Lorenzo Ghiberti's doors for the Baptistery in Florence, Rodin early asked himself, Was he an illustrator who wanted to perpetuate the Italian Renaissance idea of how to relate sculpture and architecture? Probably within a year of its beginning he had answered no to both questions. But he had alternatives. What if, instead of illustrating a medieval poem in a Renaissance format, he relied on his experience as an artist and personal observations of modern life? If great French writers like Hugo and Baudelaire working in Paris had modernized the *Inferno* in literature, why could he not do the same in sculpture? Instead of providing a literary base to which the public had access to fathom meaning in the portal, Rodin asked himself, What if one looked to literature as a source of inspiration rather than as a subject for illustration? In questioning the relationship of sculpture to literature and symbolism and building on what he had learned about the expressiveness of the human body, the sculptor had to define for himself how meaning is instilled in sculpture: How does a sculptor create, preserve, and enhance the poetic in sculpture? He proposed to avoid applied symbols and asked, Why not let meaning emerge with the modeling? Why not a name or names instead of a title and make meaning more open-ended,

leaving it to viewers to interpret *The Gates of Hell* on the basis of their experience with life and art?

While working for 20 years to complete *The Gates*, Rodin developed other fundamental and alternative premises about making art, which are crucial to the artistic freedom of modern artists. Instead of working from words and drawn blueprints for the portal at the outset and using narrative forms throughout, he asked, What if one improvised by working from the self in terms of one's own experience of life and culture and responding intuitively to the thematic and formal demands of the portal as it *evolved*? Instead of continuing the Renaissance and beaux-arts tradition of making architectural sculpture, Rodin asked, Why not make sculptural architecture? In his years of thinking about *The Gates of Hell*, Rodin had to determine how to give artistic order to the subject of chaos. His answer was unprecedented: What if one judges the result not by finished details and traditional harmonies but on the basis of its overall *decorative* effect when seen over time in daylight? This was tantamount to insisting that instead of reading a composition like an illustrated novel or just studying its parts, one should step back and survey the whole work of art abstractly in terms of its form. Such a perspective would answer questions about why the empty spaces were there, why moldings were interrupted, why a consistent graduated sizing of figures was not observed, why *The Three Shades* are above *The Thinker*, and so on.

Rodin was well aware that in his day the monument to heroes was losing credibility as audiences became more sophisticated. What was needed to restore authority in the public monument? And what if a monument was designed for a very specific site where the hero lived and worked? What if we modernize the concept of heroism and patriotic devotion and show the cost of human sacrifice? To make heroes of the past seem to be literally among the living, what if we do away with the pedestal and put the burghers among the paving stones where they offered to die for Calais? Thus *The Burghers of Calais*. What if, instead of posing for posterity and the crowd, the subject was shown alone and unselfconscious, in a situation or attitude that tells us why he was important? So *Jules Bastien-Lepage* and *Claude Lorrain* (cat. nos. 91–95). Put another way, What if the private aspect of a public figure was shown? Hence Balzac in his dressing gown (see cat. no. 103). How do we celebrate genius? What if we commemorate a great writer not through his body but by the life of his brain? So *Baudelaire*. Why not truly humanize

and further modernize the muse and show her sharing the artist's suffering and sexuality? Thus *The Tragic Muse (without Her Left Arm)* (1890–96) in the first *Monument to Victor Hugo* and *Iris, Messenger of the Gods* (cat. no. 185) in the second. Despite the originality of his questions and daring responses, Rodin's work did not stem the tide of banality in French monuments during his lifetime, but he earned the admiration of younger, venturesome artists such as Constantin Brancusi and Jacques Lipchitz.

Public monuments seen from a distance and in all kinds of light and weather prompted Rodin's powerful responses to the questions of how to make the gestures of the subjects carry over distances, how to avoid the cold silhouettes of conventional monuments, and by what means to prevent a totally black silhouette when the statue was seen against the sky. In answer to the first Rodin said, in effect, why not exaggerate the proportions of the extremities such as the hands and feet of the burghers and Balzac's face. To the second, he proposed fashioning surfaces—by the hole and the lump—that interacted with light and atmosphere around the burghers' draped forms. To the third, Rodin offered a simplification of big planes and avoidance of deep holes to preserve a range of moderate values as in the robed body of Balzac.

Surfaces

Renowned in his lifetime for the emotional and psychological profundity of his subjects, Rodin's greatest artistic distinctiveness may still reside in his surfaces. When nineteenth-century beaux-arts students came to sculpture, they were taught to make smooth surfaces that would be independent of light; hence the sculpture would be protected against accidental effects. Rodin questioned why, instead of seeing life's surfaces as flat, young artists were not taught to develop a sense of forms in terms of thickness or depth and, just as important, why should not the sculptor also incorporate light in his thinking and fashioning of surfaces so that they would appear to have a pulse or be in the process of becoming rather than being frozen? The figure would seem thus to be more animated and partake of atmosphere. For his major public commissions until the *Monument to Balzac*, Rodin accorded his figures the equivalent of a "salon finish." In his smaller sculptures by the end of the 1880s, Rodin was showing the answers to what would be the effect if the exposed touch of the artist were left intact, as in *Flying Figure* (cat. nos. 183–84). And when he enlarged uncommissioned figures to life-size and for the outdoors, the smooth yielded to the rough, the marks of making remained, as in *Meditation.*

Partial Figures and Outdoor Sculpture

It was not only to the monument that Rodin sought to restore credibility but to sculpture itself. Along with contemporaries like Cézanne, he was pondering what was essential to a work of art. Both painter and sculptor deduced that art was a matter of planes in proper relationships, and for the latter, seen from all directions. To the question of what sculpture could do without to regain the power and poetry smothered by academic teaching and salon standards, Rodin showed in private and public his alternative, which could be paraphrased, What if, in addition to titles, costumes, and props, we were to eliminate parts of the human body that distracted from those areas having the most expressive and beautiful movement? So *The Walking Man* and *Flying Figure.* What if by subtracting heads and limbs and physical movement, we focus just on the beauties of modeling and light's passage on the surface? *Torso of a Young Woman* (cat. no. 177). What if, instead of vigorous physical movement as a subject, all that is needed is a well-modeled sculpture interacting with the movement of light on the surface of a stationary figure just being? Thus *Prayer* (cat. no. 80). Rodin had studied outdoor sculpture that met contemporary standards of finish and had seen how strong light on their surfaces tended to flatten them. What if, to hold the curvature of the modeled plane against the disintegrating or flattening action of light, the surfaces were roughened, the casting seams and the shadows they cast were kept in preference to cosmetic attractiveness? So *Cybele* (cat. no. 186).

Conservatism

Consider now those assumptions about sculpture he did not question, or Rodin's conservatism. First, foremost, and always that the unclothed human figure—"nature" or "life" as he also referred to it—was to be his exclusive focus, in which as a source of inspiration he had "absolute faith." No priest was more demanding than

Rodin, who told the young, "Nature must be your only goddess," for nature "is never ugly." If at the end of his life Rodin, like the priests of his youth, had been asked why artists were put on earth, he might have replied, "To know and honor nature." Second, the great tradition of art was something from which to learn and draw new inspiration. "Love devotedly the masters who preceded you. Take care, however, to not imitate your elders. Respect tradition but know how to discern that which includes the eternally fertile: the love of Nature and sincerity." Third, mastery of and passion for métier, or craft writ large, were essential ("Love your mission passionately"), and the patient worker who loved his craft was Rodin's ideal: "Work with tenacity . . . don't count on inspiration, it doesn't exist . . . accomplish your task like honest workers."[18]

When Rodin spoke of the artist's mission, it included the practice of working for others. He was mindful how in the past and in his own day sponsorship by private individuals, organizations, and the government gave the artist the place and occasion to do great things. He did not question the importance of commissions, and as for public art, he queried only the forms it could take and how to make it thematically credible to a modern audience. With his more conservative colleagues, Rodin believed in the principle that art in public should educate, elevate, and delight the people. Where he often differed from his peers was in how and what kind of art should do these things. He agreed that public art contributed to shaping the nation's mentality, morality, and taste, and he took pride that his eventual international fame brought glory to sculpture and France.

Rodin never questioned the primacy of stone and bronze as the artist's materials of choice because of their long history, strength, and beauty. Nor did he question nineteenth-century studio practice and its division of labor by which the artist had artisans translate his work into plaster and then into carved and cast sculptures. Testifying at a customs hearing in 1913 on the dutiability of a bronze head of Balzac, Rodin affirmed his view that foundry work was for technicians, "as that is not the work of a sculptor in our days."[19]

NOTES

1. Charles Blanc, *Grammaire des arts du dessin* (Paris: Laurens, 1880), 329.
2. The phrase comes from Rodin's defense of his *Monument to Balzac*, "my principle is to imitate not only form but also life. I search in nature for this life and amplify it by exaggerating the holes and lumps . . ." *Le Journal* (Paris), 12 May 1898.
3. Ruth Butler (1980) provides an excellent anthology of critical writings.
4. No one has better written about this weave of aspects influencing Rodin's career, reputation, and personal life than Ruth Butler (1993).
5. See the discussion in Grace Glueck, "Erudite Simplifications of Art's Complexities," *New York Times*, 23 February 1989.
6. Dujardin-Beaumetz in Elsen 1965a, 179.
7. During Rodin's lifetime the best attempt to analyze his way of thinking about art may have been the articles by Camille Mauclair, especially "L'art de M. Auguste Rodin" (1898) and "Notes sur la technique et le symbolisme de M. Auguste Rodin" (1905b). Criticizing traditional art history as too limited and for not showing Rodin's relevance to a broader realm of ideas, Rainer Crone in his essay "Trauma of the Divine" (in Crone and Salzmann 1992, 9–34) sought to fathom the nature of Rodin's genius by citing Nietzsche's views on the subject. The result is disappointing: not once is Rodin's questioning mentality mentioned. Instead Crone cites Nietzsche's conception of genius: "The Genius in work and deed is necessarily a squanderer: that he squanders himself, that is his greatness." The problem with Crone's approach is that he knows more about Nietzsche than Rodin. The essay "The Many Lives of a Rodin Sculpture," which follows in the current volume, indicates how in the studio Rodin sought not to squander himself as an artist. It is Crone's view, influenced by Nietzsche, that "Pity is that sentiment that must be cast off by the genius" (21). Perhaps, but Crone's problem includes the fact that Rodin was not Nietzsche. As many of Rodin's contemporaries observed, *The Gates of Hell* provides a compassionate view of humanity's fate.
8. Mauclair 1905b, 208.
9. I am distinguishing between basic conceptual questions about what art might be as opposed to what might be called procedural or technical ones. With regard to the latter, it is a given that every artist while at work asks such questions as, What if I use this color? What if I thicken or darken that surface? What if I add weight to or lighten this part of the composition?
10. Lawton 1906, 161.
11. Cladel 1917, 56.
12. Mauclair 1905b, 208.
13. Ibid.
14. Mauclair 1918, 58.
15. Hughes 1990, 131. Hughes uses the term *autophagy* for Rodin's "cannibalizing, part by part, of his own images in numerous variations, a self-reflexive mode of invention that one associates more with Picasso than anyone earlier."
16. This is discussed at greater length in Elsen 1980.
17. Mauclair 1905b, 206.
18. Translated from Rodin's "Testament," reproduced in Descharnes and Chabrun 1967, 8.
19. "Rodin's Mask of Balzac Dutiable as Metal," *Daily Mail*, 29 June 1913.

The Many Lives of a Rodin Sculpture

Except for his more than 8,000 drawings, some small paintings, several prints, and a number of unique terra-cotta sculptures, we know Rodin's art in reproduction in thousands of plasters and bronzes. This condition has been true historically for all who modeled first in wax or clay before having others cast their work in metal or having assistants carve their work in stone. Only earlier sculptors who did their own casting, as Benvenuto Cellini did, or who carved their work directly in wood or stone, as Donatello and Michelangelo did, produced unique sculptures. By the nineteenth century most sculptors, with the exception of Antoine-Louis Barye who ran his own foundry for a time, relied on a division of labor and had their plasters cast in bronze or carved in stone by specialists.

Rodin's impressive productivity depended not only on his great energy but on the commercial laws of supply and demand resulting from an expanding international clientele for bronze and marble sculptures and on a large pool of skilled artisans and artists to assist him.[1] Rodin's creativity was his own, but his means of production were mostly inherited from predecessors like Jean-Baptiste Carpeaux and Albert-Ernest Carrier-Belleuse. It is worth tracking the lives of a Rodin sculpture to understand how he was so prolific, meeting the demands of commissioners and collectors from the world over while husbanding time to be creative.

Rodin's sculptures began in clay and, if not life-size or portraits, were often small enough not to require an armature. They were not made from drawings. It was Rodin's custom to leave a work in clay for long periods, relying on skilled assistants such as his model, lifelong assistant, and mistress Rose Beuret (1844–1917) to keep the wrapping cloths humid so that the clay would not dry out, crack, and break. Often Rodin would interrupt his work to go on trips of many weeks or months, and his letters to Rose included queries about conditions of his clay sculptures. While in London on 1 June 1886, he wrote, "My work is in your hands. Do not moisten [the damp cloths] too much and test with your finger." Shortly thereafter and obviously upset by Rose's reply, he sent a second letter: "I do not understand that you let the model moisten [the cloths] when I have given you that task. I do not want the model when she comes to the studio to look at the works in clay every day."[2]

Rodin loved to work in the heat of feeling, but he also loved to study his work in clay over time. One of the best eyewitness accounts of his working procedure came from Paul Gsell.

In his studio on the rue de l'Université, we often saw naked women and men who walked around him. He paid them to live and move before his eyes. If he caught one of them in a pose that struck him, he asked the model to stop walking and quickly he fashioned a small sculpture in clay. He thus executed a great number of études. Then he chose those that pleased him the most for enlargement. . . . Rodin worked very quickly. His hands were extraordinarily large with strong short fingers. He kneaded the clay with a fury, rolling it in balls or cylinders, using in turn the palm and the nails, playing on the clay like a piano, making it shudder under the small bones of his fingers; sometimes brutal, sometimes caressing, twisting in a single effort a leg, an arm, or lightly stroking the swelling of a lip. . . . When the fury of a sketch charmed him, he refused to work on it anymore. He savored the verve of the quick execution where without any weakness the unity of feeling ruled all the details of

a figure. And he feared dulling his idea by more careful work. If he saw in restudying a figure that a part came out badly and compromised the significance of the rest, he broke it off without scruple and the statue lost an arm or a leg. . . . He abandoned a work, leaving it to rest for a time. He began a new one. He continued with a third. In the studio he always had a large number of works in process, and he moved from one to the other according to his humor. Certain figures, certain groups, ripened if one can call it that. Others were never finished. Clients were impatient, but he couldn't care less.[3]

A second such account came from the Austrian writer Stefan Zweig, who as a young man visited Rodin and later recalled the event. After lunch the sculptor took him to the studio.

The master led me to a socle on which was concealed under damp cloths his last work, a portrait of a woman. He removed the cloths with his hands, heavy and wrinkled like a peasant's, and stepped back. It drew from me an involuntary "Admirable!" and I immediately blushed at this banality. But with his objective tranquillity, in which one could not find a grain of vanity, he murmured while contemplating his own work, "Is it not!" Then he hesitated: "Only there, the shoulder . . . one moment!" He removed his jacket, put on a white blouse, seized a spatula and with a magisterial touch smoothed the tender skin of the shoulder that seemed to live and breath. He stepped back again, "And then, there" he murmured. The effect was intensified anew by his slightest touch. Then he spoke no more. He advanced and retreated, considered the figure in a mirror, uttered groans and other inarticulate sounds, changed, corrected. His eyes that at the dinner table wandered distractedly and were filled with amiability now projected a singular glimmer. He seemed to have become larger and rejuvenated. He worked and worked and worked with all the passion and strength of his powerful and heavy body; each time that he stepped forward and brusquely retreated the floor boards cracked. But he did not hear it. . . . A quarter of an hour passed thusly, a half hour. . . . Rodin was so absorbed . . . in his work that a thunder clap would not have awakened him.

He worked more and more quickly. Then his hands became more hesitant. They seemed to have recognized that there was nothing more for them to do. Once, twice, three times he drew back, without changing anything. Then he murmured something in his beard, delicately replaced the cloths around the figure the way one slips a shawl around the shoulders of a woman he loves.[4]

When he could find no more to add or subtract from a clay sculpture, he would then have one of his assistants, such as Dieudonné or Eugène Guioché, father and son who specialized in moldmaking, make a mold of it, from which several plaster casts would then be made. The clay itself, particularly if small or at the beginning of a major effort, might be baked into a terra-cotta, thereby preserving it as a permanent record. We know from the artist's files that these terra-cottas were sometimes used for enlargements. On 12 May 1912, for instance, an enlarger named Anciaux von Elsberg billed Rodin 160 francs for "a crouching woman—modeled in terra-cotta, enlarged to twice its original size."[5] Rodin's assistants, particularly those who worked in stone, seem to have preferred working from plasters rather than the unique terra-cottas, which contracted as a result of dehydration during the baking. When Rodin was finished with a clay sculpture, especially a large figure, and did not have it baked into terra-cotta because of its size and the metal armature inside, it would then be destroyed. In the instance of a large sculpture that had been cast in plaster, such as the life-size clay figure of Claude Lorrain which Rodin left in his Nancy studio, it would be referred to in studio notes as the "carcass," and destruction included dismantling the metal armature.

The molds that produced the plasters could also be used by Rodin to make additional clay impressions, which were known as *estampages* (stampings). A fresh clay impression allowed Rodin to continue modeling without further fatiguing his original material, and as in the case of portrait studies, like those of Clemenceau, they allowed him to assay different expressions or facial adjustments. The value of making new clay casts from the plasters was explained by Rodin himself: "It is almost always at the very last moment that I find what I want in a figure or bust, after wandering around in the deepest despair. Sometimes I do not find my idea until the work is cast in plaster, then I reproduce it in clay, and make it as I want it."[6] The making of clay impressions or casts was

a timesaving device for an artist who constantly saw ways of changing what he had done and never considered a work finished. Rodin did not invent this method but learned it probably while working in the studios of his former employer Carrier-Belleuse.

Another use to which the clay impression was put is revealed in a letter to Rodin from one of his carvers, Marcel Jacques. Rodin often gave his carvers (*praticiens*) plaster models that were not totally resolved, and they had to consult with the master if they did not want to exercise their own initiative in interpreting Rodin's intentions. Thus Jacques's comment, "When the model is not very resolved, I believe that the best means to help you would be to retake an impression of the model in clay; with your indications and [working from] nature, nothing would be easier and one would realize your idea. Then, one would only begin the marble with a well-resolved model: that would not cost much more and you would be completely satisfied."[7] As well as providing the artist the wherewithal to continue his modeling and make alterations, additional clay impressions could be made into terra-cotta editions—popular since the eighteenth century because of their color and low cost—such as his portrait of Albert-Ernest Carrier-Belleuse (cat. no. 84). Thus it was possible to have both clay and terra-cotta versions of a sculpture that were, in fact, reproductions.

Rodin always had numerous plaster casts made of his initial clay sculpture (usually from six to twelve), even if only a figural fragment like an arm. They served myriad purposes beyond replacement of broken casts. Usually more than one of these plasters went into what he termed his *bibliothèque anatomique* (anatomical library) as a record for later study of what he had done or for other future uses, according to René Chéruy, Rodin's secretary from 1902 to 1908, who left many notes that he intended for a book on Rodin.[8] Rodin's anatomical library grew to be his world-famous personal museum of about 7,000 plaster casts at Meudon, where he lived just outside Paris (fig. 10).[9]

Today's public does not generally consider Rodin's plasters as final or "finished." Plasters are thought of as a kind of limbo, something far less attractive than a bronze and a nuisance because of their susceptibility to breakage and dust. While he did have a disparaging word to say about plasters on occasion, Rodin thought of his plasters as works of art as shown by the fact that he exhibited, sold, and gave them away: "Rodin had no superstition (or preference) for either bronze or marble. He was only

Fig. 10. Contents of drawer from Rodin's studio containing 28 plaster fragments including a torso, arms, legs, feet, hands. Musée Rodin, Paris, S710-36.

interested in the form and modeling. He preferred the plasters, and in his 'museum' he took care to only keep there fresh casts, which, of course, caused him considerable expense. (Rodin employed three moldmakers at all times.) His only regret was that the plasters would get dirty and were fragile. He hoped that an unbreakable plaster would be invented."[10]

Most of Rodin's sculptures never got beyond the plaster stage during his lifetime because of his practice for the most part of only bronze-casting or carving on demand. From the edition of plasters Rodin would select one for exhibition, as was the custom in his day, and buyers would then order a bronze cast or stone carving. All dirt would be removed from the exhibition cast. Sometimes a plaster cast would be painted to look like a bronze for purposes of exhibition or study, as when Rodin placed a bronze-painted plaster cast of the large *Thinker* in front of the Panthéon to consider its relation to the building. If, as in the competition for *The Burghers of Calais*, it was a presentation plaster, it might even be polished. When Rodin wanted to give a friendly critic or frequent client a token of his appreciation, it was often in the form of a plaster cast, which might bear a personal inscription. Rodin probably gave away more plaster sculptures than he sold bronzes, which did not hurt his reputation among those in the art world who supported him. The collector Antony Roux was the rare client who demanded his plasters be unique and none others be sold, as with *The Bather* (cat. no. 150), sold in 1888 to

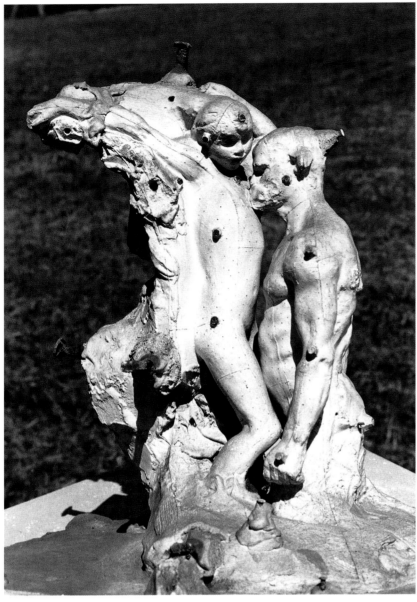

Fig. 11. *Man and His Thought*, 1889, plaster with nails. Musée Rodin, Paris, S618.

His practice of sometimes compensating or rewarding his favored assistants with a plaster, or just leaving a plaster working model in an assistant's studio, caused serious problems after his death, when these sculptures were translated by their owners into bronzes and carvings unauthorized by the French government, which had obtained all reproduction rights in 1916. In 1919 the government brought several artists and a foundry to trial on this basis.[13] The son of a sculptor named Charles Jonchery was found guilty of such abuse, despite the pleas of the defendant and his lawyer that Jonchery's father, who died in 1907, had been given reproduction rights by Rodin in 1904 or 1905.[14] In the same trial it was further revealed that Mathet on certain occasions received two plasters and two marbles for his services. He assumed that the rights of reproduction were his after Rodin's death, and he sold the plasters and their reproduction rights to a dealer named G. Danthon. This man was in turn found guilty of participating in the illegal reproduction of Rodin's sculpture.[15]

A plaster that was to be used for a bronze was sometimes reworked by Rodin, who would use tools to sharpen details lost in the moldmaking. (Stanford's plaster head of a one-eyed, one-eared man [cat. no. 144] shows such marks, although in the absence of the varnish then used often for moldmaking, the plaster seems not to have served for a bronze-casting in Rodin's lifetime.) A bronze foundry such as Leblanc–Barbedienne, with which Rodin entered into a contract in 1898 for open-ended editions of *The Kiss* and *Eternal Spring*, would receive a plaster that in turn might be reduced to a size the editor deemed commercially attractive. Instead of relying on the fragile plaster for future moldmaking, the foundry would make at times an unbreakable iron casting so that numerous molds could then be taken for years afterward.

Plasters that served Rodin's assistants in carving stone might have nails driven into them at certain points, known as *points de repère* (guiding marks), on which the leg of a compass could be placed for measuring purposes (fig. 11). The surface of the plaster would be covered with hundreds of graphite points for the second leg of the compass, thereby assisting the carvers in reckoning distances to be copied in the stone.[16]

When a marble was finally carved from a plaster, Rodin usually had a plaster cast made of the result as a record. (Constantin Brancusi learned this from Rodin.) The process of reproducing the marble usually began by

Roux. The collector wrote to Rodin, "Except Danae, for which you have reserved to yourself the right of reproduction (three in marble with enlargement), all the other compositions remain my exclusive property, it being understood that you will not keep any examples."[11]

At least by 1900 Rodin's plasters had the value of currency, and he so used them. That they were often highly regarded by artists is shown in a letter to Rodin from one of Emile-Antoine Bourdelle's assistants, Nuala O'Donel, who in 1905 wanted work as a carver: "I would be very happy if you permitted me just to keep the plaster that served as my model."[12] According to one of Rodin's former and most skilled assistants, the sculptor and *practicien* Georges Mathet, he did not pay them well.

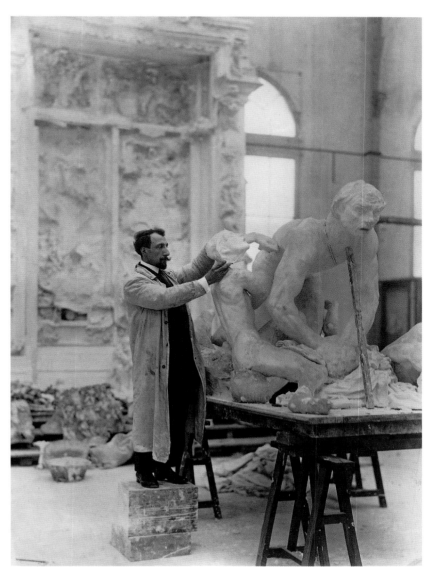

far left: Fig. 12. Three views of sculpture technician Georges Bigel in his Paris studio using a Collas machine to reproduce a sculpture.

Left: Fig. 13. Photographer unknown, plaster expert (*mouleur*) Paul Cruet attaches *The Head of Sorrow* to the enlargement of the Ugolino group at Meudon, c. 1911.

making a mold out of clay as plaster would have adhered to the stone.[17] That this reproductive process was not always a simple matter was shown in a letter from Rodin's *practicien* J. Menque, who warned, "[If] you have the intention of taking a hollow mold of the marble I am about to deliver to you, it would be prudent to mold the weaker part in gelatin, the marble not being solid there."[18] When he was especially pleased with a carving, as in the case of *Illusions Received by the Earth*, Rodin would have its plaster cast in bronze (cat. no. 168). A not-unusual sequence for a Rodin sculpture consisted of eight or nine states: the clay, then a plaster and occasionally a terra-cotta, then possibly a clay enlargement, followed by its casting in plaster, then a bronze or a carving,

and if the latter, then a plaster that in turn would be used to make a bronze.

Rodin used plasters for his own enlarging and reduction. With the introduction in 1836 of Achille Collas's machine it became possible—and common—for artists to have reductions made of their most popular works (fig. 12).[19] There were technicians then (and are still today) who specialized in making smaller versions that were easier to sell.[20] Rodin's contribution seems to have been, after *The Burghers of Calais*, to use the Collas process and technicians like Henri Lebossé (1845–1922) to enlarge new sculptures from less-than-life-size plasters (see fig. 13). In this manner the final *Balzac*, the large *Thinker*, and the larger-than-life-size

Top: Fig. 14. *Small Torso of a Seated Woman*, n.d., plaster, 7½ in. (19 cm). Musée Rodin, Paris, S532.

Above: Fig. 15. *Torso of a Seated Woman*, n.d., enlarged 1907?, plaster. Musée Rodin, Paris.

Whistler's Muse were made by Lebossé in clay. Rodin saw this as a labor-saving device. There were frequent consultations between Rodin and Lebossé about changes that had to be made in the larger clay from the smaller plaster version. On the one hand Rodin had confidence in his own sense of scale, that his modeling could accommodate enlargement (figs. 14–15), and that he could make corrections during the actual enlarging process. But on the other hand he told Chéruy, "The enlargement of a figure also enlarges the errors if they exist. They are invisible to the uninitiated and are visible only to the author . . . I prefer my first version."[21]

How Rodin might deal with the errors in the enlarged plasters was graphically recorded in Ambroise Vollard's account of visiting Rodin's studio: "He had a large saber in his hand. On the studio floor one saw the debris of statues, hands, decapitated heads. . . . Rodin spied one of the statues, the only one that remained intact. . . . He wielded his sword. The head fell. . . . Rodin then held the head in his hands. "How beautiful it is without the body! I will tell you one of my secrets. All these fragments that you see come from enlargements. Now, in an enlargement if certain parts keep their proportions, others are not in scale. But one must know where to cut!"[22] The *membra disjecta*, such as the head Rodin exclaimed over, would be treated as self-sufficient works of art and possibly cast in bronze.

Along with studying them in a mirror, Rodin often had his plasters, as well as clay versions, photographed in the studio (fig. 16). He used mirrors and these photographs for a more detached evaluation of his work. Thanks to a photograph taken in 1887 by Jessie Lipscomb (1861–1952) of Rodin in his studio before *The Gates of Hell*, we can actually see one of the mirrors he used (fig. 17). At times he would draw on the photographs, testing possible changes in the arrangement of hair, drapery, costume, or socle (fig. 18).[23] Thus photographs on which he had drawn became "states" in the evolution of a sculpture. From photographs taken under his direction and surviving examples in the Musée Rodin, we know that Rodin would add clay to his plasters to try out new ideas or improve on the work of his assistants.[24] Rodin would first establish a physical reconnaissance of the sitter in clay and then plaster. After he had established what for him was the "type," he would begin his interpretations. When working on a portrait, such as that of Clemenceau (cat. no. 145), he filed the surfaces of four plaster casts to provide a greater purchase for the addition of clay, which allowed him to alter his interpretation of the subject (fig. 19). If he was satisfied with the additions, a new mold would be taken so that a fresh plaster would make the changes more permanent.[25] Rodin had separate molds made of Clemenceau's features so that he had an inventory of eyes and eyebrows, mustaches and mouths. With this repertory and like an actor using props such as wigs, mustaches, and false eyebrows, Rodin tested minimal featural changes in successive plasters.

Plasters were cheap, abundant, and they crowded his studios, as photographs and eyewitness descriptions tell us. (Edmond de Goncourt likened them to a coral reef.) They were surrogates for live models and encouraged Rodin to continue working when the models themselves had gone. Not only did Rodin think with his hands while modeling clay, but he also thought with the manipulation of his plasters, his own ready-mades. Many of his audaciously paired figures, for example, were not the result of models posing but derived from the sculptor's manipulation of plasters separately made. Their joining, in what is called *marcottage*, depended on the fruitful friction or interaction of surfaces in contact with one another as well as the overall, abstract, aesthetic effect, not psychological or physical probability (see, for example, cat nos. 50, 169; figs. 150, 230, 571).[26] As Rodin put it, "When the figures are well modeled, they approach one another and group themselves by themselves. I copied two figures separately; I brought them together; that sufficed, and these two bodies united made 'Francesca da Rimini and Paolo.'"[27]

Rodin's anatomical library allowed him to invent fig-

Top left: Fig. 16. Harry C. Ellis, *Centauress* (A137)

Top right: Fig. 17. Jessie Lipscomb, *Rodin in the Mirror with "The Gates of Hell" in background*, 1887. Musée Rodin, Paris.

Bottom left: Fig. 18. Victor Pannelier, *"Eustache de Saint-Pierre," in clay*, 1886, albumen print with ink additions. Musée Rodin, Paris.

Bottom right: Fig. 19. *Study for "Portrait of Georges Clemenceau,"* c. 1911-14, plaster and plastilene. Musée Rodin, Meudon, S1730.

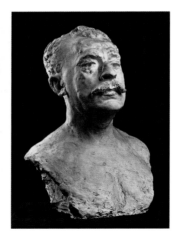

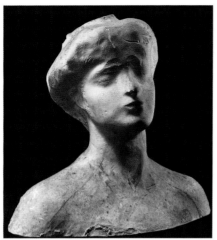

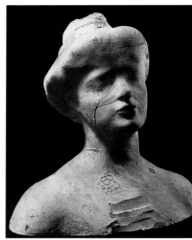

Top left: Fig. 20. *Study for "Portrait of Etienne Clémentel,"* second state, 1915-16, plaster, 22¾ x 24¹⁄₁₆ x 11¹¹⁄₁₆ in. (57.8 x 61.1 x 29.7 cm). Musée Rodin, Paris.

Top right: Fig. 21. *Study for "Portrait of Etienne Clémentel,"* second state, 1915-16, plaster with plaster coating, 21¹¹⁄₁₆ x 14⅝ x 10¹¹⁄₁₆ in. (55.1 x 37.2 x 27.2 cm). Musée Rodin, Paris.

Bottom left; Fig. 22. *Bust of Helene von Nostitz*, 1902(?), plaster, 8¹¹⁄₁₆ x 8¹¹⁄₁₆ x 4¾ in. (22 x 22 x 12 cm). Musée Rodin, Paris, S688.

Bottom right: Fig. 23. *Bust of Helene von Nostitz*, 1902(?), plaster with graphite notations, 8¹¹⁄₁₆ x 8¹¹⁄₁₆ x 4¾ in. (22 x 22 x 12 cm). Musée Rodin, Paris, S689.

small study of Ugolino that he wanted her to ship to him. He instructed that his assistant Paul Frisch was to make a wooden base for the sculpture and that "he whiten it, and if there is a need he will give a coat [*une couche*] to the plaster so that it is even."[28] The practice of dip-casting his plasters offered many advantages besides unifying the surface color and texture of paired figures or of a single figure, such as *The Sphinx* (cat. no. 79). When making studies of a head, such as that for *Saint John the Baptist Preaching* (1878), by dipping a rough plaster sketch, he could get the sense of a more finished appearance. In portraiture, such as that of Etienne Clémentel (figs. 20–21), the process allowed him to modulate previous touches of the clay thereby transforming them from appearing to be warts to facial muscles and giving the subject more resilient skin and hence a more youthful look. As the new coat masked tiny details, it allowed him to foresee what a plaster might look like when carved in marble. In the case of a dipped plaster *Bust of Helene von Nostitz* (figs. 22–23) Rodin produced the effect of a veil covering part of her face.[29]

The various states through which a sculpture might pass had an equivalent in Rodin's drawings, further evidence of his inventive frugality and never considering a work finished. Before about 1890 he might begin with a pencil sketch, then rework it with inks and gouache so that the drawing had become many layered. (His art school teachers had urged him to improve at night drawings made in the daytime.) After 1896 his initial pencil sketch might be traced by the artist holding two sheets of paper up to a window, thus allowing him to give one of the drawings to a friend while retaining the original or copy or to rectify the original by adjusting the figure's placement within the field of the copy. (There are two such tracings on onionskin paper in the Stanford collection [cat. nos. 202–203].) To a pencil-drawn sketch Rodin often added a wash of body color through which he could alter or rectify contours. If the drawing was to be reproduced, a technician, like Auguste Clot, would make a transfer lithograph, or an engraver, like J.-L. Perrichon, would translate it into a

ures, like *Orpheus* (cat. no. 96), in which he showed indifference to consistency of gender. He was also able to vary the position of a figure's arms, like those of *Meditation* (cat. nos. 61–62), without changing her torso. Drawing from his inventory of plasters, Rodin showed no concern for consistency of sizes, so that a life-size adult figure might be joined with a half-life-size one as in *"Shade" with "Meditation"* (see fig. 192).

Usually the plaster figures, such as Stanford's *Ugolino and His Sons* (cat. no. 45), were joined with wax, and sometimes they were given new common surfaces by dipping them in liquid plaster. This technique of providing a plaster with a new coat or skin may have been learned from ceramists in producing glazes, as Anne Pingeot suggested to me, or it may have just developed in earlier nineteenth-century studio practice as a quick and inexpensive way of cleaning plaster casts. It seems Rodin may have been using it as early as 1877, when in a letter to Rose Beuret he referred to a

line cut. On more than 80 occasions, and anticipating Henri Matisse, Rodin used scissors to silhouette a figure drawing in wash, thereby having a third chance to shape its bodily contours. With his cutouts Rodin might make a montage, similar to his *marcottage* of plaster sculptures (fig. 24), in which he joined separately made figures in a new composition.[30]

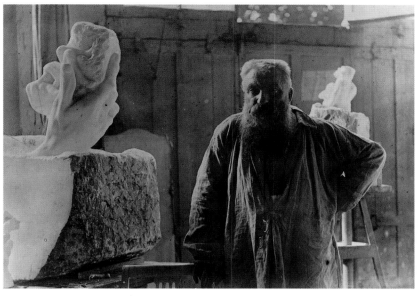

NOTES

1. The reader should find informative Frederic V. Grunfeld's chapter about the manner in which Rodin's atelier was run (Grunfeld 1987, 555–95). Now, see also Antionette Le Normand-Romain, "Rodin's Studio" in *Rodin: A Magnificent Obsession* (London: Merrell, 2001), 27–41.
2. *Rodin 1860–99*, 74, 75.
3. Gsell 1918, 406–8.
4. Stefan Zweig, *Le monde d'hier: Souvenirs d'un europ*éen, trans. J.-P. Zimmerman (Paris: J.-P. Belfond, 1982), 178.
5. Guioché file, Musée Rodin archives.
6. Bartlett 1887–88; and Bartlett in Elsen 1965a, 94.
7. Jacques to Rodin, 7 November 1907, in Jacques file, Musée Rodin archives.
8. Chéruy file, Musée Rodin archives.
9. This was made possible in 1901, when Rodin moved his Paris exhibition pavilion to Meudon next to his home in order to house his collection as much as to serve as a studio. (I owe this statistic to Nicole Barbier of the Musée Rodin.)
10. Chéruy file, Musée Rodin archives.
11. Roux to Rodin, 6 November 1890, in Roux file, Musée Rodin archives.
12. O'Donel file, Musée Rodin archives.
13. A transcript of this trial concerning posthumous carvings is in the Musée Rodin archives. For the testimony of Mathet see Cahier 5.044–7, Musée Rodin archives.
14. Ibid., 32.
15. Cahier 5.044–7, Musée Rodin archives.
16. Some years ago in his zeal to restore a damaged plaster cast of Rodin's life-size *Eve*, which had served as the source of a carved version, the then director of the Maryhill Museum of Art in Goldendale, Washington, did not prevent the equally eager and historically uninformed conservator from removing all the cosmetically unattractive graphite markings. As impressive evidence of his ardor as an educator, Rodin had chosen that cast to go via Loie Fuller to the American collector Sam Hill and his museum to further public understanding of the work of art. On this collection see Jean-Luc Bordeaux, *Rodin: The Maryhill Collection*. Exh. cat. J. Paul Getty Museum. Pullman, Wa.: Washington State University Press, 1976.
17. Grunfeld 1987, 558.
18. Menque to Rodin, 2 October 1904, in Menque file, Musée Rodin archives.
19. For an excellent description of this machine and process,

see Arthur Beale, "A Technical View of Nineteenth-Century Sculpture," in Wasserman 1975, 47–49.
20. See author's "Rodin's 'Perfect Collaborator,' Henri Lebossé" in Elsen 1981, 248–59.
21. Chéruy file, Musée Rodin archives.
22. Ambroise Vollard, *Souvenirs d'un marchand de tableaux* (Paris: Albin Michel, 1937), 233–35.
23. See Elsen 1980, 16–18.
24. See photograph of the Barbey d'Aurevilly bust, all of which was done by an assistant from visual documentation except for the clay additions, in Elsen 1980, pls. 123–24. See Grunfeld 1987, 560–61, for how a young Russian artist named Nicoladze made the bust.
25. It is hoped that the Musée Rodin's inventory of molds at Meudon will tell us more.
26. See Beausire's essay "Le marcottage" in Pingeot 1986, 95–106, and author's "When the Sculptures Were White" in Elsen 1981, 127–50.
27. Dujardin-Beaumetz in Elsen 1965a, 159.
28. *Rodin 1860–99*, 38. Paul Frisch is not to be confused with Victor Frisch, who wrote a fraudulent book on Rodin, in which he claimed to have been the artist's assistant for many years.
29. This method is discussed and illustrated in "When the Sculptures Were White" in Elsen 1981.
30. For further discussion of Rodin's cutouts, see Elsen 1987, 38–39.

Fig. 24. Photographer unknown, *Rodin with "The Hand of God,"* n.d., aristotype. Musée Rodin, Paris.

Casting a Rodin Sculpture

All bronze casts authorized by Rodin and later by his heir, the French government, are authentic and original.[1] There are some purists who argue that only when the sculptor himself has chased or reworked a casting is it authentic.[2] By this standard not a single bronze authorized by Rodin would be authentic, as he did not himself work on the casting and finishing, and he reportedly never set foot in the foundries that worked for him.[3] Rodin believed that foundry work was for artisans and not sculptors like himself.

The public's confusion about which of the 21 casts of the large *Thinker* is the "original," for example, stems from equating original with unique or first. Like lithography and etching, bronze is a reproductive medium, and all works in an authorized edition are original. What was chronologically the first in an edition is not necessarily any better than what came last. When a work is bronze-cast, the final mold is broken to release the metal sculpture inside. What is not destroyed are the plasters from which were made the various molds used in the casting process. These plasters are the property of the Musée Rodin and are usually stored at Meudon. As they could be damaged in the casting process, Rodin always had several made of the same subject.

Without a complete and accurate history of a bronze cast's ownership, its continuous presence in a museum before the artist's death, or its having come from a foundry that worked for Rodin but closed before 1917, such as Griffoul and Lorge, it is usually impossible to tell if a bronze was made during Rodin's lifetime.[4] Before the Musée Rodin had foundries date the casts made for it, they were not so marked. During and after his lifetime, Rodin's signature, A. Rodin, was inscribed in the cast by foundrymen. No question but that the Alexis Rudier foundry, which cast Rodin's work from 1902 until its closing in 1953, produced many of the best casts, but even that fine foundry was not infallible. Lifetime casts of Rodin's work were not of consistently high quality, and the same is true of authorized posthumous castings. The connoisseur of Rodin casts must take them on an individual basis. Judging the quality of casting includes an evaluation of the bronze used; determining its fidelity to the modeling achieved by either sand or lost-wax casting (Rodin preferred the greater precision of the latter but was often forced to settle for the former); examining the chasing or reworking of the raw cast to bring it closer to the plaster from which it was made; and finally considering the patina or color produced by the application of acids to the bronze. In the judgment of this author, to 1995 the finest casts of Rodin's work in terms of consistency, accuracy, and quality have been those made by Jean Bernard, master founder at and president of the Fondation Coubertin (fig. 25). (It was explained to me by a director of the Musée Rodin that Coubertin could not be used exclusively because the government could not be seen to favor a single foundry over others.) In Rodin's lifetime the demands of clients dictated which works were cast in bronze, as the sculptor evidently did not want to maintain an expensive inventory or seem to be keeping a sculpture shop like his contemporary Emmanuel Frémiet and bronze editors like Barbedienne. At least since 1975 the decision as to which Rodin plasters were to be cast has been made by the administration of the Musée Rodin.

The Stanford cast of *The Gates of Hell* (cat. no. 37) was commissioned by the French government from the Fondation Coubertin at the request of B. Gerald Cantor in 1977. He wanted it to be shown in *Rodin Rediscovered* (1981–82), the largest exhibition ever of the artist's work, organized by the author for the National Gallery of

Art. In the period 1978–81 the casting was done by the Fondation Coubertin under the supervision of Bernard (fig. 26).[5] Rodin had made it clear that he wanted the doors cast by the lost-wax method: "For its reproduction in bronze it is an absolute condition that it shall be by the lost-wax process."[6] His reasons were that the lost-wax process gave greater precision and because the surfaces of *The Gates of Hell* were so complex.

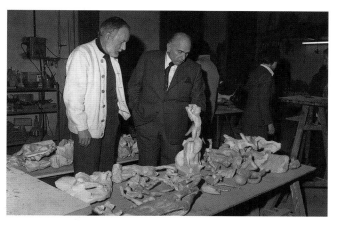

Left: Fig. 25. B. Gerald Cantor with master founder Jean Bernard (left) at the Coubertin Foundry, 1977.

Below: Fig. 26. *The Gates of Hell* in the Coubertin Foundry, 30 January 1981.

The Stanford cast was made in 7 sections, and 92 parts were poured separately and then welded to the portal. Both numbers are smaller than those required for sand castings: 15 sections and more than 120 separate figures. The old foundry-man who supervised the four sand casts for Rudier observed the results of the Coubertin casting with the author in 1981 and pronounced them superior to his own in terms of accuracy and quality. This superiority extends to the higher quality of the bronze, greater fidelity to Rodin's modeling, decreased need for chasing, and superior welding. (Less chasing, according to Bernard, means "less abuse" to the metal.) Unlike the Stanford cast, none of the previous sand casts were patinated; the advantage of patination being a more even coloration over time and less variability with changing light conditions. The earlier cast in the Musée Rodin garden had an interior iron armature that in 1977 disintegrated due to electrolytic action over the years. As

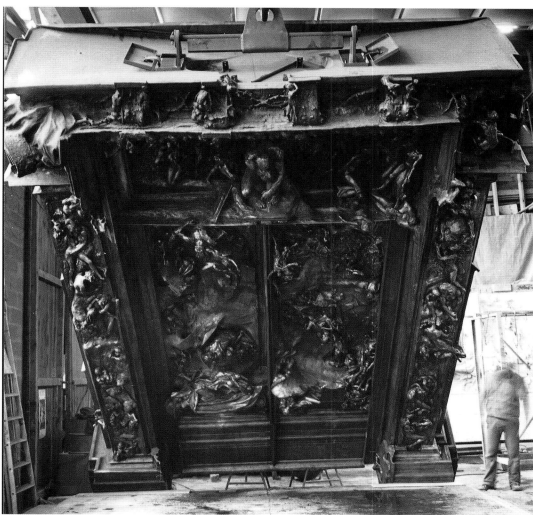

designed by Bernard, the Stanford cast has a bronze and steel armature, and a drainage system to remove water from the roof that in the Musée Rodin cast rusted and damaged *The Thinker* below it. Like all but the Meudon cast, the Stanford *Gates* include the standing nude figure, *The Small Fauness* (fig. 27) on a ledge attached to the upper right molding, just below the lintel and opposite *The Falling Man*. (Indicative of their interest in educating the public, the Cantors commissioned an illustrative record of the stages of the lost-wax casting of *The Small Fauness*; one set is in the Stanford collection [figs. 28–38].)

Fig. 27. Detail of *The Gates of Hell: The Small Fauness*.

BELOW AND OPPOSITE PAGE
Figs. 28-38. Eleven-step lost-wax casting process of *The Small Fauness* from *The Gates of Hell* (A21-31). Descriptions were written by Léonard Gianadda for the catalogue of the 1984 exhibition *Rodin* (see Gassier 1984, 50-55). Bracketed comments are by the author.

Fig. 28. Step 1. The sculptor creates a model, which is generally made of plaster, clay, marble, stone, or wood.

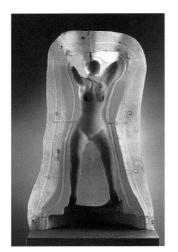

Fig. 29. Step 2. An impression of the model is made in a bed of very fine elastic material (such as latex) supported by a rigid outer mold. The supportive outer layer is designed to withstand the pressure of melted wax running through the mold.

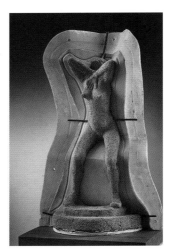

Fig. 30. Step 3. This sharply defined mold is used to create a fireproof clay model, or "core," identical to the artist's original model. [This step is necessary for several reasons but chiefly to make the final casting hollow rather than solid, as the core is scraped out when the bronze has cooled.]

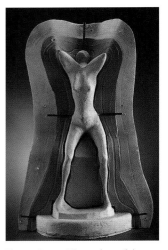

Fig. 31. Step 4. The surface of the clay model core is scraped, reducing it by the desired thickness of the final bronze. [For large sculptures this requires experienced foundry workers who know where to use thicker bronze to enhance the structural integrity of the piece.]

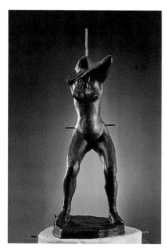

Fig. 32. Step 5. After closing the mold around the clay model, wax is poured into the space between the core and the mold. This stage is crucial in producing a perfect reproduction of the initial sculpture. The result is a wax model, which is finished by hand to restore any lost fidelity to the modeling of the original sculpture and to incorporate the artist's signature, cast number, and foundry seal.

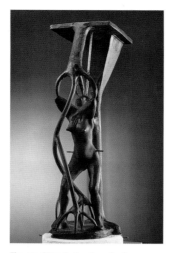

Fig. 33. Step 6. A network of wax conduits, called sprues and gates, are attached to the core model. They will act as channels through which the wax when heated will escape from the mold.

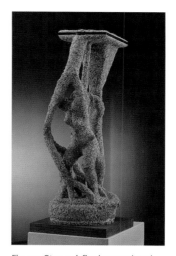

Fig. 34. Step 7. A finely granulated ceramic is gradually applied to the surface of the core model and its conduits until it becomes thick and coarse. The end result is called an investment mold. The mold is then dried and heated; the melted wax now flows through and out of the mold, leaving a space between the fire-resistant clay core and the investment mold. This method of losing the wax is called "the lost-wax process.".

Fig. 35. Step 8. The investment mold is then heated to a high temperature and covered with a coating, which must be completely dry before bronze pouring begins. [For large casting there is often a reinforcement of the mold by metal mesh.]

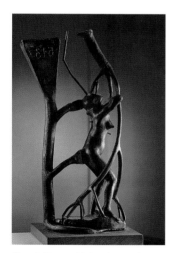

Fig. 36. Step 9. Molten bronze is then poured into the cavity of the mold, filling the spaces left by the wax model. After it has cooled, the mold is broken and the metal appears—the figure and the conduits are an exact reproduction of the wax figure in step 5.

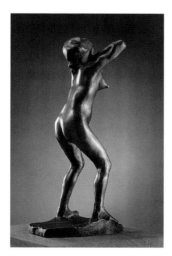

Fig. 37. Step 10. The network of conduits are then cut and the surface reworked so that no trace of them can be seen. This procedure of hand finishing the bronze to perfection is called chasing. Remains of the fireproof clay model core left inside the bronze are now removed.

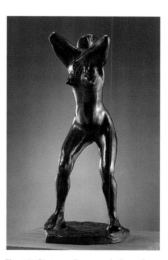

Fig. 38. Step 11. On completion of the chasing, hot or cold oxides are applied with a brush to the surface of the bronze to create a thin layer of corrosion. This layer, which, depending on the oxides used, is usually brown, green, black, or blue in color, is called the patina.

NOTES

1. For a discussion of this subject the reader is encouraged to see Jean Chatelain's essay in Elsen 1981, 275–82. See also Monique Laurent, "Les éditions de bronze du Musée Rodin," in *Rodin et la sculpture contemporaire (Paris: Musée Rodin*, 1982), 13–19 and "Vie posthume d'un fonds d'atelier: les éditions de bronzes du musée Rodin," in *La Sculpture du XIXe siécle, une Mémoire Retrouvée. Les fonds de sculpture* (Rencontres de l'École du Louvre; Paris: La Documentation française, 1986), 245–53.

2. De Caso and Sanders discussed this view (1977, 32) and also referred to the opinion of Frisch and Shipley (1939, 393).

3. See Chéruy file, Musée Rodin. This information seems not to have been available to Patricia Sanders, who wrote the otherwise helpful essay "Notes on Rodin's Technique," in de Caso and Sanders 1977, 29–33.

4. See Laurent's essay "Observations on Rodin and His Founders" in Elsen 1981, 285–93.

5. In 1977 the author was asked by the Musée Rodin to give an opinion on the appropriate foundry to do the casting. After study of the subject and foundry visits, the Fondation Coubertin was recommended and accepted. This was on the basis of Rodin's desire that the work be made by the lost-wax process, and in my opinion the Fondation Coubertin was outstanding in this regard. After World War II, Jean Bernard, son of the famous French sculptor Joseph Bernard, who was interested in bronze-casting all his life, obtained from the U.S. Air Force declassified information on improvements made in the lost-wax method in order to precisely cast engine parts for American fighter planes. This new technology coupled with Jean Bernard's inventiveness with such things as the backing of the latex molds, new formulas for making investment molds, and pouring molten bronze through the bottom of the cauldrons rather than spilling it over the edge, has meant that life-size casts, such as the individual burghers of Calais, can be done in one piece, thereby eliminating the problem of joints and extensive chasing.

Of the first five bronze casts of *The Gates of Hell* made after Rodin's death, that by Coubertin is the only one done by the lost-wax process. The others were made by the Alexis Rudier foundry using the sand-casting method. In 1992 a sixth lost-wax cast was completed by Coubertin for the Shizuoka Prefectural Museum of Art in Japan, and in 1993 a seventh for the Rodin Gallery in Seoul, South Korea. The first two casts were purchased by Jules Mastbaum for his Rodin Museum in Philadelphia and for the Musée Rodin. The third, in Tokyo's Museum of Western Art, was purchased by the great Japanese art collector Prince Matsukata. On the advice of Arno Breker the fourth was ordered by Hermann Göring for Adolf Hitler during World War II and since 1954 has been outside the Kunsthaus Zurich.

6. Bartlett in Elsen 1965a, 74. Other citations regarding cost estimates are in Elsen 1985a, 62.

Catalogue

Catalogue entries are arranged thematically. Within each section, works follow an approximate chronological sequence with occasional departures to juxtapose works related by theme or derivation.

Each work is identified by main title. One French title, either that given by Georges Grappe, author of the fundamental Musée Rodin catalogue, or one conventionally used by the Musée Rodin has been supplied, followed by principal title variations historically carried by the work; these variants are provided in English. Title variations are given only once when more than one version of the subject is discussed. References to Musée Rodin encompass the collections in Paris and at Meudon which may be specified by an inventory, or "S" number.

Dates given for each work are those of the object's conception or a reasonable approximation thereof. For sculptures, where appropriate, a date of reduction or enlargement and, if known, the date of the present cast is also provided.

For each sculpture, signature, inscriptions, and marks are indicated. A statement such as "signed on left shoulder" (see, for example, cat. no. 4) denotes the figure's own, or proper, left shoulder. The foundry as well as uninscribed cast and edition numbers are indicated if known. Provenance is cited if known. Versions and variants of the works are discussed in the entries; documenting the multitudinous versions and variants and their whereabouts, however, is outside the scope of the present enterprise.

For each entry the Literature includes selected monographs and collection and exhibition catalogues in which the composition is discussed, including some references to versions and variants in other media and dimensions. Citations to Grappe refer to the *Catalogue du Musée Rodin*, 1944 edition, unless otherwise noted. The sources, listed chronologically in the Literature in abbreviated form according to author (or editor) and date, are keyed to the Selected Bibliography, which provides full apparatus.

The date of a gift is included in the accession number. Photographs are by Frank Wing unless otherwise noted. Translations are by Albert Elsen or Rosalyn Frankel Jamison (or cited authors) unless otherwise noted. Bracketed interpolations within quotations are Elsen's unless otherwise noted.

Patriotic Themes

By 1900 Rodin was viewed by many as a great artist who belonged to the world, yet he always reckoned the honors paid to him outside France to be tributes to France and French art. It was in certain sculptures of the 1870s and 1880s that he unabashedly displayed his love of country and pride in being a Frenchman. In this section have been grouped proposals for and actual patriotic monuments, such as *The Burghers of Calais*. They are reminders that for Rodin and his contemporaries there was total confidence in public sculpture's power to affect the people's mentality and emotions with regard to their country's history and identity. Working within an old tradition, Rodin nevertheless dramatically altered the standard for patriotic public art.

The Age of Bronze (L'âge d'airain), 1875–76

- Title variations: The Age of Brass, Age of Iron, Age of Stone, The Awakening of Humanity, Man Who Awakens to Nature, Primeval Man, The Vanquished, Wounded Soldier
- Bronze, Alexis Rudier Foundry, cast c. 1920
- 71 x 20 x 20 in. (180.4 x 50.8 x 50.8 cm)
- Signed on top of base, left: Rodin
- Inscribed on back of base, right: Alexis Rudier/Fondeur. Paris; interior cachet: A. Rodin
- Provenance: Reynaud Icare, Paris; Wildenstein Gallery; Charles Zadak, New York; Bruton Gallery, Somerset
- Gift of B. Gerald Cantor Collection, 1983.300

Figure 39

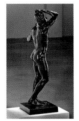

The Age of Bronze, 1875–76, reduced (small reduction) 1903–4

- Plaster, Alexis Rudier Foundry
- 26 x 8½ x 7 in. (65 x 21.6 x 17.8 cm)
- Signed on top base, left : Rodin
- Inscribed on back of base: Alexis Rudier/Fondeur Pa[ris]
- Provenance: Alexis and Eugène Rudier Collection, Paris; Sotheby's, Monaco, 25 November 1979, lot 34
- Gift of the Iris and B. Gerald Cantor: Foundation, 1984.431

Figure 41

The Age of Bronze, 1875–76, reduced (large reduction) 1903–4

- Bronze, Georges Rudier Foundry, cast 1969, 11/12
- 39 x 15½ 13 in. (99.1 x 39.4 x 33 cm)
- Signed on top of base, left: *A. Rodin.*
- Inscribed on back of base, right: Georges Rudier/Fondeur. Paris; on base, left side, near front: © by Musée Rodin 1969; interior cachet: A. Rodin
- Provenance: Musée Rodin, Paris; Paul Kantor Gallery, Los Angeles
- Gift of the Iris and B. Gerald Cantor Foundation, 1974.51

Figure 40

*T*oday when sculptors have midcareer retrospectives before the age of 35, it is astounding to realize that Rodin did not even make his public debut as a maker of statues, the most important title to which a sculptor could then aspire, until the age of 36. To earn his bread in the wake of the Franco-Prussian War and its aftermath, he had been forced to leave France in 1871 for Belgium, and he worked for years in the employ of other sculptors or in collaboration with them, not signing his name to his work.[1] In 1875–76, a period when there was a shortage of work for him in Belgium, Rodin used his modest savings from his commercial enterprises to support himself for the 18 months necessary to complete *The Age of Bronze.* During that period he took a trip to Italy in 1875, interrupting work on the figure to study Michelangelo at first hand and at the same time make an important discovery about how his profiling method corresponded with that of the Greeks.[2] One of Rodin's most important qualities was patience, fortified by the belief, as he told young artisans in Belgium, that "it is only necessary to make a single statue to establish a reputation."[3]

Although he had made earlier life-size figures, a lost *Bacchante* (1865– c. 1868) and his *Seated Ugolino* (1876), Rodin knew that this single statue was to be a critical turning point in his career. It would mark his return to Paris after seven years in Belgium and the hoped-for establishment of his reputation in his own country. On a more personal level, through its exhibition in an official Salon he would find out by comparison with good sculp-

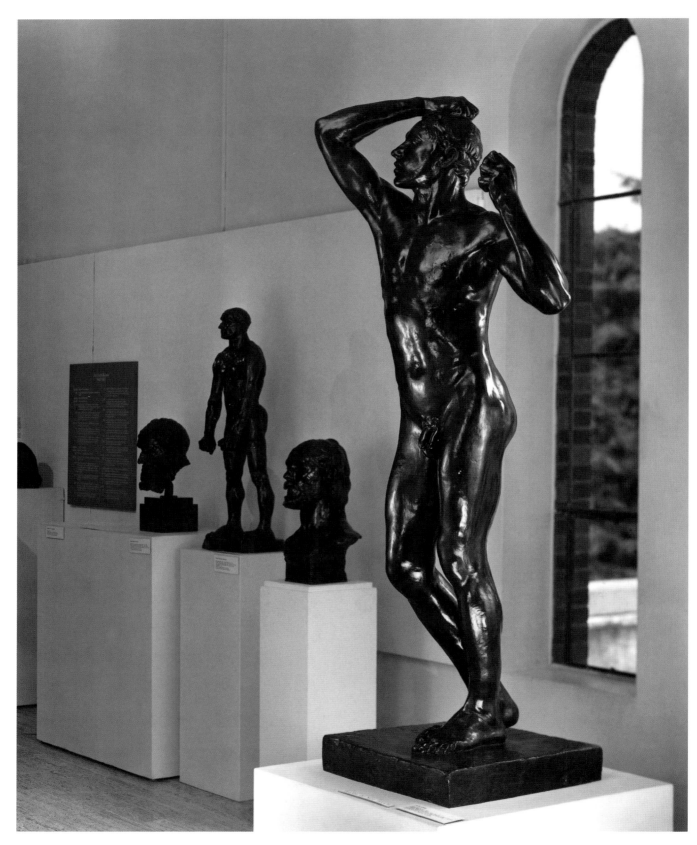

Fig. 39. *The Age of Bronze* (cat. no. 1).

tors if he possessed only skill and hence was fated to spend his life forever as an artisan or if he had both the skill and talent to be a professional maker of statues.[4]

Near the end of his life Rodin seems to have forgotten his original intentions when he expressed to a writer, "I wanted at first to make a wounded soldier, leaning on a lance."[5] In 1887, when his memory was presumably more reliable, Rodin, speaking in the third person, shared his recollected intention with the American sculptor Truman Bartlett: "The sole idea in the sculptor's mind was to make a study of the nude, a good figure, correct in design, concise in style and firm in modeling—to make a good piece of sculpture." Bartlett continued, "For the sake of elucidation, the process of the origin may be sketched as follows: The necessity of artistic action moves the artist into contact with nature, its recognized inspirer, and he places his model in various positions, in keeping with its character, until he finds one that is harmonious in every way. In this instance, the question of subject is not included. The position, movement, attitude of the model, as found by the artist, is satisfactory to him, and he makes the statue. After it is completed it suggests various names and subjects to those who see it [as well as to the artist] though it is really nothing more or less than a piece of sculpture—an expression of the sculptor's sense of understanding of the character of his model, and of his capacity to reproduce it in clay."[6] That this was the sculpture's initial and primary purpose seems seconded by the fact that in his early letters Rodin referred to the work as "my figure."

Rodin baptized his figure *Le vaincu ou le soldat blessé* (The vanquished or the wounded soldier).[7] Giving a name to his figure before its exhibition in 1877 was Rodin's concession to the salon practice of the day, but he did not arrive at his decision mindlessly. He had been conscripted during the Franco-Prussian War and fled Paris before the Commune, two terrible events for France that moved Rodin's heart as a patriotic Frenchman. As Ruth Butler has shown, he was well aware that his country looked to sculptors such as Henri Chapu, Jean-Alexandre Falguière, and Antonin Mercié for images to console a defeated nation.[8] *The Vanquished* must have seemed apt to a sculptor returning from years of self-imposed exile who had used a young soldier as a model. Judith Cladel interpreted *The Vanquished* to mean "glorification of tragic heroism that had touched his French heart."[9]

Despite the great pleasure and pain the sculpture brought Rodin in its making and reception, ten years after its debut, when his international reputation was being established, the artist shared with Bartlett his nostalgia for the circumstances of its creation: "So little does Rodin sympathize with the circumstances that have surrounded him during the past ten years, that today, in the full possession of his powers, his sole ambition is to relive the time of 'The Age of Brass' [*The Age of Bronze*]; to begin again to make a simple piece of sculpture without reference to subject."[10]

Rodin's model was a young Belgian soldier named Auguste Neyt, "a Flemish youth, of twenty-two years of age . . . a fine, noble-hearted boy, full of fire and valor."[11] Neyt recalled his experience after the sculptor had selected him from among "the best built" men in the company: "I was at once introduced to his studio in the rue Sans-Souci in Ixelles, where I had to go through all kinds of poses every day in order to get the muscles right. Rodin did not want any exaggerated muscle, he wanted naturalness. I worked two, three and even four hours a day and sometimes for an hour at a stretch."[12]

Neyt was subjected to a rigorous and exacting scrutiny as part of a method Rodin later described thus:

I strive to express what I see with as much deliberation as I can. I proceed methodically by the study of the contours of the model which I copy, for it is important to rediscover in the work of art the strength and firmness of nature; translation of the human body in terms of the exactness of its contours gives shapes which are nervous, solid, abundant, and by itself [this method] makes life arise out of truth. . . . When I begin a figure I first look at the front, the back, the two profiles of right and left, that is, their contours from four angles; then, with clay, I arrange the large mass as I see it and as exactly as possible. Then I do the intermediate perspectives, giving the three-quarter profiles; then, successively turning my clay and my model, I compare and refine them. . . . In a human body, the contour is given by the place where the body ends; thus it is the body which makes the shape. I place the model so that light, outlining it against a background, illuminates the contour. I execute it, I change my position and that of my model, and thus I see another contour, and so on successively all around the body. . . . It is important to look at the shapes from beneath and above . . . to look down on the contours from above, and to see those which

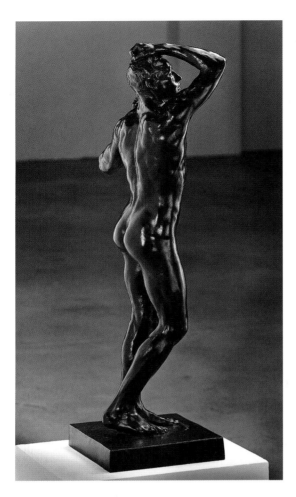

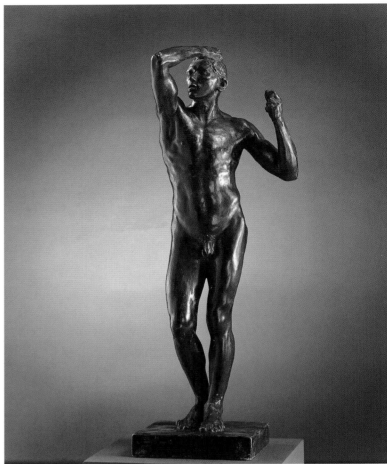

overhang, that is, to become aware of the density of the human body. Looking at a skull from above, I see the contours of the temples, the hollows, the nose, the jaws—all the cranial construction which is ovoid when seen from above. Next I see and compare with my clay the plane of the pectorals, the scapulas, the buttocks; I look at the springing of the muscles of the thighs; below, the planting of the feet on the floor. When I was working on "The Age of Brass," I procured one of those ladders painters use for their big canvases; I climbed up and did what I could to make my model and my clay agree in foreshortening, and I looked at the contours from above. What I do might be called "drawing in depth," for . . . it isn't possible to make something that looks flat.[13]

Rodin showed Henri-Charles Dujardin-Beaumetz the *Treatise on Sculpture* by Benvenuto Cellini, citing a passage that showed the affinity of his method with that of the older artist. Rodin paraphrased Cellini's ideas on sculpting in the round,

Painting is one part of the eight principal points of view to which sculpture is committed. When a sculptor wants to model a figure, nude or draped, he takes the clay or wax and begins with the front of the figure, which he doesn't leave without many times having raised up, cast down, advanced, shoved back, turned, and returned each limb. When finally he is satisfied with this first point of view, he works on one of the sides of his maquette; but then quite often it happens that his figure seems less graceful to him. Thus he finds himself forced, in order to make his new point of view agree with the former one, to modify that which he had already thought finished. And each time that he changes his point of view he will encounter the same difficulties. There are not only eight of these points of view, but yet more than forty, for however slightly one turns the figure, a muscle shows too much or too little and the aspects vary infinitely.[14]

One would expect that with such a system Rodin could have achieved his figure without too much diffi-

culty and only patience, but he told Bartlett, "I was in the deepest despair with that figure, and I worked so intensely on it, trying to get what I wanted, that there are at last four figures in it."[15] Bartlett opined that " 'The Age of Brass' is the sculptor himself concealed in the figure of a young warrior waking from the half-sleep of unknown strength, in the 'St. John' he is fully manifest as the matured chieftain heralding the coming of a new and reviving force in art. But from a truer point of view the latter has as little to do with any biblical purpose as the former with an historical period. Both are, purely and simply, pieces of sculpture."[16]

Unlike his later full figures, such as the *Saint John the Baptist Preaching* (1878), *The Age of Bronze* does not seem to have been preceded by a series of preliminary and smaller figure studies. (If such had existed, Rodin could have made them available later to a skeptical jury.) There is, however, in the reserve of the Musée Rodin at Meudon a smaller-than-life-size study of the head and right arm in terra cotta (fig. 42), which may be explained by the fact that Rodin seems to have departed most from the model in the area of the face, a conjecture that is only now possible because of the scandal evoked by the statue when it was first exhibited in Paris during the spring of 1877, and because of Rodin's attempt to vindicate himself by having the actual model photographed. The precious photographs by a Brussels photographer named Gaudenzio Marconi (1842–after 1885) include those of the actual model and those of the plaster that was probably exhibited first in January 1877 at the Cercle artistique et littéraire in Brussels and then in April at the Paris salon (figs. 43–46).[17]

Rodin first offered the work as *The Vanquished* but had removed a spear and a fillet from the figure before its debut. He used Marconi's photographs as the basis of two drawings, one of which showed the weapon, which had been represented by a baton used by the model in the studio to support his left hand (fig. 47).[18] At its salon debut, if not at its inception, the sculpture reflected Rodin the patriot, celebrating the heroism of French youth (although the nation had been defeated by the Prussians in 1870), a theme he was to repeat in the late 1870s in *La défense* and one adopted by other French sculptors. When shown in Paris, the work was renamed more broadly *The Age of Bronze*. The latter name Rodin explained as early man awakening to his humanity, "in the infancy of comprehension, and beginning to awake to the world's meaning."[19] The equivocal nature of the

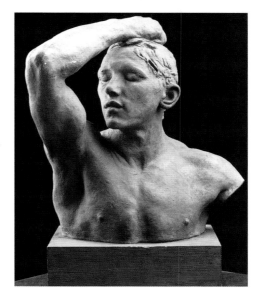

Left: Fig. 42. *Study for the Head and Right Arm of "The Age of Bronze,"* 1876(?), terra cotta, 11⁷⁄₁₆ x 9¹²⁄₁₆ x 8¾ in. (29 x 25.2 x 22.3 cm). Musée Rodin, Paris, S2582.

Below, top left: Fig. 43. Gaudenzio Marconi, *Auguste Neyt, Model for "The Age of Bronze*, (front)" 1877, albumen print. Musée Rodin, Paris.

Below, bottom left: Fig. 44. Gaudenzio Marconi, *Auguste Neyt, Model for "The Age of Bronze*, (rear)" 1877, albumen print. Musée Rodin, Paris.

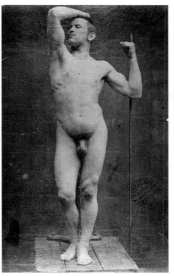
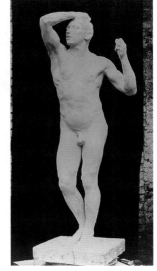

Top right: Fig. 45. Gaudenzio Marconi, *"The Age of Bronze,"* 1875-76, *in plaster* (front), albumen print. Musée Rodin, Paris.

Bottom right: Fig. 46. Gaudenzio Marconi, *"The Age of Bronze,"* 1875-76, *in plaster* (rear), albumen print. Musée Rodin, Paris.

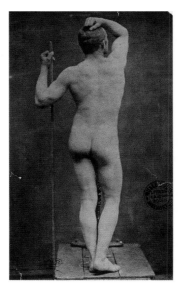

Fig. 47. *"The Age of Bronze" with Lance*, 1876, pen and ink(?). Location unknown (from Mauclair 1918).

sculpture's meaning and its pathetic heroism give it a theme that, along with its form, reflects a modern consciousness. How the name or its change after the first showing came about was indicated by Rodin: "When I was making 'The Age of Brass' I was in the deepest darkness. I thought it a failure. I had no name for it. This name was given to it by some one."[20]

The Reception of The Vanquished

In Rodin's day, as in our own, critics and the public reflexively looked for a figure sculpture's title or an identifying attribute to explain its meaning.[21] *The Vanquished* did not satisfy Rodin's critics in Belgium; one wrote, "Without having any indication other than the work itself, it seems to us that the artist wished to represent a man on the verge of suicide."[22] A friendly critic named Jean Rousseau, who knew the artist and the circumstances of the sculpture's making, reassured his readers, "Everything is clearly and logically explained by the title: 'The Vanquished,' and it is sufficient to add that the raised hand was to have held two spears."[23]

Rodin knew he could change the sculpture's name, and he did, but a far more damning comment came from an anonymous reviewer who wrote, "What part casting from life has played in making this plaster we can not discuss here."[24] Rodin immediately wrote to the editor, "One asks if my figure has not been cast from nature. If some connoisseur will give me the pleasure of reassuring him. . . . I will put him in the presence of the model and he can notice at what point an artistic interpretation must distance itself from a servile copy."[25]

When Rodin brought the plaster sculpture to Paris for exhibition in the spring Salon of 1877, even before the opening he received from the jury bad news, which he imparted in a letter to Rose Beuret who had remained in Brussels: "I am very sad. My figure was found to be very beautiful by [Jean-Alexandre] Falguière [a member of the jury] but they say that it was cast from life."[26] Rodin also wrote a letter to the Marquis de Chennevières, who was then the government's director of fine arts and president of the jury. It reveals how important the sculpture's reception was to Rodin's reputation and uncertain financial future.

It has been brought to my attention that the figure I submitted to the Salon was cast from life. By this terrible doubt the jury has robbed me of the fruit of my labor. Contrary to that opinion, suppose that I have not cast from life and that I actually took a year and a half and that my model came almost constantly to my studio.

Again grant that I utilized my thrift to work on this figure that I hoped would find in Paris, as in Belgium, a success because the joining of the modeled planes [le modelé] seemed right, is good and it is only the process that one attacks.

What an unhappiness to see my figure, which was to help me find a future, a future that is starting late because I am 36 years old—what an unhappiness to see it rebuffed by this dishonoring suspicion.[27]

Rodin's sculpture was admitted to the Paris salon, but his request for its purchase by the state was denied. When the salon opened, Rodin's statue garnered mixed reviews, and not surprisingly he was preoccupied with the negatives. He wrote to Rose Beuret, "They say I have made a cast from a cadaver and put it on its feet."[28] For sculptors exhibiting at the salon, the placement of their work and what light it received was crucial. In a letter to his friend Gustave Biot, Rodin noted the casting charge and the comments of some who said his figure was bad, adding, "As for me, I am badly placed such that one cannot judge my figure completely while there are well lighted sculptures that are only the efforts of amateurs."[29] In Rodin's case good lighting, especially as his work was in plaster, was essential to dispelling the life-casting charge.

What the critics had to say gives us a perspective on the sculptural standards of the time, especially with the choice of model and the need for clarity of meaning.

Charles Tardieu pointed out that "M. Rodin has undertaken to symbolize the hardships of war; only he has, perhaps, neglected to give the statue an explanatory attribute that would have made his intention clearer." Tardieu then defended Rodin against the "inanity" of the charge of casting from life but went on to say, "The work of M. Rodin is a study rather than a statue, a too servile portrait of a model without character or beauty; an astonishingly exact copy of a low type. But if M. Rodin appears to care so little for style, he makes it all up in the living reproduction of the life of his model. On this point his work is very interesting, and, with the addition of a few modifications, such as a little more nobility in the head, a little less thinness in the lips, it might easily rise above the criticisms now made against it."[30] Charles Timbal also took exception to the choice of model—"this sickly nude fellow"—and saw the work as "a curious atelier study with a very pretentious name."[31]

Rodin had set nature as his guide, but he was also very much of his time and conditioned by the sculptures and their titling that he saw in the salons.[32] He had carefully selected a model, but without making the expected cosmetic improvements, and deliberately posed him in the studio. For these decisions he was belabored by critics in reviews that he kept and showed to Bartlett: "Incomprehensible, this 'Age of Brass.' . . . Why does this little man grasp his head? Why do his eyes appear to be blinded? Why, anyway, does he not stand straight on his legs?" "Too much of the pose and study of the studio. M. Rodin shows too much of what he has learned, in this good study, not to give a little more freedom to his imagination. 'The Age of Brass' has too much suffering in it, and too little of its author's philosophy and poetry."[33] Rodin was not indifferent to or unmindful of these negative criticisms, as some were right on the mark. He would later move away from the obvious *académie* or studio pose.

Quite a different perspective of the statue's Paris debut came from a then young sculptor, probably Jules Desbois (1851–1935), who later worked for Rodin: "The first work of Rodin's that I saw was his 'Age of Brass,' in the Salon of 1877. Among the real artists it had a great success. But the old school, many of whom had made fine things, and were still making them, were down on it to a man. We thought that it was the most lifelike piece of sculpture that had been produced in French art since the 'Mercury' by Jean-Louis Brian [shown in the Salon of 1864], and that it was really entitled to the Medal of Honor. We were wild over it."[34]

Another aspect of the statue went unremarked by both critics and supporters. Writers commented on the hesitancy of the warrior's step but not the effect of the entire statue's almost imperceptible movement. Because the statue is wider toward the top than its tapered base in the feet, and the body leans slightly forward, if one looks at the sculpture for a long time from various angles, it is possible to develop the impression that the figure is swaying slightly. A case can be made that this was intended by the sculptor. The soldier's weight on one foot and the upraised right arm gave Rodin the asymmetry and extended contours he wanted, and the counteracting in-and-out movements of the contour of the body seen in profile, a way of posing the figure that Rodin called the "console" shape and that he had learned from Michelangelo's work. What Rodin gained from his study of Michelangelo's figures were structural principles. It was possibly by studying the console structure of *The Bound Slave* in the Louvre,[35] for example, that Rodin came upon his idea, which *The Age of Bronze* excellently embodies: "Every well made figure will swing back and forward when standing on both feet in an erect position, often as much as an inch and a half and quite imperceptible to the ordinary eye, as well as to many artists . . . but poorly made human figures stand nearly still. This is the lateral elasticity of the human figure. Then is the perpendicular also, both well understood by great artists and made use of in their work. It is the foundation of the purpose of a figure . . . [and] marks the difference between great and little, or good and bad sculpture. It is the leaning of the figure that makes it appear to the real observer as moving or on the very point of doing so."[36]

The accusation of having formed a mold upon a living person was a stunning insult to Rodin's integrity, which he never forgot, even though he was able in subsequent work to vindicate himself. When in 1917 a life cast was made of his hand, he posed holding a small torso of a woman so that one could see the difference between a mechanical reproduction and Rodin's art (cat. no. 194). In all his work, starting especially with *The Gates of Hell*, Rodin strove to show this difference, but in *The Hand of Rodin*, he stated it explicitly, as a final manifesto. The government purchased a bronze cast of *The Age of Bronze* in 1880 (with a fig leaf added); it was exhibited in the Jardin du Luxembourg between 1885 and 1901 and later in the Musée du Palais du Luxembourg.[37]

How that life-casting charge came about in Paris may be explained best by one of Bartlett's informants, proba-

bly Desbois: "Those who could not explain its existence by the ordinary process of making sculpture were obliged, in spite of themselves, to say that it must be a cast from nature, a trick by no means rare in these days. I don't think that the men who made this accusation against Rodin really knew or thought at the time what they were saying, or were conscious of the gravity of the charge."[38]

Rodin told Dujardin-Beaumetz that the sculptor Eugène Guillaume said, "Have a cast of your model made, we will compare them. The model lent himself to this. I sent a cast and photographs to the Salon. The crate was never opened."[39] Though amplified, this recollection by Rodin seconds what he had previously told Bartlett: that it was at the suggestion of the jury that he requested Neyt to have himself photographed. (He also obtained testimony from Neyt's commanding officer that the soldier had posed for Rodin over a long period of time.) Rodin showed the photographs to at least one of the 81 jurors, the sculptor Falguière, who was to become a close friend, but the jury's verdict was not overturned. We can now study photographs of the model against those of the plaster sculpture as Rodin intended. Neyt conscientiously posed in exactly the right stance, aided by a baton and a model's stand, whose vertical pipe rises between his legs (see figs. 43–44). The photographer cooperated by setting the camera at the approximate distance and angle from the model as in his photographs of the plaster (see figs. 45–46). The reader might imagine that he or she is a juror in 1877 studying this evidence.[40] Do the photographs vindicate Rodin or confirm the accusation of life-casting? Could a case be made that Rodin's profile method produced discernible differences from a life cast? Would you, the reader, agree with one of the original jurors that "even if it is cast from nature, it's very beautiful; it should be accepted anyway"?[41]

Without having seen the photographs of Neyt and almost 90 years later, Leo Steinberg, one of Rodin's most perceptive critics, offered this view: "Perfect parity was the hoped-for illusion: no nuance of M. Neyt's body surface was to lack in his bronze double, and every turn of the bronze must follow the young man's physique. The result is a frustration, almost aggressively boring. But it took the earnestness of a genius to pursue the reigning cant about objectivity to this end. *The Age of Bronze* was a paradigm of the esthetics of analogues, and the scandalous charge that the sculptor had merely taken a cast from the life model, though unjust in fact, was esthetically justified."[42] Contrast this reading and judgment with that of the poet Rainer Maria Rilke: "Here was a life-sized figure in all parts of which life was equally powerful and seemed to have been elevated everywhere to the same height of expression. That which was expressed in the face, that pain of a heavy awakening and at the same time the longing for that awakening, was written on the smallest part of this body. Every part was a mouth that spoke a language of its own. The most critical eye could not discover a spot on this figure that was the less alive, less definite and clear."[43]

While the photographs help to judge the extent to which Rodin adhered to the model's proportions, they do not give us vital evidence with regard to details of Neyt's body surface. The negative verdict of the jury tells us that even in Rodin's day professional sculptors in a crucial situation did not look closely at his work or comprehend, as Desbois pointed out, how another sculptor could make sculpture so differently than they. Admittedly, in contrast to studying a plaster under natural ambient light, examing a bronze cast under similar conditions makes it somewhat easier to see not only how Rodin treated the surface, but why. (The problem with working from a bronze is that sometimes the viewer has to discriminate between Rodin's editing marks and those made by the technician chasing the metal cast.) What Rodin's account of his method of modeling the profiles leaves out is the long process of editing that comes at the end, and this is one of the most important areas in which Rodin's signature touch is to be found.

Rodin's Achievement

Much of the writing on *The Age of Bronze* is about its subject and the scandal it produced. If we set aside the subject and just study the sculpture's form, we arrive at the core of Rodin's intention: to make a good piece of sculpture of a freestanding, life-size figure by his personally developed modeling method.[44] It is a study of the sculpture's form that helps us appreciate why Rodin agonized for so long over the work, not its subject. Such an inspection guides us to an understanding of how certain later commentators reckoned what Rodin achieved. For the abstract sculptor William Tucker, who looked back from the vantage of modern sculpture's evolution, *The Age of Bronze* was "the first statement in a new language based

on two fundamental propositions: 1. The sculptor takes responsibility for every aspect of the work; its conception, its form, its size, its material, its finish, its relation to the spectator. 2. The structure of the sculpture is identified with the structure of the figure."[45] Steinberg assayed *The Age of Bronze* in comparison with ancient Greek sculpture, and he saw the achievement of "a continuous modulation of surface, transitions smooth enough to become imperceptible, so that the body seems to have no divisions. That whole antique armature of clarified articulations which, since ancient Greece, had made male anatomy thinkable as an art object dissolves in the skinflow of continuity. What makes it seem appallingly real is not simply that the imitation is close, but that conceptual distinctions are blurred; nameable parts melt in an organism possessed only of its own molten unity."[46]

The Age of Bronze does lack the strong flanking muscles above the hips and protruding cartilage below the ribs and above the abdominal cavity that one can find in ancient Greek sculptures of more muscular men. On at least one occasion Rodin found in ancient sculpture of female nudes the fluid condition Steinberg ascribed to *The Age of Bronze*. Describing a little ancient torso seen under light, Rodin told Cladel, "It does not catch the light, the light catches it, glancing over it lightly, without any effect of roughness, any dark shadows. . . . She is indivisible . . . her unity is not disturbed."[47]

That molten unity Steinberg referred to—more apparent when the figure is seen from a distance rather than within arm's length—was won by Rodin's subtle joining of planes of the body, his *modelé*. But there was another aspect to Rodin's work and thought on this sculpture that acted against the "skinflow of continuity," namely, the way the continuous bronze surface was fashioned to make discontinuous the light that landed on it. It was an academic maxim to make the surfaces of a sculpture independent of light. Look at the surfaces of any bronze figure by a nineteenth-century sculptor such as Jean-Paul Aubé, Aimé-Jules Dalou, Mercié, or even Jean-Baptiste Carpeaux before 1880. In terms of surface incident, you will see nothing like what was done to *The Age of Bronze*. Photographing the bronze or viewing it from a distance by other than natural light imparts to the sculpture a deceptive appearance of smoothness. With his first exhibited statue, Rodin took his liberties more with the surface than with anatomy. Unlike his predecessors and contemporaries, he did not try to improve on the model; rather, he attempted to give bronze surfaces a

life in light they had never before known in the history of sculpture.[48]

An hour's patient study of this figure from all angles can produce revelations of what bronze figure sculpture can be, and a memorable aesthetic experience. It makes vivid Rodin's statement, "The great concern of my life is the struggle I have maintained to escape from the general flatness."[49] Close inspection of the sculpture's surfaces at first makes it seem ironically as if Rodin was deliberately signaling us in all areas that he was not working from a life cast. The most obvious signs are the fluid treatment of the hair, the soft rather than dry mergence of the facial features with each other, unlike a life or death mask, and the very rough area below the figure's left shoulder blade. Blind visitors to the museum have felt the differences by touching the tendons behind their own knees and those of Rodin's figure, which have been considerably roughened, for example. Looking at the surfaces against the light, as Rodin advised, helps one see that their electrifying quality owes to almost every square inch having been reworked, often with a knife as in the slicing away of vertical sections on the long muscles on the outside of the thighs. (By contrast, he seems to have thickened slightly the outer muscles of the man's upper thighs, giving him more pleasing curves to be seen against those of the lower and upper abdomen from the side.) Keep in mind that for Rodin sculpture was an art of relationships, and when such indentations are looked at, not just isolated head on but as parts of an edited profile against adjacent profiles, they make beautiful artistic sense. The added indentations break up otherwise uninterrupted passages of light, thereby helping the artist hold the curvature of the plane against an impression of flatness. When light hits a Rodin surface, it does not flatten out, but we see the plane bend under the light. None of the big longitudinal contours with their strips of light are uninterrupted.

And the effects of all this? The overall pattern of lights and shadows on and around the figure is beautiful and positively abstract.[50] The figure is not a cutout in space but exists in its own luminous atmosphere. Rilke understood what Rodin was after in this statue: "[Sculpture] had to be fitted into the space that surrounded it, as into a niche; its certainty, steadiness, and loftiness did not spring from its significance but from its harmonious adjustment to its environment." In the same essay Rilke perfectly described what Rodin discovered in *The Age of Bronze* and what remained the essence of his art: "It was

the surface—this differently great surface, variedly accentuated, accurately measured, out of which everything must rise—which was from this moment the subject matter of his art, the thing for which he labored, for which he suffered, and for which he was awake."[51]

Rodin's Reflections

As he grew older, Rodin came to look on *The Age of Bronze* with mixed feelings. At times it struck him as timid and cold but a necessary first stage in his development: "Yes, it is good, but the Bust of Rochefort, the Victor Hugo are superior to it. It is a question of modeling with a greater largeness of effect; however, I would not have arrived at that second manner without the first that represents strict study. It is that which won me anatomical knowledge, science. Only afterward did I understand that art demanded a little more grandeur, a sort of exaggeration."[52] Cladel recorded an anecdote concerning an exhibition of 50 Rodin sculptures that were to be shown at the Maison d'art in Brussels in 1899:

> I begged him to include among them *The Age of Bronze*. . . . He declared that in twenty years his modeling had undergone a complete transformation, that it had become more spacious and supple. . . . I urged him to go and look at it again. . . . Two or three years afterward . . . I led him unsuspecting toward the little grove [in the Luxembourg Gardens in Paris]. . . . Surprised, he examined it. Finally he admitted quietly that he had been mistaken, that the statue seemed to him really beautiful, well constructed, and carefully sculptured. In order to comprehend it he had to forget it, to see it again suddenly, and to judge it as if it had been the work of another hand. After his readoption, his affection for it was restored; he had several copies cast in bronze and cut in stone, and it became one of his most popular and sought after works.[53]

In 1905 Rodin added still another perspective in conversation with the poet and critic Camille Mauclair: "I began by very faithful studies of nature, as in 'The Age of Bronze.' Then I understood that it was necessary to raise one's self to a higher level, which is the interpretation of nature by a temperament. Thus I have been led to the logical exaggeration of forms, to the research into char-

acter, to its reasoned amplification. I have understood the necessity of sacrificing a detail of a figure to its general geometry, or that part to a synthesis of its aspect."[54] To Cladel, Rodin amplified the point late in his life: "The aim of art is not to copy literally. It consists in slightly exaggerating the character of the model in order to make it salient; it consists also in reassembling in a single expression the successive expressions given by the same model. Art is the living synthesis."[55]

Recognizing its popularity, thanks in no small part to its accessibility in Paris, Rodin agreed, despite his reservations, to a half-life-size and a 26–inch reduction of *The Age of Bronze*.[56] Ultimately more bronze casts were made, and it was exhibited thirty times, more often than any of his other sculptures during his lifetime.[57]

NOTES

LITERATURE: Bartlett 1889, (in Elsen 1965a) 31–33, 39–43; Cladel 1936, 114–21; Grappe 1944, 15–16; Mirolli (Butler) 1966, 160–69, 173–75; Spear 1967, 39–40, 94–95; Steinberg 1972, 349, 358, 361, 379, 385; Spear 1974, 126–27S; Tucker 1974, 23–27; Tancock 1976, 342–56; de Caso and Sanders 1977, 38–47; Butler 1980, 32–35; Elsen 1981, 33–34; Schmoll 1983, 53–56; Butler 1984, 162, 164–65; Elsen 1984, 215; Ambrosini and Facos 1987, 57–58; Fonsmark 1988, 67–69; Goldscheider 1989, 114–16; Butler 1993, 99–112; Kausch 1996, 252–54; Le Normand-Romain 1997, 246–319; Butler and Lindsay 2000, 310–17; Le Normand-Romain 2001, 148

1. His agreement with the Belgian sculptor Antoine Van Rasbourgh (1831–1902) stipulated that Rodin's name would appear only on work exhibited outside Belgium.
2. Mauclair 1918, 70–77. "When I had finished my *Age of Bronze*, I was in Italy and I found an Apollo having a leg in exactly the same pose as that of my *Age of Bronze*, and which had required six months of work. I saw that superficially [the treatment of the Greeks] appeared summary, [while] in reality all the muscles are constructed, and one discovers that one by one all the details are there. This is because the ancients studied everything by the successive profiles, because in a figure, in reality not one profile is the same as another. Since one studies each one of them separately, the whole would appear simple and living."
3. Cladel 1936, 114.
4. Bartlett in Elsen 1965a, 14. That Rodin seemed eager to compete with salon artists on their own terms was discussed by Mirolli (Butler) 1966, 174–75.
5. Coquiot 1917, 100.
6. Bartlett in Elsen 1965a, 96–97.
7. See Monique Laurent on this sculpture in Gassier 1984, 61.
8. Butler in Elsen 1981, 33–34.
9. Cladel 1936, 114.

10. Bartlett in Elsen 1965a, 107.

11. Ibid., 31.

12. Descharnes and Chabrun 1967, 49.

13. Dujardin-Beaumetz in Elsen 1965a, 154–56.

14. Ibid., 162–63. The source appears actually to be Cellini's *Discorso sopra l'arte del Disegro* (see Paola Barocchi, ed. *Scritti d'Arte del Cinquecento*, 2 vols. [Ricciardi: Milan, 1971–73] II, 1932–1933. We do not know when Rodin first encountered this treatise. On the question of where Rodin acquired the idea of profile modeling, first applied in making *The Mask of the Man with a Broken Nose*, see Sobieszek (1980), who may have been the first to raise this question in his excellent article. Sobieszek showed that using photographs taken from many profiles of the sitter as the basis for portrait sculpture was popularized in the 1860s by François Willème and others. He also pointed to the Collas machine, patented in 1834 for reducing and copying sculptures, as one in which a technician worked from multiple profiles of the original work.

15. Bartlett in Elsen 1965a, 32.

16. Ibid., 81.

17. These photographs, found in the Musée Rodin archives by Patricia Elsen while she and this author were doing research for *Rodin Rediscovered*, were first published in Elsen 1980, pls. 2–5.

18. De Caso and Sanders 1977, 46 n. 15. Note that the drawing in Maillard 1899 (opposite p. 6) shows a broken lance in the left hand this underscores the question of whether the spear accompanied the sculpture itself, which remains open to conjecture.

19. Lawton 1906, 45.

20. Bartlett 1887–88.

21. For a good discussion of the sculpture and its reception in the context of its time, see Mirolli (Butler) 1966, 165–69. Decorum, that is, appropriateness, was crucial to critics.

22. Reprinted Butler 1980, 32.

23. Ibid., 33.

24. Ibid., 32.

25. *Rodin 1860–99*, 35.

26. Ibid., 37.

27. Ibid., 18.

28. Ibid., 41.

29. Rodin to Biot, 26 April 1877, ibid., 45. In this letter Rodin hints at a conspiracy.

30. Bartlett in Elsen 1965a, 40.

31. Quoted in Butler 1980, 35.

32. For an exemplary discussion of this subject, see Butler in Elsen 1981.

33. Bartlett in Elsen 1965a, 47.

34. Ibid., 41. The deduction that the artist was Jules Desbois is mine.

35. In her discussion of this sculpture's relation to Michelangelo's *Bound Slave*, Mirolli (Butler) (1966) did not take up this point nor the fact that the eyes are almost, or entirely, closed in both statues (160–62).

36. This statement was made to Bartlett ten years after the statue was first exhibited. See Bartlett 1887–88, 149.

37. Rodin was concerned about the condition of *The Age of Bronze* after its exposure for several years in the Jardin du Luxembourg, and perhaps because it was often lent by the government for important exhibitions, he offered to clean it. The bronze was then brought inside in 1901; it entered the Louvre in 1933 and then in 1986 it was transferred to the Musée d'Orsay.

38. Bartlett in Elsen 1965a, 100.

39. Ibid., 152. The crate seems to have subsequently been lost, and years ago, when the author had access to the Meudon reserve, it could not be found.

40. M. J. Morgan of the Psychological Laboratory, University of Cambridge, and M. C. Corballis of the Department of Psychology, McGill University, noted that "McManus has pointed out that most artists depict the left testicle of man lower than the right, in accordance with the facts. An exception occurs in Rodin's famous sculpture *L'Age d'Airan* [sic] where the right testicle of the figure seems (from photographs we have seen) to hang lower than the left. We should like to suggest that Rodin was genuinely confused about left and right. Evidence that Rodin suffered from a specific reading disability, which is commonly associated with left-right confusions, has been reviewed by Thompson" ("Scrotal Asymmetry and Rodin's Dyslexia," *Nature* 264 [18 November 1976]: 295–96). This article was called to my attention by Joanne Brumbaugh when she was making a medical study of Rodin's use of anatomy. I wrote the authors and invited them to make a comparison of the naked Neyt in Marconi's photographs and the plaster sculpture, which shows that Rodin was indeed accurate. In a personal communication of 14 March 1983, Morgan and Corballis acknowledged that they had made "several serious errors." Rodin's reading disability was early recognized by his teacher Horace Lecoq de Boisbaudran as myopia. Recent attempts to attribute Rodin's sculpture style to myopia overlook the fact that for much of his life he had glasses.

41. This was Rodin's recollection, shared with Dujardin-Beaumetz in Elsen 1965a, 152.

42. Steinberg 1972, 361.

43. Rilke in Elsen 1965a, 121.

44. In the Neue Pinakothek, Munich, there is a damaged cast of this sculpture without arms and head so that one is forced to focus on its form.

45. Tucker 1974, 24.

46. Steinberg 1972, 379.

47. Cladel 1917, 224–25.

48. It should appear obvious that I cannot agree with the following statement: "It is particularly in the finish of the work that we might feel something un-Rodinlike" (Mirolli [Butler] 1966, 174).

49. Cladel 1917, 224.

50. Tucker recognized the abstract in this work: "Rodin's devotion to 'nature,' to truth in representation, results

paradoxically in an increasing tendency towards abstraction" (1974, 23). Closer to my view on the surface treatment than Mirolli's (Butler's) and published far earlier than mine is Tucker's reading: "Every inch of the surface is considered, worked on, invented; every inch is equally and differently expressive; expression is diffused from facial expression, from depicted gesture and muscular contortion into the animation of the entire surface" (27). Where this author parts company with Tucker is his conclusion from the foregoing that "Rodin had no reverence for the human figure as such" (23). To base such a view on Rodin's audacities in sculpture strikes this author as unwarranted. Rodin always revered the figure because it

inspired many of the liberties he took in his sculpture to emulate the effects of living form.

51. Rilke in Elsen 1965a, 115.
52. Cladel 1903, 39.
53. Cladel 1917, 85. For the exhibition history see Beausire 1988, updated in Le Normand-Romain 1997, 247–48 n.3.
54. Mauclair 1905b, 205.
55. Cladel 1917, 218.
56. Reductions in two sizes are listed in Lebossé's notes for 1903–04, reproduced in Elsen 1981, 258.
57. Beausire 1988, 368, 400 (for the exhibitions indexed).

4

Study of the Head for "The Spirit of War" from "The Defense" (Tête du génie de la guerre du monument de la défense, 1879 (monument), 1883 (figure alone)

- Title variations (for the monument): *The Defeated Homeland, The Spirit of War, The Call to Arms*
- Bronze, Georges Rudier Foundry, cast 1965, 6/12
- 6½ x 6 x 6½ in. (16.5 x 15.2 x 16.5 cm)
- Signed on left shoulder: A. Rodin
- Inscribed on back, right: Georges Rudier/Fondeur. Paris; on back, left: © by Musée Rodin 1965; Interior cachet: A. Rodin
- Provenance: Musée Rodin, Paris
- Gift of the Iris and B. Gerald Cantor Foundation, 1974.80

Figure 48

*F*ollowing the bitter defeat of France in the war against Prussia, the practice of erecting monuments commemorating the defense gained momentum. These were intended to commemorate the patriots who died for the nation and to assuage the humiliation of those who survived. Eventually these memorials came to incarnate the spirit of revenge against the Germans. In 1879 a competition was announced by the Prefecture de la Seine for a monument that would commemorate the defense of Paris.[1] (Rodin had served for a few months in

the national guard and was stationed in Paris but saw no fighting.) The site chosen was the rond-point de Courbevoie (since called the rond-point de la Défense), the locus in 1870 of terrible combat; it is on the northwest axis of the Arc de Triomphe and connected to it by the avenue de Neuilly. *Departure of the Volunteers of 1792* (1833–36), the great relief on the Arc de Triomphe by François Rude (1784–1855), was very much on Rodin's mind when he made his unsuccessful entry for the competition (fig. 49). Rude had symbolically shown Frenchmen of all ages responding to the call of the Spirit of Liberty to arm themselves and go into battle for their country (fig. 50). For his friend Paul Gsell, Rodin analyzed "this sublime poem of war" as a true "dramatic composition" in four phases, initiated by "bronze-armored Liberty, who roars, 'To arms, citizens!' . . . at the top of her voice as she cleaves the air with her spread wings. . . . It even seems that you can hear her, for truly her stone mouth vociferates as if it could break your eardrums. Now as soon as she utters her call, you see the warriors rush in."[2] Rodin's own conception is like a tragic sequel to the departure of the volunteers, of which now only one, mortally wounded, remains, supporting himself on a sword driven into the ground. In this figure Rodin used a Michelangelesque torsion, like that of Christ in the Florentine *Pietà* (Santa Maria del Fiore, Florence), to effect a narrative that shows the one-eyed warrior looking up or listening to the frenzied, disarmed, and battered figure of Liberty, who in turn, is poised above a bomb or mine.[3] If Rude's Liberty could deafen, Rodin's counterpart could rally the dying from the grave. According to Judith Cladel, the face of *The Spirit of War* "is the interpretation of the mask of Rose Beuret."[4] Just as Rude did, Rodin sought to show that

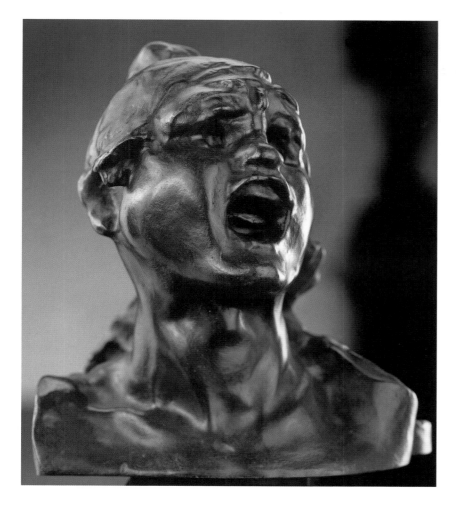

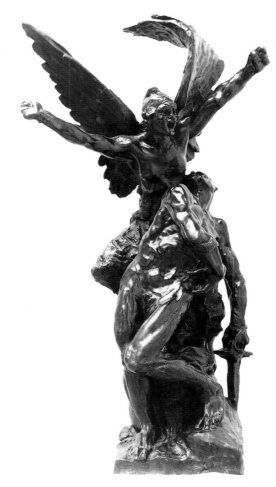

Left: Fig. 48.
*Study of the
Head for "The
Spirit of War"
from "The
Defense" (The
Call to Arms)*
(cat. no. 4).

Right: Fig. 49.
*The Call to
Arms*, 1883,
bronze, 44½ x
22½ x 15¹⁵⁄₁₆ in.
(113 x 57.8 x
40.6 cm). Fine
Art Museums of
San Francisco,
gift of Alma de
Bretteville
Spreckels.

sculpture could compete with the theater. Unfortunately, he could not convince or move the jurors, who did not accord his entry even an honorable mention; the commission went to what Cladel called a "solemn pastry" by Ernest Barrias.[5] Rodin later expressed the view that in the jurors' eyes his work had "too much violence, too much vibration."[6]

Rodin's custom of making a composition by creating, finishing, and casting two or more separate figures was "a method of composition that became generally prevalent in late nineteenth century sculpture."[7] Rodin would have learned this practice from such contemporary sculptors as Jean-Baptiste Carpeaux, Antonin Mercié, and others. For *The Call to Arms* he made the warrior and the figure of Liberty or War independently. As Frederick Lawton saw them, "A winged female figure, naked to the waist, hovers above and close to . . . the body of a slain warrior. Her arms are extended, her fists clenched; one of her spread wings is bent and broken, but still beats the air, and her face beneath the helmet, covering her head, is distorted by the cry of anguish that issues from her open mouth. . . . Rodin was so interested in the central figure of his composition that, when the competition was over, he copied it several times, introducing slight modifications."[8] The warrior has not been "slain," only severely wounded, and he supports himself on his sword driven into the ground. Perhaps the modifications Lawton referred to are to be found in the Musée Rodin reserve at Meudon, but more likely he was referring to what we see in the Cantor Foundation *Spirit of War* (fig. 51), in which Rodin added drapery across the woman's thigh in 1883, when it was bronze-cast and sold to a collector.[9]

Rodin once spoke of how "life surges from a center," and there is no better description of his winged figure, whose energy seems to explode centrifugally, starting at her contracted abdomen. In the back of this splendid bronze, cast during Rodin's lifetime, one can see that

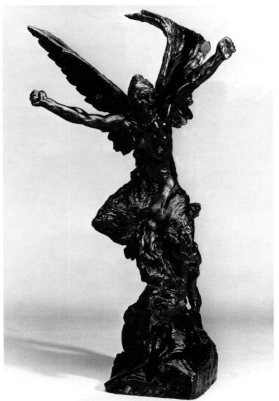

strengthens the figure's attachment to the base, and he kept rough the contracted abdomen, against which the man's neck would be placed. The drapery is not carried into decided fold patterns front and back, and the aggregate of their spontaneous formation augments the sense of energy in the whole.

Side views show the winged woman bent forward beyond the front of the base. The forward edges of face, hands, and base line up in an implied frontal plane. The whole is imaginable in a tall polyhedron. As the monument was to be freestanding, Rodin had to give serious thought to its dorsal view. His daring was in balancing a composition extremely wide at the top on a narrow unstable base: the partially buried spherical bomb. By design he paired the outspread knees and the diamond pattern thus created against the extended arms and curved wings so that the monument's pulse is that of alternating contraction and expansion.

Rather than a helmet, as Lawton read it, or some attribute connecting her with the city of Paris as called for in the competition of 1879, the woman wears a Phrygian cap, symbol of the Republic. This was a motif Rodin would not have used during the Second Empire but

this spirited woman is shown with both feet off the ground. It is as if she is levitated by her patriotic passion rather than by her wings. Her extended, naked, muscular arms ending in clenched fists are like those of a young man.[10] Rather than the obvious device of having the wings parallel the movement of the arms, Rodin bent her left wing back, perhaps signifying its being wounded like the warrior.[11] (In the full monument the bent wing continues the zigzag compositional structure inaugurated in the soldier's bent left leg.) Where the warrior was to go between her splayed knees (she supports his left side with her left thigh), presumably in 1883 Rodin added the smooth, downward flow of drapery that

which was totally appropriate at a crucial moment in the history of the Third Republic, when liberal forces triumphed over the conservatives. It is a mystery why this figure is referred to in the literature as the Spirit of War and not Liberty, as Rodin referred to Rude's winged allegorical figure as Liberty or the Spirit of France. Rodin's *Bellona* (cat. no. 5) is a war goddess. As to the appropriateness of Rodin's ideas for the time, Ruth Mirolli (Butler) put it aptly: "It was the perfect moment for Rodin's *La défense*, so much more meaningful than that of Barrias, for politically the monarchists lost all hope in 1877 and the business of the real foundation of the Third Republic got under way."[12]

We do not know the source of Cladel's statement that Beuret inspired the shouting woman's face, and there is little to connect it with the stern visage of *Bellona*, for which supposedly Rodin's first and almost lifelong mistress was also the model. The head's proportions to the body and the fine, consistent modeling of the extended neck with no evidence of grafting suggests that the same model, Rose or someone else, might have posed for the whole figure. The face is contracted in the effort of crying out, the open mouth framed at the top by the line of upper front teeth, the eyes only indented sockets without pupils. Above the nose in the brow are rude indications of contracted muscles, forerunners of what later became in the heads of Baudelaire and Balzac Rodin's unaccountable touches.

The Call to Arms had an interesting history in Rodin's art, being enlarged twice, once during and once after his lifetime, the latter serving as Holland's tribute to the defenders of Verdun.[13]

NOTES

LITERATURE: Maillard 1899, 68–78; Lawton 1906, 54–55; Cladel 1936, 129; Grappe 1944, 19; Mirolli (Butler) 1966, 195–201; Tancock 1976, 370–75; de Caso and Sanders 1977, 199–202; Fusco and Janson 1980, 331–32; Schmoll 1983, 45–47; Butler 1984, 165–66; Goldscheider 1989, 134; Tilanus 1995

1. For an account of this competition, see de Caso and Sanders 1977, 199, 202. See also Daniel Imbert, "Le monument de la Défense de Paris," in *Quand Paris densait avec Marianne (1879–1889)*. Exh. cat. musée du Petit Palais. (Paris: Paris–Musées/Tardi, 1989), 86–103.
2. Gsell [1911] 1984, 36.
3. For a photograph of the nearly hidden, previously unpublished head of the wounded warrior see Elsen 1980, 161. For a good analysis of the warrior and the project as a whole, see Mirolli (Butler) 1966, 195ff. The identification of the partially buried weapon is owed to Louk Tilanus of the University of Leiden, whom the author thanks for sharing his research on the history of the monument.
4. Cladel 1936, 129.
5. Ibid. Barrias's monument is illustrated in Fusco and Janson 1980, fig. 15.
6. De Caso and Sanders 1977, 202 n. 3, citing Coquiot 1917.
7. Mirolli (Butler) 1966, 199.
8. Lawton 1906, 55.
9. Maillard 1899, 153.
10. I thank Louk Tilanus for pointing this out. See Tilanus 1995.
11. In Rude's *Departure of the Volunteers*, Liberty's right wing is bent to accommodate the relief format.
12. Mirolli (Butler) 1966, 201.
13. Elsen 1981, 256, 259.

OPPOSITE PAGE
Left: Fig. 50. François Rude, *The Departure of the Volunteers of 1792 (La Marseillaise)*, 1833-36, stone. Arc de Triomphe, Paris.

Right: Fig. 51. *The Spirit of War*, 1883, bronze, 44½ x 22½ x 15 in. (113 x 57.2 x 38.1 cm). Iris and B. Gerald Cantor Foundation.

5

Bellona (Bellone), 1878–79

- Title variations: *Clorinde, France, Hippolytus, The Republic*
- Bronze, A. Gruet Foundry, cast c. 1893
- 31 x 18½ x 17¾ in. (78.7 x 47 x 45.1 cm)
- Signature on base, left side: A. Rodin
- Inscribed on back of base, right side: A. Gruet ainé Fondeur/Paris

- Provenance: Hugh Valdave Warrender; Garrick Club, London; Christie's, London, 12 December 1969, lot 92
- Gift of the Iris and B. Gerald Cantor Foundation, 1974.63

Figure 52

*T*he monumental bust known as *Bellona* appeared at a key juncture in Rodin's career, a time when he was emerging from his position as assistant to other sculptors and establishing himself as an artistic personality in his own right. In the late 1870s Rodin's sculptures, in fact, began to achieve full maturity and some degree of notoriety. *The Age of Bronze* (cat. nos. 1–3), *Saint John the Baptist Preaching* (1878), the project for *The Call to Arms* (see

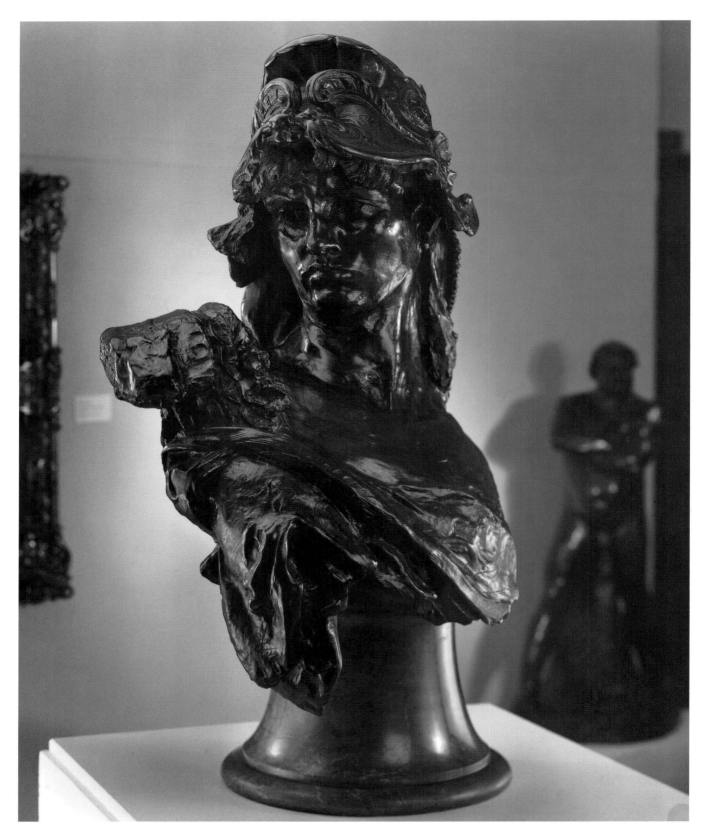

Fig. 52. *Bellona*
(cat. no. 5).

cat. no. 4), and the commission for *The Gates of Hell* (cat. no. 37) mark a quick succession of major achievements for Rodin in these years.[1]

Commentators at various times have compared *Bellona* to works by Jean-Baptiste Carpeaux and François Rude or have emphasized its decorative conception and baroque style.[2] While all these aspects play a role in this work, other qualities of the sculpture, such as its strong Michelangelesque flavor and audacious stylistic and thematic features, still need to be explored. These latter characteristics clearly placed *Bellona*, like most of Rodin's major works of the late 1870s, in opposition to prevailing tastes and must have contributed to its rejection in a competition for a bust of the Republic.[3] Even then, however, the sculpture's bold conception did not go unnoticed: "A work of singular originality," stated one contemporary newspaper, and "other notices of the bust did not fail to recognize," Truman Bartlett reported, "that it was conceived from a different point of view from that which the public had been accustomed to seeing."[4]

The bronze *Bellona* in the Stanford collection offers a fine opportunity to study this work in a splendid early cast, perhaps the first or second cast ever made.[5] The cast has been dated to the 1890s and from a purely technical point of view is superb.[6] It was no doubt cast according to the lost-wax process. Not only was this the method preferred by Rodin before 1900, but also the deep undercutting, intricate ornamentation of the helmet, and extremely fine surface detail make it hard to conceive it as having been cast in any other way.[7] Accordingly, the work displays amazingly fine nuances of texture and modeling. The patina is also of very fine quality.[8] The Stanford *Bellona* once belonged to the collection of Lt. Col. Hugh Valdave Warrender, who bequeathed it to the Garrick Club in London, presumably at his death in 1926. No doubt the dramatic expression of this bust seemed a suitable addition to the Garrick's distinguished collection of portraits of famous actors by artists such as Reynolds, Gainsborough, and others. It is not difficult to imagine Rodin's bust as a tragic muse.[9]

Four bronze versions and one marble *Bellona* are known in addition to the one at Stanford.[10] The original terra-cotta still exists in the Musée Rodin in Paris. Most of the bronzes, including the one at Stanford, seem to adhere very closely to that original.[11] A drypoint of *Bellona* was executed by Rodin in 1883 (fig. 53). Three states survive. The impression of the third state in the collection of the Musée Rodin bears the inscription "*A*

Fig. 53. *Bellona* (A1).

ma femme" (To my wife).[12] The drypoint differs from the sculpture in several respects, primarily in the rendering of the drapery and the hair. While the drapery was simplified, the hair was more fully developed in response to the special potential of the drypoint technique. This permitted Rodin to create the effect of soft curls and wisps of hair encircling the face. In the sculpture, instead, the hair is drawn back in heavy tresses, whose billowing mass is only fully appreciated from the back. The sculpture and drypoint share, however, the effect of the face cast in deep shadow.

The precise date of *Bellona* is difficult to establish. In 1976 John Tancock proposed a new date for the work. "In the first two editions of the catalogue of the Musée Rodin, Grappe assigned a date of 1881 to *Bellona*. In subsequent editions, however, he dated the terra-cotta 1878 and the bronze 1881, basing the dating of the former on the fact that it appeared in an exhibition of decorative art early in 1879. Other commentators state that Rodin submitted the work known as *Bellona* in a competition for

a bust of the Republic, which was announced only in 1879. Since it seems unlikely that Rodin would have tackled this subject and on such a grand scale, solely for his own pleasure, Grappe's dating of 1878 is here rejected and a date of 1879 proposed instead."[13] While Tancock may well have been right in dating *Bellona* to 1879, his reasons for dismissing Georges Grappe's somewhat earlier date are not altogether convincing. There seems to be ample indication that Rodin did not necessarily need the incentive of a competition to undertake a major work on a scale similar to or even grander than *Bellona*, starting in 1874 with the bust of the *Man with the Broken Nose* (see cat. no. 125) and continuing with *The Age of Bronze*, *Seated Ugolino* (1876), *Saint John the Baptist Preaching*, and many others. Of course, Rodin planned to exhibit his works at the salon and hoped they would be appreciated and purchased, preferably by the state.

Moreover, it is difficult to reconcile what Tancock said, on the one hand, about Rodin's apparent distaste for figures of the Republic with his readiness, on the other, to believe that Rodin could only have conceived *Bellona* in direct response to the competition for such a bust. Tancock, in fact, quoted Rodin as saying, "When a sculptor makes a republic, he always makes a slut."[14] He also stated in his discussion of *The Call to Arms* that "it is significant that Rodin decided to enter the competition for the monument to the defense of Paris rather than for the monument to the Republic. . . . A monument to the war of 1870 could be expressed in terms of dynamic human content, while a monument to the Republic would of necessity be more abstract in concept."[15]

Thus, while Tancock's proposed origin and dating should not be excluded, it also seems plausible that Rodin may have simply conceived this work as "a good piece of sculpture." The bust of *Bellona* could be an example, for instance, of Rodin's practice of depicting certain female models, especially Rose Beuret, Camille Claudel, and Mrs. Russell (née Marianna Mattiocco della Torre), in different costumes and headdresses. In an earlier portrait entitled *Flora* (1865–70) and in the later portraits of Mrs. Russell as Athena (see fig. 382), Rodin demonstrated that he was at times inspired to depict his models in the guise of Greco-Roman deities, perhaps as a tribute to the classical art he so loved. The hypothesis that *Bellona* was not solely or initially conceived in response to the competition for a bust of the Republic would also explain why, as Ruth Butler put it, Rodin "almost perversely it would seem . . . failed to include the

Phrygian bonnet, thus not identifying the figure as the Republic, which was the essence of the competition."[16]

Most commentators, starting with Judith Cladel, stated that Rose Beuret was the inspiration and model for this work: "Rodin did not hide the fact that he had caught her from life, during the scenes his wife often threw."[17] This type of story and origin is typical of several of Rodin's works, namely, the *Saint John*, which was also supposedly inspired by the features, expression, and stance of a particular model. The truth of the story regarding *Bellona* seems to be confirmed by later evidence indicating that this bust had a very special personal significance for both Rodin and Beuret, as suggested by the inscription on the Musée Rodin drypoint. Moreover, it is not difficult to demonstrate that there is a close resemblance between the physiognomy of Beuret and that of *Bellona*, by comparing the bust to photographs and other portraits of her (see fig. 374). Born in 1844, Rose Beuret must have been about 35 years old when she sat for *Bellona*.[18]

A specific thematic analysis of Rodin's *Bellona* is especially difficult due to the uncertainty regarding its conception and the impossibility of knowing whether it was intended as a Republic or not. Starting with *The Age of Bronze*, we find that a specific identity and its attendant attributes are not essential to Rodin's conceptions but often follow rather than precede the finished work. Consequently, an iconographic analysis of this sculpture can provide only a general context for understanding the bust.

It is interesting, for instance, to note that the iconographic traditions of Bellona and the Republic are actually quite similar, sharing many attributes, such as the shield, torch, and Phrygian bonnet. Marvin Trachtenberg, in his study of the closely related image of Liberty, has shown that an entire host of figures, including Doctrine, Truth, Eternal Felicity, Divinity, and Faith, share one or more attributes of Liberty.[19]

Broadly speaking, Rodin's *Bellona* belongs to a long tradition of heroic male and female figures going back to the helmeted deities of antiquity: Minerva, Mars, and such belligerent females as the Amazons. Specifically, Bellona was a Roman deity connected with war and Mars. She was at times identified with other minor divinities and later identified with Virtue. In general, her principal attribute seems to have been that of being armed.[20]

As for the image of the Republic, it was extremely popular among sculptors during the 1870s. The renewed interest in this subject was part of that larger revival of

public patriotism and public monuments resulting from the events of 1870–71. The image developed by artists earlier in the nineteenth century, during the First and Second Republics, "had a dual aspect: on the one hand, it represented a deified image of force and power; on the other, its incarnation in a female body emphasized qualities of charity and sustenance, that is, the maternalistic protection of the people."[21] The image favored during the First Republic tended to emphasize the former, more intimidating qualities, while the image preferred in 1848 was of a softer, more feminine, and maternal character. The personification of Liberty in Rude's *Departure of the Volunteers* and the heroine of Eugène Delacroix's *Liberty Leading the People* (1830; Louvre, Paris) belong to the older tradition.

The more temperate and low-key tradition developed during the Second Republic was still popular in the 1870s. Frédéric-Auguste Bartholdi, for example, in his *Liberty Enlightening the World* (known as the *Statue of Liberty*), conceived in these years, settled for a basically tame and peaceful image.[22] Rodin's *Bellona* and his *Call to Arms*, belong instead to the earlier tradition of more aggressive, dramatic images, and this is no doubt at the root of their rejections in the public competitions. In Rainer Maria Rilke's words, Rodin's sculptures of the late 1870s "with the inconsiderateness of a great confession . . . contradicted the requirements of academic beauty which were still the dominating standard. In vain Rude had given his Goddess of Rebellion on the top of the triumphal gate of the Place de l'Etoile that wild gesture and that far-reaching cry."[23]

The unusually forceful and expressive character of Rodin's *Bellona* clearly stands out against sculptures of similar subject and format conceived by some of his contemporaries, such as Jean Gautherin's *Republic*, exhibited in the Salon of 1879, or the slightly later *Gallia victrix* by Augustin-Jean Moreau-Vauthier.[24] While all three depict more or less powerfully built, strong-featured women, the faces of the figures by Gautherin and Moreau-Vauthier, in contrast to that by Rodin, seem almost completely impassive, revealing little or no trace of emotion. Likewise, while Bellona's head is turned dramatically to one side, the busts by Gautherin and Moreau-Vauthier are almost perfectly frontal and symmetrical, confronting the viewer in the manner typical of symbolic, hieratic images of this kind.

By endowing Bellona with a vivid expression, an expression at once tragic and defiant, by showing the head turned in dynamic movement, the tendons of the neck straining, the head drawn back in a gesture of anger and pride, Rodin humanized and revitalized this traditionally aloof and stoic image. A similar humanization of the heroic subject is found in Rodin's *Spirit of War* from his *Call to Arms* and in his later *Burghers of Calais.*

Rodin's *Bellona* bears the same relation to Gautherin's *Republic* as his *Call to Arms* does to Antonin Mercié's *Quand même* (1882).[25] In both cases, while sharing certain compositional and symbolic devices, the figures by Gautherin and Mercié are, by comparison with Rodin's, overdressed, exceedingly finished, and compositionally stationary; they represent an attitude rather than movement. Even Jules Dalou's 1898 monument *The Triumph of the Republic* still shies away, in the figure of the Republic, from the forceful expression of Rodin's two works.[26]

The major attribute of Bellona, namely, the helmet, is unusual for images of the Republic. Most nineteenth-century Republics wear a Phrygian bonnet or some type of crown—of laurel, oak leaves, or radiant light. Neither Moreau-Vauthier's *Gallia victrix* nor Rude's Liberty are, strictly speaking, Republics. Rodin's other works depicting closely related images, such as *The Spirit of War* (cat. no. 4) and *Head of France* (cat. no. 36), adhere to the more traditional attribute of the Phrygian bonnet, thus suggesting once more that this bust may not have been conceived as a Republic. At the same time, as we have seen, a certain amount of belligerence is not atypical of some images of the Republic, and swords and shields at times accompany these figures. Another iconographic source for *Bellona* may be the tradition of armed and helmeted Joan of Arc figures, such as Emmanuel Frémiet's *Joan of Arc on Horseback* erected in 1874 on the place des Pyramides.[27] It is possible that Rodin may have had such a type in the back of his mind when making *Bellona*.

Also unusual is that the helmet, we now know, was executed for Rodin by a young sculptor, Auguste Ledru (1860–1902).[28] This collaboration may be considered an extension of Rodin's well-known habit, especially in later years, of using trusted assistants and technicians (as in the carving of his marbles). As René Chéruy wrote, "I had asked him why he had had the excellent helmet of *Bellona* executed by Ledru. . . . The *Bellona* needed a helmet. Maybe because he was interested solely in the figure, maybe because he was too pressed with other work, he entrusted its execution to a talented sculptor named Ledru. . . . Rodin probably discreetly oversaw its execution. The helmet is in such harmony with the figure,

forms a harmony with the figure—forms such a perfect whole, that it is difficult to believe that they are not both by the same hand. Ledru was, moreover, an artist of great talent, with a great feeling for decoration. And Rodin did not try to hide this collaboration."[29] Ledru was very young when he undertook the helmet, no more than 18 or 19 years old; Rodin was 20 years his senior. Their relationship may have well been similar to that from which Rodin was then emerging as assistant to other sculptors. It is impossible to know precisely their respective roles in this extraordinarily successful collaboration. It seems reasonable, however, to assume that Rodin was largely responsible for the overall concept and the marvelous integration of the helmet with the figure noted by Chéruy. It also seems possible that Ledru's role may account for the relatively unusual character of this helmet in Rodin's work as a tour de force of decorative modeling. Other versions of this helmet by Rodin are considerably more generalized, perhaps because of Rodin's greater interest, as Chéruy suggested, in the figure itself rather than in the decorative details that so dazzle us in the helmet. The major exception to this is the helmet on the marble version of *Bellona* (location unknown), which is even more exuberant in its decorative conception. In the back, the marble helmet is graced not by a branch of laurel, as in the bronze, but by two putti holding an arrangement of feathers. One naturally wonders whether this helmet too may have been by Ledru.[30]

The specific features of the helmet for the bronze *Bellona* have their source in both the history of art and the history of armor. The helmet belongs, first of all, to the tradition of ceremonial or parade helmets, highly decorative headgear not meant to be worn in battle. The basic shape of the helmet with its projecting brim and long, swooping neck guard resembles that of Andrea del Verrocchio's *Equestrian Monument of Colleoni* (c. 1483–88; Campo SS. Giovanni e Paolo, Venice). Paul Dubois also used this type of helmet in his *Military Courage* (1876) for the memorial to General Juchault de Lamoricière in Nantes Cathedral. Another prototype for Bellona's helmet is provided by a sixteenth-century Italian bronze of a helmeted Perseus, which was then in the collection of the Trocadéro.[31] The fish-scale pattern, embossed tendrils and foliation along the spine of the helmet, and undulating border are all common to Ledru's helmet as well. The volutes on the brim seem typical of headdresses of this kind. Examples are to be found in Michelangelo's *Dawn*, on the helmet of Maria de' Medici as Bellona in Peter-Paul Rubens's famous

series of paintings (1621–25) then on view at the Louvre, and in the coiffure for *Bianca Capello* (1863) by Adèle d'Affry Marcello, admittedly derived from a drawing by Michelangelo.[32] The front termination of the brim in a kind of grotesque animal head is also not uncommon.[33]

In the history of armor, Ledru's helmet for Rodin seems to combine features of the Italian sallet, a fifteenth-century headpiece with a long tail, and the sixteenth-century burgonet, "an open helmet, the salient parts of which are the umbril, or brim, projecting over the eyes, and the upstanding comb. . . . Ear flaps are sometimes hinged to the sides. . . . Many are elaborately decorated."[34] In particular, Rodin's helmet resembles several sixteenth-century Italian examples and a parade helmet of Louis XIV dating to about 1700. The latter, or one very close to it, was represented in a portrait of Louis XV by Hyacinthe Rigaud and on Jean Varin's statue of Louis XIV in the Musée de Versailles.[35]

The most unusual feature in Ledru's helmet for Rodin, as it seems to find no direct counterpart in either the history of art or the history of armor, is the crest that emerges curling forward like a wave from the top of the helmet. One source for this, other than Rodin's own imagination, seems to be a somewhat similar element in the helmet of Michelangelo's *Lorenzo de' Medici* (1520–34; Medici Chapel, Florence). It is significant that in both works this feature plays a similar compositional role by creating an area of deep shadow echoing the shadow cast on the face by the projecting brim. Moreover, it is possible that this feature was meant to echo the shape of the Phrygian cap traditionally used in representations of the Republic, France, and Liberty.

Rodin was to return to this helmet in several portraits of Mrs. Russell as Athena (1896).[36] The helmets in these works clearly derive from the earlier one. They differ only in the somewhat more generalized shape, less articulated profile, and less detailed ornamentation. They thus testify to the enduring fascination of this decorative form for Rodin and once again suggest that the *Bellona* was perhaps originally conceived not as a Republic but more simply as an ornamented headpiece together with a highly expressive portrait.

Stylistically, Rodin's *Bellona* also displays a mixed heritage. On the one hand, as Tancock noted, the work displays "a baroque vitality." The baroque period was, moreover, especially rich in images of Bellona, both in sculpture (Jean Cosyns, Ignaz Günther) and in painting (Rubens, Rembrandt van Rijn).[37] In its forceful expression Rodin's

Bellona is perhaps closer to Pierre Puget (1620–1694) than any other baroque sculptor. On the other hand, the fierce intensity of Rodin's *Bellona*, the way movements are pitted one against the other, as in the simultaneous turning and drawing back of the head, point to the Italian Renaissance and specifically to Michelangelo.

As Albert Alhadeff demonstrated, this return to the Italian Renaissance was not unique to Rodin, being shared with varying degrees of success by a number of contemporary sculptors, such as Carpeaux and Dubois.[38] In particular, the fourth centenary of Michelangelo's birth in 1875 had brought renewed attention to this sculptor and his works. In Rodin's own production of this period, Michelangelo's influence has been observed in the *Loos Monument* (1874–76), *The Age of Bronze, Saint John the Baptist Preaching, Vase of the Titans,* and *Adam* (see cat. nos. 39–40).

Generally speaking, the pronounced gesture of Bellona's head and shoulders is common to Rodin's figures of Industry, Commerce, and the Sailor on the *Loos Monument,* which, as Alhadeff noted, are stylistically related to Michelangelo: "Like the *Giuliano de' Medici,* Rodin's figures turn to the side and thus reveal in one bold gesture assurance and pride. Their massive chests are seen full front, in striking contrast to the profile faces. These incisive changes in direction are reminiscent of the rhythm Michelangelo instilled in his figures."[39]

More specifically, the torsion of *Bellona*'s head and neck, the diagonal displacement of the shoulders and accompanying emphasis on the strained tendon of the neck, the angry expression conveyed by the deeply set eyes and contracted forehead recall Michelangelo's *David* (1501–04; Academy, Florence). Even the effect of *David*'s curls projecting forward over the forehead finds its counterpart in Rodin's *Bellona*.

The use of drapery in Rodin's bust may at first recall such baroque prototypes as the *Bust of Louis XIV* in Versailles by Giovanni Lorenzo Bernini (1598–1689), although a closer look shows that this feature is used differently by Rodin. Rodin used the drapery to reinforce the main axes and planes of the composition rather than to give the figure a wind-swept quality and mask its relation to the base as in the Bernini bust. In *Bellona* the diagonal fold of drapery reiterates the slanting plane of the chest and the diagonal axis established by the line of the shoulders, while the vertical loop of drapery reinforces the major vertical established by the head and neck. This loop of drapery also counterbalances the heavily articu-

lated area of the head and helmet, thus preventing the bust from appearing top-heavy. Moreover, from a frontal point of view, this loop repeats, merely by inversion, the general shape of the head and helmet. Thus, while the head and helmet point slightly to one side, the drapery inclines slightly to the other. In addition, from a profile view, the fold of drapery swooping diagonally across the chest repeats not only the diagonal of the shoulders but also the swooping curves of the helmet.

The bust is unified by a skillful use of lights and shadows, of hollows and projections. Starting at the top of the helmet, recessions and projections alternate in a rhythmic, rippling sequence. The viewer's glance emerges from the deep shadow created by the crest of the helmet along the sharply projecting brim to plunge again into the deeply darkened area of the face and eyes. Another deep pool of shadow is created by the concavity between the neck and right shoulder. Our eyes then glide down the broad plane of the chest, encounter the fold of drapery, and turn back along the sweep of hair and curve of the neck guard to admire the superbly crafted back of the bust.

The profiles of the bust have been accorded careful attention, giving rise, in Rodin's own words, to "shapes which are nervous, solid, abundant." The bust is full of surprises as one turns around it, and it is clearly meant to be seen from all sides. In particular, some old photographs, taken under Rodin's supervision, suggest that the left profile, with the helmet clearly displaying its superb decoration and the face cast in shadow, was one of Rodin's favorite views of this work. In profile, the relatively smooth, uninterrupted curve of the back contrasts dramatically with the broken, highly articulated, cascading silhouette of the front. The stepped profile established by the in-and-out movement of the front of the helmet is countered by the similar, but receding, stepped profile of the face.

The relationship of the bust to the base is especially striking when compared with nineteenth-century academic examples, such as Gautherin's bust of the Republic. Even Carpeaux in his more dynamic and dashing portraits never dared to place his busts in such a pronounced asymmetrical relationship to the base. From a side view, if a line is drawn along the central axis of the base of Rodin's *Bellona*, most of the bust—that is, more than two-thirds—will be seen to be on one side of the base in a strongly "unbalanced" relationship to it. If a similar line is drawn down the middle of Gautherin's bust, the figure will be divided into two almost equivalent parts.

The use of bodily gesture in the bust of *Bellona* is masterful, as Rodin managed to convey a sense of form moving through space. The head and right shoulder surge forward, defying gravity and their attachment to the base. The projecting brim of the helmet and front loop of drapery act like a prow, opening the way for the advancing figure, while the heavy tresses are swept back as if by a strong gust of wind. Leo Steinberg skillfully expressed this quality in Rodin's busts: "They seem not poised but propelled, discharged into space by the abstracted energy of gesture alone."[40]

The surface of this bust presents, on the one hand, a dazzling display of skillfully and sensitively handled textures: from the porosity of the skin to the metallic smoothness of the helmet, to the rough texture of the hair and back, alternating with more fluid, almost liquid passages. On the other hand, the surface also presents unaccountable touches that were to become more and more characteristic of Rodin's work. Lumps of unincorporated clay appear in the area of the forehead, eyelids, and drapery. In addition, there are numerous traces of the process of working in clay, especially in the drips of liquid clay on the back of the sculpture, in the marks of different tools, in the deep gouging of the eyes, in the gashes at the juncture of head and neck, and in the roughly shaped clay of certain areas of the hair and drapery.

Another outstanding quality of this bust is the wide range of emotion it displays from different points of view and in different lighting conditions. From the front and under harsh lighting, *Bellona* bears a fierce, scowling, almost violent expression. At other times the figure seems to pout. In gentler lighting in the terra-cotta version and from certain three-quarter or profile points of view, the face has a melancholy look. Rodin managed to combine both strength and pathos. The deep sockets of the eyes and the shadow cast by the helmet over the face give it a mysterious, reserved expression that seems to contradict the defiant gesture of the head and shoulder. The tension in this work between different states of feeling reflects the physical tension between the various movements of the head, chest, and shoulders, at once turning to the attack and proudly retreating.

Like other Rodin works of the late 1870s, *Bellona* embodies daring traits while preserving a strong footing in tradition, especially evident in the decorative virtuosity of the helmet and the inclusion of certain, albeit ambiguous, allegorical trappings. With other works of this period, it also reflects Rodin's close study of Michelangelo and exemplifies the thematic ambiguity that so disconcerted his contemporaries in works such as *The Age of Bronze*. Evident is a new freedom in the treatment of the surface that incorporates purely expressive rather than exclusively descriptive touches. Finally, *Bellona* illustrates Rodin's innovative use of expressive, spontaneous gestures, thereby breathing new life into the impassive heroes and heroines of academic tradition.

MARGHERITA ANDREOTTI

NOTES

LITERATURE: Bartlett 1889 in Elsen 1965a, 46; Cladel 1936, 241; Grappe 1944, 20; Tancock 1976, 585–88; Fusco and Janson 1980, 332–33; Elsen 1980, 163; Elsen 1981, 42, 99; Butler 1984, 165; Goldscheider 1989, 134–36; Le Normand-Romain 2001, 206

1. Dating as it does to such an important period in Rodin's career, *Bellona* has nonetheless received little scholarly attention. To date, Tancock provided the most extensive treatment in a valuable but by no means comprehensive entry in Tancock 1976, cat. no. 107; Butler devoted an informative entry on this piece in Fusco and Janson 1980, cat. no. 193.

2. Bartlett reported that the newspaper *La France* in 1879 (?) described *Bellona* as "a sculpturesque fantasy, a bedeviled fervor that makes one dream of Carpeaux when in his most audacious moments of imaginative composition" (in Elsen 1965a, 46). Alexandre referred to *Bellona* as a "tragic female head with helmet, her face contracted in anger, reminiscent of Rude's art in its simple modeling and forceful expression" (1900, 24). Vallon also compared *Bellona* to Rude's *Departure of the Volunteers* (1928 73–74). Finally, Grappe (1944) and Tancock (1976) emphasized respectively the decorative and baroque conception of the bust. Butler cited (in Fusco and Janson 1980) two articles reviewing the entries for a competition for a bust of the Republic: M. V., "Lettres, science et beaux-arts," *La France*, 18 December 1879, and *Petit moniteur universelle*, 17 December 1879. The article in *La France* may be that mentioned by Bartlett. Both articles apparently emphasized the dramatic and nontraditional aspects of the work.

3. Announced in *L'art* (Paris) 4 (1879) vol. 19: 119: "The City of Paris announces two competitions: one, for the bust of the Republic destined to be placed in the town hall of the XII arrondissement and to serve as a model for the other municipal buildings. This bust will be one meter high not including the small pedestal. . . . Projects should be deposited at the Palais des Tuileries, Pavillon de Flore, before next December 16; the public exhibition will open the 18th and last eight days."

4. Bartlett in Elsen 1965a, 46.

5. Tancock stated (1976) that "according to information

provided by the Musée Rodin at the time of purchase," the Philadelphia *Bellona*, cast in the early 1920s, is the third cast (586 n. 1). If this is correct, then the Stanford bronze must be the first or second.

6. This bust bears the foundry mark "A. Gruet aîné Fondeur Paris." The dating of the Stanford cast to the 1890s finds confirmation in letters and bills in the Rodin archives that indicate that "A. Gruet aîné" did most of its work for Rodin precisely in these years. Like the better known Rudier foundry, the Gruet foundry seems to have been a family operation composed of Adolphe Gruet, father and son. The foundry mark on the Stanford cast refers to the son, "Adolphe Gruet Fils Aîné Seul Successeur de Son Père," according to the letterhead on correspondence and bills preserved in the Rodin archives. Based on these archives, it appears that A. Gruet père worked for Rodin in the early 1880s and that by the early 1890s he had been succeeded by his son. There are references to at least fifteen different works in the documents dating to this period, though no reference to *Bellona*. One bill of 1902 testifies, moreover, that Rodin also did some business with a certain E. Gruet, probably a relative, who owned his own foundry (Cantor Art Center archives).

7. Wasserman 1975, 147; de Caso and Sanders 1977, 29–30.

8. A. Gruet aîné was a highly skilled *patinateur* (see letters 3–4 in the Gruet Foundry file, Cantor Arts Center archives), a fact that accords with the high quality of the patina of the Stanford *Bellona*. Sanders gave *Bellona* as an example of Rodin's high standards in the matter of patinas, reporting that "his *Bellona* had to be redone three times before he was satisfied with it" (de Caso and Sanders 1977, 30). Her source for this comment, Lami 1914–21, vol. 4 (1921), 163, however, made no mention of this.

9. Vera Green, B. Gerald Cantor Art Foundation, to author, 28 February 1979.

10. Tancock 1976, 586. Presumably the marble version listed in Tancock as "location unknown" is the one in the collection of Dr. and Mrs. Jules Lane, Hicksville, New York, that was shown in the *Rodin Rediscovered* exhibition (National Gallery of Art, Washington, D.C., 1981–82). Butler states that the marble in the Lane collection is unique and the one shown in the 1889 Monet-Rodin exhibition (in Fusco and Janson 1980, 333). Whether this and the one purchased by the French government around 1906 are one and the same has yet to be established. Its location is "unknown" in Beausire 1989, 102.

11. An exception is the Philadelphia *Bellona*, which differs from the other casts in one principal feature: the termination of the left arm and shoulder. The Philadelphia version presents the stumplike suggestion of a left arm and armpit, which is completely lacking in the terra-cotta, bronze, and marble versions. Otherwise, the major differences are to be found, not unexpectedly, between the terra-cotta (or bronze) and marble versions. The marble is substantially smaller (27 vs. 32 in. high) and less detailed. The drapery was simplified and major changes made in the shape and decoration of the helmet, the

most notable being the addition of two putti on the back. A marble version of *Bellona* was exhibited in the 1889 Monet-Rodin exhibition, cat. no. 13. This or another marble version of *Bellona* was purchased by the French government around 1906 (Ministère de l'instruction publique des beaux-arts et des cultes to Rodin, 24 November 190[6?]).

12. Delteil 1910. The third state is most frequently reproduced and seems to differ from the second state primarily in the heavier inking of the plate. See also Thorson 1975, 25–27.

13. Tancock 1976, 585. Butler likewise assumed that *Bellona* was created in direct response to the competition for a bust of the Republic and accepted Tancock's date of 1879 (in Fusco and Janson 1980, 332).

14. Tancock 1976, 586 n. 9.

15. Ibid., 370.

16. Butler in Fusco and Janson 1980, 333.

17. Cladel 1936, 241.

18. More than 25 years later Ludovici was still remarking on the resemblance of the model to the sculpture of Bellona: "When I was at Meudon, in spite of her great age, her features were still recognizable in this bust [*Bellona*]. She must have been a very handsome woman, for even in old age she was pleasant to look upon, although her features were large and not the soft, smooth kind usually associated with good looks in a woman" (1926, 18). This last remark on Rose Beuret's particular type of beauty—a strong-featured, forceful, rather than delicate beauty—confirms her appropriateness as the model for *Bellona*, a bust that was to bear both female and male names at different times during its history. Around this time Beuret also served as the model for the screaming countenance of the Genius of War in *The Call to Arms*. Finally, a photograph of Rose Beuret taken around 1880–82, only a few years after she sat for *Bellona*, shows the same features that distinguish the sculptured bust, particularly the deeply set eyes veiled in shadow; the photograph was reproduced by Tancock (1976, 485). The motif of the curls escaping from beneath the brim of the helmet and framing the forehead of *Bellona* may also have been inspired by the model's coiffure as shown in the photograph.

19. Marvin Trachtenberg, *The Statue of Liberty* (New York: Penguin, 1977), ch. 3.

20. *Enciclopedia dell'arte antica*, vol. 2 (Rome: Istituto della enciclopedia italiana, 1959), 47.

21. Albert Boime, "The Second Republic's Contest for the Figure of the Republic," *Art Bulletin* 53 (1971): 76.

22. Trachtenberg, *Statue of Liberty*, 68.

23. Rilke in Elsen 1965a, 118.

24. For Gautherin's *Republic*, see *L'art* (Paris) 3 (1879) vol. 18: 10 (ill.); for Moreau-Vauthier's *Gallia victrix*, see Tancock 1976, 585.

25. For Mercié's *Quand même*, see Hale 1969, 62.

26. For Dalou's *Republic*, see *L'art* (Paris) 4 (1879) vol. 19, 130, 132, 134 (ills.), 134–35; and John Hunisak, *The Sculptor Jules Dalou* (New York: Garland, 1977), 209–29.

See also John Hunisak, "Dalou's *Triumph of the Republic:* A Study of Private and Public Meaning," in Janson 1984, 169–75. Dalou's figure has more grace but much less impact than the *Genius of War* of Rodin's *Call to Arms.* Paul Dubois's *Military Courage,* reproduced in *L'art* (Paris) 3 (1877) vol. 8, 275, provides another example of a helmeted figure with a number of points of contact with *Bellona* (see Fusco and Janson 1980, cat. no. 119). The two figures both wear helmets of approximately similar shape and similar Renaissance derivation, and the two heads are similarly turned to the right in a gesture reminiscent of Michelangelo. In *Bellona,* however, this gesture is full of vigor and implied movement, while in the Dubois the gesture has been subdued and subordinated to a sense of unstrained composure.

27. Fusco and Janson 1980, cat. no. 141.

28. Not surprisingly, Ledru became known primarily as a decorative sculptor, the author of "vases, plates, platters, cups, fountains, in plaster, bronze, and pewter" (Lami 1914–21, vol. 3 [1919], 279–80).

29. I am grateful to Albert Elsen for bringing to my attention this excerpt from Chéruy's notes in the Musée Rodin archives, Paris. The notes are unpaginated and undated. Chéruy started work for Rodin in December 1902, the year of Ledru's death. Perhaps it was that death that prompted the two men to discuss his work. Rodin's further comment in which he used the past tense ("He had talent") may imply Ledru's death.

30. Compare, for example, Ledru's *Espiègle,* a pewter vase, shown at the Salon des Champs-Elysées in 1894 (reproduced in *Revue des arts décoratifs* 15 [July 1894]: 15), which features a nude figure cavorting on one side in a manner reminiscent of the two putti on the helmet of the marble *Bellona.* Included in the 1889 Monet-Rodin exhibition, the marble is reproduced in Beausire 1989, 102, no. 13.

31. Illustrated in Saint-Raymond, "Les grands collections au Trocadéro," *L'art* (Paris) 4 (1878) vol. 15: 5.

32. For the latter see Victor Beyer, *The Second Empire, 1852–1870: Art in France under Napoleon III* (Philadelphia: Philadelphia Museum of Art, 1978), 232.

33. For example, see *Historical Armor: A Picture Book* (New York: Metropolitan Museum of Art, 1951), cat. no. 24; Michelangelo's *Lorenzo de' Medici* helmet; and Moreau-Vauthier's *Gallia victrix* helmet.

34. See G. C. Stone, *Glossary of the Construction, Decoration, and Use of Arms and Armor* (Portland, Me.: Southworth Press, 1934), 156.

35. See *Loan Exhibition of Medieval and Renaissance Arms and Armor from the Metropolitan Museum of Art,* exh. cat. (San Francisco: California Palace of the Legion of Honor, 1953), no. 12; *Historical Armor* (as in no. 33), nos. 3, 24; Claude Blair, *Arms, Armour, and Base-Metalwork* (London, 1974), no. 1.

36. For example *Pallas Wearing a Helmet* (1896, executed 1905, marble, height 21¼ in.; Musée des beaux-arts de Lyon), discussed in Durey 1998, 116–17, and *Minerva Wearing a Helmet* (1896, marble and bronze; Walker Art Gallery, Liverpool), reproduced in Tancock 1976, 599–600.

37. See Cosyns's *Bellona* (1697; Maison de Bellone, Brussels); Günther's *Bellona* (c. 1772; Bayerisches Nationalmuseum, Munich); Rubens's *Maria de' Medici* series (1621–25; Louvre, Paris); and Rembrandt's painting of his wife as Bellona (1633; Metropolitan Museum of Art, New York).

38. Alhadeff 1963, 363–67.

39. Ibid., 365.

40. Steinberg 1972, 338.

6

The Crying Lion (Le lion qui pleure), c. 1878–81

- Title variations: *Lion Roaring, Seated Lion, Weeping Lion, The Wounded Lion*
- Bronze, Georges Rudier foundry, cast 1955, 1/9
- 11 x 13¼ x 6¼ in. (27.9 x 33.7 x 15.9 cm)
- Signed on base by right rear leg: A. Rodin
- Inscribed inside cast: Georges Rudier/Fondeur Paris; on front of base, at edge: © by Musée Rodin 1955; on drapery beneath right forepaw: garde bien; interior cachet: A. Rodin

- Provenance: Musée Rodin, Paris; Julien Aime, New York; Worldhouse Galleries, New York
- Gift of B. Gerald Cantor Collection, 1992.150

Figure 54

*I*n gratitude for Edmond Turquet's purchase of *The Age of Bronze* for the state and the commission for *The Gates of Hell* in 1880, Rodin seems to have offered him the plaster of the lion, apparently in memory of his recently deceased wife, Octavie.[1] There seems to be a question as to whether or not the small sculpture was actually commissioned and intended for use on Mme Turquet's tomb.[2] The words *garde bien* (guard well) inscribed on the scroll of the sculpture were from her family coat of arms.[3]

Adding to the question of whether or not the lion was

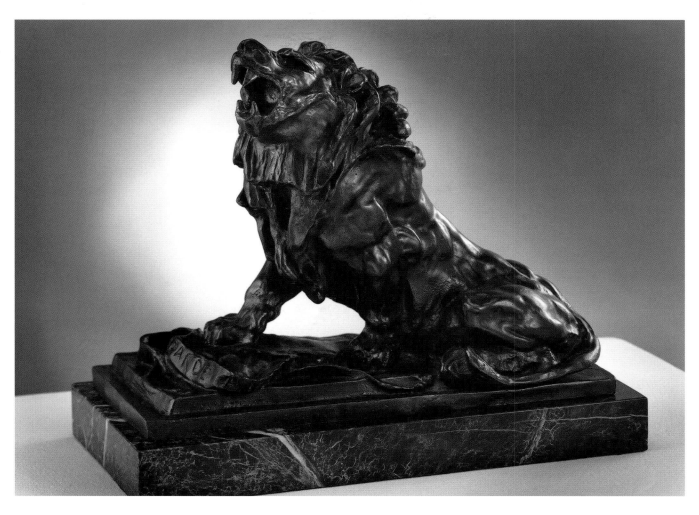

Fig. 54. *The Crying Lion* (cat. no. 6).

actually commissioned for a tomb is the fact that Rodin gave the widower a roughly 11-inch plaster, a material that could not have served that funerary purpose. It was not until around 1887 or thereafter that the plaster was offered back by a member of the family in exchange for a promised bronze, which was not actually cast until 1902, 21 years after the death of Mme Turquet.[4]

The sculpture is dated 1881 on the basis of the gift to Turquet. It is probable, however, that Rodin made it earlier, in the late 1870s, when he was competing for monuments to the Republic and the defeat in the Franco-Prussian War. Frédéric-Auguste Bartholdi's gigantic *Belfort Lion*, 38 feet high and 70 feet long, was carved in the red granite blocks set into the hillside above Belfort between 1875 and 1880. The model was exhibited in Paris in the Salon of 1878 and could have inspired Rodin to make his own leonine symbol of the nation's defense against the Prussians.[5] As well as a tomb guardian, the lion as a civic symbol of strength and courage has a long history. Rodin's proposed monument for the defense of Paris (see fig. 49), for example, shows a wounded soldier

rallied from dying by the screaming spirit of war (fig. 51), and if the small sculpture of the lion was done with the same intent, it might properly be called *The Wounded Lion*, as it was. Adding the scroll with the words *garde bien* before making the gift could have been easily done if, in fact, needed, and they were totally appropriate to what may have been Rodin's original political intention for the sculpture.

It was not uncommon for Rodin to utilize an existing sculpture for a purpose other than that for which it was made. Later, in 1911, for instance, an upright winged version of *The Martyr* (cat. nos. 72–73) was used for a tomb in Amiens and named *The Broken Lily* (1911). In 1881 Rodin was deeply into the work on *The Gates of Hell* and spent some weeks in London. It is questionable whether he would have taken time to make the lion just as a gift. It would have been possible for him to select a figure like *Fallen Caryatid* (cat. nos. 56–57) for the Turquet tomb, but this might have seemed imprudent at the time as the figure came from the government commission for *The Gates of Hell*. In my view, the death of

Edmond Turquet's wife and the family motto may have inspired the artist not to make the lion sculpture but rather to make the gift. Further, its small size and material would have made it problematic for the tomb; moreover, no evidence suggests that Rodin and the family planned its immediate enlargement or bronze-casting as one would expect if, in fact, a commission had taken place. It was not enlarged to almost twice its size until so done by the *practicien* Peter Victor, who carved it in marble in 1910 for the artist.

Despite his many student drawings of animals, made when he was studying with Antoine-Louis Barye, and his so-called black drawings in the early 1880s of men on horseback, in Rodin's sculpture there are only the horse for the *Monument to General Lynch* (cat. no. 7), the charging horses pulling Apollo's chariot on the pedestal of the *Monument to Claude Lorrain* (cat. nos. 93–95), and *The Wounded Lion*. Shown under the name *The Crying Lion*, the sculpture was exhibited three times, all in Paris (1912, 1913, 1917).[6] The second exhibition was organized by the French *animaliers*, those who focused on the sculpture of animals, in connection with a Barye retrospective. This was fitting as Rodin had studied with Barye in 1855, and no doubt his love of animals and the vigor and anatomical knowledge he imparted to his beast reflected that exposure. Barye's *Lion Crushing a Serpent* (1833) had been purchased by the state and placed in the garden of the Tuileries, where Rodin could have been inspired by it from the time he was a student.

Usually reproduced in side view, Rodin's sculpture can be experienced most effectively when one starts with the back, where the animal's hind legs are in a crouch. The curved tail begins a long, continuous, twisting movement, which proceeds up the spine and into the mane and head. This kind of powerful and expressive dorsal torsion Rodin would have imbibed from the older *animalier*. How observant Rodin was of the way a lion roars is shown by his treatment of the open jaws with the upper twisted to its right and disaligned with the lower part of the mouth. Seen from the side, it is as if the roar begins deep inside the animal and issues from its whole body. The only sign of a wound might be found in the absence of the animal's left eye. The profile view also encourages the sense of the animal lifting itself from a crouched position; its hind legs are still folded under the haunches, and the straightened left front leg is pulled back in the effort of lifting the front of the body. The right is also straight but seems to advance. Thus the ani-mal appears to be moving in fluid stages from a stationary to a mobile position, from rest to angry action. Rodin told a Dutch visitor how years after he had left Barye's class, he saw the master's bronze sculpture of two greyhounds: "They ran . . . not for an instant did they remain in one spot. . . . An idea came to me suddenly and enlightened me; this is art, this is the revelation of the great mystery; how to express movement in something that is at rest."[7]

This summation or succession of movements Rodin had worked with in his *Saint John the Baptist Preaching* (1878).[8] It also differentiated his lion from Bartholdi's stationary beast, which looks as if his two front feet are braced. The head of Rodin's lion is far more natural, expressive, and ferocious because of its twist and the bared teeth, whereas the more regally posed head of Bartholdi's lion, emerging from a carefully groomed mane, looks less menacing. Rodin made more—sculpturally—of the animal's bone and muscle structure than did Bartholdi. The mane is more robustly handled, with the result that his beast seems wilder, leaner, and meaner, belonging to the same pride of lions as Barye's rather than Bartholdi's. Contrary to the view that Rodin was "out of his realm when he turned from the human figure,"[9] the lion shows that if he had concentrated on animals, Rodin could have been the best nineteenth-century *animalier* of them all.

Unfortunately there are many unauthorized casts of Rodin's lion, which seem to have been made from a badly repaired plaster from which the teeth and part of the tail are missing, and the lower jaw is less accurately and sharply defined.[10]

NOTES

LITERATURE: Bénédite 1926, 17; Grappe 1944, 26; de Caso and Sanders 1977, 117–19; Barbier 1987, 80; Goldscheider 1989, 162

1. Barbier cited the correspondence of Edmond Turquet's son-in-law, Gabriel Deglos, which states that the plaster was made and offered by Rodin at the time of his mother-in-law's death in 1881 (1987, 80 n. 1).
2. Léonce Bénédite, the first curator of the Musée Rodin, wrote, "And did not his thoughts turn again, finally, to the great animal sculptor, when he did the little *Weeping Lion*, crouched above the arms and device of the Montgomery family, to which Madame Edmond Turquet belonged . . . a little figure which Rodin conceived as a sort of monumental effigy?" (1926, 17). Grappe wrote, "The sculpture

adorns the tomb of an illustrious family" (1944, 26). De Caso and Sanders described the lion as being reportedly a commission (1977, 117). Barbier noted that, contrary to previous writings, there is no proof of the existence of a stone or marble that would have decorated the tomb (1987, 80). Goldscheider implied that the lion was a gift (1989, 162).

3. See Bénédite 1926, 17. A bronze cast further inscribed with the date 21 May 1881 is in the collection of the California Palace of the Legion of Honor. De Caso and Sanders pointed out that the date of Mme Edmond Turquet's death was, in fact, 23 May, according to an obituary they cite (1977, 119 n. 3).

4. Goldscheider 1989, 162. When Bénédite began casting more bronzes of the lion in 1919, the Turquet family vainly protested.

5. Busco in Fusco and Janson 1980, 121–22.

6. Beausire 1988, 336, 339, 367–68.

7. Grunfeld 1987, 29, citing Byvanck 1892, 9.

8. De Caso and Sanders wrote that the lion "is less inventive than his figures" (1977, 117). On the contrary, if done about the time of *Saint John*, it would have shared with this human figure one of Rodin's most inventive ideas for showing movement in sculpture.

9. Ibid.

10. This is the view of Alain Beausire of the Musée Rodin. De Caso and Sanders cite Frisch and Shipley 1939, 389–90, to show that unauthorized casts were made to Rodin's annoyance during his lifetime (1977, 119 n. 8). If true, this may be one of the rare instances in an otherwise fraudulent book in which Shipley did not rely on Frisch's imagination but obtained the information from a published source; Frisch and Shipley's further claim (220), however, that the Montagutelli brothers, who made the unauthorized casts, also made plasters for Rodin is questionable, since this was done normally by Rodin's studio assistants, notably the Guiochés.

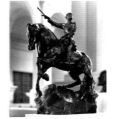

7

Maquette for "Monument to General Lynch"
(Maquette pour le monument Général Lynch), 1886

- Bronze, Georges Rudier foundry, cast 1973, 3/12
- 17¼ x 9 x 5¼ in. (43.8 x 22.9 x 13.3 cm)
- Signed on base, top center: A. Rodin
- Inscribed on back of base: Georges Rudier/Fondeur Paris; on base, left side: © by Musée Rodin 1973; interior cachet: A. Rodin
- Provenance: Musée Rodin, Paris
- Gift of Cantor Fitzgerald Art Foundation, 1975.85

Figure 55

One of the heroes of the war between Chile and Peru (1879–82) was Admiral-General Patricio Lynch (1825–1886), leader of the Chilean army. Through his friendship with Mme Morla Vicuña, wife of the Chilean ambassador to France, Rodin was asked by her government to create a monument. In the summer of 1886 the maquette won the approval of Lynch, himself now ambassador to Spain. Rodin showed his subject presumably dressed as a Chilean admiral, mounted, and with his sword extended toward the field of battle rather than

actually leading a charge. The hero sits relaxed rather than tensed for combat. (As it was but a maquette, Rodin did not indicate bridle or stirrups.) Despite its small size, the distinctive head bears a residual likeness, which must have pleased its owner. Probably because of changes in Chilean politics, the monument was never realized.

Of greatest importance to Rodin was the opportunity to make his first equestrian monument. Whether or not he used an assistant for the figure, as he did for an unrealized monument to another Chilean, the statesman and writer Benjamin Vicuña-Mackenna (model 1886), the horse was undoubtedly Rodin's. Since his student days Rodin had been thinking about them; his notebooks show workhorses at the Left Bank Paris markets. Before this monument he had only realized parts of horses in relief for *The Gates of Hell*. Rodin's knowledge of equine anatomy informed the modeling of Lynch's mount, and his establishment of the big planes and their junctures, especially in the flanks, would have been impressive in full size seen from below and at a distance. The position of the sword, the horse's lowered head and tail between his legs help compact the design within a cube. Perhaps because he did not know if the maquette would be realized in bronze or stone, but probably anticipating the latter, Rodin used the mane for the neck and kept the tail between the legs and touching the ground as structural braces. The hooves are shown at different levels atop the rocky ground. The impression is that of the horse bracing itself and waiting to charge. A pedestal was designed,

presumably by an assistant, but rejected because Rodin found it smacked too much of "carpentry."[1] Despite the fact that the monument was never realized, Rodin made good use of the body of the horse in his *Centauress* (cat. no. 158).

NOTES

LITERATURE: Lawton 1906, 69, 70–71; Cladel 1936, 148–49; Grappe 1944, 58; Tancock 1976, 200, 204; Grunfeld 1987, 169–70, 266; Goldscheider 1989, 194–95; Pingeot 1990, 242–43; Barbier 1992, 21 Le Normand-Romain, 2001, 192.

1. Grunfeld 1987, 266.

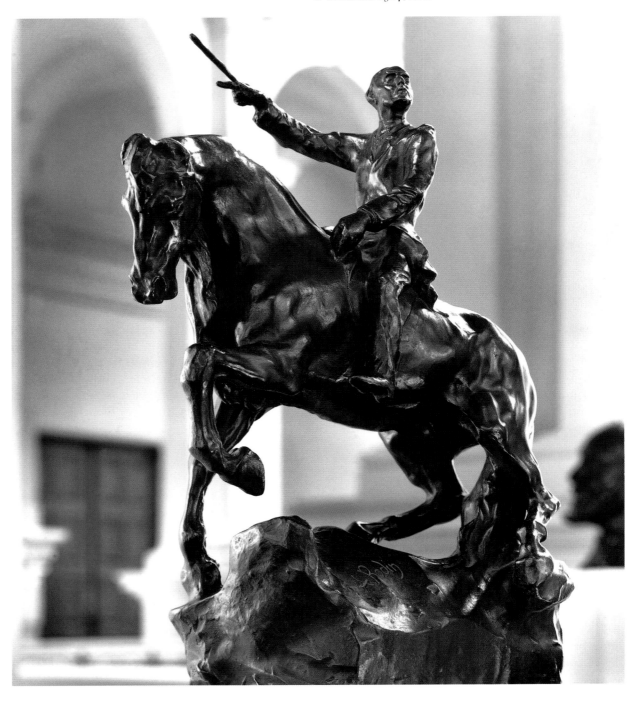

THE BURGHERS OF CALAIS

Monuments to military defeat by the defeated are rare in the history of art. They begin to make their appearance after the Franco-Prussian War, when France sought through public art to rally the people after one of the worst military disasters in the nation's history. Rodin experienced the challenge of showing heroism in defeat when he competed unsuccessfully in 1879 with *The Call to Arms* (fig. 49) for a monument to the defense of Paris against the besieging Prussian army. In the United States Maya Lin's *Vietnam Veterans Memorial* (1981–83; Washington, D.C.) similarly expresses America's effort to come to terms with a terrible military disaster and to honor its victims in the armed forces by means of a work of art.

The Burghers of Calais (fig. 56) stands at the beginning of modern public sculpture both in theme and form. Ironically, aspects of Rodin's art contradicted what many modern artists believed until recently; words that were anathema to modernists that could be applied to *The Burghers* are illustrative or literary, theatrical, heroic, and patriotic. His creation was based on Jean Froissart's fourteenth-century account and not the artist's personal experience; the sculptures celebrated heroes and sacrifice for one's country; and the monument was intended to be theatrical in the sense of inviting the viewer's sympathy by staging in public the emotional and psychological reactions of six men who faced an honorable but unjust death (figs. 56 and 57). Thus, expression was depicted in the subjects' faces, gestures, and bodies as opposed to emanating from the elements of art and their overall arrangement, as modernists since Henri Matisse have preferred. The monument was made in the service of government for patriotic purposes. Modernist sculpture throughout most of its history celebrated life and living, not death and dying for one's country. The modernity of *The Burghers of Calais* lies in the fact that Rodin had to impose his vision on his clients and the public.[1] Despite severe and externally imposed restrictions of many sorts, the sculptor carried out the commission on his own terms.

There are those art historians who believe that the plural contexts or spirit of the age in which a work is made explain the art. Rodin gave comfort to such a view when he said, "A true artist always puts something of his time into his work, and also of his soul."[2] Besides that intangible and elusive soul, Rodin also reminds us of the limitations of contextualism: "When one is preoccupied with pleasing that million-headed monster called 'the public,' one loses one's personality and independence. In limiting his needs, one can work as he intends, remaining completely free within his own thoughts. I know very well that one must fight, for one is often in contradiction with the spirit of the age."[3] Ernst Gombrich is fond of pointing out that "art is the product of individual artists and sometimes it's even they who influence history."[4] Such was the case with *The Burghers of Calais*.

Rodin was dealing with a public that knew by heart the burghers' story from plays, prints, and paintings as well as from history books.[5] From the arts, his public had a clear idea of what they wanted him to do in the monument: show the unflinching devotion of the heroes to their city and its citizens in a theatrical way. Rodin introduced into public art a modern concept of the heroic, namely that courage meant triumph over fear. He humanized and eventually won a new credibility for the public monument by bringing his heroes down to earth emotionally, and if he had had his way, artistically. Rodin defied similar but conventional municipal compositions of the period and their use of architectural elements, allegorical trappings, and the expected attitudes of the victims as he deliberately sought an original statement that would bring honor to himself and his client. Forgotten by those who criticized Rodin then and later for not being able to finish a major commission is that *The Burghers of Calais* proved that he could do so under the most trying circumstances. As would happen subsequently with other controversial public sculptures, Calais eventually took pride in being associated with the work of a great artist. *The Burghers of Calais* is historically unique and at the time of its installation in 1895 was a rare monument in having six freestanding figures that could be seen outdoors in the round. Historians have vainly sought historical prototypes and influences.[6]

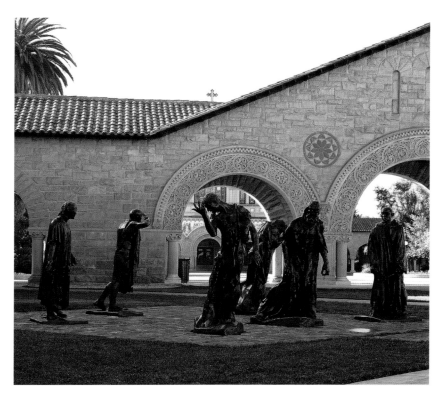

Fig. 56. *The Six Burghers of Calais* in Memorial Court, Stanford University.

Circumstances of the Commission

When Rodin was officially commissioned to create a monument to the six fourteenth-century heroes of Calais, he was the beneficiary of a number of events and circumstances. Following the Franco-Prussian War there was a wave of patriotism fostered by the government and a desire for monuments that appealed to the nation's Gallic spirit, preparing the nation for revenge against Prussia.[7] The story of the burghers included devotion to one's country and willingness of the bourgeoisie to sacrifice themselves for their fellow citizens, heroic resistance to an invader, and a reminder of how Calais had survived two hundred years of English rule, just as Alsace-Lorraine would have to survive under Prussian control. In 1884 the French government passed a law permitting municipalities to commission public monuments.[8] The city of Calais was about to merge with the adjacent and larger city of Saint-Pierre (though retaining the name Calais) and to the dismay of its citizenry was in the process of tearing down its medieval walls and many of its old buildings in order to be both a more modern city and to achieve physical unity with its new partner. The last mayor of the historic city, Omer Dewavrin (1837–1904), seconded by the city council, wanted to commemorate his Calais and a glorious though controversial moment in its past with a work of modern, not academic, sculpture.[9] The monument was to be paid for by a grant of 10,000 francs from the city supplemented by public subscription to a national appeal.[10]

The commissioners hoped that Rodin's models for the monument would be exhibited in the Paris salons as early as 1885, thereby giving favorable publicity to their cause, and this was why in Rodin's contract he agreed to provide a model "completely finished and carefully executed, in the same manner as the works admitted to the annual salons."[11]

The proposed monument—only the most recent in a line of projects for Calais that had never been carried out—was intended also as a vindication of the medieval burghers' reputations, especially that of their leader, Eustache de Saint-Pierre. His integrity had been challenged since the eighteenth century by certain historians who claimed that he was actually a traitor, for after the siege of Calais had been lifted, he was restored to a fine house and rewarded financially by the English king.[12] Originally the commission was to be for a monument to Eustache alone, but it was Rodin who with his first model convinced his clients that it was more appropriate, desirable, and financially feasible to memorialize all six citizens.[13]

Dewavrin was guided in his selection of Rodin as a possible creator of the monument by a small number of Calaisians at home and in Paris, some of whom were friends of both the artist and the mayor.[14] Two well-known artists, Jean-Charles Cazin (1841–1901) and Alphonse Legros (1837–1911), interceded with Dewavrin on Rodin's behalf. There was no formal competition, but when the project for the monument became known, several sculptors sent entries that were publicly exhibited in the Calais city hall and considered by a committee, which consisted initially of 24 citizens appointed by the mayor.[15] Even later, when the committee was enlarged, its members did not include any artists other than the architect Ernest Decroix, who eventually designed the pedestal for the monument. As

shown in the contract, these provincial commissioners were impressed by the standards of the official Paris art world, of the salons and their prizes, and federal commissions. Rodin's professional credentials included the government purchase of his *Age of Bronze* and *Saint John the Baptist Preaching*, the commission for *The Gates of Hell*, and awards won at the salon. Not surprisingly the selection of Rodin, a Parisian, especially displeased local sculptors and their friends and supporters, judging from the negative press his project received in the first years and from demands by these artists for a more traditional competition.

In 1880 Rodin began work on *The Gates of Hell* but by 1884 it was less than half completed, so a fair question is why he sought the exacting task of making six life-size figures? More difficult for us to comprehend today is that the contract he signed required him to be responsive to the criticisms and suggestions of his clients, none of whom were artists: "he in any case, ultimately, would execute the changes that the examination of the said maquette might suggest to the committee and would apply them to the final group."[16] An Ecole des beaux-arts standard was imposed and agreed to by the artist, whereby he would "execute a model one-third life-size completely studied, finished and achieved, requiring nothing more than to be enlarged and carried out."[17] His acceptance of these conditions was a matter of the artist's pride and ambition as well as confidence in his art and powers of persuasion. At the time his reputation, though growing, was insufficient to give him the clout to dictate more congenial terms. Yet, he must also have been aware that he had influential friends with access to the mayor and committee. What his commissioners may not have known was that Rodin had failed in several previous competitions. As he would also make clear in *The Burghers*, Rodin was an ardent Frenchman. He deeply desired to make commemorative art to honor his country and French sculpture and to add to his own reputation, thereby attracting more commissions. He was fully in sympathy with the idea of the existence of a new national or Gallic spirit to which artists should appeal and that France itself had a great artistic tra-

dition beginning in the Middle Ages, which in place of Italian sources should inspire modern French art. In accepting the Calais commission, Rodin, to use his own word, "abandoned" for a few years the great portal. He was not being pressured by the government to complete it as there was no specific site or existing building to receive it. For all the foregoing reasons and probably others, Rodin truly, if not desperately, wanted the Calais commission. Finally, and most important of all, he immediately recognized when reading Froissart's *Chronicles* that he had a great and inspiring story to work with.

In 1347 King Edward III of England invaded France, beginning what became known as the Hundred Years' War. The besieged city of Calais was ordered by the king of France to hold out at any cost. The French king tried but failed to reach Calais to raise the siege, and after months of fighting the Calaisians succumbed to famine and parleyed for surrender. Angered by the delay the stubborn city had caused, the English king violated the rules of war, which dictated surrender and ransom, and set a cruel price to end the conflict. As recounted by Froissart, King Edward said:[18]

Gautier, you will go to those of Calais and you will tell the captain that the greatest favor that they can find and have from me is that they send from the

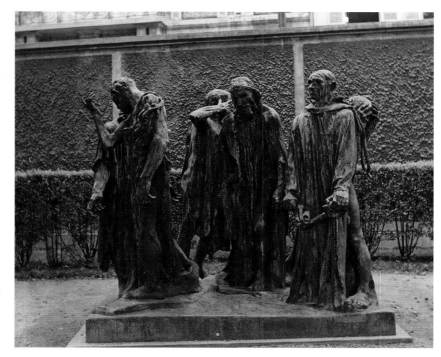

Fig. 57. *The Monument to the Burghers of Calais*, 1884-95, bronze, 82½ in. (210 cm). Musée Rodin, Paris.

city six of the most notable burghers, their feet bare, rope around their necks and the keys to the city and of the chateau in their hands and with them I will do as I please and on the rest I will take pity.

Gautier de Mauny went to the foot of the rampart where Jean de Vienne waited, and reported to him the will of his master. Jean de Vienne asked for a few moments to reunite the inhabitants, in order to make known the will of the king of England.

He went to the market, rang the bell, at the sound of which men and women came, all curious to know the news.

When all were together, Jean de Vienne imparted to them the king's will. When they had understood this report, they all began to cry and weep, so much and so bitterly that there is no heart in the world so hard that having heard and seen them would not have pitied them. . . .

A moment later there arose the richest burgher, Sir Eustache de Saint-Pierre, who said: "Lords, it would be a great misfortune to let such a people die here of famine when one can find another means. I have such hope of finding grace and pardon from Our Lord if I die in order to save these people, that I want to be the first: I will willingly strip to my shirt, bare my head, put the rope around my neck, at the mercy of the king of England."

When Sir Eustache de Saint-Pierre had said these words each one was aroused to pity and many men and women threw themselves at his feet. . . .

Secondly, another very honest and rich burgher, who had two beautiful daughters, who was called Jean d'Aire, arose and said that he would keep company with his companion Eustache de Saint-Pierre.

Afterwards there arose a third who called himself Sir Jacques de Wissant who was a man rich in property and heritage and said that he would accompany his two cousins. So did Pierre de Wissant, his brother, Jehan de Fiennes and Sir Andrieux d'Andres.

And there the six burghers undressed, all naked, in their breeches and shirts . . . and they put the rope around their necks . . . and took the keys to the city and the citadel: each one holding a handful.

When they were thus prepared, Jean de Vienne, mounted on a small nag, put himself in front of them and took the route to the gate. Then one saw men, women, children, weep and wring their hands, and cry in a loud voice very bitterly. . . . Thus they came to the gate, convoyed by cries and tears. Outside the gate they found Sir Gautier who was waiting. Jean de Vienne told him:

As Captain of Calais I deliver to you, with the consent of the poor people of this city, these six citizens: and I swear to you that they have always been the most honorable and notable of body, property and ancestry of the city of Calais; they carry with them all of the keys of the said city and chateau. I beg you noble sir, to intercede for them with the King of England in order that they not be put to death.

I do not know, replied Sir de Mauny, what the king will do; but I swear to you that I will do all in my power to save them.

And they went to the English camp.

Rodin's reaction to this story is made clear in the first model and his accompanying comments to his benefactor, Calais's mayor.

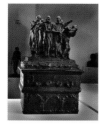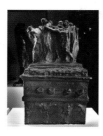

8

First Maquette for "The Burghers of Calais"
(Les bourgeois de Calais, première maquette), 1884

- Bronze, Godard Foundry, 2/12
- With pedestal: 23⅜ x 13 x 11¼ in. (59.4 x 33 x 28.6 cm)
- Signed on top of base, front left corner: A. Rodin
- Inscribed on base, left side, lower edge, near back: E. Godard/Fondr/Paris; on base, left side, lower edge, near front: © by Musée Rodin; on top of base, left front corner: No. 2
- Provenance: Musée Rodin, Paris
- Gift of the Iris and B. Gerald Cantor Foundation, 1974.97

Figures 58–59

Within a few weeks of their first meeting, probably in late October 1884, and having received Dewavrin's invitation to submit a model to the Calais committee, Rodin made his first maquette. The artist's enthusiasm for the project is evident in his first two letters to the mayor.

Since the honor of your visit, I have been thinking about the monument and was lucky to come across a thought I liked, the execution of which would be original. I have never seen such an arrangement suggested by the subject matter, nor a more singular one; it would be even better since all cities have ordinarily the same monument, give or take a few details.

I will therefore make a clay model, which I will have photographed, and I would be grateful if you encouraged me, assuring me of your considerable influence.[19]

I just made a sketch in clay and had it cast. In that way, you will be able to make a better judgment. If you would like to see it more expressive, you could commission me to double the size with a pedestal more articulated and finished.

The idea seems to me completely original, from the point of view of architecture and sculpture. Nevertheless, it is the subject itself that is important and that imposes a heroic conception. The general effect of six figures sacrificing themselves is expres-

sive and moving. The pedestal is triumphal and has the rudiments of a triumphal arch to carry, not a quadriga [four-horse chariot], but human patriotism, abnegation and virtue.

The simplicity of the architecture will keep the costs low; the amount of bronze in the six figures will be reduced because the figures support one another, so casting will be less expensive. I believe 25,000 francs will cover the cost, and there will not be more than the sculptor's fee on top of that. Rarely have I succeeded in doing a sketch with so much élan and sobriety.

Eustache de St. Pierre, alone, through his dignified movement, motivates and leads his relatives and friends, arm slightly raised.[20]

In a letter to P. A. Isaac, whom Dewavrin had asked to head a Paris committee to search for a sculptor and who introduced the two men, Rodin expanded on his ideas:

If these gentlemen find the maquette insufficiently developed, I can make it more so and a little larger. But it is necessary that I be compensated for the execution of the sketch that will be done with all the desired rigor. It has been impossible for me to do more, not liking to work other than with a firm commission.

The thing is original and there is at the same time the spirit of these heroes which communicates itself better by viewing the six rather than a single one. The sacrifice has its appeal already and cannot fail to move the viewers. The architecture is simple and triumphal. The subbasement and terrace are to be added.[21]

The letter included a small drawing of a second idea, which shows, unlike the actual first maquette, a tripartite conception with the figures atop the triumphal arch mounted in turn on a rectangular foundation, presumably with a terrace, and sloping ramps rising from the flanks.[22] As this sketch was intended for a fellow artist, with his pen Rodin merely scribbled atop the monument an indication of the vertical figures (five are so signified) in the same up-and-down, or wavelike, notational mode used to indicate shading in the foundation. It appears from its absence in subsequent correspondence that the idea of the broad foundation was dropped.

Rodin's enthusiasm for the first maquette, which was

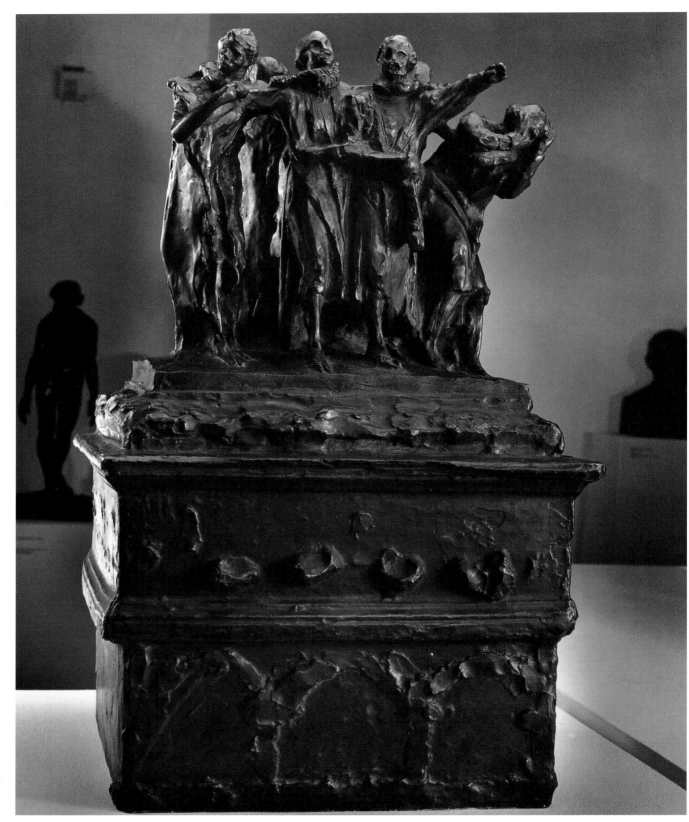

Fig. 58. *First Maquette for "The Burghers of Calais,"* front (cat. no. 8).

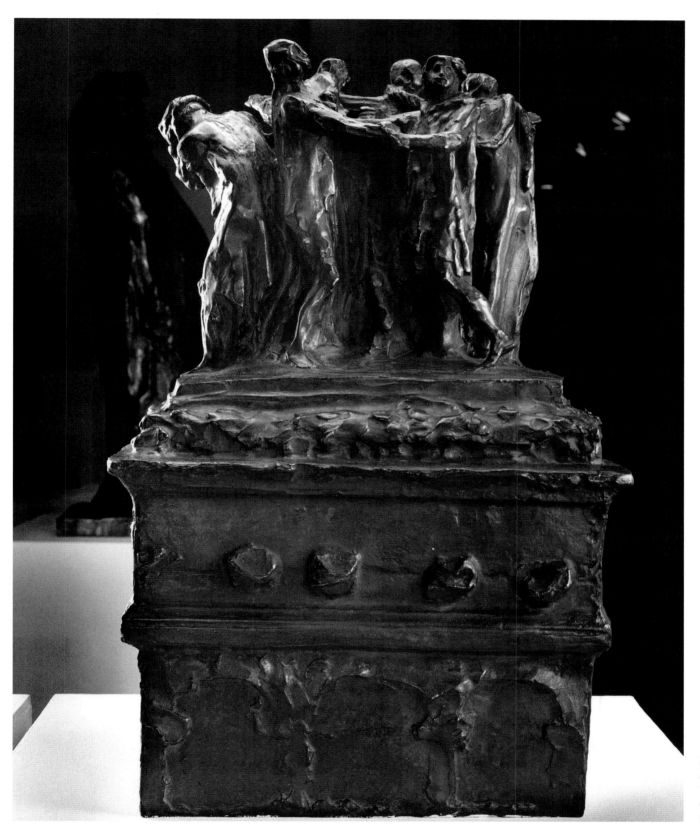

Fig. 59. *First Maquette for "The Burghers of Calais,"* rear (cat. no. 8).

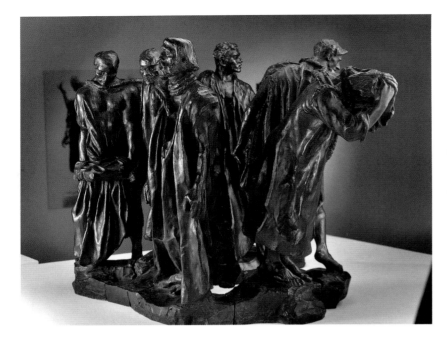

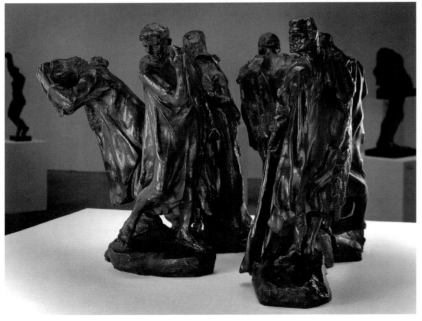

able to reading individual figures depends on the concerted movements achieved by the vigorously modeled drapery and their interconnecting gestures. Perhaps assuming his audience's habit of reading from left to right, Rodin began his composition at the extreme left with a slightly bent figure whose body language makes us look to the right. This figure, later called Jean d' Aire, serves as a kind of interlocutor between viewers and the sculptural group. He stands still, with feet together in advance of the others, body turned slightly to his left. His left arm around the shoulders of his companion, Pierre de Wissant, he looks in the other direction and with his right hand makes a gesture of seeming self-interrogation as if asking whether he has the courage to perform the sacrifice. The second figure from the left puts his left arm around the shoulders of Eustache and with his right hand grasps the older man's right arm in support and solidarity. Head up, he marches in step with the leader. As described and modeled by Rodin, Eustache raises his left arm slightly above shoulder level and outward to signal the hostages' departure while perhaps pointing to the gate through which they will leave.

From the evidence of the second maquette (see figs. 60–61) we have the reason for one of Rodin's most controversial decisions. To ensure that Eustache's dramatic gesture would be clearly visible and not overlap the head of the man to his left, Rodin decided to have the burgher at the extreme right bend over. To justify this unusual posture, Rodin resorted to a narrative device. Being particularly mindful in this early stage of historical details such as the required halter, Rodin simulated a rope, thick and heavy enough to be a hawser like those used in a port city such as Calais to moor ships. It is already wrapped around the necks of the first three figures starting at the left. The stooped posture of this rightmost man, who came to be known as Andrieu d'Andres, is made plausible by showing him in the act of harnessing himself to the others. He is positioned a quarter turn to his left and bends from the waist as if to pull the heavy rope with his right hand around his lowered head. By turning this figure in the same direction as its far left counterpart, Rodin avoided obvious compositional closure. The man's despair is mimed further by the left hand that clutches his head. To some critics on and outside the committee it appeared that the figure's desperation was unseemly. He appeared to have lost all self-control, as if stumbling into his grave. It was this figure alone

later seconded by the committee, warrants a closer look at its narrative.[23] Seen head on, the burghers appear to be arranged in two irregular ranks. Imagining the group within a cube, Rodin worked, unsuccessfully it turned out in terms of the committee's reaction, to avoid a monotony of effect. Seen close up in the round or viewed from above, it is clear that the figural sequence in parallel planes from front to back is that of alternating single and paired figures. The figures are thus seen in depth with resulting variances in light and shadow.

The overall effect that Rodin singled out as prefer-

that, after receiving the committee's comments, Rodin conceded he could modify.

For many, the two figures in the back of the maquette seemed to be doing a kind of dance. In fact, they are breaking off their mutual farewell; for each an out-stretched hand is still clasped by the other. Seen from the rear of the maquette (fig. 59), the figure to the right, whose slightly raised head is turned toward the viewer, pushes with his free hand against the shoulder of his companion. The figure to the left, whose upturned face is the least articulated, raises his bent left elbow to avoid hitting the arm of the man next to Eustache, which is across the older man's back. (The gesture of the raised and bent elbow foretells that of the final *Jacques de Wissant*.) The palm of his left hand is turned toward the other figure, implying perhaps that it is time to break off their leave-taking. In this early phase, when the names of five of the burghers were still unassigned by the artist (or the Calais jury), Rodin may have imagined this intimate duet enacted by the Wissant brothers mentioned by Froissart.

Contrary to the view that Rodin was only an inductive thinker and built the story of the burghers from its small-est figural parts, the first maquette shows that from the start Rodin visualized the scene in terms of an overall or group effect, within an implied cube, even though all six men were not reacting to one another. He pointed out in his second letter to Dewavrin that there would not be six freestanding figures to cast, for they would be supporting one another, thereby saving bronze and economizing on foundry costs. In fact, he broke the narration into two duo and two solo performances. While each figure is in some form of physical contact with one other, mutuality was expressed only in the pairings of the men. As Rodin was later to develop the characters and postures of each burgher, these gestural connectives—like the rope itself—would be broken, though the cubic composition would remain.

Still, in November 1884 Rodin sent a letter and draw-ing, now lost, to Isaac along with ideas for reliefs for the pedestal. "I have sent you the drawing, on the front there is a group of women and children, those whom Saint-Pierre had ransomed by his heroism, the population [in] two bas reliefs on the sides."[24]

Later that month Rodin sent a note to Dewavrin. "I believe that yesterday I omitted the height in which the figures would be executed. They would be 1 m 90 or 2 meters. That depends on the site and the decision of you and your committee."[25]

Rodin's winning of the early approval of his concept by the commissioners was signaled to him by the mayor on 13 January 1885. "The committee has decided to ask you to double the size of the maquette you have sent us. It is understood that if you were not charged with doing the definitive work you would be paid the sum of 2,000 francs for the work." The minutes of the committee's meeting on 6 January record that "it was decided unani-mously that the monument would consist of a group in bronze representing Eustache de Saint-Pierre sur-rounded by his companions (2 meters in height) and that the monument would be erected on the new square in front of the Hôtel des Postes et des Télégraphes now under construction." Near this site stood the gateway by which the burghers had left the city, and this undoubt-edly influenced Rodin's conception and thoughts about the monument's orientation.[26] In effect, Rodin was being asked to make a second model one-third life-size.[27]

There were demands by two members of the munici-pal council after the foregoing decision to organize a true competition and to publish the new requirements for the monument. It appears that a local sculptor named Edward Lormier (1847–1919) had been asked, presumably by the committee, to prepare a maquette showing only Eustache, as was originally intended, and he found it strange that without explanation the commit-tee had abandoned its first project.[28]

On 24 January 1885 Rodin received a telegram from Dewavrin that the "council has yesterday approved a firm commission from the committee providing 15,000 francs."[29] From the minutes of the municipal council's deliberation it is clear that to its supporters Rodin's mon-ument represented not only all the implications of the subject but that "it was not exploitable by others," and that it "precisely responded to that denigrating spirit which for some time had come to light in certain places" that was "incredulous of the civic virtues and heroic action of Eustache de St. Pierre" and wanted "to truly judge whether, after the siege, he might have put himself in the service of the king of England."[30]

What is clear from Rodin's own statements regarding the first maquette was his determination to be original and to challenge the conventions of public monuments in a way he had not done before, though he had begun to move in this direction in his 1879 model for *La défense*.[31] The concept of figures atop a triumphal arch, as suggested in the base, was probably inspired by his medi-tations on the Carrousel Arch between the Louvre and

the Tuileries. The raised pedestals of Breton calvaries also may have influenced Rodin's thought about the monument's final mounting.[32]

Rodin sought to democratize the use of the triumphal arch by replacing allegorical figures, the quadriga, with actual historical heroes. Recognizing that the medieval burghers were viewed virtually as hostage saints by the contemporary Calaisians, Rodin wanted the traditional heroic associations with the triumphal arch. Although the first model seems to differ radically from the final monument, it contained ideas that would be retained: a group of almost equally sized figures, most of whom were in motion, arranged within an oblong cube with the front being on the broadest side. The flanking figures were the most demonstrative in terms of gestures. Eustache who is just off-center, as he would be ultimately, continued as the focal figure. The extreme elevation of the composition always remained in Rodin's thinking and culminated in the installation of *The Burghers* on a tall pedestal in London in 1915 (see fig. 69). What he changed was not just the characterizations of the burghers and their positioning but also their earlier mutual physical and psychological support. This came about as he focused on the individual figures, to which he gave a self-sufficiency lacking in the first model.

Second Maquette for The Burghers of Calais

In January 1885, while beginning to work on his second maquette (figs. 60–61),[33] Rodin wrote to Dewavrin, "I intend to study some expressive portrait heads in the countryside for the companions of Eustache."[34] (Rodin apparently asked the painter Cazin, who claimed to be a descendant of Eustache de Saint-Pierre, to pose for that figure.)[35]

Just before he sent the second maquette to Calais six months later, Rodin wrote to Dewavrin, revealing a second method he was employing: "The group will be sent Wednesday by slow train. It is made to be executed on a large scale; therefore the lack of details should not be surprising, because generally all drapery is done over on a large scale. The modeling of the folds varies as the mannequin on which the drapery is thrown does not give the same result twice." (Rodin had no previous experience with draped male figures, and one wonders what type of mannequin and drapery he employed.)[36]

Rodin's letter continued, "I have my nudes, that is to say, what is underneath is done and I am going to have them executed in order to not lose time. You see, it is that which one does not see, and which is most important, that is finished."[37] Studying the individual figures for the second maquette, however, and in terms of what has survived in the Musée Rodin reserve, it seems that only Jean de Fiennes and Pierre de Wissant (fig. 62) were first modeled in nude studies, and the rest were not. Ironically, in his revolutionary project Rodin was partly following a principle of figure construction used by Jacques-Louis David and his academic followers, which involved first portraying figures nude before draping them so that the artist could be assured that the body was correctly modeled before it entered into its dialogue with the drapery.

As it exists at Stanford today, the so-called second maquette consists of six figures, each on an integral base. Some of the bases bear marks that indicated a position relative to one or more other bases. These études for the individual burghers are discussed in detail below, but it is appropriate to say something here about what the second maquette looked like in terms of the placement of the figures. Newspaper accounts do not give detailed descriptions but single out individual burghers or address overall qualities. If they were taken, no photographs seem to have survived showing the final arrangement of the maquette, but there exist tantalizing, partially obstructed views of the plasters in the background of the photographs by Karl-Henri (Charles) Bodmer (1809–1893) of the nude Pierre de Wissant still in clay.[38] The photographs date from 1886 and show the small plaster figures bunched atop a shipping crate, from which they might have been removed after their return from Calais. Given the placement of the figure of Andrieu d'Andres at the far left in these photographs, for example, which is totally opposite from that in the written accounts after the group's showing in Calais, in all likelihood the individual sculptures were not arranged as for their formal presentation but just casually placed together on the available narrow surface.

By the way he shaped portions of the bases and marked five with notches, it is possible to reconstruct the order of the second maquette's assembly.[39] Starting at the extreme left as one faces the front and then proceeds around the group counterclockwise to the rear, the sequence is (as later named): Jean d'Aire, Jacques de Wissant, Eustache de Saint-Pierre, Andrieu d'Andres, Pierre de Wissant, and Jean de Fiennes (see fig. 60).

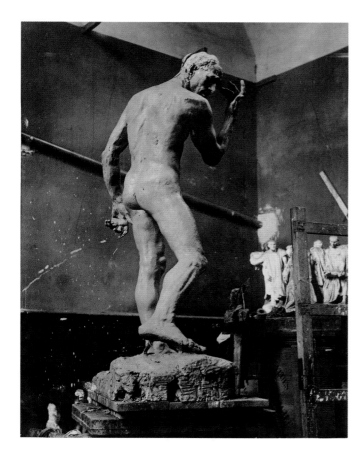

Fig. 62. Karl-Henri (Charles) Bodmer, *Nude Study for "Pierre de Wissant" in clay with second maquette in background*, 1886, albumen print. Musée Rodin, Paris.

might have been the closest precedent.) Rodin's subject was that of bourgeois heroism, ideal for the Third Republic, which was still looking for examples of valor in the humiliating defeat of the Franco-Prussian War. Specifically, Rodin chose to depict six distinct citizens in a painful leave-taking, departing in a disorganized way from a city square. It was to be a scene of surrender by six self-sacrificing individuals who show devotion to their city. In looking for models from Calais and the surrounding countryside, Rodin was being more than a nineteenth-century realist; he had recourse to a tradition going back to the late Middle Ages, which he could have learned from sculptors such as Claus Sluter and Donatello. Artists then and thereafter were encouraged to use living persons for their religious or secular characters to increase their credibility and encourage the beholder's sympathy with the subject and personal visualization of the story. [40] Where Rodin parted company with many of his commissioners was in wanting to show the personal cost of that sacrifice by how each burgher reacted to impending violent death. This was not the kind of subject that would have been commissioned by pre-Republican rulers in France—or in any other country. Rodin's problem as an artist was to give artistic order to that which in life was without order.

To that end, he positioned the figures so that they did not form distinct ranks, only a compact group in which the members did not act in unison. (Viewed from above, the composition repeats the grouping in the first maquette.) For the most important historical figure, Rodin eschewed the old authoritarian symbolic devices of central location, size, gestures, costume, and props, situating Eustache de Saint-Pierre to the right of center, a modified or conditional centrality. (That there is a divide just to his right between the left and right trios of figures is not made obvious.) Because of the lowered heads that flank him, he is given prominence by appearing taller than the others. Despite an expression of sadness, he was made the most dignified figure. His head is still upraised, but gone is the obvious gesture of the elevated arm of the first maquette, replaced now by his station, slightly in advance of the rest, and his movement, for with arms hanging at his sides and empty-handed he steps forward. To add to Eustache's prominence, Rodin created space around him by pushing Jean d'Aire and Jacques de Wissant to his right and so close together that the sculptor had to cut off part of the former's left foot. In compacting the group, Rodin placed Jean de Fiennes and Pierre

There were two versions of Jean de Fiennes, but from the details in Bodmer's photographs the one actually shown wore drapery over his shoulders. Absent the notches, the front of Jean de Fiennes's base does fit against the back of that for Jacques de Wissant.

As he did with the final monument, I believe Rodin wanted people to walk around the group counterclockwise so that on the first three sides they would see faces, as if the figures were advancing toward them. On the fourth side they would see only the backs of heads, but the strong impression that the group is moving forward would have been imparted. There is only a single vantage from which one can see the faces of all six burghers, that is by standing back and at an angle that shows both the front and right side of the group, not unlike the way Rodin wanted his individual figures seen and photographed, from an angle showing both breadth and depth.

No sculptor before Rodin had attempted to show six freestanding life-size figures in a composition intended for the open air that was not prescribed by a ritual, such as a funeral procession or parade. (Breton calvaries

de Wissant directly behind Jacques de Wissant and Eustache, respectively. These alignments in depth are not readily apparent because of the discrepancies of the paired figures' head and bodily orientations.

To resolve the unprecedented compositional challenge he had posed himself, Rodin ignored all the traditional devices, such as psychological mutuality, rhymed gestures, and physical contact between figures in the manner of Rude's *Departure of the Volunteers of 1792*, for example. What might Rodin have had in mind for the arrangement of his group when he started? From the first maquette he kept the cubic containment, the fairly even line of heads that democratized the figures' heroism, and the idea of four figures who could be seen from the front, with Eustache the most important, and the bent figure of Andrieu at the far right and two men in the rear. There is evidence in the rough and irregular, nondescript surfaces of the sides and rear of several figures, notably the adjacent pairs of Jean d'Aire and Jacques de Wissant, Andrieu d'Andres and Pierre de Wissant, that at one time they may have been joined but then were broken apart.[41]

For overall harmony Rodin relied on establishing and adhering to, as he put it, "the lines of my movement," established presumably by the subtle differences in the heights, actions, and intervals between his figures. He also counted on the excellence and consistent quality of their modeling under light, the general complementarity of the draperies, his intuition about a burgher's placement when seen in relationship to adjacent figures, and the effect of the whole: in short, his decorative sense. Some years later, and seeming to reflect his experiences with *The Burghers*, Rodin explained to his friend Henri-Charles Dujardin-Beaumetz his thoughts on composition: "When the figures are well modeled, they approach one another and group themselves by themselves. . . . When the forms are right there is less need for composition."[42] Nevertheless, Rodin counted on the use of an imaginary cube to guide him in achieving the group's overall movement, while permitting greater or more natural motion for each figure. Ironically, it is our experience with abstract art—learning to scan a work's totality for its harmony—that allows us to see more clearly than could his contemporaries the sculptor's unconventional (and hence modern) formal intentions and basis for judgment. From the second maquette certain other things become clear. Rodin was thinking of his group's installation on a rectangular pedestal. They were neither

to be arranged single file nor, at this point and given the variegation in the shaping of their bases, to be actually set among the paving stones of a square.

Rodin was so anxious for the Paris art world to know of the progress of the commission that, it appears without asking permission of the Calais committee, he invited the press to see the second maquette in his studio.[43] On 2 August an article appeared in *L'intransigeant* praising Rodin's effort: "This maquette is far enough along to give an idea of the monument, which will be several meters high. The personages are harmoniously grouped; the expression and attitude of Eustache de Saint-Pierre are particularly successful. The draperies are hardly indicated, but their disposition is very artistic, and if the final execution responds to the idea that this maquette gives of Rodin's work, the city of Calais will possess one of the truly remarkable monuments."[44]

On 26 July 1885 Rodin personally presented his maquette to the Calais committee, whose reaction was summarized in a communication in August, a document unusual in the history of art as it gives us a graphic indication of how intelligent and deeply patriotic laymen responded to a great artist's work, knowing that by contract he was bound to respect their views and make changes accordingly. It is apparent that they were not persuaded by praise of the maquette in the Paris press. If the reader gets the sense that the committee members were naive or archaic in their criticism, it should be remembered that their comments were consistent with critical standards of the time, including those used by the artist himself as well as by writers favorable to Rodin. The committee judged the sculptures largely as if they were critiquing a play and the plaster figures (specially cleaned and polished for the presentation) were live actors disposed on a stage. In a letter sent to a man named Desfontaine in Calais, Rodin used this theatrical analogy: "You must send me a note from the Committee. I hope I will not be too disturbed, for you know that upsetting the harmony of a sculpture calls for another effort. It is like a play, tragedy, or opera, one thing removed and everything is dislocated and necessitates beginning again an enormous amount of work to find another harmony."[45]

The committee's collective conception of the six may have been conditioned not just by their own imaginings or "religious" views of the men but by representations in paintings and prints, none of which showed the complex attitudes and emotions invented by Rodin. The contract

with the artist encouraged comments on the form of the whole, which at least credited Rodin with not being conventional or out of date. Although we have no record of Rodin's reactions to the committee's communication, at the time Rodin did respond to criticisms expressed in the press. In the end, he was to radically change the characterizations as well as the form of the monument, but in ways undreamed of by his commissioners.

The committee's reaction:

Recently we were called to the old town hall of Calais to look at the sketch of the burghers of Calais that M. Rodin had just brought. It is sufficiently studied to give a good idea of the effect intended by the artist, and all of us felt a slight disappointment.

We did not imagine our glorious citizens going to the camp of the king of England that way. First, their depressed attitude shocked our religious feelings, and we felt that the work we were looking at, far from glorifying the devotion of Eustache de Saint-Pierre and his companions, only produced the opposite effect.

After due reflection, and a new examination, we feel that M. Rodin's interpretation does not agree with ours. Our Calaisian pride will certainly suffer to see the most beautiful pages of our local history illustrated by the work he submitted.

It is far from our thought to demand that the artist give these men a theatrical attitude or conform in style to that of the sculpture done from 1830 to 1860. But there is too considerable a step between that outmoded style and the one he has used. We think the artist is right in refusing to give the figures a haughty attitude; but the despondency shown by Eustache de Saint-Pierre and his companions does not seem to represent our ancestors' devotion, which was both simple and sublime. Recognizing the grandeur of the act they would accomplish, they must have walked toward death, not as criminals condemned to capital punishment, but as true heroes, who gave their lives simply and generously; as men proud to do so with strength and dignity, without boasting or weakness.

We can accept that the artist, wishing to depict the various emotions felt by Eustache and his companions, tried to translate them by the plurality of the figures and possibly showed one of them expressing weakness at the prospect of dying. But we don't understand why the three major subjects, most prominently on view, show grief. This uniformity of attitude and feelings gives the group a cold and monotonous character.

We think M. Rodin went too far by showing the companion on the right in a desperate pose and the behavior of the burgher on the left, who cannot hold back his tears as he presents the city's keys.

After studying it, we find the shape, or rather the silhouette, leaves much to be desired in terms of elegance. Without being bound by artistic conventions, or by the so-called rules governing this discipline, we recognize nevertheless that this silhouette is not very graceful.

The artist could undulate the ground supporting the figures and even break up the monotony and the dryness of the outside lines by varying the size of the five figures. The scale model does not allow us to judge the details; nevertheless we noticed that Eustache de Saint-Pierre is covered with a cloth the folds of which are too thick to represent the light costume as indicated in history.

We do not think this detail is that significant, and M. Rodin probably realized it before us, but we feel it is necessary to insist that he change the attitudes of the subjects, as well as the outline made by the group. We hope that he will take these few observations into consideration, and we intend to submit them to him.[46]

On 2 August the Calais *Patriote* printed a long negative critique of the maquette, echoing many of the sentiments expressed by the committee, especially the characterizations of Eustache and the others. The writer misread the meaning of the work and assumed the six were standing before the king of England. The critic argued that Rodin should have shown Eustache alone at the moment he volunteered his life, and it was suggested that one of the other entries that showed Saint-Pierre thusly should have been chosen rather than Rodin's. Rodin was faulted for not using "the pyramid shape" rather than a "cube, the effect of which is most graceless." It was then argued that when seen from a distance the monument would lack "graceful and elegant lines." The article concluded by crediting the maquette with being "the work of a great artist," which is not "banal." The writer urged that

the monument be placed in a public building or a garden where it would be seen from a fixed distance.[47]

Rodin was quick off the mark in writing his reactions to Dewavrin the very day of the article's publication:

I just reread a note from the Calais *Patriote*, pretty much summing up the criticisms already heard, which would mutilate my work; *the heads should form a pyramid* (the Louis David method) *rather than a cube, or a straight line*, quite simply it is The School's rules [the Ecole des beaux-arts] and *I am directly opposed to that principle*, which has prevailed to this day since the beginning of the century and is directly opposed to previous great artistic periods. The works conceived in that spirit are cold, conventional, and lack movement.

Second. Eustache de Saint-Pierre seems to the critic to be in front of the king; what then are the ones behind him doing? No, he leaves the city and descends toward the camp. This gives the group the feeling of a march, of movement. Eustache is the first to descend, and it has to be this way for my lines.

Third. The monument must be in a garden or as part of a monument designed by an architect. *It must be in the center of a square.* Only the one who is desperate and plunges forward can be modified. My group is saved if you can obtain just that concession. These gentlemen do not realize that a model has been executed on one-third scale and that it is not a matter of consultation in order to make a new work. . . .

The work I have done and begun on the nudes is considerable. Saint-Pierre has already been enlarged to his final dimension. . . . The cube gives expression, and the cone is the horse, the hobbyhorse of those students competing for the Prix de Rome.[48]

After the merger of Calais and Saint-Pierre, Dewavrin lost his position as mayor to H. van Grutten. Rodin wrote to the new mayor in early August 1885, responding again to the negative views expressed in *Le patriote* and asking for his support:

The note that appeared in *Le patriote* of Calais does nothing less than to put me under the judgment of that taste of The School that I reject. Heads in a

pyramid instead of heads in a straight line is to recommend the conventional to me. Have you seen in Holland the admirable paintings of the council of burgomaster aldermen? All looking at you almost all the same way, what power! What an exclusion of affected false elegance, of coldness. To place the monument in a garden or in a building is to kill me. It is not worth the trouble that Calais has had the courage to choose me in order to then cut my beak and nails. The monument must be in the middle of a square. If you will, my dear mayor, it will be there and your energy in defending me will double my own. . . . You know that in Paris I have withstood the struggle for a long time but I have support in the great Parisian public. Here I do not and the superannuated modes of The School can still win.[49]

There exists a draft of a letter from Rodin to Dewavrin written just before the appearance of a letter that appeared subsequently in *Le patriote*:

No rule—no obligation requires the adoption of the pyramidal form: this convention is good, it has its justification in a good many cases, but for the subject in question it would be particularly bad.

The equality of height among all the figures of the group is in a way a just union, their sacrifice is equal—their dimensions must be the same, they must distinguish themselves only by their differences in attitude.

This equality of size among all the figures is on the contrary the original artistic conception of this group, it is this equality that gives to it the impression of grandeur that it possesses.[50]

Rodin's view of how to show equality of heroism in death reminds one of the *Vietnam Veterans Memorial*, on which are recorded all the names of those members of the armed forces who died. The names follow strictly the order of their deaths. No ranks are given. Each name is fully capitalized, hence all the letters are the same size. Thus for both monuments there is democracy in death.

On 19 August 1885 *Le patriote* printed a letter from Rodin:

I am a little late in telling you that I have read the article published in *Le Patriote* about the monu-

ment to Eustache de Saint-Pierre. I must tell you that the model is executed on a scale one-third the final size . . . it does not give the final feeling. Thus, I can assure you the final Saint-Pierre would obviously have more energy, without, however, changing the movement. The expressions of the personalities are arrived at by the correct modeling of nuances. For example, when I make busts, I set the head straight on the neck, and the expression comes from the strength of the modeling.

I find the title of your paper *Le Patriote* very beautiful; and you must agree with me in thinking that our sculpture must be treated in the national taste, that of the sublime Gothic epoch, which did not have to search for its movements . . . which places us so far above anything that can be seen in Italy, where their admirable renaissance is copied from a yet more admirable style: the Greek (which is so realistic that it was thought to be idealized). But this renaissance, which nevertheless dominates the French, has nothing to compare with the sublime (that is the word), which is the Gallic soul of our Gothic epoch. What pure, powerful, and naive genius. It is for that reason, sir, that I have chosen to express my sculpture in the language of Froissart's time, if you prefer.

It is for that reason I reject the pyramid, which belongs to our conventional art and which immobilizes. Curved lines are also very dull.

. . . It is possible to do beautiful things with ideas other than mine, but allow me to work with my mind and my heart, or otherwise you totally take my energy away and I become a workman; in short, I am a sculptor whose only wish is, as yours, to achieve a masterpiece, if possible, and for whom the question of art takes precedence over all others.[51]

The Burghers of Calais, 1885–95

For the rest of 1885 and into 1887 Rodin worked on the enlargement of his figures to life-size. In May 1886 he received the bad news that a series of bank failures in Calais had caused the loss of monies already raised for the monument and that the fund-raising had stopped. Rodin was paid, however, the sums due to him. That the sculptor had accepted other commissions during the

Calais project, such as the monuments to the painters Claude Lorrain and Jules Bastien-Lepage, vindicated his judgment concerning the risks of such enterprises and the need to keep himself and his assistants working.[52] Rodin had hopes of finishing *The Gates of Hell* in time for the centennial of the French Revolution in 1889 and devoted increased time to that project.

In May 1887 Rodin reported to Dewavrin in his capacity as head of the Calais committee that he had finished three of the figures and that three others were well along.[53] In the same letter the sculptor reported that the three finished works—*Eustache de Saint-Pierre, Jean d'Aire,* and *Pierre de Wissant*—were being successfully exhibited at the Galerie Georges Petit. A year later he showed *Jean d'Aire* at the Exposition internationale d'art monumental in Brussels, and in October 1888 he told Dewavrin that he was working simultaneously on *The Gates of Hell* and the monument.[54]

We lack a record from the artist or anyone else of what happened in the months that Rodin deliberated on and agonized over the composition of the monument with its six figures, which had been made separately. There is an old photograph of the figures in plaster, arranged in two rows in front of a fireplace in a house Rodin acquired, known as the Clos payen. As this photograph was taken between 1896 and 1898 by Eugène Druet (1868–1917) and given the fact that Eustache is in the second row concealed by Jean de Fiennes, it is not a record of Rodin's study for the final arrangement.[55] We do not know, for example, whether the figures had been ranked by Rodin or his assistants. Presumably the former, as Rodin signed the photograph as was his practice for prints that he wanted made public. When it came time to arrange the final composition, Rodin had to modify the bases of the figures so that they would fit more closely together at the angles and intervals he wanted.[56]

In June 1889 Claude Monet and Rodin exhibited together at the Galerie Georges Petit, and for the first time the definitive state of *The Burghers of Calais* in plaster (fig. 63), was shown in public. There were at least two critics who faulted it seriously. Their century-old comments about a monument of which today nary a disparaging word is heard are worth reading. Alphonse de Calonne wrote in *Le soleil,*

The subject . . . is such that it is not sculptural. This is a frequent fault with sculptors who want to encroach on the domain of painting and even of

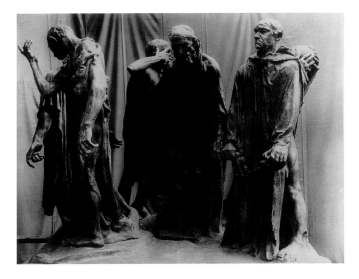

Fig. 63. Jacques-Ernst Bulloz, *"The Burghers of Calais,"* Final Composition, 1889, in plaster, after 1903. Musée Rodin, Paris.

literature. From these encroachments there results always ill-conceived works, ill ordered, obscure to interpret, lame and disconnected in their appearance.

Such is the group of the *Burghers of Calais*, which is not a group, which is not statuary, which has neither justness nor truth and which so strongly resembles by its willed awkwardness the attitudes of the Breton or Flemish calvaries, which at least save themselves from being comical by the naiveté of expression and the simplicity of attitudes. Here it is a convolution of the limbs and a contortion of the muscles that could only be envied by the clowns in our lowest spectacles.[57]

Rodin sent the review to Dewavrin but shrugged it off by saying that this was the only paper that had attacked him and that the other reviews had been eulogies.[58] Rodin's comment was premature, for in *Le journal des arts* Auguste Dalligny voiced his doubts: "They advance in a disjointed group, in no hurry to arrive . . . but not exalted enough even by the feeling of their patriotic sacrifice. Assuredly the composition is original, unexpected, but is it as unusual as one claims it is? Is it comprehensible at first glance? No; it needs too many commentaries for whomever is not informed. By itself would the nature of the subject really offer a sculptural motif from nature capable of being treated other than in bas-relief? It is permitted to be doubtful."[59]

The favorable comments on *The Burghers* as a group are of importance and interest because some writers like Geffroy were close to Rodin and understood his inten-

tion. In his essay on Rodin for the exhibition catalogue Geffroy wrote:

It is the marching past of these burghers that Rodin had been charged to install on a square in Calais. One imagines immediately what grandeur the procession of these figures in bronze will have: differing ages, aspects, attitudes, character, affirming at the same time a complete vision of humanity and a new conception of decoration for public places.

. . . He refused to construct an ordinary group in a pyramid where the heroes rise tier upon tier, or where the supernumeraries apply their silhouettes against the pedestal. He wanted the slow procession, the group spaced apart, the march toward death, with the steps of febrile haste.[60]

In a separate review for *La justice*, Geffroy amplified his view of what the monument meant to public art, saying that Rodin "takes possession of a public place as perhaps no one has ever so taken possession before him. . . . He creates a grouping of personages, he installs it on the pavement of a city of epic familiarity. Henceforth the six men who left from the market of Calais . . . will be mixed, in the disorder of their departure, in the proud tears and emotional regrets of their goodbyes, with today's crowd of the living, as they mixed with the crowd of the fourteenth century."[61]

It is not only Geffroy's comment about Rodin's intention in 1889 to mount his monument directly on the Calais market pavement but also that of Hugues Le Roux, with whom Rodin spoke on the subject, that confirms the sculptor's idea of having living people elbow his sculptures—both comments were made long before the much later statements that are often quoted as if to show that the concept of a ground-level installation came to Rodin years after. Writing of Jean d'Aire, Le Roux said, "One feels that he speaks to the crowd.—To the crowd that surrounds the group, Rodin told me, and which is composed not only of those who happened to be there that day, but of us all, of those who read their beautiful action."[62]

The many strongly favorable Paris reviews gave Dewavrin important arguments to use before the committee he headed, to explain that Rodin's conception, especially its composition, was right and that the committee members were wrong. Instance Fernand Bourgeat's appraisal: "Rodin has had the very modern and very powerful thought to place his figures alongside one another

without 'arranging' them theatrically. Thus they each have their physiognomy, their own and within the group. This monument will have an absolutely unique character."[63]

For those committee members who still felt Rodin's monument was lacking in the traditional heroic gestures, Dewavrin could show them the following view of the burghers: "They do not take advantage of the heroic poses to which we have become accustomed. . . . They are not Apollos, but men whose flesh cries, whose stare is charged by the explosion of a soul, whose face reflects the agony of the last hour of life. They are worn and real. The anatomical parts that are revealed are not theoretical nudes; they are the stripped, limbs modeled in an absolute sincerity, without research into the ideal."[64]

Perhaps most critical for winning the committee's eventual acceptance of Rodin's design was the Belgian poet Georges Rodenbach's praise of the composition: "The group imagined by Rodin is admirable, on a uniform plane, instead of the ordinary pyramidal disposition and without the habitual melodramatic gestures." He singled out Eustache de Saint-Pierre as an examplar of human sadness unique in the history of sculpture.[65]

The published correspondence between Rodin and Dewavrin gives us some idea of what happened in the years intervening before the monument's inauguration in June 1895. In 1892 the subscription drive was renewed. Letters were exchanged regarding the foundry to be used, and Rodin was sent copies of the architect Decroix's plans for the pedestal, which he accepted perhaps because he felt he could not win a fight with the committee on a ground-level installation.

Rodin's Reading of The Burghers

On 7 March 1895 Rodin appeared before the committee, presumably for the last time. When a newspaper reported shortly afterward that Rodin's monument had been attacked by his commissioners, the artist responded by saying, "to the contrary . . . after having heard my explanations for the choice and attitude of the personages, made aware of the motives that dictated their physical structure and having studied with me all the sources from which I drew the exact reconstruction of this scene of heroic devotion, the members of the committee approved without reservation the model that had been presented to them."[66]

What follows appeared many years after Rodin pre-sented the final monument to the Calais committee, but it may give us a sense of the explanation that convinced them.

I did not hesitate to make [the figures] as thin and as weak as possible. If, in order to respect some academic convention or other, I had tried to show bodies that were still agreeable to look at, I would have betrayed my subject. These people, having passed through the privations of a long siege, no longer have anything but skin on their bones. The more frightful my representation of them, the more people should praise me for knowing how to show the truth of history.

I have not shown them grouped in a triumphant apotheosis; such a glorification of their heroism would not have corresponded to anything real. On the contrary, I have, as it were, threaded them one behind the other, because in the indecision of the last inner combat which ensues, between their devotion to their cause and their fear of dying, each of them is isolated in front of his conscience. They are still questioning themselves to know if they have the strength to accomplish the supreme sacrifice—their soul pushes them onward, but their feet refuse to walk. They drag themselves along painfully, as much because of the feebleness to which famine has reduced them as because of the terrifying nature of the sacrifice. . . . And certainly, if I have succeeded in showing how much the body, weakened by the most cruel sufferings, still holds on to life, how much power it still has over the spirit that is consumed with bravery, I can congratulate myself on not having remained beneath the noble theme I dealt with.[67]

Let us grant the power of Rodin's persuasion and that the makeup of the commissioning body had probably changed; there was still another reason why the committee accepted the final monument that differed so markedly from its predecessors. Kirk Varnedoe put it well: "When the Calais committee hired Rodin in 1884, it was taking a chance on a promising artist at a bargain rate, and felt it had the right, indeed the obligation, to direct him. By the early 1890s, however, when the final drive to purchase the monument began, they were dealing with a far more established sculptor, critically acclaimed and widely sought after. The interim increase

Right: Fig. 64. Jean-François Limet, *"The Burghers of Calais,"* 1889, in plaster at Meudon, after 1901. Musée Rodin, Paris.

Below, left: Fig. 65. Jean-François Limet, *"The Burghers of Calais,"* 1889, in plaster, c. 1908, gum bichromate. Musée Rodin, Paris.

Below, right: Fig. 66. Jean-François Limet, *"The Burghers of Calais,"* 1889, in plaster, c. 1908, gum bichromate. Musée Rodin, Paris.

in Rodin's credibility as an interpreter of the commission, and the greater prestige now attached to the acquisition of the monument, must certainly figure in our understanding of the committee's silence regarding its previous objections."[68] In 1889 the full monument consisting of the final arrangement of the six figures in plaster had been shown in Paris and with few exceptions had earned enthusiastic acclaim as a major work of art.

The Final Composition

Just how did the great sculptors of the past want their sculptures to be seen? Whereas the tastes and judgment of photographers conditioned the recording of sculpture since the invention of the medium, it was Rodin who recognized photography's value as a vehicle for sharing his own vision of the ways in which his art could be viewed, studied, and understood. Rodin believed that his major figures, like the *Monument to Honoré de Balzac*, were best seen from five or six points of view. From what views of the final burghers' monument did Rodin think his work was seen to greatest advantage? The best answer we have is through the lens of the camera belonging to Rodin's *patineur*, Jean-François Limet (1855–1941), who took a series of photographs of the monument in plaster and at eye level (figs. 64–66).[69] It was Rodin's practice to

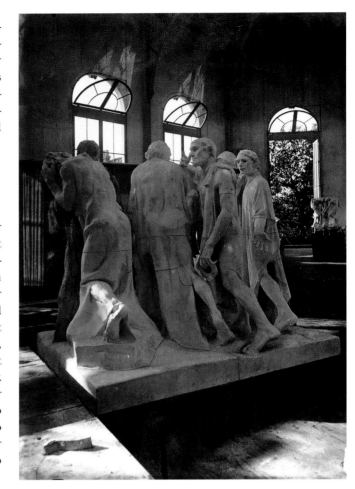

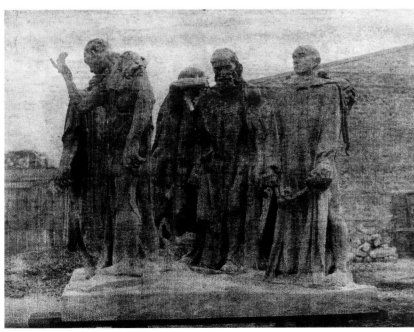

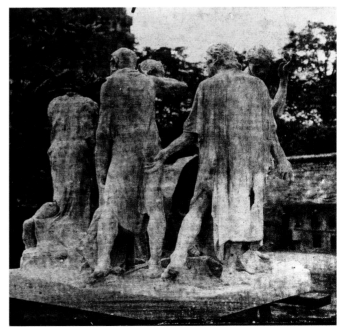

direct his photographers in such matters as viewing angle, distance, and composition.[70] These prints do not stress the frontal view that has prevailed ever since, but they are always from an angle that shows the monument in depth. Some of the best gum bichromate prints of Rodin's art were made by Limet, who of all Rodin's assistants had perhaps the keenest sensitivity to Rodin's work. These prints in turn also allowed Rodin to see the way the big planes of the figures worked together when viewed in dim light or fog, such as Calais and London experience, which blocks out the details.

In Rodin's lifetime the composition of the burghers was most beautifully analyzed by the Rainer Maria Rilke, who could have seen Limet's photographs as well as the monument itself:

> The figures do not touch one another, but stand side by side like the last trees of a hewn-down forest united only by the surrounding atmosphere. From every point of view the gestures stand out clear and great from the dashing waves of the contours; they rise and fall back into the mass of stone [sic] like flags that are furled. The entire impression of this group is precise and clear. Like all of Rodin's compositions, this one, too, appears to be a pulsating world enclosed within its own boundaries. Besides the points of actual contact there is a kind of contact produced by the surrounding atmosphere which diminishes, influences, and changes the character of the group.
>
> . . . To Rodin the participation of the atmosphere in the composition has always been of greatest importance. He has adapted all his figures, surface after surface, to their particular space and environment. . . . When interpreting nature he found, as he intensified an expression, that, at the same time, he enhanced the relationship of the atmosphere to his work to such a degree that the surrounding air seem to give more life, more passion, as it were, to the embraced surfaces.[71]

The effect of atmosphere, which is the monumental principle of Rodin's art, is wonderfully achieved in 'The Citizens of Calais.' These sculptural forms seen from a distance are not only surrounded by the immediate atmosphere, but by the whole sky; they catch on their surfaces as with a mirror its moving distances so that a great gesture seems to live and to force space to participate in its movement.[72]

The Final Monument: Another View

Since Rodin's death, *The Burghers of Calais* has sometimes been judged as demonstrating the artist's preoccupation with a dramatic subject at the expense of form.[73] We have it on the good authority of Roger Fry in his *Transformations* that Rodin's monument "hangs together by its dramatic but not its plastic unity."[74]

In the 1880s, as Rodin's art came closer to life, his strategies as a composer were less apparent not only to contemporaries accustomed to academic geometries and stylization but also to our own time conditioned by abstract art.[75] If not for a high formal consciousness, *The Burghers* would have been a chaos of joints and draperies. We measure an artist by the magnitude of the problems he chooses to confront. Consider Rodin's self-set goal: the harmonizing of six active, life-size, freestanding figures so that the result seemed natural to the action and not artificial due to the imposition of the academic cone. Rodin's solution takes place within a space seven feet high, eight feet wide, and six feet deep. Genius loves frugality.

Changes in the physical site at Calais after the original commission, notably the destruction of the old gateway in the place des Armes, as discovered by McNamara, may have caused Rodin to abandon any dream of a literal, single-file arrangement with the bases of the figures inserted amid the paving blocks. Previous compositional designs made no sense without the physical and historical focal points of both town hall and fateful gateway. Thus the compositional problem became one of giving the same group greater self-sufficiency without dramatic loss. Rodin adapted the single-file and phalanx arrangements to one in the round, like a rosary, his "chaplet of suffering." The evocation of a heroic incident was transformed into a metaphor of perpetual self-sacrifice. Event became symbol. Genius loves winning the most with the least.

Hold in mind that Rodin had sought to combat conventional solutions that had infected contemporary French monumental sculpture with monotony, frigidity, and false expression. He warred on artificial attitudes and on self-consciously struck poses in public statuary. "Look at some of the groups begotten of the school that

cares nothing for this truth to nature's architecture. The figures they make have parts that fly out in directions and at angles that have no rhyme or reason, and frequently are false to the centre of gravity."[76]

To modernize the monument, to make it credible and inspirational, Rodin convinced himself that sculpture must close with the truth of life. To arouse patriotism in an audience he credited with modern sophistication, Rodin had to inspire identification with his heroes, who were not docilely or stoically compliant with an unjust fate. (Rodin's predecessors had not focused on the capricious and vindictive demands of the English king, who ignored medieval codes of chivalry in warfare.) Only by placing the safety of fellow citizens above personal values could the volunteers resolve the war of the divided self and step toward death.

Lack of academic training at the Ecole des beaux-arts and Rodin's confidence in his intuitions inspired him to seek art's power by breaking the rules, especially those constraining the natural in feeling and movement. He had to find his own harmonic line and frame within which figures could be disposed naturally while retaining their human warmth and freedom of movement. When he said "the cube gives expression," he may have meant that this format provided the necessary disciplinary restraints on the composition's extremities, while allowing maximum variation within the field.[77]

Rodin knew his jurors would vainly search for alternatives within the "conventional art I despise" and that critically his work would suffer by comparison with exhausted idioms that comforted provincial critics and public. He was right. The form of *The Burghers* was reckoned as dry, monotonous, and inelegant in silhouette by most of his Calais clients.

The most crucial decisions made by Rodin toward winning a new autonomy for the final group were relocation of Eustache de Saint-Pierre near the exact center of the imagined cube and placement of Jean d'Aire to his left. Perhaps reasoning that we tend to read from left to right, he thereby invited the viewer to move from the front to the right-hand side of the monument. To experience the drama sequentially, one should move counterclockwise around the six, seeing first their faces and fronts and then their backs, as if they were, in fact, filing past and the viewer were standing still. It makes less sense to read the story as done by Tancock by moving in a clockwise fashion, jumping from Eustache to Pierre de Wissant and ignoring the powerful line made by the leader and Jean

d'Aire, for the volunteers would be seen first from the back and then from the front, as if they were walking backward.[78] Theatrically it would be like skipping from the first to the sixth act.

Like *Saint John the Baptist Preaching, The Walking Man,* and *The Gates of Hell, The Burghers of Calais* was to be experienced in time. While individual figures are artistically self-sufficient, Rodin's intelligence manifests itself in the ordering of his figures in pairs, trios, and quartets, serially encountered as the monument is circumambulated. Further compelling rotation around the group is the positioning of the corner figures, who do not align their axes with those of the base but are set to twist diagonally in space. They do not conceal those behind them and are so paired as to be like second natures to each other: Jean d'Aire, the most self-possessed, has in Andrieu d'Andres a most despairing doppelganger; Pierre de Wissant looks within, Jean de Fiennes, without. Four of the six use identically paired gestures, and the two who have the contrasting hand movements are fittingly the brothers de Wissant. No film has done justice to the cinematic character of the composition, and it remains to mentally mime the eloquent unfolding of gestures: compliance, defiance, abandon, interrogation, supplication, and resignation.

The siting of Eustache in the final composition not only established the *mise en scène* but also unlocked the interior space of the monument, which secured Rodin several formal advantages. Placing five of the figures along the periphery gave him maximum exposure to the sky, and this must have encouraged his thoughts about a very tall pedestal. Thus seen in isolation or in concert, all their silhouettes tell. Irregular distances between the figures and the open interior space allow astonishing effects of shadow. At certain times shadows cast on the simulated paving stones of the modeled base double the rhythm and increase the tempo of the group's tread. Men project shadows on their fellows, providing contacts unavailable through touch. The shadow on Jean de Fienne's thigh of his left hand is like a memory or the premonition of another gesture. Shadows alone tell the story.

The intervals between figures formed by body contour and draped silhouette convey the sense of being themselves decided rather than accidental shapes. Who can say that Rodin's surplus of parts for this project, notably the hands, resulted only from the test of their expressiveness and not from their detraction from evolving formal harmonies between figures? No audit exists of hours spent meditating on the revelations offered with

each new draping of a mannequin and positioning of one burgher against another. Certainly Rodin recognized that his work would not provide equally satisfactory perspectives from every angle. Fortunately we have Limet's photographs, taken under Rodin's direction, that show us exactly which angles the sculptor thought were most successful for viewing the final monument (see figs. 64–66).[79]

Rodin intended his composition not just to be read dramatically but to be pondered at length, in terms of its form and as a whole from five or six viewpoints at eye level. (When he realized that the monument might later be viewed from some distance below, he made no changes.) As an example, in the frontal view the spectator takes in the critical, single line of the heads (made possible by the upward tilt of the base of the forward-sloping Eustache) and looks downward through a succession of approximately latitudinal axes made by the figures' flexible joints: shoulders, elbows, wrists, knees, and ankles. Only the paired joints of Jean d'Aire are maintained parallel to one another, which is why the line is flexible throughout, not frigid and architectural by conventional standards. Against this phrasing, the vertical chording of the drapery, as a totality, reads left to right and back again, front and back. Dictated by the story, Rodin made costume the critical connective in his complex form. It operates like an irregular but continuous curtain imparting a strong commonality of textural relief. When Eustache steps out, his left leg parts the shameful shroud like the opening of a play. Just in the orchestration of the drapery Rodin refuted the criticism that he was incapable of liaison between figures and was short-winded as a composer. Nowhere did he better display sensitivity to the pathos of shadow than in this medieval tragedy, a fitting repayment to his Gothic mentors for great lessons learned.

From any of the monument's prospects one is met with a sense of tremendously disciplined energies emanating from creator and offspring. The powerful forms of the burghers were necessary to Rodin not only because of the facts of citizen warriors who survived siege and starvation but also to convince us that even at the end, the strengths that turned in on themselves were considerable. The six are larger than life because they experience the leaving of it so fiercely. Without descending to what Rodin resented as the theatrical art of his day, the men were made to live their ordeal on a public stage; each movement generated by the oversized hands and feet was exaggerated because it was meant to carry from a distance, yet seemingly wrung from their beings and not conscripted from repertorial clichés. Roger Fry to the contrary, artistically the six are a group and not a crowd. *The Burghers* reminds us that before Rodin was a man of the world he was a fervent Frenchman. To mindless bourgeois patriots of the Third Republic the message was disturbingly clear: respond to the call of duty, but when it is unjust, count the cost.

Two Installations: Low and High

For many reasons *The Burghers of Calais* stands at the beginning of modern public sculpture, bridging traditional and modern public monuments. The competing claims of both were echoed in Rodin's own thinking about how to present the heroes. Today we are most aware of his expressed desire for the original monument to stand at street level, without a pedestal, freely accessible to grownups, children, and even the dogs of Calais. Both thematically and in terms of its form, Rodin wanted to bring the modern monument down to earth, to unite the past and present, the dead with the living. But this was not his only intention, and granting that the idea for the ground-level installation was in his mind early on, his recorded expression of it came late in the monument's history.

In December 1893 Dewavrin sent Rodin the plans for a pedestal for the monument drawn up by a Calaisian architect. Rodin replied,

> The project which you did the honor of sending me regarding the execution of the pedestal looks good, well conceived, strong yet not heavy.
>
> However, I had at first thought of the burghers, leaving the marketplace; in the confusion of the farewells only de Saint-Pierre begins to walk in order to cut short this painful scene. I had thought that, placed very low, the group would become more intimate and would allow the public to enter into the drama of misery and sacrifice. It might be good perhaps to have a second project from an architect, very low.[80]

In 1903 Rilke, who had come to know the sculptor, published the first of two major essays on Rodin. In it he wrote concerning the monument, "The place that was

decided on for the erection of the monument was the marketplace of Calais, the same spot from which the tragic procession had formerly started. There the silent group was to stand, raised by a low step above the common life of the marketplace as though the fearful departure were always pending."[81]

As related by Paul Gsell in 1911, Rodin recalled,

I wished, as you perhaps know, to fix my statues one behind the other on the stones of the Place, before the Town Hall of Calais, like a living chaplet of suffering and of sacrifice.

My figures would so have appeared to direct their steps from the municipal building toward the camp of Edward III, and the people of Calais today, almost elbowing them, would have felt more deeply the tradition of solidarity which unites them to these heroes. It would have been, I believe, intensely impressive. But my proposal was rejected, and they insisted upon a pedestal which is as unsightly as it is unnecessary. They were wrong. I am sure of it.[82]

In 1914 Rodin was quoted in a magazine article:

I did not want a pedestal for these figures. I wanted them to be placed on, even affixed to, the paving stones of the square in front of the Hôtel de Ville in Calais so that it looked as if they were leaving in order to go to the enemy camp. In this way they would have been, as it were, mixed with the daily life of the town; passersby would have elbowed them, and they would have felt through this contact the emotion of the living past in their midst; they would have said to themselves: "Our ancestors are our neighbors and our models, and the day when it will be granted to us to imitate their example, we would show that we have not degenerated from it."[83]

Rodin's first thought expressed in the 1884 maquette had been to democratize the old tradition of placing symbolic figures of victory atop a triumphal arch. Instead of a quadriga driven by fame or some other allegorical figure, such as stood between the Louvre and the Tuileries in Paris, Rodin situated the burghers, as if departing from the town square, on top of a historiated base. (Rodin would retain that oblong composition to the end.) Again, following tradition, the proposed arch was to have had reliefs on its sides showing the citizens of Calais who had been spared by the sacrifice or "devotion" of the six. In one drawing Rodin planned to have untraditional ramps—"the terrace" as he referred to it—leading to the arch.[84] The estimated costs of this first project and his commissioners' reaction seem to have discouraged Rodin from its pursuit, but the high elevation of the figures remained in his mind.

From the outset Rodin determined to provide Calais with an original conception. In the first proposal, the format was obviously traditional, but Rodin reckoned his informal group composition on its top to be without precedent. What he wanted to avoid was the formula for similar municipal commissions in which figures were grouped in pyramidal fashion around the base and surmounted by an allegorical figure of the city or fame or victory. Rodin knew that his figures would have to be seen from below and at a considerable distance. Placing them in two ranks would have made it possible for all six to have been seen as one moved about the monument.

Even after the concept of the supporting arch was abandoned, there remained in Rodin's thought the prospect of seeing his group high up, against the sky. He was to later propose that the burghers be installed on a very tall pedestal, perhaps near the sea, where they could be seen in silhouette. Rilke, who undoubtedly talked to Rodin about the monument, wrote in 1903, "The city of Calais refused to accept a low pedestal because it was contrary to custom. Rodin then suggested that a square tower, two stories high and with simply cut walls, be built near the ocean and there the six citizens should be placed, surrounded by the solitude of the wind and sky. This plan, as might have been expected, was declined."[85] Lawton recalled that Rodin wanted his composition to fit into "an oblong, a right-angled parallelogram. . . . I wanted the group to be placed on the top of a fairly high pillar."[86]

To test his own idea about the tall elevation he had a scaffold built at Meudon and had the plaster figures of the burghers photographed from ground level (figs. 67–68). While his idea for elevating the heroes was rejected by the Calais commissioners, it was adopted by the British in the one instance when Rodin's wishes for the installation were adhered to.[87] When *The Burghers* was first installed, without ceremony, in the park next to the House of Parliament in 1915, they were mounted on a very tall stone pedestal. Due to protests about its height, that pedestal was removed in 1956, except for its upper section bearing an inscription carved by Eric Gill, which

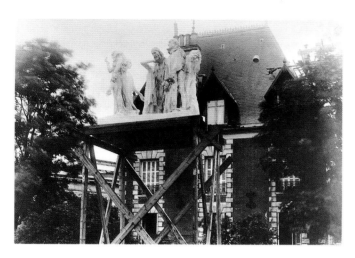

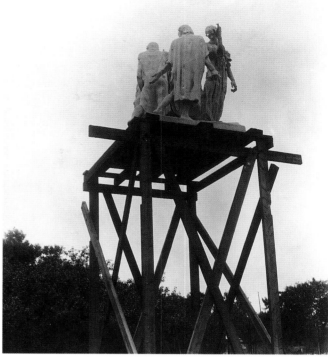

Far left: Fig. 67. Jacques-Ernst Bulloz, *"The Burghers of Calais,"* 1889, in plaster on a scaffold at Meudon, front 1913, gum bichromate. Musée Rodin, Paris.

Left: Fig. 68. Eugène Druet, *"The Burghers of Calais,"* 1889, in plaster on a scaffold at Meudon, rear 1913, gelatin silver print. Musée Rodin, Paris.

Below: Fig. 69. Photographer unknown, *"The Burghers of Calais,"* 1884-95, in bronze installed at Houses of Parliament, London, 1915. Country Life, 31 July 1915.

has served ever since as a low plinth for the bronze (figs. 69, 595–97). Why did Rodin not ask the British to place his figures at ground level? At Calais placing the figures at ground level in the historic square of the place des Armes would have been in keeping with their history. They might have stood on or amid the very paving stones trod by their ancestors. (The base of each of the final burghers is in the shape of a large paving stone.) In Parliament Park placing the figures at grass level would have had no historical or dramatic justification, according to Rodin's thinking just before World War I.

Rodin's own letter to the British Office of Works is wonderfully revealing of his thinking about how a tall installation would continue a great tradition:

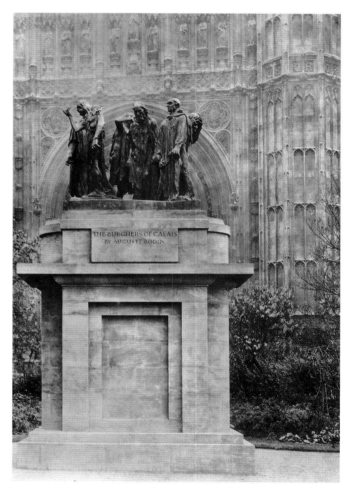

At Venice and at Padua, two monuments raised to a height of five or six meters each support an equestrian figure, the base of which is oblong. These monuments are in close proximity to the walls of adjacent churches. . . . As you may imagine the effect is splendid and is an improvement on present day practice. It is in this form that I would propose the erection of "Les Bourgeois de Calais" which is an oblong, and which should be placed on a high pedestal like the "Colleone [sic]." This high pedestal and the architectural group will have a grandeur which I cannot emphasize too highly, and the vast architecture of the Houses of Parliament will lend additional effect to them. . . . I suggest this idea to you, seeing in my imagination the wonderful effect of the granite stone of the pedestal and the bronze on the gray stone of the Houses of Parliament.[88]

At the same time Rodin wrote about the project to the Scottish sculptor John Tweed (1869–1933): "I've ex-

plained it all—on a high pedestal, less high than the 'Colleone' [sic] because one's got to remember the Colleone is bigger than the 'Burghers of Calais,' but that sort of proportion. I'll make a wooden frame as a trial. This is going to set my group apart from those sculptures which are presented as if for art exhibitions. The function of my monument is to celebrate courage and clemency, raised high up with the grace of the 16th century, great age of art, which can once again serve as an example to us."[89]

In 1913 Rodin visited London and was shown a number of possible sites. In August he wrote to the official charged with the installation that he "had mounted plaster casts of the burghers on a wooden substructure five meters high and this, in my view, was sufficiently elevated."[90] He preferred a sketch sent to him of a pedestal based on that for Donatello's *Equestrian Monument of Gattamelata* (1445–50; Piazzo del Santo, Padua).

Rodin's thinking in the 1890s about how to mount his monument where it would be seen from a distance was influenced by his work on the Balzac project and his reflections on what was wrong with contemporary public sculpture when seen outdoors and against the sky. Camille Mauclair recorded Rodin's views at length, and they included his thoughts about *The Burghers:* "When the academic school wishes to make use of a background to a figure, it confines itself to a hollow or a relief. Rodin desired that a statue should stand free and should bear looking at from any point, but he desired nevertheless that it should remain in relation with light and with the surrounding atmosphere. He was struck by the hard, cutout aspect of ordinary statues, and asked himself how an atmosphere might be given them."[91] Rodin's solution was "from the time of the *Burghers* . . . to find a method of exaggerating logically . . . that method consists in the deliberate amplification of the modeling."[92] Elsewhere Mauclair elucidated this objective, "The thing was to *amplify*, with tact, *certain parts of the modeling*, the edges of which were swept by the light, so as to give a halo to the outline."[93] Rodin added to his comments about exaggeration, "It consists also in the constant reduction of the figure to a geometrical figure and in the determination to sacrifice any part of a figure to the synthesis of its aspect."[94]

How It Ended

Rodin was so taken with parts of the monument that he could not detach himself from them after its completion.

They became part of his great repertory troupe in plaster, free to assume new identities and situations. To give them new life, he quarried his plasters and enlarged to over life-size the heads of Jean d'Aire and Pierre de Wissant (cat. nos. 21, 31). He assembled several heads and hands of the reduced version of *The Burghers* and surmounted them with a winged figure in a horizontal relief (c. 1900). He placed a hand on the cheek of Jean de Fienne (c. 1900), and the left hand of Pierre de Wissant seems to caress the temple of the plaster portrait of Camille Claudel (c. 1885–95). The head of Pierre de Wissant was juxtaposed with the partial figure of a naked woman (1895–1900 or later).[95] Some hands he considered self-sufficient as sculpture.

At Calais, the monument was dedicated on 3 June 1895 in an elaborate three-day ceremony attended by thousands. It had been placed on a pedestal slightly more than five feet high and situated inside an elaborate iron fence, all of which was located next to a public lavatory in the place Richelieu. Since that time and for its protection during wars, as well as repair, the sculpture was removed and reinstalled several times. Many in Calais wanted the monument placed in the place des Armes, as Rodin originally intended, but this area was reduced to rubble in World War II. Today it stands on a mound planted with grass and flowers in front of the city hall, where the bronze surface is corroding from pollution.[96]

For those members of the committee who finally approved the monument but who privately may not have cared for it, and for other Calaisians who felt their heroes if not art had been betrayed by Rodin, revenge was to be had. To honor its war dead in 1904, Calais dedicated a *Monument aux enfants du Calais*, more than 30 feet high, by a sculptor from Lille named Mangandre.[97] It epitomized every single thing Rodin hated in "The School's rules" for public monuments, from its cutout silhouette to its antiquated symbolism to the dominance of the architecture. Standing atop a tall, truncated obelisk is a French soldier in stone posing for posterity with his right arm limp in a sling, the left extended outward and slightly downward, breaking what Rodin considered the essential cube in which a figure should be set. Judging by his epaulettes and cap, he is an officer from the Franco-Prussian War who is being crowned with a metal wreath by a stone angel. From the front and below, a nude seated figure of France carved in high relief looks up approvingly. Above three steps as symbols of mourning,

the base is framed at the four corners by funeral wreaths connected to each other by drapery that looks like a giant dropcloth fallen after the monument's unveiling. Rodin's audacious attempt to change public monuments in France failed, even in Calais. That incomprehension of Rodin's intent persists in Calais is shown by the fact that today, in front of the rebuilt Hôtel de Ville, the two monuments face each other across a busy street.

NOTES

LITERATURE: Spear 1967, 40; Jianou and Goldscheider 1969, 97; Goldscheider 1971, 166, 169; Tancock 1976, 382, 390, 396; Judrin, Laurent, and Viéville 1977, 147–49; McNamara and Elsen 1977, 16, 25–27; Fusco and Janson 1980, 339–40; Lampert 1986, 102–5; Miller and Marotta 1986, 46–48; Ambrosini and Facos 1987, 99; Butler 1993, 199–202

1. Beutler summarized (1972, 39) what he believed to be the three revolutionary aspects of the monument: (1) rather than a classic monument to a single heroic individual, standing on a socle, enacting a transporting and pathetic gesture against the sky, it is a tribute to a group of human beings sharing the same fate; (2) instead of a heroic and positive conception Rodin showed the burghers suffering under destiny's blow; (3) what is most astonishing and revolutionary in the history of sculpture is the suppression of the pedestal.
2. Dujardin-Beaumetz in Elsen 1965a, 185.
3. Ibid., 179.
4. Grace Glueck, "Erudite Simplification of Art's Complexities," *New York Times*, 23 February 1989, B2.
5. The history of representations of the Calais subject is reviewed in Annette Haudiquet, *Les bourgeois de Calais: Fortunes d'un mythe* (Calais: Musée des beaux-arts et de la dentelle, 1995).
6. H. W. Janson pointed to the presence in Paris of the fifteenth-century Burgundian tomb of Philippe Pot, with its eight grieving monks carrying the effigy of the duke lying on a platform that they bore on their shoulders (H. W. Janson. "Une source negligée des *Bourgeois de Calais.*" *La revue de l'art* 5 [1969]: 69–70). The idea of freestanding, large figures set in the open air, as the tomb was later displayed and placed without a pedestal, may have held interest for Rodin. The two monuments are otherwise totally different.
7. See Mary Jo McNamara's introductory essay in McNamara and Elsen 1977, 7–15, elaborated in her doctoral dissertation ("Rodin's Burghers of Calais" [Ph.D. diss., Stanford University, 1983]).
8. Judrin, Laurent, and Viéville 1977, 30. This exhibition catalogue is distinguished by its abundant documentary material and informative essays. For an excellent historical overview of the commission, see also Butler 1993, 199–213.

9. Rodin referred to Dewavrin as "the author" of the project. Out of respect, gratitude, and affection, he made a portrait of Dewavrin (cat. no. 135). For more than ten years they carried on a lengthy and revealing correspondence, fully documented by Viéville in Judrin, Laurent, and Viéville 1977.
10. Coquiot wrote that the idea for *The Burghers of Calais* came from Baron Alphonse de Rothschild, who through his agent, Léon Gauchez, the editor of the periodical *La revue des deux mondes de l'art*, offered Rodin 15,000 francs to do a statue of Eustache de Saint-Pierre (Gustave Coquiot, *Le vrai Rodin* [Paris: Editions Jules Tallandier, 1913], 132). In his later book (1917), Coquiot has Rodin recount the meeting with Gauchez, the offer, and then the sculptor's reading of the story. The next day Rodin supposedly told Gauchez that he wanted to do all six burghers. "I began to work, and furiously, in my studio on the boulevard de Vaugirard, alone, I modeled the six Calaisian heroes. Then I had them cast; and that is when my troubles began. The city of Calais refused to take possession of my six statues" (104–5). Coquiot alone gave this account, no part of which is sustained by the documented record. Gauchez may have been the source of the story. Coquiot relied on other writers, such as Geffroy and Paul Gsell, for much of what he had to say about the monument, and I do not find his long quotation from Rodin to be reliable, much less authentic. Frisch and Shipley (1939) took their story from Coquiot, but their book is a fraud.
11. The contract is given in full in Judrin, Laurent, and Viéville 1977, 51.
12. For an account of these charges and their rebuttal, see Tancock 1976, 376, 380; Judrin, Laurent, and Viéville 1977, 23–25; McNamara and Elsen 1977, 9–10, 13.
13. Rodin had help from an important source in Saint-Pierre. McNamara discovered that the newspaper *Le patriote* "demanded that the monument 'in all justice' remember the devotion of the five other burghers" (4 October 1884; cited in McNamara and Elsen 1977, 13).
14. In Paris they were the painters P. A. Isaac and Jean-Paul Laurens.
15. Judrin, Laurent, and Viéville 1977, 46–47.
16. Ibid., 51.
17. Ibid.
18. The original French text of the excerpt is reprinted in Judrin, Laurent, and Viéville 1977, 113–14.
19. Ibid., Rodin to Dewavrin, 3 November 1884, 41.
20. Ibid., Rodin to Dewavrin, 20 November 1884, 41–42. Beutler makes several good observations, but an untenable thesis is that the subject of this first maquette, far from being original with Rodin, is "incomprehensible" without the sculptor's having been influenced by Ary Scheffer's 1819 painting of the burghers in the Palais Bourbon with its "incontestable" resemblances to Rodin's work (Beutler 1972, 44). The motif of the hostages leaving Calais by one of its gates was not unique to Scheffer, and Rodin wrote of his figures leaving the marketplace,

but he does not mention them being outside the city gate. Beutler ignored Rodin's sensitivity to the possible siting of the sculpture and his desire to site the monument on the square from which they actually departed, oriented toward the Richelieu Gate. In seeking to show that Rodin's figures in movement, composition, and costume were influenced by the painting, Beutler asked his readers to believe that Scheffer's wooden, pallid, painted personages would have touched a sculptor disinclined to work from paintings in lieu of life and his own imagination, not to mention the problem of thinking of his project in the round and outdoors. When Rodin wrote of his project being completely original, that included the way the figures were to be dressed, and he ignored Scheffer's use of robes. Despite the facts that a copy of Scheffer's painting was owned by Calais and that Dewavrin supposedly showed it to the sculptor, not one of the artist's contemporaries is recorded as having made any comparison, for better or worse, or other connection between Scheffer's work and any phase of Rodin's project.

21. Rodin to P. A. Isaac, 19 November 1884, in Judrin, Laurent, and Viéville 1977, 42 n. 2. Rodin conceived of the pedestal in hard stone to withstand the Calais climate, estimating it would cost about 4,000 francs (43–44).

22. For a reproduction and discussion of this drawing, see Judrin, Laurent, and Viéville 1977, 42, 149–50.

23. See the reading of this maquette by McNamara in McNamara and Elsen 1977, 16–27. Such a reading and Rodin's insistence that his effort was original, with which the Calais committee concurred, discourages further the notion of influence from Scheffer's painting. Monique Laurent gave a far less detailed reading of the figures, and as did McNamara earlier, naming all of them despite the absence of the artist's designations with the exception of Eustache and recognizing the dramatic role played by the rope (in Judrin, Laurent, and Viéville 1977, 147–48).

24. Judrin, Laurent, and Viéville 1977, 43 n. 2. If Rodin did try out in small clay reliefs his ideas about the women and children, one wonders if they are those at the bottom of the sculptured portion of the two doors of *The Gates of Hell*, just below the tombs, which were added in 1899 or 1900, as he concluded his work on the portal. The reliefs that show only women and children are sketchlike, having been modeled in the most summary fashion by comparison with the larger figures immediately above. They also carry a strong resemblance to those groups Rodin had been modeling for ceramic vases at Sèvres as recently as 1882. (See Schmoll 1983, 228, for further discussion of the reliefs and work at Sèvres).

25. Judrin, Laurent, and Viéville 1977, Rodin to Dewavrin, 26 November 1884, 44.

26. Ibid., Dewavrin to Rodin, 13 January 1885 and 6 January 1885, 45 and n. 2.

27. In a subsequent letter (13 January) Dewavrin added, "Is it understood that the cost will be 15,000 francs for the casting and 15,000 francs for you?" Ibid., 46.

28. Ibid., 46–47 n. 2 (agenda, 17 January).

29. Ibid., 47.

30. Ibid., 47–48 n. 3.

31. For a reproduction of another municipal monument (to those who heroically resisted the siege of Saint-Dizier) such as Rodin was countering, see McNamara and Elsen 1977, 20 (fig. O).

32. For a reproduction of a calvary of this type, see McNamara and Elsen 1917, 20 (fig. N).

33. Literature references for the second maquette include Spear 1967, 42; Jianou and Goldscheider 1969, 97–98; Goldscheider 1971, 167–74; Tancock 1976, 382–83, 390, 396–402; Judrin, Laurent, and Viéville 1977, 170–74; McNamara and Elsen 1977, 27–44; McNamara 1983, Lampert 1986, 111; Butler 1993, 203–4

34. Rodin to Dewavrin, 31 January 1885, in Judrin, Laurent, and Viéville 1977, 49. Viéville rightly points out that this was not only Rodin's first mention of how he would work, but it was the method he would follow a few years later while working on the *Monument to Honoré de Balzac* (49 n. 3).

35. Ibid., 49–50 n. 3, for Cazin's letters with their positive response.

36. Ibid., Rodin to Dewavrin, 14 July 1885, 53. Later Rodin would use and cast the drapery for his Whistler monument (the enlarged figure) as well as for the enlarged *Ugolino and His Sons* from dropcloths and even a tablecloth.

37. Ibid.

38. See Elsen 1980, pls. 55–56, for reproductions.

39. Goldscheider published an article (1971) in which she showed her discovery of how four of the burghers—Jean d'Aire, Jacques de Wissant, Eustache de Saint-Pierre, and Andrieu d'Andres—fit together because of the notched bases (169–70). In 1983, while conducting research for her dissertation, Mary Jo McNamara found the markings that connected Pierre de Wissant with Andrieu d'Andres and so arranged Stanford's second maquette.

40. Although Rodin supposedly used Cazin as a model for Eustache, there is no record of anyone noticing this source in either the second maquette or the final composition.

41. As he may have modified by remodeling some broken areas, it is not possible to get perfect matches between the figures cited bearing these scars of severance. Before the Calais presentation Rodin may not have had the time to totally remodel the edited areas, and he may have counted on the fact that this was understood to be a small maquette and one so tightly composed as to make detailed reading of the figures' backs difficult. He knew also that the jurors would be preoccupied with other and more important aspects such as characterization, narrative, and composition.

42. Dujardin-Beaumetz in Elsen 1965a, 159, 184.

43. There were favorable reviews in other Paris papers, and Rodin sent them to Dewavrin, who seems not to have been bothered by a possible lapse in protocol and who would have been pleased, for as early as February he had

expressed the hope that the maquette would be shown in the 1885 salon (Judrin, Laurent, and Viéville 1977, 50).

44. Ibid., 54 n. 2.

45. Rodin to Desfontaine, 27 October 1885, translation in McNamara and Elsen 1977, 73.

46. Ibid., translation 70; the French original is in Judrin, Laurent, and Viéville 1977, 116–17.

47. The full text is given in McNamara and Elsen 1977, 71–72; the French original in Judrin, Laurent, and Viéville 1977, 114–15.

48. Rodin to Dewavrin, 2 August 1885, translation in McNamara and Elsen 1977, 72; the French original in Judrin, Laurent, and Viéville 1977, 55.

49. This document, found by Kirk Varnedoe in the Fitzwilliam Museum library, is reprinted in Varnedoe 1978, 485. Varnedoe speculates that "in conceiving of a group of burghers leaving the city gate, motivated by a central figure, [Rodin] may have had in mind the compositions of shooting companies, such as Rembrandt's *Night Watch* (1642; Rijksmuseum, Amsterdam). No significant visual parallel obtains, however" (485 n. 7). I would amend Varnedoe's supposition to say that Rodin's six figures were leaving and moving toward the city gate. Judging by his brief description of Dutch paintings with regard to the line of heads of "council" members and the burgomasters' "common regard of the viewer," Rodin may have had in mind rather Rembrandt's more compact and frontal composition of the six figures in *The Syndics of the Draper's Guild* (1662; Rijksmuseum, Amsterdam).

50. This draft was found by Viéville in the Musée Rodin archives (reprinted in Judrin, Laurent, and Viéville 1977, 56 n. 2).

51. Translated in McNamara and Elsen 1977, 73.

52. Judrin, Laurent, and Viéville 1977, 48. Many letters from Rodin to Dewavrin and, later, to his wife speak of his need for funds to be advanced by the city to cover his expenses. By 1884 Rodin had surrounded himself with a team of skilled assistants, including the gifted young Camille Claudel. This team, by undertaking such tasks as enlarging models, making studies of hands, and making molds and plaster casts, freed him to be creative. This cost a lot of money, however, and Rodin could have made good use of the agreed fee of 15,000 francs, which was equal to the monument's estimated casting costs plus additional funds to cover the expense of making models. In a letter to the secretary of the committee or the mayor, Rodin put it well: "You know that sculpture is an admirable art that always leaves the artist crushed with expenses."

53. Rodin to Dewavrin, May 1887, in Judrin, Laurent, and Viéville 1977, 63.

54. Ibid., Rodin to Dewavrin, October 1888, 65.

55. See Lampert 1986, 114–15, regarding her point that "a second Jean d'Aire replac[ed] Jacques de Wissant." Rodin in fact had reused the head of Jean d'Aire for that of Jacques.

56. Without citing her source, Lampert described the bases of the six plasters not visible in Druet's photograph as "chess-like" (1986, 114).

57. Alphonse de Calonne, in *Le soleil*, 23 June 1889, reprinted in Judrin, Laurent, and Viéville 1977, 67 n. 3.

58. Ibid., Rodin to Dewavrin, June 1889, 68.

59. Auguste Dalligny, in *Le journal des arts*, 5 July 1889, reprinted in Beausire 1989, 235.

60. Beausire 1989, 67.

61. Gustave Geffroy, in *La justice*, 21 June 1889, reprinted in Beausire 1989, 220.

62. Hugues Le Roux, "La vie à Paris," *Le temps*, 20 June 1889, reprinted in Beausire 1989, 219. Mounting on a pedestal of any height would not have permitted Rodin to engage the living in such a dialogue with his art.

63. Fernand Bourgeat, "Paris vivant," *Le siècle*, 22 June 1889, reprinted in Beausire 1989, 222.

64. J. Le Fustec, "L'exposition Monet-Rodin," *La républic française*, 28 June 1889, reprinted in Beausire 1989, 229.

65. Georges Rodenbach, *Le journal de Bruxelles*, 28 June 1889, reprinted in Beausire 1989, 230.

66. Rodin, in *Le Français*, 19 March 1895, reprinted in Judrin, Laurent, and Viéville 1977, 92 n.2.

67. Translation in Tancock 1976, 388–90, from *L'art et les artistes* 1914.

68. Varnedoe 1978, 486.

69. For additional photographs see Le Nouëne and Pinet 1987, 62–65. We now know that Limet, who worked for Rodin from 1900 to 1915, made the gum bichromate prints of the *Burghers*.

70. The interaction of the sculptor and his photographers is discussed in Elsen 1980, 9–32 and Pinet 1985.

71. That Rilke had talked with Rodin about the involvement of sculpture with atmosphere is evident when he continues, "A similar effect may be observed in some of the animals on the cathedrals to which the air relates itself in strange fashion" (Rilke in Elsen 1965a, 140). The reference to the sculpture of the Gothic cathedrals was probably inspired by Rodin's own extensive studies.

72. Rilke in Elsen 1965a, 139–40.

73. This section is based on the author's essay of the same title in McNamara and Elsen 1977. For additional views see Hermann Bünemann, *Auguste Rodin: Die Bürger von Calais* (Stuttgart: Reclam-Werkmonographien, 1957); J. A. Schmoll gen. Eisenwerth, "Rodin's 'Bürger von Calais' und ihr Kompositionsproblem," *Saarbrücker Hefte*, no. 10 (April 1959): 59–70; Varnedoe 1990, 133–39.

74. Fry wrote (1956, 199–200) his critique not long after Rodin's death, and his analysis and criticism of *The Burghers* is worth repeating: "Rodin's rhythmic sense had only a short range. It was confined to his nervous organization. In the larger relations it broke down. So here the group remains a crowd. Each figure has been separately conceived, and then they have been moved about until they fitted together with as little inconvenience to one another as possible. At least that is the impression one gets. There is no controlling rhythmic idea, no liaison between the different parts, no interplay of planes, no estimation of the relative quantities of unbroken surfaces to intricate and agitated ones. An uncoordinated monot-

ony and uniformity of quality pervades the whole. It hangs together by its dramatic but not its plastic unity. Rodin could achieve texture, he could not achieve architectural structure. He could not hold and vary his rhythms throughout a sustained phrase. He could only repeat the short phrases over and over again."

If to those who know the sculpture of Rodin's nineteenth-century contemporaries it sounds as if Fry regretted that Rodin was not a Beaux-arts-trained sculptor such as Jules Dalou, they are right. In the same essay (201–02) Fry praises Dalou's *Maternity* (1879) as "London's one really good . . . first-rate sculpture." Fry admired it for "the continuity of the movement throughout every part." According to John Hunisak, Fry misnamed the statue which was commissioned as "Charity" and installed in 1879 over a public drinking fountain behind the Royal Exchange. Dalou's original marble has been replaced by a bronze replica. A reduced marble replica entered the Tate collection with the erroneous title "Maternity" (letter to Bernard Barryte, 7 February 2001).

75. William Tucker, himself an abstract sculptor, gave a reading that seemed to answer Fry when he wrote (1974), "Viewed from the right-hand end, the insistent repetition of three exactly parallel and diagonal lower legs counteract the effect of the highly individual and exactly realized heads by affirming the role of the limbs, of twenty-four arms and legs, in a gravitationally and expressively unified structure. *The Burghers of Calais* is not, as is sometimes said, six separate statues: it is as architectural as Rodin was capable of being . . . the repeated internal verticals, the arches formed by raised and gesturing arms, evoke the Gothic cathedrals to which he was so attached" (149).

76. Lawton 1906, 162.

77. Rodin to Dewavrin, 2 August 1885, translation in McNamara and Elsen 1977, 72. Lawton further explained, "In speaking of the statues an allusion is made to the sculptor's using mathematical designs in forming his groups. More than once in our talks together, the master explained his observance of these designs, and with a special reference to 'The Bourgeois de Calais.'

'Nature,' he said, 'is the supreme architect. Everything is built in the finest equilibrium; and everything, too, is enclosed in a triangle or a cube, or some modification of them. I have adopted this principle in building up my statuary, simplifying and restraining always in the organization of the parts so as to give the whole a greater unity. This does not prevent, it aids rather, the execution, and renders the diversity and the arrangement of the parts more rational as well as more seemly'" (1906, 161–62).

78. See discussion in Tancock 1976, 385.

79. See Elsen 1980, pls. 60–64.

80. Rodin to Dewavrin, 8 December 1893, translation in McNamara and Elsen 1977, 75; the French original in Judrin, Laurent, and Viéville 1977, 76. The individual *Burghers* were installed amid paving stones and at ground level in Memorial Court, Stanford University, 1998. See fig. 56.

81. Rilke in Elsen 1965a, 139.

82. McNamara and Elsen 1977, 78, from Auguste Rodin, *Rodin on Art and Artists: Conversations with Paul Gsell*, translated by Mrs. Romilly-Fedden (1912).

83. Tancock 1976, 385, from *L'art et les artistes*, 1914. The most interesting and credible idea in Christian Beutler's article is that Rodin may have gotten the thought of placing the figures at ground level or on a low pedestal, thereby involving the spectator with the subject, from contemporary panoramas and dioramas and the installations in Alfred Grevin's wax museum, opened in 1882, and those in museums such as the Musée de l'Artillerie, showing mounted knights in armor set on low plinths (Beutler 1972, 49).

84. Drawing reproduced in Judrin, Laurent, and Viéville 1977, 150.

85. Rilke in Elsen 1965a, 139.

86. Lawton 1906, 150.

87. For an excellent account of the history of the monument's acquisition and the controversies over its installation in London see Susan Beattie, *"The Burghers of Calais" in London*, exh. cat. (London: Arts Council of Great Britain, 1986). See also watercolors by Jane Evelyn Lindsay (A172–174)

88. Ibid., Rodin to British Office of Works, 28 November 1912, 80.

89. Ibid., 8–9. Rodin's reference to clemency, which is unique in connection with his statements about the monument, concerns the fact that the English king spared the lives of the burghers. Rodin may have wished to flatter the nation that sought to honor him. What sixteenth-century monuments Rodin had in mind is not known, but Rodin may have thought that Verrocchio's *Colleoni* dated from that period.

90. Ibid., 9.

91. Mauclair 1918, 52.

92. Ibid., 57.

93. Ibid., 54.

94. Ibid., 57. On the continuing artistic impact of the monument, see Rŭth and Appel 1997.

95. See Judrin, Laurent, and Viéville 1977, 226–38 for photographs of these works and further discussion.

96. This history is recounted in Gisèle Peumery, *Les bourgeois de Calais: Leur histoire, leur monument* (Calais: E. Butez, 1971), 27–30.

97. I am indebted to June Hargrove for this identification.

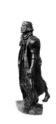

9

Second Maquette for "Eustache de Saint-Pierre" (Eustache de Saint-Pierre, deuxième maquette), 1885

- Bronze, Susse Foundry, cast 1971, 3/12
- 27½ x 12 x 11½ in. (69.9 x 30.5 x 29.2 cm)
- Signed on top of base, right, front: A. Rodin
- Inscribed on back of base, right: Susse, Fondeur, Paris; under signature: No. 3; on front of base, left: © by Musée Rodin, 1971
- Provenance: Musée Rodin, Paris
- Gift of The Iris and B. Gerald Cantor Foundation, 1974.102

Figures 70–72

Rodin made substantial changes to the burghers during the evolution from initial sketch to final work. He was far more unwilling to be held as an intellectual prisoner by committee-accepted models than such contemporaries as Jules Dalou. The richness of Rodin's imagination, inspired by Froissart's *Chronicles,* and his originality as an artist comes through in the studies for the second maquette. In this first study for Eustache de Saint-Pierre we can also see evidence of Rodin's susceptibility to indecision in the matter of a pose.

Rodin knew that because of the historical controversy over Eustache de Saint-Pierre's integrity, the Calais committee would scrutinize this figure more closely than any other in the second maquette.[1] He therefore chose to show the oldest burgher with his bearded head up; rope coiled around his neck; bare, thin, but muscular arms hanging at his sides; and leaning slightly forward as he takes a step on his right foot (fig. 72). From the front his torso and legs are totally concealed by the thick folds of a heavy garment, so that one sees only the toes of the right foot. In the judgment of the Calais committee, however, Rodin's conceptions of Eustache and the group were a failure. Their depressed attitudes seemed an affront to Calaisian religious sensibilities and their heavy costumes a deviation from the story as told by Froissart. Concerning the speculation that Rodin did respond to the committee's criticism of the group, with regard to Eustache, far from acceding to the committee's objections, in the final version he lowered the old

man's head, making him truly despondent, and kept the heavy garment.

The writer for *Le patriote* who saw the second maquette actually misread the pose of Eustache, compounding his misdemeanor with sarcasm: "His appearance is heartbreaking; he seems not to have enough strength to carry the enormous rope wrapped around his neck, [a rope] that looks as though it were there to ward off laryngitis, a useless precaution at such a time and in such a . . . light outfit. . . . He looks crushed by the burden of his wretchedness."[2]

While the committee commented to Rodin in its report, "The scale model does not allow us to judge the details,"[3] it was not the size of the figures but the way the group had been fitted together that made it difficult, if not impossible, for them to study each figure closely. If the one-third life-size figure of Eustache could have been studied in the round, the artistically conservative committee might have found even more objections.

Contrary to the way in which Rodin would rework Eustache immediately after this étude (study) and go on to create the life-size final versions, the old man was not at first modeled naked. The étude gives little evidence of the man's body inside the garment, specifically by revealing only something of the chest and upper abdominal area. Those who think that Rodin modeled his figures from the ground up will find this work quite a surprise. It is as if Rodin first thought of the torso and upper legs largely in terms of the drapery, so that he hung the implied figure in its garment without being certain of where to put the feet or which foot would carry the figure's weight. The lower legs, made separately and not from the same model, were inserted under but not inside what is a solid, draped form, leaving them still maneuverable. Neither foot is modeled in the same manner. The left foot is raised and extends beyond the back of the base, perhaps because Rodin wanted small bases that would allow him greater maneuverability in arranging the six sculptures. The base is wider than deep, suggesting that at first Rodin may have thought of having Eustache stand with his feet together. Even after he decided to have Eustache initiate the fateful march, from the front it is hard to discern that he is moving forward.

Rodin had obviously not yet resolved how to handle the stride. The figure leans slightly to its left, but the weight is on the right leg. The raised left foot looks as if it had been broken above the ankle as its Achilles tendon does not line up with the central axis of the calf. The

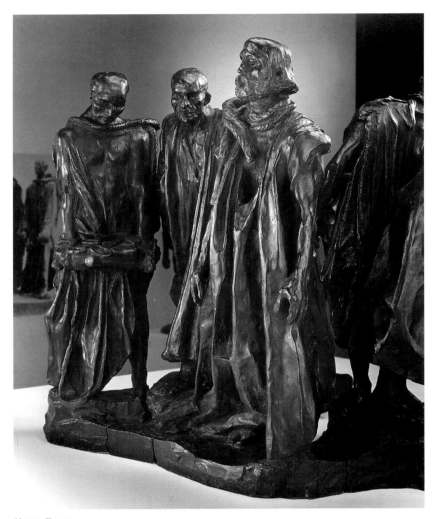

Above: Fig. 70. *Second Maquette for "Eustache de Saint-Pierre,"* figure at right (cat. no. 9).

Right: Fig. 71. *Second Maquette for "Eustache de Saint-Pierre"* (cat. no. 9).

Far right: Fig. 72. *Second Maquette for "Eustache de Saint-Pierre"* left profile (cat. no. 9).

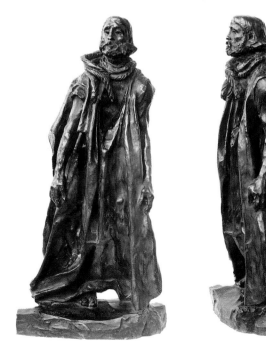

right foot is undeveloped, so that the form of the ankle and the toes have been only roughly indicated. Both feet are so close to being on the same horizontal axis that if the left foot were brought forward it might hit the right. In effect the figure seems more supported by the drapery, which touches the ground on either side, rather than by the supposedly weight-carrying right foot. This solid anchorage allowed Rodin to try different choreographies.

Viewed from either side, it is as if the figure were walking through a curtain. The thicker front folds run almost straight up and down and reach the ground except where Rodin turned back the garment to show the leading section of the right foot. The back is more form fitting. Thinner and more loosely hanging, the robe suggests the forward lean of the shoulders and the big hollows of the man's flanks. It is not as if the robe is shaped by a form inside it but rather the reverse: portions of the body are modeled in the robe. The swell of the drapery supposedly caused by the man's thighs does not seem to accord with the lines or vertical axes of the exposed leg and foot even if his legs were severely bowed. Rodin's consciousness of the need for a largeness of design comes through in the overall pyramidal outline of the back with the down-and-outward sweep of the garment.

Eustache's head was crucial with respect to the jury's concerns. Even a two-and-three-quarter-inch étude, which Rodin must have modeled in his hand, had to show a lot, such as Eustache's appearance, attitude, and character.[4] The hair of the erect and somewhat narrow head is very full, falling straight down on the forehead and behind the ears. The mustache and short beard, marvelously suggested by faceted planes and hollows, are well groomed. As befitting the leading burgher of Calais, Eustache was prepared to die in style. From age and the siege his cheeks are especially gaunt, accentuating the long, straight, thin nose. Only the thick neck seems out of character. The hollowed eyes are set deeply with only the man's left upper eyelid evoked. Depending on the light and one's angle of vision, they can convey a sad or distracted look or a sense of being unfocused and withdrawn. Alternative interpretations depended in 1885 on the predilections of the committee, which was not pleased with what it saw. By contrast with the final version, dramatically and sculpturally the head is upstaged by the rugged lines and shadows of the drapery. There is no sense, as will come later, of the flow of one into the other.

NOTES

LITERATURE: Jianou and Goldscheider 1969, 98; Goldscheider 1971, 167–70; Tancock 1976, 388, 390, 400; Judrin, Laurent, and Viéville 1977, 164; McNamara and Elsen 1977, 27–29; Miller and Marotta 1986, 53

1. It was thought that Eustache had accepted favorable treatment from the king and queen of England; for a historical account see Tancock 1976, 376, 380.
2. Translated and reprinted in McNamara and Elsen 1977, 71.
3. Ibid., 70.
4. Listed in Tancock 1976, 401.

10
Nude Study for "Eustache de Saint-Pierre" (Eustache de Saint-Pierre, nu), 1885–86

- Bronze, Georges Rudier Foundry, cast 1969, 3/12
- 26½ x 10¼ x 8¾ in. (67.3 x 26 x 22.2 cm)
- Signed on top of base, left: A. Rodin
- Inscribed on base, right side, lower edge: Georges Rudier/Fondeur, Paris; on back of base, lower edge, left: © by Musée Rodin 1969; interior cachet: A. Rodin
- Provenance: Musée Rodin, Paris
- Gift of the Iris and of B. Gerald Cantor Foundation, 1974.104

Figure 73

*W*hen placed next to the figure of Eustache de Saint-Pierre in the second maquette, it is clear that Rodin used much but not all of this nude study for the robed figure. Though similarly positioned, the two pairs of feet are very different, with those of the costumed figure being far less developed. Differentiated by the treatment of their beards, the heads are nevertheless from the same model, probably Jean-Charles Cazin, but that of the clothed figure is held erect by the ropes wound round its neck. While changing the fingers slightly, Rodin kept the pose of the downward-hanging, muscular arms and outstretched hands with palms turned toward each other, as if perhaps to support a large cushion for a city key, but in the clothed figure the hands simply touch and frame the edge of the robe hanging down the man's front.

What comes through the rough drapery of the clothed figure is the lithe, well-formed, and still youthful body that shapes it from the inside out. The roundness of the nude, forward-leaning shoulders and buttocks

informs the cloth Rodin modeled over them. The jury's critical comments did not seem to include dissatisfaction with the age of Eustache's body but rather his lack of heroic gesture and attitude. The artist and not the jury was here his own worst critic; it was Rodin who found this handsome, marvelously fluid study totally wrong dramatically.

LITERATURE: Grappe 1944, 44; Jianou and Goldscheider 1969, 98; Goldscheider 1971, 170; Tancock 1976, 387, 390, 400; Judrin, Laurent, and Viéville 1977, 160–62; McNamara and Elsen 1977, 30; Miller and Marotta 1986, 53

11
Nude Study for "Eustache de Saint-Pierre (As an Older Man)" (Eustache de Saint-Pierre, nu), 1885

- Bronze; Georges Rudier Foundry, cast 1973, 10/12
- 38½ x 13 x 17 in. (97.8 x 33 x 43.2 cm)
- Signed on base, near right foot: A. Rodin
- Inscribed on back of base, behind right foot: Georges Rudier. Fondeur. Paris.; right of signature: No. 10; right of founder's inscription: © by Musée Rodin 1973
- Provenance: Musée Rodin, Paris
- Gift of the Iris and B. Gerald Cantor Collection, 1998.358

Figure 74

*I*n July 1885, even as he was showing the second maquette in Calais, it seems that Rodin had already in progress drastic changes for the individual burghers, starting with Eustache. It may not have helped his concentration on the next étude of Eustache to receive an urgent message from Omer Dewavrin on 26 September:

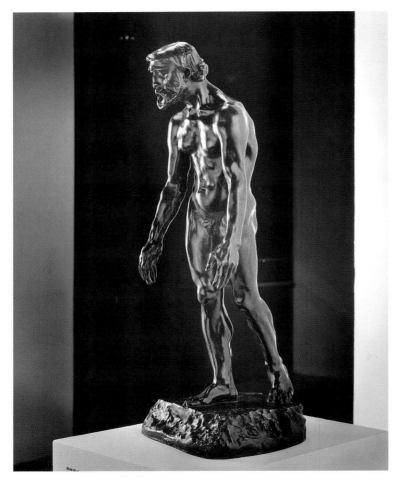

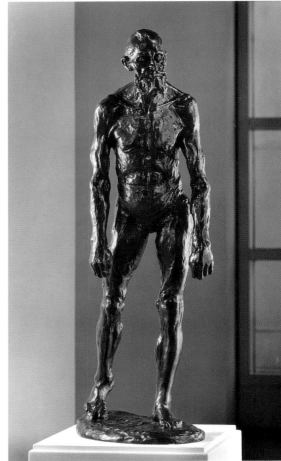

Left: Fig. 73.
Nude Study for "Eustache de Saint-Pierre" (cat. no. 10).

Right: Fig. 74.
Nude Study for "Eustache de Saint-Pierre (As an Older Man)" (cat. no. 11).

"We are embarrassed, public opinion is so vigorously pronounced against the attitude of Eustache that we do not dare to continue the subscription without being able to say that there will be a change."[1] There seems not to have been a written reply from Rodin. The new study, however, can hardly be seen as a concession to public opinion, as it shows a much older and leaner, naked man, who now bends forward from the waist and advances stiffly on his left foot, palms empty and hands turned backward, with fingers bent. Here began Rodin's simple gesture of surrender, later admired by more enlightened critics. In the search for a new credibility, he came up with an old man's bony, square-rigged body, which creaks from age and privation. Rarely in sculpture has a naked male figure displayed so many harsh extrusions, starting with the flared ears and running down through the shoulders, elbows, hips, knees, and ankles. Rodin is now getting deeper into his story and history.

With the possible exception of the head, I propose that this figure was not modeled by Rodin but rather by one of his very able assistants, such as Jules Desbois. The fashioning of the body throughout lacks the master's touch, including the fluidity of his modelé, or joining of planes. Many passages of clay patches, especially around the knees and on the back, are left raw or untempered, and for lack of an organic feeling they just seem applied. When Rodin added a slab or mashed ball of clay, it became the extension of something underneath, whether bone and muscle or even the interior life of the figure. Most unlike Rodin is the way the quadrate abdomen and the spine are drawn rather than modeled. The effect of the surface is not that of bone and muscle pushing outward against flesh but rather a kind of rough *écorché* (flayed) figure effect in the thighs, for example. The man's skeleton fiercely asserts itself in the area of the clavicles, and this is convincing, but the man's left hip seems out of its socket, and the treatment of the kneecaps seems uncertain.[2]

The head was Rodin's real find. Whether or not Pignatelli (Rodin's model for *Saint John the Baptist Preaching* [1878]) served as its model, it became the source of the great final Eustache.[3] A hornlike tuft of hair protrudes from the forehead's center, like the keel of an overturned boat. Otherwise there is little hair to soften the

cranial hardness. The temples are indented, eye sockets deep, brows contracted, and above the flaring cheekbones is mounted the man's intense but downcast gaze that is like a banked fire. More has been made of the mustache and beard, which are less kempt and more agitated than in the previous figure.

NOTES

LITERATURE: Jianou and Goldscheider 1969, 98; Goldscheider 1971, 170; Tancock 1976, 387, 390, 400; de Caso and Sanders 1977, 211; Judrin, Laurent, and Viéville 1977, 193–94; McNamara and Elsen 1977, 30–31; Miller and Marotta 1986, 55

1. Dewavrin to Rodin, 26 September 1885, in Judrin, Laurent, and Viéville 1977, 58.
2. De Caso and Sanders believed (1977) that a section was added to the man's left leg, and though this may be correct, throughout the legs as a whole one has the sense of their being additive rather than conceived as single, integrated limbs (211).
3. Laurent introduced the possibility of Pignatelli as the model for the whole figure, but she also pointed to what she believed discounted the possibility (in Judrin, Laurent, and Viéville 1977, 193). Judging from photographs taken of Pignatelli for the École des beaux-arts, Rodin probably used an older model for Eustache.

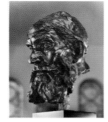

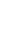

Head of Eustache de Saint-Pierre (*Eustache de Saint-Pierre, tête*), 1886

- Bronze, Georges Rudier Foundry, cast 1968, 3/12
- 13 x 9⅞ x 9⅞ in. (33 x 25.1 x 25.1 cm)
- Signed on neck, left side: A. Rodin
- Inscribed on back of beard, right side: Georges Rudier/Fondeur, Paris; on back of beard, left side: © by Musée Rodin 1968
- Provenance: Musée Rodin, Paris
- Gift of the Iris and B. Gerald Cantor Foundation, 1974.105

Figure 75

*T*he impression left by study of this sculpture is that it is a great head: inspired in the liberties taken, powerful in design, memorable in the intensity of its expression. It is a moving characterization of the vulnerability of a hero, eschewing both pride and pathos in favor of resignation that has come from weighing the costs of the past and the alternatives of the present. This memorable head may well have been a portrait of Rodin's friend, the painter Jean-Charles Cazin, who wrote to the sculptor, "You have had a most friendly thought. I am ready to pose for the figure of your Eustache de Saint-Pierre, rope around the neck, feet and arms naked. This excellent man, from whom I believe I am descended on my mother's side, would himself approve

of your choice because I profoundly admire the simple grandeur of his action."[1] The head of Eustache in the second maquette (cat. no. 9) and in the later nude version of an older man (cat. no. 11) are greatly different from the final version (cat. no. 13). That the new, or third, living model was Pignatelli does not seem likely, as the Abruzzi peasant would not have aged that much in the short time since he posed for *Saint John the Baptist Preaching* (1878). Having as a model someone who claimed descent from Eustache would have appealed to Rodin's predilection for historical truth. Given the problem of our having only a profile photographic portrait of Cazin, but seeing there the prominent cheekbone, large nose, abundant beard that starts in the cheeks, and centrally parted hair, it is likely that Cazin was the source of Eustache's face.[2]

As with all his portraits going back to that of *Mask of the Man with the Broken Nose* (cat. no. 125), Rodin sought every evidence of asymmetry to develop his subject's identity. As seen directly from the front, this search extended beyond facial features, such as the creases under the eyes, and produced the off-center part in the hair and the greater projection of the man's left ear than that of his right. The hair is kept close to the head, having no clear separation from the brow's center, thereby forcing attention down into the face and the finely shaped, bony nose. Rodin fashioned the face as a kind of hourglass design, which starts with the flaring cheekbones, tapers to the mustache, and then swells outward in the beard. It is the deeply and asymmetrically indented cheeks, intended to evoke not just age but the privations of war, which give the cheekbones their prominence and are so sculpturally dramatic. As with

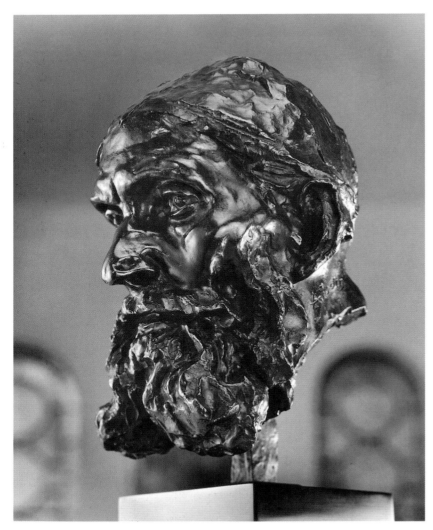

spection rather than fixation on anything external. Taken as a totality, whether erect or tilted, just the head of the hostage leader imparts a sense of an unbearable burden of being.

NOTES

LITERATURE: Grappe 1944, 61; Jianou and Goldscheider 1969, 98; Tancock 1976, 401; Judrin, Laurent, Viéville 1977, 195–99; Lampert 1986, 105, 217; Miller and Marotta 1986, 56; Ambrosini and Facos 1987, 102; Barbier 1992, 159; Butler 1993, 202–5

1. Cazin to Rodin, 29 May 1885, in Judrin, Laurent, and Viéville 1977, 49–50 n. 3. The final version of the head includes a rope round the neck (197). Viéville pointed out that a note of 1907 from the Alexis Rudier foundry concerning a *Tête Pignatelli* may refer to this work, but this is questionable evidence that Pignatelli was the model (196).
2. Photograph of Cazin in Judrin, Laurent, and Viéville 1977, 252.
3. Rilke in Elsen 1965a, 138.

13

Eustache de Saint-Pierre, Final Version (*Eustache de Saint-Pierre, vêtu*), 1885–86

- Bronze, Coubertin Foundry, cast 1981, 2/12
- 85 x 30 x 48 in. (220.2 x 77.7 x 124.3 cm)
- Signed on front of base: A. Rodin
- Inscribed on back of base: © by Musée Rodin 1981; under signature: No 2
- Mark on base, left side, near back: Coubertin Foundry seal
- Provenance: Musée Rodin, Paris
- Gift of the B. Gerald Cantor Collection, 1992.145

Figure 76

W hen the English king's terrible terms for the surrender of Calais were made known to its citizens gathered in the market place, Jean Froissart wrote in his *Chronicles*: "A moment later there arose the richest burgher, Sir Eustache de Saint-Pierre, who said: 'Lords, it would be a great misfortune to let such a people die here

the deep drapery folds on the man's body, with these bold hollows Rodin pulled dark shadows into the composition to give it tragic overtones. Imparting great force to the image is the vigor of Rodin's rhythmic and exaggerated concave and convex featural sequence, which begins with the hair, then the temples, under which is the counterplay of the big arcs of the cheekbones and cheeks, ending in the out-and-downward flow of the mustache and beard. The sculptor achieved a marvelous fluidity for his composition by knowing when to suspend description in the areas of hair and to merge their beginnings with flesh.

Rainer Maria Rilke commented on "an expression of weariness that flows over his face into the beard."[3] No doubt the poet was influenced by seeing also the downward tilt of the head in the final full figure. Crucial to showing the fateful moment in the old man's life are the eyes: his left has an indented pupil while the right is an orb, both of which under Rodin's fingers evoke intro-

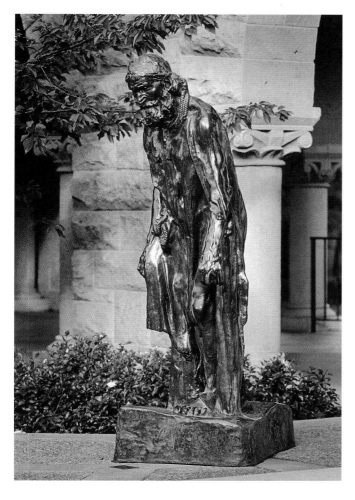

Left: Fig. 76. *Eustache de Saint-Pierre, Final Version* (cat. no. 13).

Right: Fig. 77. Karl-Henri (Charles) Bodmer, *Model for "Monument to Benjamin Vicuña-Mackenna" with "Eustache de Saint-Pierre" in clay in background,* 1886, albumen print with ink drawing. Musée Rodin, Paris.

of famine when one can find another means. I have such hope of finding grace and pardon from Our Lord if I die in order to save these people, that I want to be the first: I will willingly strip to my shirt, bare my head, put the rope around my neck, at the mercy of the king of England.'"[1]

Not from any artistic precedent nor further documentation but from these lines Rodin had to conjure the single most important figure of the Calais commission. We gain an idea of what he accomplished and how it was viewed in the words of the finest French art critic of the time, Gustave Geffroy, who saw the final sculpture in conjunction with the others and wrote in his essay for the Monet-Rodin show:

> The first, the one who appears at the head of the funereal cortege, is the old man who spoke first, it is Eustache de Saint-Pierre, debilitated and broken. He advances with slow steps, his head oscillating, his shoulders depressed, his arms stiff, his hands

hanging and thin, muscles knotted, arteries blocked. On his arms, on his hands, the veins make swollen networks, where the blood circulates slowly. The stiff jointed fingers are useless for grasping anything. The legs are staggering, the feet are distended. The whole grinding carcass, difficult to put in movement, tells of the sadness of an anatomy of old age. The long hair, the sorry beard, the forehead lowered and shriveled, the long face speak of resignation, of sacrifice humbly accepted. The road is hard like the way of the cross to this thoughtful condemned one, dressed in a coarse robe, tied at the neck with the rough hangman's cord.[2]

The best but incomplete record of how Rodin arrived at this powerful characterization is to be found in photographs taken in the boulevard de Vaugirard studio in 1886 by Victor Pannelier.[3] In another photograph, by Bodmer, the nude Eustache modeled in clay is to be par-

tially seen behind the model for a monument to Benjamin Vicuña-Mackenna (fig. 77). Rodin seems to have worked from a different model for the body than the older person used for the second, one-half life-size étude. What we can see of the old man's frame in clay explains the way the final robe is shaped in the chest area. While the man's left pectoral is largely a memory of strength and the abdomen appears soft because the flesh has shrunk, the tensed left arm is quite muscular, ending in a taped-over hand. Absent a written record, there seems no way of identifying the model for the body as it was not the painter Cazin, who had inspired the head.

Rodin would sometimes tell friends about agonizing over some aspect of his work. It is hard for us to imagine what would cause this great sculptor problems. What this and other photographs tell us is not only Rodin's conservative practice of first fashioning his figures nude, but his preoccupation, if not agonies, with gesture, specifically the old man's left hand, which in the picture is heavily bandaged. As with the head, Rodin auditioned different positions for the extremities on the study made from a model, whose own hand may or may not have been its

source. The artist seems to have had more difficulty in satisfying himself and arriving at the final treatment of the left hand than the face. (The man's right hand, which hangs vertically in the photos showing the clothed figure in clay, does not have the left's extensive and swollen vein pattern.) In a slightly later photograph taken by D. Freuler, we see how Rodin tested the expressiveness of Eustache's left hand alone by hanging it straight downward from a string looped over a nail and attached to the plaster cast (fig. 78).[4] From what one can tell of the bandaged limb, with its splint on the wrist area, Rodin was trying a different angle, slightly upward, at which the wrist was to be held and the thumb extends out and away from the forefinger. This position is seen also in the Pannelier photographs of the draped burgher but with the fingers removed (fig. 79). What was Rodin seeking to convey by this gesture? It was his custom to avoid as much as possible having a figure's two hands do the same thing. (The despairing gesture Andrieu d'Andres makes by clutching his head with both hands is a notable exception.) As in the final work, Eustache's right hand hangs downward as if in compliance with fate. Per-

Left: Fig. 78. D. Freuler, *"Suspended Hand of Eustache de Saint-Pierre" in plaster* (A145).

Right: Fig. 79. Victor Pannelier, *"Eustache de Saint-Pierre" in clay*, 1886, albumen print(?). Musée Rodin, Paris.

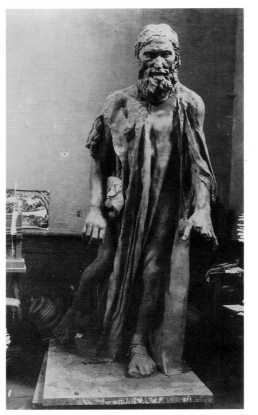

haps Rodin had in mind that the slightly upraised left hand would serve as Eustache's signal for the group's departure. On a photograph of the robed Eustache in clay, Rodin used a pen to draw over what he had done, and in so doing he added the missing fingers of the left hand but pointed them toward the ground (see fig. 18).[5] By later actually turning the final modeled hand downward, in imitation of the right, the starting signal was given by the old man's forward left step.

Pannelier's photograph of Eustache from the rear, in addition to showing lumps of clay recently scraped from the sculpture, reveals something

rarely seen in the visual documentation: some of Rodin's actual modeling tools, including round and straight-edged wooden spatulas still on the saddle or modeling stand.[6] The robe had been modeled directly on the finished clay figure and was still being refined when Pannelier tripped the shutter. That refinement continued with pen and ink when Rodin saw Pannelier's proofs. In the view of Eustache from his right Rodin clarified the way he wanted the accents in the garment around the right arm, and with a pen he signified more inflections in the chemise in front of the trailing leg.[7] The photograph of Eustache from the front, which was heavily edited, shows how Rodin equated shadows with pathos.[8] The inked lines tell us how deep he wanted the shadows that were made by the tightened arm muscles, drapery folds, and the modeling of the face and beard and, most importantly, what the overall impression would look like. In the same photograph and despite the heavily inked lines, one can make out the word *plein* written just left of center in the upper abdominal area, suggesting that he wanted this section to be fuller. The drawn lines as much as the modeled drapery itself show how Rodin thought of the robe in long, continuous sequences. What all of this tells us also is that Rodin did not call Pannelier to the studio to record a finished work. The time must have been a critical juncture when Rodin wanted a detached way of studying what he had done. He thus used these reworked photographs as states in the evolution of his sculpture rather than to supply the demands of the press.

Rodin was to make some important changes after Pannelier was finished. The exposed vertical metal armature that comes out of Eustache's left arm and seems to terminate in a ball-like, wrapped joint, which may have covered a brace leading to the hand, will either be removed or contained in a repositioning of the forearm, wrist, and hand.[9] The bundle of cloth between the old man's right arm and thigh will be replaced by ropes, and Rodin would work out how the halter would then be shown in the back. Instead of being totally free, the trailing right leg will have drapery hanging from it, and the left foot will be made to appear as if torn cloth covered it.

The Final Figure

As Rodin stated, "I did not hesitate to make them as thin and as weak as possible. . . . These people . . . no longer have anything but skin on their bones.[10] He further explained, "They had asked of me the gestures of [Rude's] 'Marseillaise.' I refused. I wanted to show my burghers simply sacrificing themselves, as they did in those days, without signing their name."[11] As with *Saint John the Baptist Preaching* and *The Walking Man*, Rodin's sculpture of Eustache rewards reading in time as one looks at the figure from all sides, starting with the front. Head on, the impression is of a figure taking a slow step forward, head bowed as if Eustache has already given up the sight of the living in exchange for that of the path to the grave. From the sides the figure appears to pick up momentum and is on the verge of toppling forward. The lowered head thrusts in advance of the lead foot in violation of the academic insistence on a figure being plumb with the head and the supporting foot being aligned. The shoulders are bent as if pulling a great load. The trailing foot is pushing off, and the long bony leg is fully exposed. From the back, where one cannot see the straight left leg, the figure seems in full solemn stride. There is an uninterrupted upward sweep of the drapery from the ground to the lowered head, which adds to the impression of forward propulsion.

In conceiving Eustache's fatal step, Rodin did something unusual in figure sculpture. He counted on his ability to inspire us to think of a figure in its sequential motion starting from the time it was at rest until the movement was complete. It is as if the old man had been standing originally with feet apart and did not first draw them together before advancing. As he steps forward and shifts his weight to the left leg, the right foot drives off the ground, and the knee bends, but the leg is seen as being at about a forty-degree angle to the forward direction of the body. (From the front, the trailing leg seems almost like a diagonal brace.) To have kept both legs on the same forward axis would have meant that from a frontal view the right one would have been hidden totally by the drapery, hence the man would have appeared to be standing on one leg. Thus what seems an anomaly was for Rodin an artistic imperative: overall stability had to accompany the illusion of movement.

An imperative for Rodin as a dramatist was to convince the viewer that these were citizen warriors who had surrendered because of physical privation and to save their fellow citizens. Eustache's head, bowed as if inclining to destiny, as opposed to its more erect position in the second maquette, was anything but a concession to popular opinion in Calais. So well did Rodin succeed in his declared intention that Geffroy could write of

Eustache's "grinding carcass" and the sad anatomy of old age. The cadaverous head and emaciated left forearm with its bulging veins magnetize the viewer's attention, but then one sees how the bony chest marks the drapery from beneath, and the large, naked left kneecap and surrounding musculature recall flayed anatomical figures in medical schools. One has the sense that, seen from the rear, the drapery covers only muscle and bone. There is the big, beautiful curve of the lower spine, which is in turn flanked by powerful muscles; there is no fat on the hard buttocks that push through the robe.

As he would do with all the burghers, there are passages where Rodin intentionally obscured the difference between fabric and flesh, especially in the upper back and in the area where the drapery supposedly hangs from the left leg. Eustache's shroud of shame is more tattered than the others, and its rents allowed Rodin cavernous intrusions into the overall form. Rodin was able to make the robe, though shapeless to start with, seem a literal extension not only of the body but also of the mood of its wearer. Folds seem extensions of muscles and tendons; the compliance of the long garment with gravity is like that of the man with fate.

For the critic Hugues Le Roux, who visited the 1889 exhibition and saw the full monument, Rodin had created a compelling characterization: "The Saint-Pierre . . . the one who was the soul of the sacrifice, who said to the others: It is necessary."[12] For Rilke, "He created the old man with loose-jointed, hanging arms and heavy, dragging step and gave him the worn-out walk of old men and an expression of weariness."[13] It was the Belgian poet Georges Rodenbach, however, who earlier than Rilke saw Rodin's achievement in this figure in terms of the art of the time: "This is the human sadness of vanquished and silenced patriotism, with a single gesture of resignation and strange grandeur in the unique personage who walks ahead—a gesture absolutely new and never before seen, because Rodin's glory will have been to find in sculpture new attitudes."[14]

By itself, the final full-size version of Eustache de Saint-Pierre seems to have been publicly exhibited only twice: first in plaster at the Galerie Georges Petit in 1887 and then in bronze at the Paris Salon of 1895.[15]

NOTES

LITERATURE: Grappe 1944, 59–62; Spear 1967, 40–47; Jianou and Goldscheider 1969, 97; Tancock 1976, 376–90; Judrin, Laurent, and Viéville 1977; McNamara and Elsen 1977, 45–49, 61–64; Miller and Marotta 1986, 56; Ambrosini and Facos 1987, 100; Fonsmark 1988, 111–15; Butler 1993, 204–13

1. The original French text of the excerpt is reprinted in Judrin, Laurent, and Viéville 1977, 113–14.
2. Reprinted in Beausire 1989, 67.
3. With the exception of a sketched-over photograph showing the sculpture from its right side (reproduced in Le Nouëne and Pinet 1987, 27), these photographs of Eustache in clay were first published in Elsen 1980, pls. 51–54). Pinet cited Rodin's letter to Dewavrin of July 1885, in which he regretted not having made a systematic photographic record of *The Burghers* (24).
4. I saw this cast with the string still attached in the Meudon reserve in 1977. I was the first to make the connection of this hand with *The Burghers of Calais* (Elsen 1980, 18) but was not so credited by Pinet, who reproduced it and wrote about the work (in Le Nouëne and Pinet 1987, 29).
5. Pinet is of the view that these " 'repentances' that he sketched doubtlessly under the impulse of an idea were not followed by any correction on the sculpture itself" (in Le Nouëne and Pinet 1987, 29). While I would say this was true of most of Rodin's drawn editing of his work on photographs, in this instance I believe it is the drawing of Eustache's left hand that led to the final change in its position.
6. Elsen 1980, pl. 54.
7. Compare photographs reproduced in Elsen 1980, pl. 53, and Le Nouëne and Pinet 1987, 27.
8. Elsen 1980, pl. 51.
9. Ibid., pl. 53.
10. Translation in Tancock 1976, 388, from *L'art et les artistes* 1914.
11. Hugues Le Roux, "La vie à Paris," *Le temps* (20 June 1889), cited in Beausire 1989, 219.
12. Ibid.
13. Rilke in Elsen 1965a, 138.
14. Georges Rodenbach in *Le journal de Bruxelles* (28 June 1889), reprinted in Beausire 1989, 230.
15. Beausire 1988, 95, 123.

14

Left Hand of Eustache de Saint-Pierre
(Eustache de Saint-Pierre, main gauche), c. 1886

- Bronze, Valsuani Foundry cast
- 11 x 5½ x 5¾ in. (27.9 x 14 x 14.6 cm)
- Signed on top of forearm, near base: A. Rodin
- Provenance: Feingarten Galleries, Los Angeles, 1975
- Gift of the Iris and B. Gerald Cantor Collection, 1998.359

Figure 80

ee cat. nos 187–94 for a discussion of this and other hands.

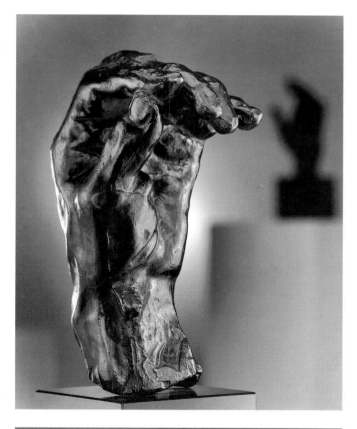

Fig. 80. *Left Hand of Eustache de Saint-Pierre* (cat. no. 14).

15

Eustache de Saint-Pierre
(Eustache de Saint-Pierre, vêtu), reduced 1902–03

- Bronze, Alexis Rudier Foundry
- 19 x 10 x 6 in. (48.3 x 25.4 x 15.2 cm)
- Signed on top of base, back right corner: A. Rodin
- Inscribed on base, back right edge: Alexis Rudier/Fondeur Paris
- Provenance: Feingarten Galleries, Los Angeles
- Gift of the B. Gerald Cantor Collection, 1992.163

Figure 81

*R*odin ordered reductions of the final figures of the burghers, with the exception of Jacques de Wissant. The reductions began to be issued in 1895, the year the monument was inaugurated. The archival records of the Musée Rodin indicate that the reduction of the Eustache was made in 1902–3. It seems to have been the last of the series, having been preceded in 1895 and 1899 by reductions of three figures (unspecified in the records) and in 1900 by that of Andrieu d'Andres.[1] These small-scale figures gained immediate popularity and continued to be

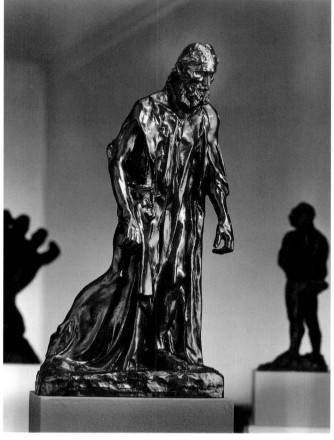

Fig. 81. *Eustache de Saint-Pierre* (cat. no. 15).

issued posthumously. Rodin included examples in his 1900 exhibition at the Pavillon de l'Alma. The precise number of casts made has not been determined by the Musée Rodin from its archival data. The surface on the reductions is in general smoother than that on the full-scale figures.

NOTES

LITERATURE: Jianou and Goldscheider 1969, 98; Tancock 1976, 390, 400; de Caso and Sanders 1977, 215–16; Judrin, Laurent, and Viéville 1977, 222–23; McNamara and Elsen 1977, 44

1. For a discussion of the dating, see Judrin, Laurent, and Viéville 1977, 222, which also contains their exhibition history and production.

16

Second Maquette for "Jean d'Aire" (*Jean d'Aire, deuxième maquette*), 1885

- Bronze, Susse Foundry, cast 1971, 3/12
- 27½ x 9½ x 9¾ in. (69.9 x 24.1 x 24.8 cm)
- Signed on top of base, center, front: A. Rodin
- Inscribed on base, right side, near back, lower edge: Susse Fondeur Paris; below signature: No. 3; on base, back, lower edge: © by Musée Rodin 1971
- Provenance: Musée Rodin, Paris
- Gift of the Iris and B. Gerald Cantor Foundation, 1974.103

Figures 82–84

*I*n the first maquette it is supposed that Jean d'Aire, because he was the second to volunteer, is the figure to Eustache's right, holding the older man's arm. Reflecting how his imagination must have been flooded with various possible images for the second maquette, Rodin conceived a totally different Jean d'Aire. Given a distinct identity and new role, he now acts as the sole bearer of the city's keys, anchoring the left side of the group when frontally viewed. On the cushion that he holds with stiffened arms, ropes binding his hands, are three keys, not the two specified by Edward III. (This discrepancy seems not to have been noted in the recorded comments.) The fact that the bearer of the keys stands still with feet set apart and is in the front may have caused one contemporary commentator, to Rodin's annoyance, to misread the moment, not as the group's departure, but as its appearance before the vengeful king. Given the importance of his placement and function, it was not surprising that the Calais committee objected to his dejected demeanor and especially the tears just below the corners of his eyes: "We think M. Rodin went too far by showing . . . the behavior of the figure on the left, who cannot hold back his tears as he presents the city's keys." The critic for *Le patriote* commented, "He bows to the king of England while giving him the key to the city, and that is a humiliating gesture."[1]

There is no nude study for the figure, nor do we know from whom, if any living person, Rodin derived the head. He is a man of middle age, balding in the front, his right ear pressed against his head, which anticipates the later cauliflower ear of the final figure. His head tilts slightly to the left, the downcast eyes are set above very broad cheekbones, the nose curved downward like that of Jacques de Wissant, who stands next to him. In all, Rodin gave his new Jean an expression of sweet sadness, which touched the wrong nerve of the committee.

The compact stance and rectilinear design of the rope around the neck, whose ends frame the man's left arm, make this the most squared-off, or cubic, figure in the group and in some ways the most self-sufficient (fig. 83). It is as if the new Jean d'Aire alone tells the whole story. The étude's movement is in the robe: gathered in the front against the man's right side, the folds are shown in precipitous cascade, while across the fully developed chest the garment seems to thin out and become almost transparent. As if to reassure us that the chest is covered, Rodin made knife cuts in several areas to suggest rents in the fabric. In the back there is a deep groove below the neck that runs downward like a spine but then veers sharply to the left in a way that defies anatomical explanation (fig. 84). The rear view of the garment is a surprise because it conveys through its design an energy belied by the figure's static pose. The folds sweep back and forth in broad planes, creating a kind of zigzag pattern unconstrained by fidelity to a body beneath them.

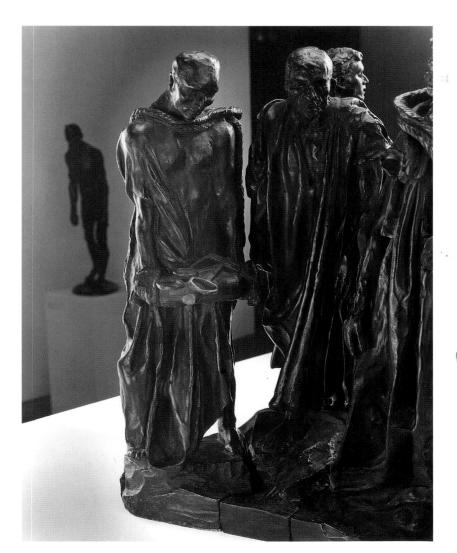

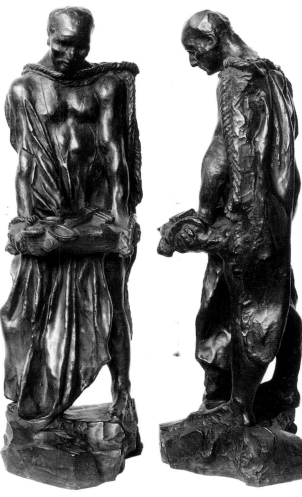

Left: Fig. 82.
*Second
Maquette for
"Jean d'Aire"*
(figure at left)
(cat. no. 16).

Middle: Fig. 83.
*Second
Maquette for
"Jean d'Aire"*
front (cat. no.
16).

Right: Fig. 84.
*Second
Maquette for
"Jean d'Aire"*
left profile (cat.
no. 16).

This is heavy-duty drapery in its thickness, and by sight and touch one can reexperience the action of Rodin's fingers in hollowing it out. Some depressions are a thumb's width. When working on this figure, Rodin may have already had in mind its general location in the group and known that the man's back would be visible and prominent from the monument's right side.

The base, while one of the flattest is also one of the smallest in the second maquette; Jean's feet align with its sides and his right heel overlaps the rear edge. There is strong evidence that at one time the figure of Jean d'Aire was actually joined physically to an adjacent figure, possibly that of Jacques de Wissant, but then Rodin broke, rather than cut, the clay figures apart. As a result, Jean d'Aire has only half of his left foot, as both it and the base were broken off lengthwise, leaving very rude fractures.

Midway down the man's left rear the ropes and drapery break off, leaving roughly flattened, unmodeled areas. This editorial decision must have come just before Rodin settled on the group's exact composition and sent the whole maquette to Calais. Rodin may not have had enough time to remodel the edited areas before having them plaster-cast. Given the position of Jean d'Aire in the composition, the raw fractures would not have been clearly visible as they face inward toward the figure of Jacques de Wissant. The tangible interval between the bases of Jean and Jacques shows that there would have been room for the full foot and completely modeled drapery of the key bearer if Jean d'Aire had been conceived originally to stand where he does in the second maquette.

After receiving the committee's judgment, Rodin

wrote to Omer Dewavrin that only one figure could be modified, that of Andrieu. He was, in fact, not only to modify but rethink all six, and perhaps in response to the reaction that faulted the mood of depression of the front figures, he changed that of Jean d'Aire most drastically.

NOTES

LITERATURE: Spear 1967, 45, 96; Jianou and Goldscheider 1969, 98; Goldscheider 1971, 167–70; Tancock 1976, 388, 390, 398; Judrin, Laurent, and Viéville 1977, 167–68; McNamara and Elsen 1977, 31; Miller and Marotta 1986, 58

1. Both quotations are translated in McNamara and Elsen 1977, 70–71.

17

Nude Study for "Jean d'Aire" (Jean d'Aire, nu), 1885–86

- Bronze, Georges Rudier Foundry, cast 1971, 1/12
- 42 x 13¾ x 12 in. (106.7 x 34.9 x 30.5 cm)
- Signed on top of base, left, near front: A. Rodin
- Inscribed on back of base, lower right: Georges Rudier/Fondeur. Paris; below signature: No. 1; on base, left side: © by Musée Rodin, 1971
- Provenance: Musée Rodin, Paris
- Gift of the Iris and B. Gerald Cantor Foundation, 1974.117

Figure 85

18

Nude Study for "Jean d'Aire" (Jean d'Aire, nu), 1885–86, enlarged 1886

- Bronze, Coubertin Foundry, cast 1981, 4/12
- 82 x 30 x 24 in. (208.3 x 76.2 x 61 cm)
- Signed on top of base between feet: A. Rodin
- Inscribed on back of base, left: © by Musée Rodin 1981; below signature: No. 4
- Mark on back of base, left: Coubertin Foundry seal
- Provenance: Musée Rodin, Paris

- Gift of the Iris and B. Gerald Cantor Collection, 1992.184

Figures 86, 88

*R*odin's over-life-size enlargement of his study for the nude Jean d'Aire is arguably his greatest sculpture of a male subject. He was never better as a psychological dramatist of the human body. Nor did he surpass himself in transforming anatomy into what the twentieth century understands as sculptural form. Inspired and driven by the burghers' story and the challenge of a great commission, Rodin created one of the most powerful sculptures in the history of figural art. For this artist, who customarily found his inspiration by letting freely moving models surprise him with an unexpected expressive movement, *Jean d'Aire* and the other burghers were his conception, unaided by any artistic precedent or literary description of how the voluntary hostages looked and acted. He enlarged the figure to monumental size soon after he conceived it.

Rodin's theme was a selfless man's brave defiance of destiny. The intensity of that rebellion has engaged the man's total being. A contemporary commentator speculated that the man may have been a lawyer, thus prompting the thought that he above all the burghers was aware that the English king was violating the rules of chivalry by promising their execution instead of demanding their ransom. The powerful muscles with which he waged honorable but unsuccessful combat against the English are now tensed against invisible enemies: injustice and the warring instincts of self-sacrifice and self-preservation. He stands like a pitchfork driven into the earth. At this moment no power can move him.[1]

Rodin counted on sympathy with his figures, as his audience was accustomed to viewing public figural sculpture like actors on a stage. He exaggerated every shape, proportion, and gesture, so that what *Jean d'Aire* has to express can be seen, believed in, and identified with

from the farthest reaches of the balcony, so to speak. Just as Edgar Degas made the nose of the *Little Dancer Fourteen Years Old* (1881) the climactic point of that sculpture, so Rodin made his figure seem to exist in order to support the thrust of the resolute chin that is clearly visible from many yards away.

When compared with the *Second Maquette for "Jean d'Aire"* (cat. no. 16), it is evident that as a dramatist Rodin recast parts of the pose and person. He kept the location of the body as well as its stance; he replaced the cushion with a single very large key. Perhaps in response to the commission's criticism of unheroic demeanor, Jean's head was replaced and upraised.[2] In view of Rodin's reuse of the new head for three of the burghers, we cannot be sure that the same model posed for the entire figure. "The shoulder circumference, patella height and lower leg length are too small for the chest circumference. The inseam, crotch thigh circumference and the hips are too small for the chest circumference. . . . The arms, chest, shoulders and back are all proportional. However, the waist, hips, thighs (but not calves) are all too small for the chest. It appears the chest is approximately 1.5 times normal size and the legs are within normal range."[3] We know that a few years later in his studies for the statue of Balzac, Rodin occasionally used different models for the same body and frequently the head and body were not from the same man. When Edmond de Goncourt visited the boulevard de Vaugirard studio in 1886 and saw the life-size burghers in clay, he noticed "a model stripped to the waist, who had the air of a workman, a stevedore."[4]

There is even a question whether one man posed for the whole head. Judith Cladel believed that the sculptor's son, Auguste Beuret, posed for the "sloping forehead" and "well-planted nose" of Jean d'Aire, as she believed these features were traits of the Rodin family.[5] The major portion of the head may have come from that of an unidentified man, of whom a photograph exists in the Musée Rodin archives.[6] If Cladel is right, then there is the irony that this artist so committed to copying nature had to invent a head that met his standard of reality.

The over-life-size version was probably made around 1886, and the final clothed figure was exhibited in 1887. We do not know if Rodin or one of his assistants carried out the enlargement, but for such an important work we may be certain that the final clay knew his touch. (The presence of the live model seen by Goncourt supports

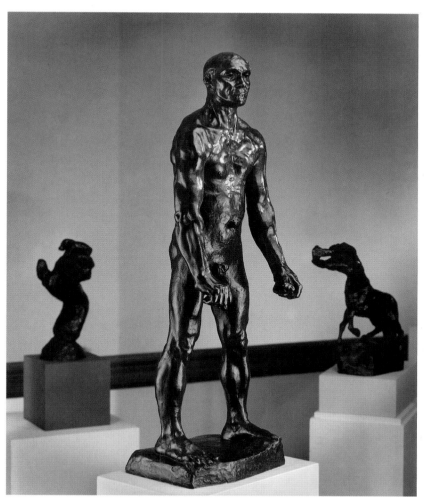

Fig. 85. *Nude Study for "Jean d'Aire"* (cat. no. 17).

that assumption.) In the wonderful photograph taken in 1886 by Bodmer, we see the full figure still in clay in Rodin's studio, probably exactly as Goncourt saw it (fig. 87). Rodin may have caused this picture to be taken just before the nude clay figure was cast in plaster. Visible are braces employed to secure the distance of the figure's left hand from the thigh and the right arm from the torso. Part of the latter brace remains visible on the inside of the man's right arm just above the elbow in the final plaster and bronze casts. That this piece of armature embedded in the man's right arm is to be found in the smaller earlier version suggests that Rodin wanted it kept in the enlargement so that it could serve as a place of attachment for a larger brace that would hold an even heavier arm in correct position.[7]

As shown by the figure from the second maquette, for the body of Jean d'Aire Rodin had a well-developed, young male subject. By 1885 Rodin came to see his prob-

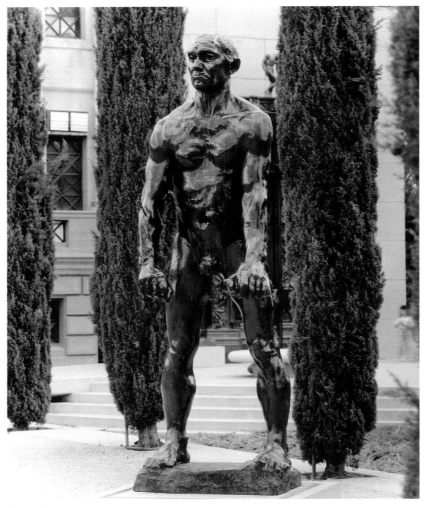

Fig. 86. *Nude Study for "Jean d'Aire"* front (cat. no. 18).

left. Given his views on ugliness and beauty and his sometime interest in medical abnormalities in hands, it is not surprising that Rodin modeled and then enlarged Jean d'Aire with his tumor. Under strong light on the big bronze the convex lump actually helps hold the broad curvature of the abdomen, but Rodin knew this area would be covered by a robe in the final work. Rodin was also aware that if he had exhibited this étude, there would have been strenuous criticism for including the tumor.

Rodin once complained to Henri-Charles Dujardin-Beaumetz about contemporary art school education, which caused students to view the figure in bas-relief, hence only half the surface, in the manner of a painter: "He doesn't see the back. . . . And yet the spine is the principal armature, the very equilibrium of the human body."[8] As if illustrating what he had in mind as well as other things that the treatment of the spine could convey, on the sculpture's dorsal side the famine-induced central hollows are like a riverbed (fig. 88). Below the neck begins a broad concavity made by the extruding scapula, which next narrows into the deep channel steeply banked by the big, vertical muscles along the spine. It then debouches onto the shallow delta of the lower lumbar area before a final descent into the defile made by the crease between the buttocks. On the sides of the back, the hollows begin a rhythmic descent, first under the shoulder blades, then below the ribs, and finally in the deep swales of the buttocks. It is likely that this last prompted the comment from Goncourt that they were "modeled with a powerful accusatory realism, and the beautiful holes in the human flesh that Barye put in the flanks of his animals."[9]

Sculpturally the most stunning discovery is the great inflected arch Rodin effected between the legs. When seen from either the front or the back, the first concave segment of the great arch springs from the heels to the anklebone; then the second cavity is made by the line moving first in and then out above the ankle to the swollen leg muscles. The arch continues by moving back into the knees, above which it then moves out and up to the astonishing hollows Rodin made in the man's inner lower thighs. Rodin took his cue to exaggerate from the natural indentation where the sartorius muscle overlaps the adductor muscles. The result is as though the man had been so long in a saddle that it had left permanent depressions. Just above are the final convex forms of the upper thigh muscles before the two profiles meet in the culminating arch of the groin. As with his geometry

lem differently. It was to convince the viewer that his Jean d'Aire had indeed been a warrior, who if need be could wear battle dress and wield a heavy weapon all day long and fight weeks on end but who was finally forced to surrender because he and the people of Calais were starving. Rather than change models, as he did in studies for Eustache de Saint-Pierre, he edited the young man's well-formed body to make it credible. It was in this editing that Rodin took licenses that have made this figure into such a marvelous sculpture.

No other male figure is more eloquent in defining what Rodin did in the art of the hole and the lump. Consider just the concavities. They begin in the face, in the hollows of the cheeks, and move downward in the substantial depressions between the tensed neck muscles that rise from the area of the collar bone. There are some deep incursions into the upper pectoral area and in the arms, particularly around the elbow and the wrist. The abdominal region seems undermodeled except for the navel and the large paraumbilical tumor that swells to its

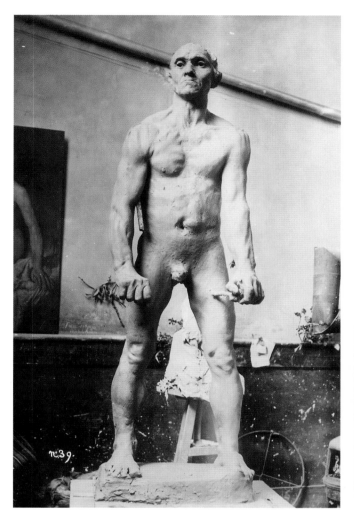

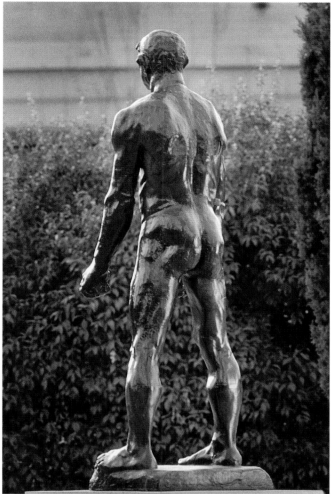

Left: Fig. 87. Karl-Henri (Charles) Bodmer, *"Jean d'Aire," Nude, 1885-86, in clay*, 1886, albumen print. Musée Rodin, Paris.

Right: Fig. 88. *Nude Study for "Jean d'Aire"* rear (cat. no. 18).

derived from discoveries in the human form, this beautiful architecture was not imposed on the body, but its source was found within it. It remained for Rodin to exaggerate what was there without diminishing the look of the natural. As Rodin put it when assaying his modeling after *The Age of Bronze*, "I have only given my contours a little more movement and much more action within general outlines."[10]

The "lumps," or convexities, the prominent saliences of the muscle-tendon system complete the duet. Absent any fat on the man's body, their tensed state makes them all the more prominent and easy targets for the sun. Rodin's concern for an outdoor sculpture maintaining a range of values, especially half-shadows, can be seen even on the brightest day with the sun full on the figure's front. On the man's sides the planes of the concavities that face downward pick up light reflected from the ground. Hence when the light is on the figure's face, the sides and back do not go black.

Squinting one's eyes at the sunlit sculpture reveals what seems at first a random pattern of highlights throughout the whole figure. Holding that slightly diminished perception, however, allows one to see there is a balance of those bright, dispersed areas. Because of the varying sizes of the protruding forms of bone and muscle and their constant curvature, the highlights all differ in shape, and there is a considerable range in their size. Part of Rodin's genius was to think in bronze and be able to foresee all this play of light while working in clay.

Although critical of Rodin as a composer, Roger Fry appreciated his sculptural quality for "all the minute unconscious movements of the hand as it manipulates . . . clay to conform to some deep instinctive rhythmic urge. It is this that gives the vibration of life to a surface, transmutes it from dead matter into a medium of the spirit. . . . In the *Burghers of Calais* this quality is fortunately evident. Look, for instance, at the tense nervous modeling of the taut muscles in the man holding the key of the town. . . . It has the palpitation, the possibility of movement and change of life itself."[11]

The naked Jean d'Aire draws the viewer's attention to his very large extremities, which seem distortions.[12] The tendency is to isolate a modeled hand or foot and compare it with one's own. The feet are very big indeed, but so is the man's leg in proportion to the thigh, for example. Rodin had to assume that "spectators," as he put it, would learn to see and think as he saw and thought: forms in *relationships* rather than in isolation, seen not just close by but from afar. Rodin summed up his thinking on how the artist might exaggerate to tell the truth: "The artist . . . must choose and must proportion his detail to the distance at which his work ought to be regarded, and he is entitled to ask that his work shall be regarded with the perspective that he himself has chosen."[13]

After the Middle Ages it is very rare to find a life-size figure sculpture in which the weight is carried equally on both feet. The Renaissance reintroduced the old Greek practice of having the weight carried on one foot in order to make the figure appear more natural and graceful. But Rodin seems to have had something else in mind by reverting to an archaic method of weight disposition. Those grand feet of Jean d'Aire make good structural sense when one steps back and takes in the big figure from either side. The key bearer is not absolutely vertical. He leans slightly forward, his grasping hands protruding beyond the front of the base, and it seems as if he were swaying slightly on both feet in keeping with Rodin's belief that "every well made figure will swing back and forward when standing on both feet in an erect position."[14]

Despite the extensive exhibition history of *The Burghers* as a group and individually, especially the final version of *Jean d'Aire*, there seems to be no evidence that Rodin ever exhibited this great étude either in plaster or bronze.

NOTES

LITERATURE: Spear 1967, 45, 96; Jianou and Goldscheider 1969, 98; Steinberg 1972, 349, 380; Tancock 1976, 382, 398; Judrin, Laurent, and Viéville 1977, 208–9, 210–12; McNamara and Elsen 1977, 31–32; Lampert 1986, 110, 217

1. Steinberg (1972) saw him giving his whole strength to "the labor of holding on. . . . For the *Jean d'Aire*, standing his ground is an ultimate effort. His huge feet do not rest flat but turn in like a grasping ape's, clutching their clod of earth. Such actions are hard to see in a photograph, hard to see anywhere if they are not re-experienced internally; one must do it oneself" (349). Following Steinberg's instructions and having stood next to the statue in bare feet mimicking the stance, I must report that the burgher's feet do rest flat and do not clutch the earth. The man's left foot seems to turn in because it follows the curvature of a small mound or rock or simulated cobblestone underfoot. The toes are straight and do not grasp at the earth in the manner of *The Thinker*'s. The ape man association is repeated by Tucker (1974): "With the over life-size studies for the *Burghers*, and notably the gorilla-like *Jean d'Aire*, Rodin took naturalism in terms of the 'life-like' as far as it can be taken in sculpture" (35). Steinberg's and Tucker's unfortunate simile seems to have inspired Lampert (1986): "The defiant *Jean d'Aire* belongs to Rodin's ape-like interpretation of primitive man and his descendants" (110). What primitive man? What does this have to do with *The Burghers of Calais*? To what was Lampert referring?

2. Laurent made this observation years ago (in Judrin, Laurent, and Viéville 1977, 208).

3. This is from Joanne Brumbaugh's Stanford University Medical Scholars Project, "The Anatomy of the Rodin Sculpture Collection," 30 May 1986. Brumbaugh used an anthropometric methodology and compared her many measurements with equivalent proportions reported for a sample population of 25,000 U.S. Army white males published in 1951. Paper in the Cantor Arts Center archives.

4. Goncourt and Goncourt 1935–36, 7: 92.

5. Cladel 1936, 158–59. Absent documentary proof and a photograph of Auguste Beuret (b. 1866) at that time, it is impossible to verify Cladel's assertion.

6. First reproduced in Judrin, Laurent, and Viéville 1977, 252.

7. Rodin was to have even more difficult problems in bracing the upraised right arm of Pierre de Wissant.

8. Dujardin-Beaumetz in Elsen 1965a, 160.

9. Goncourt and Goncourt 1935–36, 7: 92.

10. Dujardin-Beaumetz in Elsen 1965a, 160.

11. See "London Sculptors and Sculptures," in Fry 1956, 198–99.

12. Steinberg found (1972) that "his pronated left hand is not tuned to a corresponding rotation of arm. The left arm intrudes rigidly between hand and shoulder; it suggests a . . . breakdown in nervous transmission. . . . The limb wrongly fitted is one of Rodin's devices for locking it in its task" (380).

13. Lawton 1906, 159.

14. Bartlett 1887–88, 149. Tucker noticed (1974) this illusion in the final version of Jean d'Aire: "Even the four-square Burgher with the key gives one the feeling that he is rocking back and forth on his feet" (149).

19

Jean d'Aire, Final Version (Jean d'Aire, vêtu), 1886

- Bronze, Coubertin Foundry, cast 1982, 1/4
- 86 x 34 x 35 in. (218.4 x 86.3 x 88.9 cm)
- Signed on top of base, front corner: A. Rodin
- Inscribed below signature: No I/IV; on back of base: (c) By Musée Rodin 1982
- Mark on top of base: Coubertin Foundry seal
- Provenance: Musée Rodin, Paris; Mrs. Gianna Sistu (for the University of Wyoming); Jeffrey H. Loria
- Gift of the B. Gerald Cantor Collection, 1992.164

Figure 89

Secondly, another very honest and rich burgher, who had two beautiful daughters, who was called Jean d'Aire, arose and said that he would keep company with his companion Eustache de Saint-Pierre.[1]

There were undoubtedly those who hoped that Rodin might depict the moment when the six burghers volunteered their lives for Calais. At least one of Rodin's competitors, Emile Chatrousse, showed Eustache de Saint-Pierre at such a moment.[2] Rodin had early determined to show the men about to leave the marketplace, having stripped themselves of their customary outer dress as instructed by the king of England.

The key now grasped by Jean d'Aire is appropriately huge, like those of medieval cities and fortresses. We do not know if he used as a model an actual old key from Calais. The key has been modeled to suggest age and use. Unlike that hanging downward as it is carried in one hand by Jean de Wissant, the key held by Jean d'Aire seems to have been grafted to his tensed hands. It is held in such a way as to avoid a strict horizontal line and to make the two bits seem continuations of the fingers on the bearer's right hand. The whole effect is of both compliance and defiance.

The final version of Jean d'Aire shows both Rodin's audacity and conservatism. Knowing that the figure would be ultimately robed, but not in what exact fashion, Rodin had modeled Jean d'Aire nude according to academic custom. The sculptor realized that where the gar-

ment actually adhered to the body, the results would be more accurate, beautiful, and expressive. Rodin used a mannequin at some point to test the fold patterns, but he complained that such a prop was not reliable.[3] From Bodmer's photographs taken in the studio on boulevard de Vaugirard in 1886, we can see that the robe of shame was actually modeled on the final clay figure.[4] Rodin must have taken a plaster cast of the entire naked form before this addition. As there are no visible casting seams from piece molds on the exposed areas of the body in the final version, it is probable that Rodin eradicated the seams and used the original clay figure.[5] Absent any written record, we do not know exactly whether in lieu of a mannequin an actual robe was first draped on a clay impression or on plaster cast of Jean d'Aire and then copied or worked from the full-size clay figure.

Much thought was undoubtedly given to how Jean d'Aire would be dressed. According to Jean Froissart's *Chronicles*, "the six bourgeois undressed, all naked, in their breeches and shirts."[6] Rodin's instincts as a sculptor-dramatist here overrode total textual accuracy. Shirts and breeches would not do for his sculptures. Rodin was to later regret that he had not dressed his figures in sackcloth. Instead, he decided on a heavy material like that used for tarpaulins, whose weight would make it hang right and give him good fold patterns. The fabric was cut so that the plain, shapeless garment was long, and it gave him great lines and timelessness.

In clothing Jean d'Aire, Rodin was willing to give up the rich modeling of the figure's front (except for the head and hands). The tensed big muscles of the man's right pectoral and right arm above the elbow still inflect the robe. As he had in the second maquette (cat. no. 16), Rodin split the robe in different areas, but now he chose to reveal only the outer sides of the two legs and the central section of the back down to the buttocks. Defying Froissart and probability, Rodin positioned the halter on the man's left shoulder rather than have it encircle the neck, as it did in the earlier small version of the key bearer in the group study (see fig. 82). Instead, he created a kind of collar in the front with the folds of the cloth, from which the halter is made to emerge. Rodin must have used an actual thick rope that was loosely looped back on itself in the middle and then placed directly on the clay figure so that the knot was at the base of the neck. The two remaining rope lengths were then adjusted to trail downward from the man's shoulder in concert with the folds of the sleeve.

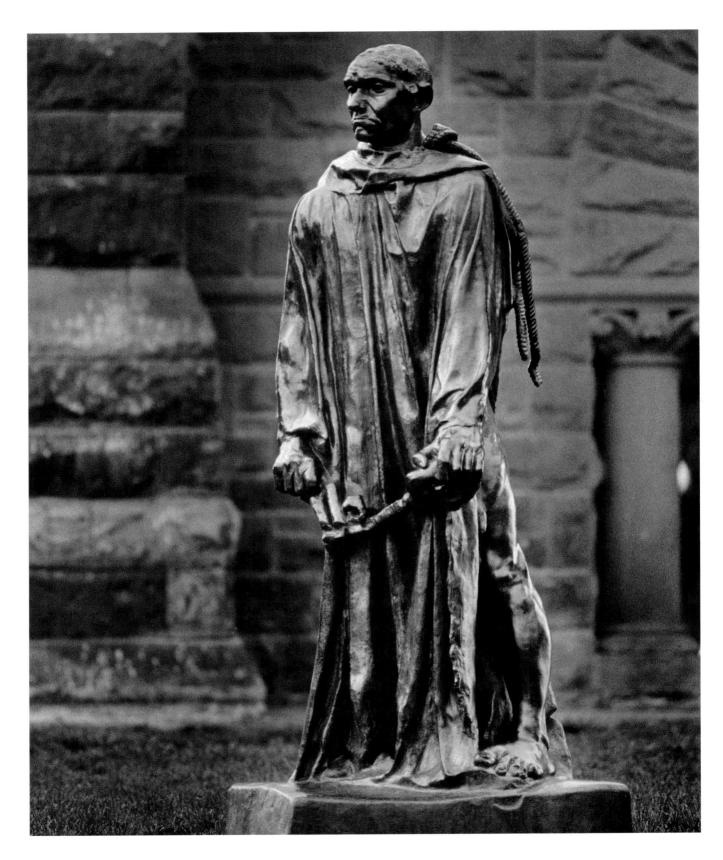

Fig. 89. *Jean d'Aire, Final Version* (cat. no. 19).

As conditioned by the man's erect posture and broad shoulders, the long, uninterrupted, roughly vertical folds on the front echo the man's silent but pugnacious rectitude. The way the flutes of a Greek column build to their Doric capital, so does the articulated shroud climax in the great head. This simile, while helpful in evoking the total effect of the work, is useful also in seeing how differently a sculptor thinks and works with the figure than does an architect in designing a column. To avoid predictability and dryness in the robed form, to make it look natural and responsive to the dictates of the body and gravity, Rodin had recourse to several devices by which to edit what the carefully draped fabric gave him. As he would with the final versions of all six hostages, he varied the folds in their shaping, spacing, and mutual relationships. No two folds have the same projection or depth and deviation from the vertical. Finally, their terminations are conjugations of what usually took the forms of a V or a U.

As with the nude version of Jean d'Aire, however, it is the back that is most interesting sculpturally. Still visible is the great central sequence of modeled anatomical concavities starting with the upper back. The reason Rodin did not wind the halter all around the neck is that it would have broken the line from spine to hairline. The heavy drapery allowed Rodin to fashion very deep vertical grooves to frame the spinal area. So taken was he with these expressive cavities that he pulled the drapery in between the legs to create a huge beautifully shaped hollow below the buttocks extending to the ground.

Despite the literal-mindedness of his future audiences, Rodin dared not always delineate textural distinctness where flesh and cloth meet. He fused portions of the rent drapery with the lower area of the man's back so that the union was seamless. (The same was done where the sleeves meet portions of the wrists.) It was as if either figure or garment, or both, were wet. While much is made of Rodin's study of Gothic sculptural drapery— and the deep folds in the rear show such experience— the treatment with Jean d'Aire recalls the practice of the classical Greeks, which he had studied in the British Museum's Elgin marbles. At times the ancient sculptors had modeled their drapery from living figures whose bodies had been oiled, not only to gain more diverse and precise drapery patterns but also to preserve the sense of the beautiful body beneath. Although many of Rodin's contemporaries, especially sculptors, would have seen and appreciated what Rodin had done with the dorsal area of Jean d'Aire, such appreciation does not seem to

have found its way into print, as writers were drawn to the subject of characterization.

When the final version of Jean d'Aire was shown in the Monet-Rodin exhibition of 1889, Geffroy wrote in the preface to the catalogue,

This one, who comes next, draped from neck to feet in his robe with long straight folds, as in a monastic robe, fists closed on the enormous key, does not express lassitude and resignation. He carries high and energetically his shaven head. He reveals by defiance and mistrust the concentrated fury and the power of resistance that growl in him. The chin comes forward, the hard mouth is locked in a bitter grimace. His spread, solid legs make the effort to move in the slow pace of his friends. He is a mature man, a robust person of forty years, possibly bearer of a musket, a burgher capable of battle. His eyes, luminous in the shadow, set in the deep arcade of the brows, look straight ahead. His skull is solid, his stature is raised and straight. He affirms his will as martyr, and the outrage committed upon them all, by the mute anger of the defeated. He carries superbly the hate and raging sadness of the city.[7]

In 1903 Rainer Maria Rilke, who described how thoughts glide over Rodin's sculptures like shadows, offered his own response to Jean d'Aire: "He created the man that carries the key, the man who would have lived for many years to come, but whose life is condensed into this sudden last hour, which he can hardly bear. His lips are tightly pressed together, his hands bite into the key. There is fire in his strength, and it burns in his defiant bearing."[8]

A year after Rodin completed the final version of Jean d'Aire in 1886, he exhibited it in plaster at the Galerie Georges Petit along with Eustache de Saint-Pierre and Pierre de Wissant. In 1888 he showed the final Jean d'Aire in Brussels.[9] He realized that there were more potential buyers for individual burghers than for the entire monument, and that for foreign exhibitions it was also easier to ship the figures singly than in a group. In 1889 the sculpture was shown in Paris not only as part of the final group on display at the Galerie Georges Petit but also individually at the Exposition internationale. A plaster cast was shown in Dresden in 1901, purchased, and given to the museum in that city. By 1903 Rodin had Henri Lebossé make reductions of five burghers, which also added to their commercial appeal, and the small Jean d'Aire was

shown in the artist's Paris retrospective (1900), Leipzig (1904), and Boston (1905). Additional casts of the final, full-size *Jean d'Aire* were shown in Brussels (1902), Saint Louis (1904), and Edinburgh (1915).[10]

NOTES

LITERATURE: Rilke [1903] 1945 in Elsen 1965a, 138 Grappe 1944, 59–62; Spear 1967, 45, 95; Jianou and Goldscheider 1969, 97; Spear 1974, 129S; Tancock 1976, 376–90; Judrin, Laurent, and Viéville 1977, 217–21; McNamara and Elsen 1977, 45–49, 61–64; Fonsmark 1988, 111–15; Butler 1993, 204–13; Levkoff 1994, 94

1. The original French text of the Froissart excerpt is reprinted in Judrin, Laurent, and Viéville 1977, 113–14.
2. McNamara and Elsen 1977, 18, fig. G.
3. Rodin's comments are included in a letter dated 14 July 1885, in the library of the Philadelphia Museum of Art; translation in Tancock 1976, 383, 393.
4. Le Nouëne and Pinet 1987, 17.
5. He may also have had a new clay impression made from the molds on which to model the garment.
6. Judrin, Laurent, and Viéville 1977, 114.
7. Beausire 1989, 67.
8. Rilke in Elsen 1965a, 138.
9. Beausire 1988, 95, 98.
10. Ibid., 100, 104, 212; 192, 260, 266; 220, 250, 359.

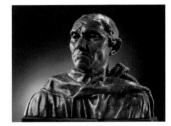

20

Bust of Jean d'Aire (Jean d'Aire, buste vêtu), 1904

- Stoneware, Paul Jeanneney, cast no. 4
- 18 x 20½ x 10¼ in. (45.7 x 52 x 26 cm)
- Signed on chest, lower left: Rodin
- Inscribed on back: Jeanneney and P E J
- Provenance: Paul Kantor Gallery, Malibu
- Gift of Iris and B. Gerald Cantor Foundation, 1974.87

Figure 90

*R*odin made a life-size bust based on the final version of *Jean d'Aire* (cat. no. 19). It exists in several versions, both clothed and nude, and in several sizes and media, including a version in stoneware, of which the Stanford bust is a specimen.[1] The nude bust of *Jean d'Aire* corresponds to the large nude version of the figure (cat. no. 18).[2] The bust of the final *Jean d'Aire* is one of several works for which Rodin commissioned replicas from the ceramist Paul Jeanneney (1861–1920), whose signature along with that of the sculptor, appears on the Stanford cast. Jeanneney executed the ceramic bust in 1904. In 1903 Rodin had also authorized Jeanneney to make casts of the final life-size figure of *Jean d'Aire* (1904) as well as the monumental *Head of Honoré de Balzac* (1903).[3]

Rodin's interest in the ceramic medium stemmed especially from the period 1879 to 1882, when he worked under the directorship of the sculptor Albert-Ernest Carrier-Belleuse at the Sèvres porcelain factory. Rodin contributed to the decoration of vases and other ornamental pieces, using and further developing techniques that combined drawing and engraving, which he applied directly to the ceramic paste. In the 1890s Rodin again collaborated with ceramists, entrusting Edmond Lachenal (1855-1930) to execute a replica of the *Crying Girl* (cat. no. 59).[4] Rodin clearly showed interest in the possibilities for replicating his works but also seems to have appreciated the expressive qualities of the ceramic medium itself.

NOTES

LITERATURE: Spear 1967, 96; Jianou and Goldscheider 1969, 98; Fourest 1971, 40, 52; Spear 1974, 129S; Tancock 1976, 400; de Caso and Sanders 1977, 33; Judrin, Laurent, and Viéville 1977, 230, 233; Le Normand-Romain 1998, 395; Butler and Lindsay 2000, 342–45

1. Other versions are listed in Tancock 1976, 399–400; Spear 1967, 96; and Spear 1974, 129S; also a life-size version in plaster was catalogued in Miller and Marotta 1986, cat. no. 25. The bust in ceramic and its related documentation are discussed in Judrin, Laurent, and Viéville 1977, 230, 233 and in Le Nomand-Romain 1998, 395. Six casts were made, including that at Stanford.
2. For discussion of the nude version of the bust, see Judrin, Laurent, and Viéville 1977, 233–34.
3. Fourest 1971, 52. For more detailed discussion of these works, see Le Normand-Romain 1998, 393–95.
4. In 1891 a porcelain statuette of a fauness by Rodin was executed by M. Chaplet; see Fourest 1971, 52. For Rodin's decorative work in the ceramic medium during the Sèvres period, see cat. nos. 196–97.

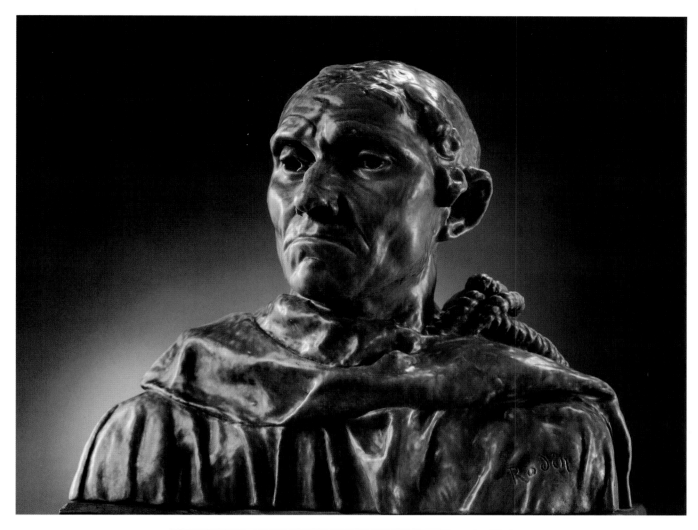

Fig. 90. *Bust of Jean d'Aire* (cat. no. 20).

21

Monumental Head of Jean d'Aire (Jean d'Aire, tête colossale), c. 1886, enlarged c. 1900

- Title variations: *Colossal Head of Jean d'Aire*
- Bronze, Georges Rudier foundry, cast 1973, 4/12
- 26¾ x 19⅞ x 22½ in. (67.9 x 50.5 x 57.2 cm)
- Signed on base below left ear: A. Rodin
- Inscribed on base, lower edge, at right, near back: Georges Rudier/Fondeur. Paris.; left of signature: *No. 4*; on base, lower edge,

below and to right of signature: © *by Mus*ée Rodin 1973
- Provenance: Musée Rodin, Paris; Feingarten Gallery, Los Angeles
- Gift of B. Gerald Cantor Collection, 1992.16

Figure 91

*W*hen Rodin had the enlargement of the *Head of Jean d'Aire* made, he had it mounted on a rudely modeled circular base just below the upper part of the neck. This removed the work from the tradition of portraiture in which a head surmounts a bust.[1] The head of this burgher is a case of the part standing for the whole. *Monumental Head of Jean d'Aire* became itself a monument, and a most unusual one in the history of sculpture. The result of the new mounting is that the head is turned slightly upward rather than facing straight forward. The change altered certain featural emphases

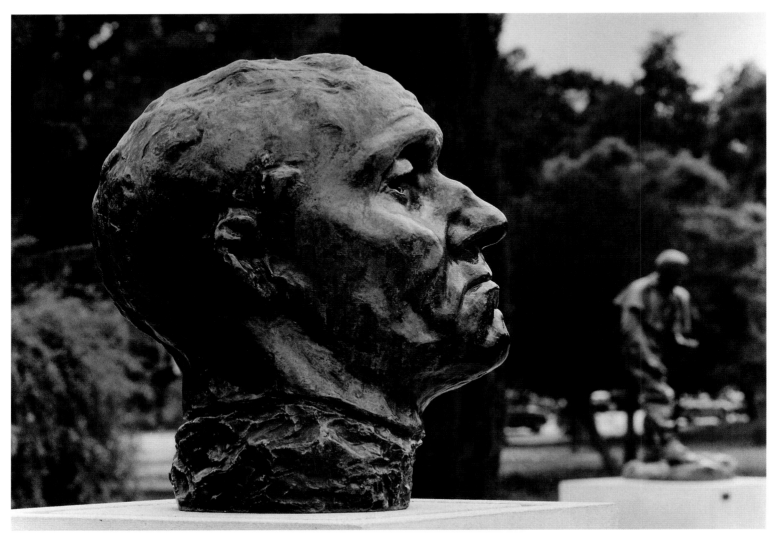

Fig. 91.
Monumental Head of Jean d'Aire (cat. no. 21).

and expressions. The chin is more prominent, for example, and one sees the nostrils and upper eyelids. Rather than the original vertical position of the head, which enforces the sense of dejection and bitterness, the raised head imparts a sense of greater pride—of overcoming fate—as well as defiance. This prompts the unanswerable question as to whether Rodin was responding to earlier criticism that his subjects were insufficiently proud of their sacrifice? As this change came after the monument had been installed and Rodin had won over his critics, it is likely that he desired to give a new expression to a favored head already used three times in the same project.

Viewed indoors, such a large tough head makes one more conscious of its size, and it can be more disturbing than when seen outdoors against the sky and in strong light. Outdoors the justification for its size is in the necessity of its being able to carry visually from considerable distances. The overall compactness of the form and the clear, clean strength of its rugged facial profiles ensure that result.

Part of the effectiveness of the enlarged head is that Rodin wins big interesting surfaces curving in and out through mergence of facial areas: his personal and distinctive *modelé*, not modeling but fitting together of planes. Monumentality is achieved because he has not trivialized the augmented size with details, so that the eyebrows, for example, are untextured and seem like muscles of the forehead; there is no pronounced hairline, and the hair, what there is of it, is matted or close-cropped and only projects near the ears.

Perhaps because of the upward tilt one is more con-

scious of the asymmetry of the head, especially when seen from the front, starting with the cauliflower ear, pressed close at the right; the differently shaped upper eyelids; and the chin and nose, which align, although the center of the mouth does not. Rodin found his geometry in the face as well as the body. The downward curve of the brows and eyelids, the descending, curving lines of the cheeks springing from the base of the nose, the inverted crescents of mouth and crease of the chin are a rhyming but asymmetrical series. None of the paired hollows—ears, sunken cheeks, nostrils, and eyes—are identically formed. Throughout there is the sense of bone—chin, jaw, cheek, and skull—all pressing relentlessly against flesh. The shapes of the features and their idiosyncratic relationships give identity; the head's hard density evokes a character different from its companions. Why enumerate these features? The better to refocus on the work itself and to understand Rodin when he responded to *Le patriote*'s critic for faulting the attitudes of his burghers: "The expression of the personalities are arrived at by the correct modeling of nuances. . . . The expression comes from the strength of the modeling."[2]

The technician who made this enlargement and its date are not known.[3] Henri Lebossé, who did so many of Rodin's enlargements and who did the reductions of five of the burghers, does not mention the colossal head in his notes and accounts to Rodin in the Musée Rodin archives. It would have been done sometime between 1895, when the monument was installed and its popularity had begun, and 1909, when the head may have been shown in Lyon.[4] Compared with the reception of the *Monumental Head of Pierre de Wissant* (cat. no. 31), *Monu-* *mental Head of Jean d'Aire* did not enjoy popular success, and no bronzes were cast during Rodin's lifetime; the first bronzes were cast in the 1970s.[5] The almost unbearable intensity of the man's expression might account for this. Alain Beausire's careful and extensive researches into the exhibitions of individual burghers does not identify definitively a showing of this colossal head.[6] In many of the catalogues for exhibitions to which Rodin contributed, the identity of the exhibited burgher was not given.

NOTES

LITERATURE: Spear 1967, 96; Goldscheider 1971, 174; Tancock 1976, 399; Judrin, Laurent, and Viéville 1977, 237–38; McNamara and Elsen 1977, 41; Ambrosini and Facos 1987, 103

1. Rodin made a life-size bust version of *Jean d'Aire* showing his neck and shoulders naked, the only burgher so treated, as well as the ceramic version of the bust with robed shoulders (cat. no. 20) and of the final figure (Judrin, Laurent, and Viéville 1977, 230–33).
2. Translation in McNamara and Elsen 1977, 73.
3. Judrin, Laurent, and Viéville 1977, 237.
4. Ibid. Viéville conjectured that the head was enlarged about 1908–09, citing a review of the 1909 exhibition that mentioned a large head of a burgher in plaster dated 1905.
5. Ibid., 237–38.
6. Beausire suggested that the *Tête de bourgeois* exhibited at the Salon de la Société lyonnaise des beaux-arts (no. 905) was possibly a head of Pierre de Wissant (1988, 308).

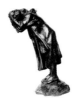

22

Second Maquette for "Andrieu d'Andres"
(Andrieu d'Andres, deuxième maquette), 1885

- Bronze, Susse Foundry, cast 1971, 3/12
- 25½ x 9½ x 15½ in. (64.8 x 24.1 x 39.4 cm)
- Signed on top of base: A. Rodin
- Inscribed on back of base: Susse Fondeur, Paris; below signature: No.

3; on base, left side: © by Musée Rodin 1971
- Provenance: Musée Rodin, Paris
- Gift of the Iris and B. Gerald Cantor Foundation, 1974.101

Figures 92–93

*I*n defending his second maquette against hostile criticism, Rodin argued in *Le patriote*, "Our sculpture must be treated in the national taste, that of the sublime Gothic epoch, which did not have to search for its movements . . . which places us so far above anything that can be seen in Italy."[1] In some ways the study of the figure that came to be known as *Andrieu d'Andres* is the most Gothic of all. Not given to citing specific historical sources as prece-

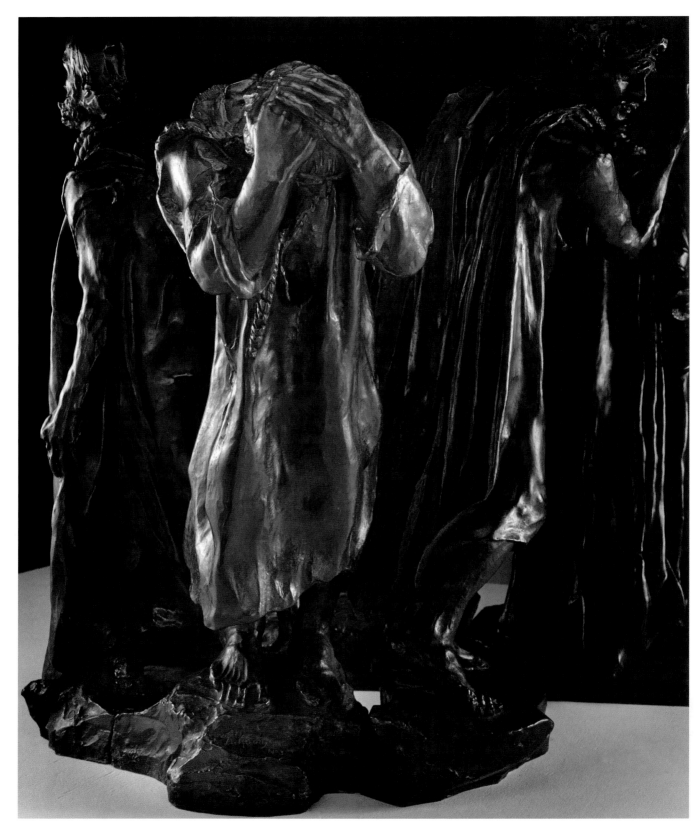

Fig. 92. *Second Maquette for "Andrieu d'Andres"* front (cat. no. 22).

dent or inspiration, when charged with a lack of decorum, Rodin had available an important precedent to serve him as bail. With the lowered and concealed face and grief conveyed by the draped posture and gestures of the hands, one is reminded of the carved *pleurants* (grieving figures) of monks who attend the tombs of the dukes of Burgundy in Dijon and the Louvre. While none is shown doubling over in despair, their carved faces are largely concealed under the hoods of their heavy robes or by gestures of the hands to their faces. Much of the expressiveness of these medieval *pleurants* comes from an inventiveness in the shaping of the drapery, which does not reveal the human form inside. Surely this was not lost on Rodin, as evidenced by the studies and final figures of the burghers. As the sculptor wrote to *Le patriote*, "I have chosen to express my sculpture in the language of Froissart's time."[2] The mourning monks carved by Claus Sluter (c. 1340/50–1406) and Claus de Werve (c. 1380–1439) for the Burgundian ducal tombs are from Froissart's time.[3]

Rodin had established the basic pose of Andrieu d'Andres in the first maquette, but in the one-third life-size version he made some interesting changes, starting with the ground on which he stood. For the figures of the second maquette, Rodin decided not to continue the uniform base. He definitely wanted a more active interplay between the figures and their supports. This alteration accompanied another change of mind: the sculptor decided not to have the figures in contact with one another. Whether he had thought that abandoning the triumphal pedestal would bring the group closer to the public and hence the base would be more apparent or that he wanted the figural supports to be more varied in order to correspond with the old stones of the square in which they would be located, we just do not know. Rather than setting Andrieu's feet apart on a slightly inclined surface, Rodin now brought them together and positioned the figure on the downward slope of a somewhat domed base. Combined with the new straight-legged stance and cantilevered pose of the upper body, this change aggravated the overall sense of instability (fig. 93). The very small base, so made probably to permit flexibility in assembling the sculptures, is not enough to keep the bronze cast from falling if otherwise unsupported. The feet themselves probably came from Rodin's inventory of extremities. (The right foot is more articulated in terms of tendons, toes, and even nails, the largest of which is suggested by an indentation made by the artist's thumb.)

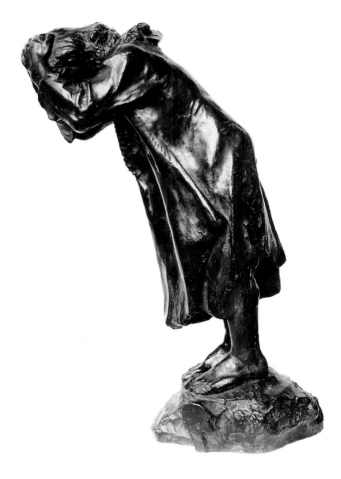

Fig. 93. *Second Maquette for "Andrieu d'Andres," left profile* (cat. no. 22).

In the second maquette Andrieu wears a rope around his neck, as Rodin removed one of the causes for his bent posture: the act of pulling the heavy halter around his neck with the right hand. Rodin's characterization of Andrieu was coming into focus even as his historical consciousness suffered lapses. Rather than dressing Andrieu in a shirt, breeches, and with the halter that Froissart reports, Rodin replaced the shirt and breeches with a robe and omitted the halter. With overlapping hands, Andrieu clutches the top of his head, a change from the first maquette in which the figure grasped his head with his hands placed on either side, and the figure is now given hair that falls in abundance straight down on his neck and forehead. Andrieu is endowed with the open-mouthed face of a young man. (Even if Rodin worked from a live subject for the face, the model did not please him, as he was later to re-use the head given to Jean d'Aire and employ it for Andrieu.) Big untempered lumps of clay serve as eyebrows above empty eye sockets. To further establish Andrieu's age and the probable

cause of his desperation—of the six, he is made to seem as if he had the most life to lose—Rodin showed the forearms, wrists, and hands as those of a physically strong youth. This was at a narrative cost, as Rodin was to speak proudly of how his figures showed the signs of the siege and starvation. Bent forward from the waist, the figure's head, hands, and elbows extend outward in front of the feet in defiance of traditional rules of figural balance in relation to gravity. In the second maquette Rodin has the man lean out beyond even the perimeter of the group. (Rodin's imagined cubic container for the group, recognized by those who saw it in Calais, seems not to have been limited by the extreme edges of the bases.) The artist used the diagonal slant of the front drapery so that, viewed from either side, it modifies the hard angle made by the stooped body and the sense of the étude's precarious equilibrium.

The drapery is thick and in its big, broad, curving planes largely unreflective of the body beneath. Absent a visible face and coupled with the hand gestures, this garment became a surrogate physiognomy to express the man's agitated state. Seen from the front of the second maquette, the drapery of Andrieu's right side is the most expressive and interesting as an abstract form. One has the sense that the artist neither worked from a cloth-draped mannequin nor modeled the robe on an already modeled nude figure, as was the case with *Pierre de Wissant*.[4] Where the drapery pulls across the back, for example, there is no evidence of the spine or the stretched shoulder muscles that would appear in the final version. Unless Rodin thought of Andrieu as severely bowlegged, his lower left leg does not quite align with the hip. In fact, a live model would have had a very difficult time holding such a pose for any length of time. Thus the drapery, like the pose, seems to have been purely Rodin's invention.

There is no evidence that Rodin ever named this figure Andrieu d'Andres.[5] His interpretation of Andrieu came in for severe criticism by the Calais committee and local critics. The report of the former singled the figure out as "one of them expressing weakness at the prospect of dying. . . . We think Rodin went too far by showing the companion on the right in a desperate pose."[6] The critic for *Le patriote* took his shot: "Another one of the six burghers is pulling out his hair and seems to abandon himself to fits of anger that are untimely, we feel, for we want to say, 'If your sadness is so great, if you regret at this point your dedication, why didn't you stay at home? Another of these brave burghers would certainly have taken your place with pride.' And under the burden of his desolation, the unhappy man bends down so far it seems he is ready to plunge, preferring judicial drowning to the capital punishment that awaits him."[7]

When Rodin wrote to the mayor of Calais about the critical reception and what he insisted on preserving, he singled out this figure without naming him, probably because he had no name in mind: "Only the one who is desperate and plunges forward can be modified. My group is saved if you can obtain just that concession."[8]

NOTES

LITERATURE: Jianou and Goldscheider 1969, 99; Goldscheider 1971, 167–70; Tancock 1976, 388, 390, 402; Judrin, Laurent, and Viéville 1977, 168, 170; McNamara and Elsen 1977, 41–42; Ambrosini and Facos 1987, 104

1. *Le patriote*, 19 August 1885, translation in McNamara and Elsen 1977, 73.
2. Ibid.
3. On the mourning figures, see Kathleen Morand, *Claus Sluter: Artist at the Court of Burgundy* (Austin: University of Texas Press, 1991), 121–59, 350–60.
4. According to Monique Laurent, there is no known nude study (Judrin, Laurent, and Viéville 1977, 168).
5. The name has been used by Musée Rodin curators Cécile Goldscheider and Monique Laurent.
6. Translation in McNamara and Elsen 1977, 70.
7. Ibid., 71.
8. Ibid., Rodin to Dewavrin, 2 August 1885, 72.

23

Andrieu d'Andres, Final Version
(Andrieu d'Andres, vêtu), c. 1886–87

- Bronze, Coubertin Foundry, cast 1981, 2/12
- 79 x 33 x 51 in. (200.7 x 83.8 x 129.5 cm)
- Signed on top of base: A. Rodin
- Inscribed on back of base, left: © By Musée Rodin 1981; below signature: No. 2
- Mark to left of copyright: Coubertin Foundry seal
- Provenance: Musée Rodin, Paris
- Gift of the B. Gerald Cantor Collection, 1992.162

Figure 94

*I*n the final monument, the burgher known as Andrieu d'Andres stands directly behind Jean d'Aire.[1] Both figures have the same face. This raises the question of why such an inventive sculptor as Rodin would repeat himself so obviously in the same monument?[2] Rodin knew that one hundred years need not pass before people looking at the burghers would see what he had done and wonder why. There is the psychological explanation: It is as if we are seeing two aspects of the same man, or the divided self; resistance one moment, submission the next. But Rodin may not have had the final pairing in mind when he fashioned this figure, and we cannot be certain that this provocative psychological association was intended. (It may well have been recognized by the artist after the fact.) In the second maquette, for example, they are on opposite sides and do not bear the same face. The artist did make some slight changes in the final face of Andrieu as well as the head as a whole, which mitigates against the second-self notion.

Then there is the possibility of the motive of family resemblance inspired by Froissart's text. Rodin must have remembered that among the volunteers, there were brothers, and except for Eustache, Jean, and Pierre, under whose names Rodin exhibited these three burghers in 1887, we cannot be sure how firmly he associated the names of the three remaining burghers with his statues. When Rodin reread Froissart, he would have seen that the brothers were the de Wissants, and his

Pierre looks nothing like the figure that has come to be known as Jacques de Wissant.[3] Finally, there is the frugality argument in Rodin's precedent of not letting a good piece of modeling go to waste, especially in the absence of a better alternative. Rodin's reuse of the basic mask of Jean d'Aire's face for Andrieu d'Andres and also for Jacques de Wissant may have come about because he did not find living models with the kinds of physiognomy he wanted. And it was his practice, begun in *The Gates of Hell*, on which he worked before and during *The Burghers*, to recycle favored expressive parts of figures because he knew that they would appear different if their contexts and orientations were changed. As he used Jean d'Aire's face, it was always seen from different angles or hidden by hands or a beard. The fourth explanation may be that in some ways all the previous three reasons obtained.

Both as a sculpture and characterization, *Andrieu d'Andres* deserves close attention because it offers insights into Rodin's mentality as an artist and great rewards for the patient reader of his art. In 1889 the critic Hugues Le Roux wrote of the figure, "Another hides his head in his hands. After the heroic decision, after the superhuman act, for a moment nature reclaims its rights, and this weakness of the flesh moves us to tears."[4] Rilke described Andrieu as "the man who holds his bent head with both hands to compose himself, to be once more alone."[5] To this reader, the image is one of total physical and psychological compression. This effect is developed and sustained throughout and is not restricted to the pose of the head in a two-handed grasp of despair. Consider the man's ambivalent movement and start with his exposed right foot. It toes in, discouraging any sense of a stride or purposeful forward movement. The toes themselves are curled as if gripping the ground. As with Eustache's angled right leg, Andrieu's bent left leg is at about a 40-degree angle to the body, and the heel is raised with the toes not pushing off but poised so that their tips touch the ground. At this moment all the weight is carried on the man's right foot. We know from a photograph taken in the studio of the naked Andrieu in clay that originally both feet were firmly planted (fig. 95).[6] Perhaps finding the pose too static and too much like the rigid stance of Jean d'Aire, Rodin altered it by bending the leg so that when seen from its left side the figure would appear about to stumble forward. The drapery hanging from the trailing leg binds the limb to the big silhouette, sustaining its compactness.[7]

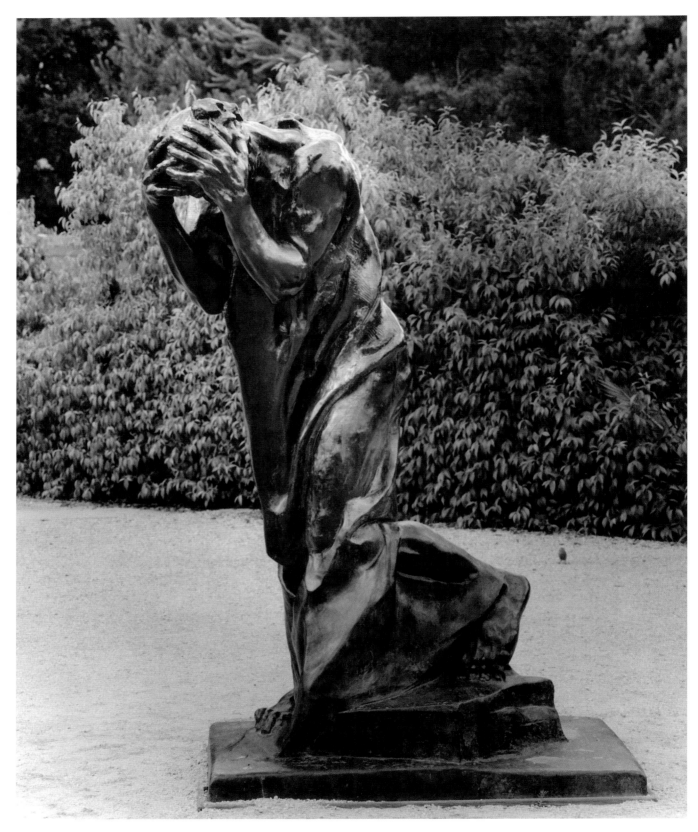

Fig. 94. *Andrieu d'Andres, Final Version* (cat. no. 23).

Rodin used the randomly spaced and raggedly edged rents in the robe to reveal the man's anatomy, which is that of a young well-developed male, whose deprivation of sustenance before the end of the siege is signaled only in his hollowed buttocks and thighs. In a more obvious break with textual accuracy, Andrieu wears no halter, so that one sees the deepest anatomical cavities, which are in the area of the lowered neck with its tensed muscles. The man's right clavicle is actually an undisguised metal bar, part of the armature used to support the weight of the lowered head. (That this affront to the standard of "salon finish" went unnoticed by Rodin's contemporary commentators suggests that they did not look too closely at this part of the figure.)

Rodin used the facial mask of Jean d'Aire but otherwise gave Andrieu another and largely bald head with a new pair of ears and different hair, which included a kind of off-center topknot. To Andrieu's right cheek, Rodin applied a vertical, rude strip of clay that evokes a crease made by the cheek when pulled back in a grimace. Wisps of hair or beard have been added to the left cheek. This kind of cosmetic change Rodin would carry out later with his studies of Balzac's head and in the great series of studies for Clemenceau's portrait.

There is a daring piece of stagecraft in Rodin's presentation of Andrieu. His face is hidden. It is the spread of the powerful fingers of the hands cradling the bowed head that serve as a dramatic surrogate for the face. Rodin could make hands as expressive as bodies and faces, and nowhere was this gift as extensively on view as in *The Burghers* and particularly *Andrieu d'Andres*. This daring device works because the hands are so eloquent in the shaping of the coarse fingers and their spacing that few who look at this sculpture bother to look for the face.

Rodin's audacious stagecraft can be seen in back as well, as he takes advantage of the hidden face. Standing behind the figure one sees no head, just the ragged upturned collar of the robe that is like a gruesome forecast of the royal headsman's work. With the arms pulled around to the front, it is the big curving muscular back that, so to speak, puts another face on Andrieu's grief. More than with his faces, this back helps us to understand how Rodin did not apply expression to a figure; rather, he claimed that it was a natural consequence of careful observation of anatomy in his modeling from life. Rodin seems never to have flagged in his enthusiasm for a well-formed back as a setting for the courtship of light

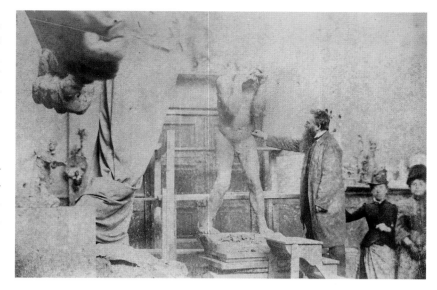

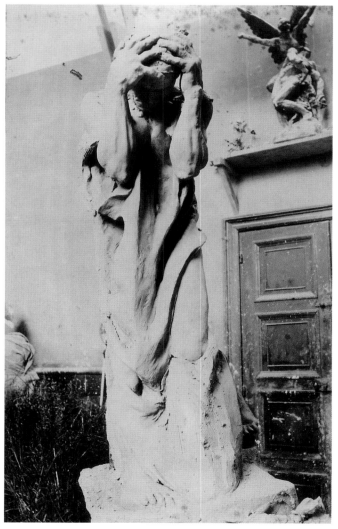

Above: Fig. 95. Jessie Lipscomb, *Rodin with "Nude Figure of Andrieu d'Andres,"* 1886, *in clay*, 1887, albumen print. Musée Rodin, Paris.

Right: Fig. 96. Victor Pannelier, *"Study for 'Andrieu d'Andres' " in clay*, 1886, albumen print. Musée Rodin, Paris.

that stimulates a sense of the body's hard firmness, as a rich internal construction that pulsates with life. Rilke put it well: "There was not one part of the human body that was insignificant or unimportant; it was alive. The life that was expressed in faces was easily readable. Life manifested in bodies was more dispersed, greater, more mysterious, and everlasting."[8]

Victor Pannelier's photograph of the robed *Andrieu* in Rodin's studio shows it near completion but with evidence of editing in progress (fig. 96). At the bottom of the photograph one can see Rodin's wood-handled, wire scraping tool next to a mound of clay. Just above in the drapery under the figure's left knee are the striations caused by the scraper. It appears that before Rodin changed the position of the leg from straight to bent, it would have been fully exposed. When he changed its position, he filled in the gap below the knee with drapery but chose not to indent the new area with folds in order to give the impression of more solid support for the leg. Thus, from the front the figure appears immobile.

What Rodin did with the drapery shows how he accommodated an awkward pose with the figure almost toppling forward. The drapery placement and arrangement is crucial to the drama and the formal construction of the whole. Viewed from either side, the overall impression of the front is of a great vertical crescent from head to hem, a gigantic declivity that bodies forth the internal emptiness felt by the despairing man. The line of the bent arms is picked up by the shroud and accelerated in a downward curve. In the front the nether part of the garment flares out, like a brace, thereby countering the overhang of the head and hands and making the hand plumb with the head. The profile of the man's back, beginning with the almost squared-off line of the head, neck, and shoulders, has by contrast more angular inflections. Rodin's turn of mind that made continuous what before him in life was discontinuous is apparent in his making fluid the meetings of flesh and fabric, so that there are no sharp junctures in the silhouettes. These edges vary in pace, swelling, and depression, and are never dry or predictable. From many angles, looked at from top to bottom, Rodin worked for and earned uninterrupted contour lines, whose hugging action abets the overall quality of manifold compression. Again Rilke: "However great the movement of a sculpture may be . . . it must return to itself; the great circle must complete itself, the circle of solitude that encloses a work of art."[9]

Rodin's genius included taking each burgher as a fresh problem and not imposing on it either clichés or a decided style, as he wanted to remain open to new discoveries and challenges. The relation of the drapery to the figure provided such problems and rewards. As is visible in *Andrieu d'Andres*, he found new ways by which the garment could accompany the broad movements of the limbs, accentuate gestures, and unify the silhouettes.

NOTES

LITERATURE: Rilke (1903) 1945 in Elsen 1965a, 138 Grappe 1944, 59–62; Spear 1967, 40–47; Jianou and Goldscheider 1969, 97; Tancock 1976, 376–90; Judrin, Laurent, and Viéville 1977, 217–21; McNamara and Elsen 1977, 45–49, 61–64; Lampert 1986, 110; Ambrosini and Facos 1987, 107; Fonsmark 1988, 111–15

1. It is not clear who first named this figure and when. There is no evidence that it was Rodin, and he seems not to have exhibited the final figure of Andrieu d'Andres by itself. Grappe so identifies him in his catalogue of the Musée Rodin (1944, 60–61).
2. Referring to Rodin's multiplication of the same parts in *The Burghers* and elsewhere, Varnedoe observes, "Making evident his piecemeal bodies and modular compositions proved to be a way to give newly expressive form both to the psychological torments of fictive worlds, in *The Gates*, and to complex dilemmas of social order, in *The Burghers of Calais*" (1990, 133). But Rodin did this as well and to a far greater extent without recourse to modular repetition. While aptly characterizing what Rodin did, Varnedoe does not elucidate a motive beyond giving newly expressive form, and it is not clear what *newly* refers to. If a fragment or module had been made years earlier and previously used, how could it be new? What of the other forms already in *The Burghers* and *The Gates*?
3. Rilke saw the possibility of family resemblance: "Six men rose before him [Rodin], of whom no two were alike, only two brothers were among them between whom there was, possibly, a certain similarity" (in Elsen 1965a, 138). Rilke went on to refer to Jean de Fiennes and Jacques de Wissant as the brothers.
4. Hugues Le Roux, "La vie à Paris," *Le temps*, 20 June 1889, reprinted in Beausire 1989, 219.
5. Rilke in Elsen 1965a, 138.
6. This photograph was also reproduced in Lampert 1986, fig. 189. One can see on the modeling stand in front of the sculpture the discarded clay resulting from Rodin's reworking of the enlarged figure. Assuming that Rodin had an assistant enlarge the figure and that the sculptor, who is in the photograph touching the figure's left hip, had done the editing, this could at least partially contradict Stanislas Lami's assertion that Rodin did not touch enlargements made by his assistants (1914–21, vol. 4 [1921], 174).

7. Lampert, in the grip of her unfortunate caveman view of Rodin's intentions, read the transformation from naked to robed as follows: "Naked and potent as he appears in the photograph . . . after the addition of the final drapery and raising of the left leg he lost the brute clarity and was made pathetic" (1986, 110). The reader is invited to look at the photograph and try to divine why the naked clay figure is itself not pathetic, and what is the potency and brute clarity that is lost.

8. Rilke in Elsen 1965a, 116.

9. Ibid., 120.

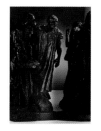

24

Second Maquette for "Jacques de Wissant" (Jacques de Wissant, deuxième maquette), 1885

- Bronze, Susse Foundry, cast 1971, 3/12
- 27½ x 9½ x 4 in. (69.8 x 24.1 x 10.2 cm)
- Signed on top of base: A. Rodin
- Inscribed on back of base: Susse Fondeur, Paris; below signature: No 3; on base, left side: © by Musée Rodin 1971
- Provenance: Musée Rodin, Paris
- Gift of the Iris and B. Gerald Cantor Foundation, 1974.99

Figures 97–99

*I*n his one-third life-size study, Rodin showed Jacques de Wissant leaning forward and in full stride, following his leader and picking up the slow cadence of the march. There is neither hesitancy nor self-doubt nor despondency in his demeanor, although the Calais committee may have read this figure as contributing to the general air of dejection to which it objected.

Among Rodin's small études of heads that of Jacques de Wissant is one of his best. The model for Jacques's head was a real find, inspiring the creation of a man who is balding and with a nose like a big bent beak, open mouth framed by sharply scored cheeks, gaunt, thrusting neck culminating in a hard chin. The head seen straight on is violently asymmetrical with its flat, ridged nose twisted in one direction and its mouth in another. The right side of his face has suggestions of beard; the left is clean-shaven. The left cauliflower ear is flat against the head; the right ear tilts outward. Due largely to the treatment of the head, Jacques is made to seem the toughest and most intense of the burghers.[1] There is, however, something very curious about the Stanford cast in bronze. Under, rather than in, the deep-set, empty eye sockets and immediately flanking the nose are two small roughly spherical lumps of clay. They are too big for tears and wrongly placed for eyeballs or bags under the eyes. As reproduced in Judrin, Laurent, and Viéville and confirmed by examining the plaster cast in the Musée Rodin, there are, in fact, two orbs in his right eye socket.[2] One suspects that the original plaster may have been carelessly handled. It is possible that the two small orbs came loose and were improperly and carelessly reset and subsequently went unnoticed by the Musée Rodin staff or at the foundry.

Unlike the head of Eustache in this series, Jacques's head seems more inspired, distinctive, and memorable, the profile echoing the form's lean hardness (fig. 98). His urge to speak seems to well up through his entire body, beginning with the trailing right foot and ending in the thrust of his head. This Jacques has far more character, but less good looks, than his final replacement. We will probably never know if Rodin abandoned his model for Jacques in favor of the bearded mask of Jean d'Aire because he feared that others would see him as too ugly to be one of Calais's secular heroes.

Jacques's walk is curious. There is a coordination of legs and arms that is not normal in walking: the right leg and arm are in advance of the left arm and leg. (Try walking so that your arms move only in tandem with their adjacent legs.) To further differentiate what was otherwise a pose similar to that of Eustache, Rodin turned Jacques's head in a different direction and changed the front foot. This works in the second model, as one gets the sense that at least one burgher is following Eustache's lead, and together these two central and adjacent figures are beginning the departure from the marketplace.

There was no prior study of a naked Jacques de Wissant, and Rodin seems to have modeled his draped body from scratch. The drapery is generally very thick, and one senses Rodin's fingers pulling clay away to fashion the robe and then running his fingers into the deeper

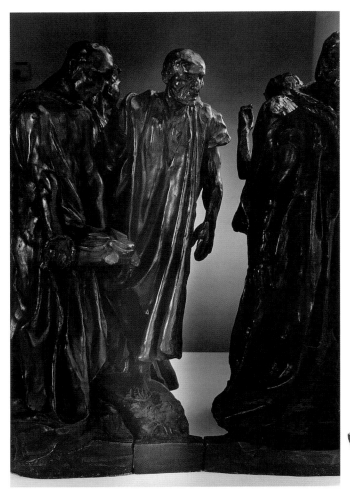

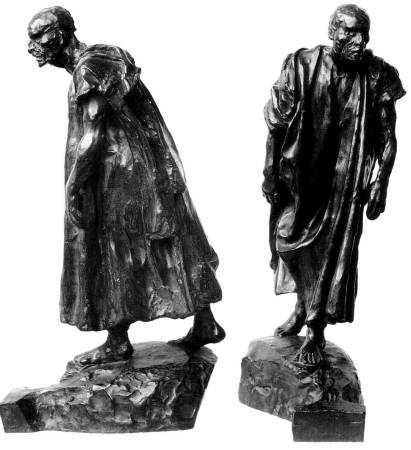

depressions between folds to smooth them, as in the back. Neck and head as well as both feet seem to have been added to the articulated clay block. No attempt was made to suggest a rope halter, and large areas of the back were left rough and unmodeled into any fold pattern. From his correspondence on this commission, it appears that Rodin used a draped mannequin, and just how much of the way Jacques's costume hangs was observed from a model or was Rodin's invention is impossible to say.

In the front, two full-length, slanting grooves signal the figure's action (fig. 99). On the man's left side Rodin so modeled the garment as to suggest the presence of the hip and leg in motion. The sculptor's habit of thinking in relationships is evident in the coordinated curves of the man's multifaceted forearms and adjacent drapery folds. Only in the upper back is there a suggestion of flesh and bone beneath the cloth. On the left dorsal side there is no attempt to evoke the form of a robe, and all we see are large coarse, abstract planes. (Was Rodin counting on the figure's position within the group to mask this incompletion?)

As he would do with other études for the second maquette, Rodin employed the drapery to help balance the figure, whose head in this case is thrust in advance of the lead foot. From the sides the forward pitch of the heavy chemise from neck to hem gives the illusion of support as though the advancing head is plumb with at least the front edge of the robe. Rodin thus used drapery both to emphasize and stabilize figural movement.

Standing on a slightly downward-slanting base, with sleeves gathered up to free his arms, his right hand pulling back his robe to facilitate walking, Jacques seems to lunge toward his fate. All that we may admire in this spirited and in some ways surprising study Rodin was to reject immediately after the second maquette had been juried and objections raised. There would be no further study for Jacques at one-third scale. In the final version, Rodin would change everything about the figure, but in the process he would lose a certain integration of inner and outer man and an authenticity of motivation and movement.

NOTES

LITERATURE: Jianou and Goldscheider 1969, 97; Goldscheider 1971, 167–70; Tancock 1976, 387, 390, 397; Judrin, Laurent, and Viéville 1977, 167; McNamara and Elsen 1977, 44

1. Two possibly related heads were noted by Laurent in Judrin, Laurent, and Viéville 1977, cat. nos. 25–26. The resemblance to the latter head (cat. no. 26) is unclear; this head is here discussed under the title *Small Head of a Man* (cat. no. 138).
2. Illustrated, ibid., 172.

25

Jacques de Wissant, Final Version (*Jacques de Wissant, vêtu*), c. 1886–88

- Bronze, Coubertin Foundry, cast 1987, 2/4
- 83 x 46½ x 27 in. (210.8 x 118.1 x 68.6 cm)
- Signed on base between feet: A. Rodin
- Inscribed on base: © by Musée Rodin 1987; on top of base, front: No. II/IV
- Mark beside copyright: Coubertin Foundry seal
- Provenance: Musée Rodin, Paris
- Gift of the B. Gerald Cantor Collection, 1992.185

Figure 100

*A*lthough Rodin did not refer to him by name, the burgher who came to be known as Jacques de Wissant seems to have caused him the most difficulty in terms of its final realization, and circumstantial evidence suggests that, of the six statues, this one most troubled the artist.[1] No photograph of the final figure during the course of its modeling in clay seems to exist. The catalogue of the Musée Rodin's *Burghers of Calais* exhibition neither mentions nor reproduces a single terra-cotta or plaster study for the final figure.[2] There are no extensive descriptions or interpretations of this figure by the artist's contemporaries. It would seem that this statue was never exhibited by itself during his lifetime.[3] Most puzzling of all is that Rodin did not have the monumental *Jacques de Wissant* reduced in size as were his five companions. These reductions of the final figures were extensively photographed and exhibited, sold, and given as gifts by the artist. It is therefore not unreasonable to suspect that *Jacques de Wissant* was Rodin's least favorite and least successful burgher.

Jacques de Wissant may have been the last of the burghers to be finished, perhaps because Rodin could not find an inspiring model and pose. In effect, this is the most synthesized figure of the group, a skillful grafting of critical parts from his fellows. He has the face of Jean d'Aire, but bearded; most of his right arm, including the flexed bicep and the entire right hand, are the same as those of Pierre de Wissant; the left hand and positioning of the feet and legs are similar to those of Jean de Fiennes.

Set into the final monument, Jacques de Wissant is in the rear, between and slightly behind Eustache de Saint-Pierre and beside Jean de Fiennes. Seen from the monument's left rear, the position of Jacques's bent, trailing leg echoes those of Andrieu, Eustache, and Jean, thus imparting a sense that the men are finally en route. Rodin could well have decided on Jacques's stance when he was thinking about the final composition and positioning the figures next to one another. Jacques carries a large key in his left hand. It is slightly smaller and of a different, more modern design than that held by Jean d'Aire. The tensing of his left arm implies the carrying of an extremely heavy load, but it is caused by the fact that the man holds the key slightly forward, in advance of the moving left leg. Jacques actually carries the key with his second and third fingers. (The position of the hand is very similar to the upturned left hand of Jean de Fiennes, but rotated 180 degrees.) Most striking is the gesture made by the right arm, raised to a right angle with the shoulder, and with the fan-shaped gesture of the hand poised a few inches away from the face. (From certain angles the hand appears to be in front of the face.) When the monument was first shown in 1889, Hugues Le Roux read the pose: "Another turns slightly away, his hand over his eyes. One would say that there was before him a face that he did not want to see at all, out of fear of losing his courage."[4] Paul Gsell interpreted this figure: "A fifth notable puts his hand before his eyes as if to dispel a terrifying nightmare. And he stumbles, so much has death frightened him."[5]

If not by fear of death, Jacques will surely stumble for

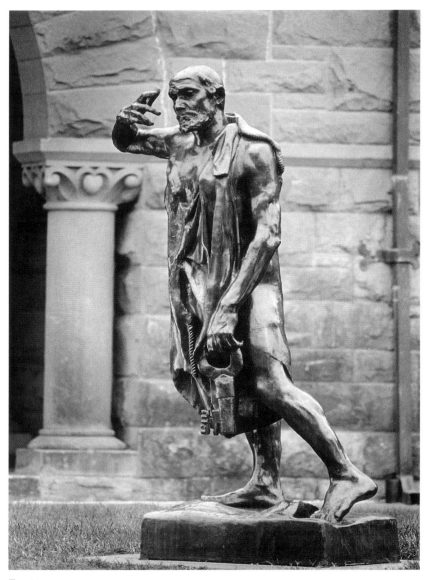

Fig. 100.
Jacques de Wissant, Final Version (cat. no. 25).

Rodin inexplicably put the man's left foot literally in a hole so that when he tries to move his trailing foot forward, it will hit the mound made by the depression. (Was that excavation made in the base because Rodin changed the original position of Jacques's left foot or was it merely expedient? Or, more probably, did he use the depression to lower the figure slightly to achieve a more uniform line for the heads?) As there was so much to see for those viewing the monument for the first time in 1889, it is not surprising that this narrative or staging lapse, as well as others, was not noticed. The figure was also placed in the back of the group, hardly visible from the front. Rodin had contractually agreed to a salon finish, but here, and elsewhere as with his handling of the ropes, he seems to have been constitutionally incapable of compliance. We know also that Rodin spoke of placing his figures directly on or amid the stones of the old marketplace, but there is no evidence in the bases of the final burghers that he sought to simulate pavement of any sort.

Although by the standards of nineteenth-century sculpture this is an impressive figure, except for the provocative gesture of the right arm, Jacques de Wissant is the least interesting dramatically and sculpturally of the six figures. Further, unlike the gestures of the other five, Jacques's gesture does not seem to grow out of the whole figure's movement nor to be generated from within the man himself. The body is that of a strong and healthy man, lean but with no signs of starvation. It certainly does not support Rodin's later claim that "I did not hesitate to make them as thin and weak as possible." With the beard and mustache covering much of the mouth and lower face, this area loses the grim assertiveness of Jean d'Aire. The expression becomes more stoic than defiant. Jacques's neck and chest areas are uneventful anatomically or artistically, unlike those of his brother Pierre. The moderate movement of the upright body encouraged Rodin to compensate by doing interesting things with the garment and props, such as the rope and key. They betray any attempt to make Rodin into a literal realist sculptor such as his archaeologically minded contemporary Emmanuel Frémiet (1824–1910). Rodin has treated a section of rope as the edge of what becomes a sort of mantle on top of the man's left shoulder and behind the neck. The drapery is interesting because of Rodin's improbable but artistically logical connectives. The robe seems to grow out of the man's right pectoral and armpit. It then falls straight downward, making the arm gesture appear almost semaphoric. He would make the chemise thick or thin as dictated by what he wanted for visual effect or to show off the body, so that in the area of the lower front edge it is dense, but on his left thigh it seems like a transparent undergarment. As he would do in the final statue of Claude Lorrain (cat. no. 95), in which the palette catches the edge of the painter's jacket, Rodin wedded the key's border to an adjacent fold of the garment. Rodin clearly did not want any holes or spaces inside the overall silhouette of his individual outdoor sculptures.

NOTES

LITERATURE: Grappe 1944, 59–62; Jianou and Goldscheider 1969, 97; Tancock 1976, 376–90; Judrin, Laurent, and Viéville 1977, 217–21; McNamara and Elsen 1977, 45–49, 61–64; Fonsmark 1988, 111–15

1. The figure is so named in Grappe 1944, 61.
2. A photograph in Le Nouëne and Pinet 1987, 41, shows the upper half of the last version of Jacques in plaster minus his arms.
3. Beausire (1988) does not list any solo exhibition.
4. Hugues Le Roux, "La vie à Paris," *Le temps*, 20 June 1889, reprinted in Beausire 1989, 219.
5. Gsell [1911] 1984, 37–38.

26

Second Maquette for "Jean de Fiennes"
(Jean de Fiennes, vêtu, deuxième maquette), 1885

- Bronze, Godard Foundry, cast 1979, 1/12
- 25⅝ x 10¼ x 14⅛ in. (65.1 x 26 x 35.9 cm)
- Without forearms
- Signed on top of base, right: A. Rodin
- Inscribed on back of base, left: E. Godard Fondr; on back of base: © by Musée Rodin 1979; adjacent to signature: No. 1
- Provenance: Musée Rodin, Paris
- Gift of the B. Gerald Cantor Collection, 1992.146

Figure 101

Rodin made two studies of the sculpture *Jean de Fiennes* that relate to his conceptions for the second maquette, this version without forearms and a nude variant with forearms (cat. no. 27). In this author's opinion, this is the first, the one shown to the Calais committee as part of the group. In the background of Bodmer's 1886 photograph, just to the left of *Jean d'Aire* and seen from its left side, is the étude for *Jean de Fiennes* fully draped (see fig. 62).

There was at least one nude, armless study made for Jean de Fiennes, which is preserved in a battered plaster in the Meudon reserve.[1] The plaster for the Stanford bronze étude in the reserve is also without forearms.[2] One can see in both the plaster and the Stanford bronze the exposed joint Rodin used to attach the figure's left forearm, indicating that he had either different thoughts about the gesture to be made or wanted the limbs removed to prevent breakage in the studio.

This figure was a totally new invention after the first maquette. Jean's stride, concealed from the front by the heavy robe that falls to the very base itself, puts him in step with Jacques, Eustache, and Pierre; and like the latter, he looks back while making a gesture that when completed by the forearms would suggest supplication. Particularly effective is the way the deep creases and folds of the front garment build to the exposed neck and profiled head. This handsome head will serve as the basis for the final version of *Jean de Fiennes*, but Rodin will downplay the drapery beneath it. Like Pierre de Wissant, the open-mouthed Jean de Fiennes does not go silently, and despite its small size, his handsome, still-youthful face

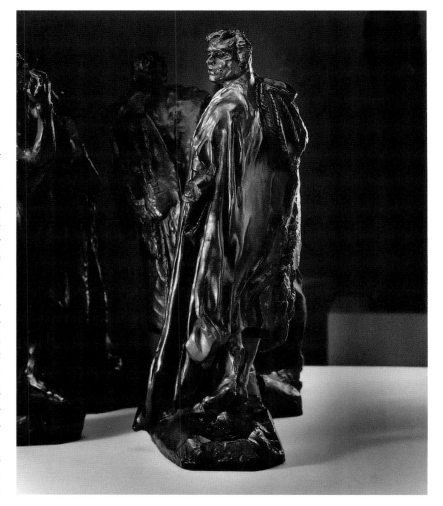

Fig. 101. *Second Maquette for "Jean de Fiennes"* (cat. no. 26).

imparts a concentrated urgency to his speech. This was one of those inspired occasions when Rodin made the facial expression grow out of the whole clothed figure.

Rodin bunched the ropes together with the drapery on the back of Jean's right shoulder so that the ropes are not visible in front. By their placement, they seem to defy gravity as much as the customary logic of anatomy. This also suggests that Rodin may have thought that in the second maquette the man's back would be visible from the rear and that his front would have been turned in toward others in the group, specifically toward the backs of Jacques de Wissant and Eustache de Saint-Pierre.

The irregularly shaped base, the largest of any of the burghers in the second maquette, is the only one in which the figure seems to be walking up a slight incline. Jean's raised left heel has been pulled off, not unlike Jean d'Aire's left foot. The drapery in the figure's right rear has been similarly rudely removed and in a different manner from those vertical folds of the front that have

clearly been broken off, perhaps by a studio accident. The editorial decision prompts the speculation that at one time *Jean de Fiennes*, like *Jean d'Aire* and *Pierre de Wissant*, was physically joined with another burgher. (The rough remains of previous joining with other figures do not, however, match up.) The back of this figure is basically a big hollow, not as strong in design as that of the version that followed, which may explain why Rodin made another étude.

In the second maquette, *Jean de Fiennes* follows directly behind *Jacques de Wissant*. There is a good fit of the lead edge of Jean's base with the back edge of Jacques's.

NOTES

LITERATURE: Goldscheider 1971, 167–70; Judrin, Laurent, and Viéville 1977, 151–52, 154; Miller and Marotta 1986, 65

1. Judrin, Laurent, and Viéville 1977, 150.
2. Ibid., 151.

27

Second Maquette for "Jean de Fiennes," nude with forearms (Jean de Fiennes, torse nu, variante du personnage de la deuxième maquette), 1885

- Bronze, Susse Foundry, cast 1971, 3/12
- 28 x 17 x 16½ in. (71.1 x 43.2 x 41.9 cm)
- Nude variant with forearms
- Signed on top of base: A. Rodin
- Inscribed on top of base, near front left corner: Susse Fondeur, Paris; below signature: No. 3; on base, right side, near back: © by Musée Rodin 1971
- Provenance: Musée Rodin, Paris
- Gift of the Iris and B. Gerald Cantor Foundation, 1974.100

Figure 102

*T*his nude figure with forearms is a second study of *Jean de Fiennes* (see cat. no. 26 for maquette without forearms). In this author's opinion, it was not part of the second maquette shown to the Calais committee in 1885,

although it was at one time probably joined to another burgher in the group.[1] Further, the drapery was not done by Rodin's hand but was probably modeled by an assistant under his direction.

Using a clay impression of the naked Jean de Fiennes, with changes in the man's hair and slight alterations to the face and neck, Rodin conceived a daringly dramatic change in the costume. It is shown torn in the center so that it barely covers the man's hips. Rodin was certainly audacious but not crazy. One cannot conceive of him showing the Calais jury a burgher with partially exposed genitals. All that holds up the riven shroud are Jean's extended arms, thereby riveting him forever to this pose and place.

Though handsome in its design, the drapery literally lacks Rodin's touch as well as a certain fullness. The surface of the robe is treated in a detail that borders on the finicky, particularly where it gathers above the man's upraised left ankle. The whole garment has a more linear pattern and overall flatness than those of the other burghers in the second maquette. The material is here made to seem very thin—holes have been inserted in the front portion—and susceptible to small wrinkles unlike the heavy-duty cloth employed for the other burghers. Much of its surface in the back seems to have been worked over with a scraping tool, which has left a succes-

sion of diagonal striations. This may have been done by Rodin himself, for these editing marks help restore a largeness of effect missing elsewhere, particularly in the front.

Because it begins at the man's waist, the garment floods down onto both the base and larger, rectangular plinth on which it rests. The result is a tangle of thin, ropy strands that would surely trip any one trying to move through it, especially one who was preoccupied with keeping his robe on. The size and shape of the plinth alone limits, if it does not preclude, maneuvering this sculpture in relation to the rest. On the right rear side of the drapery, however, are the rough, nondescriptive textures seen in the études *Pierre de Wissant* and *Jean d'Aire*, which intimate breakage of the clay to partition two previously joined figures. After this cleavage and the decision not to use this figure in the presentation of the second maquette, Rodin probably mounted the figure of Jean de Fiennes and its original base on the plinth, after which the strands of drapery were modeled on its surface.

When Rodin used this second version with the group, he probably would have caused Jean to bring up the rear with his broad back to the viewer. This is the most arresting perspective with an ingenious yet plausible relationship between the naked back with its strongly shaped spine and the drapery with its central, vertical hollow echoing the depression of the spinal column.

NOTES

LITERATURE: Jianou and Goldscheider 1969, 97; Goldscheider 1971, 167–70; Tancock 1976, 387, 390, 397; Judrin, Laurent, and Viéville 1977, 154; McNamara and Elsen 1977, 44; Miller and Marotta 1986, 65

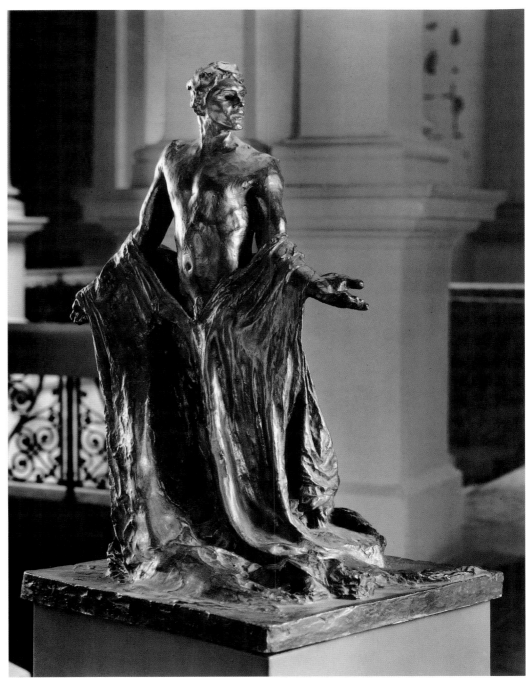

Fig. 102. *Second Maquette for "Jean de Fiennes"* (cat. no. 27).

1. Goldscheider believed that it was so joined (1971, 167–70). The view of the plaster figures seen in Bodmer's photographs (see fig. 62) argues that the more fully draped figure of Jean was employed.

28

*Jean de Fiennes, Final Version
(Jeanne de Fiennes, vêtu), 1885–86*

- Bronze, Coubertin Foundry, cast 1981, 1/12
- 82 x 48 x 38 in. (212.4 x 124.3 x 98.4 cm)
- Signed on front of base: A Rodin
- Inscribed adjacent to signature: No 1; on base, left side: © By Musée Rodin 1981
- Mark on base, left side: Coubertin Foundry seal
- Provenance: Musée Rodin, Paris
- Gift of the B. Gerald Cantor Collection, 1992.147

Figure 103

"*T*hey are still questioning themselves to know if they have the strength to accomplish the supreme sacrifice— their soul pushes them onward, but their feet refuse to walk."[1] The youngest of the burghers epitomizes the psychological division of which the artist spoke. Having committed his bodily weight to the step taken by his right foot, the left about to push off from the toes, Jean de Fiennes nevertheless turns and looks back. With arms wide and palms up he speaks out. The attitude is one of questioning, yet compliance with destiny.

After his study for the second group maquette showing the man in the same pose, Rodin made a full-size, completely naked Jean de Fiennes, apparently unphotographed while in clay by Bodmer or Pannelier but surviving in a plaster in the Musée Rodin reserve. Except for some later modifications of the hair, the plaster appears to be that of the figure on which Rodin draped the robe.[2] The torso is not as heavily muscled or of comparable sculptural interest as that of Jean d'Aire, which could have decided Rodin to cover it completely. The legs and arms that denote strength obviously were preferred for final exposure. The whole has a certain simple and fluid elegance of movement, but it does not seem that Rodin exhibited the plaster during his lifetime. (Nor does it appear that the artist exhibited the final figure solo.)[3] Rodin's subsequent use of costume was not just for historical purposes but may have been a way of masking what, despite its nuanced modeling, was for him a rela-

tively bland torso, gaining for the figure some dramatic punch. In effect, by now emphasizing the head, forearms, and lower legs, so that attention on each of them is more easily isolated, Rodin had made a kind of partial figure out of a whole costumed body.

The most expansive of the six burghers in terms of gesture, *Jean de Fiennes* is the least complex in its form. With its simple V-shaped collar and short sleeves, his robe is the most complete and simplest in design, throwing the expressive emphasis to the figure's extremities. The cascade of folds reiterates the body's basic upright stance. There is no rope or key, only the plain, unevenly edged garment to associate the questioning man with the episode. But how he questions his fate! Even as his whole body leans in one direction, the open-mouthed face is thrust out in another, beyond the line of the feet. He pleads his case against fate with eloquent, strong hands bereft of weapons. He is one of the "Christ burghers," as some of Rodin's contemporaries saw these figures.

Like good actors on the nineteenth-century French stage, Rodin's figures, with the exception of Andrieu, never duplicate the gestures of their own hands. Both of Jean de Fiennes's are relaxed, while the right is lower, as if the arm were about to swing downward to a normal hanging position while walking. Although they do not lie in the same vertical plane, in angle the left forearm rhymes that of the bent left leg. Rodin thickened proportionately the forearms in relation to the hands so that the gestures would carry over distance. (In all likelihood the same model did not serve for both arm and hand.) Rodin exaggerated the forearm muscles of the left arm so that their swelling picks up the light. Midway between wrist and elbow in right forearm, Rodin bent slightly outward the flexed extensor muscle, thus indenting the normal contour.

There is no real front to this sculpture, whose major parts are oriented in three different directions. An historically original pose, the squared shoulders are at a severe angle to the direction of the man's stride, and it is almost as if the man were walking sideways. Except when viewed from directly opposite the man's chest, Jean's body leans drastically forward. Of the six, even more than Andrieu d'Andres' the pose of that of Jean de Fiennes offers the most severe challenge to gravity. (Before his *Monument to Honoré de Balzac*, whose backward tilt so upset many artists and critics in 1898, Rodin challenged earth's pull by the forward lean of several burghers.) Dujardin-Beaumetz provides a record of how Rodin viewed his challenge to equilibrium:

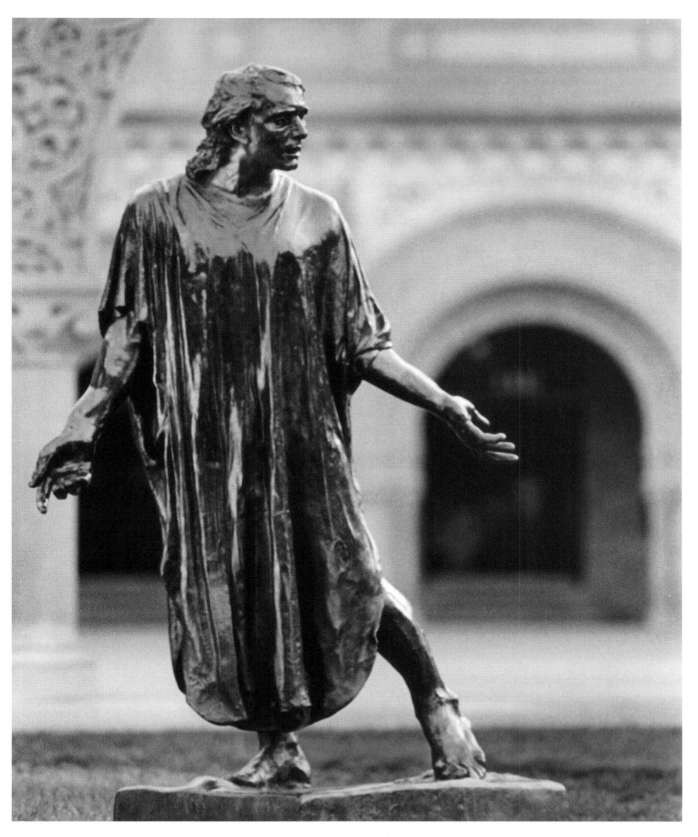

Fig. 103. *Jean de Fiennes, Final Version* (cat. no. 28).

. . . . the search for balance is necessary to all figures . . . but the points of balance are as numerous as movements and they are as numerous as the seas. . . . One must find the equilibrium given by each movement and vary with it.

I believe that equilibrium is not only that vertical determined by the laws of gravity. . . . It is made up of other essential equilibria: those which result from the whole, and those which are occasional and irregular.

The true balances result from the general movement of the figure, and those whose line passes through all planes which give to the figure its stability and balance.[4]

Viewed from either the left or right sides, the broad, irregularly corrugated, sloping plane of the draped back is answered by the almost vertical drop of the garment in the front, that gravitational vertical about which Rodin spoke, that stabilizes the form. Absent the artist's own chronicle of how these figures and the final composition evolved—and instead of thinking of Rodin's having finished each one first and apart from one another—it is reasonable to imagine that decisions such as the degree of body inclination and final draping of Jean de Fiennes, as well as those of the others, may have been made while the figures were still malleable in clay and the artist could actually place them together in his studio. A comment to Henri-Charles Dujardin-Beaumetz about how the artist should always think of his work in relation to light seems apt here: "We never see anything in isolation; an object is always in rapport with what is in front, beside, behind. . . . The relations are important."[5] *Jean de Fiennes*'s drastic forward pitch, for example, which seems curious for a freestanding sculpture, makes even more sense or seems further resolved in the ensemble because it gives momentum to the final group when seen from behind and from the monument's right. As he did when establishing the composition for *The Burghers* as a whole, no doubt Rodin visualized this figure within an imaginary cube in order to get both a natural movement and one that was artistically controlled and would turn back on itself rather than seem to fly outward.

In the formation of the features and overall appearance, none of the studies for Jean de Fiennes's head proposed with qualifications by Viéville looks like the definitive version.[6] In fact, the head of the earlier maquette (cat. no. 27) in which the drapery is split down the center and hangs from his forearms seems closest to the last state. In the definitive version, the head is framed by abundant, matted hair, modeled in a sequence of passages kept rough to suggest its neglect, and has an angular profile overall when seen from the sides. The hair tumbles down the neck and onto the shoulders, thereby serving to buttress the head's forward projection. Rodin pulled the hair out and slightly over the ears to frame the features and to give the head as a whole a proportionately greater and irregular mass when seen conjoined with the broad body and its unbroken contours. Above the wide cheekbones are the deeply recessed eyes with their concave, modeled irises. There results a look of poignant intensity, as if Jean is seeking with his eyes the invisible answer to the fateful question posed by his lips and hands.

One of the rare attempts in print to read Jean de Fiennes's expression was made by Paul Gsell, who interpreted the condemned six in Rodin's presence and won for his efforts the artist's approval: "Finally, here is a sixth burgher, younger than the others. He still looks undecided. A terrible anxiety contracts his face. Is it the image of his lover that occupies his mind? Yet his companions are walking. He catches up and stretches forth his neck as if to offer it to the axe of Fate."[7]

NOTES

LITERATURE: Grappe 1944, 59–62; Jianou and Goldscheider 1969, 97; Tancock 1976, 376–90; Judrin, Laurent, and Viéville 1977, 217–21; McNamara and Elsen 1977, 45–49, 61–64; Miller and Marotta 1986, 65; Levkoff 1994, 94

1. Translated in Tancock 1976, 390, from *L'art et les artistes* 1914.
2. This was observed by Monique Laurent in Judrin, Laurent, and Viéville 1977, 215–16; the figure is illustrated on 215.
3. Both judgments are based on the absence of such a record of exhibition in Beausire 1988. Rodin did have a reduction of this figure made in either 1895 or 1899; see Judrin, Laurent, and Viéville 1977, 224.
4. Rodin cited in Dujardin-Beaumetz in Elsen 1965a, 162.
5. Ibid., 171.
6. Judrin, Laurent, and Viéville 1977, 212–14. Viéville himself puts a question mark after the captions and bases his judgment on their resemblance to the head in studies for the second maquette; and he may be right, but the photographs do not at all make this convincing.
7. Gsell [1911] 1984, 38.

29

Second Maquette for "Pierre de Wissant"
(Pierre de Wissant, deuxième maquette), 1885

- Bronze, Susse Foundry, cast 1971, 3/12
- 27½ x 11 x 11 in. (69.8 x 27.9 x 27.9 cm)
- Signature on top of base, left: A. Rodin
- Inscribed on back of base, lower edge: Susse Fondeur Paris; below signature: No. 3; on base, left side, lower edge: © by Musée Rodin 1971
- Provenance: Musée Rodin, Paris
- Gift of the Iris and B. Gerald Cantor Foundation, 1974.98

Figures 104–106

For the *Pierre de Wissant* that was part of the second maquette, Rodin did studies of a nude figure in the same pose as the draped version.[1] This was probably due to the pose, with its *désinvolture* highlighting the body's graceful twisting in depth, which was unusual for Rodin. When Rodin was in London in 1882, he would have been taken by his friend Alphonse Legros to the Grosvenor Gallery to see an exhibition that included a 29–inch statuette by Alfred Gilbert entitled *Perseus Arming* (1882).[2] Nude except for a winged helmet and holding a sword and belt in his lowered left hand, Perseus extends his bent right arm outward in order to look down at the winged sandal on his raised right foot. Gilbert's figure is plumb with the head over the right foot, and the suave curve of the torso has the sternum aligned with the navel, the hips and shoulders in the same plane. It is not impossible that when reworking the initial version of *Pierre de Wissant* in the first maquette, Rodin may have remembered the unusual pose of Gilbert's statuette and adapted it with his characteristic audacity.

Strictly speaking, there is no front to the various versions of *Pierre de Wissant*. The shoulders and hips move in slightly different directions, and the figure's head is turned down and away from the direction of his stride. This gave Rodin great flexibility in placing him in relation to the others, but it also suggests that even when working on an individual burgher, the artist was thinking of the group in the round and how they individually and collectively would be seen from many points of view.

For the new bodily balance he sought, in the naked versions Rodin could study such relationships as those of the hips to the shoulders (they do not lie in the same vertical plane) and the sternum to the navel (they are in slight misalignment). The hands and face would be completely redone in the life-size version, but as we know from Rodin's 1900 exhibition of the life-size partial figure of Pierre, what was most important to him was the elegant and graceful effect he achieved in the spiral rotation of the body and arms (see fig. 108). To avoid the monotony of four figures all showing basically the same stride, Rodin not only put them at angles to one another in the group maquette, but he made Pierre's dragging leg appear longer.

Rather than using a mannequin in this case, Rodin probably applied drapery to a plaster cast of the nude form and then modeled the garment directly on a clay version. Of all the six, the body of Pierre is most revealed by his robe. The Calais committee criticized Rodin for the historically inaccurate thickness of the burghers' costumes, but Pierre's is made to seem relatively thin and most like a gown, even if it did not satisfy Rodin's critics. The man's thighs and knees are clearly visible through the simulated cloth. Rodin worked the costume so that its folds complemented the body's gestures; those that emanate from under his right arm expand upward and also downward between the legs. On the man's left side, where the arm hangs slightly away from the body and one can still see the armature connecting the inside of the elbow with the torso, the pleats comply with the upright direction of the stance. The longer hang of the robe in the back extends the sweep made by the big curve of the torso, legs, and diagonal fold sequence descending from the shoulders. Along the man's sides the drapery becomes thicker, and the fabric on his right side tempers by its vertical fall the body's concave arc. This was done perhaps to rectify visually what might otherwise have been seen as an imbalance, as the bent right arm and head project out beyond both the right shoulder and the weight-carrying foot. The large, rough passages of the man's rear suggest that Rodin may have broken off what he may have modeled, perhaps having once connected Pierre with another figure. By contrast with these raw traces of editing are the smoothing actions made by Rodin's thumb or forefinger in effecting the depressions of the robe between the man's legs and along his right leg.

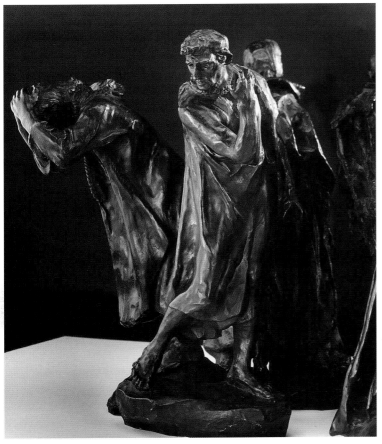

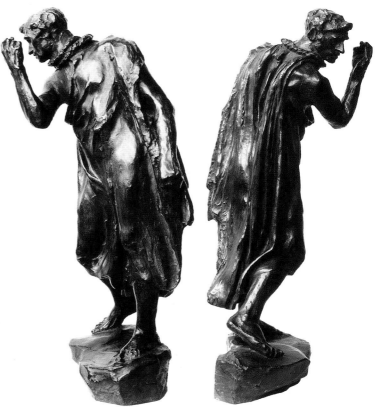

Above: Fig. 104. *Second Maquette for "Pierre de Wissant"* (cat. no. 29).

Middle: Fig. 105. *Second Maquette for "Pierre de Wissant"* left profile (cat. no. 29).

Right: Fig. 106. *Second Maquette for "Pierre de Wissant"* right profile (cat. no. 29).

The double thickness of rope around Pierre's neck provides also the mount for his face. It is a handsome but not memorable visage with its strong nose, slightly opened mouth, and cavities for the eyes, all set under a full head of hair that projects over the forehead. As yet there is none of the deep anguish mobilizing the facial features and the right hand that will come later.

The bases on which the nude and clothed études stand differ in shape and size, with the former being more rectangular and the latter more ovular. There is a slight incline to the clothed figure's base; it seems Rodin avoided making any of the bases in the second maquette absolutely flat. The base for the final study is the smallest, perhaps to permit closer relationships with those of the others during the times Rodin tried various arrangements.

NOTES

LITERATURE: Spear 1967, 47, 96; Jianou and Goldscheider 1969, 97; Goldscheider 1971, 167–70; Tancock 1976, 388, 390, 401; Judrin, Laurent, and Viéville 1977, 160; McNamara and Elsen 1977, 42; Miller and Marotta 1986, 61; Ambrosini and Facos 1987, 108

1. See Judrin, Laurent, and Viéville 1977, 155–60, cat. nos. 15, 17–18, for what they present as several studies.
2. Susan Beattie, *The New Sculpture* (New Haven: Yale University Press, 1983), 138–39; and Richard Dorment, *Alfred Gilbert* (New Haven: Yale University Press, 1985), 38–42, fig. 16. In May and June 1882 Rodin exhibited a mask and portrait of Legros in the Grosvenor Gallery.

30

Pierre de Wissant, Final Version
(*Pierre de Wissant, vêtu*), c. 1886–87

- Bronze, Coubertin Foundry, cast 1981, 4/12
- 81 x 40 x 48 in. (209.8 x 103.6 x 124.3 cm)
- Signed on top of base, front, left: A. Rodin
- Inscribed on back of base: © by Musée Rodin 1981; below signature: no. 4
- Mark on back of base: Coubertin Foundry seal
- Provenance: Musée Rodin, Paris
- Gift of the B. Gerald Cantor Collection, 1992.148

Figure 107

*T*he burgher known as Pierre de Wissant captured the imagination of two of the most eloquent contemporary critics. Before photographic reproductions were used in great number, such writers as Gustave Geffroy and Rainer Maria Rilke conjured synoptic word portraits for their readers. Today they are still welcome descriptive accompaniments to our reading. For those who were unable to see Rodin's joint exhibition with Claude Monet in 1889, Geffroy's catalogue introduction would have done much to increase their anticipation, especially of the *Pierre de Wissant*:

> Among the others, the most characteristic is a young man. He hesitates and lingers in his gait. He turns halfway, holds himself as if in balance on his inflected body, turns his head, inclines his face, opens his mouth, closes his eyes and makes with his right hand, index finger raised, the fingers extended like a fan, an extraordinary gesture of strange grandeur, of a profound tenderness, a gesture that does not say *au revoir*, but *adieu*, a definitive adieu to ephemeral life, a gesture that expresses the fatality of the irretrievable. The condemned youth advances toward death with an automatic step, the bony head and the svelte leanness let the elegant skeleton show through. This man, whose body bends, whose legs stop but are going to resume movement, whose face bends toward the earth, of whom the hand sketches an instinctive gesture, is the man who travels through life, fixed in a prodigious statue, that one must call perhaps simply the Passerby.[1]

Rilke had obviously read Geffroy but was moved to record his own response:

> [Rodin] created the man with the vague gesture whom Gustave Geffroy has called *"Le Passant."* The man moves forward, but he turns back once more, not to the city, not to those who are weeping, and not to those who go with him; he turns back to himself. His right arm is raised, bent, vacillating. His hand opens in the air as though to let something go, as one gives freedom to a bird. This gesture is symbolic of a departure from all uncertainty, from a happiness that has not yet been, from a grief that will now wait in vain, from men who live somewhere and whom he might have met sometime, from all possibilities of tomorrow and the day after tomorrow; and from death, which he had thought far distant, that he had imagined would come mildly and softly and at the end of a long, long time.
>
> This figure, if placed by itself in a dim, old garden, would be a monument for all who have died young.[2]

Just how much Rodin esteemed his study of Pierre's pose was demonstrated in 1900 when he used the naked life-size plaster étude without head and hands as the frontispiece for his Paris retrospective (fig. 108). It was positioned on the porch of the exhibition hall near the front door, where it was the first and last sculpture seen by thousands of visitors.[3] Fortunately we have Rodin's own words on why he favored this plaster and wanted it placed in a prominent location. Knowing that Sir William Rothenstein wanted to buy one of his works for the Victoria and Albert Museum, Rodin wrote to him, "I have a beautiful figure who is a burgher of Calais who is placed in the small pavilion that precedes my exhibition. . . . *It is complete* even if the exhibited *morceau* is without head and hands. This figure has a great *désinvolture.*"[4] When applied to his figures, *désinvolture* probably meant to Rodin more than graceful bearing but included an easy twisting in depth. (Rodin seems not to have used the word *space* in conjunction with his sculpture.)

For Rodin the secret of the effortless arabesque was in

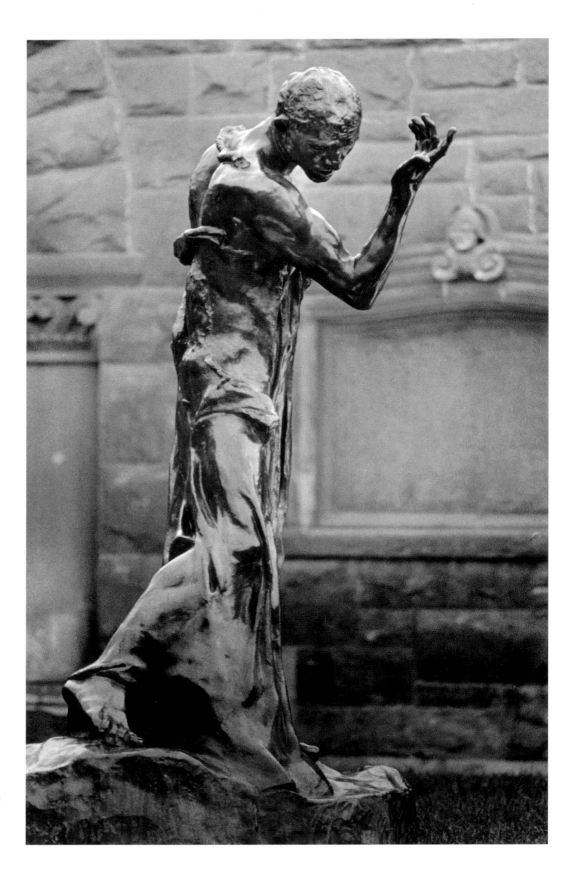

Fig. 107. *Pierre de Wissant, Final Version* (cat. no. 30).

effecting a change in the body's axis just above the navel so that the hips and shoulders are oriented in different directions. The centrifugal torsion initiated by Rodin's realignment of sternum and navel moves outward into the raised and lowered truncated arms, which add to the spiral effect of the whole. Without the distraction of the powerfully expressive extremities of head and hands, Rodin forces the spectator to concentrate on the beauty of pure balletic movement of the sculpture and of his *modelé*. By the sculpture's ostentatious location in this great exhibition, which by means of international press and photography attracted universal attention, Rodin was telling the world, as well as Rothenstein, that completeness—which Rodin defined in terms of expressiveness—counted as much, if not more, than finish. The *étude* had been elevated to the intellectual and aesthetic level of a salon statue. There was no more important legacy from Rodin to early modern sculptors like Henri Matisse than this.

Charles Bodmer's 1886 series of photographs of *Pierre de Wissant* in clay show the figure even before the plaster cast of the *morceau* version was made. The photographs reveal the right heel raised and the foot supported by an exposed armature (see fig. 62).[5] Also clearly visible in some photographs is the undisguised iron bar that runs under and along the man's right upper arm. (Both supports were removed in the final version.) The whole body is muscular and lean but not emaciated. In the left and right wrists is evidence that the hands were modeled separately and joined to the forearms, which was confirmed by the *morceau*. (Athena Spear was the first to identify Pierre's right hand as the source for the *Hand of God* [before 1898].)[6] Expressive as are these extremities, by 1900 Rodin came to prefer the partial figure because he found more satisfying the nuclear motif of the torso and just enough of the arms to indicate the general movement it generated. It appears that Rodin did not exhibit the final *Pierre de Wissant* alone, whereas he showed the partial figure not only in Paris (1900) but in Düsseldorf and Leipzig (1904).[7]

In Bodmer's photograph, the sculpture's base is covered with clay shavings from the fine tuning of the figure's surface, which Rodin surely did himself. In 1921 Stanislas Lami wrote that when, in the 1890s, Rodin began to use Henri Lebossé to enlarge his sculpture, the artist received the finished works in plaster, and "the process employed had the great disadvantage of preventing him from making any changes or improvements to

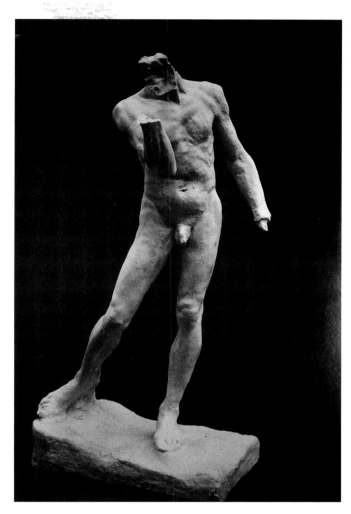

Fig. 108. *Nude Life-Size Study for "Pierre de Wissant" with neither Head nor Hands*, c. 1886, plaster, height 75 3/16 in. (191 cm). Musée Rodin, Paris.

his models."[8] Lami stated that before 1890 Rodin "had modeled his statues in the size of their [final] execution."[9] The implication seems to be that Rodin participated in the enlarging of the burghers even if he did not do it all himself.

The Final Figure

The draping of the final figure is unusual. No part of the garment passes over the man's shoulders. It begins at chest level, where the material seems to be gathered, passes tightly under the arms, and across the back just below the shoulder blades. In what it contributes to the final monument, the crucial fold pattern is in the front, hanging between the arms and legs, and accentuating the sway of the body beneath. The material is thick and heavy, roughly cut or torn, bunched, knotted, and folded

where it begins at the top. In the area of the chest it seems to grow right out of the man's right pectoral. Rodin's mentality was to create the impression that the garment was an extension of the man, who in turn appears to flower out of the shameful sheath. The deep cleavage made by the stretched tendons of the neck seems a resumption of the ruts made in the upper robe.

Rodin's treatment of the drapery is decorative in overall effect but not ornamental in being predictable. When he contrasts the pleated with the full, it seems that the latter serves a structural function as where the gown broadens out and descends to the ground like an anchor in front of the man's right knee. Whether looked at fore or aft and despite the hours Rodin studied it, the drapery has the look of the unarranged. With the garment Rodin had license to exercise a modern sense of abstract form. In the back, for example, Rodin did not feel that he had to make the drapery literally and consistently responsive to the man's body. The drapery over the calf of the right leg seems transparent, whereas that covering the buttocks does not. There are big, thick passages in the back, notably below the right scapula, which show no labor of refinement, much less an attempt at the illusion of cloth, and which encourage their identification as an abstract structural support of the body. When his lines called for it, Rodin defied both convention and probability and used only enough rope to evoke the halter, but it has no binding function and merely hangs negligently over the man's left shoulder.

Memorable, if not mesmerizing, is Rodin's conception of Pierre's upper body, head, and arms, especially when seen in or against the light with the sky as background. It reminds us of Rodin's lifelong love of human anatomy and its potential for sculpture. Through Pierre's body Rodin tells us that bone, muscles, tendons, and responsive flesh can make terrific sculptural form. His inspired rendering offers the sensual satisfaction of seeing the body's shapely thickness and surprising nuances of articulation such that no surface is numb and dumb. Rodin dissolved the academic distinction between beauty and expressive sculpture. One readily sympathizes with Pierre's grief, but almost at the same time there is the enjoyment of the formal beauty of this tragedy. Though

hand, head, and body were created from different models, Rodin had the gift of convincing us they could belong to only one man. This seamless unity depended not only on Rodin's consummate skill at assimilating different anatomies into an integrated whole but in his convincing us that the feelings that shape hands and face came from a single head and heart.

With its poignant yet elegant sweep, the final *Pierre de Wissant* by itself has inspired dancers as well as writers. Alone, it is hard to imagine this figure as part of any group. Seen in the context of the final monument from its right side, however, the total body gesture of the burgher gathers up and contains the forward tilt and wavelike movement of the draped figures of *Jean de Fiennes* and *Jacques de Wissant*. *Pierre de Wissant's* hanging, silhouetted left arm brings the composition to a stop: the bent right arm and head turn not just the man but the canted lines of the trio back on themselves.

NOTES

LITERATURE: Rilke 1903 (1945) in Elsen 1965a, 138–39 Grappe 1944, 59–62; Spear 1967, 40–47; Jianou and Goldscheider 1969, 97; Tancock 1976, 376–90; Judrin, Laurent, and Viéville 1977, 217–21; McNamara and Elsen 1977, 45–49, 61–64; Miller and Marotta 1986, 61; Ambrosini and Facos 1987, 114; Fonsmark 1988, 111–15

1. Reprinted in Beausire 1989, 67.
2. Rilke in Elsen 1965a, 138–39.
3. See photograph reproduced in Beausire 1988, fig. 44. For additional discussion of the nude figure and the variant with head and arms, see Judrin, Laurent, and Viéville 1977, 187, 191.
4. Rodin to William Rothenstein, 17 November 1900, reprinted in William Rothenstein, *Men and Memories: Recollections of William Rothenstein, 1872–1900* (London: Faber and Faber, 1931), 372. The work was not acquired. See Le Normamd-Romain 2001, 270.
5. See also Elsen 1980, 56.
6. Spear 1967, 79.
7. Beausire 1988, 196, 253, 259.
8. Lami 1914–21, vol. 4 (1921), 163. Actually Lebossé delivered to Rodin's assistants the enlarged limb, torso, or head when the clay was hardly dry, and it was immediately cast in plaster in the sculptor's studio.
9. Ibid., 162.

31

Monumental Head of Pierre de Wissant
(Pierre de Wissant, tête monumentale), c.1886–87,
enlarged c. 1909

- Title variation: *Heroic Head of Pierre de Wissant*
- Bronze, Susse Foundry, cast 1969, 4/12
- 36½ x 10¼ x 9½ in. (92.7 x 26 x 24 cm)
- Signed midway up base, left side: A. Rodin
- Inscribed on base, right side, lower edge: Susse Fondeur Paris; on base, left side, lower edge: © by Musée Rodin 1969
- Provenance: Musée Rodin, Paris
- Gift of the Iris and B. Gerald Cantor Foundation, 1974.118

Figure 109

Ironically, the model for the anguished *Head of Pierre de Wissant* may have been the comedian Coquelin Cadet, of the Comédie française (fig. 110).[1] Judging from his photograph, there are tangible similarities between the sculpture and the actor's face in the amount and type of hair, high forehead, angle and shape of the eyebrows, and the whole area of the eyes, shape of the nose, wide mouth. It would have been easier for a professional performer to strike and hold the tragic expression for the hours of its modeling, as years later the Japanese actress Hanako would do for a delighted Rodin. Despite his statement that "the expression comes from the strength of the modeling,"[2] implying that he did not prescribe an expression but just worked from the natural set of the subject's features as seems probable for the heads of Eustache and Jean d'Aire, for this head Rodin no doubt urged Coquelin to agonize until the expression he wanted to depict had been achieved.

This great tragic head is persuasive in part because of Rodin's gift of showing how not just the mouth and eyes but the entire face participates in a genuine expression. As an example, he makes an area such as the forehead, not normally considered expressive and often treated as emotionally neutral, expand the anguish conveyed by the mouth and eyes. From the largely closed eyes diagonally upward on both sides to just above the nose and almost into the hair, Rodin shows with indentations and

ridges the pained contractions of the muscles. (Eyebrows in effect become muscles rather than merely hair.) The roughly modeled hair itself forms a tight but turbulent frame for the face and even the ears. Exquisitely sensitive to the expressive nuance of posture, Rodin makes the pathetic tilt of the head echo and encase the whole drama.

Sculpturally, and consequently anatomically, there are surprises such as the big indentations of the man's upper lip, where one would expect a full, even sensuous roll of skin, as in the lower lip. This is an example of what might be called Rodin's instinctive sculptor's touch, doing something drastic—something beyond what he termed exaggeration—which changes expression but resists explanation and verbal paraphrase. No question but that he had in mind the future action of light on the mouth and how—no matter the angle of the sun—the painful darkness of the mouth's deep cavity would be extended into the upper lip. Along with his bold incursions into the most prominent expressive feature, there are others in the area of the brows that with changing shadows augment the sense of the mobility of the features and overall surface. Another surprise is the lack of similarity between Pierre's ears, adding to the asymmetry of the subject's individuality. His left ear seems normal in shape and position and is fully modeled. His right ear, like that of *Jean d'Aire*, is pressed more closely to the head, is differently shaped than its mate, and has had areas near the lobe pulled away. In fact, the left ear may have come from a different model.[3]

In choosing to roughly model an upward, curving, nonillusionistic base under the upper neck, Rodin eschewed the portrait bust format and, in effect, showed the head as a fragment. What may have encouraged this unconventional format were fragments of late medieval sculpture, such as the sixteenth-century *Head of Christ as a Man of Sorrows*, which he could have seen in the Louvre and which would have confirmed his belief that a part could be as expressive as the whole.[4] Even before Rodin's

Fig. 110. Boyer. *Coquelin Cadet*, after 1889. Collections Comédie-française, Paris

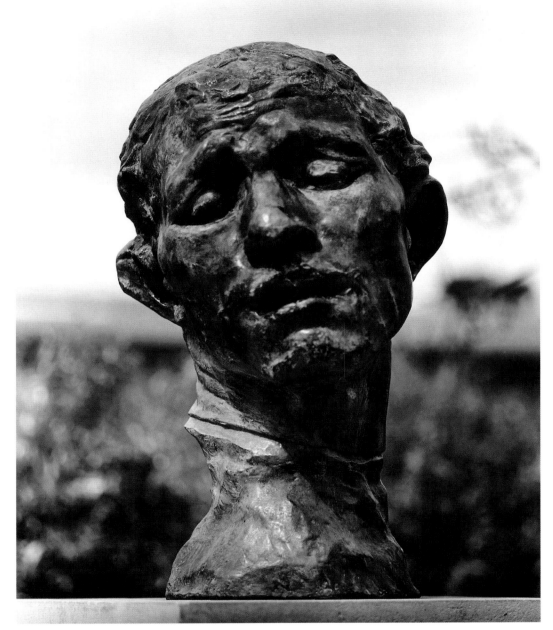

Fig. 109.
*Monumental
Head of Pierre
de Wissant* (cat.
no. 31).

seemed to be) of Froissart's time. The tilted, tortured head that he fashioned needed no halo or crown of thorns for his contemporaries to make the association. As with Rodin's *Head of Sorrow* (cat. no. 55), which in small form summarizes the spirit of *The Gates of Hell*, this one monumental head of a single burgher is a surrogate for the passion of all six.

Neither the enlarger nor the exact date of the enlargement of this head is known. It was shown first in 1909 (probably the approximate date of its augmentation), and a bronze cast was given to Ghent in 1910. Pierre de Wissant's head seems to have enjoyed a greater exhibition history than the *Monumental Head of Jean d'Aire*, perhaps due in strongly Catholic countries to its kinship with pathetic heads of Christ.[6]

NOTES

LITERATURE: Elsen 1963, 75, 78; Spear 1967, 45, 96; Jianou and Goldscheider 1969, 98; Goldscheider 1971, 174; Spear 1974, 129S; Tancock 1976, 397; Judrin, Laurent, and Viéville 1977, 234–35, 237; McNamara and Elsen 1977, 43; Ambrosini and Facos 1987, 110

monument, the Calais burghers were considered "burgher Christs," to the annoyance of socialists in Saint-Pierre. They were seen as men of sorrows who experienced their own Via Crucis in order to ransom their people from evil. Geffroy described them in 1889 as "these Christ burghers dedicated to the welfare of all."[5] Rodin was moved by both the natural, even portraitlike character and pathos of late medieval sculptures (which he may have thought of as being and to him they may have

1. According to Laurent (in Judrin, Laurent, and Viéville 1977, 252), Coquelin proposed to Rodin that he pose for one of *The Burghers of Calais*. Viéville also made the connection (174).

2. Rodin to the editor of *Le patriote*, 19 August 1885, cited in McNamara and Elsen 1977, 73.

3. Pierre de Wissant's right ear was not always so battered, as shown in at least one study, but the extent that both ears stuck out from the head Rodin may have found too distracting. See McNamara and Elsen 1977, 177.

4. This type of head is illustrated in Elsen 1963, 74.

5. Reprinted in Beausire 1989, 67.

6. Judrin, Laurent, and Viéville 1977, 234.

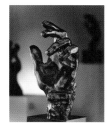

32

Large Left Hand of Pierre de Wissant (Pierre et Jacques de Wissant, main gauche), c. 1886

- Title variation: *Left Hand of Jacques de Wissant*
- Bronze, Georges Rudier Foundry, cast 1967, 4/12

- 11 x 7½ x 6 in. (27.9 x 19.1 x 15.2 cm)
- Signed on wrist: A. Rodin
- Inscribed on wrist, below thumb: Georges Rudier/Fondeur Paris; on back of wrist: © by Musée Rodin 1967
- Provenance: Musée Rodin, Paris
- Gift of the Iris and B. Gerald Cantor Foundation, 1974.119

Figure 111

*S*ee cat. nos. 187–94 for a discussion of this and other hands.

Fig. 111 *Large Left Hand of Pierre de Wissant* (cat. no. 32).

TOWER OF LABOR

Rodin's political and religious views were as unique to him as his art, hence they defy easy definition or classification. He did not belong to any political party, nor after his youth did he adhere to any religious sect. His never-to-be-realized project *Tower of Labor* (fig. 112) prompts the thought that he may have been a socialist, but there is no evidence to support such a speculation. The closest he came to an affiliation with a partisan group may have been in 1889, when he joined the short-lived Club de l'art social, which met monthly for about a year in the offices of the *Revue socialiste*.[1] Articles by socialist adherents were written about Rodin's sympathy with the workers and the supposed appeal of his art to people of all estates, but there was no proof of any formal political affiliation.[2] According to Alain Beausire, socialist intellectuals tried to monopolize Rodin. From a 1907 interview with the artist by F. Duranteau, it is clear that Rodin was either unaware of or disinterested in social problems, but he called for French workers to organize against "the disappearance of art" and loss of "innate French taste" to "nameless productions." Characterizing what he felt was the degeneration of French society and resulting denigration of the worker, he called for the closing of bars to curb alcoholism among workers, elimination of the distinction between art and craft, and restoration of pride and taste by artisans in their work. He cited the corruption of the voters under universal suffrage and criticized elected officials for their special rather than general interests in the nation's welfare. He deplored the disintegration of the family and advocated a return to a simpler, more healthful life. The publication of these views resulted in charges in the press that Rodin was antidemocratic. He favored the selling of plaster reproductions made by children as it gave young artists greater exposure to those who could not afford bronzes.

The Cantor Rodin collection at Stanford includes a drawing and two sculptures for the *Tower of Labor*. Arguably the only parts of the project done by the artist himself, *Benedictions* (fig. 113) certainly and probably *Night* and *Day* (cat. nos. 34–35) were drawn from his inventory.

The tower was not a commission but rather a project suggested to Rodin by fine arts inspector Armand Dayot at the latest in 1898. As shown by the sculptures of Aimé-Jules Dalou (1838–1902) and Constantin Meunier (1831–1905), paintings in the salons, and the Galerie des métiers for the Paris Hôtel de Ville by Pierre-Victor Galland (1822–1892), the glorification of work had been very much on artists' minds since the 1880s.[3] Dayot, who was an artist and critic, had conceived the project as early as 1894, hoping for its realization at least in the plaster-model stage for the 1900 Exposition universelle in Paris. He harbored the vain hope that several artists, including Jean Baffier, Camille Claudel, Dalou, Jules Desbois, Jean-Alexandre Falguière, Meunier, and Rodin, would collaborate on a tribute to work and workers. Dayot envisioned a monument for Paris to glorify not just the worker but to represent an "apotheosis of work," and "the glory of human effort" as the symbol of the new era. The workers represented would range from the humblest laborers to the most illustrious scholars, all of whom would lead humanity "toward a higher ideal."[4]

His format, which Rodin was to adopt, consisted of a column with a spiral of bas-reliefs rising from a pedestal to the summit. Dayot believed that the monument would also show the new tendencies in collaborations between architects and sculptors. As Rodin was in the last campaign on *The Gates of Hell* with its new ideas about the relation of sculpture to architecture, this aspect would have had great appeal. Dayot, as would later Rodin, counted on not just the federal government and municipalities for "voluntary subscriptions" but above all on the new *syndicats* or unions, which had been sanctioned by law in 1885. Dayot's primary inspiration, also later shared with Rodin, was Meunier, "the great artist who consecrated his genius to the humble of this world."[5] Both Meunier and Dalou already had their own dreams of monuments to laborers, and Desbois, who had worked for Rodin over a long period and to whom on 21 March 1898 Dayot had published an "open letter" on the subject of the monument, urged successfully that Rodin be given the honor.[6]

We do not know exactly when Dayot convinced Rodin to undertake a model of the project, but it may have been during the final months before the exhibition of the *Monument to Honoré de Balzac* in 1898. On 8 September 1898 the writer Gabriel Mourey, who later would be important in raising a public subscription for *The Thinker*, published an article offering the first eyewitness account of a model for the tower and a record of Rodin's intentions for it.[7] After summarizing Dayot's wish for a monument that glorified "human effort" to be realized by a team of sculptors, Mourey wrote, "But no beautiful and generous idea remains infertile. On the day after the struggle that he sustained with his *Balzac* against ignorance, partisanship, and foolishness, Rodin felt the idea germinating in him. To celebrate work and glorify effort must have tempted this indefatigable worker. He searched and searched and he found, and yesterday I had the joy to discover and see in his rue de l'Université studio the first maquette of the Monument to Labor."

Mourey went on to compare Rodin's design with the Column of Trajan (A.D. 106) in Rome and the Place Vendôme column (1806–10) in Paris, pointing out, however, that it was impossible to see these sculptures above the lowest level. Rodin wanted the ensemble to please as a whole, but he also wanted all details to be visible. "Therefore if one builds a spiral path around the column from whose view the subjects could be easily contemplated, and if one encloses the whole in an arcaded tower through which the light would largely penetrate . . . it seems that all difficulties would be overcome."

There are many views of the architectural source of the tower, including the external staircase of the Château de Blois, but Rodin later put it succinctly, "Why not put the Column of Trajan into the Tower of Pisa?"[8] He was to make or cause to be made at least two models of the tower's architecture, of which the first in clay seems to have survived only in a contemporary photograph.[9] It is not even certain—with at least one exception, the Stanford drawing (cat. no. 33)—that the surviving drawings of the tower were by Rodin's hand and not those of an architect working under his direction, as was his practice when overwhelmed with work. In the summer of 1898 Rodin was undoubtedly thinking about his impending retrospective and readying his great portal for its first public showing. That exhibition may have seemed to Rodin an appropriate occasion to unveil his maquette, and it accorded with Dayot's timetable.

Fig. 112. Jacques-Ernst Bulloz, "*Model of 'Tower of Labor,'*" 1898–99, in plaster at Meudon with "*Tragic Muse,*" 1890–96, in plaster on a column in foreground, after 1903, gelatin silver print. Musée Rodin, Paris.

Rodin's program for his monument has been published several times, with slight variations, but here we follow Mourey because he seems to have been a careful reporter not only of what he saw but of what the sculptor told him.

By a door that is guarded by the figures of *Day* and *Night*, symbolizing the eternity of labor, one penetrates under the tower into a vast chamber that is reserved for the trades that extract raw materials from the bowels of the earth. In large bas-reliefs of an almost brutal facture, of a synthetic sculpture in great planes in order to make them more visible in

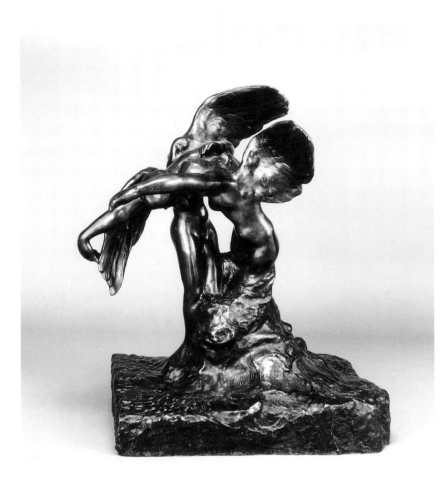

Fig. 113.
Benedictions,
1894, bronze,
35½ x 24 x 19
in. (90.2 x 61 x
48.3 cm). Iris
and B. Gerald
Cantor
Foundation.

Mourey then went on to a physical description of the monument:

As for the proportions . . . the column itself would be near that of the Column of Trajan, that is to say three to three and a half meters; the spiral covered walk would be two and one-half meters wide, thus making the diameter 8 meters in all. As for the height . . . one must count around ten turns of the spiral of two and a half to 2.8 meters in height. The dimension of the bas-reliefs will be those of the Panathenaic frieze [of the Parthenon] and they will be lighted in the same fashion [by daylight]. It goes without saying that all the figures of the monument, except the symbolic figures of *Day* and of *Night* and the two *Benedictions*, would wear modern costumes representing work such as we see it manifested every day around us.

Mourey concluded by saying that the monument would be realized "with the aid of a group of artists chosen by him [Rodin], and who would accept the general plan of his work, while preserving the independence of their efforts." Rodin was accustomed to supervising teams of artists helping him with commissions, and he might have enlisted Desbois and the young Emile-Antoine Bourdelle but not the others named by Dayot.

Over time Rodin's ideas for his program seem to have changed somewhat, and in 1906 his friend Gustave Kahn reported that "the crypt door would be guarded by or decorated with the images of Hercules and Prometheus. Inside the chamber electric lights would illuminate the bronze bas-reliefs showing Hercules draining the swamps, purging the world of wild beasts and monsters, and the works of the inventor of fire." The tower was to be surmounted by a platform from which one could see the "human work of the city. In the center of this platform will rise . . . two women entwined, Strength and Thought, dominating the modern city, [about to] take wing toward infinity, toward the future, toward the better or toward nothingness."[10]

the half light that there reigns, is depicted the life of the miners, the divers, the somber and perilous labors of the earth and sea. Then the ascent begins. The snail-like spiral unrolls from right to left. As one mounts, the more refined trades are depicted, [then] those in which the mind takes the most part. From one bas-relief to another the subject changes; a type of caryatid-corbel synthesizing each trade separates them and supports the ceiling. You mount to the summit, and there pure thought resides, the most noble work, that represented by the artist, the poet, the philosopher. Then, crowning the monument against the sky, posed on the extremity of the column . . . are two spirits, two benedictions, pouring love and joy on work, because it is love and joy, despite all the pains and all the hatreds, which constitute labor.

Rodin exhibited the model of the tower in his 1900 retrospective, for which perhaps the artist had written on its base, "Project for a *Monument to Labor*. In the crypt miners, the deep-sea divers. Around the door, *Day* and *Night*. And around the columns, the trades: masons, carpenters, forgers, joiners, potters, etc., in the costumes of the period. At the top: the *Benedictions* come from heaven. An effort has been made to recall a hive, a lighthouse."[11] In an unsuccessful attempt by Loie Fuller to raise funds for it, the model was shown in the National Arts Club of New York in 1903. In 1906 Rodin's communication with Andrew Carnegie failed to enlist the industrialist's support.[12]

Not surprisingly in the years before his death Rodin thought of using *The Gates of Hell* as the portal to the basement chamber and "in the crypt below the ground will repose my remains when I am no more—the remains of one who was a great worker."[13]

NOTES

1. Herbert 1961, 23.
2. This subject was well reviewed by Beausire (1988) in his chapter "Rodin et le socialisme."
3. See "The Visual Artist" in Herbert 1961.
4. Cited in Hunisak 1981, 693–95. For more on the background of the project, see Schmoll 1972, 253–81 and Grunfeld 1987, 416–17. The model was exhibited at Rodin's 1900 retrospective (Le Normand-Romain 2001, 232).
5. Philippe Dubois, "L'apothéose du travail," *L'aurore*, 1 April 1898; Armand Dayot, "A la gloire du travail," *Le matin*, 7 April 1906.
6. The letter was published in *Le journal*. Regarding Dayot's views see also Tancock 1976, 294.
7. Gabriel Mourey, "Aspects et sensations: 'Le monument du travail' par Rodin," *L'écho* de Paris, 8 September 1898. René Chéruy left what he claimed was Rodin's account, reprinted in Rice 1965, 41. Chéruy would have obtained this material while working intermitantly for Rodin's between 1902 and 1908.
8. Grunfeld 1987, 417, citing Ernest Beckett, "A Visit to Rodin," *Current Literature* (New York), June 1901, 730.
9. It was reproduced in Maillard 1899, the first book on Rodin (67).
10. Gustave Kahn, *Le siècle*, 16 August 1906.
11. Translated in Descharnes and Chabrun 1967, 152.
12. *Tour de travail* file in the Musée Rodin archives.
13. Tirel 1925, 113–14.

33

Sketch for "Tower of Labor"
(*La tour du travail, esquisse*), 1898?

- Graphite on paper
- 14½ x 10¼ in. (37 x 26.2 cm)
- See also *Seated Nude Woman* (cat. no. 204)
- Provenance: Mrs. Jules E. Mastbaum, New York and Philadelphia; Louise Dixon, Beverly Hills
- Gift of Charles Feingarten and Gail Wiley Feingarten, 1973.48.2

Figure 114

*T*his is a rare drawing of Rodin's ideas for the architecture of the *Tower of Labor*. That it is on the back of one of his continuous drawings of a seated nude woman (cat. no. 204) testifies to his authorship rather than that of a professional architect, such as Henri Nenot, who was asked by Rodin to make at least one sketch. In the Musée Rodin drawing collection there is a sketch for the tower, now attributed to Nenot, which shows the lower portion of the spiral structure.[1] Nenot's drawing was done in graphite, ink, and brown watercolor heightened with gouache on cream paper. Rodin's was done freehand in graphite on cheap paper and lacks not only the polish of an architect's presentation drawing but also its straight lines. (One is reminded of *The Gates of Hell*, in which there are no perfectly straight lines.)

The profiles of the sculptor's tower are decidedly more completely modeled or, as Rodin would say, more like the silhouettes of the human form. Starting with the entrance, Rodin wanted arches throughout. Engaged columns separate the arcades with their pronounced keystones

and low balustrades. It seems clear that Nenot was carrying out Rodin's ideas, tidying up the artist's conception and extending it to indications of the reliefs around which the ramp curled.

When compared with the architectural model in the Musée Rodin (see fig. 112), presumably made under Nenot's direction, Rodin had changed his mind about the arched entrance portal in favor of a rectangular entrance with rounded framing corners. This new doorway introduced the same motif of flattened arches for the upper arcades thereby assuring as much light as pos-

Fig. 114. *Sketch for "Tower of Labor"* (cat. no. 33).

sible for the interior reliefs. The whole effect is lighter, more elegant, but less sculptural than Rodin's ideas in his drawing, and it has the look of sixteenth-century French architecture rather than Italian.

NOTES

LITERATURE: Eitner, Fryberger, and Osborne 1993, 360

1. Judrin 1984–92, vol. 4 (1984), 192.

34

Night (La nuit), 1898?

- Title variation: *Standing Woman Doing Her Hair*
- Bronze, Georges Rudier Foundry, cast 1971, 1/12
- 10 x 4¾ x 6 in. (25.4 x 12.1 x 15.2 cm)
- Signed on lower back: A. Rodin
- Inscribed on back, right: Georges Rudier/Fondeur, Paris and © by Musée Rodin 1971; below signature: No. 1; interior cachet: A. Rodin
- Provenance: Christie's East, New York, 10 June 1980, lot 23
- Gift of the Iris and B. Gerald Cantor Foundation, 1981.9

Figure 115

As with the figure named *Day* (cat. no. 35), this small sculpture, known as *Night*, seems to have derived its name from its placement next to the model for Rodin's proposed *Tower of Labor* (see fig. 112). The woman stands with feet together, bending forward from the waist, with hands addressed to her hair as if in the act of arranging it. The relatively immobilized pose may have prompted Rodin's pairing of the figures as appropriate to monumental forms that would flank the tower. Gabriel Mourey described the program for this project, explaining that the *Tower* is entered through "a door guarded by the figures of *Day* and *Night*, symbolizing the eternity of labor."[1] One of a small group of sculptures, including *Day*, in which the figure's weight is evenly distributed between the two legs, its side views show Rodin's daring. From a sculptural standpoint, the figure is precariously balanced. Her lowered head extends beyond the line of the feet, defying the artistic tradition of positioning the head above a supporting foot.

Unlike the uniformly smooth facture of *Day*, that of *Night* is consistently coarse, and the energy of its execution is more visible. There is no face to speak of, and in this étude one can see how Rodin's fingers pushed the clay to coax into being the form of the abdomen. The lower legs are barely shaped and are partly engaged with the mound that helps support her. Since this étude is unrecorded as an independent sculpture by Georges Grappe, until the relevant portion of the Meudon inventory is published, it remains to be determined whether it had a further life in Rodin's art.[2] As the *Tower of Labor* was never realized, Rodin probably did not enlarge or refine this figure.

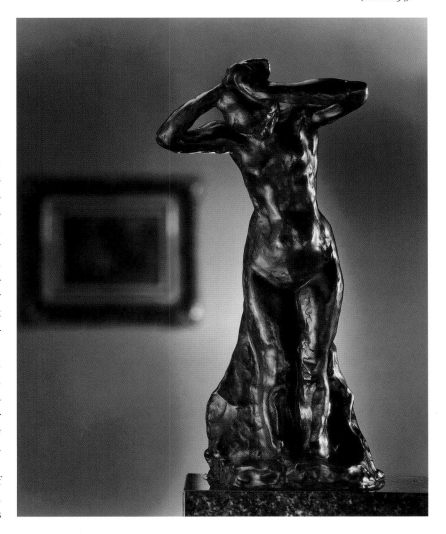

Fig. 115. *Night* (cat. no. 34).

NOTES

LITERATURE: Descharnes and Chabrun 1967, 149; Tancock 1976, 294

1. Gabriel Mourey, "Aspects et sensations; Le monument du Travail par Rodin," *L'écho de Paris*, 8 September 1898. Descharnes and Chabrun 1967, 149–52.
2. A similar gesture of the hand is seen in the female figure for the study for and final group *Fugit amor* (c. 1887; in Grappe 1944, 62–63).

Day (Le jour), c. 1882

- Bronze, E. Godard Foundry, cast 1978, 4/12
- 10⅝ x 2¾ x 2⅜ in. (27 x 7 x 6 cm)
- Signed on top of base, right, near front: A. Rodin
- Inscribed on back of base: E. Godard/Fonde; on base, right side: © by Musée Rodin 1978; below signature: No. 4
- Provenance: Musée Rodin, Paris
- Gift of the B. Gerald Cantor Collections 1983.202

Figure 116

*T*his sculpture, apart from its location next to Rodin's model for the *Tower of Labor*, performed other supporting roles. In *Small Standing Torso* it appears without head and arms.[1] In a variant form it was the central figure in both *The Three Virtues* (1882)[2] and the variant group *The Secret* (c. 1882).[3] Two variants of *Day* flank a male figure in *Group of Three Figures* (mid-1890).[4] And in 1900 an armless version appeared in an assemblage with Rodin's plaster of *The Sculptor*, as shown in a photograph.[5] Although it is unrecorded by Georges Grappe, we know at least that it had been created by circa 1882.

The sculpture seems almost like a bald mannequin due to its relatively slick finish, masklike face, and gestures limited to the raised forearms. Not unlike those of a mannequin, the hands of *Day* are extremely fine. The woman's back has greater articulation of the shoulder blades and buttocks than,

for instance, the breasts. Rodin's distinctive touch seems literally missing, suggesting that this was possibly a work done by an assistant whom the master admired. The headless, armless version in the Musée Rodin does not mask the symmetry of the legs and torso, which one does not normally associate with Rodin but which appears in other figures, such as the *Standing Nude with Arms Crossed* (cat. no. 170). This idol-like stance may have prompted Rodin's selection of the plaster to serve as a symbol and to frame a large architectural work.

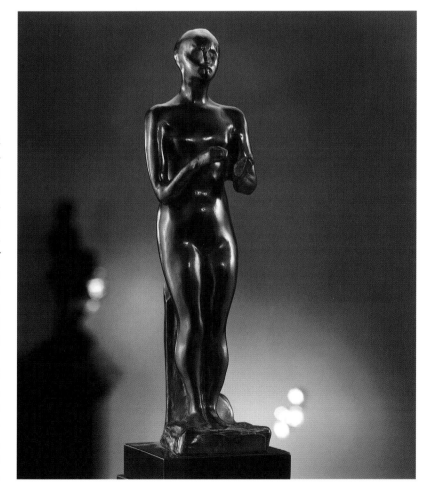

Fig. 116. *Day* (cat. no. 35).

NOTES

LITERATURE: Descharnes and Chabrun 1967, 149; Tancock 1976, 294, 304; de Caso and Sanders 1977, 244; Beausire 1988, 182, 193

1. Grappe 1944, 35, cat. no. 90; see Le Normand-Romain (2001, 130) who dates this figure to about 1890 (identifying it in the *Gates of Hell*) and a varient without arms as c. 1899.
2. Ibid., cat. no. 89.
3. Tancock 1976, 304.
4. Ibid., 300.
5. Beausire 1988, 193.

Head of France (*La France, tête*), 1904

- Title variations: *Bust of a Young Warrior, The Byzantine Princess, The Empress of the Low Countries, Saint George, Study for "France"*
- Bronze, Georges Rudier Foundry, cast 1966, 4/12
- 20 x 18 x 12½ in. (49.8 x 45.7 x 31.8 cm)
- Signed on left shoulder: A. Rodin
- Inscribed on back, lower edge, right: Georges Rudier/Fondeur.Paris.; on back, lower left: © by Musée Rodin, 1966
- Provenance: Musée Rodin, Paris; Paul Kantor Gallery, Malibu
- Gift of the Iris and B. Gerald Cantor Foundation, 1974.66

Figure 117

*I*n certain ways this work exemplifies both Rodin's conservatism and his audacity. From the time he made *Bellona* (cat. no. 5) using Rose Beuret as his model, Rodin would occasionally craft a helmet to go atop the head of a woman. Sometimes Camille Claudel sat for him, rendered as *Saint George* (c. 1889), and at times Mrs. Russell was portrayed as Athena (fig. 382). Rodin was following a tradition that went back to antiquity and was still flourishing in the nineteenth century. In 1912 he received a commission from the states of New York and Vermont to honor the French explorer Samuel de Champlain with a monument personifying France, to be placed on the shores of the lake he discovered. Rodin decided to use an early portrait of Claudel, made perhaps in 1884, not long after they met.[1] To this head, he had already earlier added the most daring and roughly modeled headgear he had ever made. In no other work by the sculptor is there such a dramatic coexistence of the rough and the smooth. At some time after he had modeled *France*, he made it into two reliefs. René Chéruy, Rodin's secretary

at the time, was present when this was done, and as he recalled shortly before a visit to Rodin's studio by Edward VII: "He placed [a cast] as a high relief in front of a plaster plaque with the indication of a vault. Profile turned to the right he called it 'France.' Immediately after, perhaps the next day, he took a second cast and repeating the same process he turned the profile to the left and called it 'Saint George,' a little flattery in expectation of the royal visit, or perhaps in the hope of a commission. (A deception on his part.)"[2]

The helmet and its skirt, which comes down to and covers the shoulders, are so fashioned as to create a kind of niche for the woman's neck and head. To avoid stiffness without diminishing the regal nature of the new subject, the woman's head is turned slightly to her right. What suggests that the head is an early portrait of Camille Claudel is not only her youthfulness but Rodin's straightforwardness. Claudel as France displays a wide-eyed serenity, as if Rodin were content to capture not just her personality but rather the physical character of her fine features, including the muscle in low relief under her right eye. Even the pupils are modeled and indented. Rodin's passion for the woman who had left him ten years earlier seems to come through in the costume's turbulence.

Sculpturally it is the improvised and vigorous modeling of the helmet that is most surprising and rewarding. From the back the work is an abstraction, but there is evidence below the helmet's rude crest on her left side of studs holding a curving metal band. Perhaps Rodin or an assistant had begun the simulation of an actual helmet when Rodin decided that he wanted a broader and bolder effect, and the headpiece was then reworked in a more spontaneous fashion. In style, the skirt of the headgear is similar to that used for the Saint George head. Once into this mode of improvisation, Rodin extended it to the shoulders and garment covering the woman's bust. The raw traces of a scraper create textured strips that reiterate the roundness of the shoulders they cover, and seen from her right profile, they start an upward series of

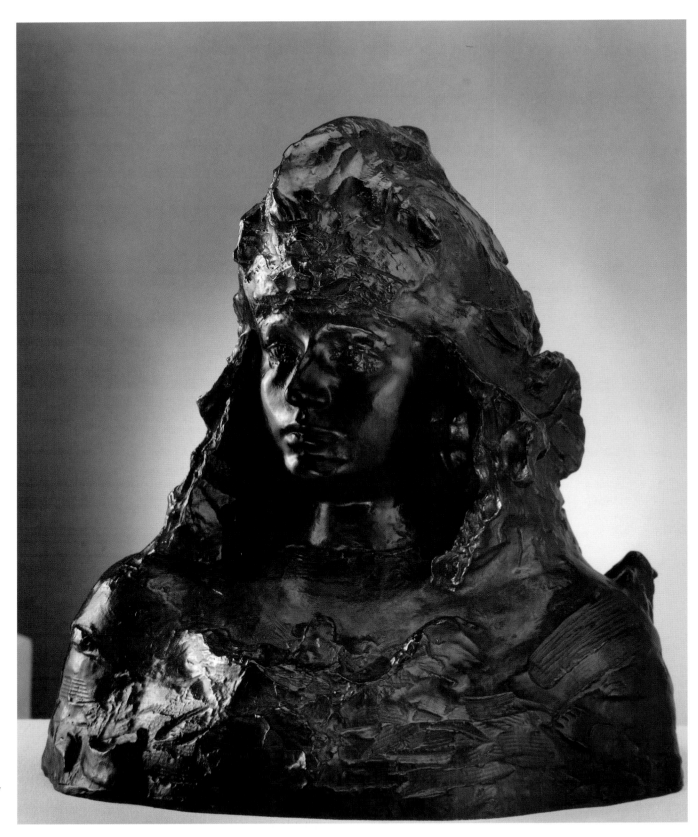

Fig. 117. *Head of France* (cat. no. 36).

banded rhythms, against which Rodin played the wilder portions of the skirt that becomes like windblown hair.

After spending two decades on *The Gates of Hell*, Rodin by 1904 may have found no more ways to fashion a relief. What Chéruy did not see or tell us, but which is available through contemporary photographs, is how the reliefs *Saint George* and *France* were actually made. It appears that Rodin was so taken with the timesaving improvisation on the bust that he created the final versions of the monument by perforating a piece of board to create a niche in such a way that, when placed upright next to the sculpture, he could ram the full bust into it and then cut away what he did not need. Voilá! An instant relief. Rodin was so pleased with this impromptu solution to the problem of making a relief that he had a photograph taken of the bust still in plaster jammed into the board, which shows daylight through the cracks made in the niche (fig. 118). To ensure that the world knew about his audacity, Rodin had a postcard made from the photograph by Jacques-Ernest Bulloz (1858–1942).[3]

Both the bust and the relief were exhibited several times after 1904. According to the research of Alain Beausire, the relief named *Saint George* was shown in Weimar and Paris (1905), Glasgow (1907), and Leipzig (1910).[4] On 3 May 1912 the monument was installed and dedicated on the shore of Lake Champlain.

NOTES

LITERATURE: Grappe 1944, 114–15; Alley 1959, 215–16; Jianou and Goldscheider 1969, 97; Tancock 1976, 601–2; de Caso and Sanders 1977, 289–90; Lampert 1986, 131, 134–35, 230; Ambrosini and Facos 1987, 176; Butler and Lindsay 2000, 376-81

1. For a discussion of the dating of the *Study for France*, see Tancock 1976, 601. He too accepted Grappe's date of 1904 (1944, cat. no. 337).
2. Chéruy's letters are discussed in Tan-

cock (1976, 601) and cited in Alley (1959, 215). Tancock rightly points out that Chéruy, writing fifty years after the event, may have misremembered the date of 1907 for the execution of the helmet, for in 1906 Rodin gave the *France* version of the relief, with the title changed to *Saint George*, to the University of Glasgow. Based on this information, Tancock proposed 1906 as the date for the definitive version.
3. Reproduced in Elsen 1980, 22.
4. Beausire 1988, 251, 257, 259, 271, 283.

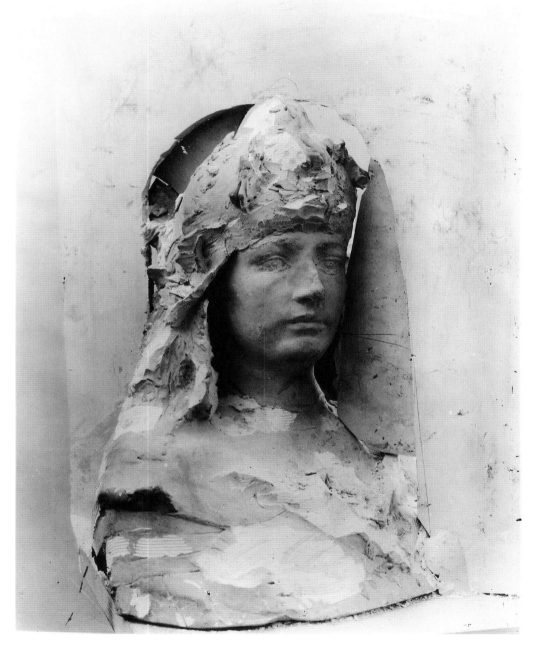

Fig. 118. Jacques-Ernst Bulloz, *"France in niche,"* plaster and clay, c. 1906, gelatin silver print. Musée Rodin, Paris.

Monuments to and Portraits of Artists

Perhaps no other artist made as many portraits and monuments to art and artists as Rodin. This section begins with *The Gates of Hell*, which were intended for a museum of decorative arts and to celebrate the central role of the artist in society. *The Gates* are a monument to creators and creation as personified by *The Thinker* and the agitated population that has issued from his brain. Rodin's public monuments to the painters Jules Bastien-Lepage and Claude Lorrain were far more successful by comparison with what the artist felt to have been a disastrous defeat for his proposed tribute to Honoré de Balzac. Monuments to writers tried his imagination and skill far more than those to painters.

Recalling the struggle of artists since the Renaissance to win intellectual respect equal to writers or practitioners of the liberal arts, Rodin's portraits of painters and sculptors are free of professional attributes such as palettes and mallets. Aimé-Jules Dalou, Jean-Alexandre Falguière, and Pierre Puvis de Chavannes, for example, are given the dignity of statesmen and a capacity for serious reflection. The portraits of artists are here joined with the monuments and separated from other portraits to give a sense of how much of Rodin's art was devoted to the artist's profession.

The Gates of Hell
(La porte de l'enfer), 1880–c. 1900

- Bronze, Coubertin Foundry, cast 1981, no. 5
- 250¾ x 158 x 333/8 in. (636.9 x 401.3 x 84.8 cm)
- Inscribed on left socle, left side: Fonderie de Coubertin; below that:
 © By Musée Rodin 1981; left side, back, lower corner: No. 5
- Marks on left socle, left side: Coubertin Foundry seal
- Gift of the B. Gerald Cantor Collection, 1985.86

Figures 119, 144

*T*he *Gates of Hell* is an original work of art in every sense. It was unusual from the nature of the commission in 1880 to the time the artist stopped working on it in 1900. Never before had an artist working for a government insisted on and received the freedom that Rodin did. No previous artist had taken comparable liberties with the relationship of sculpture to architecture and with a subject that was ultimately beyond iconographic tradition and without a definitive textual base. The modernity of *The Gates of Hell* lies in Rodin's reliance on his intuition, shaped by his experience with life and art, to give *The Gates* its self-contained unity of meaning and form.

Neither when Rodin began nor when he stopped work on this project did there exist a building to receive the doors. The government's unrealized intention had been to build a new museum of decorative arts somewhere in Paris, at one time on the site of the ruined Accounting Court, which is today occupied by the Musée d'Orsay.[1] Rodin was never given measurements for his doors nor assigned an architect with whom to work and who could have designed the frame and its moldings. No delivery date was set. Moreover, Rodin explained, "they left to me the choice of my subject."[2] The several persons who subsequently occupied the government office that had commissioned *The Gates of Hell* seem never to have concerned themselves with how strictly Rodin adhered to the agreed theme of Dante's *Divine Comedy*, perhaps because the sculptor had chosen it. He was unjustly accused of being unable to finish his commission, but, in

fact, the French government never called for its casting during the artist's lifetime. (This may well have been because a location could not be agreed on by officials.) There were several times in the 1880s when the artist informed the government that his sculptured doors were ready for casting. Rodin, in fact, completed *The Gates of Hell* in less time than Ghiberti finished either of his two doors for the Florentine Baptistery, 22 and 27 years respectively. We know *The Gates of Hell* in bronze only because of posthumous casts requested privately and authorized by the French government, which had owned them from the time Rodin accepted the commission.

It was in the summer of 1880 that Rodin received the official commission to make a bronze portal containing reliefs based on Dante's *Divine Comedy* to go in front of a proposed museum of decorative arts in Paris.[3] To give such a commission to a middle-aged artist without École des beaux-arts training and no previous experience on such a project, whose limited exposure in the salons had been tainted by the accusation of having cast from life, was an act not only of great confidence but also of daring.[4] Rodin was the beneficiary of a more liberal climate in government, whereas under the previous, conservative regime he had been ignored. The new undersecretary for fine arts, Edmond Turquet, was a lawyer and avid amateur of the arts, who had thoroughly investigated the charges against Rodin regarding the modeling of *The Age of Bronze* (cat. nos. 1–3) and found them unwarranted. He was replacing a very conservative official, the Marquis de Chennevières, and the selection of Rodin, without a competition, was an affirmation of Turquet's faith in the artist, his own political independence, and a demonstration of a liberalized attitude toward government commissions.

Rodin set the theme and format for the doors himself with Turquet's concurrence. Through friendly intermediaries who were advocates of his cause, Rodin knew months before the official decree that he would get the commission. This gave him time to rough out his plans sufficiently to reassure Turquet. At least since 1875 Rodin had been reading Dante in Antoine de Rivarol's eighteenth-century French translation and making drawings; his *Seated Ugolino* (1876, fig. 154) had been inspired by Dante's cantos. Some years later he was to tell a reporter that he had lived for a whole year making drawings after Dante at the outset of his project, but in a letter written in 1883 to art critic Léon Gauchez, Rodin indicated that he was still making drawings after the poem.[5]

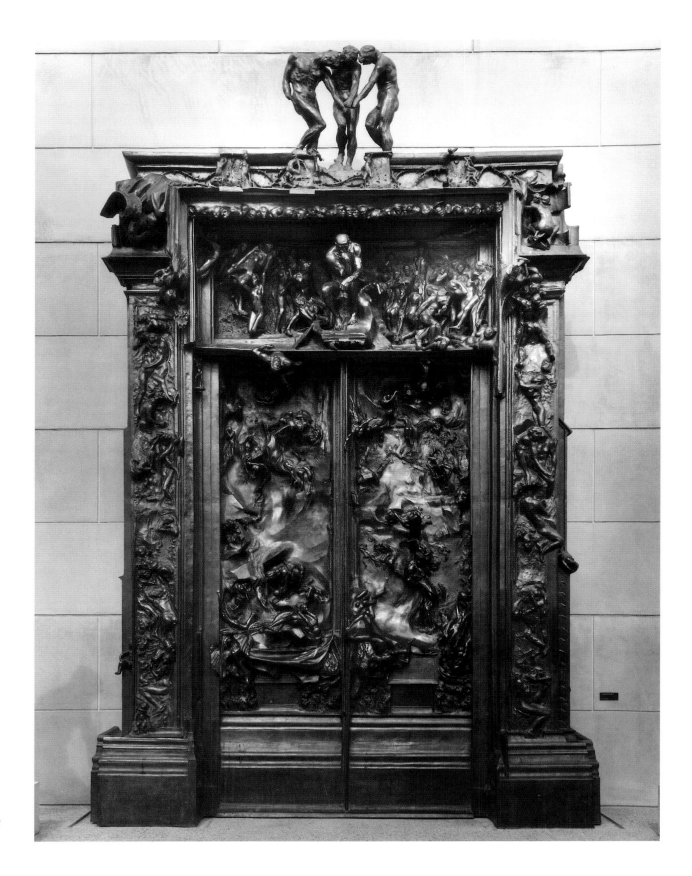

Fig. 119. *The Gates of Hell* (cat. no. 37).

The mood of these drawings after Dante is black. Rodin was drawn to characters who experienced self-inflicted tragedy and aggressions against the body.[6] The drawings inspired by Dante that were most germane to the final portal were those related to the tragic lovers Paolo and Francesca and the horrific story of Count Ugolino and his dying children. There are several drawings of seated, muscular male nudes in states of cogitation and funereal despair, which may be considered ancestral to *The Thinker*. The presence in the drawings of centaurs, mothers with children, and falling figures presages their equivalents on *The Gates of Hell*.[7] There are a few drawings of large groups of people in relieflike arrangements, but there is no evidence Rodin planned to systematically use drawings to compose the eight large relief panels called for by his architectural sketches.

That none of these figural drawings provided the literal basis for the sculptures in *The Gates* is indicative of Rodin's decision, at least by 1883, to work from many live models freely roaming about his studio. Critical to the portal's sculptural development and also to that of his entire art and artistic freedom, the commission gave Rodin both a free studio and the funds to hire a large number of models, which encouraged him to work more from life than from memory and imagination. Written in the third person for the editor Gaston Schéfer in 1883, the sculptor included in his autobiography this description: "Overjoyed at the happiness of being able to create sculpture with complete freedom as he had always wanted, Rodin now worked with the same joyful enthusiasm as the artists of former times, needing money chiefly to pay the models he always has in his studio and whom he often allows to move about freely, though he watches them out of the corner of an eye in order to learn from the originality which is in nature."[8] Rodin's drawings after Dante, for example, were derived from his imagination rather than conceived as paraphrases of paintings and illustrations by other artists. For the most part these beautifully worked drawings resisted translation into sculpture. The sculptor was determined to be an original even as an illustrator.[9] Given the existence of only a handful of drawings relating to *Purgatory* and *Paradise*, it is clear that Rodin was fascinated with the *Inferno* and with the evocative power of Dante's words, a sensory richness that, in fact, he compared with sculptural expression: "Dante is more profound and has more fire than I have been able to represent. He is a literary sculptor. He speaks in gestures as well as words; is precise and compre-hensive not only in sentiment and idea, but in the movement of the body."[10]

All known architectural drawings and models for *The Gates of Hell* have been published and elsewhere analyzed. Out of inexperience and perhaps to reassure his commissioner, Rodin fell back on clear historical models for the architecture and presentation of the sculpture. Quite simply, the evolution of the preliminary studies is from a relatively shallow, Italian, Ghiberti-like Renaissance paneled portal containing bas-reliefs to a deeper, quasi-late-French Gothic portal with figures ranging from very high to low relief and including some in the round (figs. 120–21). It was when he erected a big wooden, boxlike frame for his project, sometime after 1880, that he broke with older formats and invented his own.

Early Development of The Gates of Hell

Rodin was not an École des beaux-arts-trained sculptor, and his natural inclination was to rely on his intuition to solve problems rather than to follow the received solutions of others. This meant that he did not produce detailed drawings or plans for the final execution of *The Gates of Hell*. By the end of 1880 or later, in 1881, without warning his patron, and in his middle age, Rodin undertook a historically unprecedented gamble for a commission of this magnitude: *trusting his artistic intuition and experience as a decorative artist, he would improvise an epic on a heroic scale*. Today we can see the result, but of great interest is the course this twenty-year improvisation took and what it tells us, not just about Rodin's skills as a sculptor but about his mentality as well.

Early on he developed a general sense of the overall aesthetic effect he desired, which meant a more active and integrated relationship of sculpture to architecture, and for his great number of small figures he determined to employ all forms of relief and sculpture in the round. His literal frame of reference was basically a design of five rectangular compartments of varying depths demarcated by the architecture: two vertical side reliefs, two door panels and a tympanum. Until 1986, when Catherine Lampert published Jessie Lipscomb's 1887 photographs of *The Gates of Hell* (figs. 17, 122–124),[11] we had only contemporary descriptions of the evolving project that confirmed Rodin's method of trial and change, additions and subtractions. Unique in providing such a

Above: Fig. 120. *Preliminary Sketch for "The Gates of Hell", showing "Adam," "Eve," and "The Thinker,"* 1881, pen and ink, 6½ x 4⅜ in. (16.5 x 11.2 cm). Musée Rodin, Paris.

Right: Fig. 121. *Third Model for "The Gates of Hell,"* 1880, plaster, 43⅞ x 29½ x 11¹¹⁄₁₆ in. (111.5 x 75 x 30 cm). Musée Rodin, Paris.

complete record before 1900, the year Rodin completed *The Gates,* Lipscomb's photographs are most exciting to those who for years have wondered just how *The Gates of Hell* were made and what they looked like in the process. They tell us much about the way Rodin improvised form and theme. We now have visual evidence of what Rodin's thoughts and intuitions looked like long before he resolved his artistic problems and a far better sense of the problems, themselves and the staggering number of decisions he had to make.

What Lipscomb's photographs do not show us, however, is the appearance of the artist's studio filled with sculptures awaiting addition in the doors. Geffroy gave us a verbal picture of this situation in 1889, probably close to what Lipscomb would have seen: "The Door stands in the atelier on the rue de l'Université. . . . It is standing, and it is disseminated. . . . Everywhere in the vast room, on the sculpture stands, on the shelves, on the couch, on the chairs, on the floor, statuettes of all dimensions are scattered, faces upturned, arms twisted, legs

tensed, pell-mell, by chance, lying down or standing, giving the impression of a living cemetery. Behind the Door, six meters high, there is a crowd, a crowd mute and eloquent, that one ought to look at, individual by individual, as one leafs through and reads a book."[12]

Between 1884 and 1887 Rodin had also been working intensely on the commission for *The Burghers of Calais*, and much time was taken away from *The Gates*.[13] The year that Lipscomb took her pictures, however, was one during which Rodin evidently made many changes on the portal, to judge from the differences between the photographs and Truman Bartlett's descriptions of the doors. Having seen the doors in November 1887, Bartlett published his observations in ten articles in 1889.

By 1887 Rodin must have suspected that the proposed museum of decorative arts would not be built. Why then such intense activity? It may have been motivated by anticipation of the portal's proposed first public showing two years later in the Exposition universelle of 1889.[14] This was the centenary of the French Revolution, and Rodin was also planning to exhibit his *Burghers of Calais* in completed form. For a patriotic French artist such as Rodin, this occasion, the opportunity to show the public the fulfillment of two great commissions and establish his reputation, was the chance of a lifetime.

As seen in Lipscomb's photographs, the portal was divided into a series of large, discrete plaster sections, which could be mounted with rotating, wedge-shaped clips on the plaster armature, reinforced with wood. When detached, the plaster sections could be worked on with greater ease.

Top: Fig. 122. Jessie Lipscomb, *Upper Section of "The Gates of Hell" with "The Three Shades,"* 1887, albumen print. Musée Rodin, Paris.

Above: Fig. 123. Jessie Lipscomb, *Upper Section of "The Gates of Hell,"* 1887, albumen print. Musée Rodin, Paris.

Fig. 124. Jessie Lipscomb, *Lower Section of "The Gates of Hell,"* 1887, albumen print. Musée Rodin, Paris.

Whether the plaster was in a vertical or horizontal position, Rodin could insert figures or make background changes in clay directly on the plaster panels.[15] Lipscomb's photographs clearly show some dark places where clay had been applied directly to the plaster. When judged successful, the clay additions were cast in plaster and attached to the panels.

We have always known that the tympanum was a box that could be separated from the structure as a whole; it exists as such in the reserve of the Musée Rodin. The photographs make it clear that all the major sections—the door panels, vertical side reliefs, corner areas above the cornices, and the entablature—were distinct, and in the case of the right side relief with its subdivided units, they could be fitted into or onto the basic frame of the doors. The extruding wedges along the right side of the doors, visible in the Lipscomb photographs, hold the side reliefs out from the frame to which the tympanum and door panels are attached. It seems that Rodin wanted the side relief to protrude farther from the door panel to increase the depth of the structure. In the photograph showing the lower half of the door (fig. 124), it is apparent that Rodin had begun to model in the right corner a deep, Gothic-style molding directly onto the plaster or plaster-coated wood framing. It protrudes farther than the surface of the external right relief and would have distinguished this area from the doors. This tentative architectural feature is very different in design from the final, similarly truncated molding that ends

lower down, just at the point where the bottom of the right side relief begins.

We know that Rodin planned to have deep, continuous, vertical moldings, which would have separated the side reliefs from the doors even farther. In Lipscomb's photographs we can see that at the top and bottom these deep moldings are truncated. In the final portal each of the four truncated moldings are of different lengths and design, as if Rodin were testing their suitability. We cannot be sure that he ever actually extended the vertical moldings on the sides to the entire height of the door, but it is reasonable to assume that if he decided not to do so by 1900, it would have been because he could see that they would cast too much shadow on both the door panels and the side reliefs.

In his few recorded comments on the doors after 1900 no mention is made of unifying the moldings' design or of connecting the upper and lower segments that flank the doors. Rodin thereby sustained architectural asymmetry in all areas above the lower horizontal moldings and below the topmost cornice. Why? This was probably one of those decisions not made at the outset but arrived at over time as he reflected on the potential overall effect and his desire to avoid a cold and dry appearance.

The 1887 photographs dramatize Rodin's problems with the architecture of the portal. Due to inexperience he may have fretted more over the moldings than over his figures, and he never seems to have been satisfied with what he had done. At first he hired an architect but then rejected his designs. From the photographs it appears that Rodin would later change the design of every visible molding, capital, and cornice based on how their effects accorded not just with the sculpture but with the portal as a whole.

At the top of the portal, on which stands *The Three Shades*, the upper cornice is separated from the tympanum by a series of wedge-shaped corbels. As seen in a lithograph (after a photograph) reproduced by Bartlett in 1889, the corbels were removed and replaced by an enlarged cornice above *The Thinker*'s head.[16] It was not until a decade later that along the bottom edge of this cornice Rodin would model a series of human heads, like a rosary of suffering. It would also appear that the

sagging profile of the final tympanum's upper cornice may not have been caused by the weight of *The Three Shades* but could have been deliberately introduced by Rodin to eliminate straight lines, thereby softening its interaction with the sculpture, probably as part of his final reworking of the architecture.

The photographs give insight into the empirical, intuitive way Rodin developed his rich symbolism. The motif of the entwined vines is an example. Just below the topmost cornice, Rodin, by 1887, had modeled vines that are increasingly laden with fruit as they extend to the right. (The thick line of rounded fruit above and to the right of *The Thinker's* head might have suggested the later addition of the line of heads.) By 1888, however, Rodin had removed the foliage, replaced the vines with coarse ropes, and introduced the two inverted central brackets, as evidenced by the lithograph. In 1888 Bartlett's unpublished notes indicate that "thorn vines are to be found below the *Three Shades*." Rodin may have modeled the vines with clay on the ropes themselves. The vines were then made to navigate behind four inverted brackets. At the far right, these vines begin, or end, next to the lesbian couple ("two young female forms embracing each other," according to Bartlett), who were presumably added shortly after Lipscomb took her photographs but before Bartlett saw them later in 1887, thereby filling the upper-right corner, which appears vacant in the photographs.[17] The mother and child visible in the upper-left corner (fig. 122) were in harmony with the fruitful nature of the foliate motif, but, as Rodin seems to have realized later, not in keeping with the overall retributive message of *The Gates*.[18] The final crisscrossed vines above the head of *The Thinker* evoke the association of a crown of thorns, not just for the portal's population but especially for the secular figure who has taken Christ's judgment seat. This sequence of changes suggests the evolution of Rodin's thought concerning the way that decorative elements could assume symbolic significance as well.

What Lipscomb's photographs show is that the artist was only about two-thirds of the way to completion by 1887. Granted that some figures and panels may have been finished but not yet inserted, there was still a considerable amount of work to do on the sculpture, not to mention Rodin's almost complete redesign of the architecture. This helps explain the enormous expense of two periods—1887 to 1889 and 1898 to 1900—of intense work engaged in by Rodin with a large crew of assistants.[19] Rather than the tympanum's figural arrangement having been completed by 1884, as previously thought, Lipscomb's documents prove that three years later it remained unfinished and that Rodin would later redo the outer edges of the left and right tympanum groups. Probably within months of Lipscomb's photography, judging by Bartlett, Rodin introduced the flying figures that come from the tympanum's upper left to hover above a new figure, *The Kneeling Fauness*, who would be placed slightly in front of the original group (compare figs. 122 and 130).[20] Behind *The Thinker* it appears that Rodin made drastic changes; a sheet of paper hides what may have been a hole in the relief where he deleted one or more figures. In the final tympanum Rodin introduced the upright version of the small *Martyr* (see fig. 211), who in her vertical orientation just behind *The Crouching Woman* (1880–81) appears to be running to the right, led by the figure of a stumbling woman.

In Lipscomb's photographs most of the final figures are in place on the right side of the tympanum, but the highest male figure is headless and would later be given a horned head, presumably of a demon.[21] The kneeling figure with twisted torso stands out in the right corner, but she was replaced shortly after the photograph by four other figures, two of whom are lying on their backs. Bartlett was moved by the last standing figure to the right, "a young girl whose right hand is raised to her chin, the latter meeting it at the shoulder, while her left arm is extended near her body."[22] It is hard to tell from the photographs, but it also appears that the swaying and somewhat bowed figure later known as *Meditation* (cat. nos. 61–62) was not in the right-hand group in 1887. In sum, the tympanum area when Lipscomb saw it did not have as many figures in the round nor its corners filled as they would later be, and it lacked the final concerted lateral drive of the crowd. Probably within a year, Rodin created a second crowd in front of the original groups, enriching the motif and giving the composition greater depth and heightened chiaroscuro. By adding the prone figures at the right—the head of one protrudes beyond the lintel (*Study for "A Damned Woman,"* cat. no. 63)—he was able to pick up lighting accents that balanced *The Falling Man* (cat. no. 64), who clings to the same lintel just below and to the left of *The Thinker*.

Except for the uppermost section on the right panel (see fig. 123), the two vertical side reliefs had been completed. These too were admired in late 1887 by Bartlett, who appreciated their "extraordinary reach of line. As pieces of color they are almost beyond praise."[23]

Lipscomb's photographs were taken before the top of the right bas-relief had been completed. Rodin was to fill this gap later by adding the couple (*I Am Beautiful* [see fig. 197]), formed in 1882 by his union of *The Crouching Woman* with *The Falling Man*, atop which was added the form of the fallen angel whose wings were merged with the architectural molding. When Bartlett visited the studio, he saw the couple, whom he assumed (or was told) were *Paolo and Francesca* (cat. no. 50), awaiting their placement atop the right bas-relief. "Of the many studies which the sculptor has made of this subject, the one that will go on the door represents the figure of a powerful man holding to his breast and neck, with all the desperation of undying love, the folded together form of a woman."[24] In Lipscomb's photograph, in the right side relief (see fig. 123) one can see where Rodin added clay around the leg of the headless, squatting mother located in the second register from the top. The absence of heads for the mother and the child next to her may reflect Rodin's practice of removing sections in high relief to prevent studio damage, or he may have sought to change them.

A reasonable explanation for the early completion of the side reliefs is that in the years between 1878 and 1882 Rodin had made reliefs for ceramics at the Manufacture of Sèvres.[25] This was part of the artisanship Rodin counted on to underwrite his gamble. In terms of motifs and form, the Sèvres porcelain reliefs are certainly parents or, if contemporary, brothers and sisters of those on the flanks of the portal.[26] In the years 1880–82 Rodin could have worked on the Sèvres projects by day and his own reliefs at night, weekends, or days not spent at the factory. These ceramics with their motif of the mother and child would also have served as background for the reliefs below the tombs that Rodin added in 1899–1900 (figs. 125 and 212).

Clearly, the door panels gave Rodin the greatest trouble in terms of sculpture. The low reliefs of figures in shallow space that he had made at Sèvres helped him get started but did not prepare him for the problems of working in the deep space afforded by the doors, where the action of light and shadow was more complex. It was his early decision to introduce figures and groups almost in the round, like that of Ugolino and his sons, that reworked the problem. Rodin had removed from both doors what Octave Mirbeau had described in 1885 as "tragic masks, the heads of furies, terrible or gracious allegories of guilty passions."[27] With the exception of the *Ugolino* group and the new version of *Paolo and Francesca* just below them, almost the entirety of the two doors was to be reworked. Although Lipscomb's photographs are not sharply detailed, it appears as if Rodin almost totally scrapped the right door panel and probably after 1898 made a drastically different composition. By that time he had clarified the clusters of figures and of volumes, or what he would have referred to as the "principal masses." He gained more variety by augmenting the figural range—especially of strongly projecting and receding forms—from small to large and from low to high relief, achieving greater compositional vigor and more extreme tonal contrasts. The addition of the falling angel seen foreshortened just below *The Falling Man* in the left panel and of the falling man with arms outstretched in the right door at its left edge brought light into the upper zones of both doors. In the left panel above *Ugolino* Rodin retained a few of the original figures and added *The Three Sirens* before 1889 (fig. 434).[28]

Fig. 125. Detail of *The Gates of Hell*: tomb on right door panel flanked by reliefs of mothers and children, c. 1899-1900.

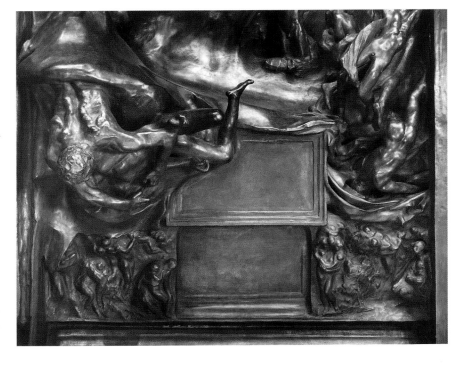

Rodin totally resolved the background, opening up the area just above the *Ugolino* group. This gave his composition greater breathing space and created areas to receive deposits of shadow or to reflect light.

The Final Doors

In 1899–1900 the two reliefs with the masks of grieving women in their centers were replaced by the tombs and figures above them, and new reliefs of women and children closed out the program at the very bottom. The reliefs with the masks may have come to seem static and conventional compositionally, and they certainly did not help interweave the movements of the groups in the lower doors. After 1898 Rodin would finally add the lower moldings to the door panels, which in 1887 had not even been inserted, and the two lower jamb reliefs of his self-portrait with a muse and *Eve* (figs. 126–127).

Crucial to Rodin's thinking from beginning to end was how to marry his sculpture with changing natural light, the effect of which gave him sculptural color. Looking at a photograph of the final doors in plaster (fig. 128), one can see how he won a greater tonal range from the highlighted forms of the side reliefs and those of *The Thinker, The Falling Man*, and groups at the bottom of the door panels, to the middle tones of the blond shadows, and then gradually to the deepest values in the tympanum and areas of the tombs. The staging of *The Thinker* stresses his physical detachment from the crowd in the tympanum. This depends on the framing and depth of the tympanum, which causes him to be often the only strongly illuminated figure. All these things underscore the inductive nature of Rodin's thought and demonstrate that the final doors could not have been visualized at the outset. By deciding early against a continuous narrative and against relating the compartments of the doors to Dante's circles of hell segregating types of sin and degrees of pain, Rodin was free to introduce individual or paired figures and groups wherever he liked as compositional or structural needs dictated.

Not the least of the reasons Rodin was a modern artist is that in the evolution of *The Gates* he enacted what was to become a fundamental right for the most daring artists, such as Henri Matisse and Pablo Picasso, who followed: it was the demands of the evolving work of art that gave Rodin his warrant of artistic freedom. Lipscomb's photographs are precious testimony to

Fig. 126. Detail of *The Gates of Hell:* Rodin's self-portrait relief, c. 1899-1900.

Fig. 127. Detail of *The Gates of Hell: Eve,* c. 1899-1900.

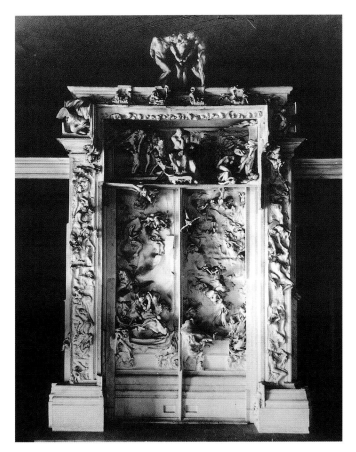

Fig. 128. Charles Berthelomier, *"The Gates of Hell" in plaster* (A96).

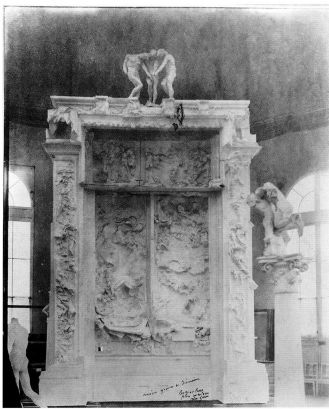

Fig. 129. Eugène Druet, *"The Gates of Hell" as installed in Rodin's 1900 Exhibition*, 1900, gelatin silver print inscribed in ink by Rodin. Musée Rodin, Paris.

Rodin's unique and unsystematic, improvisational method of work, in which he did his creating as part of the continuum of fabrication, drawing inspiration not from existing models or plans but in direct response to the work in progress, from what he judged would make artistic sense. Geffroy understood this well, and he commented in 1889 that "with [Rodin] the form is born at the same time as the idea, and perhaps even before the idea."[29]

Aware of Rodin's unconventional and highly personal method, many critics faulted the artist for taking so long and for showing *The Gates* in 1900 divested of those parts in high relief or in the round (fig. 129). These components had been removed to prevent breakage in transportation, but time was lacking to restore them as his great self-sponsored and expensive retrospective was close to opening. For the exhibition to have failed financially would have meant economic ruin for the sculptor. Ignored by even his defenders was the fact that the government never called for the portal's casting. Some who saw the 1900 exhibition, such as the young Emile-Antoine Bourdelle, argued that the sculptor should leave *The Gates* the way they were. In response to the criticism that his portal divested of figures in high relief was preferable to their inclusion, that it was "too full of holes," Rodin personally expressed his intentions:

> Take more room to examine my gate from a little farther off, and you will see at once the effect of the whole, the effect of unity which charms you when it is deprived of its ornamentation. You must understand that my sculpture is so calculated as to melt into the principal masses. For that matter, it completes them by modeling them into light. The essential designs are there: it is possible that in the course of the final work I may find it necessary to diminish such and such a projection, to fill out such and such a pool of shadow; nevertheless leave this difficulty to my fifty years of artisanship and experience, and you may be sure that quite by myself I shall find the best way of finishing my work.[30]

What Rodin was enunciating was the early modern principle of *the decorative*, in which the treatment of the parts is subject to the aesthetic requirements of the whole.

It is conventional wisdom that the form and aesthetic

effect of *The Gates* reflect the influences of Michelangelo, Rubens, Théodore Géricault, and Eugène Delacroix, whose paintings inspired Rodin to create their equivalent in bronze and in his own sculptural idiom. Such views are often based on looking at photographs, which literally put painting and sculpture on the same plane, freeze light and shadow in *The Gates*, and do not take several factors into account. At the outset Rodin rejected the idea of a continuous narrative based on a written text in favor of disjunctive episodes, isolated groups, pairs and single figures, mostly of his own invention. He rejected showing the sculptures as if they were to be seen from a fixed point of view. Look, for example, at the various ways by which Rodin's figures are seen against the background to which they are attached: from above and from the side, sinking into or exploding out of it. Trying to visualize such an environment in one's mind is impossible. Rodin's modernity included creating not just the unthinkable in terms of subject but the otherwise *unimaginable* in terms of place and space. (Bartlett settled for calling the doors a "perpendicular section of the damned world.") Except for the tympanum, there is no part of the portal with a preexisting space and scale to which figures must conform. There is nothing in the work of the painters with whom Rodin has been compared to match his disjunctive narrative, roving perspective, close conjunction of figures in wildly different sizes and orientations who largely create the space in which they move, and creation of open spaces to receive actual changes of light and shadow. Rodin did not need painters to teach him how to model his figural masses, as he put it, "into light." To Henri-Charles Dujardin-Beaumetz, Rodin expressed it well: "Sculptors today want to see and work like painters; they are fooling themselves; this doesn't lead them to the truth; their eye sees in bas-relief."[31]

Always conscious that his work was originally intended to go in the front of a museum of decorative arts, Rodin was inspired by the opportunity to build on the past but also to take relief sculpture and architecture where they had never been before. No contemporary French architect would have permitted the liberties Rodin took with the sculptures' relation to their framing. Rather than architectural sculpture, he created a sculptural architecture. Further, he was no more interested in translating pictorial devices into sculpture than in a literal translation of Dante's verses into bronze. He reveled in those properties of sculpture unavailable to painters. Sculpture was tangible and lived in actual space, animated by changing natural light. Unlike the painter of a fresco or mural who depicts light, the sculptor had to predict how his composition would look not just from a frontal prospect but from side and oblique views, near and far, all in varying levels of illumination. One can stand back to take in the whole of *The Gates* or move close to the tomb at the lower right and look up, around, and into Rodin's world. The disjunctive arrangement of episodes, the roving perspective, the inconsistent scale and orientation of figures were unprecedented. There is no equivalent experience to be accommodated in painting, much less in sculpture, before or after Rodin.

Just as for his contemporary Paul Cézanne, Rodin's modernity includes the change in his mentality, which caused him to prefer and champion in sculpture the *artistically complete*—meaning that there was nothing more the artist wanted to add—over "finish" in terms of the treatment of all details. After 1900 there is no evidence Rodin was dissatisfied with the sculpture of *The Gates* or that he did not consider this major project as complete. On Druet's photograph of the plaster *Gates* in 1900 (fig. 129) Rodin wrote that he wanted "the dimensions less bulky, the moldings less colorful and more fine" (*Moins grosses à dimension, les moulures plus incolorés, plus fines*). He also told René Chéruy sometime between 1902 and 1908 that he was not yet satisfied with its architecture and wanted to work more on the molding.[32] From 1900 until his death, Rodin had more than a dozen years of good health during which to make these changes. He could have ordered removal of the stepped pilasters on the flanks of the portal to reduce the overall width. He could have redesigned the moldings, made them simpler, finer, and consistent in style, and had this work executed and applied by his assistants. Lipscomb's photographs show how this might have been done, but he did none of these things.[33]

It was really not a matter of waiting for the government to call for their casting. The two or three months he claimed would be required to finish the doors would have involved the reassembly of the elements that had been removed in 1900. During the last years of his life he knew *The Gates* would stand in his own museum in Paris, sufficient incentive to make further minor changes if he had been so inclined. It is my view that out of disappointment Rodin may have deferred architectural revisions in the years immediately after 1900, when the government did not call for the work's casting and placement in the

Louvre. But as time passed, he came to terms with his creation, considering it complete if not finished, accepting its stylistic inconsistencies the way he did with such sculptures as *Meditation with Arms* and *Meditation without Arms* (cat. nos. 61–62). The truncated vertical moldings were analogous to the stumps of limbs he had amputated from such figures as the latter and such figures as *Torso of a Young Woman* (cat. no. 177). The final portal (see fig. 128) was assembled in 1917 by the first curator of the Musée Rodin, Léonce Bénédite; it is doubtful that he had Rodin's consent, as he later claimed.[34]

For those who stand close to *The Gates*, the details are certainly compelling, and one has no sense of the totality. But to stand back and take in the whole, as Rodin asked, is to see that his sculptor's intuition as a modern composer was guided by what he and the more sophisticated critics considered "the decorative effect." As Camille Mauclair put it, "He never forgot the decorative effect and the harmonious aspects and concordances that the portal had to have."[35] Some contemporary critics of Rodin recognized his extraordinary compositional achievement. In 1901 W. C. Brownell offered his analysis after having studied the disassembled plaster portal in Rodin's 1900 exhibition:

> He is said to have a defective sense of design. . . . It is true that he is not a great composer in the sense of composing with native zest and seeing a completed ensemble first of all and with intuitive imagination. . . . I do not think it can be said that the *Porte de l'Enfer* is not a great composition. It is distributed on large lines and the treatment of the theme is balanced and counterweighted with a curious felicity which serves to coordinate and throw into artistic relief the tumultuous hurly-burly and tremendous anarchy of the immensely various elements. These latter perhaps make more impression than the whole does; that is all one can reasonably say. If Rodin had been as instinctively drawn to the ensemble as he was to its elements, he would never have been so long in executing it.[36]

One look at *The Gates of Hell* reveals that for Rodin life after death is chaos.[37] Rodin's hell is no different from life: humanity's fate is to be afflicted by incessant movement without the hope of realizing goals and peace. In rejecting the systems of Dante's infernal geology and Catholic theology, Rodin was following in the wake of such great nineteenth-century French writers as Victor Hugo, Honoré de Balzac, and Charles Baudelaire, who modernized Dante's *Inferno* in terms of their experience with modern life in Paris.[38]

The Influence of Victor Hugo on Rodin's Gates of Hell

Rosalyn Frankel Jamison has proposed that Rodin's veneration of human creativity is the central theme of this modernized vision of Dante's hell. Crystallizing many aspects of the romantic view of genius and reflecting the influence of Victor Hugo in particular, *The Thinker* is the visual and thematic centerpiece of the ensemble. Though the ideas of Baudelaire have been regarded as the portal's closest literary counterpart, Jamison's research illuminated the clear and perhaps greater significance of Hugo's thought and suggested an unrecognized, overriding thematic unity in the portal.

The influence of Hugo's work on Rodin is embodied in the poet's central theme throughout his works, that of the universal poet-thinker, a concept related to Hugo's own concept of Dante—his imagery of a Dante-inspired hell and his figure of Dante as a symbol and prototype of the ideal poet. This notion was part of the century's larger theme of universal genius, which Hugo reflected and helped shape. Rodin was inspired to express this theme in his own sculptural terms in *The Gates* by formally expressing rather than illustrating Hugo's conception of the romantic genius as creator of the artistic epic. Rather than a canonical spiritual meaning in the portal—the hell of modern life viewed as the legacy of original sin, as might be suggested by Rodin's stated intention in 1881 to flank the portal with Adam and Eve—Rodin's image of hell contemplated by a thinker is given a revised interpretation through the filter of Hugo's thought. Hugo's taste for fusing symbols included a syncretistic interpretation of religious themes, which mined the parallels between the symbols of Adam, Christ, Prometheus, Orpheus and the notion of the poet-thinker. Inspired by Hugo's multivalent symbols and imagery, Rodin further transformed and personalized the nineteenth-century theme of genius.

Rodin's break with the traditional architectural format of a structured, multipaneled door corresponded with his move away from using Dante's *Divine Comedy* as the explicit inspirational source. This early departure—

between late 1880 and early 1881 from a literal sculptural equivalent of the tiered structure and narrative format of Dante's hell in favor of a more open, multidimensional theme and form accords with the influence of Hugo's work. In Rodin's move away from the literary source in Dante while responding to influences from modern literature, the theme of Dante remained. The influence of Baudelaire's hell, itself reflecting the romantic interest in Dante, was clearly emphasized by Rodin. Baudelaire's *Fleurs du mal* (The Flowers of Evil, 1857) lay open in Rodin's studio as he worked on the portal, and indeed Rodin's image of hell shares the cynical and pessimistic spirit of Baudelaire's depiction of the ennui of modern life. If not as overtly acknowledged by Rodin, the influence of Hugo's thought is nevertheless proposed by Jamison as central to comprehending the theme and form of Rodin's hell. Hugo was the national poet of France, whose triumphal return to Paris in 1870, after the fall of the Second Empire, charged the political and artistic atmosphere of the decade preceding the portal's commission.[39]

Central to Hugo's recurrent theme of the poet-thinker was his evocative imagery of a thinker contemplating an epic vision of chaos: an image of crowds and space shifting in time, merging all of history, myth, and religion. These visions evoke not only Dante's *Inferno* but also Hugo's recurring theme of chaos tamed by the poet-thinker's inspired vision and his emphasis on the spiritual nature of the poet-thinker's role.[40]

Hugo offered a heroic image of the poet-thinker that contrasts with the early romantic image of a recluse isolated in an interior world of contemplation. Hugo's thinker, a strong and active figure engaged in civic and political action who creates a "literature of protest," represented the universal genius motivated by an optimistic idealism to advance human progress. Hugo's concept of the thinker, however, encompassed paradoxes: at times he was a heroic figure vigorously fulfilling a noble spiritual mission, at other times the thinker was reduced to a tragic creator-martyr overcome by epic aspirations and the creative process, an austere and naked figure trembling before a chaotic vision of society and an elusive God.

Jamison stressed that Hugo's imagery and theme of chaos influenced not merely the theme of *The Gates* but its form as well. Most important thematically and chronologically for this interpretation is Hugo's epic *La légende des siècles* (The Legend of Centuries). A collection of poems published in three series (1859, 1877, and 1883), *La légende* constituted a philosophical and spiritual epic about humanity's progress. It originated in modern history but integrated myth, religion, and legend to express universal themes. In it Hugo replaced classical form, encompassing delimited time, space, action, and idealized heroes, with a new concept of place as the universe and of the hero as anonymous, unconventional, and even paradoxical.

In the introductory poem of the 1877 series, "La Vision d'où est sorti ce livre" ("The vision from which this book emerged"), the image from Hugo's earlier works of a "wall of contemplation" receives its most graphic expression.[41] The poem opens with the poet announcing that he has had a dream in which "*le mur des siècles*" (wall of centuries) appeared to him. He goes on to evoke the paradoxical nature of this wall as both a barrier and a threshold, inanimate solidity as well as palpitating flesh, an immobility comprised of anxiety. It is a barrier and at the same time a mob, its elements like vast bas-reliefs or colossal frescoes, its solid surfaces fluid, transforming themselves before the poet's gaze into openings in which groups of figures evolve into an image of all existence and human destiny going back to Adam and Eve. Before the poet's gaze the surfaces prolong themselves endlessly into all of humanity, the universe, and destiny: "Les fléaux, les douleurs, l'ignorance, la faim, / La superstition, la science, l'histoire, / Comme à perte de vue une façade noire" (The calamities, suffering, ignorance, hunger, / Superstition, science, history, / As far as the eye can see, a black facade [lines 34–36]). The final paradox: a wall rises to a great height yet its interior seems formless and collapsing: "Et ce mur, composé de tout ce qui croula, / Se dressait, escarpé, triste, informe" (And this wall, composed of all that crumbled, / Stood erect, precipitous, sad and formless [lines 37–38]). Hugo later reveals the wall's metaphorical meaning: "C'est l'épopée humaine, âpre, immense,— écroulée" (It is the human epic, bleak, immense,—crumbling [line 240]).

Beyond these complex images, Rodin would have been especially intrigued by Hugo's beckoning the reader to envision the poetic creator of this great epic as a titan painter or sculptor:

Quel titan avait peint cette chose inouïe?
Sur la paroi sans fond de l'ombre épanouie
Qui donc avait sculpté ce rêve où j'étouffais?

Quel bras avait construit avec tous les forfaits,
Tous les deuils, tous les pleurs, toutes les
 épouvantes,
Ce vaste enchaînement de tenebres vivantes?

What titan had painted this unheard-of thing?
On the bottomless wall of expanding shadow
Who then had sculpted this dream in which I
 suffocated?
What arm had constructed with all the crimes,
All the sorrow, all the tears, all the terror,
This vast enchainment of animated gloom?
 (lines 119–24)

These analogies to the visual arts, frequently invoked by Hugo to render more graphic the "unrivaled" power of the word and his own poetic feats, may have posed a challenge to Rodin to create the poet's "wall of contemplation" on his own terms.

Rodin's image of hell is comparable to poems such as "La Vision d'où est sorti ce livre," which are more evocative in relation to the medieval prototype, rather than to poems like "La vision de Dante" (*La légende*, 1883, poem XX), which are a closer paraphrase of Dante's themes and long narrative sequences. "La vision d'où est sorti ce livre," for example, presents the thinker's epic visions by evoking chaos through disjunctive episodes and motifs that mirror the poet's process of dynamic thought and creation as he endeavors to synthesize the history of humanity in all of its epic breadth and scope. Rodin's format and composition in *The Gates* suggest an equivalent achievement in visual synthesis. Rather than an illustration of the imagery in this poem, the portal shows a comparable disjunctive mode of composition, an image of chaos ordered intuitively and improvised according to principles of decorative unity to produce the novel effect of a discontinuous, fluid structure. *The Gates* may represent Rodin's effort to give sculptural form to Hugo's themes. If so, then the imagery of poet-thinker confronting chaos can be interpreted as an act of symbolic union with Hugo's thinker theme itself, though it is a creative act to be importantly distinguished from that of illustration.

Exploring the potential of sculpture to its fullest, Rodin produced within the armature of a door a monumental composition expressive of chaos. Aside from the few larger figures that surmount and flank the structure, the composition is devoid of the large figures, clear fig-

ural groupings, and compositional structure traditional for monumental works and comprises instead, a whirlwind of small figures and empty spaces. Rodin created a compelling and expressive visual metaphor for the interior of the mind, fusing in one dynamic space a structure of chaos and unity that captures the most abstract aspects of Hugo's image of the wall of contemplation: its sheer flow of space and figures, paradoxical sensations of architecture and flesh, and astonishing fluidity. This profound relationship of Rodin's work to a literary source provides a context for understanding Rodin's innovations in forming a "wall of chaos" in *The Gates*. It provides as well and somewhat ironically his defense of the portal's unliterary character, intended to assert his nonillustrational approach to literary sources in a time when some of the most advanced artists favored art inspired by formal values.

Viewing the portal in relation to Hugo's work also deepens our understanding of Rodin's identification with *The Thinker*. This identification is further suggested by Rodin's apparent placement of his self-portrait on the side relief at the portal's base (see fig. 126) and by his designation of *The Thinker* as his own tombstone at Meudon.[42] In the context of Hugo's thought, Rodin's self-portrait as a visual parallel to Rodin's *The Thinker* not only identifies the portal's creator but offers a philosophical signature: Rodin identifies himself with Dante as the universal poet-thinker in Hugo's work and with the open-ended legacy of Dante championed by Hugo. Through this legacy Rodin could advance his self-definition as creator and place the "thinker-sculptor" within the universal line of genius.

Imposing his personal interpretation onto one of the century's rich and universal literary symbols, Rodin's *Thinker* fulfills the sculptor's own definition of a "clear symbol," a self-sufficient, intuitive, and natural symbol, one that does not rely on text to be understood. The form and composition of the entire portal embodies the meaning of *The Thinker* and affirms Rodin's place within the history of creative genius. Rodin's identification extended the meanings Hugo gave to the thinker; conversely, Rodin did not reflect every aspect of the social and prophetic role Hugo gave his thinker. Most important, Hugo elucidated the heroic challenges and tragic sacrifices of creativity but stressed the mysterious, quasidivine nature of the creative act itself, offering a theory of genius based on the premise that art is a basic manifestation of God. The analogy of art to divine creation was a

lifelong preoccupation for Rodin and a theme seen in many of his works. Viewed in the context of Hugo's thought, the portal may have served Rodin as an emblem of the vital spiritual function of art in a society that questioned traditional spiritual values and institutions. This meaning would have been particularly apt if, as originally commissioned, the portal had served as a monumental entranceway to a decorative arts museum.

Rodin's Artistic Intentions in The Gates of Hell

In 1887, the earliest date at which the artist discussed his intentions, Rodin told Bartlett, "My sole idea is simply one of color and effect. There is no intention of classification or method of subject, no scheme of illustration or intended moral purpose. I followed my imagination, my own sense of arrangement, movement, and composition. It has been from the beginning, and will be to the end, simply and solely a matter of personal pleasure.[43] . . . It is very difficult for me to express in words just what I . . . have done on the door."[44]

 "*There is no intention of classification.*" Rodin was not a philosopher. He knew that Dante's society was not his own and that he would have to build his own image empirically, improvising over time, trusting to his intuitions about life as well as art as he lived and worked on *The Gates*. Not surprisingly the particular location of a figure or couple in the doors is not an indication of a type or degree of sin or pain. The same figure, such as *The Falling Man*, can be found in more than one area. Suffering is suffused throughout. High and low, left and right are not, as in previous Last Judgments, indicators of salvation or damnation. Having early rejected any symbolism of place on the portal, other than perhaps for *The Thinker*, Rodin was free to try an expressive couple, figure, or fragment anywhere it would seem to him to work as part of a group or area. That prerogative and the fact that some areas are often visually inaccessible to those standing on the ground must have constituted an important part of that "personal pleasure" about which he spoke.

 "*[No] method of subject, no scheme of illustration.*" Today the viewer of *The Gates* does not need a program to identify the cast of characters. Rodin's modernity lay in his creation of expressive figures and unresolved situations, and in his invitation to viewers to make of them what his or her own imagination and culture suggest. *The Gates of*

Hell did not start out that way, but after Rodin had made *Paolo and Francesca*, or *The Kiss, Ugolino and His Sons*, and possibly *The Three Shades* early in the project and within the first four years, he stopped illustrating specific characters and episodes in Dante. But there remain nameless entities whose progenitors appear in the cantos. There are centaurs in the *Inferno* who are guardians and inflict punishment, but those in *The Gates* are victims of passion. Rodin's hell has a greater population of women than does that of Dante.[45] Dante's epic—actually *Purgatory* and not the *Inferno*—knew the sound and sight of children, and likewise figures of children and infants abound on *The Gates*. What is stunningly modern in *The Gates* is that Rodin was the first sculptor to show the single-parent family. The family's fracture could be viewed as the result of the passions that obsessed Rodin's thinking. Dante's hell knew winged figures and serpents, and so does Rodin's, as he collapsed distinctions between his own time and the past, between mythology, literature, and religion, reflecting both the fundamental nineteenth-century interest in syncretizing these areas and intervening influences.

 "*[No] intended moral purpose.*" *The Gates* represented a daring commission by a new and more liberal arts administration as part of the Third Republic's effort to achieve the separation of church and state and the secularization of education.[46] The portal was intended to be the entrance to a museum, not a church, school, or administrative building.[47] Rodin had left the Church and its service as a young man. Nevertheless, his work is a compassionate commentary on the spiritual state of his time, or, one might say, it is Rodin's personal accounting, so unlike the positive image of modern life in impressionist works, of the moral cost of modern life. Rodin was showing the hidden conflicts of his age. Probably no more than Baudelaire did Rodin hope that his image of hell would make better people out of those who saw it. He offered no alternative thematically or theologically, suggesting only perhaps the consolation of self-knowledge and the hard work of art as salvation for the artist.

 "*It is very difficult for me to express in words just what I . . . have done on the door.*" By comparing his verbal limitations to Dante's eloquence, Rodin was also refuting the charge that his was a literary imagination. When he chose, he could illustrate Dante better than any sculptor before him. But after a period of living intensively with the *Inferno*, Rodin found that his vision of Dante was "not close enough to reality."[48] By 1881, when he could

employ a number of models to roam his studio, the word gave way to the reality of moving flesh, stretched muscles, arched backs, to provocative buttocks, grasping hands, collapsed bodies, exhausted countenances, and even lesbian love-making. In turn, this reality helped draw Rodin to the writers of his own time, and he continued to love poetry as another way to articulate and confirm his experiences. His discoveries in the living bodies of men and women, for example, gave the sensual striving and restless despair in Baudelaire's poetry new and personal meaning.[49]

Rodin's imagination obviously encompassed more than concerns about color and effect or making a monument to sculptural decoration. To a Dutch visitor in 1891 he pointed out that while working on the doors, "all of life passed through my mind while I studied this work. . . . Look at these lovers, condemned to eternal pain; they have given me the inspiration to represent love in different phases and poses where it would appear to our imagination. I must say the passion, because, above all, the work must be living."[50] One of the great ironies of *The Gates of Hell* was that through his sculpture Rodin wanted to pay tribute to life. For him life reduced to movement, not just the play of muscles in physical exertion, but agitations of the spirit manifested through the whole body and its surface. The passions motivated movement, and their unrequited nature constituted an internal and eternal hell. All phases of loneliness as well as love animate Rodin's people, and for the former he had the inspiration of his models in the studio as well as people on the street. Rodin talked of color and effect, but he also wanted his figures read as individuals. The precedent in literature for a disjunctive narrative was given to Rodin by Baudelaire and Hugo.

The key to understanding the meaning of *The Gates* is *The Thinker*. He is the creator in the creative act of forming within his mind the vision of life and art that we see realized all around him. The visionary's rugged countenance and powerful body were Rodin's way of democratizing the artist and calling attention to the physical work of art. In this figure Rodin champions and offers tribute to the central intellectual and spiritual role of the artist at all times in all societies. What better location for such a tribute than before an art museum.

Within *The Gates*, *The Thinker* is clearly the artist who thinks about art and life, the visionary surrounded by his vision. To understand *The Thinker*'s meaning, Rodin may have counted on his public's possible familiarity with Hugo's views on genius, as Jamison has argued, but certainly he did not rely on their knowledge of Hugo's themes or imagery for his thinker to be comprehensible. He created universal symbols that could be intuitively understood, "clear symbols," as he called them.[51] He relied on our being observant if not learned. Large or small, in or out of *The Gates*, *The Thinker* is blind, deaf, and dumb. Amid the howling mob that surrounds him in the portal, *The Thinker* hears nothing. Physically it is impossible for him to look down and into the doors below his feet, but even if he could, he is sightless as there are no irises in his eyes. His mouth is crushed against his right hand, which does not make a fist but instead points to the self. Shutting off all these physical attributes expresses for Rodin the requirements for the most important moment in the artist's life, that of creative thought. A life is spent gathering through the senses experiences on which the artist draws. That moment when the artist forms his vision means total exclusion of the external world of sights, sounds, and sensations; complete concentration with every muscle and brain cell is required to realize an inner vision, the creative idea.

No question but that Rodin was making propaganda for the artist. He was combating the popular image of the artist as all brawn and no brains, skill without intelligence.[52] Rodin, who called himself an artist-mason, was saying that the artist like himself who works with tangible often obdurate materials is brains and brawn; muscle is needed for the hard work of translating thought into visual art.

The Thinker cannot reproduce himself biologically, an ironic situation for an artist who, like Balzac, equated the making of art with sexuality. But Rodin, a father disappointed in his son, seems to be saying that art is the artist's true offspring. In *The Gates*, just behind and to the left of *The Thinker* and pressed against the rock on which he sits, is the form of *The Crouching Woman*, who can be seen as the artist's muse, with whom he spiritually and physically mates (fig. 130). Her expressive, agonized pose and gestures—one hand touching her breast, recalling the traditional gesture of inspiration, and the other grasping her foot, recalling the French idiom for orgasm—serve to convey the anguished strivings and sexual dynamics of inspiration and creation.[53] There results a poignant duet between her anguished gestures of desire for orgasm and the painful effort of *The Thinker*, seen in the tension in his body, to give birth to his creative thought.

Rodin could never be sure whether his portal would be installed indoors or outside, but his treatment of the reliefs and the door's depth suggests that he counted on the latter. *The Thinker* does not sit entirely within the tympanum; Rodin has pulled him forward so that he projects beyond the lintel. In this way he is both part of and detached from the damned, in and outside society. When the bronze portal is oriented so that it faces south, as at Stanford, it is not by accident that the early morning and late afternoon sun illuminate first and last the creative source of *The Gates of Hell*, *The Thinker*'s head and hand.

Rodin's self-portrait in relief in the lower-right section of the portal's base (see fig. 126), placed there by 1900, takes us back to the origins of the commission and one of his principal motivations in accepting it: "I wished to do something in small, nude figures. I had been accused of using casts from nature in the execution of my work, and I made the 'Saint John' to refute this, but it only partially succeeded. To prove completely that I could model from life as well as other sculptors, I determined . . . to make the sculpture on the door of figures smaller than life."[54] It appears that Rodin showed himself from his right profile, naked, crouching, his left hand to his forehead, his right hand by his right shoulder, with the small, splayed figure of a naked woman near but not actually touched by his open hand and close to his right ear. Perhaps she is a muse or the issue of the artist's god-like hand. Put into words, Rodin was signing his work and saying in effect, *I, Auguste Rodin, made this work of art from the inspiration of human form and thought.*

It is the mark of great works of art that over time they inspire renewed interpretation, confirming that their meaning is not immutable. This explanation was written by Rainer Maria Rilke in 1903:

From "The Gates of Hell" memories of Dante emerged. Ugolino; the wandering ones; Dante and Virgil, close together; the throng of the voluptuous from among whom like a dried-up tree rose the grasping gesture of the avaricious. The centaurs, the giants and monsters, the sirens, fauns, and wives of fauns, all the wild and ravenous god-animals of the pre-Christian forest rose before him.

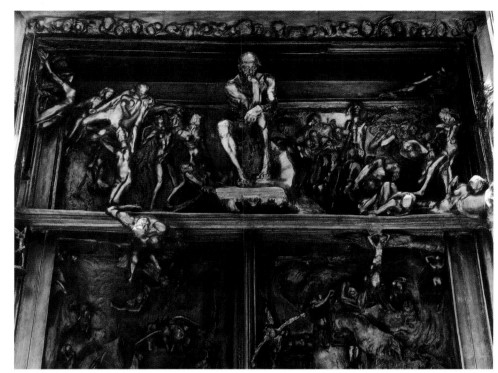

Fig. 130. Detail of *The Gates of Hell: The Thinker*.

He conjured all the forms of Dante's dream as though from out of the stirring depths of personal remembrance and gave them one after another the silent deliverance of material existence. Hundreds of figures and groups were thus created. The visions of the poet who belonged to another age awakened the artist who made them rise again to the knowledge of a thousand other gestures; gestures of seizing, losing, suffering, and abandoning, and his tireless hands stretched farther and farther beyond the world of the Florentine to ever new forms and revelations.[55]

This more recent interpretation was written in 1981 by Robert Hughes in reviewing the *Rodin Rediscovered* exhibition at the National Gallery of Art:

In some way he seems such a modern artist. There is to begin with, his relentless autophagy: the cannibalizing, part by part, of his own images in numerous variations, a self-reflexive mode of invention that one associates more with Picasso than anyone earlier. This point is brought home dramatically by the gallery of motifs from *The Gates of Hell*, from *The Thinker* . . . to the battalion of flying, crouching, writhing figures, bare forked animals all, that crowd the plinths. Then there is the refusal to submit to external schemes or narratives. *The Gates of*

Hell cannot be read as a Renaissance fresco or a medieval Last Judgment because it has no iconographic program. Rodin made up its meaning as he went along. It is less about divine doom than about the condition of secular despair, bad faith, the unrooting of the self—a vast and almost illegibly complex dirge that touches now and then on the original imagery of the Inferno but does not, in any consistent sense, illustrate it. Yet its formal properties—the sudden shifts in scale, the aggressive protrusions of figures from the bronze skin, the sense of strain and rupture—speak more eloquently of dislocation and frustration than any orthodox treatment could have hoped to do.[56]

NOTES

LITERATURE: Bartlett 1889 in Elsen 1965a, 66–80; Rilke 1903 [1945] in Elsen 1965a, 125–26 Grappe 1944, 23–24; Boeck 1954; Elsen 1960; Alhadeff, 1966; Spear 1967, 49–66; Tancock 1976, 90–107; de Caso and Sanders 1977, 123–29; Elsen 1981, 63–79; Schmoll 1983, 215–32; Janson 1984, 221–30; Elsen 1985a; Jamison 1986; Lampert 1986, 43–99; Miller and Marotta 1986, 11–13; Hare 1990, 160; Fath and Schmoll 1991; Bothner 1993; Butler 1993, 141–49, 214–25; Levkoff 1994, 54–57; Le Normand-Romain 1999; Le Normand-Romain 2001, 134–39

1. In Serge Basset's article, "La porte de l'enfer" (*Le matin*, 19 March 1899), Rodin spoke of how his monumental portal was called for "in the project of the engineer Berger." In 1900, when the museum of decorative arts was opened in the Louvre, it appears that Georges Berger did not show any interest in installing Rodin's portal either inside or outside Pavillon Marsan, as Rodin told a reporter (Le Nain, in *L'écho de Paris*, 10 January 1901).

2. Basset, "La porte."

3. The story of how Rodin obtained the commission for *The Gates of Hell* has been discussed elsewhere. See Elsen 1985a and Butler 1993, 214–25. A brief note in the Musée Rodin file on *The Gates* states that the "Commission of the Under-Secretary of State Turquet relative to *The Gates of Hell* would go back to 1879."

4. Rodin described Turquet's act as daring in autobiographical notes written in 1883; see Hare 1990, 160.

5. Basset, "La Porte." Many of these drawings are discussed in Elsen 1960, 1985a. See also Fath and Schmoll 1991. Claudie Judrin reproduced many of them in her essays in Güse 1985, 63–81; in Fath and Schmoll 1991, 59–85; in Judrin 1981, and in Judrin 1982. Rodin's letter of 1883 to Gauchez is discussed in Judrin, 1983, 5, and cited in translation in her essay in Güse 1985, 81: "At the moment, my drawings are rather an illustration of Dante

from a sculptural point of view; they are quite numerous. It seems to me that the poet's expression is always and concretely visual." Judrin cited Léonce Bénédite as identifying the edition of Dante read by Rodin as that of Artaud de Montor (Judrin, 1983, 8), but in 1887 Rodin told Bartlett, "I have read only one translation, that of Rivarol, the five-cent edition, and I have always carried it in my pocket" (in Elsen 1965a, 69.) Bartlett seems the more reliable source.

6. The number and high quality of these drawings merit further analytical study.

7. These drawings were discussed in Elsen 1960, 1985a. See also Jacques de Caso in Crone and Salzmann 1992.

8. Grunfeld 1987, 150, citing a manuscript in the Bibliothèque de l'institut, Paris.

9. In 1897 many of these drawings were beautifully reproduced in a limited, color facsimile edition, *Les dessins d' Auguste Rodin* (Paris, 1897), with a preface by Octave Mirbeau, published by Boussod, Manzi, and Joyant.

10. Bartlett in Elsen 1965a, 69.

11. Jessie Lipscomb was a young Englishwoman who came to Paris in 1863, met Rodin, studied with him, and in his studio also became a close friend of Camille Claudel. Catherine Lampert was the first to publish these valuable photographs (1986, 47, 52), but she made only brief comments on their condition and the way that Rodin would not only add to but also change what he had done.

12. Geffroy's preface to the catalogue of the Monet-Rodin exhibition, reprinted in Beausire 1989, 61.

13. In a letter to Omer Dewavrin, Rodin wrote, "It is necessary that I finish my door that I had abandoned, after I will return to the Burghers" (Rodin to Dewavrin, December 1877, in *Rodin* 1860–99, 90).

14. Rodin wrote, "I am ardently working on my door, and I hope to exhibit it in '89" (Rodin to Noirot, 7 October 1888; in *Rodin* 1860–99, 95.) "They promise us . . . *la Porte de l'Enfer* for the next Salon, and more, for the Exposition universelle" (Armand Sylvestre, in *Revue de Paris*, 15 July 1888). Rodin did not exhibit his portal at either. In both 1887 and 1889, however, he did exhibit a number of the figures from *The Gates* at the Galerie Georges Petit and received an excellent press.

15. "After the first large sketch of the entire structure had been determined on, the sculptor intended to model the sculpture in wax on its background of plaster, but as this material was found to be too expensive, clay was used in its stead. The figures were then cut off in pieces and sections, and cast in plaster" (Bartlett in Elsen 1965a, 74).

16. This reproductive lithograph was published in *L'art français* (4 February 1888) and earlier in *L'art* (1887), as noted in Fath and Schmoll 1991, 28. It was reproduced by Bartlett in 1889 (see Bartlett in Elsen 1965a, 71).

17. Regarding the vines, see Bartlett in Elsen 1965a, 78.

18. In the studio Bartlett saw the work that later replaced the mother and child and referred to what came to be known as *The Fallen Caryatid* as "sorrow . . . a young girl pressed

19. This final effort is discussed in Elsen 1985a, 133–41.
20. Bartlett in Elsen 1965a, 74.
21. In his Sèvres ceramics made in the same period Rodin depicted a horned figure in a farandole (see Marx 1907, pl. VII).
22. Bartlett in Elsen 1965a, 74–75. Bartlett went on to write of this figure, "Beautiful in every sense, in its life, naturalness, delicacy of outline, and exquisite sensibility of modeling."
23. Ibid., 77.
24. Ibid., 73.
25. He worked for an hourly wage to support himself as the commission for *The Gates* covered only expenses related to the project. This also explains his eagerness to exhibit individual figures from *The Gates* starting in 1883, to further his reputation and to enable him eventually to give up working at Sèvres.
26. For the Sèvres ceramic work, see Marx 1907.
27. Octave Mirbeau, "Auguste Rodin," *La France*, 18 February 1885.
28. Of these figures Bartlett commented, "At [Ugolino's] left there will be a group of human and half-human figures surrounding The Three Sirens" (Bartlett in Elsen 1965a, 75).
29. In this extraordinary essay Geffroy gave one of the most perceptive readings of the subject of *The Gates* (reprinted in Beausire 1989, 62).
30. Cladel 1917, 280–83; and see Tancock 1976, 102, 105 ns20–21.
31. Dujardin-Beaumetz in Elsen 1965a, 170.
32. See Tancock 1976, 102, citing Rene Chéruy, "Rodin's 'Gate of Hell' Comes to America," *New York Herald Tribune*, 20 January 1929, 18 (magazine supplement).
33. The bronze ropes on all casts of the portal are there by accident as they undoubtedly were installed in 1900 to assist those moving the doors between the studio and the pavilion.
34. This is further discussed in the author's essays in Elsen 1981, 79 n. 33, and Elsen 1985a, 147–48.
35. Mauclair 1918, 24.
36. William C. Brownell, *French Art: Classic and Contemporary Painting and Sculpture* (New York: C. Scribner's Sons, 1901), 219.
37. In an essay entitled "Trauma of the Divine: The Critique of Convention—Fragments in the Work of Auguste Rodin and Friedrich Nietzsche," Rainer Crone and David Moos question the value of "conventional" art history in ascertaining meaning in a work. They challenge "the very nature of art history," which includes paying attention to the artist's intentions, and ask, "Will the reading that one is eventually able to generate bring a significance other than that which is plain in the facts and arguments studiously presented?" By implication their answer was no, and they argued that in their new art history Rodin's work should also be "regarded in the wider scope of the ideas that it embodies" (in Crone and Salzmann 1992). One wonders about Crone and Moos's familiarity with traditional art history, for what they advocated is nothing more than old-fashioned art historical iconology. They inveighed against "entrenched methodology" and preferred aerial bombardment to getting into the trenches and coming up with even a single new interpretation of *The Gates of Hell*. Their "new" methodology was to impose Nietzsche's ideas on Rodin, the persuasiveness of which was often in inverse proportion to what one knows about the sculptor. What Crone and Moos propose suggests the "the author is dead" argument, meaning the artist's intentions do not count, to liberate viewers' responses from constraints, such as knowing these intentions and how and why the work came into being. This theory has been promoted by philosophers and critics, partly in revenge against artists who do not work from theory and whose visual, not verbal, art is invariably more interesting than what they write. What adherents to this theory do has the effect of allowing them to elbow the artist offstage in order to parade their culture before us, this in the guise of giving the reader "hermeneutic certitude," as if such were possible.
38. Rosalyn Frankel Jamison wrote an important dissertation (1986) on the influence of Hugo on *The Gates of Hell*, which is summarized here. For a literal reading of *The Gates* in terms of Dante's epic, see Aida Audeh, "Rodin's *Gates of Hell*: Sculptural Illustration of *Dante's Divine Comedy*" in *Rodin: A Magnificent Obsession* (London: Merrel, 2001), 93–125.
39. Jamison suggested that the sculptor showed reserve in indicating an influence by the poet perhaps precisely because Hugo's impact on his era was so pervasive and because the poet was still living at the time work on *The Gates* began. Hugo died in 1885.
40. See, for example, the a short poem entitled "Après une lecture de Dante" from the collection *Les voix intérieures* (XXVII), published 1837, and the opening poem, "La fonction du poète" from *Les rayons et les ombres* (1840).
41. Victor Hugo, *La légende des siècles* (Paris: Garnier-Flammarion, 1967), 2 vols. "La vision d'ù est sorti ce livre" is in vol. 1, 65–70.
42. Regarding this self-portrait, see Alhadeff 1966, 393–95.
43. Bartlett's note added, "of making hundreds of nude figures in sculpturesque movement and masses to reproduce what appears to him the simple quality of color" (Bartlett 1887–88).
44. Bartlett in Elsen 1965a, 69.
45. My thanks to my colleague John Freccero, the distinguished Dante scholar, for this observation.
46. See Butler 1993, 26, 118–20.
47. Ibid. and 141–49. Butler illuminated the historical background for this period and also the interest since midcentury in creating a museum of decorative arts. This interest was enhanced following the Franco-Prussian War, during which many examples of decorative arts were destroyed.
48. Basset, "La porte."

49. Rodin's drawings to accompany *Les fleurs du mal* were all based on sculptures made before he received the commission to illustrate Paul Gallimard's 1857 edition of these poems (see Thorson 1975, 82–105).

50. Byvanck 1892, 8.

51. Jamison 1986, 274, 320.

52. Debora Silverman wrote, "*The Gates of Hell*, with its tympanum figure *The Thinker-Poet*, represented literary creation, *Claude Lorrain*, visual art" (1989, 256). In Rodin's day *poète* meant more than those who wrote in verse; it included those who used imagination. Rodin's *Thinker* welcomes associations with all artists to be sure, but one must ask Silverman why, in front of a museum of decorative arts encouraged by the Union centrale des arts déco-

ratifs, of which Rodin was a member, would Rodin give the place of honor to writers alone and not visual artists?

53. See Jamison's discussion of Rodin's various personalized muse figures (1986, 126–27 and in Elsen 1981, 107–8).

54. Bartlett in Elsen 1965a, 69.

55. Rilke 1903 [1945] in Elsen 1965a, 125–26.

56. "Auguste Rodin," in Hughes 1990, 131. Contrast Hughes's reading with the bilious commentary of John Russell: "*The Gates of Hell* by Auguste Rodin . . . is to my mind the single most repulsive work of art ever produced by a major artist. . . . It is an unsavory mixture of fear, sadism, guilt, sexism and superstition" ("Rodin's 'Gates of Hell' Was His Dish," *New York Times*, 20 June 1982).

38

The Thinker
(*Le penseur*), 1880–81, enlarged 1902–04

- Title variations: *The Poet, The Thinker-Poet*
- Bronze, Georges Rudier Foundry, cast 1972, 10/12
- 79 x 51½ x 55¼ in (200.6 x 130.8 x 140.3 cm)
- Signed on base, top left: A. Rodin
- Inscribed on back of base: Georges Rudier/Fondeur Paris
- Iris and B. Gerald Cantor Foundation, promised gift to the Iris & B. Gerald Cantor Center for Visual Arts at Stanford University, 1988.106

Figure 131

*I*n its original smaller size *The Thinker* may have been, if not the first, one of the earliest sculptures made for *The Gates of Hell*.[1] For the overall design and meaning of the portal, it is the focal figure, and visitors to Rodin's studio in the 1880s and 1890s are recorded as referring to this figure as Dante. In 1882 the editor of the English *Magazine of Art*, William Henley, wrote to Rodin, asking for sketches of the portal and of "the thinker" that Rodin had mentioned in a letter.[2] Constantine Ionides, who in 1884 purchased an unpatinated bronze cast directly from the artist for 4,000 francs, provided another early record of the sculpture being called *Le penseur*.[3] Rodin first exhibited *The Thinker* publicly in 1888 in Copenhagen. Between 1902 and 1904 it was enlarged and then

cast by Henri Lebossé and immediately exhibited in the Paris salon, where it caused considerable controversy. It was this exhibition, however, that led to a successful public subscription to acquire the bronze for the state[4] and to place it outdoors in Paris. In 1906 it was inaugurated in front of the Panthéon (fig. 558) but relocated in 1922 to the garden of the Musée Rodin, where it remains today on its original pedestal. The fame of its creator, the wide dispersal of the 21 monumental casts, the memorable pose, and its susceptibility to varied interpretation, including satire, have contributed to making *The Thinker* perhaps the most famous modern sculpture in the world.[5]

The possible influences on *The Thinker* have been explored elsewhere, and far into the future historians will be connecting seated figures from older art with Rodin's work. Modeled directly from a live and anatomically mature model rather than from an imagined idealized type, as he had used in his earlier decorative figures, or from the memory of something seen in older or contemporary art, Rodin may have sought to further naturalize Michelangelo, whose art was the most obvious influence.[6] What Rodin did in this figure was to rethink the visual concept of a cogitating male and to accentuate the total effort required of mind and body to resolve a difficult problem. The lowered head alone, caused by the crossover gesture of the right arm to the left thigh, both of which are part of the body's expression of total self-absorption, separates Rodin's *Thinker* from the many prototypes proposed by scholars.

Within the artist's own sculptures and drawings *The Thinker* has a rich ancestry that includes sketches of seated brooding figures, grieving funerary figures, and

Dante's Ugolino with his dying children (cat. no. 45), seated allegorical figures for the *Vase of the Titans* (cat. no. 39), similar figures for the *Monument to Burgomaster J. F. Loos* (1874–76 dismantled 1960), Rodin's own large but fragmentary *Seated Ugolino* (fig. 154), and a small seated male nude in wax (1875–76 or 1880). In many of the precedents, and not merely the grieving funerary figures, thinking assumes a tragic bent of suffering or struggle. *The Thinker* appears in some drawings for the overall plan of *The Gates* (see fig. 120), and in the third and last architectural model for the portal (see fig. 121) there is a rough but recognizable prototype in sculpture.[7]

The Thinker represents a democratization of an ancient tradition of the muscular intellectual in sculpture. In works by such artists as Michelangelo and Jean Goujon a seated, powerfully built male figure represented a biblical, mythological, aristocratic, or culturally significant person whose identity was clear. Costume, objects, inscriptions, and sometimes the sculpture's location, as with Michelangelo's Medici figures (Medici Chapel, San Lorenzo, Florence), revealed the subject's identity. For the enlarged *Thinker* none of these identifying features obtain. Rodin's seated figure, as we see him today, seems not to have been identified by the artist as a specific individual. *The Thinker*'s present ambiguity owes much to its ubiquity and being seen in contexts as varied as art museums, libraries, philosophy departments, a royal cemetery, and even a savings bank. To begin with, there were the artist's own changing interpretations, whether voiced or not: from the work presumably representing Dante to his publicly exhibiting the figure as *The Poet* (1888), *The Thinker-Poet* (*Le penseur; Le Poète, Fragment de la Porte*) (1889), and *The Thinker* (1896), and finally his speaking of the enlarged *Thinker* in 1906 as a symbol for the workers of France. What follows are the two most important statements by Rodin on his figure. The first he made in 1904. "*The Thinker* has a story. In the days long gone by, I conceived the idea of *The Gates of Hell*. Before the door, seated on a rock, Dante thinking of the plan of his poem. Behind him, Ugolino, Francesca, Paolo, all the charac-

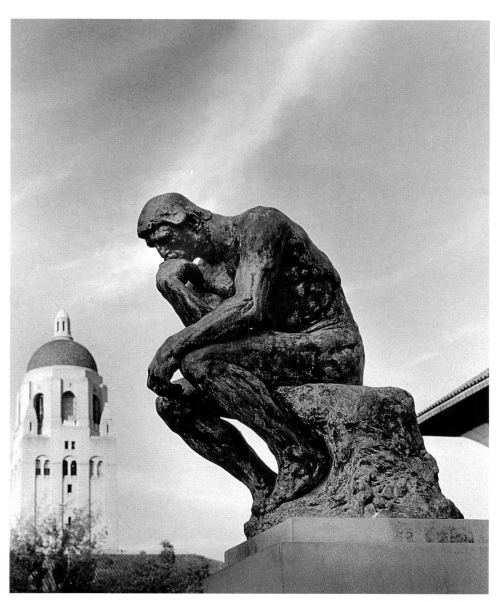

Fig. 131. *The Thinker* (cat. no. 38).

ters of *The Divine Comedy*. This project was not realized. Thin, ascetic, Dante in his straight robe separated from the whole would have been without meaning. Guided by my first inspiration I conceived another thinker, a naked man, seated upon a rock, his feet drawn under him, his fist against his teeth, he dreams. The fertile thought slowly elaborates itself within his brain. He is no longer dreamer, he is creator."[8] In 1906, the day before *The Thinker* was inaugurated in front of the Panthéon and while France was racked with social and economic strife, Rodin made a second statement:

My work, why must one speak of it? It magnifies the fertile thought of those humble people of the soil who are nevertheless producers of powerful ener-

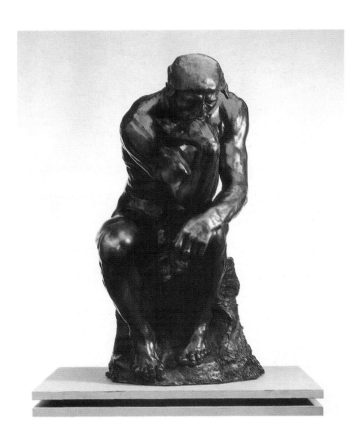

Fig. 132. *The Thinker*, 1880, bronze, 28¾ x 14 9/16 x 20 in. (73 x 37 x 50.8 cm). National Gallery of Victoria, Melbourne, Felton Bequest 1921.

gies. It is in itself a social symbol and is like the sketch of this *Monument to Labor* that we dream of erecting to the memory of national labor and the workers of France.

All those who believe and grow, do they not take their source of energy from the little and eternal artisans of public riches, from the methodical gleaners of the good grain opposite the sewers of tares? One can never say enough in this period of social troubles, about how totally different is the mentality of the workers and the spirit of the unemployed of this country.

The Thinker on his socle dreams of all these things, and be assured that in him vain utopias will not germinate, there will not come from his lips unpious words; his gesture could not be that of a provocateur abused by false promises.

Yes, let us exalt the little people and tomorrow we will have brought a remedy to social conflict.[9]

Then there is a version of *The Thinker* that is not well known. The first and earliest version of the finished *Thinker* made for *The Gates of Hell* in 1880 appears to be

Left: Fig. 133. *The Thinker* (front view of fig. 132).

Right: Fig. 134. *The Thinker* (rear view of fig. 132).

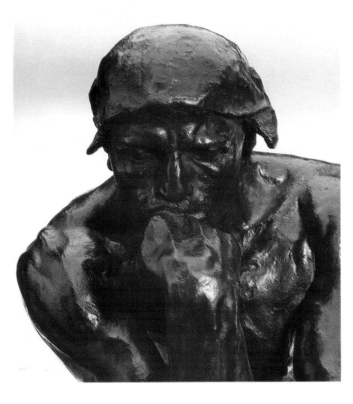

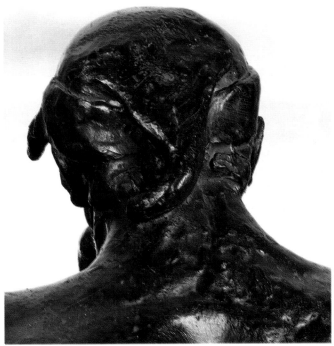

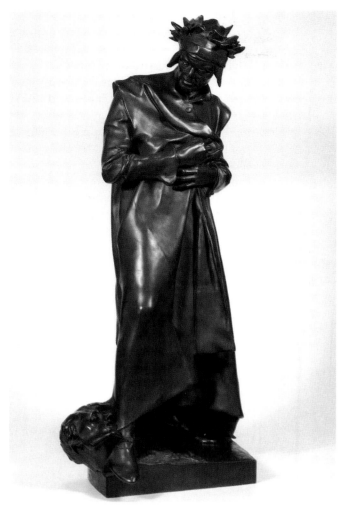

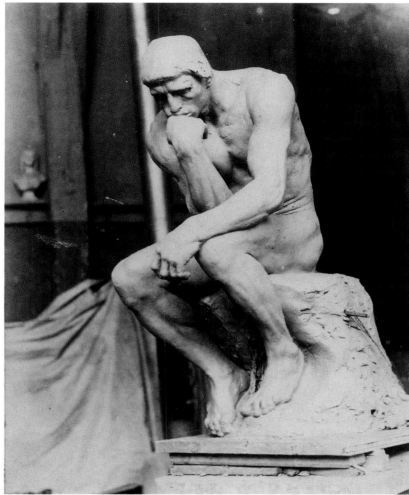

the Ionides bronze cast, in which the seated cogitator wears a tight-fitting cap with side flaps and a tail that lies on his bowed neck (figs. 132–134). Though less elegant, the cap nevertheless clearly derives from the famous hat of Dante known from Giotto's fresco of c. 1332–37 (Cappella del Podesta, Bargello, Florence), and, more relevantly, from that worn by the poet in *Monument to Dante* (fig. 135) by Jean-Paul Aubé (1837–1916).[10] With such a specific reference to the poet, why then in 1881, 1882, and 1884 were Ionides and Henley not given *Dante* as the name of the work instead of *Le penseur*? Even more puzzling is that Rodin made no attempt to reproduce the distinctive facial features, tall, slim figure, or robe of the garbed poet—all of which had become canonical in depictions of Dante and which Aubé had observed. With or without the medieval Florentine headpiece and aside from the designation of Dante made by writers after visits to Rodin's studio, how can we tell if Rodin associated his naked figure with Dante? In 1888 Rodin received a letter from Léon Gauchez, the editor of *Revue universelle-illustré*,

with whom he had become friends. Gauchez, who might have seen the Ionides cast while in London, wrote, "I shake your hand in friendship while maintaining that a nude Dante is a heresy that raises for you an admirable antithesis."[11] The Ionides cast seems to have been unique, and there appears to be no comparable plaster in the reserves of the Musée Rodin. When Rodin first exhibited his *Thinker*, it was presumably capless, as we know it today on the portal and from offspring. But was he taking Gauchez's advice by titling it *Le poète*?

Even at this late date there are new questions to be asked of *The Thinker*'s evolution. We know from contemporary photographs taken of *The Thinker* still in clay that Rodin had problems with the top of the head. One shows his having crossed it out with pencil.[12] Another shows the hair on the right side of the head coming down in front of and below the man's left ear (fig. 136). Possibly this may have prompted the idea of adding Dante's hat or after its removal, his wanting the area to suggest hair? When, then, did Rodin remove part of the cap and

Left: Fig. 135. Jean-Paul Aubé, *Monument to Dante*, 1879-80, bronze, 32 x 13 x 13 in. (81.2 x 33 x 33 cm). Iris & B. Gerald Cantor Center for Visual Arts, Stanford University, gift of the B. Gerald Cantor Collection.

Right: Fig. 136. Attributed to Victor Pannelier, "*The Thinker*," 1880-81, *in clay*, c. 1881, albumen print. Musée Rodin, Paris.

Fig. 137. Photographer unknown, *"The Thinker" on a Scaffold*, 1880– 81, in clay, gelatin silver print. Musée Rodin, Paris.

might make 1881 the date for the bareheaded *Thinker* as we know him.

When Rodin abandoned the cap, he also reworked the back of *The Thinker*'s neck and the upper dorsal area of the left shoulder blade, "unmaking" them both so that they are much rougher.[13] Thus the Ionides cast is by academic standards the most finished version of *The Thinker*. When we recall that Rodin at one time thought of placing his Dante in front of the portal, albeit in a larger size, this finish would have made sense, as would selling a cast of it to an important collector in England at a stage when his own career and reputation were still being established. Why Rodin changed the back when *The Thinker* was set high up in the portal, where this area could not be seen, is not clear. (One has to believe that Rodin knew he would be exhibiting figures from *The Gates* by themselves both to win recognition and earn money, as he made no profit from the commission.) Seven years later, when he exhibited the capless *Thinker* by itself, he made no attempt to bring the reworked back to a high level of finish. By the late 1880s Rodin's aesthetic had changed, and his criterion of artistic completeness supplanted the finishing of details. When Lebossé enlarged *The Thinker*, the roughness was aggravated, and in the Salon of 1904 there were protests that Rodin had shown an étude and usurped space that belonged to artists who had finished their entries.[14] By 1904, if not in 1881 or 1888, Rodin would have defended the more broken contours of the figure on the grounds that he detested the cutout silhouettes of contemporary sculpture and he wanted his sculptures to partake of the atmosphere around them.

Even before its enlargement, and many times thereafter, *The Thinker* was faulted for a lack of decorum: noble subject, ignoble form. Such critics believed that Rodin was expressing thought in general, but conditioned by Michelangelo's aristocratic Medici sculptures, they could not accept such a rude embodiment. This was unquestionably a conservative stance, and Rodin knew it. It must have given him great pleasure in 1906 to tell the workers of France that *The Thinker* was their brother. He republicanized *The Thinker* before the Panthéon and the world.

When Rodin put Dante's cap on *The Thinker*, he created the antithesis Gauchez may have recognized. From his own drawings of the effeminate, sometimes fainting, often frightened, and as he described him, "thin ascetic Dante," it is hard to believe that Rodin ever saw his rugged thinker only as Dante. In identifying with *The Thinker*, Rodin would have identified not merely with

rework what remained to look as if it were closely cropped hair, except for the one flap that he retained beside the man's left ear? It is the capless figure that Rodin placed on a scaffolding before the wooden frame of *The Gates* in order to study the figure's effect from below (fig. 137). The sequence and intentions may never become known, but the reasons for the cap's removal seem obvious: analogous to the removal of the spear from The Vanquished's left hand in *The Age of Bronze* (cat. nos. 1–3) before it was first exhibited, a thinker divested of specific historical references won timelessness and universality. Perhaps the headgear was discarded when, just after the first year of work, Rodin decided to forgo Dante's *Inferno* as the subject of *The Gates* in favor of a modern, personal, and more timeless view of hell. Ionides must have seen the capped clay figure in 1881, when he began negotiations for a purchase of its cast. That

Dante but with the theme throughout Hugo's work of Dante as a prototype in a universal line of thinkers. Giving sculptural form in *The Gates* to a poet-thinker set before an epic vision of chaos encompassed not only the prototype of Dante but also Victor Hugo's notion of Dante. In 1881 Rodin was grappling with all the intensity of his being with the choice of following the mind of the medieval poet or his own. Like the title *The Thinker-The Poet*, the capped *Thinker* was perhaps a symbolic union, as if indicating that Dante provided the inspiration and Rodin committed all his intelligence and strength to the poet's service. Medical opinion puts the age of the model for *The Thinker* at between 40 and 45, the artist's own age at the time of its conception.[15] Any doubt that the sculptor identified with *The Thinker* was laid to rest quite literally by the artist when in 1917 he had himself buried beneath it; the low pedestal's inscription, *Rodin*, announces who is above and below.

On 27 October 1988 Rodin's *Thinker* was installed on the Stanford campus before the western entrance to Meyer Library. It was the gift of B. Gerald Cantor. For ten years Cantor had circulated this cast of the enlarged version of *The Thinker* in Japan and the United States, where it was seen by hundreds of thousands of people. Because of and not despite *The Thinker*'s unparalleled reproduction in photographs, cartoons, and advertisements during its public displays, whole families would come to see this world famous statue. So much for Walter Benjamin's prediction that works of art would lose their aura because of their mechanical reproduction.

On the Stanford campus *The Thinker* was installed on an eight-and-one-half-foot pedestal, whose height and shape the architect Robert Mittelstadt derived from Rodin's own design for the sculpture's installation before the Panthéon. The pedestal's tall stepped design creates an imaginary cube within which *The Thinker* can be visualized. This was Rodin's intention, for it was his maxim that the cube, not nature, was the mistress of appearances. This imagined geometrical form guided him in the design and composition of his figures.[16]

NOTES

LITERATURE: Grappe 1944, 24–25; Mirolli (Butler) 1966, 218–23; Spear 1969, 52–55, 96–97; de Caso and Sanders 1973, 130–38; Spear 1974, 130S; Tancock 1976, 111–21; de Caso and Sanders 1977, 130–38; Fusco and Janson 1980, 334–35; Elsen 1985a, 71–74; Elsen 1985b; Jamison 1986; Lampert 1986, 24, 50–52, 205; Fonsmark 1988, 73–78; Beausire 1989, 174–76; Fath and Schmoll 1991, 141; Butler 1993, 157–58, 219, 223, 306, 422–30; Le Normand-Romain 1999, 70–71; Butler and Lindsay 2000, 321–26; Le Normand-Romain 2001, 258–60

1. On the form and history of *The Thinker*, see Elsen 1985b.
2. Lampert 1986, 50.
3. In 1888 a cast of *The Thinker* was offered for 2,500 francs. Did Rodin charge Ionides a much larger sum because he was a wealthy collector or because he knew that the cast (now in the National Gallery of Victoria, Melbourne; figs. 132–134) would be unique?
4. Beausire 1988, 250.
5. For a listing of the location of these casts, see de Caso and Sanders 1973, 27–28; Tancock 1976, 120–21; and Elsen 1985b, 163–64. The cast listed as being in a Denver bank has been privately purchased, and its present location is unknown.
6. Rodin was of the opinion that Michelangelo had actually worked from living models. "I believed . . . that movement was the whole secret of this art, and I put my models into positions like those of Michelangelo. But as I went on observing the free attitudes of my models I perceived that they possessed these naturally, and that Michelangelo had not preconceived them, but merely transcribed them" (Mauclair 1918, 65). See also Fergonzi 1997, 98–99, 172–75.
7. For further discussion of Rodin's precedents for *The Thinker*, see Elsen 1985b, 24–42.
8. From a letter to the critic Marcel Adam, printed in *Gil Blas* (7 July 1904).
9. Unsigned article on *The Thinker* in *La patrie*, 22 April 1906.
10. For a discussion of this statue and the interest in Dante at the Paris salons, see Butler in Elsen 1981, 45. See also Aida Audeh, "Rodin's *Gates of Hell* and Aubé's *Monument to Dante*: Romantic Tribute to the Image of the Poet in Nineteenth-Century France," *Journal of the Iris & B. Gerald Cantor Center for Visual Arts* 1 (1998–99), 33–46. On Giotto's prototype, see Ernst Gombrich, "Giotto's Portrait of Dante?" in *New Light on Old Masters* (Chicago: University of Chicago Press, 1986), 10–31.
11. Gauchez to Rodin, 11 May 1888, in Gauchez file, Musée Rodin archives. "Un Dante nu est une hérésie qui vous enlève un antithèse admirable." My thanks to Alain Beausire for helping to decipher the handwriting. Gauchez could, of course, have been referring to the capless thinker.
12. Elsen 1981, pl. 19.
13. Rodin would have done the reworking on a fresh clay figure made from the molds taken of the first version.
14. On the critical reception of the 1904 Salon debut, see Elsen 1985b, 86–93.
15. For this opinion I am indebted to physicians William Fielder and Gary Fry of the Stanford University School of Medicine.
16. Because the cast is resuming its travels, this pedestal will be demolished in 2002 and the figure will reside at the Cantor Arts Center when it is not touring.

39

Figure from "Vase of the Titans" (Le titan), 1877

- Terra-cotta
- 11⅝ x 6 x 6 in. (29.5 x 15.5 x 15.5 cm)
- Provenance: Hôtel Drouot, Paris, 1971; John Wisdom; J. Kirk T. Varnedoe
- Gift of the Iris and B. Gerald Cantor Foundation, 1984.430

Figure 138

*T*his is one of four nude male figures seated on a circular base, shown in a sequence of contorted poses, their bent backs forming the support for a ceramic vase. This work, known as the *Vase of the Titans* (figs. 139–40), issued from the period when Rodin was turning out decorative pieces for the workshop of Albert-Ernest Carrier-Belleuse, works that were either unsigned or that carried the signature of Carrier-Belleuse.[1] After the initial 1957 exhibition at the Musée Rodin of a terra-cotta version of the vase signed by Carrier-Belleuse and the sale a year later in New York of two maquettes attributed to Rodin, Albert Alhadeff observed the correspondence of the maquettes to two of the vase figures and reattributed the vase to Rodin. Based on the strong Michelangelesque style of the figures, he dated the vase and figures to the late 1870s, the years immediately following Rodin's return from Italy in 1876. Alhadeff suggested that the vase was executed for the Sèvres porcelain factory, which had been directed by Carrier-Belleuse since 1875 and where Rodin had worked from 1879 to 1882.[2] H. W. Janson subsequently made a further, detailed study of the terra-cotta vase and the four original terra-cotta maquettes for the figures, which are in the collection of the Maryhill Museum of Art.[3] More recently Ruth Butler found documentary evidence showing that Rodin was employed by Carrier-Belleuse in 1877 and proposed this earlier date for the vase.[4]

The titan at Stanford is a seated figure with its arms raised to its head in the supporting pose of an atlas. The figure's right arm crosses the face, which is turned to the side, while the left arm presses against the side of the head. The pose of the raised arms and turned head recalls that of Rodin's earlier decorative work, the caryatids of the boulevard Anspach in Brussels (1874). As seen here and in the other three titans, the exaggerated musculature, contorted pose, and intense emotions especially reflect Rodin's strong interest in Michelangelo, which began prior to his trip to Italy in 1876. The influence of Michelangelo, as discussed by Alhadeff, becomes evident in Rodin's seated muscular figures, especially the sailor for the base of the *Loos Monument* (1874–76) and in the wax study of the male nude at the Nelson-Atkins Museum of Art in Kansas City, Missouri. Here Rodin began to move away from academically exact modeling and to embrace the anatomic skill but clearer geometry and planes and breadth of modeling of Michelangelo's style.[5] Rodin's titans show a strong kinship to Michelangelo's *ignudi* of the Sistine Chapel ceiling (1508–12)—to their powerful, majestic poses and gestures expressing internal torment, to the motifs of raised arms and raised, bent legs shown in contrasting movements, their heads often turned to the side or their faces lowered or obscured. For example, the Stanford titan, with its right arm raised overhead and crossing its face evokes the comparable gesture of the nude at the right of *The Sacrifice of Noah*. Rodin's titans anticipate his approach to the male figure in works he created after his return from Italy, particularly the fallen warrior in his *Call to Arms* (see fig. 49), the figures on the external reliefs of the last architectural model for *The Gates* (see fig. 121), and early studies for the portal, such as *The Thinker* (cat. no. 38), *Adam* (cat. no. 40), and *The Despairing Man* (1880–85).[6]

The original conception of the *Vase of the Titans* is preserved in a drawing signed by Carrier-Belleuse and inscribed "*V[ase] des Titans*." As Janson observed, Rodin imaginatively interpreted and stylistically transformed his employer's model. Rodin's figures enhance the tragic character of the titan theme, in contrast to Carrier-Belleuse's graceful figures that, despite the identification of the figures as titans, are without anguish or physical strain. Rodin also recast the figures in the drawing by giving them more spatially complex poses, seen especially in a comparison of the drawing's central titan and Rodin's maquette (the latter pose corresponds to that of the Stanford figure). Rodin also enhanced the individual character of the figures and set them each on an irregularly shaped mound, aspects that, Janson pointed out, anticipate the mood and form of *The Thinker*.[7]

For their use on the *Vase of the Titans*, Rodin's maquettes

required adaptations, which included the removal of the figures from their mounds and the editing of secondary details. Presumably a separate set of casts was given to Carrier-Belleuse to join to the vase and adjust as needed (fig. 140).[8] The Stanford titan, detached from its original mound, is shown seated in front of a vertical backdrop. The exact number of existing casts of each titan figure is not known. In addition, the problem of illicit copies of each in plaster, terra-cotta, bronze, and marble has been noted.[9]

NOTES

LITERATURE: Alhadeff 1963, 366–67; Goldscheider 1967, 93; Janson 1968; Tancock 1976, 238, 240; Fusco and Janson 1980, 333–34; Lampert 1986, 18–19, 194–95; Barbier 1987, 250; Goldscheider 1989, 9; Butler 1993, 525 n.10; Fergonzi 1997, 98–99, 172–75

1. For information on versions of the vase at the Musée Rodin, Paris, and Maryhill Museum of Art, Goldendale, Washington, and other versions in porcelain and plaster see Tancock 1976, 240; Goldscheider 1989, 10; and Jean-Luc Bordeaux, *Rodin: The Maryhill Collection*, exh. cat. J. Paul Getty Museum (Pullman, Wa.: Washington University Press, 1976), 13–21.
2. The records of Rodin's work at Sèvres appear in Marx 1907, 41–44.
3. See Alhadeff 1963, 366–67, and Janson 1968, 278–80. Janson also discussed and reproduced the figures from three subsequent sets of terra-cotta casts that were made from molds. Two of these figures were listed as *Homme assis* and *Étude* in Jianou and Goldscheider 1969, 93.
4. Butler in Fusco and Janson 1980, 334, and Butler 1993, 525 n. 10.
5. See Alhadeff 1963, 366–67; also Fergonzi 1997, 98–99, 172–75.
6. See Butler in Fusco and Janson 1980, 334, and Tancock 1976, 238, 240, for a comparison of the vase figures and *The Despairing Man.*
7. Carrier-Belleuse's drawing is discussed in Janson 1968, 279, and reproduced as fig. 22. The drawing shows the vase proper resting on a column decorated by a frieze of figures in relief and a separate large vessel resting in the bowl.
8. Ibid., 279, for Janson's outline of the likely steps in the adaptation of the maquettes. Three various sets of casts made from molds, including one set of four figures, are reproduced (278) and more recently, a complete set was catalogued by Lampert (1986, 18,

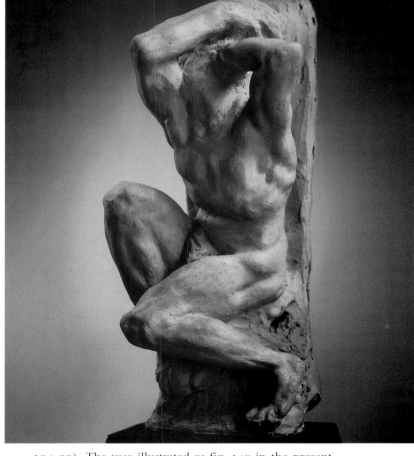

194–95). The vase illustrated as fig. 140 in the present catalogue once belonged to Carrier-Belleuse.
9. For the problem of illicit copies, see Goldscheider 1989, 11, and Barbier 1987, 250–51.

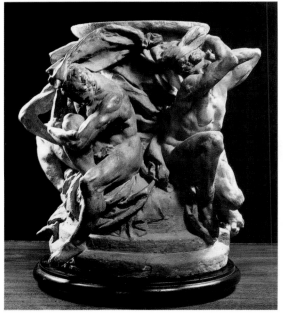

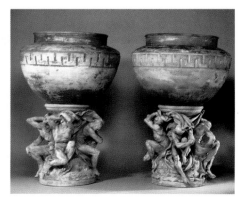

Top: Fig. 138. *Figure from "Vase of the Titans"* (cat. no. 39).

Bottom, left: Fig. 139. *Vase of the Titans*, 1877, terra-cotta, height 15 in. (38.1 cm). Musée Rodin, Paris.

Bottom, Right: Fig. 140. *Vase of the Titans*, terra-cotta. Each H. 29 in (74 cm) Allan H. Rappaport Collection.

40

Adam (Adam), 1877–79

- Title variations: *The Creation, The Creation of Man, The First Man*
- Bronze, Georges Rudier Foundry, cast 1974, 11/12; repatinated 1987
- 75½ x 29½ x 29½ in. (191.8 x 74.9 x 74.9 cm)
- Signed on base, left of left foot: A. Rodin
- Inscribed on back of base: Georges Rudier/Fondeur. Paris.; on base, left side: © by Musée Rodin 1974
- Provenance: Musée Rodin, Paris
- Gift of Iris and B. Gerald Cantor, 1985.15

Figure 141

*R*odin supposedly made a sculpture of Adam in Belgium in 1876, as Judith Cladel reported, "shortly after his return from Italy and during his hard research into discovering 'the secret of Michelangelo.' Discontented with his work, he abandoned it, but later resumed it again."[1] It is unclear whether Cladel is referring to the life-size *Adam* or its small study (fig. 142), a plaster of which was preserved as part of a project for a fireplace.[2]

In a letter to Rose Beuret, written in August 1878 when he was working in Nice, Rodin told of visiting a museum in Marseille and seeing Pierre Puget's *Faun* (1692–93; Musée des beaux-arts, Marseille) "almost in the pose of *mon grand bonhomme*," which Cladel pointed out was his *Adam*.[3] Even before he received the formal commission for *The Gates of Hell* later that year, *The Creation of Man* (by which *Adam* came to be known) was seen in Rodin's studio in February 1880 by a committee of sculptors sent by the undersecretary for fine arts, Edmond Turquet, to investigate the charge that the artist had worked from life casts of his model in making *The Age of Bronze* (cat. nos. 1–3).[4] After he began work on *The Gates of Hell*, Rodin wrote a kind of progress report setting forth his proposed size for the doors and adding: "In addition, two colossal figures will stand at either side of the gates."[5] With the intervention of his friend, the artist Maurice Haquette, Rodin was able to obtain additional funds from the government for his two figures.[6]

The Creation of Man became the first work from *The Gates of Hell* to be exhibited.[7] As the sculpture was part of a government commission, it appears that after this exhibition in the spring of 1881 Rodin had to obtain official permission for the work's return as a loan to his studio.[8] When he held his great retrospective in 1900, it seems that this work was not shown.[9] This major sculpture subsequently seems to have had a very limited exhibition history in Rodin's lifetime. He did choose to put it in one of the niches of the facade of the old Château d'Issy, which he had purchased for Meudon. Most curiously, Rodin's surviving published correspondence makes no mention of *Adam*. We do not yet know why. At the time it was created, it had to have been important to him, especially after the scandal of *The Age of Bronze*, which had not been overcome by exhibiting *Saint John the Baptist Preaching* (1878); it was the figure of *Adam* that helped exonerate Rodin in public.

In an article in 1889, Truman Bartlett excerpted a review by an unnamed author of the 1881 show in which *The Creation of Man* appeared. The sympathetic review reveals how the sculpture contrasted with prevailing styles and notions of idealism:

> If it displeases by its democratic style of treatment, we must accord to it a power and intensity of life that forces us to forget its lack of moderate idealism to which we are accustomed. We are forced to believe that this artist is destined to open a new route. His "Creation of Man" is worthy of all praise. Without doubt, it is a striking reminiscence of Michelangelo, an intended exaggeration, and extravagant expression of nature; this time, M. Rodin cannot be accused of having made, as he was two years ago, his work from molds taken from the living model. Besides, the proportions are well preserved, and the muscular rendering reveals solid anatomical knowledge. . . . Rodin is evidently haunted by some philosophical preoccupation; he wishes to show, in inert matter, a life that is unveiling itself little by little; and he has given to this person the dolorous expression of a man waking from a heavy sleep in order to enter into the sad reality of active life. . . . A conscientious and valiant effort like this . . . seems to me much more worthy of eulogy than the commonplace compositions that appear every year, stringing out before our eyes a mythology of conventionalism, a lying history of

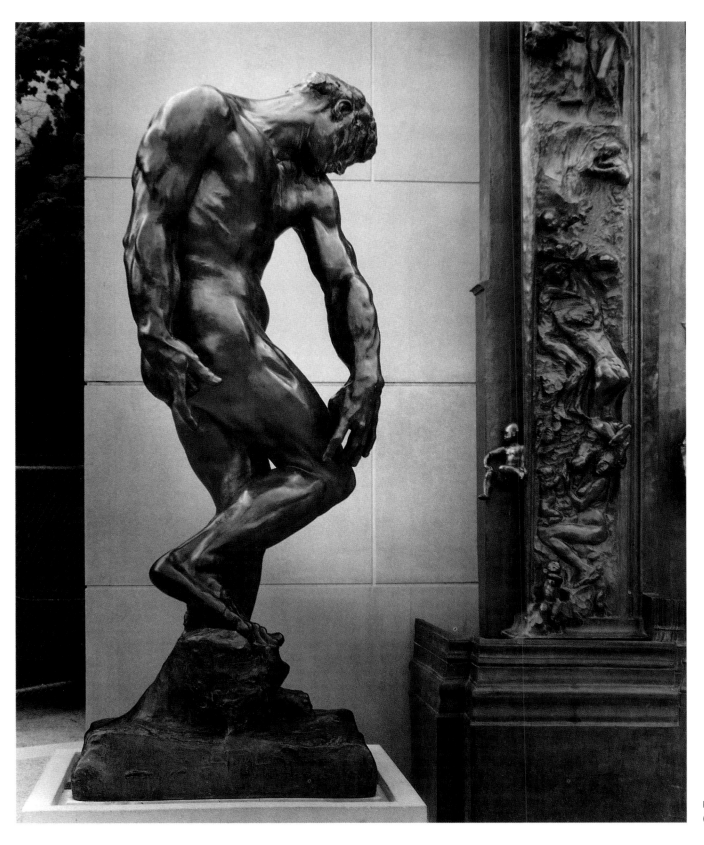

Fig. 141. *Adam* (cat. no. 40).

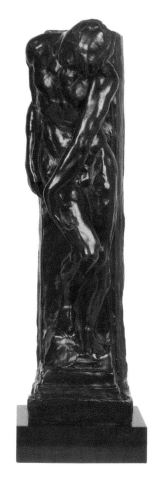

unsuccessful antiquity.[10]

As every reviewer recognized, Rodin's *Adam* was a deliberate paraphrase of Michelangelo. As time went on, the work may have lost favor with Rodin for just this reason. Its inception surely resulted from his desire to apply the secrets he believed he had fathomed from his nocturnal sketches made after studying Michelangelo's work during the day. He had felt an affinity with the great Florentine even before he went to Italy. By making a work as close as possible to Michelangelo's, perhaps Rodin thought that the experience and the resulting differences would give him a better sense of his own identity. The works he would paraphrase in sculpture were, in his *Adam*'s overall pose, Michelangelo's Christ of the *Pietà* (c. 1550–61; Santa Maria del Fiore, Florence) and, in his figure's pointing right hand, the life-receiving gestures of Adam on the Sistine Chapel ceiling (1508–12). These gave Rodin the opportunity to add to—rather than just imitate—his predecessor. By working from a live model, Rodin believed he had discovered that Michelangelo had done the same.[11] But to achieve a Michelangelesque pose, Rodin found that, unlike posing for *The Age of Bronze*, a muscular model would have to assume slightly different positions to realize the whole, and that the artist must take drastic anatomical liberties with muscles and tendons and paired flexible joints such as elbows and wrists. Cladel reported that the model for the figure of Adam was "a carnival athlete by the name of Cailloux. 'If the man could lift 100 kilos with his teeth,' said Auguste Beuret who had known him, as a model he was 'soft as a rag.'"[12]

By 1880 standards the sculpture has no front, which to his contemporaries may have been part of Rodin's "democratic style." In accord with his way of conceiving and examining his work, it is best seen from a three-quarter rather than frontal view. (Some of Rodin's analytical sketches of the Medici tombs show the figures from the side.) Oblique views alter the sense of the full, firm thickness of the form, which would always link Rodin with Michelangelo. The nameless reviewer's comment about democratic style may have referred to how the sculpture has to be seen in the round, especially its powerful back—which Rodin got from his model and not the Sistine ceiling—to be fully absorbed and appreciated.

From the navel and hips down, the figure swivels from its upper body and arms, for which the model must have shifted his position. This drastic misalignment of sternum and navel may have been one reason the reviewer believed Rodin was cleared of the life-casting accusation. (Rodin used the same type of anatomical distortion, which allowed him to suggest successive stages of a movement, in the earlier torso of *Saint John the Baptist Preaching* (1878; see also cat. no. 173), but we cannot say whether that figure came before the earlier version of *Adam* (fig. 142), in which Rodin may have first worked out this structure. As Kirk Varnedoe pointed out, Rodin's ideas for *Adam* may have begun as far back as his return from Italy and work on a proposed monument to Byron of 1877.[13]

Rodin sought to explore anatomic impossibilities for their expressiveness (fig. 143). Even those salon-goers who missed this disalignment in the torso could have seen that Adam's head is lowered at an impossible angle while twisted to its left.[14] The demands on the trapezius muscle in the neck would have tried even a contortionist. (There is a slight lump on the back of Adam's neck, perhaps indicating where Rodin had to stop working from the model because the pose was impossible to assume, and where the head had to be attached.) The left trapezius, closer to the center than the right, is flaccid, not under tension, and showing no wrinkles; it is not correct. The right trapezius is pulled to its maximal extension. There is a hollow in the man's left pectoral, as if it had been made by his chin at one time when Rodin was adjusting the pose of the head.

It was also Rodin's preference to take liberties with those bodily parts or antagonistic muscles that should be relaxed. As an example, in the figure's right thigh there is a deep hollow that accentuates the tensor fasciae latae muscle, which starts at the side of the hip. This is not the weight-bearing leg, yet Rodin showed it as tensed perhaps for a dramatic purpose, to reveal the man's inner

conflict. The figure's left shoulder is internally rotated as is the whole upper limb; while his right shoulder is externally rotated, the upper arm is shortened and the entire arm turned outward, perhaps because of the dropped shoulder and the fact that he did not want the left hand to hang any lower in relation to the right knee. Adam's right hand is in tension, and the clasping treatment of the toes evokes energy.

In the overall uninterrupted smoothness of the figure's big planes and the absence of large areas of surface editing (there is some inside the figure's right upper arm), of all his works, *Adam* comes closest to both the standards of finish for the sculpture of early Michelangelo and contemporary French salons.[15] Rodin's sure and subtle merging of surface planes, or *le modelé*, is there but not his touch so brilliantly manifest in *The Age of Bronze*. This makes us wonder just when *Adam* was made? (Was it before Rodin finished *The Age of Bronze* in 1876? If after, was he trying a Michelangelesque surface rather than his own?) There is one prophetic Rodinian practice, however. Practically invisible is the exposed armature strap on the outside of *Adam*'s left ankle, also seen in *Eve* and later *The Walking Man*.

Unmentioned by writers in Rodin's day, but always commented on by visitors to the B. Gerald Cantor Rodin Sculpture Garden, are the large hands and feet of *Adam* and Rodin's other life-size male figures. There is no question but that *Adam*'s hands and feet are disproportionately large. (Less frequently noticed is that Rodin often thickened the muscles atop the thighs of his male figures.) Today people are rarely accustomed to taking in life-size figure sculptures as a totality and reading the proportions of the extremities against those of the figure as a whole. Present-day cosmetic norms do not credit the beauty of big feet. People just compare their own hands and feet with those of *Adam*, but not their legs, arms, and torsos. Try to imagine *Adam*'s extremities made smaller. His feet support a very big and heavy body. Further, Rodin knew that his outdoor sculptures would be seen from varying distances, and it was imperative not that they soundly support themselves but that their gestures carry. So if Rodin exaggerated the size of hands, for example, it is so they could be better read from afar. And no figure sculpture by Rodin begs to be read more than *Adam*.

Adam is Rodin's most ambitious single-figure narrative. The story is framed by, begins and ends with, the arms and hands: Adam's right arm ends in a hand whose

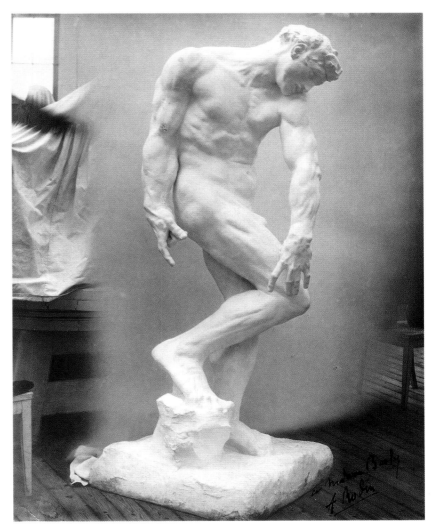

Fig. 143. Jacques-Ernst Bulloz, *"Adam" in plaster*, 1877-79, Pavillon de l'Alma, Meudon (A113).

downward pointing finger recalls the life-receiving gesture of Michelangelo's Adam in the Sistine Chapel *Creation* panel. Rodin's first man has a left arm in severe pronation in emulation of the gesture of Christ's left arm in the Florentine *Pietà* that Michelangelo carved to surmount his own tomb. Between this beginning and end, Adam's youthful body is tensed, but not against any outside threat. The key to its meaning is the figure's face with its closed eyes, which may suggest the internal torment of mortality, of what seems an endless life apart from God.[16] (In this Rodin may have been influenced by Michelangelo's *Bound Slave* [1513–16; Louvre, Paris].) The direction of the legs and the inclination of Adam's head toward the left arm evokes a progression toward or longing for death.[17]

When Rodin requested the government's permission to return *Adam* to his studio in 1881, he gave a reason that is illuminating in terms of the artistic rather than thematic role *Adam* played in connection with *The Gates*:

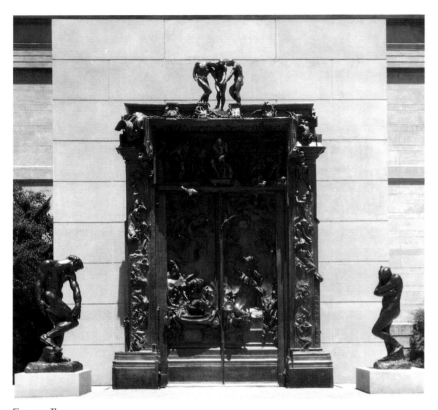

What is the principle of my figures? . . . Equilibrium is the pivot of my art. Not inertia: but the opposition of volumes that produces movement. Here is the flagrant fact of art . . . the essential are the planes. Respect them from all sides: movement intervenes, displaces volumes, creates a new equilibrium. The human body is a *walking temple.* It contains a central point [the navel?] around which the volumes distribute themselves. . . . [Michelangelo] understood that the human body can create an architecture and that in order to obtain a harmonious volume, one must inscribe a figure or a group in a cube, a pyramid, a cone, a simple geometrical figure. . . . I say that the sense of the cube is the mistress of things, not appearances.[19]

Try looking at *Adam* against *The Gates* (fig. 144). *Adam*'s hanging arms parallel the framing side bas-reliefs. The powerful rightward thrust of a line made by *Adam*'s shoulder, neck, and head is echoed in the tympanum. Neither composition as a whole is symmetrical, something Rodin equated with inertia. Follow the upward diagonal that starts with *Adam*'s raised right ankle to the knee, then back and upward to the hip, then upward to the shoulders, and finally straight along the line at the top of the body. You can find equivalent areas or clusters of figures in zigzagging movements in the door panels that cut across the central frames starting at the lower left with the fallen winged figure of Fortune. Finally, both the single figure and the great portal are circumscribable in a cube.

When Rodin set up the disassembled portal in his 1900 exhibition, he hoped the work would be called for casting by the government. Why did he not frame it with *Adam* and *Eve*? (The *Eve* was definitely in the exhibition, but none of the photographs of the pavilion show *The Creation of Man*, nor is it specifically listed in the catalogue.) Perhaps Rodin felt the government might not want the additional expense of casting these figures and the doors. That Eve before the Fall appears in relief in the portal's lower left jamb (see fig. 127) might indicate that he himself had abandoned the idea of flanking the doors with humanity's parents. There are, however, drawings that bear sketched notations of *Adam* and *Eve* flanking the portal, perhaps made between 1907 and 1910 when there was a possibility *The Gates* would go into a deconsecrated chapel at Saint Sulpice.[20]

"As it is part of a decorative ensemble it must help me to combine the different sculptural parts in harmony among themselves."[18] With *Eve*, Rodin intended having two strong life-size figures bordering the portal, perhaps as stabilizing elements for the strong sculptural actions on the surface of the doors between them. There may have been another reason. After Rodin gave up the narrative panel concepts and decided to improvise with his figures and groups over the entire surface of the portal, he needed some kind of organizing principle. Not trained at the École des beaux-arts, that which Rodin knew best came from his personal study of the human figure in movement, aided by his analysis of Michelangelo's art. It has always seemed to this writer that the structural principles used for *Adam* provided that basis. The figures of Adam and Eve were not only stabilizing elements to the improvisation on the panels behind them, but the structural, organizing principles in the figure of Adam were applied to the portal as whole. At Stanford the *Adam* has been placed with his torso frontal and with his hanging arms paralleling the vertical framework of the door, in order to facilitate a comparison. Consider Rodin's own principles:

NOTES

LITERATURE: Bartlett 1889 in Elsen 1965a, 50–51 Cladel 1936, 135–36, 140; Grappe 1944, 21; Elsen 1960, 66, 69, 74–77; Mirolli (Butler) 1966, 208–12; Tancock 1976, 122–28; Elsen 1981, 166; Elsen 1985, 74–77 Goldscheider 1989, 152; Fath and Schmoll 1991, 141; Butler 1993, 159–62, 230; Le Normand-Romain 1999, 44

1. Cladel 1936, 135. Grappe indicated (1944) that Rodin destroyed the first version (27).
2. See Descharnes and Chabrun (1967, 207); two versions of the project and variants were discussed by Tancock (1976, 155), who dated the commission to 1912 (128 n.10). A comparable small study exists for one of the versions of *Eve* for the project (see fig. 146).
3. Cladel 1936, 135. The identity of the *bonhomme* as *Adam* was not cited by Beausire and Pinet in *Rodin 1860–99*, 50. Without explanation they saw the word as referring to *Le génie funéraire* (or *Génie du repos éternel*). Cladel's association is more credible in view of Adam's muscularity and similarity to the position of the *Faun*'s legs and feet, twisted left arm, and head thrust to its left and against the left shoulder. Puget's *Faun* was reproduced in *Rodin 1860–99*, 48. Mirolli (Butler) also followed this identification of the *bonhomme* as *Adam* (1966, 207). See also *Pierre Puget: Peintre, sculpteur, architecte, 1620–1694*. Marseille: Musée de Marseille; Paris: Réunion des musées nationaux, 1994), cat. nos. 15a-b.
4. Discussed in *Rodin 1860–99*, 53. The committee's rejection of the charge that Rodin worked by *surmoulage* must have helped Turquet to decide to purchase *The Age of Bronze* for the government.
5. Rodin to Turquet, 20 October 1881, in Rodin file, Archives nationales, Paris.
6. Cladel quoted an undated letter from Rodin to Haquette, asking for his help in obtaining funding for *Adam* and *Eve*: "My dear Maurice: I learn that M. Turquet might soon offer his resignation. . . . Do me the service of speaking to him, if you can (this evening or tomorrow) of these two figures that are around my *Gate* and which are not officially commissioned" (1936, 140).
7. Beausire 1988, 72.
8. Ibid., 74. This author pointed out that in the reviews critical of *Adam* the point was made that there was an excess of vigor, acceptable in Michelangelo but not Rodin.
9. A one-half life-size bronze and life-size plaster cast of *Eve* were exhibited, but it is not clear if it was *Adam* or *The Shade* in the show; ibid., 185.
10. Bartlett in Elsen 1965a, 50–51.
11. Regarding Rodin's interest in Michelangelo's art, see in this catalogue cat. no. 38, note 6.
12. Cladel 1936, 143. See cat. no. 43 where it is suggested that Cailloux was the model for *The Shade* rather than for *Adam*.
13. Rodin included a drawing of his proposed monument to Byron in a letter to Rose Beuret in Brussels (after 13 April 1877), in which, at the upper-left corner of the page, he also sketched a figure in a pose relatable to the later *Adam*. See Varnedoe in Elsen 1981, 166 n. 9: "This sketch makes clear that the original conception of *Adam* (which has been known to have been preceded by a similar *Creation of Man*), must be dated back at least as far as the conception of the central figure of the Byron maquette." The drawing was reproduced in *Rodin 1860–99*, 39.
14. For many observations concerning Rodin's anatomical liberties with *Adam*, I am indebted to Drs. Robert Chase, Amy Ladd, and William Fielder of the Stanford University School of Medicine.
15. The Stanford cast was repatinated in 1987 by Lucien Stoenesco of the Coubertin Foundation.
16. I disagree with Tancock (1976, 125) that Adam is shown "awakening."
17. Jamison offered the interpretation that the pointing gesture alludes to the first human "creative" act: Adam's role within the creation in naming God's creations (1986, 169–72).
18. Beausire 1988, 74.
19. See Mauclair 1905a, 66–69.
20. Judrin in Güse 1985, 70.

41

Eve (Eve), 1881

- Bronze, Georges Rudier Foundry, cast 1970
- 68 x 23¾ x 30 in. (172.2 x 60.3 x 76.2 cm)

- Signed on top of base, left: A. Rodin
- Inscribed on back of base, lower right: Georges Rudier/Fondeur. Paris.; on base, left side, near back, lower edge: © by Musée Rodin 1970
- Provenance: Musée Rodin, Paris; Norton Simon; Norton Simon Museum, Pasadena; Sotheby's, New York, 22 May 1982, lot 426
- Gift of the B. Gerald Cantor Collection, 1992.151

Figure 145

*I*n 1903 Rilke described *Eve*'s gesture of withdrawal into the self: "It shrivels like burning paper, it becomes stronger, more concentrated, more animated. That Eve,

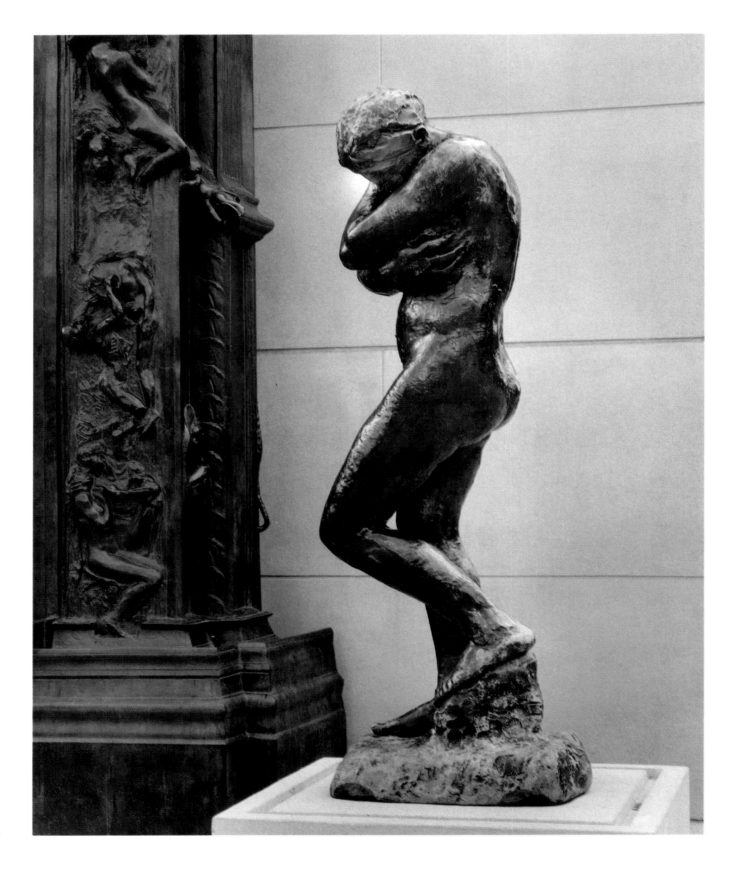

Fig. 145. *Eve*
(cat. no. 41).

[which] was originally to be placed over *The Gates of Hell*, stands with head sunk deeply into the shadow of the arms that draw together over the breast like those of a freezing woman. The back is rounded, the nape of the neck almost horizontal. She bends forward as though listening over her own body in which a new future begins to stir."[1]

The early architectural sketches of *The Gates of Hell* show that Rodin thought of first putting *Eve* between the two doors, in the manner of a Gothic Madonna and Child. As Rilke indicates, he may also have thought of putting *Eve* atop the doors. Perhaps the first full figure study for *Eve* survives along with that for *Adam* as part of a model for a fireplace commissioned of Rodin in 1912 by Mathias Errazuriz, a wealthy South American collector (see figs. 142, 146).[2] Right after the success of his 1900 retrospective Rodin was extremely busy filling orders from all over the world. For a commission such as this, it is clear that he fell back on his repertory of ready-made figures and drew on his early training at the Petit école and his experiences as a decorator under Albert-Ernest Carrier-Belleuse to compose this chimney piece. The étude of *Eve* could have dated before 1880, but following his trip to Italy in 1876, after which he may have made the studies of *Adam* and *Eve* as remembrances of what he had learned of Michelangelo's "secrets" concerning expressive body construction.[3] It shows a very Michelangelesque Eve standing with the weight on her right leg in an exaggerated hipshot pose; her left arm hangs by her side. Her chin rests on her right hand in an expression of cogitation. Half the upper torso is covered by her raised, bent arm, which predicts the similar gesture of the swaying figure later known as *Meditation* (cat. nos. 61–62).

By 1881 Rodin intended to position life-size statues of *Adam* and *Eve* on either side of *The Gates of Hell*, and he received permission and funds to do so. *The Gates* were not bronze-cast in Rodin's lifetime, and this placement was only accomplished in the 1960s by the Musée Rodin in its garden, where the statues are quite distant from the portal, and then at Stanford, where we have placed them closer according to Rodin's sketches (see figs. 120, 144).[4]

Rodin's interest in the late 1870s and 1880s in doing several statues based on biblical themes coincided with their frequency in the sculpture salons of these years. (Scholars refer to this as religious genre art since it was not commissioned by the Church.)[5] Rodin did not show his life-size *Eve* to the public in bronze until 1899, when

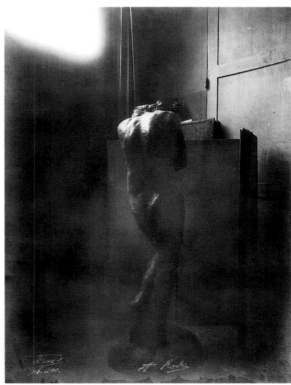

it was displayed with its base buried in the sandy floor of the exhibition hall. Perhaps influenced by thoughts of displaying *The Burghers of Calais* at ground level (see pp. 85–88), in effect Rodin had asked himself, Why not literally and figuratively take the statue of *Eve* not only off its pedestal but also off its base. He wanted *Eve* to be elbowed by the crowds. One writer observed, "One dreams of . . . this joy of the artist proved by Rodin in seeing his *Eve* exhibited at the Salon directly on the ground, surrounded by visitors, and the author showing her while murmuring these simple words that are in themselves a program for art: 'one elbows her.'"[6]

Such an audacious installation drew the comment that Rodin was a revolutionary, but it provoked even more concerning his interpretation of humanity's mother. Consider some critical reactions: "With Eve we have the suppression of the socle. Eve is standing on the ground. She digs with her young foot the earth from which she will take back all the tears and all the blood. She walks and breathes among us, mingling with the crowd. She has such a gesture of shame that it is like a child's gesture. Her features, hardly visible in the narrow space of the folded arms, have nothing to show us of our humanity, and reveal the probable initial [appearance] of our race."[7]

The Paris Salon of 1899 was held in the Galerie des machines on the Champ-de-Mars, shortly before this

Left: Fig. 146. *Study for "Eve,"* 1877-79, bronze, 16½ x 5½ x 6 in. (41.9 x 14 x 15.2 cm). Iris and B. Gerald Cantor Foundation.

Right: Fig. 147. Eugène Druet, *"Eve," 1881, in plaster*, 1898, gelatin silver print. Musée Rodin, Paris.

structure was taken down. Used to exhibit industrial products as well as art, the exposition hall had a sandy floor, which explains this comment by Félicien Fagus, who admired Rodin's audacity: "Alone on the 'rond-point' of sand, bathed pitilessly by the light that falls from the high windows, the Eve of Rodin hides her shame from the views of others. This naked bronze woman, so lifelike and moving beyond all expression, is in the middle of the crowd. This is not Eve, the vicious woman that ordinary artists serve us with, but a powerful creature who feels above all her maternal responsibility and the anguish caused by the implacable judgment that weighs on her. She hides her face in her beautiful arms, in a truly human and beautiful attitude."[8]

Rodin's *Eve* differed decidedly from contemporary interpretations, which stressed Eve before the fall in all her innocent beauty. Illustrative of his desire to show Eve's humanity and to give her greater credibility are Druet's daring photographs of Eve taken in the studio at the Dépôt des marbres (fig. 147).[9] They help us understand Rodin's interest in showing the figure in as lifelike a way as possible.[10] Inspired by Michelangelo's *Eve*, Rodin did not choose the svelte type of model then in favor; Rodin's statue looks natural, standing in the shadows of the same studio where the model had posed many years before. Rodin recalled to Henri-Charles Dujardin-Beaumetz his reactions to this beautiful woman when he first saw and modeled her:

> The dark one had sunburned skin, warm, with the bronze reflections of the women of sunny lands; her movements were quick and feline, with the lissomeness and grace of a panther; all the strength and splendor of muscular beauty, and that perfect equilibrium, that simplicity of bearing which makes great gesture. At that time I was working on my statue "Eve."
>
> Without knowing why, I saw my model changing. I modified my contours, naively following the successive transformations of ever-amplifying forms. One day, I learned that she was pregnant; then I understood. The contours of the belly had hardly changed; but you can see with what sincerity I copied nature in looking at the muscles of the loins and sides.
>
> It certainly hadn't occurred to me to take a pregnant woman as my model for Eve; an accident—happy for me—gave her to me, and it aided the character of the figure singularly. But soon, becoming more sensitive, my model found the studio too cold; she came less frequently, then not at all. That is why my "Eve" is unfinished.[11]

All the surfaces of Eve are rough, not just those of her lower abdomen, as most commentators point out. It is as if hypnotized by the story of the model's pregnancy, writers have looked only at the statue's lower abdomen.[12] By being shown a penultimate surface before his then-customary labor of refinement, we have an unprecedented exposure to Rodin's way of building a life-size figure in the early 1880s. Truman Bartlett, who may have seen *Eve* in plaster, wrote, "In any stage Rodin's modeling is direct, firm, full, and living; it never shows labor. His things seem to have grown. He accents the typical characteristics of his model with taste and judgment."[13]

Looking at the area of the loins and thighs as Rodin alerted us to do, we see that, as if to capture their daily thickening with the new life in the woman's body, he pressed side by side onto the big masses of the form short rolls of clay, about a finger in length and shape, at right angles to the long axis of the limb. Eve's lowered face, with its long crooked nose, was roughed out as well, and the eyes were barely indicated. Her mouth was not yet formed. As he made clear in his small study *Bust of Eve* (cat. no. 42), the woman's fear and anguish or remorse are conveyed not through her face but by the self-enveloping action of the arms, the upraised left hand, and the averted head, which shield against and yield respectively to God's wrath, and the action of the right hand, which pulls fiercely at her side just behind her left breast.[14] Her rounded back is the most beautiful and expressive portion of the sculpture, which Rodin recognized when he directed the photographers to photograph her in bronze. She is given roughly the same conventional one-leg-straight-and-one-leg-bent stance as *Adam* (but without the dramatic twisting of the upper torso), perhaps because they were to frame the portal and he did not want any suggestion of the two figures coming together.

It took Rodin almost twenty years to consider this sculpture sufficiently complete as a work of art and worthy of casting in bronze and public exhibition. To have done so in the early 1880s, before his reputation had been established and before his own aesthetic of completeness as opposed to finish had taken form, was unthinkable. In the studio Rodin must have studied how

the rougher surfaces reacted more actively with the light and atmosphere as compared with the highly refined contours and planes of *Adam*. We have his own judgment conveyed in a letter to a German client, who wanted a bronze to donate to a museum in Munich: "I could also propose to you the Eve, which is an interesting work, but on which certain parts have remained summary but which is very expressive. I could give a bronze of another execution of Eve, this one complete, made from the stone, but to me it is less expressive than the other that is less complete, but more vigorous in expression."[15]

By 1883 Rodin had made a second, one-half life-size version of *Eve* which became very popular not only in bronze and plaster but especially in marble, and then a third version known as *Eve on the Rock*.[16] Standing for years in his studio in plaster, the first life-size *Eve* taught Rodin the lesson he would preach to others: if the big planes were right and properly fitted together, details were unnecessary or could be omitted. To show this to the world, Rodin exhibited the first life-size *Eve* internationally: in the Netherlands (1899), Vienna and Venice (1901), Prague (1902), New York (1903), and Düsseldorf (1904).[17]

NOTES

LITERATURE: Rilke 1903 (1945) in Elsen 1965a, 122; Dujardin-Beaumetz 1913 in Elsen 1965a, 164–65 Grappe 1944, 27; Mirolli (Butler) 1966, 208–12; Jianou and Goldscheider 1969, 88–89; Tancock 1976, 148–57; de Caso and Sanders 1977, 143–47; Fusco and Janson 1980, 335; Elsen 1985a, 74–78; Pingeot 1986, 108–9; Ambrosini and Facos 1987, 150–51; Nash 1987, 187; Beausire 1988, 83–85; Fath and Schmoll 1991, 141; Butler 1993, 161–62, 188, 340, 404; Levkoff 1994, 61–63; Le Norman-Romain 2001, 268

1. Elsen 1965a, 122.
2. The fireplace model is reproduced in Descharnes and Chabrun 1967, 207. The relief, *The Death of the Poet*, occupies the upper part of the proposed structure. See also n. 2 of previous entry (cat. no. 40).
3. For a discussion of these early sketches of *Adam* and *Eve*,

see Mirolli (Butler) 1966, 208–10.
4. See Judrin in Güse 1985, fig. 25.
5. Mirolli (Butler) 1966, 210; see also Butler, "Religious Sculpture in Post-Christian France," in Fusco and Janson 1980, 88–95. Mirolli (Butler) appropriately projected *Eve* as a salon entry at its inception, although she did not know at that time that the life-size *Eve* came before the smaller versions. For the somewhat complex history of the large and small versions of *Eve* (referred to respectively as *Eve the Mother* and *The Young Eve*), see Beausire 1988, 83–85.
6. "On se coudoie." G. de Pawloski, "Le style," *Comoedia*, 27 June 1911.
7. This is from an article in *L'art français*, 6 May 1899, of which Rodin's friend the critic Armand Sylvestre was the artistic director.
8. Félicien Fagus, "Société nationale," *La revue blanche*, 15 May 1899.
9. See also Elsen 1980, pl. 25.
10. Rosalyn Frankel Jamison suggested that Rodin may have transmuted the traditional Adam and Eve symbolism to a nineteenth-century interpretation of original sin as related to human creativity, in which Adam and Eve are understood to be the first seekers of knowledge, ideas analogous to Victor Hugo's thought (1986, 163–75).
11. Dujardin-Beaumetz in Elsen 1965a, 164–65. Ambrosini believed the model was Carmen Visconti (in Ambrosini and Facos 1987, 151).
12. Dr. Robert Chase, Stanford University School of Medicine, noted that the woman's enlarged right breast suggests pregnancy as well.
13. Bartlett in Elsen 1965a, 95.
14. Mirolli (Butler) pointed out that Eve's upraised, palm-out gesture "has been taken from Michelangelo's Adam of the *Expulsion* in the Sistine Ceiling and by this reference Rodin clarified his interpretation of the *Eve* as a figure of guilt when she was brought into the context of *La Porte de l'Enfer*" (1966, 211).
15. *Rodin 1900–1907*, letter 305.
16. A photograph of the small, definitive version of *Eve* in the course of completion was reproduced by Beausire (1988, 84). For discussion of the marble versions, which include several based on the life-size *Eve*, see Beausire 1988, 84–85; Barbier 1987, 198; Rosenfeld in Elsen 1981, 89, 101; and Le Norman-Romain 1999, 45.
17. Beausire 1988, 153, 208, 215, 235, 242, 253.

42

Bust of Eve (Eve, buste), by 1883

- Bronze, Coubertin Foundry, cast 1982, 1/4
- 8¾ x 8¾ x 7 in. (22.2 x 22.2 x 17.8 cm)
- Signed on front of base, center: A. Rodin
- Inscribed on back of base: © (Musée Rodin 1982; to left of signature: Nº I/IV
- Mark on back of base: Coubertin Foundry seal
- Provenance: Musée Rodin, Paris
- Gift of the Iris and B. Gerald Cantor Collection, 1998.348

Figure 148

*H*aving determined to place his *Eve* in front of *The Gates of Hell*, Rodin's first problem was to establish the pose. Eve before the Fall was the preferred salon subject, but this would have been inappropriate for the opening act of *The Gates of Hell*. In this small little-known study Rodin decided to tell the story in the upper third of the woman's strong body. While the pose of *Adam* is open so that we see his right facial profile, chest, and arms, this study announces that *Eve's* will be closed. In what may have been intended as an expression of shame and guilt, Rodin made the woman seem to bend in on herself. The position of her arms and hands that squarely frame the head carry the drama, while *Eve's* face is not only hidden from sight as she lowers her head but, except for her ears, the features are not even modeled. Her summarily modeled, even mittenlike right hand is continuous with her left breast. The upper abdomen is not modeled but left rough, and her right breast is fused with her right arm.

At the time *Eve* was made, Rodin was unquestionably thinking of what he had learned from Michelangelo, and the final *Eve* does have Michelangelesque resonances. But this study shows Rodin's attempt at being an original interpreter, avoiding obvious or trite gestures of despair or those used by his predecessors in painting and sculpture. For a titled sculpture such as this and *Adam*, Rodin was dictating the pose. The woman's shame is expressed by resting her bowed forehead on her upraised right forearm; there is not even a separation between the two, as if they were modeled from the same clay at the same time. Her left open hand reaches back, touches her neck, and seems to push back her hair. Overall the gesture seems more protective than cosmetically inspired, however.

Rodin would abandon this conceit because he found more expressive gestures for the two arms and hands, but he kept the idea of *Eve's* compact self-enclosure. Artistically, the most impressive view includes the big curve of *Eve's* broad upper back with its stretching of the muscles, something the sculptor preserved in the final figure (fig. 147). Rodin prided himself on making backs as expressive as faces, and studies such as this show us the source of his confidence.

LITERATURE: Fonsmark 1988, 148

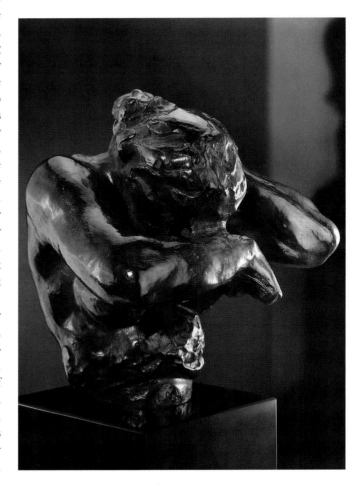

Fig. 148. *Bust of Eve* (cat. no. 42).

43

The Three Shades (Les trois ombres), 1881–83

- Title variations: *Spirits of Despair, Three Despairing Ones, The Three Phantoms, The Vanquished*
- Bronze, Georges Rudier Foundry, cast 1978, 8/12
- 38½ x 35½ x 17¾ in. (97.8 x 90.2 x 45.1 cm)
- Signed on front of base, left: A. Rodin
- Inscribed on back of base, left: Georges Rudier/Fondeur Paris; below signature: No. 8; on base, right side, near back: © by Musée Rodin 1978
- Provenance: Musée Rodin, Paris
- Gift of the Iris and B. Gerald Cantor Collection, 1998.360

Figure 149

Conventional wisdom has it that Rodin's *Adam* (cat. no. 40), with some changes in the arms, became *The Shade* and that we can see his reworked form in triplicate in *The Three Shades* atop *The Gates of Hell.*[1] *Adam* may have been made by 1877 and *The Shade* some years after, so it is not surprising that two different male models posed for these works. For *The Shade* the model could well have been the carnival strongman Cailloux, who, according to Judith Cladel also posed for *Adam*. As *Adam* may have been started in Brussels, its model could have been someone else, as Cailloux was later known to Rodin's son, Auguste Beuret.[2] The model for *Adam* was shorter, stockier, and more heavily muscled to the extent that his ribs did not protrude as much as those of *The Shade*. While both figures experience the unnaturally exaggerated horizontal position of the neck, that of *The Shade* is far more extreme, and it is as if Rodin added at least two inches to the trapezius muscle in the neck. The position of the head is so low as to endanger the brachial plexus (in the collarbone area), which affects the motor and sensory functions of the body. The destiny of *The Shade* atop *The Gates*, where one has to look up at it, may explain Rodin's recourse to such a drastic anatomical change so that the lowered face would be more visible. The heads and faces of the two sculptures are totally different.

Rodin also made important changes in the pose of *The Shade* compared with that of *Adam*: the left side of

Adam's face is pressed into his left shoulder, while that of *The Shade* is turned away from the shoulder; *Adam's* upper-right arm is pressed tightly against his torso, while in *The Shade* it extends from the body; *Adam's* right knee is pulled around in front of his left, whereas in *The Shade* the knees are parallel. The exaggerated twist of *Adam's* right leg yields a discrepancy between the location of his navel and sternum that is greater than that in *The Shade*. Rodin takes dramatic liberties by lowering the placement of the quadriceps, probably in consideration of *The Shade's* being seen from below. *Adam's* overall silhouette as viewed from a three-quarter frontal view is squared off, as if in an invisible cube, while that of *The Shade* is more open because of the outward gesture of the left arm. It is only with the tripling of *The Shade* that an overall cubed silhouette comes into being when seen from the front (or rear). This compels the thought that almost from the beginning, Rodin may have intended to triple the figure and that the conjunction was not a studio game or accident.

Without contrary evidence, it appears that the figures were always intended for the top of the portal; Rodin referred to them as "phantoms," whom he associated with Dante's *Inferno*.[3] In their symmetrical grouping and placement, *The Shades* must have been inspired by the *Baptism of Christ* (Baptistery, Florence), an outsized trio begun in 1502 by Andrea Sansovino and placed by 1584 atop Lorenzo Ghiberti's *Gates of Paradise* (1425–52).[4] (None of Rodin's many drawings of groups of males in the *Inferno* predict this composition based on triplication.) The downward gestures of *The Shades* draw the beholder directly to *The Thinker*. In all, *The Three Shades* along with *Adam* and *Eve*, *Ugolino* and *Paolo and Francesca*, and *The Thinker* were the figural anchors as he composed *The Gates of Hell*.

Visitors to Rodin's studio, like Gustave Geffroy who saw *The Shades* atop the evolving portal, made the association with Dante: "On high above the pediment three men set up, at the summit of the work, an animated equivalent of the Dantesque inscription: *Lasciate ogni speranza* (Abandon every hope). They lean against one another, bent forward in attitudes of desolation, their arms extended and gathered toward the same point, their index fingers brought together, expressing the certain and the irreparable."[5] Geffroy was customarily a careful observer, and he is the only one to write of *The Shades* as having hands. The February 1888 edition of *L'art français* published a lithograph showing the upper

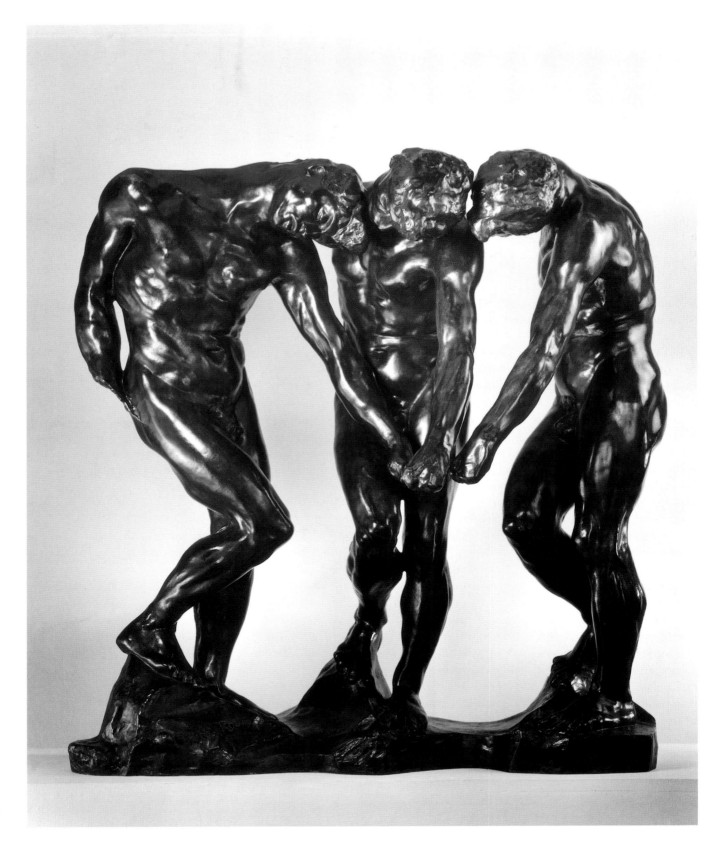

Fig. 149. *The Three Shades* (cat. no. 43).

portion of the portal, and *The Shades* lack hands.[6] It is entirely possible that *The Three Shades* were originally made with hands and that Rodin later removed them. The gesture Geffroy described may be viewed as in accord with hand gestures in the final enlargement.

Compared with the enlarged version, which has hands, why did Rodin not show these extremities on the figures above *The Gates*? Absent his own explanation, we are left to ponder the thematic and artistic effects. Some might ask, suppose Geffroy was mistaken and Rodin just did not get around to finishing them? Between 1898 and 1900, for example, he had a crew of assistants and spent a lot of money preparing the portal for exhibition. At that time, if not earlier, he could have added hands had he wanted.[7] In fact, when *The Shade* was enlarged by Henri Lebossé in 1901 and *The Three Shades* were exhibited in the Salon of 1902, they still lacked hands.[8] Viewed from below the portal, *The Three Shades* appear to resist the pull of gravity or death. The futility of that resistance could be signified by the absent hands. Artistically cutting off the lower right forearm of *The Shade* gave Rodin a cleaner, more compact silhouette, as the stump of the arm leads into the figure's right thigh.

In terms of exhibitions, *The Three Shades* without hands had a more active life outside Rodin's studio than did *Adam*, perhaps because he felt he had put more distance between himself and Michelangelo in the former.[9] We do not know the dates when hands were added (or whether they were made by Rodin or an assistant), or rejoined and then enlarged, nor if this version was exhibited.[10] For Rodin hand gestures were extremely important vehicles for expression. What did he have in mind for the final version of *The Shades* (see fig. 151)? The right hand of each, held next to the hip with the palm up, has the thumb and forefinger touching, giving the member a graceful closure, but its significance for the situation is unknown. The new left hand is also open with the forefinger extended, not stiffly as in the downward, pointing gesture of *Adam's* right hand but sufficient for Geffroy to have read it as an indicating gesture. Given the tragic implications of the trio, did the relaxed nature of the gestures signify resignation rather than resistance to fate?

It would seem that *The Three Shades* is probably the first example of Rodin's invention of the multiplication of a figure in a composition, and as such it provides insight into his mentality as an artist. Rodin never used his invention so that the figures are simply aligned without

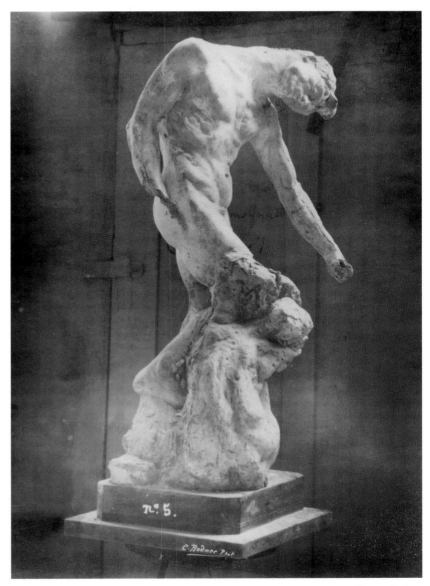

Fig. 150. Karl-Henri (Charles) Bodmer, *"Shade" with "Fallen Caryatid" in plaster* (A97).

some change in orientation toward the beholder; at first sight the composition seems quite natural and the participants different persons. For *The Shades*, Sansovino's *Baptism of Christ* may have given Rodin the idea for the placement of *The Shades* but not their replication. *The Three Shades* is a totally new compositional idea with numerous thematic and formal possibilities that would be emulated by Georges Minne in his *Fountain of the Kneeling Youths* (1898–1906; Folkwang Museum, Essen.).[11] What seems to have appealed strongly to Rodin was the type of open-ended, dramatic, nonliterary situations that multiplication of and confrontation with the self created. Leaving the sculpture's reading to the imagination of the viewer

(as Pablo Picasso would do) became crucial to Rodin's modernity, starting with *The Gates of Hell*. This must have made the charges that he had a literary imagination all the more galling. After *The Kiss* Rodin seems to have systematically explored new and unorthodox ways of composing that did away with mutuality and the entwining of limbs, trusting for new harmonies in the excellence of his modeling in the round and for surprising new silhouettes achieved by the chance encounters between his ready-made figures. Quite simply, whether by multiplication or *marcottage* (combining two or more previously made sculptures, in, for example, such composite works as *The Shade with Fallen Caryatid* and *Shade with Meditation*, figs. 150 and 192), Rodin seems to have been artistically rejuvenated. He must have relished the element of surprise, especially for himself, when seeing his old figures take on a new life.

Leo Steinberg has thought long and well about the implications of doubling and tripling the same figures: "Such multiplications are Rodin's constant recourse, and if we do not know how they were prompted, we at least recognize the effect, which is always a redoubling of energy. Multiplication generates new and more intricate rhythms of solids and intervals." Steinberg continued, "These strange replications, which cannot be read either as one figure proliferated in two or three bodies, or as one body in several roles or places at once, compel an instinctive reconsideration of what actually is represented. If it occurs more than once, the sculptural form cannot be a direct representation of nature. It must be either an artifact in mechanical multiplication, or a thought obsessively thought again. It can be both. Only one thing it cannot be: the simple analogue of a natural body whose character it is to be unrepeatable."[12]

NOTES

LITERATURE: Grappe 1944, 25; Tancock 1967, 1976, 129–35; Jianou and Goldscheider 1969, 88; Steinberg 1972, 355; de Caso and Sanders 1977, 139–41; Lampert 1986, 50–52, 205–6; Miller and Marotta 1986, 14; Beausire 1989, 176–78; Goldscheider 1989, 152; Le Norman-Romain 1999, 78

1. This writer too once subscribed to this view. (See also, for example, Goldscheider 1989, 152.) There is a great advantage to having the actual sculptures at hand to make close inspection. The problem of dating *The Shade* and *The Three Shades* is reviewed in Tancock 1976, 128.
2. Cladel 1936, 143.
3. Bartlett's notes of 1887 have Rodin saying, "The salient subjects of the door are the two episodes of Paolo and Francesca da Rimini and Ugolino, but the composition includes the three phantoms and Dante" (in Elsen 1965a, 70).
4. On Sansovino's group, see John Pope-Hennessy, *Italian High Renaissance and Baroque Sculpture*, 2nd ed. (London: Phaidon, 1970), 345–46, also G. Hayden Huntley, *Andrea Sansovino: Sculptor and Architect of the Italian Renaissance* (1935; reprint, Westport, Conn.: Greenwood, 1971), 44–42. Saint John and Christ were begun by Sansovino; the third figure, an angel, was added later.
5. This is from Geffroy's 1889 essay on Rodin for the Georges Petit exhibition, reprinted in Beausire 1989, 62.
6. Reproduced by Bartlett in Elsen 1965a, 71.
7. Photographs show that *The Three Shades* had not been placed atop the plaster portal when the 1900 exhibition opened, but by the end of the exhibition they had been. See Elsen 1980, pls. 15, 18.
8. For Lebossé's notes dating the enlargement, see Elsen 1981, 258. Tancock (1976, 130) quoted Goldscheider, who indicated (in *Auguste Rodin, 1840–1917: An Exhibition of Sculptures/Drawings*, exh. cat. [New York: Charles Slatkin Galleries, 1963], no. 23), without proof, that *The Shade* was enlarged about 1898. For the 1902 exhibition photograph of *The Shades*, see Tancock 1976, 132.
9. The enlarged *Shade* in plaster was paired with the *Meditation without Arms* (cat. no. 62) and photographed by Jacques-Ernst Bulloz in 1903–04 (see fig. 192) and later was shown at the Ny Carlsberg Glyptotek in Copenhagen as *Adam and Eve* (Tancock 1976, 134). Fonsmark clarified that the Glyptotek acquired the figures separately, before 1913, but showed them together for a period, reflecting the idea of the assemblage (1988, 81).
10. On the addition of hands, see cat. no. 44, note 4.
11. On Minne, see Robert Hoozee et al., *George Minne en de Kunst rond 1900*, exh. cat. (Ghent: Museum voor Schone Kunsten, 1982), cat. nos. 61, 62, 69–78.
12. Steinberg 1972, 355, 358. For another view of Rodin's replicating practice, see Tancock 1967.

44

The Three Shades
(*Les trois ombres*), *1881–83, enlarged 1901*

- Bronze, Coubertin Foundry, 2/12
- 76 x 76 x 42¹³⁄₁₆ in. (193 x 193 x 108.7 cm)
- With hands
- Signed on front of base, below feet of left figure: A. Rodin
- Inscribed on back of base, right side, lower edge: Fonderie de Coubertin
- Mark adjacent to inscription: Coubertin Foundry seal
- Provenance: Musée Rodin, Paris
- Gift of the B. Gerald Cantor Collection, 1992.158

Figures 151–52

*I*n 1889 Rodin exhibited the trio of small-size *Shades* as études during his exhibition with Claude Monet, suffering the criticism that he should not expose to the public parts of an unfinished commissioned work and that what he was doing was "not comprehensible because he begins at the end."[1] The great critical and financial success of Rodin's 1900 exhibition may have encouraged him to have his trio of *Shades* enlarged. It was in the early years of the twentieth century that, working with the gifted technician Henri Lebossé, Rodin extended the lives of many of his sculptures, such as *The Thinker*, through enlargement. This coincides with, if it was not caused by, an increase in the number of exhibitions in foreign countries in which large-size works attracted more attention and purchases.

In September 1901 Lebossé wrote to Rodin concerning the enlargement of *The Shade*, "Today I finished the weight-bearing leg. The one that is bent is well enough along—also the two arms. The artists who have seen [the leg that carries the weight] were stupefied by it."[2] That Rodin had his works enlarged by Lebossé was well known, and the latter enjoyed showing sculptors the quality of both Rodin's work and his own.

Just when Rodin added the hands is not completely clear. In 1902, for example, the handless *Shades* were exhibited at the Salon nationale and reproduced in the *Gazette des beaux-arts*.[3] For that exhibition the three casts

were not joined on a common base but instead were shown all facing inward in a semicircular arrangement but at a short distance from one another. In 1903 a bronze cast of *The Three Shades* was on view and for sale at 12,500 francs in Potsdam, which suggests the enlarged version, but we still cannot be sure about the presence or absence of hands. Presumably the three figures had been joined at the base. Whether or not Rodin modeled new hands for his figures or drew from his reserve of ready-mades we cannot say; perhaps with the publication of the Meudon reserves, we may learn more.[4]

Rodin had been twinning and tripling figures before 1900 as with *The Three Faunesses* (1882) from *The Gates* and the self-confronting plasters of *Old Woman* (cat. no. 51), which were exhibited as *Dried-up Springs* (1889).[5] As part of his becoming a modern sculptor through questioning what had previously been unquestionable, it was as though he had asked, What if I doubled and tripled a figure? Why not a trio of *Shades* if they work in the cube? What is gained and what is lost? Atop *The Gates* they served to focus attention downward to *The Thinker* and gave the portal more of a central axis. Seen by themselves, the life-size trio was a dramatic way of showing that strong silhouettes well modeled, not mutuality of gestures and facial expressions, were the basis for arranging if not composing figures in proximity. Repetition also caused space in the form of intervals to become more apparent. Tripling gave the asymmetrical figures a symmetrical and emblemlike configuration that held up strongly when viewed from a distance. Unification denied the suggestion of physical motion but accentuated formal movement in a closed system.

John Tancock was one of the earliest interpreters of Rodin's figural repetition. Writing of *The Three Shades* in *The Gates*, he focused on their tragic character: "seemingly drawn together and down by the force of gravity, they embody a feeling of helplessness which is depersonalized by being presented in triplicate. It is like the repetition of a line in a poem which gains in force each time it is repeated. In grouping three casts of this self-engrossed figure, Rodin ruled out any possibility of communication between them. Their physical closeness is deceptive. No consolation is possible."[6]

In his exemplary essay on Rodin, Leo Steinberg explored the formal consequences of Rodin's multiple use of a figure, and he referred to "the *Three Shades*, the triple yoke and crown of the *Gates of Hell*, one form in three bodies. . . . By assembling three casts of the figure,

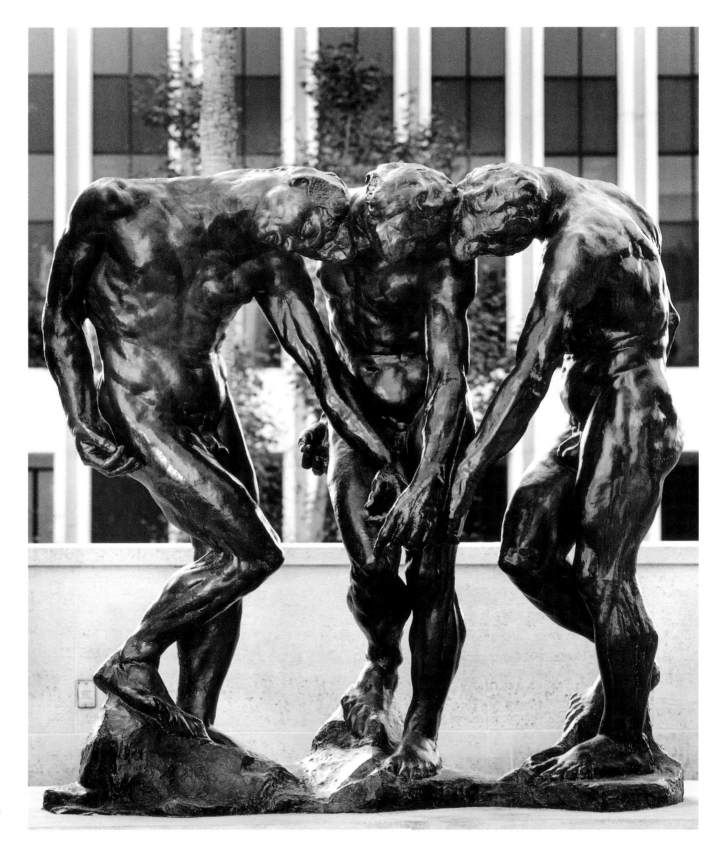

Fig. 151. *The Three Shades* (cat. no. 44).

Rodin prevents dissipation. The exterior shapes become engaged intervals, and the repeat of this one irregular body yields infinite rhythmic amplification."[7]

Separated from *The Gates of Hell* and enlarged, *The Three Shades* became the dream of later modern sculptors, to be monumental without creating a monument in the conventional sense, of giving in public serious service to sculpture itself, of provoking interesting thoughts of the beholder's own design.

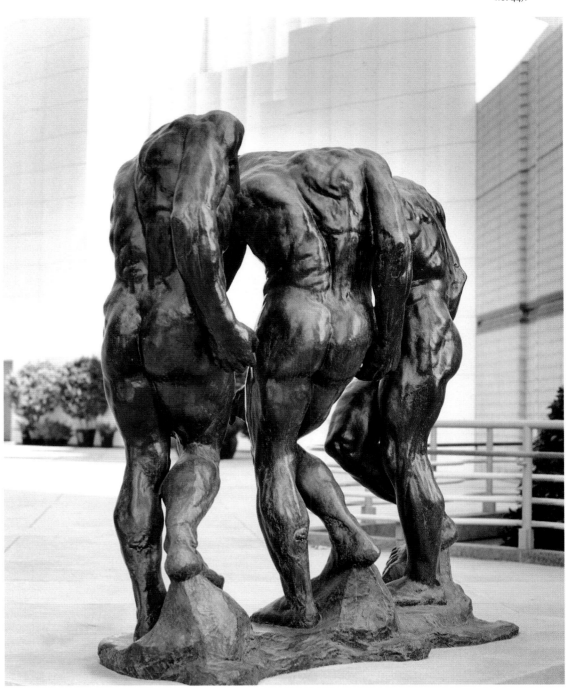

Fig. 152. *The Three Shades* back view (cat. no. 44).

NOTES

LITERATURE: Grappe 1944, 25–26; Tancock 1967, 1976, 130; Steinberg 1972, 355; de Caso and Sanders 1977, 139–41; Fonsmark 1988, 79–83; Levkoff 1994, 58–59; Le Norman-Romain 1999, 78–79; Le Norman-Romain 2001, 140

1. Beausire 1988, 29–30.
2. Lebossé to Rodin, 4 September 1901, cited in Beausire 1989, 176.
3. Marcel H., "Les salons de 1902," *Gazette des beaux-arts* 18 (August 1902): 129. A photograph was reproduced in Tancock 1976, 132.
4. In 1904, Rodin had his assistant Josef Maratka replace the missing right hand, and Rodin also grouped the trio on a single base; see Le Norman-Romain 1999, 78–79, where the group is dated 1902–04.
5. These works are discussed and reproduced in Steinberg 1972, 354, 358.
6. For his views in full, see Tancock 1967, 38–41.
7. Steinberg 1972, 355, 358.

45

Ugolino and His Sons (Ugolin et ses fils), 1881–82

- Title variation: *La bête humaine*
- Plaster (later varnished for casting)
- 16½ x 25 x 16 in. (41 x 63.5 x 40.5 cm)
- Provenance: Alexis and Eugene Rudier; Sotheby Parke Bernet, Monaco, 25 November 1979, lot 19
- Gift of the Iris and B. Gerald Cantor Foundation, 1987.38

Figure 153

*I*n the last circle of his *Inferno* Dante put Count Ugolino, frozen in the same hole with Archbishop Ruggieri, both traitors to their native city of Pisa. Following the concept of making the punishment fit the crime, Dante has Ugolino gnawing on Ruggieri's head, then stopping to recall his treason and tragic punishment. As punishment for his betrayal, Count Ugolino, who once commanded the Pisan navy, was locked in a tower with four of his offspring and left to starvation and cannibalism. Dante's story was one of the two earliest stories from the *Inferno* (canto 33) to be interpreted in sculpture by Rodin. A life-size plaster, *Seated Ugolino*, dates from 1876 at the latest and was made in Belgium after Rodin's trip to Italy (fig. 154).[1] The third architectural model for *The Gates* shows the doomed count with a child across his lap (see fig. 160), and Stanford has a sheet with two drawings of this motif (cat. no. 47).[2] In the Musée Rodin collection a sheet with other sketches includes a small drawing of Ugolino crawling.[3] Probably drawn very late in the studies, it was nevertheless not a blueprint for the composition Rodin created for the portal.

The best discussion of Rodin's sculptural group of Ugolino and his children was written by Ruth Mirolli (Butler), who pointed out how drastically different his interpretation was from that of Jean-Baptiste Carpeaux's work of 1860 and how unprecedented was the horizontal grouping.[4] As with *The Kiss* (cat. nos. 48–49), Rodin's departure from the drawings of this theme must have been caused by working in the round with live models, reportedly Pignatelli, who had served him for *Saint John the Baptist Preaching* (see fig. 446).[5] The new sculptural

group could have been begun in 1880 or 1881. By showing the starving father on all fours, Rodin dramatically altered the theme's *mise en scène* from that of the seated pose in the third architectural model and most of the drawings, probably inspired by a rereading of Dante and the lines describing the last days of the ill-fated family left to starve in a dungeon: "When we had come to the fourth day, Gaddo threw himself stretched out at my feet, saying,'My father! Why don't you help me?' There he died; and even as thou seest me, saw I the three fall one by one, between the fifth day and the sixth; whence I betook me, already blind, to groping over each, and for three days called them, after they were dead; then fasting had more power than grief."[6]

While the Ugolino group was still in clay, Rodin made at least two recorded critical changes before casting the Stanford plaster group.[7] The changes were photographed probably between 1881 and 1883, with the naked, wooden, boxlike armature of *The Gates* behind one of them.[8] The earlier of the two versions in clay shows Rodin's dissatisfaction with the top of Ugolino's head. He subsequently changed the whole head, lowering its position and eliminating the bared teeth. The second photograph shows that he also changed the pose of the child who lies directly beneath Ugolino, raising the head (fig. 155). On *The Gates* itself he returned to the boy's original posture with the head down and both legs to the ground (fig. 156). This version is smaller than *The Kiss* and shows the group from the side opposite that revealed by these photographs, indicating that Rodin had no fixed viewpoint from which to see the figures when he was working on them for the portal. To achieve the angle and depth he wanted when he inserted the group into the left door, Rodin omitted the fourth child, who lies across the father's right leg.

Seen in the round, the final form of the Ugolino group can be visualized not within the imagined pyramid used by Carpeaux but, instead, within Rodin's cube. The group has no front and back, thematically or artistically. (If we take its orientation in *The Gates* as a guide, it seems Rodin particularly liked a three-quarters left view.) There is no one view from which all the figures can be seen, as is the case with Carpeaux's seated Ugolino biting his fists and flanked by his dying children. From whatever angle it is viewed, *The Kiss* offers a graceful, closed silhouette. In contrast, the many contours of the doomed family have a harsh angularity due to the bony nature of the starved bodies. As with all Rodin's compositions, the

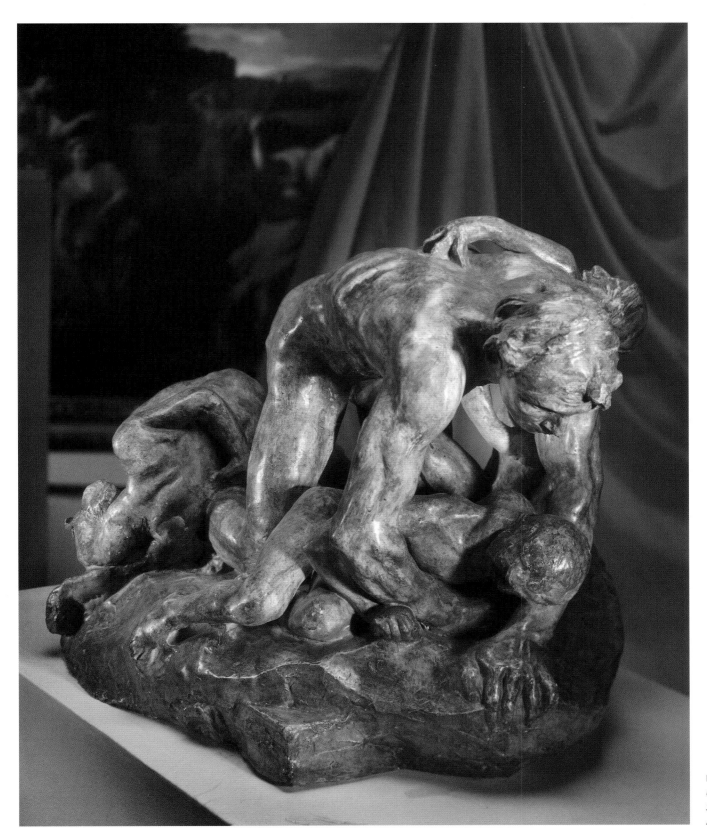

Fig. 153.
Ugolino and His Sons (cat. no. 45).

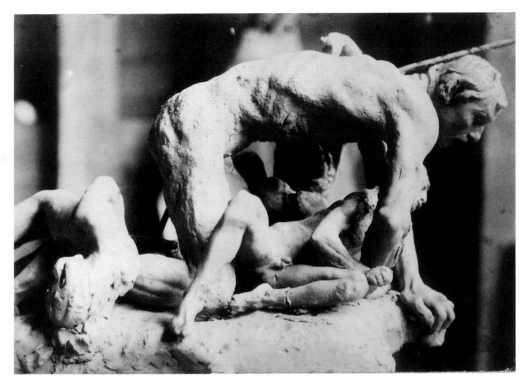

Ugolino group must be experienced sequentially by circumambulation. Only such a roving inspection can reveal Rodin's inventiveness in creating postures of death. Many arms and legs of the dead and dying children are in positions impossible to attain in life. Rather than violence, however, they evoke the slowness of the boys' demise and perhaps the inadvertent buffeting of the bodies by the sightless and desperate Ugolino crawling in their midst (see fig. 554). Most inventive and touching is the pairing of the father with a dying child, who lies cradled between Ugolino's arm and hand. The boy's head hangs downward, but his eyes and mouth are still open. Ugolino's right hand is under the boy's frail chest, and with his left forearm the blind parent tries to support the son's head, as if refusing to let it touch the ground.

Mindful of the prolonged nature of their dying, Rodin made his figures with a gauntness appropriate to their age. Ugolino's skin is without elasticity, and it hangs on his skeletal frame. The youngest child, in fact, an infant, is not emaciated because by Rodin's reasoning he would have died first. Faithful to Dante's story, Ugolino appears blind while groping on all fours, his stomach contracted as through his open mouth he seems to cry the names of his offspring. In *The Gates* we can look up into Ugolino's face. To those who know the story, Rodin's conception of Ugolino's face is brilliant, allowing multiple interpretations: the father is realizing that his punishment fits the

crime of betraying his greater family, the city of Pisa; the open mouth presages the eating of the dying son he cradles. The most memorable and pathetic of the boys is about to lose his grip on his father's back. The head of this slumping youth is one of Rodin's most expressive and had a rich life in his art (cat. nos. 50, 55, 96).

Truman Bartlett saw the Ugolino group in the studio during his 1887 visit and compared it with that of Carpeaux: "Of Rodin's power of seizing the most dramatic point of a subject, the group of Ugolino and his sons is a terribly real example. Various artists have treated this subject at the moment when the father is in the act of biting his fingers in the first scene of his agony, and when his sons are suffering the first pangs of hunger. Rodin goes at once to the depths of the whole tragedy. The youths have fallen to the ground, and Ugolino, seeing them so, and feeling the full terror of his situation, throws his own emaciated carcass down and crawls over the bodies of his offspring like a beast benumbed with rage and famine. . . . The impression made by this being is so forcible that it seems more like the half-conscious response of an unburied corpse to the trumpet of the resurrection. . . . It is the horror of the door."[9]

The museum's plaster shows evidence of having been prepared for bronze-casting, both by the varnish and marks of editing with files and knives over all the surface. As the Cantor collection at Stanford was formed in part to show how Rodin worked, this plaster is extremely valu-

able technically. Most Rodin plasters were not reworked but were made for sale or exhibition, as gifts, or to be incorporated into new compositions. The editing of the Stanford work was done primarily to restore definition lost from the original clay when it was cast in plaster. It could also reflect subtle changes, perhaps with respect not only to sharpness of definition but also to the future bronze surface's reaction to light. At least the extensiveness of the reworking, not just of the figures but of the rocky base as well, shows how concerned Rodin was to ensure a bronze surface as close as possible to the clay he had modeled. The same editing marks, as distinguished from those made in the chasing of the metal, do not show in *The Gates of Hell* bronze cast of *Ugolino and His Sons*. This is because the latter was made from a different plaster, one that was cast and assembled in 1917 on orders of Léonce Bénédite for the opening of the Musée Rodin. The Stanford figures were separately cast in plaster and joined to each other and the base with white wax.

Rodin appears to have exhibited this group in bronze in Brussels (1887), Edinburgh (1893), Geneva (1896), Florence (1897), the Netherlands (1899), and in his own retrospective (1900).[10] Between 1901 and 1904 Henri Lebossé enlarged the group to more than life-size, at which time Rodin made some changes.[11] It appears that after its enlargement Rodin exhibited *Ugolino* alone in Venice (1903) and in Edinburgh, Düsseldorf, and Dresden (1904).[12]

NOTES

LITERATURE: Bartlett 1889 in Elsen 1965a, 72; Grappe 1944, 30–31; Elsen 1960, 10, 64, 74–75, 92; Mirolli (Butler) 1966, 224–27; Jianou and Goldscheider 1969, 89; Tancock 1976, 90, 94, 97, 108; Elsen 1980, 166–67; Elsen 1981, 191–200; Judrin 1982; Elsen 1985a, 78, 80–81; Miller and Marotta 1986, 19–21; Lampert 1986, 198; Fath and Schmoll 1991, 147; Le Normand-Romain 1999, 48–49

1. Rodin wrote letters to Rose Beuret in Brussels in April 1877 requesting that this *Seated Ugolino* be sent to him; see *Rodin 1860–99*, letters 15, 17, 19. Somewhat confusing is Rodin's reference in letter 19 to "le petit Ugolin," suggesting that there was either a second version or an étude for the life-size

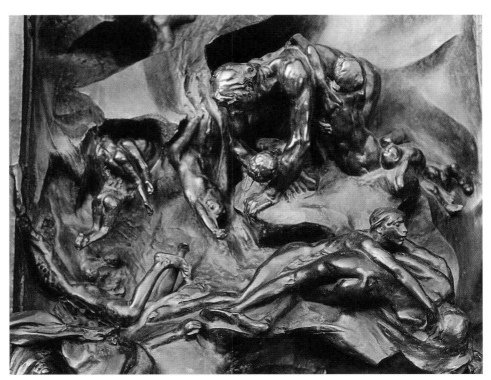

Fig. 156. Detail of *The Gates of Hell: Ugolino and His Sons.*

figure. Whether Rodin also made Ugolino's sons while in Belgium and later destroyed them is not known.

2. For interpretations of Ugolino, see Frances A. Yates, "Transformations of Dante's Ugolino," *Journal of the Warburg and Courtauld Institutes* 14 (January–June 1951): 103–17. For discussion of Rodin's Ugolino drawings, see Judrin in Elsen 1981, 191–200; and Judrin 1982.

3. Elsen 1981, fig. 8.27. A second drawing with Ugolino in this posture was formerly in the Mastbaum collection.

4. Mirolli (Butler) 1966, 224–27.

5. Cladel 1936, 133.

6. Dante 1932, canto 33, verses 67–75.

7. Rodin's compositions might remain for months or even years in clay. On 13 October 1883 Rodin received a bill from a moldmaker named Ganet Aîné for a "moule à creux perdu, un groupe d'Hugolin, 95F" (lost hollow cast, an Ugolino group, 95 francs), Musée Rodin archives.

8. These photographs were reproduced and discussed in Elsen 1980, 166–67 and pls. 27–28. Beausire (1988, 187) properly corrected the author's designation of a group of Niobe and her children as being a third version of Ugolino (see Elsen 1980, 167, pl. 29). The children are from the Ugolino group, but Niobe has the head of *The Falling Man* (cat. no. 64) from *The Gates* and the body of a woman. The Niobe group was shown in the 1900 retrospective and so listed in the catalogue.

9. Bartlett in Elsen 1965a, 72. Carpeaux's *Ugolino* is discussed by Anne Wagner and reproduced in Fusco and Janson 1980, 146–48.

10. Beausire 1988, 96, 116, 126, 131, 153, 185.

11. See author's essay on Lebossé in Elsen 1981, 258. Mirolli (Butler) discussed these changes (1966, 227).

12. Beausire 1988, 240, 244, 253, 255.

46

*Torso of a Son of Ugolino
(Torse d'un fils d'Ugolin), c. 1880*

- Title variation: *Male Torso*
- Bronze, E. Godard Foundry, cast 1980, 3/12
- 9¼ x 7¾ x 7 in. (23.5 x 19.7 x 17.8 cm)
- Signed on left stump: A. Rodin
- Inscribed on left thigh: E. Godard/Fondr.; under buttocks: © by Musée Rodin 1980; below signature: no 3
- Provenance: Musée Rodin, Paris
- Gift of the Iris and B. Gerald Cantor Collection, 1998.349

Figure 157

*R*odin did not build his figures from the ground up. The torso was the nuclear core of his thinking, and that is evident in this version of the son who clings to Count Ugolino's back. Once the body was formed, the arms and legs could be attached, usually with no modification of the muscles in the torso, as shown in *Ugolino and His Sons* (cat. no. 45) and *Paolo and Francesca* (cat. no. 50). Rodin did modify the head in each case; the *Head of Sorrow* (cat. no. 55) and this head for Ugolino's son differ in their surface details. The more compact shape and abstract hair treatment of the partial figure accords better with the curve of the youth's raised buttock. Without the arms to obstruct the view of the front of the torso, it is possible to see the disalignment of navel and

sternum, which gives the body the expressive twist Rodin so prized. The beauty of this sculpture is seen when taken in as a whole and the body becomes a unified gesture, a strong upward diagonal thrust. It was such discoveries—that fewer limbs could be more artistically expressive—that encouraged Rodin to focus on partial figures, even rendering them life-size, after 1900.

LITERATURE: Miller and Marotta 1986, 20; Ambrosini and Facos 1987, 80; Fath and Schmoll 1991, 146–47

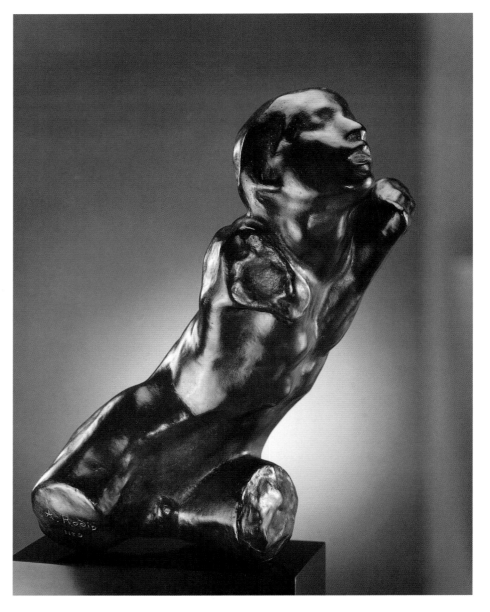

Fig. 157. *Torso of a Son of Ugolino* (cat. no. 46).

Study for Ugolino and His Son
(Ugolin et son fils), 1879–80

- Recto: ink and graphite on paper
- Verso: ink and graphite on paper
- 5⅝ x 3⅝ in. (14.3 x 9.3 cm)
- Signed on recto, lower right: AR
- Inscribed in graphite on recto, lower right: ugolino; on recto in ink, upper left: planche
- Provenance: Feingarten Galleries, Los Angeles
- Gift of the Iris and B. Gerald Cantor Foundation, 1987.39

Figures 158–159

*M*ore than thirty drawings witness Rodin's attraction to, if not obsession with, the episode in the *Inferno* that was interpreted in the nineteenth century as cannibalistic infanticide. With rare exceptions these drawings show a seated father with his children around or before him or with one son on his lap. Just why Rodin was so drawn to the theme of infanticide remains open to speculation. That he himself was a father must have counted in strong measure.[1] The Ugolino motif belongs with so many drawings in this outline manner having to do with men that it might be called Rodin's masculine mode. At times men are shown in violent situations or in deep thought, when the figures are associated with tomb projects.[2]

In her excellent essay on Rodin's treatment of this theme, Claudie Judrin illustrated 27 versions in drawing and sculpture according to what she believed was their narrative sequence. Not included were Stanford's two drawings, unknown to her at the time. She did reproduce an engraving of the recto, which was published in *The French Magazine* in April 1899.[3] This explains the inscription *planche* (plate) on the drawing, as it indicated that it should be reproduced in that article. Judrin persuasively associated the front, or recto, with the fourth day of Ugolino's incarceration, when his children offer themselves to be eaten by their parent. One of the sons lies across the lap of the naked Ugolino, who averts his gaze from his tragic burden. He supports the child's shoulder with his right forearm and the boy's feet with

his left hand. The child's open mouth evokes the plea for his father's help but also the offer of his own flesh ("Father, it will give us much less pain, if thou wilt eat of us: thou didst put upon us this miserable flesh, and do thou strip it off").[4] That the boy's eyes are wide open adds to the horrific sense of the moment.

The verso (fig. 159) shows the son lying on his back across his father's lap with his arms reaching upward. His legs, however, are in two positions. In one they lie passively across the father's thigh. In the other the legs are raised vertically with the feet framing Ugolino's head as if the boy was desperately hanging onto his father and to life. Perhaps Rodin was sympathizing with the child and his imagination was not circumscribed by any postural convention. Judrin appropriately compared the pose of the first drawing with those of the Virgin holding the Christ Child on her lap, but one thinks specifically of Rodin's having seen in 1875 Michelangelo's mother with her dead son in the Saint Peter's *Pietà*. This outline mode, with its heavily muscled types often in contorted or strenuous movement, evinces Michelangelo's powerful influence on Rodin in these years. When Rodin began to work entirely from live models in movement, he slowly shifted away from imaginative drawings in the 1880s and found what he felt was the true secret of Michelangelo's art.

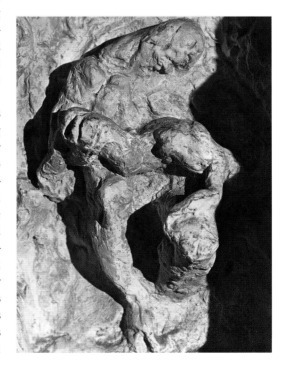

Fig. 160. Detail of *Third Architectural Model for "The Gates of Hell": Ugolino and His Son*, 1880 (fig.121).

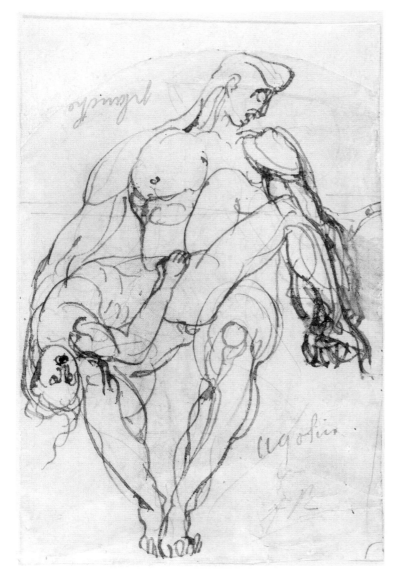

Left: Fig. 158.
Study for
"Ugolino and
His Son," recto
(cat. no. 47).

Right: Fig. 159.
Study for
"Ugolino and
His Son," verso
(cat. no. 47).

The recto side of the Stanford drawing comes close to Rodin's modeled sketch for the subject in the third architectural model for *The Gates of Hell*, but the position of the child is reversed with regard to the sculpture, and in the latter the father appears to be looking at the son (fig. 160). The closeness of the two interpretations supports a date of 1880 for the drawing. (As we know, Rodin did not make sculptures from drawings but rather the reverse, as when he needed a drawn illustration for a salon catalogue and in his 1887 drawings that accompanied Charles Baudelaire's *Fleurs du mal*.) Just when he began sketching from Dante is not known for certain.[5] The small size of the Stanford drawing on cheap paper reminds us that Rodin always carried paper in his pocket and would draw anywhere at anytime.

Stylistically the drawing may be associated with works from the 1870s, if not earlier, and is based on a technique taught to Rodin by Horace Lecoq de Boisbaudran, his drawing master at the Petit école.[6] To establish a pose or movement quickly, this flayed figure, or écorché method as it was known, called for outlining the big muscles and tendons of a figure without concern for details. This simple outline method, allowing for the absence of a live model—as well as speed of execution—could be made anywhere. Shading and correctives might come later, and it is clear that in the recto Rodin reworked Ugolino's left arm and its juncture with the boy's feet. Lecoq de Boisbaudran's method was intended to encourage and help artists draw from memory and their imagination. The imaginative drawings from Dante that precede *The Gates of Hell* are unthinkable without this education. When he had made one of these imaginative

drawings, Rodin often inscribed the name of a subject that he associated with it afterward, but in this case the association and inscription came before the fact, to provide a caption for the reproduction in a periodical. What the imaginative drawing did for his modeling was to give the sculptor the sense of the disposition—what he later referred to as the equilibrium—of the body's main masses that created the overall movement of the figure. Although they look radically different, this outline mode later nourished the contour or continuous drawings that began in the 1890s as they reinforced Rodin's understanding of anatomy. Rodin's passionate nature found early expression in posture, whereas later it was manifested in the act of drawing itself.

NOTES

LITERATURE: Elsen 1981, 198; Miller and Marotta 1986, 19; Eitner, Fryberger, and Osborne 1993, 360

1. On Rodin's relation with his son, Auguste Beuret, see Butler 1993, 51–55, 87–90, 480–81.
2. For a thoughtful analysis of this and other types of drawing by Rodin, see Kirk Varnedoe's essay in Crone and Salzmann 1992, 203–9. This and many other Ugolino drawings may be an exception to Varnedoe's view that "his choice of motif preceded any conscious consideration of literary meaning." See also Judrin 1982.
3. Judrin in Elsen 1981, fig. 8.23.
4. Dante 1932, canto 33, verses 61–63.
5. The different views are summarized by Judrin in Elsen 1981, 192.
6. On the teaching methods of Lecoq de Boisbaudran, see Lecoq de Boisbaudran 1911 and Lecoq de Boisbaudran 1953.

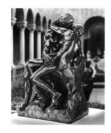

48

The Kiss (Le baiser), c. 1880–81

- Title variations: *The Faith, Francesca and Paolo, Francesca da Rimini*
- Bronze, Georges Rudier Foundry, cast 1966, 9/12
- 33½ x 20 x 22 in. (85.1 x 50.2 x 55.9 cm)
- Signed on base, left side: A. Rodin
- Inscribed on back of base at bottom: Georges Rudier/Fondeur. Paris; on back of base, at bottom, left: © Musée Rodin. 1966; interior cachet: A. Rodin
- Provenance: Dominion Gallery, Montreal; Paul Kantor Gallery, Beverly Hills
- Gift of the Iris and B. Gerald Cantor Foundation, 1974.36

Figure 161

*T*he Kiss, which did so much to establish Rodin's reputation as a sculptor of the erotic, and *Ugolino and His Sons* (cat. no. 45) were the sculptor's most illustrative works, being directly inspired by Dante's *Inferno*. In the circle of carnal sinners Virgil leads the poet to Paolo and Francesca, and the latter speaks to them: "One day, for pastime, we read of Lancelot, how love constrained him; we were alone, and without all suspicion. Several times

that reading urged our eyes to meet, and changed the colour of our faces; but one moment alone it was that overcame us. When we read how the fond smile was kissed by such a lover, he, who shall never be divided from me, kissed my mouth all trembling."[1]

From the first moments devoted to planning the motifs in *The Gates of Hell* but possibly even earlier (as we cannot date the many drawings of embracing couples exactly), Rodin seems to have determined to depict this tragic pair and feature them in *The Gates*. They are probably the couple visible in the second architectural model and are definitely in the third (fig. 162). Just why Rodin did not include *The Kiss* in the final portal is not totally clear beyond such tantalizing clues as Truman Bartlett's statement that "the first study . . . was too large for the purpose intended, it being over half life size."[2] This suggests that the Stanford bronze is associated with this first freestanding version.

Unlike his contemporary in sculpture, Aristide Croisy (1840–1899), Rodin ignored the narrative device of showing two young people, heads close together, reading a book (fig. 163).[3] Rather than a piece of period furniture for the couple's seat, Rodin employed a rock, suggesting a garden or natural setting. His many drawings of the imagined pair and their inclusion in the last maquette for the door testify to his commitment to the theme and to showing the lovers unclothed and embracing. Presenting them naked and outdoors, Rodin, who

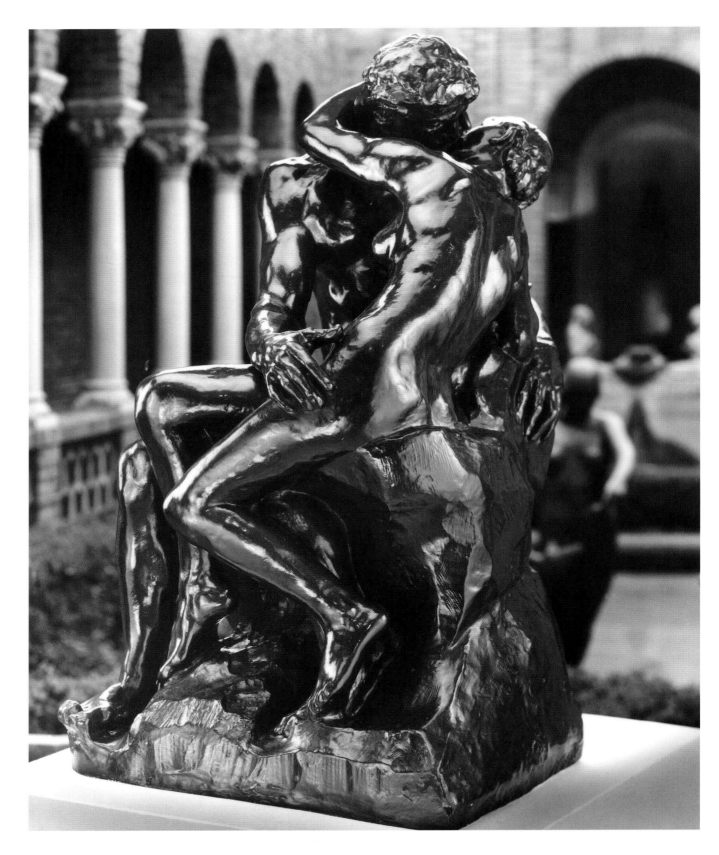

Fig. 161. *The Kiss* (cat. no. 48).

had an aversion to historical costumes, asked that we suspend any suspicion that their reading did not begin in innocence. Coupled with its name, *The Kiss*, which the artist chose for its first exhibition in 1887 in Paris, this divestment won for the artist greater timelessness and universality as proved by the sculpture's international fame since it was first exhibited.[4] Excluding from its title and from visual cues in the group any specific reference to the *Inferno* was like removing Dante's cap from *The Thinker*. Consequently, few viewers from Rodin's lifetime onwards are aware of the sculpture's source in Dante.

No single drawing predicts precisely the pose or subtle narrative of the doomed pair. Such was not Rodin's practice because in sculpture like *The Kiss* he was modeling from living people. (Despite the claims of some to have posed for the sculpture, we still do not know the identities of the models.) The drawings of lovers and the final sculpture show Rodin's determination to personalize the theme rather than paraphrase predecessors, such as Jean-Antoine Houdon, in the motif of the embrace.[5] Unlike his academically trained contemporaries, Rodin did not presume a strict frontality, which meant that he was not limited to projecting his image onto an imagined frontal plane and depicting only one moment in a story. Contemporaneous photographs, such as Eugène Druet's of *The Kiss*, show that Rodin directed the photographers who worked for him to always view his sculptures from an angle that displayed the work's breadth and depth and, by implication, successive moments in the narrative (fig. 164).[6] Even though the group was intended for *The Gates*, Rodin distanced himself from the tradition of architectural sculpture by not conceiving it as a relief. Most of the figures and groups in *The Gates*, such as *Ugolino and His Sons*, were modeled in the round and then attached to the plaster panels within the portal's frame. With his system of plural contour modeling, Rodin had greater latitude in choosing the angle that he wished to set the figures into the surface of the doors. This meant that he knew his composition would read well from several points of view rather than just one. Having a good-size, freestanding version of *The Kiss* also allowed Rodin to exhibit such works independently, thereby adding to his reputation and income. This may have been one of his initial intentions.

During his lifetime *The Kiss* contributed greatly to Rodin's reputation as a sculptor. After his death, and particularly between the two world wars, the marble versions of *The Kiss* contributed more to the decline of his reputa-

Above: Fig. 162. Detail of *Third Architectural Model for "The Gates of Hell": Paolo and Francesca*, 1880 (fig. 121).

Left: Fig. 163. Aristide Croisy, *Paolo and Francesca*, 1876, plaster, 59 x 40½ x 29½ in. (150 x 102 x 75 cm). Musée de l'Ardenne et Musée Arthur Rimbaud, Charleville-Mézières.

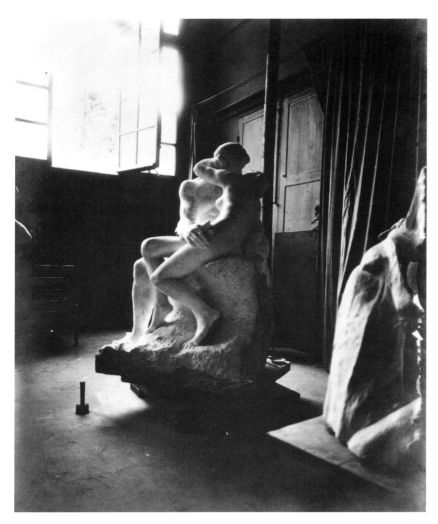

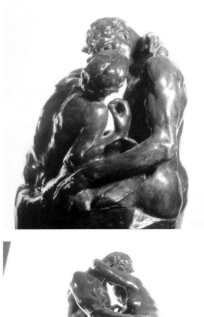

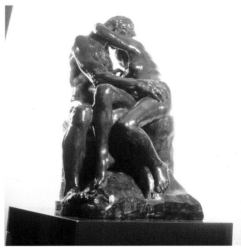

tion among artists and critics who favored "do it yourself" and "truth to the medium" ideals than any other sculpture he created. From Constantin Brancusi to Henry Moore, *The Kiss* in marble exemplified what early modern sculptors were reacting against: literal narration, illusionistic treatment of materials, and not just sentimentality but the very depiction of expression through gestures and body language. That Rodin did not carve the stone himself increased the disdain of many modern artists for *The Kiss*, though it has continued to find favor with the public. Overexposure through reproduction in the media and abuse by commercial artists and cartoonists have distracted us from the historical originality of the composition and superb quality of its execution in the first freestanding version represented by the Stanford bronze. There is no question but that *The Kiss* in its original size and in bronze is far superior to its later enlarged translation into stone by Rodin's carvers.[7] The Stanford bronze allows us to see the beauty of uninterrupted surface nuance and the conjoining of the big planes of the bodies that issued from Rodin's own hands throughout the entire piece. Close examination of the bronze shows that at times Rodin sacrificed anatomical exactitude for the artistic logic of surface planes and their interaction with light, as well as for compositional unity. *The Kiss* has gained in appreciation in the wake of what happened in the art of the 1980s; the words *literary* or *illustration* are no longer opprobrious when applied to art, the dogma of truth to the medium has been all but forgotten, and artists now show their feelings in sculpture as well as painting.

While Rodin would later play down the sculpture's importance, by comparison with subsequent works, his thinking about showing the unfolding of successive (versus simultaneous) movements that formed *The Kiss* would influence our experience of it through time, the later composition of *The Burghers of Calais*, and even the way he wanted us to read *The Walking Man* (cat. no. 174). With live subjects Rodin could compose his narrative in the round, and this is the way *The Kiss* should be read, as

an unfolding story starting at the back. To appreciate Rodin as a great dramatist of the body, the reader is asked to bear with the author in a descriptive reading and commentary on *The Kiss*, in the way we examine the art of the old masters, such as Bernini in his *Apollo and Daphne* (1622–24). No famous modern sculpture has been as misread since its conception as *The Kiss*.

Rodin departed from his predecessors who treated the theme literally, by making Francesca and not Paolo the instigator of the seduction.[8] From the rear of the sculpture and slightly to the left we see the open book, one side of which is pressed flat against the rock by Paolo's open left hand, reminding us that the drama began with the sudden interrupted reading (fig. 165). Francesca's bent right arm has brushed aside its pages. The back of her upraised hand barely touches Paolo's left breast. Her hand, framed in the space between the lovers' shoulders, makes an erotically suggestive gesture of a circle formed by the touching of the thumb and forefinger. Paolo's back is erect, the shoulders still close to being squared, evoking his sense of moral duty as the brother of Francesca's husband and his role as a teacher.

Moving counterclockwise around the sculpture, we see that Paolo's right leg and foot are still firmly set, as when the two sat more upright and slightly separated from each other while reading (fig. 166). Paolo's right leg, with its extended thighbone, is turned out and slightly away from his companion, recalling a male's normal spread-knee sitting position. His toes are tensed, however. The whole impression from the sculpture's right is one of Paolo's slowly eroding resolve and awakening desire. Where Croisy's Francesca coyly cuddles, Rodin's heroine spontaneously but systematically seduces in a succession rather than simultaneity of movements. (Rodin counted on our proximity to the sculpture and reading of the gestures one after the other rather than our just standing back and taking it in from one or two viewpoints.) Contrary to Dante, Rodin's Francesca has taken the initiative in the seduction by the way she has reached up and with her left forearm pulled her tutor's head toward her own. Her left hand is open, resting sideways on Paolo's shoulder and not grasping her lover's neck. Francesca's right leg has been slung over the left of her partner. This gesture of sexual appropriation is what Leo Steinberg has aptly termed the "slung-leg" motif, but surprisingly it was not commented on by critics when the work was shown.[9] (Rodin employed the slung leg motif in the woman of the couple

at the top left bas-relief in *The Gates*, and it has affinities with the theme and style of ceramics he made at Sèvres; see cat. no. 83.) Francesca's left leg is pressed against Paolo's as if enclosing it in a gentle vise, her foot poised so that her toes partially cover his. With neither foot solidly planted, she is still able to extend her body back and to the right. From a sculptor's viewpoint, this posture gave Rodin a beautiful, vigorous, undulating arabesque for Francesca's labile body when seen slightly to the right of front. It contrasts with the more rectilinear profile of her lover.

Looking at the front of both figures' torsos reveals Rodin's use of a device developed in *Torso of a Man* (cat. no. 173), a torso study for *Saint John the Baptist Preaching* (1878). The navel and sternum are not vertically aligned in order to show the same figure in successive movements. Paolo's and Francesca's navels are still seen in the positions they would have been in relation to the hips before the interrupted reading, while their sternums respond, in an anatomic impossibility, to the twisting of the upper body as they converge to embrace. A look between his legs shows that Paolo has no genitals.[10] Surprisingly, in view of the finish with which the rest of the figure is realized, Paolo's left thigh is only summarily modeled, and the area just above it, presumably the cover of the book, reveals the raw, deep gouges Rodin's fingers made in the clay.

The one gesture in the sculpture that everyone notices and remembers is that of Paolo's right hand on Francesca's left thigh. That Paolo's right wrist is raised in line with the forearm and that the hand is flexed slightly downward as if Paolo had changed his mind in midmovement have gone unremarked. In the sculpture's original size and bronze version he lightly touches his lover's left thigh with three fingertips. The thumb and right forefinger are still raised, signaling his hesitancy. This delicacy of touch, so important to the tact with which Rodin treats the theme and the emotional charge he sought with the contact points of flesh against flesh, is lost in subsequent enlarged versions and in other media.

The Kiss Is Not a Kiss

Despite the fact that the sculpture's base is squared in the front when we look up from the contact of hand and thigh at the tilted heads, Francesca's left shoulder blocks the view of their mouths. We have to continue moving

around to the right to see the climax, which it appears most writers have not done: "kissing as only lovers can kiss" (Bartlett);[11] "and the two mouths meet in a kiss" (Geffroy);[12] "The scene is voluptuous and their kiss is a violent one" (Mirolli).[13] Paolo's eyes are still open; those of Francesca, almost closed. Between his lips that are still shut and hers about to part, the small interval will never be closed. In this author's view, Rodin is showing the instant before and not after the actual kiss, which represents his personal dramatic sense and final tact. When we look down, we see the opened book and are brought back to the episode's beginning.

The rock on which the lovers sit is interesting sculpturally. It is on top of and often merges with a shallow base. Rather than being the conventional rectangle, the base is cut to conform generally to the polygonal outline of the bottom of the rock except for a ledgelike extension under Paolo's right foot. It is as if Rodin had decided to change the foot's original position, and rather than extend the rock, he added to the base. Like that for *The Thinker*, the rock has been shaped to conform to those parts of the figures that come into contact with it, such as the arc made by Paolo's buttocks. No attempt is made to produce a Bernini-like resemblance to actual stone, as was done by Rodin in the marble versions. The surfaces are treated quite broadly and abstractly. Knife cuts are undisguised, and for the first time Rodin has left the traces of damp cloths in the clay, thereby imparting a dimpled texture to the stone. What is here marginal to a sculpture, retaining evidence of its making, Rodin will later make more central.

As with his *Saint John the Baptist Preaching*, made two years earlier at a stage in his career when salon finish was still central to his thinking, Rodin worried over the exact shaping and positioning of the couple's every limb and extremity. An old photograph of Rodin's studio shows the finished plaster of *Saint John the Baptist Preaching* and in the lower left-hand corner *The Kiss* in plaster.[14] Many of the couple's limbs have been removed, as he had done earlier while working on *Saint John* and would later do with his *Burghers of Calais*. Rodin was still showing that he could work in the approved manner when it came to gesticular expression, such as conveying emotional mutuality through the arrangement of the limbs.

By circling *The Kiss*, the viewer experiences the story's past, present, and future. This circular unfolding of successive movements initiated by changes of feeling in his subjects was Rodin's contribution to a long history of narrative, freestanding sculpture. Rodin was quoted in *La revue* as saying, "Without doubt the interlacing of *The Kiss* is pretty, but in this group I did not find anything. It is a theme treated according to the tradition of the school; a subject complete in itself and artificially isolated from the world which surrounds it."[15] *The Kiss* contradicts the view that lacking a beaux-arts education Rodin never learned to compose, yet its "pretty interlacing" helps us recognize the academic principles that he well understood but from which he would depart for the later figural couplings on *The Gates of Hell*.

Given the subject's prominence in his drawings and the last sculptural model for the doors, it is probable that the first version of *The Kiss* was modeled as early as 1880 or 1881. *The Thinker* (cat. no. 38), *Ugolino and His Sons* (cat. no. 45), and *Paolo and Francesca* (cat. no. 50) were a crucial triad for the portal's early thematic and compositional purposes. As shown in the last architectural model (see fig. 121) and from what we know of the portal's early years, *The Thinker* was at the apex of an implied triangle whose base was formed by *The Kiss* in the left door panel and *Ugolino* in the right. These major sculptures were the anchor points around and between which Rodin was to improvise the rest of his figures. The decision to exclude the couple from *The Gates* may have been due to Rodin's desire to eliminate, in Rilke's words, "everything that was too solitary to subject itself to the great totality."[16] Rodin may also have felt that *The Kiss* did not evoke the tragedy of the lovers and hence was inappropriate for the evolving theme of despairing couples which he was creating.

In 1887 Rodin exhibited the one-half life-size plaster in Paris with the title *Le baiser*.[17] It was shown in Germany under the title *Intimacy* (1897) and later *Adam and Eve*. (It is not recorded whether Rodin was ever asked to explain how a book got into the Garden of Eden.)[18] In 1888 Rodin was commissioned by the French government to have the plaster carved in marble, and the result was first shown to the public in the May Salon of 1898 in the place of honor, some fifty feet from the *Balzac* (see fig. 331).[19] It was Rodin's intention that the public see how far he had progressed as a sculptor in two decades, but not surprisingly the public and many critics preferred the earlier work.[20]

The Kiss became Rodin's most censored work. According to Bartlett, when the statue was exhibited in Brussels (1887), it was ridiculed because they were naked.[21] When shown later in the 1898 Paris exhibition, it

received great critical and public approval, although its nudity shocked some who were unaware of the story and thought the figures depicted their own contemporaries. During the 1893 Universal Exhibition in Chicago the sculpture provoked a scandal. When the marble version was shown in 1913 in the town hall of Lewes, England, "its public exhibition caused local puritans to make so many objections that it had to be surrounded by a railing and draped with a sheet."[22] In 1919 photographs of *The Kiss* were censored in Canada. In 1924 its showing was censored in Japan, and a screen of bamboo was placed around it.[23] Similar reactions continued to occur.[24] By contrast, several years ago a curator at the Tate told this author that he had collected many letters from young people expressing their gratitude for Rodin's sculpture as it was important to their sex education; and, indeed, it still serves as a cover illustration for books on the subject.

The evocative photographs by Druet, taken in the studio in 1898, about the time he first worked for Rodin, tend to overcome that fault Rodin commented on when he saw the marble couple out of doors: an artificial isolation from the world around them. (The photographs mask the terrible flaws in the marble itself, which greatly shock people who actually see the work today at the Musée Rodin.) A mallet stands on the floor in figure 164, although in later prints it was unfortunately removed. On the saddle at the right is a small dish, which probably held the matrix (possibly gum arabic) for the marble dust used to fill the holes left when unmetamorphosed grains of sand fell out, pointing holes went too deep, and the many pieces of the defective marble that broke off had to be put back. Placing the figures by a window in the shadows with the mallet evokes the Pygmalion theme popular in the 1890s and treated elsewhere by Rodin. Druet captured the figures as Rodin would have had us see them, and it is possible to enjoy the big planes and simplified vigor of which he approved.

NOTES

LITERATURE: Bartlett 1889 in Elsen 1965a, 63–64, 72 Grappe 1944, 59; Alley 1959, 225–26; Mirolli (Butler) 1966, 232; Jianou and Goldscheider 1969, 100; Bordeaux 1975, 123–28; Wasserman 1975, 169–70; de Caso and Sanders 1977, 149–53; Butler 1980, 201; Elsen 1980, 181–82; Elsen 1981, 82, 85–87; Elsen 1985a, 78–81; Barbier 1987, 184–86; Fonsmark 1988, 106–8; Barbier 1992, 152–55; Le Normand-Romain 1995a

1. Dante 1932, canto 5, verses 127–36. The lovers were then surprised by Francesca's husband, who slew them both.

2. Bartlett in Elsen 1965a, 72.

3. For the list of Rodin's predecessors who treated this theme in the nineteenth century, see Mirolli (Butler) 1966, 245. For literary as well as artistic precedents, see Bordeaux 1975.

4. Beausire 1988, 95–96. Later that year in Brussels he called it *Francesca da Rimini*.

5. For further background on the kissing theme, see Nicolas Perella, *The Kiss: Sacred and Profane* (Berkeley and Los Angeles: University of California Press, 1969). Houdon's *Le baiser donné* (1778), a bust-length couple embracing, is illustrated in H. H. Arnason, *The Sculptures of Houdon* (New York: Oxford University Press, 1975), cat. no. 51. Another possible prototype is Albert-Ernest Carpeaux's *Confidence* (1873; Musée d'Orsay, Paris; Pingeot, Le Norman-Romain, and de Margerie 1986, 88–89, RF2938).

6. See Druet's photographs reproduced in Elsen 1980, pls. 108–9, and the series by Jacques-Ernst Bulloz reproduced in Pinet 1985, 21 (of which one is fig. 563).

7. The first marble version in the Musée Rodin is seriously marred by the poor quality of the material, which resulted in numerous distracting flaws, compared with the superior quality of the stone and carving in the Tate Gallery's version. For example, the structural limitations of stone in the first marble version altered the subtlety of the gesture of Paolo's right hand. For further discussion of *The Kiss* in marble, see Rosenfeld in Elsen 1981, 82, 85–87.

8. Bordeaux made a femme fatale of Francesca (1975, 126).

9. Leo Steinberg, "Michelangelo's Florentine Pièta: The Missing Leg," *Art Bulletin* 50, no. 4 (December 1968): 343–53. Octave Maus described it as "the most tender and chaste bodily embrace that art has ever brushed with its wing" (in Butler 1980, 62). Gustave Geffroy wrote "The woman, in the flowering of her puberty, is seated on the left knee of the man" (*La vie artistique*, vol. 2 [Paris: Editions Dentu, 1893], 93). It would appear that commentators have generally looked at the sculpture from the thighs up. Witness Truman Bartlett: "A catalogue description of the group would read like this: A young girl sitting in the lap of her lover, arms of both entwined around the bodies and necks of each, kissing as only lovers can kiss—both figures nude" (in Elsen 1965a, 64). All these descriptions are wrong. She is seated not on his lap or knee but on the rock.

10. Edward Perry Warren, who commissioned what is now the Tate Gallery's marble version of *The Kiss*, requested of Rodin that Paolo's genitals be included in its marble version. See Alley 1959, 225–26.

11. Bartlett in Elsen 1965a, 64.

12. Geffroy, *La vie artistique*, 2: 94.

13. Mirolli (Butler) 1966, 232.

14. The photograph was taken by Charles Bodmer, who worked for Rodin in the 1880s. Varnedoe reproduced the photograph in Elsen 1981, 210, pointing out that the plaster of *Saint John* was prepared for casting in bronze; this could date the photograph to 1881. Rodin's pride in the composition is apparent in this volume's frontispiece.

15. *La revue*, 1 November 1907.
16. Rilke in Elsen 1965a, 128.
17. Beausire 1988, 95.
18. For titles, see Grappe 1944, 59. He also records that the couple was called *The Faith*. The correct date of the first marble is not 1886, as Grappe indicated, but 1898.
19. For the history of the various sizes, carvings, and castings of *The Kiss*, see Sanders in Wasserman 1975, 168–73.
20. For an in-depth study of *The Kiss*, see Le Normand-Romain 1995a.

21. Bartlett in Elsen 1965a, 64.
22. Alley 1959, 226.
23. *Le canada*, 2 October 1924.
24. As recently as October 1997 Brigham Young University Museum of Art in Provo, Utah, excised *The Kiss* and three other works from the traveling exhibition *The Hands of Rodin: A Tribute to B. Gerald Cantor* (*Salt Lake Tribune*, 27 October 1997, 10).

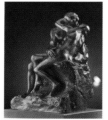

The Kiss (Le baiser), reduced 1898

- Gilded bronze, F. Barbedienne Foundry
- 10 x 5⅞ x 6¼ in. (25.4 x 14.9 x 15.9 cm)
- Signed on base, left side: A. Rodin
- Inscribed near bottom, right side: F. Barbedienne, fondeur
- Provenance: Feingarten Galleries, Los Angeles
- Gift of the Iris and B. Gerald Cantor Foundation, 1974.107

Figure 167

When Rodin first exhibited the enlarged marble version of *The Kiss* in the May Salon of 1898, it was a critical and popular success, unlike his *Monument to Honoré de Balzac* which was shown at the same time. That year Rodin entered into a 20–year contract with the foundry Gustave Leblanc-Barbedienne to make from the marble four differently sized reductions in bronze. Under this contract 329 casts were made and sold.[1] In 1919 the founders were convicted by a French court of having continued to cast reductions of *Le baiser* after Rodin's death in November 1917. The foundry was forced to desist and to turn over the models and unsold casts to the Musée Rodin, and the owners went to prison. There is no way of knowing how many illegal casts were sold.

The Barbedienne casts were reductions made by foundry technicians probably from a plaster that in turn was made from the marble version in 1898, as it was Rodin's practice to have plasters made after a suc-cessful carving as a record or to be used for enlarging and reducing into bronze and to allow the reducers to mark up the plaster when taking measurements. There is no indication that Rodin was in any way involved in this process. That he entered into such a contract was acknowledgment of the work's popularity and his desire not to tie up his own staff's time making reduc-tions.[2] He did not want to invest his own resources into casting a large edition and exhibiting it in his studios because this would have made him look like a mer-chant. Rodin did not believe in the practice of the lim-ited edition for bronzes or the economics of scarcity. All through the nineteenth century, foundries like Leblanc-Barbedienne made commercial editions of reductions of famous sculptures; they called themselves bronze editors.

When matched with the bronze cast of the original one-half life-size version, the Barbedienne reductions seem woefully inadequate in terms of the loss of detail and vitality. Gone are such subtleties as the interval between the lovers' lips, Paolo's hesitant gesture on Francesca's thigh, and all sense of bone in his right hand. Francesca's gestures are not the same as in the bronze, and she has no navel; the book is not as clear; and it is as if Paolo is wearing a short skirt. The base on which the couple sits is more rocklike but less related sculpturally to the figures themselves. The reductions became only a souvenir of a great work. This drastic dif-ference is partly explained by the fact that the life-size marble was itself an enlargement made directly in the big stone by the carver Jean Turcan from the smaller original version. Rodin complained to Edmond de Goncourt in 1888 that he did not have the time to make a life-size version in clay, which would have allowed him to make a number of changes.[3] The Barbe-dienne casts are thus literally Rodin third-hand.[4]

NOTES

LITERATURE: Grappe 1944, 59; Jianou and Goldscheider 1969, 100; Wasserman 1975, 148, 169–70; de Caso and Sanders 1977, 149–52; Elsen 1981, 289; Barbier 1992, 151–53, 187–90; Le Normand-Romain 1995a; Butler and Lindsay 2000, 326–30

1. For the four reduced sizes Vassalo listed no. 1,.73m, 49 casts; no. 2,.61m, 69 casts; no. 3,.38m, 108 casts; no. 4,.24m, 103 casts (Barbier 1992, 189). The number that were gilded is not indicated.

2. Houdon had a similar experience with his marble *Le baiser donné* (1778), whose eroticism greatly pleased his audience, and versions of it were made in terra-cotta, porcelain, and bronze. H. H. Arnason, *The Sculptures of Houdon* (New York: Oxford University Press, 1975), cat. no. 51.

3. Edmond and Jules de Goncourt, *Journal des Goncourt: mémoires de la vie littéraire* 15 (Monaco: Académie Goncourt, 1956), 86 (entry for 26 February 1888), cited in Sanders in Wasserman 1975, 169, 176 n. 84.

4. In the author's opinion and in view of current auction prices for these commercial casts (one was offered to Stanford by a dealer in the summer of 1989 for $250,000), they may be the most expensive bronze paperweights ever made.

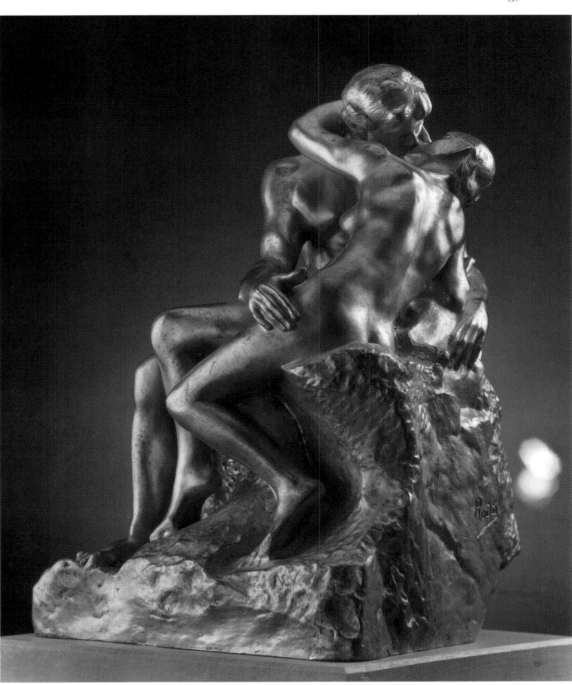

Fig. 167. *The Kiss* (cat. no. 49).

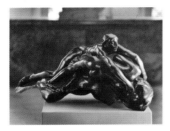

50

Paolo and Francesca
(Paolo et Francesca), 1881–84(?)

- Title variation: *Paolo and Francesca at the Door, Damned Women*
- Bronze, Georges Rudier Foundry, cast 1973, 2/12 (?)
- 12½ x 22¾ x 16½ in. (31.8 x 57.8 x 41.9 cm)
- Signed on base, front: A. Rodin
- Inscribed on base below feet of lower figure: Georges Rudier. Fondeur. Paris No. 2; underside of base, below right calf of top figure: © by Musée Rodin 1973
- Gift of the Iris and B. Gerald Cantor Collection, 1998.361

Figure 168.

This composition has come to be known as *Paolo and Francesca* but without direct confirmation from the artist. The upper figure is taken with some modifications from the upright but slumping form of the son in the Ugolino group (cat. no. 45); the hair, for example, has been changed and is more abstract. Instead of the youth's right arm bent against his chest, with no modification of the right shoulder blade, it is now extended forward and over the form of his companion. His left hand and right foot merge with the abstract planes of the base, and his left leg ends at the knee. (These details cannot be seen in situ when on *The Gates of Hell*.) The reclining woman is the same as the figure known as *Fatigue* (cat. nos. 53–54).[1] Between the two bodies Rodin has modeled a somewhat abstract passage (it is not a drape), which blocks a view between the torsos and masks the fact that they do not consistently touch.

Rodin's assembling of his ready-made figures shows how he departed from the more traditional mutuality of body language in *The Kiss* (cat. nos. 48–49), in which it would seem that he felt the conventions of figural composition had been played out. When the

Fig. 169. Detail of *The Gates of Hell: Paolo and Francesca*.

models had gone, he played with his plasters like a choreographer or casting director looking for that fruitful friction that would seem natural, dramatic, but surprising. As Rodin put it, "When the figures are well modeled, they approach one another and group themselves by themselves. I copied two figures separately; I brought them together; that sufficed, and these two bodies united made 'Francesca da Rimini and Paolo.'"[2] What counted also in Rodin's decision were the points of bodily contact and overall effects of the pairing of contours, their mutuality of surface planes rather than depicted facial expressions and gestures. It was in knowing when such chance juxtapositions worked artistically as well as thematically that Rodin revealed his ability to look at sculpture abstractly.

In *The Gates of Hell* this couple, just below the Ugolino group, is so positioned in the panel that we see only her

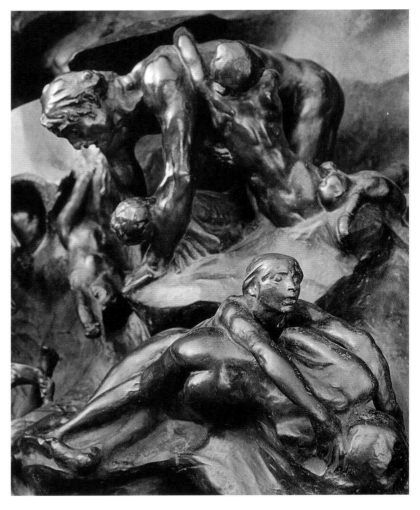

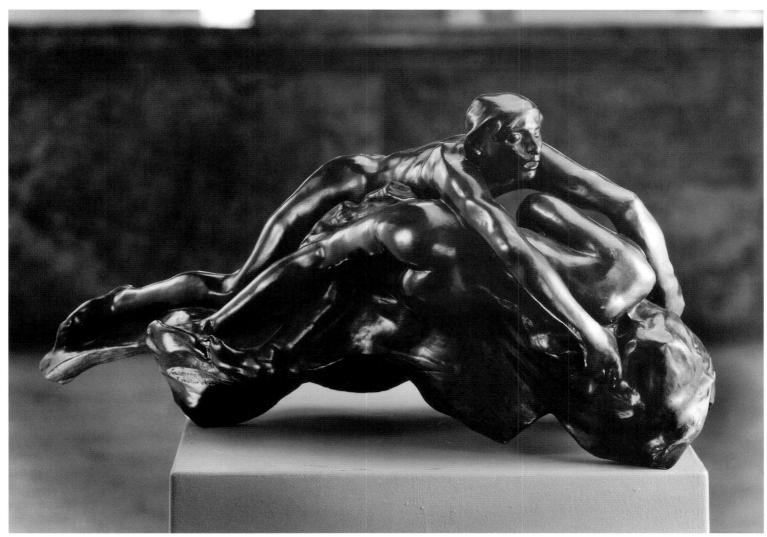

Fig. 168. *Paolo and Francesca* (cat. no. 50).

back and extended leg (fig. 169). Their horizontal extension somewhat vaguely recalls Dante's first encounter with the carnal sinners as they are buffeted in the "hellish storm that never rests."[3] What undermines the title and the thought that Rodin was attempting to illustrate Dante, however, is not only the couple's disparate origins. It is rather that in the *Inferno* it is Francesca who speaks to Dante and not Paolo, who weeps while his lover recounts their tale.[4] The great expressive head of Paolo, a modified version of *The Head of Sorrow* (cat. no. 55), does however evoke the wrenching statement made by Francesca, "There is no greater pain than to recall a happy time in wretchedness."[5]

It is difficult to date the union of these figures, each of which had separate histories. They appear to have been added to the portal by 1887 and are seen in a photograph taken by Jessie Lipscomb (see fig. 124).

NOTES

LITERATURE: Dujardin-Beaumetz 1913 in Elsen 1965a, 159 Grappe 1944, 66–67; Jianou and Goldscheider 1969, 91; Tancock 1976, 94, 97, 108, 158; Miller and Marotta 1986, 24, 26; Ambrosini and Facos 1987, 71; Fath and Schmoll 1991, 147; Levkoff 1994, 86; Le Normand-Romain 2001, 212

1. Grappe listed other variants: *The Earth and the Moon* and *Despairing Adolescent* (1944, 66–67). Le Normand-Romain (2001, 212) dates the composition "before 1886," and notes they were later to be carved in marble (A138).
2. Dujardin-Beaumetz in Elsen 1965a, 159. While describing his working method, we do not know for certain that Rodin was referring to the composition described in this entry.
3. Dante 1932, canto 5, verse 31.
4. There is no doubt that the upper figure is male, as Rodin gave him a small pudendum that can be verified by touch but not sight.
5. Dante 1932, canto 5, verses 121–23.

51

Old Woman (She Who Was the Helmet Maker's Once Beautiful Wife) (La Vieille femme; Celle qui fut la belle heaulmière), c. 1884–87

- Title variations: *The Old Courtesan, Winter*
- Bronze, possibly Georges Rudier Foundry
- 19¾ x 12⅛ x 9 in. (50.2 x 30.8 x 22.9 cm)
- Signed on front of base, left: A. Rodin
- Provenance: Herbert Tannenbaum Gallery, New York
- Gift of the Iris and B. Gerald Cantor Foundation, 1974.56

Figures 170–171

For Rodin there was no such thing as absolute beauty, nothing in nature was ugly, and every person had character. These views were shared with a lifelong friend, fellow sculptor, and frequent assistant, Jules Desbois, who made a moving sculpture, *Misery* (Musée Rodin, Paris), of an old woman and former model named Caïra, possibly begun 1887–89 or earlier when he and Rodin were working at Sèvres.[1] Caïra posed several times for Rodin, including probably for *Old Woman*, and a similar motif appears on a vase designed by Rodin and executed by Desbois, which was begun in the early 1880s and finished in 1887.[2] The seated and huddled form of Desbois's *Misery* evokes sympathy for her cocoonlike withdrawal, but there is no largeness of effect to absorb and transcend the multitude of details. This is what separates the two artists' work. In New York's Metropolitan Museum of Art is a small headless plaster figure by Rodin of Caïra standing with her arms crossed in front of her stomach.[3] In the left bas-relief of *The Gates of Hell*, which may be the figure's first appearance in Rodin's work, she is seen seated in profile, but with head turned upward and right arm and leg in different positions from the version in the round, and paired with a younger woman who kneels in front of her (fig. 172).[4]

When confronted with this sculpture, Rodin's contemporaries were prompted to think of poetic precedents in Charles Baudelaire or Pierre de Ronsard or to discourse on old age or beauty and ugliness in art. Modern commentators hasten to put the work in a historical line starting with ancient Rome and extending through Donatello's *Mary Magadalen* (1457; Cathedral Museum, Florence).[5] More attention has been given by critics and others to possible historical antecedents and literary references for its name, "Les regrets de la belle heaulmière" (The lament of the beautiful helmetmaker), inspired by a poem of 1461 by Françoise Villon, than to the sculpture itself.

When one looks closely at Rodin's *Old Woman*, the longer the figure is studied, the more conscious the viewer becomes not of biography but of sculpture. Far from illustrating a medieval French poem about an aging beauty lamenting her lost youth, Rodin found a timeless experience in the living model's own rich story and the capacity of her aged body to inspire a stunningly powerful form. He found in this old professional model someone with extraordinary character. Rodin expected us to read this woman's narrative as we moved about her. Caïra is not shown actually looking at herself. Her head is bowed, but she looks inward and not at her thinning legs, which have been pulled to the side. On her face is a surprising and marvelous expression. Seen from her left profile, there is a grim set to the mouth. Seen from her right profile, there is a smile. Seen head on, the mouth forms a crooked half-smile, a divided expression that is the climax of what her body language tells us.[6] Her not quite rigid left arm carries the weight of her upper body, and it is as if she were resisting the pull of the earth. Her right arm is bent behind her so that from the front we see her hand, with its open, outstretched fingers, visible in the triangular opening made by her body, the rock, and left arm—no obvious clenched-fist gesture of defiance but rather a reaching out.[7] Unlike her flesh, Caïra's spirit is still elastic; she is a feisty crone who can still sit on one buttock.[8]

This sculpture is a good example of why Rodin preferred to name his works. He knew that literary allusions would deflect the viewer from patiently searching the form he had found and fashioned out of sagging skin and extruding bone rather than words, and he was right. When he used the simple title *Old Woman*, he knew we would be more aware of his sharing with us his love of the body's skeletal geometry, especially as seen from the rear with the back-to-back crescents made by the shoulder blades, in turn framed by the bony prominences of the elbows and echoed and inverted in the twin hair braids. The slumping flesh of the arms, back, and chest are like

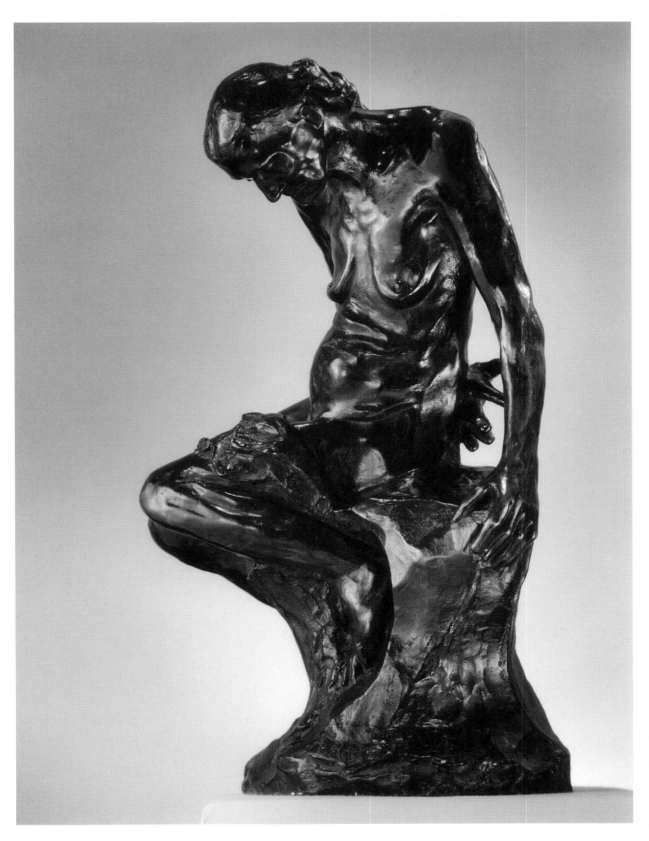

Fig. 170. *Old Woman (She Who Was the Helmet-Maker's Once Beautiful Wife)* (cat. no. 51).

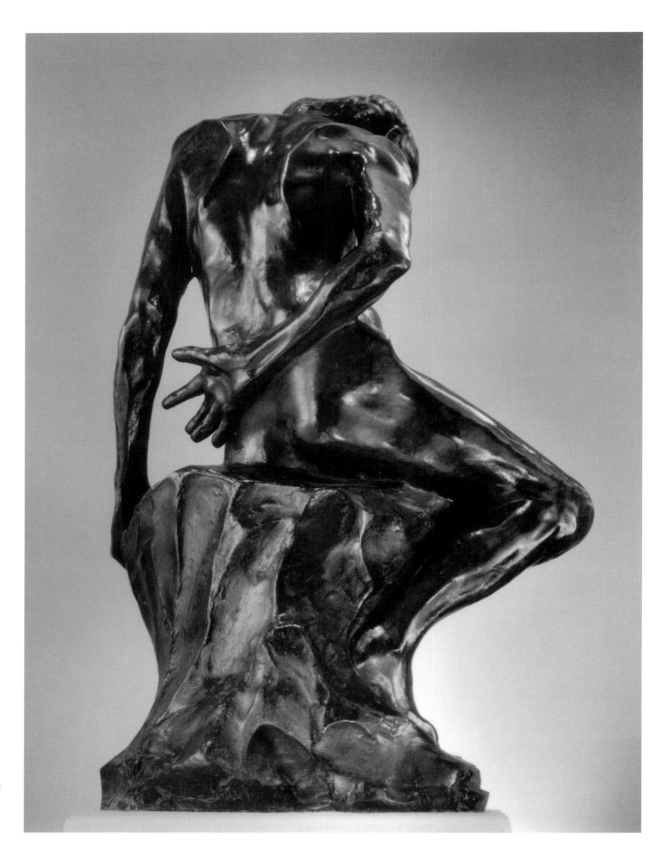

Fig. 171. *Old Woman (She Who Was the Helmet-Maker's Once Beautiful Wife)* (cat. no. 51).

windless sails hanging from firm masts and yardarms. For an artist who viewed sculpture as the art of the hole and the lump, this aged professional's body invited both in the extreme: deep probes in the cheeks, on either side of the neck, and under the armpits, rude protrusions at every joint. Rodin showed no hesitancy in isolating in space hard-angled forms like the woman's nose and chin, and the jarring sequence from her right shoulder through her elbow and hip joint has no analogue in nineteenth-century sculpture. Besides the hole and the lump, sculpture for Rodin at this stage in his development was also a matter of the hard and the soft.

There is never doubt as to which is flesh and which is bone, as when we compare the slumping crescents of the breasts with their rhyme in the collarbones above. This is no mindless or naturalistic record of wrinkles, and Rodin's treatment of the old woman's abdomen is dualistic, like that of her face. From the left side there are creases and a weighty sag, but from the woman's right profile the slightly dented but full, firmer abdomen could occasion a smile of remembrance on an old woman's face. Seen overall, the stomach and lower abdomen are a surprising, faceted form, whose junctures reward reading of this area against the rest of the bony body seen from different angles.

By pulling her partially draped legs to the side, at almost right angles to her upper body, Rodin gave the old woman new vigor and earned a surprising compactness in his form when seen from its left and right sides. He set up provocative profile views that invite pairing the contours of the woman's front and back. Seen from the sides, her forward-leaning head lines up with her knees, as if both are pressed against a frontal plane. To get the body into the position we see it, Rodin may have had to model Caïra in two positions: with the head, shoulders, and thorax addressed to the front and with upper abdomen twisted to her right so that there is no straight line between sternum and navel. When we study her from her left side, we see big downward-curving movements begun in the scapulas continued in the hooklike, upward curve of the shrunken breasts. This is the body's natural three-dimensional geometry, to which Rodin was drawn. He will exaggerate it when he can. In treating the arms, Rodin actually flattened some of the big planes running from elbow to wrist. And when we look at the woman's back from the sides, here too we see that topography of ridges and depressions is contained within an imagined tilting plane that initiates the forward thrusts

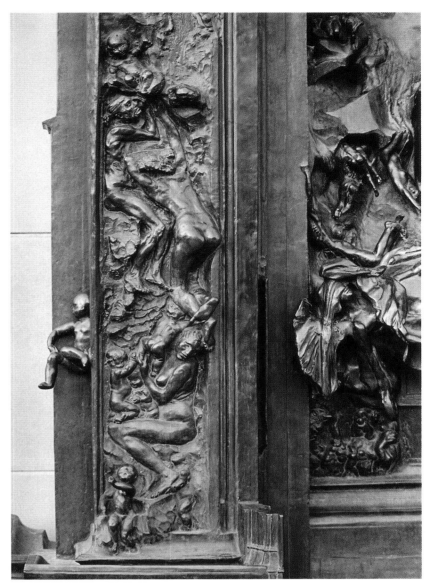

Fig. 172. Detail of *The Gates of Hell: Old Woman*.

of the head, belly, and knees. Viewed from the front, the lower legs and feet of the woman are not carried to the definition of the rest of her body. The feet merge into the rock, a form pliant to the sculptor's will and sense of design. From the front its upward, two-sided taper gives a countering spring to the downward pressures of the body. This base shows Rodin's thought at its most abstract.[9]

What has been described is impressive even when seen in a dull casting. Stanford's bronze cast, however, has a fine finish and patina, so that light and shadow can perform on one of the most dramatic surfaces Rodin prepared for them. In no other work, except perhaps the

final *Burghers of Calais*, do light and shadow polarize as clearly and strongly, as if into life and death. They further transform the modeled flesh and bone into art, and their beauty helps overcome any initial reluctance the viewer may have of invading another's privacy.

In his 1911 conversations with Paul Gsell, this sculpture prompted a long and famous discourse by the artist on ugliness, and his point came down to:

> What one commonly calls "ugly" in Nature can become great beauty in art. . . .
>
> Now, for the great artist, everything in Nature has "character," for the uncompromising frankness of his observation penetrates the hidden meaning of everything.
>
> And what is considered "ugly" in Nature often presents more "character" than what is called beautiful because in the contortion of a sickly physiognomy, in the scoring of a vicious mask, in every deformity, in every blemish the inner truth bursts forth more easily than from regular and wholesome features. . . .
>
> There is nothing "ugly" in Art except that which is without "character," that is to say, that which offers neither outer nor inner truth. . . .
>
> When he [the artist] tones down the grimace of pain, the deterioration of old age. . . . when he organizes Nature, softens it, disguises it, tempers it to please the ignorant public; he creates ugliness because he is afraid of the truth.[10]

In the Monet-Rodin show of 1889 Rodin exhibited, as *Deux Vieilles Femmes* (Two Old Women), a composition in plaster juxtaposing two casts of the figure in a grotto; it is also known as *Dried-Up Springs*.[11] In the Salon of 1890 he exhibited the figure in bronze as *Old Woman*.[12]

NOTES

LITERATURE: Grappe 1944, 46; Spear 1967, 75, 77, 100–101; Jianou and Goldscheider 1969, 90; Spear 1974, 133S; Tancock 1976, 141–47; de Caso and Sanders 1977, 55–56, 58; Elsen 1980, 171–72; Fusco and Janson 1980, 338; Ambrosini and Facos 1987, 68–69; Pingeot 1988, 5–15, 17–20, 35; Fath and Schmoll 1991, 145; Levkoff 1994, 76–79; Le Normand-Romain 2001, 228

1. See Tancock 1976, 141, 144, regarding the various accounts of how Rodin met Caïra, including that given by Desbois who said that Rodin asked about Caïra after seeing Desbois's *Misery* (plaster, c. 1887–89, Musée Rodin, Paris; wood, 1894, Musée des Beaux-Arts, Nancy). Regarding *Misery* see Pingeot 1986, 333; Pingeot 1988, 6, 11–12, figs. 12–13; and Jocelyn Mercier, *Jules Desbois, illustre statuaire Angevin* (Longué: Vieux-logis, 1978), 43.

2. Rodin worked at Sèvres in 1879–82 and again in 1887. It was formerly thought that the first time Caïra posed for him was during his second stint there. As observed by Tancock (1976, 141), her profile appears on a vase, *Limbo and the Sirens* (Marx 1907, pl. XVII), which Marx dated to 1887. The vase may postdate the similar pairing in *The Gates of Hell* however. Ruth Butler clarified the vase's completion date of 1887 and dated the sculpture *Old Woman* to the mid-1880s based on Octave Mirbeau's description of the work to Edmond de Goncourt (in Fusco and Janson 1980, 349 n. 50). Pingeot reassigned the vase's completion to 1888–89 and dated *Old Woman* to 1890 (1988, 8–10); *Old Woman* is dated 1887 by Le Normand-Romain (2001, 228).

3. Vincent 1981, 7.

4. In the Meudon reserve is yet another seated version of the *Old Woman* with almost half of the figure cut away.

5. Donatello's *Mary Magdalen* is illustrated and discussed in H. W. Janson, *The Sculpture of Donatello* (1963; reprint, Princeton: Princeton University Press, 1979), 190–91, pl. 90–91.

6. Gsell is an example of those who have not truly read this sculpture. He contrasts Donatello's *Magdalen* who, "because of her desire for renunciation, seems more radiant in her joy, as she sees herself become more repugnant," with Rodin's *Old Woman*, who "is terrified to find herself so like a cadaver." (Gsell [1911] 1984, 16). In addition, to make the image even more lifelike, Eugène Druet photographed the bronze by artificial light, using a sodium ring and reflectors, and from certain close-up angles that caused a peripheral blurring, which suggests optical distortion (see Elsen 1980, pl. 49).

7. The woman's hands are different: her left has a long thumb and fingers, while their counterparts on the right hand are shorter and thicker.

8. In contrast, Gsell ([1911] 1984, 16) characterized what Rodin did as follows: "And I know of no other artist who has ever evoked old age with such ferocious coarseness."

9. The base of the Stanford cast is different from those owned by the Metropolitan Museum of Art, New York (Vincent 1981, 6), and the Philadelphia Museum of Art's Rodin Museum (Tancock 1976, 142–43).

10. Gsell [1911] 1984, 17, 19–20.

11. This plaster is illustrated in Beausire 1989, 204.

12. Beausire 1988, 109.

52
Triumphant Youth (La jeunesse triomphante), 1894

- Title variations: *Eternal Youth, Fate and the Convalescent, The Grand-mother's Kiss, Old Age and Adolescence, Young Girl and Fate, Youth and Old Age*
- Bronze, Thiebaut Frères Foundry, 2/11
- 20⅞ x 19¾ x 12⅝ in. (53 x 50.2 x 31.6 cm)
- Signed on front of base, left side: A. Rodin
- Inscribed on base, right side, on seal: Fumière/Thièbaut Frès/Paris/et Cie sucrs; on base, right side, below seal: II Epreuve
- Mark on base, right side: Thiebaut Frères
- Provenance: Sotheby's, London, 9 December 1969, lot 41
- Gift of the Iris and B. Gerald Cantor Foundation, 1974.37

Figure 173

*T*he acquisition of *Old Woman* (cat. no. 51) by the state and its placement in the Palais de Luxembourg was an act of confidence and courage, as there was public protest against its ugliness. This criticism, brought to his attention by Paul Gsell, prompted Rodin's response:

> The common man would like to believe what he judges ugly in reality is not material for the artist. He would like to prohibit us from representing what displeases and offends him in Nature.
>
> This is a grave mistake on his part.
>
> What one commonly calls "ugly" in Nature can become great beauty in art.[1]

Rodin then cited precedents in older art and literature of great artists transfiguring the "ugly" and went on to say:

> The reason is that in Art, beauty exists only in that which has "character." "Character" is the intense truth of any natural spectacle, beautiful or ugly. . . .
>
> "Character" is the soul, the feeling, the idea expressed by the features of a face, the gestures and actions of a human being. . . .
>
> The ugly in Art is that which is false; that which is artificial; that which seeks to be pretty or beautiful, instead of being expressive; that which is affected

and precious; that which smiles without motive; that which is pretentious without reason; the person who throws out his chest and swaggers without cause; all that is without soul and truth; all that is only a parade of beauty and grace; all that lies.[2]

According to Georges Grappe, to the figure *Old Woman* Rodin added in 1894 that of an adolescent girl, creating a composition variously entitled *Young Girl and Fate, The Grandmother's Kiss*, and *Fate and the Convalescent*.[3] The girl is the otherwise reclining figure known as *Fatigue* (cat. nos. 53–54), now modeled fully in the round and placed across the old woman's lap. In a vertical orientation and combined with a male figure, the girl was also used in *Aesculapius* (cat. no. 169). Atypically Rodin introduced a narrative or anecdotal attribute: in back of the sculpture is an open pair of scissors that seems to have fallen from the old woman's outstretched hand, as if she had been cutting cloth across her knees when interrupted by the impetuous embrace of the young girl. The scissors recall the narrative device of the book held by Paolo in *The Kiss* (cat. nos. 48–49). Another meaning, suggested by the titles *Young Girl and Fate* and *Fate and the Convalescent*, allows for a reading of the scissors as an allegorical attribute identifying the old woman as Atropos, one of the Fates, who has decided not to cut short the convalescent girl's life.[4] Perhaps by means of a clay *estampillage* (cast) Rodin just bent the old woman's body forward without otherwise changing the modeling and pulled the woman's head downward toward that of the girl. The paradox is that the solitary figure of the old woman was seen by Rodin's contemporaries as literary, which it was not, whereas its later version is actually more dramatic and evocative of a literary idea, ambiguous as its meaning might be.[5]

One of the ideas that the couple prompts is that of a madame being joyfully embraced by a young protégée. Among the possible meanings Rodin added to the form of this work is the theme of lesbianism, which at times appeared in his images of paired women: *The Metamorphoses of Ovid* (cat. no. 68), *Damned Women* (1885), and *Illusions Received by the Earth* (cat. no. 168). As he had hoped, it is the beauty of these sculptures, their anatomical correctness and lively animation, not to mention Rodin's established reputation as a great artist, that in our time protects them from criticism.

The work was first shown in a marble version in Paris (1896). A bronze was exhibited in Berlin (1903, 1905).[6]

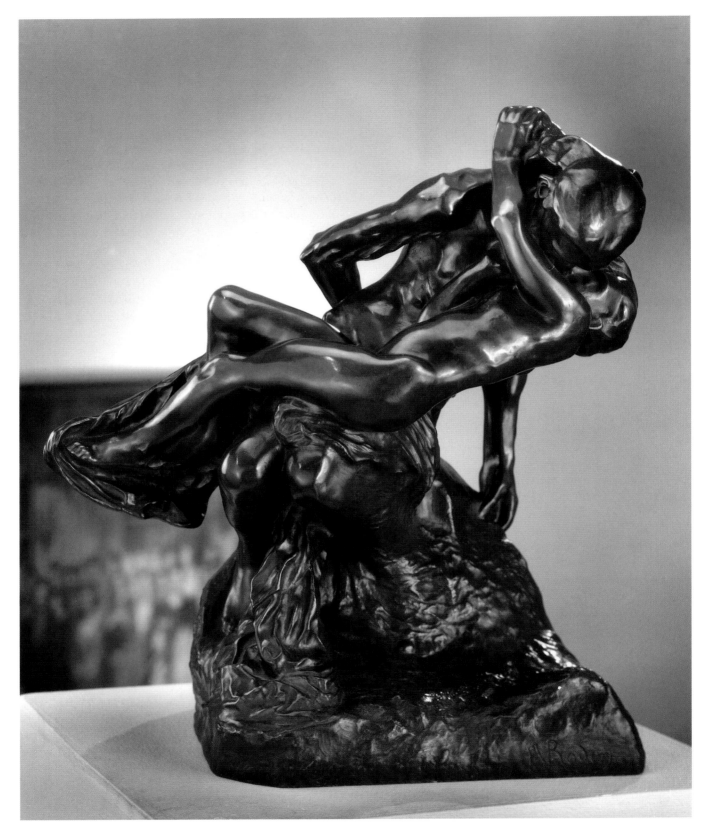

Fig. 173.
Triumphant Youth (cat. no. 52).

NOTES

LITERATURE: Grappe 1944, 92; Spear 1967, 100; Jianou and Goldscheider 1969, 106; Spear 1974, 132S; Tancock 1976, 225–26; de Caso and Sanders 1977, 55–58; Elsen 1980, 171–72; Ambrosini and Facos 1987, 88

1. Gsell [1911] 1984, 17.
2. Ibid., 19.
3. Grappe 1944, 92.
4. De Caso and Sanders 1977, 56.
5. Rodin had a plaster cast of the work photographed in his studio courtyard, evocatively set against a background of "ruins"; see Elsen 1980, pl. 50.
6. Beausire 1988, 127, 244, 264.

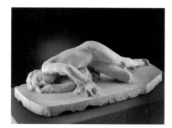

53

Fatigue (La fatigue), 1887

- Title variations: *Reclining Figure, Reclining Woman*
- Plaster
- 6¼ x 8¼ x 20½ in. (16 x 21 x 52 cm)
- Provenance: Marie Cartier, France
- Gift of the B. Gerald Cantor Collection, 1992.140

Figure 174

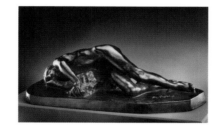

54

Fatigue (La fatigue), 1887

- Bronze, Georges Rudier Foundry, cast 1974, 5/12
- 6¾ x 8¼ x 20½ in. (16 x 21 x 52 cm)
- Signed on front, right: A. Rodin
- Inscribed on back, left: Georges Rudier/Fondeur Paris; on base, left, at bottom: © by Musée Rodin 1974; interior cachet: A. Rodin
- Provenance: Musée Rodin, Paris
- Gift of the B. Gerald Cantor Collections, 1992.152

Figure 175

*F*atigue was dated to 1887 by Georges Grappe, who recorded its name and listing in an inventory by Gustave Geffroy.[1] Made from a recumbent young woman with certain adjustments to the torso and arms, *Fatigue* was used by Rodin in combination with the old woman in *Triumphant Youth* (cat. no. 52), with a naked male figure in *Aesculapius* (cat. no. 169), and with Paolo in *Paolo and Francesco* (cat. no. 50) and for *The Gates*.[2] In the first two compositions the young woman plays ambiguous, if not provocative, roles, respectively as seducer or loving offspring and agitated adolescent. Seen by herself, the figure lies on her side across a small mound, her right hand to her face with its closed eyes, her left resting on a small rock, causing her elbow to be raised in the air. This is a far from comfortable position: the head below the hips, the torso not flush with the ground. The woman embodies exhaustion. The raised elbow and left hip, with the prominent bones, depart from the graceful, recumbent poses in the repertory of nineteenth-century professional models, most of whom would have had more physically mature bodies. For Rodin, it is consistent with his use of positions naturally struck by his usually amateur models, often at the end of a long and tiring session when they unselfconsciously sought to rest. What Rodin found compelling is the truthful or natural aspect of a pose. There is no concession to the grace of limb formation and arrangement expected in sculpture of the time because the artist was bent on broadening expectations of what sculpture could and should show.

By its cursory modeling in the back of the head (no neck is visible) and summary treatment of the features, it is possible that Rodin added a different head to the body. The hands and feet also lack refined modeling, which was not needed in *The Gates*, and the left shinbone does not align with the kneecap. The position of the feet confirm that the subject was lying down when the sculpture was made, as they carry no weight. No attempt was made to fashion an entirely illusionistic base, perhaps indicating that Rodin wanted at least some plasters in the studio repertory of figures to be free of any sizable support so that he could use the forms with other figures, which, in fact, he did.

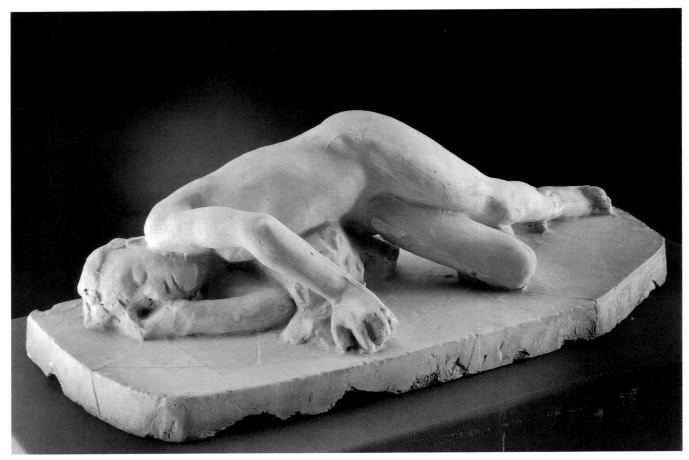

Fig. 174. *Fatigue*
(cat. no. 53).

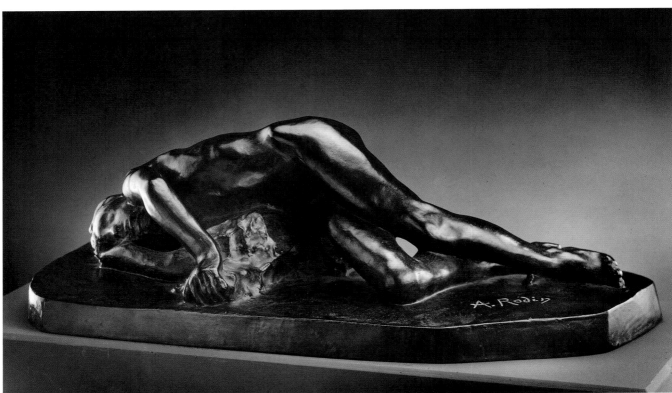

Fig. 175. *Fatigue*
(cat. no. 54).

NOTES

LITERATURE: Grappe 1944, 65; Jianou and Goldscheider 1969, 91; Tancock 1976, 29, 47; Lampert 1986, 208

1. Grappe 1944, 65. The figure was exhibited, according to Grappe, as *Reclining Woman* at the Monet-Rodin exhibition of 1889 and as *Reclining Figure* in Rodin's 1900 retrospective. Beausire (1988, 104, 184, 353) believes that the figure exhibited in 1889 was more likely *The Martyr* (cat. nos. 72–73).

2. The figural motif was used in Rodin's illustrations for Emile Bergerat's *Enguerrande* (1884) and for Charles Baudelaire's *Fleurs du mal* (see Thorson 1975, 79, 100).

55

Head of Sorrow (*Tête de la douleur*), 1882

- Title variations: *Agony, Anxiety*
- Bronze, Georges Rudier Foundry, cast 1963, 9, 10, or 11/12
- 9½ x 8½ x 8 in. (24 x 21.6 x 20.3 cm)
- Signed on neck, left side: A. Rodin
- Inscribed on back of neck, right: Georges Rudier/Fondeur, Paris; left side, lower edge of hair: © by Musée Rodin 1963; interior cachet: A. Rodin
- Provenance: Parke-Bernet Galleries, New York, 26 February 1970, lot 14
- Gift of the Iris and B. Gerald Cantor Foundation, 1974.78

Figure 176

If one head from *The Gates of Hell* expresses the spirit of the whole, it is *Head of Sorrow*, which utters a cry of world anguish. This head in several sizes served in other works, including *The Prodigal Son* (A93), *Paolo and Francesca* (cat. no. 50), the son of Ugolino who gropes for his father's back (cat. no. 46), and the male figure in the group that became known as *Fugitive Love* (before 1887)—all in the portal— and *The Centauress* (cat. no. 158). The sexual ambiguity of its features allowed Rodin to title marble versions *Head of Medusa, Head of Orpheus,* and *Joan of Arc* (fig. 177).[1]

On his trip to Rome in 1875 Rodin visited the Vatican Museum and probably the Terme Museum as well, and he could have seen the *Laocoön* and *Niobid* groups, whose expressions of despair may have fostered *Head of Sorrow*. The head made its first appearance in connection with a dying son of Ugolino. Rodin's head has no stylistic parentage in antiquity, however, for when he worked from life, he felt he had penetrated the sources of all style, especially that of the Greeks.

It is unusual in the history of sculpture to have an isolated head that is not a portrait, an allegory, or a symbol. *Head of Sorrow* is exactly what is shown and was inspired by the sculptor's encounter with a living but today anonymous model. It belongs to a custom of making heads as études to illustrate expressions, generally for the education of artists. The life-size *Head of Sorrow* is a large-scale version of the original that had been used on one of Ugolino's sons.[2] It has been suggested that the Italian actress Eleanora Duse posed in 1905 for a reworking of the large version, but no significant changes were made that would have been occasioned by the use of another model. According to Georges Grappe, Rodin, inspired by Duse's readings from Dante, took an enlarged scale version of the head and renamed it *Anxiety*.[3]

The striations and bunching of the hair in different areas are basically the same as in the original head, but the shaping of the almost-closed eyes has been more developed, and in the large-scale version the indentations above the eyebrows are more acute. This head confirms that Rodin did not seek to purify or perfect his model, and there are no perfect arcs or flat areas. More visible in the larger size is the beautifully observed asymmetry of the face: the slightly crooked nose, the open, asymmetrical mouth, and the subtle differences in the cheeks. On their surfaces nothing is constant or unworked to impart nuance to break up the light. Overall one gets the sense that everything flows (the open mouth and nostrils are filled) or merges, such as the features with each other and the flesh and the hair. The fluid surface still manifests the underlying presence of cheek and jawbone, which along with the eyes second the inward focus of the subject. To elevate the head, Rodin added a section at its base without any sustained attempt to fuse the addition with the neck. Looked at in profile, one appreciates Rodin's sculptural thinking in the shaping of the hair that complements the in-and-out movements of the facial silhouette. The subject's hair, which for lesser artists might be a nuisance or be treated

Right: Fig. 176. *Head of Sorrow* (cat. no. 55).

Below: Fig. 177. Jacques-Ernst Bulloz, *"Joan of Arc," 1906, in marble* (A109).

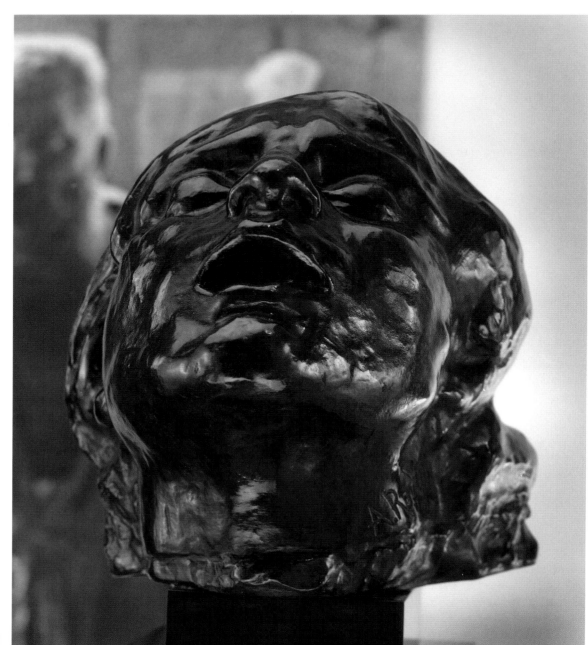

negligently, became in Rodin's hands a beautiful abstract form, so that we are given a series of continuously expressive profiles from the neck to the back of the head.

The head was again used in connection with commissions in marble in 1907 and was subsequently utilized in a 17–inch version with faggots emerging through the surface of the marble in 1913 for an unrealized monument to Joan of Arc to be erected in the United States.[4]

Abetting the pleasure of studying this bronze is the fine patina done by Jean Limet, who worked for the Georges Rudier Foundry until his retirement in 1968.

NOTES

LITERATURE: Grappe 1944, 31; Jianou and Goldscheider 1969, 89; Tancock 1976, 158–62; de Caso and Sanders 1977, 160; Miller and Marotta 1986, 24; Ambrosini and Facos 1987, 64–65; Fonsmark 1988, 91–92; Fath and Schmoll 1991, 146

1. These titles were reviewed in Grappe 1944, 31.
2. For review of the dating see Grappe 1944, 31, and Tancock 1976, 158.
3. Grappe stated that the life-size head was again enlarged in 1905 (1944, 31). De Caso and Sanders noted that the life-size head was reworked with Duse as model (1977, 60), citing Frisch and Shipley 1939, 415. It appears, however, that Rodin may have had a copy made in bronze of the life-size head (see Tancock 1976, 158, and Fonsmark 1988, 91).
4. For further discussion of these projects, see Tancock 1976, 160, and Fonsmark 1988, 91–92.

56

Fallen Caryatid with a Stone (La Cariatide tombée à la pierre), 1880–81, enlarged by 1911 and 1917

- Title variations: *Caryatid with Stone, A Damned Woman, A Damned Woman from Dante's Hell, Destiny, Fallen Caryatid Carrying Her Stone, Sorrow*
- Bronze, Coubertin Foundry, cast 1982, 3/8
- 52½ x 33 x 39 in. (133.4 x 83.8 x 99 cm)
- Signed on front of base: A. Rodin
- Inscribed on front of base: No. 3/8; on back of base, lower edge: © by Musée Rodin 1982
- Mark on back of base, lower edge: Coubertin Foundry seal
- Provenance: Musée Rodin, Paris
- Gift of the B. Gerald Cantor Collection, 1992.138

Figure 178

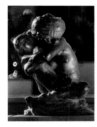

57

Fallen Caryatid with an Urn (La Cariatide tombée à l'urne), 1883, enlarged by 1911 and 1917

- Title variations: *A Damned Woman, A Damned Woman from Dante's Hell, Destiny, Fallen Caryatid Carrying an Urn, Sorrow*
- Bronze, Susse Foundry, cast 1976, 2/12
- 49¾ x 35½ x ½ in. (126.4 x 90.2 x 92.7 cm)
- Signed on top of base, below right haunch: Rodin
- Inscribed on back of base, bottom edge: Susse Fondeur.Paris; on back of base, left side: copyright by Musée Rodin 1976
- Provenance: Musée Rodin, Paris
- Gift of the B. Gerald Cantor Collection, 1983.201

Figure 179

*R*odin obviously modeled this figure at first without a burden and, with some adjustment to her arms, she so appears in *Illusions Received by the Earth* (cat. no. 168). Georges Grappe pointed out that *Fallen Caryatid with a Stone* dates from before 1881 and that the substitution of the urn came about at the request of a client in 1883. A plan to multiply *Fallen Caryatid with a Stone* into a quartet to support a platform for a tomb monument was not realized.[1]

Within *The Gates*, the *Fallen Caryatid* in her original,

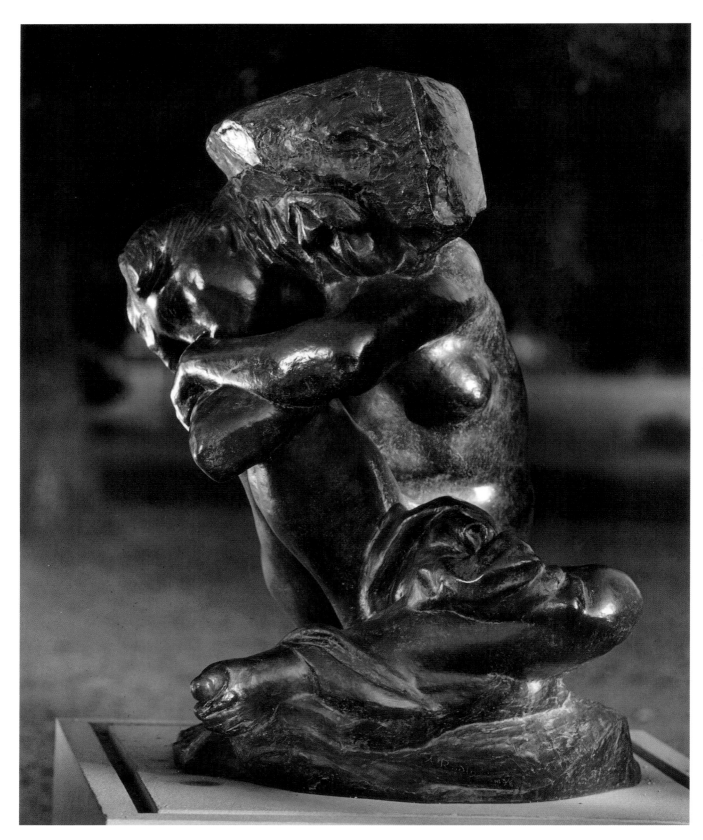

Fig. 178. *Fallen Caryatid with a Stone* (cat. no. 56).

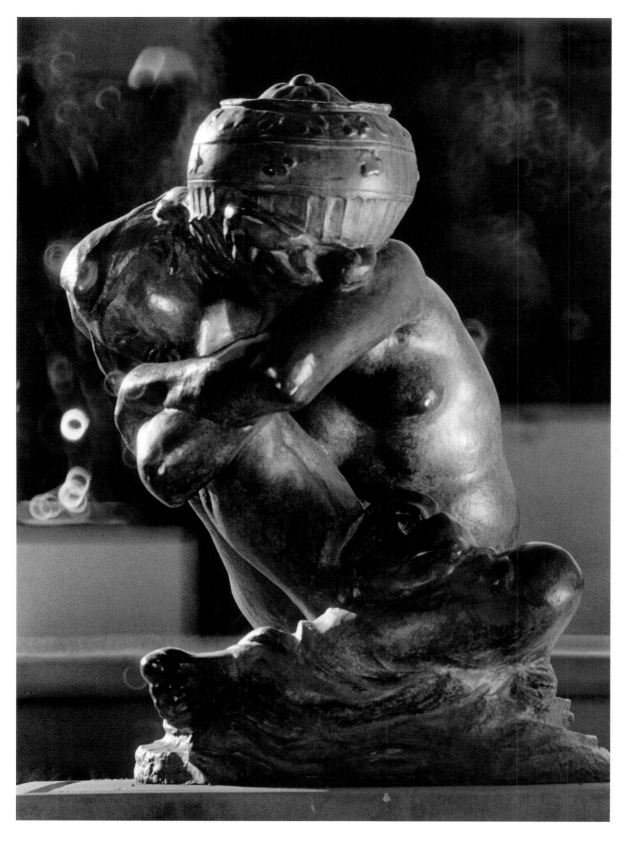

Fig. 179. *Fallen Caryatid with an Urn* (cat. no. 57).

smaller size occupies the upper-left corner where she was added during 1898–1900. Because she is partly concealed by a heavy drapery (fig. 180), it is impossible to know whether she bears a stone or urn or, as is more likely, nothing at all. Although she was one of the very first figures made for *The Gates of Hell*, probably in 1880 or 1881, the *Fallen Caryatid* does not appear in Jessie Lipscomb's 1887 photographs of the portal in plaster. As shown by the photographs and also by recorded descriptions, she was preceded in this location by the relief of a mother and child in a grotto (see fig. 122). After the public showing in 1881 of *Adam, Eve,* and the *Fallen Caryatid with a Stone,* the next figures from *The Gates* were shown early in 1883.[2]

Fallen Caryatid is a work crucial in Rodin's development, for it was made when he began to move away from Michelangelo's influence as seen in *Adam, Eve,* and *The Thinker.* Rodin began to ask himself, Why not work directly from life? The results contributed greatly to his reputation for originality, an explosive productivity in the early years of working on *The Gates,* and an expansion of body language in sculpture.

Behind Rodin's turning to nature and away from working out of his imagination was a personal quest shared with the most venturesome artists of his generation, such as Claude Monet and Edgar Degas: What is truth in art? Years later he would tell Henri-Charles Dujardin-Beaumetz about his modeling by a succession of profiles:

> When, by the hugging execution of the contours, one has entered into truth, it seems that the expression comes by itself . . . the work expresses itself by itself. . . .
>
> Without a steady base for the rational guidance of his work, without points of comparison with nature, free to his fantasy, to his imagination, to his feeling, which is always ready to lead him astray, the artist has that impressionability which . . . makes him sometimes destroy what he has done well and often doubt his own work.[3]

Among the unposed attitudes assumed by his models that inspired Rodin to fix them in clay were those in which the women may have been weary or exhausted, as in *Fatigue* (cat. nos. 53–54), *Despair* (cat. nos. 69–71), *The Martyr* (cat. nos. 72–73), and probably *Fallen Caryatid.* Unlike *Adam,* there is no beginning or end to the woman's story. No matter her burden, the fallen caryatid is a sculpture without a front in the traditional sense of the word. Her spiraling form drives us completely around the sculpture. No two paired limbs lie in the same plane. The lowered head, partially screened by crossed arms and her upraised right hand, are a variant on the pose of *Eve.* The lowered position of the head gave Rodin the open area along the line of the neck and her left shoulder into which he would later add the rock and the urn. (The addition of these objects invited Rodin's contemporaries to speculate on the woman's psychological state but had the effect of distracting them from the power of the sculptural form.) The largest and most stunning passage is that of the woman's back, a big uninterrupted plane, curving in depth, filling the field of vision, which gives the piece its luminous side as opposed to the shaded areas of the arms and legs. The woman's face, like that of *Meditation* (cat. nos. 61–62), confirms the sense of self-absorption achieved by the pose. The big closed eyes and large blunt nose are closer to Pablo Picasso's neoclassical heads than to those of Jean-Baptiste Carpeaux.

Truman Bartlett, being a sculptor, was particularly sensitive to Rodin's break with frontality, and in writing about *Fallen Caryatid with a Stone,* he ascribed its inspiration to Charles Baudelaire: "One idea inspired by the French poet is represented in the figure of 'Sorrow,' a young girl pressed down by a weight upon her shoulder, and as difficult to represent by any process as the siren group. Nor does any single view tell its whole story, for each profile gives a new and unexpected grace."[4]

This ascription of the work to Baudelaire's influence is supported by the poet's lines that Rodin appended to the catalogue entry for the 1886 exhibition at the Galerie Georges Petit: "Mainte fleur épanche à regret / Son parfum doux comme un secret / Dans les solitudes profondes" (Many a flower overflowers with regret / Its sweet perfume like a secret / In profound solitude).[5] Associations such as this, as well as the use of the stone by Rodin, must have contributed to the criticism that his "inspiration was more literary than sculptural," as pointed out by Paul Gsell. Amplifying the charge, this diligent recorder of Rodin's views on art continued, "They maintain that you have skillfully won the approval of writers by furnishing them with themes that give free rein to their rhetoric. And they declare that art does not allow so much philosophical ambition." Rodin's "heated response" was to argue that beyond technique he had the right to offer meanings as well:

If my modeling is bad . . . if I commit faults in the anatomy, if I interpret movements poorly, if I ignore the science of animating marble, these critics are a hundred times right.

But if my figures are correct and full of life, then what do they criticize? And by what right would they prohibit me from attaching certain meanings to them? . . . In addition to my professional work, I offer them ideas. . . .

Painting, sculpture, literature, music are closer to one another than is generally believed. They express all the feelings of the human soul in the presence of nature.[6]

Rainer Maria Rilke, who understood Rodin's belief that "expression comes by itself" from the model, readily accepted the artist's invitation to interpret the ideas offered in addition to the modeling: "A woman's form kneels crouching, as though bent by the burden, the weight of which sinks with a continuous pressure into all the figure's limbs. Upon every smallest part of this body the whole stone lies like the insistence of a will that is greater, older, and more powerful, a pressure, which it is the fate of this body to continue to endure. The figure bears its burden as we bear the impossible in dreams from which we can find no escape."[7]

Fallen Caryatid with a Stone had a rich history of public display in Rodin's lifetime, having been exhibited in plaster, bronze, and marble in Paris, London, Amsterdam, the Hague, Rotterdam, Brussels, Liege, and Rome.[8] In 1917 Henri Lebossé enlarged both versions.[9] Given its accessibility and provocative motif, it is possible that the Belgian Georges Minne took the idea of a naked figure holding a stone for his *Rock Bearer*, or *The Little Relic Bearer* (1897; Musées royaux des beaux-arts de belgique, Brussels), and his *Fountain of the Kneeling Youths* (1898 and 1906).[10]

Fig. 180. Detail of *The Gates of Hell: Fallen Caryatid*.

NOTES

LITERATURE: Bartlett 1889 in Elsen 1965a, 79; Rilke [1903] 1945 in Elsen 1965a, 129–30 Grappe 1944, 27, 35–36; Spear 1967, 98–99; Jianou and Goldscheider 1969, 88; Spear 1974, 104S, 131S; Tancock 1976, 40–41, 51–53, 100; de Caso and Sanders 1977, 155–57; Miller and Marotta 1986, 16; Fonsmark 1988, 84; Fath and Schmoll 1991, 141–42; Levkoff 1994, 73–74; Le Normand-Romain 1999, 74–75

1. Grappe 1944, cat. nos. 63–64, 91. Grappe also reported that a cast of the enlarged *Fallen Caryatid with a Stone* was acquired by an Argentinean for his home and noted that the version with an urn was also likely envisioned for a tomb. In one composition she was also juxtaposed with a shade (fig. 150). Le Normand-Romain dates cat. no. 56 to c. 1881–82 (2001, 160).
2. Beausire 1988, 82.
3. Dujardin-Beaumetz in Elsen 1965a, 158.
4. Bartlett in Elsen 1965a, 79. Bartlett added, "This supple little creature, not more than eighteen inches high, is regarded by the sculptor and his friends as one of his very best compositions and many copies of it have been made . . . in both marble and bronze."
5. Beausire 1988, 94.
6. Gsell [1911] 1984, 69–70.
7. Rilke in Elsen 1965a, 129–30.
8. Beausire 1988, 400, for specific references. He does not list any public exhibitions of *Fallen Caryatid with an Urn*. For discussion of the marble versions, see Fonsmark 1988, 84. The vessel borne by the Caryatid resembles the vessel in the versio of *Vase of the Titans* formerly belonging to Carrier-Belleuse (fig. 140).
9. Work on an enlargement in 1911 of *Caryatid with a Vase* is listed in Lebossé's notes (in Elsen 1981, 259). Both *Fallen Caryatids* were recorded as present in Lebossé's studio at the time of Rodin's death; they were on his machines or intended for enlargement (Elsen 1981, 256).
10. Minne's original *Fountain* is now lost; one of three replicas belongs to the Folkwang Museum, Essen. This and *The Rock Bearer* are both are illustrated in Robert Goldwater, *Symbolism* (New York: Harper and Row, 1979), figs. 156–57.

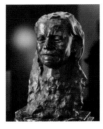

58

Crying Girl (La pleureuse), c. 1885

- Title variations: *Crying Woman, Head of Grief, Mask of Crying Girl*
- Bronze
- 12½ x 6¾ x 4½ in. (31.8 x 17.2 x 11.4 cm)
- Signed on bust, left side: A. Rodin
- Provenance: Sotheby's, London, 4 April 1974, lot 228
- Gift of the Iris and B. Gerald Cantor Foundation, 1975.86

Figure 181

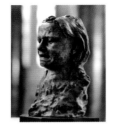

59

Crying Girl (La pleureuse), c. 1885

- Title variations: *Crying Woman, Head of Grief, Mask of Crying Girl*
- Glazed ceramic by Edmond Lachenal, cast 1895
- 12½ x 6¾ x 4½ in. (31.8 x 17.2 x 11.4 cm)
- Signed near lower edge, left side: Rodin/sclt^eur
- Inscribed interior of mask, right side: 5961 and Lachenal/Ceramiste/1895
- Provenance: Chabaud La Tour collection; Hôtel Drouot, Paris, 26 March 1974, lot 112
- Gift of the Iris and B. Gerald Cantor Foundation, 1975.87

Figure 182

*T*his mask is one of a pair that Rodin modeled for his early version of *The Gates of Hell*. The masks of grieving women were affixed to reliefs, two bronze casts of which are in the Philadelphia Museum of Arts Rodin Museum (figs. 183–184).[1] They were inserted in the lower section of the door panels and were seen by several writers who visited the sculptor's studio in the rue de l'Université. The first to comment on them seems to have been Octave Mirbeau, who wrote early in 1885, "Below these groups, still more bas-reliefs, on which project masks of sadness." Mirbeau went on to describe the figures surrounding the masks.[2] A year later Félicien Champsaur

wrote about the plaster portal and mentioned that "faces contracted by anguish are moistened by tears."[3] The masks in their relief setting are visible in the photographs taken by Jessie Lipscomb in 1887 (see fig. 124). They reveal what Truman Bartlett would have seen on his first visit to the studio in November of that year: "A short distance below Ugolino a narrow panel begins, which has two central pieces of masks of those who have died in misery, and the spaces on each side are filled with illustrations of the festival of Thetis and Peleus when invaded by Centaurs."[4]

Rodin liked the version of the Stanford bronze mask so much that he exhibited a plaster of the grieving woman at the Galerie Georges Petit in 1889 had it recast in ceramic by Edmond Lachenal (1889–1930).[5] In 1900 Rodin included in the catalogue of his retrospective the following gloss on one of the two masks: "Face violently contracted by sadness and crying 'bitter tears,' hair disheveled."[6] This curt description likely tells us what Rodin had in mind when he made the masks, probably independently of the reliefs and any particular story from Ovid. The base that the sculptor roughed out to support the mask, which otherwise terminated at the neck, seems to continue the woman's hair. He wanted what might be called emblematic heads that summarized the collective grief and despair of the portal's multitude while giving a decorative anchor to the lower doors. One has the sense that he may also have wanted the two life-size faces as compositional stabilizing points. It seems that Rodin only replaced the two reliefs with their centered masks during in his last effort to complete the doors, in 1899. From photographs it appears that he set or stored the reliefs in the area behind the tombs that replaced them at the bottom of the two big door panels.[7]

Unlike *Head of Sorrow* (cat. no. 55), the Stanford mask of a grieving young woman imparts the impression, unusual in Rodin, of an imposed expression, one suggested to a model, and a foretaste of the Hanako series he would begin in 1907 (see cat. nos. 120–122). The ceramic mask shows us Rodin's interest in trying color in his sculpture and in making casts cheaper than bronze.[8] Normally for Rodin "color" in sculpture meant the shadows and highlights achieved by the modeling; bronze allows a greater subtlety and richness in this regard than ceramic, which may be augmented by patination. That Rodin favored this mask was shown by its being carved in stone as well.[9]

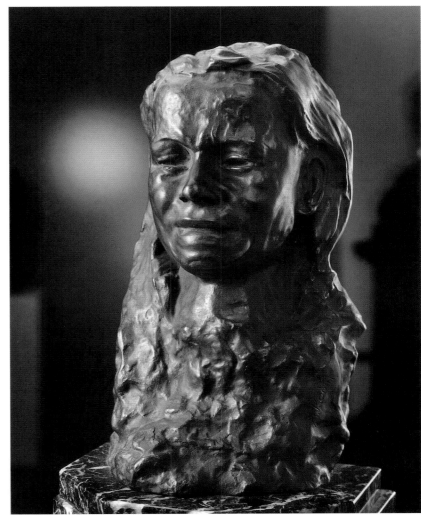

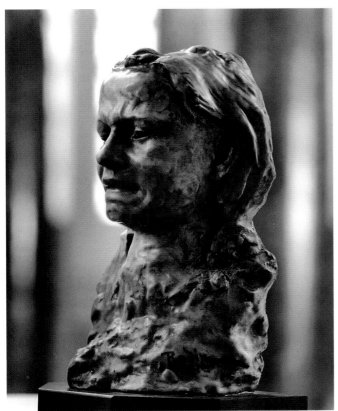

Above: Fig. 181.
Crying Girl (cat.
no. 58).

Left: Fig. 182.
Crying Girl (cat.
no. 59).

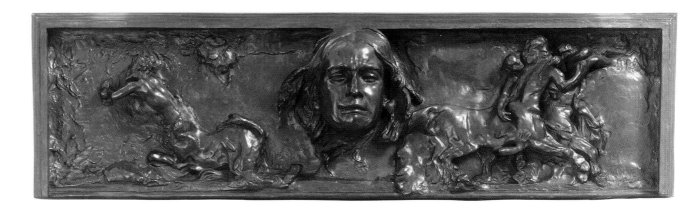

Fig. 183. *Bas-relief with Mask for Left Side of "The Gates of Hell,"* by 1885, bronze, 12½ x 43½ x 5¾ in. (31.7 x 110.5 x 14.6 cm). Rodin Museum, Philadelphia Museum of Art, gift of Jules E. Mastbaum.

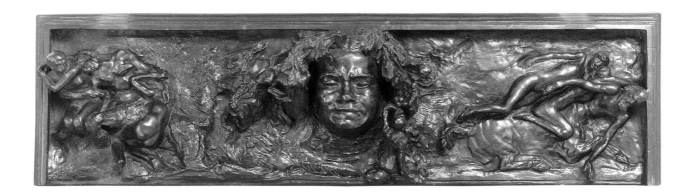

Fig. 184. *Bas-relief with Mask for Right Side of "The Gates of Hell,"* by 1885, bronze, 12½ x 43½ x 6¼ in. (31.7 x 110.5 x 15.9 cm). Rodin Museum, Philadelphia Museum of Art, gift of Jules E. Mastbaum.

NOTES

LITERATURE: Barlett 1899 in Elsen 1965a, 75 Grappe 1944, 76; Jianou and Goldscheider 1969, 92; Tancock 1976, 176–80; de Caso and Sanders 1977, 186; Barbier 1987, 84; Fath and Schmoll 1991, 150; Fourest 1971, 52; Tancock 1976, 180; Barbier 1987, 84; Grunfeld 1987, 400; Beausire 1989, 188; Lajoix 1997, 81–83; Le Normand-Romain 1999, 53

1. See discussion in Tancock 1976, 173–75. Other heads similar to the bas reliefs intended for the portal, ibid., cat. no. 14, and de Caso and Sanders 1977, cat. no. 30.
2. Octave Mirbeau, in *La France*, 18 February 1885. The remainder of the description was given in Elsen 1985a, 123.
3. Félicien Champsaur, in *Supplement du figaro* (Paris), 16 January 1886.
4. Bartlett in Elsen 1965a, 75. Tancock noted that Bartlett (or was it Rodin?) seems to have confused this story with one from Ovid, the wedding festival of Pirithoüs and Hippodame (1976, 173).

5. Beausire 1989, 188. Subsequent exhibitions of the mask of the *Crying Girl* in bronze and in plaster were in Geneva (1896), Paris (1900), Vienna (1901), and Rome (1913).
6. See Le Normand-Romain 2001, 92.
7. Tancock 1976, 174.
8. For further discussion of this mask and the context of Rodin's other works executed in the ceramic medium, see Lajoix 1997.
9. Tancock 1976, 180, reproduced the carved variations. For discussion of the marble versions, see also Barbier 1987, 84. For discussion of the effort to introduce color into sculpture in the later nineteenth century, see Andreas Blühm, *The Colour of Sculpture, 1840–1910*, exh. cat., Van Gogh Museum, Amsterdam (Zwolle: Waanders, 1996), especially Blühm's essay "In Living Colour: A Short History of Colour in Sculpture in the Nineteenth Century," 11–60.

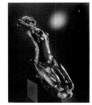

60

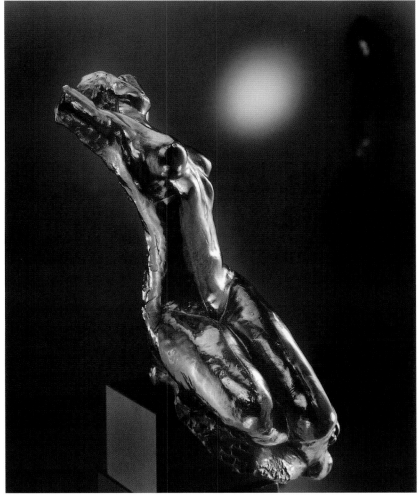

Fig. 185. *Seated Female Nude* (cat. no. 60).

Seated Female Nude (*Nu féminin assis*), before 1887

- Bronze, Coubertin Foundry, cast 1979, 8/12
- 20 x 7 x 11 in. (51 x 18 x 28 cm)
- Signed on figure, right side, near base: A. Rodin
- Inscribed on back of figure, near base: © by Musée Rodin 1979; below signature: No. 8
- Mark on back of base, bottom: Coubertin Foundry seal
- Provenance: Musée Rodin, Paris
- Gift of B. Gerald Cantor and Co., 1982.299

Figure 185

This is a real studio piece, or étude, in which Rodin was working out how to find energetic movement in a stationary figure. Such a concern is seen also in many of Degas's sculptures as well as those of Matisse. This étude has what might be called *désinvolture*,[1] a free and easy upward twisting of the body. To accomplish the pose, such as a model might assume while stretching to relax, the seated woman with her feet off the ground had to hook one foot behind the other so that she could lean back and, with raised arms, turn her torso in a different direction than her thighs. What must have appealed to Rodin was the extended abdomen and rib cage and the rotation of the breasts in a contrary direction to the thighs. Editing marks, as if made by a file or clawlike tool, score areas of the torso and face, suggesting that the artist wanted a different texture and surface response to light.

There is only half a face, whose features are summary at best, and the back of the head and arm are cut off along roughly the same plane. (When seen from the profiles, especially her right, the location of the amputation of the arms makes the end of the sculptural line the artist's subject.) The back was left unresolved, and Rodin, as was his custom, eschewed the studio prop of a stool or chair and fashioned a simulated rock as support for her seat and extended legs.

The sculpture evokes Rodin's pure enjoyment in the way the human body can balance itself naturally by the movements that coordinate body weight and volume. The pose gave Rodin simultaneously frontal and profile views, something Pablo Picasso would carry even further by violating anatomy in ways undreamed of by Rodin. The editing of this partial figure also reminds us how we can see new relationships between different parts of the body: the rhyming of breasts and knees, for example.

At one time Rodin found a temporary home for this étude in the tympanum of his *Gates of Hell*. It is visible in the right corner of Jessie Lipscomb's 1887 photograph (see fig. 123). We may account for this location not just on the grounds that the kneeling woman seen from below seems in agitation, but the positioning of her torso and thighs counters the strong group movement to the right. Several similar études made up the crowd on either side of *The Thinker*. This figure in a pose of *désinvolture*, however, came to be replaced in the portal by the figure known as *Meditation* (cat. nos. 61–62).

NOTES

1. For another partial figure in a comparable pose and known under that name, see Laurent 1988, 91.

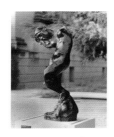

61

Meditation without Arms (La méditation, étude sans bras), c. 1894; enlarged 1895–96

- Title variations: *The Inner Voice, Meditation, The Muse*
- Bronze, Coubertin Foundry, cast 1981, 2/8
- 57½ x 30 x 22 in. (146 x 76.2 x 55.9 cm)
- Signed on front of base: A. Rodin
- Inscribed below signature: No. 2; on back of base, lower edge: © By Musée Rodin 1981
- Mark on back of base, lower edge: Coubertin Foundry seal
- Provenance: Musée Rodin, Paris
- Gift of the B. Gerald Cantor Collection, 1992.136

Figure 186

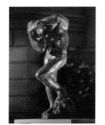

62

Meditation with Arms (La méditation, étude avec bras), after 1900

- Title variations: *Meditation, The Muse*
- Bronze, Coubertin Foundry, cast 1979, 7/12
- 61½ x 29 x 26 in. (156 x 74 x 66 cm)
- Signed on base, left side, below left foot: A. Rodin
- Inscribed to right of signature: No. 7; on back of base, bottom: © by Musée Rodin 1979
- Provenance: Musée Rodin, Paris
- Gift of the Iris and B. Gerald Cantor Foundation, 1984.429

Figure 187

*F*or artists, art historians, anatomists, and the public Rodin's *Meditation* figures are among his most challenging. For many reasons, largely anatomical, they just seem wrong but artistically intriguing. That Rodin was especially taken with the motif was shown by frequent exhibitions of his many variations on its form.[1] Its diverse uses included its appearance as one of the damned in hell, a muse for a writer, a siren, Mary Magdalene, and a lone figure.

The Stanford casts of the full and fragmented figures bearing the names *Meditation with Arms* and *Meditation without Arms* (or *The Inner Voice*) represent two of several states after the figure's first appearance in the extreme right of the tympanum of *The Gates of Hell*.[2] The original height is roughly 28 inches, and in *The Gates* she appears as a partial figure: the right hand is addressed to the head, and her left arm is not shown (fig. 188). The two Stanford casts of *Meditation* differ from the first version principally in this larger scale and in the positioning of the arms: in the full figure the arms are joined and raised to the level of the head; in the partial figure they are severely edited. The Stanford armless version derives from another full figure, which was detached from *The Gates* in 1885 and slightly enlarged and modified. A cast of this is in the Philadelphia Museum of Art's Rodin Museum (fig. 189).[3] In it the woman's right arm is doubled back, and she rests the lower right side of her face on the forearm, the left hand pressing her left breast.

Not unlike his legendary Greek predecessor Zeuxis, who painted an image of Helen by taking the most desirable features from the most beautiful virgins of Croton, Rodin synthesized his large figures of *Meditation* from previously fashioned parts of other models. In a very un-Greek way he was not always gender specific when he appropriated parts from other projects. Artistically the figure in both of Stanford's sculptures is a marvel, but anatomically the figure is an extreme anomaly.

To start with, in the full figure are adhesions between the massive arms and breasts, which are unaesthetic anatomically and yet absolutely aesthetic artistically, so that the figure still conveys a sense of poetic beauty. For Rodin the problem of supporting the big arms that were added to an existing sculpture, or the artist's desire not to have a spatial interval, probably required these adhesions, and he was not inhibited by a concern to show reality or anatomic possibility but rather followed his expressive aims. The fragmented form we see in the Stanford cast is the most stripped down of all the versions of *Meditation*. The head is in an anatomically impossible position and the neck extends beyond the upper limit of the spine. As with his positioning of the head of *Adam* (cat. no. 40), Rodin wanted to pull the woman in on herself.[4]

The expressive core of each sculpture is the torsos' great lateral bending, which exemplifies Rodin's love of easy, graceful bodily torsion, or *désinvolture*. There is a radical disalignment of the sternum and navel, which

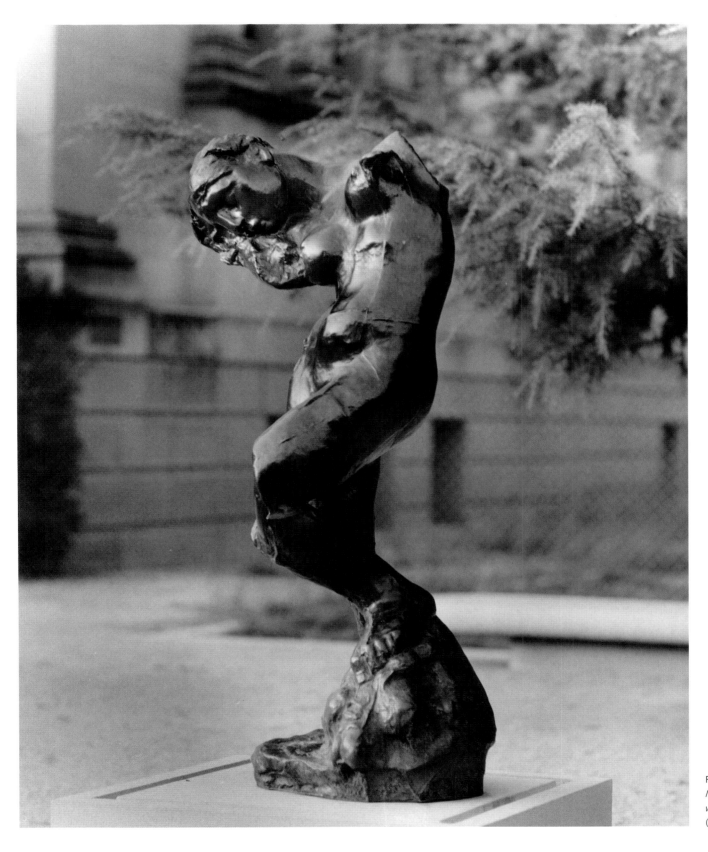

Fig. 186.
*Meditation
without Arms*
(cat. no. 61).

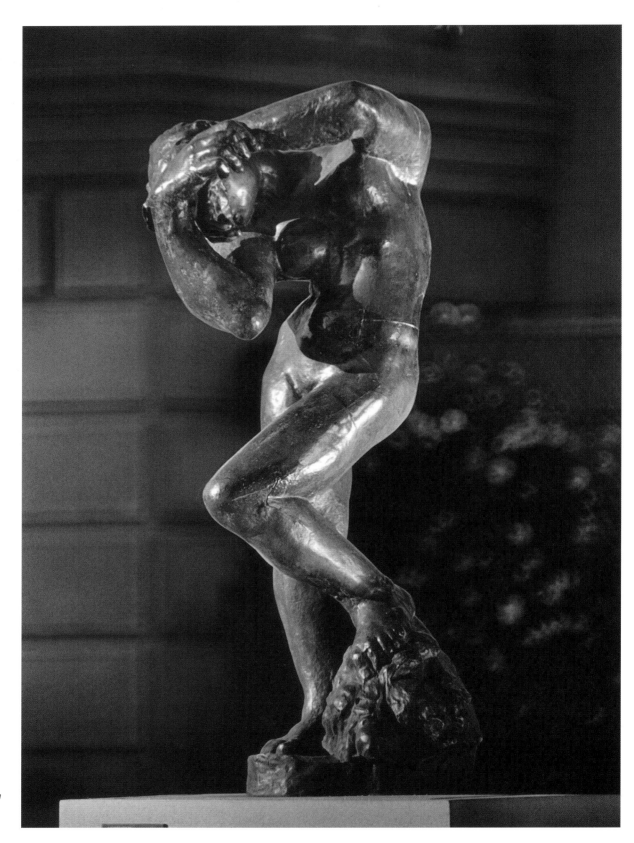

Fig. 187.
Meditation with Arms (cat. no. 62).

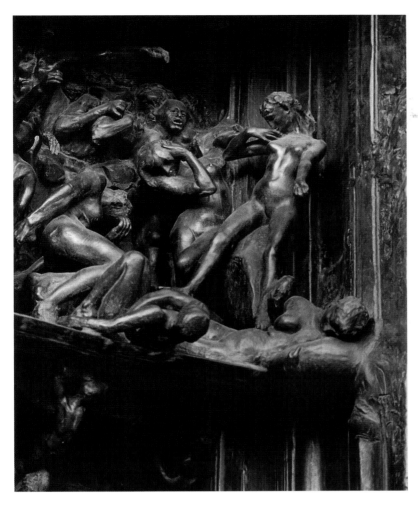

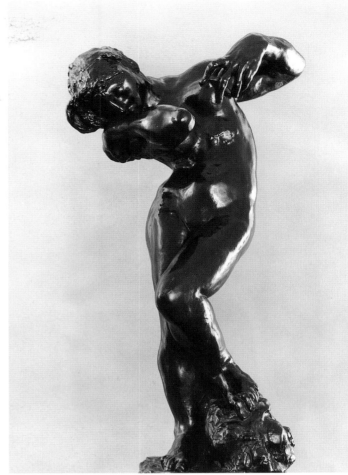

Rodin needed to achieve that exaggerated sway; in addition, the model may have been pregnant.[5] If the model for the torso was Camille Claudel, as some writers such as Lampert believe, then the appearance of *Meditation* might be evidence that she became pregnant at least once by Rodin and give credence to hearsay that she had at least one abortion, as she was childless.[6] Assuming that the diagnosis is correct and the model was pregnant, this makes the version of *Meditation* pressing her left breast in a nursing gesture all the more appropriate and, in Camille's case, poignant.[7]

The torso is mounted on a pair of small firm buttocks and huge upper thighs, neither of which belong to the former.[8] The legs resemble but are not those of *Eve* (cat. no. 41), as has been often suggested; in fact, their positioning more closely resembles that of *Adam* legs. The same liberties in the relative positioning of the weight-bearing and free limbs were taken in *Adam* and *Eve* and the *Meditation* figures. *Meditation*'s left leg and bent knee, which are not weight-bearing, could only assume their position if there was pressure on the left foot, which

there is not.[9] Rodin had done the same thing with *Adam*'s right leg. He may have learned from Michelangelo to take liberties with muscles that were supposed to be relaxed. As with Rodin's *Adam*, too, *Meditation*'s feet are very large, yet she lacks an Achilles tendon and articulated anklebones in her left foot.

The woman's back shows no articulation of the scapulas and shoulder muscles, which may have encouraged Rodin to position the arms variously. In the version with arms the shoulders appear disjointed.[10] The broad curvature of the back is relatively shallow, with little spinal definition. The spinal column does not extend to the neck, suggesting that a different head than that of the torso's model was added, and roughly modeled hair was used to mask this substitution. Nor does the spine line up with the crease of the buttocks, implying that the torso was added to the legs just above the pelvis. Furthermore, the figure has a crooked spine because the vertebrae are rotated in on one another and at angles.[11]

Why would an artist with Rodin's consummate knowledge of anatomy create such a hybrid, a figure that was

CLOCKWISE
Fig. 190. D.
Freuler,
*"Meditation
without Arms"*
*1895-96 in
plaster, Dépôt
des marbres*
(A143).

Fig. 191. Eugène
Druet,
*"Meditation
without Arms"*
*in "Monument
to Victor Hugo,"*
*in plaster, as
exhibited at the
Salon of 1897*
(A131).

Fig. 192.
Jacques-Ernst
Bulloz, *"Shade"*
*and
"Meditation,"*
*after 1901–02,
in plaster*
(A110).

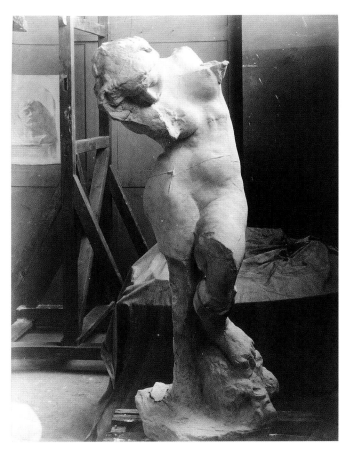

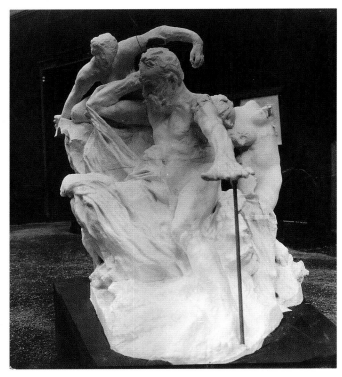

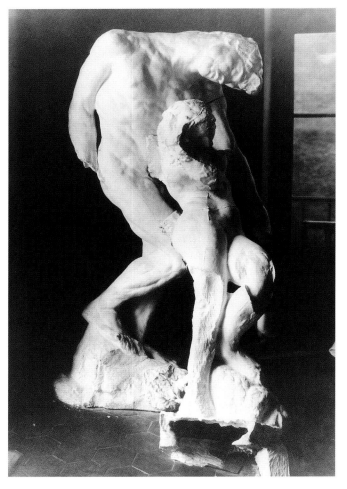

not true to nature? This is a subject not discussed by the artist's contemporaries who had the opportunity to ask him. Rodin would probably have said to look at the result in the sculpture itself for the way his "exaggerations," as he called creative license, contributed to the overall effect. Does it work as art? That was his criterion for truth. The sculptor once commented, "The way in which the artist arrives at his goal is the secret of his own existence. It is the measure of his own vision. . . . He exaggerates or deforms the literal in sculpture. . . . He suppresses or diminishes one part; and yet the whole is true because he seeks only truth."[12]

Recall that for Rodin nothing in nature was ugly, and demonstrably that included a crooked spine and midterm pregnancy. By positioning his figure with the weight on one foot (one leg straight, the other bent), a pose referred to by art historians as contrapposto, it was as if Rodin was challenging the salon clichés derived from the ancient Greek pose assumed by near-perfect living models that the classical artist might then improve on, if not wholly idealize.[13] Salon nudes of Rodin's time were positively svelte in their legs and ankles by comparison. Beauty in sculpture, he seems to tell us, does not have to depend on the anatomically normal and consis-

tent. Rather than impersonal and eternal, rules of proportion are now, in fact, relative to the work the artist is constructing and to what he believes are its needs. Rodin's modernity was, in large part, his recognition that an evolving composition, not the rules of the School, dictated its own aesthetic and expressive needs.

Zeuxis looked to many women for his parts. Rodin may have done the same, but he also mined his inventory of plaster parts, to which not just he but assistants like Claudel were always adding. When Rodin did not find what he needed, he improvised, as in the shoulders, if not the arms, of *Meditation*. For Rodin's time *Meditation* in all its variations is a brilliant example of a gifted sculptor's vision of what sculpture could be. *Meditation* reminds us that Rodin could make almost classically beautiful parts of the body. Rarely looked at or commented on in the literature but easily recognized in the partial figure version is the head with its very beautiful, near classical facial profile, which is similar to that used in the two versions of *Fallen Caryatid* (cat. nos. 56–57). As the original small versions of these sculptures were made in about the same period for *The Gates of Hell*—1880–81 and 1883 for the caryatids and 1884 or 1885 for *Meditation*—it is possible that the same model's head served for all. Judging by his portraits of her, Claudel may have inspired the body but certainly not the face. Compared to her narrowed feature the width of the flattened ridge of the modeled nose is almost an inch.[14]

When possible, as in *Adam* and *The Shade*, Rodin liked to square off the upper contour of his figure. (This practice achieves its culmination in the headless *Torso of a Seated Woman* [cat. no. 182] and *Cybele* [cat. no. 186]). In *Meditation* the anatomically impossible but dramatically desirable joining of the lowered head with the shoulder evokes introspection, hence the title *The Inner Voice*. The figure may have been edited as early as 1894 to evoke this idea.[15] Unlike the initial appearance of the figure in *The Gates of Hell* where she is part of a loud and turbulent mob, the figure seen in isolation appears to express an internal stimulation. This almost dreamlike state was an important means by which Rodin sometimes gave his freestanding figures a sense of self-sufficiency, alleviating the need by the viewer to look for something outside the figure to complete its dramatic action. Rilke was obviously moved by this figure, as he wrote, "Never was a human body assembled to such an extent about its inner self, so bent by its own soul and yet upheld by the elastic strength of its blood. . . . It is striking that the arms are

lacking. Rodin must have considered these arms as too facile a solution of his task, as something that did not belong to that body which desired to be enwrapped within itself."[16]

Rodin's editing of the *Inner Voice* helps clarify how his art bridges tradition and modern sculpture. Rodin was the first sculptor to see the body abstractly *and to act accordingly on his sculptures*. Thus artistic form won over anatomical form. To understand his vision, we have to examine his changes. The partial figure evolved from the version of *Meditation* touching her left breast. Except for the area on the woman's left breast, that is, the remnant of where her left hand touches it, the heads and unedited bodies of the Stanford *Meditation with Arms* and *Meditation without Arms* are identical.

To understand what Rodin was working toward by his amputations, one has to look at *Meditation without Arms* in the round, especially from the front but also the back in terms of its overall contours (fig. 190). Not only do the absent arms open the face and upper chest to light, but the overall silhouette is now more compact, fluid, and continuous.[17] The severing of the arms and the woman's right knee are not capricious but calculated in terms of how they can prolong and tighten certain silhouettes of the torso, shoulders, and legs. The most troublesome amputation to justify artistically is that of the back of the woman's right leg, and this may have been due to dissatisfaction with the results of its enlargement.[18]

Alain Beausire attributed Rodin's amputations of *Meditation without Arms* to broken works from antiquity, but this ignores more modern and sculptural motives.[19] When Rodin amputated the arms, left knee, and back of the right leg, he had the choice of redoing the rejected parts and having a new cast made. He chose instead to fill the exposed hollows in the truncated cast by patching, probably with wet plaster that could be manipulated, with no attempt at restoring illusion.[20] As when he occasionally left graphite or chiseled editing marks on marbles that were sold, he wanted to retain the raw signs of his editorial intervention in his plasters and their bronze casts. Rodin sought to demonstrate that perfection was a false goal and that art was a continuum: a well-made work might never be finished as it was susceptible to improvement. He was also saying in effect that he might complete a sculpture by subtraction or by its partial unmaking.

There were still other incentives for retaining the marks of the sculptural process. The exposed casting seams in the area of the abdomen may momentarily and

superficially suggest scars, but after prolonged observation they serve to remind us of the subtle curvature of the planes, the way undulating lines on a topographic map help us visualize surface configurations.[21] Most important, the seams also preserve the sensuous, convex surfaces from flattening under brilliant sunlight.

Henry Moore, for one, could well have been inspired by the bronze cast of *Meditation without Arms* that Rodin gave to the Victoria and Albert Museum in 1914 but which for many years was shown in the Tate. Besides its public exhibition, armless as part of the project for the *Monument to Victor Hugo* in Paris in 1897 (fig. 191) and 1900, it was also shown in Marseilles (1897 and given by Rodin in 1896 to the museum in that city), Stockholm (1897), and Düsseldorf (1904). The large versions were shown in Dresden (1897), Amsterdam (1899), Berlin (1901, 1914), Prague (1902), Rome (1913), and Edinburgh (1915).[22] There were marble versions of *Meditation with Arms*: one carved in 1915 for an American client named Colt, and one known as *The Siren* that shows the figure with one arm touching her breast and with the lower body of a fish, which is in the Musée Rodin.[23] *Meditation with Arms* appears in the bronze cast of the Victor Hugo monument in Paris at the avenues Victor Hugo and Henri Martin. The definitive model for the monument was completed shortly after 1900, at which time *Meditation with Arms* was also given a separate existence, independent of the monument.[24]

Rodin's custom of reusing a favored work in differing contexts is nowhere better seen than with *Meditation without Arms*. Not only was she shown with Victor Hugo as a muse but juxtaposed, with revised arms, with a hovering nude in *Constellation* (1900), and then as a partial figure joined in 1901–2 with the enlarged *Shade* (see *The Three Shades* cat. no. 44), a pairing at times referred to as *Adam and Eve* (fig. 192).[25] For her role in *Christ and Mary Magdalene* she was given a new left arm and hand, with which she clutches the cross, while her new right arm reaches around but does not touch Christ's body in the original Musée Rodin plaster of 1894. Elsewhere this erotic composition has been interpreted as a spiritual self-portrait of Rodin and Claudel made during the time of their breakup when the sculptor's "heart is on the rack."[26]

NOTES

LITERATURE: Rilke 1903 in Elsen 1965a, 122–23; Grappe 1929, 54; Grappe 1944, 48; Schmoll 1954, 56–58; Alley 1959, 213–14; Elsen 1969, 23; Steinberg 1972, 370–75; Tancock 1976, 193–99; Elsen 1980, 169; Alley 1981, 645; Elsen 1981, 112; Schmoll 1983, 124–29; Lampert 1986, 93–95, 116, 119, 212; Miller and Marotta 1986, 142; Fonsmark 1988, 130–31; Pingeot 1990, 210–11, 215, 312; Butler, Plottel, and Roos 1998, 86–90, 94–95; Georget and Le Normand-Romain 1997; Le Normand-Romain 1999, 72–73.

1. See Beausire 1988, 402.
2. Tancock 1976 contains a good discussion of this work and its variations (193–99). The figure with arms and the armless version were used in various later stages of the *Monument to Victor Hugo* (193–94, 417; figs. 71-7–8, 419). The best analysis is Leo Steinberg's (1972, 370–75). See also Alley (1981, 645), Schmoll (1954, 56–58), and Georget and Le Normand-Romain 1997.
3. Le Normand-Romain clarified that *Meditation without Arms* was probably derived from the small model of *Meditation*, the second version with arms, which she dates c. 1887–1890. She also explains that the arms of *Meditation with Arms* were derived from the figure of "Meditation" in the fourth maquette for the Monument to Victor Hugo (c. 1895). See Georget and Le Normand-Romain 1997, cat. no. 4 and 19–20, 23, 26, 28.
4. The author thanks Dr. Robert A. Chase of the Stanford University School of Medicine for sharing his anatomical observations with me.
5. The author thanks Dr. Amy Ladd of the Stanford University School of Medicine for sharing her observations about the figure's pose. A study of the lower abdomen by Dr. Chase convinced him that the model was sixteen weeks pregnant.
6. Lampert observed, "Only the middle, the torso, has the thick, short-waisted ripe look of Camille" (1986, 93).
7. Although she was thinking in terms of this version of *Meditation* in her role as muse, Rosalyn Frankel Jamison's analysis may have been particularly prescient: "He also introduced a new symbolic gesture—the fingers of the left hand pressing the breast. The gesture recalls one traditionally associated with inspiration (the muse squeezing milk onto books or musical instruments seen in Renaissance and baroque paintings); Rodin was probably attracted to it as a natural and intuitive symbol for uncertain fertility" (in Elsen 1981, 108).
8. Indicating the extent of Rodin's exaggeration of form, to Dr. Chase the upper thighs are of such thickness they suggest limp epidemia or elephantiasis. Visible on the plaster is a horizontal seam on the right hip, suggesting the joining of torso and legs.
9. This according to Dr. Ladd.
10. Dr. Ladd.
11. The spinal rotation is pronounced enough that in real life it would suggest scoliosis, according to Drs. Chase and Ladd.
12. Lawton 1906, 161.
13. Falguière's *Eve*, shown in the Salon of 1877, is a good example (reproduced in Fusco and Janson 1980, 94) as is Ernest Guilbert's *Eve* (1884; reproduced in Elsen 1981, 312).

14. Rodin's "classicism" is closer to Picasso's of the early 1920s, and the painter could have used this large, extraordinarily broad, straight-nosed, closed-eyed, round-jawed woman for one of his pastel or painted classical heads.

15. Tancock pointed out that this is the title of a collection of Victor Hugo's poems, *Les voix intérieures* (1976, 193). According to Le Normand-Romain (1992, 72) the editing of *Meditation* may be dated around 1894, reflecting Rodin's decision to create an allegorical figure to evoke the "interior voices." The baptism came when the large armless figure was introduced as a muse in the final project for the monument to Victor Hugo exhibited at the Salon of 1897. See Georget and Le Normand-Romain 1997, 19–20, 24.

16. Rilke in Elsen 1965a, 123.

17. An exception is when one sees from the sides the remnants of the woman's left hand on her breast, which interrupts the silhouette's fluid continuity. Rodin may not have been able to excise all the remnants of the fingers without damaging that part of the torso.

18. Beausire (1988, 130, 132) wrote that the *Meditation* was isolated from the *Monument to Victor Hugo* and presented in different exhibitions, and for that "Rodin had to section the left knee in order to remove the drapery that the artist had added." The drapery is visible in Eugène Druet's photograph of the project shown in the 1897 Salon (see fig. 191).

19. Beausire 1988, 132.

20. This was not a matter of being lazy, as Rodin had a small corps of highly trained assistants who could have replaced the missing parts.

21. Henry Moore built an entire mode of drawing on Rodin's use of casting seams. He would build up imagined figures by drawing sections that were not anatomical but were like those made when piece-molds were taken (conversation with author).

22. Beausire 1988, 131, 135–36, 138, 151, 188, 212–13, 233, 253, 344, 352, 354, 359. It is not always clear in the information available to Beausire from old catalogues whether the version with or without arms was shown; at times it is indicated that the edited cast is *Meditation I* and at other times *sans bras* is noted. Regarding the armless version, see Georget and Le Normand-Romain 1997, 13

23. *The Siren* was reproduced by Tancock (1976, 198).

24. See Butler, Plottel, and Roos 1998 for reproductions of the *Monument* and further discussion, fig. 45, 15–20, 105–09. The *Monument* was first cast in the early 1960s and inaugurated in 1964. Regarding the final monument see Georget and Le Normand-Romain 1997, 26–28.

25. He directed his photographer, Jacques-Ernst Bulloz, to photograph this pairing, showing how two previously self-sufficient figures could be married in a new composition and asking the viewer to read the agitated dreaming couple not only as human forms but also abstractly, in terms of the play of their contours and modeled volumes.

26. Elsen 1980, 180. See also de Caso and Sanders for their interpretation of the plaster made from the somewhat different marble version (1977, 93–94).

63

Study for "A Damned Woman" (*Etude pour une damnée*), c. 1884

- Title variation: *Woman Lying on Her Back*
- Bronze, Georges Rudier Foundry, cast 1966, 10/12
- 8 x 15½ x 10¼ in. (20.3 x 39.4 x 26 cm)
- Signed on abdomen, left side: A. Rodin
- Inscribed on back of torso, around opening: Georges Rudier/fondeur, Paris © by Musée Rodin 1966
- Provenance: Musée Rodin, Paris
- Gift of the Iris and B. Gerald Cantor Foundation, 1974.61

Figure 193

*T*his figure entered *The Gates of Hell* at the lower right of the tympanum probably between 1887 and 1889, but possibly not until 1898–99 when Rodin completed the portal (figs. 194, 226). It does not appear in the Jessie Lipscomb photographs of 1887. Given its position high above the viewer and lying on its back on the tympanum floor, where only the upper third of the figure's back and its raised knees can be seen, it is not surprising that Rodin did not address certain details. The hands are not resolved and, like those of *The Falling Man* (cat. no. 64), are mittenlike. There does not appear to be any record of this figure's having been exhibited in Rodin's lifetime apart from the portal or bronze cast, although it would have been visible as a separate figure to the thousands who visited his studios.

Like *The Martyr* (cat. nos. 72–73) this recumbent figure does not rest easily: her body touches the ground in only one small area of her back, below the left shoulder.

Her anguished head and neck are raised, both legs are drawn up, bent to her left, and her feet are off the ground, while her two arms are flung to her left. This creates two strong, divergent diagonal axes of the arms and hips, played off against the straight axis of the torso and slightly inclined head. This may have been one of Michelangelo's secrets for structuring the body that Rodin learned in 1876 on his Italian journey. By dropping the woman's right hip, the sculptor created a long and beautiful contour along the torso to the right shoulder. With its open mouth her head resembles but is not identical to *Head of Sorrow* (cat. no. 55). Rodin did not provide the figure with a modeled base, further suggesting that her destiny was the tympanum floor and that she

did not have an independent exhibition life. The figure seems to have been wholly made at one time, but with Rodin one can never be sure.

In the context of the tympanum, *Damned Woman* appears to have just fallen or been flung to the ground. The circular group of figures in front of *Meditation* at the tympanum's right, which includes the kneeling woman to *Damned Woman*'s left, the fallen woman to her right, and then the standing figures *Meditation* and the figure with the *Martyr*'s outstretched hand, possibly show the sequential movement of one figure's tragic fall. This is part of a larger theme across the tympanum in which this figure may be related to the meaning of the caryatid-muse.[1] *Damned Woman* reminds us that in portrayals of life beyond the

Fig. 194. Detail of *The Gates of Hell: A Damned Woman*.

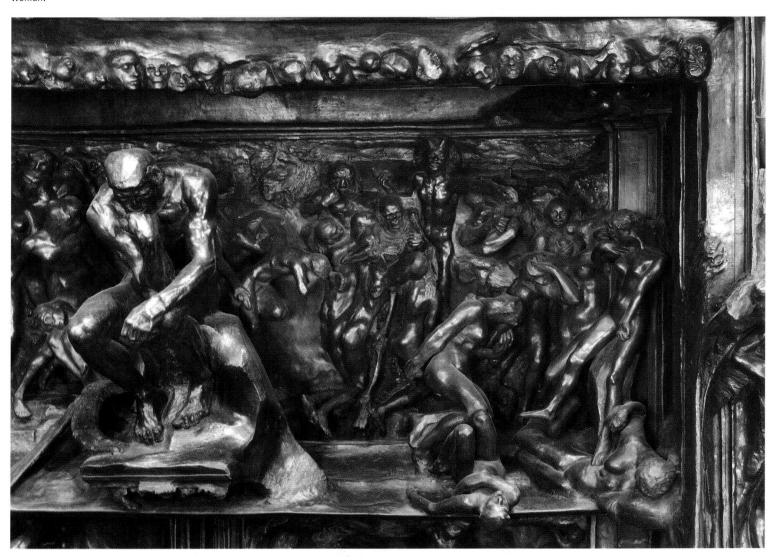

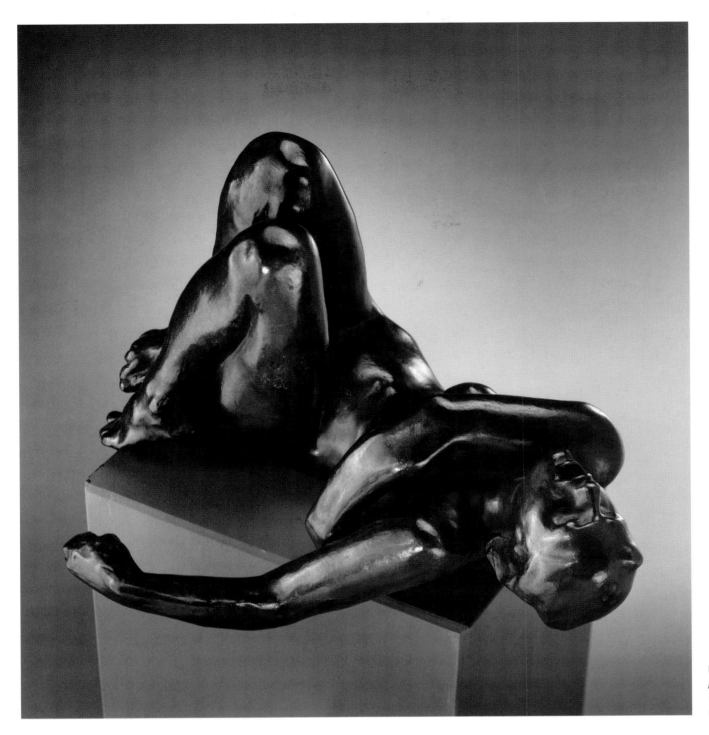

Fig. 193. *Study for "A Damned Woman"* (cat. no. 63).

tomb, none of Rodin's figures appear to be dead. Even when prone, they fight the pull of gravity and are filled with energy. Thus we can understand why Rodin favored unprofessional models who had character to go with lithe bodies that could move spontaneously. In the years he worked on the portal, Rodin continued to search for all possibilities of movement no matter the figure's orientation.

NOTES

LITERATURE: Lampert 1986, 90, 208; Fath and Schmoll 1991, 144

1. Jamison 1986, 145–46.

64

The Falling Man (*L'homme qui tombe*), 1882

- Title variation: *The Fall of Icarus*
- Bronze, Susse Foundry, cast 1978, 7/12
- 21 x 16¾ x 11¾ in. (53.2 x 42.5 x 29.8 cm)
- Signed on base, right side: A. Rodin
- Inscribed on base, bottom, left side, toward back: Susse Fondeur Paris; below signature: No. 7; on base, bottom, right side, toward back: © by Musée Rodin 1978
- Provenance: Musée Rodin, Paris
- Gift of the B. Gerald Cantor Collection, 1992.139

Figure 195

*O*ne of Rodin's favored male figures, judging by his repeated use of it not only in *The Gates* but elsewhere in his art, *The Falling Man* makes us wonder how the model posed. The position of the feet and legs in the bronze seems to deny that he stood upright. Rodin, however, could have posed him in a kneeling position with his weight on his right knee and ball of the left foot. A photograph of the plaster *Falling Man* holding *The Crouching Woman* (c. 1880–82), a work called *I Am Beautiful* (1882), shows a different modeled base for the male figure with his right foot braced against the ground.[1] The genitals of *The Falling Man* hang upward, suggesting that the model may have also posed while doing a headstand. But Rodin could have made this change without requiring the model to take such a strenuous position. Rodin claimed that he did not dictate poses to his models but let them find their own movement. Did Rodin arrive at the idea while seeing his athletic model doing stretching exercises? (This may have been the source of the model's pose in *Despair*, cat. nos. 69–71). If the model was Cailloux, the strong man who performed on the streets of Paris and who had posed for *The Shade* and perhaps for *Adam*, then this artistically unusual and demanding pose might be explainable.[2]

It was Cailloux's back that inspired Rodin's modeling of *The Shade*, for example, and *The Falling Man* was first to be seen from below, in a dorsal view, clinging to the lintel of *The Gates*, to the left of *The Thinker* (fig. 196). The

man's closed eyes or implied blindness evokes Charles Baudelaire's tragic figure of Icarus in "The Voyage" (1859), blinded by the sun. The fingers of his hands are shown unseparated, formed like mittens. The left hand remains out of view, as it was destined to rest on the top of the lintel, while the right, though it hangs downward at the figure's side, also is not visible from below. The striations on the man's abdomen, made in the plaster from which the bronze was cast, suggest a rough surface to provide a better purchase for the white wax or adhesive used to attach the figure to the bottom of the lintel.

When Rodin learned that his portal would not be functional because the museum of decorative arts would not be built, he may have added *The Falling Man* at some time before Jessie Lipscomb's photographs of 1887 (see fig. 122). Depending on whether or not the figure was attached below the lintel to the upper-left door panel, the presence of *The Falling Man* might have made it difficult if not impossible for that door to swing inward.

While the pose of the torso would be retained by

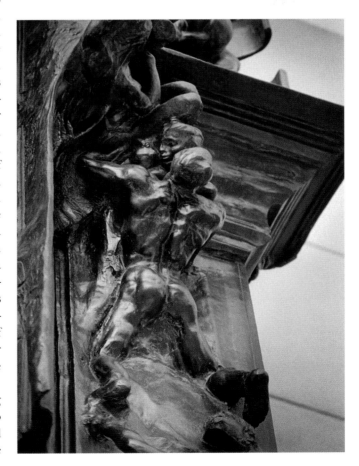

Fig. 197. Detail of *The Gates of Hell: The Falling Man* in the group *I Am Beautiful*.

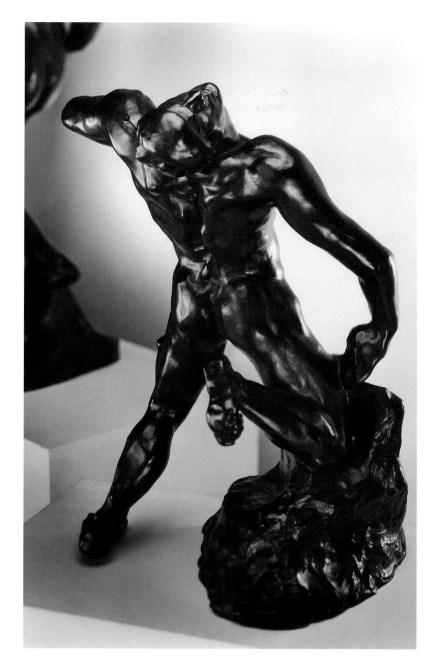

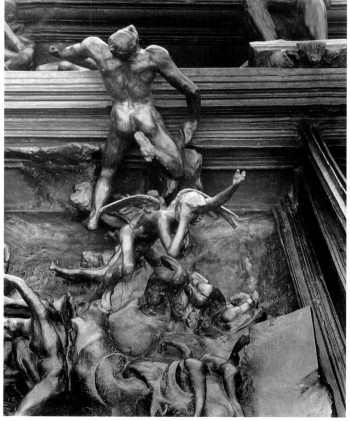

Left: Fig. 195.
The Falling Man
(cat. no. 64).

Below: Fig. 196.
Detail of *The
Gates of Hell:
The Falling
Man*.

Rodin, as was his customary approach, the figure's limbs were susceptible to various repositionings. *The Falling Man*'s left thigh bears a lump, suggesting that at one time his left hand may have touched it there. In 1882, when joined with *The Crouching Woman* in the composition that became known as *I Am Beautiful*, the man's arms were completely changed to encompass the compacted body of the woman. The couple was added to the upper right of the bas-relief in *The Gates*, his orientation remaining vertical (fig. 197). Between 1898 and 1900 he was joined with one of the women seen also in the upper left of the tympanum, cut off at the waist, and suspended upside

down next to the tomb in the lower right door of the portal (see fig. 201); this group was later known as *Avarice and Lust* (cat. nos. 66–67).³ In none of these three drastically different orientations and couplings did Rodin change the modeling of the back and position of the muscles. That kind of exactitude did not interest him as he knew that it might be noticed only by the most literal minded who were knowledgeable in anatomy but not in art, and he was right.

NOTES

LITERATURE: Grappe 1944, 32–33; Jianou and Goldscheider 1969, 89; Tancock 1976, 163–67; Lampert 1986, 62–66, 205; Pingeot 1990, 129–30; Fath and Schmoll 1991, 146; Levkoff 1994, 64; Le Normand-Romain 1999, 51

1. Elsen 1980, pl. 30.
2. Regarding Cailloux, see cat. no. 43.
3. For discussion of *The Falling Man* and variants, see Nicole Barbier "Homme gui tombe" in Pingeot 1990, 129–32.

Monumental Male Torso
(*Grand torse d'homme*), c. 1882, enlarged 1915–17

- Title variations: *Man through His Death Returns to Nature, Marsyas, Torso Louis XIV, Torso of a Man in Extension, Torso of the Falling Man*
- Bronze, Georges Rudier Foundry, cast 1979, 9/12
- 40½ x 27½ x 18½ in. (102.9 x 69.8 x 47 cm)
- Signed on front of left leg: A. Rodin
- Inscribed on back, at bottom: Georges Rudier/Fondeur.Paris; below signature: No. 9; on outer side of left leg: © by Musée Rodin 1979
- Provenance: Musée Rodin, Paris
- Gift of the B. Gerald Cantor Collection, 1983.21

Figure 198

Rodin generally conceived his figures first in terms of their torsos. It was a nuclear motif to which he might subsequently attach different arms and legs and even heads. The torso was the center of the figure's action. As shown in other partial figures without heads, such as *Prayer* (cat. no. 80) and *Cybele* (cat. no. 186), the torso for Rodin was the residence of the spirit and generator of energy. This was true for *Torso of Adele* (c. 1879–82), *Meditation* (cat. nos. 61–62), *The Martyr* (cat. nos. 72–73), *Torso of a Man* (cat. no. 173), *The Walking Man* (cat. no. 174), and others. Though the torsos were made usually from an upright model (the torso of *The Martyr* being an exception), Rodin would subsequently deploy a well-made and expressive torso in various orientations without making changes to reflect different responses of the body to gravity. His modeling, which rendered the figure in all its contours from above as well as at eye level, assured the sculptor that his forms would look right when seen from any angle. Such was the case for this torso, which served three figures, each seen in a different perspective in *The Gates of Hell*: horizontally for *The Falling Man*, clinging to the floor of the tympanum to the left of *The Thinker* (see fig. 196), vertically in the upper-right relief, where the male clutches *The Crouching Woman* to his breast (see fig. 197); and half-length and inverted for the male figure of the group that became known as *Avarice and Lust* to the left of the tomb in the right door panel (see fig. 201).

The date in which this torso was made and its association with the figure known as *The Falling Man* is not known for certain. Georges Grappe reasonably estimated it to be 1882, during the earliest period of *The Gates*.¹ It is likely, in view of Rodin's procedure with *Torso of a Man* (cat. no. 173), that the torso was made before the full figure of *The Falling Man*. An 1887 photograph by Jessie Lipscomb of the plaster *Gates* shows *The Falling Man* in place (see fig. 122). In 1889 it appears that Rodin exhibited the original small-size torso by itself in bronze as *Torse*.² The first version of the torso was shown in Rodin's great 1900 exhibition as *Marsyas*. It was armless but with the head and legs of *The Falling Man*.³ In that show *The Falling Man* without arms was paired with an armless female torso and the composition was entitled *Two Struggling Figures*.⁴

Rodin had the small torso of *The Falling Man* enlarged by Henri Lebossé in 1904 and/or 1915–17.⁵ If 1904 was the time of the enlargement, it is inexplicable that Rodin would not have exhibited it in Paris as he did *Prayer, Cybele,* and *Torso of a Young Woman* (cat. no. 177) almost immediately after the process was completed. As *Torso of a Young Woman* and *Torso of the Falling Man* both show the same pose with arched back, one would think that Rodin

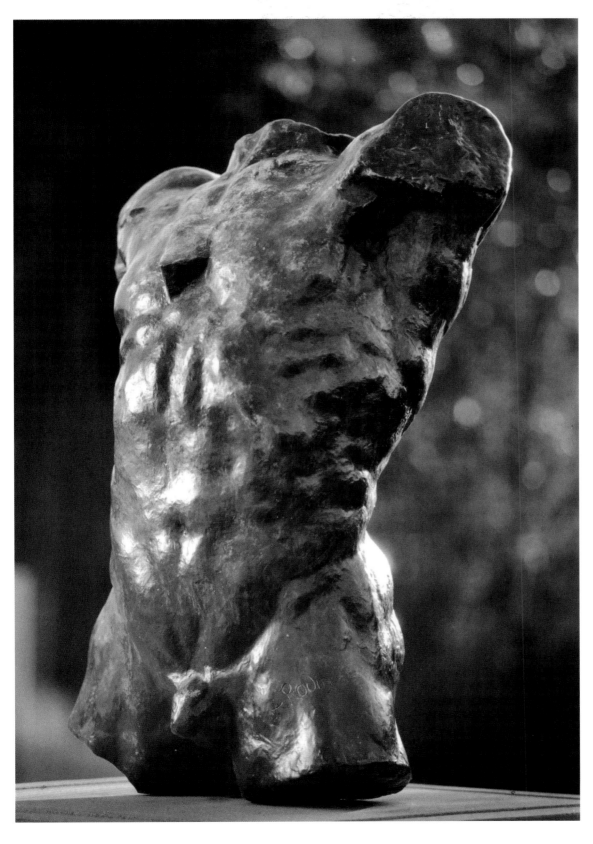

Fig. 198. *Monumental Male Torso* (cat. no. 65).

might have enjoyed exhibiting them together if the second figure was, in fact, available to him before the First World War broke out. There does not seem to be any exhibition history of or critical commentary on the enlarged *Torso of the Falling Man*, an absence that would be reasonable if the work had been made during the war.

This enlargement was not made from the original torso of *The Falling Man*, as the original version is without the wedge form that protrudes from the figure's right pectoral. This wedge was undoubtedly added to a plaster of the small torso to assist in supporting either the snake in *The Man with a Serpent* (1885) or *The Crouching Woman* in *I Am Beautiful* or both. We know from *The Walking Man* and *Eve* (cat. no. 41) that Rodin would preserve the exposed armature in the final work; also the inside of the right arm of the *Nude Study for "Jean d'Aire"* (cat. no. 18) reveals the persistence of what was probably an armature. Rodin may have retained the wedge because it suggested the broken shaft of a spear, thus suggesting that the falling figure is a wounded warrior defying death. (Such pathos was treated by Rodin in his wounded warrior for *The Defense*, see cat. no. 4.)

As originally conceived, if not edited, the splayed form of *The Torso of the Falling Man* is easily imagined within a cube, Rodin's preferred guide to composition. It was also essential for him that enough of an amputated limb be retained to preserve the sense of the direction of its gesture, something his younger imitators ignored. In this case Rodin was able to give or preserve in the form an explosively centrifugal movement not imparted by the full figure of *The Falling Man*. The amount of limb amputated was determined by Rodin's judgment of the resulting proportions and counterbalance with the other truncations. Crucial to the thematic and formal aspect of this sculpture are the angles at which the thighs were cut, which cause the figure to appear poised on two thin edges, thereby countering the expected downward pressure of great body weight and augmenting the radiating explosiveness of the figure's energy.

To those familiar with Hellenistic art, *Torso of the Falling Man* looks like a fragmented Hercules. Rodin admired ancient sculpture for its verisimilitude but not as a source to be literally imitated. This admiration especially included ancient fragments in which he saw unique expressiveness in the amputations resulting from time and chance. That the classical sculptors made their life-size sculptures for the outdoors drew Rodin's admiration for how his predecessors accommodated light. "Look at antique sculptures and the effect which is produced by even their most mediocre copies. . . . Light shows us the antique in all its majesty; its clarity envelops it so entirely that we are allowed to admire only the decorative power of its ensembles."[6]

To those who share the aversion of early modern sculptors—especially Aristide Maillol—to expression through tensed muscles, this torso might remind them of Constantin Brancusi's derision of Michelangelo for having produced "beefsteak art." Rodin was aware before 1914 that the move in early modern sculpture was away from detail and toward simplification in figure sculpture. He justified the inclusion of detail: "Even if a statue contains too many details, if they are exact, it will always be—although less beautiful—an affirmation of life. It is important above all that a work be living."[7] One of the constant aspects, or details, of Rodin's art, admired by Henry Moore because it indicated the presence of life, was the sense in the older sculptor's art of an inner animating force such as bone pressing hard against flesh. Rodin explained how he achieved this:

I applied it to the execution of figures. Instead of imagining the various parts of the body as more or less flat surfaces, I represented them as projections of interior volumes. I endeavored to express in each swelling of the torso or the limbs the presence of a muscle or a bone that continued deep beneath the skin.

And so the trueness of my figures, instead of being superficial, appeared to grow from the inside outward, as in life itself.[8]

In his male figures of the early 1880s, such as *The Thinker, Adam,* and *The Three Shades* (cat. nos. 38, 40, 43) Rodin showed his taste for mature, heavily muscled models, such as strong men who performed on the streets. Such a man could have posed for this sculpture. When the torso was enlarged, there was inevitably an exaggeration of the already developed musculature, especially in the back on both sides of the spine, and perhaps a thickening and roughening of the skin, as was Rodin's practice when *The Defense* was going through the enlarging process. What did Rodin have in mind by these liberties that resulted in exact modeling, if not exact anatomy? He explained in an interview around 1913, "In sculpture, there are no flaws; there are only exact forms, the distribution of light is given by nature herself. . . . Light

separates, disjoins, decomposes, destroys false forms . . . but when it shines on exact modeling, it gives the work the aspect and character of life."[9]

This enlarged torso thus embodies lessons Rodin had learned in his long life and experience with outdoor sculpture. Consider his further thoughts on the subject in the 1913 interview: "A beautiful work takes on all its strength when, in gardens or public places, free to all the caprices of light, it affirms itself; the unity of color is added to the unity of form. . . . It dominates and imposes itself, resplendent with that incomparable brilliance of the nude figure in the open air."[10]

Looking at this sculpture, which is Rodin's celebration of physical and spiritual male strength, one is also reminded of his words: "The art of the sculptor is made of strength, exactitude, and will. In order to express life, to render nature, one must will and will with all the strength of heart and brain."[11]

NOTES

LITERATURE: Grappe 1944, 33; Jianou and Goldscheider 1969, 89; Tancock 1976, 164, 167; Schmoll 1983, 133–34; Beausire 1989, 180, 182; Pingeot 1990, 130; Barbier 1992, 174–75; Levkoff 1994, 66–67

1. Grappe 1944, 32.
2. Beausire gave *Marsyas* or *Torse d'homme en extension* (Torso of a man in extension) as alternate titles and illustrated,

incorrectly, I believe, the enlarged version in his catalogue of the Monet-Rodin exhibition of that year (1989, 104, 182–83). To my knowledge, Lebossé did not start to make enlargements for Rodin until 1894, and the Stanford cast reflects the work of this technician and Rodin's later views on how the surface of such an outdoor piece should be made.
3. Beausire 1988, 181. He speculated that Rodin may have exhibited the work as *Torse* in 1890 in a bronze cast with a patina made to look like an antique (109).
4. Reproduced ibid., 191. For further discussion of these variants, see Pingeot 1990, 130–31.
5. The Lebossé notes for 1904 are not clear, except that he was enlarging a male torso. It is possible that Rodin did not like the first version of 1904, and Lebossé was redoing it in 1915 (Elsen 1981, 258–59). It seems to have been still in Lebossé's studio in 1917 (Lebossé file, Musée Rodin archives).
6. Dujardin-Beaumetz in Elsen 1965a, 171. For example, Rodin wrote an appreciation of the Venus de Milo ("A la Vénus de Milo," *L' art et les artistes* 11 [March 1910]: 243–55; translated by Dorothy Dudley as *Venus: To the Venus of Melos* [New York: B. W. Huebsch, 1912]). As can be seen in A176, Rodin's collection included ancient statuary.
7. Ibid., 173.
8. Gsell [1911] 1984, 25.
9. Dujardin-Beaumetz in Elsen 1965a, 170.
10. Ibid., 171.
11. Ibid., 161.

Avarice and Lust (*L'avarice et la luxure*), c. 1881–84

- Title variations: *Avarice, The Irreparable, The Last Judgment, Resurrection*
- Plaster
- 8½ x 20½ x 16½ in. (21.6 x 52.1 x 41.9 cm)
- Provenance: Heim Gallery, London
- Gift of the Iris and B. Gerald Cantor Collection, 1998.350

Figure 199

Avarice and Lust (*L'avarice et la luxure*), c. 1881–84

- Bronze
- 8½ x 20½ x 16½ in. (21.6 x 52.1 x 41.9 cm)
- Signed on rock behind female figure: A. Rodin
- Gift of the Iris and B. Gerald Cantor Foundation, 1975.184

Figure 200

*S*ome time in the 1880s, after Rodin had made *The Kiss* (cat. nos. 48–49) and other sculptures of couples for

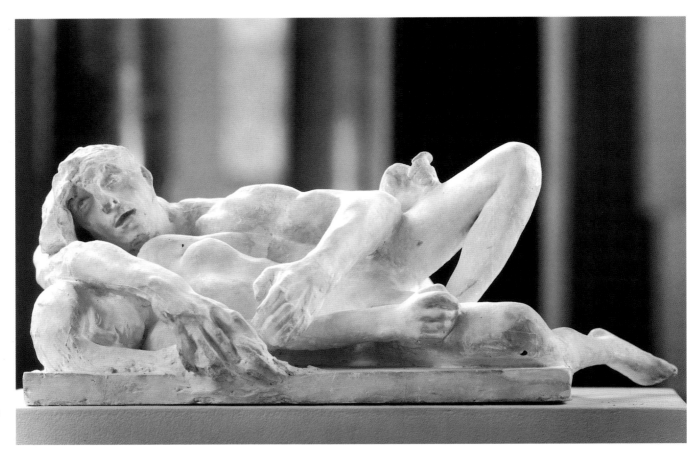

Fig. 199. *Avarice and Lust* (cat. no. 66).

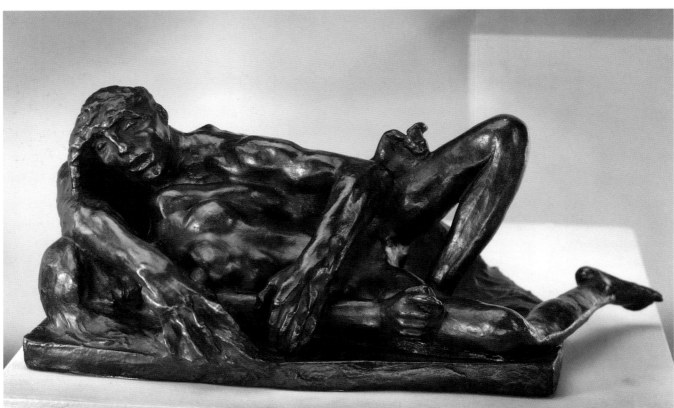

Fig. 200. *Avarice and Lust* (cat. no. 67).

which models posed, he began to create pairings from sculptures or parts of sculptures already made. It appears that these invented pairings came about while working on *The Gates of Hell* and were probably inspired by this great project. Aside from a few critical figures such as *The Thinker*, the Ugolino group, and *The Kiss*, Rodin did not plan in advance all the figures he would introduce into *The Gates*. (The infernal population was completed around 1899–1900.) By 1881 he was committed to improvising and trusting to his sense of mood and movement rather than to a preconceived iconographic program. When he closed his copy of Dante, about 1881, and committed himself to working with live models, Rodin's own imagination was liberated. He rapidly built an awesome inventory of small figures in plaster, which overflowed the flat surfaces of his studios. The physical nature of the portal, which encouraged reliefs, meant that he could use parts of his figures. Deciding to abandon single-point perspective freed him from the need to worry about size discrepancies between adjacent figures. Having modeled his subjects in the round and from above and below, he found that they could be applied in different orientations. As his estimate of whether a figure or couple was artistically right for the doors depended on its contribution to the overall decorative effect, Rodin was not always concerned about the visual accessibility of the motif. All of this is by way of background for the sculpture named *Avarice and Lust*.

We know from one of Jessie Lipscomb's photographs that the couple existed in plaster by 1887, although they were probably not actually introduced into the lower right door panel until sometime between 1899 and 1900.[1] The male figure is a composite. The torso is that of *The Falling Man* (cat. no. 64), with arms repositioned from that sculpture, a new head, and hair. The woman is one of the flying figures found in the upper left of the tympanum.[2] Her hands touch her outspread thighs, with the lower left leg adjusted into a different position for purposes of this composition. Judging from Lipscomb's photo, the group was horizontal when first joined, but the pair is seen vertically on *The Gates*, with the man upside down and facing the portal and the woman's body facing toward us (fig. 201). The man does not look at the woman, in fact, in the plaster, and in the bronze version in the final portal, he does not touch her body with his hands. His right arm is across her averted face, and the hand touches her hair, but the left is suspended above her arm. In our freestanding bronze, however, the man's

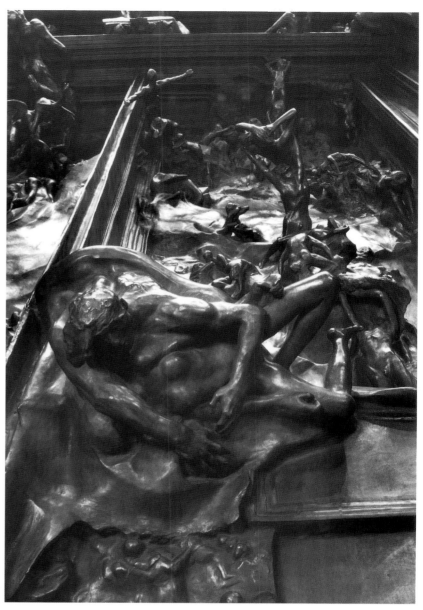

Fig. 201. Detail of *The Gates of Hell: Avarice and Lust.*

left hand has been reworked, and the thumb and fingertips touch the woman's arm. (Someday, when the complete inventory of the Meudon plasters is published, we may see similar slight gestural changes not only in the plaster for this couple but in other pairings as well.) The impression gained by seeing the sprawling woman with her eyes closed and mouth opened, sightless and grasping her lover, is like that of the dying Ugolino groping for his recumbent child. Despair and unfulfilled gestures are the mood and movement to which Rodin keyed *The Gates of Hell*.[3]

NOTES

LITERATURE: Grappe 1944, 63–64; Jianou and Goldscheider 1969, 91; Tancock 1976, 288, 292–93; Lampert 1986, 48–49, 206; Fath and Schmoll 1991, 143

1. Lipscomb's photograph of Rodin's studio showing *Avarice and Lust* is reproduced by Lampert (1986, fig. 89).
2. This figure was used in Rodin's drawings to illustrate Baude-laire's poem "Une charogne" in *Les fleurs du mal* (Musée Rodin, no. 2037) reproduced in Thorson 1975, figs. 88–88a). The figure also relates to the severely edited torso *Flying Figure* (cat. no. 183), in which her head, part of her left arm, left leg, and lower half of the right are severed.
3. For a discussion elaborating this view, see Lampert 1986, 43–99. The group is associated with Victor Hugo's poem "Aprés une lecture de Dante" in Le Normand-Romain, 2001, 214.

68

The Metamorphoses of Ovid
(Les métamorphoses d'Ovide), c. 1884

- Title variations: *Child and Young Woman, Damned Women, Death of Sappho, Les fleurs du mal, Voluptuousness, Young Girl and Death, Satyresses*
- Bronze, Georges Rudier Foundry, cast 1972, 6/12
- 13 x 15¾ x 10¼ in. (33 x 40 x 26 cm)
- Signed on front of base, left corner: A. Rodin
- Inscribed on base beneath upper figure's right foot: Georges Rudier/Fondeur. Paris; on base below lower figure's left foot: © by Musée Rodin 1972
- Provenance: Musée Rodin, Paris
- Gift of the Iris and B. Gerald Cantor Foundation, 1974.42

Figure 202

Lesbianism was a theme of great interest in the nineteenth century. In Rodin's work it is usually associated with the poetry of Charles Baudelaire, as Rodin made drawings (1887–88) for Baudelaire's "Femmes damnées" in *Les fleurs du mal*.[1] When first modeled, the figures in this sculpture lacked a base, and no rock supported the shoulders of the woman who resists the embrace. Nor was there a short, tufted tail attached to the lower spine of the upper figure. It was a later addition, which made the woman a mythological creature. When Rodin named the work *The Metamorphoses of Ovid* and added the appendage, he was protecting himself against public reaction to showing lesbians. Rodin's depiction of lesbian lovers brought to mind the Roman poet's concept of love as a restless malady, which acted as a springboard for Rodin's own reflections.

Rodin is on record as telling a Dutch visitor in 1891 that he sought to show "all forms of love" in *The Gates of Hell*, and this pair appears in the upper right of the portal, but in an upright position so that one sees only the handsome, big planes of the unadorned back and buttocks of the aggressive partner, not her gender (fig. 203).[2] Contemporary photographs show that Rodin considered rotating the couple and its base from a horizontal to an upright position. He drew with pencil on one print a fuller, curved bottom for the newly aligned base.[3] As Jessie Lipscomb's photographs show the right corner empty, it was sometime after 1887 that Rodin placed the source of a barren thorn vine just above and to the right of the embracing women. That neither element is visible from below is a reminder of how personal was Rodin's thinking and treatment of this public commission.

Whether the introduction of the lesbian motif inspired the change to a thorn from a fruited vine is probable but difficult to confirm. Rodin was always open to creation by serendipity. As shown in a Lipscomb photograph, for a long time the upper-left corner of *The Gates* held a relief composition of a naked mother and child (see fig. 122; later replaced by the *Fallen Caryatid*, see fig. 180), which was in accord with the fruitful vine motif. The two couples would have made an interesting thematic contrast, but it may have finally struck Rodin as incongruous for *The Gates of Hell*.

Rodin was known to have hired lesbians as models, and he took pains to show one as more masculine than the other. The assertive woman has short hair and the upper part of her face has a more masculine cast. Prominent, erect nipples signal her sexual excitement. Rodin invites us to imagine that a few moments earlier the long-haired woman was sitting on the lap of her partner, who suddenly forced her back and downward by planting a kiss on her right temple. The reluctant figure keeps her ankles and knees firmly together while burying her head in her crossed arms. The eager lover is not actually

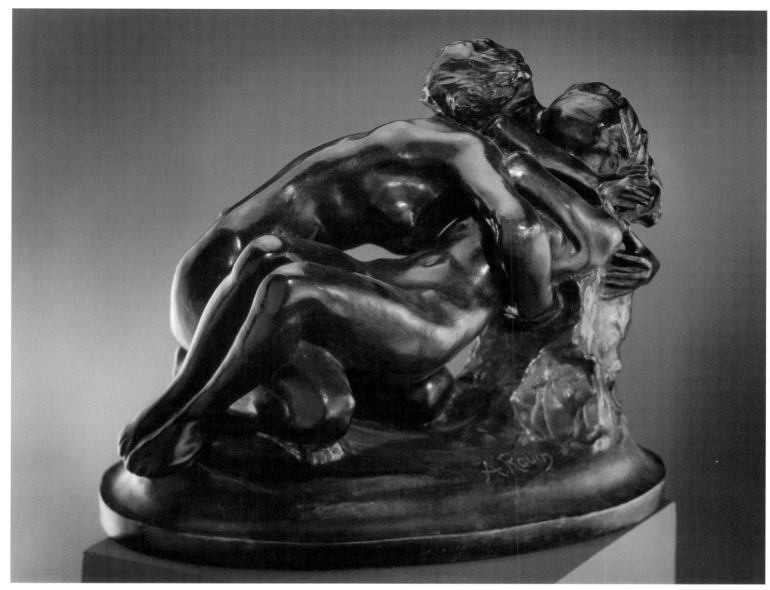

Fig. 202. *The Metamorphoses of Ovid* (cat. no. 68).

clutching the other, and her arms with the elbows out are in the midst of an encircling action. As a dramatist Rodin favored the penultimate moment and opposed the frozen final action in a story. For the beholder to have a sense of what came before and after, Rodin expected close reading of the gestures. The defensive position of the reluctant woman's arms seems to foreshadow her submission, but Rodin shows the thumb of the ardent wooer touching the extended right thumb of the other, thereby closing a compositional circle but suggesting successive events in their sexual drama.

The work was also known as *Damned Women*, and it inspired the following from Camille Mauclair: "We must further note some groups of Women Damned in which Rodin's art attains the highest point of voluptuous ten-sion, audacious suggestiveness, and tragic eagerness of the flesh aspiring to impossible delight. This whole world of figures is ruled by the same lyrical and poetic imagina-tion. . . . The aspiration of a troubled time toward an ide-ality which would deliver it from . . . pessimism; the hope of escape by the way of desire; and love sought for in the over excitement of neurosis. Rodin, gloomy psychologist of passion, understands the disease of the age, and at the same time pities it."[4]

Unlike many other paired figures that Rodin made in which each figure had a separate history, the two women in *The Metamorphoses of Ovid* seem to have been modeled at the same time just for this work. Rodin claimed not to have imposed postures on his models but allowed them to behave naturally. His many drawings after about 1895

of lesbians making love in his studio prompt the conclusion that he encouraged this practice much earlier for his sculpture. This work was exhibited, mainly in marble, and it was first shown at the 1889 Monet-Rodin show in Paris as *Satyresses*, then in Vienna (1898), Dresden and Berlin (1901), Helsinki and Prague (1902), Helsinki again (1906), and in bronze in Paris (1917).[5]

NOTES

LITERATURE: Grappe 1944, 54–55; Jianou and Goldscheider 1969, 91; Tancock 1976, 257–58, 260; Elsen 1980, 176; Lampert 1986, 86, 207; Fonsmark 1988, 118–19; Fath and Schmoll 1991, 142; Barbier 1992, 53–54, 56; Le Normand-Romain, 1999, 76-77.

1. See Thorson 1975, figs. 101-101a.
2. Byvanck 1892, 8.
3. See the photograph reproduced in Elsen 1980, pl. 77. On another photograph he drew the arc of a circle touching the group and inscribed on the arc "zodiaque" (see Barbier 1992, fig. 40).
4. Mauclair 1918, 87.
5. Beausire 1988, 104, 139, 212–13, 219, 228, 273, 367.

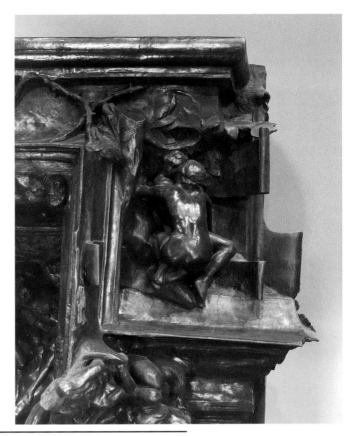

Fig. 203. Detail of *The Gates of Hell: The Metamorphoses of Ovid.*

69

Despair (Le Désespoir), c. 1890(?)

- Title variations: *Shade Holding Her Foot, Woman Holding Her Foot*
- Plaster
- 11 x 5⁹⁄₁₆ x 10 in. (27.9 x 14.1 x 25.4 cm)
- Provenance: Anthony Roux; his sale Paris, 20 May 1914, lot 130; Sotheby's, London, 28 June 1967, lot 11
- Gift of the Iris and B. Gerald Cantor Foundation, 1974.116

Figure 204

70

Despair (Le Désespoir), c. 1890?

- Title variations: *Shade Holding Her Foot, Woman Holding Her Foot*
- Bronze, Perzinka Foundry, 1/10
- 11 x 5⅝ x 10 in. (27.9 x 14.3 x 25.4 cm)
- Signed on base, left side, near back: A. Rodin
- Inscribed on back of base: L. Perzinka/fondeur Versailles; above signature: traces of another inscription
- Provenance: Sotheby's, London, 1 July 1970, lot 41
- Gift of the Iris and B. Gerald Cantor Foundation, 1974.62

Figure 205

*T*he figure known as *Despair*, seated and grasping her left foot in her hands, appears in *The Gates of Hell* in the upper area of the left door panel below the falling winged figure and just to the left of the serpent's coils (fig. 206). That area was not completed as we know it

today when Jessie Lipscomb photographed the doors in plaster in 1887. Georges Grappe dated the figure 1890,[1] but the date is probably earlier, and the addition of *Despair* to the doors may have occurred in 1888–89 or between 1898 and 1900. (During both periods Rodin was preparing the portal for public exhibition, and in 1897 this figure was first exhibited in Venice.)[2]

There is no previous history in sculpture nor an allusion to a specific character in Dante that explains the pose of this plaster. In a letter written in 1908 indicating what he intended to exhibit that year in Frankfurt, Rodin referred to this and other figures as "shades belonging to different circles of Dante's Hell."[3] Yet *Despair*, a name Rodin used after 1900, suggests simply someone in distress.[4] When first exhibited, the work was named *Shade Holding Her Foot*.[5] The origin of the woman's pose cannot be found in the *Inferno* or another literary source; more probably it derives from a tired, seated model or maybe an acrobat, as Grappe suggested, who lowered her head as her shoulders were pulled forward by the stretching of her arms in order to grasp the bottom of her extended left foot, an action to perhaps relax her neck and back. Grappe pointed out also that in Rodin's atelier inventories many figures carry the title *Woman Holding Her Foot*.[6] The French idiom that equates putting one's foot in one's hand with sexual orgasm may have occurred to Rodin, a meaning that would have made this unusual and expressive pose all the more appropriate for *The Gates of Hell*. As shown in old photographs and the inventory of the Musée Rodin at Meudon, Rodin considered ways of truncating this composition. In one photograph a foreshortened front view focuses on the genital area. In another photograph, a three-quarter view, he had covered the woman's head with a blanket.[7] On one plaster at Meudon he cut away the figure's extended leg. As with his *Crouching Woman* (c. 1880–82), it is as if Rodin were searching for a form of the body that was most compact and took up the least space. The editing of the extended leg drew more attention to the woman's exposed genitals.

NOTES

LITERATURE: Grappe 1944, 84; Jianou and Goldscheider 1969, 92; Elsen 1980, 178; Lampert 1986, 82–83, 208; Miller and Marotta 1986, 33; Fath and Schmoll 1991, 147; Le Normand-Romain, 1999, 59–60

1. Grappe 1944, 84. A figure in a related pose appears on the right panel of the portal; the figure's left leg, with the

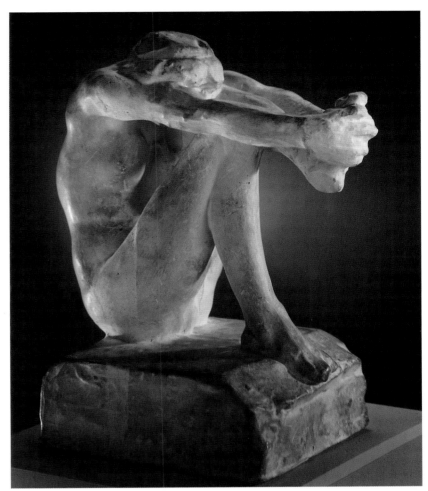

Above: Fig. 204. *Despair* (cat. no. 69).

Left: Fig. 206. Detail of *The Gates of Hell: Despair.*

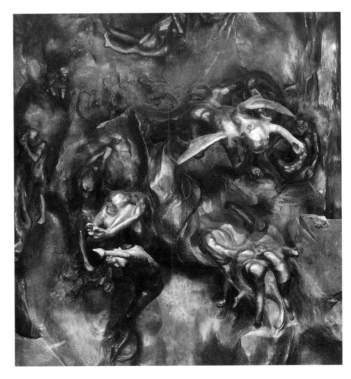

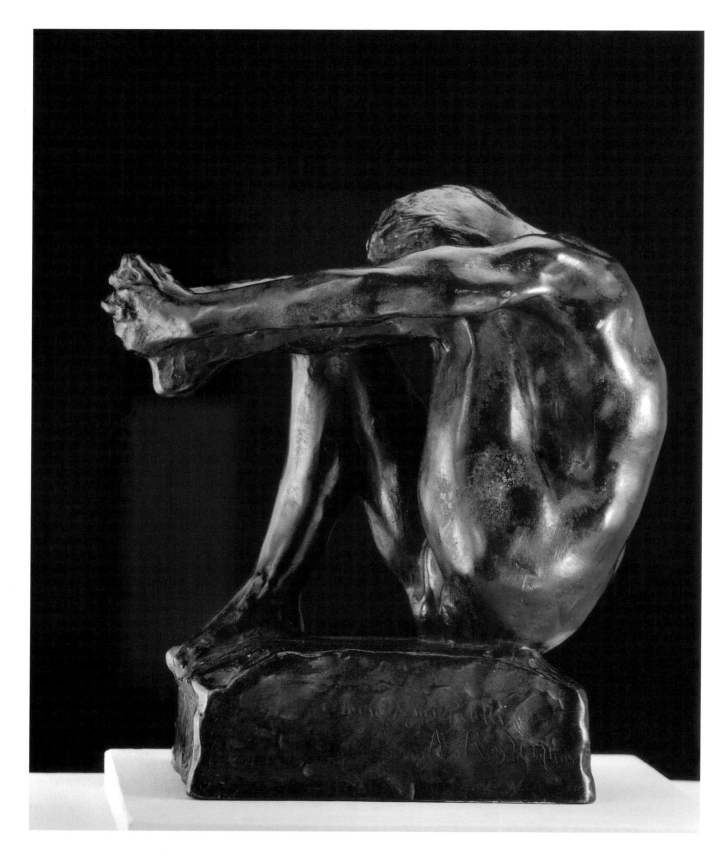

Fig. 205.
Despair (cat.
no. 70).

left hand grasping the foot, is raised, and the right hand rests by the other foot (ibid., cat. no. 244).

2. Beausire 1988, 131.

3. Rodin to the painter Ignacio Zuloaga, 12 September 1908, in Ghislaine Plessier, *Étude Critique de la Correspondence échangée entre Zuloaga et Rodin de 1903 à 1917* (Paris: Editions Hispaniques, 1983), 87.

4. A similar name, *La douleur*, suggesting pain or anguish, was also given to Rodin's *Crouching Woman* (Beausire 1988., 303).

5. Ibid., 131. It was subsequently exhibited as *Despair* (185, 256, 266, 366), except in 1908, when three sculptures were shown as *Figure Holding Her Foot* (303).

6. Grappe 1944, 84.

7. See Elsen 1980, pls. 93–94.

Despair (*Le Désespoir*), 1914

- Title variations: *Shade Holding Her Foot, Woman Holding Her Foot*
- Limestone
- 37 x 13½ x 31 in. (94 x 34.3 x 78.7 cm)
- Signed on base, right side, near top front corner: A. Rodin/1914
- Provenance: Madame Lara; Mrs. Madeleine Charles de la Malaide; Galerie Charpentier, Paris; Galerie de l'Elysée, Paris; Mrs. S. Freeman, Manhasset, New York; Parke Bernet, New York, 16 April 1969, lot 34
- Gift of the Iris and B. Gerald Cantor Foundation, 1974.86

Figure 207

*T*his appears to have been among the last of Rodin's carvings. Rather than in marble, it is in limestone, a type of stone used for both outdoor architectural and freestanding sculpture. Further suggesting its intended location is the weep hole drilled next to the raised left ankle, which would have allowed water to drain from the upper cavities between the extended arms and raised leg. The stone is signed in the base, *A. Rodin/1914*. The actual inscribing of the stone would have been done by the technician and not Rodin, as this was the artist's practice. The inclusion of the date is unusual in Rodin's stones. The signature implies that the work was finished, yet large areas of the back, upper left arm, and lower right thigh are still rough or severely pitted from being worked by a chisel known as a point. These rough areas, compared with the front of the torso, upper right thigh, and top of the head, show no evidence of abrasion with a file to smooth the surface.

In comparison with the plaster (cat. no. 69), the carving has a more developed lower face, and the fingers of the two hands pulling against the woman's ankle have been fully delineated. (Whether Rodin made these refinements by reworking the plaster model or allowed his experienced carver to make them we do not know.) With its simple geometric base, broad treatment of the body's planes, and such features as the hair, ample proportions, and firm form of the woman, this is the closest Rodin's carvings come to those of Aristide Maillol in works such as *Night* (1902).[1] Maillol was an artist whose work Rodin owned and admired for its simplicity and joyful beauty. (Maillol criticized Rodin for his illusionistic bases and excessive attention to details or parts.) Whether deliberate or not, Rodin's stone *Despair* seems an answer to Maillol. Rodin could have been showing that they were united in their goal of "the decorative," achieving an overall effect to which details would be sacrificed.

NOTES

LITERATURE: Jianou and Goldscheider 1969, 92; Elsen 1980, 178; Rosenfeld 1993, 555–60

1. Reproduced in H. W. Janson, *Nineteenth-Century Sculpture* (New York: Abrams, 1985), 269.

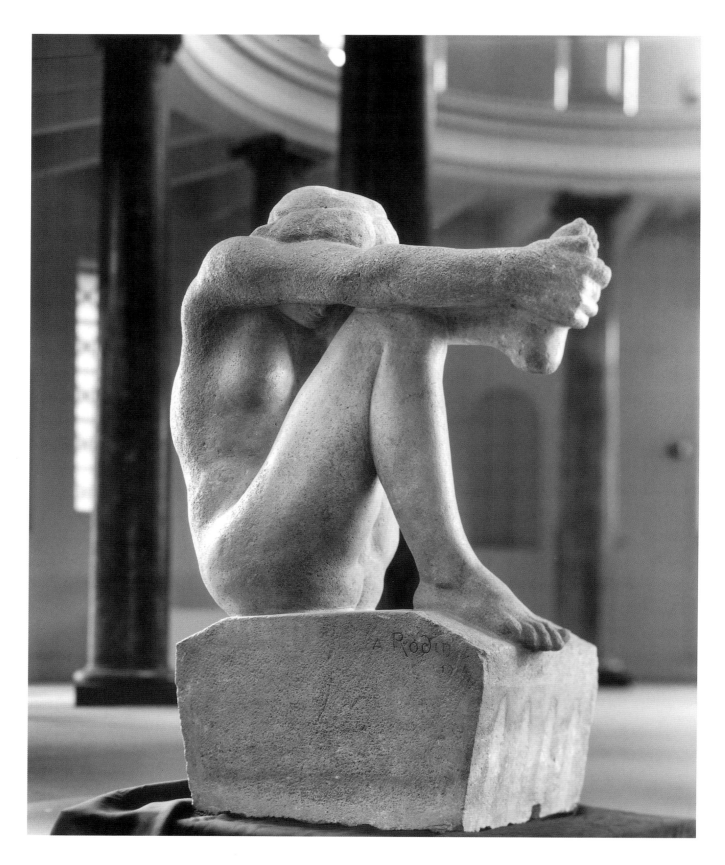

Fig. 207.
Despair (cat.
no. 71).

72

The Martyr (La martyre), 1885

- Title variation: *Christian Martyr*
- Bronze, Georges Rudier Foundry, cast 1979, 9/12
- 4½ x 24 x 17¼ in. (11.4 x 61 x 43.2 cm)
- Signed on left side, beneath head: A. Rodin
- Inscribed on left buttock: Georges Rudier Fondeur Paris; beside signature: No 9; on back of left shoulder: © Musée Rodin 1979
- Gift of the Iris and B. Gerald Cantor Collection, 1998.362

Figure 208

73

The Martyr (La martyre), 1885, enlarged 1899–1900

- Bronze, Godard Foundry, cast 1983, 8/8
- 60½ x 41½ x 14 in. (152.4 x 105.4 x 35.6 cm)
- Signed on hair, right side: A. Rodin
- Inscribed on left buttock: E. Godard Fondeur; right of signature: 8/8; on back of base: © by Musée Rodin 1983
- Provenance: Musée Rodin, Paris
- Gift of the Iris and B. Gerald Cantor Collection, 1998.351

Figure 209

*N*amed by Rodin after the fact, *The Martyr* is the most unquiet *gisant* (reclining figure) in the history of sculpture. Knowing Rodin's studio practice and given the absence of any historical postural precedent in art, the work must have begun as a study of an exhausted model sprawled on her back on what was probably a mattress, her upraised feet supported perhaps by pillows.[1] Her head is thrown back, and her hair falls downward beyond the original support, to spread out and form a kind of flattened base that helps stabilize the figure. (This accounts for the stepped wooden base for the original small version.) The splayed position of the breasts pre-

supposes the present supine position. Until her torso was enlarged (fig. 210) and used for *Half-Length Torso of a Woman* (cat. no. 74), Rodin did not model the left portion of her back, which had been in contact with the original support, and this is true also of the underside of the raised legs, which were left in a very rough state, perhaps because they were originally supported on pillows. Rodin seems not to have modeled a base for her form, but in the enlargement there is a curious, narrow ridge emanating from underneath the woman's left thigh, which may have been introduced to stabilize the figure.

The first version of *The Martyr* appears in *The Gates* in the tympanum, just to the left of *The Thinker* and immediately behind *The Crouching Woman* (fig. 211). We know she was added after 1887 because the figure does not appear in Jessie Lipscomb's photographs of that year. Though modeled in a horizontal pose, the figure was turned upright and the unmodeled area of the woman's back was attached to the rear wall; her head and legs are entirely different from the horizontal version of the figure, but there seems no way of knowing which version came first or if they were contemporaneous; this means that having made the torso and having two plaster casts of it, Rodin then chose different extremities for each. Her upright position in the tympanum makes it appear that she is running. In fact, the figure seems to be moving in two directions: from the navel down her body is directed to her left, while above the navel her body and arms are twisted to her right and turned toward the front of the tympanum. As such a pose is anatomically difficult, if not impossible, to assume or sustain, Rodin could have worked from the model, who may have taken two different recumbent positions.

Rodin's liberties with anatomy, based on sound knowledge, abound in this work.[2] For purposes of compositional closure he made the woman's right foot toe in, but to do this he had to break the leg above the ankle so that it looks like a badly set fracture. The area of the Achilles tendon was greatly thickened and flattened. The powerful adductor muscles of the thighs bulge far more than can be explained by the absence of a support beneath them. To achieve the big curvature of her left arm and to make it more expressive, Rodin rotated the forearm and wrist so that they do not align with the hollow of the elbow. The navel and sternum are not on the same axis, supporting the view that Rodin may have worked from the model in two positions. The cartilage below the left breast is made prominent, the raised area serving to

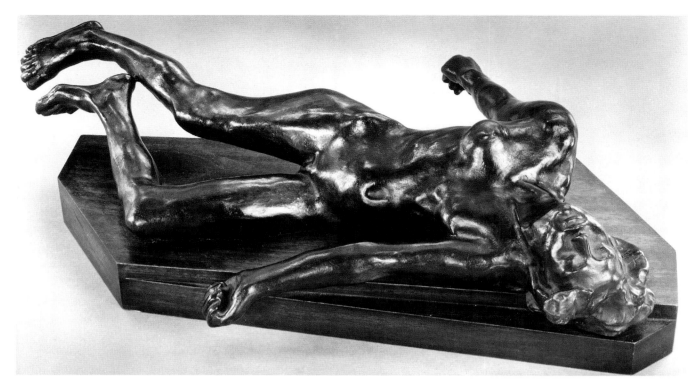

Fig. 208. *The Martyr* (cat. no. 72).

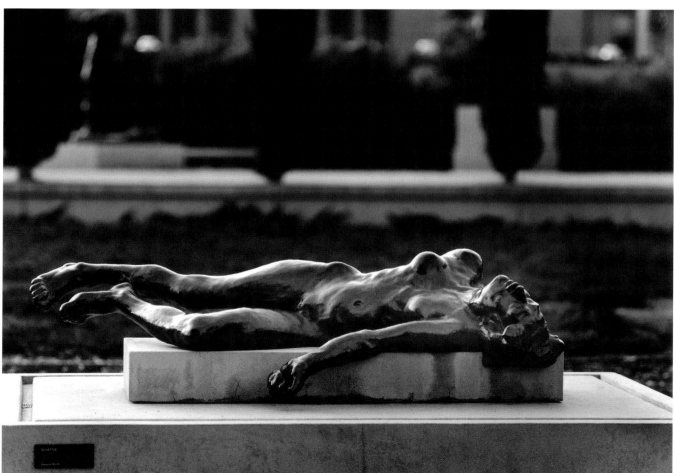

Fig. 209. *The Martyr* (cat. no. 73).

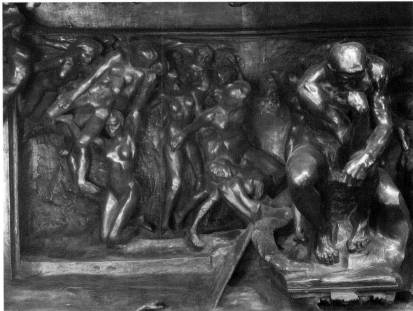

interact with the light. There may have been a similar motive for accentuating the muscles of the woman's right shoulder. Rodin fused the woman's left shoulder, parts of which are not defined by modeling, with the neck and breast, thereby offering greater support to the extended head. All these distortions were sculpturally motivated. That Rodin did not change any of the anatomy of the torso when it appeared in its upright version, hence in a different relation to gravity, was a conscious decision by the artist in whose judgment the modeling still worked *visually* or artistically.

When he chose to show the work by itself, probably in 1889 at his exhibition with Monet, the sculpture seems to have been named *Figure couchée* (Recumbent figure), which would have accorded with the subject's studio origin.[3] The vulnerable position of the reclining woman could have inspired the name. Alternatively, the art dealer Georges Petit, in whose gallery the work was first shown, could have given the name, possibly reminding Rodin of the taste of contemporary collectors for titles encouraged by salon practice. Rodin was reluctant to give what seemed like titles to his works, thereby imply-

ing the sculptures were illustrations, preferring to call them études or assigning purely descriptive names, such as *Reclining Woman*, as he realized that titles could distract the public from studying the sculpture itself.

Even today this is a startling sculpture. Unlike his predecessors' treatment of the reclining figure, such as *Woman Bitten by a Serpent* by Jean-Baptiste Clésinger (1847; Louvre, Paris), Rodin took no pains to arrange the limbs gracefully, suggestively, or theatrically or even to mute the protruding bone structure of his reclining model.[4] There is no cushion of soft, abundant flesh to mitigate the protrusion of the pelvic bones and ribs, and neither the extended, stiff arms nor raised legs behave in the accepted nineteenth-century manner for

CLOCKWISE

Fig. 210. Eugène Druet, *Torso of "The Martyr"* in 1899-1900, *plaster*, Dépôt des marbres (A125).

Fig. 211. Detail of *The Gates of Hell: The Martyr.*

Fig. 212. Detail of *The Gates of Hell: The Martyr* as the fallen winged figure Fortune.

gisant sculptures. In the recumbent *tableau vivant* sculpture by Rodin's friend Jean-Alexandre Falguière, *Tarcisus, Christian Martyr* (1868; Louvre, Paris) supports himself on his elbows, and his extended legs comply with the horizontal tomblike slab on which they rest.[5] Armand Bloch's *Martyr* (1891; Musée d'Orsay, Paris) clasps her hands in anguished resignation as she lies on her back, well within the perimeters of the base and pedestal.[6] Along with the look of the unarranged, the result of Rodin's audacities creates the strong rhythm of accents and shape of light patterns in his *Martyr*. The figure overflows its support as radically as Tony Caro's abstract, late 1960s *Table Pieces*, parts of which drop or fold over the pedestal edge.[7]

The *Martyr* was a figure Rodin mined for its various parts—torso, arms, and head—which he used in other contexts. No other single figure, nor head from that figure, appears as many times in *The Gates of Hell*.[8] The *Martyr* plays the role of the fallen winged figure Fortune above the left tomb, her outstretched right arm holding a wheel (fig. 212). Behind and slightly below her is the upper portion of a twin sister.

NOTES

LITERATURE: Grappe 1944, 53; Spear 1967, 55–56, 98; Jianou and Goldscheider 1969, 91; Spear 1974, 103–4S, 131S; Tancock 1976, 186–92; Vincent 1981, 25; Lampert 1986, 96, 212; Pingeot 1986, 95–96; Beausire 1989, 178–80; Fath and Schmoll 1991, 143; Barbier 1992, 67–68, 72; Le Normand-Romain 1999, 68–69.

1. I thank Alain Beausire for our discussions of this work. See also his discussion of this work in Pingeot 1986, 95–106. For reasons that follow, I believe Clare Vincent was incorrect in stating that *The Martyr*, extracted from *The Gates*, was originally a standing figure" (1981, 25).
2. For the following anatomical observations I am indebted to Dr. William Fielder of Stanford University School of Medicine.
3. Beausire 1988, 104. Beausire reported, however, that a contemporary news article indicated a figure *Martyre chrétienne* (Christian martyr) was sold out of the exhibition for 20,000 francs (105). Thereafter, as in Rodin's 1900 exhibition, the *Martyre chrétienne* label was used (189). Beausire questioned whether the sculpture may have been subsequently displayed in 1901 and 1902 as *Résurrection* (215, 233). In 1913 it was simply named *La martyre* (348).
4. Pingeot, Le Normand-Romain, and de Margerie 1986, 100–101. Clésinger's bronze is also discussed in Fusco and Janson 1980, cat. no. 58.
5. Fusco and Janson 1980, cat. no. 127. Also see Anne Pingeot's entry on this work in Victor Beyer, ed., *The Second Empire, 1852–1870: Art in France under Napoleon III*, exh. cat. (Philadelphia: Philadelphia Museum of Art, 1978), 227–28.
6. Reproduced in Pingeot, Le Normand-Romain, de Margerie 1986, 52–53.
7. See William R. Rubin, *Anthony Caro*, exh. cat. (New York: Museum of Modern Art, 1975), 143.
8. Spear suggested that the head appears at least ten times in the tympanum and panels of the door (1967, 55). For further discussion of the figure's use both on and detached from the portal, see Barbier 1992, 67–79.

74

Half-Length Torso of a Woman (*Torse de femme à mi-corps*), 1910

- Title variations: *Female Torso, Meditation*
- Bronze, Georges Rudier Foundry, cast 1969, 5/12
- 29 x 18 x 25 in. (73.7 x 45.7 x 63.5 cm)
- Signed on left hip: A. Rodin
- Inscribed on right hip: Georges Rudier/Fondeur.Paris; on side of left

buttock, bottom: © by Musée Rodin 1969
- Provenance: Musée Rodin, Paris; Paul Kantor Gallery, Beverly Hills
- Gift of The Iris and B. Gerald Cantor Foundation, 1974.31
Figure 213

*I*t is a mark of great artists that long after their deaths their work continues not only to gratify but also to challenge. Rodin's *Half-Length Torso of a Woman*, made early in the twentieth century, still calls into question certain assumptions that we bring to figure sculpture: for each figure an entire body; anatomy that complies with gravity; an unmistakable front to the sculpture; a consistent mode of representation; a representation that comports with traditional divisions, i.e., portrait head, bust, half length, full length. In contrast, this infrequently dis-

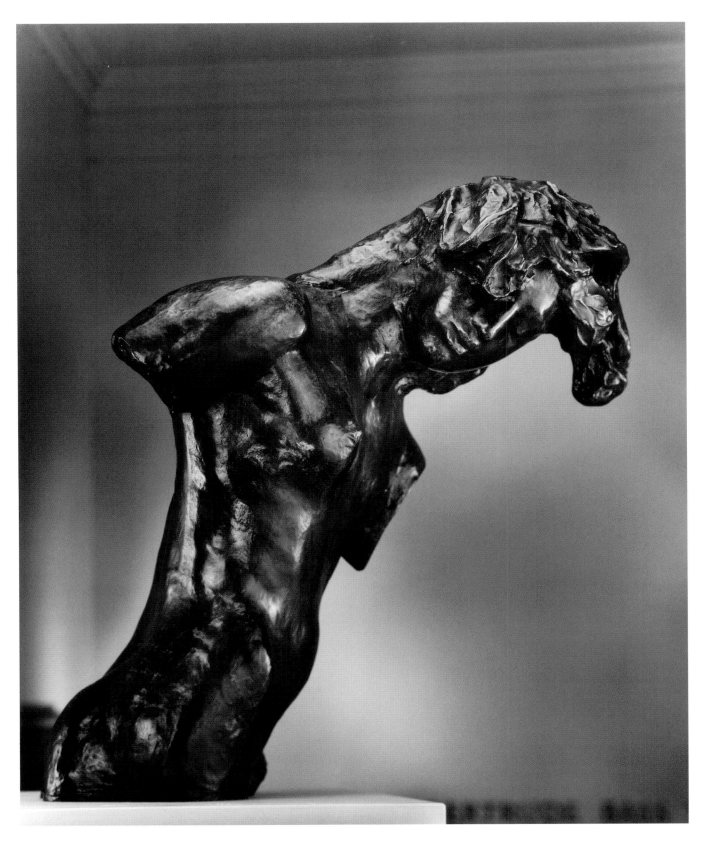

Fig. 213. *Half-Length Torso of a Woman* (cat. no. 74).

cussed but wonderfully disturbing sculpture disappoints all these assumptions.

Rather than undertaking new, large sculptures after 1900, in certain respects Rodin was re-creative, meaning that from his vast inventory of previously made plasters he would select figures or, as in this case, part of a figure and give them new life by various and distinctly personal means. *The Martyr*, from the enlarged version of which *Half-Length Torso of a Woman* derives, had been first modeled with the subject reclining (cat. nos. 72–73). In 1899–1900 *The Martyr* was enlarged to life-size by Henri Lebossé, and Rodin showed a demonstrable interest in a cast made of just her torso. (Lebossé would enlarge a full figure in sections and then mount them together as we see Paul Cruet doing in fig. 13.)[1] Perhaps in 1900 Rodin had the plaster torso photographed upright in the studio by Eugène Druet, against the light, letting the sun limn the contour while highlighting the beauty of the soft-toned shadow resulting from the modeling of the front of the body (see fig. 210).

According to notes in the Lebossé file in the Musée Rodin archives, in 1908–10 he again enlarged *The Martyr* to a life-size torso. Rodin or an assistant following instructions added a complete back, new neck and hair arrangement, and repositioned the head so that it tilted downward and faced right.[2] The half-length figure leans drastically forward and in this third orientation can only be supported by the attachment of the bronze cast to a base or pedestal. (To conservative sculptors, such as those who opposed the *Monument to Honoré de Balzac* [see cat. no. 112] on the same grounds, the figure not being plumb "does not carry.") There is no modeled metal base to counter the off-centered bodily thrust as with *Balzac* and *Spirit of Eternal Repose* (cat. nos. 98–100).[3] The woman's eyes are closed as if she is dreaming. There are crucial changes in the hair from that of *The Martyr*, some now sweeps down in front of her right eye, partly masking her face, and then there is the pendant mass in front of the forehead, which closes off the composition as if it were visualized in a cube.[4] There is no apparent cause for her precariously tilted posture, such as an observed movement in a model. It is purely the artist's invention, the result of Rodin's vision.

As was his custom with works such as *The Falling Man* (cat. no. 64), when Rodin aligned the *Half-Length Torso of a Woman* vertically, he made no adjustment in the anatomy of *The Martyr*'s torso, which had been modeled in a reclining posture. As a result, we do not see in the woman's body a reaction to the earth's pull nor what it feels like to be in such a precarious pose. When he engaged in such transforming manipulations, it was Rodin's habit to ignore finally such physical contradictions if the work looked right as a sculpture. The adverb *finally* is used because, even for Rodin, it seems that when he first saw the enlarged torso of *The Martyr* upright in 1901, he had difficulty with it in that orientation. Lebossé wrote to Rodin, "That which annoys you for *The Martyr* will surely not be present in your statue. Here is why. *The Martyr* exists lying horizontally and the pieces have been made and presented vertically. That is not at all the same thing for the actual statue . . . you therefore do not have the same disagreement."[5] By disagreement Lebossé was probably referring to such things as the position of the breasts, which had been modeled while the woman was supine. Rodin may have caused Druet to photograph the enlarged torso vertically so that he could study its effect, and years later the photograph may have helped the artist decide on its third orientation in *Half-Length Torso of a Woman*.

Lending credence to the possibility of an assistant having modeled the buttocks, back, and reinforced portion of the neck is the decidedly different, less fluid, and less subtle modeling in these areas. There appears far less feeling for muscle and the bones of the spine and shoulders than is usually found in the backs Rodin modeled or that is displayed in the front of this torso, particularly the beautiful curve of the woman's protruding right hipbone, which rhymes with the curves of her abdomen and breasts. (Here again Rodin was responsive to a discovered bodily geometry.) Especially upsetting to the literal minded are the woman's laterally splayed breasts and misalignment of the abdomen, which is now unaccountably twisted to its left—all of which recalls the model's original supine position. If he had not done it himself, Rodin had to have approved also the crude, poulticelike brace that supports the back of the neck and the head made heavier by changes in the hair and now cantilevered out in front of the hips. Such a raw and hardly disguised reinforcement destroys the consistency of the work's modeling.

In his excellent inventory of Rodin's exhibited works Alain Beausire does not record a public exhibition of *Torse de femme à mi-corps*. One Sunday, however, when Paul Gsell visited Rodin's studio before the appearance of his 1911 book of conversations with the artist, he saw,

one of his most striking works. This represents a beautiful young woman whose body is painfully twisting. She seems prey to some mysterious torment. Her head is sharply bent. Her lips and eyelids are closed, and she seems to sleep. But the anguish of her features reveals the dramatic conflict of her spirit.

What completes our surprise, when we look at it, is that she has neither arms nor legs. It seems that the sculptor broke them off in a fit of dissatisfaction with himself.

And you cannot help regretting that such a powerful figure is incomplete. You deplore the cruel amputations to which she has been submitted.

I expressed this feeling, despite myself, to my host.

"Why are you reproaching me?" he said with some surprise. "Believe me, I left my statue in this condition on purpose. It represents meditation. This is why she has no arms for taking action, nor legs for walking. Haven't you noticed that when reflection is carried very far, it suggests such plausible arguments for the most opposite decisions that, in effect, it recommends inertia?'"[6]

Given what we know of the figure's source in a previous sculpture, Rodin's comments tell us more perhaps of how he read the final work than of his intentions. He had set out to do something neither he nor any sculptor before him had ever done rather than to illustrate the resulting contradictions of concentration. Near the end of his productive life as an artist, and drawing on that very history, Rodin demonstrated an audacious capacity to see the human form abstractly and in the round while remaining true to his commitment to follow nature. There is no customary front to this sculpture, for example, no single view that shows us an expected whole aspect of the woman. To see her most identifying attributes, we must take a vantage point to her right which gives us the side and portions of the front and back of the subject. If we stand facing the front of the woman's body, we find her head lowered and face turned to her right so that what we are looking at is the top of the hair. Rodin challenged the viewer's habit of taking a fixed position; to see the face, we must move to her right side, and even then we must bend down and look up under the hair.

Made at about the same time as *Prayer* (cat. no. 80)

and for the same reasons, the amputated arms that so disturbed Gsell allow full vision of the torso and the diagonal thrust of the body, which was sculpturally Rodin's subject. The stump of her right upper arm extends backward, working into the back's curving form and seeming to propel the body's forward thrust.[7] The stump of her left upper arm, which cleaves to her breast, is carved in a concave manner that echoes the concavity of the torso viewed in profile. Seen from the woman's left side, from which the face is averted, the sculpture is most abstract but not as interesting.

Thus what began as the pose of a recumbent but unquiet figure on her back was many years later transformed into an historically new figural gesture in sculpture that disconcertingly ignores gravity and hovers between the upright and prone. It is surprising that nowhere in his recorded conversations or statements does Rodin seem to have used the words *gravitation* (gravity) or *espace* (space), words that are common coin in the literature on Rodin after the mid-twentieth century. We do not need Rodin's words, however, to tell us that *Half-Length Torso of a Woman* is a more drastic challenge to gravity than either the *Monument to Honoré de Balzac* or *Spirit of Eternal Repose*. This partial figure was more appreciated by artists after the appearance of abstract sculpture only a few years later.[8] We do not encounter again in sculpture such a diagonal movement until Vladimir Tatlin's model for a *Monument to the Third International* (1919–20, Russian State Museums, St. Petersburg), Antoine Pevsner's *Developable Column* (1942, Museum of Modern Art, New York), and certain of the 1980s figurelike pieces of Joel Shapiro.[9]

NOTES

LITERATURE: Grappe 1944, 134; Grappe 1947, 144; Jianou and Goldscheider 1969, 113; Tancock 1976, 188, 192; de Caso and Sanders 1977, 341; Elsen 1981, 255, 258; Pingeot 1986, 106; Barbier 1992, 76

1. Albert Elsen, "Rodin's 'Perfect Collaborator,' Henri Lebossé," in Elsen 1981, 258–59.
2. No small version of this sculpture seems to exist at Meudon. Lebossé's notes (Lebossé file, Musée Rodin archives) show that he was having great difficulty enlarging the torso, despite having done so eight years earlier, suggesting that now it had been supplied with a back and buttocks. On 31 May 1909 he wrote that he regretted not having given complete satisfaction with *The Martyr*'s torso, "but for several days I believe I have understood the motif

which will not slow completion and I will redo it almost entirely."

3. There is no clear indication of how Rodin wanted this work mounted. Since his death, if not before, foundries supplied a wooden base for support of the bronze cast of this work and for *The Martyr*. Grappe showed *The Martyr* on an improvised wooden pedestal (1944, 52) and *Half-Length Torso of a Woman* on a thin wooden plinth (133).

4. The modeling of the hair makes it seem as if Rodin had first draped a cloth or towel atop the head and worked from that.

5. Lebossé to Rodin, 4 September 1901, in Lebossé file, Musée Rodin archives.

6. Gsell [1911] 1984, 68.

7. Despite the fact that the woman's left shoulder is in advance of the right, from her right side we see the por-tion of the back to the left of the spine, which Rodin must have wanted for what it gave the silhouette.

8. Unfortunately this sculpture is not included in William Tucker's interesting if not always convincing discussion of gravity in Rodin's art and his comparison of Rodin's use of a diagonal in the *Balzac* with Brancusi's *Endless Column* (1974, 145–50).

9. Hermann Obrist made a little-known, small clay *Sketch for a Monument* (c. 1902), which shows an abstract diagonal spiral structure that appears to have a winged form at the top, perhaps his answer to published photographs of Rodin's *Tower of Labor*, a spiral structure similarly crowned by the winged *Benedictions* (see figs. 112–13). See Werner Hofman, *Turning Points in Twentieth-Century Art: 1890–1917* (New York: Braziller, 1969), 115.

75

Youth (Jeunesse), c. 1879

- Title variations: *Niobid, Study for Adam, Study for a Bather*
- Bronze, Godard Foundry, 1/12
- 10¼ x 3 x 4 in. (26 x 7.6 x 10.2 cm)
- Signed right of support: A. Rodin
- Inscribed on base, right side: E. Godard/Fondr Paris; on back of base: © by A Rodin; below signature: No: 1
- Provenance: Hal T. Skolnick, London
- Gift of the Iris and B. Gerald Cantor Foundation, 1992.60

Figure 214

*I*n *The Gates of Hell* this figure is found at the top, attached to the outer right corner of the first corbel on the right (fig. 215). Despite its relatively small size, the vigor and clarity of its design make it visible from the ground. This addition must have taken place between 1899 and 1900. Separated from the doors, the figure's abstract, curving base, which rises up to the figure's left buttock, shows that at least this version had been made as part of a decoration.[1] Its origins, however, are more intriguing. *Youth* is a close paraphrase of Pierre Puget's *Faun*, which Rodin first saw in the Musée des beaux-arts in Marseille in 1879. In a letter to Rose Beuret he said, "I saw a satyr [sic] Puget almost in the pose of my big *bonhomme*."[2] At that time Rodin would have been referring to his *Adam* (cat. no. 40). The small figure of *Youth* is certainly not a *grand bonhomme*, but it could be Rodin's own later, leaner, and more youthful figural reworking of the Puget *Faun*, including the suggestion of drapery held in the figure's right hand.

Rodin's small figure might have been done from memory in 1879, while he was working in Nice, as a kind of étude made in admiring emulation of a great seventeenth-century sculptor. Rodin's tact would have been to change bodily proportions to elongate the figure, reverse the positions of the arms and legs, and lower the head. At this time Rodin was seeking all he could get from bodily contortion. The figure's style is certainly not like that of Rodin in 1899, the date given by Georges Grappe. The pose seems contrived and unlike those the artist was to find in the natural movements of the models he could afford after 1880. Suggestions that this figure might have

Fig. 215. Detail of *The Gates of Hell: Youth*.

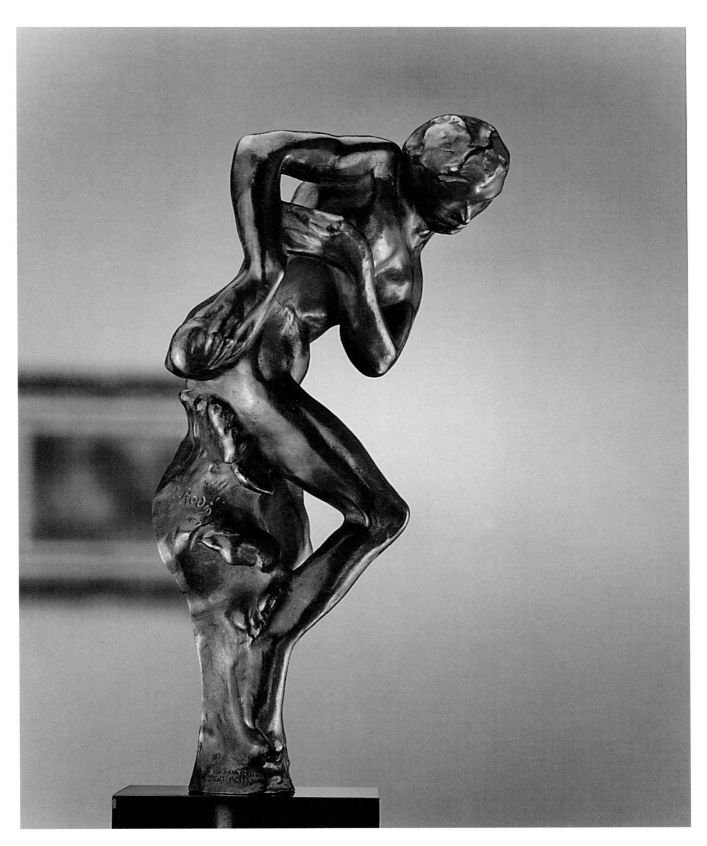

Fig. 214. *Youth*
(cat. no. 75).

been a study for *Adam* are contradicted by the known preliminary studies in sculpture and drawing for the older and more muscular figure, whose feet are solidly planted, gripping the ground.[3] *Youth*, nevertheless, does have a certain elegance and sureness of touch, and it is a handsome study.

NOTES

LITERATURE: Grappe 1944, 104; Tancock 1976, 125, 128; Fath and Schmoll 1991, 142

1. Giving a date of 1899, Grappe described this figure as a study for a bather as part of a four-figure terra-cotta decoration for a bathroom (1944, 104).
2. Rodin to Beuret, 10 August 1879, reprinted in *Rodin 1860–99*, 50; a photograph of Puget's work is reproduced ibid., 48. Puget's statue represents a faun (see p. 187, no. 3.)
3. Regarding the figure in relation to *Adam*, see Tancock 1976, 125, 128 n. 9. Also see Fath and Schmoll 1991, 142. The figure was used as the model for the marble sculpture *Niobid* (c. 1900, Toledo Museum of Art), as noted and reproduced in Tancock 1976, 127, fig. 4.3.

Suppliant Old Man
(*Vieillard suppliant*), before 1886

- Bronze, Godard Foundry, 5/12
- 13 x 2¾ x 6¼ in. (33 x 7 x 15.9 cm)
- Signed on left thigh: A. Rodin
- Inscribed on back of right thigh: E. Godard/Fondr © by Musée Rodin 1977; below signature: No. 5
- Provenance: Musée Rodin, Paris
- Gift of the B. Gerald Cantor Collection, 1992.153

Figure 216

*I*n the portal this figure appears from the waist up in the upper-left door panel to the left of *Despair* (see fig. 206) and twice in the upper-left corner of the right door panel (fig. 217), first, upside down behind the inverted figure with outstretched arms whose left wrist touches the door frame and, second, just to the right of that, upright and twisting toward the right. These areas were extensively reworked between 1898 and 1900, at which time the top half of this figure was probably enrolled in *The Gates*.

Fig. 217. Detail of *The Gates of Hell: Suppliant Old Man*.

Rodin could have observed this posture while the seated model clasped his hands together and stretched his arms in front of him with the right wrist rolled over the left. The movements of the figures in *The Gates* often pulse between maximum extension, as with this figure, and contraction, as with women such as *Despair* (cat. nos. 69–71), who turn in on themselves. Georges Grappe noted that a similar gesture was used again on the female figure *Invocation* of 1886.[1]

Unlike the figures of Edgar Degas, which are always gravity specific and provided with bases that forever fix their orientation, Rodin accepted no such limitation with his études for *The Gates*. Separated from the doors,

this étude was named the *Suppliant Old Man* (probably not by Rodin but rather by one of the Musée Rodin curators). It has had two orientations, sitting and kneeling, as shown by the flat plane by his left knee.[2] Rodin must have had plasters of this figure, and hundreds of others, unmounted so that he could pick them up and try them at any angle in *The Gates.*

Rodin's gift included his touch, by which even in the smallest figure he could create a fluidity of surface without loss of bodily firmness generated by the internal anatomy. He knew which details to suppress. Thus those broad but nuanced body surfaces in figures like the *Suppliant Old Man, Glaucus* (cat. no. 77), and the son in the Ugolino group reaching for his father's back (see fig. 156) carried visually a long way in *The Gates* and kept the light moving.

NOTES

LITERATURE: Grappe 1944, 57; Jianou and Goldscheider 1969, 91; Fath and Schmoll 1991, 149–50

1. Grappe 1944, 58.
2. A plaster version in a seated pose was catalogued by Grappe (1944) as cat. no. 158 and dated before 1886.

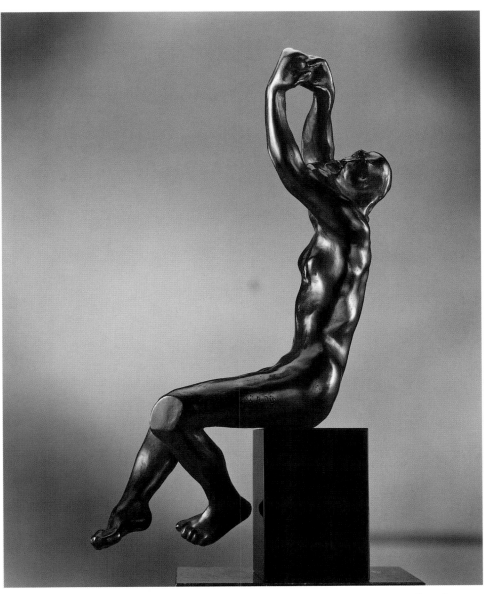

Fig. 216.
Suppliant Old Man (cat. no. 76).

77

Glaucus (Glaucus), 1886–87

- Bronze, Godard Foundry, cast 1979, 4/12
- 8 x 6¾ x 5½ in. (20.3 x 17.1 x 14 cm)
- Signed on front of base, left side: A. Rodin
- Inscribed on back of base: E. Godard/Fondr; on base, right side: © By Musée Rodin 1979; below signature: No. 4
- Provenance: Musée Rodin, Paris

- Gift of the B. Gerald Cantor Collection, 1983.203

Figure 218

*T*he seated, bearded man with his hands on his knees appears twice in *The Gates.* He can be seen both times from the back, once at the top on the edge of the second corbel from the left, just below the left figure of *The Three Shades* (fig. 219), and again in the lower section of the right door panel, directly above the tomb and the kneeling figure above a cave (fig. 220).[1] This is undoubtedly another of those poses struck spontaneously by a nonprofessional model in Rodin's studio, which the artist modeled and then tried in different areas of the doors. By showing only the dorsal view, Rodin added to the

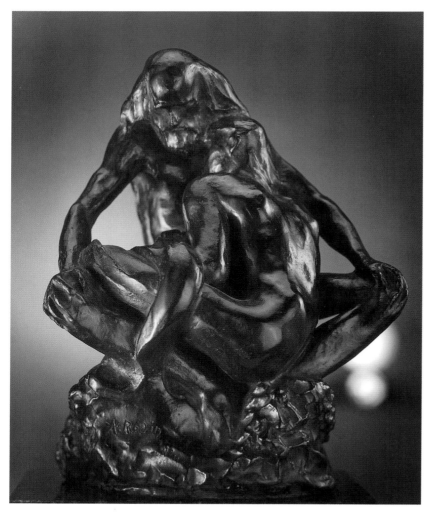

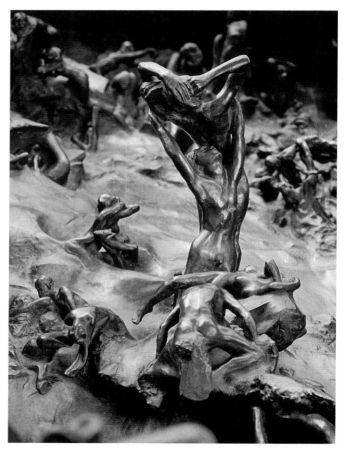

CLOCKWISE

CLOCKWISE

Fig. 218. *Glaucus* (cat. no. 77).

Fig. 219. Detail of *The Gates of Hell: Seated Old Man*.

Fig. 220. Detail of *The Gates of Hell: Seated Old Man*.

unselfconscious character of his infernal crowds and their obliviousness to us. Hiding the face further discouraged viewers from trying to guess the figure's identity in Dante. It also allowed Rodin to show figural movement in the round by adding these backs to the many three-quarter frontal views.

Truman Bartlett saw the seated man in the doors and wrote, "The grave old being that sits with his legs well apart and rests his hands on his knees represents a man turning into a tree. On the door his back is towards the observer, and while going through his peacefully transforming process, he contentedly views the agitated panorama that stretches out in endless vista before him."[2]

The studio plasters of this man with knees outspread must have provided Rodin with an inviting cavity to fill. At some point into one of these plasters he added between the man's legs the figure of a cuddling woman whose body ends in coils like that of a siren. Rodin inserted them, in a close variant, on the right side of the

left door panel of *The Gates* by 1887 (see figs. 123 and 196 lower right). Her relationship to the bearded man, who became a kind of protector, may have suggested the title *La confidence* (The secret) given to the close variant in which the woman leans against the man and lifts her hands to his face, as if to impart a secret.[3] This couple is a wonderful example of Rodin at play, marrying disparate forms capable of provoking mythological allusions, as in this case to an Ovidian sea god who loved a nymph.[4]

In what was for him an unusual concession to a collector, Rodin sold the plaster of *Glaucus* and its exclusive casting rights to his friend Antony Roux.[5] This small sculpture had no extensive exhibition history in Rodin's lifetime.[6]

NOTES

LITERATURE: Bartlett 1889 in Elsen 1965a, 77; Grappe 1944, 105; Jianou and Goldscheider 1969, 100; Tancock 1976, 32–33; Ambrosini and Facos 1987, 82–84; Fath and Schmoll 1991, 148; Barbier 1992, 129–31

1. Grappe (1944) dated the plaster (cat. no. 99) to 1883. Known as *Glaucus* in this composition, the figure is referred to as *Seated Old Man* when he appears alone on *The Gates of Hell.*

2. Bartlett in Elsen 1965a, 77. The facial expression is hardly contented, and he is self-absorbed rather than gazing.

3. Grappe (1944) catalogued but did not illustrate the variant (cat. no. 309) and in the entry interchanged it with *Glaucus.*

4. Ambrosini (in Ambrosini and Facos 1987, 82–84) was aware of such ex post facto titles, noting that Rodin did not attempt to illustrate the myth precisely, but she still made much of the Ovidian name. She was on much firmer ground in observing that the woman who seems to terminate in a coiled tail has a counterpart in the siren-like figure in the lower right door panel of *The Gates* next to the man on his knees.

5. For a discussion of the Roux contract's exclusivity in the context of other *Glaucus* plasters, see ibid., 82.

6. No exhibitions are recorded by Beausire (1988) for either *Glaucus* or *La confidence.*

78

Torso of Polyphemus (Torse de Polyphème), c. 1888

- Title variations: *Milo of Crotona, Narcissus, Shade Looking at the Abyss*
- Bronze, Godard Foundry, 3/12
- 17 1/16 x 6 3/4 x 5 3/4 in. (43.3 x 17.1 x 14.6 cm)
- Signed on front of base, right of center: A. Rodin
- Inscribed on back of base: E. Godard/Fondeur.Paris; below signature: No. 3
- Provenance: Musée Rodin, Paris
- Gift of the Iris and B. Gerald Cantor Foundation, 1974.33

Figure 221

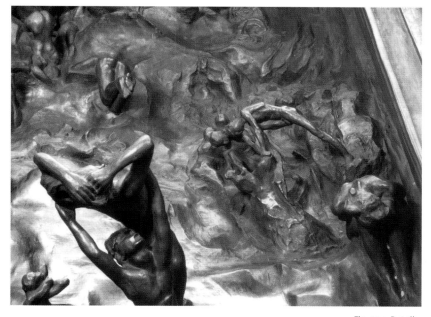

Fig. 221. Detail of *The Gates of Hell: Polyphemus.*

*T*his is an enlargement of the head and torso, including parts of the right and left thighs, of the small full figure known as *Polyphemus,* which is midway up the right door of *The Gates of Hell* (fig. 222).[1] The origin of the pose of an upright male, his right leg pulled up so that the thigh is against the torso, may have been a model stretching in the studio with one foot raised on a stool. Rodin juxtaposed the original small full figure, with his foot poised on a rock (fig. 223), looking downward, with a couple embracing, and titled the group *Polyphemus, Acis, and Galatea* after the Ovidian story of the jealous giant who destroyed Galatea and the shepherd Acis when he found them making love.[2] Rodin's name for the work may have been inspired by seeing the nineteenth-century Medici fountain sculpture by Auguste Ottin in the Luxembourg Gardens.[3]

Unless it is in the Meudon reserve of Rodin plasters, there does not seem to have been an enlargement of the full figure.[4] The truncated figure suggests that Rodin was only interested in the portion in which the body is compacted by the joining of the right thigh and torso. The

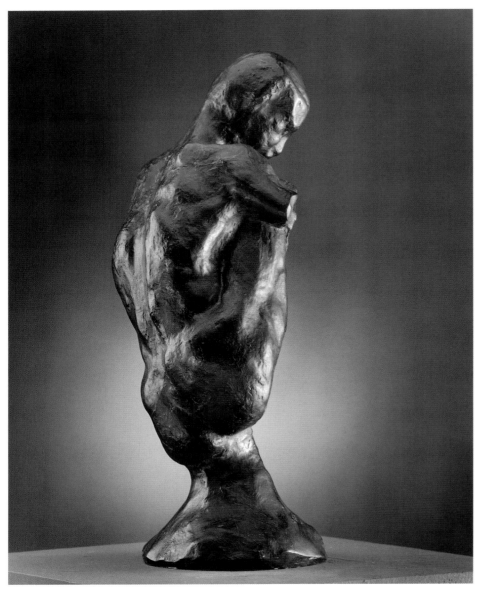

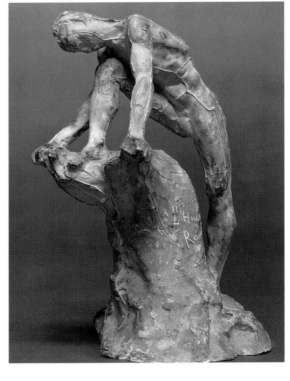

to have exhibited. Rodin improvised a conical base that leads to the stump of the left thigh so that the fragment would be self-supporting and he could get the form up into the air.

In this étude we see Rodin's fascination with the strangeness of the body caused by its pose, so unusual for sculpture, in which he is able to impart sculptural movement in a motionless figure. By retaining just the torso—and despite the evocative name—Rodin was subtracting meaning as well as limbs, confirming his capacity to look at the human form abstractly.

Above: Fig. 222. *Torso of Polyphemus* (cat. no. 78).

Right: Fig. 223. *Polyphemus*, 1888, plaster, 9¾ x 5¾ in. (24.7 x 14.6 cm). Rodin Museum, Philadelphia Museum of Art, gift of Jules E. Mastbaum.

bent head and angle at which the arms have been cut off accentuate the form's closure and sense of the man's self-absorption. No attempt was made to bring the simplified treatment of the man's head to further definition, but Rodin found it useful in completing the form, and by its contrasting tilt he animated the entire figure. There is no diverting us from the total form as would have been the case had Rodin shown a more detailed facial expression; for example, one focuses on the back view, which has the greatest continuity along the big curvature of the spine, and on the homogeneity of the form from the buttocks to the top of the head. The strenuous pose has stretched the body vertically and caused the ribcage to project outward under the left armpit. There is nothing ingratiating about the work, which the artist seems never

NOTES

LITERATURE: Grappe 1944, 71; Jianou and Goldscheider 1969, 92; Tancock 1976, 212–14; Gassier 1984, 86; Fath and Schmoll 1991, 149; Barbier 1992, 144

1. For variations on this figure, excluding this enlarged partial version, see Grappe 1944, cat. nos. 200–203, 367.
2. Ovid, *Metamorphoses* bk. 13, lines 86ff. On Rodin's group, see Tancock 1976, 212; de Caso and Sanders 1977, 169; Le Normand-Romain 1999, 57; Le Normand-Romain 2001, 102.
3. Grappe 1944, 71. For Ottin's group see Pierre Kjellberg, *Le guide des statues de Paris* (Paris: La bibliothèque des arts, 1973), 68–69.
4. Laurent noted that "the Musée Rodin has several plasters of the full figure, annotated in pencil by Rodin, with the titles *Milo of Crotona* and *Narcissus*" (Gassier 1984, 86).

79

The Sphinx (La sphinge), before 1886

- Plaster
- 8¼ x 6¼ x 6 in. (21 x 15.9 x 15.2 cm)
- Provenance: Marie Cartier, France
- Gift of the B. Gerald Cantor Collection, 1992.157

Figure 224

*I*t was Georges Grappe who first identified this figure and its location in *The Gates of Hell*, high up in the left door panel, just beneath *The Falling Man* (see fig. 196). Grappe also pointed out that it was mentioned by Truman Bartlett in 1887 and was later enlarged, carved in marble, and exhibited in Chicago in 1897.[1] Another plaster of this figure was shown in 1889 in the Monet-Rodin exhibition at the Galerie Georges Petit.[2] One problem in establishing the exhibition history of this piece is that in 1889 Rodin also called *The Succubus* (cat. nos. 161–163) by the name "The Sphinx." At times they were shown together, as in 1889 and in 1900 during the sculptor's retrospective.[3]

The work was obviously named, rather than given a literary title, as Rodin found the kneeling pose in one of his models, one of hundreds of such discoveries that encouraged his rapture over what nature revealed to him. By placing the woman's arms at her sides and having the lower legs tucked beneath her, Rodin was able to make one continuous form out of many parts. By raising the woman's head and turning it to one side, the sculptor gained lyrical profile views of the whole body when seen from her right. The woman's forward-leaning, compacted form gave him the opportunity to emphasize the hourglass shape of the back and buttocks. Symptomatic of Rodin's sexuality as well as his formal concerns in many areas of

The Gates, especially in the left door panel, all that one sees of a woman, or group of them, is the dorsal view, often from only the waist down.

The Stanford plaster is unusual among those outside the Musée Rodin, not because it is a dipped cast but because of the built-up base, which was rudely modeled in plaster, not clay, over what may have been a wooden block, the bottom of which still retains the actual French newspaper on which it sat. One can still see the ends of a brown fibrous material protruding midway up the back of the base, which Rodin may have employed to cause

Fig. 224. *The Sphinx* (cat. no. 79).

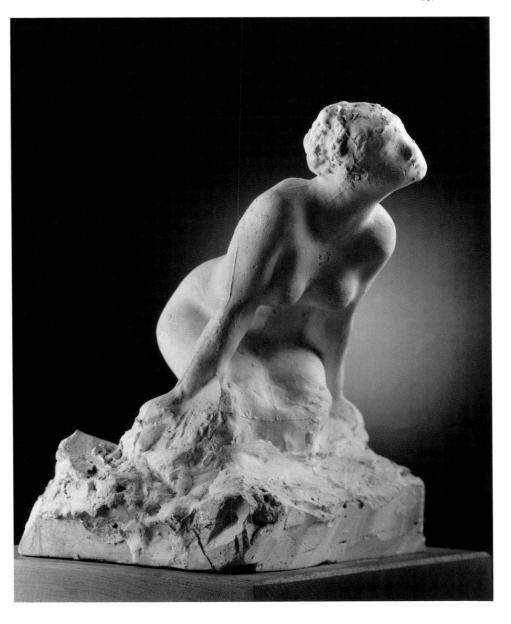

the layers of plaster to better adhere. That the figure was immersed in wet plaster is evidenced by the muted surfaces pockmarked by air holes and fine cracks (see the woman's left hand). The fresh plaster layer added to the overall fluidity of the form, as where the arms meet the body.

NOTES

LITERATURE: Grappe 1944, 56–57; Jianou and Goldscheider 1969, 91; Beausire 1989, 201; Fath and Schmoll 1991, 147; Barbier 1992, 119–20; Butler and Lindsay 2000, 338–42

1. Grappe 1944, 56–57; Beausire recorded that this work was possibly shown in an exhibition of foreign works in American collections at the World's Columbian Exposition in Chicago in 1893, (1988, 117).
2. Beausire (1989, 101, 201) shows a plaster variant in which the woman's head seems to have been turned to her right and more upward than in the Stanford plaster, and there is no addition to the original base, so that the woman's knees are visible. In the bronze version the base is smaller and rounded in comparison with that of the Stanford plaster.
3. Beausire 1988, 104, 194. Other exhibitions of *The Sphinx*, including in bronze and marble, ibid., 117, 123, 135, 253, 266, 327, 367. She was displayed on a tall pillar in Rodin's 1900 retrospective (Le Normand-Romain 2001, 250–51).

Prayer (La prière), 1883–84(?), enlarged 1909

- Title variations: *Damned Woman, Figure on Her Knees*
- Bronze, Godard Foundry, cast 1979, 6/12
- 49½ x 21⅝ x 19⅝ in. (125.7 x 54.9 x 49.8 cm)
- Signed on base, in front of right knee: A. Rodin
- Inscribed on base, right side, lower edge: E. Godard/Fondr; on back of base, lower left: © by Musée Rodin 1979; on back of base, lower left: No. 6
- Provenance: Musée Rodin, Paris
- Gift of the B. Gerald Cantor Collection, 1983.199

Figure 225

*I*t is certain that *Prayer* comes from the torso of the reclining woman who, with her hands close at her sides, touching her legs, is found in the upper-right corner of the tympanum (fig. 226).[1] She may have been a late addition, made when Rodin was working to complete *The Gates* before his 1900 retrospective. The Meudon reserve contains an old small plaster cast of this torso, with head which was probably the one shown in the retrospective and in Prague (fig. 227).[2] It also exists in a partial version of the same size but headless and with arms cropped, which became the basis, with slight modification, for the enlarged figure known as *Prayer* (fig. 228).[3] Rodin's original name for the small version, *Figure*

on Her Knees, indicates that it was inspired by the sight of one of his models kneeling, perhaps at rest. The name of the enlargement, *Prayer*, may have appealed to Rodin for the kneeling aspect of the pose, but perhaps even more for his association of the woman's sensuous, naked form with reverence.

Prayer, along with *Torso of a Young Woman* (cat. no. 177), was probably enlarged by Henri Lebossé in 1908–9. Commenting on two small torsos given to him by Rodin, Lebossé thought their enlargement would be easy: "There is a superior modeling with the beautiful planes and it will be a veritable *tour de force* if I can give you satisfaction with this difference in size."[4] The life-size *Prayer* was first exhibited in plaster in 1910 (fig. 567) in conjunction with *Torse de jeune femme cambré* (Torso of a young woman with arched back).[5]

Its fragmented character earns *Prayer* the designation *sculpture* rather than *statue*. The latter implies a finished full figure intact by salon standards. It is unusual among Rodin's figures for being the most static and symmetrical. Perhaps no other sculpture by Rodin comes as close to ancient Greek classical torsos as *Prayer*. The extent to which in the enlargement Rodin's *Prayer* was actually inspired by ancient sculptures is suggested by Camille Mauclair's account: "He made essays while very closely examining the antiques [presumably in Rodin's own collection]. He took the fragments of his statues [presumably his own and perhaps the small version of *Prayer*] and began to reinforce them in certain areas by layers of plaster, thickening the modeling and enlarging the planes. He then noticed that the light played better on these enlarged planes; on the amplified surfaces the light refraction was softer, the dryness of the cutout sil-

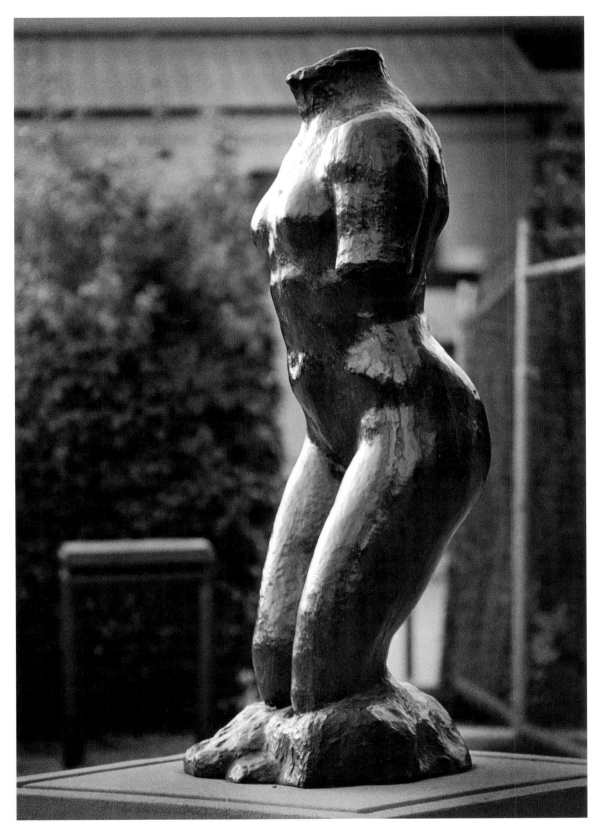

Fig. 225. *Prayer*
(cat. no. 80).

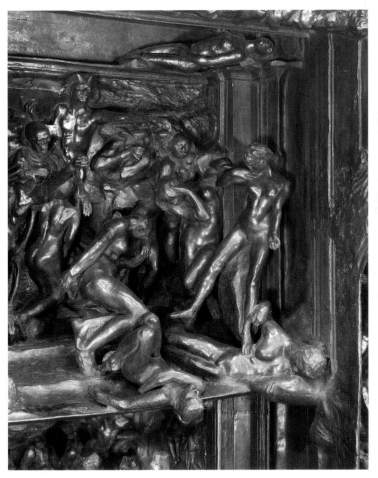

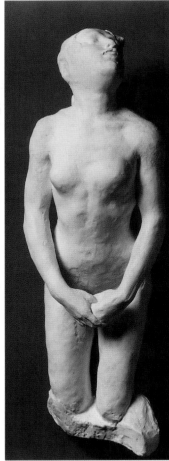

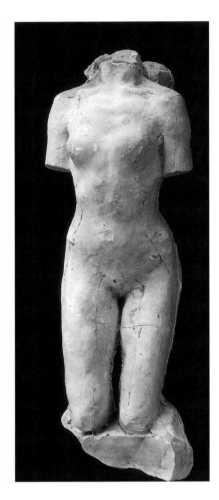

houettes was abolished and there formed about his figures a radiant zone that united them gradually with the atmosphere."[6]

In or shortly before 1906 Rodin spoke to his secretary (soon to be his biographer) Frederick Lawton about how his ideas on movement had changed: "I used to think that movement was the chief thing in sculpture, and in all I did it was what I tried to attain. My 'Hell Gate' is the record of these strivings. . . . I have come gradually to feel that sculptural expression is the essence of the statuary art—expression through the modeling. This is what made the grandeur of the Greeks. There is repose, wonderful repose . . . in their sculpture; not the repose of the academic style, which is the absence of nature, the absence of life, but the repose of strength, the repose of conscious power, the impression resulting from the flesh being under the control of the spirit."[7]

Rodin could have been speaking to Lawton about *Prayer* in terms of "expression through the modeling." If one can attribute a theme to this work, it might be described as an upright woman in repose, just being. Seen under the sun in the B. Gerald Cantor Rodin Sculp-

ture Garden, it is apparent that the movement throughout the form is caused by the action of the light on the sculpture's calculatedly inconstant surface. What animates this figure, giving it a pulse, is Rodin's relentless war not just on flatness but also on unrelieved smoothness. Unlike the insistently unrelieved surfaces of figures by Aristide Maillol, Gaston Lachaise, or Constantin Brancusi, which impart the sense of the figure holding its breath, Rodin's exposed touch makes the form seem to vibrate. The slight irregularities of the overall surface win for Rodin his envelope of light and air around the figure. His touch defies prediction by its variability from work to work.[8] He was always on guard against developing habits of the hand, tantamount to refusing to impose a style on his figures. Rodin's style was to seem to have no style, and it is with these partial figures, stripped of thematic drama, that one can focus on his surfaces.

The frontal view of *Prayer* explains the basis for Rodin's removal of the arms, for example. This editing was an important way by which he worked against the bodily symmetry occasioned by the pose in which the weight is carried equally on both knees. Their amputa-

tion was not arbitrary. He deliberately did not cut off the arms at the same distance from the shoulder. Because of his ability to view the human form in his sculpture abstractly, he considered at what point segmentation worked best with the contours of the torso and the overall lines of the form. The stumps, just sufficiently roughened to avoid the sense of accidental breakage or the cutting action of a saw as in ancient fragments, were made to merge with the contours of the torso, which is now more fully and better seen from the sides in the absence of the lower arms. The contours that begin at the knees now flow directly into the upper arms. The profiles of the truncated neck, seen from the front, are inversions of the shapes made by the juncture of upper arms and torso. When seen from the side, the neck extends the line of the shoulder blades upward and effects the transition to the profile of the figure's front while serving also to compact the form. Several plasters at Meudon testify to Rodin's interest in exploring the kind of contours achieved through fragmenting a torso and through composing with these fragmented figures. These include a plaster of the small *Prayer* with its right leg entirely removed to the pelvis and the stump of the arm on that side further shortened (fig. 229) and an assemblage combining the small partial figure *Prayer* with another fragmented kneeling figure (fig. 230).[9]

Some contemporary critics did not take kindly to Rodin's partial figures and their amputations. One commented in his review of the 1910 Salon and the showing of *Prayer* and *Torso of a Young Woman*, "He would not be content to examine with his pious hands the planes of an ancient Torso. He wants to give many feminine pendants to it. . . . [We] regret that such a vanquisher of material confines himself to his études, that such a modeler of flesh has put so much perseverance into a sketch. Virginal or powerful, each of these two feminine torsos is a palpitating fragment of a goddess . . . they have the morbidity of the young Delacroix depicting a captive in the *Massacre of Chios.*"[10]

Rodin told Lawton, "Art is not imitation, and only fools believe that we can create anything. What remains for us is interpretation according to nature."[11] One begins to understand what the sculptor had in mind by interpretation when *Prayer* is viewed in its right and left profiles. The side views show not only the forward projection of the knees but how Rodin compensated for their thrust by the splendidly full roundness of the buttocks, which extend beyond the vertical line of the upper back.

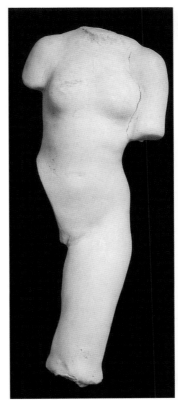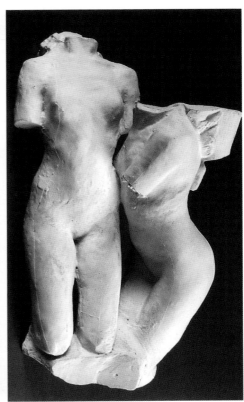

Credit the model with a fine form but recognize also that Rodin loved to exaggerate what he found in his source. *Prayer* is a brilliant example of Rodin's working from a found and gentle geometry in his model in ways that accentuated the firm fullness of her body but which also made for a more exhilarating sculpture.

Prayer looks to our eyes, conditioned by almost a century of modern sculpture, quite different than to the sympathetic critic Henri Bidou. In 1910 he gave it a close and poetic reading according to the ethos of a time which saw a sculpture as a living being: "The light strikes the shoulders and lightly draws the upper ribs. Below the breasts, the body withdraws into shadow. The muscles, which bend it downward, grouped in the half-shadow, vary in delicate layers and in inflections. The stomach is slender and the hips high. But, while all these parts yield graciously to gravity, the young bosom, ripe and pure, ignores the tired appeal of the earth."[12]

In a modern sense, *Prayer* is one of Rodin's most beautiful sculptures. To the classical Greeks, for whom beauty depended on the harmonious relation of parts to each other and the whole, Rodin's work might have seemed ugly because the whole body was missing. Rodin taught himself to think about proportions in harmonious relation to each other and a truncated bodily whole. Never did he invite the viewer to try to imagine the absent head

and limbs. He had learned from the ruins of ancient art something unthinkable to the Greeks: that beauty could be found in a fragment. And this lesson has been passed on to modern sculptors to the present day.

It was with sculptures such as *Prayer* that Maillol's art came closest to that of Rodin, but it was the latter who gave the younger artist the example and courage to consider the well-made torso alone as a complete work of art. With the work of Gaston Lachaise, Henry Moore, and Jean Arp in the 1930s, there was seen again in modern sculpture comparable joy in the sensuousness of forms generated by a woman's belly, bust, buttocks, and back.

NOTES

LITERATURE: Grappe 1944, 128; Jianou and Goldscheider 1969, 112; Elsen 1981, 142; Schmoll 1983, 75, 134; Miller and Marotta 1986, 139; Pingeot 1990, 142; Barbier 1992, 105, 109

1. Grappe dated *Prayer* from 1909, and he believed that the original small version of *Prayer* derived from *The Gates* but was not included in it (1944, 128).

2. Beausire 1988, 195, 236.
3. Barbier referred to these two small figures as *Damned Woman* and *Damned Woman, Arms Cropped (without Head)*, reserving the title *Prayer* for the enlargement (1992 105–9).
4. Elsen, "Rodin's 'Perfect Collaborator,' Henri Lebossé," in Elsen 1981, 253.
5. Beausire 1988, 316; photographs of both works are reproduced.
6. Mauclair 1918, 54.
7. Lawton 1906, 160–61.
8. Lebossé, a professional *reducteur* engaged in reducing and enlarging sculptures enlarged most of Rodin's works and also reduced some during the last twenty years of the sculptor's life. He prided himself that he could reproduce Rodin's touch. See Lebossé file, Musée Rodin archives.
9. These plasters are discussed by Antoinette Le Normand-Romain and Nicole Barbier in Pingeot 1990 (142, 251) and in Barbier 1992, 105, 110–11.
10. Raymond Bouyer, "Les salons de 1910: La sculpture." *La revue de l'art*, no. 159 (June 1910): 428.
11. Lawton 1906, 160.
12. The original excerpt is cited in Beausire 1988, 316–17.

Skull (Crâne), c. 1899

- Plaster
- 3 x 2¼ x 3¼ in. (7.6 x 5.7 x 8.3 cm)
- Given in honor of Mr. and Mrs. B. Gerald Cantor by Albert E. and Patricia Elsen, 1983.316

Figure 231

*T*his skull comes from *The Gates of Hell*. The full skeleton is seen in the right half of the tympanum, to the left of the horned figure (fig. 232). Skulls are also found interspersed in the line of heads over *The Thinker* on the cornice of the tympanum. The meaning of *The Gates of Hell* has been interpreted as analogous to a modern memento mori, and the juxtaposition in the tympanum of the skeleton and a frenetic crowd of living figures evokes the medieval theme of a dance of death, as first observed by the English writer Arthur Symons in 1892.[1]

The skeleton's gesture, like the horned figure's gesture beckons the viewer to participate in the dance.

The plaster cast of a skull was part of Rodin's 1916 donation to France and is currently at Meudon. The Meudon cast extends below the jaw. Other casts, including the one at Stanford, were subsequently made.[2]

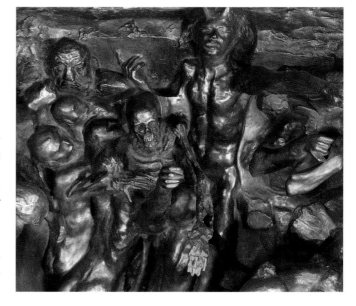

Fig. 232. Detail of *The Gates of Hell: Skull.*

Fig. 231. *Skull*
(cat. no. 81).

NOTES

LITERATURE: Elsen 1960, 137; Fath and Schmoll 1991, 144

1. Regarding the tympanum's modern dance of death iconography, see Elsen 1960, 137, 1985a, 212; for the full quotation by Symons, see Elsen 1985b, 62. For another expression by Rodin of this theme in his print *The Round*

(A2), see the discussion in Elsen 1965b, 290–99, and Thorson 1975, 32–37.

2. Fath and Schmoll 1991, 144. The *Skull* is included in the catalogue Siero Mayekawa, Nicole Barluer, and Claudie Judrin *Rodin et la Porte de l'Enfer*. Exh. cat. (Tokyo: National Museum Western Art, 1989), cat. no. 34.

82

Decorative Pilaster from "The Gates of Hell" (Pilastre décoratif de la porte de l'enfer, fragment), c. 1882–83 (original version), reduced 1902

- Bronze, Alexis Rudier Foundry, cast 1978, 3/12
- 10¾ x 2¼ x 1¼ in. (27.5 x 5.8 x 3.2 cm)
- Signed on obverse, upper-left corner: A. Rodin
- Inscribed on upper right: Alexis Rudier/Fondeur Paris; cachet on reverse: A. Rodin
- Provenance: Musée Rodin, Paris
- Gift of the B. Gerald Cantor Collection, 1992.41

Figure 233

Despite its appearance of incompleteness, this small relief was not a study for the right external bas-relief of *The Gates of Hell* (fig. 234). It is a reduced version of the completed relief as it was when Rodin had his assistants remove those portions just before the plaster portal was to be moved from the studio to his 1900 retrospective. Other small decorative reliefs were also made that were reductions of the full-scale pilasters on the stripped version of *The Gates*; another is included in the Stanford collection (cat. no. 83).[1] This reduction was made by the highly skilled Henri Lebossé, who was also a sculptor. Although figures have not yet been compiled, it appears that Rodin gave away as many sculptures as he sold, if not more. In all probability Rodin wanted this small relief as a commemorative gift for friends or those who supported his art, particularly *The Gates*. That this small relief was made shortly after the portal's only exhibition (1900–01) substantiates this hypothesis. In the accounts kept in his Musée Rodin file, Lebossé lists in 1902 a fin-

ished reduction of one of the flanking bas-reliefs of *The Gates of Hell*.[2] The very fine Stanford cast was made by the Alexis Rudier Foundry, which began its extensive casting of Rodin's work in 1902, at the time Rodin would have wanted it in bronze as a souvenir for friends and other admirers.

In Rodin's time it was customary for artists to have reductions made of popular works, and the sale of these domestic versions were an important source of income. In this instance, income was not an incentive since by 1902 Rodin was swamped with commissions and by the demands for casts of existing sculptures. The exhibition of *The Gates* had not been an unalloyed critical triumph,

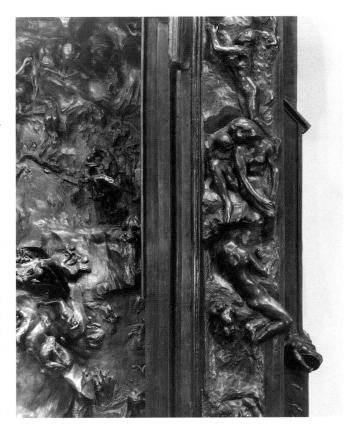

Fig. 234. Detail of *The Gates of Hell: Right Pilaster Bas-Relief.*

and the government had not called for its casting. By making this reduction of the partially dismantled relief Rodin wanted more than a souvenir. He wanted to teach and show among other things why he objected to the public's expectations of "finish." It was as if he were saying that even without some of its parts, this relief, like the truncated version of *The Gates* as a whole, is still complete. It works *decoratively*. He causes us to focus on the sequence of three figural registers out of the six that he may have felt to be artistically successful. Divisibility of the pilaster was possible for, as shown by Jessie Lipscomb's 1887 photographs (see figs. 122–124), Rodin modeled the portal's side reliefs by the addition and subtraction of parts rather than by modeling the whole surface simultaneously.

One of his great incentives in making the portal was to show what he could do to modernize relief sculpture, and the two external compositions on the portal came in for extensive praise from critics, especially Truman Bartlett: "As pieces of color they are almost beyond praise."[3] In this fragment, for example, all the figures are in varying degrees of relief as their backgrounds are in different depths. Looked at from the sides, it is clear that there is no imagined frontal plane or, as Bartlett called it, "surface line" of the door to which the reliefs are bound, and this contributed to the varied and rich effects of light and shadow that made the big portal three dimensional as well. It is also as if we are seeing the same woman in the round but from three different viewpoints—back, front, and sides—a dramatic demonstration of Rodin's democratization of the body. In this trio of markedly different postures Rodin has nevertheless found a subtle rhythm, natural in repeated diagonals that link the figures. Although the architectural frame has been made more consistent and complete than in the original, Lebossé meticulously preserved the way Rodin's sculpture takes priority over architectural restrictions: thus the knee of the lowest woman protrudes into space beyond the border.

NOTES

LITERATURE: Miller and Marotta 1986, 34–35; Fath and Schmoll 1991, 145

1. These reliefs were discussed by Tancock (1976, 228–30) and de Caso and Sanders (1977, 179–83).
2. Albert Elsen, "Rodin's 'Perfect Collaborator,' Henri Lebossé," in Elsen 1981, 258. The reduction of a second bas-relief listed for 1903 may have been Stanford's small cast, *Protection* (cat. no. 83).
3. Bartlett in Elsen 1965a, 77–78. Bartlett went on to say, "The one on the right of the door represents souls in limbo, and is composed of figures of all ages and sexes who have sinned in ignorance. The sculptor chose to treat this preliminary region in order that he might introduce infants and children, and thus give greater variety of form and interest to the art effect."

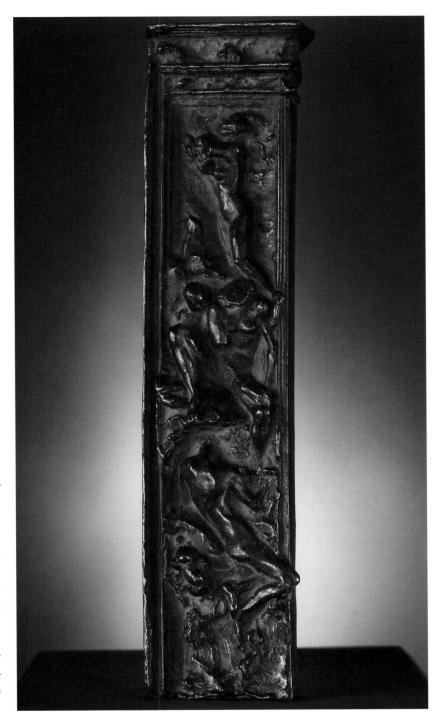

Fig. 233. *Decorative Pilaster from "The Gates of Hell"* (cat. no. 82).

83

Protection

(Protection), before 1889, reduced 1902–03

- Bronze, cast 1916
- 3½ x 1⅝ in. (8.9 x 4.1 cm)
- Signed on front of base: Rodin
- Inscribed on reverse: protection/Auguste Rodin; on back of base: MCMXVI; on right edge: bronz[e]
- Provenance: Max Bodner Galleries, New York
- Gift of B. Gerald Cantor, 1977.17

Figure 235

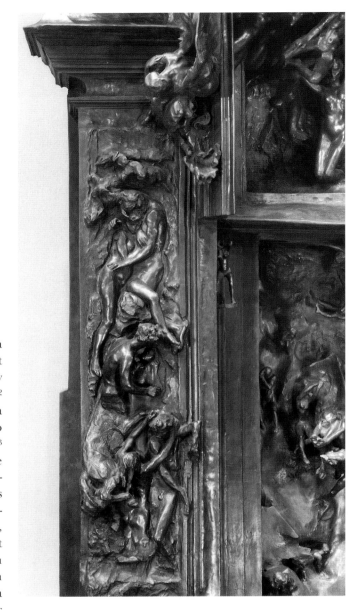

OPPOSITE PAGE
Fig. 235.
Protection (cat. no. 83).

Fig. 236.
Detail of *The Gates of Hell: Keft oukaster*.

*O*riginally cast in bronze and silver, this plaquette is a reduction of a couple from the top of the external left bas-relief of *The Gates of Hell* (fig. 236).[1] The reduction by Henri Lebossé probably dates from late 1902 or 1903.[2] The reduced relief existed by 1905 when Les amis de la médaille unsuccessfully sought to use it on a plaquette to be titled *L'art enlaçant la matière* (Art embracing matter).[3] Entitled *Protection*, it was offered by the artist in response to a solicitation for an auction in 1916 to benefit the society L'aide aux artistes et employés de théâtre de Paris (Aid to artists and theater personnel of Paris).[4] At an earlier date, before 1889 according to Georges Grappe, Rodin had isolated this couple in their original size but retained the background against which they are seen in *The Gates* and called the bronze relief *Vaine tendresse* (Vain tenderness). *Protection* is designated by Grappe as a reduction of this work.[5] The external reliefs of the door seem to have been made in the early 1880s and were in place when Jessie Lipscomb photographed the portal in 1887 (see figs. 122–124).

The small Stanford relief was given a name and not a title, perhaps with the thought of the wartime fund-raising purpose, to aid actors and theater personnel. In theme and style the couple has affinities with those on the ceramics Rodin made for Sèvres, and it is conceivable that this composition dates from as early as 1882. The woman's leg slung over that of her male companion suggests a sexual assertiveness belied by the cuddling posture of her upper body. Rodin made *The Kiss* (cat. no. 48) around 1880–81, employing the same leg gesture for the woman, the initiator of the seduction of the man. In *Protection* the man puts his left hand on the woman's right hip, the reverse of the contact in *The Kiss*.

NOTES

LITERATURE: Grappe 1944, 138; Spear 1967, 63, 99–100; Jianou and Goldscheider 1969, 114; Tancock 1976, 228; Miller and Marotta 1986, 37; Ambrosini and Facos 1987, 85; Fath and Schmoll 1991, 145

1. For discussion of small decorative reliefs that were made

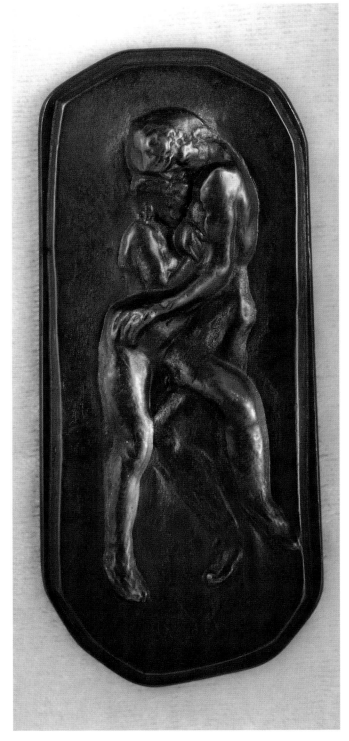

as reductions of the full-scale pilasters on the stripped version of *The Gates*, see Tancock 1976, cat. nos. 27–28, and de Caso and Sanders 1977, cat. no. 29.

2. Elsen 1981, 258.
3. Grappe 1944, 138.
4. Ibid., 74, 138; Beausire 1988, 363.
5. Grappe 1944, 74, 138.

84

Bust of Albert-Ernest Carrier-Belleuse
(*Buste d'Albert-Ernest Carrier-Belleuse*), 1882

- Terra-cotta
- 18½ x 17⅜ x 11 in. (47 x 44.1 x 27.9 cm)
- Provenance: Anne-Marie Morin (née Carrier-Belleuse, granddaughter of the subject)
- Gift of B. Gerald Cantor Foundation, 1974.88

Figure 237

*B*etween 1864 and 1882 Rodin worked several times for Albert-Ernest Carrier-Belleuse (1824–1887), one of the most successful decorative sculptors of the period. Shared tastes and aspirations drew Rodin to Carrier-Belleuse's service in addition to the younger sculptor's need for employment. Classically trained at the École des beaux-arts, Carrier-Belleuse favored eighteenth-century French decorative art, an admiration shared by Rodin.[1] Carrier-Belleuse was able to be productive in a wide variety of decorative arts because of his facility and because he ran an efficient studio based on the division of labor, from which Rodin probably learned how to manage his own studio when he was later able to employ several assistants. Like Carrier-Belleuse, from whom the famous sought portraits, Rodin also received a multitude of portrait commissions. When he modeled this bust, Rodin was working not only on *The Gates of Hell*, for which he was paid expenses but no salary, but also at the Manufacture de Sèvres, which had been reorganized under the leadership of Carrier-Belleuse; there he was paid an hourly wage. As the new director was responsible for a revival of sculpture in biscuit (porcelain that has been fired but not glazed), a technique almost extinct at Sèvres, Rodin may have conceived the bust with reproduction in this medium in mind in order to enrich his homage.[2]

Rodin had mixed feelings about his employer, who, as Ruth Butler put it, "employed him, taught him, used him, fired him, befriended him, and employed him again."[3] Rodin told Truman Bartlett:

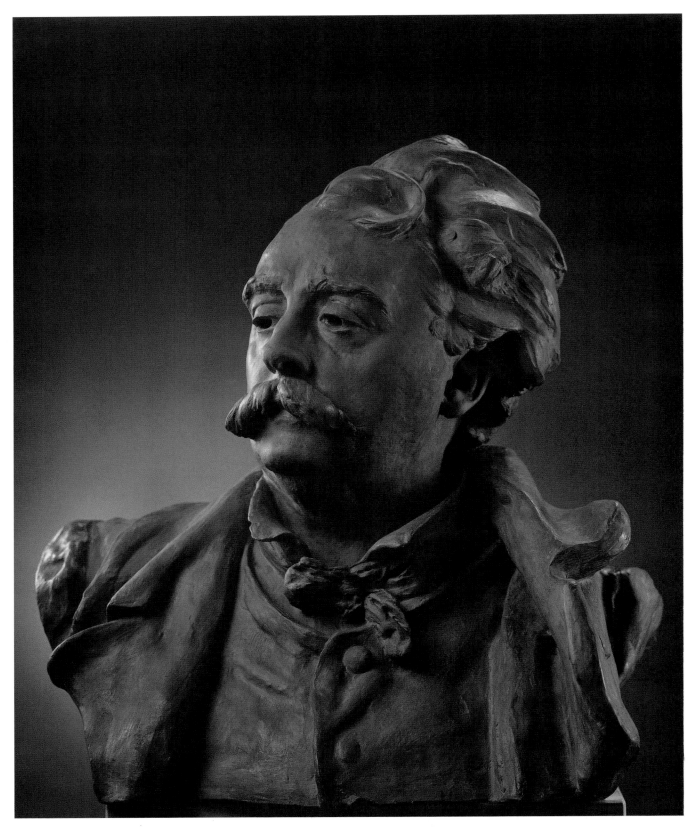

Fig. 237. *Bust of Albert-Ernest Carrier-Belleuse* (cat. no. 84).

Though I was making poor sculpture for Belleuse, I was always thinking to myself about the composition of figures, and this helped me later on. I carried to the work I did for him the result of my study [from life] at home. He occasionally praised me, though not much or often, and rarely, if ever, criticized. I knew he liked what I did. He was too much of a businessman to praise much, for he did not wish to raise my wages. He was no common man, was very intelligent, understood his own kind of work, and was lucky to have me for the price he paid. I think, in sentiment, Belleuse was an artist. He had good ideas of arrangement, a pretty correct eye, and composed well. . . . He could make a sketch that no one could finish as well as myself, and he did not always know this. He was a man of his day in sculpture. Nothing that I ever did for him interested me.[4]

Despite his reservations, when exhibiting in public, Rodin listed himself as a pupil of Antoine-Louis Barye and Carrier-Belleuse until 1885.[5] Many years after the latter's death Rodin told Henri-Charles Dujardin-Beaumetz, "Artists always have a feminine side. Carrier-Belleuse had something of the beautiful blood of the eighteenth century in him; something of Clodion; his sketches were admirable, in execution they became chilled; but the artist had a great true value; *he* didn't use casts from nature!"[6]

The bust at Stanford is a terra-cotta cast, an inexpensive and popular medium used by Carrier-Belleuse himself. When Rodin first exhibited the work, in the Paris Salon of 1882, it was shown in this material. (It was subsequently issued in a reduced size in an unlimited biscuit edition.) The area of the flesh shows none of the distinctive unaccountable or nondescriptive touches Rodin would later employ to build up the character and sculptural interest of his portraits.[7] Carrier-Belleuse at 58 is not shown with the marks of aging; Rodin gives his visage a smooth but robust character. (The terra-cotta medium as here used is most congenial to the evocation of flesh.) The head taken as a whole has a wonderful, round full-

ness, closely reflecting the sitter's appearance. The most engaging portions of the work may be the treatments of the hair and costume. The former is done with flair, based on great manual skill and study of eighteenth-century French portrait art. What is distinctively Rodin is that he sees the man's hair as crucial to his identity, if not personality, just as the costume, which seems rather negligently worn, could only have been shaped by the use of its owner. (Rodin had a sense of clothing having a physiognomy.) Avoiding finicky detail, Rodin used the lines and rhythms of the folds in the coat and vest to build to the neck and face. The casual appearance of the attire conforms with the unselfconscious pose in which the subject seems relaxed and thoughtful. Perhaps because the Carrier-Belleuse head is turned and invites viewing from more than one angle, one is encouraged to see how different prospects produce different expressions and even moods. Rodin's warm personal regard and professional respect may have motivated his decision to show the most successful Second Empire sculptor not as a proud or aloof and extraordinary being but as a sensitive artist who was also an astute business man.

NOTES

LITERATURE: Grappe 1944, 34–35; Tancock 1976, 496–99; Fusco and Janson 1980, 336–37; Hare 1984, 262–68; Goldscheider 1989, 168; Butler 1993, 169–70

1. For more on his background, see Tancock (1976, 496).
2. Butler in Fusco and Janson 1980, 336.
3. Ibid. See also Butler 1993, 570.
4. Bartlett in Elsen 1965a, 26. Carrier-Belleuse's attitude toward his workers, sparing in praise and tight-fisted with money, were known later to be Rodin's traits as well.
5. Tancock 1976, 498.
6. Dujardin-Beaumetz in Elsen 1965a, 177–78.
7. See Goldscheider (1989, 168) and Tancock (1976, 499) for contemporary photographs of Carrier-Belleuse, to which the bust closely corresponds. This particular cast was exhibited at the Salon des artistes français, 1882, no. 4813. Two bronze casts are known to exist. One was given by Carrier-Belleuse to the city of Sèvres to ornament the square named for him; the second decorates the artist's tomb in the cemetery at Saint-Germain-en-Laye.

85

Bust of Jules Dalou (Buste de Jules Dalou), 1883

- Bronze, Georges Rudier Foundry, cast 1969, 9/12
- 20½ x 15 x 8⅝ in. (52.1 x 38.1 x 21.9 cm)
- Signed on left shoulder: A. Rodin
- Inscribed on back, lower left edge: Georges Rudier/Fondeur. Paris; on back, lower right edge: © Musée Rodin 1969; interior cachet: A. Rodin
- Provenance: Musée Rodin, Paris
- Gift of the Iris and B. Gerald Cantor Foundation, 1974.83

Figure 238

*A*t the end of the nineteenth century the most acclaimed French sculptor of monuments was Aimé-Jules Dalou (1838–1902). In 1899 his greatest work, the *Triumph of the Republic*, was dedicated in the Place de la Nation, where it remains today. His wonderful monument to Eugène Delacroix, inaugurated in 1890 in the Jardin du Luxembourg, can still be seen at its original site. Dalou, like Rodin, went to the Petit école but then, unlike Rodin, Dalou attended the École des Beaux-Arts. The latter education he eventually came to denounce, and he refused a professorial appointment to the school. A republican and a Communard, Dalou went into exile with his family to England when the Commune of 1871 failed. There his reputation was established. He returned to France in 1879 under an amnesty granted in 1879–80.[1] He and Rodin became good friends, and Rodin's portrait of him was made four years following the exile's return. Their relationship foundered over misunderstandings regarding the death mask of Victor Hugo, which Dalou made at the family's request because of their dislike of the bust Rodin had made in 1883; Dalou apparently executed the mask without informing Rodin. Also a factor was Dalou's failure to support Rodin's project for a monument to Hugo in the Panthéon. Both had submitted projects for the monument, and in 1889 the commission went to Rodin. Rodin recognized Dalou's talent, but he came to think it was wasted by his involvement in art world politics.

The most important Dalou scholar, John Hunisak, said of the artist, "Although he was a humble man who remained passionately attached to his working class origins, Dalou could also assume the role of a proud and manipulative artist, so much so that Rodin accused him of wanting to become the Lebrun of the Third Republic."[2] Hunisak was referring to Rodin's statement to Paul Gsell:

Dalou was a great artist, and several of his sculptures have a superb decorative rhythm. . . .

He would never have produced anything but masterpieces had he not had the weakness of desiring an official position. He aspired to become the Le Brun of our Republic and something like the conductor of all contemporary artists. He died before attaining this.[3]

Contemporaries who knew both artists read the portrait very differently than do we today. Gsell gave an interesting interpretation of Rodin's portrait:

It is a proud and provocative head: the thin and sinewy neck of a child of the working-class neighborhoods, the bushy beard of the artisan, a wincing forehead, with the ferocious eyebrows of the former Communard, the feverish and arrogant air of the intractable democrat. At the same time, he has large and noble eyes, and in the design of the temples delicate incurvations reveal the passionate lover of Beauty.

To a question I asked, Rodin responded that he had modeled this bust at the moment when Dalou, taking advantage of the amnesty, had returned from England.

"He never took possession of it," he told me, "since our relations ceased soon after I introduced him to Victor Hugo."[4]

Rodin's portraits of his fellow artists cast them as the intellectual and physical equals of the most important members of French society. Portraits such as that of Dalou are Rodin's way of praising artists. No doubt he saw his fellow sculptor as the proud artist and politician rather than the son of a worker. The dignified bearing of the old Communard is tempered by the thoughtfulness of the downcast eyes. Rodin makes Dalou of but not in the world of other men.

The gaunt, bony, and naked figure is so treated by Rodin that the light fairly crackles across its hard sur-

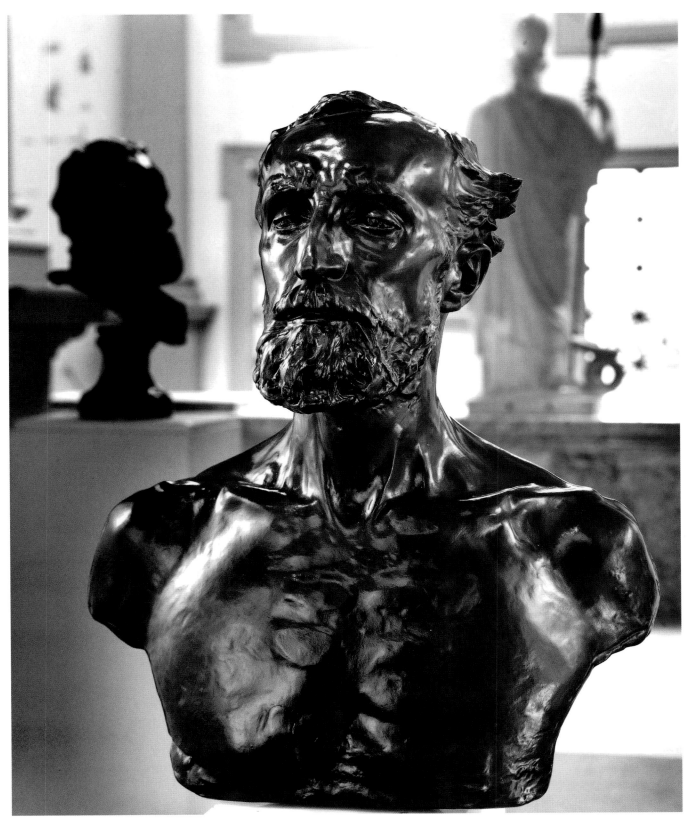

Fig. 238. *Bust of Jules Dalou* (cat. no. 85).

faces. Stripping him of clothing, Rodin released Dalou from time and place and put him in the company of the ancients. (For such an ascetic figure, however, one has to go back to Roman republican portraits.) The long thin nose might have had regal associations for the French who remembered sixteenth-century physical attributes of royalty, and for Rodin it made a marvelous rudder, or thrusting shape, whose force he had to counter with the man's eccentric hair, which on his left sweeps out and back. Subtle artistic liberties cushion the near symmetry of the whole as in the uneven eminences of the forehead. On the whole, however, there are relatively few unaccountable touches, and the bust has a salon finish akin to the portraits Dalou himself made.

The starkness and clarity of this bust bring to mind Rodin's own thoughts on the making of a portrait, which he shared with Frederick Lawton some 20 years after this likeness was made:

I always carefully model by profiles, not from a merely front view. It gives depth and solidity, the volume, in fine, and its location in space. I do this, however, with a line that starts from one's own brain. I mean I note the deviation of the head from the oval type. In one, the forehead bulges out over the rest of the face, in another, the lower jaw bulges out in contrast with the receding forehead. With this line of deviation established, I unite all the profiles, and thus get the lifelike form. Those who wish to penetrate into some of the invariable rules nature follows in composing, should observe her opposition of a flat to a round. . . . They should notice also her gradations and contrasts of light producing color in the real object, and should be careful not to produce effects that are out of accordance with the natural ones. In general, they should avoid blacks. . . . On beginning their work, they should exaggerate characteristic features; the exaggerations will get toned down fast enough later on. In the first instance, the exaggerations are nec-

essary to establish the structural expression. It is only by the graduation of these more characteristic traits that the relative value of all the parts can be determined. In the flesh there is the spirit that magnifies one or another detail of expression. In the clay or marble, it must be by the positive magnifying of the material part, not especially by size, but by the line, by the direction, the depth, the length of its curve, that the expression is made equivalent.[5]

When the Dalou bust was exhibited in 1884, the young critic Roger Marx, who would become one of Rodin's most articulate and ardent champions, read the portrait in the spirit of the maker's account of how he worked: "Especially admirable is the bust of M. Jules Dalou with its extraordinary boldness in the modeling and composition. Above the plain, naked torso rises the fine head of the great sculptor, gaunt, lean, nervous, energetic; what character in the curve of the lips, the narrowing of the nostrils, the power of his gaze! And the carriage of the head is superb. If you step back ten paces from sculptures close to you they cease to say anything, but this little bust goes on talking."[6]

NOTES

LITERATURE: Grappe 1944, 36; Tancock 1976, 500–503; Fusco and Janson 1980, 337–38; Grunfeld 1987, 165–67; Hare 1984, 269–77; Fonsmark 1988, 99; Goldscheider 1989, 172; Butler 1993, 171–72, 176, 400; Le Normand-Romain 2001, 68

1. A photograph of Dalou from this period is reproduced in Tancock (1976, 503).
2. Hunisak in Fusco and Janson 1980, 185.
3. Gsell [1911] 1984, 63.
4. Ibid.
5. Lawton 1906, 163–64; also cited in connection with the Dalou portrait in Grunfeld 1987, 163–64.
6. Grunfeld 1987, 166, citing Roger Marx, untitled article on Rodin in *Nancy-artiste*, 22 May 1884. For other reviews, see Butler in Fusco and Janson 1980, 338.

86

Bust of Victor Hugo (*Buste de Victor Hugo*), 1883

- Bronze, J. Petermann Foundry, cast 1883
- 22½ x 10½ x 11 in. (57.2 x 26.6 x 27.9 cm)
- Signed under right shoulder: Rodin
- Inscribed on base, right side, below signature: J. Petermann, Fondeur/Bruxelles
- Gift of Cyril Magnin, 1971.5

Figure 239

*T*wo important accounts give us an excellent background to Rodin's making of this portrait of Victor Hugo. The first was given to Truman Bartlett by the artist himself just four years after having completed the sculpture:

The history of the Hugo bust is an interesting one. Sometime in 1883, M. Edmond Basière [Bazire], one of the editors of the Paris journal, *L'intransigeant,* and an ardent friend of Rodin, and who wished to have him make a bust of the poet, went with him to see Hugo to consult about it and arrange for some sittings. Unfortunately, the latter had just completed giving a wearisome number of hours for the same purpose to another sculptor, and he did not feel disposed to begin again. But a member of Hugo's family, who was not pleased with the bust, was very desirous that Rodin should at least make an attempt in some way, and as a preliminary step he was cordially invited to come to Hugo's house every Sunday evening, dine, and study his subject as best he could.

After a number of these agreeable visits the sculptor brought his modeling stand and clay, established himself out of the way, in one corner of the veranda, and began his work, without in any way disturbing or expecting the poet to pose expressly for him. The bust was practically made from memory, the sculptor first looking at Hugo, wherever he might be, and then returning to his clay and working out the result of his observation,

losing, of course, much that he had seen and been impressed with, in going from the subject to his work. It was a difficult and almost endless task, and the bust was completed only about six months before Hugo's death. By many of the poet's friends it was, at first, regarded as a complete failure, but time gradually developed its merits, and those who at first disliked it became its enthusiastic admirers. . . .

To assist him in modeling the bust the sculptor had made many sketches, on paper, of his unwilling sitter from every possible point of view.[1]

Bartlett then quoted Rodin: "Hugo had the air of a Hercules; belonged to a great race. Something of a tiger, or an old lion. He had an immense animal nature. His eyes were especially beautiful, and the most striking things about him. As a man he was large and agreeable, no personal pride."[2]

The second, entirely first-person account was given by Rodin to Henri-Charles Dujardin-Beaumetz before 1913:

The first time I saw Victor Hugo, he made a profound impression on me; his eye was magnificent; he seemed terrible to me; he was probably under the influence of anger or a quarrel, for his natural expression was much more that of a good man.

I thought I had seen a French Jupiter; when I knew him better he seemed more like Hercules than Jupiter. He had been so solicited for his portrait or his bust that he didn't want to pose; furthermore, he had just given long hours to a sculptor named [Victor] Vilain. Victor Hugo believed that after [Pierre-Jean] David d'Angers . . . no one would be capable of doing his bust. Mme Drouet arranged that he pose for me for half an hour, but that was all. He was so convinced that I was going to make a bad bust that he wouldn't even look at it; my bust was so criticized by his entourage that I was somewhat cast down.

I worked entire hours in the veranda of the *hôtel* filled with flowers and green plants. I saw Victor Hugo sometimes, across the salon, hard and cold of aspect; he would also go and sit at the end of the room, absorbed, reflective.

The director of the Petit École, Lecoq de Boisbaudran, made me follow a method which has, at least, the advantage of being possible—I learned to

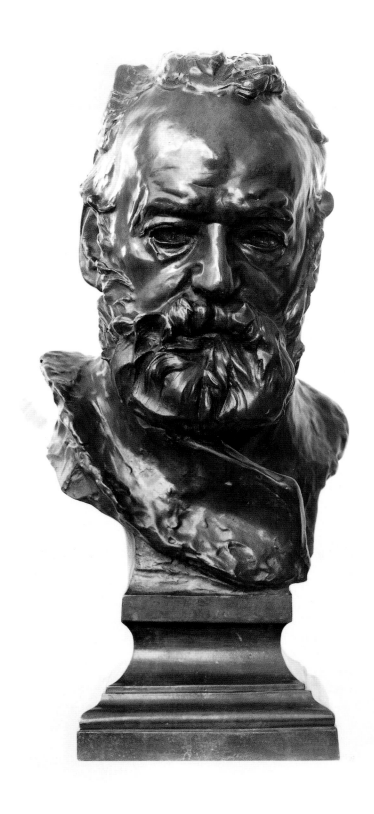

Fig. 239. *Bust of Victor Hugo* (cat. no. 86).

draw a great deal from memory and thus I learned to observe; this always proved useful to me, but especially . . . in this case.

You know that I hold as a principle the comparison of all the contours of a work with those of nature. Being unable to follow my habitual procedure, I placed myself beside or behind him, following him with my eye, making quick sketches of him, drawing as many profiles as I could on little squares of paper; he didn't look at me, but had the goodness not to dismiss me; he tolerated me. I made many drawings of the skull; I then compared those contours with those of the bust; thus I managed to execute it, but with such difficulties. . . .

I believe I rendered the first impression I felt; I worked three months, then I was given to understand that the bust was finished. I took it away.[3]

It was while at work on the Hugo bust and experiencing so many difficulties that Rodin may have first had recourse to using photographs and drawing on them to visualize possible changes he might make in the clay. Rodin was probably the first sculptor to use these photographic records like states of a print or plaster casts. A sequence of photographs taken by Charles Bodmer on Hugo's veranda shows the bust in clay still on the modeling stand.[4] One print discloses Rodin in the background holding a corner of the stand and smiling as he looks at Hugo's left profile. Two prints bear Rodin's inked notations: one for adding drapery to the base and one for changing the hair. The ultimate popularity of this portrait of one of the greatest heroes of the Third Republic, in fact, encouraged Rodin to try different versions of the base. In the Bodmer photographs the head is tilted slightly to its right, something not found in the bronze casts, where the head is more upright. Rodin may have caught a characteristic pose of the writer, whose partial deafness caused him to miss some of the conversation at his table. The photographs also capture a crispness to the clay, which was somewhat diminished in the bronze casts. Athena Tacha Spear attributed the latter to the "dull, generalized surface of a portrait made from memory."[5]

Rodin's 1885 drypoint portraits of Hugo, done possibly after the writer's death that year, indicate that working from memory could deepen what an artist had to say. As admirably catalogued by Victoria Thorson, the prints show that he worked from his own modeled bust, viewing

Fig. 240. *"Victor Hugo," Front View* (A8).

it from slightly below eye level to create the print (fig. 240). Though reversed in the print, Rodin preserved the head's tilt. By introducing observed or invented shadows to soften the powerful countenance, especially in the area of the eyes, Rodin emphasized what had so attracted him on his first encounter.[6] It is in the prints, especially a frontal view, that one has the sense that the writer is aware of our presence. Far from diminishing the power of his portraits, the model's absence encouraged Rodin to put the head into a more atmospheric ambiance and also to insinuate more of his own interpretation of the poet.

Mindful of the intense criticism to which his work would be submitted when finished, given the national adulation of Hugo and the familiarity of his facial image, Rodin not surprisingly did what was for him a straightforward portrait, including showing the poet's upright jacket collar closing at the side. The bust was exhibited at the Salon of 1884.[7]

As Rodin was forced to terminate work on the bust, the result, though handsome, is not much of a progression beyond his *Mask of the Man with the Broken Nose* (cat. no. 125) of 20 years earlier, at least in terms of interpretation. Rodin recognized this himself, and when it came to creating a monumental version of the Hugo head years later (cat. no. 87), he was less inhibited and more inventive in making the clay respond to his intuition. The first portrait did not please the writer's family, and Jules Dalou was invited to make another. Though this undertaking was aborted by Hugo's death, Dalou subsequently made the poet's death mask.[8]

NOTES

LITERATURE: Bartlett 1889 in Elsen 1965a, 55–56 Dujardin-Beaumetz 1913 in Elsen 1965a, 169–70; Grappe 1944, 37; Spear 1967, 5–8, 90; Spear 1974, 124S; Judrin 1976, 78–80; Tancock 1976, 504–11; de Caso and Sanders 1977, 269–75; Hare 1984, 278–87; Elsen 1980, 177; Barbier 1987, 68; Fonsmark 1988, 96; Goldscheider 1989, 174; Butler 1993, 173–77; Butler, Plottel, and Roos 1998, 53–61

1. Bartlett in Elsen 1965a, 55. These drawings made on cigarette paper were lost for a number of years, but many are now in the Musée Rodin drawing collection. See Tancock 1976, 504, 506, and Judrin 1976, 80–85.
2. Bartlett in Elsen 1965a, 56.
3. Dujardin-Beaumetz in Elsen 1965a, 169–70.
4. Elsen 1980, pls. 85–88.
5. Spear 1967, 5. These photographs do not support this.
6. Thorson 1975, 46–56. Thorson included some small sketches as well.
7. The portrait and its subsequent history, including marble versions, were well covered by Tancock (1976, 504–10), and de Caso and Sanders (1977, 269–75); see also Goldscheider 1989, 174–77.
8. The death mask was illustrated by Tancock (1976, fig. 87-7).

87

Monumental Bust of Victor Hugo (*Victor Hugo, buste héroïque*), c. 1897

- Title variation: *Heroic Bust of Victor Hugo*
- Bronze, Coubertin Foundry, cast 1981, 8/12
- Signed on base, lower left: A. Rodin
- Inscribed on right side: © by Musée Rodin 1981; below signature: no. 8
- Mark on rear of base: Coubertin Foundry seal
- Provenance: Musée Rodin, Paris
- Gift of the B. Gerald Cantor Collection, 1992.142

Figure 241

*T*his monumental bust was a reworking of the 1883 portrait (cat. no. 86). It was used for both the large seated and standing figures of the writer as part of Rodin's commission to create a monument to the writer for the Panthéon (see figs. 242 and 191, 246).[1] Unusual historically is the fact that the bust does not present the viewer with a full, upright face.[2] Unlike the inclined head in the *Bust of Henri Rochefort* (cat. no. 134), that of Hugo

came from a full-figure version. The shoulder areas, if not the chest, derive not from the naked standing version but from the naked seated figure (see fig. 191), which was used in several multifigure projects for the monument and finally as a solo figure. The bust's truncated upper arms show they were in the position dictated by the raised and bent right arm and the extended left arm, which characterize the seated writer who gestures imperiously to silence the sea while he meditates. The absence of clothing reflects Rodin's view, long after his first portrait of the clothed writer, that Hugo "was a man of nudity and not a man of draperies."[3] The large size and nakedness of this imposing sculpture still encourages, as it did for Rodin, associations with the ancient gods.[4]

Hugo's head is dramatically changed from the 1883 bust. Rather than being neutral or purely descriptive, the brow more than the eyes is now the carrier of facial expression. The head's inclined position emphasizes the center of the poet's existence, his brain, within the form of the forehead, which has now been drastically reworked and roughened. It is no longer a quiet frame for the eyes and lower face. The entire right side of the forehead has been indented and then overlaid with rough passages of clay whether for artistic reasons—to engage the light more actively without disintegration of the volume—or to evoke the life of the world within Hugo's mind. In 1892 Rodin similarly had added clay

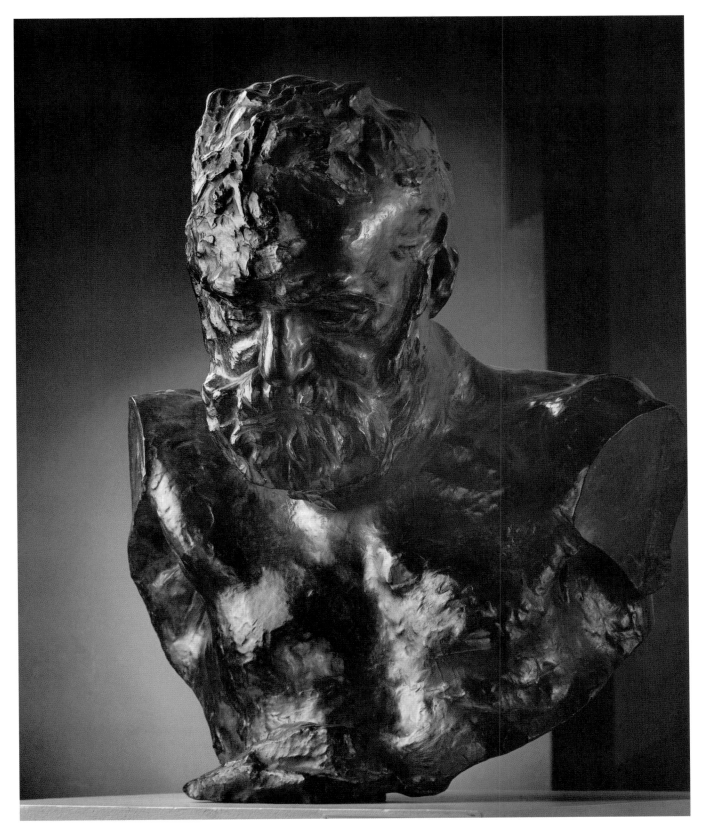

Fig. 241.
Monumental Bust of Victor Hugo (cat. no. 87).

Fig. 242.
Jacques-Ernst
Bulloz, *Study
for "Apotheosis
of Victor Hugo,"
1891–94 in
plaster* (A103).

patches to the forehead of his portrait of Charles Baude-laire (cat. no. 101) but retained the full convexity of the skull. It was rare for Rodin to excavate where bone formed the basic structure.

Hugo's left profile is faithful to the natural form of his features. Seen from the subject's right side, the entire profile except for the ear creates a cube as the planes of the neck, face, and beard have been squared off. Whether this was done to receive the supporting gesture of the right hand and fortify the neck as the head was used on more than one body, we do not know. The handling of the hair on this side is also arbitrary, and there are no clear textural distinctions between it and the brow. Starting with the amputated area of the right arm, there results a large and continuous upward flow of big abstract planes culminating in the hair. The carriers of Hugo's likeness remain the ocular area and brow, cheeks and bearded portions of the face, but as seen in Rodin's 1883 drawings, the blockish character of the head is also distinctive.[5]

Rodin may seem to have taken liberties with the 1883 portrait, but his sense of Hugo had changed after the great man's death. As he told Bartlett, "It was not until two or three years after his death that I really saw the man, the amplitude of his character, and felt the force of his private work and impersonal nature."[6] By the 1890s, as seen in his work on the monument to Balzac and here in the Hugo bust, Rodin had become convinced one had to exaggerate anatomical features in order to body forth the intuited internal nature of the subject.

Rodin seems to have not waited long to exhibit the great bust; it was shown in Dresden (1897), then Vienna (1898), the Paris salons (1902, 1907), and Edinburgh (1911).[7] Although she was writing about the 1897 exhibition of the rejected project of a monument showing the seated Hugo flanked by two muses, Catherine Lampert speculated convincingly concerning Rodin's thought about what he would show: "As a rejected work it could somehow be that much more of his own, and could withstand a perpetually unfinished look—one that declared Rodin's feeling for the studio as museum, and the Salon as atelier. . . . Rodin's indifference to finish was obviously his way of saying that artists should make art out of the facts and circumstances of their lives."[8]

NOTES

LITERATURE: Dujardin-Beaumetz 1913 in Elsen 1965a 169; Grappe 1944, 97–98; Spear 1967, 7, 90; Jianou and Goldscheider 1969, 94; Tancock 1976, 506, 508, 512; Hare 1984, 278–87; Lampert 1986, 218; Ambrosini and Facos 1987, 173–74; Levkoff 1994, 133–34; Butler, Plottel, and Roos 1998, 99

1. Grappe (1944, 97), Tancock (1976, 506), and others assigned the source of the bust to just the standing figure; these versions of the monument were illustrated by Tancock (417–18). The best account of Rodin's trials with this commission was given by Jane Mayo Roos, "Rodin, Hugo, and the Panthéon: Art and Politics in the Third Republic," Ph.D. diss., Columbia University, 1981; a related article in which Roos suggested 1901–02 as a possible date for the enlargement of the figure (1986, 652, n. 115); and her essay in Butler, Plottel, and Roos 1998, in which she noted 1890–97 or 1901–02 as dates for the bust (99).
2. Rodin intended the version of the seated naked Hugo to go on a low base so that the head would have been at about eye level (Roos 1986, 644).
3. Jules de Goncourt and Edmond de Goncourt, *Journal: mémoires de la vie littéraire*, vol. 15, entry for 9 December 1887, quoted in Roos 1986, 648.
4. Dujardin-Beaumetz in Elsen 1965a, 169. For figure studies of Hugo standing, see A99 and A108.
5. See drawings reproduced in Judrin 1976, 80–81.
6. Bartlett in Elsen 1965a, 56.
7. Beausire 1988, 135, 139, 221, 292, 322.
8. Lampert 1986, 118.

88

Head of the Tragic Muse
(*Tête de la muse tragique*), c. 1893–96

- Bronze, Georges Rudier Foundry, cast 1973, 1/12
- 11⅜ x 7⅛ x 9¹⁄₁₆ in. (28.9 x 18.1 x 23 cm)
- Signed on left side of neck: A. Rodin
- Inscribed on back, lower edge: Georges Rudier/Fondeur, Paris; below signature: No 1; on back of base: © by Musée Rodin 1973; interior cachet: A. Rodin
- Provenance: Musée Rodin, Paris
- Gift of the Iris and B. Gerald Cantor Foundation, 1974.84

Figure 243

*R*arely reproduced, undiscussed in the literature until very recently, and of an uncertain date, this forceful head, though separately made, was joined with the body of a crouching woman to create *The Tragic Muse* of Rodin's fourth project for the *Monument to Victor Hugo* (figs. 191, 246). The *Tragic Muse* was first exhibited in 1896 and a version lacking her left arm was later photographed atop a pillar (figs. 244, 245)[1] Although the enlarged version of *The Tragic Muse* was bronze cast in 1897 by Griffoul and Lorge during the artist's life, there is no indication that the head alone was exhibited separately or cast in bronze before Rodin's death, nor was it listed in Georges Grappe's 1944 catalogue.

In many ways this is the most drastic reformation of a human head in Western art since the Middle Ages and before Pablo Picasso's cubist *Head of Fernande Olivier* (1909; Museum of Modern Art, New York). Seen from the back, *Head of the Tragic Muse*, for example, appears a total abstraction with no textural clues to the fact that Rodin was evoking hair. The large roughly ovular clay lumps disposed in a random and layered fashion have not been submitted to the stylized patterning of sharp crested ridges, or arrises, formed by the meeting of two surfaces, as employed by Picasso. Where Picasso was waging war on the imitation of nature and reordering the head by showing the intervention of his mind in the form of invention, Rodin was taking imitative art beyond previous limits, conveying the extreme anguish of his subject through his own strong empathic feeling.

Rather than having been created from his own fancy, it is more likely that this head was inspired by an anonymous model with an expressive face. It seems not to have been made by consistent use of his profile method, the close observation of successive profiles, that he used for portraits. Some of its profile views, showing the upper portion of the face, indeed verge on abstraction. The extreme distortions of such areas as the eyes and nose appear to have been built in from the beginning, rather than having been applied to a previously finished likeness in clay. The whole area of the woman's right eye and brow has been fused by the pressing or pulling action of a thumb that left a large concavity. There is a calculated misalignment horizontally of the eyes and vertically of the nose with the mouth. It is almost as if the eyes were pressed back into the head. The nose is askew, tilted to its right, like an untrustworthy keel in a heavy sea. There is no bridge to the nose, which rises directly into a thickened area central to the brow but which destroys its normally smooth, continuous arc. The whole face above the cheekbones seems to contract and push backward until it merges with rude indications of the hair. In tilting the head to one side, the woman's left jawbone is suppressed. (There is no tension in the neck indicating that Rodin only used this area to raise the head.) As if the open mouth with exposed tongue and the warped features were not enough to convince of deforming internal anguish, Rodin seems to have forcefully slammed his left hand into the area of the woman's right temple; one can actually set one's palm into the depressions above and below the cheekbones.

Distinct from a labor of refinement such as Rodin might have engaged in for a portrait, here the process is reversed, one of making countless unaccountable or nondescriptive touches. This was another assault in Rodin's war on smoothness in sculpture by coarsening as well as animating large surfaces. They occur in the areas not usually associated with expression such as the cheeks and brow, and they act to harness not only light but shadow to these areas, thereby abetting the tragic tenor of the piece. It was in such works that Rodin dared again to be ugly, but now by what he did, not what life had previously done to his model (compare *Old Woman*, cat. no. 51). He was waging war on cosmetic norms and expectations of descriptive skill, while giving full vent to his own feelings. If we grant that he was, at the time of its creation, thinking of this head as a muse for an artist, in this instance Victor Hugo, and knowing how he had human-

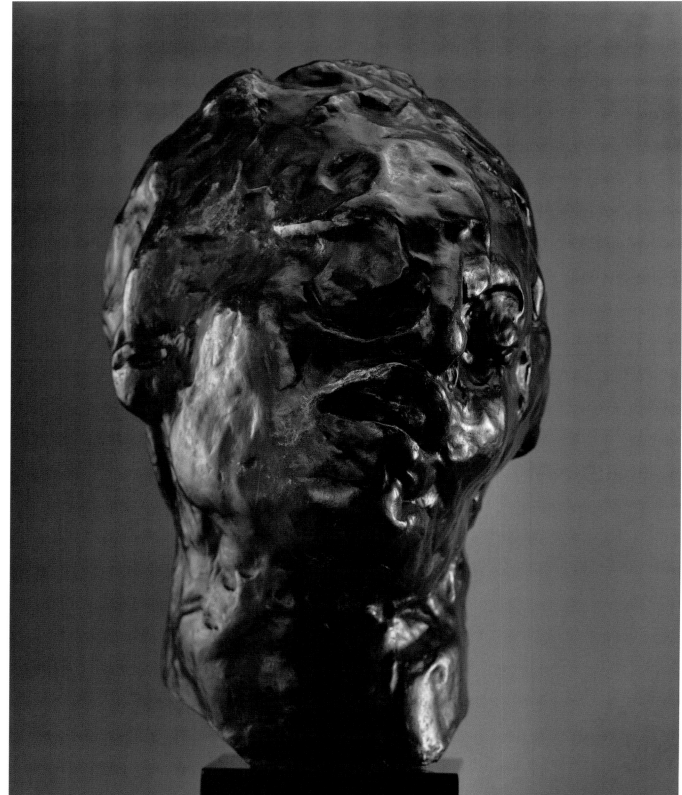

Fig. 243. *Head of the Tragic Muse* (cat. no. 88).

OPPOSITE PAGE, CLOCKWISE
Fig. 244. *The Tragic Muse without Her Left Arm*, 1890-96, bronze, 13 x 25½ x 15¼ in. (33 x 64.8 x 38.7 cm). Iris and B. Gerald Cantor Foundation.

Fig. 245. Jean-François Limet, *"The Tragic Muse" on a column, Pavillon de l'Alma, Meudon, 1902* (A155).

Fig. 246. D. Freuler, *"Monument to Victor Hugo" with "The Gates of Hell" in background* (A144).

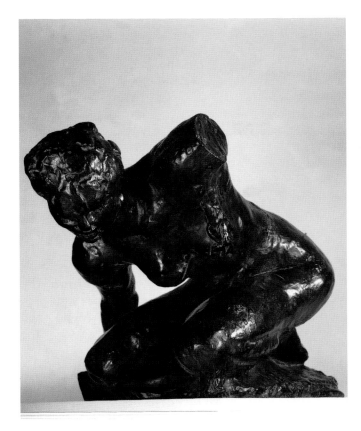

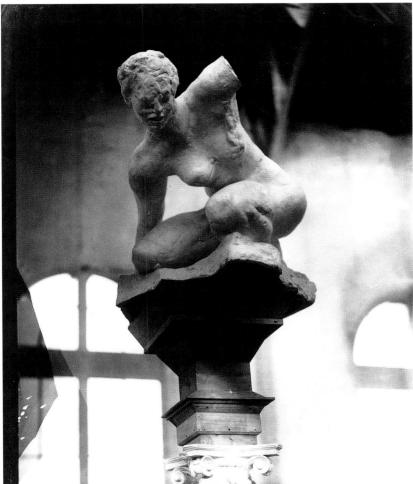

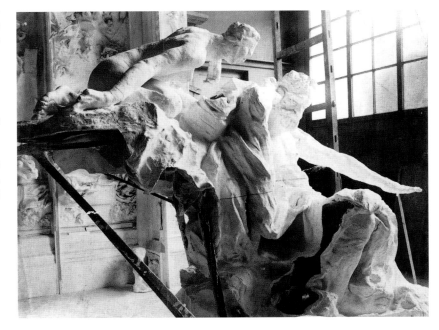

ized the muse to the extent that she shared the artist's creative pain, this head is perhaps also Rodin's self-portrait and most expressionistic work. Based on the nature of Rodin's audacities, this writer tends to date this head to the mid-1890s, perhaps in that interval between 1893 and 1896, when the sculptor had broken off from his Balzac studies and was working on his fourth project for the Hugo monument.

NOTES

LITERATURE: Ambrosini and Facos 1987, 156–13; Pingeot 1990, 213; Butler, Plottel, and Roos 1998, 90, 93

1. For further discussion of *The Tragic Muse* and of the Hugo monument see Beausire 1988, 125–26; Pingeot 1990, 203–18; Butler, Roos and Plottel 1998, especially 85–96; and Le Normand-Romain 2001, 184, and fig. 50.

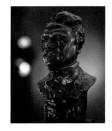

89

Henri Becque (Henri Becque), 1883, reduced 1908

- Bronze, Georges Rudier Foundry, cast 1969, 6/12
- 6 x 3¼ x 2¾ in. (15.2 x 8.3 x 7 cm)
- Signed on base, left side: A. Rodin
- Inscribed on base, right side, near back: Georges Rudier/Fondeur. Paris.; on base, left side, lower edge: © by Musée Rodin 1969
- Provenance: Musée Rodin, Paris
- Gift of the Iris and B. Gerald Cantor Foundation, 1974.79

Figure 247

*T*his small bust of the militant playwright Henri Becque (1837–1899; fig. 249) is a reduction of a unique life-size terra-cotta, modeled about 1883. In 1904 Rodin apparently borrowed the terra-cotta from the family to make an enlarged version, that was carved in marble for a monument inaugurated in 1908.[1] In that year Rodin may have produced this reduced version, which was issued in an edition for the subject's many friends after the public monument was dedicated. In 1904 an article appeared in *La cocarde* that discussed the enlargement on which Rodin was working and which was intended to serve for the execution of the marble monument: "This bust has its own original story known only to a few Parisians. In sum, it is a bust 'after nature' as Becque was dead before Rodin began it. In effect it is nothing but the enlarged reproduction of a very small bust made in 1885 that one could only admire by intimacy. In those days, Rodin, Becque, Villiers de l'Isle-Adam, Maupassant . . . often took their dinner together at the old Lion d'Or. . . . Afterward, Becque customarily accompanied Rodin to his studio, where he remained for hours talking. This was the occasion for the sculptor to shape [*tailler*] the bust of the writer— a small work of a friend, a few centimeters in height, but with an admirable vigor and resemblance."[2]

All commentators are of the view that this small terra-cotta bust seems to have preceded

Rodin's 1883 drypoint triple portrait of Becque (fig. 248).[3] Rodin told Gustave Coquiot, "When I engraved his portrait, I took great pleasure in trying to convey that resolute, stubborn expression, deeply imbued with a passionate candor."[4] Rodin admired Becque, whose writing against injustice and silence earned him great respect but not money. The two met after the playwright gave the artist copies of his *Les honnêtes femmes* (Respectable women; 1880) and *Les corbeaux* (The vultures), the latter having earned critical success in 1882. Rodin remembered Becque as "a rough man, incisive and proud of his poverty. He wore it like a plume. He was full of bitterness, no doubt, but he reserved his gall for the mediocre people and things of his period."[5]

This small bust, which can be easily held in the hand, was probably so fashioned and without an armature. It is a crisp characterization, a man's appearance reduced to the size of a weighty nugget. The sharp definition and quality of the detailed modeling, especially around the eyes, argues for this having been done by Rodin rather than a technician who might have been requested to reduce it. The bust defines what is meant by a good, strong, honest face. That Rodin saw this, not as an étude, but as a completed work is shown probably by the modeled, cubic plinth set under the bust.

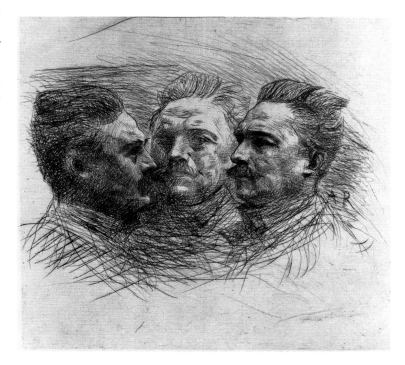

Fig. 248.
Portrait of Henri Becque (A5).

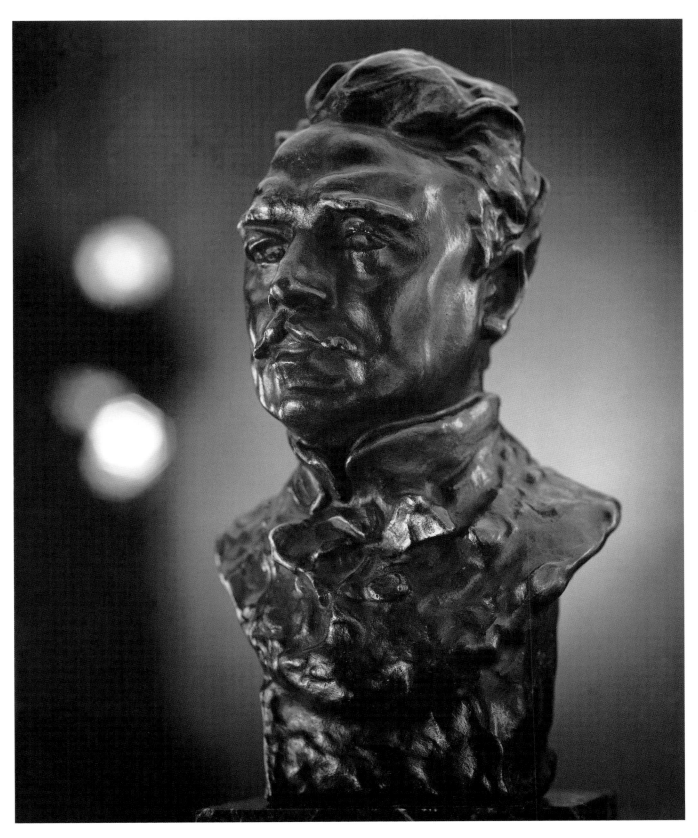

Fig. 247. *Henri Becque* (cat. no. 89).

NOTES

LITERATURE: Grappe 1944, 38–39; Judrin 1976, 61–62; Tancock 1976, 513–16; Hare 1984, 293–98; Grunfeld 1987, 164–65, 561; Goldscheider 1989, 180

1. Grappe dated the terra-cotta to about 1883 and the plaster enlargement to 1907 (1944, 38, 122). Tancock, following Grappe, dated the enlargement to 1907 and the reduction to probably the same date (1976, 513–16.) The recent literature somewhat alters these dates. Lebossé's notes record the enlargement in 1904 (see Elsen 1981, 258); Goldscheider dated the reduction to 1908 (1989, 180).

2. *La cocarde*, 30 September 1904 (anonymous clipping in the Becque file, Musée Rodin). Goldscheider noted that the original bust (terra-cotta, 30 cm) was probably made in late 1883 and was celebrated at a literary occasion in 1885 (1989, 180). The 1904 reference to a very small bust of 1885 is contradicted by the data recorded by Goldscheider and Grappe.

3. Grappe argued that the drypoint was likely made after the terra-cotta bust and not the reverse, which is why he revised his date for the bust to 1883 (1944, 38–39). Thorson indicated that Rodin copied the drypoint from the bust (1975, 40) in her discussion of the print. As Rodin did not keep even a plaster of the bust for himself, it is possible that the drypoint was in part his own record of the work.

4. Coquiot 1917, 113, quoted in Tancock 1976, 513.

5. Ibid.

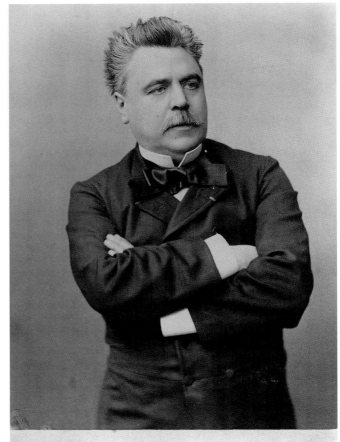

Fig. 249. M. M. Benque, *Henri Becque*, n.d., albumen print. Musée Rodin, Paris.

 90

Portrait of Camille Claudel in a Bonnet (*Camille Claudel au bonnet*), *1885 or 1886*

- Title variations: *Camille Claudel in a Phrygian Cap, Camille Claudel with a Cap, Mlle Camille Claudel*
- Bronze, Georges Rudier Foundry, cast 1969, 7/12
- 10 x 5½ x 6 in. (25.4 x 14 x 15.2 cm)
- Signed on base, left side: A. Rodin
- Inscribed on back: Georges Rudier/Fondeur. Paris.; below signature: No. 7; on back, under edge: © by Musée Rodin 1969
- Provenance: Musée Rodin, Paris
- Gift of the Iris and B. Gerald Cantor Foundation, 1974.77

Figure 250

*I*n March 1898, no doubt encouraged by Rodin, the critic Mathias Morhardt published in a prestigious periodical an unusually long article on Camille Claudel (1864–1943; fig. 251), an art world rarity, a woman who was a professional sculptor. At the very beginning of his essay Morhardt made it clear that his subject's gender was not the basis for his writing: "In effect Mademoiselle Camille Claudel is less a woman than an artist—a great artist—and her work still small in number as it may be, confers on her superior dignity."[1] With Rodin's encouragement and assistance, although not of the magnitude of Morhardt's, Claudel had exhibited several works before the article appeared and received praise from other critics, including Aristide Maillol's approval of her ability as a rare direct carver of stone.[2] The timing of this article seems to have coincided with the final professional and personal break between the two artists, and Rodin may have sought to promote yet again the career

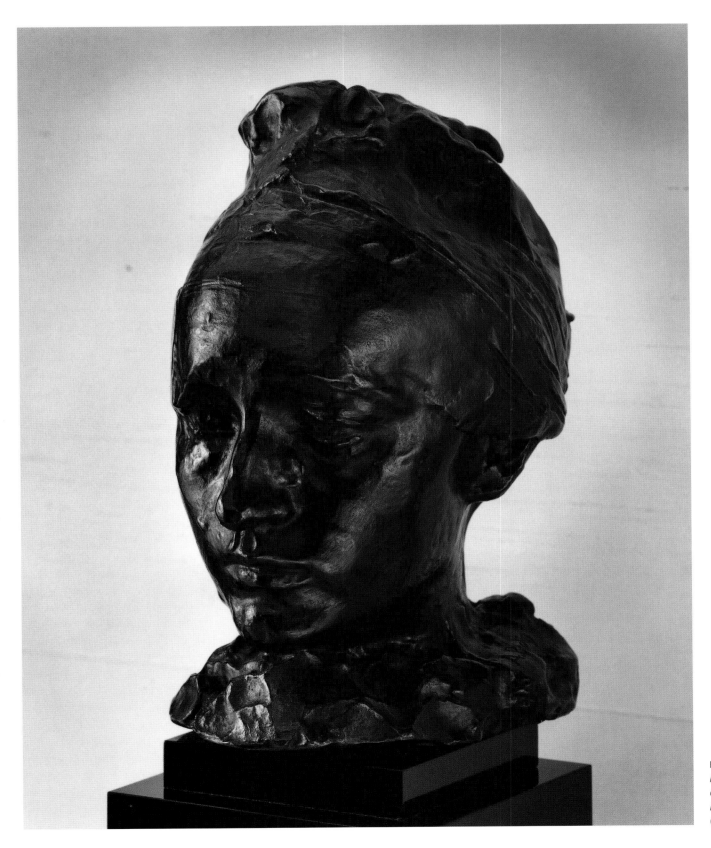

Fig. 250.
*Portrait of
Camille Claudel
in a Bonnet*
(cat. no. 90).

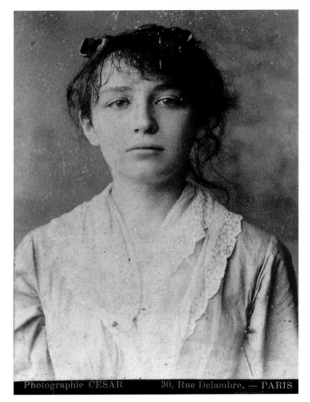

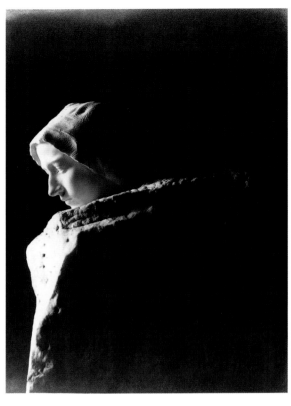

Left: Fig. 251. César, *Camille Claudel*, c. 1884, albumen print. Musée Rodin, Paris

Right: Fig. 252. Jacques-Ernst Bulloz, *Camille as Thought*, 1893-95, in marble (A111).

she was his student, his assistant, the first woman to work in his studio (between roughly 1888 and 1892), frequent model, lover, and professional as well as personal confidant. Rodin referred to her as his "collaborator."[5]

Several sources record that she modeled hands and feet for Rodin's figures.[6] Claims that, for example, she was responsible for such works as *The Kiss* and for major changes in *The Gates of Hell* have absolutely no supporting evidence. Aside from a keen artistic intuition, this convent-trained young woman brought no artistic culture to her relationship with Rodin, who was more than 20 years her senior and who had traveled extensively and made a lifelong study of art. In Pierre Daix's view, she helped make Rodin more couth and socially at ease in the high social and intellectual circles to which he introduced her.[7] When Rodin refused to give up Rose Beuret and marry Claudel, the break came.[8] The separation was traumatic for both artists.[9] Even after their rupture Rodin sought to help her with money and exhibitions, but she became a recluse with delusions that Rodin was persecuting her and stealing sculptures from her. Her eccentric behavior of neither eating nor maintaining hygienic standards while harboring countless cats, of destroying much of her own work, and of sending offensive and ordure-scented letters to government officials led her brother cruelly to commit her to an institution in 1914. The real villain in her life was this younger jealous brother, Paul Claudel, who self-servingly blamed Rodin for his sister's breakdown almost 20 years after their split. It was this hero of French letters who incarcerated and rarely visited her and, worst of all, never persuaded the authorities to allow or to encourage her to make art during her confinement, which lasted till her death in 1943. Despite attempts at helping Claudel, which included influencing

of the younger, defiantly independent woman. When Rodin heard the criticism that Claudel was too much under his influence, he offered the oft-quoted reply, "I showed her where to find gold, but the gold she found was her own."[3]

Since about 1980 there seem to have been more articles and books written on Claudel than on Rodin. Appropriately, two major exhibitions of her work were held in Paris, which led to the rediscovery of this gifted woman's art not only by the public but also by feminist and amateur scholars.[4] The 1988 film *L'interdite: Camille Claudel*, directed by Anne Rivière, has given this sculptor's unhappy love story and tragic final thirty years worldwide notoriety. Unfortunately most of those who have written about Claudel know little of Rodin and his art. Ambitious but unsubstantiated claims have been made regarding her supposed influence on the older man's sculpture.

The biographies of Claudel tell us that she came to sculpture very young, on her own, and with a ferocious tenacity. A woman of extraordinary will, she was largely self-taught as a modeler and carver but was given advice by the sculptor Alfred Boucher, through whom she met Rodin in 1882 when she was 18 years old. Her relationship with Rodin lasted until 1898, but during that time

the government to purchase some of her best work for its museums and declaring to others such as Morhardt and Judith Cladel his intent that her work be shown in his own future museum, Rodin has been blamed unfairly for the woman's mental problems, which seem to have centered on paranoia.[10]

The Portrait

Rodin's portrait of Claudel is very much an étude and studio enterprise. The truncated neck rises from an improvised or roughly modeled base, which allowed the sculpture to stand by itself. No attempt was made to give the portrait a bust format. What he was establishing in this study was a nuclear motif for possible future commissions or projects. Her likeness became part of Rodin's repertoire, and in a sense she became a woman in waiting. Given Rodin's turn of mind conditioned by sculptural practice during his lifetime, as seen earlier in his uses of the face of Beuret, the beautiful, youthful features of Claudel prompted his giving her different symbolic identities. In 1885 he used her face to personify Dawn in marble. The presence of the Phrygian cap here makes Claudel a personification of the Republic; wearing a Breton wedding cap she personified *Thought* (bronze, 1886; for marble, 1893–95, see figs 252, 569), and in helmets she personified *Saint George* (c. 1889), *France* (1904, cat. no. 36), and the face of the victorious Apollo in the *Monument to Sarmiento* (1895).[11] In the touching 1892 sculptures *Farewell* and *The Convalescent* presumably Claudel plays herself at about the time she left Rodin's studio.[12] Undated and not reproduced by Georges Grappe, the present work may have been modeled in 1885, probably after an earlier portrait showing Claudel with her short hair flattened on her forehead.[13]

The private or studio character of the head, a plaster cast of which is in the collection of the California Palace of the Legion of Honor, is patent in its surfaces, which still bear undisguised and unrefined traces of its making. The untempered, small clay patches may have been Rodin's notes to himself about building up the areas of the cheeks under the eyes and next to the nose as well as above the upper lip. Such future changes might depend on the age and identity of who or what Claudel might next represent. The large flattened circular area above her right eye eludes explanation unlike the marks made by casting seams of the piece molds. Had the head, still

in clay, fallen, or did Rodin intend to join something to the face in this area, as he would later do by adding a hand from one of the burghers of Calais?[14] It has been suggested that Rodin wanted to call attention to the creative process, which is plausible, but in determining to keep the head in its present state, Rodin had to be satisfied that in terms of life and art the total effect was successful. As shown by the marble *Thought*, Rodin knew that his carvers would smooth over the rough areas.

In this portrait Rodin shows how important asymmetry is in evoking a person's facial and psychological identity. As the light changes on the head, so does the expression, as was the artist's intention, and we can observe the breadth of expression—ranging from intense thought to brooding gaze—that Rodin achieved through modeling. Looking at the excellent photograph of Camille, which, though published in 1913, may show her nearer the time of this portrait, one can see a serious sadness in the face, with its beautiful large eyes.[15] Not surprisingly Rodin was exquisitely sensitive to his subject's eyes. In the bust Camille's right eye is wide open, so that the iris directs her gaze outward. Her left eye, without an iris, is partially closed by the heavier upper lid, and the result has the effect of seeming to turn the woman's attention inward. Physical asymmetry allowed Rodin to reveal the psychological nature of his subject, in this case a woman with a chameleonlike nature, projecting, as Daix pointed out, a summary of emotional attitudes in the way *The Walking Man* (cat. no. 174) was a summation of physical movements.

Despite her many gifts, with the exception of her portrait of Rodin, Claudel was not a profound portraitist. Her subjects are two dimensional psychologically and emotionally. This may have been the reason Rodin had her concentrate on modeling hands and feet and not faces.[16] In the presence of others, whether in or outside the studio, the two referred to each other in formal terms: Monsieur Rodin and Mademoiselle Claudel.[17] This professional demeanor carried over into their portraits of one another, although not in her two versions of the sculpture entitled *L'age mûr*, which are poignantly autobiographical, and not in her bitter caricatures of Auguste Rodin and Rose Beuret.[18] In this portrait of Claudel, Rodin shows how, given his strong feelings toward the subject, he would model in an unsentimental way, even forgoing cosmetic attractiveness. Alert to all surface evidence, he breathed credible life into his portrait with a few almost ineluctable touches, as in the eyes.

Unlike the lessons in technique he imparted to the young woman who came to him untutored in such matters, it was these touches that, because they were instinctive and came naturally out of his own life, could not be taught.

Perhaps because of its character as an étude, Rodin seems not to have exhibited his portrait of Claudel in her bonnet publicly before 1914. Alain Beausire reports that the bronze sculpture was shown in London that year, when it and 17 other sculptures were given to the Victoria and Albert Museum, and then a year later in Edinburgh. In his great 1900 exhibition Rodin appears to have shown still another version of this head, a mask without a bonnet.[19]

NOTES

LITERATURE: Grappe 1944, 134; Jianou and Goldscheider 1969, 97; Tancock 1976, 590, 592–93; de Caso and Sanders 1977, 285–87; Hare 1984, 332–39; Lampert 1986, 131, 216; Butler 1993, 180–87, 192–93; Le Normand-Romain 2001, 82

1. Morhardt 1898, 709.
2. See Cladel 1936, 231.
3. Ibid.
4. See the books by Paul Claudel's daughter, Reine-Marie Paris (*Camille Claudel* [Paris: Gallimard, 1984]), who had access to medical records; Jacques Cassar (*Dossier Camille Claudel* [Paris: Librarie Seguier/Archimbaud, 1987]), which reproduces the Morhardt article; and J. A. Schmoll (*Auguste Rodin and Camille Claudel*, trans. John Ormrod [Munich: Prestel, 1994]). Especially interesting and informative, despite a dubious use of the concept of censorship, is Claudine Mitchell, "Intellectuality and Sexuality: Camille Claudel, the Fin-de-Siècle Sculptress," *Art History* 12 (December 1989): 41–47. See also Monique Laurent and Bruno Gaudichon, *Camille Claudel, 1864–1943*, exh. cat. (Paris: Musée Rodin, 1984), and Pingeot 1988.
5. No question that he enjoyed discussing his work with Claudel, but Rodin also asked many others for their advice, as his secretaries pointed out. In my view Claudel was more of a *practicien*, and the term *collaboratrice* was associated with her out of affection and to help her reputation rather than as an artistic and historical fact.
6. The principal source seems to have been Judith Cladel, who knew both Rodin and Claudel and who wrote, "He consulted her on everything, assigned to her with the most demanding directives the task of modeling the hands and feet of the figures that he composed" (1936, 230).
7. Author's discussion with Pierre Daix in Paris, 28 January 1988, on the occasion of the publication of his book on Rodin.
8. Cladel wrote that Camille "wanted to become the unique object of the master's affection and the companion of his private life" (1936, 231). See also Daix's speculations on Rodin's decision (1988, 111–12); as he pointed out, there was irony in the fact that a woman liberated from the many social prejudices of her day would want to regularize her relationship with Rodin. Daix believed this was because she did not want to lose face socially (108).
9. For Rodin's reaction, see Cladel 1936, 232. This author has argued that Rodin's 1894 sculpture *Christ and Mary Magdalene* is an autobiographical expression of his anguish over the separation from Claudel (1980, 180).
10. It was probably no coincidence that important critics, such as Gustave Geffroy, Roger Marx, and Octave Mirbeau, who wrote favorable reviews of Claudel's work, were thorough and devoted admirers of Rodin and his art. As Daix points out, we do not know if there was a history of mental problems in the Claudel family. Rodin has been faulted for not visiting Claudel during her confinement, but he was 74 and had suffered his first stroke by the time she was institutionalized and then transferred to a hospital in southern France.
11. This last was noted by Cladel 1936, 234; for illustrations of these works see Tancock 1976, figs. 77–3, 77–4c, 108–4, 108–5, 110, 110–2.
12. For reproductions of these works see Pingeot 1988, 37–38, and Tancock 1976, 594. Whether *The Convalescent* was inspired by Claudel's recuperation from an abortion following her impregnation by Rodin has not been proved. Cladel remembered asking Rodin about the rumors, circulated, it would appear, by Rodin's assistants, that "your friend" had four children by him. "In this case, he responded simply, my duty would have been clear" (1936, 232).
13. For the earlier portrait, see Tancock 1976, 593, fig. 108–3; he dated the portrait 1884 following Grappe (1944, 40). Grappe also catalogued a *pâte de verre* reproduction of the head, which was cast in 1911 (1944, 134). The head with bonnet exists in terra-cotta and was dated 1886 by Jianou and Goldscheider (1969, 97). A plaster version was catalogued by de Caso and Sanders (1977, 285–86).
14. This assemblage of the left hand of Pierre de Wissant with the mask of Camille Claudel is reproduced and discussed in Judrin, Laurent, and Viéville 1977, 230, 232.
15. This photograph was noted in de Caso and Sanders 1977, 285–86. The photograph was reproduced in Paul Claudel, "Camille Claudel statuaire," *L'art décoratif* 30 (July 1913): 25.
16. One of the first and most astute comparisons between the styles of Claudel and Rodin was made by Morhardt (1898, 739). He pointed out that in Rodin's work the surface planes extend to the extremities of the figures, and the strength in Rodin's work has also a softness and suavity. He saw Claudel's work as more vehement with fewer gradations between the planes, resulting in vigorous contrasts and passages without transition between light and

shade. Quite rightly Morhardt pointed out that "her figures are never sufficiently three-dimensional." Claudel's figures, especially her couples and groups, tend to be relieflike or two dimensional in comparison with those of Rodin. Her modeling lacks his subtlety and overall sense of a largeness of effect. Claudel could not resist a wrinkle. In one of his few recorded comments on Claudel's art, in 1902 Rodin said to a government inspector critical of her sculpture *The Waltz* (1891–1905; Paris, Musée Rodin) that "Mademoiselle Claudel only wants to do the nude, so we should let her, for it is right and she does not want drapery; she would only do it badly" (Mitchell, "Intellectuality and Sexuality," 437). On Claudel's statue, see Laurent and Gaudichon, *Camille Claudel (1864–1943)*, cat.

nos. 17, 74.

17. In the early years of their amorous relationship, Rodin was in effect seducing a minor according to French law, and like Picasso's relationship with the young Marie-Thérèse Walter years later, secrecy and discretion were obligatory. In 1882 or 1883 a scandal involving a bourgeois minor would have been irreparable for Rodin (Daix 1988, 96–97).

18. Claudel's preserved letters to Rodin lack passion and are at times coquettish. It is her 1888 portrait of Rodin, more than that by any other artist, that captures his sensuous nature.

19. Beausire 1988, fig. 52 reproduces this mask, and 353, 356, 359.

91

Maquette for "Monument to Jules Bastien-Lepage" (*Maquette pour le monument à Jules Bastien-Lepage*), 1887

- Bronze, Godard Foundry, cast 1973, 3/12
- 13¾ x 7 x 7 in. (34.9 x 17.8 x 17.8 cm)
- Signed on base, top left: A. Rodin
- Inscribed on back of base, right: E. Godard/Fondr; below signature: No. 3; on back of base: © by Musée Rodin 1973
- Provenance: Musée Rodin, Paris
- Gift of the Iris and B. Gerald Cantor Foundation, 1974.54

Figures 253–254

*T*his maquette was made for the commemorative statue of the painter Jules Bastien-Lepage (1848–1884; fig. 255) for his native city, Damvillers, near Verdun. The commission was awarded in 1886, and the studies for the monument were finished by late 1887 when a maquette was exhibited at the Galerie Georges Petit.[1] With this work Rodin made two major statements: first, how to celebrate in art the accomplishment of a realist painter who contributed to the history of painting in the open air, and, second, how to make outdoor public sculpture. The maquette captures Rodin's fervor, a spontaneous inventiveness, and formal fluidity, which do not transfer wholly to the final work.

Having convinced or agreed with the committee that he should show the painter in his working clothes, Rodin further established through the stance and base that Bastien-Lepage was in the very countryside in Meuse for which he had gained fame as a painter. He was a contemporary and close friend of Rodin, and when he died in 1884, Rodin desired to show him painting in the open air because he regarded the painter as the "strongest living representative of that way of working."[2] In the early conception represented by Stanford's maquette, it is as if the painter is bracing himself on uneven ground, up to his left knee in a field of wild, thick grass, while he bends forward from the waist to study the landscape. His left hand is raised to indicate that he holds both palette and brushes, and while his right elbow is away from the torso, the fist is pressed, perhaps impatiently, against his side. In what was probably an earlier study, Rodin considered a more aggressively bent pose, the figure leaning forward to study nature with his head turned to his right and his right arm extended (fig. 256).[3] Although the Stanford maquette moves toward the greater reserve and upright stance of the final monument (cat. no. 92), no passive reconnaissance is conveyed by Rodin in the x-like structuring of the body that he learned years earlier from studying Michelangelo: right foot advanced, right shoulder pulled back; left shoulder thrust forward, left foot set back. No two paired limbs lie in the same plane parallel to the viewer, and the head is not directly over a supporting leg but over a void. The effect of this dynamic structuring and attentiveness to the strong design and expressiveness of all sides of the figure is to challenge the primacy of a frontal view as determined by the position of the subject's face and to drive the viewer around the form.

The vigor of the maquette is expressed as much by the

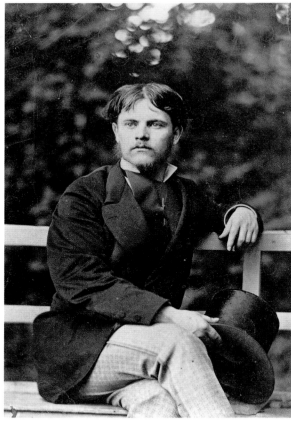

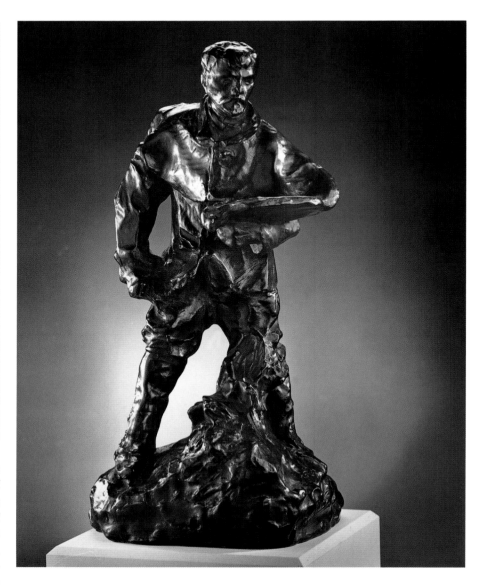

Left: Fig. 255. Photographer unknown. *Jules Bastien-Lepage*, Musée Rodin, Paris.

Right: Fig. 253. *Maquette for "Monument to Jules Bastien-Lepage"* (cat. no. 91).

inspired modeling as by the pose and by the exaggerated billows of the artist's overcoat and cape that create a continuous dialogue of bold concave and convex planes running laterally, wavelike around the back and front of the figure.[4] To get the large planes that give the maquette its wonderful flow and monumental effect, he merged the cape with the palette, heightened the outward flare of the jacket in the back to create a sweeping, concave sculptural spine, made no descriptive textural distinctions between palette and cape, and even engraved a rhythmic series of striations on the cape with his sculptor's tool. The final fold pattern of the trousers began to take the form that would give the life-size statue's silhouettes variety and surprise when seen against the more ample curves of the jacket and cape. In this maquette we are reminded of the professional affinity the sculptor had for the painter, as we see Rodin's determination to make his sculpture partake of the atmosphere around it, just as he saw Bastien-Lepage

seeking to capture the light and air of his landscapes and rural scenes.

Despite the heavy costume—indeed by the way Rodin formed and inflected its surfaces with his fingers—one has the sense of an athlete's body and self-assurance in the way Bastien-Lepage is made to carry himself. The direction and decisiveness of the sometimes flattened planes of the man's right sleeve, more arbitrary here than in the final work, impart the feeling of the covered limb's strength. He is ready for anything. The head not only conveys the strong rudiments of the painter's likeness but also an alert toughness and unshakable intensity of intellectual concentration. To counter the public image of the artist as a recluse and unmanly, Rodin made

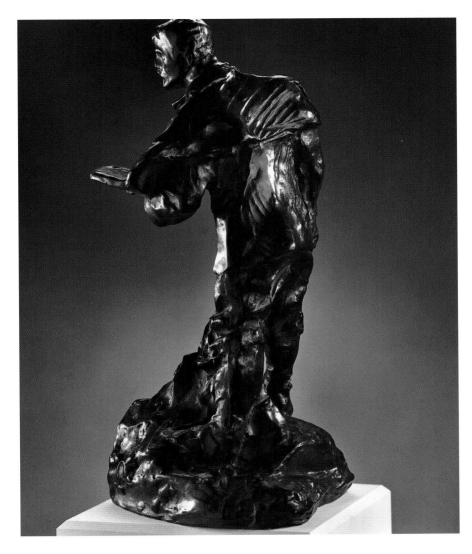

Fig. 254. *Maquette for "Monument to Jules Bastien-Lepage"* (cat. no. 91).

Fig. 256. *Study for "Monument to Jules Bastien-Lepage,"* 1886, bronze, 14³⁄₁₆ x 9⁷⁄₁₆ x 7⁷⁄₈ in. (36 x 24 x 20 cm). Musée Rodin, Paris, S1077.

Bastien-Lepage into a modern athlete of virtue in the arena that will test body and mind to the limit.[5] Rodin's imagery of the suffering artist won him fame during and after his lifetime. Forgotten are such monuments as those to Bastien-Lepage and Claude Lorrain (cat. nos. 91–95) by which Rodin conveyed the joy to be experienced with all that art demands of those artists who would try to understand and master nature's abundance on her own ground.

NOTES

LITERATURE: Bartlett 1889 in Elsen 1965a, 59; Lawton 1906, 76–78; Grappe 1944, 65–66; Descharnes and Chabrun 1967, 149; Jianou and Goldscheider 1969, 101; Schneider 1975, 225–28; Tancock 1976, 71, 404, 411; Schmoll 1983, 39–43; Grunfeld 1987, 266–68; Levkoff 1994, 118, 121

1. Grappe 1944, 66; Beausire 1988, 95. Either this maquette or probably an earlier study was exhibited.
2. Bartlett in Elsen 1965a, 59.
3. Grappe 1944, 66; a cast of this study at the Baltimore Museum of Art was catalogued and illustrated in Tancock 1976, fig. 70-4. This conception "with the right hand extended in a simple, instinctive movement" was described by Lawton (1906, 78) and possibly was the one exhibited in 1887, as noted by Levkoff (1994, 208 n. 6).
4. According to Lawton who must have been told by Rodin, details of the dress were argued, and there were those who thought he had produced "too naturalistic a figure" (1906, 77). See also Schneider 1975, 228 n.1.
5. On "the athlete of virtue" theme, see p. 330, n.9 and 390, n.62.

92

Monument to Jules Bastien-Lepage
(*Le monument à Jules Bastien-Lepage*), *1887*

- Bronze, Coubertin Foundry, cast 1983, 1/8
- 69 x 36 x 33½ in. (175 x 91 x 85 cm)
- Signed on top of base, left side: A. Rodin
- Inscribed on top of base, below signature: No 1/8; on back of base, below right foot: © By Musée Rodin 1983
- Mark on back of base, below right foot: Coubertin Foundry seal
- Provenance: Musée Rodin, Paris
- Gift of the B. Gerald Cantor Collection, 1992.149

Figure 257

In 1889, three years after it had been commissioned, Rodin's monument to the French painter Jules Bastien-Lepage was dedicated in the commune outside the cemetery of his birthplace, Damvillers (fig. 258). The event marked a significant first in different ways for the sculptor. It was the 49–year-old sculptor's first commissioned freestanding public monument installed outdoors.[1] It was also the first monument to an artist whom Rodin had known personally and whom he did not have to re-create exclusively from documents or accounts of the subject from friends. In 1887 Rodin told Truman Bartlett,

> The first time I saw Lepage was several years ago, at a club that met in the rue Veron, called the Pieds Crottées. He was talking very loud and a good deal, his hair was brushed down over his forehead, and he made considerable noise generally. I said to myself: Who is this young chap who makes such an uproar? He can never be a friend of mine. Some time after this he came to my studio, expressed his admiration for my work, and after he returned home he sent me a very charming letter, full of appreciation of what he had seen, and assuring me that he would get some of his friends to buy my things. In a little while he came again and bought a marble copy of the figure of "Sorrow," which he placed in his studio as the only piece of sculpture there. We, of course, became the best of friends,

and, after he died, the committee who had charge of the erection of the statue, and knew of our friendship, gave the commission to me. I made him painting in the open air, because he was the strongest living representative of that way of working. It will be a little larger than life. Lepage was a follower of Manet, with a little touch of the school [Bastien-Lepage had attended the Ecole des beaux-arts]. He had a great tenacity for nature, and was very sincere.[2]

Some years later Rodin recounted the concept for the monument to Frederick Lawton: "I have represented Bastien-Lepage starting in the morning through the dewy grass in search of landscapes. With his trained eye he espies around him the effects of light or the groups of peasants."[3]

In 1884, when Bastien-Lepage died of cancer at age 36, his many friends and family sought successfully to raise a monument to his memory that Rodin would execute.[4] As the monument's advisory committee numbered several persons who were friends of Rodin, it was one of the least difficult commissions for the artist to obtain.[5] The family eagerly supplied Rodin with many documents, including several photographs, from which he was able to model a striking likeness of the artist's face. Hélène Pinet believes that these documents would not have sufficed to inspire Rodin: "It is important to recognize that he will realize a classical enough monument— the painter standing with palette in hand—which does not let us suspect that he had any familiarity with the painter whatsoever."[6]

Rodin's monument was anything but classical or conventional. The vigor of the historically unusual pose must have come from firsthand acquaintance with the young painter as well as from Rodin's desire to show artists as men of action rather than as individuals posing passively or pensively for posterity.[7] Consider what Rodin gave to the memory of his good friend. The painter braces himself with his feet, but the upper body is bent slightly forward. As with *Saint John the Baptist Preaching* (fig. 446); the clothed figure is not plumb, as the academicians would have it, because the head is not on a straight vertical line above a supporting leg; it is over empty space. His straight right leg and left shoulder are thrust forward creating a torsion in the figure at the waist. The preceding studies were yet more nonacademic, with a pose more inclined and with more torsion at the waist (see

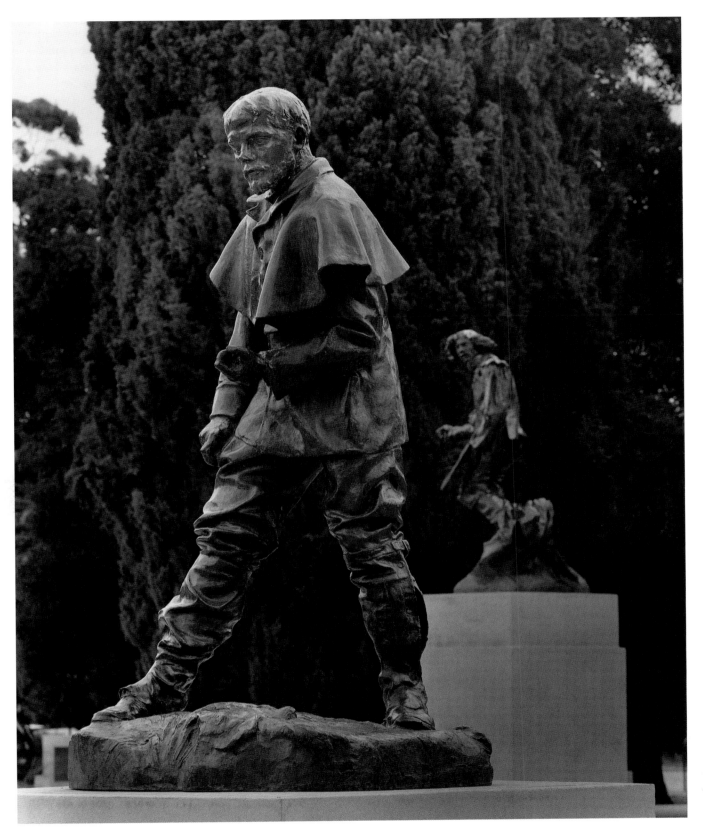

Fig. 257.
Monument to Jules Bastien-Lepage (cat. no. 92).

cat. no. 91). Mindful that Bastien-Lepage was one of the first French painters to work in the open air, Rodin sought to show what for him was the thrilling drama of an artist directly confronting nature.[8] It is as if the young artist is a duelist and nature his adversary. Overall, Bastien-Lepage's stance seems assertive or even combative, for he is braced as if to receive an onslaught but ready to parry. In the actual monument in Damvillers the painter is holding a brush in his right hand and palette in the left, suggesting a sword and shield.[9]

Knowing that his monument was to stand amid those who had known Lepage best, Rodin sought a pose that was not just suitable to his own taste for vigor in figural sculpture but that would be recognized as belonging to his subject.[10] Though talking about portraits, what Rodin told Paul Gsell seems apt for this statue, "The portrait must be more than the facsimile of a face . . . that which must be found is the characteristic pose, that which does not express such and such a moment, but all the moments, the entire individual."[11]

No classical monument would have shown a modern hero in contemporary dress, especially when the garments were the painter's clothes for working in the field. The decision on the painter's costume was made by Rodin with the full knowledge and consent of the committee.[12] The Musée Rodin archives do not contain any photographs of the painter dressed, much less posed, as in the monument. In view of the sculpture itself, and of Rodin's obtaining a few years later, from Balzac's tailor a costume such as the writer would have worn, it seems very probable that Rodin asked for and was not only shown but lent the painter's clothing by his brother, who was in correspondence with Rodin. There are no known

surviving studies of a nude surrogate for Bastien-Lepage, such as Rodin produced for the *Monument to Claude Lorrain* (see fig. 262) and *The Burghers of Calais* (see fig. 108), on which he was working at the time. (We know that at Nancy, Rodin had found a living stand-in for Claude Lorrain.)[13] But the sculptor must have had a model (perhaps the dead artist's brother) put on the garments so that he could study *in the round* such things as the way the cape was carried by the shoulders and how the folds in the sleeves, trousers, and leggings responded to the flesh, muscle, and bone inside them. In the final sculpture one can see, for example, how the calves of the model's legs are pressing against the partially buttoned leggings.

The painter's attire may have given some commissioners and later critics difficulty, perhaps because they thought it too informal, inappropriate, or unclassical for a monument.[14] It was certainly a far cry from the plain, vertically draped garments Rodin was using to robe his burghers but not from the seventeenth-century costume he re-created for his monument to Claude Lorrain. From photographs it appears that Bastien-Lepage could dress in high style, but Rodin was interested in commemorating him as an artist-worker, not in the trappings of success that had come to a man reckoned by contemporaries to be almost as influential as Edouard Manet. For Rodin, who was committed to the naked human form for public as well as private statuary—as seen in *The Age of Bronze* (cat. nos. 1–3), *Saint John the Baptist* (1878), *Adam* (cat. no. 40), and *Orpheus* (cat. no. 96)—this was a new challenge. Despite not having made a study of the naked painter beforehand, he nevertheless worked with accuracy but not pedantry, to the extent that at least one critic called attention to the painter's imagined body. One sees how the garments were buttoned and clasped, but these details are muted so as not to counter the larger effects Rodin sought in the big patterns made by the broad undulating planes of the cape and jacket and the zigzag fold patterns of the trousers and leggings. Walking around the sculpture, as did Rodin, and studying its costumed silhouette, one can see how he was fighting the cutout cardboard silhouettes he despised in academic art. The modeled garments reach out for the light and air and husband the shadows in their folds. Seen even against the sun, the front of the sculpture is not in solid black shadow but possesses those values or halftones Rodin sought in outdoor statues.[15]

While the slightly forward-projecting head is a compelling likeness of the painter and imparts a sense of intense concentration, such as one sees in the head-on photograph Rodin had at his disposal (see fig. 255), it is not as sculpturally or visually compelling as the rest of the figure.[16] The fixed, wide spread of the legs and forward thrust of the head tell us he is not "starting out," as Lawton recalled Rodin saying, but *staring* out in search of landscapes or peasants; nor is it "in the morning," as Lawton recounted, because of where Rodin oriented the monument in relation to the compass. That "dewy grass"—more like flattened marsh grass—indicated in low relief on the base, was intended to suggest that this artist worked outdoors in the fields.

A sympathetic critic, Charles Frémine, was not deterred by the costume details that upset some Damvillers population, and he grasped Rodin's intentions. Of the plaster version, exhibited in the Monet-Rodin show of 1889, Frémine wrote, "It is a portrait of Bastien-Lepage standing, palette and brush in hand. He is represented in the country, head bare, a short cloak on his shoulders, the leggings on his legs, rough shoes on his feet. The sculptor has surprised the painter in a *tête à tête* with nature, penetrating it with his look, waiting for the moment to seize and fix on his canvas. The ardent face, vibrant with expression, is a striking resemblance. Under the clothes that envelope him, all of the body is in movement: one feels it vibrate in accord with the head, with the thought held in the brain: one can disrobe him, expose his naked anatomy, each piece, each muscle is in place."[17]

The monument was installed on a family plot outside the Damvillers cemetery wall on a plain pedestal that Rodin did not design but to which he must have assented. (The pedestal may have been designed by Emile Bastien-Lepage, the painter's brother, who was an architect and who designed the surroundings of the monument, the family plot, and its marker.) The statue was positioned at an angle to the main axes of the cubical pedestal, continuing the tension of the body itself in relation to a real and imagined cube. (Rodin would do this with *The Burghers of Calais*, standing them at the corners of the final monument.) The bronze figure of the open-air painter faces west toward the setting sun and toward the fields where he painted (but where since 1960 there are houses).[18] Thus the monument to Jules Bastien-Lepage was indeed a site-specific sculpture.

NOTES

LITERATURE: Bartlett 1889 in Elsen 1965a, 59–60; Lawton 1906, 78–79; Grappe 1944, 65–66; Jianou and Goldscheider 1969, 101; Schneider 1975, 225–28; Tancock 1976, 404, 411; Schmoll 1983, 43–46; Grunfeld 1987, 268; Beausire 1989, 172; Butler 1993, 207–08, 222, 237–38, 256–57; Levkoff 1994, 118–21

1. His previous unsuccessful attempts in the 1870s and 1880s to gain commissions for outdoor monuments included those for George Gordon Lord Byron, Lazare Carnot, Denis Diderot, Jean Marguerite, and Jean-Jacques Rousseau.
2. Barlett in Elsen 1965a, 59.
3. Lawton 1906, 78.
4. Emile Bastien-Lepage to Rodin, 31 March 1885, in Emile Bastien-Lepage file, Musée Rodin archives. "Some friends of my brother have wanted to express the desire that a monument would be raised to his memory in Damvillers. . . . We will talk among friends [at a meeting] as to the means by which to realize this idea."
5. The commission members included, among others, Roger Marx, Antonin Proust, and the painters Jean-Charles Cazin and Alfred Roll. The nineteenth-century archives of the commune of Damvillers were destroyed in World War I, but Grunfeld seems to have had access to the family papers (1987, 267).
6. Pinet 1990, 48.
7. For example, see Honoré-Jean-Aristide Husson's statue *Eustache le Sueur* (1858; Luxembourg Gardens; reproduced in Tancock 1976, 406). Rodin's work is in the tradition of Jean-Baptiste Carpeaux's monument to *Watteau* (1884; Place Watteau, Valenciennes) and its lively naturalism, as discussed by Schneider (1975, 237).
8. Lawton (1906, 78) and Grunfeld (1987, 267) saw the pose as that of the artist who has stepped back from his imaginary easel to view the effect in his painting.
9. The Stanford cast lacks both accessories. The author asked Jean Bernard, who headed the Fondation Coubertin Foundry that cast the Stanford sculpture, why that was so. He said the brush and palette had been lost and hence could not be cast. Gerard Koskovich, who visited the actual monument at Damvillers, which he rightly calls "the definitive version," communicated that also lacking in the Stanford cast is "the extended bootstrap at the outside of the right calf and the detailed curling frond or plant at the left heel." Koskovich observed also that on the bronze palette is Bastien-Lepage's monogram as well as the modeling of smears of paint. Communication in the author's files.
10. There were, in fact, those who worried that in Rodin's treatment the painter would not be recognized by contemporaries and his identity would be lost to posterity (Grunfeld 1987, 267–68).
11. Pinet 1990, 48.

12. In the Musée Rodin archives of clippings is a notice from the Nancy newspaper *Le progrès de l'est*, 9 March [probably 1885], "This committee has decided that a life-size statue representing Jules Bastien-Lepage, in his '*costume d'atelier*' would be executed by the sculptor Rodin, and placed in Damvillers, *extrà-muros*, near the fields from which he knew how to extract and render poetry."

13. That there are no known studies of a surrogate was confirmed for the author by Hélène Marraud of the Musée Rodin.

14. As noted by Ernest Beauguitte in "Jules Bastien-Lepage," *Le magasin pittoresque*, 15 March 1902, there was bewilderment among the townspeople of Damvillers before the statue of "Petit Bastien" by Rodin: "The powerful sculptor had dared to represent Jules, dressed in leggings that were half-buttoned."

15. Sculptors who have viewed the bronze in the B. Gerald Cantor Rodin Sculpture Garden have admired such views as those of the back, with its big planes and surprising shifts in rhythms from those of the jacket to the trousers. Any doubt that Rodin could look at a clothed figure abstractly can be settled by looking at it purely for the inventive richness of its form.

16. See also Pinet 1990, 53–54, for other photographs. Schmoll made much of the intent gaze of the artist and, as did certain critics of the time, saw it as the crux of the whole (1983, 43). Subsequent to completing the statue, in 1889 Rodin also created a high-relief plaster portrait of the artist (see Grappe 1944, 81).

17. "Claude Monet et Auguste Rodin," *Le rappel* (Paris), 23 June 1889, reprinted in Beausire 1989, 224. Beausire indicated that the work exhibited in 1889 possibly may have been the full-scale plaster maquette at Meudon (172), whereas it was described as half-size by Cladel (1936, 170.)

18. Information provided by Gerard Koskovich, author's files.

93

First Maquette for "Monument to Claude Lorrain" (La première maquette du monument à Claude Lorrain), 1888

- Bronze, E. Godard Foundry, cast 1972, 1/12
- 14¼ x 5½ x 6¾ in. (36 x 14 x 17 cm)
- Signed on base, left side: A. Rodin
- Inscribed on back of base, left side: E. Godard/Ciré Perdue; on base, left side: No. 1; on back of base: © by Musée Rodin
- Provenance: Musée Rodin, Paris
- Gift of the Iris and B. Gerald Cantor Foundation, 1974.55

Figure 259

*U*nder the Third Republic important changes in the commissioning and subjects of public monuments were made in France. Provincial towns increasingly initiated commissions, and heroes of culture became such frequent subjects that their numbers began to rival those of politicians and soldiers. The native cities of famous artists and writers undertook efforts to establish monuments honoring the genius of native sons; by implication such monuments celebrated the artists' birthplaces as well. These initiatives often started with one person who would form a local committee and begin raising funds by public donation. So began the history of the *Monument to Claude Lorrain* in 1877.[1]

As was often the case, lack of funds or disputes within the local committee caused such projects to remain dormant for years or never come to fruition. In 1883 the young Nancy-born writer and critic Roger Marx formed a committee in Paris to work in concert with the local committee toward commissioning a monument to Claude Gellée (called Claude Lorrain, 1600–1682). Although such provincial commissions were partly motivated to show independence from the Paris art world, it was Paris that in this case (and others) gave crucial knowledge, advice, and funds to make the monument possible. Marx and Rodin seem to have met and become friends in 1882.[2] A year later Marx might have informed the artist of the Nancy project, which was initially conceived as a pantheon of great sons of Nancy in an open-air gallery.[3] In 1886 funds were raised with the help of many artists, including Rodin himself, who donated 229 works to be sold from a Paris exhibition and benefit.[4] Thus fortified financially, the Nancy committee went about setting up a limited competition to assure that the best sculptors would be encouraged to enter. Nine sculptors were chosen by the Paris committee and four by that at Nancy, but for the final contest the number was reduced to twelve. Contestants were told in a directive that "the figures will be in bronze, the pedestal in stone or in marble." As for the rest, "the greatest liberty is given to the artists . . . the proportions are left to the judgment

Fig. 259. *First Maquette for "Monument to Claude Lorrain"* (cat. no. 93).

of each contestant."[5] The artists were given a plan worked out in 1888 showing where the work was to be located in Nancy's Pépinière Gardens, and they were to deliver their numbered but unsigned models to the Palais de l'industrie before 20 February 1889.

For the Claude competition Rodin's first maquette, whose exact date of creation is not known, was not the one he submitted, but it is welcome evidence of how he realized his first thoughts.[6] Judith Cladel reconstructed how the first maquette came about, presumably from conversations with the sculptor Jules Desbois, Rodin's friend and frequent assistant. She unfortunately gave no date, but late 1888 seems likely.

One day, upon returning from an official meeting, his head filled with his project, he went to the studio of Jules Desbois, rue des Plantes, in order to explain to him and have him double the size of a sketch that he would consign. Then, carried away by inventive fever . . . without taking the time to fully remove his overcoat, [which] remained on his arm, still wearing his top hat, astonishing his collaborator, accustomed however to this magisterial game, in three-quarters of an hour, on a corner of a stand he improvised this sketch, sixty centimeters in height, very complete, trembling with life and spirit, while emitting verbal indications that were less quick and less precise than those of his hand: on a pedestal, linked by its lines to the style of Louis XV and that the sculptor wanted to be in harmony with the eighteenth-century architecture of Nancy, Claude Lorrain, "the painter of light," caught in action, is represented walking, his palette in his hand, toward the landscape that he will paint. His shoulder struck by the first rays of the rising sun, with a lively gesture, the artist turns toward the dawn. As a commentary on this charming movement, an apparition: the horses of Apollo burst forth from the stone subbasement, urged on by the young god who like them is intoxicated with space and life, while bringing the day to the earth.[7]

Given Cladel's probable source and her personal familiarity with how rapidly the artist could work in circumstances such as this and given the improvised nature of the sketch itself, her account has a ring of authenticity. Her reading of the statue, however, which has the artist walking toward the field where he will paint does not correspond with the stance of the painter. In the first maquette we see not just the vigorous thumbing and fingering of the clay, suggesting that the horses' energetic enthusiasm matched that of the sculptor who made them, but also that he could develop entirely in his head such an ambitious conception as a *whole*. This excited and exciting maquette contradicts critics, such as Roger Fry, who argued that Rodin could think only inductively or in terms of the parts. That he could and did think in terms of overall basic contrasts, structures, and movements is here evidenced by the fact that the essentials of the first maquette, which besides the active and quiet motifs include the shape and direction of the big planes, remain in the final monument.

The first maquette has a vigorous cohesiveness, not just because the two sections of the monument were modeled in the same material but because of Rodin's strong sense of how the sections should work together. The illusionistic base seems to grow out of the pedestal. The horses freed by Apollo's upraised arm explode out of the block. That liberating gesture also drives the attention of the viewer, whether in front or at the sides, up to the figure of the artist and the culminating shape of his head, which is addressed to the light and landscape. Seen from the front, Apollo's head and body, but not his elevated signaling arm, are off the vertical central axis. *Claude*'s bent left leg in turn points downward toward the sun god, who seems himself to be leaping from his chariot, which is signified by only a small, circular disk between the horses. Further connecting the figures is the curve of Apollo's arm, echoed in *Claude*'s arms, while the strong diagonal of the rearing head of the horse at the left is directly paralleled by the painter's raised leg. Contrasted with this mythological mayhem is the stately serenity of the mortal artist who stands leaning slightly backward, taking in the magnitude of the awesome sight.

For the reader interested in Rodin's touch but unaccustomed to thinking about or looking at planes in sculpture, this study makes them explicit, as when Rodin drags his thumb through a roll of clay to mark the rims of the pedestal or makes of the chest a flattened slab or when a small band of clay is pinched and folded back on itself to evoke the profile planes of the painter's head. The rude planar treatment of the horses, whose study goes back to Rodin's youth and earliest sketchbooks, establishes brilliantly the straining and jointed gestures of necks and forelegs. Curator's privilege allowed the author to palpate the maquette and to insert his thumb where Rodin's

had indented a surface near the base of the pedestal's right side and with thumb and forefinger to feel how Rodin had pinched into shape the planes of a horse's extended head. Supporting Cladel's account of the rapid execution as confirmed by sight and touch, there are no important areas that betray a labor of refinement. The great irony is that the pedestal, so promptly and ebulliently materialized in the maquette, would come to torture Rodin over its execution in marble and adverse public reception.

From the sketch it is difficult to tell whether the artist is clothed or not, but given the probability of the latter, Rodin would have worked in planes whose basic nature was undisturbed by details of costume. The painter's position from the waist down is a variation on the same area of Rodin's *Adam* (cat. no. 40), both having one leg straight and the other bent. Rodin uses a simple x-pattern figural composition with the right arm and left leg bent and the right leg and left arm vertical. As with *Adam*, the profiled head of *Claude* aligns with the shoulders for he looks at right angles to the direction of his body. No palette or brushes have been included, perhaps because of the hasty realization of the maquette or because Claude did not actually paint in the open air, as Rodin presumably knew. It is as if the empty-handed artist was making a strictly preliminary reconnaissance. If the sculptor did not intend initially to use brush and palette, perhaps he thought that the escutcheon, modeled with customary skillful rudeness on the back of the pedestal, would confirm Claude's identity as a painter to those who were not from Nancy. As seen in the second maquette, Rodin realized that he needed the artist's

tools as identifying props even if this meant changing history by showing Claude as two hundred years ahead of his time, anachronistically painting out of doors.

NOTES

LITERATURE: Cladel 1936, 167; Goldscheider 1962, 101; Jianou and Goldscheider 1969, 102; Charpentier 1970, 149; Schneider 1975, 233; Tancock 1976, 403, 411; Schmoll 1983, 26–32; Pingeot 1986, 111; Butler 1993, 238

1. Véronique Wiesinger, "Le concours pour le monument à Claude Gellée dit Le Lorrain érigé à Nancy," in Pingeot 1986, 218–19. This short but informative essay is in an interesting section, "Mécanisme de choix et financement," of Pingeot 1986. See also Charpentier 1970, 149–50, and for a good synoptic chronology of events leading to the inauguration of the monument in 1892, 155–56.
2. Charpentier 1970, 150.
3. Ibid., 152. For discussion of Roger Marx's role in connection with the Claude Lorrain monument, see Schmoll 1983, 26–39.
4. Pingeot 1986, 219.
5. Ibid., 221.
6. Charpentier unconvincingly implied that the maquette dates earlier than 1888 by referring to its source in Rodin's work of 1880–82 (1970, 152). Weisinger dated it between 1883 and 1889 (in Pingeot 1986, 222); Butler dated it equivocally to 1886 (1993, 535 n. 3).
7. Cladel 1936, 167. Regarding Claude as the painter of light, Schneider suggests that the monument may allude to the apotheosis of Claude, with the base expressing the idea of the artist's transcendental ascendance toward the light or summit of human aspiration (1975, 238–40).

94

Second Maquette for "Claude Lorrain"
(Claude Lorrain, deuxième maquette), c. 1889

- Title variation: *Study for the Clothed Figure of Claude Lorrain*
- Bronze, Georges Rudier Foundry, cast 1972, 1/12
- 19⅞ x 8 x 8 in. (50.5 x 20.3 x 20.3 cm)
- Signed on front of base, left: A. Rodin

- Inscribed on back of base, left: Georges Rudier/Fondeur. Paris.; on back of base: © by musée Rodin 1972
- Provenance: Musée Rodin, Paris
- Gift of the Iris and B. Gerald Cantor Foundation, 1974.53
Figure 260

*O*n 20 February 1889 Rodin deposited this figure joined with its pedestal—both in plaster—in the Palais de l'industrie in Paris. There it was reviewed along with the maquettes of eleven other artists by a jury made up of the Paris and Nancy committees for the Claude Lorrain monument. Rodin won over Jean-Alexandre Falguière by six votes to four.[1] Most of the other entries show on the top register a costumed Claude sitting and painting while

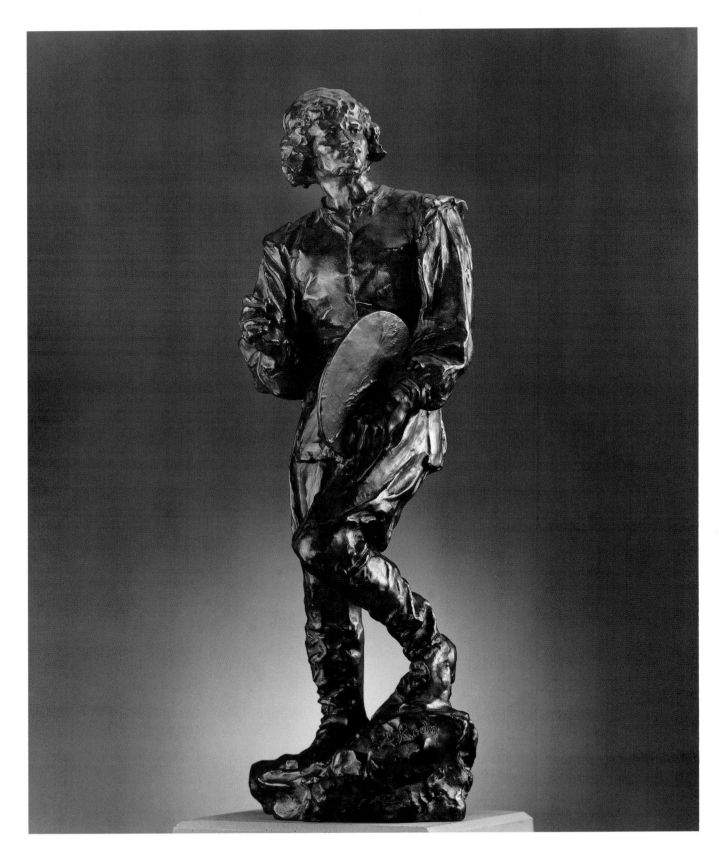

Fig. 260.
*Second
Maquette for
"Claude
Lorrain"* (cat.
no. 94).

below allegorical figures of fame look up adoringly, proffer laurel wreathes, or, as conceived by Jean-Paul Aubé, offer to light his way with a torch. Rodin seems to have won for the aptness and daring of his pedestal. According to the president of the jury, M. Français, who later spoke at the inauguration of the monument in 1892, it was "the fine idea of putting, on the pedestal itself, the motif to which Claude consecrated his life, light, that won him the majority of the votes."[2]

As required by the competition, Rodin had to submit a short statement of his intentions along with the actual model. Fortunately that statement survives. "The preoccupation of the artist in this project has been to personify, in the most tangible manner possible, the genius of the painter of light, by means of an allegorical composition in harmony with the Louis XV style of the capital of Lorraine. In Claude Lorrain's face, enveloped with air and light, it is proposed to express the master's attentive admiration for the nature that surrounds him. The idea is that the statue itself should be in bronze, the socle, with its decorative composition, would be in stone. A. Rodin."[3]

This second maquette was made at a time when Rodin was occupied with other major projects, such as *The Burghers of Calais* and the completion of the Jules Bastien-Lepage monument. He therefore worked with the assistance of Jules Desbois (1851–1935), and, as was often the case when Rodin used trusted assistants on projects such as this, it is not clear exactly how much was done by them.[4] Although Desbois has been described as a collaborator on the second maquette, the word *collaborator* implies shared initiatives and ideas in the creation as well as realization of a work. Desbois was an extremely competent sculptor and was used because he understood what Rodin told and showed him, but there was no creative parity between the two men. In her account of how the first maquette came into being on a visit to Desbois's studio, Judith Cladel mentioned how Rodin, while he worked, gave Desbois verbal instructions as to the enlargement of the sketch. On his own initiative, Desbois would not have known such crucial matters as the nature of the costume and appearance of Claude's face. Using the first maquette as his guide in all probability, Desbois roughed out forms from a live model. Because of his training in the crafts, what Desbois would have been able to do largely on his own, but still with Rodin's guidance, was the detailing of the sculptural decoration of the architectural portion of the pedestal.[5] As the work would

have been in clay, it must have been easy for Rodin to edit and add until he was satisfied that every square centimeter was exactly as he wanted. The small size of the model would have allowed Rodin to rework the entire surface in a short period. For these reasons this author does not refer to the authorship of the maquette in the plural.

The second maquette was made knowing it would come under the jury's intense scrutiny. Rodin therefore carried his second study to a far greater degree of definition than the first, while retaining in the figure the stance of action in repose. The second étude was sufficiently detailed to satisfy the judges' curiosity about such things as the sculptor's accuracy in his portrayal of Claude, who is shown as a young man and still painting in Lorrain, in his historical costume with the capped-sleeve leather jacket and the raveling of the high soft leather boots—all of which, like the garments of Bastien-Lepage (cat. nos. 91–92), was a *costume d'atelier* such as the painter would wear while tramping the fields. Romantic realist portraits of artists tended to emphasize an artist's personality through the momentary emotion expressed in the turn of a head, the eyes, the animated facial expression, and the historical costume, including the more casual open collar or work attire. Compared with the tradition of descriptive realism associated with Pierre-Jean David d'Angers (1788–1856), for example, Rodin seems to have more aggressively aimed to show Claude at work, in this way going beyond the lively descriptive realism of romantic portraiture.[6] Not just in Rodin's day but even now Claude is respected by the French as one of their greatest artists, and Rodin was confronting national as well as the local pride of the citizens of Nancy, and as shown by the reception of the final monument, often at his own peril.

Crucial to the reading of the second maquette is Rodin's stated view of what he wanted to show: "the master's attentive admiration for the scenery in which he stands." The painter's handsome head is slightly raised to make it seem that he looks off into the distance. Now showing the painter armed with his palette and brush, Rodin made it appear that Claude actually painted outdoors in the same manner as Bastien-Lepage. Rodin, who had studied the landscapes painted by Claude, chose to depict Claude as no ordinary painter but not by enlisting the aid of allegorical figures. Instead Rodin depicted the man who was known as the "Raphael of landscapes" in a contemplative moment to

signify the melding of intelligence, reflection, and observation.

The structure of the figure, while not as dynamic as that of the Bastien-Lepage maquette and final figure, continues Rodin's thinking about invigorating public statues through contrasting movements of bodily parts, especially when they are paired, like shoulders, hands, and knees. This energizing of the statue was accompanied by Rodin's war on conventional frontality. In all stages of the monument to Claude, it is only when the statue is seen in relation to the pedestal, viewed head on with Apollo and his horses, that one can clearly determine the equivalent of a frontal view of the figure. Claude's head is turned away from the frontal axis of the body, thereby giving added stress to the artist's right profile. The right shoulder is in advance of the left, which is also higher; the right leg is straight, and the left is bent with the foot and its raised heel poised rather than resting on a rock. When one views the sculpture so that the face is seen frontally, the body is turned to its left from the waist up but is seen more-or-less in profile from the waist down. Having a democratic attitude toward the body and hence lacking the academic prejudice for its front, Rodin achieved a kind of serpentine construction, as if he was seeking to show us as many interesting views of the man's figure as he could from each of several angles—something Pablo Picasso would carry even further in painting, beginning with the squatting right-hand figure in *Les demoiselles d'Avignon* (1907; Museum of Modern Art, New York).

Unlike that of Bastien-Lepage, the figure of Claude is plumb, with the head aligned over the supporting leg. The forward and backward movement of the projecting knee and twist of the shoulders varies the reception of light and shadow, but to emphasize the dignified straight-shouldered erectness of the artist's stance, Rodin channeled the light upward and downward on the sculpture's many raised ridges. The turn of the head helps direct the viewer around the form. Sculpturally the most rewarding view is from the front and to the right of center so that the artist is seen full-face and the in-and-out projections and recessions of the statue's contour, made by his hair, right shoulder, right hand, the palette in his left hand and left knee, can play against one another and create the most active silhouette. None of Rodin's competitors had his subject partake so energetically of the space around him.

This close formal reading offers insight into Rodin's mind. His modernity included the capacity to view abstractly even this period piece. The best of the older artists could do this as well, but Rodin's distinctiveness is in the nature of the liberties taken with illusionism. His thinking as an artist was conditioned by formal relationships, especially contrasts, as found in raised and recessed surfaces, and was expressed by sometimes creating connectives not intrinsic to the subject and by rectifications of what he had previously done. It was his vision of what the final effect of the whole should be that made him unique, and that was as much a warrant of artistic freedom as an expression of artistic intelligence. His genius was knowing when to suspend knowledge of facts in favor of what for him made good sculptural sense. Unlike some of his more literal-minded contemporaries, such as Emmanuel Frémiet, Rodin never tried to dazzle with data. All this is what makes the patient study of his figures so intensely revealing.

Rodin's commitment to achieving a dramatic harmony in his art by making the figure asymmetrical was compulsive. To do something with one side of a figure, for example, meant a countermeasure on the opposite. Seen in relation to the lead edge of the palette, Claude's extended right hand creates an implied plane of an imaginary cube, Rodin's favored geometrical form, in which he visualized his figures. Though more famous for his later abandonment of base as well as pedestal, when he used the former, as seen here, it was not in a passive way. The rocklike ridge rising from the edge of the base and cresting between the feet not only gives a vertical impetus to the figure through the bent left leg, but its shape also echoes the curve of the seat of the trousers when seen from the sculpture's left side. The downward folds of the trousers at thigh level converge to the ridge, and the skirt of the jacket flares outward in the back to compensate for the forward thrust of the left thigh. There are also other connectives: the line of the jacket's center that curves from the neck to the line of the inseam of the trousers and boots below; the alignment of the curved left arm that merges with the protruding left leg; and the fold in the sleeve that leads to the palette.

Boots and sleeves, trousers and jackets—details that one does not associate with Rodin's art nevertheless gave him new opportunities unavailable in the naked figure to show his inventiveness with what he believed were the basics of sculpture. The costumes of Bastien-Lepage and Claude, which raised among critics questions of accuracy and appropriateness, still reward the more sophisticated

viewer by their rhythmic interplay between cavities and ridges and their respective responses to light and shadow. As worn by living models, Rodin found in the costumes the inspiration for his own decorative and expressive geometry. Even more than for the Bastien-Lepage maquette, in the second study for Claude, Rodin used an exaggerated crispness for the raised edges which creates vertical, lateral, and downward movements and sometimes triangular and rectangular shapes in the fold patterns. The bold extrusion of the right sleeve at a 90–degree angle to the arm is a major and satisfying addition to the silhouette seen from front and rear.

Two particularly interesting passages in this sculpture are distinctive Rodin touches. One is to be found on Claude's left sleeve. It is a flat, slightly curved, half-inch strip of clay running from just below the capped portion of the sleeve to the elbow. No attempt was made to model the applied clay band to create the illusion that it was integral to the garment. This was a sculptural decision left raw. It is as if Rodin saw that he needed something to stiffen visually the form of the sleeve, to counteract the strong vertical of the projecting fold of the garment, and to connect the shoulder with the protruding flap of the jacket. A second rectification is found on the inside of the painter's right leg, where, while keeping the big inflections, Rodin smoothed over previous modeling to get a more continuous curving plane, which also strengthened the shape of the interval between the legs.

There is still much that Rodin changed in the final, full-scale figure, notably the treatment of the back and the costume. Unlike the first maquette (cat. no. 93), for which Rodin had no live model, for the second version one senses there was a live body inside that costume as evidenced by the pressure of the chest against the jacket, the suggestion of shoulder blades, and the unmistakable pressure of the bent left knee against the trousers. The fold patterns would be reworked, and the broad plane of the back would be strengthened and clarified. In all, Rodin would need an even stronger form for the statue to hold up against the powerful design of the pedestal.

NOTES

LITERATURE: Lawton 1906, 138–41; Grappe 1944, 79; Jianou and Goldscheider 1969, 102; Charpentier 1970, 149–56; Schneider 1975, 234–38; Tancock 1976, 403–4, 411; Schmoll 1983, 32–34; Miller and Marotta 1986, 72; Pingeot 1986, 110–12, 218–23; Silverman 1989, 246–49; Butler 1993, 237–39

1. Several weeks later the entries were exhibited publicly in the Durand-Ruel Gallery. See Véronique Wiesinger, "Le concours pour le monument à Claude Gellée dit Le Lorrain érigé à Nancy," in Pingeot 1986 for more detailed information (221–23) and for reproductions of the now lost original Rodin plaster and several entries by his competitors (218–22). It appears that most of the entries are in the Musée des Beaux-Arts, Nancy.

2. Tancock 1976, 403.

3. This is from "Notes préparatoire d'un projet de Mnsr. Rodin," a document stolen by Ernst Durig from the artist's papers a few years before his death and recovered by the Musée Rodin some years after the death in 1965 of this notorious forger. This author's translation, which is directly from the document, differs slightly from that of Lawton 1906, 140.

4. Such a discrimination is not made by Véronique Wiesinger in "Les collaborations: A propos du monument à Claude Gellée dit Le Lorrain d'Auguste Rodin" in Pingeot 1986, 110–14. The only evidence Wiesinger offered of the collaboration is a telegram sent by Desbois to Rodin, 10 March 1889, in which he asked for the help the next day of a moldmaker named Cariou with making the molds of Claude (411 n. 8).

5. Based on her careful examination of the full second maquette in the Philadelphia Museum of Arts Rodin Museum (Tancock 1976, cat. no. 70) and knowledge of decorative art in Nancy, Debora Silverman gave an excellent account of these details: "The eighteenth-century derivation of Rodin's project was evident in several elements of the bronze model. . . . The leafy wreath that encircled the base of the statue above the pedestal was a typically eighteenth-century detail. Moreover, at the back of the pedestal, just below the statue, a familiar sign of rococo heritage appeared: a cartouche surrounded by fanning shell forms. Resting on it was a crown. The crown and cartouche had appeared together in the late seventeenth- and eighteenth-century versions of the royal banner . . . resurrected by the Third Republic. And a raised cartouche and crown bedecked the splendid gates at Nancy, which guarded the entrance to the park where the statue was to be situated" (1989, 246–49). Silverman made good connections between the precedent for the composition of the horses and Apollo with eighteenth-century fountain art at Versailles and Parisian architectural sculpture by Robert Le Lorrain.

6. Charpentier observed that the choice of a youthful painter was not by chance and was calculated to show him while he was still working at Nancy (1970, 154). Charpentier said that Rodin's source for the face of Claude was an engraving by Joachim von Sandrart. Tancock reviewed other possible visual sources (1976, 404). The source, Sandrart, is far more credible than Charpentier's view that in addition, the painter's facial expression "owes something" to Rodin's having earlier seen Gian Bernini's *Ecstasy of Saint Teresa* (1645–52; Santa Maria della Vittoria, Rome). In fact, Rodin was capable of inventing such expressions by himself and it was not his custom to take

such things as facial expressions from other artists. Images of Claude Rodin may have known are an anonymous painting in the Galleria dell'Academia di San Luca, Rome; an anonymous portrait in the Musée, Tours, and Claude's *Self-Portrait* drawn on the first sheet of his *Liber Veritatis* (London, British Museum). See Marcel Rothlisberger, *Claude Lorraine: The Paintings*, 2 vols. (New Haven: Yale University Press, 1961), 1: 84–85.

95

Claude Lorrain, Final Version (Claude Lorrain, vêtu), 1889

- Bronze, Coubertin Foundry, cast 1983, 1/8
- 84½ x 42½ x 46 in. (214.6 x 108 x 116.8 cm)
- Signed on lower left of base by right foot: A. Rodin
- Inscribed on back of base, under left leg: © by Musée Rodin, 1983; on lower left of base by right foot: No. 1/8
- Mark on back of base, under left leg: Coubertin Foundry seal
- Provenance: Musée Rodin, Paris
- Gift of the B. Gerald Cantor Collection, 1992.154

Figure 261

On 6 June 1892 Rodin's *Monument to Claude Lorrain* was dedicated in the Pépinière Gardens of the city of Nancy. During the ceremonies it was praised by the officials, including the president of the Republic, Sadi Carnot. Rodin's many friends and admirers, such as Roger Marx and the Nancy ceramist Emile Gallé, supported him in personal compliments and in articles. After the official ceremonies, however, negative reaction was so severe that for once in his life, and to his later regret, Rodin changed what he had considered a finished work. It was the decorative group on the unusual carved stone pedestal supporting the bronze figure of Claude that incited the most antagonism to the monument, but the statue of the artist also came in for bitter denunciation.

Our best indication of how Rodin saw his own statue was given by the artist to a studio visitor and then published by Frederick Lawton: "Rodin in his statuary has a main idea which, in each piece, constitutes its moral unity." Lawton noted that Rodin's interpretation was given while the statue was still in his studio: "My Claude Lorrain has found, and he is admiring what he always found, what he always admired, and what we find and admire in his pictures—a splendid sunrise. The broad orange light bathes his face, intoxicates his heart, provokes his hand armed with a palette . . . so that the good workman may be recognized in him. The resemblance I caught in this way. The best and only likeness we have of him is just Marchal's face, the painter Marchal. This is a happy chance for me and flattering to Marchal. So I have a living Claude Lorrain, instead of a sheet of paper more or less covered with black strokes. As regards the soul, the thought, the genius of Claude, I had his pictures, in which he has put the sun and himself."[1]

In 1889 Rodin was working on *The Burghers of Calais* and *The Gates of Hell*, trying to complete both during the centenary of the French Revolution and to establish his reputation as his country's leading sculptor. When on 2 July he was given the commission for the monument to Claude Lorraine, Rodin counted on his very able assistants, the modeler Jules Desbois and his carving *praticiens* Victor Peter and Jean Escoula, to realize the pedestal in stone. In 1891 Rodin won the competition for the monument to Balzac and devoted most of his time for at least the next two years to that project.[2] That Rodin was relying on his assistants to execute the monument to Claude was no secret, but in a letter of 1890 to Emile Adam, the mayor of Nancy, the sculptor had clarified his own role: "I will also come to Nancy toward the end of the work to myself retouch the execution in stone of the horses."[3] According to the records in the archives of the Musée Rodin, which show a day-by-day accounting of expenses, Jules Desbois became the *chef d'atelier* in Nancy, where Rodin set up a studio for the enlargement of his prize-winning maquette.[4]

At least one or two male models were found from whom Rodin and Desbois could work to achieve not only a portrait likeness but also a life-size nude figure. Rodin would have familiarized himself with the available but limited resources documenting Claude's appearance, but as with his work on the Balzac and Baudelaire monuments, he was most fortunate and happy to find a living person, the painter Charles François Marchal, whom he thought resembled the seventeenth-century artist.[5]

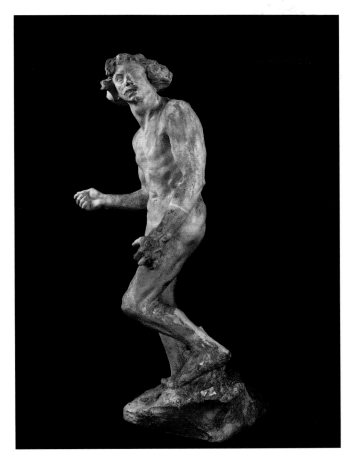

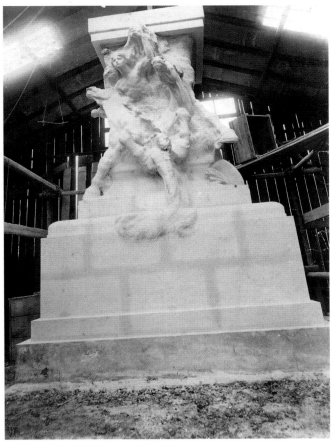

Left: Fig. 262. *Nude Study of Claude Lorrain*, c. 1889–90, plaster, height 90¾ in. (231 cm). Musée Rodin, Paris, S171.

Right: Fig. 263. Photographer unknown. *"Pedestal of 'Monument to Claude Lorrain' in marble and stone,"* c. 1891–92, Nancy (A92).

The statue has been described as showing "taut immobility."[18] When we analyze the figure, however, what Rodin has shown is a *summation* or *succession of movements and emotions.* There are three discernible stages to the movement. It starts with the left leg and foot, left hand holding the palette, and right with upraised brush—all evoking the original relaxed stance, and presumably calm attitude, before an imaginary canvas and easel. Augmenting the sense of the artist's having been concentrating on his canvas is the fact that the shoulders and neck are not as erect as in the second maquette but are bent slightly forward. Secondly, the right foot, now with toes pointed inward, and shoulders have pivoted toward the figure's left, and, as seen in the model of the nude figure (see fig. 262), the body is becoming tense, perhaps as the artist senses the light hitting his left shoulder. In the third stage of movement, and without straightening the neck, the slightly bent head is pulled around drastically to its left so that the artist fully faces the sun.[19] What has been described is fully consistent with Rodin's own oral and written interpretation and his audacities in

putting the figure in movement by means of asymmetrical orientation of bodily parts. Tancock wrote of "the clumsy although intense figure of the final monument."[20] If one views the statue as being seen in a fixed moment, such a reading is plausible, but then one has to forget all that one knows about Rodin. The same could be said of *The Walking Man* (cat. no. 174), with his flat-footed stride and diverging bodily axes employed to show a succession of movements. As a great dramatist and psychologist of the body, Rodin used this sequential rather than fixed presentation to show a momentous change in Claude's consciousness brought about by a sudden secular epiphany. As with the tensed, powerful figure of *The Thinker* (cat. no. 38), Rodin here used the muscular capabilities of the body not only to impart the sense of the hard physical work of art but to emphasize how the inspirational moment engages the artist's entire being.

Compared with the second maquette, the changes Rodin made in the statue from boot to brow are far more imaginative and daring than anything his assistant Des-

bois could have conceived. The entire base has been rethought and then reshaped so that by its new upward-sloping design it adds to the springiness of the figure when seen from the front of the pedestal. Viewed from this angle, a zigzag design starting with the base and rising through the left leg and into the body appears. The base and raised left heel of the painter are partially covered by a heavy cloth, perhaps a partially folded cloak that the artist might have impatiently dropped from his arm or shoulders as he took up his brush. Seen from the back of the sculpture, what is a rock supporting the painter's left foot is now concealed behind the mound made by the vertical folds of the mantle.

The booted feet of the painter were enlarged so that in isolation they seem huge. At least since his *Adam* (cat. no. 40) and consistently with *The Burghers of Calais* (see, for example, cat. no. 13), Rodin had made the extremities of his life-size statues disproportionately large. Seen against the big bodies they support, however, the feet are in a plausible *artistic* proportion. The exaggerated size of the extremities not only satisfied Rodin's demands for structural and visual plausibility but also ensured that their gestures carry from a considerable distance. Rodin in effect developed what might be called *functional proportions*, such as Pablo Picasso later used for the feet and hands of his *Man with a Sheep* (1943; Philadelphia Museum of Art).[21] In the Claude statue, for example, the figure is top-heavy by conventional standards, due largely to the very broad shoulders and flared sleeves. The wide-topped figure tapers down to the very narrow base of support provided by the two feet that have been brought close together. Their enlargement offers visual logic to their functional role. In changing the position of the right foot, Rodin also moved the bent left leg closer to and slightly in front of the weight-bearing right leg, thereby closing the space between the two limbs and increasing the sense of imbalance between the upper and lower portions of the body. The design of the boots was changed, their tops are turned down, and there are fewer wrinkles, which give simpler silhouettes, hence a cleaner, more easily read form.

In the new treatment of the jacket we can see fresh connectives and formal rhymes as well as examples of Rodin's found geometry in his motif. The front of the jacket has been caught by the edge of the palette, and the result makes a bridge between the two shapes. (Rodin may have effected this union to provide a brace for the thin form of the palette.) The vertical edges of the two sleeves, especially that of the painter's left arm, made prominent to swell the overall silhouette from the front and back, make a succession of rounded forms with the palette. Due mainly to the style of the jacket, from the back the upper silhouette has a somewhat squared-off character. One has a strong sense of a well-muscled body beneath the garment, and its tight fit reveals the concavity of the figure's spine down to its hollowed base, below which are the inverted and vertical V-shapes of the body of the jacket.

The biggest change in the costume is the upturned collar, open at the neck, by which Rodin could thicken the juncture between head and shoulders as he would do in the neck area of the final Balzac statue (cat. no. 112). As if to add to the youthful vigor and rugged masculinity of the figure, a frontal view emphasizes the line of the bare neck rising to join that of the open-mouthed profile. That he was at one time not completely satisfied with the head, or was interested in another treatment, is shown by an ink drawing Rodin made on a photograph of the statue still in clay. With a pen he changed the hair so that it was tidier, strengthened the mustache, added a small goatee, and redesigned the collar.[22] These alternatives were not carried out. Rodin obviously decided that the fitting climax to the statue of the youthful artist was the framing of his astonished countenance by the agitated shapes of his windblown hair seen against the sky.

In 1892 Rodin demonstrated that he could still produce a finished statue by salon standards. Five years later in his *Balzac* he would show a calculated disregard for such a finish, but it would cost him the commission.

Reactions to the Monument

Criticism of the Claude monument did not reach national proportions, but local reaction for and against it gave Rodin a foretaste of what he was to encounter in 1898 with his *Balzac*. An avalanche of letters appeared in the local and regional press. As one writer with the nom de plume JeanJean observed, "For once beautiful Nancy has come out of its solemn apathy." Discontent focused on the rapport of the statue with the pedestal, the treatment of the horses in the latter, the characterization of the painter, and the relation of the monument to its garden setting. JeanJean expressed the sentiments of many when he wrote, "On first sight the monument raised to the memory of Claude Gellée produces a painful impres-

sion. One is shocked by the meanness of the work's ensemble which affects singularity by a complete absence of harmony of the lines. In truth, the surrounding landscape crushes and annihilates it. . . . The great painter instead of appearing to shout Hosanna to the light, seems rather to ask the passerby to forgive the sculptor who so bizarrely dressed him in bronze."[23]

The censure of the monument's proportions was based on what seemed to skeptics to be a statuette perched on a vast pedestal, and the ensemble was compared to a frog sitting on an ox. People complained that when seen against the light, the statue was unreadable and seemed like a figure from a Chinese shadow play. It was pointed out that Claude did not paint out of doors but memorized the effects of light or noted them with wash in his sketchbook.[24] It was also contended that as Claude did not paint outdoors, his windblown hair was incorrect, and therefore this could not be his portrait.[25] The horses of the pedestal were given a mixed reception: admiration for their spirited character but criticism for tactless unrestrained fury. For Rodin what seems to have been the most influential negative criticism was the dismay of many that the horses' hindquarters were still engaged in the pedestal and hence did not really look like "true legs."[26] To his later regret, Rodin had an assistant bring the rear legs into greater relief.

Perhaps prodded by JeanJean's printed complaint that the artists who defended Rodin's work had not taken the trouble to explain the reasoning behind their "formulas of admiration," the ceramist Gallé wrote a long and penetrating analysis of the monument itself and the fundamental basis of the controversy. He found that Rodin's research into unusual or strange movement, rather than searching in nature for simple, beautiful, and harmonious attitudes as found in ancient art, wounded the viewer's innate sense of beauty.[27] He traced that popular sense of beauty to a very old and narrow-minded system, "a secular theory of beauty, professionally patented, jealously supported since Plato," held in regard presumably by the academic tradition and in modern times by the École des beaux-arts.

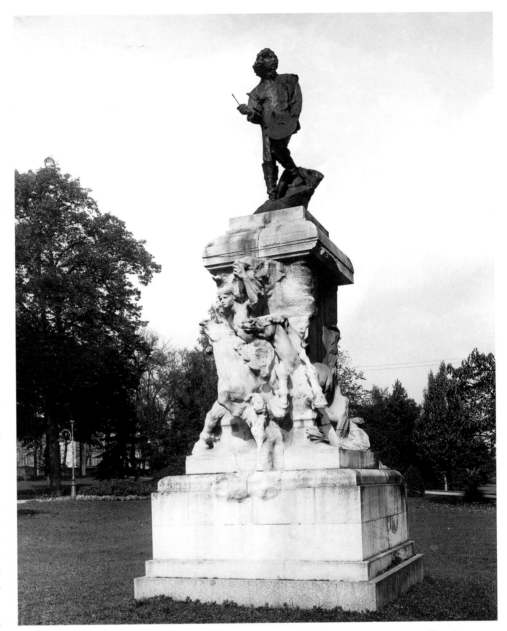

Gallé divined two basic forms by which artists worked: "one decorative, the other expressive." The "art of beauty," he argued, was a decorative one that had produced much that was admirable, such as the art of ancient Greece. Gallé saw the second tradition as attaining beauty by the "simultaneous expression of physical and moral life, the subject intensely rendered in his visible form and in his interior being as perceived through the artist's own personality." Gallé cited French medieval art and that of Michelangelo as "sacrificing form" to capture "inner emotion." Thus, he continued, "We have come to demand of our artists the thought, the example, the emotion, the human tragedy." To satisfy these

Fig. 264. Jacques-Ernst Bulloz, "Monument to Claude Lorrain," bronze and stone, Pépinière Gardens, Nancy, 1892. Rodin archives, Iris & B. Gerald Cantor Center for Visual Arts, Stanford University.

demands of showing states of the soul and the sad condition of the human personality, the artist would risk breaking with charming the senses and the delicate instinct of the beautiful. "The theory that makes the beautiful the exclusive object of art is for narrow minds. . . . Expressive art has nothing to do with plastic beauty." For Gallé the work of Rodin and particularly the statue of Claude was incontestably characteristic of a mode of beauty equal to, if not morally and vitally superior to, the other.

Gallé then challenged the reader to really look at the monument in its site, and he pointed out that Claude's face is illuminated by the sun at dawn and all during the morning. "It is thus logically placed." He considered the best views to be found when the spectator stood to the right of center and also so that the figure was well seen against the branches of a great elm. He closed by discussing the statue itself, arguing that the awkward body is rent by the labor of a stubborn idea and that the painter's face is illuminated less by the growing light than by internal genius. "It is an instantaneous vision of life seized between several attitudes of innumerable variety. . . . It pleases me to think that Rodin has wanted to mark the difficult labors of mind and body through which Claude had conquered the secret of his luminous palette."[28] Finally—and he deserves the last word—Gallé attributed Rodin's use of figural torsion and breaking of "the line that pleased the crowd" to the sculptor's "translating for us the intellectual labor and physical demands of his hero."

NOTES

LITERATURE: Maillard 1899, 58; Lawton 1906, 141–45; Cladel 1936, 168; Grappe 1944, 79; Jianou and Goldscheider 1969, 102; Charpentier 1970, 154–58; Schneider 1975, 229–40; Tancock 1976, 404, 406, 411; Elsen 1980, 175; Schmoll 1983, 33–39; Pingeot 1986, 112–14; Silverman 1989, 252–56; Butler 1993, 256–59, 262–63

1. Cited by Lawton 1906, 141, 142; see above p. 323, n.6.
2. Regarding the competition for the commission, see Véronique Wiesinger, "Le concours pour le monument à Claude Gellée dit Le Lorrain érigé à Nancy," in Pingeot 1986, 218–23, and Charpentier 1970, 149–58.
3. Rodin to Adam, 12 September 1890, reprinted in Charpentier 1970, 157.
4. For a summary of Desbois's duties, see Véronique Wiesinger, "Les collaborations: A propos du monument à Claude Gellée dit Le Lorrain d'Auguste Rodin," in Pingeot 1986, 110–14. Desbois supervised Rodin's employees, such as the moldmaker and carvers, dispensed tips,

bought tools and materials from paper to charcoal and rags, paid the models, and kept the studio clean. There is even a record of the dismantling by one of Rodin's employees of the carcass, or clay statue and its metal armature, when the project was completed.

5. Tancock 1976, 404 and also fig. 70–3, an anonymously painted portrait of Claude Lorrain in the Musée des beaux-arts in Tours, which Rodin could have seen as he visited that city while working on the *Monument to Honoré de Balzac.*
6. Tancock observed, "Although no small nude study of the painter is known to exist, some idea of its appearance may be formed from the work generally known as *Aesculapius*" (1976, 404). Grappe dated this sculpture after 1900 (1944, 110), but Tancock, who dated it c. 1903, was right in seeing postural similarities between the two. For the life-size, clothed study of Claude, see Tancock 1976, fig. 70–6. For *Aesculapius*, see this volume, cat. no. 169.
7. Wiesinger, "Les collaborations," 111: "That would explain the notable differences that exist between the maquette such as it was accepted and the monument."
8. This statement is from a letter to a Nancy lawyer named Jules Rey, who published samples of his correspondence with others regarding Rodin's monument in "La statue de Claude Gellée," *L'est républicaine,* 11 July 1892.
9. According to Debora Silverman's hypothesis, "Rodin's image, resonant with the themes of *fin-de-siècle* French '*psychologie nouvelle,*' cast artistic labor as the union of psychological strain and physical pain" (1989, 252). The phrase "athletes of virtue" alludes to the essay by Colin Eisler (see Eisler 1961, I:82–97). For a discussion of athletic iconography in Rodin, see p. 390 n.62.
10. This is a paraphrase of Emile Gallé's defense of Rodin in his important article "L'art expressif et la statue de Claude Gellée," *Progrès de l'est,* 7–8 August 1892. Silverman aptly commented on its significance, "A senator from Lorraine reminded the citizens of Nancy that Rodin's sculpture was inaugurated as part of the Festivals of the Union of Gymnastic Societies. What had the image of a slight, deformed, twisting and 'pockmarked' painter to do with the event designed to instill the love of physical agility, harmony and muscular strength? In Nancy, rife with campaigns to avenge the provinces lost in the Franco-Prussian War, gymnastics was inseparable from nationalism, the fostering of bodily power among young anti-German recruits" (1989, 253).
11. See also Elsen 1980, pls. 73–74. From an article written by N. Pierson, "Le monument de Rodin," *Progrès de l'est,* 21 April 1892, it appears that this studio, or "maison des planches," was made of large planks or wooden partitions, had dust-covered windows, and was built on the grass near a kiosk in the Pépinière Gardens. According to Pierson, it was the subject of curiosity among strollers in the gardens who could hear, if not see, Rodin's assistants at work on the stone pedestal.
12. Elsen 1980, pl. 73.
13. Ibid.

14. Further discussion of the final pedestal is outside the compass of this essay. The roles of Desbois, Peter, and Escoula were ably discussed by Wiesinger ("Les collaborations"), who attributed the loss of unity between statue and pedestal composition largely to Desbois (112–14). For Rodin's correspondence relating to the pedestal, see Charpentier 1970, 156–58.

15. Claude's landscapes show the late afternoon, by implication, and the cast shadows suggest that the sun was low in the sky, but Rodin's view was shared by everyone else.

16. Maillard 1899, 58.

17. There is no brush in the Stanford statue. Jean Bernard of the Fondation Coubertin Foundry informed the author that, the one used for the monument was probably coated in plaster and its mold had been lost.

18. Silverman 1989, 252.

19. Tancock wrote, following Lawton (1906, 141), that "the painter compares the brilliance of the sun with his own depiction of it" (1976, 404), but that would be a fourth movement that Rodin did not show and Tancock filled in.

20. Tancock 1976, 404.

21. See Albert Elsen, "Picasso's *Man with a Sheep*: Beyond Good and Evil," *Art International* 21 (March-April 1977): 8–15, 29–31.

22. Elsen 1980, pl. 75.

23. JeanJean, "A propos de la statue de Claude Gellée," *Dépêche Lorraine*, 17 July 1892.

24. "Rodin et la statue de Claude Gellée," *Revue des beaux-arts*, 6 August 1892. Some of Rodin's competitors for the commission, among them Aubé and Falguière who had a greater concern for historical accuracy, in their maquettes showed Claude seated and working in a large sketchbook (Wiesinger, "Le concours," 220–21).

25. Cited by Gallé in "L'art expressif."

26. E. Goutière-Vernolle, "La statue de Claude Lorrain," *La Lorraine-artiste*, 12 June 1892.

27. Cited by Gallé in "L'art expressif."

28. The important phrase printed in italics in the original is "*la peine d'esprit et de corps, l'effort non ais*é," which Silverman translated (1989), "the physical and spiritual pain, the immense effort." The translation of *peine* as pain, while not the only one possible, is perfectly correct, but it is essential to her thesis of "pain and strain" and the influence of the "new psychology" that Rodin supposedly derived from Jean Charcot and the poet Maurice Rollinat.

96

Orpheus (Orphée), 1892, enlarged 1900

- Title variation: *Orpheus Imploring the Gods*
- Bronze, E. Godard Foundry, cast 1981, 8/12
- 56 x 36 x 48 in. (142.2 x 91.4 x 121.9 cm)
- Signed on back of base, right: A. Rodin
- Inscribed on back of base: E. Godard Fondr; on back of base, left: No. 8; on base, right side: © by Musée Rodin 1981
- Provenance: Musée Rodin, Paris
- Gift of the B. Gerald Cantor Collection, 1992.156

Figure 265

*T*he story of Orpheus, the most famous poet and musician in Greek myth, was recounted by Ovid in his *Metamorphoses*. Several copies of Ovid's works can still be seen in the sculptor's library in the Musée Rodin. The muses taught Orpheus to play the lyre, a gift from Apollo. His music charmed everything in nature, from beasts to stones. He married Eurydice, who was killed by a viper's poisonous bite while trying to escape a rapist. Orpheus descended into the Underworld to bring his wife back to life. His music so moved the guardians, judges, and the ruler of the Underworld that Eurydice was allowed to return to earth on condition that Orpheus not look back at her until they both were in sunlight. Impatient to see his love, Orpheus looked back before Eurydice could step into the light of day, and she was lost forever.

The Orpheus theme, so popular with symbolist artists at the end of the nineteenth century, was compelling for Rodin as well, not simply for being a tragic love story but because of its relevance to his private life and his profession.[1] A frequent subject in his art is the despairing lover, who can also be the artist, and his muse. Troubled love and the remoteness or elusive nature of inspiration are almost always personified by a woman.[2] If Georges Grappe was correct and this sculpture showing a solitary Orpheus dates from 1892, it and a second version almost ten years later of the Orpheus and Eurydice story may reflect the artist's agonies over his impending or actual separation from Camille Claudel, his mistress, model, and assistant.[3]

Orpheus is an example of a Rodin sculpture that was titled and not named, a deliberate figural narrative

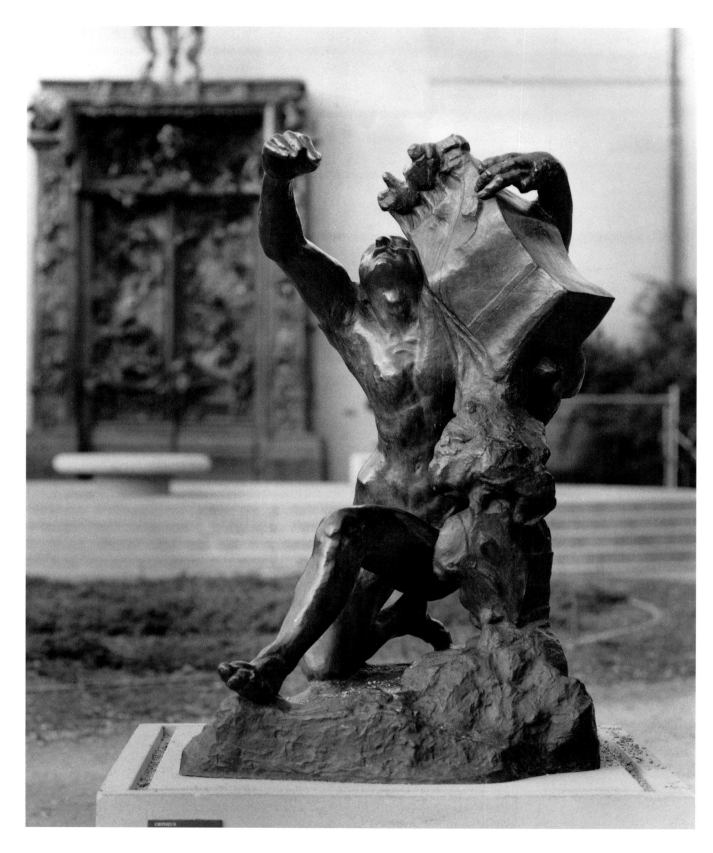

Fig. 265.
Orpheus (cat.
no. 96).

inspired by Rodin's own readings in Ovid, perhaps by the Latin poet's popularity among contemporary artists as well. Rather than a found pose spontaneously generated by one of his freely moving models, the half-kneeling posture of Orpheus would seem to be Rodin's original invention, made to evoke different aspects or moments of a tragic event: the physically arduous quest, the ordeal of playing for infernal audiences, and the final loss of Eurydice. The musician's right arm is raised, his hand partially closed on the air. (Dorothy Kosinski suggests that the thumb and forefinger are joined as "if frozen in the backward motion of the rhythmic strumming of the instrument.")[4] As a result of accidental studio breakage or Rodin's deliberate amputations, some fingers are missing from the figure's left hand. In Jacques-Ernst Bulloz's photograph, taken under Rodin's direction, it is clear that at least his fifth finger has been broken off (fig. 266). Although Orpheus was right-handed, the sculptor perhaps retained the damaged fingers of the left because they may have suggested that the loss of love and inspiration crippled his ability to perform. Orpheus's closed eyes suggest simultaneously the attempt to hold the vision of the lost Eurydice, blindness resulting from his separation from inspiration, and possibly his impending death.

Rodin gave one interpretation of his figure to an American reporter in 1901, but knowing the sculptor's penchant for plural readings of his own work over time, there must have been others: "I have represented Orpheus at the moment when having tuned his lyre for the infernal chorus and having been awarded the coveted prize of Eurydice he sinks back overcome by the fatigue of his wanderings and the memory of his past anguish. One folded leg partly supports his failing body and his left hand upholds the lyre, while his right hand is extended in supplication. He is to lose Eurydice again, but he does not suspect this now, when the bliss of regaining her has broken the long strain of suspense and suffering."[5]

It seems to have been around 1901 that Rodin conceived the idea of showing both tragic lovers in plaster; the upper portion of the reclining figure of *The Martyr* (cat. nos. 72–73) played the role of Eurydice, poised above the straining form of Orpheus and facing downward, as is visible in Bulloz's photograph.[6] The upper half-length cast of the enlarged *Martyr* from which Rodin did not remove the traces of its supporting material behind her head and left shoulder, was partially sup-

ported by Orpheus's raised right forearm. This was not the version Rodin interpreted for the American journalist, and Eurydice does not appear in the bronze cast. All that remains of Eurydice in the final bronze is her hand on the back of the lyre, something Rodin added when the half-length plaster cast of the woman was removed as, in the plaster, she made no such gesture. At the time that he exhibited a plaster of just the figure of Orpheus in the Paris Salon of 1908, Bulloz's photograph was reproduced in the journal *Je sais tout* (15 July). This publication of the assembled pair was an excellent example of Rodin effectively asking, What if one showed the public what was normally done in the privacy of the studio?[7]

Fig. 266. Jacques-Ernst Bulloz, *Orpheus Imploring the Gods* in *Imploring the gods*, c. 1892, *in plaster* after 1903, gelatin silver print. Musée Rodin, Paris.

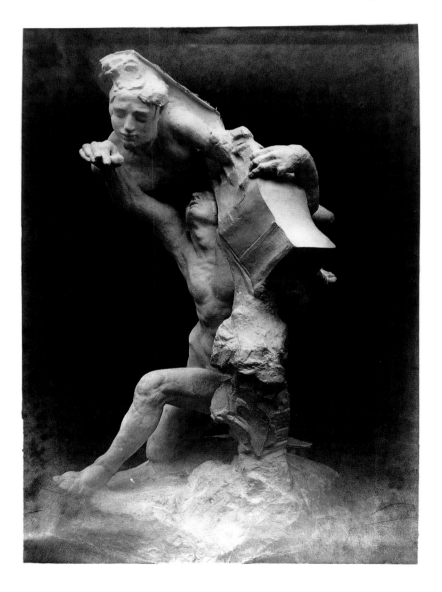

The figure of Orpheus is an anatomical hybrid and, despite the presence of genitals, is somewhat androgynous and of uncertain age.[8] Following the loss of Eurydice, Orpheus scorned the company of women in favor of young boys, so from Greek myth Rodin knew of his subject's bisexuality. The entire figure was not taken from a single model, and the whole depends more on artistic logic than anatomical consistency and, in the broader context of his art, exemplifies Rodin's sometime disregard for gender and age specificity in an individual figure. Orpheus's arms, hands, and legs have a masculine character. In the back there is no attempt to show the shoulder blades or tensed deltoid muscles or to effect a natural anatomical transition to the raised and proportionately very large arms. Probably to help support the heavy elongated arm (and the addition of Eurydice), the area of the right armpit is very thick. When approached from the rear, the torso with its smooth back and extraordinarily thin waist appears to be that of a woman. From the front the lower body is like that of a late adolescent, but the rib area shows a greater fullness of modeling and also has breasts. The projection of the right hipbone, which is high in relation to the iliac crest, drew the admiration of one Parisian critic who nevertheless felt that this did not add up to a "true statue."[9] The hypertrophied joint below the left toe and the bulking up of the foot and toes would not normally be found on a person as young as that represented by the lower torso. As with *Head of Sorrow* (cat. no. 55), with which it has affinities but is not identical, the lower torso of Orpheus could serve either sex. Similarly, for example, Rodin used a smaller version of the head on the son on Ugolino's back (cat. no. 45) and on *The Centauress* (cat. no. 158).

Rodin chose to give Orpheus a heavy and bulky musical instrument unlike that depicted by contemprary painters such as Gustave Moreau.[10] (This suggests that Rodin may have been evoking art's burden.) For practical purposes, namely, the sculpture's structural strength, this required that it receive support from below. To meet that need Rodin improvised a very rugged, vertical succession of bulbous forms that are closer to abstraction (and the modeled sculpture of the 1980s by Alain Kirili and William Tucker) than anything in nature or the convenient tree stump used by ancient Greek sculptors. This vertical support helps square off the composition so that the whole can be visualized within the cube that Rodin thought guided his art even more than nature.

The sculptural virtues of the statue reside not least in several of its profile views, especially that to the right of front. (We are guided in this by Rodin's choice of angle for Bulloz.) There is a kind of gentle geometry initiated by the contrast of the rectilinear silhouette of the bent left leg and big concave curve that springs upward from the right side of the pelvis and is generated by the raised arm.

In 1900 Rodin had Henri Lebossé enlarge the sculpture to three times its original size. There does not seem to be any preliminary study for *Orpheus*. The sculpture did not have as rich an exhibition history as many others by Rodin, but it was shown in Prague (1902), Dresden (1904, the torso), Paris (1908), and possibly Lausanne (1913).[11] During the 1908 Salon showing of *Orpheus*, Rodin's sculpture received brutal criticism for its lack of either decorum or an ennobling idea as well as for being unfinished and merely a fragment. It is instructive to note the incomprehension of the artist's contemporaries at the same time that other radical experiments were being initiated by painters: "A little Orpheus, a young man, is in the act of falling over. The pose is ridiculous: a character who is falling over cannot be the subject of a statue; immobilize the movement, what an adventure! . . . But the young man tumbles over because of a very heavy object that he carries on his left shoulder; it resembles a piece of a monument: and it is a lyre since the young man is Orpheus. Behind the lyre is a hand, all alone, cut off at the wrist, a hand that has fallen there one does not know how, and which is not lent to Orpheus. These three statues [*Whistler's Muse* (cat. no. 117), *Triton and Nereid* (c. 1886), and *Orpheus*] are ugly . . . ugly and insignificant . . . in the Orpheus there is no idea, not even a little one. It is nothingness and chaos together."[12]

NOTES

LITERATURE: Grappe 1944, 89; Tancock 1976, 188, 200, 204; Pingeot 1986, 102; Ambrosini and Facos 1987, 165–69; Kosinski 1989, 159–62; Levkoff 1994, 127–28

1. For interesting and convincing interpretations of the statue, see Dorothy Kosinski, *Orpheus in Nineteenth-Century Symbolism* (Ann Arbor: UMI Research Press, 1989), 159–62; and Ambrosini and Facos 1987, cat. no. 51.
2. See Jamison in Elsen 1981, 105–25.
3. Grappe 1944, 89. Beausire accepted the date 1892 (in Pingeot 1986, 101). The marble *Orpheus and Eurydice Leaving Hell* (Metropolitan Museum of Art, New York) is

signed and dated 1893, the year Rodin and Claudel separated. The marble is illustrated in Vincent 1981, 12–13.

4. Kosinski 1989, 159.

5. This important quotation from "Rodin's Tears Seem Real," *Chicago American*, 3 August 1901, was reprinted in Ambrosini and Facos 1987, 167.

6. Beausire briefly discussed the plaster version of the couple and other versions of the Orpheus theme in Pingeot 1986, 98–102; see also A140 and A151. The figure of Eurydice in the Metropolitan Museum of Art's marble (see note 3 above) is recognizable as the *Martyr* in her earlier appearances on *The Gates of Hell* (see cat. nos. 72, 73).

7. Beausire cited the publication of this photograph (1988, 298). Bulloz's shop was and remains just a few steps from the main entrance of the École des beaux-arts on rue Bonaparte in Paris, where students could often see Rodin's latest sculptural adventures in photographs, which was the artist's intention.

8. For these anatomical observations the author is indebted to Dr. William Fielder of the Stanford University School of Medicine.

9. Beausire 1988, 99.

10. See Pierre-Louis Mathieu, *Gustave Moreau: with a Catalogue of the Finished Paintings, Watercolors, and Drawings*, trans. James Emmons (Boston: New York Graphic Society, 1976), cat. nos. 71–77.

11. Beausire 1988, 235, 256, 297, 340.

12. André Beaunier, "Les salons de 1908," *Gazette des beaux-arts* (September 1908): 186–87.

97

Bust of Pierre Puvis de Chavannes
(Buste de Pierre Puvis de Chavannes), 1890–91

- Bronze
- 17½ x 10 x 10 in. (44.5 x 25.4 x 25.4 cm)
- Signed on base, left side: A. Rodin
- Provenance: Sacha Guitry, Paris; Feingarten Galleries, Los Angeles
- Gift of the B. Gerald Cantor Collection, 1983.204

Figure 267

On his death bed Rodin's last words were reportedly, "And they say that Puvis de Chavannes's work is not beautiful!"[1] There was no other artist portrayed by the sculptor whom he held in higher esteem than Pierre Puvis de Chavannes (1824–1898; fig. 268). This admiration was shared by conservatives as well as by the most audacious artists of the late nineteenth century, such as Georges Seurat and Paul Gauguin.[2] Some years earlier Rodin told Paul Gsell:

Has not Puvis de Chavannes, the greatest artist of our time, endeavored to dispense the sweet serenity to which we all aspire? His sublime landscapes—where sacred Nature seems to rock in her bosom a humanity that is loving, wise, august, and simple at the same time—are these not for us admirable lessons? Assistance for the weak, love of work, devotion, respect for elevated thought. He has expressed it all, this incomparable genius! . . .

To think he has lived among us. . . . To think that this genius worthy of the most radiant periods of art spoke to us, that I have seen him, that I have shaken his hand.

It is as though I had shaken hands with Nicolas Poussin.[3]

The two men met presumably in the late 1880s while serving as salon jurists, which caused the sculptor to characterize the painter as "a man of such perfect distinction."[4] At Rodin's instigation Puvis sat for his portrait in 1890, and it was exhibited in plaster a year later at the Salon of 1891.[5] While still in the studio, the first version of the portrait showed Puvis in the full-bust format with bare shoulders. Rodin had done the same with portraits of other artists, namely Jules Dalou (cat. no. 85) and Jean-Paul Laurens (1881–82). Puvis objected and insisted on being attired: "It seems to me that by the carriage of my beard, very modern and to which I give a good deal of time, my shoulders and chest are too uncovered. There is in this a sort of anachronism. What do you think?"[6]

Such was Rodin's admiration of the man that he not only complied but added the rosette of the Legion of Honor to his lapel.[7] At its exhibition in plaster, the portrait was well received, and the critic Gustave Geffroy responded positively: "Here, as in all the busts modeled by the artist, the preoccupation with the whole and with the dominant expression affirms itself and triumphs.

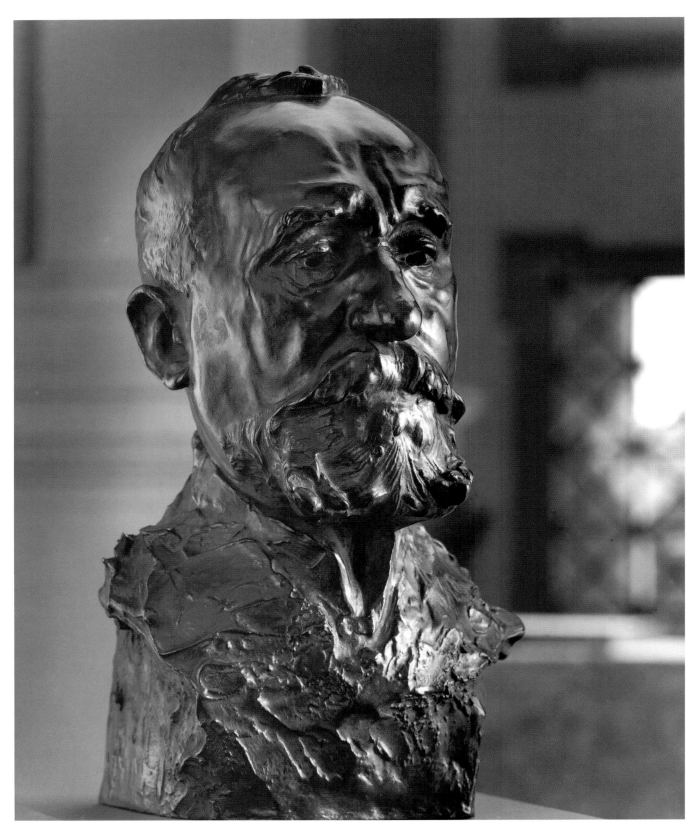

Fig. 267. *Bust of Pierre Puvis de Chavannes* (cat. no. 97).

One can walk around the plinth, look at the work from ten different points of view, always a profile of significant lines will be inscribed in the field of vision, always the attitude will be physiologically and intellectually informative. It is thus that M. Puvis de Chavannes appears robust and calm, proud and reserved, the jaw and the neck solid, the crease of attention between the eyes, the look fixed, the rugged receding forehead of a Lyons mystic." Geffroy concluded by asking why Puvis had "to demand of his portraitist so much precision in the costume?"[8]

Rodin remembered that "[Puvis] held his head high. His skull, solid and round, seemed made to wear a helmet."[9] Rodin's association of Puvis with a medieval warrior reminds us that when he made portraits, there was in Rodin's mind a coexistence of his close observation of facial formation and similes. A man very much of his time who recognized the esteem that major artists were given by French culture, Rodin was interested in celebrating Puvis as an important artist, not by giving us a clue to his profession as such but rather by suggesting that this man could have been a warrior and was a handsome, modern gentleman worthy of the highest social status.

Just how important and meaningful was the position of the head to the sitter as well as the sculptor comes through in a letter Puvis wrote to Rodin: "I have a favor to ask of you . . . it is to render my bust in its first position without the backward movement which gives an arrogant air, contrary I believe to my rather thoughtful nature. All our friends have been thus struck and the need for less amplitude of the body. . . . It would be better to limit one's self to the head."

Rodin replied, "I will return in about ten days and I will put in place the other head without shoulders, only I desire to make this change myself, because the lighting is too much overhead, and if I moved the bust backward it was to seek out the light. . . . We owe it to the bust to continue more and that the eyes, the beard and all must simplify themselves and grow in the simplicity of effect."[10]

The Stanford version, like that in the Philadelphia Museum of Art's Rodin Museum, has a cut-down base that eliminates the shoulders and shows only the man's collar. Perhaps mindful of the criticism from Geffroy, whom Rodin may have respected more than any other critic, and rather than celebrate the work of Puvis's tailor, Rodin abbreviated the bust and kept the base intention-

 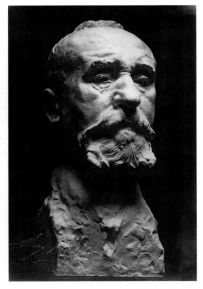

Left: Fig. 268. Photographer unknown, *Portrait of Pierre Puvis de Chavannes*, n.d. Musée Rodin, Paris.

Right: Fig. 269. Eugène Druet, *"Head of Pierre Puvis de Chavannes"* in plaster (A123).

ally rough. The painter's head is shown erect, as Puvis wanted, but turned slightly to the man's left, alerting us to the first of many subtleties that mark Rodin's distinctiveness in portraiture. To combat the appearance of lifelessness and to appreciate how he warred on dryness and symmetry, it pays to start by looking at the whole rather than the details and to see how Rodin achieved the simplicity of effect about which he had written. He took in the broad diverging movements such as those generated by the painter's well-groomed facial hair and deviations from the central axis of chin and nose. The architecture of the skull and differences in the paired eminences of the forehead work along with the hard density to make this area satisfying to sculptors and phrenologists. Rodin's device of merging hair and flesh sustains the visual flow across the surface. As an example, here he does not fully delimit the eyebrows. In great Rodin portraits such as this, there is the sense that the whole head is artistically and psychologically a frame for the area of the eyes. Against the smooth facture of the flesh are rough passages of the ocular area, in the pouches and upper eyelids, the bearers of an individual's history perhaps more than any other area. Rodin knew that in time dust would gather in the deep recesses under the brows and, along with the light, accentuate the modeling in relief. The eyes are the means by which Rodin had access to the private life of the public man, and with Puvis his aim would have been to indicate the painter's capacity for serious thought that informed his work: the artist as a gentleman and intellectual. (Presumably Rodin did not know the Puvis who made for himself some of the most sadistic caricatures in the nineteenth century.) Rodin turned Puvis's big nose into a sign of his strength, charac-

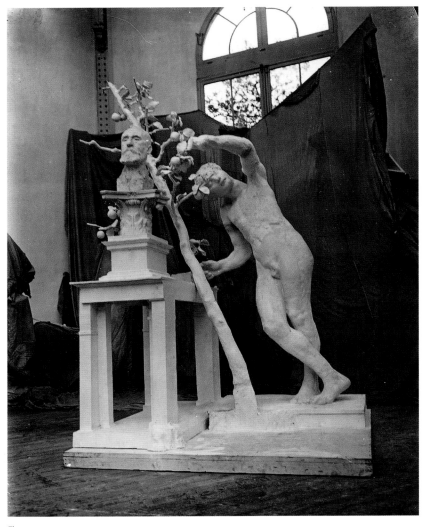

photograph (fig. 270): "I was passing through the vast workshops, lost in thought, and I noticed that everything was in a state of growth and that nothing was in a hurry. There stood the *Thinker*, in bronze, mightily concentrated within himself, completed; but he was part of the still growing complexity of the *Gate of Hell*. There was one of the monuments of Victor Hugo, advancing slowly toward completion, still under observation, still liable perhaps to alteration, and further off stood the other versions still incomplete. There lay the Ugolino group, like the unearthed roots of an ancient oak, waiting. There was waiting the remarkable monument for Puvis de Chavannes with the table, the apple tree, and the glorious spirit of eternal peace. And over yonder was what I took to be a monument for Whistler."[14]

In 1899 a committee of the Société nationale des beaux-arts, headed by its president E.-A. Carolus-Duran, commissioned Rodin to create a monument to Puvis to be located in the new Paris square of Cluny. The commission must have been received with mixed feelings by Rodin, already overcommitted to monumental projects and still inwardly suffering from what he termed the defeat of his *Balzac*. In 1902 he discussed ideas that included a bust based on his earlier bust of Puvis, and a figure of about 1898 called *Spirit of Eternal Repose* (cat. nos. 98–100)[15] showing the committee the final model in 1903. Rodin estimated the project would be finished by 1904.[16] In 1910 newspapers carried the information that the monument would be completed that year and that the bust had been carved in marble. He exhibited this bust in the Salon of 1913. According to Georges Grappe, by 1914 the figure had reached only as far as the *saumon*, or roughed-out stage in stone.[17] Rilke's description matches the assemblage seen in the old photograph, although the table and apple tree seem not to have figured in the proposed monument after 1910. (The apple tree, covered with plaster, stands in the Meudon reserve.) As with other unfinished monuments, Rodin seems not to have discussed the reasons for not completing them. Contemporary commentators noted that he preferred to exhibit his partial figures, and undoubtedly he put his heart into his études after 1900. In fact, he exhibited an armless version of the muse (cat. no. 98) in his 1900 show; another version exists without head and arms (cat. no. 99). Not surprisingly, recent commentators have repeated the view that Rodin was incapable of thinking in monumental terms, as if *The Burghers of Calais* and *Balzac* were not artistically successful monuments.

ter, and pride and made of it a powerful, vertical, stabilizing force supporting the rotary areas of the eyes.

As so often happened to Rodin, Puvis disliked the result, and reportedly the vain painter showed Rodin how poorly the sculpture fared against photographs and the mirror image of the painter.[11] "Puvis de Chavannes did not like my bust, and this was one of the disappointments of my career. He felt that I had made a caricature of him."[12] Rodin's disappointment may have been softened by the popularity of the bust and the government's commissioning of a marble version. In plaster (fig. 269), bronze, and marble, the bust was exhibited at least 16 times throughout Europe from 1892 until 1917.[13]

The Proposed Monument to Puvis de Chavannes

In his 1907 essay Rainer Maria Rilke described the sculptor's studio and noted what is shown in a contemporary

On the contrary, he had determined not to think in terms of conventional monuments, which he could have realized. Accused in his lifetime and afterward of being too uncritical of his work, of permitting *"patisseries"* to escape from his studio in profusion, perhaps the problem really was that Rodin was too critical of his monumental projects and too dedicated to trying to be original in revitalizing the public monument. The argument that he may have begun to feel that in the new century monuments were inappropriate is not persuasive, as evident in this assemblage intended to express in monumental form his devotion to the poetic and evocative simplicity of the art of Puvis.

NOTES

LITERATURE: Lawton 1906, 91–92, 250, 270; Rilke [1903, 1907] 1954, 157; Grappe 1944, 88; Jianou and Goldscheider 1969, 104; Tancock 1976, 521–25; Elsen 1980, 185; Hare 1984, 363–69 185; Lampert 1986, 130–31; Barbier 1987, 62–65; Grunfeld 1987, 300–301; Fonsmark 1988, 133; Le Normand-Romain 2001, 152, 172

1. Descharnes and Chabrun 1967, 270.
2. Robert Goldwater treated this anomaly in "Puvis de Chavannes, Some Reasons for a Reputation," *Art Bulletin* 28 (March 1946), 33–43. See also Richard Wattenmaker, *Puvis de Chavannes and the Modern Tradition*, exh. cat., rev. ed. (Toronto: Art Gallery of Ontario, 1975).
3. Gsell [1911] 1984, 108, 64.
4. Grunfeld 1987, 300, citing Coquiot 1917, 113.
5. Tancock noted that it is probable that the bronze bust, exhibited in plaster in 1891, was begun in 1890 as a preparatory study for a marble portrait commissioned by the Ministry of Fine Arts (1976, 521).
6. Puvis to Rodin, 23 March 1891, Puvis file, Musée Rodin archives, brought to my attention by Louk Tilanus, University of Leiden. The bust of Laurens is discussed in Tancock 1976, 490–92
7. Grappe 1944, 88.
8. Tancock 1976, 522, citing Gustave Geffroy, *La vie artistique*, vol. 1 (Paris: Floury, 1892), 286–87.
9. Gsell [1911] 1984, 64.
10. Puvis to Rodin, 15 May 1891, and Rodin to Puvis, 23 May 1891, Puvis file, Musée Rodin archives; copies were kindly sent to the author by Louk Tilanus.
11. Grunfeld 1987, 301.
12. Gsell [1911] 1984, 64–65.
13. See Beausire 1988, 403.
14. Rainer Maria Rilke, *The Rodin Book: Second Part*, reprinted in Rilke [1903, 1907] 1954, 157. Rilke published the first part of his book on Rodin in 1903 (Berlin: Julius Bard). The second part was published in 1907 (Berlin: Marquardt). The two parts were published together in 1913 (Leipzig: Insel Verlag).
15. Grappe 1944, 101. See also Butler 1993, 543 n. 1; Le Normand-Romain 2001, 152
16. Rodin had considered a first version, which included, according to a newspaper account, a retouched copy of the earlier bust to be placed on a stele decorated by an allegorical woman, *Painting*; see Tancock 1976, 613, 615 n. 1.
17. Grappe 1944, 101, 137; see also Barbier 1987, 236.

98

Spirit of Eternal Repose (without arms)
(Le génie du repos éternel, sans bras), c. 1898

- Title variations: *Funerary Spirit* (full figure), *Spirit of Eternal Youth*
- Plaster
- 34 x 15 x 12½ in. (86.4 x 38.1 x 31.8 cm)
- Provenance: Thomas Vinçotte, Brussels; gift of Vinçotte's widow to P. Theunis; Sotheby's, London, 1 July 1981, lot 260; Bruton Gallery, London
- Gift of the B. Gerald Cantor Collection, 1992.137

Figure 271

99

Spirit of Eternal Repose (without head and arms)
(Le génie du repos éternel, sans tête et bras), c. 1898?

- Bronze, Coubertin Foundry, cast 1980, 2/12
- 34 x 15 x 12½ in. (86.4 x 38.1 x 31.8 cm)
- Signed on top of base, near right front corner: A. Rodin
- Inscribed on front of base, lower left: No 2; on front of base, lower right: © by Musée Rodin 1980
- Mark on back of base, below foot: Coubertin Foundry seal
- Provenance: Musée Rodin, Paris
- Gift of the Iris and B. Gerald Cantor Collection, 1998.352

Figure 272

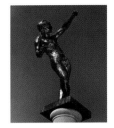

100

Spirit of Eternal Repose (Le génie du répos éternel), c. 1898, enlarged 1898–1899

- Bronze, Coubertin Foundry, cast 1981, 1/12
- 76 x 46 x 48 in. (193 x 116.8 x 121.9 cm)
- Signed on front of base: A. Rodin
- Inscribed below signature: no. 1; on back of base: © by Musée Rodin 1981
- Mark on back of base: Coubertin Foundry seal
- Provenance: Musée Rodin, Paris
- Gift of the Iris and B. Gerald Cantor Collection, 1998.353

Figure 273

W hat we do not know for certain about this sculpture is the date when Rodin made it. We do know that the name of this most precariously balanced figure, *Spirit of Eternal Repose*, was not given in jest. According to Georges Grappe, the figure was also named *Génie funéraire* (Funerary spirit), and according to Monique Laurent, this was the original meaning of the figure's name.[1] Grappe dated it to about 1898, which indicates that Rodin modeled at least the torso and legs a year before the commission for the Puvis monument with which it has always been associated.[2] Laurent, however, asserted that the headless and armless figure was probably made in Belgium as early as 1876 or 1877. "The original clay would have been modeled by Rodin during his stay in Belgium, and his friend, the Belgian sculptor Thomas Vinçotte, would have cast it during his absence, probably in 1877, in order to prevent it from breaking. If the information that comes from an oral tradition is true, the slit, or gap, that marks the cut [in the torso] would therefore be the trace of the beginning of a crack in the clay."[3] Laurent left us in the dark about where she encountered this oral tradition. The break at the waist does not encircle the figure completely, so it could have been made purposefully or accidentally by the artist. The concept of defying gravity, the varied facture within the same work, the use of "accidents," and daring technical manipulation of piece molds do not support such an early dating but rather one in the 1890s, as Grappe proposed.

In 1899 a committee of the Société nationale des beaux-arts commissioned Rodin to create a monument to the painter Puvis de Chavannes to be located in Paris. Rodin's proposed monument would have been the first assemblage of ready-made parts in the history of public sculpture. Why and how did this come about? The timing of the commission was not propitious. It came within a year of the artist's disastrous experience with his proposed *Monument to Honoré de Balzac*. He was sending works to exhibitions all over Europe and to Philadelphia in the last two years of the century. The traveling exhibition for Brussels, Rotterdam, Amsterdam, and The Hague numbered nearly 80 sculptures. Rodin was deeply involved with preparing for his solo retrospective in 1900, and this included intensive work to complete *The Gates of Hell*. There was no artist of his time that Rodin admired more than Puvis, however, and he would later praise the painter on his own deathbed. It is probable that Rodin accepted the commission having in mind building much of the monument out of parts already made: the bust of the painter from 1890–91 and the figure of the spirit, completed at least a year before the commission. The rest—an architectural capital, a table, the large branch of an apple tree—would come from his studio and garden. This assemblage is known through a contemporaneous photograph (see fig. 270).

Rodin showed a plaster *Spirit of Eternal Repose*, without arms or head (fig. 271), in the touring exhibition of 1899. Just how important he considered this figure was demonstrated in the 1900 exhibition. There he showed it twice, one version without arms in plaster and a smaller plaster version with his left arm behind his head, on a tall column (see fig. 274).[4] In 1902 the life-size armless version was displayed in Prague and the following year Rodin showed the monument committee plans for the composition of bust and muse he was developing in his studio (see fig. 270) that he estimated would be completed by 1904.

Camille Mauclair's 1905 book described the monument: "Instead of making the customary statue, [Rodin] considered the purely Greek quality of Puvis's genius and chose to pay homage to him in a form reproduced from the antique. The bust of the great painter is placed on a plain table, as the ancients placed those of their dead upon little domestic altars. A fine tree loaded with fruit bends over and shades the head. Leaning on the table behind the bust is a beautiful naked youth, who sits [sic] dreaming in a well-chosen supple attitude."[5]

In his 1906 biography of Rodin, Frederick Lawton described the monument as he saw it while serving as Rodin's secretary: "In the museum at Meudon stands a plaster model of a monument to the memory of Puvis de Chavannes. . . . The monument consists of a bust copied from the one already described . . . which is placed on a small altar, after the Greek custom. On the left [sic] stands a male figure, allegorically representing Eternal Repose. The statue is a worthy companion of the bust. Both posture and feature are full of melancholy grace, but with avoidance of any theatrical gesture. Rising from the ground behind the altar is a tree that overshadows both bust and statue, and serves as a grove of quiet contemplation. Rodin confesses to have intentionally arranged all—the slender trunk, the branches and leaves not too thick, so as to obtain silhouettes capable of standing out against the sky, and yet in a manner mingling with it. This was the Greek idea."[6]

Unconventional in concept and form, Rodin's proposed monument was a synthesis of ready-mades, including the *Spirit* to whose body Rodin was to add a head and arms. These limbs and the head in all probability already existed in the reserves of Rodin's studio. Its most audacious aspect in addition to the graceful *Spirit* would have been the bronze and probably gilded cast of an actual small apple tree.[7] Thus, *Spirit of Eternal Repose* would pluck a golden apple for Puvis as a symbol of eternal life. The head has a deeply introverted character with the eyes closed as if the figure is acting in a dream. In this assemblage Rodin seems to have reinvigorated classical prototypes showing the muses or Apollo paying tribute to a poet.[8] The table and tree, against which the spirit was leaning while plucking an apple, seem not to have figured in the proposed monument after 1910, when newspapers stated that the monument would be completed and that the bust had been carved in marble. By 1914 the *Spirit* had been roughly carved in stone,[9] but for reasons that are not clear the monument was never realized. One problem seems to have been that the committee could not decide on a location; another was the long time it took for subscribers to give sufficient funds.[10]

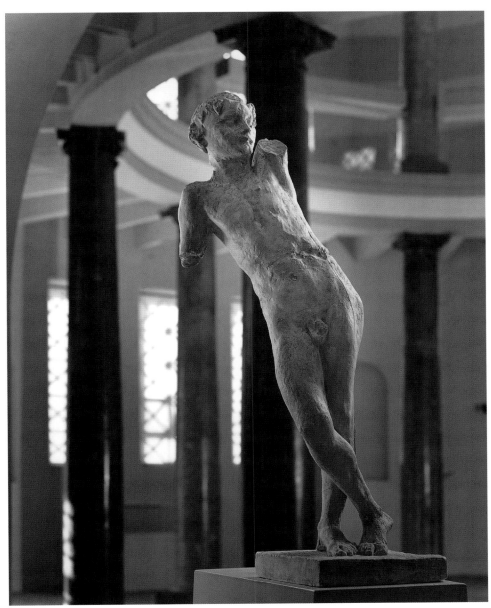

Fig. 271. *Spirit of Eternal Repose* (cat. no. 98).

Many have noticed the affinity of the Spirit's pose from the waist down with Greek sculpture, but the lesson Rodin learned from their hipshot pose with crossed-over leg further set him against academic practices. For examples, in Florence Rodin could have seen the Greek statue *Pothos* (Longing) in the Uffizi; in England he could have seen the Greek marble *Paris* in Landsdowne House. Both marbles employ this relaxed posture for the lower body.[11] Above the waist the Greek figures bend slightly to the left and right, respectively, and the *Paris* leans on a stump with his right hand, while the *Pothos* gestures to his left. Their balance is natural and sustainable without effort. What could have been a revelation to Rodin, however, is that the heads of the figures are not directly above a sup-

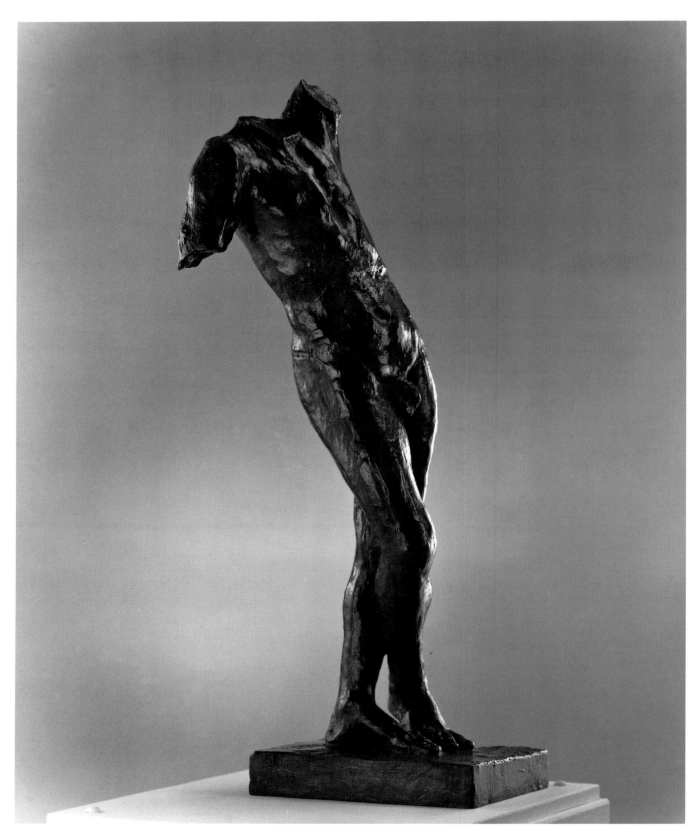

Fig. 272. *Spirit of Eternal Repose* (cat. no. 99).

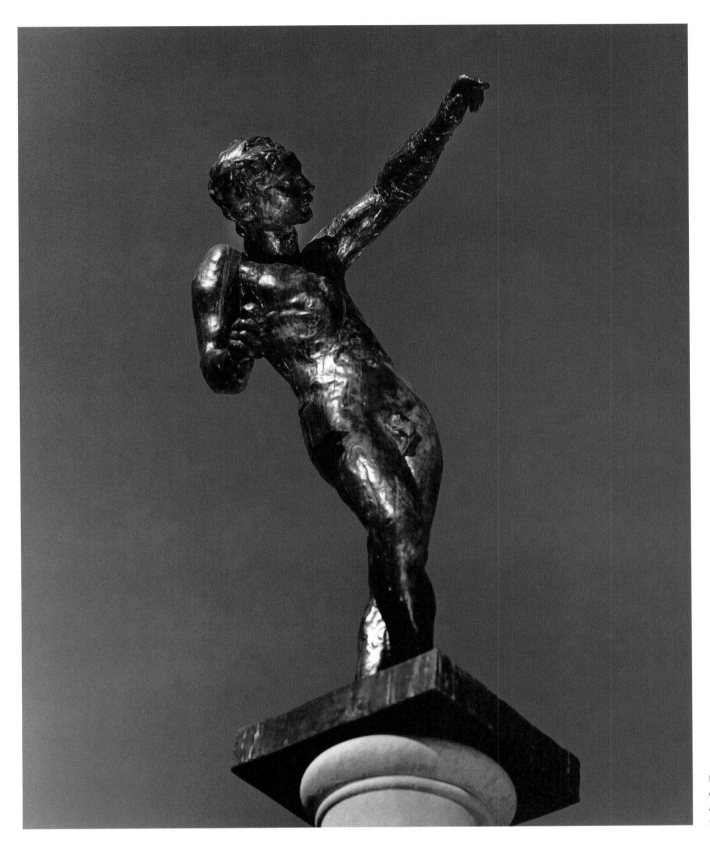

Fig. 273. *Spirit of Eternal Repose* (cat. no. 100).

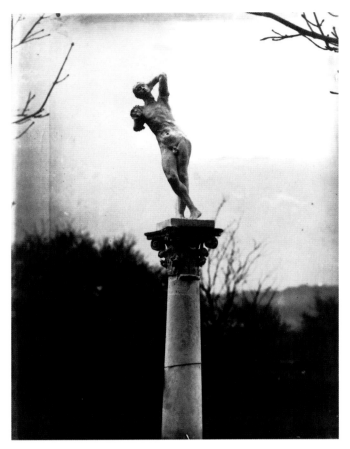

ferent and perhaps older model. A photograph from Rodin's time (fig. 274) shows the arms in a totally different position than in the life-size bronze at Stanford. That figure's raised left arm seems to have come from the figure's conjunction with the tree, and the gesture was of picking an apple.[12] For this reason the smaller plaster and bronze versions in the museum's collection should not be considered preliminary studies for a final figure as Rodin appears not to have had any in mind. Like the unfurled torsos of *Flying Figure* and *Iris, Messenger of the Gods* (cat. nos. 183–185), they are independent states, sufficient unto themselves, eloquent of Rodin's notion of his art as a continuum.

The way the legs and torso are made is as astonishing as the vertigo-inducing posture. Starting with the weight-supporting leg, it is as if we are looking at a casting flaw or misalignment. The lower leg appears to have been cast in two sections, front and back, that were not fitted together perfectly so that the back portion protrudes to our right as we face the figure. This slippage is disturbing because it is more noticeable than the misalignment of the lower legs in *The Earth* (cat. no. 176). Although anatomically impossible, the provision of a second profile for the *Spirit's* leg makes visual sense if read against the leg's contour as a whole. It is like a vertical reinforcing brace. (On a smaller scale we have Rodin retaining the armatures in the area of the Achilles tendons in *Eve*, *Adam*, and *The Walking Man*.) Given the novelty of the pose, this disjuncture below the knee may not have been a casting accident as Rodin had superb technicians working for him. Taking advantage of the piece-mold process, Rodin, who was unrivaled in his daring use and knowledge of studio techniques, may have called for the molds' separation in order to decide which of two profiles of the lower leg worked best and then decided to retain both. That he was proud of this deliberate "flaw," or, more positively, his invention, which forced the viewer to look at sculpture in a new way, was shown by the frequent exhibition of the sculpture.

For the viewer who expects the surface to be a consistent analogue of the body, *Spirit of Eternal Repose* is deeply upsetting. The surface facture varies from large areas of a granular texture, such as damp cloths might have made, to undisguised mashed pellets of clay, to a fluid, sensuous evocation of flesh on the figure's left leg and thigh. There is a jarring, jagged crack traversing the upper abdomen. (Was Rodin thinking of reorienting to vertical the axis of the thorax above?) The head in the

porting foot, contrary to the academic rules in his day. When Rodin added the head to his *Spirit*, he refused to position it upright, as the Greeks would have done, but instead set it at a severe angle so that, seen with the arms, the figure by itself appears from certain views about to topple to its right. Rodin's motive for the positioning of the arms and head appears to have been to relate the figure to the tree and the plucking of an apple. Detached from the prop, Rodin seems to have accepted and enjoyed the now unaccountable pose and its graceful movement in space freed of gravitational concerns.

Surely the adolescent *Spirit* in any of his incarnations is one of the most surprising upright figures in the long history of figure sculpture. It violates the ancient Greek tradition of a self-balancing figure that resists gravity by its uprightness, as well as the French academic tradition of having a standing figure plumb, the head on a vertical axis above the foot that carries the body's weight. Even without arms the impression is of an insouciant, cross-legged figure leaning on air rather than on the stump of a tree or some other prop. That Rodin considered the legs and canted torso a provocative nucleus was demonstrated by its public exhibition without arms and the varied ways he added arms to it as well as a head from a dif-

Stanford bronze cast is rudely attached and less disguised as an addition than the figure's right foot.[13]

What Rodin proudly offered the world in 1899 and thereafter were the discoveries and inventions of a lifetime of making art in the studio. For the alert and sympathetic beholder it was to be a dualistic experience: revealing art's capacity for traditional illusion and revealing the liberties the artist exercised in finding non- or less-illusionistic devices to evoke rather than to describe the figure that made the sculpture and its process self-reflexive. But Rodin's intent was not to have us dwell on piece-mold slippage and damp-cloth impressions. His thinking was always in relationships and their effects: what did these marks of making contribute to the overall expressiveness, movement, or larger effect of the whole? In 1898, but not 1877, Rodin was very much concerned with relating the silhouettes of his outdoor figures with the atmosphere and the wrapping of the form in soft luminous shadows.

NOTES

LITERATURE: Mauclair 1905a, 89; Lawton 1906, 270; Rilke [1903, 1907] 1954, 157; Grappe 1944, 101; Jianou and Goldscheider 1969, 104; Tancock 1976, 613–14; Elsen 1980, 186; Elsen 1981, 116–17; Gassier 1984, 108, 122; Lampert 1986, 130–31, 222–23; Miller and Marotta 1986, 142–44; Barbier 1987, 236; Le Normand-Romain 2001, 152, 223

1. Grappe 1944, 101; Laurent in Gassier 1984 (cat. nos. 61, 79). For further discussion of the funerary meaning, see Lampert 1986, 131.

2. Grappe 1944, 101. Antoinette LeNormand-Romain, *Rodin* (Paris: Musée Rodin, 1997), 113-14.

3. Laurent in Gassier 1984, 122.

4. Beausire 1988, 151–55. On the versions shown, see LeNormand-Romain 2001. 223.

5. Mauclair 1905a, 89. Arsène Alexandre described seeing the monument (in *Paris illustré*, March 1904), as discussed in Lampert 1986, 131.

6. Lawton 1906, 270. Looked at from the front in a vintage photograph, *Spirit* is to our right. Rodin's contemporaries did not always have the aid of photographs to refresh their memories when they wrote. For Rilke's 1907 description, see in this book cat. no. 97.

7. On Rodin's use of twigs in other smaller works to give scale and environment, see Lampert 1986, 130, 222. Lampert observed that "a large apple-tree branch was placed on the same diagonal as the inclined figure, stressing the classical association with the guardian of the door to Hades" (131). This makes no sense as Rodin saw Puvis's destiny in the Elysian Fields.

8. See Jamison's discussion in Elsen 1981, 116–17.

9. Grappe 1944, 137; Barbier 1986, 236.

10. *Rodin 1908–12*, 79.

11. For a reproduction of *Pothos*, see Margarete Bieber, *The Sculpture of the Hellenistic Age* (New York: Columbia University Press, 1961), fig. 62; for *Paris*, see Adolf Furtwängler, *Masterpieces of Greek Sculpture* (Chicago: Argonaut, 1964), fig. 154.

12. The figure on the column derives from the antique Sleep, or Spirit of Eternal Repose, in the Louvre (Le Normand-Romain 2001, 223).

13. Lampert's (1986, 131) association of the *Iris* heads is not self-evident, not only because the subject is male but because of the difference in expression and modeling.

101

Head of Charles Baudelaire (*Tête de Charles Baudelaire*), *1892*

- Bronze, Georges Rudier Foundry, cast 1955
- 8¾ x 7¾ x 9 in. (22.2 x 19.7 x 22.9 cm)
- Signed on left jaw: A. Rodin
- Inscribed on back of neck: Georges Rudier/Fondeur.Paris; on right side of neck: © by Musée Rodin 1955; interior cachet: A. Rodin
- Provenance: Bruton Gallery, New York

- Gift of the Iris and B. Gerald Cantor Foundation, 1985.16

Figure 275

Contributing to Rodin's undeserved reputation for not being able to complete a commission was his assignment in 1892 to "mount a bust on the tomb of Charles Baudelaire" (1821–1867; fig. 276).[1] The fact that today there is a monument by José de Charmoy (active 1899–1919) standing over the poet's grave in the Montparnasse Cemetery was not due to Rodin's professional delinquency.

The commission came to Rodin from a committee headed by Charles Leconte de Lisle, which included such famous writers and artists as Anatole France, Edmond de Goncourt, Joris-Karl Huysmans, Maurice Maeterlinck, Stéphane Mallarmé, Roger Marx, Stuart

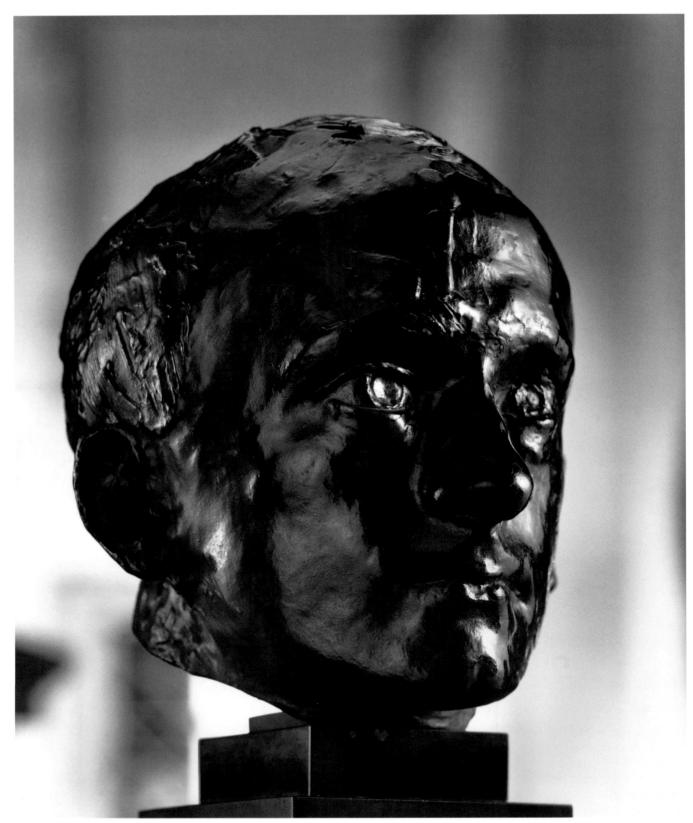

Fig. 275. *Head of Charles Baudelaire* (cat. no. 101).

Merrill, Félicien Rops, Algernon Swinburne, and Emile Zola. The writer Léon Cladel (father of Rodin's biographer Judith Cladel) was credited with the idea for the monument. "Cladel remembered that Baudelaire had earlier taught him to respect style."[2] According to committee member Léon Deschamps, "that which guided us in our enterprise is to not only honor Baudelaire since at this time his influence is fertile and we dream of a classical tradition. But rather . . . we would glorify pure poetry in a cemetery where merchants and tradesmen have installed themselves as masters of French letters."[3]

There was some opposition to the monument led by a severe critic of Baudelaire's poetry, Ferdinand Brunetière, the editor of *Revue des deux mondes*, who years before had been the first to publish poems from *Les fleurs du mal*. Brunetière found Baudelaire's writing "degrading," and he objected to "dirty words" and what he saw as the poet's "pathological self-love, antisocial and antihuman sentiments."[4]

At the outset there seems to have been some uncertainty about the format of Rodin's undertaking, and journalists conjectured whether it would be a bust amid figures illustrating Baudelaire's poetry, a medallion, a mask, a bust alone, or a statue.[5] The reason for this ambiguity is explained by Rodin's letter accepting the commission, "Dear Monsieur Deschamps: I am very honored to have been chosen for the monument to be executed for Baudelaire. . . . According to the amount [of funds] we will study what must be done." A few days later the poet Georges Rodenbach wrote, "The idea of public honors in bronze or marble does not accord with Baudelaire's deepest attitudes; and the committee has understood this in dreaming only to adorn the place where he rests with a bust."[6]

Why even the artist was unsure of the commission's final format was revealed when an unnamed writer visited him in his studio.

> I enter and what do I see right away? A first sketch in clay of the bust of Baudelaire on the corner of a bench. It is on this head that Rodin works, his hands gray with clay. And as I exclaimed, "Already!" Rodin smiled while responding: "Oh! it is a simple étude made under certain conditions that I will later explain." . . . When he spoke of Baudelaire, one sensed that he was on a favorite subject and that the sculptor is taken with the poet. "I cannot tell you much on the subject of the monument," he said while mechanically rolling the small balls of

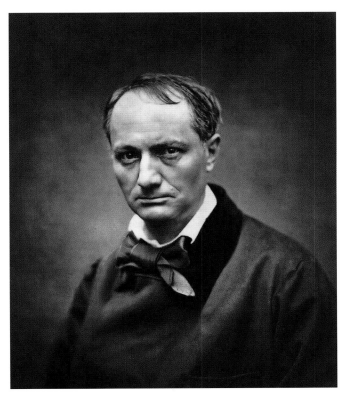

Fig. 276. Etienne Carjat, *Charles Baudelaire*, c. 1863, woodburytype, 9 x 7¼ in. (22.8 x 18.6 cm). Published in *Galerie contemporaine* (1878). Iris & B. Gerald Cantor Center for Visual Arts, Stanford University, gift of the Committee for Art.

clay between his strong but subtle fingers. "The committee is gathering funds, but how much will the subscription amount to? Will the monument be in marble, bronze or stone? That is a serious question because one does not treat these materials in the same way.[7] Before anything else it is necessary to decide on this: will one raise to the memory of Baudelaire a bust, a work in the round, a medallion, surmounting, dominating a group symbolizing his work, or will one make the ordinary statue?" . . . One sensed irony in the voice of Rodin in that last phrase. "I do not want to express myself . . . because they will undoubtedly discuss the matter a lot and perhaps it will be prejudicial if I show a preference that would raise opposition." Nevertheless, what is your opinion? "Since you want it, I acknowledge to you that I do not see the statue of Baudelaire. What is a statue after all? A body, some arms, some legs covered with banal clothing. What do they have to do with Baudelaire who lived only by his brain? The head is everything with him. Much more topical would be the monumental group . . . the group adequate to the work, faithfully translating it, the group above which one could put some kind of figure. And there you have in my opinion the true way to express Baudelaire . . . but statue, bust or medallion, the head of the poet is neces-

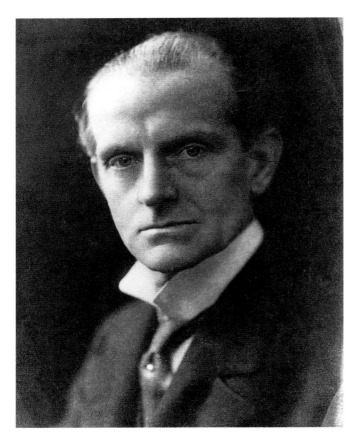

crowd, and if his work is well translated by the monument, this monument will not be understood any more than he. The general brandishing his saber, the tribune—there is the hero of public places; but never the profound thinker, the impeccable artist who holds himself disdainfully apart from noisy manifestations. Baudelaire is too much a secret for the crowd."[8]

In his account Rodin referred to a draftsman named Louis Malteste, whom he had chosen as a model for the portrait (fig. 277). Years later Rodin remembered, "What was of most use to me was a living model, a young draftsman who bore an astonishing resemblance to the poet. It is from this living model that I constructed my bust, that is to say, that I established the general idea, the demeanor . . . the type. It was only afterward that I applied myself to producing the special character of the individual."[9] Shortly before 13 September 1892 Rodin had written to Malteste, who, on hearing of the commission, may have sent the artist a photograph of himself: "Will you give me the pleasure of coming to see me in my studio? Some lines in your face resemble those of Baudelaire and would serve me for studies. I would make a sketch in clay if my request does not seem too indiscreet to you."[10] Malteste replied, "Very happy to be able to please you and also very flattered at the honor you will accord my head."[11] Looking through the Musée Rodin's collection of unidentified photographs, this author came across the one here illustrated that could only be of Malteste. There is no mistaking the resemblance to Baudelaire as seen in his photographs: the hairline receding off the broad forehead and tapering of the head to the jaw; the strong eyes, straight nose, and sinuous line of the mouth, which Rodin made more sensuous. Malteste did not have Baudelaire's deep facial creases running from the sides of the nose to the edges of the mouth, and it is clear Rodin worked more from the living model than from photographs of the dead poet. The high collar covering Malteste's neck is a reminder that in his portrait Rodin showed only the head, or "mask," and had no interest in anything else.

sary." And the artist showed me the bust on which he was working a few moments before. "It is not Baudelaire . . . but it is a head of Baudelaire. There are a series of individual characteristics that, atavistically without a doubt, preserve the same cerebral conformation that constitutes what one calls the type; this bust is of a draftsman named [Louis] Malteste who shows all the characteristic lines of the Baudelaérian mask. See the enormous forehead, swollen at the temples, dented, tormented, handsome nevertheless, the face described at length by Cladel; the eyes have the look of disdain; the mouth is sarcastic, bitter in its sinuous line, but the swelling of the muscles, a little fat, announces the voluptuous appetites. In short, it is Baudelaire. And now, while admitting that one makes the monument and not the statue, in what form will I present the mask of the poet? Will it be a bust or a medallion? I will not be far off if the conditions permit me to adopt this one." . . . And now a last question. . . . Where do you think the monument to Baudelaire's glory should be raised? Is it on a public street or in a cemetery? "That is still a matter of controversy. As for me, I do not understand a public street. Baudelaire will never be understood by the

In a long account in *La République* Rodin interpreted his portrait with such words as *bitter, sarcastic, disdainful,* and *voluptuous,* referring to Baudelaire as described by Léon Cladel. More than descriptions of the poet's appearance already provided by artists, caricaturists, and photographers, Rodin required analyses of his character,

such as that by Cladel, to take his portrait beyond mere physical resemblance: "Always polite, proud and at the same time unctuous. There was something in him of the monk, the soldier and the man of the world. . . . He was open to those he thought sensible, but ferocious to those he judged otherwise. . . . Elegant, a little mannered, circumspect, timid and fault finding all in unison. . . . His astonishing reserve . . . derived from profound disdain for braggarts. . . . He had great self-respect . . . Irascible . . . at times his malicious cruelty went too far. . . . In his home it was his habit to work in his shirt sleeves, like a field or road worker. A soft cravat of purple colored silk streaked with black, negligently knotted, floated around his robust and solidly attached neck of which the delicate man was so proud. Close shaved and shining like a new penny . . . his long gray hair a little frizzled, gave him a sacerdotal air.[12]

How much Rodin thought about the format of his commission and the nature of his subject is apparent in an interview by René Malliet. "The subscription opened yesterday and one does not know what it will raise. Will Baudelaire be a god, a table or a wash basin? That depends on the public and the recognition he has with the young generation. I first thought of a medallion set against satanic allegories, then a bust with bas-reliefs expressing the character of the *Fleurs du mal*. . . . If we are rich we will make a monumental group like Dalou's *Delacroix*." Malliet then asked if the subject captivated him, and Rodin replied, "Yes. This smooth and complex physiognomy arrested me; it is engaging as a problem and painful as a reality. There is inside him a priest, a comedian and something of Pierrot, with a certain British behavior. The gaze blazes superbly from under the high forehead of the thinker and an entire poem of irony can be read in the firm drawing of the shriveled mouth." To Malliet, Rodin confided his preference for the future location of the monument: "For me, I would opt for one of the Trocadéro gardens. Baudelaire had lived in those parts. There must be a verdant and discrete frame, not too encumbering, far from the passing crowd. It should be a poetry of intimacy like his. One could still place the statue in the Luxembourg Gardens because of the morbid influence exercised on some of our youth by his neurotic rhymes. Above all, I would not agree with relegating my work to a cemetery. The profusion of gravestones would spoil the effect."[13] By January 1893 the committee had a new chairman, and there was a news report that "It is in the Luxembourg Garden that

the committee for the monument to Baudelaire, over which M. Félicien Rops presides, wishes to obtain a placement. The sculptor Rodin has been charged with the execution and made the sole judge of the monument's form."[14]

Remembering that for seven years Rodin was working on the Balzac monument and others and that the committee was having fund-raising difficulties, it is not surprising that there was no further activity recorded on the project. An article appeared in November 1898 confirming lack of progress: "We have spoken yesterday of the monument a committee of admirers would raise to the disturbing author of the *Fleurs du mal*—and the difficulties raised by the modesty of the sum put at Rodin's disposition. One of our colleagues went to see the great sculptor about this subject and asked him about it. 'I surely think . . . that it will require at least 15,000 francs to raise a monument to Baudelaire, a monument worthy of him and his work. And I set this figure, a little by chance, without thinking of any personal benefit. . . . I have done a lot of work on it in the past. At Sèvres I have a bust that will require a little retouching to put it in proper condition. Consequently, there only remains the body to execute. That would go very quickly. But it is necessary for the committee to arouse itself and give me my marching orders.'"

This interview took place six months after the scandal of the *Monument to Honoré de Balzac*. To his visitor Rodin could not resist making a comparison: "I conceived it according to the same system as my Balzac. But I do not say that the execution will be the same. Not because I concede anything to the fear of seeing myself again severely judged. No, it is simply because I search, because it is proper for the true artist to always search, because no one ever attains a definitive manner. . . . I told you that I had already studied at length my face of Baudelaire. . . . I, in fact, have concerning him quantities of documents, portraits, excellent photographs."[15]

With the statue mania of the late nineteenth century, there were, in fact, more public subscriptions than monuments realized. In November 1898 Rodin began to receive criticism in the press for not having completed the monument, and at least one critic of the number and administration of public subscriptions assumed that the necessary money had been raised: "The sculptor Rodin still has not put his hand to the statue of Baudelaire for which a subscription was raised in 1890 [sic]. It has been almost eight years since you paid your money and you

have friends who have been waiting 20 years. You keep quiet and congratulate yourself on being luckier than others."[16]

In January of 1899, a reporter indicated that 6,000 francs had been raised for the Baudelaire monument and that "Rodin executes the bust of Baudelaire. Only the head of the poet will be represented, the neck losing itself in a sort of sheath. Around, in the thickness of the marble, will appear, personified by small figures, the inspirations and the sentiments that dominate the work of Baudelaire."[17]

More than two years later, Robert d'Ailon reported Rodin saying, "I am ready. . . . As soon as they put together 15,000 francs, that is the strictly necessary sum, I will get to work. And I will work with ardor, regardless of my time and my difficulty. . . . I have searched for a long time; today it is put together."[18] This newspaper was of the opinion, probably correct, that the Balzac affair had cooled the ardor of the subscribers to the Baudelaire monument.

In September 1901 an anonymous reporter recalled talking with Rodin perhaps four years earlier in his studio. "He waited. The committee . . . had had much difficulty in raising a few thousand francs, but the sum was insufficient." Then Rodin repeated to this reporter, "I am ready." After recounting his history of study, the sculptor concluded prophetically, "I am very much afraid, the way things go, that all my work will end with these studies and researches." The reporter added, "Rodin was right. It has been years since one heard the monument spoken of and one does not know if the committee even exists."[19]

The committee was reconstituted in 1902, headed by Jean Aicard (whom a writer for *La plume* referred to as "strangely presiding" and "le macabre M. Aicar"). He had been involved with the rejection by the Société des gens de lettres of Rodin's *Monument to Honoré de Balzac*. The new committee no longer contained friends of Rodin and awarded the commission to José de Charmoy, whom, it appears, offered to do a monument including cost of the plot in the Montparnasse Cemetery for 6,000 to 7,000 francs, half the price set by Rodin. One version of what happened was that "the subscribers to the original project informed themselves and learned the truth that the funds no longer existed and that the treasurer who was responsible for them was dead."[20]

It does not appear that Rodin cast in bronze the *Head of Charles Baudelaire*, but he did exhibit it, probably in plaster, in his 1900 retrospective.[21] Apparently there are no preliminary studies for the head in the Musée Rodin's Meudon reserve.[22] In this author's judgment the portrait is complete.

The search about which Rodin spoke in relation to the monuments of Balzac and Baudelaire could have taken different forms. One of the forms had to be how to express that such heads belonged to creators seen in the creative moment, when, as with *The Thinker*, all sensory distraction had to be shut out. In the photograph Malteste looks right at us, acknowledging our presence. As transformed by Rodin, Malteste became Baudelaire the visionary, whose eyes are fixed on some internal horizon. The Musée Rodin was lax in permitting the foundries that cast this work to mount some heads so that they are upright as if confronting the beholder rather than having the head sit directly on the truncated base of the neck with the face looking upward. With the *Balzac* no such liberties could be taken, for the upward tilted head conditions the entire stance of the figure.

Rodin repeatedly referred to all the documents and portraits of Baudelaire that he had gathered. Unmentioned in print was the fact that he had known Baudelaire's poetry from the time it was published, and a copy of *Les fleurs du mal* was seen in his studio by several visitors. Baudelaire had thus lived in Rodin's brain all his adult life. In 1887 he had provided commissioned drawings made from his sculptures to accompany a special edition of *Fleurs du mal*, later published by Gallimard.[23] Rodin had a deep-rooted feeling for the poet, and his interpretation thus went far beyond the information that documents and a living surrogate could provide. The profile method of modeling was only a springboard for his interpretations. As an example, to impart the sense of a man who lived by his brain, Rodin muted distracting surface detail such as the frizzled hair and eyebrows. The flesh seems drawn taut by the outward pressures of not just the bony cranium but the artist's expanding thought. The completed head projects an unbearable intensity of concentration.

Rather than the mark of a sketch, the untempered vertical passages above the poet's right eye are Rodin's finishing touch, like the giant wartlike form on the bridge of Balzac's nose in the final head.[24] Anatomically unaccountable but artistically plausible, these raised patches permit the artist to hold the forehead's curving plane when strong light is full on it, otherwise there would be an impression of flattening. This is one of many anti-impressionist touches by which Rodin sought to preserve

his sculptural form from disintegrating under sunlight. When the subject is genius, such prosaic explanations are sometimes ultimately unsatisfying. Let us therefore conclude by observing that the ambiguity of meaning caused by this sculptural accent contributes to the portrait's poetry and durability as a work of art in the fullest sense.

NOTES

LITERATURE: Grappe 1944, 103–4; Elsen 1966a; Jianou and Goldscheider 1969, 107; Steinberg 1972, 393; Judrin 1976, 21; Tancock 1976, 75, 432; Butler 1993, 259–60, 287; Le Normand-Romain 2001, 241

1. "Le monument de Charles Baudelaire," *Gironde* (Bordeaux), 29 September 1892. It is from newspaper articles, not books and magazine articles by contemporary critics, that we have the best information on this project.

2. "Chronique littéraire: La question de Baudelaire," *Le pays*, 14 September 1892. Another source was credited with the idea of the monument, and an anonymous commentator wrote, "I do not believe that Baudelaire was a great partisan of statues, but he was endowed with a very fine artistic taste and surely he would have devoutly loved the works of Rodin who is of the same intellectual family and who, like him, makes one think of Dante" ("Chronique: La statue de Baudelaire," *Sud ouest*, 28 September 1892).

3. "Le monument de Charles Baudelaire."

4. "Ferdinand le Censeur," as he became known, was challenged to a duel by one of Baudelaire's defenders. It did not take place because an arbitrator decided that "the quarrel had not gone beyond the limits of a purely literary discussion, and there is no place to duel" ("Chronique: La statue de Baudelaire").

5. As an example, an anonymous writer indicated that "Rodin has promised to execute a medallion or the bust that will reproduce the features of Baudelaire" (*Evènement*, August 1892). In *Sud ouest* an unsigned article states, "It is not a statue that Rodin proposes to model, but a bust surrounded by figures symbolizing the diverse aspects of Baudelairian poetry" (28 September 1892).

6. *La plume*, 1 September 1892; Georges Rodenbach, "Baudelaire," *Le figaro* (Paris), 6 September 1892.

7. One of the strongest reactions against Rodin late in his lifetime and after his death was what might be called his failure to observe "truth to the medium." This meant that Rodin was indifferent to the intrinsic qualities of his materials and treated them all illusionistically. Truth to the medium is relative to a time and place, and throughout his life Rodin showed a keen sensitivity to the differences between bronze and stone and the appropriateness of certain materials for various projects, as indicated by this statement.

8. "Le monument de Baudelaire," *La république*, 22 September 1892. A public statue mania in the early 1890s made increasingly difficult the choice of public sites for sculpture ("Chronique littéraire: La question de Baudelaire," *Le pays*, 14 September 1892). For example, there was a fight over the location for a monument to Claude Chappe, who invented the telegraph, whether it should go in Montmartre on the rue de Bac or on the boulevard Saint Germain.

9. Jean Caujolle, "Chez Rodin: Balzac et Baudelaire," *La lanterne*, 7 November 1898.

10. *Rodin 1860–99*, 136.

11. Malteste to Rodin, 13 September 1892, in Musée Rodin archives.

12. Cladel had written several articles on his relationship with Baudelaire beginning in 1876, and one was published in *La plume* (November 1892). The excerpts presented here are from E. J. Crepet, *Charles Baudelaire: Étude biographique* (Paris: Messein, 1906). The author thanks for this reference Professor Ray Poggenberg of Vanderbilt University, who helped establish that institution's great Baudelaire archive. It is highly probable that Rodin was at that time acquainted with Léon Cladel, whose daughter Judith supposedly met Rodin a few years later and who became a good friend and biographer of the sculptor.

13. René Malliet, in *Le rappel*, 14 October 1892. Rodin went on to refer to the many portraits of the poet, citing the living likeness by Henri Fantin-Latour and the abundant documents. He also cited the "magisterial notice" with which Théophile Gautier had prefaced *Les fleurs du mal*, "itself an inexhaustible source." On Dalou's *Delacroix*, see Fusco and Janson 1980, cat. no. 78.

14. Dated article in Musée Rodin archives, no source given. The authority assigned to the artist in the last sentence of the quotation, if true, does not seem to have been known by Rodin.

15. Caujolle, "Chez Rodin"; also "Baudelaire et Rodin," *La volonté*, 8 November 1898.

16. Georges Jubin, "Notes journalières: 'Souscriptions,'" *Le jour*, 5 November 1898.

17. Gustave Schneider, "Les monuments de Baudelaire et Verlaine," *Le petit bleu de Paris*, 9 January 1899.

18. Robert d'Ailon, "La statue de Baudelaire," *La patrie*, 17 July 1901.

19. "Notes d'art: Les monuments," *La patrie*, 18 September 1901.

20. "Le monument Baudelaire," *La fronde*, 1 February 1902.

21. Beausire 1988, 192.

22. The author was informed by Hélène Marraud of the Musée Rodin.

23. For a discussion of this project, see Thorson 1975, 82–105; Fergonzi 1997, 140–41.

24. As Leo Steinberg saw it: "His real theme then is the intimacy of gestation, every available means being used to maintain a given figure as a telescoped sculptural process. . . . The little clay pellets or trial lumps which a sculptor lays down where he considers raising a surface—even if the decision is no—they stay put and, in a dozen portraits of the mature period, get cast in bronze" (1972, 393).

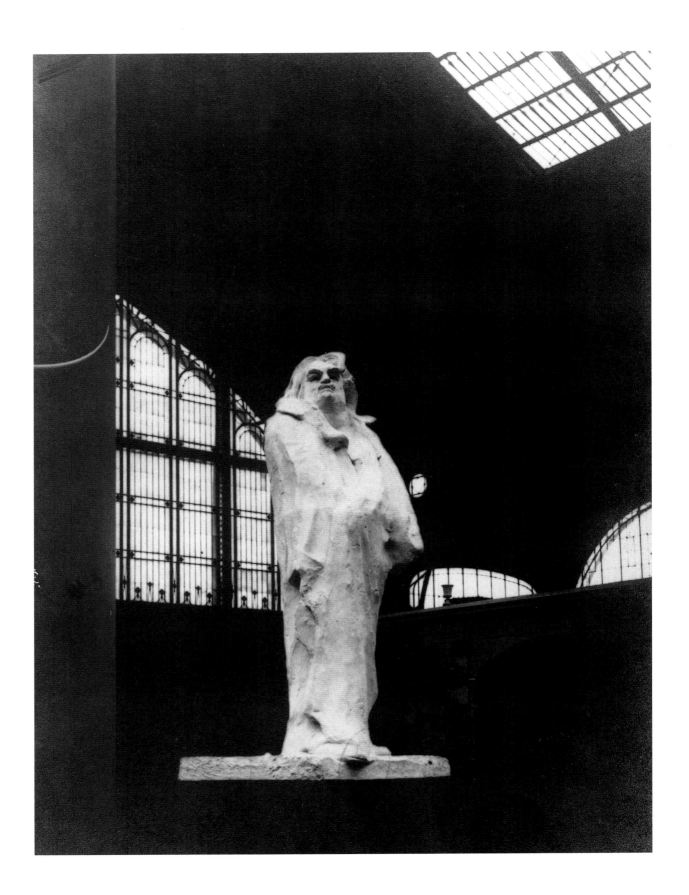

MONUMENT TO HONORÉ DE BALZAC

I am happy to announce to you officially that the Committee of the Société des gens de lettres, at their meeting of July 6, [1891], selected you by twelve votes against eight to execute the statue of Balzac, which is to be erected on the Square of the Palais Royal. —E[mile] Zola.

Rodin and Balzac: Creators of Tumultuous Life[1]

The commission was for a monument three meters high to be executed for the sum of ten thousand francs and delivered in eighteen months.[2] The artist was asked by reporters for his thoughts on the great writer. "He is a creator who brings to life all that he sees . . . and knows how to paint it with traits of a striking reality. I consider *The Human Comedy* (La comédie humaine) as the greatest piece of true humanity ever thrown down on paper. . . . Balzac is before everything a creator and this is the idea that I would wish to make understood in my statue. . . . As of now I would want to execute a figure standing rather than seated."[3] Months later Rodin expanded on his ideas in a prophetic way: "There, in the middle of the place du Palais Royal, I see Balzac dressed in his monk's robe, arms crossed, a simple pose, looking down at the passersby, the real actors of *The Human Comedy*, he depicted for us. I want a very simple architectural base with a single figure holding a mask in bas-relief."[4]

Rodin had experience with making monuments to the painters Jules Bastien-Lepage and Claude Lorrain (cat. nos. 91–95). Now he would be working simultaneously on those for three great writers. Two were his personal heroes for having contributed so much to his intellectual development: Victor Hugo (see cat. no. 87) and Charles Baudelaire (cat. no. 101). The mind and work of the third, Honoré de Balzac (1799–1850), were less familiar. The serious question confronting Rodin was how to make sculpture that appropriately celebrated the genius of writers. He answered in three markedly different ways, but none of these great projects would reach successful conclusions. This discussion of the *Monument to Honoré de Balzac* shows how the commission challenged all of Rodin's considerable intellectual resources. Long after

the Balzac affair was over, Rodin look backed and said, "Never has a statue caused me more worry, put my patience more to the test."[5]

Rodin's accomplishment in his *Monument to Honoré de Balzac* may be best understood in terms of the problems, apparent and real, with which he had to cope. He was first of all a sculptor dedicated to working from life, yet his subject had died more than forty years earlier. Thus Rodin began work on the monument when he was 51, the same age as Balzac at his death. In his vanity, Balzac had a cast made of his right hand, but there was no death mask to give exact facial dimensions such as Rodin often took from his subjects with a pair of calipers.[6]

The most accurate record of Balzac's physical proportions were in caricatures and his tailor's records. (Balzac had a 42–inch waist and 27–inch inseam.) The sculptor Alessandro Puttinati (1801–1872) had made a one-half life-size portrait in marble of Balzac in his dressing gown, standing with arms folded (fig. 278), but there was no life-size portrait or full-figure sculpture to provide true measurements of the man or to recall his profiles from the many points of view that for Rodin were crucial to the making of any work of art. There was ample circumstantial and verbal documentation on the writer's appearance: people to talk with who had known him, an awesome literary production to reveal the workings of his mind, and his home in Tours to visit. Not the least of Rodin's real problems was the staggering amount of material he tried to absorb. Rodin could have spent at least the first year reading Balzac's 47–volume *The*

Fig. 278. Alessandro Puttinati, *Statue of Honoré de Balzac*, 1837, marble, height 32¼ in. (82 cm). Maison de Balzac, Paris.

Human Comedy (1829–50). From all those words and images he had to fashion not a portrait of a writer but the sculpture of a man who is "before everything a creator."

Several good accounts have been written on the history of Rodin's project for a monument to Balzac, namely those by Ruth Butler, Judith Cladel, Jacques de Caso, Cécile Goldscheider, Frederic Grunfeld, Athena Tacha Spear, John Tancock, and most recently the richly documented Musée Rodin catalogue *1898: Le "Balzac" de Rodin*, edited by Antoinette Le Normand-Romain. The literature reminds us of the difficulties Rodin encountered with his patrons after the first two years. From the outset this group was not unanimous in its support of Rodin to replace the deceased sculptor Henri Chapu (1833–1891). Rodin was not silent on the subject, as he recognized that the sculptor Anatole Marquet de Vasselot (1840–1904) and his supporters were waiting in the wings for him to fail.[7] Except for the first study presented in January 1892, the models for the final sculpture that Rodin showed the Société brought no satisfaction, and subsequent demands for the sculptor to speed the work's completion reached the absurdity in 1894 of a vote by the committee requiring the sculpture's completion within 24 hours.[8] Only by agreeing to put his fee in escrow was Rodin able to win a reprieve, but by then Zola, his champion, was no longer president. In view of the national importance of both Balzac and Rodin, from the time of Rodin's selection the press kept recording the progress and lack thereof, giving the sculptor's supporters and critics ample space to express their views. For Rodin to have satisfied all the committee members' respective opinions would have been equal to Frenhofer, Balzac's fictional painter in the *Chef d'oeuvre inconnu* (*The Unknown Masterpiece*), successfully creating a perfect synthesis of line and color.

In his professional life, Rodin's affinities with the man he sought to honor were remarkable. Like Balzac, he agreed to a great undertaking for which the time allotted was far too short as measured by his own creative procedures, which required long periods for the gestation and condensation of ideas.[9] Writer and sculptor tended to interrupt difficult projects with trips. Rodin underscored Balzac's "mania to travel in the midst of an unfinished work" in a book on the writer by Charles de Lovenjoul.[10] Both men were compulsive editors of their own work, reluctant to give it up, and even then reworking it in their minds or creating new versions of what they had done. As they grew older, their conceptions matured

with them. Their "characters" reappear changed and under different circumstances.

Like Balzac, Rodin could not refrain from concurrently working on other projects such as the memorial to Baudelaire, the *Monument to Victor Hugo*, the *Tower of Labor*, the completion and installation of *The Burghers of Calais*, and the Claude Lorrain sculpture at Nancy. Balzac had others do some of his writing to meet financial commitments.[11] Rodin employed a number of skilled assistants to help him work simultaneously on many projects. Although he had a substantial studio practice to support, the sculptor's acceptance of major commissions, unlike Balzac's, did not stem from such overwhelming *personal* financial need. Like the writer, Rodin was goaded by the challenge to do many great things at the same time for the public. Balzac wrote to live well; Rodin lived to work well. In that connection it must have amused Rodin to read in his copy of the biography by Balzac's publisher Edmond Werdet that Balzac's two servants were named Auguste and Rose.[12]

Of all the male subjects Rodin was to interpret in his career, Balzac provided the greatest problem because he possessed the least likely body to be celebrated in serious sculpture. Consider the following description by Alphonse de Lamartine, which Rodin would have learned by heart: "[Honoré de Balzac] was big, thick, square at the base and shoulders; the neck, the chest, the body, the thighs, and the limbs were powerful. . . . There was so much soul that he carried himself lightly, gaily, so that his body was like a flexible covering and not a burden. This weight seemed to add and not detract from his strength. His short arms gestured with ease, and he chatted the way an orator speaks . . . his legs on which he occasionally rocked a little, easily carried his body; his large fat hands responded expressively to his thought."[13]

From Werdet, Rodin learned also that the writer was "a small man, heavy, fat, stocky, broad-shouldered, rather badly dressed, with a head adorned with graying hair, long, straight, and disheveled over his collar."[14] The only description of Balzac unclothed, except perhaps for a bathing costume, comes from the photographer Nadar (Félix Tournachon, 1820–1910), whom Rodin consulted. Nadar had proposed to go bathing in the Seine at lower Meudon, and Balzac accepted. "Never," recounted Nadar, "have I ever seen a mortal so hairy. He was a veritable bear cub. And I noticed with an all too natural emotion that his head of hair was extraordinarily 'populated.' I took care to bathe upstream of the great man."[15]

During his lifetime Balzac and his body had been ripe

for caricature, and his detractors had reaped the harvest. Rodin may have seen Nadar's caricature of Balzac (fig. 279), and Werdet observed that "A statuette by [Jean-Pierre] Dantan [1820–1910], as it inclines forward as if to charge, reproduces with infinite exactitude the figure, the pose, the toilette, the hair, right to the celebrated cane" (fig. 280).[16] Despite Werdet's characterization, Balzac was neither a man of physical action nor attraction, and he made much of the fact that for weeks on end he would sit for 16 to 18 hours a day at his writing table. According to various contemporary descriptions, when standing he revealed gnomelike legs, an enormous paunch, and a huge head. His profile spurred comparison with the ace of spades. Only when his audience could observe his eyes or when he spoke was he impressive. At first sight and before they talked, the printmaker Gavarni (Guillaume-Sulpice Chevalier, 1804–1866) mistook him for a bookseller's apprentice (fig. 281). While the great man thought of himself as a gentleman of fashion, he was, in fact, given to outlandish dress in public but worked at home in a Dominican friar's habit. He was prematurely potbellied and gaptoothed, so that even if Rodin had finally opted for a younger Balzac, as his commissioners at least once reminded him was his privilege, most of these physical characteristics would have still obtained.

More interesting than the choice of the subject's age was why Rodin consented to do a full figure of a writer. For him the most important problem in a public monument was the head, which a few years before he felt David d'Angers had solved for a memorial to Balzac. In an interview in 1888 with an unnamed reporter, both Rodin and Dalou said that whoever would make a statue to Balzac would have more or less to copy and respect the bust by David d'Angers (fig. 282). According to Rodin, "That leaves the artist to make a

CLOCKWISE FROM TOP LEFT

Fig. 279. Nadar (Félix Tournachon), *Caricature of Honoré de Balzac*, c. 1856, charcoal with gouache. Bibliothèque nationale, Paris.

Fig. 280. Jean-Pierre Dantan, *Statuette of Honoré de Balzac*, 1835, plaster, height 13⅜ in. (34 cm). Musée Carnavelet, Paris.

Fig. 281. Gavarni (Guillaume-Sulpice Chevalier), *Honoré de Balzac*, 1856, etching, 4⅜ x 7⅜ in. (11.2 x 18.8 cm). Former collection Christian Galantaris, Paris.

Fig. 282. Pierre-Jean David d'Angers, *Bust of Honoré de Balzac*, 1844, plaster. Musée de Saumur.

choice of symbolic figures . . . and I have not thought about them." (But Rodin had given some thought to the body that should support the bust and told the reporter it should have "broad shoulders.")[17] Many years later, when the project was over, Rodin took a different view in talking to Gabriel Ferry: "David d'Angers had a great deal of genius . . . but he was an idealist; all his busts are alike, whether it is Balzac, Victor Hugo, Goethe or Frédérick-Lemaître. . . . Therefore I do not take inspiration from the bust of David d'Angers. I even wish to forget it. Besides, in my works I consult only myself, never others."[18]

Rodin's years of trial and changes to his *Monument to Victor Hugo* were to culminate in the cutting away of everything but the author's bust, which Rodin finally acknowledged as the best of his labor. In 1892, in a statement concerning the memorial to Baudelaire, which probably paralleled in time the making of the *Nude Honoré de Balzac with Folded Arms* (cat. no. 109), Rodin gave a persuasive argument against including the body of a writer in a commemorative sculpture: "I do not see the statue of Baudelaire. What is a statue after all? A body, some arms, some legs covered with banal clothing. What do they have to do with Baudelaire who lived only by his brain? The head is everything with him."[19]

Not the least of Rodin's problems was the fact that his sculpture was originally to be placed facing the Louvre, near the Théâtre français (today the Comédie-Française) in the very heart of Paris. In the place du Palais Royal it would have to contend with a large open, heavily trafficked space with varied architecture. It also meant that the sculpture, and especially the head, would have to be seen from considerable distances and different angles under all lighting conditions. Judith Cladel, who came to know the sculptor during the time of his work on the monument, remembered: "The site where the statue will be erected is the object of long observations. From each one of the angles of the place du Palais Royal, Rodin measures with his eye the cube that the sculptured mass will occupy. The frame made by the buildings and the houses with broken lines demands planes of great sobriety; the figure, independently of the socle, must reach three meters in height—which is very little—in order to not be crushed by the decor."[20] It is pertinent that Rodin was attentive to his sculpture's intended location; in present-day terminology it was intended to be site-specific.

Rodin's greatness as an artist derived in part from an inquisitive mind that caused him to create original solutions to difficult problems. What must have haunted Rodin from the beginning was the question of what would be his conception for interpreting the writer. Judging by the number of studies, Rodin must have asked that question at least fifty times. But even an initial conception presupposed an intimate and thorough knowledge of his subject. The trouble was that in 1891 Rodin did not, by his standards, really *know* Balzac inside as well as out, as he would later claim when judging his own work for its sense of the man's essential character rather than just his physical appearance. When he received the commission, he wrote to Zola, "You will be of great help to me with ideas, for at the moment I have none, and you certainly have thought about the monument."[21] It was perhaps a measure of his initial insecurity over not sufficiently knowing his subject, his pride in having been chosen by a great living writer, his deference to him, and his awareness of his own tenuous position with the committee that, far from shutting himself off immediately from the world to plumb his own thoughts, Rodin's first reaction, as he told the press, was to talk with Zola to get a sense of how he and the commissioners thought of and wanted Balzac to be shown. Rodin knew what he did not like in public statuary: "photo-sculpture" and the subject "posing for the crowd." But should he show Balzac seated or standing, in street clothes or his Dominican robe? At what age should the writer be shown, and what should Balzac be doing with his famously expressive hands? Should the writer be smiling or serious? Crucial to showing "a creator" was the question of attitude. What should Balzac's pose, gestures, and expression convey?

From these uncertain beginnings in 1891, Rodin was about to dedicate most of seven years to creating for an impatient committee of sculpturally unsophisticated writers a heroic public monument destined for the heart of the nation's capital. The subject of this daunting effort was a short fat, ugly man who wrote books. The challenge would require of Rodin a heroic, self-surpassing effort in synthesizing into a single sculpture the many Balzacs he would come to know intimately but which in the end the committee could not or would not recognize.

Although it was seven years before Rodin stopped work on this monument, it appears he did not sustain throughout this time the concentrated effort of the first and last years. Both Balzac campaigns resulted in masterpieces, however, with the *Nude Honoré de Balzac with Folded Arms* (cat. no. 109) climaxing, if not terminating, the first and the final robed figure (cat. no. 112) bringing Rodin to artistic triumph and critical disaster.

Solving the Problem:
The Sculptor as Biographer and Historian

The problem of bringing Balzac back to life was one to which Rodin did, in fact, bring considerable experience. His *Saint John the Baptist Preaching*, the six *Burghers of Calais*, and portraits of Claude Lorrain and Baudelaire had been based largely on live, nonprofessional models whose appearance and expression he felt were sufficiently close to those of his subjects. Rodin's re-creation of a great subject was similar to the method employed by Balzac when he prepared to portray Napoleon, for example. The sculptor even reconnoitered more than once the geographical terrain of Balzac's life, much as the writer had revisited old Napoleonic battlefields. Balzac drew inspiration for his characters from close friends, chance acquaintances, or people seen momentarily on the streets. Rodin trusted successfully, as it turned out, to chance encounters in Balzac's home country of Touraine and Paris itself to give him ideas and models. This we know from several accounts by his friends and reporters.

Balzac's appearance was easily found, as it was familiar through a plethora of drawings, caricatures, prints, paintings, photographs, and some sculptures. These include the bust by Anatole Marquet de Vasselot (fig. 283) and the model for the monument to Balzac by Henri Chapu (see fig. 284). Rodin wrote to Zola that, in addition to consulting with Lovenjoul, "there are in the Bibliothèque de Paris 7 or 8 lithographs of Balzac—they are very small. I had photographs made of a very handsome pastel (life-size) by [Antonin] Court which is in the Musée des beaux-arts in Tours where there is also a drawing by [Louis] Boulanger [1806–1867; fig. 285]."[22] Once Rodin's interest in assembling documentation was known, many people sent him material. On his behalf, newspapers printed descriptions of Balzac for his guidance, and he was able to accumulate an impressive dossier: "The file was completed by the addition of all the iconographic documents, paintings, drawings, caricatures among which fortunately was the precious portrait by [Louis-Auguste] Bisson [1814–1876] which by itself would be enough to justify the invention of photography [fig. 286]. It is Balzac toward the end of his life, grave, ill, his hand extended flat on his chest as if to call attention to the malady of which he was to die and the immensity of the work that would thus be cut short."[23]

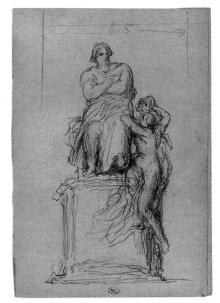

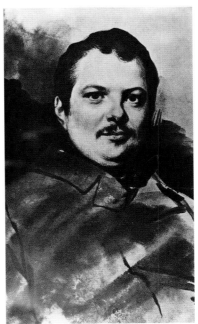

CLOCKWISE FROM TOP LEFT
Fig. 283. Anatole Marquet de Vasselot, *Bust of Honoré de Balzac*, 1876, marble. Musée de Tours.

Fig. 284. Henri Chapu, *Sketch for a Monument to Honoré de Balzac*, 1891. Louvre, Paris, Department of Graphic Arts, Collection Musée d'Orsay.

Fig. 286. Louis-Auguste Bisson, *Honoré de Balzac*, 1842, daguerreotype. Maison de Balzac, Paris.

Fig. 285. Louis Boulanger, *Honoré de Balzac*, 1830, sepia, 7⅟₁₆ x 9⅟₁₆ in. (18 x 24 cm). Musée des beaux-arts, Tours.

Le temps recounted what at the time seemed for Rodin a lucky find: "M. Rodin made several excursions to the Touraine in search of people recalling the great novelist. He even had the opportunity to search out an old tailor who had formerly made pants and vests for Balzac. This tailor, who lived in retirement . . . remembered his client quite clearly. He had even kept the measurement of Balzac's pants and vests. Naturally, M. Rodin had him make a suit with these measurements."[24] Although the clothes were seen lying in Rodin's studio, there is no certainty that he used them on a model.

More pertinent to the making of his sculpture was Rodin's intensive study of the writer, noted by Geffroy in 1893: "The other documents from which the work of the sculptor draws inspiration are not less convincing. I believe that since the day when the commission was made, Rodin has read and reread not only all Balzac's works but also all the writings published on Balzac, all those which contain, at the same time as information about his mind, the indication of some physical detail through which one might be able to catch a glimpse of the physiognomy and the attitude of the man."[25]

The Art Historian's Problems

The historian's problem of reconstructing exactly the sequence of the studies is not now, and may never be, solvable because some were destroyed by the artist, according to writers during those years. (A convincing attempt to establish the sequence was made in 1998 by the staff of the Musée Rodin, on which see note 1.) The texts we have from eyewitnesses often lack precision and thoroughness in descriptions of works, so that it is difficult to link surviving studies with literary sources and hence with firm dates. Often brief descriptions could apply to more than one work. Lastly, not all the studies are mentioned in the texts.

Both for the photographic sequence and this essay, the author has tried to suggest the evolutionary flow of Rodin's thought primarily in terms of the figural studies to which certain portraits can be attached. These figural studies have been arrayed according to what seems the most logical progression in terms of particular postural explorations and solutions to problems, some of which could have overlapped in time. What this arrangement assumes, perhaps naively, is that Rodin did not double back in time to an earlier idea. The short number of

years in which these works were created makes stylistic analysis precarious at best. No matter the chronology scholars contrive—and Athena Tacha Spear's was a brave initial and mostly persuasive effort—what is clear is the extraordinary testimony of almost 50 sculptures that precede the final monument. As Rodin himself recognized by having some of them cast in bronze, many are self-sufficient as works of sculpture. The number of heads alone established the method Rodin would use on his great portrait of Georges Clemenceau (cat. no. 145), for which there were roughly 29 versions or states. Attracted to the history around as well as of the project, the artist's personal problems and those with his clients, critical reactions, and the archaeology of dating and linking studies with literary documentation, most commentators have said little about the sculptures themselves as art and what they tell us about these two great creators. That is the purpose of this commentary.

The Early Studies, 1891–92

Available to Rodin were some insightful verbal descriptions of Balzac's face from people who knew him and interpreted what they saw. Alphonse de Lamartine observed,

> The face of Honoré de Balzac was the face of an element: big head, hair disheveled over his collar and cheeks, like a wave which the scissors never clipped. . . .
>
> In front of the face you no longer thought of the frame. This expressive face, from which one could not detach one's eyes, was entirely charming and fascinating. The hair fell upon the forehead in great curls, the black eyes were as piercing as darts . . . his rosy cheeks were full . . . the nose was well modeled although a little long; the ample lips were gracefully shaped and turned up at the corners . . . the head often rested to one side on the neck and then with a heroic pride straightened itself as he became animated in the discussion. But the predominant characteristic of the face, even more than its intelligence, was the goodness it communicated. . . . No passion of hatred or envy could have been expressed by that face; it would have been impossible for it to be anything but kind.[26]

And from Werdet's biography, these observations:

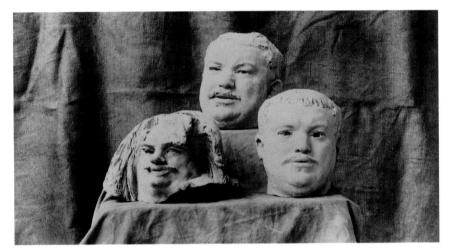

The face of a monk, wide, ruddy, jovial, large mouth smiling under a mustache; the ensemble of features revealed something common, except the eye which, although small, had an extraordinary sensitivity and variety.[27]

The face was radiant. It was the face of Silenus which brightened up. . . . His bursts of laughter were such that the entire banquet hall shook.[28]

Serious attempts have been made by scholars to show that certain early heads were based on Balzacian iconography, from images collected by or given to Rodin by friends. The matching by art historians of photographs of prints, paintings, and drawings to those of plaster facial studies is a game whose seriousness and accuracy depend often on the quality of the reproduction of the sculpture, the angle from which it was photographed, the lighting, and whether or not the player actually consulted the sculpture *in the round*.[29] For example, handling the Stanford bronze heads in the sunlight and looking at them from various angles, particularly from below, inspires the suspicion that, for an artist who studied his subjects from many profiles, none of the early heads was made literally and exclusively from *two*-dimensional sources. Earlier portraits must have guided Rodin in the choice of living models, a process we can be certain he engaged in. Geffroy reported that "during his walking and searching [in the Loire valley] Rodin distinguished a *Tourangeau* type which is the type of Balzac. He chose several of those who were marked most deeply with these traits, and he modeled their masks during careful sit-

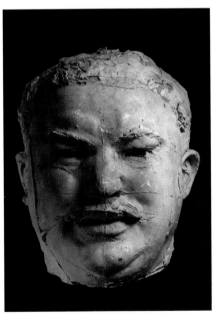

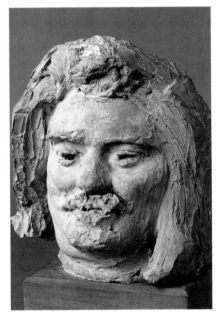

Top left: Fig. 287. *Mask of Honoré de Balzac Smiling*, 1891, plaster, 9⅝ x 7½ x 7⁷⁄₁₆ in. (24.5 x 19 x 18 cm). Musée Rodin, Paris, S1650.

Top right: Fig. 288. Unknown, photographer, *Estager, "Conductor of Tours," Model for "Honoré de Balzac,"* 1891, albumen print. Musée Rodin, Paris.

Center: Fig. 289. Unknown, photographer, *Three Studies for "Head of Honoré de Balzac,"* plaster, 1894, albumen print. Musée Rodin, Paris. The *Head of Young Balzac*, 1891, is at the right.

Bottom left: Fig. 290. *"Mask of Honoré de Balzac,"* called "The Conductor of Tours," 1891-92, plaster, 9⁷⁄₁₆ x 8¼ x 6¹¹⁄₁₆ in. (24 x 21 x 17 cm). Musée Rodin, Paris, S610.

Bottom right: Fig. 291. *Study for "Head of Honoré de Balzac,"* after Benjamin Roubaud(?), 1891-92, terra-cotta, 10¼ x 10 x 7⅝ in. (26 x 25.4 x 19.4 cm). Musée Rodin, Paris, S1789.

tings with the scrupulous concern, the dutiful study which he brought to the reproduction of nature. . . . My astonishment from the first time I saw them has kept increasing. With less height of forehead, with less width of cheek, it is physically Balzac. One of them above all, a smiling peasant, nearly laughing."[30] Geffroy was writing possibly of the masks of Balzac smiling (cat. no. 105 and fig. 287).

Judith Cladel wrote, "He met a young man, a traveling salesman; he had him pose, and from him executed a large well-worked bust, then he animated this frank and open face with a Rabelaisian joviality and with the spiritual flame that burned 'in the eyes filled with gold' of the novelist. And there it was, a smiling Balzac, with the charm of youth, with confidence in himself and life; but this was still not the father of *The Human Comedy*."[31]

More than the biographies and iconography, these stand-in models gave the sculptor not only the type, the broad physiognomic character of his quarry, but likenesses, faces seen under the animating influence of natural light and conversation (fig. 288).[32] They smile benevolently or speak intimately yet with an orator's style, or they stare straight ahead with a provincial self-consciousness before the unfamiliar inspection by an artist from Paris (figs. 289–291). As intimated by the biographers, rather than the portraitists, these early heads exude good nature, kindness, and well-being, but, in Balzac's term, they were still "commonplace beings," betraying neither in their spirit nor in their modeling signs of the creator's tumultuous life.

In the eyewitness accounts only one mention is made of a study showing Balzac in street clothes, and the 1830 costume described does not accord with available or existing studies. We do not know when Rodin started such costumed figures or whether they preceded, coincided with, or came after the robed bodies of the writer. Circumstantial evidence would put them in the period of 1891–92. Biographers reported that in a drawing room addressing a group Balzac liked to rock back and forth on the balls of his feet. Lamartine described his bending forward as if to gather up ideas, like sheaves of wheat, and then straightening up on his toes as if to watch the flight of an idea toward infinity.[33] Seen together, what may be among the earliest three studies show the social Balzac. In two he is holding forth as in a salon, hands together behind the tails of his frock coat, balancing easily as he leans forward and backward in conversational thrust and parry (figs. 292–293).[34] Rodin sought the essential volumes of the figure and also an overall atti-

tude, so that the bowed head might evoke the private thoughtful writer in a public situation. Dantan's sculptural caricature, as Werdet affirmed, could have given Rodin the most accurate proportions of the writer.[35] The third early sketch of a clothed Balzac (fig. 294) shows him standing with his left arm curled behind his back and his right forearm resting on a short rude stand. The spread-legged stance and body posture was to be the source for a brilliant conception of a naked Balzac as orator. Given what Balzac's contemporaries reported, it is interesting that in the early rough sketches Rodin concealed the hands "expressive of his thought" and in this last sketch the right hand is passive.

The informality of the early clothed conceptions reached its height, and probable termination, in a study of the casually posed writer, legs crossed, arms folded, leaning back against a support, referred to as *Honoré de Balzac in a Frock Coat* (cat. no. 102). The clothes the figure wears may, in fact, reflect those made for Rodin by Balzac's tailor. No other study is as relaxed or self-immobilized. The crossed ankles may have been appropriate for an intellectual in the sculptor's mind, and the unusually informal pose reflected an insouciance toward monumental sculptural tradition on Rodin's part, which matched Balzac's disdain for sartorial orthodoxy.

Many reasons encouraged Rodin to forsake pursuit of a monument to Balzac's tailor, not the least of which was the more timeless appeal of the cloaklike garment the writer lived in during his endless working hours. Louis Boulanger in painting (fig. 295), Alessandro Puttinati in sculpture, and Benjamin Roubaud (1811–1847) and Etienne Carjat (1829–1906) in lithography and engraving (figs. 296–297), to name a few, had satisfied the confident, arm-folded, monkish self-image of the private Balzac. For Rodin, Balzac's "habit of working in a sort of dressing gown, gave me the opportunity of putting him into a loose flowing robe that supplied me with good lines and profiles without dating the statue."[36] On 9 January 1892 the committee visited Rodin's studio to view three studies, selecting one: "Balzac is standing, his arms crossed, his head high, dressed in his legendary monk's robe tied by a cord at the waist. The committee congratulated M. Rodin on his project and asked him to start work immediately on the marble."[37] More than a month later Roger Marx wrote:

If we do not have the statue yet, at least we can anticipate it because a study of the future work

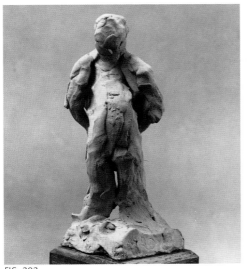

FIG. 292

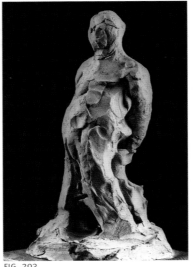

FIG. 293

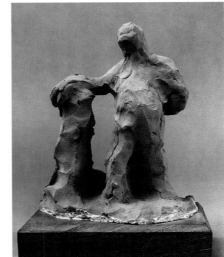

FIG. 294

Top left: Fig. 292. *Honoré de Balzac in Frock Coat*, after Paul Gavarni?, 1891–92, terra-cotta, 7¹¹⁄₁₆ x 3³⁄₁₆ x 3⁵⁄₁₆ in. (19.6 x 8.2 x 8.5 cm). Musée Rodin, Paris, S262.

Top middle: Fig. 293. *Honoré de Balzac in Frock Coat*, after Paul Gavarni, 1891–92, terra-cotta, 7¹⁄₁₆ x 4¹⁄₈ x 4⁵⁄₁₆ in. (18 x 10.5 x 11 cm). Musée Rodin, Paris, S125.

Top right: Fig. 294. *Honoré de Balzac in Frock Coat, Right Arm Resting on a Stand*, after Jean-Pierre Dantan?, 1891-92, terra-cotta, 5¹³⁄₁₆ x 5⁷⁄₈ x 3¹³⁄₁₆ in. (14.8 x 15 x 9.7 cm). Musée Rodin, Paris, S258.

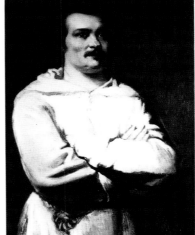

FIG. 295

Middle: Fig. 295. Louis Boulanger, *Honoré de Balzac in a Robe*, 1836-37, oil on canvas, 24 x 19⁷⁄₈ in. (61 x 50.5 cm). Musée des beaux-arts, Tours.

Bottom right: Fig. 296. Benjamin Roubaud, *Caricature of Honoré de Balzac*, 1838, lithograph, 8³⁄₁₆ x 10¹⁄₄ in. (20.8 x 26.1 cm). Former collection Christian Galantaris, Paris.

Far left: Fig. 297. G. Perrichon after Etienne Carjat, *Caricature of Honoré de Balzac*, 1856, wood engraving. Bibliothèque Mazarine, Paris.

FIG. 297

FIG. 296

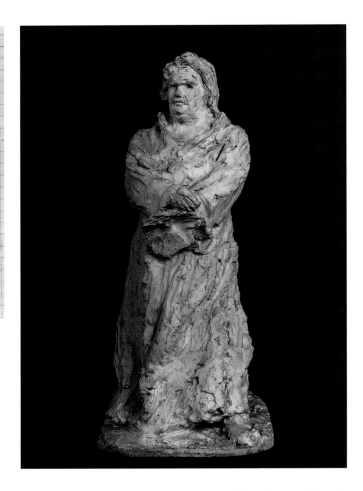

Right: Fig. 298.
*Honoré de
Balzac in a
Robe Holding a
Manuscript,*
1891–92,
plaster, 37⅜ x
16⅛ x 15¾ in.
(95 x 41 x 40
cm). Musée
Rodin, Paris,
S181.

Left: Fig. 299.
*Sketch of
Honoré de
Balzac Nude,* c.
1891–92(?),
pencil on
paper.
Philadelphia
Museum of Art.

Middle: Fig.
300. *Sketch of
Honoré de
Balzac Robed,*
c. 1891–92(?),
pencil on
paper.
Philadelphia
Museum of Art.

exists, well under way, very precise, definitive and first-rate. Balzac is presented standing, draped in the Dominican's frock which was the shroud that this obstinate thinker riveted to his task never took off. . . . And since the large secular garment does not indicate any date, the thought remains generalized and the only idea suggested by the costume is that of toilsome seclusion, that of work taken up each morning, without respite. . . . [The garment] is not treated at all like a photograph; it expresses a great deal through willful abbreviations. Never does it distract attention from the face where life and thought are. Here the attitude is full of calm and sovereign repose. The arms are crossed on the chest, without allowing anything to be seen of those prelate's hands of which Balzac was so proud, and for this even, the eye is immediately carried to the mask and desires to penetrate its engima.[38]

Just which study did Rodin show the committee? No mention is made by the writers of the figure holding a manuscript. Neither the described work or works nor any studies of the nude it presupposed seem to have survived. It is nevertheless interesting that with the initial efforts shown to the committee Rodin pleased them, for the first and only time, so that he was offered the chance to translate the selected composition into marble. But obviously Rodin had second thoughts almost immediately. Perhaps responding to a criticism by Zola, he wrote "I have arranged the leg, mounted it, and moved it farther back; the figure has gained a lot, so much so that I

am happy about it, and I take up the clay and begin impatiently to arrive at your wish."[39]

Caricaturists like Dantan, Roubaud, and Carjat were important to Rodin, who knew from experience that for an outdoor monument the sculptor had to lie, to exaggerate his subject's features for them to impress the viewer at a distance with the truth of identity and expression. The shapeless, quiet white gown was a perfect foil for the rubbery resiliency of the rounded features and blackness of Balzac's hair and eye sockets. One of the earliest surviving robed studies of the writer parallels the cross-legged, folded-arm pose of the resting clothed figure, but the right hand now holds a manuscript (fig. 298), signifying a dramatic moment of inspiration sought during the evening hours, a crucial though not original find for Rodin, which would help him years later establish the motivation for his character in the last act.

From the self-constricted posture Rodin then may have proceeded to open up the stance to get more action in the body. In a second robed figure (cat. no. 103) Balzac is shown with his weight on both legs, head tilted back, arms in a pose that rotates the upper torso, one hand at his waist absently clutching what appears to be

an open manuscript, the other hand presumably intended to be bent at the wrist, while resting on his left hip. Actually, no hand emerges from the sleeve. A pile of manuscripts is suggested near the figure's right leg, like the trophies at the foot of a conquering hero. The triviality and transparency of this prop did not survive, but the mound may have suggested the support of the upraised right leg of what is possibly the first remaining nude in the series (cat. no. 104). The weight of the conqueror's pose is carried on the left leg, and to further activate the static stance the arms spiral in front and behind the headless torso. Drawings from a small sketchbook in the Philadelphia Museum of Art may show Rodin's wrestling at an early date with the problem of dramatizing a stable, cloaked figure (figs. 299–300).[40]

Having unlocked the body and opened the composition, Rodin's next step may well have been the inspired creation of the orator's pose, incorrectly referred to in the literature as that of a wrestler (cat. no. 108). It derives from the clay sketch of the clothed Balzac with his right arm resting on a stand (see fig. 294). The study celebrates Balzac's prowess as a public speaker, debater, and playwright reading unfinished dramas to an assembled company of actors or prospective backers in the Théâtre français, near where the final sculpture was to stand. Figures 299 and 300 and a third drawing also in the Philadelphia Museum of Art forecast the paunchy model in the sculpture, and while the stage prop may foretell the situation, the stance is not as dynamic an orator's pose as that in the sculpture.[41] The modeled, spread-eagled posture invited the extended right arm, which, according to French theatrical ideas of good stage comportment, is balanced by the left, curled behind the back, a counterpoise of open and closed form. It was in such moments of forensic display that Balzac could dispel the audience's consciousness of his physical shortcomings. Rodin's writer straddles the world stage, compassing the earth with his legs, his mind miniaturizing French society. But this is Balzac posing for the crowd, and it came to Rodin even before he spoke of it years later to a friend that this was too close to the convention of pretentious memorials to public figures.

The small orator conception so captured Rodin's imagination that he reworked it in half life-size, from a live model. The result is an astounding sculpture (fig. 301). (A variant plaster cast exists in the Meudon reserve, differing by how much of the legs is shown).[42]

No attempt was made to mute or disguise the figure's impressive girth, as it would be later through the use of arms crossed over the chest. In fact, the shape that resulted from Balzac's gastronomic indulgence and physical indolence is flaunted. Key to Rodin's thinking is the forked stance that widens the base beyond the torso. The strong modeling of the body's broad planes give it sculptural presence. The figure's left foot was broken off, but the right arm was carefully edited as Rodin pondered the gesture it should make. (From what remains of the upper right arm, it seems Rodin at first wanted to continue the gesture of the smaller figure.) Having found an appropriate and inspiring model, Rodin went on to use him for the startling figure studies that for years have been on view in the Meudon pavilion.

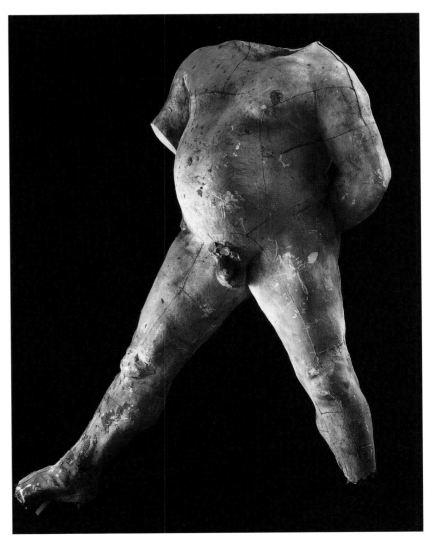

Fig. 301. *Nude Study for "Honoré de Balzac as Orator,"* c. 1891–92, plaster, 50⅜ x 23¹³/₁₆ x 15¼ in. (129 x 60.5 x 38.8 cm). Musée Rodin, Paris, S3198.

TOP TO BOTTOM
Fig. 302. *Study for "Head of Honoré de Balzac,"* after Benjamin Roubaud?, 1892–93?, terra-cotta, 11 x 10⅝ x 9¹⁵⁄₁₆ in. (28 x 27 x 25.2 cm). Musée Rodin, Paris, S1770.

Fig. 303. *Study for "Head of Honoré de Balzac,"* 1892–93?, plaster, 10⅝ x 10¾ x 9¹³⁄₁₆ in. (27.1 x 27.3 x 25 cm). Musée Rodin, Paris, S1393.

Fig. 304. *Study for "Head of Honoré de Balzac,"* 1892–93?, terra-cotta, 8¼ x 7¹¹⁄₁₆ x 8⅞ in. (21 x 19.5 x 22.5 cm). Musée Rodin, Paris, S1653.

Fig. 305. *Study for "Head of Honoré de Balzac,"* 1892–93?, terra-cotta, 8¹⁄₁₆ x 7½ x 8 7/16 in. (20.5 x 19 x 21.5 cm). Musée Rodin, Paris, S1644.

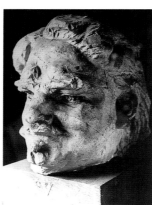

There is a group of heads, probably from 1892–93 or later, that shows Rodin passing from the reconnaissance of facial types to the building of an image by intuition, which conforms with Balzac's self-image as "an exceptional being," the creator of tumultuous life (figs. 302–305, cat. no. 107). As had Balzac, Rodin was enlarging on commonplace human beings, and by a reverse idealization he was achieving the horrifying and grotesque. Neither man believed in stylization. Life was their style. Both believed in a kind of spontaneity and the natural in narration and modeling. Both had their pedestrian modes that at crucial times could be graced by the inspired phrase or modeled passage.

One of Balzac's anatomical features that fascinated Rodin was the writer's thick neck, described in words and seen in images such as the portrait lithograph by Emile Lassalle (1813–1871; fig. 306). In retrospect the only error to which Rodin admitted in his final Balzac was the excessive exaggeration of the neck. Perhaps thinking of Lamartine's description of how Balzac might incline his head to one side while listening, Rodin made at least two studies with the long-necked and robed writer in this attentive pose (figs. 307–308); the second is an

M. DE BALZAC.

Galerie des Contemporains illustrés

Imp. de P. Gaubreau E. Ducrocq r. Hautefeuille, 22.

enlargement of the upper part of the first. The girth and uninflected nature of the cylindrical neck are flagrant. Perhaps Rodin was thinking of the distance from which the outdoor sculpture would be seen, and through exaggeration he wanted to identify his subject and draw attention to his head. In characteristic fashion Rodin used the same head at least three times, once by itself with only a portion of the upper neck retained (cat. no. 106). Of all the Balzac faces he fashioned, this is the most reflective in mood and indicative of the private individual.

The sculptures themselves testify that, having established a certain basic type in plaster, Rodin would take a second or third cast and add clay or plaster to alter a nose, brow, or curl of hair, like an actor altering his makeup to show aging and ripening of personality, a head battered as much from within as without. Mustaches, eyebrows, and hair slowly lose their textural distinction and seem more like fleshy growths, imparting a heaving, curling surface pressured from below. As with Balzac's characters, Rodin's heads of the writer always show the trace of the living model behind the abstrac-

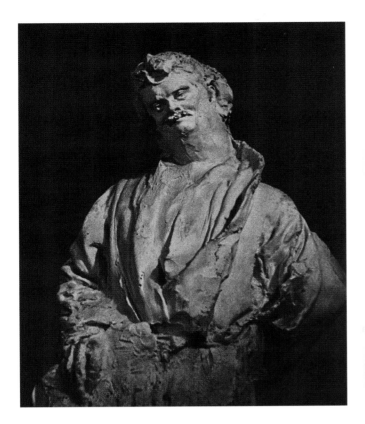

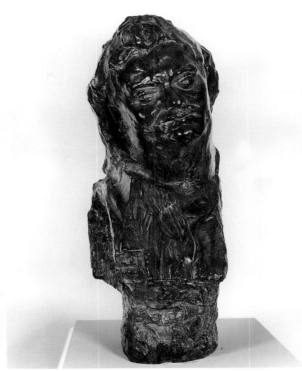

tion. And as with Balzac, Rodin could get caught up in inspiration. Fact and fiction, reality and the impossible would shift in proportion or fuse to the annoyance of their critics. What we see in these studies is that from supporting a face, the head was being slowly transformed into a force. From first to last Rodin's evocations of the writer's head are like a Balzac digression on how one of his characters traveled from health to ruin, talent to genius, or observer to visionary.

What body was capable or worthy of supporting one of these heads? The answer may have been that provided by the model for the enlarged version of the orator's pose. He could have served for the body of the next naked figure that Rodin probably made, a Balzac with arms crossed over a big belly (fig. 309); which was followed by a partially robed version (fig. 310). Previously dated 1893–95 (Spear and Tancock) or 1897–98 (de Caso), this plaster seems more likely to have been made around 1892.[43] Now as then, the *Nude Balzac* still shocks the beholder. Charles Chincholle wrote, "During the year 1892 . . . the artist had conceived a strange Balzac, in the attitude of a wrestler, seeming to defy the world. He had placed over very widespread legs an enormous belly. More concerned with a perfect resemblance than with

the usual conception of Balzac, he made him shocking, deformed, his head sunk into his shoulders."[44] Although used by some historians to date what I believe is the next version of the *Nude Honoré de Balzac with Folded Arms* in the Stanford cast (fig. 311), Chincholle's general description is at least as apt for the Meudon plaster, and the reference to deformity seems more applicable. From the small orator figure, Rodin preserved the open stance, now warped by the knock-kneed model. He returned to the posture of the arms in the first robed sketch, with the right hand slightly extended, as if it might hold a manuscript or pen (see fig. 298). All this was done from a model's living body with the same terrifying exactitude that Balzac prided himself on as a writer. Although grotesque, the character remains human by the verisimilitude of the modeling.

At the line of the navel Rodin cut the plaster sculpture in half (fig. 309), and today we can see that the upper and lower sections do not fit precisely.[45] Rodin was faithful to Balzac's habit of standing with toes pointed outward, and the sculpture's feet point like the hands of a clock to twenty minutes of two. Being dissatisfied with the original direction of the upper torso, Rodin's problem was then to choose the direction in which the head

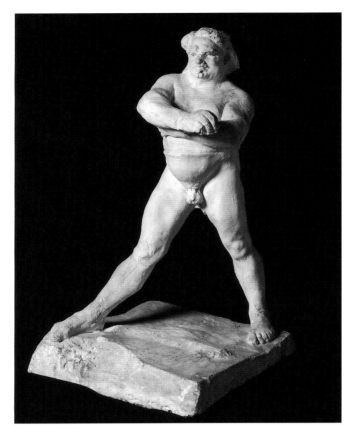

Fig. 309. *Study for "Nude Honoré de Balzac with Arms Crossed,"* 1892–93?, plaster, 52¾ x 29½ x 3⅞ in. (134 x 75 x 81 cm). Musée Rodin, Paris, S147.

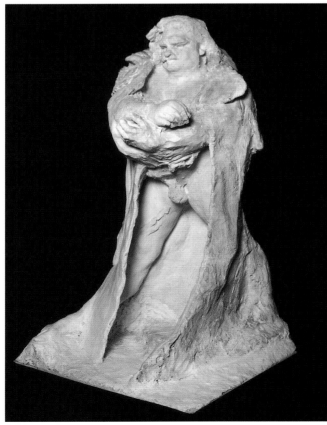

Fig. 310. *Study for "Robed Honoré de Balzac with Arms Crossed,"* 1892–93?, plaster, 58⁵⁄₁₆ x 31½ x 30⁵⁄₁₆ in. (137 x 80 x 77 cm). Musée Rodin, Paris, S148.

and chest should point. In typical economical fashion, he cut the plaster and pivoted the upper half until the direction of the head split the angle of the feet.

The sight of the naked, misshapen figure in a brazen pose surmounted by a head that must have looked caricatural could not have secured confidence in Rodin's clients. Its robed version must not have fared better (fig. 310). The arms are crossing as if Balzac is about to close the robe, which hangs open to reveal his nakedness. The effect of the misshapen body on its cloak remains stunning. The arabesque heaves and curls like a tidal wave, and even the collar engulfs one side of the head. The focus is not shared between head and body but is dominated by the robe on three sides. The undulant sweep of the garment—not the face as Lamartine observed—evokes an element of nature.

Nude Honoré de Balzac with Folded Arms

The stage was now set for the emergence of the great *Nude Honoré de Balzac with Folded Arms* (cat. no. 109, fig. 311.). By his previous daring Rodin had created exciting new options as well as obstacles to the realization of a sculpture that had both formal and psychological resolution. *Nude Honoré de Balzac with Folded Arms* cannot be read, in this author's estimation, as having preceded the grotesque nude at Meudon, for this would have constituted an undoing or regression in both the form and character of the figure. That two different men were used as a model may be explained by the account of one writer who commented on the artist's loss of a favored model. "The statue progressed to the liking of . . . the master; but one fine day no more model, he had disappeared."[46] By comparison, the Meudon figure's stance was too open and the directions in which the body was aimed too varied and, like the gestures, indecisive or unresolved. There was too discrepant a difference between the width of the feet and the upper part of the body to fit into Rodin's imagined cube, by which he judged the compactness of his work. From the side the gesticulating hands broke the lines of the silhouette and exaggerated even further the subject's awesome girth. The divergent angles of the torso and legs destroyed continuity of profile from ankle to neck, and the thrust of the legs did not seem to carry up into the body. The head at Meudon was set too low in relation to the shoulders and collar of the robe. Finally, as a symptom of his prefer-

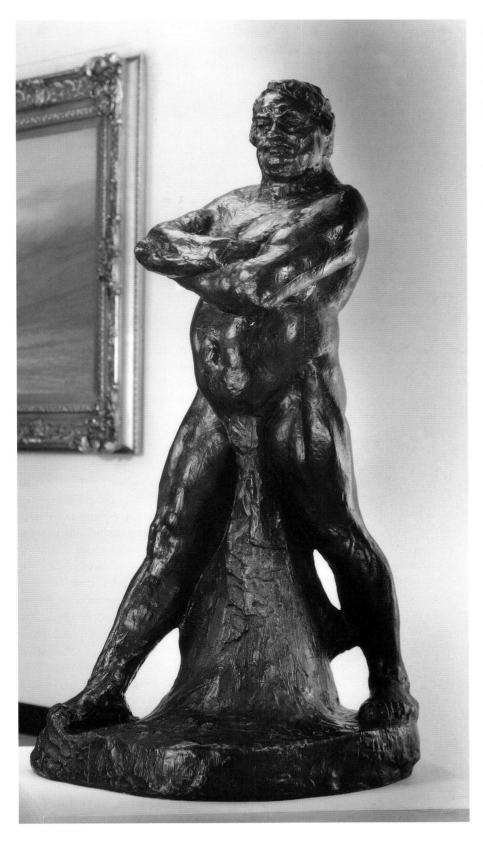

Fig. 311. *Nude Honoré de Balzac with Folded Arms* (cat. no. 109).

ence in terms of what he had decided, Rodin did not reduce in size the Meudon versions as he did the *Nude Honoré de Balzac with Folded Arms* represented in the Stanford figure.

In 1894 the writer and social activist Séverine (Caroline Rémy) published an account of a work she saw during a visit to Rodin's studio. Although used by Tancock and de Caso with reference to the two Meudon plasters, consider its appropriateness to this naked Balzac with folded arms. She saw it as a

bonhomme in clay, furiously hammered with thumb marks. . . . Close up, it was very ugly, the skin as if flayed, the face barely indicated—quite naked, what a horror! But the arms were folded in such a manner over the powerful pectoral muscles, and the space between the legs, as if in the position of walking, with the conquering advance of the step, suggested so magnificently taking possession of the ground, the feet as if attached to the mother earth by roots. And from that formless face, full of holes, with a grin like a scar, a nose like a bird's beak, cannibal-like jaws, a rugged forehead beneath a mass of hair like a clump of weeds, there emanated such an imperious sovereignty, almost superhuman, that an austere shiver, known by intellectuals, passed down my spine.[47]

All three "wrestler" types raise the question of Balzac's age. Why did Rodin choose to portray an older figure in the pose selected

by the Société's delegation in 1892? (From the sculpture's anatomy, the model was probably in his early fifties.) Admittedly Rodin's various portrait reconnaissances show various ages. Though talented and energetic and dreaming of greater things, Balzac, like Rodin, was obliged as a young man to do a considerable amount of hackwork, even letting others sign their names to his efforts or writing under the nom de plume Horace de Saint-Aubin. Before he was 30, Balzac had not written enough nor sufficiently well to warrant his later commemoration. Rodin was surely aware of the long apprenticeship they both endured and the tenacity married to energy that begot their respective characters. In their productive early years, as well as later, both were subjected to bitter and often scurrilous attacks. It was not until his late thirties that Balzac conceived of the grand plan for *The Human Comedy*. His conception, like Rodin's *Gates of Hell*, was strongly inspired by Dante's *Divine Comedy*. Thus, at about the same age, roughly 40, both men, working in Paris and drawing from a common inspiration, came to undertake an epic that would re-create their own societies.

It is hard to believe that having done so much personal research that Rodin was unaware of or unimpressed by Balzac's personal magnetism and debauchery, which were as herculean as his prodigious literary output. Biographers described how he feasted while facing bankruptcy, how his abundant belly reverberated to joviality, and how his eyes melted the resistance of beautiful women when they first saw him. In Rodin's imagination Balzac lived not only by his brain but also through his body. Balzac had referred to himself as being many men, and one can conjecture which Balzac might Rodin have imaged in his mind in 1891: the womanizer who knew the other sex better than they themselves; the financier gifted with prophecy but damned by naiveté; or the aesthete who awarded himself bejeweled canes. The choices for Rodin could have been between the Rabelaisian Balzac of the *Contes drolatiques* (*Droll Stories*) or the visionary of *Séraphita* or the astute sociologist of the *Physiologies*, to name but a few. Rodin's sculpture suggests that in many respects he decided not to choose but to fuse.

The Sculpture

Much of the brilliance of the *Nude Honoré de Balzac with Folded Arms* derives from its strident pose. Psychologically

and aesthetically it wins a commanding presence for the figure. The assertive stance readily lends itself to an interpretation of the figure as an athlete, a wrestler, a man whose fleshy body preserves the memory of physical strength. Judith Cladel astutely described this posture as "the movement of a fighter who marches to combat."[48] Rodin's decision to position his figure thus was genuinely inspired, not suggested by the visual iconography or written descriptions of the man. Paintings, drawings, prints, and sculptures do not show this pose, nor do such biographers as Lamartine and Werdet specifically describe this wide-open stance as being natural or instinctive to the writer. Boulanger's portrait (see fig. 295), which Balzac admired for conveying his tenacity and self-confidence in the future, does represent the writer with arms folded across his chest. (Balzac liked the monastic associations of his white robe, and he hoped it would convince his Polish mistress, Eveline Hanska, of his fidelity during their separation.)[49] Rodin's sense of the appropriateness of the folded arms may also have come from or been reinforced by reading *Autre Étude de Femme* (*Another Study of Woman*; 1842), in which, while describing Napoleon, Balzac wrote, "A man is depicted with his arms folded, but who did everything! . . . A man who could do everything because he willed everything."[50] This ironic image of the passive gesture for men who in their own ways reshaped the world may not have been lost on Rodin.

The pose of the *Nude Honoré de Balzac with Folded Arms* satisfies different demands. It imparts suggestions of strong character and self-assurance. Secondly, it was the brilliant artistic solution to the problem of achieving an imposing sculpture of a short obese individual. In the present-day absence of rhetorical sculpture, we have forgotten the importance of figure composition and symbolism before and during Rodin's lifetime. (We have even forgotten what single-figure composition consists of and that since antiquity the naked body was used metaphorically.) Rodin's sculpture reminds us that good figure composition includes minimizing and harmonizing physical disparities. Better than any alchemist, Rodin transforms the lead of Balzac's physical characteristics into artistic gold.

There is every reason to believe that for this sculpture Rodin used the body of one model and the head of another. (The head is disproportionately small for the body.) That this was a frequent practice is testified to in *The Gates of Hell* and *The Burghers of Calais*. One of his

many considerable achievements in this sculpture is to persuade us that the body can only belong to the head on its shoulders and the reverse. Balzac's famous thick neck permitted Rodin to effect the graft.

In her 1894 article Séverine wrote about the space between the figure's legs, "as if in the position of walking, with the conquering advance of the step, suggested so magnificently taking possession of the ground."[51] It is for this and other reasons within the sculpture itself—the tensed muscles, the elongated left leg—that the legacy of *Saint John the Baptist Preaching* (see fig. 446) on the *Nude Balzac* can be considered. An armless study made in the 1890s as well as the final *Saint John* remained in Rodin's studio and therefore were accessible for study and comparison. In turn it is reasonable to think that the *Nude Balzac*'s stance, especially with the left foot turned out, affected Rodin's changes in *The Walking Man* (cat. no. 174). As with *Saint John* and a few years later *The Walking Man*, it is probable that Rodin intended the viewer to read his Balzac sculpture sequentially from the base upward, the back leg to the front leg. Such a reading can be made with profit.

As has been mentioned, it seems to have been Balzac's habit to stand with his toes pointed outward. In both *Walking Man* and *Saint John* Rodin's figures are somewhat pigeon-toed; the feet firmly identified with the base and its shape or perimeter. The base of the Balzac sculpture has, in fact, been trimmed more closely to coincide with the angle and diameter of the feet; the left foot overlaps the base as it does in the final version of 1898. Examination of the right foot and leg of the *Nude Honoré de Balzac with Folded Arms* shows a discontinuity of their axes and a drastic curvature of the shinbone of the right leg.[52] A surgeon would correct such a condition by an operation, but Rodin induced this physical deformity by altering the position of the foot or leg, but not both. The upper part of the figure's right leg seems to be turned outward as if the foot were similarly angled. As with *The Walking Man*, it is possible that Rodin wanted some closure to the open stance and found that the present angle of the foot produced a more dramatic muscular tension and overall visual effectiveness as compared with the Meudon version.

By spreading the feet wide apart, Rodin gained many advantages. Physiologist Dr. Harold Lewis, studying photographs of the sculpture, suggested that the stance would accommodate a figure who had a shortened leg and wished to appear normal. There is another reason to believe that Rodin's model was not so handicapped, and we must also judge his distortions within the context of the whole sculpture. Rodin's concerns for perfection were aesthetic and expressive, not cosmetic. The forked stance produced a broad base for the figure, which preserved the overall squarish appearance Lamartine described and kept the stomach from visually overbalancing the whole. This posture also allowed the artist to build dramatically to the stomach area and discreetly to lengthen the subject's short legs. As in *The Walking Man* the rear, or left, leg is a few inches longer than the right, or front, leg. By spreading the legs Rodin did himself and his subject a service as he was able to hollow the flanks where there was likely to have been fat in his middle-aged model. The swell of the left thigh muscle, most noticeable from a left rear view, is anatomically questionable unless induced by a pressure exerted on the inner part of the leg. But this area must be read visually as part of the passage from the left ankle up through the stomach and left elbow in order to understand the artistic incentive of visual continuity for this exaggeration.

The mound between the legs served as a quarry from which Rodin extracted clay to build the figure. Its presence is something of a puzzle. While it may have concealed part of the armature, which is debatable, the stance and Rodin's skill at building armatures suggest that the figure was actually self-sufficient.[53] Further, the mound has been deliberately shaped. It can be viewed aesthetically against the profiles of the legs from several angles for example. It is quite probable that Rodin left it there because he intended the final figure to be robed and in studying it did not want daylight between the legs. Judith Cladel wrote of how Rodin would repeatedly study the sculpture's intended site, measuring the cube of space his figure would occupy.[54] This type of study would have taken into account a more solid silhouette than that which the mound's absence would have produced.

The rear view of the sculpture is surprising after one has seen the figure from the front (fig. 312). Anatomically the back shows less fat than the front, and the deep trough of the spinal area tells us that Rodin's model had a history of considerable physical exertion and lifted heavy weights. (But he was not a weight-lifting athlete, for the chest by comparison has much more subcutaneous tissue, which blurs the pectoral area.) The pose of the folded arms suggests strength, but, as Dr. Lewis pointed out, Rodin showed a kind of "cuddling up of fat." Rodin's empirical study of many living subjects had

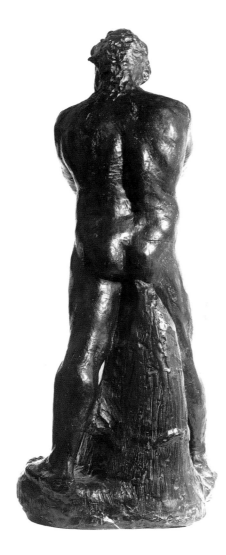

Fig. 312. *Nude Honoré de Balzac with Folded Arms*, 1892–93, bronze, 50⅛ x 19⅞ x 24 in. (127.3 x 50.5 x 61 cm). Museum of Art, Rhode Island School of Design.

body's structure led him to produce figures that are closer to Gustave Eiffel's engineered structures than any post-and-lintel architecture.

Continuing the upward reading of the *Balzac*, the torso is like the second act of a drama. The stomach's pugnacious swell is not a perfect sphere such as one finds on baroque sculptures of Silenus or Ferdinando Tacca's *Bacchus* (1665) that crowns his *Bacchino Fountain* (Galleria Comunale, Prato)—the latter seems never to have experienced hunger and appears permanently inflated. The pliant surfaces of Rodin's sculpture evoke recollections of its owner's feasting and fasting, and we sense the presence of inner organs as well as the impressions made by clothing. On the one hand, Rodin gives us evidence that his model was at least a candidate for a hernia, and on the other, he handles fat as if it were muscle. The stomach thrusts forward with the impact of a clenched fist. (Werdet once described Balzac as "entering a salon like the point of a lance.")[55] Nothing, least of all the navel, is played down. Rodin reminds us that the body is the perfect exemplar for sculpture in that sculpture consists of the hole and the lump. For Rodin there is no such thing as an ugly model; only sculpture without character and beauty came from the sculptor. Since the time of the Old Kingdom Egyptian sculpture *Sheikh el Beled* (Egyptian Museum, Cairo), there is no more glorious and expressive stomach in sculpture than Balzac's. What Edmund Rostand did for Cyrano's nose, Rodin did for Balzac's abdomen. It calls to mind an ironic inversion of the writer's *La Peau de chagrin* (*The Magic Skin*; 1831), a story about a magic talisman that shrank as its owner's wishes were fulfilled, thereby shortening his life. As Balzac's skin enlarged, his own life decreased. Like Raphael de Valentin, Balzac too was a victim of desire and action. He well knew that overwork and dissipation amounted to excessive withdrawals from his life's account.

Rodin often spoke of his use of geometry as a guide to achieving good form. What he meant is best illustrated by his posturing of Balzac. He would visualize a cube within which his imagined or emerging figure would be contained. At certain points the figure would touch but not trespass the limits of the cube. By folding the great flabby arms across the stomach (but concealing the hand of which Balzac was so vain), Rodin called attention to the figure's compactness and its invisible Euclidean container. The folded arms also concealed an unheroic chest, and their elevated angle caused by their protruding support seems to enhance the propulsive quality of

shown him that individuals can have this type of asymmetry. Anatomists as well as artists have admired his ability, shown in this sculpture, of discriminating in his modeling between muscle and fat. Balzac's back gives at once the impression of a firm but flexible skeletal frame, to which are attached strong muscles with a thin layer of fat beneath the flesh. The squared back's division by the graceful curve of the lumbar region does much to ensure the sculpture's beauty and power from this angle.

The young sculptors who reacted against Rodin around 1900 felt that he did not have a sufficient sense of the latent architecture of the body. His work was thought of as too soft and susceptible to dissolution in the open air. Today one finds it hard to understand how sculpture such as the *Nude Balzac* could be found guilty on either count. The legs, for example, are like two flying buttresses or canted pillars that thrust or plunge into the pelvic area rather than passively receiving the inert weight of the stomach. Rodin's great insight into the

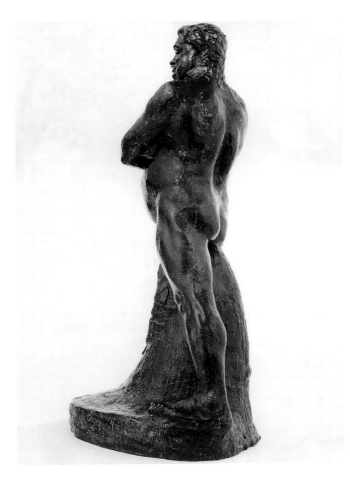

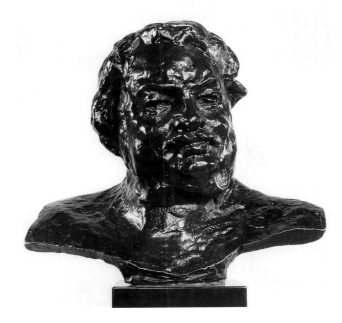

the man when seen from the side (fig. 313). This viewpoint also allows us to see how Rodin made complementary the profiles of the stomach and lower curve of the back. The great arc formed by the back in its erect posture adds to the impression of pushing off from the ground, while the line from the head to the right foot creates a braking action. It is from a left rear view that the *Nude Balzac* most resembles *The Walking Man*. From the front it is apparent that the squared shoulders dip to Balzac's left, again like those of *The Walking Man*. This creates the suggestion of slight imbalance (as if the figure were listening and beginning to move), which stimulates the beholder to move around the sculpture in order to see how its balance is recovered.

The head (fig. 314) is the final act, and as a dramatist (and casting director) Rodin does not let us down. Rather than the famous daguerreotype of Balzac (see fig. 286), this author believes the source of this head was a living model.[56] For a daguerreotype the sitter had to sustain a pose for a long period and was, of course, severely self-conscious. Rodin has modeled a head in which the lips are so formed as to suggest that the man is about to speak.[57] As with the head of Baudelaire, Rodin

eschewed direct copying of photographs, even avoiding obvious facial characteristics, such as the cheeks' creases formed at the edge of the nostrils and passing diagonally downward.[58]

One of Rodin's self-imposed problems may well have been how in a single head to show the multiple moods of his subject. Rodin was often criticized for making sculpture that was rendered shapeless by accidental lighting effects. Yet, when we move about, above, and below this head of Balzac under various lighting conditions, we can see that it always holds its firmness of form and reveals new dimensions of the man's character. Multiple viewings evoke an interpretation of Balzac as aloof, benign, smiling, attentive, meditative, and on the verge of speaking.[59]

In actual life Balzac had an extremely expressive face, one that instantly responded to his thought and feeling. Its elasticity was partly caused or reinforced by alternating periods of gauntness and fullness, depending on whether he was working and dieting or relaxing and being self-indulgent. Balzac's mobility of being has been brought back to life under Rodin's hands. No sculptor was as successful as he in thawing out the frozen or suspended look or two-dimensional character of so much nineteenth-century portrait sculpture. This kaleidoscopic portrayal of Balzac depends on the inconstancy of the facial surface throughout, including such areas as the forehead, where portrait sculptors tended to leave the surface calm. While retaining the impression of a solid

cranial substructure, Rodin, like Honoré Daumier in his drawings, built his surfaces on the plausible if not actual response of the flesh to the contraction and expansion of muscle beneath it, the reaction of skin to nerves. Balzac's modeled face is figuratively like a simultaneous mapping of the scope of movements enacted by each area while the head is in the same position.

The head is like a miniature of the body in its block-ishness and violent surface undulations. (Observe the almost right-angle cubing of the back and top of the head when seen from the side.) The subject's heavy jowls are made into a sculptural asset by permitting Rodin to fashion a short but thick neck appropriate in proportion and texture to the broad square shoulders and softness of the pectoral area. The richness and drama of the head are equal to Balzac's statement "I shall carry a world in my head." This type of extravagance Rodin readily understood and expected of his heroes. As when we judge the accuracy of medieval manuscript illustrations by comparing them with texts rather than nature, so in Rodin's sculpture we must keep in mind textual images such as Lamartine's, which nourished Rodin's thought and criteria of this portrait's accuracy.

The attitude of Balzac toward himself in this sculpture strongly affects our response.[60] Rodin was aware that the writer knew of his physical defects but arrogantly and certainly rightly trusted to his intelligence and personality to transform himself in the eyes of others. Why should not a man who fervently believed and publicized his conviction that great creative labor required heroic culinary and sexual excess proudly measure himself against fellow men? Rodin shows the Balzac who unstintingly gave of himself to the public, even to assigning his physique and personality to numerous characters in his novels; the Balzac meditative and observant who was above, yet of, the crowd; the Balzac whose brain and vision armed him to mine every vein of society.

The Sculpture's Meaning

Yes, Rodin has given us Balzac the fighter and worker. Did not Werdet describe him as a "courageous athlete" (which Rodin underlined) and elsewhere recount how he spoke of rolling up his sleeves to the elbow, spitting on his hands, and laboring?[61] When we reread the life of Balzac, we see that Rodin has also given us a lie or, more charitably, a distortion. Balzac's most strenuous physical

activities were in bed or at the table. How could a man prostrated for a month by a muscle pulled while jumping a mud puddle be considered an athlete? Can we ascribe physical bravery to one who by pseudonyms and back-doors evaded military service and creditors? Would a worker nearly cripple himself climbing into a stagecoach or sleep on a gigantic fur-covered circular bed? The answer to these paradoxes is that Rodin used his intense anatomical and physiological study of living models to create a convincing metaphor of Balzac's spirit as a creative artist. Historically and aesthetically Rodin's critics in the Société des gens de lettres were benighted conservatives. If they had thoroughly comprehended Balzac's life, the history of art, and what Rodin had achieved, it is curious to think that this sculpture should have pleased the naturalists and displeased the symbolists instead of the reverse. Rodin's *Nude Balzac* continues the ancient tradition of what Colin Eisler has called the Athlete of Virtue, which comprises not only the art of Phidias, Donatello, and Michelangelo but also that of Rubens, Bernini, and Puget.[62] Furthermore, in keeping with changing sociological interest of nineteenth-century art, Rodin was broadening this tradition to include what might be called the Virtuous Laborer or Spiritual Workman, known to us in works of Jules-Aimé Dalou, Honoré Daumier, Constantin Meunier, Jean-François Millet, Vincent Van Gogh, and Vincenzo Vela as well as Rodin's own project for a great *Tower of Labor*. Unlike Jean-Alexandre Falguière, who inherited the Balzac commission after Rodin's dismissal,[63] Rodin continued the baroque belief in the body as a full, richly expressive vehicle for abstractions. Balzac was made into an athlete of the spirit. Werdet had used his words as metaphorically as Rodin used posture.

As shown by his portraits and memorial sculptures, Rodin fully shared the Renaissance and baroque attitude that the fraternity of heroes included not only saints, soldiers, and statesmen but also artists, writers, and musicians, to which he added the worker. He referred to himself and Balzac as workers and did not discourage others from calling him a poet. Robustness and strenuous posture in his sculpture are the continuations of those qualities admired in Rubens and Puget, as they evoked the spirit's vitality. This is why his memorials to Claude Lorrain, Bastien-Lepage, and Balzac show active postures that descend from those of his own *Adam, Saint John,* or *The Walking Man.* Balzac was certainly not a full-time ascetic, a model of continence or renunciation, nor one

given to the care and training of his body for moral or patriotic reasons. But to the extent that the old tradition of the Athlete of Virtue also meant intellectual fortitude and artistic courage, Balzac the creator belonged. It may not have been pure luck that gave Rodin models from the working class, models who helped transform a mesomorphic type to an endomorphic figure, a flabby, round aesthete into a tough, square, albeit overripe, herculean laborer.

In referring to his own work, Rodin personally eschewed such labels as naturalist or symbolist. We have tended in recent years to stress his naturalistic approach to the human body, perhaps because it suited our taste. Because of sculpture like his *Nude Balzac* Rodin should today be reconsidered as a *visionary*, as many in his own time saw him, and in the same way that Baudelaire defined the word and appraised Balzac by writing: "It has always astonished me that Balzac owes his fame to the fact that he passed for an observer. To me it has always seemed that his chief merit lies in his having been a visionary, and an impassioned visionary. All his characters are endowed with the blazing vitality that he himself possessed. All his fictions are as highly coloured as dreams. From the peak of the aristocracy to the lowest levels of the plebs, all the actors in the *Comédie* are more furious in living, more vigorous and cunning in conflict, more long suffering in misfortune, more greedy in pleasure, more angelic in devotion, than the comedy of the real world shows them to be. Every soul is stuffed with will power to the throat. They are all Balzac himself."[64]

The fertility for inspiration of Rodin's posturing of Balzac stems from the monument's being both natural and symbolic. It summons to mind the writer's defiance of the past and feelings of equality with Rabelais, for example. It conveys his contempt for critics and competitors. The same pose may be read as Balzac's metaphorical victory over death and assurance of future glory. Should not a man who had immortalized his time thus stand solidly in the city of his labors? And could not his work have helped inspire Rodin to say in 1894: "I want him immense, a dominator, a creator of a world."[65]

The Last Campaign, 1896–98

While today we may recognize the greatness of Rodin's *Nude Honoré de Balzac with Folded Arms* and the artist probably saw it as the soul and form he wanted, the work did not satisfy the commissioners. The writer's age, his ungainly person, Rodin's fidelity to the wrong Balzac, or the wrong view of idealism, and the sculpture's challenge to conventional statuary all presumably dismayed his clients. Between 1894 and 1896 Rodin's efforts to fulfill the commission seem to have been intermittent. Like Balzac, Rodin's intense periods of creative effort sometimes led him into deep troughs of physical and mental exhaustion and depression. During these years it must not have helped Rodin's state of mind that he was taking a beating in the press for not delivering the statue, and questions were raised about his competence.

In the mid-1890s in addition to suffering long bouts of influenza, Rodin, like Balzac before him, yielded to distractions that postponed his coming to grips again with the monumental project. As an example and probably as a result of his heart-wrenching breakup with Camille Claudel, he made for himself the powerful sculpture *Christ and Mary Magdalene*, which was unquestionably a spiritual portrait of himself and Camille.[66] Once returning to a sketch made with love and confidence, Rodin complained he did not recognize in it the image of Balzac that kept evolving in his brain. The evidence suggests that in 1896 his interests and energies revived, and in about 18 months he took the project to the point where he would reluctantly agree to its public exhibition.

If the *Nude Honoré de Balzac with Folded Arms* represented the writer confronting the world of the living, the final version shows him joined in thought to the world of his own creation. The seeds for this new conception that comprised the focus of the second great campaign may be visible in a small rude clay sketch of an erect, mummy-like figure (fig. 315). It is closer to the final form of the *Balzac* than all the preceding figural studies. In it Rodin hastily thumbed a form having a narrow vertical thrust, the arms now dropped for the first time and crossing below the waist.[67] The former silhouette was contracted, and the artist abandoned fidelity to the subject's earthbound rotundity and the iconographic folded-arm gesture in favor of a more expressive erectness, which has the general thrust and pointedness of an Egyptian obelisk.

The logical next step would have been to work from a live nude model, no longer sought as Balzac's physical double but still solidly and squarely built. This he was doing presumably in 1896–97, first in a small (fig. 316), and then in a one-half life-size headless study (cat. no. 110, figs. 344–345). "A sturdy, squat, powerfully muscled

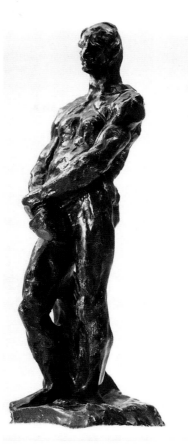

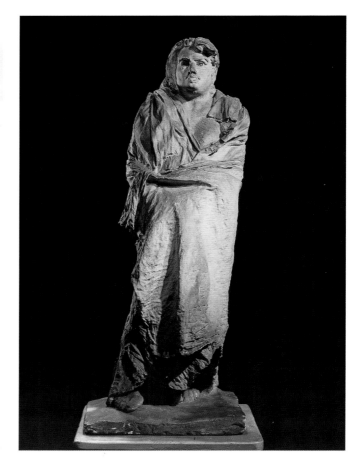

Left: Fig. 315. *Sketch of Draped Figure of Honoré de Balzac*, 1896?, terra-cotta, 6¹¹⁄₁₆ x 1¾ x 2⅜ in. (17 x 4.5 x 6 cm). Musée Rodin, Paris, S263.

Middle: Fig. 316. *Nude Figure Study for "Honoré de Balzac" with "Head of Jean d'Aire,"* 1896, bronze, height 11½ in. (29.2 cm). Museum of Modern Art, New York.

Right: Fig. 317. *Study for "Honoré de Balzac in a Robe,"* 1896–97, plaster, 40¹¹⁄₁₆ x 15⅝ x 14¹³⁄₁₆ in. (104 x 39.8 x 37.6 cm). Musée Rodin, Paris, S2845.

model came to pose for Rodin. Of course, he posed nude. He stood with his [right] foot a half step in front. But this first sketch did not yet give any idea of the magnificent swing of the head."[68]

With his new model Rodin went back to academic fundamentals. The model was posed in an *académie*, a standard studio posture of the period, such as Georges Seurat used, for example. The weight was carried on the left leg, the right placed slightly forward, and the broad shoulders thrust back so that the spine curved up and outward like a bow. The stance with the shoulders thrust back would dictate the backward tilted pose of the final robed Balzac, not Medardo Rosso's *Bookmaker* (1894; Museum of Modern Art, New York) as suggested by those unaware of the internal evolution of the sculpture. This was basically the model and stance Rodin kept through the project's termination, as he tried various draping designs on plaster casts of this figure. "One day we found in one of the studios of the

rue de l'Université six copies of the plaster cast that Rodin had made of the one-half life-size figure that he had just modeled. In a corner was a roll of cloth. This cloth was then cut into six approximately equal pieces, and soon one piece was wrapped around each of the studies according to the instructions Rodin gave. Thus the Balzac was born."[69]

The one-half life-size headless figure (cat. no. 110) is a vigorous piece of modeling. There is absolutely no dryness in the handling of the musculature, and the surface is a marvelously fluid topographic study of rugged terrain. It was this kind of study that encouraged Rodin to define modeling as an art of projections and depressions and of fashioning the interconnecting surfaces. In the legs and torso Rodin exercised his right to exaggerate or, as he put it, logically amplify the forms to express his feelings and sense of the model's *caractère*. The silhouettes of the figure are so variegated as to prevent a cutout cardboard look and to allow the form to more fully engage the light and atmosphere.

Even with a postural cliché, in the one-half life-size

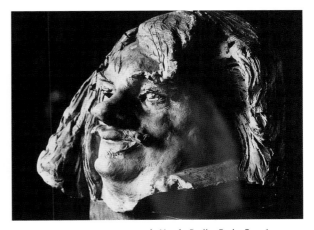

CLOCKWISE FROM LEFT

headless figure Rodin betrayed his unorthodox, daring, and intimate understanding of his fellow creator. True, the left hand clasps the right wrist in front of the groin in art-school fashion.[70] But the right hand firmly grasps the figure's penis in an autoerotic gesture. The absence of the head in the large study of the naked model makes the gesture all the more suggestive. Rodin must surely have known of Balzac's erotic obsessions and his compulsion to test constantly his creative powers. Was Rodin remembering Lamartine's description: "His large fat hands responded expressively to his thought"? For Balzac, artistic creativity was identified with male sexual prowess, and as Maurice Z. Schroder also pointed out, with Flaubert and Baudelaire masturbation was the sexual image for creation. Balzac explained to Countess Eve-

Fig. 318. *Study for "Final Head of Honoré de Balzac,"* 1896?, terra-cotta, 6¹⁵⁄₁₆ x 6⁹⁄₁₆ x 6⅝ in. (17.6 x 16.7 x 16.8 cm). Musée Rodin, Paris, S128.

Fig. 319. *Study for "Final Head of Honoré de Balzac,"* 1896–97, plastiline, 5¾ x ⁵⁄₁₆ x 4¹¹⁄₁₆ in. (14.7 x 13.5 x 11.9 cm). Musée Rodin, Paris, S265.

Fig. 320. *Study for "Final Head of Honoré de Balzac,"* 1897, terra-cotta, 7 x 9⁷⁄₁₆ x 7⅞ in. (18 x 24 x 20 cm). Musée Rodin, Paris, S1576.

Fig. 322. *Late Study for "Head of Honoré de Balzac,"* 1896–97 1895–96, bronze, 7 x 6¾ in. (17.8 x 17.2 cm). Iris and B. Gerald Cantor Collection.

Fig. 321. *Final Study for "Head of Honoré de Balzac,"* 1897, bronze, 7¼ x 7⅝ x 6⅛ in. (18.5 x 19.4 x 15.6 cm). Iris and B. Gerald Cantor Collection.

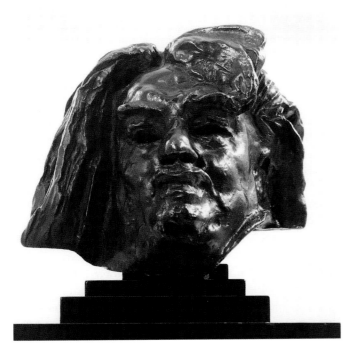

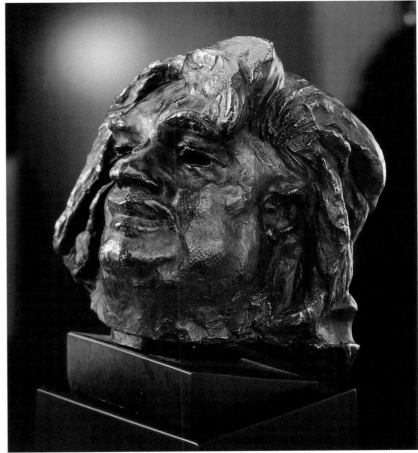

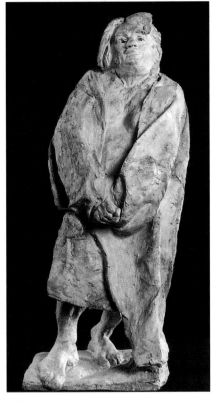

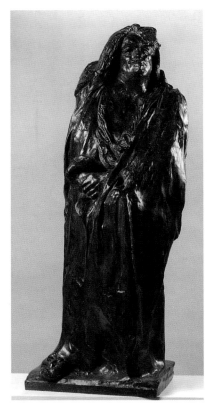

Left: Fig. 323.
*Study for
"Honoré de
Balzac in a
Short Robe,"*
1896–97,
plaster, 43⁵⁄₁₆ ×
16¹⁵⁄₁₆ × 14³⁄₁₆ in.
(107.5 × 43 × 36
cm). Musée
Rodin, Paris,
S2844.

Right: Fig. 324.
*Study for
"Honoré de
Balzac in a
Cowled Robe
and Lace Shirt,"*
1897, bronze,
43⁷⁄₈ × 17½ ×
16⁵⁄₁₆ in. (111.5 ×
44.5 × 41.5 cm).
Musée Rodin,
Paris, S1369.

line Hanska, whom he later married, that he had to work himself up to write a novel by "masturbating his brain."[71]

The stationary stance and pose of the hands brought Rodin closer to the final image. When the figure was robed, the hands did not project as far and were made to appear as if they were holding closed the dressing gown, while the crossing of the wrists evoked the writer's generous girth (fig. 317). A comparison of this last nude study with the final clothed version in its original size (see fig. 329) indicate that Rodin made other crucial adjustments; keeping the slightly backward tilt of the stance and position of the legs but narrowing the width of the shoulders. In a succession of studies Rodin wrestled with the selection and orientation of an appropriate head (figs. 318–322) and the draping of the robe (figs. 323–324), especially in the area of the collar. There was probably no reluctance in covering the hard-won naked figure, as Rodin knew that the credibility of the way the robe fit depended on where it touched the body. The nude study would stand in its own right as a complete sculpture. He had it photographed in one of his houses.[72]

As Mathias Morhardt described it, Rodin tried many variations on the draping of the robe, and he was so taken with the raw modeling of the mold being made of his own bathrobe that he had several photographs taken

of it with the armature of the cast still exposed.[73] Successively he wanted accuracy of the robe's weight, texture, and responsiveness of the folds to the body and gravity (figs. 325–327). The sculptural demands of his new aesthetic also intervened. There was the slowly solved problem of the collar and how it should frame the head. The empty sleeves had to be accommodated to a growing sense of the final overall contour, which Rodin wanted as compact as the interior silhouette of an Egyptian sarcophagus. By 1898 he could see the entire robed body as a second socle supporting a head that, because of the pedestal, would be about fifteen feet above the ground. Therefore, the garment's great expanse caused him to pare away evidence of its local texture and to arrest patterns of pleats, in favor of a fuller, more continuous, upward surface sweep that irreversibly focused attention on the head.

Seen close up, the *Monumental Head of Honoré de Balzac* (cat. no. 111, fig. 328) may seem as caricatural as the engraving by Carjat (see fig. 297). Rodin would later comment that he was not interested in imitating photography in sculpture, but he used it to familiarize himself with Balzac's features. In the article Gabriel Ferry published in 1899, Rodin told him: "I have seen and studied all the possible portraits of this author of the *Comédie humaine*, after a laborious examination I decided to take my inspiration from a daguerreotype plate of Balzac executed in 1842; in my opinion, it is the only faithful likeness and true resemblance of the illustrious writer. . . . I have studied this document at great length. Today I have captured Balzac. I know him as if I had lived with him for years."[74] When Rodin said, "today," we unfortunately do not know if he was referring to 1899 or to an earlier time, and it is not clear exactly when Nadar made Rodin a photograph of the daguerreotype by Bisson (see fig. 286), but evidence indicates this was about 1892. That the final head and the photograph are as much marked by dissimilarities as by affinities leads this author to conclude that a living model rather than the Bisson portrait was Rodin's source. Writing in defense of Rodin's *Balzac* against the charges that the artist was not faithful to the writer's features, Arsène Alexandre explained what a sculptor could do who did not want to make "photo-sculpture," by pointing out that to achieve "the plastic representation of the human face . . . [the sculptor] has no other material means at his disposal than to underline the characteristic traits of the visage; for example, to push back or advance the lip in a mocking fold to indi-

cate a satiric expression, to accentuate the arcade of the eyebrow and to enlarge the cavity of the eyes, so that, by the beautiful patches of shadow they recall the expression of meditation and observation, and last, to exaggerate the need for relief and height of the forehead to underscore the creative faculties. This is precisely what Rodin has done for the head of Balzac."[75] Because of his own interest in exaggeration of modeling to bring out the character of his subject, Rodin would have been more drawn to caricatures.

The final head was an inspired formation according to an intuition enriched by countless hours of meditation, search, and even suppression of the evidence of other artists. Unlike a caricaturist, Rodin grounded his exaggerations in Balzac's humanity and on the challenge of Lamartine's metaphor of Balzac having "the face of an element."[76] With the veiling of the body it was left to the features of the face to impart the history of Balzac's sensuous appetites, the passion and pain of work and critical abuse, and finally, as Lamartine wrote, that disproportionate sense of what was real and what was possible. The nose is like a gigantic curved beak, whose depression near the brow contains one of Rodin's unaccountable touches. It is like an oversize wart, but besides changing the profile views of the nose, it also served as a light

reflector into the deep dark pits of the empty eye sockets. (Balzac is reported to have told David d'Angers, who was making his portrait, "Be careful of my nose; my nose is a world."[77]) This lump was no accident as it appears in several studies. Muscle and eyebrow fuse over the eyes like giant hoods, and the light that gets past them hits the upper eyelids rather than pupils. This is finally a head such as no photographer had seen before, as it was Rodin's invention of the birthplace of the tumultuous life he had found in Balzac and his art.

When joined to the body, it is the upturned head and backward tilt of the figure (fig. 329) that effect the relocation of Balzac into the world of his *Human Comedy*. By throwing back the head and shoulders, Rodin violated the academic dictum of aplomb, by which an imaginary line drawn from the center of the head should bisect the instep of the foot on which the weight is carried, and he would pay for it critically. Viewed in profile, the final *Balzac* appeared in conservative eyes to be on the verge of toppling. To the academicians it did not "carry." Rodin's daring was, in fact, to line up the center of the head, marked by the hairline, with the outer edge of the left heel. When he doubled his final version in scale, the deviation from the

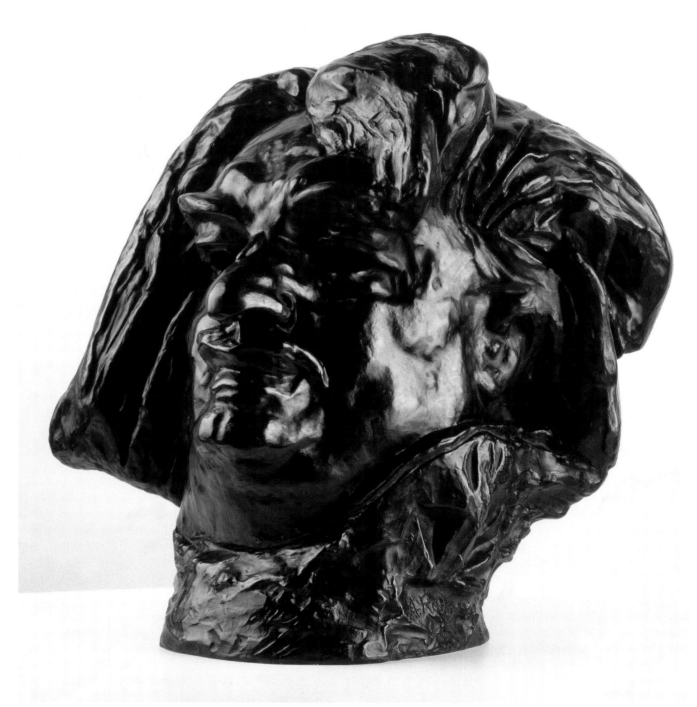

Fig. 328.
*Monumental
Head of Honoré
de Balzac* (cat.
no. 111).

center of gravity was, in fact, so precarious that he had to extend the base of the sculpture farther to the rear, a circumstance not lost on his critics who believed figure sculpture should appear to be self-supporting even when attached to a base.

Judith Cladel reported that "Rodin felt frightened by his own work."[78] It is not clear whether she was referring to the penultimate one-half life-size version or its enlargement or both. Just before the enlargement was made, a visitor to the studio observed: "We went yesterday to M. Rodin to ask him when his work would appear. It is finished but he works on it continuously with love, retouching a detail, accentuating a feature of the physiognomy, without changing the pose of the thinker [who] looks with arms crossed upon the passing human crowd. M. Rodin told us that the statue was going to be delivered soon for enlargement. 'Now,' added the master, 'I work above all on a low relief figure that I want to place on the pedestal which Frantz Jourdain is preparing. It will be a woman holding a mask, *La Comédie humaine*. Within a month . . . I will be finished with it.'"[79]

We gain a sense of how Rodin worked in those crucial months of the spring and early summer of 1897 by the recollections Rodin offered to Camille Mauclair not long after the monument's public appearance:

He came to think that by the systematic exaggeration of the modeling of certain parts, of those which expressed the principal movement, the figure could only gain in vitality, in energy, in the clear revelation of his soul. This reasoning led M. Rodin to the *deformation of the true with the view of reinforcing expression*. . . . The relation between the exaggerated parts and the others must therefore be subordinated to the total silhouette of the work. It was a question of the reasoned amplification of the modeling, in the sense of movement, and as a result, the soul of the personage . . . by movement we do not mean only a gesture. As long as there is life there is a movement: an immobile figure has its movement, repose is one, there is an action even in the fact of repose. . . . Rodin proposes to continually modify the application of his idea. He begins cautiously, working on a piece already executed in very faithful proportions to the model, to add clay to the relief, to improve the hollow of a cavity, to deform in places; then, he is encouraged and is more satis-

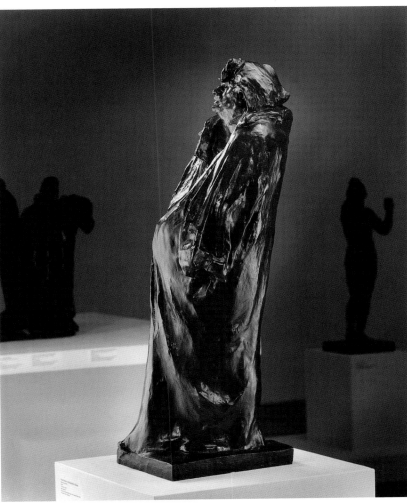

Fig. 329. *Final Study for "Monument to Honoré de Balzac"* (cat. no. 112).

fied. The halftones . . . are made softer and more mellow, the light flows better on the surfaces, the large silhouette was made more firm and at the same time less dry, less cutout against the background of the studio: the atmosphere grazing the contours is amplified, vibrating around them. All the essential modelings were expressed in their true place, but they were in more intelligent agreement with the whole. . . . Around the plasters there was no void, the reflection of the light striking their high reliefs mixed them in waves with the surrounding space.[80]

Starting in the summer of 1897, Rodin had Henri Lebossé double the size in plaster. Charles Chincholle, writing in March 1898, described what was done when the enlarged plaster sections were assembled:

The *practiciens* will install the pieces of the definitive modeling on the scaffolding. Only then will he

judge with certainty the effect produced. If the statue leans too much to one side, he will modify the movement with the aid of wedges, either adding or subtracting, then he will deliver it to the founder.

And so it is only in the open air that he will come to a decision as to the interest of a symbolic figure that he wants to make emerge from the plinth, to the statue's right. It is his fancy to imagine that there was in Balzac's study a small column supporting a figure of Fame brandishing a crown.

You see, he said, this statue which he touches with his foot without seeing it represents belated fame which today tries to raise itself to him without being able to. It is not in plaster yet, but it will be in gilded bronze and will break the monotony of the black robe.

The base, which is the work of M. Frantz Jourdain, is like those Assyrian capitals, consisting of unequal tiers. . . . A long time ago Rodin had a reduction made in wood. On the principal surface he modeled a naked, grimacing woman in plaster who has just removed a mask. For him, it is the *Comédie humaine*.[81]

Rodin's decision in the end not to use the relief may have been because it might have seemed anecdotal or trivializing of the effect of the large figure that was the main issue. Rodin had enough to worry about before the statue's debut in May. He even edited a plaster of the upper half of the figure with a pencil on a photograph taken of the cast in his studio, indicating that he wanted to connect the lines of the man's hair with the collar.[82] But Rodin also sought the critical judgment of Camille Claudel. Their break had come around 1893, well after Rodin had started his studies, and her response reflects that background: "Through Lebossé you have asked that I write you my opinion of your statue of Balzac. I find it very great and very beautiful, and best of all the studies of the same subject. Above all, the very accentuated effect of the head which contrasts with the simplicity of the drapery is a real discovery and gripping. I also like very much the waving sleeves, which have captured well the negligent aspect of the man. In sum, I believe you can expect a great success, above all from the true connoisseurs, who will not be able to make any comparison between this statue and those that up to now decorate the city of Paris."[83]

What Rodin also agonized over was the lack of time to detach himself from the sculpture and to reexamine it afresh after several months. He told Judith Cladel in April 1898, "The artist must be able to forget his work, and for months not look at it, so that he can judge it as if it were a stranger. But try and make the bureaucrats understand!" Cladel was present also in Rodin's rue de l'Université studio when the plaster was about to be moved to the salon. "He had taken the *Balzac* out of the studio to examine it in the open air. It was an agonizing examination . . . the open air diminished the importance of the volumes, equalized the planes, devoured the modeling. Would the statue hold up in the pitiless clarity of daylight?"[84]

The Salon of 1898: A Bitter Defeat

The bureaucrats not only did not understand, they were at the end of their patience. On 1 May the *Monument to Honoré de Balzac* was exhibited in the salon (figs.

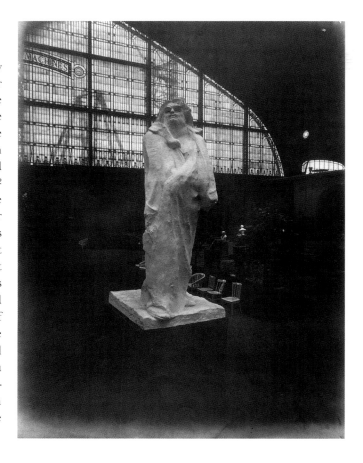

Fig. 330. Eugène Druet, *"Monument to Honoré de Balzac"* in plaster at the Salon of 1898 (A127).

330–331; A128). Under severe pressure from the Société des gens de lettres, Rodin had agreed to exhibit it. As president of that salon, Rodin escorted Félix Faure, the president of the Republic through the exhibition. President Faure was effusive in his compliments for *The Kiss* (cat. nos. 48–49), which had been given the place of honor. But he turned his back on *Balzac*, saying nothing about it. The critical storm that had been building for years exploded. It rivaled in intensity, but not longevity, the attention given to the Dreyfus affair, in which Rodin unwillingly became caught up as his supporters were almost all Dreyfusards. As the critic Jules Claretie wrote, "It was itself the great polemic of the moment . . . one had to be for or against Rodin as it was necessary to be

for or against Esterhazy . . . young sculptors avoided going so as to not take sides."[85] The mountain of published criticism for and against Rodin's *Balzac* has proved to be more attractive to most historians and biographers than an analysis of the work itself.[86] Rodin would have further identified with Balzac, whom he had read in Werdet's biography suffered attacks by 30 newspapers. Against the waves of negative reactions, Rodin was protected by a seawall of defenders, which included the best critics—Alexandre, Geffroy, Marx, Mauclair, Mirbeau, and Rodenbach—and major artists—Paul Cézanne, Henri Cros, Claude Monet, Camille Pissarro, Paul Signac, Alfred Sisley, and Henri de Toulouse-Lautrec—not to mention politicians such as Clemenceau. The case

Fig. 331.
H. Roger-Viollet, *The Salon of 1898*, 1898, gelatin silver print, 9 x 11½ in. (22.9 x 29.2 cm). Rodin archives, Iris & B. Gerald Cantor Center for Visual Arts, Stanford University. *Balzac* is at the lower left foreground, across from *The Kiss.*

against Rodin was similar to that faced by many later sculptors who placed work in public spaces. Worst of all Rodin's sincerity was questioned, and he was viewed as mocking the public.[87] As they do today, professional and amateur critics vied with each other for the most memorable insults: *Balzac* is a "snowman"; he is dressed for a "sack race"; he will fall because he is drunk or is not plumb; "he has climbed out of bed to receive a creditor"; "he has no eyes." Prophetic of recent outcries against government-sponsored public art in this country, critics pointed out that "It is a dangerous thing for society, and if one would tolerate similar works in a public place, one would stop paying taxes."[88] On the last charge Alexandre wisely observed, "how works of art are compared to bombs, with a political source. . . . A new work of art never changes the government."[89]

Shortly after the exhibition's opening, and after committee members had read the many negative reviews, Rodin received a letter, which was reprinted in *Le figaro* (Paris), 11 May 1898: "The committee of the Société des gens de lettres voted, in fact, the following order of the day which was immediately brought to the attention of M. Rodin. 'The committee of the Société des gens de lettres has the obligation and the disappointment to protest against the sketch which M. Rodin has exhibited at the Salon and in which [the committee] refuses to recognize the statue of Balzac.'"[90]

Rodin thereby lost his considerable expenses, the 10,000 francs in escrow, plus the interest of almost 350 francs that he had to pay. On the advice of his lawyer, P. A. Chéramy, and because of the time and expense required, he decided not to sue the Société.[91] Two weeks after its debut, Rodin did, however, withdraw his *Balzac* from the salon and took it to Meudon, where he and his friends could contemplate it. (He subsequently showed it in Paris during his 1900 retrospective and Vienna in 1901.) The commission was then awarded by the Société to Falguière, who died before its completion in marble. Laurent Marqueste finished the work and out of friendship Rodin attended the dedication in 1902, where at its close the crowd spontaneously rose and applauded Rodin "wildly."

Today the word *censorship* is used too loosely. The committee's rejection of Rodin's *Balzac* was not censorship. The monument was a victim of a contractual dispute and what might be called the selection process, specifically the judgment of the commissioners (eleven votes to four, by one account, unanimous by others) that the artist had

not fulfilled his contract. The attempt by one committee member, Alfred Duquet, to have an official statement published forbidding Rodin to ever cast his *Balzac* was defeated, and if it had not been and the sculptor had renounced all financial claims to his contract, which he did in effect, Rodin would have undoubtedly won the legal right (the moral right, or *droit moral*) from the French courts to cast and exhibit it.[92] When he returned their money, Rodin was quits with his commissioners and free to do with his *Balzac* whatever he wanted. Despite offers from several would-be private and municipal commissioners and a successful subscription arranged by his supporters to pay for a bronze for Paris, he refused to cast the work, as he wanted to keep it for himself alone. The city of Paris withdrew its offer of a public site for the monument. The final *Balzac* was not bronze cast and installed in Paris until many years after the Rodin's death. On 1 July 1939 it was unveiled by the two most famous French sculptors of the time, Aristide Maillol and Charles Despiau. Except for the years of the German occupation of Paris when the French Resistance removed it for safekeeping, it has stood continuously near the intersection of the boulevards Montparnasse and Raspail (fig. 332).

In an anonymous article that appeared the day after his monument's official rejection Rodin summarized his reaction:

> Without doubt the decision of the Société is a material disaster for me, but my work as an artist remains my supreme satisfaction. I am anxious to recover the peace and tranquility of which I have need. I sought in *Balzac*, as in *Victor Hugo*, to render in sculpture what was not photographic. One can find errors in my *Balzac*, the artist does not always realize his dream; but I believe in the truth of my principle; and *Balzac*, rejected or not, is nonetheless in the line of demarcation between commercial sculpture and the art of sculpture that we no longer have in Europe. My principle is to imitate not only form but also life. I search in nature for this life and amplify it by exaggerating the holes and lumps, to gain thereby more light, after which I search for a synthesis of the whole. . . . I am now too old to defend my art, which has sincerity as its defense. The taste of the public has been tainted by the habit of making casts after the model, to which it has grown accustomed.[93]

If nothing else, this bitter defeat encouraged Rodin to speak out at greater length on his artistic principles, allowing us a better understanding of his art and the *Balzac*. Exactly ten years after the debacle of its salon showing and as evidence of how long the criticism lasted, especially in Rodin's mind, he spoke with an unnamed reporter from *Le matin*: "I no longer fight for my sculpture. For a long time it has been able to defend itself. To say that I hastily threw together my *Balzac* as a joke is an insult that at one time I would have answered by calling for the arrest of my accuser. . . . This work about which they laughed, and at which they scoffed because they could not destroy it, is the result of my life, the pivot even of my aesthetic. . . . There are young sculptors who come to see it . . . and who think of it as they leave in the direction where their ideal calls them."[94]

Rodin's Intentions for Balzac: How He Read the Sculpture

The last versions of the *Monument to Honoré de Balzac* were conceived and revised according to the sculptor's distillation of his conception of the writer's attitude. So much attention is paid to the dramatic formal accomplishment of the sculpture and its shocking contrast with other nineteenth-century monuments, it is forgotten that Rodin was also guided by a dramatic conception. The day after the Société's rejection was printed in *Le figaro*, Chincholle reported Rodin's own view of the work:

I swear that, personally, I had the awareness to realize my dream absolutely. I wanted to show the great worker haunted at night by an idea, and getting up to write it down at his desk. I understood him, thinking beforehand of the new attacks that he would arouse, and overcoming them, despising them. . . . It is possible that my hand betrayed me. For me, modern sculpture cannot be photography. The artist must work, not only with his hand but above all with his brain. Have I succeeded in making what I wanted? I swear that I am too close to my work to judge it fairly. I would need to be away from it for a year. By that time I would have disengaged my personality. I would judge it like a stranger. The only thing I realize today is that the neck is too strong. I thought I had to enlarge it because, according to me, modern sculpture must exagger-

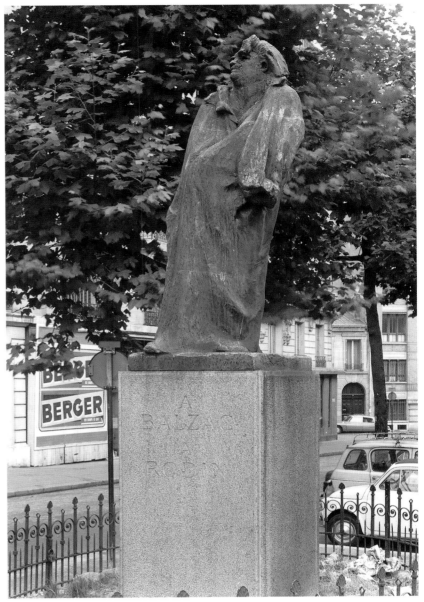

Fig. 332. *"Monument to Honoré de Balzac,"* 1898, Inaugurated 1939, boulevards Raspail and Montparnasse, Paris, bronze.

ate the forms from a moral point of view. Through this exaggerated neck I wanted to represent strength. I realize that the execution exceeded the idea. Nevertheless, have you looked at my statue, putting yourself to the right of Balzac about twenty feet from the pedestal?[95]

Because Rodin's statement was made to Chincholle so soon after he had completed the statue, it is extremely valuable. Some time earlier, in 1897, he gave a reporter the demanding measure by which he would judge his own work, which is just as important: "I do not want to put my *Balzac* on a small cupboard, a trunk or bookshelves, but on stone. I have sought to express the char-

acter, the power of the great novelist to the exclusion of all other aspects of his work. The severity of my project is destined to glorify not a man of the mind, but a man of genius."[96]

In a statement made to Paul Gsell in 1907, Rodin amplified his intention:

By what right do they reproach this dressing gown with its hanging, empty sleeves? Does an inspired writer dress otherwise when at night he walks feverishly in his apartment in pursuit of his private visions? This just was not done before. By convention, a statue in a public place must represent a great man in a theatrical attitude which will cause him to be admired by posterity. But such reasoning is absurd. I submit that there was only one way to evoke my subject. I had to show a Balzac in his study, breathless, hair in disorder, eyes lost in a dream, a genius who in his little room reconstructs piece by piece all of society in order to bring it into tumultuous life before his contemporaries and generations to come; Balzac truly heroic who does not stop to rest for a moment, who makes night into day, who drives himself in vain to fill the gaps made by his debts, who above all dedicates himself to building an immortal monument, who is transported by passion, whose body is made frenetic and violent and who does not heed the warnings of his diseased heart from which he will soon die. It seems to me that such a Balzac, even, seen in a public place would be greater and more worthy of admiration than just any writer who sits in a chair or who proudly poses for the enthusiastic crowd. In sum, there is nothing more beautiful than the absolute truth or real existence.[97]

"The Secret Law of My Art"

To Charles Morice, Rodin related how he saw the *Balzac* in the court of his studio in the presence of the marble version of *The Kiss*. "I had the feeling that [*The Kiss*] was soft, that it fell before the other, like the celebrated torsos of Michelangelo before beautiful antique works." Then, Rodin went on to give us the crucial result of his evaluation of the *Monument to Honoré de Balzac*. "My essential modeling is there, regardless of what people say, and it would be there less if I had 'finished' [it] more

in appearance. As for polishing and repolishing the toes, or the hair curls, that has no interest in my eyes. That compromises the central idea, the great line, the *spirit* of what I wanted."[98]

Rodin must have discussed this sculpture in the same way with his friend Georges Rodenbach, for the Belgian poet wrote, "It is apparent that Rodin has wanted a decisive simplification. He has broken with the boring tradition that makes a statue a portrait, an exact effigy. . . . In this case it was a question of a genius, of whom Lamartine said that the face was like an element. It is this face, and it alone, that it was necessary to express."[99]

Of what the "pivot of my aesthetic" and "decisive simplification" consisted and their reason for being is made clearer by a seldom-cited article published in June 1898 by Camille Mauclair. It contained the artist's most important assessment of what he had done in his *Balzac* and how it revealed the "secret law" of his art. "In my own eyes I have made my most serious progress since the first sketch. Nothing that I had made satisfies me as much because nothing has cost me as much, nothing summarizes as profoundly that which I believe is the secret law of my art." After telling Mauclair that it would take him at least a year to speak of one of his works, he went on to formulate those things that he himself would not address to the public.

He had the idea of no longer working on his figures from a single side at one time, but of the whole ensemble, constantly turning around and making successive drawings . . . of all the planes, modeling by a simultaneous drawing of all the silhouettes and summarily uniting them in such a way as to attain above all a drawing of movement in the air without concern for a preconceived harmony of his subject. It was to obey the natural principles of statuary made to be seen in the open air, that is to say, the search of contour and of what painters call value. In order to understand this notion exactly, one should remember what one sees of a person standing against the light and the sky at twilight: a very precise silhouette, filled by somber coloration with indistinct details. The rapport of this dark coloration with the tone of the sky is the value, that is to say, that which gives the sense of the body's materiality . . . its value remains independent of its color. The principle is the same for painting and sculpture. Essentially all that we see of a statue installed

high in a square . . . is its movement, its contour, and its value. The examination of details such as the folds of clothing can only distract our minds from the whole . . . the figure's principal movement, and consequently from his soul and all that he incarnates. In sacrificing everything to this drawing of movement M. Rodin was obedient to a preoccupation with syntheses which was at the same time pure realism because he was seeking principally the figure's instinctive movement [*sursaut*] with no concern for its stylization. This double tendency, synthesizing of the figure while reducing it to its silhouette and to its value, a simultaneous and rapid study of movement on all sides, M. Rodin felt growing in him over the years.[100]

What Rodin Achieved

After so many fragmented and incomplete interpretations of *Balzac*, Rodin had met his self-imposed challenge for a psychological and formal wholeness and achieved a stricter unity of form and subject that today we recognize as belonging more to the present than to the past. The concessions to his vision of sculptural form, which demanded subordination of detail to the contours, were not made at the expense of *Balzac*'s character. The final silhouettes presuppose the reconstitutions of a naked body, just as the explosive head is the summation of the writer's life and Rodin's chronicling of temperament and aging. As a mountain from a distance reveals its physiognomy, the ridges, caves, and crevices of *Balzac*'s features mock the efforts of light and space to erase their identity. It was Rodin's courage in refusing to finish more of the "appearance" and his creation of a unified silhouette with its "great line" that may have excited the admiration of younger artists such as Constantin Brancusi, whose *Bird in Space* (1919[?]; Museum of Modern Art, New York) carried sculptural form toward abstraction, yet also deeper into nature and a new, personal sexual symbolism. Consciously intended or not, side views of the final *Balzac* evokes a phallic shape, an investment of the entire sculpture with the significance of the earlier gesture of the hand grasping the penis and consonant with the virile image of Balzac as creator of his own world. Was this part of what Rodin meant when he spoke of Balzac "transported by passion"? Rodin had transformed the embattled writer into a godlike visionary who belongs on a pedestal aloof from the crowd. His head had become a fountainhead of creative power, and by a kind of Freudian upward displacement it continues the sexual emphasis of the earlier headless nude study. What more fitting tribute to Balzac's potency as a creator from the sculptor most obsessed with the life force! Rodin had raised the portrait of a writer to a symbol of creation, thereby fulfilling his earliest intentions for the monument.

The *Balzac* is a Janus-headed sculpture, looking both to the past and the future. From the front it represents Rodin's effort to revitalize monumental commemorative sculpture and to be modern through exaggeration of the features. But the Société des gens de lettres proved to be a disbelieving cult. Paradoxically, the *Balzac* stands at the beginning of the modern artistic tradition of culture without cult: the artist working from his personal values rather than those of institutional guardians of orthodox beliefs. Think of such twentieth-century masterpieces as Jacques Lipchitz's *Figure* (1926–30; Museum of Modern Art, New York) and Alberto Giacometti's *Invisible Object (Hands Holding a Void)* (1934–35; Museum of Modern Art, New York) or Henry Moore's reclining women, and Brancusi's *Bird in Space*. All have a resonance with ancient cult objects housed in shrines for devotional worship in Africa, Egypt, India, or pre-Columbian Mexico. In the past, great cults were great patrons, and inspired artists could believe in or comply with communal values and heroes. What makes Rodin's *Balzac* still so meaningful to many modern sculptors is that he sought on a heroic public scale to convey without compromise truth as he experienced it in a form natural to its implications. Like so many artists who have come after him, Rodin was convinced that in time his work would educate and convert the public from its false gods of art and life.

From the rear Rodin's *Balzac* is as astonishing as from the front. Seen against the sky, it is abstract and was compared by his contemporaries to a prehistoric menhir. In retrospect, it forecasts Brancusi's *Bird*, tapering upward and outward, seeming to soar from its stand. Here in its purest form is Rodin's "great line," the essential energy force. Like the obelisk, it is a manmade symbol of life thrusting upward and challenging the heavens, the head-like tip catching the morning light before earthbound mortals and at day's end clothed in a luminous aureole like Christ in the tympana of medieval epiphany imagery.[101] Against the moon, as Edward Steichen pho-

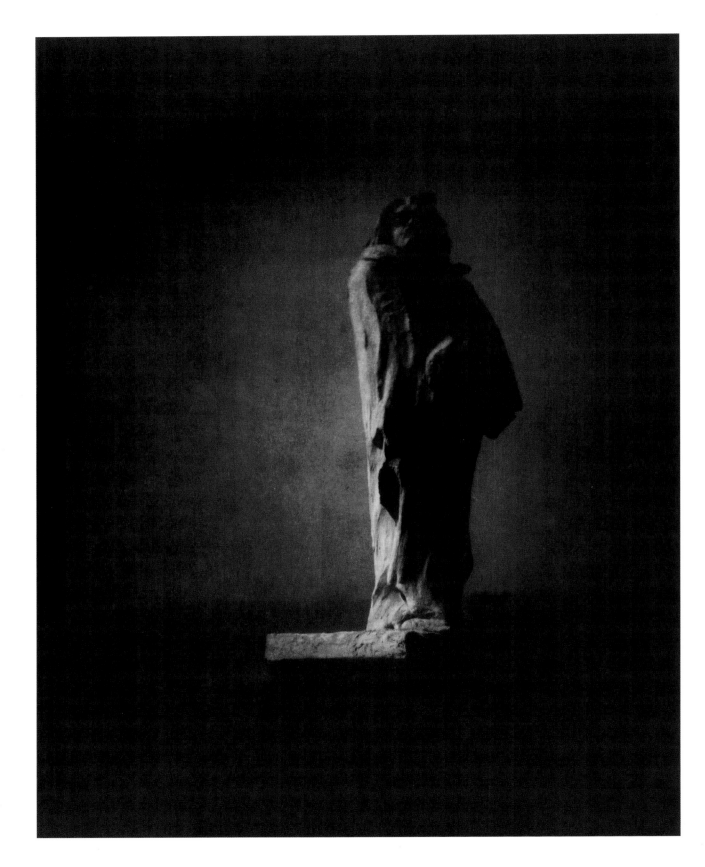

Fig. 333.
Edward
Steichen,
*Balzac—The
Open Sky*
(A161).

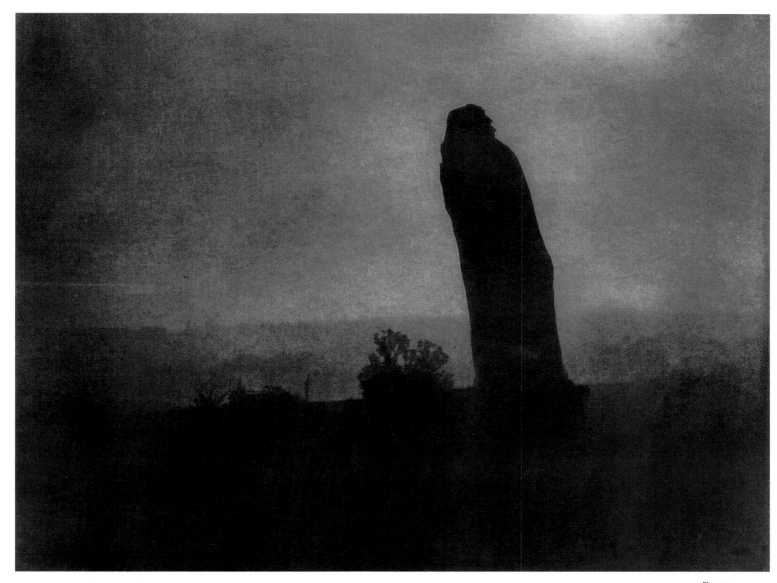

Fig. 334.
Edward
Steichen,
*Balzac—The
Silhouette*, 4
A.M. (A163).

tographed it in Rodin's Meudon garden, Balzac is reborn as the solitary walker in a sleeping world (see figs. 7, 333–334).

Monument to Balzac was also a metaphor of Rodin's artistic life. Recall that it was to have stood facing the Louvre in the place du Palais Royal. The background of the Balzac was literally and figuratively the history of Western sculpture: of the Greeks, Romans, Middle Ages, Michelangelo, and Bernini. Rodin yearned for comparison of his work with the past, as when in 1912 he approvingly viewed his *Walking Man* in Rome against the ruins of ancient statuary and Michelangelo's architecture (see fig. 452).

Today we know Balzac partly through Rodin, and we are only now beginning to discover how deep and strong were their ties. How regrettable that Balzac did not live

to characterize Rodin: Frenhofer might have been a sculptor, and *The Gates of Hell* the *chef d'oeuvre inconnu*.

NOTES

1. This essay, based on Elsen in Elsen, McGough, and Wander 1973, includes additional Balzac studies and references. Quotations are integrated from Wander, ibid., with translations by Elsen and Wander. See also Elsen 1963 and 1967b. Subsequent to the author's death the Musée Rodin's detailed study of this monument was published (see Le Normand-Romain 1998). The present essay largely retains Elsen's sequence and dates which in most cases overlap with those offered by the Musée Rodin; significant discrepancies in date or sequence are indicated in the essay notes. Other minor adjustments have been made by the editors to account for new research.

2. See Lawton 1906, 176–77. Rodin's rival for the commission was the Comte Anatole Marquet de Vasselot, an ama-

teur sculptor, a long-time, passionate admirer of Balzac, and a symbolist who had done several portraits of the writer (Elsen 1981, 308–09; see fig. 283). In its 1888 competition for a monument to Balzac, the committee voted in favor of the sculptor Henri Chapu, with Marquet de Vasselot second; Rodin received two votes. In 1891 Léon Cladel successfully encouraged Zola, then president of the Société, to push for Rodin's selection. For an excellent summary of Balzac's reputation in this period, see Butler 1993, 252–55.

3. "Chez Auguste Rodin," *La presse*, 11 July 1891. For the correspondence between Rodin and Zola, see Newton and Fol 1985, 187–201. When asked about Rodin's victory, Marquet de Vasselot said, "I have certain reasons to fear that the Balzac that he will give us will not be the true Balzac because M. Rodin generally arouses more feelings than thought. Now thought is the only thing one can search for in Balzac" (A. B. de Farges, "La statue de Balzac," *La France*, 15 July 1891). Besides indicating he would have made a carved statue of Balzac standing, his robe open to show his male chest, Marquet de Vasselot indicated that he thought Balzac would be best shown as a giant sphinx mounted atop a column the height of the Eiffel Tower. In 1896 he actually exhibited his *Balzac Sphinx*.

4. Rodin, in *Le matin*, 9 December 1891.

5. Coquiot 1917, 107–8.

6. "Balzac had a truly beautiful hand. M. de Lovenjoul owns a cast. It is one of the joys of his collection. When M. Rodin came to Brussels to familiarize himself with documents he saw this hand; he declared, 'I now have all that I need. With this hand I will rebuild Balzac'" ("Le monument de Balzac," *Les nouvelles illustrées*, 20 November 1902). Vicomte Charles de Lovenjoul was the acknowledged expert on Balzac and was most helpful to Rodin in telling him which were the best portraits of the author.

7. On Chapu's maquette (Musée d'Orsay, Paris), see Anne Pingeot, "Le *Flaubert* et le *Balzac* de Chapu," *Revue du Louvre* 29, 1 [1979], 41–42, and Le Norman-Romain 1998, 269). After his death in 1891, the Société des gens de lettres asked the sculptors Dubois, Falguière, and Mercié for their advice. They recommended giving Chapu's maquette to a *practicien* for enlargement. Chapu's proposed monument would have shown Balzac dressed in a monk's robe, seated in an armchair, which in turn was mounted on a pedestal. On one side stood a woman who symbolized Glory and on the other *un amour* inscribing the name of Balzac.

8. One waggish commentator wrote, "We have survived for twenty four years without a statue of Balzac, but it seemed impossible to wait for two more days: our patience was exhausted; Balzac was urgent." Rodin then received a telegraph: 'Send Balzac return post.' M. Rodin answered (reply paid): 'Inspiration recalcitrant; await revelations from On-High'" (cited in June Hargrove, *The Statues of Paris: An Open-Air Pantheon* [Antwerp: Mercatorfonds, 1989], 159).

9. In an undated letter to Zola, Rodin wrote, "I have lost no time since you entrusted the Balzac to me. I have worked on and made some projects. Additionally I have studied masks, [and] documents important from the point of view of life. Nothing is yet as I want, for the moment, and it is from you, Cher Maître, that I would ask the first evaluation. A friend came to see me who without warning has written about my studio. It was too soon for I am in the midst of work that is not yet condensed and visible" (reprinted in Newton and Fol 1985, 193).

10. Charles de Lovenjoul, *Un dernier chapitre de l'histoire des oeuvres de Honoré de Balzac* (Paris: Dentu, 1880), 12–13. This book is in the library of the Musée Rodin.

11. This comes from Baudelaire's essay "Comment on paie ses dettes quand on a du génie," cited in Lovenjoul, *Un dernier chapitre*, 614.

12. Edmond Werdet, *Portrait intime de Balzac* (Paris: Dentu, 1859), 339. This book is in the library of the Musée Rodin.

13. Alphonse de Lamartine, *Balzac et ses oeuvres* (Paris: Levy, 1866), 16–17.

14. Werdet, *Portrait*, 336.

15. "Nadar et Balzac," *Le cri de Paris*, 3 April 1910.

16. Werdet, *Portrait*, 339.

17. *Le temps*, 12 September 1888.

18. Gabriel Ferry, "La statue de Balzac," *Le monde moderne* 10 (July-December 1899): 652.

19. "Le monument de Baudelaire," *La république*, 22 September 1892; for full quotation, see cat. no. 101.

20. Cladel 1936, 189–90. The cube to which she refers was Rodin's conceptual guide in the composition of his figure sculptures.

21. Ibid., 186.

22. Rodin to Zola, 21 August 1891, reprinted in Newton and Fol 1985, 192.

23. Gustave Geffroy, "L'imaginaire," *Le figaro* (Paris), 29 August 1893.

24. *Le temps*, 19 August 1896

25. Geffroy, "L'imaginaire."

26. Lamartine, *Balzac*, 16–17.

27. Werdet, *Portrait*, 356.

28. Ibid., 228.

29. See Goldscheider 1952 on the *Balzac* genesis; also Descharnes and Chabrun 1967, 164–75. For extensive documentation of Balzac iconography, see Jean A. Ducorneau, *Album Balzac* (Paris: NRF, 1962).

30. Geffroy, "L'imaginaire." A *Tourangeau* is a person from Touraine.

31. Cladel 1936, 188. The bust described by Cladel is possibly that illustrated in Elsen, McGough and Wander 1973, pl.1, where it is dated 1891. A later date 1893?, is proposed for this bust, refered to as *Bust of Balzac after Achille Déveria* in Le Normand-Romain 1998, cat. no. 57.

32. The photograph is also noted and reproduced in Pinet 1985, p. xvii.

33. Lamartine, *Balzac*, 15.

34. For further discussuion of these studies, see Le Normand-Romain 1998, 270–71.

35. Werdet, *Portrait*, 359.

36. Ludovici 1926, 111.

37. *Le temps*, 11 January 1892. Regarding the three maquettes shown to the committee, see Le Normand-Romain 1998, 42–43. She notes that although the chosen maquette does not survive, its compostiaion is recalled in a charcoal drawing (cat. 34); another study showed Balzac standing with hands behind his back; for the third study, see cat. no. 102.

38. Roger Marx, "Balzac et Rodin," *Le Voltaire*, 23 February 1892.

39. Rodin to Zola, 15 January 1892, reprinted in Newton and Fol 1985, 194.

40. Additional sketches are reproduced in Elsen, McGough, and Wander 1973, pls. 15a-j.

41. Ibid., pl. 15m, for the third drawing.

42. In about 1980, Monique Laurent generously allowed this author access to the reserve, which was then just being put into order; there these previously unpublished sculptures were found. They cannot stand by themselves, lacking feet and a base. In the Musée Rodin's sequence, the figure of *Balzac as orator* (cat. 108 of present volume) and also this half life-size study (fig. 301 of present essay), for which the former served as a sketch, are both placed later in the sequence and dated c. 1894. See Le Normand-Romain 1998, cat. nos. 73 and 74, where the study and its varient are shown).

43. Tancock saw the Meudon plasters (this plaster and its robed version) as "developments of Spear's nudes h and i in the direction of a much greater grotesqueness. The legs are even more widely spread apart than in the earlier work and consequently throw the stomach into even greater prominence" (1976, 434, 448 n. 30; Spear 1974, 20–24). Tancock did not know the "orator" study, with its broad spread of the feet, but even so he did not argue why Rodin would go to a more "grotesque" study after the version represented in the Stanford cast. It is contended that there are grounds to believe that it is at least as logical for Rodin to have tightened the figural pose and moved away from the greater grotesqueness. De Caso gave his view that the Meudon plasters date to 1897–98 (1966, 12), but it is based on Mathias Morhardt's mistaken notion of when these figures were made and it assumes the influence of images of Balzac offered by the naturalist and symbolist writers, which is unconvincing.

In the Musée Rodin's sequence, the nude and robed versions of the "grotesque" Balzac with arms crossed over a big belly (figs. 309–10 of present essay) are dated later, to c. 1894, and the nude study of *Balzac as Orator* (cat. 108 of present study) and a third large-bellied figure for which it served as a sketch (fig. 301 of present study), both also dated c.1894, come next; see Le Normand-Romain 1998, cat. nos. 71–74.

44. Charles Chincholle, "Balzac et Rodin," *Le figaro* (Paris), 25 November 1894.

45. In the Musée Rodin sequences it is suggested that this study [the *Study for Nude 'Honoré de Balzac with Arms Crossed* fig. 309 of present essay] dates c. 1894 and that it follows, and was derived from, *Nude Honoré de Balzac with Folded Arms*, dated 1892 (fig. 311 of present essay). The latter figure was cut across the torso and the segments were repositioned (see Le Normand-Romain 1998, cat. nos. 36, 71). The present essay places the figure with folded arms directly following the figure with crossed arms.

A similar studio device of segmenting a torso can be seen in Rodin's *Torso of Adèle* (see fig. 415), usually dated 1882 but made possibly in 1879, while Rodin was working on the decoration of a villa in Nice. See Descharnes and Chabrun 1967, 80. This device enabled Rodin to adjust the extravagantly twisting postures of the *Sirens*, made for the Villa Neptune, which broke the normal line of the sternum, navel, and pubis. See Goldscheider 1989, 122–23.

46. Gaston Stiegler, in *L'echo de Paris*, 12 November 1894.

47. Séverine, "Les dix mille francs de Rodin," *Le journal* (Paris), 27 November 1894 (cited in Tancock 1976, 434). Tancock rightly disagreed with de Caso's dating of the two Meudon studies to 1897–98, by which time Rodin had totally changed his conception and type of model. Tancock believed that the reference to the hair as a "clump of weeds" fit the Meudon plasters; he saw the figure represented in the Stanford cast as having "relatively short" hair (448, n. 30). This is not true in the rear, where the roughly modeled hair is made to cover the back of the neck, at which point Rodin joined the separate study of the head with that of the body. How big does a clump of weeds have to be? Quantitatively the hair above the brow is about equal in size for all three figures. Further, Tancock undermined his argument by seeing the Stanford figure as having, unlike its Meudon counterpart, "considerable majesty"; Séverine referred to "an imperious sovereignty" in the figure she saw and arguably the feet of the Stanford figure better "take possession of the ground" in the manner she described. Most important, the Meudon figures do not have their folded arms resting on their chests; rather they are held slightly out from the pectoral muscles. The "flayed" skin comment may allude to the extensive damp-cloth marks visible only on the arms and thighs of the Stanford cast. When Séverine noted surfaces "furiously hammered with thumb marks," she would not have been referring to the smoother finish of the Meudon plasters, as their modeling lacks the more consistently exposed touch of the Stanford cast.

48. Cladel 1936, 189.

49. André Maurois, *Prometheus: The Life of Balzac*, trans. Norman Denny (London: Bodley Head, 1965), 327. This is a superb biography, to which the author is indebted for much information and many ideas. Now see also Graham Robb, *Balzac, a Biography* (New York: Norton, 1994).

50. Cited in Maurois, *Prometheus*, 402.

51. Séverine, "Les dix mille francs."

52. Dr. Harold Lewis of the University of London indicated to me that this imperfection was not an anatomical impossi-

bility, for the human ankle and calf muscles are capable of slight variations in structure and position. Further, the back of Balzac's right leg was not completely finished by the artist. Its angular editing and vectorlike thrust suggest that Rodin wanted to contest the natural curvature of the model's leg and perhaps impart more strength and vigor into the stance. The variation in overall surface handling in this work seems much greater than in the Meudon plaster version, in which de Caso saw evidence of a "revolutionary change of style." Rodin had many modes throughout his career, and he was liberal in their use in works such as this which prolonged attention.

53. The argument that the mound concealed an armature is not convincing, as the Meudon figure of the same scale did not require this. Athena Spear imaginatively interpreted it as symbolically linking Balzac with the earth (1967, 20).

54. Cladel 1936, 189–90.

55. Werdet, *Portrait*, 282.

56. Goldscheider (1952, 42) and de Caso (1966, 9) believed the head was based on the daguerreotype by Bisson of the dying Balzac. Spear added two other sources: the caricature of Balzac by Nadar and Louis Boulanger's portrait of the writer (1967, 20). Tancock wrote, "Albert Elsen. . . . concedes that 'the photograph could have inspired the choice of a living model'" (1976, 433). The aforementioned writers did not believe that Rodin worked from life, as they seem to have been committed to finding a documentary rather than a living source and did not try to explain the three-dimensional character of this brilliant head. Finally, if the Bisson photograph was the source, why did Rodin not copy the hairline as well as the hair, the set of the eyebrows and expression of the eyes, the unindented forehead and jowls below the cheeks? Consider just Rodin's modeling of Balzac's arched left eyebrow and its action on the muscle above.

57. Dr. Lewis posited that the conformation of the mouth suggests a man about to speak.

58. See Elsen 1966a.

59. Boccioni's portrait of his mother, entitled *Antigraceful* (1913; Metropolitan Museum of Art, New York), has been observed by many to show changing expressions as one moves around it. I do not think this makes Rodin a futurist; rather it reflects Boccioni's indebtedness to Rodin.

60. One could argue that Balzac's attitude in this sculpture presupposes his being clothed. I agree with de Caso that Rodin probably did cast this figure in bronze during his lifetime as well as having reductions made in plaster to give to devoted friends, such as Judith Cladel. This would indicate that he was satisfied with the self-sufficiency of the conception.

61. Werdet, *Portrait*, 274.

62. Eisler 1961, 1: 82–97. Rodin's art contains an athletic iconography; his head of the *Man with the Broken Nose* includes a version in marble with a fillet around the hair, which in antiquity was a symbol of victory. Rodin thus transformed a broken-faced *quartier bricoleur* (local jack-

of-all-trades) into an Olympic champion. *The Age of Bronze* and *Saint John the Baptist Preaching* possess athletic bodies. Shortly after 1900 an American boxer made several transatlantic trips to pose for Rodin in a work (cat. no. 142) that is reminiscent of the Appolonius pugilist in the Museo Nazionale Romano in Rome. Rodin asked Vaslaw Nijinsky to pose as a seated athlete. The body of *The Thinker* also qualifies as that of an athlete.

63. For Falguière's plaster model, see Elsen, McGough, and Wander 1973, pl. V.

64. Charles Baudelaire, *L'Art romantique* cited in Maurois, *Prometheus*, 419–20.

65. "Trois monuments," *L'art français*, 17 November 1894.

66. This work is discussed in Elsen 1980, 180.

67. Another mummylike terra-cotta sketch at the Musée Rodin (S260) shows the figure's crossed hands resting on a vertical support; see Le Normand-Romain 1998; cat. nos. 101–102, where both are dated c.1897. (The terra-cotta head [53900] that the author suggested may also date from the same period as the mummylike sketches, is dated earlier, to possibly 1891, in the Musée Rodin's proposed sequence; see Elsen, Wander, and McGough, 1973, pl. 28 and Le Normand-Romain 1998, cat no. 35.)

68. Morhardt 1934, 467. Written in 1934, Morhardt's memory may have been slightly off. At the end of 1897 Rodin had presumably gone much further. By the summer of 1897 he was ready to have the work enlarged. This first sketch, a nude figure study with the head of Jean d'Aire is discussed in Le Normand-Romain 1988, cat. no. 78, where it is dated c. 1894–95.

69. Ibid.

70. The same crossing of the wrists is found in one of the studies for *Jean d'Aire* (see Judrin, Laurent, and Viéville 1977, 210–11). Laurent, who was able to examine both figures, wrote that the head of *Jean d'Aire* had been placed on the body of the model for the *Balzac*, which she said was datable to around 1896. Perhaps the muscular body seemed right for the heroic burgher and Rodin, as a kind of *jeu d'esprit*, joined them together. For further discussion of this study, see Le Normand-Romain 1998, cat. no. 84 where it is dated c. 1894–95.

71. Honoré de Balzac, *Lettres à Madame Hanska*, 2 vols. (Laffont: Paris, 1990) 2, 451, cited in Graham Robb, *Balzac, A Biography* (New York: Norton, 1994), 65. Balzac himself made the equation and his views were likely familiar to Rodin. Based on reports from Gavarni and Paul Lacroix the Goncourt brothers explain, "Sperm for him was an emission of pure cerebral substance, a sort of filtering out and loss, through the penis of a work of art. After some misdemeanor or other, when he had neglected to apply his theory, he turned up . . . crying, 'I lost a book this morning'" (E. and J. Goncourt, *Journal: Memoires de la Vie Lettéraire* (Laffont: Paris, 1989), I, 639–40 (30 March 1875), cited in Robb, *Balzac*, 179. See also Maurice Z. Schroder, *Icarus: The Image of the Artist in French Romanticism* (Cambridge: Harvard University Press, 1961), 232–33.

72. See Elsen 1980, pl. 111.
73. Ibid., pl. 112, where the actual collar of the robe is still visible, and 182. This was part of Rodin's use of photography to demystify the studio and the sculptor's practices. See also Morhardt 1934, 467.
74. Ferry, "Statue de Balzac," 653, cited in Tancock 1976, 433, 447 n.22.
75. Arsène Alexandre, *Le Balzac de Rodin* (Paris: H. Floury, 1898), 29. (By "photo-sculpture" Alexander is referring to the method of François Willème; on which see p. 47, n. 14, in the present catalogue).
76. Lamartine, *Balzac*, 16–17.
77. *Pages oubliées*, May 1896.
78. Cladel 1917, 319.
79. "Petite chronique," *L'art moderne*, 25 July 1897.
80. Mauclair 1898, 600–602.
81. "La statue de Balzac," *Le figaro* (Paris), 19 March 1898, cited in Tancock 441.
82. Elsen 1980, pl. 113.
83. Camille Claudel file, Musée Rodin archives.
84. Cladel 1936, 204.
85. Quoted by Morhardt 1934, 464. The review appeared in *Le temps*, 5 May 1898. Esterhazy was the actual traitor, not Dreyfus.
86. See especially the extensive coverage of the critical reception in Cladel 1936, 204–28; McGough in Elsen, McGough, and Wander 1973, 60–66; Grunfeld 1987, 371–86; Butler 1980, 91–99; Daix 1988, 171–85. Read in tandem, the small book by Alexandre, *Le Balzac de Rodin*, and Morhardt (1934) give the best summaries of the reactions and the attempts by Rodin's supporters to defend his work. See also Le Normand-Romain 1998, 77–96
87. Alexandre, *Le Balzac de Rodin*, 20.
88. These and other comments are discussed by McGough in Elsen, McGough, and Wander 1973, 60–61.
89. Alexandre, *Le Balzac de Rodin*, 21. This astute comment reminds us why the most venturesome late-nineteenth-century French art did not have sufficient political impact to warrant a negative governmental response.
90. Committee of the Société des gens de lettres to Rodin, reprinted in *Le figaro* (Paris), 11 May 1898.
91. Rodin thought he had a case: "To defend my material interests I could go to court. I would win, my contract is formal. But I will avoid the troubles of a trial. The whole thing can be easily settled elsewhere. Someone has offered to buy my statue. I am going to sell it if I so decide." Léon de Montarlot, "Les monuments de Balzac," *Le monde illustré* [Paris], 6 April 1898.
92. Cladel 1936, 210. The proposed statement began, "The Committee of the Société des gens de lettres prohibits M. Rodin from casting in bronze the plaster of the statue exhibited in the Palais des Machines."
93. *Le journal* (Paris), 12 May 1898.
94. *Le matin*, 13 July 1908.
95. Charles Chincholle, "La statue de Balzac," *Le figaro* (Paris), 12 May 1898.
96. This is from a clipping (*Eclair*, 1897) in the Balzac file, Musée Rodin archives. Neither the author's name nor a more precise date are included.
97. Gsell 1907, 410–11.
98. Charles Morice, "L'oeuvre de Rodin, II," *L'art moderne*, 21 May 1899.
99. Georges Rodenbach, "Une statue," *Le figaro* (Paris), 17 May 1898.
100. Mauclair 1898. The implications of Mauclair's record of Rodin's thinking about sculpture for his late drawings was first recognized and discussed by Kirk Varnedoe, "Rodin's Drawings," in Elsen 1981, 179.
101. In 1902 Henry Nocq struck a medal showing Rodin's *Balzac* and an obelisk. This was reproduced in *Art et decoration* 13 (January-June 1903), 106.

102

Honoré de Balzac in a Frock Coat (Honoré de Balzac en redingote), 1891–92

- Title variations: *Honoré de Balzac in a Frock Coat, Leaning on a Pile of Books*
- Bronze, Susse Foundry, cast 1972, 4/12
- 23½ x 9½ x 11¾ in. (59.7 x 24.1 x 29.8 cm)
- Signed on base, right side, near front: A. Rodin
- Inscribed on back of base, lower left: Susse Fondeur.Paris.; below signature: No. 4; on back of base, right: © by Musée Rodin 1972
- Provenance: Musée Rodin, Paris
- Gift of the Iris and B. Gerald Cantor Foundation, 1974.91

Figure 335

*I*n his eagerness to know Balzac thoroughly as he created this monument, Rodin found the great writer's tailor and had a suit of clothes made from Balzac's measurements. The clothes were seen in the studio, but we cannot be sure they were worn by a model, specifically one who served the sculptor for this study.[1] Rodin may have set himself the problem of how to show an intellectual who wrote books without having obvious recourse to a seated posture or making it seem the writer was posing for the public. (Rodin did allude to the fact that the subject sat a lot as evidenced by the wrinkles in the pants near the crotch.) In the only known study of Balzac in street clothes, Rodin shows him with arms folded—a characteristic gesture—as if leaning casually against a vertical support, such as a wall in his study. (The back of the étude is broadly treated with big indentations for the spinal area, but Rodin must have seen that he would have

problems trying to convert this work to a freestanding sculpture that would have been viewed from all sides.)

Most unusual for a proposed monument was the decision not to show the man standing squarely on his feet but rather having his ankles crossed. Resorting to a more obvious stratagem to declare the subject's occupation, Rodin piled manuscripts around his booted feet. The pose does not derive from images of Balzac made by artists but probably from descriptions given to Rodin by Balzac's friends or from the sculptor's imagination.

In his étude Rodin did not insist on details of the costume, and the frock coat—too big to be custom-made—became an amorphous cloak, extending almost to the ankles on his right side. The model lacks Balzac's later-in-life girth, and this along with the face shows the writer when young. Coat and collar are open at the neck, and here Rodin began to work with his subject's big neck and the fat under his chin. The face is decidedly youthful, and the big, flaring mustache makes it seem that Balzac is smiling.

NOTES

LITERATURE: Goldscheider 1952, 41, 42; Descharnes and Chabrun 1967, 170; Spear 1967, 16–17, 92; Jianou and Goldscheider 1969, 105; Elsen, McGough, and Wander 1973, 40, 68; Tancock 1976, 425, 432, 453; Schmoll 1983, 129; Goldscheider 1985, 9; Miller and Marotta 1986, 78; Levkoff 1994, 104; Le Normand-Romain 1998, 282

1. This sculpture is discussed in Le Normand-Romain 1998, cat. no. 33, and dated 1891 based on the studio visit on January 9, 1892 by representatives of the Société to inspect three maquettes. The probable initial state of the second maquette, which shows the writer leaning against the back of an armchair, is represented by a plaster in the Mahoumoud Khalil Museum, Cairo (fig. 118). In a second state (the precise date unknown), the motif of the chair was dropped and the pile of manuscripts was introduced as reflected in *Balzac in a Frock Coat.*

103

Honoré de Balzac in a Dominican Robe (Honoré de Balzac en robe de dominicain), c. 1891–92

- Bronze, Georges Rudier Foundry, cast 1976, 7/12
- 42 x 20½ x 15 in. (106.7 x 52 x 38.1 cm)
- Signed on bottom edge of robe, left side: A. Rodin
- Inscribed on back of base, lower right: Georges Rudier/Fondeur.Paris; below signature: No. 7; on left side of base, bottom right: © by musée rodin 1976; interior cachet: A. Rodin
- Provenance: Musée Rodin, Paris
- Gift of the B. Gerald Cantor Collection, 1992.167

Figure 336

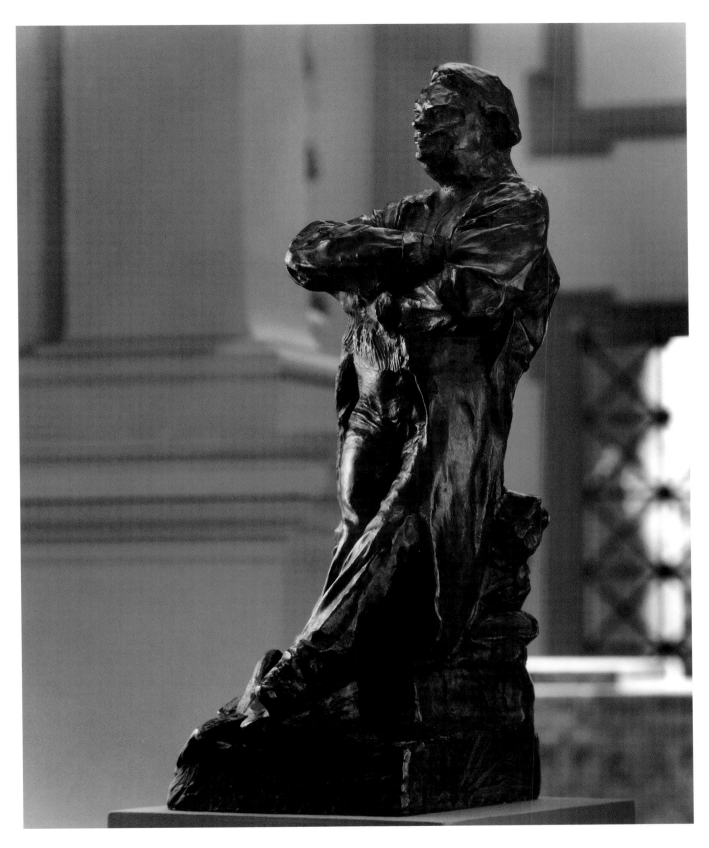

Fig. 335. *Honoré de Balzac in a Frock Coat* (cat. no. 102).

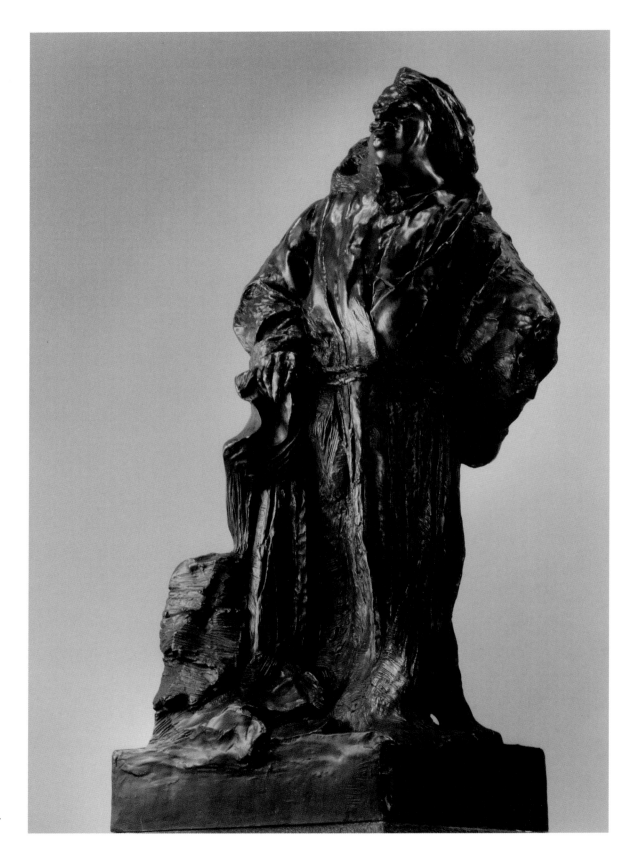

Fig. 336.
*Honoré de
Balzac in a
Dominican
Robe* (cat. no.
103).

The visual documentation on Balzac is rich in images showing him in his monklike robe or dressing gown, which he used during his long and often nocturnal writing stints. Not surprisingly Rodin made the folds of the hooded robe more sculptural and energetic than did previous sculptors. Although *Balzac in a Dominican Robe* is absent from contemporary accounts by studio visitors, given its degree of completion, it is likely that the commissioners saw this work; they recorded their admiration for one like it in which the arms were crossed.[1] Unlike the leaning pose of *Honoré de Balzac in a Frock Coat* (cat. no. 102), here Rodin set the writer squarely on his feet, one slightly in advance of the other, and rotated the upper body slightly through the positioning of the hands. With his right hand Balzac holds at his waist an open manuscript, while his left, judging by the location of the robe's empty cuff, would have been posed on his hip. (There is no left hand projecting from the robe.) This study shows similarity, in the long robe and place-

ment of the hands near the waist, to Gavarni's etching of Balzac (see fig. 281). Rodin still resorted to the books stacked by the author's right leg to indicate Balzac's fecundity as a writer. The overall cubic shape of this study reminds us that Rodin often visited the intended site in order to visualize his monument in that space and at a certain height. Rodin conceived his novelist, more corpulent here than in his frock coat, standing on a pedestal in the public square, posed as a self-confident surveyor of life.

NOTES

LITERATURE: Goldscheider 1952, 42–43; Descharnes and Chabrun 1967, 170; Spear 1967, 18–19, 92; Jianou and Goldscheider 1969, 106; Elsen, McGough, and Wander 1973, 40–41, 68; Tancock 1976, 432, 457; Goldscheider 1985, 9; Miller and Marotta 1986, 80; Ambrosini and Facos 1987, 124; Levkoff 1994, 104, 107; Le Normand-Romain 1998, 46, 300

1. Spear 1967, 18, and Tancock 1976, 433. The sculpture is dated c. 1893 in Le Normand-Romain 1998, cat. no. 49.

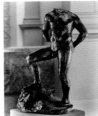

104

Nude Study for "Honoré de Balzac"
(Honoré de Balzac, étude de nu), c. 1891–92

- Bronze, Georges Rudier Foundry, cast 1972, 2/12
- 42 x 20½ x 15 in. (106.7 x 52 x 38.1 cm)
- Signed on top of base, front left: A. Rodin
- Inscribed on back of base below right foot: Georges Rudier/Fondeur.Paris.; on back of base, below left foot: © by musée Rodin 1972; below signature: No. 2
- Provenance: Musée Rodin, Paris
- Gift of the B. Gerald Cantor Collection, 1992.166

Figure 337

This may well be the earliest nude study for the monument to Balzac.[1] When it came to re-creating Balzac's unclothed body, Rodin was on his own, and this work stands at the outset of what became an exciting sculp-

tural adventure. We are reminded of how the making of a statue could be a complex problem and how Rodin broke it down into parts, such as head, body, and costume. Even within the bodily portion, as here, the omissions and unevenness in completing the modeling showed graduated interest by the sculptor: the legs and their surfaces are more developed than body and arms. Trunk, arms, and legs were to each become like characters in a play, and they had to be developed and coordinated through rehearsal.

As shown by the many artists who portrayed him, the writer's face throughout his life was public knowledge but not his unclothed body. Absent evidence that Rodin's many advisors helped him select the appropriate model for a still youthful Balzac, this headless étude reminds us of how Rodin had to think for himself about what to memorialize of Balzac's age and rather sedentary lifestyle, including well-documented dietary habits that helped shape and proportion his physical character. Despite the fact that he always knew the figure would be robed eventually, it was Rodin's discipline to create the underlying physical form of his subject, thereby ensuring credibility in the way the final costume fit over the man's anatomy.

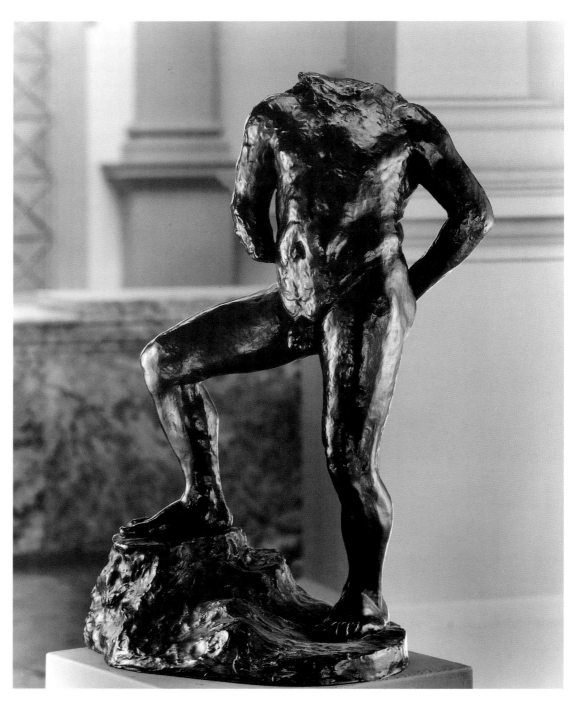

Fig. 337. *Nude Study for "Honoré de Balzac"* (cat. no. 104).

At this moment the sculptor wanted the total gesture of body and legs, for which the extremities of head and hands were not essential. Rodin seems to have been concerned to give the standing figure more vigorous movement than in the preceding robed versions. To this end, there is a calculated anatomical lack of coordination between the upper and lower portions of the figure. The arms without hands, but not the shoulders, are set in a rotating action, with the left arm curled behind the back, while the right is bent so that the forearm passes in front of the waist. In what might be termed the conqueror's pose, the stance was opened up so that Balzac's right foot rests on a flattened mound, which perhaps replaced the pile of manuscripts in the earlier, robed version (cat. no.

103). Not surprisingly, the legs are more muscular than the writer's corpulent body. (Rodin may have used different models for the torso and the legs.) The thick torso shows a reworking of the sternum, and the navel seems slightly misaligned to accommodate the frontality of the chest and positioning of the man's raised right leg, which is at right angles to the weight-bearing left. Thus, the upper gyrating pose of the arms is contrasted with the fixity of the legs in a more open stance.

Rodin had not yet decided to go beyond a thick torso and to fashion a large distended abdomen. Unlike so many other figural studies in the series, there seems to be no visual source for this positioning of Balzac's figure, nor does it accord with customary oratorical postures. In seeking the solution to an artistic problem, Rodin may have sensed later that he lost a natural or characteristic pose. Except for the left arm, more developed than the right, this avenue of thinking was largely a dead end, and Rodin would reconceive his basic idea in the subsequent small orator's study (cat. no. 108).

NOTES

LITERATURE: Spear 1967, 20, 92; Jianou and Goldscheider 1969, 105; Elsen, McGough, and Wander 1973, 41, 68; Tancock 1976, 457–58; Goldscheider 1985, 8; Barbier 1987, 159; Le Normand-Romain 1998, 302

1. This study is dated late 1892–early 1893 in Le Normand-Romain 1998, cat. no. 50. She notes that the third maquette shown to the commissioners in 1892 probably led to the nude *Balzac with Folded Arms* (cat. no. 109).

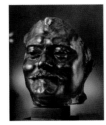

Mask of Honoré de Balzac Smiling
(Masque de Honoré de Balzac souriant), 1891–92

- Title variations: *Honoré de Balzac: Smiling Head*
- Bronze, Georges Rudier Foundry, cast 1972, 3/12
- 12½ x 6 x 6 in. (31.8 x 15.2 x 15.2 cm)
- Signed below jaw, left side: A. Rodin
- Inscribed rear right edge, below ear: Georges Rudier/Fondeur.Paris.; below signature: No. 3; on lower left edge: © by Musée Rodin 1972; interior cachet: A. Rodin
- Provenance: Musée Rodin, Paris
- Gift of the Iris and B. Gerald Cantor Foundation, 1974.92

Figure 338

*I*n all probability this mask of a young smiling Balzac came from a living model Rodin encountered in Tours. Goldscheider saw the mask as being close to a sepia portrait of the author by Louis Boulanger (fig. 285).[1] Rather than trying to reconstruct in clay a portrait drawn by someone else, Rodin's common practice was to use records of Balzac's appearance to select live models, such as those he encountered in the area of the writer's birthplace. The mask, cut off just above the forehead and behind the ears, presents Balzac not yet run to fat as shown by the indentations below the cheekbones and absence of jowls. There are no pupils in the eyes, just the upper and lower lids. Recommending the conclusion that Rodin worked from life is the decided asymmetry of the face, especially in the ocular area and that of the mouth, where the mustache is given a slant. The effects of light on the bulging surfaces in the bronze highlight a mobility of expression. Done probably in 1891 at the outset of his project, Rodin was getting to know his subject chronologically—here in his youth, long before he began *The Human Comedy*—and had begun to ponder what the head that birthed such a creation should evoke.

NOTES

LITERATURE: Goldscheider 1952, 38; Descharnes and Chabrun 1967, 166; Spear 1967, 10–11, 91; Jianou and Goldscheider 1969, 104; Elsen, McGough, and Wander 1973, 39, 68; Tancock 1976, 432, 454; Goldscheider 1985, 6; Barbier 1987, 157; Le Normand-Romain 1998, 278

1. Goldscheider 1952, 38; discussed in Spear 1967, 11 and Le Normand-Romain 1998, cat. no. 28.

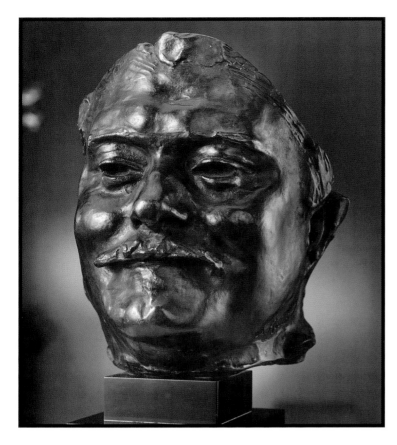

Above: Fig. 338.
*Mask of Honoré
de Balzac
Smiling* (cat.
no. 105).

Right: Fig. 339.
*Head of Honoré
de Balzac* (cat.
no. 106).

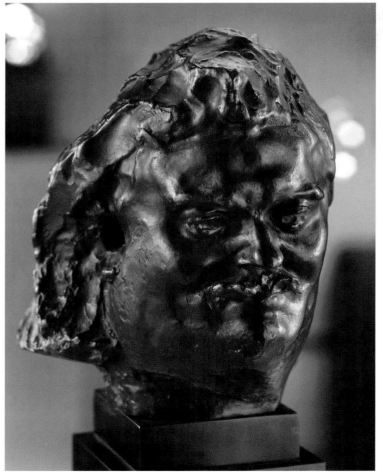

106

Head of Honoré de Balzac
(Tête de Honoré de Balzac), c. 1892–93

- Title varitation: *Honoré de Balzac: Smiling Head*
- Bronze, Georges Rudier Foundry, cast 1972, 2/12
- 6¾ x 5¾ x 5¾ in. (17.1 x 14.6 x 14.6 cm)
- Signed on neck, left side: A. Rodin
- Inscribed on neck, right side: Georges Rudier/Fondeur.Paris.; below signature: No. 2; under edge of hair at back, left side: © by Musée Rodin, 1972; interior cachet: A Rodin
- Provenance: Musée Rodin, Paris
- Gift of the Iris and B. Gerald Cantor Foundation, 1974.93

Figure 339

*I*n his campaigns to portray Balzac, Rodin often worked separately on the heads and figures, but in all likelihood he also worked simultaneously on more than one head, so that it is presently impossible to establish a chronology with certainty. In the present work one can see that Rodin further subdivided the treatment of Balzac's head into studies that focused on the face and those that included the writer's big long neck. Rodin continued to be fascinated by this anatomical feature, and when he was finished, he felt that his one artistic error was in too greatly exaggerating the neck. There is a half-length, robed study with this head, and the upper part of this study was used to produce an enlarged bust (see figs. 307–08).

The face in this study is still youthful but pensive, as if the burden of the writer's thought has caused him to tilt his head to its right.[1] From the painted and lithographic portraits made by others, Rodin obtained a good idea of how at times Balzac tilted his head. The hair, which in later studies received more detailed attention, is here roughed in as if by a plastering action of the sculptor's fingers. The sculptor abets the asymmetry of the face by having its central axis unaligned with that of the neck. Against the cursory treatment of the hair that flares out to the sides beyond the line of the ears and the quick recession of the chin into the broad neck, the face seems small for the head. The sculptor had always to keep in mind that Balzac's head would be seen from a considerable distance and at various low angles. Particularly noticeable is the way Rodin accentuated the bulge of the forehead muscles as well as the those of the cheekbones and chin, which gave the head big protuberances to catch the light. The eyelids are modeled, thereby animating the cavities around them. Rodin was not relying primarily on the eyes for expression but rather on those areas not normally thought of as the carriers of expression. As compared with the earlier *Mask of Honoré de Balzac Smiling* (cat. no. 105), Rodin is beginning to obtrude the eyebrows and mustache, but he still is a long way from their aggressive projection in the final face (cat. no. 111).

NOTES

LITERATURE: Goldscheider 1952, 40; Descharnes and Chabrun 1967, 167; Spear 1967, 11, 13, 91; Jianou and Goldscheider 1969, 105; Elsen, McGough, and Wander 1973, 23, 68; Tancock 1976, 432, 455; Ambrosini and Facos 1987, 127; Le Normand-Romain 1998, 304

1. In Le Normand-Romain 1998, cat. no. 51 (see fig. 125), the torso with this head is dated c. 1893 and the date for the execution of the enlarged bust (cat. no. 55) is suggested as 1899(?).

107

Bust of Honoré de Balzac
(Buste de Honoré de Balzac), c. 1892–93(?)

- Bronze, Georges Rudier Foundry, cast 1972, 2/12
- 12 x 12 x 9½ in. (30.5 x 30.5 x 24.1 cm)
- Signed on left shoulder: A. Rodin
- Inscribed on back, right side: Georges Rudier/Fondeur.Paris.; on edge, under shoulder at left side: © by musée Rodin 1972; below signature: No 2; interior cachet: A. Rodin
- Foundry mark on back, right edge: Georges Rudier
- Provenance: Musée Rodin, Paris
- Gift of the Iris and B. Gerald Cantor Foundation, 1974.96

Figure 340

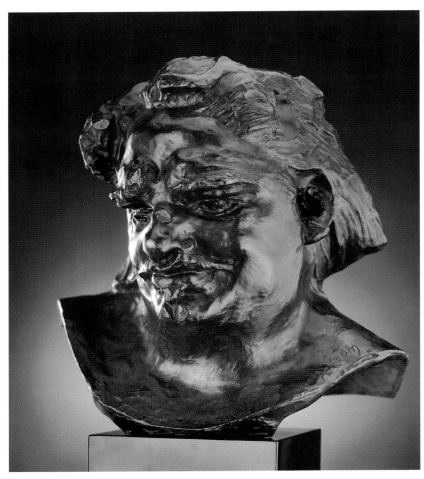

Fig. 340. *Bust of Honoré de Balzac* (cat. no. 107).

Caricatures may have served Rodin well in his meditations on Balzac's face. His problem as a sculptor was to create the writer's visage so that it would be recognizable outdoors and far away. This encouraged the idea of exaggerating the features so that they would carry from a considerable distance, and for this purpose the shaping and proportion of features in caricatures, such as those made of Balzac in 1856 by Nadar and Etienne Carjat, could have been inspiring without being the sole sources of the study (see figs. 279, 297). Various views, especially profiles extending back to the ears, suggest that Rodin had started with a live model.

By contrast with earlier studies,[1] this bust results in a face more interesting and animated because of how the light works with the bolder projections of facial hair and musculature. The brow's muscular reliefs mediate between the bunched cheeks and negligent hairdo. The hair around the mouth (also seen in Carjat's print) enlarges this area and from a distance could suggest a smiling or speaking Balzac. There is a sliced indentation just below the bridge of the nose, where later Rodin would add a raised ridge. Perhaps it originated as a studio accident to the clay, but it was then preserved rather than corrected in the plaster, seconding the impression that the surgery was planned. For what reason? This is one of many unaccountable touches, like the lumps on Baudelaire's forehead, applied by Rodin probably intuitively because they produced an effect that in some way improved the whole conception but was not intended to draw attention to itself.

As if following Nadar and Carjat, Rodin did not give the writer a neck, and the broad sphere of the head seems to grow right from the shoulders. The resulting face is more susceptible to imparting changing expressions as the light moves, intensifies, and diminishes. Rodin is here evoking the plural nature of his subject, bringing him closer to a living likeness in terms of mobility of expression and revelation of his many sided personality. Rodin's conception is beginning to take on the quality of a Balzac character!

At Meudon there is a plaster version of this characterization that has slight changes in facial makeup, notably an unindented nose and different treatments of the mustache and goatee.[2] The plaster shows that Rodin had fashioned a basic type and like an actor, added makeup as in the patched areas of the right brow and those patches that create a dimpled chin. (This technique is one that he would build on at greater length in his studies for the portrait of Georges Clemenceau.) Possibly Rodin's purpose might not have been to increase the likeness to Balzac's face in repose but rather to effect changes in his expression. In the writer's absence, Rodin's quest to know his subject meant bringing him back to life through these animated masks.

Rodin used this Balzac head as part of the naked, full-figured version with arms crossed over a large abdomen, which exists only in plaster (see fig. 309). It does not appear that this spirited étude was bronze cast or publicly exhibited in Rodin's time.

NOTES

LITERATURE: Spear 1967, 13, 23, 92; Elsen, McGough, and Wander 1973, 42, 68; Tancock 1976, 434, 456; Miller and Marotta 1986, 86; Barbier 1987, 157; Le Normand-Romain 1998, 319

1. This study is dated c. 1894 in Le Normand-Romain 1998, cat. no. 70.
2. For the plaster versions, see ibid., 319.

108

Nude Study for "Honoré de Balzac (Honoré de Balzac as Orator)" (Honoré de Balzac, étude; Honoré de Balzac orateur), c. 1891–92

- Bronze, Georges Rudier Foundry, cast 1962, 11/12
- 14¼ x 10¼ x 6¾ in. (36.2 x 25.7 x 17.1 cm)
- Signed on top of base, near front, left: A. Rodin
- Inscribed on rear of base, left side: Georges Rudier/Fondeur.Paris.; below signature: No. 11; on left side of base: © by Musée Rodin 1962; interior cachet: A. Rodin
- Provenance: Musée Rodin, Paris
- Gift of B. Gerald Cantor, 1977.18

Figure 341

*T*his is one of Rodin's most inspired, daring, and passionate conceptions for his *Balzac*.[1] Here evoked are the author's forensic skills and ability to recite from memory several scenes of a play offered to an audience of potential backers, as happened in the theater near where the monument was to be situated. The formerly sedentary and now ripening body is transformed into one of graceful, assertive action. Rather than the sum of separate deliberations and adjustments, the figure's form is realized as the whole man, a total natural gesture. The erect spine, tilt of the head, and for sculpture a historically daring open stance show the author unselfconscious about his corpulence and proudly confronting the world. The exaggerated bracing action of the feet and extended right arm counter attention to the waist's growing girth, even though the abdomen is thrust forward with the prideful self-assurance orchestrated by the body as a whole.

The overall design of the figure recalls Rodin's habit of visualizing an emerging figure within an imagined cube, which allowed vigorous natural movement while imposing restraint on extended limbs. That he was uneasy with the extreme projection of the orator's right hand, which here extends beyond the right foot, is seconded by subsequent studies of the headless, bulbous torso and fragmentation of the extended arm. The exposure of Rodin's unrefined touch in this étude impresses with how his hands as well as mind carried so much anatomical information, which could be quickly evoked. Paradoxically its rough surface under light suggests slight movement in the stationary stance, so that rather than being frozen in time, the body's vibration or tumultuous life and the energy it took to assume the pose are projected. Making this étude so satisfying is not formal brilliance alone—the bold, open form appealing to twentieth-century taste conditioned by abstract sculpture—but its powerful characterization of an important aspect of the writer, which does not appear in the final monument.

NOTES

LITERATURE: de Caso 1966, 9; Spear 1967, 20–21, 92; Jianou and Goldscheider 1969, 105; Steinberg 1972, 349, 395; Elsen, McGough, and Wander 1973, 41–42, 68; Tancock 1976, 458; Goldscheider 1985, 8; Le Normand-Romain 1998, 324

1. This sculpture is not cited by Grappe (1944), and there seems to be no evidence that it was bronze cast in Rodin's lifetime. While not publicly exhibited, presumably it would have been visible in one of the vitrines in Rodin's Meudon pavilion after 1901. The figure is dated c. 1894 in Le Normand-Romain 1998, cat. no. 73. If there is a published visual source for the pose that could have been brought to Rodin's attention, it might have been a full-length portrait of a stout, short-legged Roger de Beauvoir by Benjamin Roubaud, published by Balzac on the front page of his *Revue parisienne* (1840; reproduced in Jean A. Ducourneau, *Album Balzac* [Paris: Gallimard, 1962], 229). Roubaud showed the writer in profile, legs apart, right hand on hip, and left extended downward, holding his large hat below his waist.

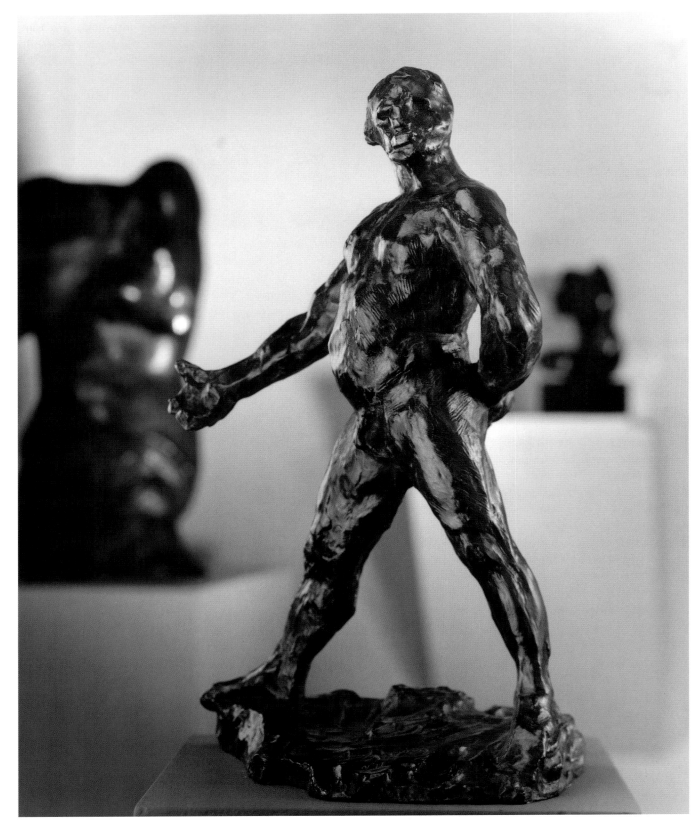

Fig. 341. *Nude Study for "Honoré de Balzac (Honoré de Balzac as Orator)"* (cat. no. 108).

109

Nude Honoré de Balzac with Folded Arms
(Honoré de Balzac, étude de nu), 1892–93

- Bronze, Georges Rudier Foundry, cast 1968, 1/12 or 5/12
- 50¼ x 20½ x 24¾ in. (127.6 x 52.1 x 62.9 cm)
- Signed on top of base, front, left: A. Rodin
- Inscribed on back of base, right: Georges Rudier/Fondeur Paris; on base, right side: © by Musée Rodin 1968; interior cachet: A. Rodin
- Gift of the Iris and B. Gerald Cantor Foundation, 1974.89

Figures 311, 342–343

*T*his great sculpture is discussed at length in the introductory essay on the *Monument to Honoré de Balzac* (366–68).

There seems to be no record that the work was bronze-cast or publicly exhibited in plaster during Rodin's lifetime. A plaster would have been visible to visitors in Rodin's studios.[1] There is a smaller version, just over thirty inches, of this sculpture. It is not clear from the records of Henri Lebossé if his reference to a *Balzac* in 1898 referred to the reduction of the *Nude Honoré de Balzac with Folded Arms*.[2] To this writer's knowledge, this is the project's only figural study that was reduced. In addition to enlargements of 1897 and 1898, Lebossé noted specifically that he worked on a bust of Balzac in 1894 and a head in 1901, but he did not specify this reduction.[3] That Rodin caused a smaller version to be made probably indicates that among all the figural studies this was highest in his favor, and perhaps he intended the reductions as gifts for those who had supported him.

NOTES

1. The study is dated 1892 in Le Normand-Romain 1998, cat. no. 36. For the history of the plaster versions and bronze casts, see Le Normand-Romain 1998, 286, 288.
2. Elsen 1981, 257.
3. Ibid., 257–58.

LITERATURE: Grappe 1944, 90–91; de Caso 1966; Spear 1967, 18, 20–21, 92; Elsen 1967b; Jianou and Goldscheider 1969, 105; Elsen, McGough, and Wander 1973, 43–53, 69; Spear 1974, 125S; Tancock 1976, 425, 433, 453; Fusco and Janson 1980, 344; Lampert 1986, 126–27; Miller and Marotta 1986, 82; Ambrosini and Facos 1987, 128; Levkoff 1994, 106–7; Le Normand-Romain 1998, 288

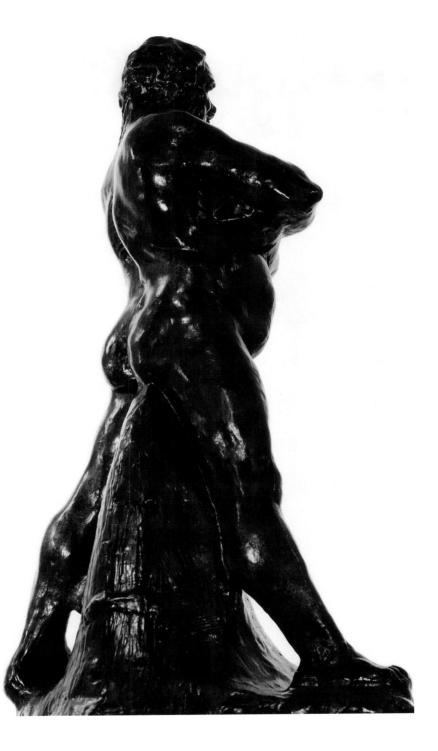

Fig. 343. *Nude Honoré de Balzac with Folded Arms* (cat. no. 109).

Fig. 342. *Nude Honoré de Balzac with Folded Arms* (cat. no. 109).

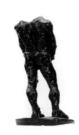

110

Headless Nude Study for "Final Honoré de Balzac"
(Honoré de Balzac, étude de nu, en athlète), c. 1896

- Title variations: *Honoré de Balzac Athlete*, *Definitive Nude Study for Honoré de Balzac*, *Second Study for Nude Honoré de Balzac Athlete*
- Bronze, Georges Rudier Foundry, cast 1967, 1/12
- 38 x 16 x 14 in. (96.5 x 40.6 x 35.6 cm)
- Signed on base, top, left: A. Rodin
- Inscribed on back of base, right: Georges Rudier Fondeur.Paris.; on base, left side, near rear: © by Musée Rodin 1967; below signature: No 1; interior cachet: A. Rodin
- Provenance: Musée Rodin, Paris; Paul Kantor Gallery, Malibu
- Gift of The Iris and B. Gerald Cantor Foundation, 1974.90

Figure 344–345

*T*his is the last of the studies from a naked model and the one that, with minor changes, the final monument to Balzac was based on.[1] Rodin admired it so much that he had it photographed by Eugène Druet and signed the print, indicative of his desire that the picture be reproduced.[2] As Rodin controlled the angle and distance from which the sculpture was to be photographed, it is illuminating to see that he chose the right profile seen from below, so that we are less aware of the absence of the head. The plaster is turned so that the man's back is toward the light entering through one of the tall windows in the Hôtel Biron. In this manner Rodin wanted us to see how the light played on the tensed muscles of the back and rear of both legs. This side view confirms the stationary stance, in which neither leg is relaxed but which he would change when the robe was added.

As with the model for the *Nude Honoré de Balzac with Folded Arms* (cat. no. 109), the man who posed for this study had very muscular legs and arms but soft pectorals. The sternum is rendered as a deep hollow, and the man's left pectoral projects forward almost like a woman's breast. His stomach protrudes below and beyond the rib cage, but it does not swell in the manner of its 1893 predecessor. By choosing to have the model hold his hands in front of his groin, grasping the penis, Rodin knew that

they would give bulk under the robe evoking the writer's famous girth. The gesture of the man's left hand was reworked as even in the bronze cast there is evidence of the wrist having been broken and remade.

The back is as impressive as the man's front. There are a deep spinal channel and strong tight buttocks with deep dimples in their flanks. The dorsal side shows that Rodin cut away sections between the left arm and torso and the upper right buttock.[3] Throughout are intermittent traces of damp cloths on the buttocks and casting seams. A curious ridge extrudes between the right pectoral and upper arm. Knoblike shapes are found on the left shoulder and the right scapula, thigh, and shin; and a large mound appears on top of the right foot. To what purpose?

We know from Mathias Morhardt that when Rodin finished this study in plaster, he caused several casts to be made and tried draping cloth over each to work out the manner in which the robe would be fitted to the form.[4] It is possible that these knobs and ridges were added to the

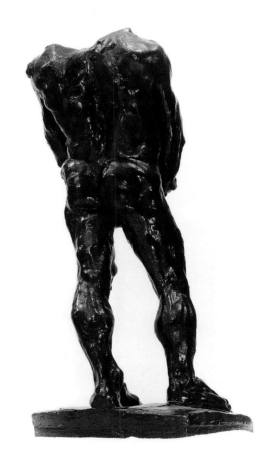

Fig. 345.
Headless Nude Study for "Final Honoré de Balzac" (cat. no. 110).

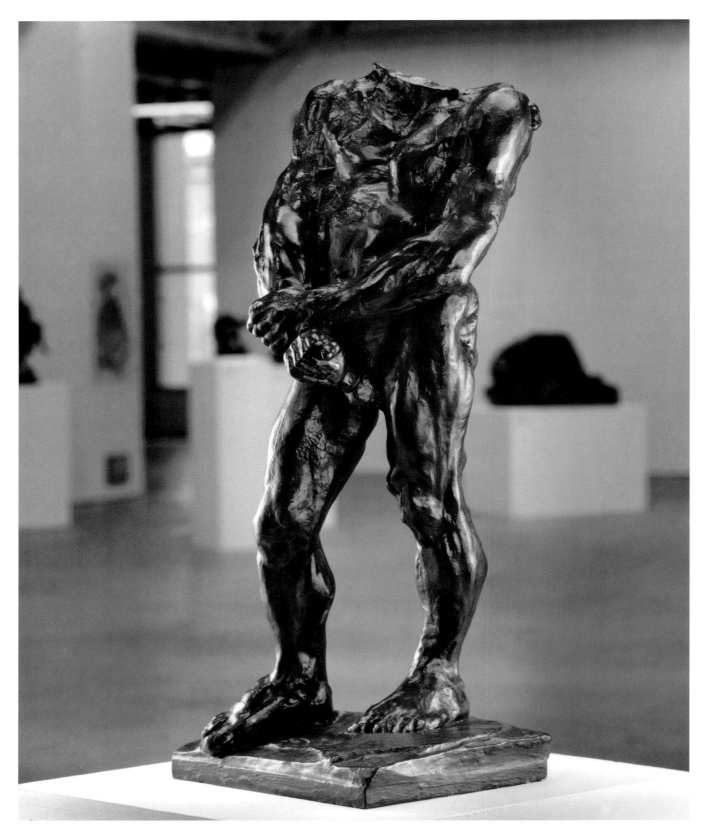

Fig. 344.
Headless Nude Study for "Final Honoré de Balzac" (cat. no. 110).

naked figure in order to obtain a better draping of the material. Rodin had no problem in retaining such technical adjustments on the naked figure, as can be seen also in the chest area of his enlarged *Monumental Male Torso* (cat. no. 65). In the case of the naked Balzac these appurtenances accorded with the rugged musculature and its eventful profiles. In sum, Rodin must have loved this sculpture for itself, as it illustrated his view that the sculptor's aim should be to model living musculature.

NOTES

LITERATURE: Spear 1967, 23–24, 92; Jianou and Goldscheider 1969, 105; Steinberg 1972, 380, 395; Elsen, McGough, and Wander 1973, 53, 69; Tancock 1976, 436, 440, 458; Elsen 1980, 182; Goldscheider 1985, 9; Lampert 1986, 127–28, 219; Miller and Marotta 1986, 84; Ambrosini and Facos 1987, 130; Laurent 1992, 72–74; Le Normand-Romain 1998, 59–60, 342

1. For further discussion of this study see Le Normand-Romain 1998, cat. no. 91; for the first study for this nude, see cat. no. 89.
2. The Druet photograph is reproduced in Elsen 1980, pl. 111.
3. We know from René Chéruy that Henri Matisse visited Rodin in his studios several times, and he could have seen how Rodin's modeling consisted not just of addition but of subtraction, which could have influenced the younger artist's own work on *The Serf* (1900–1903; Museum of Modern Art, New York) that included much editing with the knife (Albert E. Elsen, *The Sculpture of Henri Matisse* [New York: Abrams, (1972)], 25–30).
4. Morhardt 1934, 467.

111

Monumental Head of Honoré de Balzac (*Honoré de Balzac, tête monumentale*), 1897, enlarged c. 1897–98

- Title variation: *Colossal Head of Honoré de Balzac*
- Bronze, Georges Rudier Foundry, cast 1971, 2/12
- 19½ x 19½ x 15¾ in. (49.5 x 49.5 x 40 cm)
- Signed on neck, left side: A. Rodin.
- Inscribed on back of neck: Georges Rudier/Fondeur Paris.; below signature: No. 2; on neck, lower edge, left: © by Musée Rodin 1971; interior cachet: A. Rodin
- Provenance: Musée Rodin, Paris; Paul Kantor Gallery, Malibu
- Gift of the Iris and B. Gerald Cantor Foundation, 1974.95

Figures 328, 346

Anticipating the many études he would make of his portrait of Georges Clemenceau just before World War I, Rodin's last studies for the head of Balzac are basically the same as one another but with small cosmetic alternations. Having established the basic form, Rodin would then exchange different features such as eyebrows, mustache, or hair style. The late studies demonstrate the sculptor's sensitivity to the effect of even slight physiognomic changes; they remind us that he must have worked on several études simultaneously rather than in a clear chronological fashion and that he worked on the head and body separately for much of the time. While concerned in the latter with simplification of the big planes and establishing great lines, his attention was absorbed in the former with minute details, even though often nondescriptive. Out of the artist's sight, if not memory, were all the Balzac portraits done by the writer's contemporaries. After six years of thought and work, Rodin had formed for himself a head that went beyond likeness to evoke the creator of tumultuous life.

Crucial to understanding Rodin's creation of the final head are such relationships, as seen, for example, in the *Late Study for "Head of Honoré de Balzac"* (see fig. 322), as the way the hair, rudely and repeatedly incised with a knife, now seems to erupt from the muscular brow and like a crenelated roof line allows the sculpture's top to meet the sky in a more active way; mustache and upper lip fuse, exaggerating the mouth, so that from a distance and according to the light the man seems to smile or sneer. (Seen from the left, the mustache turns up with the suggestion of a smile; from the right, it is as if a sneering Balzac is about to speak.) The ledgelike, protruding eyebrows are made extensions of the ocular cavity; the fixity of the deeply inset eyes contrasts with the mobility of the fleshy areas, such as the cheeks and jowls. Also the upward tilt of the head for the final work was established to maximize illumination of the face. (This may explain the addition of the ridge on the bridge of the nose,

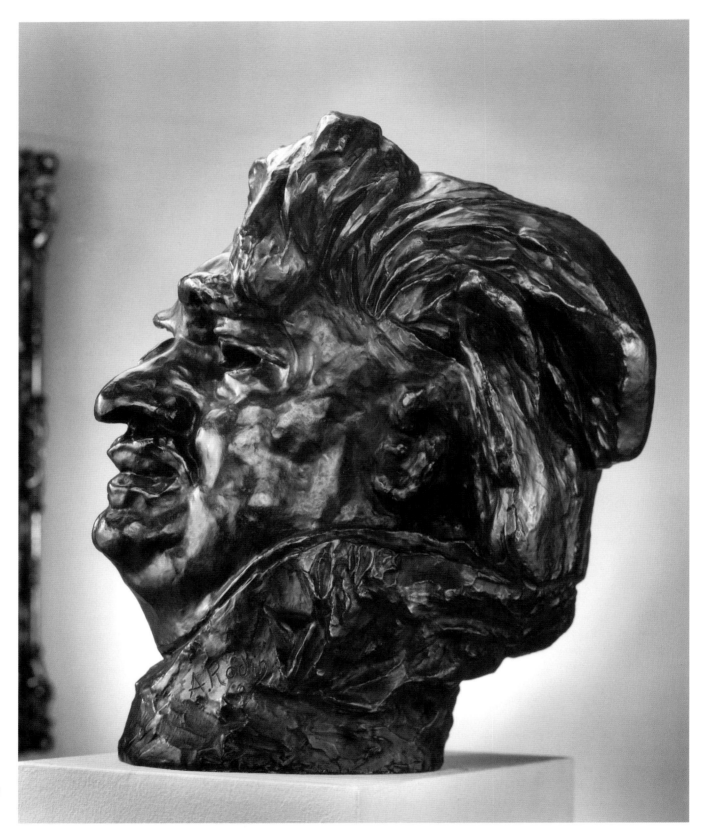

Fig. 346.
*Monumental
Head of Honoré
de Balzac* (cat.
no. 111).

which would have strengthened if not straightened the profile views of the nose but also brought light into the median area between the two deepest-shadowed recesses.) Showing that what he did in the final head was not an impulsive decision or accident, the study from which the *Monumental Head* was enlarged and this late study have the long, untempered, raised ridge on the bridge of the nose.[1]

When the enlarged plaster version of the proposed monument was exhibited (see fig. 330), specific comments by Rodin's friends and foes about Balzac's head were outnumbered by those relating to the work as a whole. Those against the work saw a writer who was "drunk," having "no eyes"; "never before has anyone thought of extracting a man's brains and smearing them on his face . . . for the love of art, may the sculptor spare us his private commentaries."[2] Prophetic of many reactions to modern sculpture in the twentieth century, Rodin's skeptical public thought that he was making a practical joke, a *fumisterie*, or hoax, which outraged him as his sincerity was challenged. Given that Rodin had probably been influenced by well-known caricatures of Balzac, the public's reaction is not entirely incomprehensible.

Favorable commentators characterized the upward tilt of the head in the monument as a gesture of pride and indicative of "his looking into the distance with a deep ironical gaze. The upper lip and mustache have a marked satirical curl."[3] No contemporary commentator was more thoughtful and eloquent than Georges Rodenbach, the Belgian poet who saw in the head what must have been in Rodin's mind for years, Lamartine's metaphor: Balzac's "face was the face of an element." To this Rodenbach added:

This face . . . wore all the masks of *The Human Comedy*. . . . But the face, not a human face, not mine, not yours, not even Balzac's, but the one which he had when he regarded all that he saw. Think about it, to have seen *The Human Comedy!* To have seen all the characters of so many novels that he wrote and the characters of so many others that he would have written, if he had not died at fifty. . . . He had seen all life, all the passions, all the souls, all the universe. The terror of having seen all that—and the anguish as well. . . . Premature death was there. It was already on his face. This is the face that had to be rendered, correct? This is what the statue of a

man like Balzac must be in the eternity of Paris. Otherwise, there is the daguerreotype of Nadar: Balzac with suspenders?[4]

A few years later it took a second poet to match Rodenbach's insightful understanding of what Rodin sought to evoke in the face. As Rodin's secretary, Rainer Maria Rilke had the opportunity to ponder at length the earlier studies and what they led to:

Rodin slowly developed form after form. At last he saw Balzac. He saw a mighty, striding figure that lost all its heaviness in the fall of its ample cloak. The hair bristled from the nape of the powerful neck. And backward against the thick locks leaned the face of a visionary in the intoxication of his dream, a face flashing with creative force: the face of an element. This was Balzac in the fullness of his productivity, the founder of generations, the waster of fates. This was the man whose eyes were those of a seer, whose visions would have filled the world had it been empty. This was the Balzac that Creation itself had formed to manifest itself and who was Creation's boastfulness, vanity, ecstasy, and intoxication. The thrown-back head crowned the summit of this figure as lightly as a ball is upheld by the spray of a fountain.[5]

While to some present-day viewers the reactions of the two poets might seem excessively interpretive or subjective, both men had access to the artist and his thoughts, and they were thinking the way Rodin wanted, which Rodin must have welcomed when he read what they had written.

What Rodin was recorded as saying about his *Balzac* referred often to the work as a whole and less frequently to the head specifically. In his most extensive statement, that made in 1907 to Paul Gsell, he spoke of the writer's feverish pace "in pursuit of his private visions. . . . I had to show a Balzac in his study, breathless, hair in disorder, eyes lost in a dream, a genius who . . . reconstructs piece by piece all of society in order to bring it into tumultuous life before his contemporaries and generations to come."[6] In 1903 Rodin told M. E. Pountney, "I am a very slow worker. . . . Balzac was an 'original' and had to be studied from many points of view." Rodin then went on to reveal how intimate was his knowledge of his subject: "He seldom heard what was going on around him and,

like Victor Hugo, who was deaf in one ear, he would often break into the conversation with an irrelevant remark. He followed out his own train of thought, and when he had something to say, said it without reference or deference to anyone."[7]

When the *Balzac* was enlarged, this head became the final and most extreme exaggeration, which Rodin felt was the moral basis of a modern art. The resulting effects went unmentioned by the artist's contemporaries because the juxtaposition of the original, smaller head and its offspring was not available outside the studio. They could not observe how the enlarged head increases the sense of fatty fleshiness, appropriate to a man with the extravagant and voluptuous appetites that finally stopped his diseased heart. Projections like the enlarged eyebrows above a nose that has become a prodigious birdlike beak take on the aspect of wings in flight.[8] The even deeper ocular cavities avoid any sense of Balzac looking outward. When Rodin spoke of how his *Balzac* "is inseparable from his surroundings," he included the very atmosphere with which the bigger head so vigorously interacted. It was thus not physical likeness alone that Rodin meant by "life." What Balzac's head represented in terms of his creativity was what Rodin sought to evoke. The evolution was complete from the early portraits of a writer to the final head of a creator. But the final *Balzac* was not to be viewed or thought of as frozen in time. As it would be seen outdoors, from below, and at varying distances, Rodin wanted his sculpture not only to carry because of his exaggerations and "essential modeling" but to possess a mobility of facial expression under changing light. He thereby summarized his subject—his many views of this multifaceted man—in the way his *Walking Man* (cat. no. 174) would shortly embody a pedestrian movement. Consider Rodin's own commentary: "The interest lies not in the figure itself, but rather in the thought of the stage he has passed through and the one through which he is about to move. This art that by suggestion goes beyond the model requires the imagination to recompose the work when it is seen close up. It is, I believe, a fertile innovation."[9]

As Rodin had worked on this and the earlier heads separately from the body and took great pride in the final result, he sought later to defy his critics by publicly exhibiting this bigger-than-life-size head. It was shown in Vienna, Berlin, Venice, and Helsinki (1901), New York (1903), and Turku, Finland (1904).[10] Freed from the pedestal of the controversial body and what many saw as a "monstrous even goiterous" neck, Rodin may have believed that others, especially artists, could concentrate on his innovative re-creation of the author of tumultuous life. More than the whole figure, the giant head was Rodin's assault on the then-fashionable salon portrait sculptures, with their prosaic descriptions, whether of heads alone or full-length figures. Just what he had put into this work Rodin summarized by saying, "I have put into it all my thought, all my taste, all my conscience, forcing myself to return to the great tradition . . . the ancient tradition to not imitate the form in a servile manner, but to bring it as closely as possible to life. Photographic sculpture has had its day!"[11]

NOTES

LITERATURE: Spear 1967, 26, 91–92; Jianou and Goldscheider 1969, 105; Elsen, McGough, and Wander 1973, 53, 55, 69; Spear 1974, 124S; Tancock 1976, 425, 441, 454; de Caso and Sanders 1977, 237–41; Lampert 1986, 219–20; Miller and Marotta 1986, 89; Ambrosini and Facos 1987, 133; Nash 1987, 187–88; Le Normand-Romain 1998, 393, 396

1. The enlargement is discussed in Le Normand-Romain 1998, cat. nos. 144, 147 and is dated 1898 (?). For further discussion of the study from which the enlargement was made, see Le Normand-Romain 1998, cat no. 98, dated c. 1897, and also cat. no. 90 for discussion of the late study, which is dated c. 1895–96.
2. Reactions to the exhibited plaster are cited by McGough in Elsen, McGough, and Wander 1973, 60–61.
3. Henri Frantz, "Rodin's Statue of Balzac," *Magazine of Art*, 22 March 1898, 617–18.
4. Georges Rodenbach, "Une statue," *Le figaro* (Paris), 17 May 1898.
5. Reprinted in Elsen 1965a, 142.
6. Gsell 1907, 410–11.
7. M. E. Pountney, "Rodin and Balzac," *Weekly Critical Review*, 22 January 1903.
8. It was Rodenbach who said, "It is the characteristic of a great artist to see analogies, in forms that escape others" ("Une statue").
9. *La revue*, 1 November 1907, 105.
10. Beausire 1988, 208, 210, 215, 218, 242, 245, 253.
11. P. Dubois, "Chez Rodin," *L'aurore*, 12 May 1898.

Final Study for "Monument to Honoré de Balzac"
(Honoré de Balzac, étude finale), c. 1897

- Title variations: *Honoré de Balzac, Honoré de Balzac: Final Model, Honoré de Balzac: Last Maquette*
- Bronze, Georges Rudier Foundry, cast 1976, 12/12
- 43½ x 17 x 15 in. (110.5 x 43.2 x 38.1 cm)
- Signed on top of base, right corner: A. Rodin
- Inscribed on back of base, right: Georges Rudier Fondeur.Paris.; on base, left side, rear: © by Musée Rodin 1976; below signature: No. 12
- Provenance: Musée Rodin, Paris
- Gift of the B. Gerald Cantor Collection, 1992.168

Figure 347

The transition from the ultimate study of the naked model to the final, clothed figure was not a simple matter of tailoring. There were many studies of the robed Balzac before Rodin settled on the last one. The big change caused by the robing was to transform a stationary figure into one that seems to pace. This was accomplished by bringing the left foot forward a few inches, thereby closing both the stance and the robe, which conceals the bent right leg. Rodin changed the left foot but not the leg where the calf presses against the gown, and the two anatomical areas are no longer aligned. Despite simplification of the draped planes, there remains subtle evidence of the supporting naked figure. What shows through the robe are the muscles of the left hip area and those of the upper right and left forearms. The knob on the right scapula influences the way the gown hangs.

When Rodin pondered the profiles of the naked plaster figure draped in cloth, he must have eventually decided that its girth was excessive, for he cut off the right hand. Between the shoulders the gowned Balzac is about as wide as he was undressed, suggesting that the sculptor trimmed the naked shoulders somewhat. When Rodin decided to have Balzac turn his head to his right, he changed the right shoulder, which no longer advances and seems to have been lowered somewhat to parallel the left one. The open collar reveals the enormously thick neck and upper portions of the bulbous pectorals, to one of which the robe is actually bonded.

The garment's vertical and somewhat concave planes in the back make sense in terms of the man's squarish frame. Rodin made no attempt to simulate cloth, and the surfaces are textured by his touch. As opposed to the robes of *The Burghers of Calais*, which appear rent by deep, vertical shadows, Balzac's robe was made to reflect as much light as possible. Here are found the largest and most abstract planes in Rodin's art. They are interrupted vertically by arrises, to which he paid the most attention, even rebuilding some and consistently tempering their edges to avoid dryness. (None of these edges is strictly vertical.) The empty sleeves were carefully calculated, and despite their appearance of negligence, admired by Camille Claudel,[1] they were pulled in against the body and made parallel to the diagonal movement of the arms, accentuating the backward tilt of the form, which gives the sculpture a sense of motion.

The trailing edge of the drapery, now located where the left heel had been, aligns vertically with the edge of the collar. When we take in the whole of the half-size model from the figure's left side (see fig. 329, the head looks plumb with the left foot. It was in the enlargement that the head seemed out of line with the foot, and coupled with Rodin's need to extend the enlarged base further to the rear, this led to the charge that the figure was not well made because it "did not carry" and was about to topple.

Rodin also undoubtedly made changes to the head when it was mounted on the cloaked body and he could see it against the ensemble. The writer's long hair literally merges with his collar. The forehead slopes into the man's huge right eyebrow. A forelock comes down and merges with the left eyebrow. The eyes are large empty sockets, a pair of black holes straddling a prominent nose, onto which Rodin put one of his unaccountable touches to reflect light and possibly to deemphasize the profile. The mustache is like a large inverted crescent, and it merges with the cheek on its right side. The nose and protruding, asymmetrical chin are on axis but not the center of the mouth, which is not aligned with the center of the face. It is as if once Rodin had the head in place, he literally pushed the chin to its right. There is no sense of a jawbone. The fleshy face descends into large jowls and the massive neck. Taken as a whole and seen close up, the head of Balzac is like a caricatural portrait. The exaggerations, even extravagances, were motivated

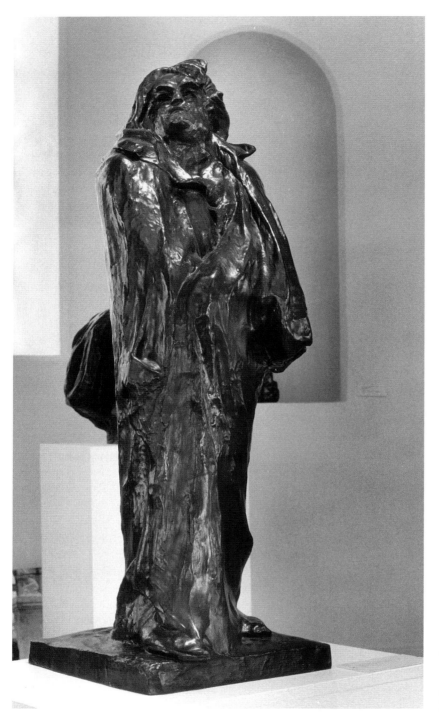

Fig. 347. *Final Study for "Monument to Honoré de Balzac"* (cat. no. 112).

Rodin had the whole dip-cast so that a fine slip of plaster coated its entirety. The figure might have been immersed upside down in liquid plaster, for when we look at the lumps on the drapery in the front, they seem to flow upward. There are signs that there was some reworking after the final coat of plaster was applied, otherwise the whole lacks a certain distinguishing rawness of touch one could expect from Rodin in the late 1890s. Dip-casting allowed elisions between lumps and planar surfaces. Why would this have been done? Perhaps to obtain a clean plaster cast or to see what the form would be like if carved in marble and to mute detail that might detract from the great lines, and certainly to win a greater largeness of effect.

This final but unenlarged figure was seen in Rodin's studio in March 1897 by Henri Houssaye, the president of the commissioning society, who wrote, "Rodin . . . has finally finished the Balzac monument. The work is beautifully conceived. The powerful novelist is represented standing, hands crossed, and looking at *The Human Comedy* whose main personages parade in front of him. . . . This composition [is] now in the process of being enlarged."[2] A year later the president announced that the work was completed.[3]

NOTES

LITERATURE: Cladel 1936, 202; Grappe 1944, 98–99; Goldscheider 1952, 37; de Caso 1964, 278–79, 1966, 112; Spear 1967, 24, 26, 93; Jianou and Goldscheider 1969, 106; Elsen, McGough, and Wander 1973, 56–58, 69; Tancock 1976, 425, 441, 459; de Caso and Sanders 1977, 21–22, 231–36; Elsen 1981, 113–14; Schmoll 1983, 129, 260, 270–71; Lampert 1986, 130, 220; Miller and Marotta 1986, 89–90; Butler 1993, 299–306; Levkoff 1994, 107; Le Normand-Romain 1998, 364–65

1. Camille Claudel file, Musée Rodin archives.
2. Quoted by Spear (1967, 24), citing *Le journal* (Paris), 17 April 1897.
3. Cladel, 1936, 202. The model is discussed in Le Normand-Romain 1998, cat. no. 16.

by the artist's concern that the identifying features of the head be visible from a considerable distance. What the face expresses depends literally on one's point of view. Balzac's expression is as varied as the light that illuminates his face.

There is almost a slippery, smooth surface over the modeling throughout. No sharp edges are to be seen or felt by the hand. It is conceivable that as a finishing touch

113

Head of Séverine (Tête de Séverine), 1893

- Title variations: *The Actress, Mulatto Head*
- Bronze, Susse Foundry, cast 1975, 9/12
- 6¼ x 5½ x 5½ in. (15.9 x 14 x 14 cm)
- Signed on left side: A. Rodin
- Inscribed below signature: No 9; on left side, bottom: © by Musée Rodin 1975
- Provenance: Musée Rodin, Paris
- Gift of the B. Gerald Cantor Collection, 1992.161

Figure 348

*I*f she is not already, the writer Caroline Rémy, known as Séverine (1855–1929), should be a heroine to the feminist movement. In the late nineteenth century and until her death at age 74, this liberated woman, who had evolved from a radical socialist into a mystic, was reckoned by some as a major journalist and writer. She crusaded to alleviate the plight of the poor and founded her own charity on their behalf; she was also one of the founders of the French Communist party.[1] When she met Rodin in 1892, she was already writing six newspaper columns a week, had defended his work in print, and from 1885 to 1888 had edited a left-wing paper, *Le cri du peuple*, inherited from her husband, Jules Vallès.

Among her gifts was Séverine's speaking ability, which mesmerized her audiences and deeply moved Rodin. He once told her, "Séverine, I have heard you speak many times; you have always charmed me. You are the angel of eloquence."[2] In a rare series of drawn portraits, which are stunning, and in this one small modeled head, Rodin depicted Séverine repeatedly in what is truly a speaking likeness.[3] The likeness, which is not a full, three-dimensional head, is almost a mask, small presumably because Rodin may have been too busy to make a larger version.[4] Her short cropped coiffure makes a tight frame for the face, which seems younger than her 38 years. As described by Edmond de Goncourt, Séverine had "a compact oval face with tender eyes, a large mouth with beautiful teeth and an air of kindness."[5] The lips are beautifully rendered, especially the commissure, the

edges where the surface of the lips meets the skin of the cheeks, and they are parted to display the teeth. The eyes protrude, and the irises are in low relief and etched. They contribute to the sense of intense concentration and ardent communication in the face as a whole.[6]

Before her death Séverine wrote an account of her experience while posing for Rodin. Not surprisingly she was eloquent about the procedure, the artist, and his hands: "He would feel your skull as a phrenologist would (fortunately my hair was my own!) and grow ecstatic over this bump and that one. . . . He was a passionate artist who had trouble restraining the ardor of his senses. At the first sitting he was respectful. At the second, less so. At the third, he ceased altogether."[7] At another time she further described Rodin: "His hands? Strangely like those of a priest or a surgeon; not at all brutal . . . but hands that could give extreme unction, obstetrical

Fig. 348. *Head of Séverine* (cat. no. 113).

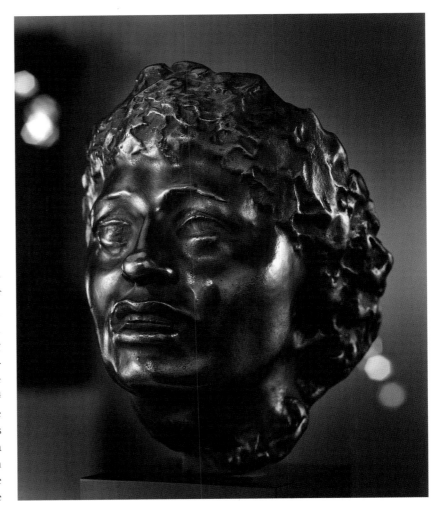

hands, delivering nature of her masterpieces. And beyond the solidity of the ensemble, a revealing mask—a rugged complexion, strong nose, immense reddish beard, tightly helmeted by close-cropped hair; while beyond the pince-nez his timid, brilliant blue gaze moves and ripples like the sea through a windowpane."[8]

Rodin had once said to Séverine, "When I die, I pray you will say a few words over my grave." At Rodin's funeral held at Meudon in November 1917, Séverine stepped from the crowd and gave a eulogy after which she took a rose, kissed it, and threw it on Rodin's coffin.[9]

NOTES

LITERATURE: Grappe 1944, 90; Spear 1967, 32, 93; Jianou and Goldscheider 1969, 106; Spear 1974, 126S; Judrin 1976, 126, 128; Tancock 1976, 526, 528; de Caso and Sanders 1977, 293–94; Grunfeld 1987, 335–38

1. For more on Séverine, see Grunfeld 1987, 335–38; Daix 1988, 245.
2. Judrin 1976, 126.
3. Ibid., 126, 128–29, for reproduction of several drawings.
4. Ibid., 126.
5. Grunfeld 1987, 336, citing Edmond de Goncourt and Jules de Goncourt, *Journal: Mémoires de la vie littéraire*, 22 vols. (Monaco: Impr. nationale, 1956), 18: 127.
6. The Susse Foundry opted for a thin patina, uncharacteristic of Rodin, which allows the light-colored metal to show through. While this reference to the metal itself reflects a twentieth-century aesthetic for bronze sculpture, in this author's view it detracts from concentration on the face. It was presumably the foundry that decided on the angle at which the head would be mounted.
7. Recorded by Leonce Bénédite, in "Musée Rodin," *Beaux-arts*, 1 November 1924, 280; cited in Grunfeld 1987, 337.
8. Séverine, "Auguste Rodin," *Le journal* (Paris), 10 November 1894, cited in Grunfeld 1987, 337.
9. Judrin 1976, 126. For a photograph of Séverine giving her eulogy, see Descharnes and Chabrun 1967, 269.

114

Bust of Alexandre Falguière (*Buste de Alexandre Falguière*), 1898

- Bronze, Georges Rudier Foundry, cast 1972, 6/12
- 17 x 9½ x 10¼ in. (43.2 x 24.1 x 26 cm)
- Signed on left shoulder: A. Rodin
- Inscribed on left shoulder, bottom: Georges Rudier/Fondeur Paris.; on lower left edge: © musée Rodin 1972; interior cachet: A. Rodin
- Provenance: Musée Rodin, Paris
- Gift of the Iris and B. Gerald Cantor Foundation, 1974.94

Figure 349

*T*he likeness of Jean-Alexandre-Joseph Falguière (1831–1900), like so many of Rodin's portraits, was done out of friendship. On the basis of their professional histories, that they were friends seems surprising. Falguière had all the professional advantages that Rodin lacked, and this portrait was made in 1898, just after the Société des gens de lettres had rejected Rodin's proposed monument to Balzac and awarded the commission to Falguière instead. Nine years older than Rodin, Falguière became a profes-

sor at the École des Beaux-Arts, Rodin's lifelong nemesis, and he was an establishment hero. He had an École des Beaux-Arts education, won a Prix de Rome, exhibited at all the salons between 1863 and 1899, and received many honors from the government, which purchased many of his works. In 1898 he rivaled Rodin as the country's leading sculptor. He was much written about and given a retrospective two years before Rodin mounted his own in 1900.[1] An exceedingly productive artist with a large studio and a number of supporters in the critical press, Falguière at times competed with Rodin for important commissions, such as that for the *Monument to Claude Lorrain*. Their friendship went back to the time when Rodin was accused of making a life cast from a model for *The Age of Bronze* (cat. nos. 1–3), a charge disputed by Falguière. What must have most touched Rodin was that the older sculptor had defended the younger man's *Balzac* against the critics. Following the reassignment of the commission to Falguière, he and Rodin agreed to model each other's portraits, which were shown in the Salon of 1899, where the former's version of *Balzac* was first exhibited.[2] Falguière died in 1900, and his Balzac monument was finished by Laurent Marqueste (1848–1920). At its dedication in 1902, Rodin represented his dead friend.

Falguière epitomized what might be called the artist of talent who lacked genius but who served his country, students, and profession well. Today he is known to many only for having been the subject of this strong portrait by

Rodin, although he certainly enjoyed Rodin's respect and personal regard. In a contemporary photograph Rodin wears a fine hat, white shirt, and suit of clothes working on the clay portrait, as if expressing respect for his profession and subject.[3] Having himself thus photographed, Rodin enjoyed being seen and pictured as a laborer but also as an executive. Rodin and Falguière had large studios and several craftspeople working for them, doing the tedium of artistic production while the masters were being creative or working the government and art public for commissions, sales, and articles.

Rodin's portrait of Falguière is so rich that one spends no time speculating on what the full figure of the sculptor looked like. Start with the position of the head: slightly lowered and far different from the chin-in-air stance given Dalou (cat. no. 85). The thick-necked figure with lowered countenance had a definite association for Rodin. He once described the head to Paul Gsell as "that of a small bull." Gsell went on to say, "A little bull! Rodin often made these comparisons with the animal kingdom. . . . These comparisons evidently facilitate the classification of physiognomies into general categories."[4] While we can see and admire Rodin's patient study of his subject's idiosyncratic features, and keep in mind Rodin's concern for the part's effect on the whole, we should remember that Rodin was also thinking in terms of analogies to other forms of life that inspired the expression he sought, a kind of comparative physiognomics well known since the eighteenth century and with which Rodin grew up.

It was part of Rodin's gift as a portraitist to convince us of the artistic logic of a human head: how the big ears balance the area of the brows and nose in profile; or in a frontal view, how the ears and hollows of the cheeks seem conjugates of each other. Rodin was sensitive to such things as the different shapes of the upper eyelids but also to the way the skin hangs on the skull in an older person so that the fleshy folds and hollows of the cheeks make an interesting rhythmic sequence. The entire face as formed by Rodin's hands became a rich, dense field of changing and surprising patterns of relationships—of light and dark and of surfaces going in and out. That richness comes from the subtly graduated hollows and projections or in the man's right temple area, surprising incursions in terms of depressed areas. Those pouches under the eyes, which a vain person would want excised cosmetically, are for Rodin carriers of a man's life and great light reflectors. Close up, the surfaces show many additions of small patches of clay, pellets mashed and

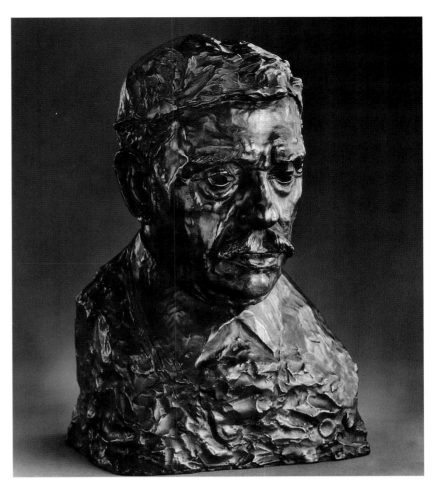

Fig. 349. *Bust of Alexandre Falguière* (cat. no. 114).

pushed along the surface, perhaps added in the model's absence when as a sculptor Rodin could study the effect of light on the total form. As the light changes, these effects evoke the mobility of the flesh as expressions change. Constant are the blacks of the recessed eyes and their impression of a deeply thoughtful person.

NOTES

LITERATURE: Grappe 1944, 100; Descharnes and Chabrun 1967, 174; Jianou and Goldscheider 1969, 107; Grunfeld 1987, 384–85, 391; Fonsmark 1988, 140; Le Normand-Romain 2001, 173

1. There is a fine synopsis of Falguière's career by Peter Fusco in the catalogue of the splendid exhibition *The Romantics to Rodin* (Fusco and Janson 1980, 255).
2. It is thus not clear why Grappe dated Rodin's portrait of Falguière to 1897 (1944, 100), when Rodin lost the *Balzac* commission in 1898. Le Normand-Romain (2001, 173) dates it 1898 and cites other versions. It was exhibited 23 times (Beausire 1988, 368).
3. Reproduced in Descharnes and Chabrun 1967, 174, along with a portrait of Falguière.
4. Gsell [1911] 1984, 65–66.

115

The Hero (Le héros), before 1900

- Title variation: *The Poet and Love*
- Bronze, Alexis Rudier Foundry
- 16⅜ x 6½ x 4¾ in. (41.6 x 16.5 x 12.2 cm)
- Signed on back of base, behind left foot: A. Rodin
- Inscribed on back of base, behind right foot: Alexis Rudier/Fondeur Paris
- Provenance: Feingarten Gallery, Los Angeles
- Gift of the Iris and B. Gerald Cantor Collection, 1998.363

Figures 350–351

*I*n early March 1900 the German writer Hugo von Hofmannsthal called on Rodin in his Paris studio. Two weeks later he visited the sculptor at Meudon. It was during one of these visits that he noticed a small plaster, *The Hero*, and ordered a bronze version.[1] Another copy in plaster was then being shown as part of Rodin's great solo exhibition.[2] There the work was described as "the vigorous, young hero, leaning against a rock, is trying to hold back a Victory, a small figure of a winged woman, who seems impulsively ready to take flight."[3] According to Rainer Maria Rilke, however, what Rodin saw in this group was "the retreat of inspiration." *The Hero* can, in fact, be classed with a group of works, the best known of which is *The Sculptor and His Muse* (1895), which together constitute a meditation on the theme of inspiration (see for example, A100). This is doubtless why it attracted the attention of Von Hofmannsthal, who referred to *The Hero* as *The Thinker and the Genius*. After 1900 Rodin confirmed this interpretation by baptizing his new, more dramatic version *The Poet and Love*. In this version the impassive head of the young man is replaced by the *Severed Head of Saint John the Baptist* (1887), whose expression can be read as one of either despair or ecstasy. This version was replicated in marble before 1908, the date when it was offered unsuccessfully to the Metropolitan Museum of Art in New York, under the title *Musset and His Muse*.[4]

To make it easier to model, the group had been turned into a high relief by the addition of a background, but this must have constituted a second configuration, the first having been a roundel that Rodin intended using in February 1912 for a monument to the painter Eugène Carrière (1849–1906). The painter's friends had initiated the project the preceding year.[5] Rodin and Carrière had formed a friendship in the 1880s. Each owned several works by the other, and Carrière's portrait of Rodin was used on the poster for Rodin's 1900 exhibition (see A45). The sculptor was, however, definitely leaning toward another composition, a grouping of three figures (the plasters for which are in the Musée Rodin), which was to be accompanied by bust sculpted by Jules Desbois (1912). The monument never went any further, and in the end it was Jean-René Carrière (1888–1982), the painter's son, who completed the monument, which was unveiled in Paris in 1936 (and later destroyed).

Composed of a male nude with left leg raised and a small, winged female torso perched on the bent knee of the protagonist, *The Hero* is a good example of assemblage. The Musée Rodin has several forms of the male nude alone, and some of these already include the plinth on which the winged figure was to rest. The same male nude can be recognized in a group entitled *Two Virtues and a Male Figure Reading a Scroll* (mid-1890s), whose meaning is obscure.[6] There the central figure seems to be trying to decipher the scroll that two flanking versions of *Day* (cat. no. 35) hold out to him. The small female torso, reduced to its simplest expression, without head, arms, or wings, and standing on a sphere, can also be identified in the holdings of the Musée Rodin.

ANTOINETTE LE NORMAND-ROMAIN

NOTES

LITERATURE: Tancock 1976, 300–306, 338–40; de Caso and Sanders 1977, 243–47; Elsen 1981, 115–16; Renner 1990

1. The bronze remained in Von Hofmannsthal's collection until 1920, when economic circumstances forced him to sell it. As a parting gesture, he commissioned a watercolor by Wilhelm Müller-Hofmann (Nationalgalerie, Berlin), on which he indicated that he had acquired the plaster in 1900 from Rodin and that it was broken in 1905 while being moved by the founder. Thanks to Rainer Maria Rilke and Jacob Burckhardt, the bronze found a buyer in Werner Reinhart, a member of the celebrated Winterthur family of collectors, who paid the rather high price of 7,000 Swiss francs and kept it until his death in 1951. It was acquired by the Nationalgalerie, Berlin, in 1961. For the history of this bronze, see Renner 1990. We know of two other bronzes: a Perzinka casting in the Rodin

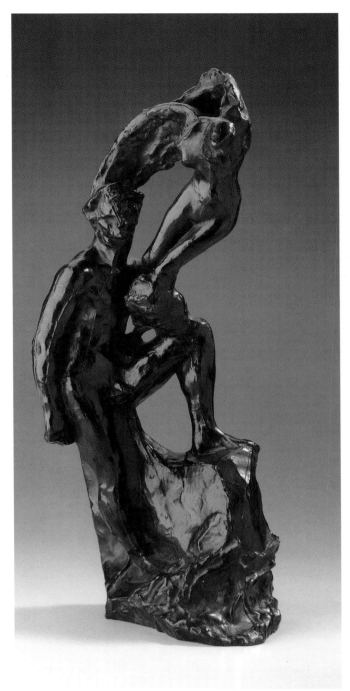

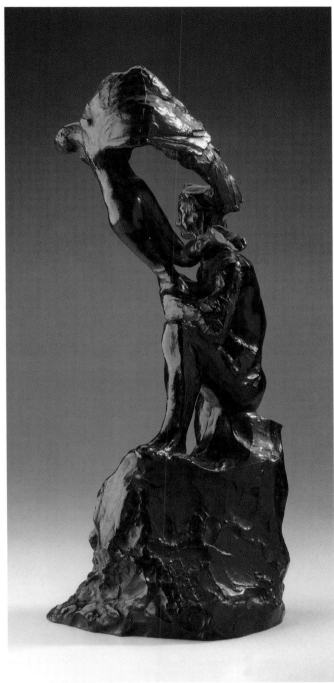

Museum in the Philadelphia Museum of Art and an Alexis Rudier cast (no. 2) at the California Palace of the Legion of Honor, San Francisco.

2. Le Normand-Romain 2001, fig. 108. This plaster was shown the following year at the Secession in Vienna and the Biennale in Venice. Only one plaster, in the collection of the California Palace of the Legion of Honor, San Francisco, is known today (de Caso and Sanders 1977, 242–44, 247 n. 2; it is identified as *Study for a Monument (to Eugène Carrière?)*, based on its association with works that bear an inscription to that artist.

3. Alexandre 1900, cat. no. 105.

4. See Vincent 1981, 28 and fig. 34. The marble was auctioned by Druot-Montaigne in Paris (18 November 1988). Some sketches and casts of the marble are kept in the Musée Rodin, Meudon.

5. Two plasters are in the Musée Rodin, Meudon, each bearing the inscription "Carrière" on the base.

6. Plasters of this group are in the collections of the Musée Rodin, Paris, and Rodin Museum, Philadelphia Museum of Art.

116

Bust of Eugène Guillaume
(Buste de Eugène Guillaume), 1903

- Bronze, Georges Rudier Foundry, cast 1972, 6/12
- 14 x 12¼ x 10 in. (35.6 x 31.1 x 25.4 cm)
- Signed on left shoulder: A. Rodin
- Inscribed on right side of figure's back, lower edge: Georges Rudier/Fondeur.Paris.; on left side of figure's back, lower edge: © by Musée Rodin 1972; interior cachet: A. Rodin
- Provenance: Musée Rodin, Paris
- Gift of the Iris and B. Gerald Cantor Foundation, 1974.73

Figure 352

That Rodin should have agreed to the request by Eugène Guillaume (1822–1905) to portray him in 1903 briefly made these two men the odd couple of the Paris art world.[1] Guillaume represented institutions, teaching, and a style of art opposed by Rodin all his life. In a devastating obituary the critic Louis Vauxcelles, famous for his naming of the Fauves at this time, summarized the academician's career. He pointed out that a num-

ber of persons who cared for arts and letters asked themselves whether Guillaume was a painter, architect, printmaker, or sculptor. Trained at the École des beaux-arts and a Prix de Rome winner, he later became a member of the Académie des beaux-arts and the Académie Française. He was director of the École des beaux-arts and headed its school in Rome for many years. "In reality he was a maker of statues and one of the most mediocre of the [neoclassical] school. . . . He accumulated a number of state commissions that he carried out with the reg-

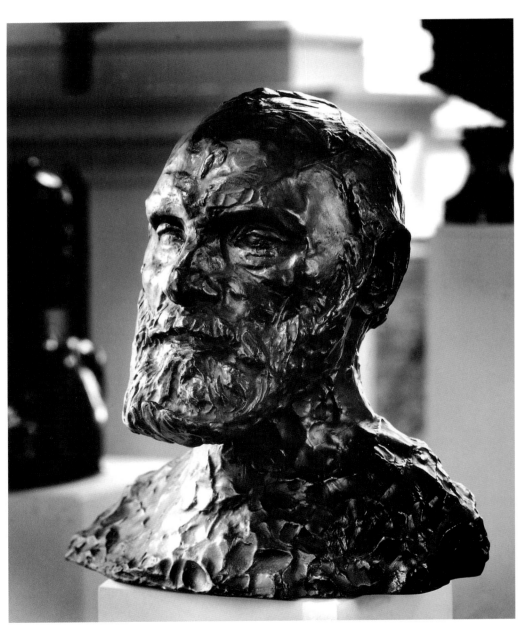

Fig. 352. *Bust of Eugène Guillaume* (cat. no. 116).

ularity of an irreproachable industrialist. . . . Eugène Guillaume was all his long life hostile, without acrimony . . . to artistic independence and to creative originality."[2]

The circumstances of its making and the portrait itself reveal something of Rodin's nature: he maintained respectful and even cordial relations with some of the most powerful artists who opposed him. Guillaume had chaired the jury that accused Rodin of life-casting *The Age of Bronze* (cat. nos. 1–3). Rodin remembered, "At first, this sculptor was far from having friendly feelings toward me. One day, finding my *Mask of the Man with the Broken Nose* at the house of one of my friends, he insisted that it should be thrown away on the rubbish heap, no less! And the entire time he presided over the destinies of the École des beaux-arts, then over the Académie de France in Rome, I can assure you our relationship did not improve. In fact, I had no worse enemy! Then time passed; and if one gets older, there are at least some consolations! For me one was to see this same Guillaume greet me one day and even visit me in Paris and at Meudon. By that time I had become a great artist for him."[3]

According to an unnamed reporter, Guillaume occupied a studio next to Rodin's in the Dépôt des marbres, and "each time that he returned from the Villa Medicis, M. Guillaume would enter into the studio of Rodin, pleased to chat with him and to not withhold his admiration. A veritable friendship was born between these two so contrary artists, and during his last stay in Paris, Guillaume asked Rodin if he would consent to make his portrait."[4]

When exhibited at the Paris Salon of 1905, the portrait was a great success, with more than one critic pointing out that Guillaume's fame now depended on his having been Rodin's subject. It is a curious portrait for Rodin. Everything in the face comes to life except the eyes. The sculptor made much of the forehead, cheeks, and brow in terms of their being eventful surfaces, but the area in and around the eyes is bland, almost as if the sitter were blind. The whole lacks that distinctive animating fire that Rodin ignited in portraits such as those of Jules Dalou (cat. no. 85) and Pierre Puvis de Chavannes (cat. no. 97). According to Georges Grappe, after Guillaume died, Rodin refused to retouch the portrait.[5] What Rodin may have wanted to rework, if not the eyes, was the bust portion, which was left in a very sketchy state with none of the care for costume the artist showed with the bust of Puvis.

NOTES

LITERATURE: Grappe 1944, 112; Jianou and Goldscheider 1969, 109; Tancock 1976, 532–34

1. Grappe (1944, 112) and Tancock (1976, 532) dated this work to 1903. This portrait, like that of Falguière, was very frequently shown—22 times, according to Beausire 1988, 368. It was exhibited in 1904 in plaster in Düsseldorf and Dresden and then in bronze in Weimar and Leipzig and in bronze in 1905 at the Paris salon (Beausire 1988, 253, 255, 257, 259, 267).
2. "Eugène Guillaume," *Gil Blas*, March 1905.
3. As told to Coquiot (1917, 112) and cited in Tancock (1976, 532).
4. "Choses d'art," *Gil Blas*, 6 April 1905.
5. Grappe 1944, 112.

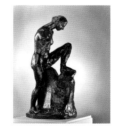

117

Study for "The Muse" for "Monument to Whistler" (*La muse pour le monument de Whistler, étude pour la muse nue, bras coupés*), *1905–06*

- Title variations: *Muse, Victory Climbing the Mount of Fame*
- Bronze, Georges Rudier Foundry, cast 1962, 1/8
- 24¾ x 13 x 13½ in. (65.5 x 33 x 34 cm)
- Signed on pillar, below left foot: A. Rodin
- Inscribed on base, left side: Georges Rudier/Fondeur Paris; below signature: No. 1; on front of base: © by Musée Rodin 1962; interior cachet: A. Rodin
- Provenance: Sotheby's, London, 3–4 July 1973, lot 61
- Gift of the Iris and B. Gerald Cantor Foundation, 1974.52

Figure 353

*I*t was two years after James Abbott McNeill Whistler's death in 1903 that Rodin, who had succeeded to the presidency of the International Society of Sculptors, Painters, and Gravers, agreed to create a monument to his friend and predecessor in that post for no fee, just expenses.[1] It was proposed to Rodin by the committee

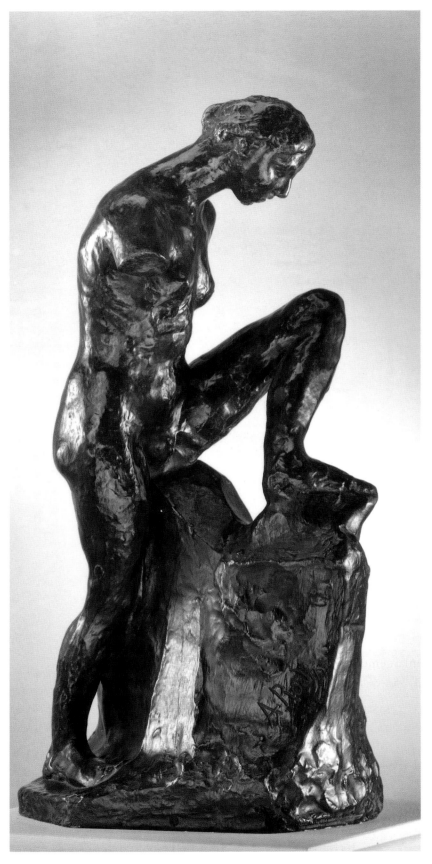

that the subject be a "Winged Victory symbolizing Whistler's triumph—the triumph of Art over the Enemies." According to Whistler's biographer, Joseph Pennell, Rodin consented, "for it gave him a splendid opportunity & besides, as he said, he had never made a portrait of Whistler & would not think of faking one."[2] The monument was to be placed in a garden on the Chelsea Embankment near Whistler's home in London, and a copy was to be placed in front of the artist's birthplace in Lowell, Massachusetts. Of the site, Rodin expressed the wish that it have as much sun and open space as possible.[3]

Since the time of this ill-fated project the sculptures and drawings associated with it have become famous largely because of the woman who posed for them. The model for the head and body of the muse was the young English painter Gwen Mary John, sister of the painter Augustus John, and today considered one of her country's finest artists. She came to study and work with Rodin in 1904 and became his mistress.[4]

During the next few years, Rodin made a few drawings and some small models, wherein the figure of a woman was transformed from a Victory to a muse. Joy Newton and Margaret MacDonald published what was probably the first modeled sketch, which shows an armless woman standing with her upper body and head inclined as if pondering a still-absent object.[5] As Rosalyn Frankel Jamison found, Rodin may have acquired the idea of having a muse pose with one foot elevated on a rock from the carved figure of Melpomene on the Louvre's *Muse Sarcophagus*. He could have naturalized and renovated the meaning of this source in pencil sketches of a naked Gwen John, shown as if drawing and using her raised right knee as a support (fig. 354).[6]

Despite its possible ancestry in an ancient Roman sarcophagus relief, Rodin's muse in the Stanford cast is presented in what at the time must have been a startlingly unconventional if not awkward pose. It was a posture, however, that from Rodin's perspective allowed him a new way of showing the self-balancing possibilities of the body and its structure, and he used a comparable pose for the male figure in *The Hero* (cat. no. 115). In his drawings Robin had allowed his models to find new movements for his art on their own. By posing John with her left leg raised and bent, he eliminated the more natural drawing stance for the young, right-handed artist.

The self-balancing aspect of the pose is best seen from the back. There is not a single vertical line, and the

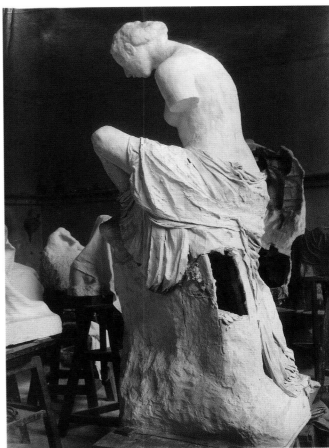

woman's head is not plumb or located over the supporting foot. Her huge right foot is solidly planted, but the rest of the supporting leg is tilted to the right, as if she might topple in that direction. Counterbalance comes from her upraised left thigh, which extends outward, and from the twist of her back and shoulders as she looks downward toward her left knee. The rock is not passive and appears fused to her left buttock and foot, which is pivoted outward like that of a trained dancer. One has the impression that figure and base were modeled at the same time and that Rodin wanted the support to interact with the figure from all prospects. The high rock, whose top is indented to complement the shape of the raised leg, brings her left knee level with her breast and precludes any sense of a figure climbing.[7] Rodin did several studies of John's head, and its origin separate from the modeling of the body may explain the thick, cylindrical neck to which it is attached and for which Rodin would be criticized. As he wanted the final sculpture sited so that it could be seen from a distance, the neck, like the large feet, may have also been functionally proportioned to avoid seeming too meager. These would be the types of intentional exaggerations, as he explained with regard to the massively modeled neck of his Balzac, in which the modern sculptor should engage.

The muse's inconstant surface is rich in sculptural decisions about adding and subtracting found in Rodin's late works: faceting in the legs, which accentuates their upward movement; untempered slabs and patches on the left buttock and top of the spine made presumably to fill out the form seen in its profiles; the marks of damp cloths on the upraised left thigh; the scars of casting seams across the shoulders; rough nuancing throughout. Although not absolutely identical in every detail, in the enlargement Henri Lebossé kept this generally rough sculptural skin (fig. 355).

Presumably from the model represented in the Stanford cast, Lebossé enlarged the muse to be taller than John's height. In the 1908 Salon, Rodin exhibited his nude, armless figure, listed in the catalogue as *The Muse: Climbing the Mountain of Fame*. Along with some praise there was a devastating review by André Beaunier in the *Gazette des beaux-arts*: "Imagine a woman, a sort of woman, standing, the left leg raised, resting on some rock; and this woman looks at her left foot; she would look at it, at least, if she had eyes. Why she shows interest in this infe-

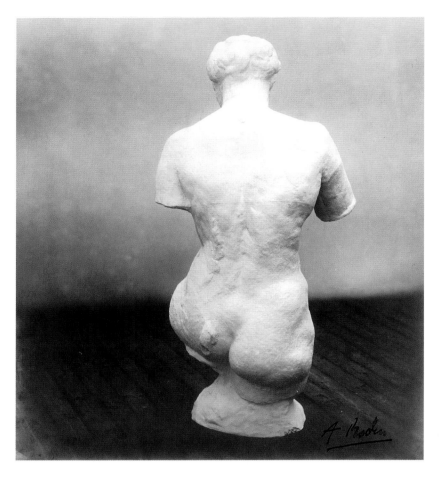

rior member one doesn't know; but she has a kind of varicose vein on the calf of her leg. . . . The right leg would serve for that of a gendarme by Armand Silvestre. The neck is an absurd cylinder. The head is that of a brute and one would call it sculpted in an enormous Indian chestnut. In the back there is some pretty modeling. Rodin never ends by completing an ensemble. It is not completely his fault if, each year, he only exhibits fragments."[8]

What drew the most approval, even from Beaunier, was the muse's back. Its beauty was compared with that of ancient sculptures. Louis Vauxcelles thought the back "sublime and Rembrandtesque," which would have pleased Rodin.[9] Rodin, in fact, had a partial figure of *The Muse* photographed directly from the back, indicating his own fascination with its beauty (fig. 356). Whether nude or draped, The Muse would not be again exhibited in Rodin's lifetime.

From the Musée Rodin archives, it seems that Lebossé completed one of the arms for *The Muse* in 1909, after having enlarged the legs, torso, and head.[10] At some point, after the 1908 Paris exhibition of the naked *Muse* or possibly earlier, Rodin added drapery by literally dipping a linen sheet in plaster and arranging it carefully around the lower portion of the woman's body and over

her elevated thigh. Granted that John's proportions are more meager, her stance less graceful, and that she was not beautiful by Greek standards (being without arms and partially draped), still, Rodin's modern *Muse* resembles nothing so much as the *Venus de Milo.* Rodin had been studying this sculpture since his school days, and though terribly poor, in his early twenties he owned a plaster cast of it from the Louvre, according to Bartlett.[11] Certainly, a Greek fragmented figure was very much on his mind as he modeled and draped his own armless *Muse.* What better evidence of this than Rodin's reflection, recorded in his essay published in 1910, "À la Vénus de Milo."[12] It is reasonable to suppose that in his *Muse* Rodin was showing his ancestry in Greek art, the supposition being that the ancient marble had been his muse, and simultaneously identifying himself as a modern artist, working not from an ideal but rather from an actual woman of his time in his own style. It may well have been that his *Muse for "Monument to Whistler"* inspired his essay.

Rodin had the draped, armless figure photographed and a print sent to the understandably impatient Whistler committee. A flood in 1910 damaged the lower portion of the big plaster, and he indicated to his clients that he was obliged to redo the drapery. In reply to a reporter's question of when he thought he would be finished with the work, Rodin stated, "It is impossible for me to fix a time for the completion of a work of art. I am unfortunately a slow worker, being one of those artists in whose minds the conception of work slowly takes shape & slowly comes to maturity. I lay my work aside while it is yet unfinished, & for months I may appear to abandon it. Every now & then, however, I return to it & correct or add a detail here & there. I have not really abandoned it, you see, only I am hard to satisfy."[13]

Rodin's self-imposed demands for originality in monuments and the fact that he had a high threshold of satisfaction, combined with the crushing claims on his time from all sources and his advancing age, contributed to the project's incompleteness. Unlike certain others of his aborted projects, such as the second *Monument to Victor Hugo*, the failure to finish the Whistler commission was entirely Rodin's fault. This author's view is that, inspired by the fragmented *Venus de Milo*, the armless, draped figure was as far as Rodin wanted to take his own work. As he visualized or tried the addition of arms and a medallion, these supplements were seen by him as sculpturally extraneous, diminishing the overall form. For him it was com-

plete, but he knew it would not satisfy his commission-ers.[14] Newton and MacDonald recount the shameful, unsuccessful effort after Rodin's death by the unscrupu-lous Léonce Bénédite to sell the committee on his bogus assemblage of missing parts added to the figure.[15]

NOTES

LITERATURE: Jianou and Goldscheider 1969, 109; Tancock 1976, 42, 81, 421; Canetti, Laurent, and Lesberg 1977, 200; Newton and MacDonald 1978; Elsen 1981, 117–19; Lampert 1986, 132–35, 223; Grunfeld 1987, 477–80, 591; Butler 1993, 394–96; Le Normand-Romain 1995b, 45–73, 88–89

1. For a thorough history of the project, see Newton and MacDonald 1978. See also Le Normand-Romain 1995b.
2. Joseph Pennell, *The Whistler Journal* (Philadelphia: Lippin-cott, 1921), 316, 307, quoted in Newton and MacDonald 1978, 222.
3. Newton and MacDonald 1978, 222.
4. On their relationship see Grunfeld 1987, 478–85, and Butler 1993, 394–95, 449–51. Her erotic letters to the artist in the Musée Rodin are signed "Mary John."
5. Described and reproduced in Newton and MacDonald 1978, 222–23.
6. Jamison in Elsen 1981, 118–19; see also Le Normand-Romain 1995b, 48 and cat. no. 4 and Judrin 1984–92,

vol. 4, cat. no. 4786.
7. There is a cutout section between the woman's pubic area and the crease of her left thigh, which, along with the rough modeling on the outside of her left hip, suggests that Rodin had perhaps raised the thigh after the figure was first set up.
8. André Beaunier, in *Gazette des beaux-arts* 39 (January-June 1908), quoted in Newton and Macdonald 1978, 224.
9. Louis Vauxcelles, in *Gil Blas*, 14 April 1908, quoted in Beausire 1988, 298.
10. Elsen 1981, 259; Newton and MacDonald 1978, 225.
11. Bartlett in Elsen 1965a, 26.
12. Published in *L'art et les artistes* (March 1910): 243–55, and translated by Dorothy Dudley as *Venus: To the Venus of Melos* (New York: B. W. Huebsch, 1912).
13. Interview with Rodin in *Morning Post*, 15 February 1910, quoted in Newton and MacDonald 1978, 226.
14. Catherine Lampert offered a plausible explanation: "It was as if this solitary female figure of a person who meant a great deal to him had become another of his companion sculptures. . . . Preserving her as a unique muse. . . . The concept of sculpture which is lived with, because it is vital, incomplete and reaches out to the viewer's way of position-ing and moving his own body . . . had become implanted in Rodin's mind. *The Monument to Whistler* is not unresolved so much as intentionally left expectant" (1986, 135).
15. Reproduced and discussed in Newton and MacDonald 1978, 226, 231.

118

Head of Gustave Geffroy
(Tête de Gustave Geffroy), 1905

- Bronze, Georges Rudier Foundry, cast 1955, 3/12
- 12½ x 7⅛ x 9⅛ in. (31.8 x 18.1 x 23.2 cm)
- Signed on neck, left side: A. Rodin
- Inscribed on back of neck: Georges Rudier/Fondeur Paris; inside back plate: © by Musée Rodin 1955; interior cachet: A. Rodin
- Provenance: Musée Rodin, Paris; Sotheby Parke Bernet, New York, 18 May 1972, lot 75
- Gift of the Iris and B. Gerald Cantor Foundation, 1974.72

Figure 357

During Rodin's lifetime the French critic who wrote the most positive and penetrating articles on his work

was Gustave Geffroy (1855–1926).[1] The two met in 1884, a year after the appearance of Geffroy's first article on the sculptor. As was his custom, the sculptor showed his appreciation by giving the writer a sculpture; he sub-sequently modeled this portrait out of friendship. A man of letters as well as a critic, Geffroy wrote the essay on Rodin for the 1889 Monet-Rodin exhibition in Paris, which did much to establish the sculptor's reputation in France.[2] As JoAnne Culler Paradise pointed out, because of his insight as well as sympathetic understanding of how the artist worked, many of Geffroy's observations and ideas were adopted by others who wrote on Rodin.

What Geffroy had to say about Rodin's portrait of Jules Dalou (cat. no. 85) is applicable to his own: "The details are more than indicated; each feature of the face is marked with an incisive precision; and yet an astounding unity of expression appears in the face. Each line, each hollow, each relief concurs to express the character of the man; the artist saw all the peculiarities of the physiognomy of his model, but he also saw the life that animated it."[3]

Knowing of his sitter's sympathy for his sculpture, Rodin may have felt freer to take certain liberties with

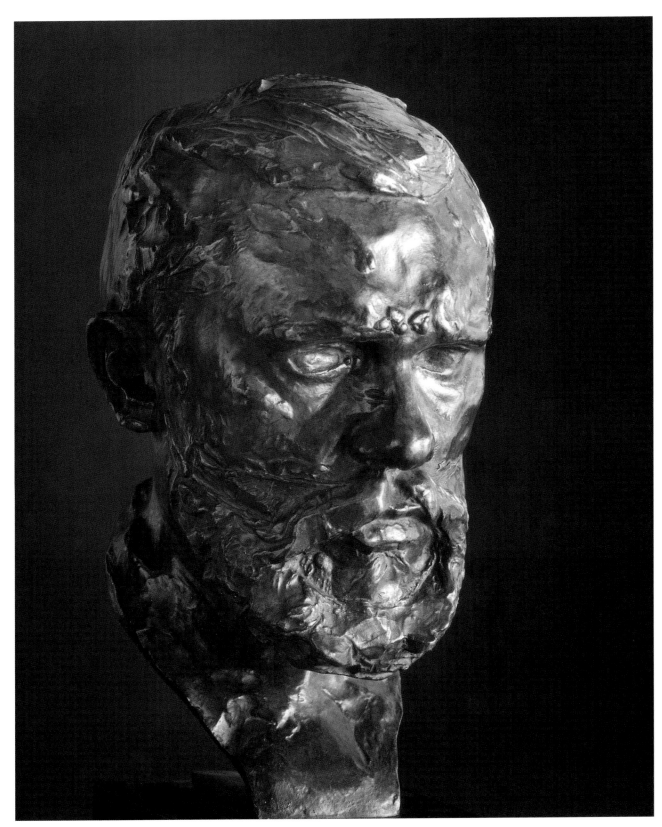

Fig. 357. *Head of Gustave Geffroy* (cat. no. 118).

description, as when he left raw strips and patches to continue the line of the beard toward the ear in the man's right profile or the way he left exposed the buildup of the left cheekbone. Created late in Rodin's career, the portrait does surprise in that the eyes do not compel attention as much as other areas of the face, particularly the forehead and beard. Rodin boldly flattened the front of the mustache and pinched the bottom of the beard to turn it up. Radiating outward along the lower cheeks and just above the mustache are big, horizontal cuts that give direction and fullness to the cheeks. In all, it is an exemplary demonstration of how to turn facial hair to sculptural advantage. As always, Rodin found new ways to pronounce the eyes. Here he accentuated the relief of the lower lids and did not introduce holes or deep depressions into the eyeballs. The tapered bust for-

mat accentuates the man's handsome visage and the cubic form of the head as a whole.[4]

NOTES

LITERATURE: Grappe 1944, 116–17; Jianou and Goldscheider 1969, 110; Judrin 1976, 73; Elsen 1981, 260–61; Hare 1984, 471–78

1. For an excellent essay on the relationship of these two men, see JoAnne Culler Paradise in Elsen 1981, 261–69.
2. Paradise noted Geffroy's accomplishments as a novelist, biographer, political essayist, and literary critic, in addition to his work as a commentator on art (ibid., 267 n. 1).
3. Quoted ibid., 265–66.
4. See Beausire 1988, 401. Regarding its exhibition history, Beausire recorded that Rodin exhibited the Geffroy portrait eleven times between 1905 and 1913.

119

Bust of Anna de Noailles
(*Buste d'Anna de Noailles*), 1906

- Title variations: *Archaic Minerva, Madame X, Unknown Countess*
- Bronze, Georges Rudier Foundry, cast 1972, 2/12
- 13¾ x 15¾ x 13¾ in. (34.9 x 40 x 34.9 cm)
- Signed on left shoulder: A. Rodin
- Inscribed on back, lower right: Georges Rudier/Fondeur Paris; © by musée Rodin 1972; interior cachet: A. Rodin
- Provenance: Musée Rodin, Paris
- Gift of the Iris and B. Gerald Cantor Foundation, 1974.71

Figure 358

Countess Anna de Noailles (1876–1933) was a poet. Well known and admired in literary circles, she was considered one of the remarkable people of her time. She was a woman of renowned conversational brilliance with a mind once described as being like an Istanbul bazaar.[1] She began sending Rodin her poems in 1901, and a friendship developed. The sculptor was undoubtedly taken by her beauty and in 1905, at his invitation through a mutual friend, she began sittings for her por-

trait. Because of many interruptions these lasted into 1908.[2] In return for his offer, the artist received the compliment of having done her "this supreme honor of a face that now will never perish."[3]

The countess described her modeling sessions as being like posing for a filmmaker. According to her, Rodin did not like a stationary subject but preferred natural movement.[4] The results of Rodin's portrait did not please her. Perhaps because she was mindful of her Greek descent, she objected to the fact that her nose was not straight. Rodin, also aware of her lineage, proposed titling the work *Minerva*, but she objected that this would not fool the public. In 1909, believing her portrait was only a sketch, she asked Rodin not to sell it to a museum without its being modified so that she would not be recognized.[5] This discord between artist and subject even made the news.[6] Nevertheless, Rodin had the portrait carved in stone and named *Minerva*. Although left unfinished because of the debate over the nose, it was acquired by the Metropolitan Museum of Art, where it is called *Madame X*.[7]

At this time in his career Rodin was doing many portraits of well-known and important women, a continuation of what might be termed his society series. That of Anna de Noailles is distinguished by the sculptor's fidelity to her cool elegance and not for any sculptural innovation or interpretive audacity in presenting her character or creativity.[8] Rodin's compulsion against symmetry, however, makes a study of the eyes rewarding. They are not equally open, and the irises are slightly flat-

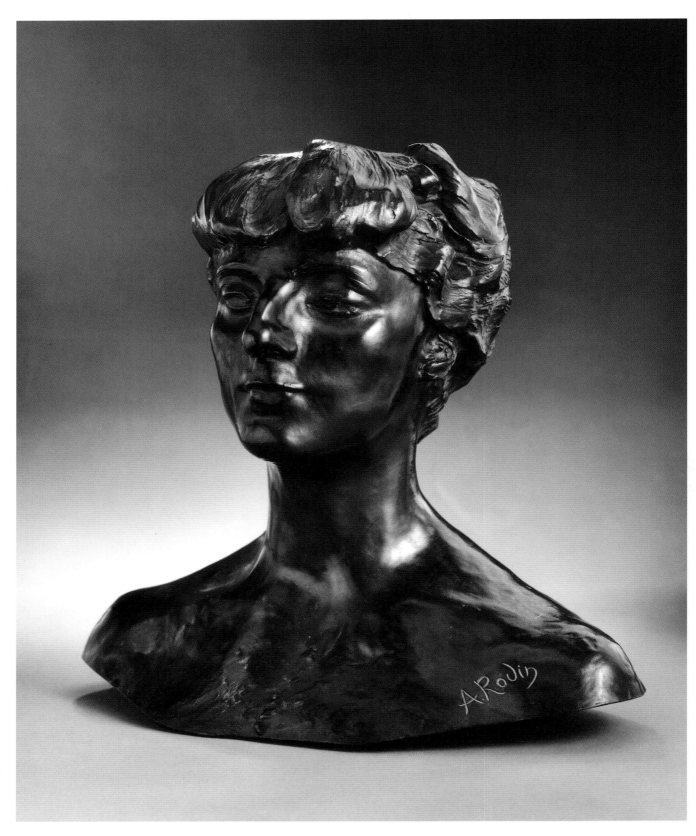

Fig. 358. *Bust of Anna de Noailles* (cat. no. 119).

tened while aimed in different directions. Rather than a cosmetic blemish, this lack of synchrony adds to the naturalness and individuality of the face and somewhat deepens the expression. The countess had this to say about the expression Rodin saw in her: "What he loves in me is the expression of contemplative sensuality. . . . He tires me out with his way of looking at me, of imagining me naked; I'm worn out by the need to fight for my dignity against his hunter's gaze."[9]

NOTES

LITERATURE: Grappe 1944, 120–21; Judrin 1976, 118; Vincent 1981, 17; Hare 1984, 487–98; Grunfeld 1987, 475–77

1. For more on this woman and her experience sitting for Rodin, see Hare 1984, 487–92.
2. Rodin's offer also stipulated that she would have to pay 2,500 francs for a bronze cast (ibid., 488).
3. Judrin 1976, 118.
4. Ibid. For the countess's unflattering account of the modeling sessions, see Grunfeld 1987, 475–76.
5. Judrin 1976, 118.
6. Hare 1984, 490.
7. Vincent 1981, 17.
8. There are plaster studies in the Musée Rodin reserve; see Hare 1984, 498.
9. Grunfeld 1987, 476.

120

Head of Hanako, Type A
(Hanako, tête, étude type A), c. 1907–08

- Bronze, Alexis Rudier Foundry
- 10 x 5 x 5x in. (25.4 x 12.7 x 14 cm)
- Signed on neck, left side: A. Rodin
- Inscribed on back of neck: Alexis Rudier/Fondeur Paris; interior cachet: A. Rodin
- Given in memory of Alice F. Schott, 1972.178

Figure 359

121

Mask of Hanako, Type D
(Hanako, masque, étude type D), c. 1907–08

- Bronze, E. Godard Foundry, cast 1979, 7/12
- 7⅞ x 7 x 6 in. (20 x 17.8 x 15.2 cm)
- Signed on neck, right side: A. Rodin
- Inscribed on back, right side: E. Godard/Fondr; on back, left side: © Musée Rodin 1979
- Provenance: Musée Rodin, Paris

Gift of the Iris and B. Gerald Cantor Collection, 1998.354
Figure 360

122

Large Head of Hanako, Type F
(Hanako, grande tête, étude type F), c. 1908–09

- Bronze, Georges Rudier Foundry, cast 1964, 7/12
- 12 x 8 x 6 in. (30.5 x 20.3 x 15.2 cm)
- Signed on neck, left side: A. Rodin
- Inscribed on back of neck: Georges Rudier/Fondeur.Paris.; below signature: No. 7; on edge, lower left: © by Musée Rodin 1964
- Provenance: Musée Rodin, Paris
- Gift of the Iris and B. Gerald Cantor Foundation, 1974.70

Figures 361

*I*n 1906, while in Marseilles to study the royal Cambodian dancers, Rodin met the 37-year-old Japanese dancer and actress Ohta Hisa (1868–1945; fig. 362). She belonged then to a troupe directed by Loïe Fuller, who gave her the name Hanako ("little flower"). Born in Nagoya and trained as a geisha, Hanako came to Europe in 1901, where she made her reputation. Rodin appreciated her astounding coordination, her ability to hold a difficult pose or facial expression, and her joints, which were as thick as her limbs. Starting in February 1907, she posed for several drawings and figure studies.[1] Fifty-three heads plus several drawings of Hanako are in the Musée Rodin. Judith Cladel, who observed some portrait sessions, wrote in her 1917 book on Rodin:

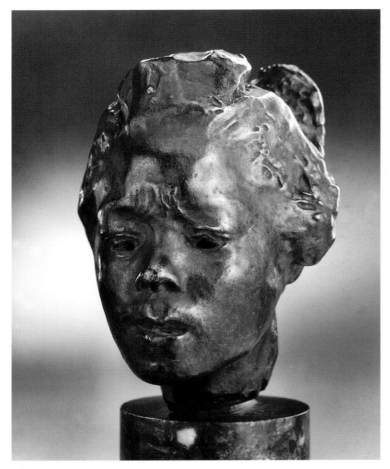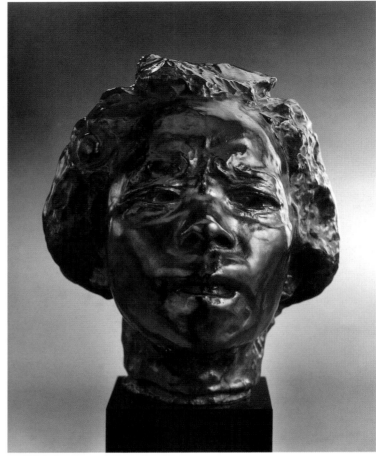

Left: Fig. 359.
*Head of
Hanako*, Type A
(cat. no. 120).

Right: Fig. 360.
*Mask of
Hanako*, Type D
(cat. no. 121).

I watched Rodin model the head of Hanako. . . . He rapidly modeled the whole in the rough, as he does all his busts. His keen eye and experienced thumb enable him to establish the exact dimensions at the first sitting. Then the work of detailed modeling begins. The sculptor is not satisfied to mold the mass in its apparent outlines only. With absolute accuracy he slices off some clay, cuts off the head of the bust and lays it upside down on a cushion. He then makes his model lie on the couch. Bent like a vivisector over his subject, he studies the structure of the skull seen from above, the jaws viewed from below, and the lines that join the head to the throat, and the nape of the neck to the spine. Then he chisels the features with the point of a pen-knife, bringing out the recesses of the eyelids, the nostrils, the curves of the mouth. Yet for forty years Rodin was accused of not knowing how to "finish"!

With great joy he said one day, "I have achieved a thing today which I have not previously attained so perfectly—the commissure.[2]

Cladel then explained why there are so many versions of Hanako's head (as well as for Georges Clemenceau's [cat. no. 145]): "In making a bust Rodin takes numerous clay impressions, according to the rate of progress. In this way he can revert to the impression of the previous day, if the last pose was not good, or if, in the language of the trade, 'he has overworked his material.' Thus one day may see five, six, or even eight similar heads in his studio, each with a different expression."[3] Cladel also described what could have been the making of the *Mask of Hanako, Type D*: "Hanako did not pose like other people. Her features were contracted in an expression of cold, terrible rage. She had the look of a tiger, an expression thoroughly foreign to our occidental countenances. With the force of will the Japanese display in the face of death, Hanako was enabled to hold this look for hours."[4]

As much as they are portraits, the series Rodin pro-

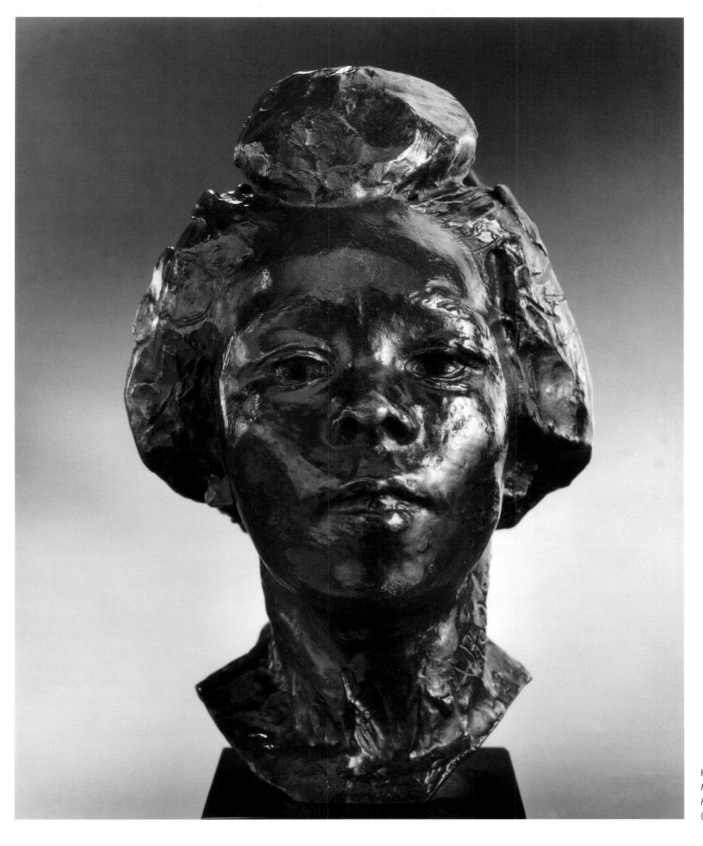

Fig. 361. *Large Head of Hanako, Type F* (cat. no. 122).

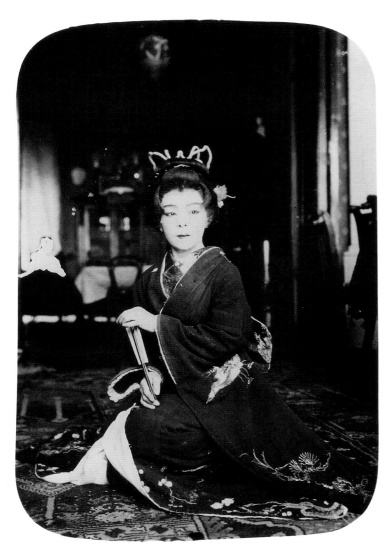

Fig. 362.
Unknown
photographer,
*Ohta Hisa,
Known as
Hanako*, n.d.
Musée Rodin,
Paris.

Hanako series alone shows Rodin encouraging a woman to express a range of feelings that include anger as well as serenity.

These three heads are impressive not simply for what is conveyed by the eyes or mouth but how the face as a whole mirrors the expression. Rodin explained how this unity was achieved: "To make a bust does not consist in executing the different surfaces and their details one after another, successively making the forehead, the cheeks, the chin, and then the eyes, nose, and mouth. On the contrary, from the first sitting the whole mass must be conceived and constructed in its varying circumferences; that is to say, in each of its profiles. . . . If one is faithful to the accuracy of these profiles, the reality of the model, instead of being a superficial reproduction, seems to emanate from within."[6]

Following Rodin's own advice, one should consider how he made the hair integral to the facial expression rather than as something neutral. In the smallest, *Head, Type A*, the hair is swept back, a continuation of the big planes on the sides of the face and seen against the forward thrust of the jaw. In the mask of death, *Head, Type D*, the hair continues the turbulence of the facial expression. In the third, *Head, Type F*, Hanako's stylized coiffure becomes a fulsome, quiescent frame for the serenity of her visage. Rodin also captured the slight squint in Hanako's eyes, what seems to have been an asymmetry to her mouth, and the unequal way the muscles bunch above the nose, all of which distinguish his portraits from actual Japanese masks. In all three portraits Rodin showed the lips parted and teeth partially exposed, a speaking likeness, if you will, which reminds us that Hanako did not speak French, but Rodin found her facial eloquence sufficient and inspiring.

Rarely in the series did Rodin use the traditional bust format, preferring instead to show just the head or neck and head. One gains the impression that these studies of someone who became a treasured friend to him and Rose Beuret were made for himself, intended literally for intimate viewing, the way Steichen may have photographed the studies close up while still in the wet clay (see figs. 589–590).[7]

NOTES

LITERATURE: Cladel 1917, 161–62; Grappe 1944, 123–24; Spear 1967, 32, 94; Jianou and Goldscheider 1969, 111; Spear 1974, 126S; Tancock 1976, 546–48, 550; de Caso and Sanders

duced over a four-year period is also a record of dramatic facial performances by a gifted actress. Rodin had seen Hanako perform a death scene in 1906, and the *Mask of Hanako, Type D*, which he called *Mask of the Anguish of Death*, was a reprise or command performance. Paradoxically, the largest of the Stanford portraits and most tranquil may come closest to capturing Hanako's generally cheerful disposition. Unlike the sequence of Clemenceau portraits, one does not have the sense that Rodin was striving for the essential Hanako or "reassembling in a single expression the successive expressions given by the same model."[5] Other than the faces of the anonymous models who inspired the anguished expressions in *The Gates of Hell*, the

1977, 305–8; Judrin and Laurent 1979, 27, 33, 38; Hare 1984, 538–43; Lampert 1986, 233; Grunfeld 1987, 520–22, 612; Levkoff 1994, 144

1. De Caso and Sanders 1977, 307 n. 3. The best and most complete collection with commentary of Rodin's works after Hanako is in Judrin and Laurent 1979, 23–38, where 26 heads and 5 drawings are reproduced. The figure drawings, especially of the naked Hanako, illustrate Rodin's comment to Paul Gsell: "I have made studies of the Japanese actress Hanako. She has absolutely no fat. Her muscles stand out and project like those of the little dogs called fox terriers. Her tendons are so strong that the joints to which they are attached are as big as the limbs themselves. She is so strong that she can stand as long as she likes on one leg while raising the other before her at a right angle. Standing this way, she looks as if she were rooted to the ground like a tree. She has, then, an anatomy that is very different from European women, and yet it is very beautiful too in its unique power" (Gsell [1911] 1984, 51). For more on Hanako, see Suketaro Sawada, *Little Hanako: The Strange Story of Rodin's Only Japanese Model* (Nagoya: Chunichi, 1984).
2. Cladel 1917, 161–62.
3. Ibid.
4. Ibid., 162.
5. Ibid., 218.
6. Ibid., 109.
7. For Steichen's photographs, see figs. 589–90 and also Pinet 1990, 82–85, which includes photographs of Hanako.

Other Portraits and Symbolic Heads

Rodin's first and last sculptures were portraits. As evidence of his passion for them, he made many more portraits of men and women than he was commissioned to do. On occasion he used portraits to advance his status in the art world or to join the history of portraitists of famous men, as when he asked to portray Pope Benedict XV. As a possible subject for sculpture, there was no face, whether that of a pontiff or broken-faced handyman, that did not interest Rodin, indisputably one of the greatest portrait sculptors in history. Women were generally spared the kind of psychological probing he invested in men. For Rodin portraiture demanded the "demon of the best," and he worried about his portrait of Clemenceau almost as much as the *Monument to Honoré de Balzac*, with astonishing results in both cases. Joined with his portraits of artists and writers, the Stanford collection offers an impressive representation in this genre. Also included in this section are Rodin's sculptures of heads that personify abstract and symbolic themes. These heads, too, reflect Rodin's probing of the psychology and emotions of the model to evoke symbolic meaning. Rather than elaborating specific symbolic themes, Rodin aimed for meanings that are evocative and open-ended.

123

Bust of Jean-Baptiste Rodin
(Buste de Jean-Baptiste Rodin), c. 1862–63

- Bronze, E. Godard Foundry, cast 1981, 3/12
- 16 x 11 x 9½ in. (40.6 x 27.9 x 24.1 cm)
- Signed on front of base, at left: A. Rodin
- Inscribed on back of base, lower edge, at right: E. Godard Fondr; on front of base, at left: No 2; on back of base, lower edge, at left: © By Musée Rodin 1981
- Provenance: Musée Rodin, Paris
- Gift of the B. Gerald Cantor Collection, 1992.160

Figure 363

*D*uring his life it seems that Rodin did not exhibit or call attention to this portrait of his father (1803–1883), who spent his vocational life as a minor official in the Paris police department.[1] Rodin's last secretary, Marcelle Tirel, claimed that she and Rodin's son, Auguste, found the plaster portrait while searching through an attic at Meudon. "It was so black with dust and covered with spider webs that only Auguste could recognize it. We carried it to Rodin like a trophy. . . . He examined it for several minutes . . . then he offered it to Rose, saying: 'It is my father.'"[2] After the sculptor's death, a bronze was made from the plaster, which was then shown in the 1918 Paris exhibition celebrating the opening of the Musée Rodin. It may well have been his first sculptural portrait. Identification of his father is confirmed by Rodin's painted portrait showing his father's bearded profile.[3]

Assuring dignity for his subject, Rodin depicted his father in the style of portraits by David d'Angers: head frontal and straight, the neck rising out of a cubic, abstract base, and the equivalent of the tough, naturalistic modeling of ancient Roman portraits.[4] Rodin told Tirel that "Papa was not happy because I refused to make his side-whiskers, which he wore like a magistrate. He did not know how to concede that in treating him in the ancient manner, I had suppressed them."[5] Rodin may have done the painted portrait to reassure his father that he had acquired the necessary skill to be a portrait

painter. It was in these critical years in his young life that Rodin and his father talked about his future as an artist, and Jean-Baptiste was unhappy about the insecurity of this occupation. While disapproving, he made sure that a professional artist validated the talent of his son so that he could apply to the École des beaux-arts.[6]

In observation, certainty of modeling, and quality, this portrait debut by such a young artist is worthy of David d'Angers. Rodin's exceptional and early understanding of anatomy comes through in the strong sense of the shape and volume of the bony cranium capped by the 60–year-old man's taut skin. Following the example of the older portraitist, it was his father's physical individuality, not his personality, that Rodin sought to preserve with unflinching objectivity. As opposed to the continuous curvature of the forehead, Rodin found a big, somewhat flattened plane in the man's right temple. The only textural differences are in the traces of eyebrows and that of the hair in the back of the nearly bald head.[7] Indications of musculature and a vein near the father's left temple also relieve the hard topography. The wide mouth is firmly set beneath a big, straight nose that is slightly off-axis. The eyes are wide open, with no upper lid. Following David d'Angers, the irises are not indicated. This contributes to the sense of a fixity in the visage, such as contemporary academicians like Charles Blanc admired in the faces of ancient statues. Jean-Baptiste is made to seem as if facing eternity, not the beholder. As the light changes and is reflected off the smooth eyeballs, however, the face becomes differently animated.

There is absolutely nothing sentimental about this portrait, nor should it be considered cold-hearted. For expression Rodin was relying on what was called then the *caractère*, the inherent psychological expressiveness of the native shapes of the head's formation seen when the set of the subject's features was habitual.[8] Building on lessons from those who taught him formally and informally, the young artist was scrupulously following nature and seeing his subject not only in depth but in the round.[9] Rodin's use of profile modeling, customarily thought to have begun with his *Mask of the Man with the Broken Nose* (cat. no. 125), is fully in evidence in this first portrait. He was also honoring his father by the association of his portrait with a Second Empire neoclassical format and ancient culture and the self-effacing classicist style he was using. Although he reportedly spoke little of him, Rodin seems to have had a serious regard for his father, who, if

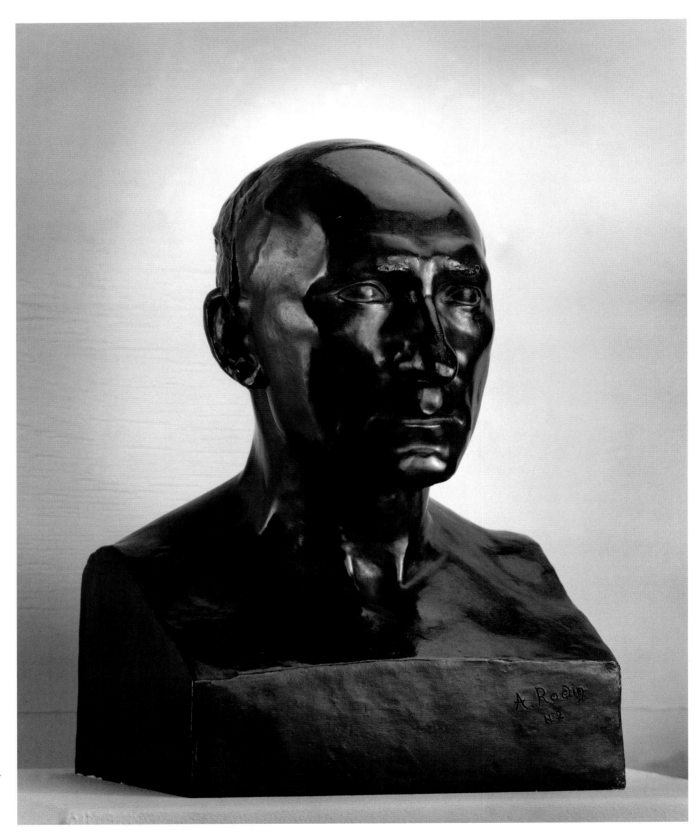

Fig. 363. *Bust of Jean-Baptiste Rodin* (cat. no. 123).

the date of the sculpture is around 1862 or 1863, had retired from his post in the Paris police department in 1861, prior to the sculpture's creation. The portrait shows him probably before his health began to fail and he lost his sight. The firm, even hard quality of his father's face reminds us of a statement the elder Rodin is supposed to have made to his own son: "He who wants to, can arrive at his goal, but he must want it seriously, that is to say [with] a male and not female energy. In your case I believe that you are a soft pear."[10] Was this portrait Rodin's way of showing his father that his son was not a "soft pear" and had the fiber to succeed as an artist? Until his father's death in 1883, Rodin showed concern for and devotion to him. Writing about Rodin, whom she knew in the last years of his life, Tirel commented, "Rodin always expressed himself about his father with respect."[11]

NOTES

LITERATURE: Tirel 1923, 68; Cladel 1936, 83; Grappe 1944, 2; Mirolli (Butler) 1966, 96–99; Tancock 1976, 19, 62, 470, 473; Miller and Marotta 1986, 48; Grunfeld, 1987, 36; Goldscheider 1989, 48; Laurent 1990, 148; Butler 1993, 13–15, 35, 46

1. See Grunfeld 1987, 2–9. We know little about the type of person he was. The best account of Rodin's father is in Butler 1993, including biographical data and a discussion of the relationship the sculptor shared with him.
2. Tirel 1923, 68.
3. Without citing a source, Tirel stated that Rodin was 17 when he modeled the portrait of his father (ibid.). Grappe (1944, 2), followed by Mirolli (Butler 1966, 96), dated the bust to c. 1860, when Rodin was 20; Laurent dated the bust to c. 1864 (1990, 148). The painted portrait was dated 1863 by Grappe (1944, 3). Laurent published a painted portrait she credited as representing Rodin's father in 1860 (1990, 26–27), but it was subsequently identified by Claudie Judrin as a portrait of Rodin by J. P. Laurens (Ruth Butler to Elsen, 7 June 1991). For reasons she does not explain, Goldscheider dated the bust to c. 1865 (1989, 48) but cited a note in the Rodin file of the Frick Art Reference Library indicating that the work was done a little before the portrait of Father Pierre-Julien Eymard, which she and Grappe assigned to 1863. This author is inclined to date the bust to 1862 or 1863 based on its resemblance, in terms of the man's aging and loss of hair, to the one known painted portrait of Rodin's father.

4. Mirolli (Butler) offers an insightful discussion of the stylistic nature of this work (1966, 97–99), but the author cannot join her in the criticisms of the bust, such as the too small proportions of the forehead and insufficiently deep setting of the eyes, which she based on comparison with Rodin's painted profile portrait. Even at this early age, the whole portrait shows that he was extremely observant with regard to anatomy, as was scientifically confirmed to the author in the case of *The Mask of the Man with the Broken Nose* by a forensic medical evaluation.
5. Tirel 1923, 68 (quoted but differently translated in Mirolli [Butler] 1966, 97, and Grunfeld 1987, 36). As if he had not understood what Rodin said about making the beardless portrait in an ancient style or not known the important influence of David d'Angers's portrait style at this time, Grunfeld discoursed on how depriving a man of his beard was to metaphorically "deprive him of his manhood" (1987, 36–37). Without evidence, other than "the oldest fairy tales," Grunfeld went on to try the reader's credulity by saying this "portrait of his father may combine filial duty with an ingenious way of working off his Oedipal resentments by removing the beard of authority (and sexual dominance) from the paternal chin." Cladel, while recognizing Rodin's intention to work in an ancient mode, ascribed the absence of the beard to the fact that being a functionary, Jean-Baptiste was very careful in his grooming (1936, 83.) Rodin's oil portrait of his father showed him with a mustache and beard (Grappe 1944, 3). A photograph of Jean-Baptiste taken in 1855 shows him fully bearded (*Rodin 1860–99*, 61).
6. Cladel 1936, 79; Descharnes and Chabrun 1967, 18.
7. Rodin's painted profile portrait of his father, dated 1863 by Grappe (1944, 3), comes close to matching the relative baldness of the sculpture.
8. This goal is described in Charles Blanc, *Grammaire des arts du dessin* (Paris: H. Laurens, 1880), 372. The first edition was published in 1867 and was the primary text of generations of École des beaux-arts students, incorporating many traditional principles. Although denied entry into the École, Rodin would have been familiar with academic precepts.
9. His formal and informal instructors included Horace Lecoq de Boisbaudran at the Petite école and an artisan named Constant Simon, who introduced the young Rodin to the science of joining planes, *le modelé*, to create a sense of a subject's volume. Rodin's debt to this teacher is reflected in the introduction he provided to the 1913 anthology of Lecoq de Boisbaudran's essays (Lecoq de Boisbaudran 1953, 1).
10. Laurent 1988, 27. No source is given.
11. Tirel 1923, 12.

124

Head of Father Pierre-Julien Eymard (Tête de Père Pierre-Julien Eymard), 1863, reduced before 1901

- Title variations: *The Blessed Father Pierre-Julien Eymard, Head of a Priest*
- Bronze; Susse Foundry, cast 1970, 3/12
- 5¾ x 4¼ x 4¼ in. (14.6 x 10.8 x 10.8 cm)
- Signed on collar, left side: A. Rodin
- Inscribed on back of collar, right: Susse Fondeur.Paris.; on back of collar: © by Musée Rodin 1970
- Provenance: Musée Rodin, Paris
- Gift of the Iris and B. Gerald Cantor Foundation, 1974.81

Figure 364

*A*t the age of 20, Rodin experienced a serious crisis in his life. Following the death of his beloved sister Maria (1837–1862), he chose to enter a religious order recently established to serve the Church and the poor and to combat injustice. It was headed by Pierre-Julien Eymard, who preached to the young men of his order the importance of self-sacrifice.[1] Rodin seems to have spent anywhere from a few months to one year with the order, during which time, presumably recognizing the young man's talent and interests, Father Eymard allowed him to work at sculpture in a garden shed. Although touched by his religious experience, Rodin chose not to become a member of the order.

As it was probably told to him by Rodin, Truman Bartlett described the background to this very early bust, a small version, cropped at the base of the neck and reduced, made after the fuller, life-size treatment of 1863, photographed by Adolph Braun (1811–1877; fig. 365):

Among Rodin's friends was a priest, named Aymar [sic], the founder of a society called The Sainted Sacrament, and who had summed up the experiences of his life and observation in the expression—which he enjoyed repeating—that "life was an organized lie," and he wanted his bust made, in some respects, in accordance with this conclusion.

Rodin gladly consented to make it as he saw his sitter. . . . After the bust was completed and several duplicates made, of reduced size, Aymar took the sudden fancy that the masses of the hair on the sides and top of his bust suggested to him the "horns of the devil," and he would not accept it unless these troublesome reminders were reduced to a more human appearance. This the inflexible young sculptor would not do. The facts of nature had more influence with him than the desire to please the fears of the superstitious priest. Besides, the head had a certain interest to Rodin. Aymar was a born Jesuit, his head and face gave no indication of its owner's age, and it had a character that the sculptor liked to study. . . . Aymar would not take the bust.[2]

In the history of Rodin's portraits, that of Father Eymard (1811–1868) came probably right after that of the sculptor's father (cat. no. 123) and before *Mask of the Man with the Broken Nose* (cat. no. 125). Bartlett's assertion that this was a face whose character Rodin liked to

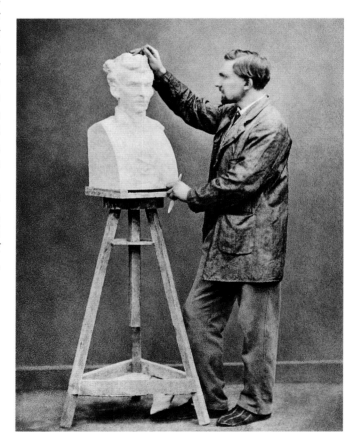

Fig. 365. Adolph Braun, *Rodin with "Head of Father Pierre-Julien Eymard"* in plaster, 1863. Musée Rodin, Paris.

study is seconded by the young artist's precocious powers of observation about the structure of the head and formation of the features. Ruth Mirolli (Butler) called attention to the emphasis Rodin gave to the forehead of his subject: "The emphasis on the forehead through the exaggerated areas over the eyebrows and bulbous frontal bones heighten the image of active concentration. . . . It is not impossible that Rodin had even read David's [David d'Angers's] ideas on phrenology; to look at the forehead of Père Eymard, the theories of David might well be responsible for the kind of emphasis Rodin has given to it."[3]

In keeping with the sculptural model the young artist had chosen to follow, his subject, an ageless Jesuit, and his position as a leader of the order, Rodin made this about the most symmetrical portrait of his career. One could imagine a quadrant placed over the face with which the big horizontal and vertical axes of the features would align. It was truly Rodin making a portrait in the manner of David d'Angers, one that encouraged his working from life but with no burden of interpretation.

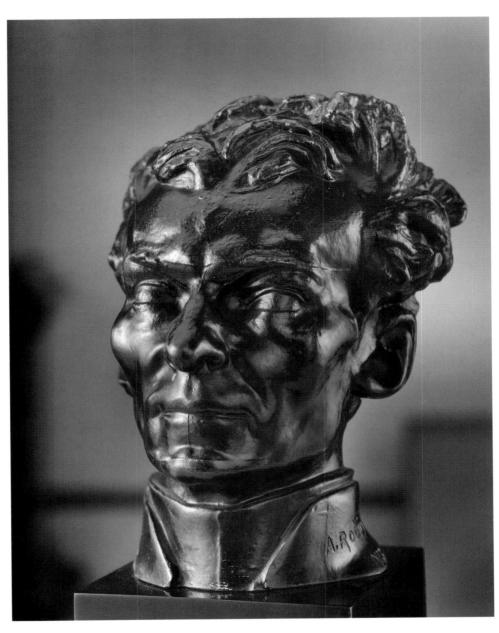

Fig. 364. *Head of Father Pierre-Julien Eymard* (cat. no. 124).

NOTES

LITERATURE: Bartlett 1889 in Elsen 1965a, 21–22; Cladel 1936, 84–85; Grappe 1944, 3; Mirolli (Butler) 1966, 99–100; Spear 1974, 108S, 111S, 135S; Tancock 1976, 468–72; Ambrosini and Facos 1987, 45; Grunfeld 1987, 39–40, 47, 75; Goldscheider 1989, 40–42; Butler 1993, 34–38, 40, 67, 307

1. For more on Father Eymard, see Tancock 1976, cat. no. 78; Cladel 1936, 84–85; Grunfeld 1987, 38–40; Butler 1993, 32–38. On the sitter, see Martin Dempsey, *Champion the Blessed Sacrament: Saint Peter Julian Eymard* (New York: Sentinel Press, 1963).
2. Bartlett in Elsen 1965a, 21–22. In his complete account Bartlett wrote that Rodin expected money for his work and did not receive it. As Tancock pointed out (1976, 470), Rodin, then in Eymard's religious order, would not have been paid, so that the tale is not reliable in this regard. See also Goldscheider (1989, 42), in which the reduction was discussed and dated "before 1901."
3. Mirolli (Butler) 1966, 99–100.

125

Mask of the Man with the Broken Nose
(Le masque de l'homme au nez cassé), 1863–64

- Title variations: *The Broken Nose, Mask of a Man, Mask of Michelangelo, Study of a Head*
- Bronze, posthumous cast
- 11 x 8 x 8½ in. (27.9 x 20.3 x 21.6 cm)
- Signed on back of neck: A. Rodin
- Provenance: Hôtel Drouot, Paris, 24 March 1969, lot 145
- Gift of the Iris and B. Gerald Foundation, 1974.74

Figure 366

*V*ariant accounts describe how this work came about. Frederick Lawton, who recorded conversations with the artist, gave the following version: "One day, a man belonging to the humbler class of society came to the workshop of the master *ornamentiste* to deliver a box. He had seen better days but had sunk to the position he then occupied through misfortune and drink. 'Did you remark what a fine head that fellow had?' exclaimed the employer when the man had gone. Rodin, being busy at his modeling, had not raised his eyes. The question set him thinking. He made inquiries about the owner of the head, whom he ultimately induced to pose. The subject was to his mind. Probably of Italian origin, the man's face resembled types common in ancient Greece and Rome. What the young sculptor sought to do was to reproduce its essential lineaments, without accentuation or deformation, and true to life."[1]

Consider an earlier version given by Rodin, probably in 1887, to Truman Bartlett:

While Rodin occupied, in the Rue de la Reine Blanche, a stable as a studio, he began to make and finished in about eighteen months, a mask which was destined to result in one of the most sculpturesque pieces of modeling of modern times, and which is now known as "The Broken Nose." It was made from a poor old man who picked up a precarious living in the neighborhood by doing odd jobs for anyone who would employ him, and who went

by the name of "Bèbè." [Rodin referred to him as "Bibi"]. . . . As the reader may have the same curiosity that the writer had, and ask why the sculptor should choose such a model, his answer is given in this place: "He had a fine head; belonged to a fine race—in form—no matter if he was brutalized. It was made as a piece of sculpture, solely, and without reference to the character of the model, as such. I called it 'The Broken Nose' because the nose of the model was broken. . . .

"That mask determined all my future work. It is the first good piece of modeling I ever did. From that time I sought to look all around my work, to draw it well in every respect. I have kept that mask before my mind in everything I have done. I tried it on my first figure, 'The Bacchante,' but did not succeed. I again tried it on 'The Age of Brass,' also without success, though it is a good figure. In fact, I have never succeeded in making a figure as good as 'The Broken Nose.'"[2]

Some 20 years later Rodin told Henri-Charles Dujardin-Beaumetz about his approach to nature in this work:

I strive to express what I see with as much deliberation as I can.

I proceed methodically by the study of the contours of the model which I copy, for it is important to rediscover in the work of art the strength and firmness of nature; translation of the human body in terms of the exactness of its contours gives shapes which are nervous, solid, abundant, and by itself [this method] makes life arise out of truth.

I have always applied this method; it is thus that I made "The Man with the Broken Nose"; I was 24 years old then.[3]

He subsequently added, "For tenacity in study, for sincerity in execution of form, I have never done more or better. I worked as completely as I could, thought of nothing else."[4]

In talking to Dujardin-Beaumetz about the stable he used as a studio at the time, Rodin remembered, "The winter that year was especially rude, and I couldn't have a fire at night. 'The Man with a Broken Nose' froze. The back of the head split off and fell. I was able to save only the face, and I sent it to the salon; it was refused."[5]

In 1903 Rainer Maria Rilke published his essay on Rodin, in which he dwelt memorably and at length on the mask, starting with its rejection by the Salon of 1865.

One comprehends this rejection, for one feels that in this work Rodin's art was mature, certain, and perfected. With the inconsiderateness of a great confession it contradicted the requirements of academic beauty which were still the dominating standard. . . .

The plastic art that was pursued was still that based upon models, poses, and allegories; it held to the superficial, cheap, and comfortable métier that was satisfied with the more or less skillful repetition of some sanctified appeal. . . .

Rodin's motive in modeling this head, the head of an aging, ugly man, whose broken nose even helped to emphasize the tortured expression of his face, must have been the fullness of life that was cumulated in these features. There were no symmetrical planes in this face at all, nothing repeated itself, no spot remained empty, dumb, or indifferent. This face had not been touched by life; it had been permeated through and through with it as though an inexorable hand had thrust it into fate and held it there as in the whirlpool of a washing, gnawing torrent.

When one holds and turns this mask in the hand, one is surprised at the continuous changes in profiles, none of which is incidental, imagined, or indefinite. There is on this head no line, no exaggeration, no contour that Rodin has not seen and willed. . . .

All these impressions are encompassed in the hard and intense life that rises out of this one face. As one lays down this mask one seems to stand on the height of a tower and to look down upon the erring roads over which many nations have wandered. And as one lifts it up again it becomes a thing that one must call beautiful for the sake of its perfection. But this beauty is not the result of the incomparable technique alone. It rises from the feeling of balance and equilibrium in all these moving surfaces, from the knowledge that all these moments of emotion originate and come to an end in the thing itself. If one is gripped by the many-voiced tortures of this face, immediately afterward there comes the feeling that no accusation proceeds from it. It does not plead to the world; it seems to carry justice within itself.[6]

What Rodin made was a modernized late Hellenistic portrait, such as he would have studied in the Louvre, not that of a poor, old person or a pathetic subject, as many have seen him, but a man in early middle age, conceivably still in his thirties, whose broken nose and fillet that binds his hair marks him as an ancient, victorious, veteran pugilist.[7]

Most commentators grade Bibi as old or aging in 1864. Photographs of the sculpture are no help in determining the age of the model. One must look at the actual bronze, which gives a strong impression that the subject's flesh has a firm sensuousness and elasticity. Hairline and presence or absence of bags under the eyes are genetically related and may not be reliable guides to judging the man's age. To help resolve this question, in 1991 Stephen C. McGough, invited a specialist in forensic identification, Dr. William E. Alexander of Eugene, Oregon, to examine the Stanford cast. He reported,

Age of the subject, I believe, is in the 30 year range. I also believe that he was a pugilist. Starting with the obvious, the nose appears fractured and mal-healed, probably due to multiple fractures occurring over a period of time. The ears have dissimilarity. The longitudinal axis seems to differ. . . . The face is asymmetrical with the right side elevated. This could be due to the fact that the lower jaw suffered a blow laterally. . . . This is consistent with the nose being fractured from left to right. The right cheekbone . . . is depressed. The right eye lids hint of ptosis [drooping from paralysis], which may be from optic nerve injury or from infraorbitol [below the eye socket] nerve damage caused by a fracture of the rim of the orbit. A nerve paresthesia [numbness] was likely present in the subject. The right eyeball appears larger than left possibly due to a "blow out" fracture of the floor of the orbit which causes the eye to distend. There is a hint of . . . protruding jaw which can be caused from fractures and loss of teeth. Some evidence points to a "closed bite." . . . With the teeth together he would most likely show a marked closure. In conclusion, this 30+ year old boxer lacked adequate defensive protection from a "Right Hook." Even if a fractured

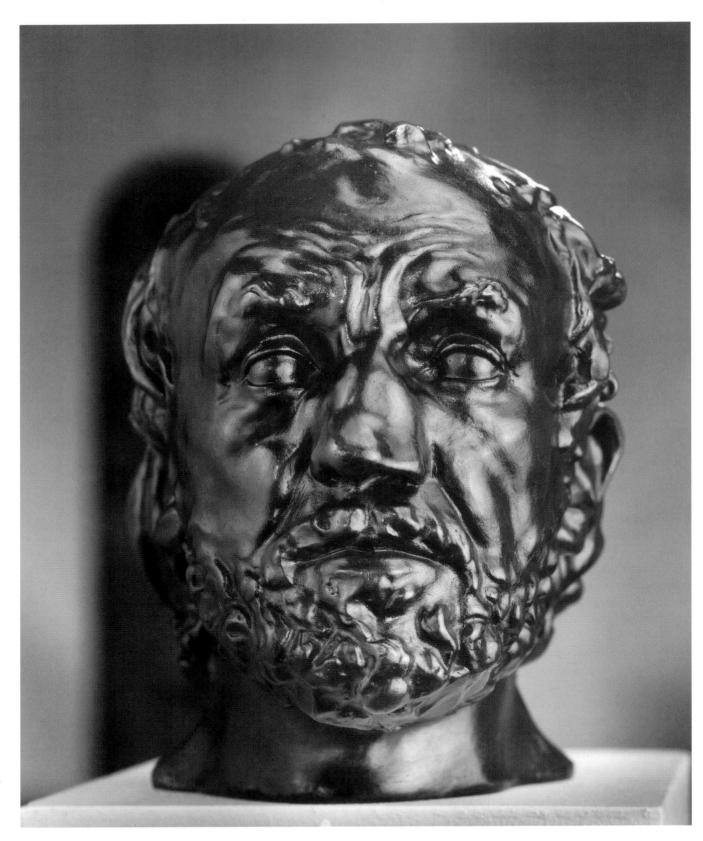

Fig. 366. *Mask of the Man with the Broken Nose* (cat. no. 125).

nose wasn't apparent, I think a typical boxer's nose would be evident.[8]

Alexander's report reminds us that Rodin was a brilliant observer who also possessed an awesome skill at rendering. Rather than boxing, that Bibi had to struggle presumably all his life for his daily bread, as Cladel indicated, could have furrowed the brow of a man in early middle age. The honorific purpose of the fillet for games like boxing was earlier noted, and the deformity and age represented in the mask argue against the view that Rodin was evoking a Greek philosopher, as many have claimed, because, according to Plato and others, one could not be a philosopher before the age of fifty. (The young Rodin had some sense of decorum, and Bibi's age argues against simulation of an elderly sage.)[9]

Rilke's "many-voiced tortures of this face" is more appropriate for the second version of Bibi made almost 20 years later, a smaller and more radically modeled head (cat. no. 126). Seen with the head erect and fully lighted, as Rodin had the mask photographed by Eugène Druet, *The Mask of the Man with the Broken Nose* is absolutely serene without a trace of pathos.[10] But for his "busted beak" Bibi is handsome. The hair and beard are well groomed, befitting a triumphant athlete who came from "a fine race—in form."[11] As for those seemingly blank, expressionless eyes, more out of David d'Angers than ancient Rome, when the light is in front of the bronze face and as one moves and looks at them, the highlights reflected on the two smooth, curved pupils follow wherever one goes.

It has been observed that "Rodin evidently chose his subject with the Salon jury and classical bias in mind,"[12] but it appears that bias did not condone physical deformity, as the piece was rejected for its first exhibition. For such a young artist about to make his debut in the salon, there was irony as well as courage in transforming a broken-faced handyman into a victor in ancient games. At his professional beginning Rodin thus took a crucial stand for artistic over cosmetic beauty, and what better seconding for the stance that there was no ugliness in nature than the art of Hellenistic Greece and ancient Rome?

Because he actually handled the sculpture as he studied it, Rilke marked well its absence of symmetry and empty spots, the decidedness of the contours as extensions of the artist's will. There is no exposed facture as the modeling is tight and, by his later standards, some-what cold. Rodin's "touch" is here not given by traces of his fingering the clay, but in the smooth joining of planes or what he later called *le modelé*, which gives the piece a sense of firm fullness and density. Rilke was also persuasive in seeing the facial creases as indicating life's permeation of the man and not a momentary expression. Those forehead folds are still there in the later portrait but framed by others.

When Rodin talked of his sculpture, he reminded us of what was for him so fundamental: it is nature that provides the sculptor with forms that have "strength and firmness" and shapes that are "nervous, solid, and abundant." As was Alberto Giacometti's practice in the next century, Rodin did not strive to interpret his model's character but rather to copy only what he saw. (Pathos is what others have tended or wanted to see.) The *Mask* was Rodin's conscience as well as talisman. In it he first enacted his personal version of modeling from successive contours and not from a few fixed viewpoints. Rodin's modeling was objective and did not apply any psychological analyses of the model. With this method he had established his ideal and the beauty and expressiveness of pure sculpture.

The *Mask* was Rodin's talisman because it taught him how to capitalize on chance and accident. When the frozen portion of the head fell off, Rodin was confronted with the questions that haunted him for much of his later life and led to his partial figures: What could sculpture do without? What was essential?[13] At his beginnings as an artist, Rodin's mentality showed itself in two ways: first, his refusal to let a good idea go to waste through only a single use or realization and, second, his belief that a work had to be conceived as a full, finished form. That he sold so many casts of the *Mask*—ten in England alone during the 1880s—and that the work was exhibited 20 times during his life tells us of the sculpture's importance for Rodin (and the art world). His reworking of the mask and bust bespeaks its importance for the sculptor himself. As he considered it, his revisions ranged from the way he would treat the back of the mask to create the full portrait bust, from the type and shape of its support to various positionings, from the refashioning of the missing cranial part and the amount of hair to show, to its application to whole figures: *The Sculptor and His Muse* (1895), *The Earth* (cat. no. 176), and a man to the horned demon's right in the right half of the tympanum of *The Gates of Hell* (see fig. 232).[14]

NOTES

LITERATURE: Bartlett 1889 in Elsen 1965a, 21–22; Lawton 1906, 24–26; Dujardin-Beaumetz 1913 in Elsen 1965a, 148, 154; Cladel 1936, 90–91; Grappe 1944, 4; Rilke [1903] 1945 in Elsen 1965a 118–20; Mirolli (Butler) 1966, 102–8; Steinberg 1972, 325, 328; Wasserman 1975, 153–65; Tancock 1976, 473–78; de Caso and Sanders 1977, 251–54; Elsen 1980, 157; Fusco and Janson 1980, 328–29; Schmoll 1983, 163–214; Fonsmark 1988, 64–66; Goldscheider 1989, 42; Butler 1993, 41–48; Le Normand-Romain 2001, 242

1. Lawton 1906, 25.
2. Bartlett in Elsen 1965a, 20–21. Many other writers have stated that the head was made at Rodin's studio in the rue Lebrun, where he worked after leaving Father Eymard's religious order (see, for example, Beausire 1988, 53). Rodin's reference to his model as Bibi is found in Rodin to Beuret, 1 October 1871 (*Rodin 1860–99,* 32). Cladel referred to Bibi as an old man well known to artists in the faubourg Saint-Marcel, who posed for them and swept their studios (1936, 90).
3. Dujardin-Beaumetz in Elsen 1965a, 154.
4. Ibid., 148. The question of where Rodin got the idea for his profile modeling method used for this mask and *The Age of Bronze* was raised by Robert Sobieszek, who made a good case that it could have come from François Willème's photosculpture, which was in vogue in Paris in the 1860s: "Simply defined, photosculpture was the adaptation of photographic portraiture to the construction of three-dimensional portrait sculptures using photographic profiles taken from sequential positions encircling the sitter. The profiles were pantographically transferred into a three-dimensional matrix from which a mold could be made, and the finished or nearly finished statue was cast. The entire process was firmly based on the idea that the sum of all its profiles would yield the volumetric whole" (Sobieszek 1980, 618). Sobieszek also discussed comparable methods of using successive profiles by both other photographers and those who used the Collas copying machine for reducing and copying. The Collas machine was invented around 1836, and Rodin would later make extensive use of it. See also Fusco and Janson, 1980, 360–61.
5. Dujardin-Beaumetz in Elsen 1965a, 148. While the 1864 Salon is always cited as the one that rejected Rodin's *Mask,* Beausire found evidence (1988) that Rodin registered a bust for exhibition in the 1865 Salon, no doubt *The Man with the Broken Nose,* but it was not shown. For further discussion, see Butler 1993 (45–46, 520 n. 15).
6. Rilke in Elsen 1965a, 118–20. Regarding Rilke's writings on Rodin, see earlier discussion in present catalogue (cat. no. 97, note 14).
7. The late Professor Emeritus Anthony Raubitschek of Stanford University pointed out the honorific purpose of the fillet that was awarded to winners of Greek games like boxing (in conversation with the author, 1 November 1990). See also Ruth Mirolli (Butler) on this mask for Rodin's interest in antiquity and how the mask relates to his earlier portraits (1966, 102–7). Her designation of the *Crysippus* head in the Louvre as an inspiring typological source for Rodin is probably apt. Rodin had role-playing in mind, but there is no question about Rodin's working from life.
8. Alexander to McGough, 28 March 1991. Ann Edwards, an outstanding docent at the Stanford University Museum of Art, added the following information, partly from the *Encyclopedia Britannica.* French boxing dates from about 1830, and it is this boxing style, with bare fists or very light gloves, in which Bibi was probably involved and from which the extensive physical damage may have taken place. This sport allowed not only punching but also kicking, head butting, and wrestling.
9. Raubitschek confirmed the Greek view of the minimum age for a philosopher. There is no certainty that Rodin told Bartlett that Bibi was an old man, and it is more probable that the American sculptor engaged in the same misreading of the man's age as have others ever since. In his account Lawton made no mention of the man's age. Scholars always will be intrigued by the search for a specific ancient source for this head. It is evident that on certain basic points this author does not follow his interpretation of this work, but Schmoll wrote the best and most extensive study and offered some possible ancient precedents (1983, 177–80). He also discussed the fillet and its uses in antiquity and the eighteenth century by such artists as Jean-Antoine Houdon, in which the hair band becomes a "ribbon of immortality" (185–89). To his further credit Schmoll offered several arguments against seeing this head as an homage to the *Bust of Michelangelo* (after 1564; Casa Buonarotti, Florence) by Daniele da Volterra. While critics made the connection after 1875, when the marble version was first exhibited, no one has shown that by age 24 Rodin knew Michelangelo's portrait (186). It should also be apparent that the two portraits do not resemble one another, especially in the area of the broken nose. For the alternative view see Fergonzi 1996, cat no. 34.
10. This photograph is reproduced in Elsen 1980, pl. 1. It is when the *Mask* is photographed with the face tilted downward and subject to shadows that it has invited a reading by Tancock, Schmoll, and others as pathetic. We do not know for certain whether Rodin or his foundrymen at times mounted the mask so that the face was inclined laterally or downward. When Rodin had a marble version made of Bibi's portrait, the head was perfectly erect (see Barbier 1987, 20–21).
11. Cladel recounted the story that Jules Desbois borrowed Rodin's sculpture and passed it off at the École des beaux-arts as an antique (1936, 91).
12. Sanders in Wasserman 1975, 153.
13. As he used the casting method and preserved his molds, Rodin could have it both ways, a mask and full bust, just as he would later have with his partial figures, such as *Meditation* (cat. nos. 61–62).

14. The mask was exhibited frequently, as noted by Beausire 1988, 401, and Sanders in Wasserman 1975, 154. Beausire's record revealed that the 1878 showing of the mask (*as Portrait of M*) was Rodin's first exhibited bronze (368), and not until its 1883 exhibition in Amsterdam was the portrait baptized *L'homme au nez cassé* (Beausire 1988, 68, 85). See Sanders's study (in Wasserman 1975, 152–65) of the variations of this work, of which Stanford's seems to fall into her Group II, Type F (in Wasserman 1975, 163, 165, fig. 16). Schmoll built on Sanders and extended the study of these variations and the use of the motif in drawings and sculptures (1983, 167–74, 191–202). As shown by photographs in Sanders's study, Rodin varied the handling of the back of the mask, from which part of the head had been lost. As an example, in what she calls Group I, Type C (Sanders in Wasserman 1975, 157, 159–60, fig. 11), there is a clean, diagonal cut with no fillet. In her Group II, Type G (ibid., 164–65, fig. 17), part of the fillet remains, the break is made to coincide with the hair on the sides of the neck, and the cast is completely open in the back. The Stanford cast has a more undulant termination, in which the fillet and hair behind the neck remain (ibid., 159, 163–64). Lawton commented, "The original has disappeared in the continued process of reproduction; but it has been replaced by an exact facsimile, which is preserved as a precious souvenir among the [Meudon] Museum's thousand and one sculptural records" (1906, 26).

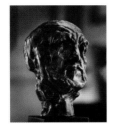

126

Head of the Man with the Broken Nose
(*Tête de l'homme au nez cassé, petite modèle*),
second version 1882

- Title variations: *Little Man with the Broken Nose, Small Head of the Man with the Broken Nose*
- Bronze, Georges Rudier Foundry
- 5 x 3 x 4 in. (12.7 x 7.6 x 10.2 cm)
- Signed on neck, left side: A. Rodin
- Inscribed below signature: Georges Rudier/Fondeur. Par[is].
- Provenance: Galerie Motte, Geneva, 16 June 1972, lot 56
- Gift of the Iris and B. Gerald Cantor Foundation, 1974.82

Figure 367

*P*oorly named *Le petit homme au nez cassé* (The small man with the broken nose) by Georges Grappe or a predecessor, but probably not by Rodin, the work should be called "The Old Man with a Broken Nose."[1] Twenty years after he made his first portrait of the neighborhood handyman Bibi which became known as the *Mask of the Man with the Broken Nose* (cat. no. 125), Rodin modeled this more spontaneous rendering of his subject's broken face. The smaller version indicates what Rodin had learned in 20 years as well as time's toll on Bibi himself.

Where the 1863–64 portrait was life-size and Rodin patiently executed it on a modeling stand according to his personally evolved plural-profile method, the reprise must have been made literally in the sculptor's hand while confronting the model mostly from the front. One can still hold the small bronze head in the left hand and feel how the muscle of the left thumb fits easily into the depressed area of the man's right side as there are no ears. The left fingertips fit comfortably into the cavities on the head's left side. In the ball of clay Rodin's fingers coaxed the features into form, and what he excavated from the deep recesses was sometime reused in flattened patches, as in the layered area above the man's right temple, molded to seem molten. No attempt was made to carry the back of the head to complete definition, and originally there seems to have been no neck at all.

Rodin's modeling of the older Bibi was more radical than what he had done to form his early personal talisman of good "pure" sculpture. For lack of a better phrase, let us call the realization of the smaller head achieving a likeness by indirection. Presupposing great skill and anatomical knowledge, this method places a premium on inventiveness during the inspired moments of confrontation. When isolated, every facial feature—brow, eyes, nose, cheeks, mouth, chin, and hair—resists ready identification. Nowhere in this rapidly realized portrayal is there a labor of featural refinement as in the initial version. Crucial to this indirect mode of limning a likeness is mergence, thinking in terms of relationships as well as achieving a greater surface fluidity. Featural boundaries are elusive or inconstant and nondescriptive. It is impossible, for example, to discriminate hair from flesh. Most astonishing is the treatment of the eyes. There are no distinctly shaped eyeballs like the earlier blank orbs. The eyes, the bags below them, and the cheekbones are evoked by single, continuous patches of clay on the left and right sides of the face. Bibi had

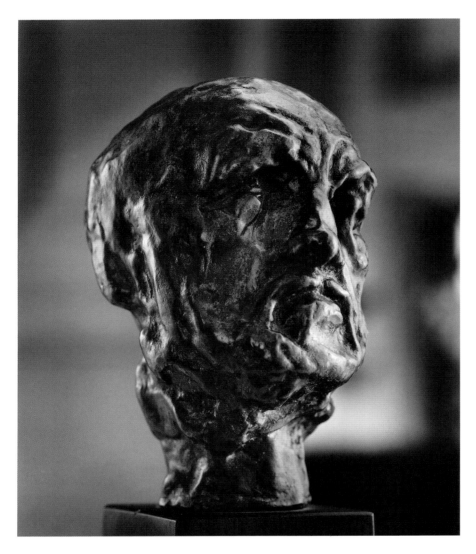

Fig. 367. *Head of the Man with the Broken Nose* (cat. no. 126).

extrusions from the eroded facial surface as audacious and inexplicable as here. Paradoxically it is the energy of the modeling that tells us flesh has lost its elasticity, mirroring what appears as a weakened spirit in the older man. There is a slight tilt to the man's left, probably his habitual facial carriage rather than an imposed pathetic touch, even when some of the neck has been added, as in the Stanford cast, in order to present the upright full face to the light.

Though not intended as a second formal portrait of Bibi, this stunning small head is more eloquent than most such reworkings of subjects by the artist. What Rodin did to challenge conventions of beauty and to show mortality in the human face was what he would later do for the body in *Old Woman* (cat. no. 51). Begun as an étude and seemingly never exhibited, Rodin twice used this head in *The Gates of Hell*. He placed it in the right side of the tympanum near *The Thinker*, and the old face with its testimony to the fate of the flesh was also placed frontally at the far right, in the line of heads of young women and skulls above *The Thinker*, which are like beads in the artist's rosary of suffering humanity (see figs. 194, 232).[2]

become deaf and blind, living behind a deeply and permanently scored mask that came into focus as a face only when seen as a whole.

Rodin did not apply any expression but let the inspired modeling of what he saw and felt speak for itself. Here rather than proving technical mastery, Rodin was reveling in the mysteries of how unselfconscious modeling based on observation and sensation could reveal the human inside and out. Rather than just by the care-creased forehead, the mashed nose, and downward turned mustache, when we are moved by the result, it is more likely because of the overall duets of dispersed highlights and shadows. The shaded hole and luminous lump do the narrating in what is now a purer and more mature expression of Rodin's conception of sculpture. Nowhere in the earlier portrait are the incursions into or

NOTES

LITERATURE: Grappe 1944, 32; Steinberg 1972, 328; Wasserman 1975, 166–67; Tancock 1976, 474, 479; de Caso and Sanders 1977, 257; Schmoll 1983, 190–93, 196, 198, 209–10; Ambrosini and Facos 1987, 48; Goldscheider 1989, 44; Fath and Schmoll 1991, 144

1. Grappe 1944, 32. Beausire did not list this particular title or a variation of it in his index of Rodin's exhibited works.
2. Additional uses include the attachment of the small head to a portion of *The Earth* in an assemblage found at Meudon (see fig. 456) and the use of a head with a similar face for the figure of the sculptor in *The Sculptor and His Muse* (1895); the latter work is reproduced and discussed in de Caso and Sanders 1977, 49–52.

127

Young Girl with Roses in Her Hair
(Jeune fille avec coiffure de roses), c. 1868

- Pigmented plaster with terra-cotta-colored slip or low-fired terra-cotta with pigmented slip
- 14 x 7¼ x 9⁹⁄₁₆ (35.5 x 19 x 23cm)
- Signed (incised) on edge of left shoulder: A. Rodin
- Provenance: Sotheby Parke Bernet, New York, 17 May 1979, lot 202
- Gift of the Iris and B. Gerald Cantor Foundation, 1986.185

Figure 368

This is one in a series that were intended to be commercially attractive heads of young women, which Rodin made during the late 1860s and early 1870s to support himself and his young family. Goldscheider dated this work 1870–75, but it may have been done even before the outbreak of the Franco-Prussian War in 1870.[1] Although not specifically mentioned by her, the style of this confection, according to Ruth Mirolli (Butler), was Second Empire, in the manner of Jean-Baptiste Carpeaux and Albert-Ernest Carrier-Belleuse.[2] Rodin had adapted their formulas for type and pose. To this observer, the head and its animated expression of a questionable innocence were shaped as much by bourgeois expectations of craft and taste as by Rodin's fingers and tools. His technical skill, which made him a frequent employee of Carrier-Belleuse, is on display in the meticulous delineation of the flowers, the indented irises, parted lips, and exposed teeth. This work in the cheap medium of colored plaster may have been typical of those Rodin displayed for sale in Paris and Brussels shop windows; according to him, they never sold.[3] Within the Stanford collection, this early work allows us to measure Rodin's growth and reaction against his native facility and early conformity to popular notions of beauty.

NOTES

LITERATURE: Miller and Marotta 1986, 101; Goldscheider 1989, 78; Le Normand-Romain 1997, 143–44

1. See Goldscheider 1989, cat. no. 55, and for the series,

78–79. The Stanford head is discussed in the context of related heads by Le Normand-Romain (1997, 142–44).
2. Mirolli (Butler) 1966, 115–20.
3. Bartlett in Elsen 1965a, 28–29.

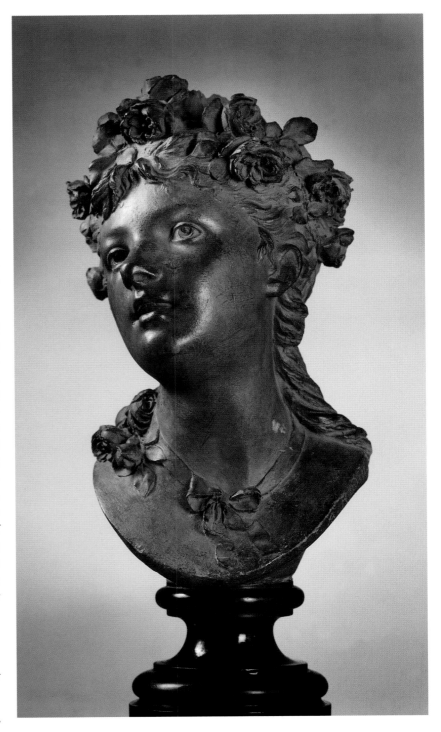

Fig. 368. *Young Girl with Roses in Her Hair* (cat. no. 127).

128

The Alsatian Orphan (L'orpheline alsacienne), 1863

- Title variation: *Young Alsatian Girl*
- Plaster
- 14½ x 8¼ x 7 in. (36.8 x 21 x 17.8 cm)
- Signed (incised) on reverse: Rodin
- Provenance: Galerie Philippe Cézanne, Paris
- Gift of Iris and B. Gerald Cantor: 1986.187

Figure 369

Fig. 369. *The Alsatian Orphan* (cat. no. 128).

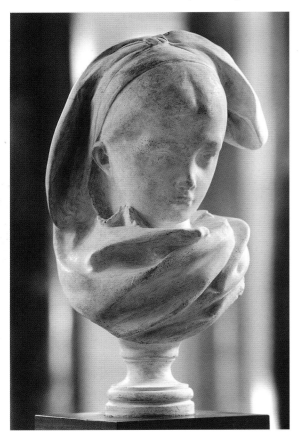

We are fortunate in having Rodin's own account of how and when this work came about. Truman Bartlett wrote that in 1863 Rodin "was asked to go to Strasbourg, by a manufacturer of church sculpture, or, what is known in the vocabulary of sculptors as a *marchand de bons dieux,* a class of men not held in good repute among artists for any reason, but for whom young sculptors are obliged to work to get their living. This one had, however, a slight recommendation of superiority for Rodin, because he followed a Gothic style of sculpture, of which, in its purity, the latter is an enthusiastic lover. He remained in this city three months, and one day, while enjoying the festivities of a grand church celebration, when thousands of fair women and young girls were filling the streets with their beauty and pretty costumes, he saw a little head which pleased him so much that he went to his room and modeled in an hour or two 'La Petit Alsacienne.'"[1]

This is the only recorded instance of Rodin's making a head from memory, and as such it was an impressive performance that was good enough to win recognition by artist juries when displayed some years later. In 1871 and 1872 Rodin exhibited the head in marble both in Brussels and Ghent, making this one of his first sculptures accepted for exhibition. It was shown in a terra-cotta version in Rouen (1882), London (1883), and Saint-Malo (1884).[2]

The slightly downward-turned head of the somber child is swathed in a large cloaklike garment, which sweeps up and around to form a type of hood. Suggestions of a lace collar are apparent, perhaps a reference to the lace made in that region. Unlike Rodin's commercial, flower-bedecked adolescent girls with their eighteenth-century, Clodion-styled broken silhouettes, the design of *The Alsatian Orphan* is strikingly spare and effective. It is a study in the power of simple forms. The almost egglike simplicity of the young head is contrasted with the big indented forms of the drape. Side views show how Rodin fashioned a beautiful ovular line with the folds of the drape that connect with the spherical forehead and then close at the chin, where the drape begins or ends. Figuratively and literally, the composition was made for marble, and it knew at least three versions.[3]

NOTES

LITERATURE: Bartlett 1889 in Elsen 1965a, 24, 36; Cladel 1936, 100–101; Grappe 1944, 8; Mirolli (Butler) 1966, 101–2, 104, 122–24, 129–30, 135; Spear 1967, 2; Butler 1984, 161; Barbier 1987, 24; Goldscheider 1989, 58; Rosenfeld 1993, 319–23; Le Normand-Romain 1997, 113–16

1. Bartlett in Elsen 1965a, 24. With no explanation, and even citing Bartlett in her bibliography, Goldscheider set the date of the small head at 1869 (1989, 58), while Grappe assigned it to 1871 (1944, 8). Le Normand-Romain notes "before 1871" in Le Normand-Romain 1997, 113.
2. Beausire 1988, 54, 61, 79, 86, 88.
3. See Goldscheider 1989, 58; Barbier 1987, 24; Rosenfeld 1993, 319–23.

129

Suzon (Suzon), 1875

- Title variation: *Little Manon*
- Gilt bronze, Compagnie des Bronzes, cast c. 1900
- 17¼ x 8⅝ x 8⅝ in. (43.8 x 21.9 x 21.9 cm)
- Signed on base, right side, near back: A. Rodin
- Inscribed on base, left side: cie. des Bronzes/Bruxelles; on inside of base, lower front, center: 8141
- Provenance: Feingarten Galleries, Los Angeles
- Gift of the Iris and B. Gerald Cantor Foundation, 1975.15

Figure 370

Rodin was compelled to make what in the studio was sometimes called "a pastry" because when he arrived in Brussels after the Franco-Prussian War, he had to support himself as well as Rose and their son, Auguste, who had remained in Paris. He found that he could sell charming pieces such as this to the Compagnie des Bronzes in Brussels in 1875.[1] As Ruth Butler pointed out, Rodin knew what would sell from his experience with Albert-Ernest Carrier-Belleuse, who clearly understood Second Empire taste, but he did not have a similarly developed business sense.[2] Until 1939 for the 50–franc purchase price of the original terra-cotta, the bronze editor was to cast thousands of copies of *Suzon* not just in bronze but in other materials as well as in different sizes.[3]

Rodin's formula, as the bronze editor recognized, was surefire: a pretty young girl rendered in impeccable detail, at ease and with lips parted as if turning to speak intimately to someone close by. Butler rightly noted that this formula and the style in which it is treated derived from Rodin's exposure to eighteenth-century art. For those today who doubt that Rodin ever learned his craft and doubt his ability to achieve verisimilitude in a head, *Suzon* should be reassuring that he did both. Almost the rest of his professional life would be devoted to fighting that skill and facility, which he never lost.

NOTES

LITERATURE: Bartlett 1889 in Elsen 1965a, 34; Cladel 1936, 106; Grappe 1944, 13; Wasserman 1975, 148, 150; Tancock 1976, 34, 65, 581, 584; Fusco and Janson 1980, 329; Elsen 1981, 286; Ambrosini and Facos 1987, 54; Goldscheider 1989, 84; Le Normand-Romain 1997, 150–52, 428–32

1. This date, representing Rodin's sale of a bust of a young girl in marble to the Compagnie des Bronzes, was clarified by Laurent in Elsen 1981, 286, and supported that given in Grappe 1944, 13.
2. See Butler in Fusco and Janson 1980, 329. She noted that the gold patina was chosen by the bronze adapter, and that the smooth and shiny result was un-Rodinlike.
3. For more information on the uses made of this sculpture by the editor, see Goldscheider 1989, 84. See also the discussion by Antoinette Le Normand-Romain and Isabelle Vassalo in Le Normand-Romain 1997, 150–52, 428–32.

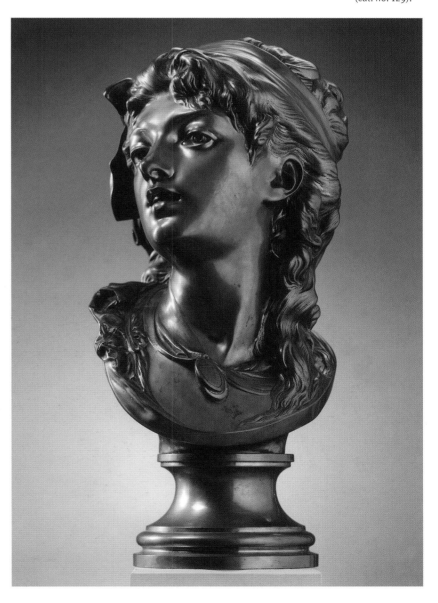

Fig. 370. *Suzon* (cat. no. 129).

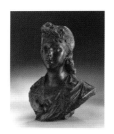

130

Young Girl with Flowers in Her Hair
(Jeune fille aux fleurs dans les cheveux), c. 1875

- Bronze, Coubertin Foundry, cast 1979, 7/12
- 18½ x 14⅛ x 10¼ in. (46.4 x 35.9 x 26 cm)
- Signed on right side: A. Rodin
- Inscribed on back at bottom: © by musée Rodin 1979; below signature: No 7
- Mark on back of base, left: Coubertin Foundry seal
- Provenance: Musée Rodin, Paris
- Gift of B. Gerald Cantor and Co., 1982.305

Figure 371

*R*ather than a portrait, strictly speaking, this bust might be called one of Rodin's confections, as it was made to satisfy a middle-class public that liked having bronzes of pretty girls in the home. Grappe dated it to 1865–70, and Goldscheider, without explanation, assigned it to about 1875.[1] The former saw it as having been made under the influence of Albert-Ernest Carrier-Belleuse. In contrast with *Suzon* (cat. no. 129), another early "pastry" for the trade, this portrait shows considerable reworking and avoidance of a slick surface. Surprisingly, but evidence of Rodin's facture, raking marks are found on the otherwise smoothly finished plaster, if not the clay, which texture the chest and neck, lower part of the face, and right temple and forehead. The raking tool was used for editing and illusion, as where the traces of the tool follow the direction of a facial plane in the downward-curving area of the right temple, and just above, the same type of serrated marks initiate the hair. By contrast, Rodin suggested details of coiffure and dress only to achieve a graduated contrast between rough and smooth.

Unfinished at the back, this decorative sculpture was probably made to be placed in a niche or on a mantel. Inside or behind the bust is a cubic plinth on which the form stands. Rodin credited the viewer with being interested in subtleties not only of execution but in his presentation of the subject: the eyes, which give the sense of a slight sadness, do not look straight ahead but slightly to her left, thereby breaking a straight, vertical axis. Abetting that breach is the indentation above the upper lip and directly below the nose, which is off-center, and the head is given a slight tilt. One has the impression that the subject is far from being an empty-headed doll and seems to be passing from adolescence into maturity. The subtleties by which the young woman is interpreted and the editing and overall deftness argue for the later date of around 1875.

NOTES

LITERATURE: Grappe 1944, 5–6; Tancock 1976, 576, 580; Ambrosini and Facos 1987, 53; Goldscheider 1989, 94; Le Normand-Romain 1997, 76

1. Grappe 1944, 5; Goldscheider 1989, 94. Le Normand-Romain (1997, 76) dated the work before 1871, possibly c. 1868.

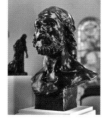

131

Bust of Saint John the Baptist
(Buste de Saint Jean-Baptiste), 1878

- Bronze, Georges Rudier Foundry, cast 1968, 3/12
- 22 x 15 x 10 in. (55.9 x 38.1 x 25.4 cm)
- Signed on front of base, left: A. Rodin

- Inscribed on back of base, right side: Georges Rudier/Fondeur. Paris.; on back of base, left side: © by Musée Rodin 1968; interior cachet: A. Rodin
- Provenance: Musée Rodin, Paris; Paul Kantor Gallery, Malibu
- Gift of the Iris and B. Gerald Cantor Foundation, 1974.65

Figure 372

*T*ruman Bartlett reported, "While Rodin was perfecting his sketch of St. John, he made a bust of the same subject and from the same model, an Italian, about forty-two years of age, named Pagnitelli [sic]. The bust was shown at the [Paris] Salon of 1879, in bronze plaster. Though badly placed, the sculptor received an honor-

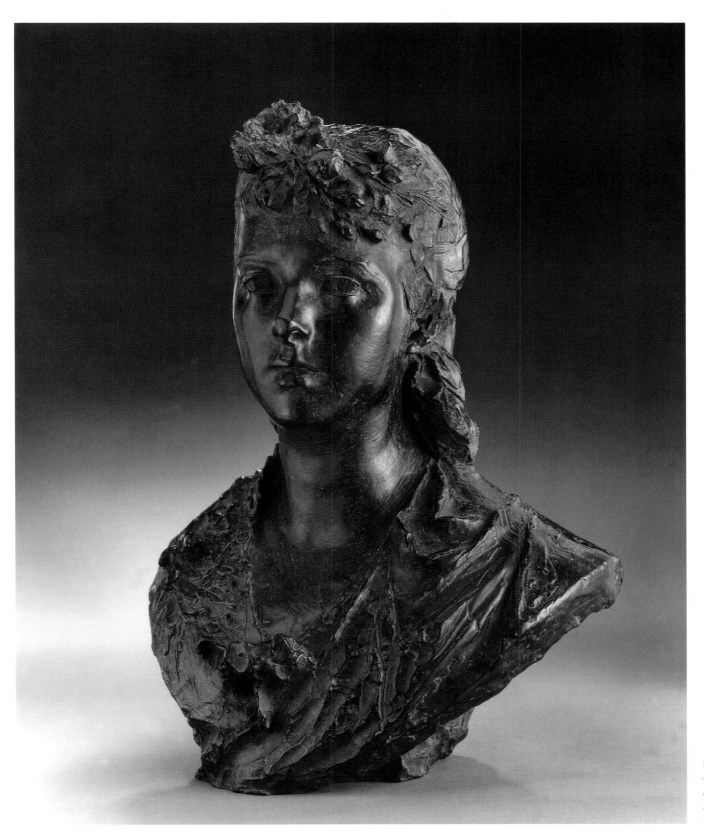

Fig. 371. *Young Girl with Flowers in Her Hair* (cat. no. 130).

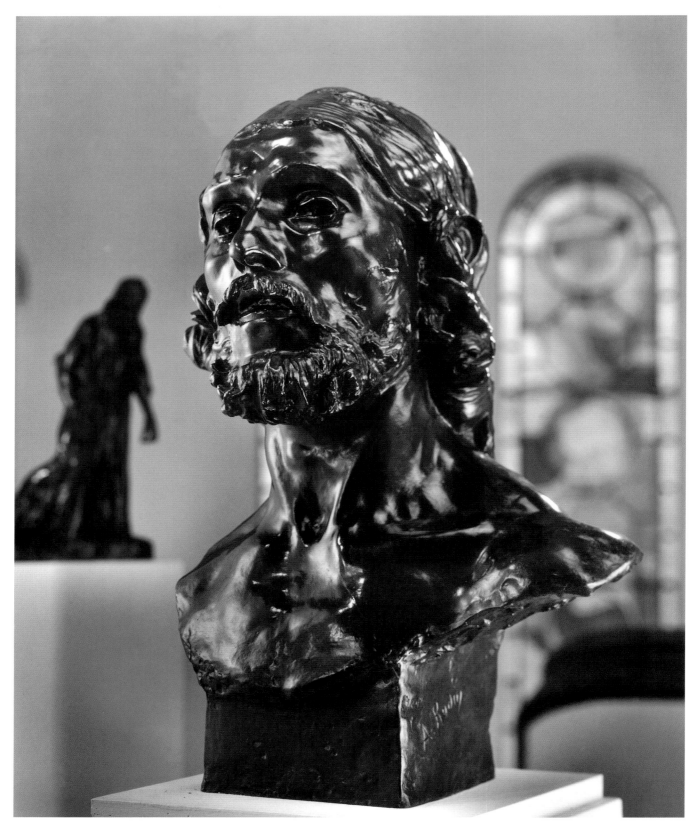

Fig. 372. *Bust of Saint John the Baptist* (cat. no. 131).

able mention. Both the bust of "St. John" and "The Broken Nose" were quite unnoticed by the newspapers."[1]

The photographs of Pignatelli from the archives of the Ecole des beaux-arts confirm that he posed not only for the body of the Baptist but also for his head (see figs. 447–448).[2] Rodin kept the central part of Pignatelli's long curling hair as well as his mustache and beard (perhaps better groomed). There is no doubt about the resemblance of the man's face to the head Rodin modeled. Both have the long, straight nose, the slightly sunken cheeks, and strong cheekbones. Pignatelli's eyes show a certain intensity, which comes through clearly in contemporary photographs. Rodin, in fact, worked close to the model for this head.

Rather than something dry and uninspired, Rodin made the man's hair into a graceful cascade that frames the face and adds to its asymmetry. When he came to the eyes, Rodin did something unusual: instead of an iris between the lids, he created a thin, vertical divide that picks up the light and is flanked by hollows. As a result, when the light changes, so does the expression of the eyes. Years later Rodin would refer to his "grasshopper eater" as having "a distant look, [which] makes one think of indefinite horizons of the desert."[3]

The area of the mouth is also unusual, for the lips are slightly parted as if the man were about to speak. It was to his study of Jean-Antoine Houdon's portrait in the Louvre of the revolutionary orator the Comte de Mirabeau (1791) that he attributed what he sought to achieve in his work:

Mirabeau . . . was small like most of the tribunes. Nature, suspicious of giving them a large and powerful chest, developed them in breadth rather than in height. They were thus obliged to raise their faces so that their voices, describing a parabola, amply expanded over the heads of those who listened to them. This particularity did not escape Houdon. His Mirabeau throws his head back which is as if [set] directly on enormous inflated lungs; because the massive neck is very short. Thus the sculptor shows the orator ready to enter into action and makes us imagine an immense auditorium. . . . That is how a simple bust can cause us to imagine a multitude. I will go further: the person's majesty forces us to not only imagine the hall where he spoke, but all of France which was attentive, all of the future to which he addressed himself. Wave after wave, like circles made by a stone [thrown] into a lake, the suggestions emanate from the marble bust and spread out and amplify. . . . It was while contemplating this Mirabeau that I had the notion of a new art. The formula that Houdon had found perhaps by chance, I resolved to apply methodically. This halo of inexpressible truth I wish to form around my images like an aureole. This was, I believe, my great discovery, something comparable to the discovery of airplanes. My "Saint John the Baptist" was the first to result from it.[4]

NOTES

LITERATURE: Bartlett 1889 in Elsen 1965a, 42; Gsell 1918, 413–14; Mirolli (Butler) 1966, 186; Tancock 1976, 11, 360, 363, 368–69; Beausire 1988, 68–69, 72; Goldcheider 1989, 124; Le Normand-Romain 1996, 15

1. Bartlett in Elsen 1965a, 42. See also Beausire 1988, 68–69, and, for subsequent exhibitions, 403. Mirolli (Butler) referred to the bust as revealing "more fully than the figure of the Baptist what is an extraordinarily beautiful traditional type of religious portrait" (1966, 186). For a review of the history of the bust and subsequent casts, see Le Normand-Romain 1996, 15.
2. These photographs were called to my attention by Ruth Butler. The author thanks the curator of the photographic archives at the library of the École des beaux-arts, Catherine Mathon, for making copies available, and his colleague Paul Turner for obtaining them.
3. Gsell 1918, 413–14.
4. Ibid. See H. H. Arnason, *The Sculptures of Houdon* (New York: Oxford University Press, 1975), 90–91.

132

Mask of Rose Beuret
(*Le masque de Madame Auguste Rodin*), 1880–82

- Bronze, Georges Rudier Foundry, cast 1965, 6/12
- 10⅝ x 6¾ x 6¼ in. (27 x 17.1 x 15.9 cm)
- Signed on neck, left side: A. Rodin
- Inscribed on back, right side: Georges Rudier/Fondeur, Paris; below signature: © by Musée Rodin 1965; interior cachet: A. Rodin
- Provenance: Musée Rodin, Paris
- Gift of the Iris and B. Gerald Cantor Foundation, 1974.76

Figure 373

*I*n 1864 Rodin met a 20–year-old seamstress, Rose Beuret (1844–1817), who became his mistress, the mother of his only son, his model, the caretaker of his works in clay, and finally, in 1917, a short time before her death, his wife. According to Ruth Butler, the painted portrait formerly considered to be of the artist's mother was, in fact, done by Rodin of Rose and would date from about the time of their meeting.[1] Her photograph (fig. 374) and Rodin's portraits show that Rose was a good looking, if not beautiful, woman with strong features. If one believed in physiognomic psychology, as did Rodin and his contemporaries, one would say that her features show she was a person of strong character, which, in fact, was true. What she lacked in culture, Rose made up for in good sense, hard work, and patience. For half a century she exhibited an astonishing capacity for loyalty to Auguste. At the outset of their relationship she endured almost 20 years of extreme poverty, during which she helped support the household and suffered long separations while Rodin worked in different cities.

When they were together in the years before he modeled her portrait, Rose was an ideal companion inside and outside the studio. As René Chéruy put it, "Rose took care of his material needs, was quiet at the right times. She was also a *garçon d'atelier*, who made casts, impressions, colored heads in terra-cotta, all better than a paid worker because she had the love of her husband and of his work. She held the candle while he worked at night on *The Man with the Broken Nose.*"[2] Rodin's letters to

Rose at the time of the modeled portrait, and for years thereafter, disclose his deep love and concern for her.[3]

In his notebooks Chéruy recorded Rodin's saying to his American student Malvina Hoffman before she was introduced to Rose that the older woman "has a violent nature, jealous, suspicious, but able to discriminate between falsehood and truth, like the primitives, and possessed of the power of eternal devotion." In his last years Rodin confided to friends that the times he and Rose spent together in Brussels were the happiest of his life. There is no evidence that before he met Camille Claudel, Rodin had ever been unfaithful to Rose during their first 20 years together. On more than one occasion Rodin was asked why he did not marry Rose, to which the sculptor replied that if he did, she would no longer obey him.

This portrait mask taken of her features, the last that he seems to have taken from his lifelong companion, was Rodin's favorite. Over the years it was redone in different media and in more amplified form in 1881 as *L'Alsacienne* (The Alsatian woman). Rose was from Lorraine, and in that year repressive measures were taken in Alsace-Lorraine by the Prussians, who had won the territory in the Franco-Prussian War, to which Rodin may have been responding. The beautiful stone version was carved in 1898. The mask's quiet composure contrasts with the earlier stern visage of *Bellona* (cat. no. 5) and the screaming head of the spirit of Liberty in *The Spirit of War* (cat. no. 4), which Rodin's biographers indicate were authentic expressions inspired by Rose. Rodin was to comment that even in death his wife had a fine head for a sculpture. John Tancock properly dated this portrait 1880–82 based on a note on the back of a photograph of Rose, formerly in the possession of Rodin's close friend and biographer Judith Cladel.[4]

Unlike the accidental mask of the *Man with the Broken Nose* (cat. no. 125), this portrait is a genuine mask as can be seen by its more irregular termination in the back. Rodin showed his 40–year-old mistress as a woman whose face had matured into beauty, her eyes downcast in quiet reverie. She showed a serenity that was soon to be broken by Rodin's relationship with Camille and then a succession of other women. The mask format tends to focus on the woman's strong nose and full lips. The deeply indented temples help accentuate the fine, bony structure of the face. Eyebrows were barely indicated, and Rodin applied his unaccountable touches to her forehead to animate and protect its curvature from the flat-

tening action of strong light. In all it is a portrait eloquent of Rodin's respect and admiration for the woman who had shared the difficult years of the first half of his adult life.

Much of the foregoing presumes naturally that Rodin actually modeled the work. Alain Beausire, who has studied not only the surviving bronze versions but also photographs of the now-lost original plaster (fig. 375), is of the opinion that the mask was taken from life. The closed eyes and mouth and the quiet, immobile set of the features suggest to Beausire that the mask was made of Rose, as was recommended in the manuals, while she was lying down. He finds an exactitude of facial reproduction in folds of the flesh under the eyes and skin texture that, he argued, could not be modeled. Further, citing instructions from technical treatises on life-casting, Beausire saw the location of the casting seams, especially the central axial one, as corresponding to the way piece molds were to be taken from living models. Then Beausire posed the crucial question: "After the accusation concerning *The Age of Bronze* . . . would he have been able to realize a life cast, a technique against which he had formally declared himself? Probably, without the intention of creating a work of art, a simple study and in the intimacy of his studio, with his faithful companion, he did not have to fear by whatever indiscretion a malevolent interpretation of his essay."[5] Rodin's *Portrait of Camille Claudel in a Bonnet* (cat. no. 90), however, has the same studio character but with the eyes open and evidence of a reworked surface.[6]

This is sharp-eyed detective work, and startling as is Beausire's conclusion, what we can actually see makes it plausible. The original plaster documented in photographs is missing, and the picture showing the work in profile suggests that it was not a mask but a full head.[7] The hair is broadly treated, but this might be explained by its having been heavily oiled or buttered to prevent the plaster from sticking to it. The curious treatment of the eyebrows might be explained by their having been coated as well. Beausire contended that Rodin may have added some touches to the life cast. (He certainly eradicated almost all the casting seams, for example.) One could add that, dissatisfied with the rear portion of the head, Rodin would have cut it away producing the mask as we know it today. The neck was not life-cast but seemingly improvised to support the face. There is a subsequent history of Rodin's taking casts rather than modeling, but only for rendering of the drapery: Rodin was later to cast directly from his own bathrobe while work-

Fig. 374. E. Graff and A. Rouers, *Rose Beuret*, n.d. Musée Rodin, Paris.

Fig. 375. Eugène Druet, *"Rose Beuret,"* 1880-82, *in plaster*, after 1896. Musée Rodin, Paris.

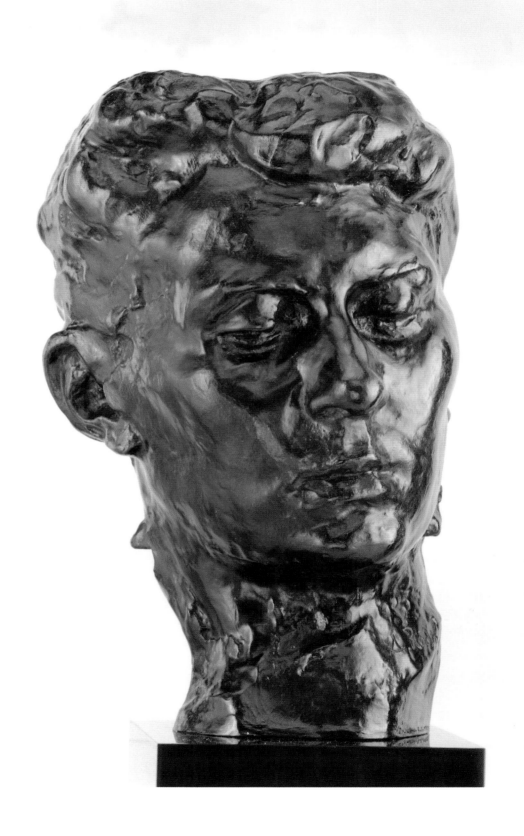

Fig. 373. *Mask
of Rose Beuret*
(cat. no. 132).

ing on the studies for the *Monument to Honoré de Balzac* (see fig. 326) and from heavy cloth for the drapery of the enlarged *Study for "The Muse" for "Monument to Whistler"* (cat. no. 117) and for the drapery under the enlarged *Ugolino* group (after 1906). Notwithstanding Beausire's conjecture, there are no known instances of Rodin's taking a cast directly from life.

Actual confrontations with the bronze mask raise some questions about Beausire's hypothesis. Rodin was, in fact, capable of meticulous, descriptive modeling of a subject as in the area of the pouches under the eyes. Secondly, as shown in the photograph of the lost plaster, which was presumably made from life, the eyes are not completely closed, as would have been required by a direct cast. As we see them, they are partly open, as if the eyes were lowered, not unlike those on the smaller-than-life head Rodin used for *Aesculapius* (cat. no. 169), which exists apart from the full synthetic figure. Depending on the elasticity of her facial flesh, if Rose had been lying down, it is doubtful, due to gravity, that the areas under the cheekbones would have been as indented as they are in the bronze. There is no double chin or pile up of fat and flesh under her chin such as a horizontal pose would have initiated in a 40–year-old woman. The overall surface of the face is far from being a dry mechanical record. There is no evidence of pores in the skin nor creases in the lips either in the plaster or the bronze. It is possible, however, that after having made a life cast, Rodin pressed fresh clay into the mold and reworked the surface for the bronze casting. But why would Rodin go to such an extreme when he had the most familiar unpaid model to work from and one who had shared his agonies over the unjust accusation of life-casting *The Age of Bronze*? During the many periods subsequent to the portrait when she was angry with Rodin, Rose could have hurt him professionally by sharing such a damning secret with others. Beausire may be right and his view should be taken seriously, but for the foregoing reasons this author does not find his argument totally convincing.

Rodin's pride in the portrait mask is suggested by the frequency with which it was exhibited, often in bronze, beginning with his retrospective in Paris of 1900. What must have pleased Rose was that the work was titled *Madame Rodin*. Where it was shown indicates Rodin's reputation throughout Europe and also the Far East: Prague (1902); Düsseldorf, Weimar, and Leipzig (1904); Paris (1906, 1910); Barcelona (1907); Lyon and Mulhouse (1908); Tokyo (1912); and Munich (1913).[8]

NOTES

LITERATURE: Grappe 1944, 86; Mirolli (Butler) 1966, 123; Spear 1967, 2, 89; Jianou and Goldscheider 1969, 103; Tancock 1976, 480, 482, 486; Elsen 1980, 164; Hare 1984, 237–43; Miller and Marotta 1986, 103; Barbier 1987, 36; Beausire 1988, 57–60; Butler 1993, 466, 569; Le Normand-Romain 2001, 82

1. Butler to Elsen, 7 June 1991. For a color reproduction of this portrait, see Laurent 1990, 26.
2. Chéruy file, Musée Rodin archives. Chéruy worked intermittently for Rodin between 1903 and 1908, including as his secretary 1906–1908.
3. Octave Mirbeau, who only knew Rose Beuret in later years, dismissed her as nothing more than a "washer-woman" or domestic for Rodin; quoted in Descharnes and Chabrun 1967, 156.
4. Tancock 1976, 482 n.16. On the question of dating this work see Grappe (1944, 86), Mirolli (Butler) (1966, 123), Spear (1967, 2), and Tancock (1976, 482).
5. Beausire 1988, 57–60.
6. See de Caso and Sanders 1977, 284, for Claudel's head in plaster. It evinces the same kind of porous, fleshy texture in the cheeks and around the mouth, as found in the old plaster of Rose. Rodin possibly used the same technique on his young model and assistant.
7. Beausire 1988, fig. 3.
8. Ibid., 400.

133

Bust of Madame Morla Vicuña
(*Buste de Madame Morla Vicuña*), 1884

- Title variations: *Bust of a Woman*, *The Charmer*, *Girlhood*
- Bronze, Georges Rudier Foundry, cast 1972, 1/12
- 15⅜ x 14¼ x 10½ in. (39 x 36.2 x 26.7 cm)
- Signed on front, lower left: A. Rodin
- Inscribed on back, right: Georges Rudier/Fondeur.Paris.; below signature: No 1; on lower edge, left: © by musée Rodin 1972; interior cachet: A. Rodin
- Provenance: Musée Rodin, Paris
- Gift of the Iris and B. Gerald Cantor Foundation, 1974.68

Figure 376

*T*he image of Rodin as an uncompromising revolutionary indifferent to worldly success founders on the shoals of his society portraits, especially those made in the 1880s. At this time Rodin did not rebel against the artistic conventions for portraying important people. He not only did them better than anyone else, he advanced the type by introducing a discreet sexuality, as shown in the marble version of this bronze. Madame Luisa Lynch de Morla Vicuña was the wife of the Chilean ambassador to France. She played an important part in introducing Rodin to influential people in Parisian society after they met, perhaps in 1884, the year when Rodin decided to make her portrait.[1] Although they were not finally realized, Madame Morla encouraged Rodin to submit proposals to the Chilean government for monuments to her grandfather, Benjamin Vicuña McKenna, and her uncle, Admiral Patricio Lynch (cat. no. 7). It was the marble bust of this beautiful lady, carved by Jean Escoula and Louis Cornu, which won for Rodin unanimous critical acclaim upon its exhibition in Salon of 1888 and its purchase by the state (fig. 377).[2] Regarding its critical reception. Bartlett reported that "over fifty newspaper notices, all regarded it, with four exceptions, as the best piece of sculpture there, and in nearly half of them, its author was referred to as the greatest sculptor of his time."[3]

The Stanford bronze comes from a plaster lacking the

Fig. 377. Etienne Neurdein (called N.D.), *Postcard Photograph of "Mme Vicuña" 1888, in marble* (A159).

bouquet of flowers and rough suggestion of a robe that frames the woman's bust in the marble version.[4] It is not clear if Rodin cast in bronze and exhibited just the upper portion of the bare-shouldered woman, but there is evidence that he preferred it to the famous marble. While this unadorned state was more to the taste of artists and critics after Rodin's death, the marble version, which was a technical tour de force as well, drew praise from critics for the way the woman's body seemed to emerge from the stone and robe in a highly sensuous manner.[5] The writer Léon Plée's reaction was typical: "We have never seen, even in the works of the Renaissance, such youthful lines or an equal suavity of contours. Those half-closed eyelids, the sweetly raised head, the young woman by Rodin seems to wake from some dream, some mysterious vision."[6] With the modish hairdo, tilted head, and half-closed eyes, which contributed to the woman's individuality and lifelike quality, along with the suggestive treat-

Musée du Luxembourg. — A. RODIN
Tête de Femme

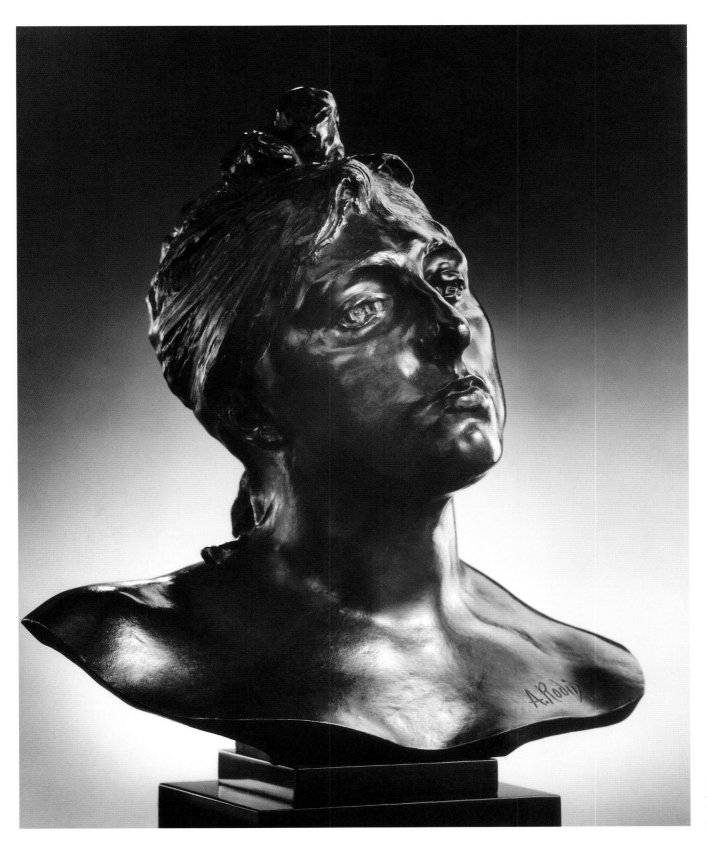

Fig. 376. *Bust of Madame Morla Vicuña* (cat. no. 133).

ment of and emphasis on her bust as noted by Plée, Rodin seemed to have created a new and daring society portrait.[7]

To Bartlett we also owe an important insight into Rodin's attitudes toward marbles:

Exquisitely charming as it is, the sculptor does not regard it as a fully satisfactory reproduction of his model, because it bears too much the impress of the character of the superior marble cutter[s] who executed it. Rodin understands the fine fact, that just in proportion that a marblecutter excels in his trade does he unconsciously give his work his own interpretation of the model which he copies. And this in spite of the most exacting means of mechanical measurement that he may employ. With a sensitive sculptor this is precisely what is not wanted, and the only way that he can insure the exact reproduction of his model in marble is to do the work himself. But this work is practically impossible, because he cannot afford to do it for the prices he receives. To escape this unfortunate condition of things, Rodin, like all good sculptors, prefers bronze reproductions of his models.[8]

Unavailable to even his most skilled assistants was the very conception of the portraits, that is, Rodin's insight into how a person's bearing was the key to their nature. Preceded by study of his subject during visits to the Chilean embassy, Rodin's actual modeling of the portrait reportedly was done quickly.[9] In this excellent example of his descriptive mode, one can see the originality of the sculptor's thinking. The woman's hair style is turned to sculptural advantage. What seems a topknot is actually a rose fixed to the woman's turban, which Rodin enlisted as a kind of rectified plumb to counterbalance the tilt of the shoulders. As with the *Portrait of Mrs. Russell* (cat. nos. 136–137), Rodin eased the transition from forehead to hair by allowing strands to invade the former, thereby giving a slightly informal, negligent air to the woman while also protecting the curvature of the brow under

strong light. The facial expression that intrigued contemporary critics, such as Plée, owes much to the treatment of the eyes, which imparts a dreamy or abstracted look. There is no clear circumscribing of the iris or even the pupil, and the eyes seen close up are like an abstract relief. In the plaster for this bronze it can be seen that Rodin etched into the surface over her right eye, and the area was smoothed with a spatula as well as raked. The cheek planes are made responsive to bone structure, flesh, and muscle, so that light does not pass over them uninterruptedly, and there are surprising highlights in the light patterns as a result. In contrast, those for the marble are more muted, and the shadows more graduated as the stone absorbs the light. Seen in profile, the shaping of the rearward projection of the neck compliments the projection of the facial profile.

NOTES

LITERATURE: Bartlett 1889 in Elsen 1965a 83–85; Cladel 1936, 149; Grappe 1944, 43–44; Tancock 1976, 517–20; Elsen 1981, 98–99; Hare 1984, 340–45; Pingeot, Le Normand-Romain, and de Margerie 1986, 233; Barbier 1987, 28; Grunfeld 1987, 168–70; Beausire 1988, 98; Goldscheider 1989, 190

1. This was the view expressed to the author by Judith Cladel, in 1950. In the early 1880s Rodin was making a number of portraits of well-known figures, which greatly enhanced his reputation as an artist. Goldscheider also indicated this date (1989a, 190). Beausire (1988, 98) believes this portrait was made around 1886–87.
2. Barbier 1987, 28.
3. Bartlett in Elsen 1965a, 83. See also Rosenfeld in Elsen 1981, 98–99.
4. The accessories would have been added for the marble version carved in 1887–88 (Barbier 1987, 28)
5. See Grunfeld 1987, 168.
6. Bartlett in Elsen 1965a, 84.
7. Ibid. Plée continued, "Her adorably modeled bosom pushes back the gown of fur that oppresses it. . . . It is the masterpiece of Rodin, and perhaps the masterpiece of the Salon."
8. Ibid.
9. Hare 1984, 341.

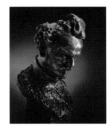

134

Bust of Henri Rochefort
(Buste d'Henri Rochefort), 1884

- Wax cast, 1883–84
- 14¾ x 8½ x 7⅝ in. (37.5 x 21.6 x 19.4 cm)
- Signed on back of stand: A. Rodin
- Inscribed on back of stand: DW1123
- Provenance: David Weill; his sale, Paris, 11 December 1916, lot 298; Ader, Picard, Tajan, Paris, 10 June 1974, lot 36
- Gift of B. Gerald Cantor, 1977.16

Figure 378

Referring to Henri Rochefort (1831–1913) as the Red Republican (and elsewhere as a "cold-eyed, turbulent, civic cynic; a fiery 'sagittary'"), Truman Bartlett described the genesis of this portrait:[1]

It was in . . . 1884, that Rodin began a bust of [Henri] Rochefort. From the very beginning things did not go well with the Red Republican. As the work went on he became more and more dissatisfied, and finally would not give any more sittings. His explanation of his experience at the sculptor's studio is amusing. He says: "I went to the studio in the morning, sat down ready for Rodin to begin. Then he would look at me for an hour or two, turn to his work and look at that for the same length of time, put a bullet of clay carefully on it, and by that time we were ready for breakfast. On returning to the studio he would go through the same preliminary operation, and then take off the bullet. The bust never will be done."

The sculptor, on his part, was equally dissatisfied with his sitter's impatience and total lack of appreciation, and, at last, he too became disgusted. But the bullets had told their little story in the production of a great work of characterization. Though not complete, it was cast in plaster, and declared to be, by Rochefort's assistant editor and friends, not only a superb likeness, but an astonishing piece of individualization. . . .

As time went on and Rodin's reputation increased, Rochefort experienced an awakened interest in the formerly despised bust of "bulleted" construction, and he indicated a willingness to resume the sittings he had before ridiculed. It was too late. The head that had looked Rochefort through and through by the hour, and had sent his cranium and visage into posterity as a powerful image of sculpture had its sense of what was due to it and to art.[2]

Rochefort was one of the most colorful figures in the Third Republic, having twice been forced into exile for his political views. Edouard Manet did three paintings for him: two depicting his escape from France (1880–81; Zurich, Kunsthaus and New York, private collection), and one a portrait (1881; Hamburg, Kunsthalle). Despite being born Marquis de Rochefort-Luçay, he became a political radical, with widely ranging and changing views, and the successful publisher of *La lanterne* (1868) and *L'intransigeant* (1880–1907), forerunners of what came to be known as "yellow journalism." He had a reputation for being totally unscrupulous.[3]

Léon Maillard knew the portrait and its subject and gave an astute reading of the former: "The physiognomy resides almost entirely in the prodigious development of the cranium and forehead, and in the acuity of the look; the head is bent down, the chin presses into the neck, as would be done by a tall man listening to a shorter person. Immediately we are part of the personal action of the writer . . . the sculptor has not neglected any of the curious discordance of the face with the creases of the cheeks, a rounded nose like a bird's beak, the jaw without significance and a chin without accent. He has noted them, but given them a subordinate place."[4]

Rochefort's bent pose suggests his reflective nature, and as Georges Grappe pointed out, it relates to the device used by Rodin in his bust of Victor Hugo. Maillard reminds us that such a posture may have derived from the writer's height but became habitual, for in all likelihood Rochefort sat for his portrait and thus would not have been looking down at the shorter sculptor.[5] The tedium of the sessions would have encouraged the sitter's introspection. From the sculptor's standpoint, however, it encouraged emphasis on the hard cranium, the pressure of the bone against flesh in the forehead, which is more demanding and rewarding of reading than the other portions of the face, especially in conjunction with

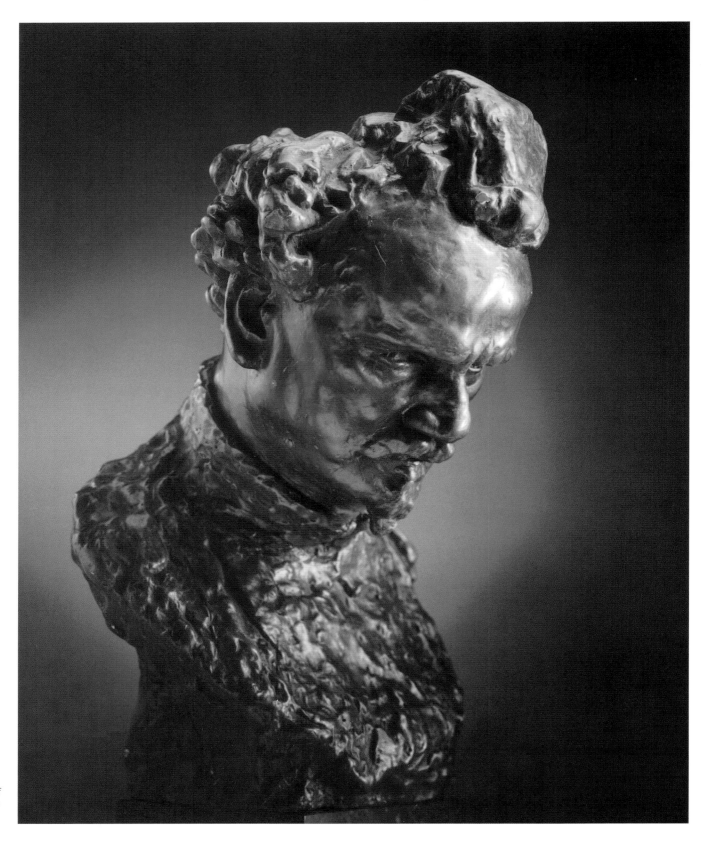

Fig. 378. *Bust of Henri Rochefort* (cat. no. 134).

the recession of the eyes. By the mid-1880s Rodin felt free to frame the face with the rough treatment of the hair and clothing, whose effect is to energize the passive pose. That Rodin saw fit not to rework the portrait suggests not only satisfaction with his characterization but with the sculpture as a work of art, aesthetically as well as psychologically complete.

The project began with a life-size, nude version, an antique type with neck and chest left bare, dated by Grappe to 1884.[6] A life-size, clothed version was then developed from the nude, a collar suggested at the neck, with the head leaning forward and bust disengaged at the back from the base. The clothed bust was enlarged in 1898 by Henri Lebossé.[7] As for the idea that the bust was never finished and Rochefort's offer after its exhibition in 1886 to sit again, Rodin told Paul Gsell: "He would never believe that my work had remained exactly as it was when I removed it from his place. 'You have retouched it a lot, haven't you?' he often repeated to me. Actually I had not so much as given it a stroke of my thumb."[8]

Rodin's use of a wax cast may have reflected the great popularity of the portrait and notoriety of its subject.[9] Green wax made the sculpture seem closer to patinated bronze than painted plaster. In its variations the portrait was widely exhibited internationally.[10]

NOTES

LITERATURE: Bartlett 1889 in Elsen 1965a, 56–57, 83; Maillard 1899, 109–10; Grappe 1944, 98; Judrin 1976, 123; de Caso and Sanders 1977, 279–82; Hare 1984, 303–10; Lampert 1986, 106, 216; Grunfeld 1987, 161–63, 270, 389; Goldscheider 1989, 186

1. Bartlett in Elsen 1965a, 83.
2. Ibid., 56–57.
3. For more on Rochefort, see de Caso and Sanders 1977, cat. no. 58; Grunfeld 1987, 161–63; and Roger L. Williams, *Henri Rochefort: Prince of the Gutter Press* (New York: Charles Schribner, 1966). On Manet's paintings, see François Cachin et al., *Manet 1832–1883*, exh. cat. Metropolitan Museum of Art (New York: Abrams, 1983), 465–70. Jules Dalou also modeled portraits of Rochefort (see Pingeot, Le Normand-Romain, and de Margerie 1986, RF 2577 and RF 3095).
4. Maillard 1899, 110.
5. Grappe 1944, 98.
6. Ibid., 41.
7. See Goldscheider 1989, 184–87, for the various versions and media.; for the enlargement, see Le Normand-Romain 2001, 171.
8. Gsell [1911] 1984, 62.
9. Wax casts exist in several sizes. See also Goldscheider 1989, cat. no. 139g.
10. See Beausire 1988, 403.

135

Bust of Omer Dewavrin
(Buste d'Omer Dewavrin), 1885

- Bronze, Georges Rudier Foundry, cast 1979, 5/12
- 10¼ x 7⅞ x 5¼ (26 x 20 x 13.3 cm)
- Signed on collar, right side: A. Rodin
- Inscribed on back of collar: Georges Rudier/Fondeur, Paris; on back of base, left: © By musée Rodin 1979; below signature: No 5
- Provenance: Musée Rodin, Paris
- Gift of the B. Gerald Cantor Collection, 1983.206

Figure 379

Omer Dewavrin (1837–1904) was the mayor of Calais in 1884 when Rodin was given the commission to commemorate the fourteenth-century heroic burghers of that city. Dewavrin and his wife were steadfast supporters of the sculptor. Even when out of office he remained a member of the city council and served as head of the monument committee. In 1885 Rodin wrote to Dewavrin, indicating that he wanted to do his portrait, and it was completed in July of that year.[1]

Rodin made more portraits out of friendship than by commission, and this less-than-life-size and rather straightforward likeness is an example of the former. After the commission for *The Gates of Hell*, that for *The Burghers of Calais* was the most important he had ever received. Rodin gave us a good, although not inspired reading of the man with his blocklike head, fleshy countenance, and carefully combed, curly hair. Animating the cubic form are the big lateral hollows below the temples and behind the full cheeks. With the trace of a cravat and jacket, the latter textured by the marks of a raking tool, Rodin showed his subject as a good, well-fed bourgeois, with a cuddling up of fat around the collar. Photographs of the bust are deceptive as there are many nuances in

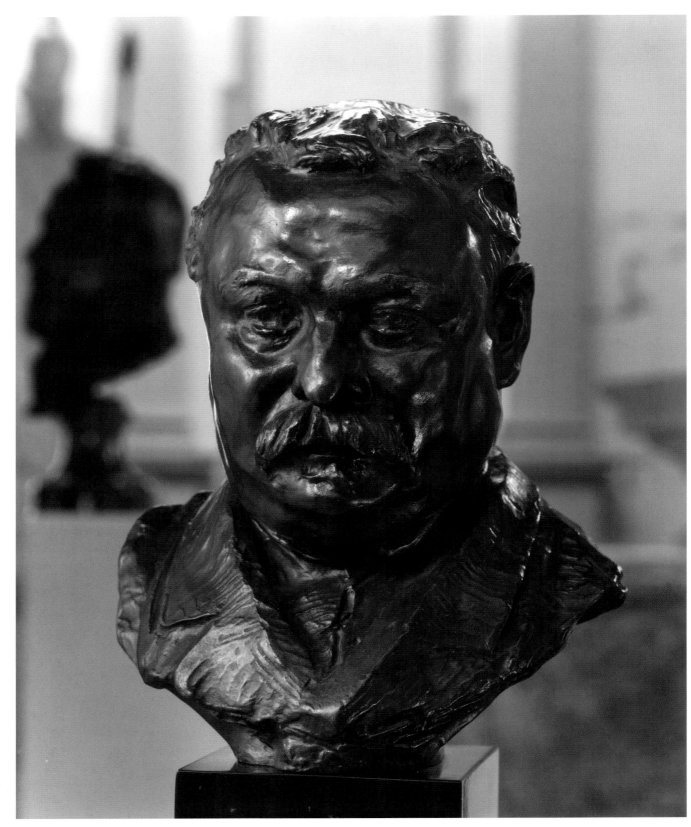

Fig. 379. *Bust of Omer Dewavrin* (cat. no. 135).

the forehead, especially on the man's right side. What animates and makes the face interesting are the divergent directions of the eyes, the left eye without an iris. The effect of this divergence, which Rodin found in nature but capitalized on, is to suggest that this able businessman had other personal and sympathetic dimensions. The Stanford bust shows none of the finicky reworking that comes with Rodin's later efforts. The sculptor gave a bronze and two plasters to Dewavrin, works much prized by his descendants.[2]

NOTES

LITERATURE: Cladel 1936, 155; Grappe 1944, 62; Jianou and Goldscheider 1969, 99; Judrin, Laurent, and Viéville 1977, 238; Ambrosini and Facos 1987, 118–19

1. Grappe (1944) dated the bust 1886 (62), but the correspondence cited by Viéville in Judrin, Laurent, and Viéville (1977, 238) makes the earlier date more accurate.
2. Judrin, Laurent, and Viéville 1977, 238.

136

Bust of Mrs. Russell (Buste de Mme Russell), 1888

- Wax cast
- 18½ x 9⅜ x 9¼ in. (47 x 23.8 x 23.5 cm)
- Signed on back of right shoulder: Rodin
- Inscribed below signature: No. 1
- Provenance: Charles Feingarten, Los Angeles
- Gift of Mr. and Mrs. William Janss, 1968.85

Figure 380

137

Bust of Mrs. Russell (Buste de Mme Russell), 1888

- Bronze, Georges Rudier Foundry, cast 1980, 8/12
- 13¾ x 10 x 10¼ in. (34.9 x 25.4 x 26 cm)
- Signed on back of left shoulder: A. Rodin
- Inscribed on back of left shoulder: Georges Rudier/Fondeur.Paris; below signature: No. 8; on rear edge: © by musée Rodin 1980; interior cachet: A. Rodin
- Provenance: Musée Rodin, Paris
- Gift of the B. Gerald Cantor Collection, 1992.144

Figure 381

*I*n Rodin's estimation Marianna Mattiocco della Torre (1863–1908), the Italian model who married the Australian impressionist painter John Peter Russell in 1888,

was the most beautiful woman in France.[1] We do not know the date of their meeting, but Rodin asked to do her portrait. The Russells and Rodin became good friends, with Rodin sometimes visiting the Russells's home at Belle-Île on the Channel coast, acquiring works by the painter for his own art collection. Perhaps inspired by her luminous beauty and blond hair, Rodin first modeled her in wax.[2] Unlike the first wax portrait, which must have been solid, the Stanford wax portrait is hollow and seems to have been a cast from a limited edition made by the Musée Rodin some time after the artist's death.[3] The subject's beauty and Rodin's interpretation of it so pleased the sculptor that he had the first metal cast made in silver and frequently exhibited it.[4] When he first submitted it to the Salon of 1889, however, it was rejected, causing Rodin to complain that the jury was jealous of him but that the bust "seemed better and better to my mind."[5] That year he exhibited the portrait in silver in his exhibition with Monet, and the year following it was admitted into the Salon nationale des beaux-arts.

Her Italian ancestry and what to Rodin may have seemed her classical beauty inspired him to use her likeness for several later marble sculptures, including *Minerva* (fig. 382), *Minerva with a Helmet* (1896), *Minerva without a Helmet* (c. 1896), *Pallas with the Parthenon* (1896), and *Ceres* (1896).[6] Absent in the stone versions is Rodin's audacious treatment in wax of the woman's forehead: first it seems roughened arbitrarily, but then it becomes apparent that Rodin may have been suggesting strands of her hair, thereby giving a more informal quality to the portrait. John Peter Russell, being an artist, well knew the differences between modeled and carved portraits. Responding to Rodin's inquiry as to the medium in which he would like his wife's portrait, the painter replied that it should be in silver "because that would be

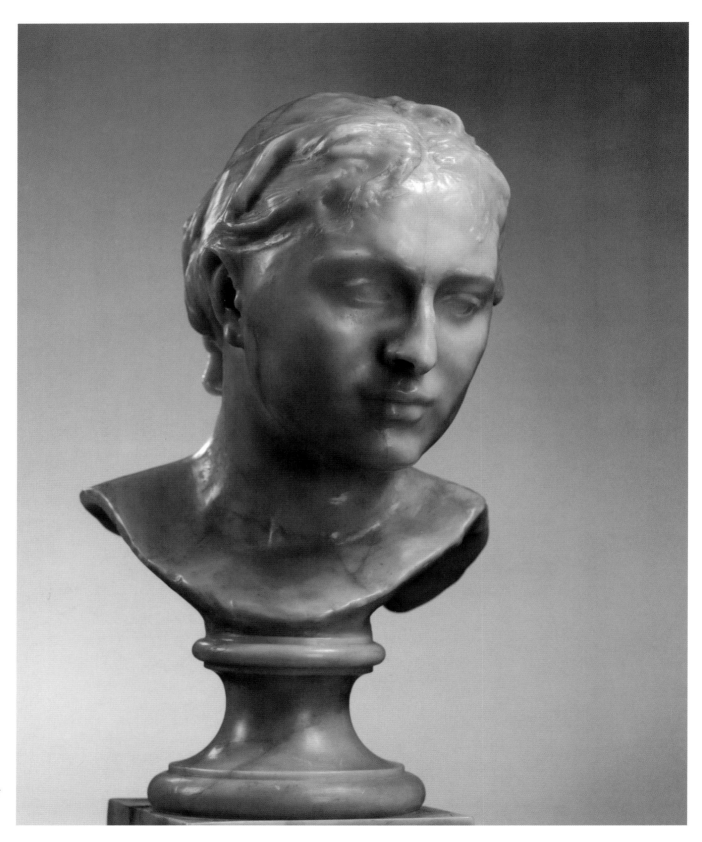

Fig. 380. *Bust of Mrs. Russell* (cat. no. 136).

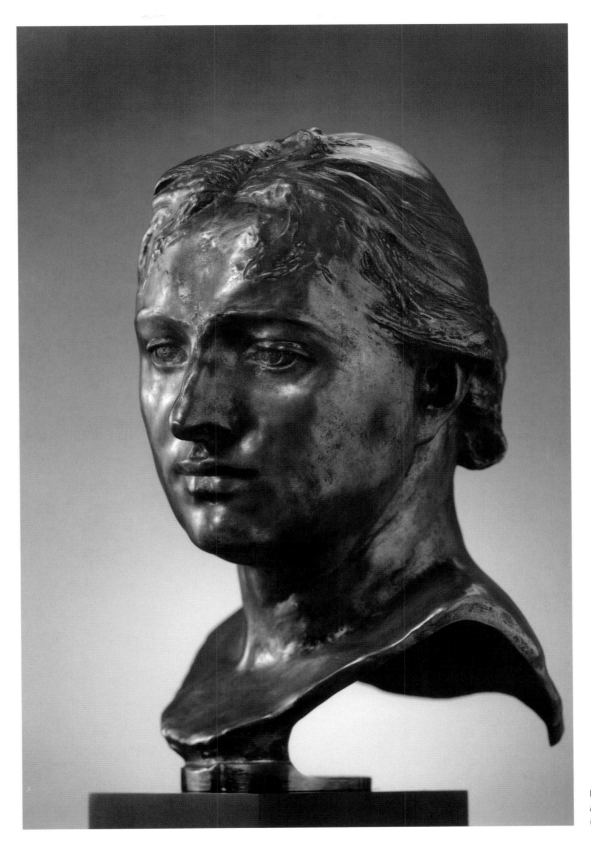

Fig. 381. *Bust of Mrs. Russell* (cat. no. 137).

the most exact reproduction of your creation. In short, what I want are all the nuances of your touch. I find that when the most perfect creases are copied into marble they lack the master's touch."[7]

The hollow Stanford wax is especially beautiful when seen against the light. The translucency and ability of wax to hold as well as refract light evidently appealed to Rodin, and it gave him a good foretaste of what could be achieved in carved stone. With the exception of those faces fashioned from anonymous models and the late portraits of Hanako, Rodin did not probe his female subjects psychologically. Rainer Maria Rilke was alert to how Rodin's faces of women could have meant more to the artist than just the identity of their features: "To Rodin the face of a woman seems to be part of her beautiful body. He conceives the eyes of the face to be the eyes of the body, and the mouth the mouth of the body."[8]

NOTES

LITERATURE: Grappe 1944, 68; Jianou and Goldscheider 1969, 101; Tancock 1976, 595–96; Hare 1984, 346–51; Miller and Marotta 1986, 104; Beausire 1988, 100, 109; Beausire 1989, 190; Butler 1993, 261–62; Levkoff 1994, 123; Le Normand-Romain 2001, 174

1. Hare 1984, 347.
2. Grappe dated the work to before 1888 (1944, 68). Antoinette Le Normand-Romain believes the portrait, which she dates 1888–89, was commissioned by John Russell and that Rodin then exploited the likeness in other works (letter to Bernard Barryte, 6 July 2001).
3. One cast was destroyed in an accident in a New York art gallery, and the author saw a wax cast in the reserve of the Musée Rodin. An edition of 12 casts in wax was authorized by the Musée Rodin in the 1950s, including the cast at the Picker Art Gallery, Colgate University (Marion J. Hare, "Rodin's Mrs. Russell," *The Picker Art Gallery, Colgate University, Annual Report/Bulletin* 1984–85 1, no. 4: 14). According to Antoinette LeNormand-Romain, a wax edition was made by the Musée Rodin in 1937. She adds that the Musée has three wax casts—two yellow and one black—in its collection in addition to a bronze version and the silver cast made for Mr. Russell (letter to Bernard Barryte, 6 July 2001). The Colgate University wax bears the number "0," the Stanford version, number "1". Number "2" is in Australia at the Queensland Art Gallery (acc. no. 1992, 137) whose chief curator, Anne Kirker, cites a letter (22 July 1888, from John Russell to Vincent van Gogh which dates the portrait. "Before I left Paris I lunched with M. Rodin (who has finished a fine head of my wife)" (letter from Anne Kirker to Bernard Barryte, 5 January 2001).
4. There seems to have been some confusion over whether the cast was in silver or in bronze and silver-plated. Beausire indicated it was silver-plated (1988, 105, 109) but later listed it as a silver cast (1989, 190). John Peter Russell asked for and acquired the first cast in silver and thereafter Rodin borrowed it on occasion for exhibitions.
5. Beausire 1988, 100. Rodin referred to the portrait of a woman, *L'Italienne*, which Beausire indicated was probably Mrs. Russell.
6. See Tancock 1976, figs. 109, 109-2–8. Hare pointed out that *Athena with the Parthenon* may have been inspired by the recent discovery of an ancient Athena with a temple on her head, which Rodin could have seen in Paris (1984, 349).
7. Russell to Rodin, 17 October 1888, quoted in Butler 1993, 262.
8. Rilke in Elsen 1965a, 134.

Fig. 382. Jean-François Limet, *"Mrs. Russell as Minerva"* c. 1896 in marble with *"Monument to Victor Hugo"* in background (A150).

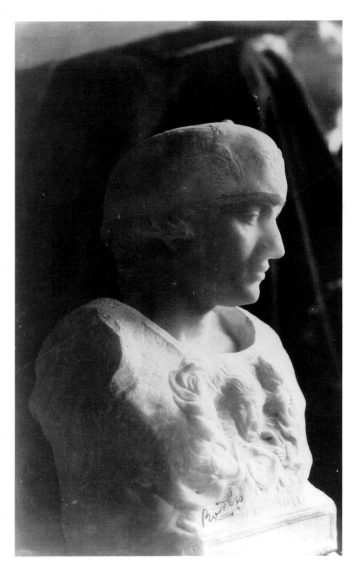

138

Small Head of a Man (Esquisse pour la tête de Jacques de Wissant), 1885

- Bronze, Georges Rudier Foundry, cast 1968, 11/2
- 4½ x 4¼ x 3½ in. (11.4 x 10.8 x 8.9 cm)
- Signed on left shoulder: A. Rodin
- Inscribed on back of base: G. Rudier/Fond. Paris; below signature: No. 11; under bust: © by Musée Rodin 1968
- Provenance: Stuart A. Fine, Los Angeles
- Gift of the Iris and B. Gerald Cantor Foundation, 1974.75

Figure 383

*M*odeled in the artist's hand, this small étude is a remarkable portrait of a strong-featured man who caught Rodin's interest. It is one of a series of small heads in the Musée Rodin reserve about which we know nothing.[1] Rodin let the character of his model's strong head, presumably made spontaneously from a subject as yet unknown, speak for itself. There is no style, no formula, no applied expression to this lean visage, just Rodin engaged by the identifying asymmetry of the features, the powerful configuration of the man's neck, big lips, and protruding nose. The profiles announce a rapidly receding forehead from a keel-like nose. Astonishing is the sense of the bony structure of the head achieved so rapidly with fingers and tools. Here is Rodin redefining sculpture as the hole and the lump, with the latter fashioning forehead, nose, cheekbones, and chin. Hollows make up the eyes and cheeks. Ears were important to Rodin even in an étude, and they help balance the protuberance of the nose and also activate the otherwise continuous, smooth contour of the head. One can see that Rodin added

small clay patches to the back of the head to be faithful to its shape and proportions.

NOTES

LITERATURE: Judrin, Laurent, and Viéville 1977, 165

1. This head has been suggested by Laurent (in Judrin, Laurent, and Viéville 1977) as a possible sketch related to the *Second Maquette for "Jacques de Wissant"* in *The Burghers of Calais* (cat. no. 24).

Fig. 383. *Small Head of a Man* (cat. no. 138).

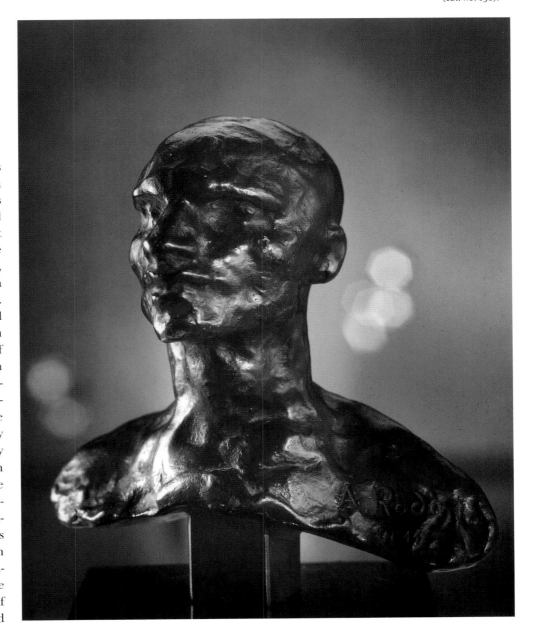

139

Head of Iris (Tête d'Iris), c. 1890

- Bronze, Susse Foundry, cast 1969, 1/12
- 7½ x 5 x 6½ in. (19.1 x 12.7 x 16.5 cm)
- Signed on lower left edge: A. Rodin
- Inscribed on back of base: Susse Fondeur. Paris.; below signature: No. 1; on right edge: © by Musée Rodin 1969
- Provenance: Musée Rodin, Paris
- Gift of the Iris and B. Gerald Cantor Foundation, 1974.85

Figure 384

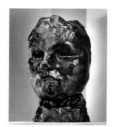

140

Monumental Head of Iris
(Iris, tête monumentale), c. 1890, enlarged 1898(?)

- Title variation: *Head of Demeter*
- Bronze, Georges Rudier Foundry, cast 1970, 7/12
- 24 x 13 x 13 in. (61 x 33 x 33 cm)
- Signed on base, left: A. Rodin
- Inscribed on back of base, right: Georges Rudier/Fondeur Paris; on base, left: © by musée Rodin 1970; interior cachet: A. Rodin
- Provenance: Musée Rodin, Paris
- Gift of the Iris and B. Gerald Cantor Foundation, 1974.64

Figure 385

*I*n the view of Georges Grappe the small head, derived from *The Gates of Hell*, was intended to surmount the figure of *Iris, Messenger of the Gods* (cat. no. 185). He also believed that in its enlarged form, the *Monumental Head of Iris* was a fragment of a never executed colossal statue.[1] Grappe was correct in that the head was attached (with wax) to the body of one of Rodin's modeled acrobatic dancers in the pose of *Iris, Messenger of the Gods*; when exhibited in Paris in 1911, it was known as *Large Woman with the Head of Iris*.[2] In the small-size Stanford cast there is no back to the head; it is really a mask, which may have

prompted Grappe to associate it with *The Gates of Hell*, where in the even smaller (almost four-inch) version, it might have been intended for the line of heads above *The Thinker*.[3] This head, however, does not appear on the portal as we know it today. The enlarged head was also based on a mask version, as shown by the roughly modeled neck and the way it seems to intrude into rather than grow from the head in the back.

In the *Monumental Head of Iris* Rodin dared to be formless. Its enlargement was likely made in 1898, although it was not a mechanical or literal enlargement.[4] Guided by Rodin (that is, if Rodin himself did not literally have a hand in the final clay), Henri Lebossé made the head even more shapeless by the standards of the time. While we cannot be sure that the final enlargement was made from a plaster of the seven-inch Stanford cast, it is worth examining their physical and qualitative differences. With this larger-than-life head, first exhibited in Amster-

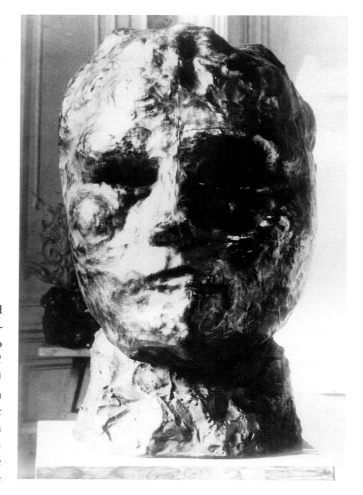

Fig. 386.
Eugène Druet,
"Head of Iris" in
bronze, c. 1898,
Hôtel Biron
c. 1912 (A122).

dam and The Hague (1899) and then in Prague (1902), Rodin was making a powerful sculptural statement to the world about new possibilities in sculptural form. After the 1911 Paris exhibition, Rodin again exhibited the head separately in Rome (1913) as *Head of Demeter*, then in London (1914) and Edinburgh (1915) as *The Large Head of Iris*.[5] As with his *Monumental Head of Jean d'Aire* (cat. no. 21) and *Monumental Head of Pierre de Wissant* (cat. no. 31), Rodin was introducing a new genre for sculpture: self-sufficient monumental expressive heads that were not necessarily portraits. This was a prelude to such subsequent monumental heads as those by Otto Freundlich, Naum Gabo, Henri Gaudier-Brzeska, and Alberto Giacometti as well as Pablo Picasso's Boisgeloup series.

One good reason for Rodin's resistance to classification as a realist, naturalist, or symbolist is that in works such as this, derived from a living, hired model, he wanted mystery, a certain ineffable quality. Among Rodin's sculptures, the *Monumental Head of Iris* offers one of the most powerful reminders that the language of the sculptor's experience is not that of verbal discourse. In both sizes we are confronted by a head with an inscrutable expression. Set in an almost anatomically motionless face, the eyes are excavated hollows with no suggestion of irises, thereby imparting the dualistic impressions of a personage who seems to see all or nothing, a quality Rodin may have associated with a messenger of the gods who would have seen everything in the worlds of men and deities. What is so unusual in the ocular areas is that there is animation in the surfaces around them rather than in the black holes of the eyes themselves. It is the surprising expression of the mouth, resistant to easy verbal description, that undermines the otherwise noncommittal, masklike character of the whole. In the enlargement, the line made by the meeting of the lips rises and falls, making an asymmetrical arc; the muscles below the lower lip are tensed or bunched off-center. The upper lip gives a suggestion of pulling to its right, the lower to its left. The twin indentations just under and flanking the chin seem caused by the upward contraction of the facial muscles just above them. It is not an expression of joy or calm but invites such characterizations as bitterness and resignation. The downward curve of the mouth is more pronounced in the enlargement, whereas in the smaller version the line of the lower lip that extends into the muscles around it is straighter.

The monumental version differs from its predecessor

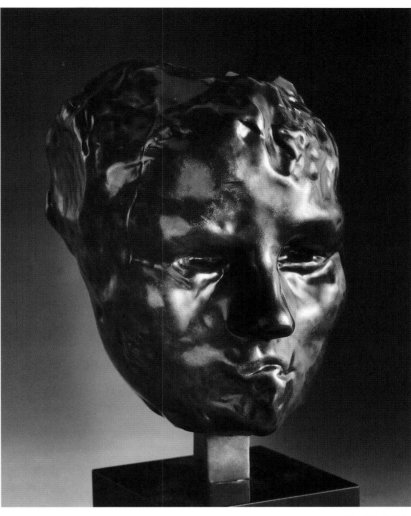

Fig. 384. *Head of Iris* (cat. no. 139).

by having a more consistently eventful surface. This is especially true in the forehead directly above the nose. Below the cheekbones the surfaces are more densely inflected. The patch on the nose in the smaller head is enlarged and more integrated with the feature, giving a new sense of its being slightly twisted. The nose is more squared, providing a stable mooring for the face against the increased agitation of the cheek surfaces. In its final enlargement the head of Iris seems swollen: enlarged indentations in the woman's right cheek and under the eyes lose their earlier pockmarked character and sharpness, and there is less evidence of the cranial structure of the head, all of which contributed to Rodin's challenge of form.

The enlargement follows loosely the freehand improvisations in the hair, including the concavity above and behind the area of the woman's missing right ear. Rodin

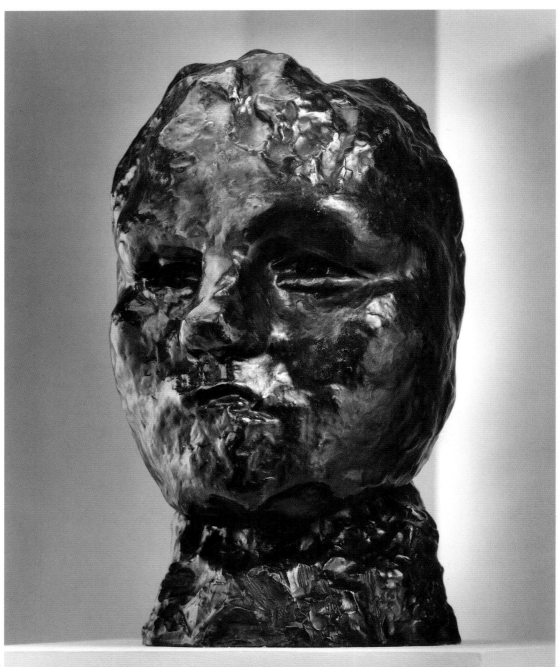

Fig. 385.
*Monumental Head
of Iris* (cat. no. 140).

made no textural distinctions between hair and flesh. This abstract handling of the hair, which does not try to mirror the spherical character of the top of the head, paralleled the coarsened treatment of the broad areas of the face, with the result that Rodin earned an overall expressiveness of facture, a quality emphasized in the photograph by Eugène Druet (fig. 386). The result shows how in works such as the *Monumental Head of Iris* Rodin mediated between traditional views of expression in art based on the action of features that reflect the sub-

ject's state of mind (the model's psychology) and the modern concept of expression residing in the artist's feelings inspired by the subject and the evolving image (the artist's psychology), which are manifested in the sculpture as a totality. Rather than depicted as deriving from the model, modern expression comes from the artist: that of the other is replaced by that of the self. With this great head, especially in its monumental version, Rodin does both.

When Rodin ventured into unknown territory, like

Picasso, he always took a round-trip ticket. The Iris heads were made for Rodin's personal study and pleasure, and he must have known that they would not be sought after by collectors. He continued to make more traditional portraits to the end of his life. This was done not only to support his studio operation but also because he genuinely enjoyed portraiture as his greatest personal challenge. But Rodin was also conscious of his historical legacy and what would have the greatest importance and interest for future sculptors. For this reason he gave a bronze cast of the *Monumental Head of Iris* to the Victoria and Albert Museum in 1914.

NOTES

LITERATURE: Grappe 1944, 87; Elsen 1963, 116, 119; Jianou and Goldscheider 1969, 103; Tancock 1976, 288, 292; Alley 1981, 642; Lampert 1986, 178, 222; Beausire 1988, 324; Levkoff 1994, 139; Le Normand-Romain 2001, 73

1. Grappe 1944, 87.
2. Beausire 1988, 324, included photographs of this sculpture in bronze and in plaster with wax. The full figure with head was intended as one of the muses in the *Monument to Victor Hugo*; see also cat. no. 185, note 8 and fig. 242.
3. Grappe 1944, 87, cat. no. 142, where this small head is called *Petite tête de damnée* (Little head of a damned soul). The small head is catalogued in de Caso and Sanders 1977, cat. no. 35.
4. See Lebossé notes in Elsen 1981, 257.
5. Beausire 1988, 151, 233, 324, 343, 353, 359.

141

Bust of Madame Fenaille
(*Buste de Madame Fenaille*), c. 1900

- Title variation: *Bust of Mme F.*
- Plaster
- 25¾ x 24¾ x 21 in. (65.4 x 62.9 x 53.3 cm)
- Provenance: Maurice Fenaille; Georges Grappe; Ader, Picard, Tajan, Paris, 22 March 1979, lot 33
- Gift of the B. Gerald Cantor Collection, 1983.205

Figure 387

One of Rodin's most devoted and effective supporters was the industrialist and collector Maurice Fenaille (1855–1937). The 1897 publication of beautiful facsimiles of the artist's drawings was due to Fenaille. He also commissioned several works from the artist, and these included a portrait of his wife, Marie (née Colrati; 1869–1941), which was carved by a *practicien* named Raynaud between 1898 and 1900 and completed in 1907. The state acquired the portrait from Fenaille that year, and another carving was made on his behalf at about that time.[1] The Stanford plaster appears to have been cast from the first carving, now in the Musée Rodin.[2]

What may be unusual about this work in the history of portraiture is that though sitting up, the subject seems asleep, the right side of her chin nestled in the folds of her robe. Perhaps she tired during the long posing sessions, but as Marion Hare discovered, from the family comes evidence that she would drift off in other circumstances as well. "When in Paris Mme Fenaille always carried out her social duties gracefully; often at soirees, however she would become bored and would doze. According to her daughter, her posture, particularly the inclination of her long elegant neck, intrigued Rodin. He made numerous studies of her in the late 1890s, all with her neck distinctly inclined, and several in which she is dozing."[3]

Beginning in the 1880s and inspired by Michelangelo, Rodin had developed what came to be known as a *non-finito*, or unfinished, mode of carving, which left areas of the stone rough, with chisel marks exposed.[4] By 1888 Rodin had integrated rough cuts and smooth finish in such carvings as his *Danaid* (cat. no. 154), but with the portrait of Madame Fenaille he used the *nonfinito* as a motif to evoke the woman's hair as well as to terminate the lower section of the bust.[5] Rodin's inventiveness with treating a woman's hair, starting with his *Young Girl with Roses in Her Hair* (cat. no. 127), culminates with what for the time was a daring display of an arrested stage of the carving process. These graduated definitions of hair and costume are in poetic accord with the dreamlike state of the woman and are also reminiscent of such treatment in the painted portraits by the sculptor's friend Eugène Carrière, which Rodin collected.

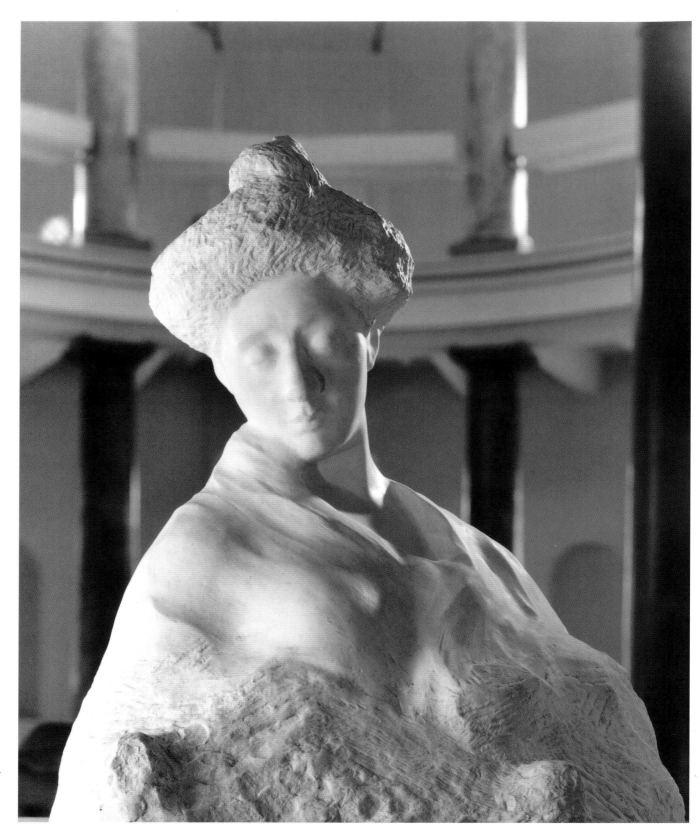

Fig. 387. *Bust of Madame Fenaille* (cat. no. 141).

It was Rodin's practice to have plaster casts such as this made from his carvings to keep as a record, to exhibit, to use as gifts, and quite probably to sell. Constantin Brancusi (1876–1957), the apostle of direct carving, was the most famous of those who criticized Rodin for his use of technicians to carve the stones. Learning from the older man, however, Brancusi, whose annual production was modest, made at least plaster casts of his own carvings in order to have something to exhibit after he parted with such sculptures as *The Kiss* (1908, Philadelphia Museum of Art).[6] With her inclined head, Rodin's facially smooth-surfaced *Bust of Madame Fenaille* also anticipates Brancusi's use of closed eyes in the series of heads, among them *The Sleeping Muse* (1910; Hirshhorn Museum, Washington, D.C.), which brought his art near to abstraction. Brancusi worked several months for Rodin in 1907, at which time he may have seen the second carved portrait of Madame Fenaille, and more certainly, the first, when it was put on permanent display at the Musée du Luxembourg in 1908.[7]

NOTES

LITERATURE: Grappe 1944, 102; Jianou and Goldscheider

1969, 107; Hare 1984, 385–91; Barbier 1987, 38–43;; Durey 1998, 63–71

1. Barbier (1987, 38–43) cites one marble completed in 1907 and a later one carved between 1905–08. For the marble version of 1898–1900 shown in Rodin's 1900 retrospective, see Le Normand-Romain 2001, 252
2. Rodin's portraits of Madame Fenaille were the subject of a recent exhibition that clarifies both the chronology of the numerous studies Rodin produced and the complicated issues of ownership; see Antoinette Le Normand-Romain in Durey 1998, 24–33 and cat. no. 52.
3. Hare 1984, 386.
4. See Rosenfeld in Elsen 1981 for the best discussion of the subject, especially 94–98.
5. Ibid., 96. Rosenfeld tracked the evolution of Rodin's carving style. The Stanford plaster also shows the elevated, cubic section atop the head where a *point de repère* (nail driven into the stone as a reference point) was located for use by the *praticien* to station one leg of his calipers when measuring distances.
6. The author owes this information to Sidney Geist, who shared it on the occasion of a plaster cast of a carved Brancusi *Kiss* coming on the New York art market.
7. For the marble portraits, see Barbier 1987, 38, 40.

142

The American Athlete, Portrait of Samuel S. White, 3rd (L'athlète), 1901–04

- Title variation: *The Athlete*
- Bronze
- 15 x 11 x 11½ in. (38.1 x 27.9 x 29.2 cm)
- Signed on base, right side: Rodin
- Provenance: Ader Picard Tajan, Paris, 22 October 1968, lot 25
- Gift of the Iris and B. Gerald Cantor Foundation, 1974.58

Figure 388

This is the first of two versions of a full-length portrait made between 1901 and 1904 of a young American athlete named Samuel Stockton White (died 1952; fig. 389), who won a medal at Cambridge University for hav-

ing the best physical development in the United Kingdom.[1] On a visit to Paris in 1901 he offered his services to Rodin as a model.[2] By White's own account, after trying him in several standing poses, the artist suggested that the muscular young man assume his own. Knowing how tiring modeling sessions could be, White later recalled that he chose a seated position, "somewhat similar to *The Thinker.*"[3] Not only because he wanted his subjects to dictate their own postures but because White's legs were proportionately thin in comparison with his upper body, the artist accepted White's decision, as it allowed him to focus on what most appealed to him as a sculptor. It appears that the young body builder posed several times over a period of years, and he told Georges Grappe that this required three transatlantic crossings.[4] The sculpture was exhibited as *American Athlete* in Düsseldorf (1904) and Philadelphia (1905), White's home city.[5]

There are two versions of what is in effect a portrait of a man's impressive body. The main difference between them is the position of the head. The Stanford version, in which White looks straight ahead, is considered the

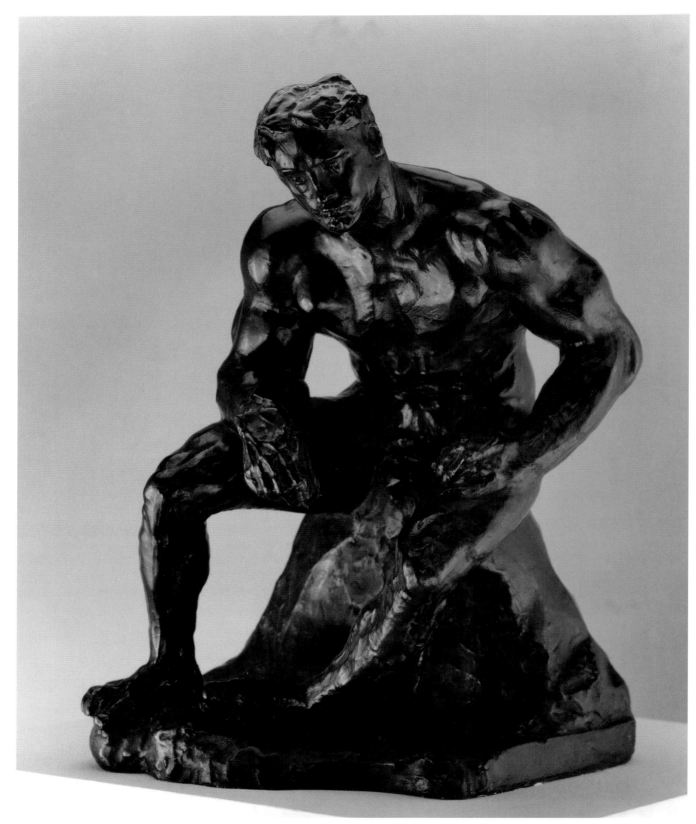

Fig. 388.
*The American
Athlete, Portrait
of Samuel S.
White, 3rd* (cat.
no. 142).

first by Tancock and by de Caso and Sanders, and in the second, a plaster cast of which is in the collection of the Fine Arts Museums of San Francisco, he looks to his right (fig. 390).[6] What Rodin achieved was an image of strength in repose, a relaxed figure evincing the potential of great physical power. Rodin does not square away the figure by planting both feet solidly on the ground, but he accepted the subject's more casual and natural penchant to position his left foot on its side. This position destabilizes the base but sets in motion a more active balancing of the form, which contributes to the subject's air of easy self-confidence and dominance of the space he occupies. One is struck by how obvious paired relationships, like the same body joints, when surveyed in the round, are made more active because they lie in different planes both vertically and horizontally. Seen from the profiles, there are big thrusting movements in and out, such as the forward curve of the torso, the backward thrust of the man's left elbow, and forward direction of

his right forearm. Reminding us of his cubic compositional sense, Rodin has the forehead line up in a plane with the right knee. The sculptor gave variety to the facture by graduating definition such as the more detailed treatment of the hands that contrasts with the broader planes of the arms and legs. This may not have been as apparent to White who recalled, "Well do I remember the care with which the master worked. He used little pellets of clay, with a most minute attention to every detail."[7] What may have had the greatest appeal to Rodin was White's broad, muscular back, which provided the sculptor with an ample fluid field of mounds and depressions to engage the light. It is the effect of light passing across this rugged terrain that further suggests the incongruity of energy in repose.

Twenty years earlier Rodin had used a strong man from the streets to model for *Adam* (cat. no. 40) and its offspring, *The Shade* (see cat. nos. 43–44), but with White there was to be no robing of the subject with a title. *Amer-*

ican Athlete suited the subject and the early twentieth-century movement away from literary nominations. Rodin may have known White's athleticism if the young American had performed what he called "hand balancing," which helped him become a medalist. Given that White was auditioning as a potential model, it is not improbable that he tried to show the sculptor what he could do with his body. Although he does not so record it, White may have been the inspiration for several instantaneous drawings in an album showing muscular males performing, which included a one-handed handstand, an extremely difficult pose that was probably not in the repertoire of the average professional male model.[8]

NOTES

LITERATURE: Lawton 1906, 269; Grappe 1944, 111; Jianou and Goldscheider 1969, 109; Tancock 1976, 322; de Caso and Sanders 1977, 295

1. Tancock 1976 has the best account of the background of this work (318, 322).

2. De Caso and Sanders pointed out that it was not unusual at this time for athletes to pose for sculptors (1977, 298 n. 1).

3. White to M. Mason, 25 May 1949, quoted in Tancock 1976, 318.

4. Grappe 1944, 111.

5. Beausire 1988, 253, 264.

6. Tancock 1976, 321; de Caso and Sanders 1977, 295.

7. *Evening Bulletin* (Philadelphia), 17 February 1926, quoted in Tancock 1976, 318.

8. There seems to have been no other model used by Rodin who was recorded as having such extraordinary athletic capabilities as White. See Judrin 1984–92, vol. 1, especially no. 464 (the drawing is reproduced upside down; it is correctly oriented in Elsen and Varnedoe 1971, fig. 61) and also series nos. 470–79. One or two of these drawings indicate that the man has a beard, however, which the American did not have. White's meeting with Rodin in 1901 would accord with the time when Rodin was using his invention of not looking at the paper while drawing the model.

143

The Tempest (La tempête), 1886(?)

- Title variations: *The Marathon Runner, Terror, The Wind*
- Bronze, cast c. 1903
- 13¾ x 11¾ x 11 in. (34.9 x 29.8 x 27.9 cm)
- Signed on right side: A. Rodin
- Provenance: Sotheby's, London, 5 December 1968, lot 259
- Gift of the Iris and B. Gerald Cantor Foundation, 1974.69

Figure 391

Fig. 392. Jean-François Limet, "The Tempest," c. 1903, in marble (A149).

*T*his is a bronze casting made after a marble version of a work called by many names, including *Terror* and *The Marathon Runner*. There are two known marbles: one in the Musée Rodin, the other in the Metropolitan Museum of Art. Based on the exact reproduction of its chisel marks, it is from the latter that the Stanford bronze was made. The original drill holes were plugged, and the chiseled textures are more muted in the bronze. Barbier dated the plaster from which the first, or Musée Rodin,

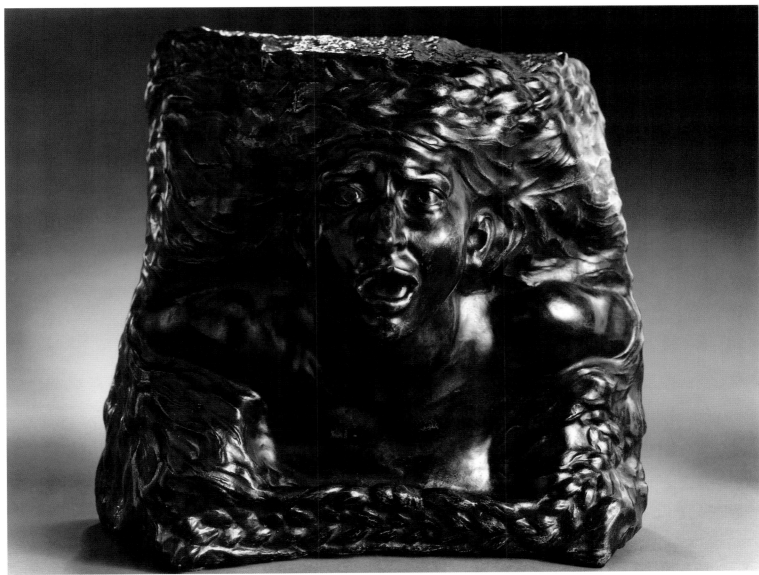

Fig. 391. *The Tempest* (cat. no. 143).

marble was made to possibly 1886 or earlier, and stylistically this seems reasonable.[1]

For *The Tempest* there are more questions than answers. What or who inspired this dramatic sculpture is not known. Perhaps it was intended for *The Gates of Hell* as one of the emblematic heads, such as that of the *Crying Girl* (cat. nos. 58–59). The explosive expression, the relief that is so high that it is almost in the round, the integration of the figure with an abstract setting prompt the association with the evolving portal. Further, Nicole Barbier noted that *The Tempest* was a reinterpretation of *The Cry* (generally dated 1886) and suggested that *The Tempest* may have been exhibited at an 1886 exhibition

Rodin had at the Galerie Georges Petit; the words *hurle de terreur* (howl with terror) were associated with a figure of a woman in marble that was likely *The Tempest*.[2] Given the irregular shape of the block from which the work was carved in both marbles, it was not intended as architectural decoration, and it is in effect a freestanding relief (fig. 392). The block from which the head was carved may have been of an irregular shape that Rodin chose not to have squared off, favoring the slant of the back, which gives propulsion to the thrusting head.

It is hard to see or speak of Rodin's actual touch, as the fine features of the woman were redone by a skilled *praticien*. Leaving so much *gangue*, or unfinished stone,

OTHER PORTRAITS AND SYMBOLIC HEADS / 477

was Michelangelo's legacy to Rodin. Despite the masses of flowing and braided hair, this is not an example of Rodin being influenced by art nouveau, as he hated stylization. The overall design with its powerful, decorative rhythms, including the adaptation of the woman to the block, is very strong, seen not only frontally but in its profiles. The decorative rhythms are rectilinear and subordinate to Rodin's own cubic approach.

NOTES

LITERATURE: Grappe 1944, 102; Jianou and Goldscheider 1969, 107; Tancock 1976, 607, 610, 612; Vincent 1981, 14–15; Barbier 1987, 86; Levkoff 1994, 117

1. Barbier 1987, 86. Although Barbier indicates this the

marble was certainly finished in 1901, it was probably finished earlier. According to Antoinette Le Normand-Romain the marble probably dates to circa 1886 as it was presumably exhibited at the Gallery Georges Petit in 1886 (letter to Bernard Barryte, 15 February 2001). Grappe put the date of the first marble at 1898 (1944, 102); Barbier recorded the Metropolitan Museum of Art's marble as having been begun by Rodin's excellent carver Georges Mathet in March 1903.

2. Barbier 1987, 86; through the work's association with *The Tempest*, the date of *The Cry* was similarly revised to possibly around 1886. Beausire lists *The Tempest* as possibly having been shown in 1886 (1988, 94). For further discussion of *The Cry*, see Levkoff 1994, 117. Le Normand-Romain (1999, 53) dates the Musée Rodin marble 1886–93 and relates the figure to the *Crying Woman* (or *Crying Girl*).

144

Head of a Man with One Ear (Tête d'un homme avec une seule oreille), c. 1898–1912

- Plaster
- 5 x 3 x 5 in. (12.7 x 7.6 x 12.7 cm)
- Provenance: Charles Feingarten, Los Angeles
- Gift of Albert and Patricia Elsen in memory of Charles Feingarten, 1982.329

Figure 393

*I*n a long essay J. A. Schmoll argued that this head is a portrait of Rainer Maria Rilke (1875–1926), who served as Rodin's secretary from September 1905 to May 1906 and who wrote and lectured about the sculptor.[1] They met in 1902 when the poet was writing his classic essay on Rodin, which was published in 1903.[2] Their relationship, interrupted many times and for different reasons, lasted until 1913. Schmoll reproduced portraits, photographs, and caricatures of Rilke to make his case and pointed out that Rilke lived with Rodin on several occasions. Using descriptions of Rilke given by others, as well as the visual documentation, the argument includes featural resemblance. (The most striking is the way in life and in the sculpture the man's nose and lips project out

beyond the end of his chin.) Schmoll could be correct, his research was extensive, and he made an intriguing case worth taking seriously, but finally he is not convincing.

There are some problems. Rilke in his extensive writings and numerous letters to the artist never mentions that he sat for a portrait or knew of the existence of a study for one. (Why would Rodin have kept it from his ardent admirer?) There was no problem of Rilke's accessibility for months on end. The young poet would have been thrilled and honored to have posed for the man he idolized. Schmoll pointed out that Rodin was known to have made heads from memory, but why would this have been necessary in Rilke's case? One of the obvious disparities between photographs of Rilke and Rodin's plaster is the absence of a mustache and hair in the latter. Rodin never avoided modeling hair, as he was interested in the total physiognomy of his subjects. Schmoll pointed out that Rilke did not have a mustache when he was young, as caricatures confirm, but we do not know the date of this head. Also, there is no evidence that he was bald—quite the contrary—and the plaster shows no indication of hair atop the cranium. In fact, the extensive editing of the plaster made by means of a sharp instrument, such as a knife, shows no indication of hair. The cranium seems to have been built up with smashed clay pellets.

There does not seem to have been a bronze cast of this head made during Rodin's lifetime. It does not appear in the literature until 1962, when a bronze was shown in the Louvre exhibition "Rodin inconnu."[3] Along with the

identity of the sitter, the sculpture itself raises questions. Outside those in the Musée Rodin, this plaster head is unusual in that it shows how Rodin would rework or edit in plaster quite probably in preparation for casting in bronze. The cuts made with a sharp instrument occur throughout the face, especially the cheeks, as well as the top of the head. They are nondescriptive, but to what end? Was Rodin thinking in terms of bronze and how he wanted the future metal surfaces to react to light. Why only one ear and one eyeball? (There is no evidence that the man's right ear had broken off.) If this was a study after Rilke, what accounts for the very narrow, or pinched, area at the top of the nose as this was not a characteristic of the poet's features? It is one of the qualities of Rodin's art that a head such as this, missing some of its anatomical parts, could look so natural.

NOTES

LITERATURE: Goldscheider 1962, 80; Goldscheider 1967, 71; Bowness 1970, 78; Schmoll 1983, 250–66

1. Schmoll 1983, 250–66.
2. Regarding Rilke's 1903 essay, see earlier discussion in present catalogue (cat. no. 97, note 14).
3. It appears in the Louvre catalogue (Goldsheier 1962, cat. no. 74) as *Homme avec une seule oreille* (Man with one ear). The casting of this bronze and its edition was posthumous. Subsequent exhibitions of the head in the literature were reviewed by Schmoll (1983, 251).

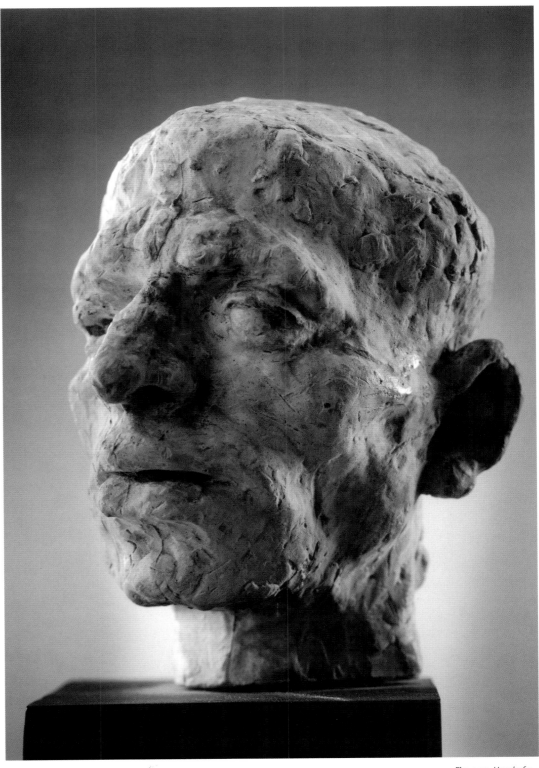

Fig. 393. *Head of a Man with One Ear* (cat. no. 144).

145

Bust of Georges Clemenceau
(*Buste de Georges Clemenceau*), 1914

- Bronze, Georges Rudier Foundry, cast 1970, 12/12
- 18⅞ x 11 x 11 in. (47.9 x 27.9 x 27.9 cm)
- Signed on base, left side: A. Rodin
- Inscribed on back of base, right: Georges Rudier/Fondeur.Paris.; on left, near base: © by musée Rodin 1970
- Provenance: Musée Rodin, Paris
- Gift of the Iris and B. Gerald Cantor Foundation, 1974.67

Figure 394

To tell the truth, there is no artistic work that requires as much penetrating insight as the bust and the portrait. People sometimes believe that the profession of the artist demands more manual skill than intelligence. It suffices to look at a good bust to redress this error. Such a work is the equivalent of a biography.[1]

*W*hen he said this to Paul Gsell, probably around 1911, Rodin could well have had in mind his efforts to penetrate to the essential Georges Clemenceau (1841–1929; fig. 395). The Clemenceau bust was the last important portrait Rodin finished, and it may have been his greatest. Excellent as they are, his subsequent portraits of Pope Benedict XV (cat. no. 146) and Etienne Clémentel (1915–16; see figs. 20–21) were not fully realized. No other portrait by Rodin required as many studies and versions as that of the great French political leader known as "The Tiger"—29 by the author's count, among them the 14 here illustrated. Other sitters had often expressed displeasure over what Rodin had portrayed, but Clemenceau went further: he would not accept the artist's gift of a bronze cast, and he forbade its exhibition with his name. He was shocked that Rodin had made of him a "Mongol general." Rodin's ironic rejoinder was, "Well you see, Clemenceau, he is Tamerlane, he is Genghis Khan."[2] Until his death Clemenceau made fun of Rodin as a result of the portrait and all the sittings that went into it.

A year younger than Rodin, Clemenceau was trained as a physician but became a journalist and politician early in his career. After defending his medical thesis before the Faculty of Medicine in Paris in 1865, he went to America, where he remained for almost four years teaching French and writing a large number of articles on the United States after the Civil War. The Franco-Prussian War ended the regime of Louis Napoleon, which Clemenceau hated and which had imprisoned him for two months for his published opposition. Clemenceau, who would spend 50 years in politics, became an elected official in the Parisian and then the national government; he was one of the founders of the Third Republic. He wrote for and established important publications, commenting on art and letters, politics, and social life. The Musée Rodin library contains two books, *La mêlée sociale* and *Le grand Pan*, signed by the author and dedicated to Auguste Rodin, "his admirer and his friend." Clemenceau defended Dreyfus and as a senator argued for the separation of church and state. In 1917 he became the leader of the French government and was a major force in changing the tide of his country's fortune in the First World War, for which he became a national hero. Removed from government by the voters in 1919, however, Clemenceau devoted his remaining years to many projects, including the unsuccessful attempt to establish a museum on the grounds of the Musée Rodin for the display of Claude Monet's series *Les nymphéas* (1906–26; Jeu de Paume, Paris).

Rodin and Clemenceau seem to have come together in 1888, when the artist gave the politician a small plaster sculpture and Clemenceau sent some distinguished English visitors to his studio. Thereafter their recorded contacts were intermittent, at times concerning the acquisition of a sculpture or Rodin's request to Clemenceau to intervene on his behalf with a government official. During the long years of controversy over the delays in the Balzac project and on the occasion when the commissioners demanded immediate delivery, Clemenceau wrote in the artist's defense: "Rodin is late. So much the better! It is because he is difficult to satisfy."[3] In 1898 at the height of the Balzac affair, Clemenceau was angered that Rodin did not openly side with those defending Dreyfus and wrote to the organizer of a petition for making a cast of the statue: "My dear confrere, M. Rodin having expressed to an editor of *L'aurore* his fear of seeing too great a number of Zola's friends subscribe to the statue of Balzac, I ask you to withdraw my name from the list."[4]

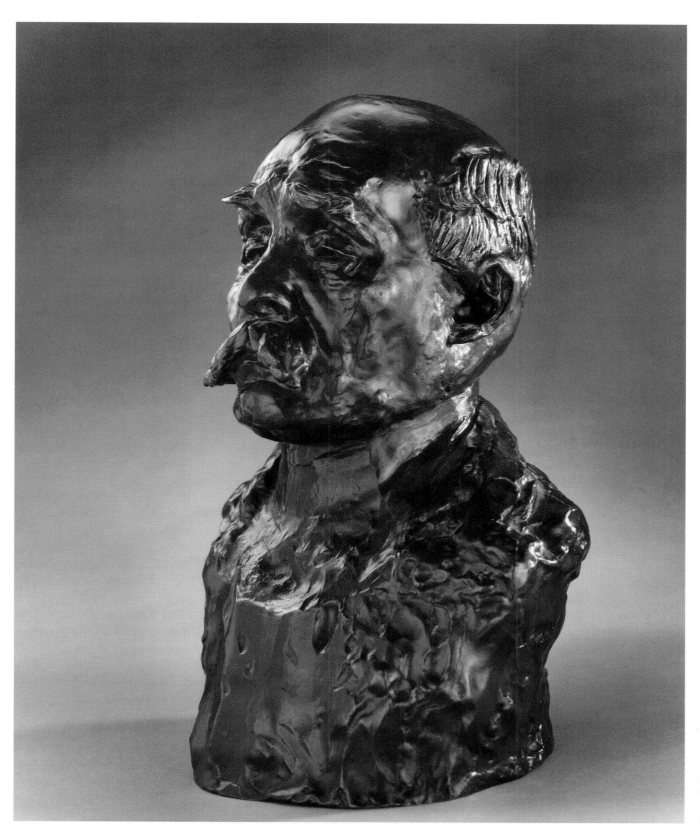

Fig. 394. *Bust of Georges Clemenceau* (cat. no. 145).

With time the two men seem to have reestablished cordial if not friendly relations, and Clemenceau played a role in the establishment of the Musée Rodin in the Hôtel Biron.[5] It was as a result of lectures on democracy given by Clemenceau in Brazil and Argentina in 1910 that friends in the latter government commissioned Rodin to make his portrait in a limited edition of ten, of which Clemenceau would receive one. The first of 18 sittings evidently took place in the spring of 1911 at the Hôtel Biron. It is difficult to say just when the sittings ended, but probably in July or August 1914. Rodin believed the portrait was complete by that summer. From the limited correspondence that survives (partly because Clemenceau destroyed much of his personal archive before his death), we gain a sense of the problems this commission caused. The extraordinary quality and historical importance of Rodin's portrait encourage a more detailed look into the difficulties attending the completion of the commission that Clemenceau considered a failure.

On 7 June 1911 Rodin wrote, "We begin Sunday morning if you can come. I am at your disposition, or Monday if you want, or the following days."[6] On 13 June he wrote to his "dear friend," "I have worked on the bust and I have cast it again. If I can have the clay before July 15th, that will suffice for finishing it with you. . . . I will make a bronze and you will have it in three months, while waiting for the marble to be made in the winter." Obviously concerned, Clemenceau wrote on 24 June, "Can you not wait for the bronze until the work is finished?"[7] Rodin gave Clemenceau a bronze cast of the bust, which was returned with this note: "My Dear Friend. . . . As [Gustave] Geffroy must have told you, while appreciating the high value, the power of the piece, I must only possess examples of finished work. You can take back the bronze when it pleases you. If it is convenient for you, we can, I hope, resume the poses."[8] A few months later seeking to exhibit or allow a version of the portrait to be photographed for publication, Rodin

was rebuffed. On 12 November 1911 Clemenceau sent Rodin a note: "I cannot give the authorization you asked of me for the reproduction of a work . . . that I have never seen."[9] Following this refusal the editor of *L'éclipse* went to Rodin in February 1912 and was told by the sculptor, "I will publish it just the same, but I will put below the reproduction, 'Portrait of an Unknown.'"[10] Alain Beausire records that the work was reproduced in the 13 April 1912 issue of *Le matin* and that Rodin withheld the bust from the salon on the grounds he was not ready.[11] That Rodin did not exhibit the bust in one of the 1912 salons made news. Georges Grappe, unsupported by Beausire who cannot find such a record, claimed that Rodin showed the bust in the Salon of 1913.[12] During the spring of 1913, while suffering from grippe, Rodin wrote Clemenceau, "I have worked on the bust and I wait for you in order to make the shoulders and some retouchings."[13] On 30 March 1914 Rodin received word from the Secretary General of the Société Nationale des beaux-arts that in connection with a proposed exhibition of the bust, Clemenceau had telegraphed, "Regrets for not being able to consent. Clemenceau."[14] Although Rodin had hoped to exhibit the bust in the Salon of 1914, his subject refused permission.[15] As the project expanded from months into years, the Argentine commissioners not surprisingly became anxious for the bust to be completed as evidenced by a note from Clemenceau to Rodin on 7 July 1914: "My friends from Argentina have pleaded with me. If you want, I will give you some days after the last week in July, and this would be the end."[16]

Rodin's agendas for the last months of the project show that on 9 May 1914, Madame Clemenceau came to see Rodin. (Later Rodin would blame her for turning her husband against the portrait.)[17] On 7 July Clemenceau visited and asked if Rodin would give him some poses at the end of July in order to finish. On 10 July Rodin's expert plaster moldmaker Dieudonné Guioché came to see the bust in order to make a cast. On 24 July Clemenceau and a lady friend came to look at the bust. On 26 July Rodin received word from an official of the senate that a committee of its members was waiting for Clemenceau's authorization to have a cast made of the bust.[18] That authorization never came. In fact, the portrait was never publicly exhibited in Rodin's lifetime.

That does not mean that many studies for it were not

seen by visitors to Rodin's studio in the Hôtel Biron. Probably in late 1911 or early 1912 Henri-Charles Dujardin-Beaumetz met with the sculptor and wrote of what happened once when there was an interruption.

I retired to an adjoining room, where I saw several studies which the master had made in preparation for the definitive bust of a famous statesman.

As I knew the subject well, I took an extreme interest in the differing interpretations of a particularly mobile and distinctive physiognomy. In one of them, the incisive, penetrating eye had a flame of special light, that of the subject when, after having reflected, he was about to act with all the intensity of a rapid will.

Rodin entered. "You are looking at my busts of M—;here is the latest one," and he took off the wet cloths which enveloped the clay. It was superb; but the eye here had an expression of reflective thought, equally right, but seeming to me to approach closer to the intimate feelings of the man, not the public figure.

While telling him how much I admired it, I said, "Why not *that* eye, dear master?" showing him the other bust. . . .

Rodin replied, "You may be right. Perhaps I will use it in a new study, but for this one it is impossible; it wouldn't go with the rest of my forms. Different harmonies elicit differing unities."[19]

Judith Cladel recalled seeing what must have been the same group of studies in the Hôtel Biron: "In the room that served him as an atelier, about ten heads of Clemenceau, in clay, cut off at the neck, resting on turntables and consoles. It was hallucinating, a museum of executed criminals. . . . Rodin practiced sculpture the way an engraver does etchings, by states. In order not to 'fatigue' his clay by numerous retouches, he had several clay casts made, worked anew on these successive proofs and did so ten and even a dozen times in sequence. These decapitated heads did not seem to me to reproduce in its force the ball of will that was the head of Clemenceau; but, my glance fell on a great bust placed near the window and this one, on the contrary, stupefied me; authority, aggressive energy, it was that of a leader, of an already legendary being, with . . . a sad lassitude, the disabused finesse of an old Chinese philosopher."[20]

A reporter for *La liberté* described a visit to Rodin's studio in 1911, during which he asked: "How many sessions? 'Around fifteen. I made three busts of him, a first one that from the point of view of physical resemblance, I consider as definitive. The two others are researches into details. And after these three, I will make a fourth which will.' [Rodin was unfortunately interrupted by the impatient reporter, who went on to ask,][21] And the others? 'They are only advanced studies. This one that you find so expressive and in which I search from the point of view of character, will be, I hope the true portrait such as I desire it of the former, and who knows, future president.' In the course of the conversation . . . [Rodin] explained to me that he worked most often without the model, from studies which served him simply as starting points, or points of reference."[22]

A measure of Rodin's importance and that of his portrait is indicated by an article entitled "Why Rodin Does Not Exhibit at the National."

Here it is a year since I began the bust, a year that I dreamed of it, that I worked on it, and that I have delayed it. I am still too close to him. I am not sufficiently detached or disengaged from it, in order to see it. Before he submits it to the public for judgment, is not an artist entitled to first judge it for himself? . . . It is necessary that I forget what I have made in order to better comprehend it. . . . I never consider as completed anything that leaves my hands. Thus the bust that I offered to Mr. Clemenceau is only a stage toward the ideal and perfect Clemenceau of which I am thinking. It is for me something like the state of an etching. Later I will return to it, I will correct it, I will retouch. . . . I have of my model a very complete image. He gave me 18 posing sessions. . . . Between times I dreamed of his face, of his expression, of his character; I will return to him his profound truth. I arrange the notes that I have made of him during our sessions.[23]

Rodin's reference to four types of portrait was a method he would use in his very last work, the portrait of Etienne Clémentel, and fortunately we have the latter's recollection of the artist's own explanation of his four-stage procedure, which he presumably also explained to Clemenceau at the outset:

From the beginning, he had indicated to me how he wanted to work. He had told me: "I will make four successive busts. In the first I am going to bring out a few of my impressions in the clay." It was true. In four or five sessions and without any preliminary study, he brought out his measurements, drawing [the contours] constantly as he made it. He studied the curvatures of the head, but always followed the lines of his plan. In a few sessions, perhaps seven at most, he brought into being a bust that is splendid, which is not a portrait, but which is admirably lifelike. It has life. It has the intense existence of the subject. He told me, "When I have that, I will make a mold of it and I will make a [clay] cast of the first bust. I will then push the clay further and this is when your sufferings will begin. I would like to work as do certain of my colleagues, whom I will not name: it is also a great artist whose work is finicky. I will work like him. I must tell you that it will be necessary to assume many attitudes, notably I would like you to permit me to work from above and that you consent to such a pose."

He had a clay impression made from the mold and continued. He worked on this in long sessions during which he said to me: "Don't be disturbed, life will come back to it." He worked in these sessions by building up the clay. . . . At a certain moment he cut off the head at the neck. He placed the head horizontally in order to work on it rather than vertically. Naturally there was a compression of the whole clay bust . . . that showed when it was raised upright again. After Rodin rejoined the head to the neck, he continued the work and took a second mold. From this he took another clay impression and told me, "Now I will return life to you. This is the third stage." He had told me, "In the fourth stage it will be the planes [that I work on]." This work was never begun. It was stopped [by Rodin's experiencing a stroke] at the third stage.[24]

That Rodin used the same method for his portrait of Clemenceau is confirmed not just by the large number of studies and their groupings, but also by The Tiger's reminiscence of a particular session: "When Rodin came in order to make my bust, he asked me for a chair, he mounted it in order to look at the summit of my skull. He descended and said to me, 'I know now how you are made externally and internally. I will come back in eight days.' Eight days later he returned to my home, he brought to me his bust in bronze!!! You know as well as I what was the result. I put it in a cupboard with that of [Paul] Troubetzkoy."[25] No doubt Clemenceau was being facetious and not an objective chronicler, but Rodin would have studied him from above.

Near the end of his life, Rodin told Marcelle Tirel his version of the sessions with Clemenceau:

Rodin was afraid of him, for M. Clemenceau always had the air of mocking Rodin. When the model left, Rodin recovered himself. "I had promised with much pleasure to execute his portrait," he told me. "The model was worthy of me. . . . In different things we are of equal strength. It has not been long that I have come to understand politics: that frightened me at first, and then suddenly I understood the mechanism. It is the simplest thing in the world. Clemenceau had politics in his blood. But he understood nothing about art. He was born a fighter, and an aggressive one. But he had a contrary mind. He adored interminable discussions and had the mind of a street urchin. . . . " Did he criticize his portrait, I asked? "With each touch of my thumb in the clay I sensed that he was discontent. He would smile pityingly. Perhaps he did not have the patience to pose. . . . His sneering expression vexed, almost paralyzed me. When the first clay version was finished he spoke to me as if to an apprentice: 'It is not me: it is a Japanese that you have sculpted, Rodin. I do not want it!' . . . [Rodin continued] "I heard that Clemenceau owned a very curious collection of Japanese masks. . . . He was so angry to rediscover their resemblance in my portrait. . . . It appears that it was his wife who urged him to refuse my portrait. . . . I am not angry with him, but I've lost a lot of money. As a caprice, and perhaps to prove to myself that I was able to make a portrait resemblance, I recommenced it ten times . . . in stone, in wax, in clay. I had the idea to make it in marble, in granite. . . . I have never said however that my bad model was an imbecile. I had said that of Victor Hugo, but then I was young. . . . Clemenceau has only to go to [Léon] Bonnat, who does good official photography. There will be more of a resemblance, but it will not be more of himself."[26]

The Studies

A few years ago with the cooperation of Nicole Barbier it was possible at Meudon to assemble in long rows the 29 surviving studies for Clemenceau's portrait. Influenced by Rodin's own comments on how he produced his portrait in four different stages, this author arranged the studies in the same number of groups and worked out a rough sequence, always trying to keep in mind that Rodin probably went back and forth among the groups to draw from the growing repertory of types and facial features. Some of these heretofore unpublished studies are here reproduced; in note 27 is the fuller sequence of studies in the author's reconstruction of Rodin's work on the portrait.[27]

The first group of four (see figs. 396–398) have no necks or bust and consist of Rodin's reconnaissance of the terrain of Clemenceau's head with little concern for expression, especially in the area of the eyes. One of the most striking (fig. 397) is just a mask. Along with an overall impression and the most salient facial characteristics, what Rodin was after were measurements that included distances between features, their size, and proportion. The eyes are treated as if Rodin were noting not just their asymmetry but two different expressions with the result of an often unfocused look. The heads seem to grow progressively more decisive but lack a strong presence.

The second stage of ten studies with the bust format might be called, after Clemenceau's remark, the Mongol emperor group (see figs. 399–404). All the eyes have a distinctive shape: straight upper lids, wide narrow eyes, and cheekbones. Figure 404 stands apart from the rest: it is a solid terra-cotta (no casting seams), and there are no casts of it. It is as if Rodin wanted to make a fresh start.

The third group of five studies shows where Rodin changed the expression and exaggerated the undulating character of the brows and upper eyelids, moving away from the Mongol look. This gives Clemenceau a more mournful mien as in figure 405. Photographs of Clemenceau, however, show the undulations in the shape of his eyes and forehead. One is reminded of Rodin's statement "A bust? It is the sea with its movements, its high waves and their depths. As on the sea, when one works, one climbs up, sinks down, believes himself lost, yet rises again and makes port."[28] In this group (see figs. 19, 405) two heads are almost completely recovered in plastilene.

In the final group of ten studies Rodin tempered the

FIG. 396

FIG. 397

FIG. 398

FIG. 399

FIG. 400

FIG. 401

PREVIOUS PAGE, LEFT TO RIGHT, TOP TO BOTTOM

Fig. 396. *Study for "Bust of Georges Clemenceau,"* c. 1912-14, terra-cotta, 10¹³⁄₁₆ x 9 ¹³⁄₁₆ x 9 ¹⁄₁₆ in. (27.5 x 24.9 x 23.1 cm). Musée Rodin, Paris, S1887.

Fig. 397. *Study for "Bust of Georges Clemenceau,"* c. 1912-14, terra-cotta. Musée Rodin, Paris, S739.

Fig. 398. *Study for "Bust of Georges Clemenceau,"* c. 1912-14, terra-cotta, 7¹⁄₁₆ x 6¹¹⁄₁₆ x 9¹⁄₁₆ in. (18 x 17 x 23 cm). Museé Rodin, Paris, S740.

Fig. 399. *Study for "Bust of Georges Clemenceau,"* c. 1912-14, terra-cotta, 17¹¹⁄₁₆ x 12³⁄₁₆ x 10⁵⁄₈ in. (45 x 33 x 24.5 cm). Musée Rodin, Paris, S1599.

Fig. 400. *Study for "Bust of Georges Clemenceau,"* c. 1912-14, plaster, 18⁷⁄₈ x 11⁷⁄₁₆ x 13³⁄₁₆ in. (48 x 29 x 33.5 cm). Musée Rodin, Paris, S1672.

Fig. 401. *Study for "Bust of Georges Clemenceau,"* c. 1912-14, terra-cotta, 17⁵⁄₁₆ x 12³⁄₁₆ x 10⁵⁄₈ in. (44 x 31 x 27 cm). Musée Rodin, Paris, S742.

THIS PAGE, LEFT TO RIGHT, TOP TO BOTTOM
Fig. 402. *Study for "Bust of Georges Clemenceau,"* c. 1912-14, plaster, 19 x 12⁵⁄₁₆ x 11⁵⁄₁₆ in. (48.2 x 32.8 x 28.8 cm). Musée Rodin, Paris, S1699.

Fig. 403. *Study for "Bust of Georges Clemenceau,"* c. 1912-14, plaster, 19¹⁄₁₆ x 11¹¹⁄₁₆ x 11¹⁄₄ in. (48.5 x 30 x 28.5 cm). Musée Rodin, Paris, S1697.

Fig. 404. *Study for "Bust of Georges Clemenceau,"* c. 1912-14, terra-cotta, 17⁵⁄₁₆ x 11 x 9¹³⁄₁₆ in. (44 x 28 x 25 cm). Musée Rodin, Paris, S1671.

Fig. 405. *Study for "Bust of Georges Clemenceau,"* c. 1912-14, terra-cotta and plastilene. Musée Rodin, Paris, S1673.

Fig. 406. *Study for "Bust of Georges Clemenceau,"* c. 1912-14, terra-cotta. Musée Rodin, Paris, S1674.

Fig. 407. *Study for "Bust of Georges Clemenceau,"* c. 1912-14, terra-cotta. Musée Rodin, Paris, S741.

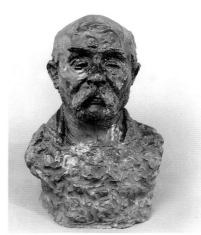
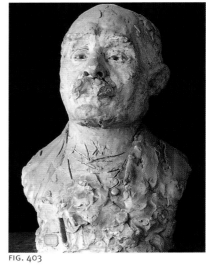
FIG. 402
FIG. 403

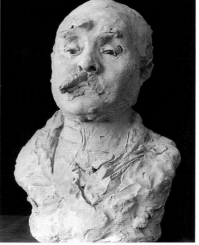
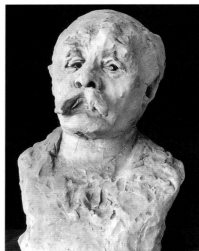
FIG. 404
FIG. 405

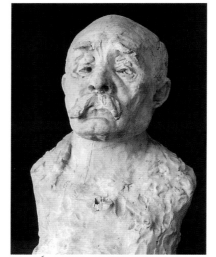
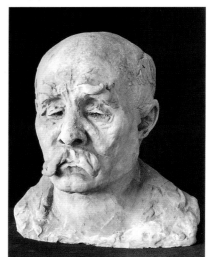
FIG. 406
FIG. 407

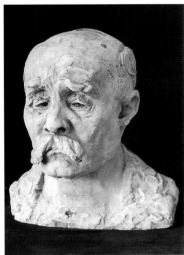

FIG. 408

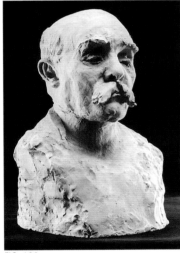

FIG. 409

Top: Fig. 408. *Study for "Bust of Georges Clemenceau,"* c. 1912-14, terra-cotta. Musée Rodin, Paris, S2120.

Bottom: Fig. 409. *Study for "Bust of Georges Clemenceau,"* c. 1912-14, terra-cotta. Musée Rodin, Paris, S35.

undulations in the eyelids, and the final brows are established with the ledge form of Clemenceau's left eyebrow (see figs. 406–409). Variations focus on the buildup above the upper eyelids; early in the series there are triple touches atop the upper lid, and then they are reduced in number. The final mustache is settled, the left side has a concavity and a smoother rapport with the cheek. The final head in this series, the plaster used for the marble, was reworked, and a number of rough-edged passages were covered over, especially in the left temple area.

Rodin himself pointed out that to save time he often made clay casts from his molds, thereby preserving a basic type that he then could vary in its details. (The many terra-cottas that have casting seams show this.) When Rodin sought to rework plaster heads, he might file or roughen the areas to be changed and then apply clay or plastilene to them. The use of dipped casts (as in the Musée Rodin head, S1598) also allowed him to make clean studies or smooth out rough areas and win a more fluid congruence of planes.

Until all the molds stored at Meudon have been opened, we will not be sure that we have seen all the studies and parts of Clemenceau's face that Rodin made and varied. (One mold Barbier opened had just the sliver of an eyebrow.) Rodin employed superb technicians like the Guioché family, who could make molds of just about anything and with the highest fidelity. When Rodin commented that in Clemenceau's presence he

assembled his notes, this repertory of facial parts is what he may have been referring to.

Why so many studies? Rodin had the time and a subject that challenged what he once called his "demon of the best," and as Clemenceau wryly pointed out, a lot of money was at stake. Clemenceau was not just a subject but a kindred spirit, in many ways a fighter who had known victory and defeat as much or even more than Rodin: a man of tremendous spirit, resilience, tough and shrewd, with great will power. From the first, however, Clemenceau was also an adversary who mocked Rodin with his look during the modeling sessions. The unusual haste with which Rodin provided his subject with a bronze cast in 1911 suggests that he was very anxious to please, and this was unusual. Perhaps after the refusal of the bronze, Rodin determined not to rush but to take fuller charge of the bust and make it a masterly effort, to be finicky like a great artist, as he put it. He spoke of dreaming about it. When it came to making a portrait, perhaps only that of Balzac had so challenged Rodin.

The great number of studies with all their changes of expression explains why Rodin felt the portrait process was like writing a biography. Just which Clemenceau did he want in the final bust: the crusading journalist, the combative politician, the connoisseur of the arts? He knew The Tiger to be a man of wit and an individual with a deep feeling for the common man. Given the commission's source, certainly the portrait was to be of the man in public office, but which man? What qualities? The answers the beholder and those knowledgeable about Clemenceau can only fathom by prolonged consideration of this great portrait.

The Final Portrait

If one could see all the studies together, it would be almost like frames of a film in which Clemenceau was being interviewed and seen to move through various expressions. What Rodin sought and achieved in the single and final work was a kind of summation of these changes of mood and expression by providing surfaces that, as the light changes dramatically, alter how we read his state of mind. To win that mobility and fix the elusive, Rodin did much of his work from memory, often in the model's absence, as he pointed out. This known, one might suspect that a number of touches were arbitrary on Rodin's part, but many turn up in photographs of

Clemenceau: the folds of flesh over his upper eyelids; wavy undulations made by the brows; the right jowl and its ridge. Rodin was a marvelously trained observer with a great memory. The problem with studying this superb head in photographs is that they freeze the expression because of the fixed lighting and viewing angle. Clemenceau's head is turned slightly upward, both as a result of his habitual prideful pose and to make the face more fully susceptible to light. The final bust was photographed in this way, from different angles and in nocturnal lighting, in a series of prints by Edward Steichen.[29]

Despite the hundreds of hours spent on the work, the final bust still has a freshness and appearance of spontaneous execution. This is due partly to Rodin's resistance to style and habits of the hand, so that every modeled centimeter seems like a new discovery that inspired an impromptu sculptural invention. When Rodin spoke to Clémentel about the fourth stage being a matter of studying the planes of the head, so with *Clemenceau*, the final bust is convincing both as an interpretation of the essential man and as a work of art. Not unlike Paul Cézanne, Rodin believed that the proper fitting together of surface planes would be the carrier of, not competition with, the subject's expression. Each in their own way exaggerated facial configuration to win that planar accord, with Cézanne showing a greater willingness to sacrifice descriptive detail.

To reexperience Rodin's structural sense and discover how he found a basic largeness of effect in the man's differentiated facial structure, we can read the head not just overall but in such sequences as from collar to chin to brow or the reverse. Take the central axis as an example. The chin, mouth, and mustache build to the base of the nose. The nose then swells and tapers upward like a tree trunk (the mustache serving as a great root system), and like branches the brows arc left and right and frame the optical area. The brow is like a stormy sky extending upward the energies of the lower area. Avoiding black holes, as he warned other artists to do, Rodin's buildup of the upper eyelids pulls light into the deep orbit under the brows. As did Rembrandt, whom Rodin deeply admired and may have learned from, in this and other portraits much of the eyes is in shadow. Clemenceau's eyes seem to lead different lives and are not in synchrony in terms of direction and expression, which is consistent with the way Rodin emphasized the difference in surface of the two profiles. All those cosmetically unattractive signs of age that mark, ravel, and crease the face of a man who lived hard, Rodin turned to his sculptural profit as he translated what he saw into mounds and depressions that constituted for him the essence of sculpture.

One of Rodin's most moving commentaries on portraits was made to Dujardin-Beaumetz during the Clemenceau project, and while he was speaking in general, what was said certainly pertains to it:

Sometimes I have started a single bust over again ten times. Thus I have made multiple aspects and diverse expressions of it; at the end, what joy to see and understand!

Wishing to do better, one sometimes demolishes even what one has done well; but one must be possessed by the demon of the best. . . .

A beautiful bust shows the model in his moral and physical reality, tells his secret thoughts, sounds the innermost recesses of his soul, his greatness, his weaknesses; all the masks fall off. . . . The artist becomes a revealer, a diviner.[30]

NOTES

LITERATURE: Dujardin-Beaumetz 1913 in Elsen 1965a, 168–69; Tirel 1923, 64–67; Cladel 1936, 275–76; Grappe 1944, 135; Jianou and Goldscheider 1969, 113; Judrin 1976, 67; Tancock 1976, 566; Elsen 1980, 184; Elsen 1981, 233–35; Hare 1984, 599–609; Barbier 1987, 72; Grunfeld 1987, 611–13; Beausire 1988, 334, 351; Daix 1988, 172–75; Fonsmark 1988, 146; Butler 1993, 477–78

1. Gsell [1911] 1984, 55.
2. Cladel 1936, 275–76.
3. Daix 1988, 172.
4. Ibid., 175.
5. Cladel 1936, 269. In the Musée Rodin archives there is a note from Clemenceau to Judith Cladel dated 15 December 1911, in which he says, "I would be very happy with the creation of a Musée Rodin."
6. Rodin to Clemenceau, 7 June 1911, archives, Musée Clemenceau, Paris.
7. Rodin to Clemenceau, 13 June 1911, archives, Musée Clemenceau, Paris; Clemenceau to Rodin, 24 June 1911 Musée Rodin Paris.
8. Clemenceau to Rodin, Musée Rodin Paris.
9. Clemenceau to Rodin, 12 November 1911, photocopy in the Musée Rodin archives.
10. "La buste de tigre," *L'éclipse*, 29 February 1912.
11. Beausire 1988, 334.
12. Grappe, 1944, 135. Discussion with Beausire in the Musée Rodin, 25 February 1988.
13. Rodin to Clemenceau, 13 March 1913, in the Musée Rodin archives.

14. Clemenceau to Rodin, spring 1914, in the Musée Rodin archives.

15. Beausire 1988, 351.

16. Clemenceau to Rodin, 7 July 1914, Musée Rodin archives.

17. The agendas are in the Musée Rodin archives.

18. Senate committee to Rodin, 26 July 1914, Musée Rodin archives.

19. Dujardin-Beaumetz in Elsen 1965a, 168–69.

20. Cladel 1936, 275.

21. The fourth stage is probably as described in the text by Etienne Clémentel that follows.

22. Gabriel Domergue in *La liberté*, 10 October 1911.

23. Claude Chenneval, "Why Rodin Does Not Exhibit at the National," *Excelsior*, 14 April 1912.

24. This testimony was given by Clémentel at a trial in May 1919, at the end of which a number of individuals were found guilty of making unauthorized reproductions of Rodin's work. The trial was held in the Paris Tribunal de Police Correctionelle de la Seine. The action was brought by the Minister of Public Instruction and Fine Arts and Léonce Bénédite, director of the Musée Rodin, against the owner of the Montagutelli Foundry, various artists, and others. The transcript of this trial in the archives of the Musée Rodin; Clémentel's deposition is in section no. 5.044–7. See Elsen 1988, 6–10.

25. Translated from Georges Wormser, *Clemenceau vu de près* (Paris: Hachette, 1979), quoted in Jacques Perot, ed., *Georges Clemenceau, 1841–1929* (Paris: Musée du Petit Palais, 1979), 105. There is a similar but slightly longer account in an article, "Clemenceau et les sculpteurs," *Dépêche de Cherbourg*, 17 January 1931.

26. Tirel 1923, 64–67.

27. At this writing all the studies are not available for reproduction. The Musée Rodin has a rule that does not allow photographing dirty plasters; they must be cleaned first. In the following list are the inventory numbers in the general sequence as this author reconstructed how Rodin worked:

Group 1: S1887, terra-cotta with casting seams (fig. 396); S739, terra-cotta (fig. 397); S740 terra-cotta (fig. 398), terra-cotta; S1597, plaster (this seems to be a cast of S740).

Group 2: S1599, terra-cotta (fig. 399); S1672, plaster (fig. 400); S1821, terra-cotta with seams; S1595, plaster; S72, terra-cotta with seams; S1698, plaster; S742, terra-cotta with armature on the interior, presumably made after S1698 (fig. 401); S1699, plaster, chestnut-painted patina, which makes it look like a bronze (fig. 402); S1697, plaster (fig. 403); S1671, solid terra-cotta (fig. 404).

Group 3: S1730, plaster and plastilene (fig. 19); S1596, plaster; S1600, terra-cotta with seams; S1673, terra-cotta covered by a thin plaster skin (plastilene) (fig. 405); S1982, plaster, inscribed inside: 13 decembre 1911.

Group 4: S1598, plaster, cachet: Montagutelli; S1686, terra-cotta; S1520, terra-cotta with seams; S1674, terra-cotta with seams, cachet: Montagutelli (fig. 406); S741, solid beige terra-cotta (fig. 407); S2120, terra-cotta with seams (fig. 408); S35, terra-cotta with red glaze (fig. 409); S1465, terra-cotta with seams; S1470, plaster for the bronze bust; S1696, plaster for the marble.

28. Dujardin-Beaumetz in Elsen 1965a, 168.

29. These prints were reproduced and discussed by Varnedoe in "Rodin and Photography" in Elsen 1981, 233–35.

30. Dujardin-Beaumetz in Elsen 1965a, 168.

146

Portrait of Pope Benedict XV
(*Le portrait du pape Benoît XV*), 1915

- Bronze, Georges Rudier Foundry, cast 1978, 9/12
- 10 x 7 x 9½ in. (25.4 x 17.8 x 24.1 cm)
- Signed on bottom of neck, left: A. Rodin
- Inscribed on back of neck, at right: Georges Rudier/Fondeur.Paris; below signature: No. 9; on end of neck (cutaway area): © by musée Rodin 1978; interior cachet: A. Rodin
- Provenance: Musée Rodin, Paris
- Gift of the B. Gerald Cantor Collection, 1992.143

Figure 410

*I*n the history of portrait sculpture Rodin's head of Pope Benedict XV (1854–1922; fig. 411) stands apart from those countless images of the office in the man, whether soldier or prelate, statesman or bureaucrat. What Rodin achieved was a great portrait of the man in the office. Even before he had met his subject, Rodin was inspired to make a great portrait by visits to Rome during the First World War and his reexperiencing that city's history of magnificent sculpture. It was on Rodin's initiative and with the help of friends that he was asked formally to make a portrait of the pontiff. In April 1915 he gained access to the pope on a far more limited basis than he wanted.[1]

Rodin had hoped for at least twelve sittings and wound up having only three or four before Benedict broke off the sessions and asked him to work from supplied photographs.[2] Rodin transported the clay study back to Paris,

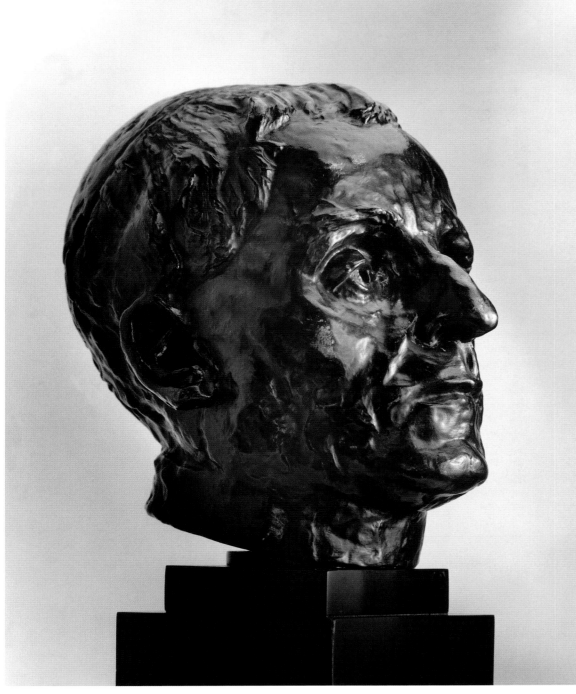

last portrait, that of Etienne Clémentel, made the following year.[4] Further physical resemblance to Benedict would probably not have been his goal, but rather through his unaccountable touches he might have evoked more of the private nature of this public figure.

The pope's insistence on facing the sculptor frontally and that the portrait be done quickly caused Rodin to complain afterward that he did not have enough time to study the pope in all his profiles or such features as the "sacred ear." Rodin's method of circling his subject to examine the profiles and viewing him from above went against papal protocol and pontifical patience.[5] Despite Rodin's misgivings, what he produced in Rome and a week's work in his Paris studio shows more than 50 years of studying the human head with a result that even he judged "incredible."

From papa to Il Papa, Rodin used the same basic method. He set out to establish the man's *caractère*, which is why he fretted over the ear. No expression was applied. In fact, we do not

Fig. 410. *Portrait of Pope Benedict XV* (cat. no. 146).

where he continued to work on it. In a letter to a Roman friend, who had helped arrange the meetings, Rodin wrote, "I've saved the bust and on Monday morning at 7, in Paris, I worked until evening, and then kept at it for six days. The bust is incredible; it has the resemblance, but you know I am far from having achieved the masterpiece that it could have been, had I been able to work patiently."[3] For an idea of what Rodin would like to have done we can look at the successive states of his next and

have even the conventional bust with shoulders and chest, just the head from the collar up. The only papal history that counted for Rodin was time's chronicle imprinted between chin and hairline. Crucial was the search for facial asymmetry and what he found: the differences in the cheeks that suggest Benedict may have suffered partial paralysis on his left side, as if from a stroke; perhaps as a consequence the eyes gaze in different directions, as if the man has an optical squint. (In

this such a daring portrait of the person in the highest Catholic office is that Rodin had shown not his venerability but his vulnerability. To do this, Rodin had to go beyond recording the man's character. Probably during those seven studio working days intuition and wisdom took over from observation. The result reminds us that for Rodin sculpture began where words left off. Nominally unfinished, because of the interrupted sittings and absence of the subject from his studio, Rodin seems nevertheless to have brought the head to artistic and psychological completion.

Why did Rodin find the head incredible? Was it just because of its likeness to Benedict? Was it because the action of the light betrayed the fixity of facial set and gave the sculpture a pulsing life of its own? Compared with his first portrait, his next to last does not seem frozen in time or psychologically two-dimensional. The fact that the sittings were broken off and Rodin did not finish the portrait in Rome may well have spared the old artist from enormous Vatican pressures to change the work to conform to conventional ideals of sovereignty. Responding to a request in 1971 by the bishop of Orta, the Most Reverend Paul C. Marcinkus, B. Gerald Cantor saw to it that Rodin's bronze portrait of Benedict XV finally entered the Vatican collections.

Fig. 411. *Pope Benedict XV*, photographer unknown, n.d. Musée Rodin, Paris.

other portraits Rodin had used this divergence to evoke character.) One has the sense of the man looking simultaneously outward and inward. Rodin may have captured Benedict's sense of his mortality.[6] The upper eyelids are important, as they hood but do not hide the hollowed irises below. By contrast with the firmness of the bones—chin, nose, brow—that support the face, there is the skin that seems crumpled because of its loss of elasticity. Against the immobile set of the head, the furrowed flesh seems a distillation of all the man's facial movements caused by a stressful life. There is a wholeness or consistency to the overall expression such that no area is easily isolatable or different in what it has to say. The face is so remade, for example, that the areas that radiate from around the eyes, leading to collar and hairline, seem a ripple effect, and featural differences are not comfortably marked. The marvelously fashioned jowls rise from the collar like a relief map of death's invasion. Rodin's modeling touch had evolved to the point where the surfaces seem formed not just by the external pressures of his fingers but from within the man himself. What makes

NOTES

LITERATURE: Cladel 1936, 43, 311–14; Grappe 1944, 138; Jianou and Goldscheider 1969, 114; Tancock 1976, 567–70; Hare 1984, 627–34; Miller and Marotta 1986, 108–9; Grunfeld 1987, 628–29; Pinet 1990, 72–73; Butler 1993, 497, 499–502; Levkoff 1994, 150–51

1. The details of how the sittings were arranged, their meeting and sessions together. are given in Cladel 1936, 311–14; Grunfeld 1987, 628–29; and Butler 1993, 497, 499–502, who offers additional information on Rodin's view of the portrait.
2. See Pinet (1990, 72–73) for photographs of the pope in the Musée Rodin archive.
3. Grunfeld 1987, 629.
4. For a discussion of the Clémentel bust, see Elsen 1988.
5. Rodin speaking to Auguste Renoir, cited in Grunfeld 1987, 629. Contributing to the pope's impatience may have been Rodin's arguments against the Germans in a war where the Vatican was attempting to be neutral (Cladel 1936, 313).
6. Cladel reports that the modeling sessions tired the pope (ibid., 312).

Small Sculptures

The international fame of Rodin, one of history's most prolific and gifted sculptors, owed much to his smaller-than-life-size sculptures. Available in glass cases for the countless visitors to Meudon after 1901 were hundreds of these works; in plaster, bronze, and stone, they were exhibited and collected all over the world during the artist's lifetime. Although often derived from major projects like *The Gates of Hell* or other monuments, for the most part these small works were undertaken at the artist's personal initiative, inspired by what he observed in the free movements of his studio models. It was in small works that the artist was perhaps least self-conscious and freer to exercise his imagination. Not surprisingly, many of Rodin's audacities occurred in these smaller works, as with his dancers and interpretation of an aged former model (cat. no. 51), and daring couplings or montages of separately fashioned figures. Several small sculptures, including *Triumphant Youth* (cat. no. 52), *Fatigue* (cat. nos. 53–54), *Seated Female Nude* (cat. no. 60), and *Meditation* (cat. nos. 61–62), are discussed in context of *The Gates of Hell* or in other sections of the present volume.

For those connoisseurs who have wanted the direct experience of Rodin's hands in modeling, the small sculptures rather than those enlarged by technicians have been preferred. The Stanford collection is fortunate in having substantial holdings in both types, including versions of the same subject in different media and sizes.

Idyll of Ixelles (Idylle d'Ixelles), 1874–76

- Title variations: *Brussels Idyll, Idyll*
- Bronze, Coubertin Foundry, cast 1980, 2/12
- 22 x 15¾ x 15¾ in. (55.9 x 40 x 40 cm)
- Signed on back of base: Rodin
- Inscribed on back of base: © by Musée Rodin 1980; below signature: 1881
- Mark on back of base: Coubertin Foundry seal
- Gift of the Iris and B. Gerald Cantor Collection, 1998.364

Figure 412

The standing, winged figure is derived from Rodin's sculptured allegory *Science* (1874). It is found on one of three main piers of the outer wall of the Palais des académies in Brussels.[1] The figure was shown originally as if kneeling with a compass in hand, measuring points on the globe of the earth. To this standing cupid Rodin added a chubby, seated male child, who tries to embrace her. The seated child tucks his right foot under his extended left leg, while a drape over his right thigh conceals his genital area. Both are mounted on a round base covered with flowers and leaves. A marble version was executed in 1884, and given the high finish and quality of the detailing in the Stanford bronze (finger-and toenails are included), it seems likely that this was a cast derived from the marble in the Musée communal d'Ixelles, Brussels.[2] Presumably in fond remembrance of his seven-year stay in Belgium with Rose Beuret, Rodin baptized the marble and its subsequent bronze casts with their present name.

Rodin's use of the motif of young children in sculpture goes back to his Petite École training and exposure to their use in decorative art from at least the eighteenth century, in which they often play the role of adults. Ruth Mirolli (Butler) put Rodin's cupid figure as used in the allegory *Science* into historical perspective by comparing it with the eighteenth-century sculptor Étienne-Maurice Falconet's work: "Whereas everything in Rodin's groups—Cupid, world, anchor, lute, torso, etc.—would have been used as identifying

Fig. 412. *Idyll of Ixelles* (cat. no. 147).

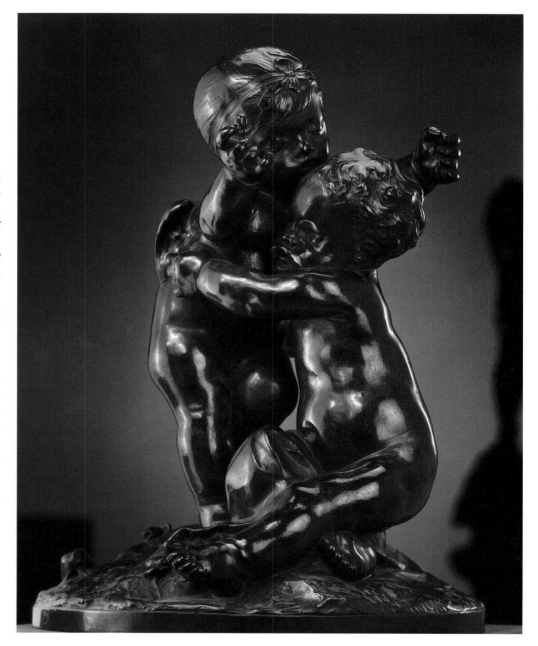

objects in traditional groups, he has made them the central figures."[3] On stylistic grounds Cécile Goldscheider speculated that Rodin was responsible for the design and carving of much of the running relief in the Brussels Bourse, dedicated to all forms of work, in which children enact scenes symbolizing such activities as war and peace and such occupations as the harvesting of grapes.[4]

Idyll still impresses the viewer with Rodin's skill as a descriptive artist—the many dimpled intrusions into baby fat to indicate joints or the way the seated infant's extended left thigh bulges from the pressure of the right foot tucked beneath it—at which he was matched by many contemporaries. It is the composition and its calculated lack of coordination, however, that reveals his incomparable artistic intelligence. The unstable union of the two figures suggests that they were separately made, and when joined, but with no concession to mutuality in terms of accomodating their gestures or expressions. Gestures that were logical in other situations, such as measuring a globe, now appear spontaneous and to be resolved in future moments. As he would do with his later adult pairings, here Rodin avoided frontality and rewarded the viewer who circles the work, by featuring the planes of the children's backs. Mirolli (Butler) summed up the work well: "It is a carefully executed piece; details . . . are accurately finished and, though there exists no record of any sale and the plaster original has disappeared, it is most likely that Rodin prepared this too for commercial edition. . . . The scale, which is larger than that of any previous decorative piece, seems to indicate that it was done either during or after the time when Rodin was working with the monumental infants of the Bourse (1871–73) and at the Palais des Académies (1874)."[5]

NOTES

LITERATURE: Pierron 1902, 160; Grappe 1944, 14–15; Mirolli (Butler) 1966, 133–34, 142–43; Ambrosini and Facos 1987, 59; Grunfeld 1987, 86, 201; Goldscheider 1989, 82; Le Normand-Romain 1997, 365–68

1. Grappe set the date for *Idyll* at 1876 (1944, 14); Goldscheider suggested 1874–85 (1989, 82). Mirolli (Butler) dated *Idyll* to 1872–75 (1966, 133, pl. 97), discussed and illustrated *Science* (143, pl. 105), and quoted the Pierron article (Pierron 1902, 160), in which Rodin claimed the allegories of *Art* and *Science* as having been made by him. A date of 1883–84 for *Idyll* was suggested by Le Normand-Romain (in Le Normand-Romain 1997, 365, 368).
2. Goldscheider (1989, 82) cited the fact that the Musée communal d'Ixelles, Brussels, gave the Musée Rodin, Paris, a plaster cast of the marble in 1929. As the Stanford cast was posthumously made by the Musée Rodin, the Paris plaster cast may well be its source. For these reasons, the inscribed date of 1881 in the plaster, from which the Stanford bronze was made, is puzzling.
3. Mirolli (Butler) 1966, 143–44.
4. See Goldscheider for reproductions of the frieze (1989, 70–73), whose conception seems to have come from Albert-Ernest Carrier-Belleuse. While pointing out that the timing of the Bourse reliefs coincided with the enactment of child labor laws, Goldscheider did not note the irony.
5. Mirolli (Butler) 1966, 133–34.

148

Eternal Spring (L'éternel printemps), 1881(?)
reduced c. 1899–1919

- Title variations: *Cupid and Psyche, The Ideal, Triton and Siren, Youth, Zephyr and Earth*
- Bronze, F. Barbedienne Foundry
- 9⅛ x 11¾ x 4⅜ in. (23.2 x 29.8 x 11.1 cm)
- Inscribed on base, right side: F. Barbedienne.Fondeur.

- Provenance: Hôtel des ventes de Versailles, 9 June 1971, lot 87
- Gift of the Iris and B. Gerald Cantor Foundation, 1974.109
Figure 413

*I*n a photograph taken by Charles Bodmer, perhaps as early as 1881, the original clay version of *Eternal Spring* can be seen mounted on a table in front of the frame of *The Gates of Hell*.[1] Both in his "black" drawings, which nourished his first ideas for the portal, and his earliest sculptures for the doors, Rodin committed himself to showing "all the stages of love," as he would later explain to a Dutch visitor in 1891.[2] As the studio in which the photograph was taken was given to Rodin by the government to execute the portal, it is fair to assume that *Eternal Spring* (fig. 414) auditioned for *The Gates* although it

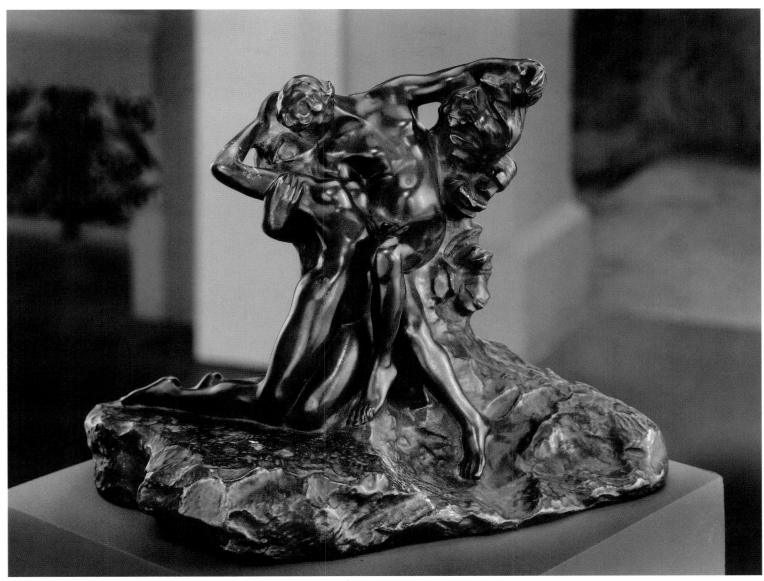

Fig. 413. *Eternal Spring* (cat. no. 148).

did not make the final cut. The athletic coupling of the pair—their seeming weightlessness and precarious positioning—suggests their aborted assignment to the deep-set leaves of the door, to which they could have been attached at their backs. The effeminate nature of the larger male figure, to which Rodin was to add wings (not visible in Bodmer's photograph), prompts the thought that at one time Rodin may have considered making this a lesbian theme, as he was to do later in the upper-right corner of *The Gates* with the couple known as *The Metamorphoses of Ovid* (cat. no. 68).[3] The position of the male's left leg masks the genital area.

Although the government commission for *The Gates*

permitted Rodin for the first time to hire many models, whom he allowed to move at will about the studio, *Eternal Spring* is a contrived composition in which *The Torso of Adèle* (1879 or 1882; fig. 415) is remade into a full figure.[4] Similar to his formal reuse of figural parts was Rodin's frequent changing of a sculpture's name.

With this work Rodin presented the unfolding of an action in its successive states. Unusual compositionally is the profile and frontal positioning of the pair, and the male is shown moving in two different directions. Unlike *The Kiss* (cat. nos. 48–49), the lovers here actually embrace, although as with the other couple the touching in *Eternal Spring* is tender if not tentative. With the addi-

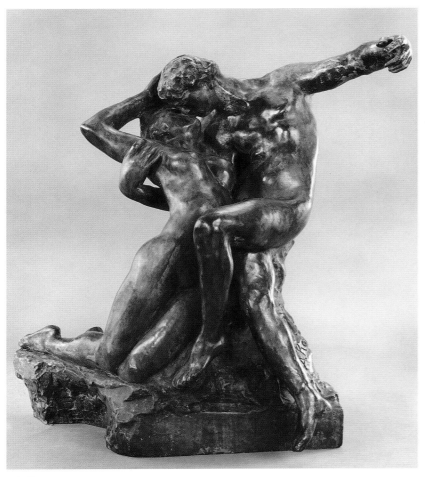

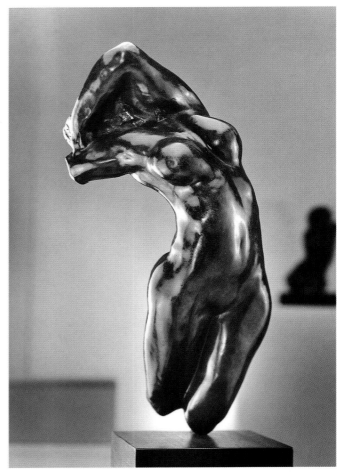

Left: Fig. 414. *Eternal Spring*, 1884, bronze 25½ x 28¼ x 16 in. (64.8 x 71.8 x 40.6 cm). Iris and B. Gerald Cantor Foundation.

Right: Fig. 415. *Reproduction of "Torso of Adèle"* (A32).

tion of wings to the body of the male figure Rodin justified its levitation and independence of any base. Perhaps Rodin was suggesting that the male was about to sweep the woman upward and off her knees. This couple with their mythological guises suggests that the sculptor early on may have considered including various mythological figures in hell, and figures such as the centaurs are found on the final portal.

The composition won great popularity, and it was carved in stone as well as cast in bronze.[5] For the former, certain structural adjustments were made to the composition, such as the addition of a backdrop and the extension of the base to support the protruding limbs—the man's extended arm, depicted as supported by a gnarled tree trunk, and his suspended leg. The Barbedienne cast, of which 151 were made in different sizes between 1899 and 1919, was a reduction of a work in marble, thus several times removed from the artist's hand as seen in Bodmer's picture. As a result, there is a loss of definition in the modeling of the spatial intervals between the bodies and, as John Tancock pointed out, of spontaneity and élan overall.[6] It was not just the production in large

quantity of relatively poor copies, but also the overtly romantic displays of affection that eventually caused Rodin and his sculpture to lose credibility. His later inventions, such as the partial figure in which he went for the essential and the worked surfaces that retained the richness of études, became the measure by which his more finished and cosmetically attractive, earlier work was for so long derided.

NOTES

LITERATURE: Grappe 1944, 42–43; Jianou and Goldscheider 1969, 96; Wasserman 1975, 148; Tancock 1976, 241–47; Elsen 1980, 171; Elsen 1981; 210, 289; Vincent 1981, 15, 33, 42–43; Lampert 1986, 206; Grunfeld 1987, 221, 262–63, 265, 363, 400; Fonsmark 1988, 100–103; Beausire 1989, 198; Fath and Schmoll 1991, 143; Sutton 1995, 134–36; Le Normand-Romain 1997, 372–74

1. On the basis of this photograph (Elsen 1980, pl. 48), this author dates the the composition to 1881 rather than 1884 (Grappe 1944, 42–43).
2. Byvanck 1892, 8.
3. Lampert 1986, 206.

4. In her more complete form, *Adèle* was to return in the work *Illusions Received by the Earth* (cat. no. 168) and reappear in the upper-left corner of the tympanum of *The Gates of Hell* (see fig. 130). The male figure's right arm and hand, which embrace his lover in *Eternal Spring*, were added to the right shoulder of the *Fallen Caryatid* (1880–81; see cat. nos. 56–57) to create a similar supporting embrace in the *Illusions* pairing.

5. Beausire recorded its first showing in 1889 at the Monet-Rodin exhibition, then in Munich (1894), a marble version in Paris (1897), a plaster in Amsterdam (1899), in Rodin's Paris retrospective (1900), and then in Berlin (1903), and Edinburgh (1908, 1913) (Beausire 1988, 104, 121, 131, 151, 192, 244, 297, 347). For further discussion of the group and its history, see Butler in Sutton 1995, 134–36.

6. See Laurent in Elsen 1981, 289. Tancock discussed the differences briefly (1976, 244).

Triton and Siren (Triton et Sirène), c. 1882–85(?)

Bronze, Georges Rudier Foundry, cast 1972
- 10¼ x 10 x 7 in. (26 x 25.4 x 17.8 cm)
- Signed on front of base, top: A. Rodin
- Inscribed on back: Georges Rudier/Fondeur Paris; on base, left side: © by Musée Rodin 1972; interior cachet: A. Rodin
- Provenance: Sotheby's, New York, 22 May 1982, lot 425
- Gift of the B. Gerald Cantor Collection, 1992.159

Figure 416

*I*n the coupling of figures by other sculptors of his time, Rodin found false harmonies and, instead of movement, inertia. After the early 1880s and *The Kiss* (cat. nos. 48–49), according to the critic Camille Mauclair, who sought through conversation to learn the artist's ideas and intentions, "The characteristic of the small groups of Rodin and his essential idea in the search for new combinations of movements was to make a dynamic art."[1] Rather than always compose by having two figures address one another in terms of their gaze, gestures, and general body language, Rodin had asked himself, What if the artist courted chance? Why not audition for pairing previously and separately made figures from his repertory? Literary analogies and deliberate symbolism seem to have been totally absent in his decision here, which appears to have been based on formal considerations resulting from the serendipitous studio encounter of the two small and otherwise independent plaster figures developed for other ends.

In place of the expected psychological, emotional, and physical coordination between the sexes, Rodin opted for what seems "discoordination." Despite the freedom from meaning with which he made compositional decisions, individual figures might carry nuances of meaning from prior contexts that resonate in a new pairing, nuances of meaning to which Rodin might respond in the process of composing. Although he left it to the viewer's imagination to weave a plot for the actors, he nevertheless expected a visually alert viewer to look at the artistic coordination of the couple's silhouettes in depth and in the round. In effect there is no strictly frontal view that allows for a reading of the motif in terms of faces and gestures, nor is there any sense that the relationships between the figures are stable, as was the academic requirement. The couple's energy is found in that in neither figure are any parts of the body separated by flexible joints found to be moving in the same direction or in a common plane. The view that shows the backs of both is particularly satisfying aesthetically. To win the dynamic quality of which Mauclair wrote, the sculptor opted for the momentary rather than the durable in the figures' contact with each other. The dialogue between the couple is formal, not narrative. There is no obvious and consistent rhyming of limbs and torsos. Instead, there are intermittent passages in which the silhouette of one echoes or seems to respond to the gesture of the other, all of which takes place within Rodin's imagined cube.[2] To some historians the open form of composition may recall baroque art, and to modernists it can seem a portent of twentieth-century sculptors engaging space and making it tangible.[3]

Undated and unrecorded by Georges Grappe and others, *Triton and Siren* has no clear history of public exhibition in the artist's lifetime. However, one can look to the earlier or later roles played by the man and woman.[4] Without question Rodin favored the twisting movement of the male form, especially in the torso and thighs, which in all likelihood he observed in the sponta-

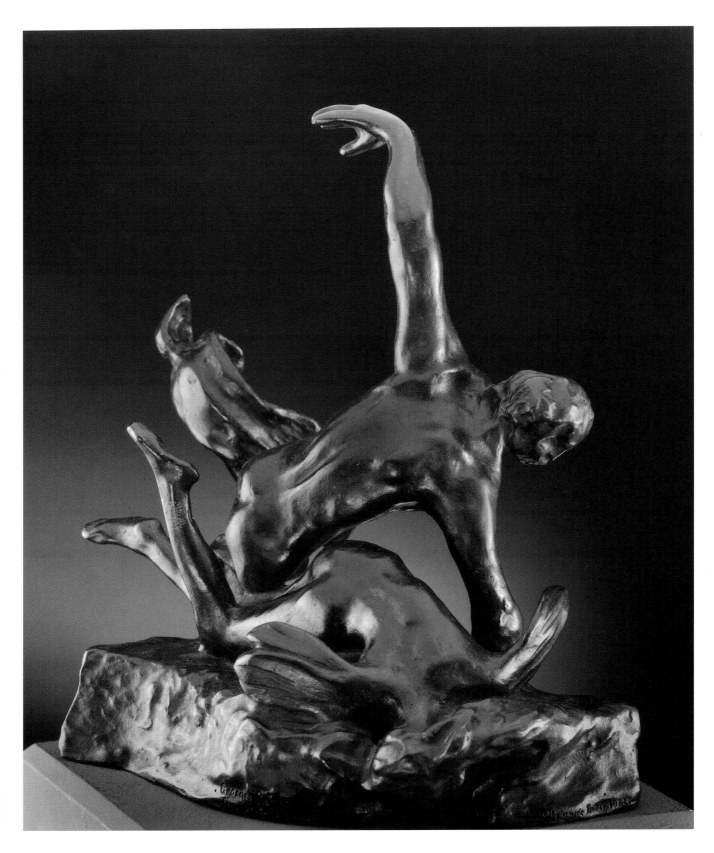

Fig. 416. *Triton and Siren* (cat. no. 149).

neous movement of one of his athletic studio models. With various changes in the arms and legs, alone and in certain couplings, he is a denizen of heaven and hell, air and sea. Barely six inches high, this figure played the roles of God, a marine deity, the poet, and a damned soul. Close in theme and form is *The Poet and the Siren*, a plaster known through photographs, exhibited in the artist's 1900 retrospective.[5] The brilliant, small male figure with legs and no modeled base when shown alone was christened *Damnée* (Damned soul).[6] In an assembled composition named *God Protecting His Creatures* (c. 1910), Rodin showed the man with legs, cradling two figures with his right arm while seeming to soar.[7] The other roles played by the woman, which probably were several, are harder to identify; with altered extremities she may apear in *The Poet and the Siren*, exhibited in plaster in 1900.[8]

Triton and Siren is Rodin at play. By replacing the man's legs with a fish tail and the woman's arms with wings, he set the stage for a provocative pairing and imagined tragic encounter. The viewer is free to think of the work as a commentary on the relation of men, including Rodin himself, to women. With Triton sitting on the back of the woman's left knee, the siren seems to be in the process of crashing. That she is not prone, which would have been antithetical to dynamism, but bent downward with hips still elevated gives a springiness to the composition. Space circulates between her and the base as well as her oppressor. Since the plasters in the studio were originally without supports, the sculpture's base was improvised to be pliant to the needs of the figures, for example, where it was cut away to accommodate the averted head of the siren or where it supports Triton's tail and right hand.

NOTES

1. Mauclair 1918, 40–41; see also Mauclair 1905a, 27.
2. The lack of consistent rhyming caused many conservative and modern sculptors to fault Rodin as a composer, but in works by artists like Anthony Caro, starting in the 1960s, discoordination reappeared in abstract art.
3. See, for instance, Leo Steinberg's essay on Rodin and his observations on the subject of Rodin and space (1972, especially 338–51).
4. The qualification "as yet" comes from the fact that often a work was given various names by Rodin and others. There is one mention of a work with this title, a plaster exhibited in Prague (1902), recorded by Beausire 1988, 233.
5. Ibid., 180–81.
6. In connection with an assemblage of heads and hands from *The Burghers of Calais*, Monique Laurent (in Judrin, Laurent, and Viéville 1977, 227) reproduced the figure with legs, said it was made for *The Gates of Hell*, and saw it as having had wings added to it for the assemblage (228–29). She did not refer to the difference in the arms and the fact that the figure was not shown from the waist down. She followed Tancock, who also reproduced the figure but with legs and indicated that, with wings added, it is found in *The Gates of Hell* (1976, 390–91), but this author has not found it there.
7. Laurent 1988, 154, fig. 11. She dated this assemblage to c. 1910.
8. See Le Normand-Romain 2001, 86.

150

The Bather (La baigneuse), c. 1883–85(?)

- Title variation: *The Zoubaloff Bather*
- Plaster
- 14½ x 7 x 8¼ in. (36.8 x 17.8 x 21 cm)
- Signed on back: Rodin
- Provenance: Antony Roux (purchased from Rodin in 1888); his sale, Paris, May 1914; Sotheby's, London, 28 June 1967, lot 12
- Gift of B. Gerald Cantor, 1977.14

Figure 417

151

The Bather (La baigneuse), c. 1883–85(?)

- Bronze, Alexis Rudier Foundry, cast 1943, 4/12
- 14¼ x 5⅝ x 7⅝ in. (36.2 x 14.7 x 19.7 cm)
- Signed on back: A. Rodin
- Inscribed on back, right side: Alexis Rudier/Paris; on back of rock, below signature: 4/12; interior cachet: A. Rodin
- Provenance: Palais Galliera, Paris, 17 March 1971, lot 31
- Gift of B. Gerald Cantor, 1978.123

Figure 418

*T*his work has the look and finish of the early 1880s, and Georges Grappe conceded that it was made before 1888, the date he assigned to it.[1] Many aspects of this deceptively simple work encourage the speculation that

Fig. 417. *The Bather* (cat. no. 150).

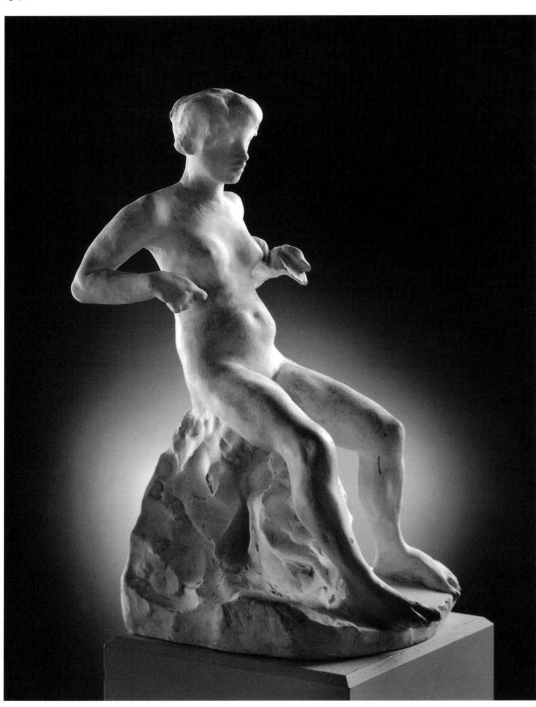

Rodin found the pose in one of his model's spontaneous movements. Perhaps to avoid symmetry, her feet are not firmly planted and are like those of the later *American Athlete* (cat. no. 142); one foot is shown on its side as a result of her legs being turned slightly to her left. Rather than being shown absolutely upright in the expected decorous pose, she leans back from the waist. Rodin obviously liked the winglike projections made by the two bent arms, which originally may have been posed to have the elbows resting on a support so that the backward-leaning model would not be fatigued. Her right hand barely touches her side while, as might be the case in a posture of rest, her left hand holds what appears to be a small cloth that Rodin may have added to prompt the name.[2] At this stage Rodin was still adding props such as the small towel and setting the subject on a rock out of doors in the tradition of a bathing beauty rather than acknowledging the studio origins of the piece.

The Stanford plaster is a dipped-plaster cast as proved when, as a result of the 1989 Loma Prieta earthquake, a small area by her left knee was chipped off, revealing the original plaster surface. Another indicator of an applied layer of wet plaster is the severe muting of the eyes. That the whole was made from a plaster Rodin had prepared for exhibition and/or casting is suggested by the surfaces, notably her thighs and shoulders, refined by filing.

Antony Roux was one of the first serious collectors to purchase Rodin's work, and he acquired some small sculptures destined for *The Gates of Hell*. When *The Bather* was sold to him in 1888, it was accompanied by a letter from Rodin saying, "I hereby deliver the original and agree to refrain from

making any reproductions. Two or three plaster proofs were presented as gifts to friends prior to this date."[3] Rodin had earlier sold Roux *Iris Awakening a Nymph* (cat. nos. 152–153) with a letter warranting that it was Roux's exclusive property, meaning that only he had its reproduction rights. As with paintings, reproduction rights that allowed the making of prints or additional casts in the same or other materials were financially very valuable.[4] As Rodin's reputation and sales of his work increased, he stopped making such concessions to collectors but entered into several contracts with bronze editors for unlimited reproductions of popular subjects such as *The Kiss* and *Eternal Spring*. In 1916 Rodin assigned all rights to his sculptures' reproduction to the French nation, which authorized the posthumous bronze version of *The Bather*, cast after the plaster was acquired by the Musée Rodin in 1927.

NOTES

LITERATURE: Grappe 1944, 69; Jianou and Goldscheider 1969, 101; Lampert 1986, 216; Ambrosini and Facos 1987, 180; Grunfeld 1987, 206

1. Grappe 1944, 69. This work and another plaster cast of it were originally sold by Rodin in 1888 to the collector Antony Roux, from whose estate sale (Paris, 1914) it was obtained by Jacques Zoubaloff (lot 148), hence the attachment of his name to the work (Grunfeld 1987, 206). At the Zoubaloff sale in 1927 the Musée Rodin acquired its plaster.
2. Rodin certainly fooled the redoubtable Grappe, who wrote about this piece as being one a series of studies of nymphs emerging from water (1944, 69), though he regarded it as far from a conventional naiad.
3. Quoted in Grunfeld 1987, 206, citing *Vent de la collection Antony Roux* (Paris: Galerie Georges Petit, 1914).
4. Ibid.

Fig. 418. *The Bather* (cat. no. 151).

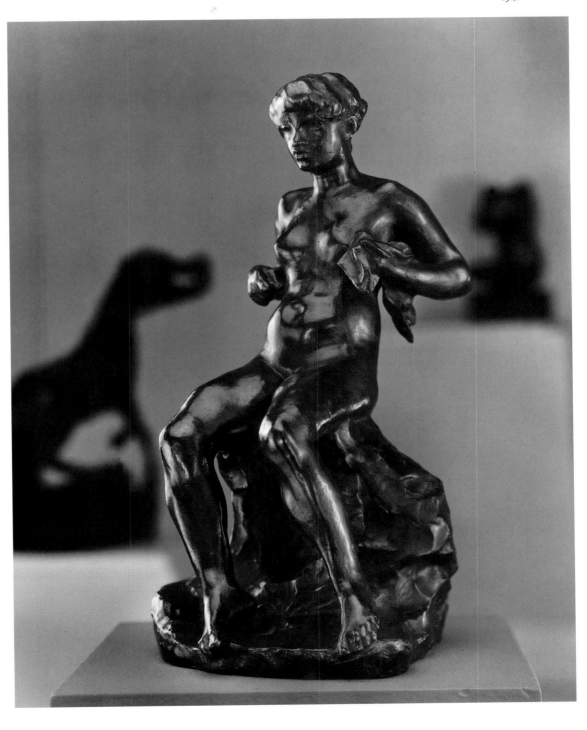

152

Iris Awakening a Nymph
(*Iris éveillant une nymphe*), 1885

- Title variations: *Iris Awakening Dawn, Venus and Love*
- Plaster
- 14½ x 7 x 8¼ in. (36.8 x 17.8 x 21 cm)
- Signed on base, right side: Rodin
- Provenance: Antony Roux (purchased from Rodin 21 September 1885); his sale, Paris, May 1914, lot 137; Sotheby's, London, 28 June 1967, lot 13
- Gift of B. Gerald Cantor, 1977.15

Figure 419

153

Iris Awakening a Nymph
(*Iris éveillant une nymphe*), 1885

- Bronze, Georges Rudier Foundry, cast 1974, 9/12
- 13¾ x 10¾ x 8½ in. (35 x 27.5 x 21.5 cm)
- Signed beneath seat, rear: A. Rodin
- Inscribed on back of rock, left: A. Rodin; on back of base, right: Georges Rudier/Fondeur Paris; on back of base, left: © by musée Rodin 1974; interior cachet: A. Rodin
- Provenance: Musée Rodin, Paris
- Gift of B. Gerald Cantor, 1982.303

Figure 420

*T*his is one of many playful and erotically titillating pieces probably intended for private collectors at a time when Rodin was in need of financial support. In fact, the plaster was purchased on 21 September 1885 by the collector Antony Roux, who asked for and was given the exclusive right to cast the plaster in bronze.[1] This was a rare concession by Rodin, and it may account for the fact that the piece was exhibited only by the artist in his 1900 retrospective.[2]

Rodin's love and experience of eighteenth-century sculpture and his work with Albert-Ernest Carrier-Belleuse may underlie this small but highly finished piece. With his customary tact in such matters, Rodin used a winged and very young Iris in what is yet another of his lesbian motifs, akin to other studies from this period related to *The Gates of Hell*, such as *The Metamorphoses of Ovid* (cat. no. 68) and *Damned Women* (1885).[3] He invited a narrative reading of finely fashioned faces and gestures, and this does appear to be not a *marcottage* but an original composition. With the act of placing her hands on the legs of the awakening woman, Iris is in the process of landing her right leg on the left thigh of the nymph, while the trailing leg is poised in space to complete the intimate confrontation. To stabilize the composition, Rodin fashioned a bridge of Iris's hair that connects with the right forearm of the nymph. There is no labor of detailing the wings; Rodin was content with just their overall shape and placement.

Typical of Rodin's sculpture, there is no one unobstructed view of the composition that allows us to read the interaction of the figures clearly. The raised arms of the nymph often elbow into our gaze, and this forces the observer constantly to change viewing angles. Further, Rodin avoided an obvious aligning of the two figures in the same plane. Side views show Rodin's sensitivity to the way intervals, here mostly triangular, between limbs and torsos can be rhymed to add subtle coherence to the composition.

NOTES

LITERATURE: Grappe 1944, 52–53; Jianou and Goldscheider 1969, 99; Ambrosini and Facos 1987, 142–43; Grunfeld 1987, 206

1. For further discussion of this sale and others to Roux, see the entry on this work by Lynne Ambrosini (in Ambrosini and Facos 1987, 142–43). After purchasing this plaster at auction Cantor rejected the suggestion that the right of its reproduction passed to him as the owner.
2. It is not listed by Beausire (1988) as having been shown in public; however, it was no. 162 in the 1900 exhibition (Le Normand-Romain 2001, fig. 113).
3. See Grappe 1944, 52, cat. nos. 144–45, for his discussion of *Damned Women* and of *Iris Awakening a Nymph*, respectively.

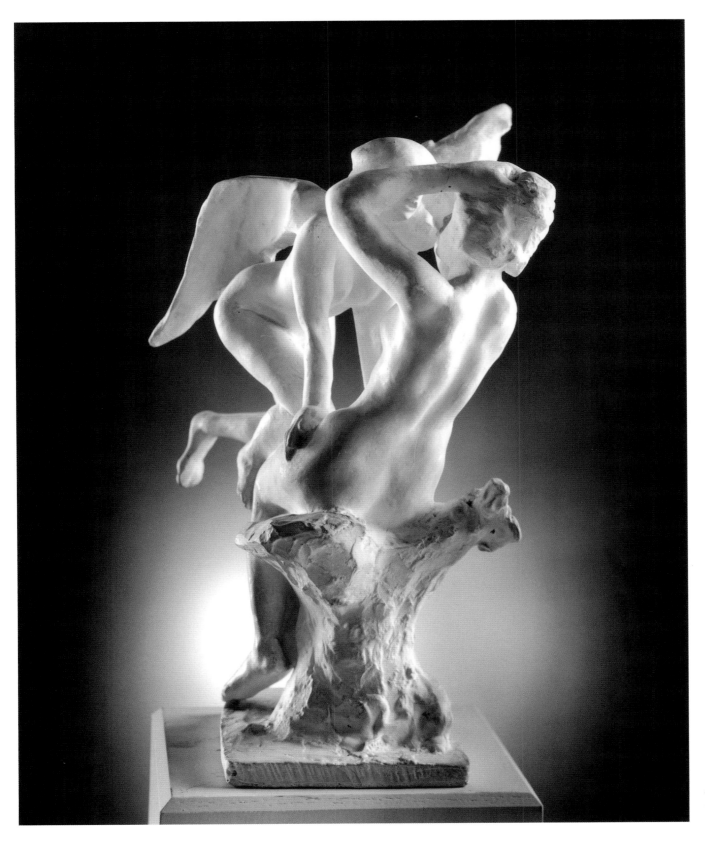

Fig. 419. *Iris Awakening a Nymph* (cat. no. 152).

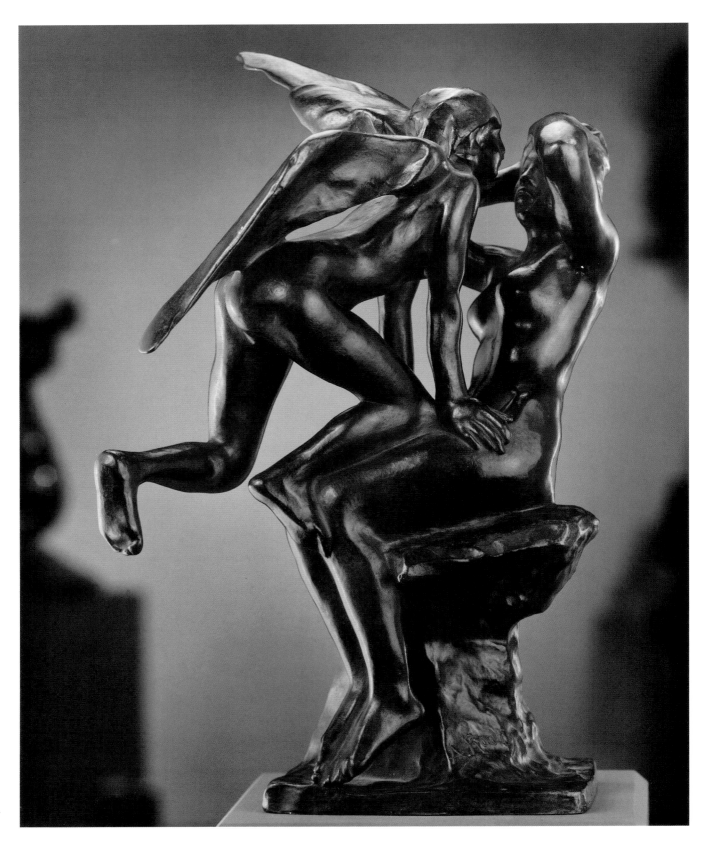

Fig. 420. *Iris Awakening a Nymph* (cat. no. 153).

154

Danaid (*La danaïde*), 1885

- Bronze, Georges Rudier Foundry, cast 1968, 9/12
- 9⅛ x 15⅜ x 10¼ in. (23.2 x 39 x 26 cm)
- Signed on rock, left side of figure: A. Rodin
- Inscribed on back: Georges Rudier/Fondeur.Paris.; below signature: © by musée Rodin 1968
- Provenance: Musée Rodin, Paris
- Gift of the Iris and B. Gerald Cantor Foundation, 1974.106

Figure 421

*R*odin greatly favored this work titled after the Ovidian myth of the daughters of Danaus, who murdered their husbands on their wedding night and were consigned to Hades, where they were fated to draw water in broken urns. He had several marble versions carved, the first of which (Helsinki, Ateneumin Taidemuseo) was exhibited in 1889 during his exhibition with Monet.[1] This bronze was not cast from one of the carvings. Whether or not this figure was destined for *The Gates of Hell* cannot be verified despite the appropriateness of the subject. It seems to have been made at the same time as *Andromeda* (cat. no. 155), and quite probably the same model with the beautiful back and buttocks served as inspiration for both works. That this model was probably Camille Claudel, as indicated by Monique Laurent, also lacks verification.[2]

When *Danaid* was first shown in 1889, what immediately set Rodin's work apart from that of his contemporaries was not skill, not touch, but the attitudes or positions of his subjects. They were clearly outside the repertory of Rodin's more conservative colleagues. In his catalogue essay on Rodin for the Monet-Rodin exhibition, which did so much to establish the sculptor's reputation in France, Rodin's most brilliant lifetime interpreter Gustave Geffroy inventoried what the public had come to expect in figural sculpture: "a straight body, a bent leg, a raised arm, an extended body . . . hands crossed behind the head to make the bust project forward, an inclined head, one hand holding an elbow, the other hand at the chin. These are the principal arrange-

ments of lines, scarcely augmented by some insignificant variants."[3]

Geffroy had often visited the sculptor's studio, perhaps starting in the mid-1880s, and was well aware of the artist's work and motivations. His 1889 essay clearly publicized what made Rodin different and original. He pointed out that Rodin had compared "existing forms" with those that had been reproduced in sculpture "and he remained stupefied before the innumerable possible positions" and resistant to typification of the natural movements of live figures. Rodin's dilemma, Geffroy suggested, was the infinite number of sculptural possibilities afforded to him every time the model moved. The sculptor felt powerless because of "the lack of time, the brevity of life, to recreate in marble and bronze all the combinations of lines and nuances of expression that are reflected in eyes that know how to see."[4]

That Rodin did more than imitate or copy was stressed by Geffroy, who referred to all Rodin's work as that accomplished "by the eyes and the mind." In what he called a "synthesis" of observation and thought, Geffroy claimed for Rodin the discovery of the universal in the particular, essential to great art. At one point he referred to an exhibited work, "a Danaid falls and remains prostrate."[5] Here Rodin's inclusion of the broken urn and title would have partially seconded Geffroy's idea of synthesis, in which, drawing on knowledge of the past, Rodin universalized and made timeless a mythical and human tragedy. Geffroy correctly characterized Rodin as an artist, rather than a theoretician, whose personal laws developed as he worked and for whom what he saw corresponded to his thought for the subject. Later critics would chide Rodin for being "literary" in so far as he included such props as a broken urn, but for Geffroy and the sculptor, the addition of such carriers of meaning did not detract from the essential, which was the quality and correctness of his modeling.

With *Danaid*, perhaps even more than with *Andromeda* and because of the greater compactness of the body's position, Rodin was claiming that he could make a woman's back as expressive as her face. In his essay Geffroy commented on a different sculpture, *The Crouching Woman* (1880–82), in terms Rodin would have appreciated: "the back, where is marked the rebellion and fatigues of the flesh."[6]

Rainer Maria Rilke knew the *Danaid* in marble. In his 1903 essay he wrote, "a figure that has thrown itself from a kneeling position down into a wealth of flowing hair. It

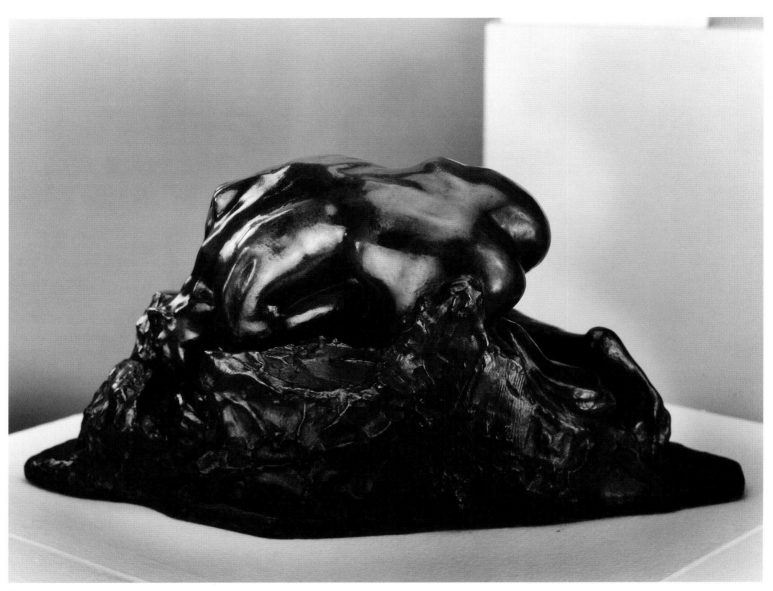

Fig. 421. *Danaid*
(cat. no. 154).

is wonderful to walk slowly about this marble, to follow the long line that curves about the richly unfolded roundness of the back to the face, [which] loses itself in the stone as though in a great weeping." The poet observed that "there was not one part of the human body that was insignificant or unimportant; it was alive. The life that was expressed in faces was easily readable. Life manifested in bodies was more dispersed, greater, more mysterious, and everlasting. . . . Here in the body Rodin found the world of his time."

Geffroy, Rilke, and other observant critics all recognized that Rodin's art depended on an infallible knowledge of the human body supported by a consummate mastery of his craft as a modeler. Coupled with the identifying originality of the poses of such figures as *Danaid*, Rodin's art was also distinguishable to the contemporary connoisseur by its surface. Rilke put it memorably: "It consisted of infinitely many movements. The play of light upon these surfaces made manifest that each of these movements was different and each significant. . . . They seemed to flow into one another. . . . There were undulations without end."[7]

NOTES

LITERATURE: Rilke [1903] 1945 in Elsen 1965a, 129; Grappe

1944, 50–51; 129; Jianou and Goldscheider 1969, 90; Tancock 1976, 253–54, 256, 276; Elsen 1981, 82, 84, 95–96; Lampert 1986, 84, 207; Miller and Marotta 1986, 32; Barbier 1987, 140–42; Laurent 1988, 98; Beausire 1989, 62, 194; Fath and Schmoll 1991, 150; Levkoff 1994, 125; Le Normand-Romain 2001, 210

1. Beausire 1989, 194–95; see also Barbier 1987, 140. For the figure's exhibitions, see Beausire 1988, 400.
2. Laurent 1988, 98.
3. Geffroy's essay is reproduced in Beausire 1989, 62. Evidence of the conservative response to *Danaid* is a bitter

critique of the sculpture in marble by one of Rodin's severest critics, a writer named Leroi (*L'art*, June 1903), who referred to Rodin's "crass ignorance in baptizing *Danaid*, a crouching woman, buttocks in the air and the head invisible, so much that she seems buried in the base of this pseudo marble masterpiece" (quoted in Beausire 1988, 240).
4. Geffroy in Beausire, 1989, 62–63.
5. Ibid., 64.
6. Ibid.
7. All Rilke quotations in Elsen 1965a, 129, 116, 115.

155

Andromeda (Andromède), 1885

- Title variations: *Nude Woman, Sorrow, Woman Leaning on a Rock*
- Bronze, Georges Rudier Foundry, cast 1968, 5/12
- 10⅛ x 8½ x 12¼ in. (25.7 x 21.6 x 31.1 cm)
- Signed on base, left side: A. Rodin
- Inscribed on back of base near right, lower edge: Georges Rudier/Fondeur.Paris.; on back of base, left lower edge: © by Musée Rodin 1968; interior cachet: A. Rodin
- Provenance: Musée Rodin, Paris
- Gift of the Iris and B. Gerald Cantor Foundation, 1974.108

Figure 422

*A*ndromeda appears to be an example of Rodin's naming rather than titling a sculpture. Archival evidence in the Musée Rodin indicates that the work had no nomination after it was first made in 1885 and then exhibited in 1886.[1] Following its listing as *Andromède* in an 1890 exhibition of a marble version at the Durand-Ruel Gallery in Paris, there was a succession of names—*Nude Woman, Woman Leaning on a Rock, Sorrow*—associated with this sculpture, which knew at least four translations into marble.[2] The Stanford bronze was made from one of the marbles.

Such provocative names distract not only from the beauty but also the daring of the form in the history of sculpture, as shown unintentionally by John Tancock's discourse on the mythological figure of Andromeda in connection with Rodin's sculpture.[3] This author's specu-

lation on the history of this work, as well as that of *Danaid* (cat. no. 154), is that far from intending to illustrate a myth, Rodin derived his subject from a tired model who had slumped onto a piece of studio furniture to rest. Inspiration from such a sight, rather than asking the model to pose as Andromeda, would have been consistent with this sculptor's practice: he claimed he never deliberately posed his model, especially not with literary dramatization in mind.

There is no principal view, but that from above showing just the woman's back may be the most satisfying. Seen from the sides, it is as if her right foot is submerged in water. (By the time of the first marble version Rodin did make the association with Andromeda chained to a rock in the sea, awaiting liberation by Perseus.) Her left forearm and hand are not articulated, and her left leg disappears into the rock on which she sits. There is intense bodily torsion in such a passive pose. The woman seems to rest her right cheek on the stone; her torso is twisted to her left. It is this movement that provides the big, graceful curve of the spine and makes the beautiful back the sculptural subject.

Andromeda is a stunning example of how Rodin was able to seek and achieve a largeness of effect using the architecture of the body. Rather than hiding the bones, he accentuated the right hip and shoulder blade. Seen from the woman's right side, the shoulder blade is crucial to the sensuous silhouette and its landscape associations. Rather than resorting to theatrics, like an anguished expression typically associated with a woman in peril, Rodin showed his model as if asleep. To preserve the sense of undulant continuity, he treated the exposed portion of the head almost abstractly, making no distinction between hair and flesh and with the cheek, temple, and brow constituting a single curving plane. Augmenting the general continuity of this almost fluid form,

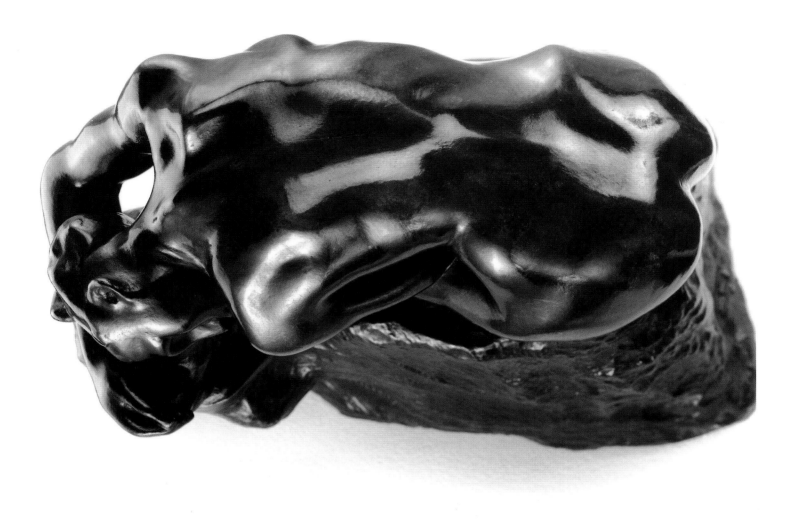

Fig. 422.
Andromeda
(cat. no. 155).

Rodin fitted the rocky base to the figure. The compacted feminine form wedded to its rocky support embodied Rodin's "cubism": his predilection for visualizing his subjects within an imagined cube, thereby, as in this work, holding all the energy of the form in as small an area as possible.

Despite Georges Grappe's claim that this work was intended for *The Gates of Hell* and appears in an early stage of the portal, there is no confirming evidence.[4]

NOTES

LITERATURE: Grappe 1944, 51–52; Jianou and Goldscheider 1969, 91; Tancock 1976, 253–56; Ambrosini and Facos 1987, 87; Barbier 1987, 138

1. Barbier 1987, 138. Grappe identified the sculpture with the figure *Bent in Half*, shown in 1886 at the Galerie Georges Petit (1944, 51). Barbier maintained that the rock was later added to the bent-over figure. Beausire recorded two subsequent exhibitions of marble versions in Chicago (1893) and Paris (1902) (1988, 94, 110, 117). See also Le Normand-Romain 2001, 220.
2. Barbier 1987, 138.
3. Tancock 1976, 253.
4. Grappe 1944, 51. Tancock noted this discrepancy as well (ibid).

156

Children with a Lizard
(*Les enfants au lézard*), c. 1886

- Bronze, Georges Rudier Foundry, cast 1968, 8/12
- 14 x 9 x 8 in. (35.6 x 22.9 x 20.3 cm)
- Signed on base, left side: A. Rodin
- Inscribed on back of base: Georges Rudier/Fondeur.Paris.; on base, left side: © by Musée Rodin 1968; interior cachet: A. Rodin
- Provenance: Sunset Art, Beverly Hills
- Gift of the Iris and B. Gerald Cantor Foundation, 1974.38

Figure 423

*T*he subject that ostensibly prompts the action in this deliberately charming though artistically unusual composition is that of a child frightened by the appearance of a small lizard on the sculpture's base just below where the infant had been standing. A somewhat older and stronger sister clutches the frightened sibling, who is precariously balanced. But for the partial support at the shoulders and her right leg on the knee of her elder sister, she is suspended in air. Such a strenuous and seemingly impromptu pairing is indicative of Rodin's instinct to avoid compositional clichés such as an obvious cradling, with the smaller child on the lap of the larger. While the lizard suggests a front to the base, neither of the infants accords with such a frontal orientation. One must circumambulate the composition to follow the design and read the gestures, such as that of the older sister's right hand, whose forefinger extends into the other's hair.

Despite the fact that there are points of physical contact between the two—the alarmed infant presses her left forearm against the face of the older child and also touches her protector's left collarbone; the latter touches her awkward burden—it is likely that the two figures were separately made and then joined. Thereafter they seem to have continued to lead separate existences. For example, at the lower-left corner of the left external bas-relief of *The Gates of Hell* the horizontal child is partially supported by an outcrop of a very pliant rock, thus gaining a new upright orientation and a radically different thematic context. As one can just make out this form in Jessie Lip-

scomb's 1887 photograph of the lower half of the doors in plaster (see fig. 124 and also fig. 172), we have not only a terminal date for its creation but can see how Rodin drew on motifs, including well-fed babies, from his more commercial art for inclusion in his epic of humanity's fate.

As early as his work in Belgium between 1871 and 1878, Rodin had made sculptures of children, usually in affectionate pairings. As a student at the Petite école he had made drawings for decorative purposes, probably copied from earlier works of art, of infants as cupids. They populate his decorative work on the Brussels Bourse from 1872–73, his vases made at the Sèvres factory between 1879 and 1882, and his prints, drawings, and ceramics of the period (see cat. nos. 196–98). In *The Gates of Hell* are many children in both the exterior bas-reliefs and the reliefs below the two tombs.

LITERATURE: Grappe 1944, 58; Goldscheider 1989, 160

Fig. 423.
Children with a Lizard (cat. no. 156).

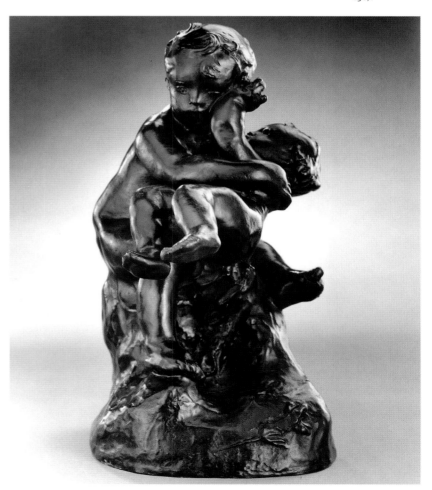

157

Minotaur (Minotaure) c. 1886

- Title variations: *The Faun, Faun and Nymph, Faun and Woman, Jupiter Taurus*
- Bronze, Georges Rudier Foundry, cast 1969, 5/12
- 13½ x 10 x 10 in. (34.3 x 25.4 x 25.4 cm)
- Signed on left side, near base: A. Rodin
- Inscribed on back of base: Georges Rudier/Fondeur Paris; on base, left side: © by musée Rodin 1969; interior cachet: A. Rodin
- Provenance: Musée Rodin, Paris; Paul Kantor Gallery, Malibu
- Gift of the Iris and B. Gerald Cantor Foundation, 1974.39

Figure 424

*T*his is perhaps the most erotic work that Rodin ever exhibited, and it was shown often. Its first recorded exhibition was in Munich (1896), and thereafter it was shown in Vienna (1898), The Hague (1899), Paris (1900, 1910, 1917), Potsdam (1903), Düsseldorf (1904), and Barcelona (1907).[1] Although the sculpture bore different titles, and the hybrid male seems more like a faun or satyr rather than a bull, the title *Minotaur* seems to have been preferred by the artist.[2] The *Minotaur* is almost certainly a self-portrait, and the composition unquestionably contributed to Rodin's reputation as a sculptor obsessed with sexuality.[3] In a contemporary cartoon he is depicted as a faun or satyr.[4] What may have protected him from contemporary censorship was the use of the old device of casting the couple as pre-Christian or mythological beings, which he could have learned from the eighteenth-century decorator Clodion (Claude Michel), whose erotic mythological groups he admired and whose legacy was continued in the work of Albert-Ernest Carrier-Belleuse.

Georges Grappe dated the sculpture to before 1886.[5] Given the large number of paired figures in Rodin's art, what makes it unusual, and what probably makes it early in date, is that the two figures seem to have been fashioned at the same time rather than separately and then joined. Rodin would use the minotaur's head again in his image *Pygmalion and Galatea* (1889), but the evidence, such as the physical contact between and bonding of the

figures by means of hair in several places as well as their overlapping gestures, does not support the idea that the *Minotaur* is an example of *marcottage*.[6]

As with *The Kiss* (cat. nos. 48–49), *Minotaur* is a narrative that invites close reading. Although Rodin knew Ovid, there is no evidence that this sculpture was inspired by the Roman author. To show the stirrings of a brute, Rodin had no need to be an illustrator and was annoyed when he was so characterized. There is no violent seduction, no clutching at the nymph by the monster, no recoiling in terror by the woman. In Rodin's way of telling a story, which was to avoid a climactic moment, the composition invites speculation about what happened before and after the situation depicted. The minotaur, or satyr, is seated on a rock, but his cloven hoofs are not braced against the ground. While open-mouthed, he seems to stare with his wide, round eyes at the nymph's hair, his left hand holds her elbow (to brace her or to get her to withdraw her left hand, which blocks his?), and the right, with its bent fingers, reaches under her extended thigh, where it is met by his partner's left hand. Rodin was concerned with what might be called the tact of the male's gestures. The tuft-tailed hybrid does not actually grab her forcibly. That the sculptor may have reworked the hand gestures is suggested in the Philadelphia Museum of Art's plaster version.[7] Although her right shoulder is decidedly raised and with her whole body she leans to her left as if to fend off the panting, horned seducer, her right arm, elbow, and hand are not used to rebuff. Her free hand simply rests on her own thigh. The woman's knees are not together, presumably having been forced apart, and her extended right leg is slung over his, but she uses her right foot to press against the ground to avert her body from his embrace.

The nymph's expression seems more of a frown rather than one of fear. Rodin invited the speculation that the woman may have been standing in front of the seated creature, with her back to him, and that he has drawn her down between his hairy flanks while lifting her right thigh over his extended leg. (Rodin did not gift the brute with genitals.) In *The Kiss* Francesca's right leg draped over that of Paolo is an assertive sexual appropriation of her still-reluctant lover. In the *Minotaur* the slung leg seems to have been at the male's initiative. The nymph's left leg is bent under her, more in the position of one seated than one attempting to rise.

Rodin made figural hybrids not only of humans and animals but of both genders in one work, as with *Orpheus*

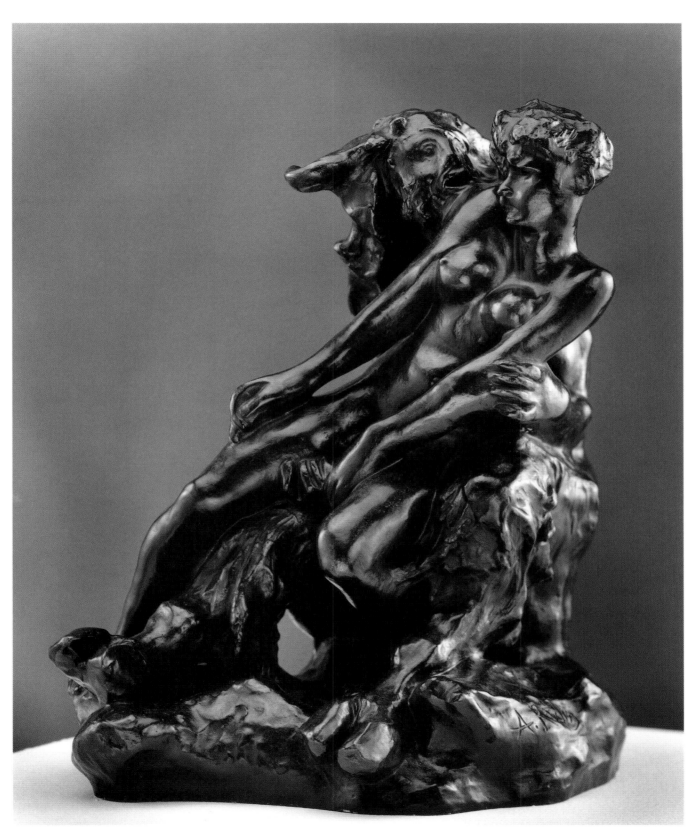

Fig. 424.
Minotaur (cat.
no. 157).

(cat. no. 96). In *Minotaur* the front of the sculpture is that of a woman; the back, that of a man. This is made possible by the proximate positions of the couple, which gave Rodin the opportunity to show in one sculpture the full-length front of a young full-breasted model, while from the rear he could display a finely muscled, mature male back. For this and other reasons, not least its appeal to discriminating clients, Rodin had the work slightly enlarged and carved in stone.[8]

As if responding to past (and anticipating future) charges of obscenity, in 1912 Rodin offered to an American reporter the following opinion: "People have often accused me of having made erotic sculptures. I have never made any erotic works. I have never made a sculpture for the sake of the erotic element. Most of the people cannot conceive this because they are unable to conceive what sculpture is, because they are forever looking in sculpture for literary and philosophical ideas. Sculpture is the art of forms."[9] His defense was that he was first an artist dedicated to making an art of forms and not appealing primarily to narrative, much less prurient interests. Consistent with all his other work, he fully intended that the beholder should look at his sculpture aesthetically as a whole and not just at the most provocative parts, which in themselves are not patently offensive.

Rodin's lusty view of antiquity predicted that of Pablo Picasso, as both artists rejected art school ideals that stressed the Apollonian rather than the Dionysian tradition, and both personalized myths and mythical creatures. *The Gates of Hell* retains evidences of lust-driven centaurs chasing women and such couples as *Nereid and Triton* (c. 1886) are energetic, passionate exercises.[10]

NOTES

LITERATURE: Grappe 1944, 57; Jianou and Goldscheider 1969, 100; Tancock 1976, 270–73; de Caso and Sanders 1977, 105–8; Fusco and Janson 1980, 342–43; Lampert 1986, 88, 215–16; Pingeot, Le Normand-Romain, and de Margerie 1986, 234–35; Pingeot 1990, 246–47, 313 ; Le Normand-Romain 2001, 100

1. Beausire 1988, 129, 139, 153, 182, 238, 253, 287, 320, 367.
2. See Tancock for his discussion of the title's implications and of the sculpture's eighteenth-century affinities (1976, 270). De Caso and Sanders (1977) review other titles for this work, discuss the implications of the title *Faun and Nymph*, and site the questionable biography by Frisch and Shipley (1939, 105–7, 108 n. 4), which purports to be the former's eyewitness account of Rodin attempting to inspire his female model's reaction to a faun.
3. De Caso and Sanders 1977, 107.
4. Claire Bretècher and Jean-Louis Mourier, *Rodin et la caricature*, exh. cat. (Paris: Musée Rodin, 1990), 49.
5. Grappe 1944, 57; Le Normand-Romain (2001, 100) dates it c. 1885.
6. The *Minotaur* led to the sculpture *Pygmalion and Galatea*, according to Rodin (see Tancock 1977, 270). For Rodin's assemblages of around 1910 based on each of the figures in the *Minotaur* (the male figure joined with *Torso of the Centauress* and the upper torso of the female figure paired with *Study for Iris*), see Nicole Barbier, "Assemblages de Rodin," in Pingeot 1990, 246–47.
7. Tancock 1976, 271.
8. For the marble version, see Tancock 1976, 272–73; de Caso and Sanders 1977, 108 n. 11.
9. Herman Bernstein, interview with Rodin, in *New York Sun*, 2 July 1912; Musée Rodin archives.
10. See, for example, *Triton and Nereid* (terra-cotta, Metropolitan Museum of Art, New York) discussed and illustrated in the context of the *Minotaur* in Tancock 1976, 270, 273.

158

The Centauress (La centauresse), c. 1887

- Title variation: *Soul and Body*
- Bronze, E. Godard Foundry, 3/12
- 15¾ x 17¾ x 7 in. (40 x 45.1 x 17.8 cm)
- Signed on base, right, near back: A. Rodin
- Inscribed on base, left, near back: E. Godard.Fondeur/Paris.; on base, right side: © by A. Rodin

- Provenance: Hal Skolnik, London
- Gift of the Iris and B. Gerald Cantor Foundation, 1974.57

Figure 425

*T*he *Centauress* is a vivid reminder that Rodin, who affirmed he could only work from nature, not only worked on portraits at times from memory but concocted whole imaginative figures from an arsenal of body parts. That this was not always a disinterested formal exercise but could be motivated by an idea, such as how to embody the warring nature of humanity, can be seen in this poignant hybrid creature. In fact, the work was early known as *Soul and Body*.[1] Centaurs romp through Rodin's "black drawings" for *The Gates of Hell*, and some

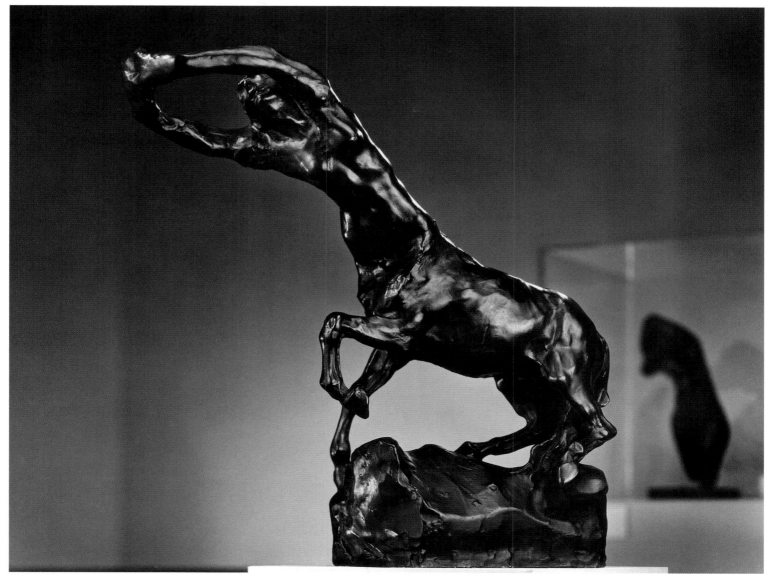

Fig. 425. *The Centauress* (cat. no. 158).

found their way into the portal and its studies, as seen in the reliefs surrounding the masks of the *Crying Girl* (see figs. 181–82). To the body of the horse from the *Maquette for "Monument to General Lynch"* (cat. no. 7), Rodin affixed a torso of unspecified gender. It resembles those of *The Prodigal Son* (created mid 1880s; see fig. 426) and *Orpheus* (cat. no. 96) with its misaligned sternum and navel, but with the addition of breasts.[2] The head is male, a derivative of that used for Paolo (cat. no. 50), for the male figure in the *Fugit amor* group (before 1887), in *The Gates of Hell* for one of Ugolino's sons (cat. no. 46), and for Rodin's androgynous figure *Orpheus*. The creature's left arm seems to have come from stock, but her right seems to have been improvised hastily and left unrefined. The hands never went beyond their present crude, stumplike configuration. When *The Centauress* was carved in stone, the hands were made to seem to be pulling against the vertical tenon used as their support, thereby enhancing the sense of the human portion of the creation trying to literally pull itself out of its animal socket.[3] From the waist up the figure was used in combination with *Large Clenched Left Hand* (cat. no. 190) to produce a powerful assemblage (cat. no. 193).[4]

A photograph in the Stanford collection shows *The Centauress* in the process of being assembled (see fig. 16). Consistent with Rodin's mature view of photography as

more than documentation, he used the medium to disclose the mysteries of the studio to the public. The sculpture itself reveals that Rodin made no attempt at consistency of illusion as he took little pain to create the semblance of a natural transition from the body of the horse to that of the woman when seen from the front, and no effort was made to refine the hands, arms, and their attachment to the shoulders. Deliberately withholding skill, Rodin seems to have been satisfied if the general movement or overall flow of the gesture made by his anatomically incomplete forms was successful.

Although not citing *The Centauress* as a specific example of what he had in mind, in 1907 Rodin talked to an unidentified reporter and seemed to be describing his intentions for this work: "[The artist] must celebrate that poignant struggle which is the basis of our existence and which brings to grips the body and the soul. Nothing is more moving than the maddened beast, perishing in lust and begging vainly for mercy from an insatiable passion."[5] Perhaps never was there a sculptor so centered on this subject and so compassionate in its rendering.

NOTES

LITERATURE: Grappe 1944, 82–83; Spear 1964, 37; Jianou and Goldscheider 1969, 103; Tancock 1976, 200–4; de Caso and Sanders 1977, 160; Elsen 1981, 146; Judrin 1981, 16; Barbier 1987, 146; Laurent 1988, 80; Pingeot 1990, 242–43; Barbier 1992, 19–20

1. Grappe 1944, 83. Tancock revised Grappe's date of 1889 for the work to "by 1887" (1976, 200). Barbier suggested a later date, c. 1900 (in Pingeot 1990, 242–43; Barbier 1992, 20).
2. Without supporting evidence, following other biographers, Laurent suggested that Camille Claudel was the inspiration for the torso (1988, 80). De Caso and Sanders saw the torso of *The*

Prodigal Son as the basis of this work (1977, 160), following the views of Spear (1964, 37).
3. Reproduced in Barbier 1987, 146.
4. For an excellent discussion of Rodin's assemblages based on *The Centauress* and on the torso of this figure, see Nicole Barbier's "Assemblages de Rodin" in Pingeot 1990, 241–46.
5. *Antée*, 1 June 1907. Tancock offered a different interpretation based on a story from Ovid (1976, 202 n. 3), citing Grappe, "Affinités électives—Ovide et Rodin," *L'amour de l'art* 17, no. 6 (June 1936): 203–8.

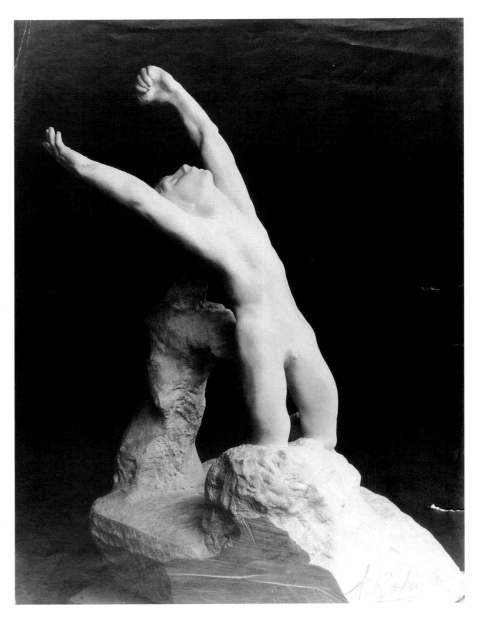

Fig. 426. Jacques-Ernst Bulloz, *"The Prodigal Son,"* after 1899, in marble (A117).

159

Crouching Bather with Arms (La baigneuse accroupie, étude avec bras), c. 1886–88(?)

- Title variations: *Crouching Bather on a Rock, Crouching Woman, Large Crouching Bather, Fauness with Legs Apart*
- Bronze, Georges Rudier Foundry, 6/12
- 12½ x 13 x 9½ in. (31.8 x 33 x 24.1 cm)
- Signed on top of base, left: A. Rodin
- Inscribed on back of base, right: Georges Rudier/Fondeur.Paris.; below signature: No. 6; on back of base, left: © by musée Rodin
- Provenance: Artneys International Ltd.; McCrory Corp., New York; Paul Kantor Gallery, Malibu
- Gift of the Iris and B. Gerald Cantor Foundation, 1974.59

Figure 427

W hen in effect Rodin asked himself, What if one did not pose the model but allowed her to move spontaneously and assume natural or instinctive attitudes, he opened sculpture to a range of historically unprecedented subjects. The squatting, naked woman with her legs splayed apart that we see in this bronze does not recall any postural precedents in sculpture. (Crouching Greek Venuses and nineteenth-century French nymphs kept their bent legs together.) Unrecorded by Georges Grappe and only briefly noted by others, the work, and its title, is problematic. In instances where a figure's pose was ungraceful or sexually blunt, Rodin sometimes had recourse to the title of *Bather* or, if the pose was indecorous, *Fauness*, evoking associations with ancient rather than contemporary subjects.[1]

Based on the style and its similarity to that of the crablike *Seated Nude Bather* (cat. no. 165), this sculpture may have been made in the mid- to late 1880s. Although working on such major projects as *The Gates* and *The Burghers* in these years, small études such as this gave the artist a welcome change. As Edgar Degas did with most of his études, Rodin felt the need to fashion a rough, rocklike base rather than use a plain, flat support such as the studio floor would have afforded. There is a smaller truncated terra-cotta version of this figure in the reserves of the Musée Rodin at Meudon, from which the arms, feet, and base have been removed, thereby simplifying the

bodily gesture and compacting the image, as well as eliminating the need for a name such as *Bather*.[2]

As here shown, Rodin liked uninhibited models who were athletic and had long sinewy limbs. In *Crouching Bather* the woman's face, hair, and mittenlike hands, with which she braces herself, are only summarized, and more attention was given to the protrusion of the spine in the beautifully curved back as well as the full, sensuous density of the compressed thighs.[3]

Rodin's daring in showing a naked woman with legs wide apart occurs in his art of the 1890s (see *Flying Figure*, cat. nos. 183–184) and in one of his erotic muses (see *Iris, Messenger of the Gods*, cat. no. 185) proposed for his *Monument to Victor Hugo*, for which he reportedly used cancan dancers as models. As the artist often said that his drawings were influenced by his sculptures rather than the reverse, it is possible that this sculpture encouraged his probably later sketches of models exposing their genital areas.

NOTES

LITERATURE: Goldscheider 1962, 96; Jianou and Goldscheider 1969, 99–100; Tancock 1976, 250, 252; Laurent 1988, 107, 150

1. Grappe (1944) listed *La femme accroupie* in his index as cat. no. 254 but did not, in fact, illustrate or write about the work. Beausire recorded but did not illustrate the exhibition of a *Grande baigneuse accroupie* (Large crouching bather) in Rodin's 1900 Paris retrospective (1988, 180), and in the catalogue of that show it is listed as *Faunesse les jambes écartées* (Fauness with legs apart) (see Le Normand-Romain 2001, 80, where the figure is dated c. 1885). *Grande baigneuse accroupie sur un rocher*, which corresponds to the full-figure version, was listed in Jianou and Goldscheider 1967, 101, and was listed as *Crouching Bather on a Rock* in the English edition, Jianou and Goldscheider 1969, 100.

2. This partial figure was identified in Goldscheider as *Grande baigneuse accroupie* (Large crouching bather) (Goldscheider 1962, cat. no. 195) and was dated 1886 (Jianou and Goldscheider 1969, 99); it was dated c. 1886 by Tancock (1976, 252); it is dated "before 1877" in Durey 1988, 150, cat. no. 12. A date of 1886–88 seems likely, as Rodin was then given to allowing his models the freedom of movement here seen, and the smooth integument of the figure contrasts with the more exposed touch of the next decade.

3. There have appeared in recent years what this author judges to be *surmoulages* (casts from an existing statue) of this sculpture, in which the prominence of the spine is reduced and the interval between buttocks and ground is eliminated.

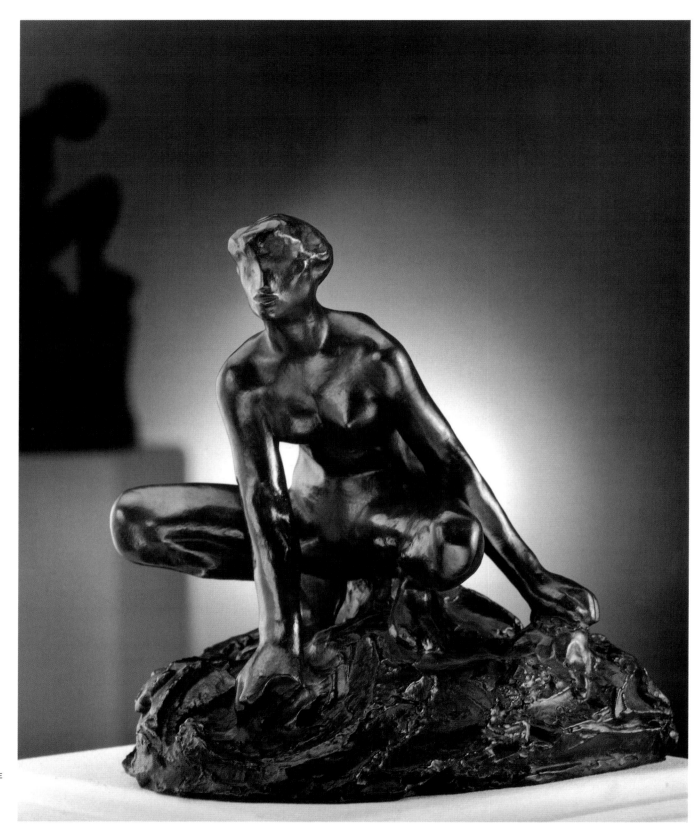

Fig. 427.
*Crouching
Bather with
Arms* (cat. no.
159).

OPPOSITE PAGE
Fig. 428.
Aphrodite (cat.
no. 160).

160

Aphrodite (Aphrodite), c. 1888, enlarged by 1914

- Bronze, Georges Rudier Foundry, cast 1978, 10/12
- 40½ x 7½ x 11½ in. (102.9 x 19.1 x 29.2 cm)
- Signed on top of base: A. Rodin
- Inscribed below signature: No. 10; on back of base: © by Musée Rodin 1978
- Provenance: Musée Rodin, Paris
- Gift of B. Gerald Cantor and Co., 1982.302

Figure 428

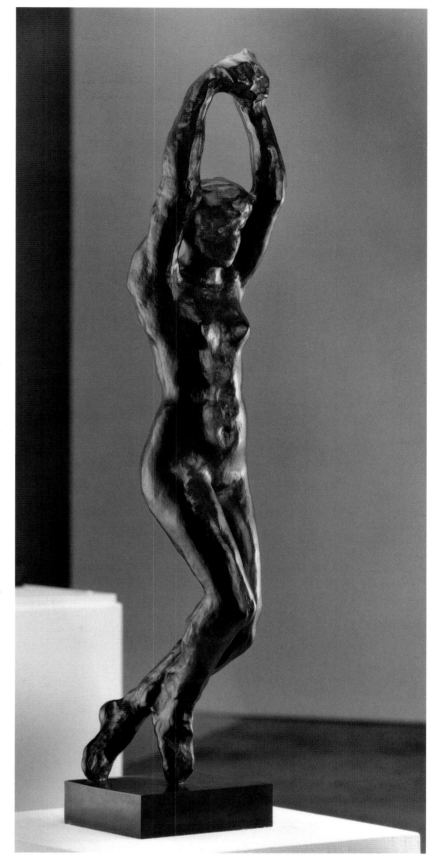

With the exception of Georges Grappe's 1944 catalogue, the Rodin literature has been largely silent about this sculpture. Grappe believed that the work, which he dated before 1889, was from *The Gates of Hell*, but unless it was a partially buried relief figure, this cannot be confirmed.[1] The Stanford cast is in all probability an enlargement from a much smaller original version.[2] By 1914 Rodin seems to have had the figure enlarged to life-size in plaster, and without the forearms it was used as a stage prop set in a niche for the play *Aphrodite* (1914), inspired by an 1896 novel by Pierre Louÿs).

This wonderful nude figure, which exudes a lightness of being, is clothed in questions beyond those alluded to. Just how did the model pose so that her feet were suspended above the ground? (The in-and-out inflection of the body discourages the thought that she hung from a rope.) The forearms and hands are summarily modeled, and the exact gesture of the latter is unclear. (In the final enlargement the figure's arms were amputated just above the elbow.) Why was there no modeled base to support the figure? (In the Stanford example the feet are attached to a base by a small bolt.) Did Rodin change the feet from a standing to a dancelike position after he had fashioned the figure? The treatment of the lower legs is unusual, probably because it represents radical editing. From her right heel to midcalf the crossed leg merges with the limb behind it. The back of her right leg looks as if Rodin had cut away most of the calf muscle, and the resulting dented planes look almost like a thick rope. The inside of the lower left leg is rougher than the out-

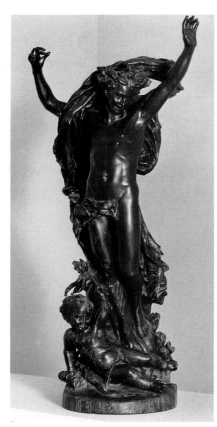

Fig. 429. Jean-Baptiste Carpeaux, *The Spirit of the Dance*, c. 1869, cast 1930s, bronze, 41½ x 17½ x 16¾ in. (105.4 x 44.3 x 42.5 cm). Iris & B. Gerald Cantor Center for Visual Arts, Stanford University, gift of Capt. Leon S. Golzer.

side, and it is as if Rodin had moved clay from above the woman's right ankle to the left leg. The anklebone of her right foot seems to have been pushed over, forming a bridge with the lower left leg behind it.

Further evidence that the figure began as an étude is the almost formless face: the ocular areas are simple indentations; there is no mouth, and the nose is a mound, as if she were wearing a mask over the lower portion of the face. One has the sense that the understating or muting of the facial features was deliberate so as not to arrest focus on this area and interrupt the upward and downward flow of the figure's undulating surfaces. The arms merge with the head indicating that this was not a synthetically made figure and that Rodin was trying to capture the model's whole movement at one go.

Taking in the totality of the figure from different angles, we can see the rhythmic flex that Rodin sought to capture. The planes move in and out at the waist and at the paired joints. In profile the resulting vertical zigzag seems a portent of the *Endless Column* (1918; Museum of Modern Art, New York) by Constantin Brancusi, who worked in Rodin's studio in 1907. To attain a sculptural rather than an anatomical balance and to maximize the use of light, the woman's hands, left forearm, and right knee would all touch an imaginary vertical plane. This was a device, Rodin explained about a statuette, to guide his compositions so that "there are no projections that interfere with the sweep of light across these surfaces and the illuminating of the various reliefs."[3]

Except in the area of the rudely shaped extremities, the sculpture's commonality of overall small-faceted surface texture is unusual. Rodin resisted habits of the hand in forming his surfaces, especially after *The Burghers of Calais*, but it is possible that with *Aphrodite* the enlarger, himself a sculptor as was customary at the time, applied this fairly uniform texture under Rodin's direction. (Henri Lebossé would do the same thing in his enlargement of *Cybele* [cat. no. 186] and *Torso of a Seated Woman*

[cat. no. 182]). The faceting is neither mechanical nor insensitive; it changes slightly in size due to the curvature of the volumes it covers. Though skilled, the enlarger would not have possessed Rodin's inventiveness in varying his treatment. This would mean that the enlargement was made after 1889, when Rodin sought sensuous volumes more than surfaces. Rather than expressionistically motivated, Rodin adapted more explicit texturing because of the way it reflected the light.

Aphrodite invites comparison with the bronze reduction of *The Spirit of the Dance* by Jean-Baptiste Carpeaux (1827–1875; fig. 429). When the Paris Opera commission was unveiled in 1869, the group known as *The Dance*, of which this sculpture is a reduced version of the central figure, caused a scandal because it lacked the physical decorum then associated with the subject. If given the same public exposure more than 20 years later, Rodin's sculpture would have incited vehement protests on other grounds: its lack of finish and coincidence of the raw and refined; its defiance of gravity and expectation of figural stability in statuary; the stripping away of all accessories and props, thematic and structural. Carpeaux, for instance, used the device of drapery under the feet to elevate *The Spirit* off the ground as well as to cover the genitals. The overall surface is dry, smooth, and hard, and the figure is finished down to its fingers and toenails. *The Spirit*'s naked chest is like a steel breastplate. By contrast with the synoptic treatment of *Aphrodite*'s lower face, for example, the male figure's open mouth reveals teeth. The light moves over Carpeaux's figure in large uninterrupted passages with predictable accent points. It is almost as if Rodin, who had admired and learned from Carpeaux in his youth, was demonstrating the differences between their two approaches.

NOTES

LITERATURE: Grappe 1944, 75; Jianou and Goldscheider 1969, 102; Gassier 1984, 81; Laurent 1988, 150

1. Grappe 1944, 75. Laurent (in Gassier 1984) dated the figure c. 1885(?), also noting that it is present but not easily distinguished in the portal (81).
2. There is no record of Henri Lebossé enlarging this work, but Rodin also employed other *reducteurs*, as the artisans were known who replicated sculptures, expanding or reducing their scale.
3. Lawton 1906, 165.

161

The Succubus (Le succube), 1889

- Title variations: *Hecuba Barking, The Sphinx*
- Plaster
- 8½ x 6¼ x 5 in. (21.6 x 15.9 x 12.7 cm)
- Signed on top of base, left rear corner: Rodin
- Provenance: Antony Roux; Sotheby's, London, 2 December 1971, lot 71
- Gift of B. Gerald Cantor, 1974.162

Figure 430

162

The Succubus (Le succube), 1889

- Bronze, Georges Rudier Foundry, cast 1974, 10/12
- 8½ x 6¼ x 5 in. (21.6 x 15.9 x 12.7 cm)
- Signed on top of base, left rear corner: A. Rodin
- Inscribed on top of base, right rear corner: A. Rodin; on back of base, right: Georges Rudier/Fondeur Paris; on left side of base, rear: © by musée Rodin 1974
- Provenance: Musée Rodin, Paris
- Gift of the Iris and B. Gerald Cantor Foundation, 1975.88

Figure 431

163

The Succubus (Le succube) 1889

- Bronze (*brut* cast with casting channels), Georges Rudier Foundry, cast 1975, 12/12
- 16 x 6⅝ x 8 in. (40.6 x 16.8 x 20.4 cm)
- Signed on top of base, left rear corner: A. Rodin
- Inscribed on back of base: Georges Rudier/Fondeur Paris; below sig-

nature: No. 12; on base, left side, toward back: © by Musée Rodin 1975; interior cachet: A. Rodin
- Provenance: Musée Rodin, Paris
- Gift of the Iris and B. Gerald Cantor Foundation, 1977.82

Figure 432

This kneeling figure was part of Rodin's repertory and with a different and shorter hairdo appears as the left-hand figure in the group called *The Sirens* (before 1887; figs. 433, 564), which in turn is found in the left door panel of *The Gates of Hell* (fig. 434) and elsewhere including the lower portion of the unfinished *The Apotheosis of Victor Hugo* (fig. 242).[1] Rodin changed her hair to make it more manelike so that it covers her shoulders and the back of the neck. Presumably it was Rodin who baptized this sensuous figure *Le Succube*, the name given to demons who assume female form in order to have sexual intercourse with sleeping males.[2] Rather than prevent moral censure (as École des beaux-arts students were advised), Rodin's choice of a mythological name made the work even more titillating. Often confused in its naming with *The Sphinx* (cat. no. 79), *The Succubus* was exhibited under the former name in the Monet-Rodin exhibition of 1889 and in Paris in 1895, but for its Prague showing (1902) it had the present identification, and for his 1900 retrospective Rodin had the work listed in the catalogue as *Hecube aboyante* (Hecuba barking).[3]

It was works such as *The Sphinx* and the small plaster *Female Torso* (cat. no. 178) that prompted a German museum curator named Alfred Lichtwark to recount to his directors in 1893 another's observation that "Rodin is nothing but a sculptor of buttocks."[4] Rodin, who was not without a sense of humor, would probably not have demurred from such a characterization. The compacted, stationary pose, which could be visualized within a cube, was given a sense of movement by the figure's forward tilt. To have shown the kneeling figure erect would have been too static for Rodin, and it would not have allowed him to free the figure's buttocks from resting on her heels.

The Stanford plaster shows wear in the details, especially the incisions in the hair, as often happened to plasters that were stored for long periods in the studio and served as the basis for casts. It was B. Gerald Cantor's idea in 1974 to ask permission from the Musée Rodin to acquire a *brut*, or an unchased bronze cast, that would allow the public to see something of the casting process. (Many years later the Musée Rodin provided all the

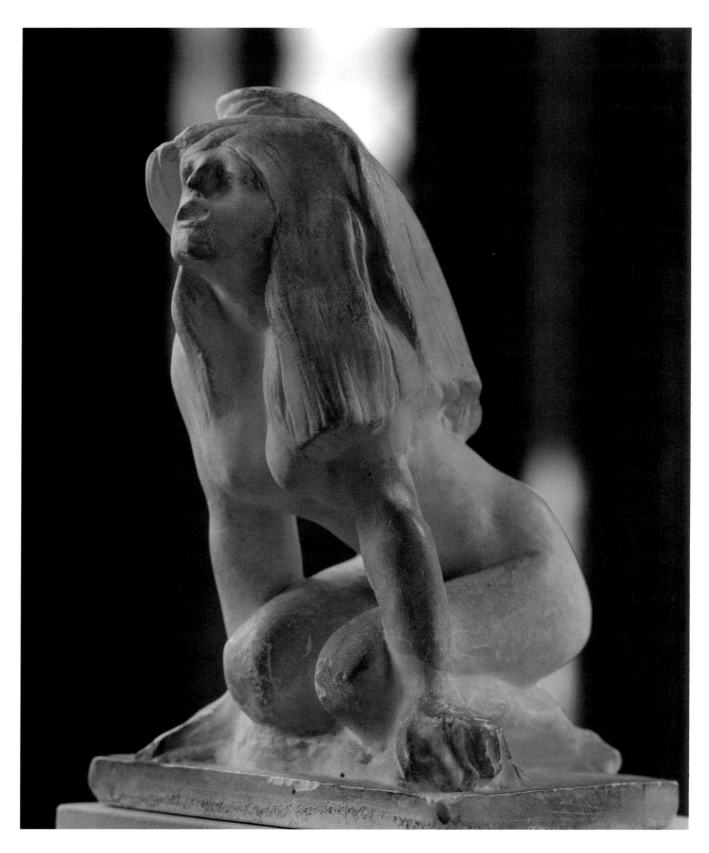

Fig. 430. *The Succubus* (cat. no. 161).

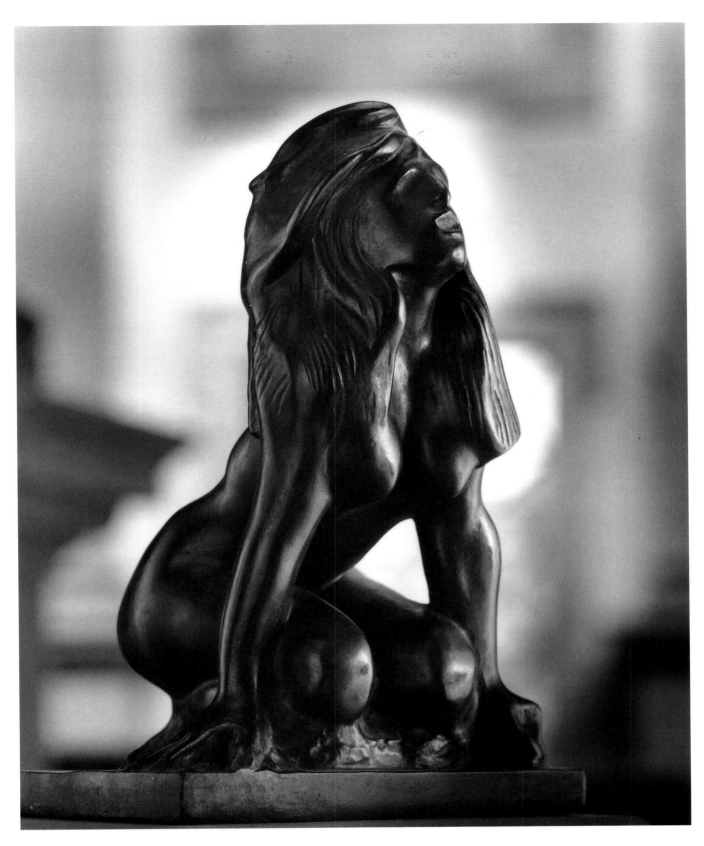

Fig. 431. *The Succubus* (cat. no. 162).

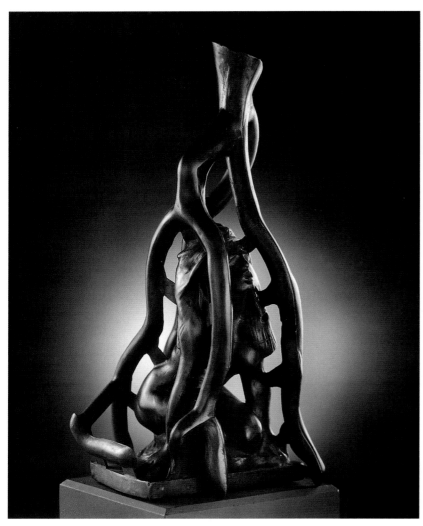

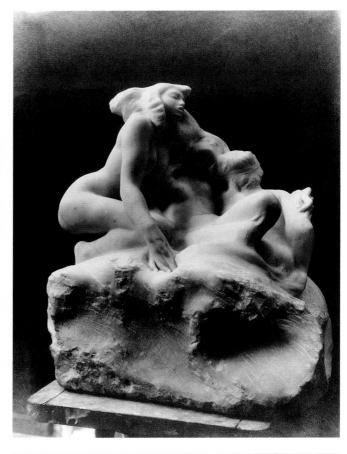

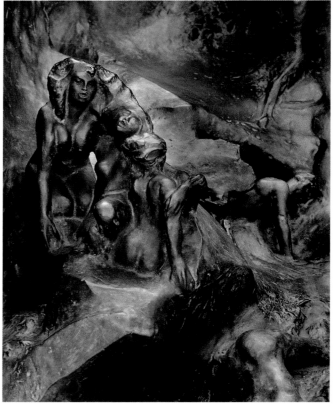

Above: Fig. 432. *The Succubus* (cat. no. 163).

Top right: Fig. 433. Jacques-Ernst Bulloz, *"The Sirens" in marble*, after 1889 (A104).

Bottom right: Fig. 434. Detail of *The Gates of Hell: The Sirens*.

stages of casting for *The Small Fauness*, which is also in the Stanford collection [see figs. 28–38]). One can compare the demon's hair in the plaster and bronze to see how the foundryman who worked on the raw bronze cast sought to recover, particularly in the hair, some definition lost in the casting.

Given what happened in twentieth-century art, the raw cast in which all the sprues, or casting channels, remain in place, makes it seem as if we are looking at a complete work of art: a kneeling figure is imprisoned in the root system of an invisible tree. The tubular forms show how the bronze entered the mold through the casting cup at the top. The holes on the top of the head, her left shoulder, and left buttock were made by removing the pins inserted into the core, which became attached to the investment, or mold, thereby preventing the former from shifting and blocking the space into which the bronze would flow to create the sculpture's exterior.

NOTES

LITERATURE: Grappe 1944, 82; Jianou and Goldscheider 1969, 103; Tancock 1976, 215; Gassier 1984, 115; Beausire 1989, 200; Barbier 1992, 119–20

1. *The Sirens* is discussed by Tancock (1976, 215–19) and Butler, Plottol, and Roos 1998, 97. See also John Porter, et al., *Rodin à Québec.* Exh cat. Musée du Quebec (Quebec: Musée de Québec, 1998), 154–55; Le Normand-Romain 2001, 106

2. Grappe was of the opinion that, given the probable date of 1889, *The Succubus* may have been inspired by Rodin's readings in Baudelaire's *Fleurs du mal* (1944, 82). In 1887 the artist was commissioned by Paul Gallimard to supply drawings for an edition (see Thorson 1975, 82–105).

3. Beausire 1988, 104, 123, 194, 233; Beausire 1989, 102, 200; Le Normand-Romain 2001, fig. 111.

4. Grunfeld 1987, 334–35, citing Alfred Lichtwark, *Briefe an die Kommission für die Verwaltung der Kunsthalle,* 2 vols. (Hamburg: G. Westermann, 1923–24), 1: 160.

Misery (*La misère*), 1889(?)

- Title variation: *Cire*
- Bronze
- 3½ x 10¼ x 6¾ in. (8.9 x 26 x 17.1 cm)
- Signed on front of base, left: A. Rodin
- Provenance: given by Rodin to Paytelle, Paris, and by descent; Genart Moderne Kunst, Zurich, 14 March 1979
- Gift of the B. Gerald Cantor Collection, 1992.155

Figure 435

*M*isery was dated 1889 by Georges Grappe, perhaps because its first exhibition was in the Monet-Rodin show of that year; in the catalogue the work was given the curious name *Cire* (Wax), though the exhibited piece was in patinated plaster.[1] Just when the sculpture was first made and when it was given the name *Misery* are really not known, but it was displayed in Rodin's 1900 retrospective with this title.[2] Grappe was of the opinion that it was made for *The Gates of Hell*, perhaps because the subject is an old woman whom he associated with *Old Woman* (cat. no. 51). As *Old Woman* preceded 1889 by several years, it is possible that Rodin found a second elderly model to pose for him shortly before the exhibition with Monet.

The 1889 exhibition in the Galerie Georges Petit was of the greatest importance to Rodin. It was the centennial of the French Revolution, and Rodin wanted a triumph and to be acclaimed his nation's leading sculptor. Without doubt his 36 exhibited sculptures were chosen with great deliberation. For the first time he exhibited the full monument in plaster of *The Burghers of Calais* and

the final plaster figure of *Bastien-Lepage.* He had also hoped to exhibit a completed *Gates of Hell,* but this proved impossible, so he showed several works from it including *The Thinker* (cat. no. 38). One of his most beautiful subjects carved in marble, *Danaid* (cat. no. 154), would have attracted far more attention than the much smaller plaster of a recumbent withered crone, so the inclusion of *Misery* would not have been a lightly considered choice. Given its theme and diminutive size, it must have been the smallest sculpture in the show. By exhibiting it, Rodin was making a critical statement about his premises concerning art's content and form.

In 1906 Frederick Lawton published Rodin's words, which could have appropriately accompanied the first showing of *Misery*: "People don't perceive . . . that reality of every kind can have its perfection, age no less than youth, what is called ugly no less than what is called beautiful. . . . The portraits of Rembrandt and Holbein show people old and wrinkled, but the beauty is there that belongs to humanity. It cannot be otherwise. Nature is always perfect. She makes no mistakes. The mistake is in our . . . vision."[3] Head encompassed by skeletal hands, an old woman lies on her left side on what originally must have been a studio mattress. (There is no left upper arm to go with the left forearm and hand that partially cup the head and unmodeled face.) Rather than a memento mori, Rodin was taking a stand for truth in art and celebrating nature's perfection. The beauty he found in the woman's wasted form had to originate in her bony frame. Rodin's statement to Lawton continues, "There is beauty and perfection even in the skeleton; but it wants observing from all round, for the fineness of the workmanship, the exact adjustment of all its parts to be duly admired and understood. . . . He who sees all this is the true artist. . . . He is the man whose eyes are open, and to whose spirit the inner essence of things is made known, at any rate, as a fact of existence."[4]

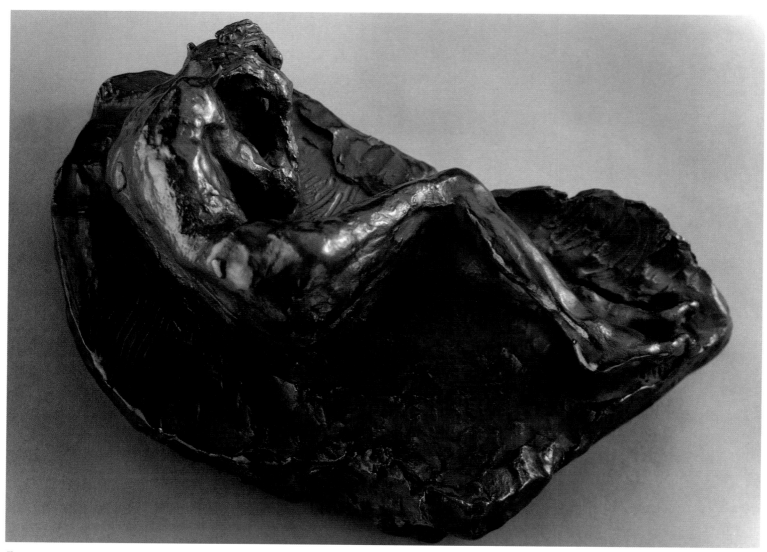

Fig. 435. *Misery*
(cat. no. 164).

Rodin not only visualized his figures within imaginary polyhedrons, he also could find geometry in the body, as with the angular shape made by the woman's drawn-up, long, bony lower limbs and upper body (like a chair on its side). Made on an intimate scale, all parts are carefully observed—the sagging stomach, for example, and the way the two bony feet are unselfconsciously and uncomfortably stacked. There is no attempt at finesse of modeling. Untempered patches of clay remain affixed to the woman's back and the buttocks are roughly textured; the marks of his scraping tool are left raw on the upper left thigh and on the front and back of the base; the base itself is a rough outline of the body's configuration.

When Rodin talked about a "fact of existence" and when he made this sculpture, he was not just being clini-

cal but also compassionate. Perhaps not intended for *The Gates of Hell*, hence homeless, the woman is nevertheless kin to those in the portal who are prisoners of their flesh.

NOTES

LITERATURE: Grappe 1944, 77; Jianou and Goldscheider 1969, 102; Beausire 1988, 104; Beausire 1989, 206

1. Grappe 1944, 77; Beausire 1989, 206.
2. Beausire 1988, 192; no further exhibitions of the work are listed. It was no. 121 in the 1900 retrospective and also illustrated by a photograph by Druet (Le Normand-Romain 2001, fig. 109 and cat. 169.
3. Lawton 1906, 157.
4. Ibid., 157–58.

165

Seated Nude Bather (*Baigneuse assise se tenant les pieds, avec tête*), late 1880s

- Title variations: *Crablike Woman; Crouching Bather Holding Her Feet; Seated Woman, Her Feet Apart; Small Crouching Bather*
- Bronze, Valsuani Foundry
- 8½ x 4½ x 4½ in. (22 x 11.7 x 11.7 cm)
- Signed on top of base, at left: Rodin
- Mark on back of base, bottom: Valsuani seal (with "ciré/C. Valsuani/perdue")
- Provenance: Galerie Alain Lesieure, Paris
- Gift of the Iris and B. Gerald Cantor Collection, 1998.365

Figure 436

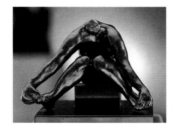

166

Headless Seated Nude Bather (*Baigneuse assise se tenant les pieds, sans tête*), late 1880s

- Bronze, Georges Rudier Foundry, cast 1967, 10/12
- 5¾ x 6⅞ x 4¼ in. (14.6 x 17.5 x 10.8 cm)
- Signed on left buttock: Rodin
- Inscribed on lower back: Georges Rudier/Fondeur Paris and © by musée Rodin 1967; below signature: No. 10
- Provenance: Feingarten Galleries, Los Angeles
- Committee for Art Acquisitions Fund, 1968.24

Figure 437

*O*nly briefly noted in the literature, Rodin's woman in a crablike pose probably derived from one of the models stretching her back by grasping her splayed feet either before or after a long modeling session.[1] It was in such unselfconscious moments that the sculptor discovered a pose that caught his fancy. The symmetry of the woman's body is unusual in his art. In this postural find, with the woman's head down and knees together, the artist had a natural way of showing off the back as a compact form comprising a continuously curving plane rising from the buttocks to the neck. That curve is rendered irregular and therefore is nuanced by the internal skeleton of the spine, which the sculptor saw as crucial to interesting sculpture. It is the extrusion of the bones through the flesh that inflects the smooth skin flow and challenges *le modelé*, the fitting together of curving planes viewed in depth, which fills out the contours. In this type of sculpture with its mundane motif and formal self-sufficiency Rodin was immune from critics who saw him as dependent on literature. The *Seated Nude Bather* relates to several other figures of bathers by Rodin from the mid-1880s.[2] On the basis of its smooth facture, always a risky speculation, the figure seems to date from the late 1880s.[3]

As was customary with Rodin's modeling of the base for a seated figure, it was so shaped that from the side view it enhances the springiness of the bent form. The squarish support adds to the sense of the figure residing within an imagined cube. As Rodin put it, "Cubic truth, not appearance, is the mistress of things. . . . I am not a dreamer, but a mathematician; and if my sculpture is good it is because it is geometrical."[4]

In the headless version we are made more aware of the beauty of the form's simplicity and Rodin's dictum that "sculpture is the art of forms."[5] The dorsal curve ends at the top of the spine and is given greater prominence. With the head removed (by accident or design), there is enough of the neck remaining to indicate its previous inclination, which then served to complete the bodily gesture. Head and illusionistic base were deemed extraneous so that, when the sculpture is seen against the light, one is more aware of the rippling effect across the back. This is probably what Rodin had in mind when he referred to his seeking the "essential" in his art and the "power of modeling that has made Greek art so perfect."[6]

NOTES

LITERATURE: Jianou and Goldscheider 1969, 100; Tancock 1976, 252, 328; Gassier 1984, 135; Ambrosini and Facos 1987, 144–47

1. An exception is Lynne Ambrosini's fine reading of the headless version in Ambrosini and Facos 1987, 144–47. The figure with head was sometimes called *Femme au crabe*, as noted by Jianou and Goldscheider (1967, 101), to denote a woman in a crablike position.
2. For a discussion of the figure's relation to other bathers by Rodin, see Ambrosini and Facos 1987, 144, and Tancock 1976, 328.

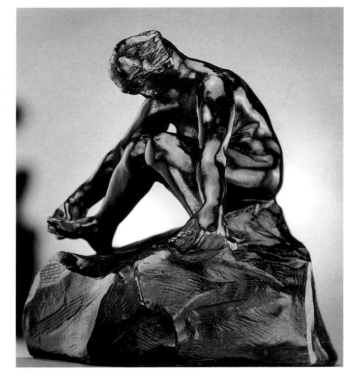

3. Regarding her evidence for dating the headless version to 1890 see Ambrosini's discussion (Ambrosini and Facos 1987, 144) of relevant letters from 1890–91 written to Rodin by the collector Antony Roux. Ambrosini hypothesized that the headless version came first.

4. Mauclair 1905a, 66, 69.

5. Ibid.

6. Ibid.

Above: Fig. 436. *Seated Nude Bather* (cat. no. 165).

Right: Fig. 437. *Headless Seated Nude Bather* (cat. no. 166).

OPPOSITE PAGE Fig. 438. *The Juggler* (cat. no. 167).

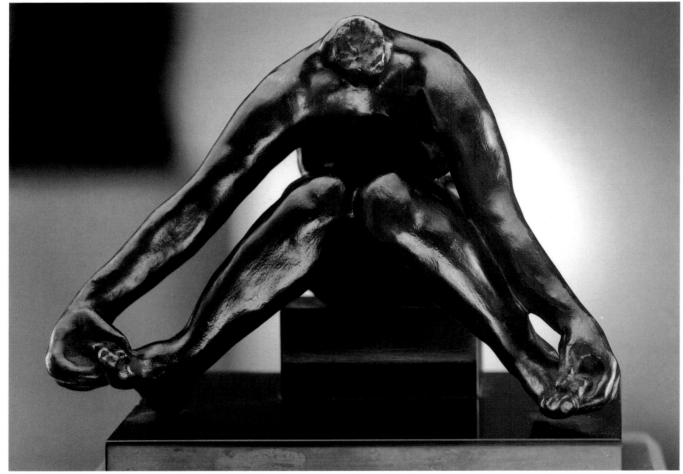

167

The Juggler (Le jongleur), c. 1892–95

- Title variations: *The Acrobat, The Play of Fauns, Triton and Nereid*
- Bronze, Georges Rudier Foundry, cast 1960, 11/12
- 12 x 6 x 5½ in. (30.5 x 15.2 x 14 cm)
- Signed on smaller figure, sole of left foot: A. Rodin
- Inscribed on back of juggler's hair: Georges Rudier.Fondeur. Paris./© by Musée Rodin 1960; below signature: No 11
- Provenance: Musée Rodin, Paris; Herbert and Mildred Lee (Lee Gallery), Belmont, Massachusetts
- Gift of the Iris and B. Gerald Cantor Foundation, 1974.40

Figure 438

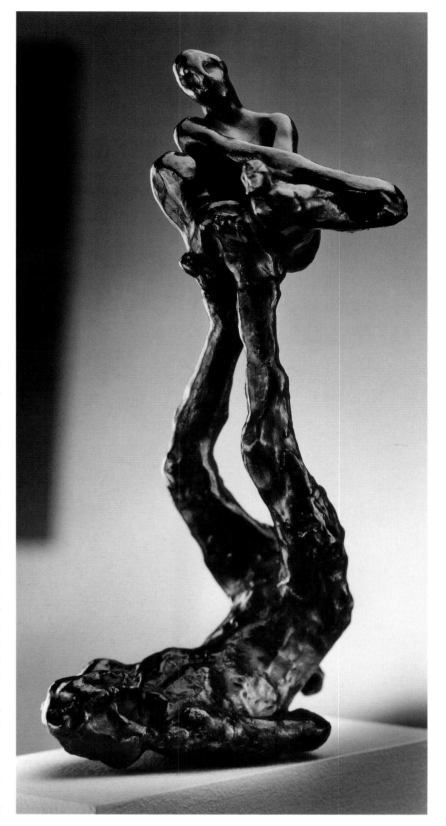

*T*hough he acknowledged that the composition must date from 1892–95, Georges Grappe listed the plaster for this work as being from 1909, based on a bronze version, now lost.[1] He further attributed the subject to Rodin's interest in the circus and the improvised dances of the Montmartre night world. At one time the work was called *Triton and Nereid*, and according to Grappe, Rainer Maria Rilke referred to it as *The Acrobat*. The figures were modeled separately and led independent lives apart from their juxtaposition here. In the Meudon reserve are enlargements of the woman, seated and grasping both feet in her hands; the male appears upright, straddling the shoulders of a standing woman, *Day* (cat. no. 35), who had served as one of the figures flanking the *Tower of Labor*. Rodin's use of the crouching woman in *I Am Beautiful* (1882) demonstrates that no pose is so self-sufficient that he could not conceive of it in union with another. As Rilke noted, what is crucial in Rodin's compositions are the points of contact between the figures and whether or not their gestures complete themselves within the imaginary orbit of the grouping.[2]

The figure of the man lying on his back has an unrectified silhouette evoking similar ragged contours in the instantaneous drawings Rodin produced in the mid-1890s, in which he did not look at the paper as he drew. As this was a difficult pose for a model to hold, feet in the air and arms under and bracing the upper back, it is possible that, as with the drawings, Rodin fixed his gaze on

the subject without looking at the clay as he palpated it rapidly with his fingers. It would have been as if he was literally feeling the swell and depression of the muscles over bone, but then forgoing any labor of refinement. He was attentive to the knees, the interval between them, and the long muscles of the legs, but the man was not given a face. Rodin took no pains to round the buttocks. Nor did he try to level the feet. The man's right foot does not actually support the woman's body, while his left foot touches her right. In selecting the small sculpture to surmount the feet, Rodin may have seen or sensed that the woman's scissors pose of the legs and the grasping of both feet by her hands required a certain limberness compatible with that of the man.

The Juggler is one of Rodin's compositions most at home in the twentieth century. In fact, it was first exhibited (as *The Play of Fauns*) at Rodin's 1900 retrospective and then (as *The Juggler*) in Prague in 1902.[3] It preserves and emphasizes the energy of its making. The whole composition remains a surprise and has a wonderful buoyancy and lightness from all angles. It is hard to speak of the work as having a front, and Rodin invited viewers to take in the contours of the whole to reexperience why he was satisfied with the result of this wedding

of figures. There is no modeled base; the man's back serves literally as the sculpture's support. Like many modern sculptures lacking a base, *The Juggler*'s foundation is the surface on which it is placed, and like frameless paintings, the sculpture loses the privileged status of a traditional work of art. Rodin was breaking with tradition in his form. His eye told him that he had a fresh, new form of sculptural balance involving the wide figure of the woman at the top and the broad upper torso of the man below, both joined by the narrower, bent, unstable forms of his parted legs. *The Juggler* is prophetic of how modern artists, beginning with Constantin Brancusi, have sometimes composed two or more disparate, self-sufficient forms by their vertical stacking, with no other attempt at their integration.

NOTES

LITERATURE: Grappe 1944, 127; Jianou and Goldscheider 1969, 112; Elsen 1980, 176; Lampert 1986, 174, 234; Laurent 1988, 151; Le Normand-Romain 2001, 238

1. Grappe 1944, 127.
2. Rilke in Elsen 1965a, 124.
3. Beausire 1988, 192, 236.

168

Illusions Received by the Earth
(Les illusions reçues par la terre), 1895

- Title variations: *Daughter of Icarus, The Fallen Angel, The Fall of an Angel, The Fall of Icarus, Illusion, Illusion Falls with Broken Wing, the Earth Receives Her*
- Bronze, Alexis Rudier Foundry, 5/12
- 20¼ x 32½ x 22½ in. (51.4 x 82.6 x 57.2 cm)
- Signed on top of base, at left: A. Rodin
- Inscribed on base, right side, at rear: Alexis Rudier/Fondeur.Paris.; interior cachet: A. Rodin
- Provenance: McCrory Corp., New York; Paul Kantor Gallery, Malibu
- Gift of the Iris and B. Gerald Cantor Foundation, 1974.111

Figure 439

*I*n terms of its gestation, *Illusions Received by the Earth* as it is frequently called, or *Fallen Angel* as it was named when first exhibited, has a complex history.[1] The two principals have separate ancestries. The crouching woman (known as *Fallen Caryatid with a Stone*, see cat. nos. 56–57) came from the upper-left corner of *The Gates of Hell* and was made between 1880 and 1881. The recumbent woman began as *The Torso of Adèle* (see fig. 415), which, although usually dated 1882, was modeled probably in the late 1870s when Rodin was making siren figures to frame the loggia of a villa in Nice.[2] Rodin later used the upright full figure of *Adèle* in the extreme left corner of the tympanum (see fig. 121). In 1884 or earlier (1881?) *The Torso of Adèle* was given legs, an upraised right arm, and head and joined with a male partner to make *Eternal Spring* (cat. no. 148). It seems then that in the early or mid-1890s Rodin joined the two women into the present composition. Rodin changed the position of the arms of the crouching figure, so that her right arm passes under the shoulders of

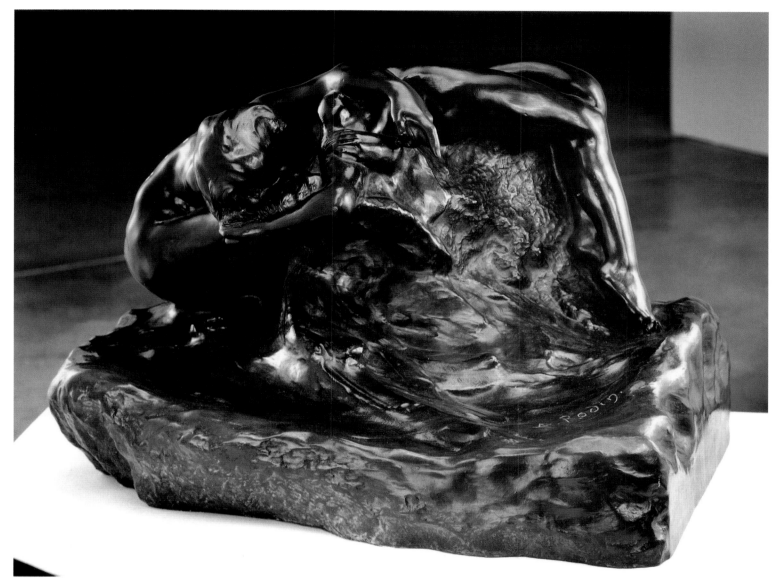

her companion and touches her companion's upper-right arm.[3] This is basically the same supporting gesture made by the male in *Eternal Spring*, except that now the extremity effecting the tender touch is that of a woman's hand. The bent head of the attending woman is made to kiss the averted cheek of the fallen figure, and their hair intermingles. The fallen figure now lies atop a rock and has been given wings. From the rear, the wing blocks the view of the woman's left side and the stone on which she lies.[4] The angel's left hand seems to emerge from the water near where her companion is crouching, concealing her companion's feet. In his figural compositions—and following tradition—

Rodin was careful to make sure that the beholder knew the owner of each body part.

The excellent Stanford cast by Alexis Rudier was made from a plaster of what appears to be a superb carving in stone.[5] In contrast to the wingless figure in a bronze cast from the original plaster version, Rodin added the wings and gave instructions when the work was being carved in stone to treat the base as if it were a rock emerging from water.[6] Carving the whole from a single block allowed concealment of the marks of *marcottage*, visible in the plaster model, and inspired Rodin to provide a more integrated and felicitous coordination between the figures and the base.

Fig. 439.
Illusions Received by the Earth (cat. no. 168).

Summarizing the various states leading to this sculpture: first the figures were modeled in clay, then cast in plaster; clay impressions were taken from the plaster molds to allow changes in gestures; this was followed by recasting the altered clay forms in plaster and adjusting them to a plaster of a previously modeled base; castings were then made in bronze; at least two carvings were made in stone from a plaster model; wings were added, and the base was drastically changed so that the legs of the fallen figure would not be suspended in space; a new plaster was then made from one of the carvings; it in turn was cast in bronze.

Rodin's predilection for these two female members of his repertory was manifested by the frequency with which he used them separately; both appear in *The Gates of Hell*. Their proximity in the portal may have prompted the idea of their union in *Illusions Received by the Earth*. In the far upper-right corner of *The Gates* are two embracing women next to a barren vine (see fig. 203); when shown separately they were named *The Metamorphoses of Ovid* (cat. no. 68). *Illusions Received by the Earth* is thus like a fatal pendant to the story of lesbian lovers. The addition of wings to the supine figure and the various names given the sculpture, such as *Illusions Received by the Earth*, could well exemplify Rodin's tact in treating this theme.[7] Again the sculpture is known by different names rather than titles, as the latter exist before the artistic fact.

Rodin's strong artistic motive for joining these two figures becomes clear when we take in the whole of the composition from front and back. Unlike other nineteenth-century couples who were usually presented frontally, in *Illusions Received by the Earth* we see them in profile. The gracefully linked forms of the women set up a big, beautifully simple compositional movement that originates in the buttocks of the crouching woman and swells upward and then down to the toes of the reclining figure, then back along the concavity of the base, completing an oval configuration. No Ovidian tale or other text could have inspired this compositional gesture and its largeness of effect. From the left side we are confronted with the handsome form of the crouching figure's back. From the right edge we see the foreshortened view of the broken-winged nude. From the back, where heads cannot be seen, the composition seems more abstract and decidedly cubic, indicating Rodin's block aesthetic. No details or pronounced textural distractions impede the lateral flow of the whole. This fluidity of surface movement is largely due to the smooth finish of the

figures, which has been wrongly viewed, in the author's opinion, as resonant of art nouveau or fin-de-siècle taste.[8]

In his lifetime Rodin suffered and responded to the criticism of being too literary. Since his death he has been faulted for often being too sentimental, and his carved works, on which this bronze was based, for being "insipid," "maudlin," and "audience oriented."[9] Posthumously Rodin was victim of his own partial figures that eliminated the pathos of gesture and had a formal succinctness appealing to later twentieth-century taste, which ironically he helped form. He was also victim of the post-Cézanne and Matisse preference for expression conveyed not by gestures and facial mien but by the total effect of a composition, an idea that Rodin pioneered in his partial figures. Thematically *Illusions Received by the Earth* is of the nineteenth century but formally, by its largeness of effect, it anticipates the twentieth century. After all that has happened in modern figure painting and sculpture since midcentury, which has included a return to older forms of expression as in the art of George Segal, the fact that *Illusions Received by the Earth* is an unabashedly beautiful sculpture should no longer make us uneasy.

NOTES

LITERATURE: Grappe 1944, 94–95; Descharnes and Chabrun 1967, 135; Jianou and Goldscheider 1969, 106; Steinberg 1972, 331, 346, 363, 377; Tancock 1976, 246; de Caso and Sanders 1977, 59–62; Lampert 1986, 214; Ambrosini and Facos 1987, 171

1. Its exhibition history indicates that when shown in Paris (1900, 1913), the work was named *Fallen Angel*, but when displayed at Potsdam (1903), Düsseldorf, Leipzig, and Weimar (1904), London and Edinburgh (1914, 1915), it was listed as *Illusions Received by the Earth* (Beausire 1988, 402).

2. For *The Sirens*, see Goldscheider 1989, 122. Cladel wrote that the Musée Rodin "possesses the initial study of these works under the simple name 'Torso of Adèle,' that of the model who posed for it" (1936, 134). A cast of the *Torso of Adèle* at Meudon shows that Rodin had broken the figure at the waist, allowing him to pivot either half to acquire more of a twist, or *désinvolture* as he called it (see Descharnes and Chabrun 1967, 80). The Cantor Arts Center owns the bronze *Torso of Adèle* illustrated in fig. 415, which was cast in 1978 under the auspices of the Nelson Rockefeller Collection.

3. In a second version the crouching figure places her left arm behind rather than across her companion (see

Descharnes and Chabrun 1967, 135). For a discussion of the two versions, see de Caso and Sanders 1977, 62

4. De Caso and Sanders saw the addition of the wings as having a spiritual function: "The wings on the fallen figure . . . an unmistakable indication of spirituality" (1977, 59). In the first bronze version there are no wings. Would spirituality have been the motive if Rodin had had a female Icarus in mind or an allegory like that of *Illusions Received by the Earth?* Rather than a spiritual motive, this author suggests a mundane artistic motive in adding the wings in the stone version as they helped Rodin relate the sensuous form of *Adèle* to the base on which she is made to lie. The broken wings also certified their owner's death, unlike the original composition with the legs of the supine body substantially overhanging its support and the whole evoking more of an athletic embrace than the kiss given to the departed. Once added, the wings allowed Rodin different names for the work.

5. The marble from which the Stanford cast was made seems to be that in the Hunterian Art Gallery and Museum, Glasgow. A different version of the marble is reproduced by Steinberg (1972, 366).

6. Rodin had wings added to *The Martyr* while it was being carved as *The Broken Lily* (see Elsen 1980, pls. 41–42).

7. Lampert wrote of this couple, "In mood, the sculpture relates to the satiated, uninhibited look of the female couples in the drawings which followed, such as *Sapphic Couple*" (1986, 214). *The Gates* as a whole are thematic variations on the theme of disillusion and fall, and given the couple's history in this connection, the naming could have had this general conception as a source.

8. De Caso and Sanders 1977: "The Art Nouveau delight in smooth sensuous forms is also a major factor in Rodin's *Fallen Angel*" (59). Smooth, sensuous forms were native to Rodin's art long before art nouveau came into being. Any relation of Rodin's art to art nouveau is coincidental, not causal, as he hated stylization.

9. Steinberg 1972, 367. Steinberg, who greatly admired the *Torso of Adèle*, faulted the carved version for loss of *le modelé* and for extraneous figural additions. The evidence of the Stanford cast is that Rodin's carver was extremely skilled and sensitive to *le modelé*, and compositionally the stone is more compelling.

169

Aesculapius (Esculape), 1903

- Title variation: *Ex-voto*
- Bronze, Georges Rudier Foundry, cast 1979, 3/12
- 26¾ x 15 x 15⅜ in. (69.3 x 38.9 x 39.8 cm)
- Signed on top of base, at left, near front: A. Rodin
- Inscribed on back of base, at right: Georges Rudier/Fondeur.Paris.; on base, left side: © by musée Rodin 1979; interior cachet: A. Rodin
- Provenance: Musée Rodin, Paris
- Gift of the Iris and B. Gerald Cantor Collection, 1998.366

Figure 440

*A*esculapius combines several of Rodin's audacities in his art after 1890: the simultaneity of rough and smooth, or the complete and the finished; ambiguous gender; and narrative ambivalence. Although not specifically cited by him, *Aesculapius* is an example of what Alain Beausire called *marcottage*, "an operation that consists of composing a new sculptured work by reutilizing partially or totally works already executed by the artist."[1] We can-

not be certain when Rodin assembled the nude study of Claude Lorrain (see fig. 262) and, with the aid of a new neck, added the head of a woman and the finished form of an adolescent girl, which had been used previously in *Paolo and Francesca* (cat. no. 50), *Triumphant Youth* (cat. no. 52), and *The Earth and the Moon* (before 1898).[2] Alone, the adolescent figure is called *Fatigue* (see cat. nos. 53–54). Georges Grappe, followed by Cécile Goldscheider, dated *Aesculapius* to about 1903.[3] He indicated that in 1903 the composition was referred to as *Ex-voto* and that in 1913 the sculpture was included in an exhibition devoted to "physical education."[4] John Tancock made the connection between the nude study of Claude Lorrain and the male body in *Aesculapius*.[5] The head of Aesculapius also exists by itself and is known as *Head with Closed Eyes* (fig. 441).[6]

What Rodin put together is worth examining, particularly since the literature is all but silent on this composition. A naked man with closed eyes seems to be holding tenderly an agitated adolescent girl, whose right hand is held at the side of her face, her left arm thrust across her head so that it extends out and down. The young woman is not cradled in the man's arms. Only his right forearm, altered from the pose in the Claude Lorrain étude, gives her support. The man's left hand, also changed from the study of the painter, touches lightly her left thigh as if steadying her hanging legs. For the literal-minded, the

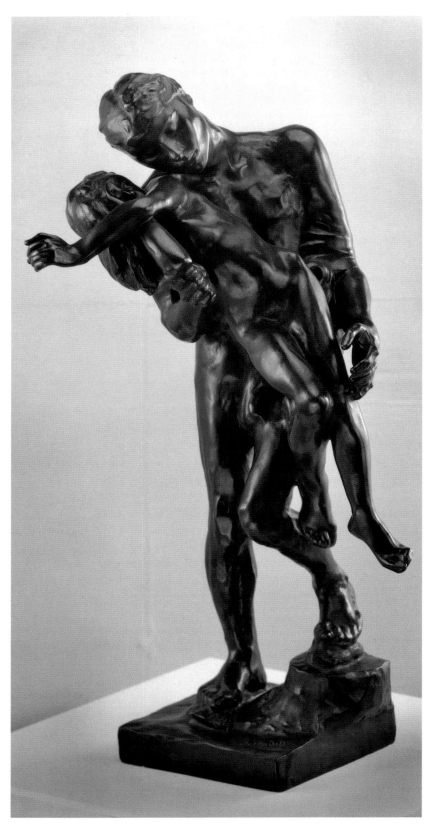

adolescent's suspension is impossible; for the poetically inclined, it is almost miraculous.

From Rodin's viewpoint, pairing the disparate parts gave him a provocative theme and a composition that fit within his imagined cube.[7] Taken as a whole, the initial impression is of a poignant tenderness expressed by the adult toward the adolescent, which could have prompted the names given to the work. Rereading the piece and thinking of the names Rodin gave to it, however, prompts the questions: If an ex-voto, or an offering made in pursuance of a vow, to whom is the offering made? Is the man giving or receiving an unwilling human "offering"? If he is a physician—the title refers to the Greek god of the healing arts—why are his eyes closed? What is this nearly naked man's intention? Is it for good or evil? Is the girl struggling to escape? As Rodin of all sculptors must have realized, the fruitful friction of his *marcottage* produced an ambivalence between caring and carnality.

Possibly for thematic reasons or to effect structurally their improbable union, Rodin had recourse to a drapery wound around the man's upper left arm, as if bunched between arm and torso, which passes over his thigh and only touches the girl at the back of her right calf. The presence of the partially draped man may have evoked in Rodin the association with the ancient physician, or he may have added this rudimentary garment to diminish sexual innuendos. The points of contact between the pair involve her back and his right breast, her hair and his right upper arm, her right buttock and his navel, her right heel and his left thigh. Except for changing the position of the man's hands from those in the Claude Lorrain study, Rodin made no attempt to contrive an obvious mutuality between the couple. The man's head inclines solicitously toward the girl but does not actually touch her shoulder. This could have been done easily, but probably for more than one reason Rodin found the interval important. (It may have muted the suggestion of the man's carnal intentions, for example.)

The addition of what by itself is a woman's head to a male body reminds us of Rodin's gender neutrality, both in making expressive heads and in their application to a torso. The closed eyes of what has become the male make him like a somnambulist and give the work a dreamlike character. Coupled with the interval between them and the way the girl is gently held, we see Rodin's tact. If, for example, Grappe is correct and the work was shown in an exhibition devoted to physical culture, this

was a curious entry to say the least, and unless we have overlooked them, it seems that there were no moral criticisms of this sculpture of an almost naked man holding a totally naked adolescent woman. The suggested toga and the name *Ex-voto*, as Rodin surely knew, would have protected the sculpture and its creator from moral censure at the time.

In a memorable short article, "Rodin and Freud: Masters of Ambivalence," Parker Tyler referred to this work: "Rodin's *Aesculapius* is a man holding an hysterical or pain-wracked child. The attitude of the girl has little relation to the standing man. . . . His habit was to cross two originally unrelated works to make a group with an altered meaning. This is the dialectic of accidentally associated ideas which Freud found so significant . . . each grasped with equal keenness the meaning of what might be called the instinctual contrapposto: the impulse of flesh turning in two directions at once."[8] Although he did not explore the implications of *Aesculapius*, Tyler also offered an insightful reading of the provocative use of the adolescent in Rodin's *Triumphant Youth*: "The juxtaposition of the two figures, especially when conceived as originally apart, has a shocking quality—not moral, but psychological. Terrible things may be involved: not only the kiss of the girl imprinted on the mouth of her malign and future fate, but the aggressiveness of the child implied in the title *Youth Triumphant* [cat. no. 52], as though she were drawing life from the old woman's mouth in a kind of death-and-resurrection; then again, as implied in the title *Old Courtesan* [cat. no. 51], this headlong contact may picture the corruption of virgins for one of the most ancient trades."[9] In the case of *Aesculapius*, by simply rotating the adolescent's body away from the man, her aggressiveness is transformed into what could be taken for fear, but by the proximity of the adolescent's buttocks to the male's genitals there is still the suggestion of the corruption of virgins.

Rodin's use of ambivalence is a characteristic of modern artistic narrative. At almost the same time *Aesculapius* was made, Pablo Picasso had already begun to develop his singular narrative style of ambivalence as seen in *La vie* (1903, Cleveland Museum of Art), wherein he created a situation in which the outcome is left to the beholder's imagination. Picasso's *Man with a Sheep* (1943; Philadelphia Museum of Art), which conceivably could be named *Ex-voto*, invites comparison with Rodin's

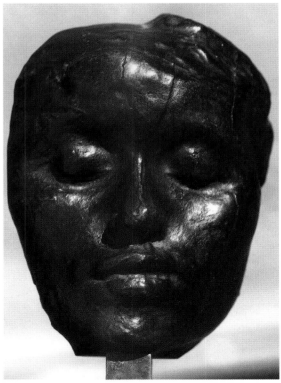

Aesculapius as in the former a naked man holds a distressed animal in such a way that we cannot predict with certainty the latter's fate: will the frightened innocent be saved or sacrificed?[10]

NOTES

LITERATURE:
Grappe 1944, 100; Spear 1967, 77, 101; Jianou and Goldscheider 1969, 109; Tancock 1976, 225, 404

1. In Pingeot 1986, 95; and also Beausire's essay, "Le marcottage," in Pingeot 1986, 95–106.
2. For the latter work, see Grappe 1944, cat. no. 294.
3. Grappe 1944, 110; Jianou and Goldscheider 1969, 109.
4. Grappe 1944, 110. Beausire (1988) does not mention this work having been exhibited with either title.
5. Tancock mistakenly derived the man's head from the row of heads in the tympanum of *The Gates* (1976, 404).
6. The head was reproduced by Lampert with no ascription to gender (1986, 210). As the owner for many years of a cast of this head, which is really a mask, the author believes it is the face of a woman. Spear speculated that the adolescent was a reject from *The Gates of Hell* (1967, 77), but given the youth's size and pose, the author disagrees.
7. In terms of formal elements, what may have prompted the initial union of the girl's body and the Claude Lorrain figure were his extended right arm, the fact that they both pivot at the waist to the right, and Rodin might have seen the concave abdominal cavity of the male figure as an invitation to set the buttocks of the girl into it.
8. Tyler 1955, 40, 63. Tyler could have pointed out that the shared interests and insights of psychologist and sculptor were cotemporal but not causal in terms of one influencing the other.
9. Ibid., 64.
10. Albert Elsen, "Picasso's *Man with a Sheep*: Beyond Good and Evil," *Art International* 21 (March-April 1977): 8–15, 29–31.

Fig. 441. *Head with Closed Eyes*, c. 1885, bronze, height in. (12.3 cm). 4⅞ x 3¼ x 2½ in. (12.4 x 8.3 x 6.4). Private collection.

OPPOSITE PAGE
Fig. 440. *Aesculapius* (cat. no. 169).

170

Standing Nude with Arms Crossed
(Femme debout, les bras croisés), 1885

- Bronze, Georges Rudier Foundry, cast 1975, 10/12
- 10⅝ x 2⅜ x 3½ in. (27 x 6 x 8.9 cm)
- Signed on right side of right in: A. Rodin
- Inscribed on back, of shins G. Rudier/Fond. Paris; on left side of left foot: © by musée Rodin 1975; above right ankle: no.10
- Provenance: Musée Rodin, Paris
- Gift of the Iris and B. Gerald Cantor Collection, 1998.355

Figure 442

*U*nrecorded in the literature, this is an unusual work, even for Rodin. First, the woman is completely frontal, her arms folded across her abdomen. Second, the figure's weight is equally divided between the two legs, and the result, like his small figure *Day* (cat. no. 35), is as close to a completely symmetrical figure as Rodin ever came. Third, without precedent in his art, over almost all the surface are cuts creating a nearly total scarification of the naked figure. Were these editing marks intended to counter the passivity of the pose and generate surface movement not provided by any play of the body's muscles? In the back of the étude Rodin added strips of clay between the legs. The back of the woman's right leg is not modeled but flattened out. In the dorsal area Rodin applied shapeless patches of clay to the head and back. The most dramatic sculptural movement is given by side views because of the arch of the back caused by the big depressed area at the base of the spine, which accentuates the protrusion of the buttocks and swell of the thighs.

Was this intended by Rodin to demonstrate to someone, if not himself, an idea about sculpture: why he avoided symmetry? What must be done to a passive pose to make it interesting as sculptural form? The étude is small enough to have been fashioned in his hand and without need of an armature.

Fig. 442.
Standing Nude with Arms Crossed (cat. no. 170).

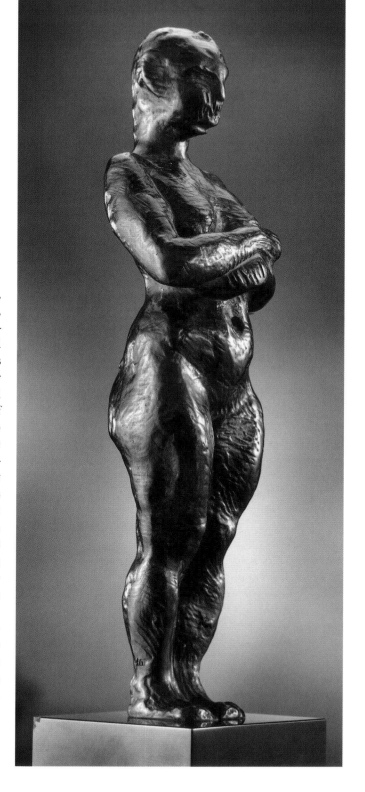

171

Pas de Deux G (Pas de deux G), c. 1911

- Bronze, Georges Rudier Foundry, cast 1969, 11/12
- 13½ x 7 x 6¾ in. (34 x 17.8 x 17.1 cm)
- Signed on sole of left foot of left dancer: A. Rodin
- Inscribed on left foot of right dancer: Georges Rudier/Fondeur. Paris
- Provenance: Paul Kantor Gallery, Malibu
- Gift of the Iris and B. Gerald Cantor Foundation, 1974.41

Figure 443

172

Dance Movement H
(Mouvement de danse H), c. 1911

- Bronze, Georges Rudier Foundry, cast 1965, 11/12
- 11¼ x 3 x 4¼ in. (28.6 x 7.6 x 10.8 cm)
- Signed on right arm: A. Rodin
- Inscribed on ankle of right leg: Georges Rudier/Fondeur Paris; below signature: No. 11; on shin of right leg: ©by Musée Rodin 1965
- Provenance: Sotheby's, London, 2 July 1970, lot 48
- Gift of the Iris and B. Gerald Cantor Foundation, 1975.84

Figure 444

*T*hese works were part of a group of small dance studies, which have come to be known as *Mouvements de danse*, made by Rodin in 1910 or 1911 but never exhibited in his lifetime.[1] They seem to have survived the artist's death in terra-cotta and/or plaster, and their naming, and perhaps mounting on socles, may have been done by Cécile Goldscheider while curator of the Musée Rodin. (As Rodin left them, they had no modeled bases and had to be handheld to be seen upright.) In "Rodin et la danse" Goldscheider proposed that their source was cancan dancers from Montmartre dance halls, pointing out that Rodin had saved an 1891 article by Grille d'Egout, one of the great Montmartre performers, on the dance

known as "le chahut."[2] In his relentless quest, begun with *The Gates of Hell*, to introduce natural movements never previously seen in sculpture, Rodin reportedly had used cancan dancers as models for works of the 1890s such as *Flying Figure* and *Iris, Messenger of the Gods* (cat. nos. 183–185).

Rodin invented a method of drawing that permitted him to capture fugitive movements by not taking his eyes off the model as he drew. This method of continuous drawing, by which he produced his so-called instantaneous sketches, was developed in the mid-1890s but may also have paralleled in time and subject his modeled dancers dated by Georges Grappe to 1911 and Goldscheider to 1910.[3] It was Rodin's obsession with movement, reflected in countless drawings, not the example of Edgar Degas's earlier sculptures of dancers and models with which he was probably acquainted, that drew him late in life to a new sculptural mode.[4] Given the strenuous and unstable nature of the models' movements, it is also probable that Rodin simultaneously invented a method of *continuous modeling* that enabled him to work the clay without taking his eyes off his subjects, the small size of the figures requiring no armature. He must have prepared rolls of clay of varying lengths and thicknesses, which were already equivalencies of the general shapes and volumes of human limbs and torsos. If he were seated with the rolls on a board across his lap, he could have watched the dancer while pinching the clay where the joints would have been located to fix the gesture of a limb. Key to this procedure and to capturing the overall unity of the movement was his noting where the flexible parts of the body were in space at a given moment. The rolls gave him instant fluid continuity for arms, thereby helping preserve suppleness of movement. He could have joined the legs and arms to a thicker roll for the torso. No need to worry about the head as it was easily added when he was looking at the clay figure. At age 70 Rodin knew human anatomy so well he could have quickly formed the flexed rolls into musculature with his eyes closed. The modeled dancers show little evidence of a labor of refinement, but it must have taken place in areas like the buttocks and shoulders where the limbs joined the torso. When he had finished studying the actual model, Rodin could have quickly edited his "snakes," as they were called. Exact rendering of musculature was not something he wanted, however. Inexactitude of surface treatment is crucial to our sense of the figure's sense of passage from one pose to another. He

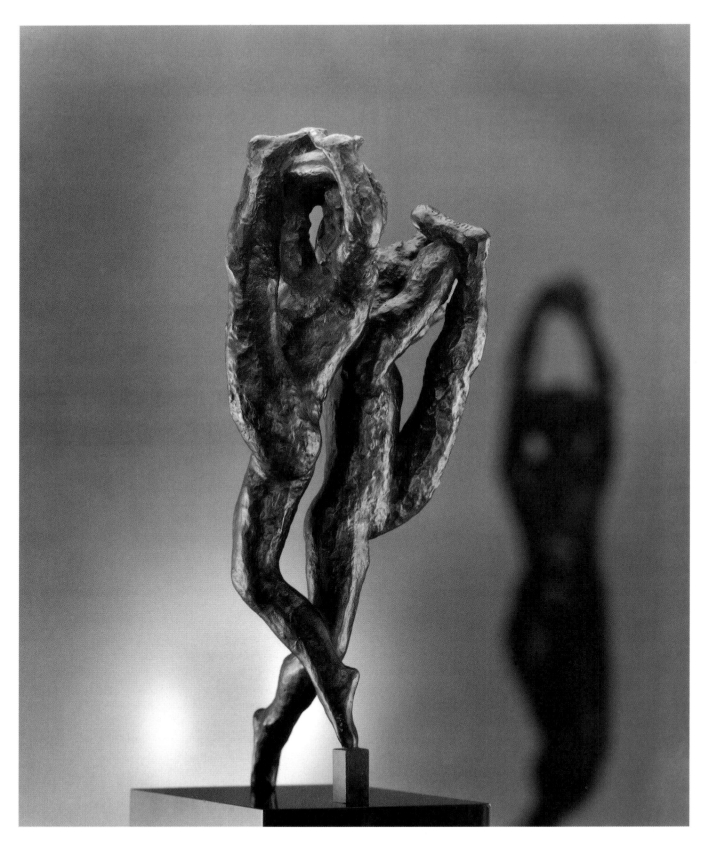

Fig. 443. *Pas de
Deux G* (cat. no.
171).

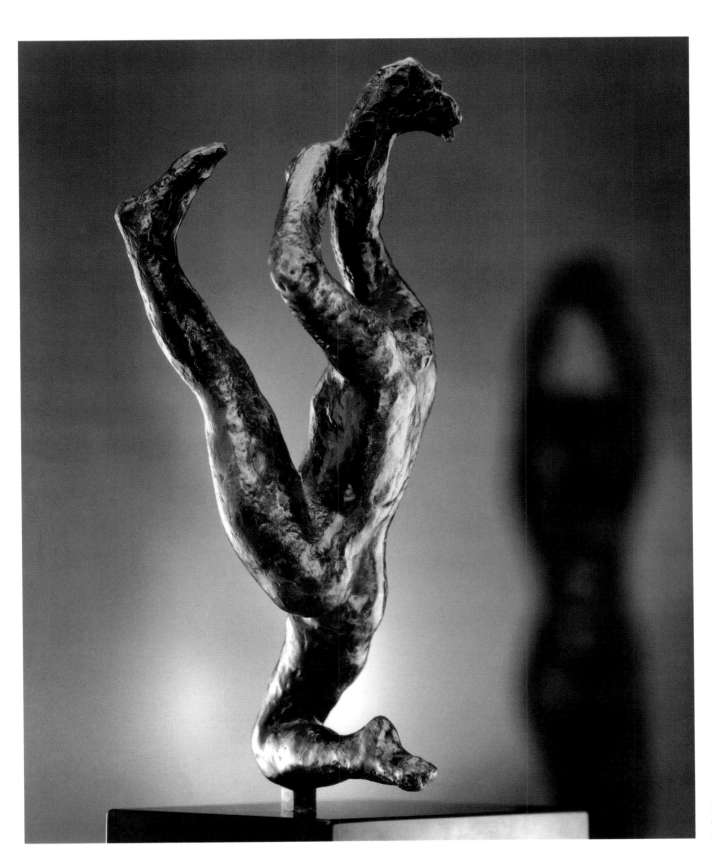

Fig. 444. *Dance Movement H* (cat. no. 172).

obviously sought to preserve not only the freshness of the models' spontaneous gestures but also the feelings those movements inspired.

The movement of the figure known as *Dance Movement H* is omnidirectional. (A small tenon is needed to support her bent right leg when the figure is upright and mounted on a base.) There are no degrees of definition, as the woman is given the same sculptural skin throughout. The absence of the head opens the area between the raised arms so that from the back we can see through this interval the raised right leg. The labile model is caught in a moment of exuberant abandon. Leaning backward she flings her arms upward, and it is as if she is holding a towel in her hands. Looked at overall, this energetic figure fits within Rodin's imagined cube.

In *Pas de Deux G* Rodin twinned the same figure, with one figure raised on a small block and turned 180 degrees to its double. The result is that the composition builds to a compact constellation of arms, hands, heads, and raised feet, unclassical by having greater breadth at the top than at the bottom. The figures are joined at two points in the back and legs. He may have used the block to gain a more felicitous rhyming and interval between the figures such that the right buttock of the raised figure is seen against the hollow of the other's lower back. In both dance movements and the series as a whole, it is as if Rodin is again taking up a challenge by Benvenuto Cellini that "one has never seen a figure equally well made on all sides."[5]

At about the time in the late 1890s when he was modeling his instantaneous sculptures, or slightly after, Rodin spoke with Henri-Charles Dujardin-Beaumetz about drawing figures in action. Because the sculptor believed good modeling depended always on drawing well, his remarks are pertinent:

One must find the equilibrium given by each movement and vary with it. . . . It is made up of other essential equilibria: those which result from the whole, and those which are occasional and irregular.

The true balances result from the general movement of the figure . . . imprecision adds to the action . . . [and] permits the imagination of whoever looks at it to add to it, thus completing what the artist sought. . . .

The complete freedom of a necessarily summary rendering has fixed the essential; and in setting

down the essential of all the elements necessary to the work, one has shown at once its beginning and its end.

How can one not admire a sketch made in a single burst, in which the artist has fixed the memory of a deeply felt emotion, of an action seen or understood, whose stirring expression is rendered with absolute sincerity, without attenuation, exaggeration, or reserve, where the sensation is complete. . . .

The sketch has that primordial quality which results from and sums up all others: unity.[6]

As shown by the prevalence of partial figures in his work after the *Monument to Honoré* de Balzac, Rodin established for and by himself his own notion of the essential in art. This translated into the question: What can art do without to achieve a new, modern power of expression? For younger early modern sculptors, such as Henri Matisse, this meant departure from the imitation of nature in favor of sculpture more expressive of the artist's own feelings, it meant the sacrifice of resemblance to the dictates of a personal conception of the work as a totality. For Rodin, withholding skill by suspension of surface description, as in the *Dance Movements*, meant a more penetrating resemblance to the subject as a whole.[7] That resemblance depended on his freeing "the spirit of the work."[8]

The most interesting assessment of the *Dance Movements* was made by Leo Steinberg, who wrote in 1963 of the

reduced mode of modeling which propels the septuagenarian Rodin into the twentieth century's avant garde.

In many of his late figurines, such as the *Jugglers*, the *Nijinsky*, the *Mouvements de danse*, Rodin's modeling blinds itself to external anatomy. His subtle acquaintance with human surface is set aside for a deepening, inward-turned acquiescence. One feels, as never before, an acceptance of the condition and shape of the material worked on, and a new willingness to let surface be no more than the track and passage of his own working hands. His little *Dance Movements* must have looked gauche indeed in 1911 when they emerged. They are so frankly made of crude rolls of clay of nearly uniform thickness; their modulations are so naively the imprint

of Rodin's thumb and the pinch of his fingers. And the marvel is that they too, the figures, their clay irradiated by movement, consent. For they dance. Accepting perfunctory surfaces and awkward limbs, they are oblivious of self and body, of style and beauty—to be only what the dance is.[9]

NOTES

LITERATURE: Grappe 1944, 135–36; Goldscheider 1962, 42, 46; Goldscheider 1963, 322–27; Descharnes and Chabrun 1967, 248, 250–51; Jianou and Goldscheider 1969, 113; Steinberg 1972, 358, 399–402; Gassier 1984, 139; Lampert 1986, 166, 168, 233; Miller and Marotta 1986, 124; Levkoff 1994, 148

1. Beausire 1988, 368. They were shown in the Louvre's exhibition catalogue *Rodin Inconnu* (Goldscheider 1962, 42–46), where several are reproduced. The exhibition seems to have been the first to draw attention to them. Some sculptures in the series were shown at the Museum of Modern Art (Elsen 1963, 147–49), and a selection was reproduced and discussed in Leo Steinberg's introduction to the catalogue of a Rodin exhibition at the Charles Slatkin Gallery, New York (Cécile Goldscheider, *Auguste Rodin, 1840–1917: An Exhibition of Sculptures/Drawings*, exh. cat. [New York: Charles Slatkin Galleries, 1963], 10–27; reprinted in Steinberg 1972). Descharnes and Chabrun reproduced not only many of the *Dance Movements* but also a photograph of the *chahut* dancers at the Moulin rouge (1967, 248–51), that had accompanied the article on them in *Gil Blas*, no. 10, 1891.

2. Goldscheider 1963, 322.

3. Grappe 1944, 35; Jianou and Goldscheider 1969, 113.

4. For more on some differences between the two artists, see Elsen 1963, 145–54.

5. Dujardin-Beaumetz in Elsen 1965a, 163.

6. Ibid., 162–64.

7. This misprision of Rodin's intentions and achievements with regard to unity came from the formalist art criticism of Roger Fry and the views of the sculptors Aristide Maillol and Henri Matisse. They characterized Rodin as limited to details and incapable of a largeness of conception, to which the former would be sacrificed. By this criticism they sought to create a distance between the older and younger artists.

8. Dujardin-Beaumetz in Elsen 1965a, 163.

9. Steinberg 1972, 399, 402. The *Dance Movements* of 1911 might not have looked more gauche in posture than Rodin's 1890s sculptures made from cancan dancers with their more emphatic insistence on the sexual and physical pivot of women's bodies. In terms of their rough facture, they would have been considered études by Rodin's contemporaries.

Partial Figures and the Hands

Rodin's greatest gift to modern sculptors was his partial figures, or *morceaux* as he referred to them. They were the most dramatic demonstration of the differences between a traditional concept of finish in sculpture and a new model of artistic completeness. After 1900 to exhibit a torso by itself was to signal that the sculptor was a modern artist. During the last decades of Rodin's life and because of his influence, European salons began to see more and more torsos not only by French but also by German, Belgian, Russian, and Dutch artists. Partial figures continue to be made at the beginning of the twenty-first century by artists involved with sculpting the the human form.

Rodin began his partial figures early in his career as nuclear studies for full figures, such as *Torso of a Man* (cat. no. 173, fig. 445) intended for *Saint John the Baptist Preaching* (fig. 446), and as complete in themselves, as can be seen in some studies in the Musée Rodin Meudon reserve. Among the last sculptures that he publicly exhibited before this death were *Torso of a Young Woman* (cat. no. 177), *Prayer* (cat. no. 80), and *Cybele* (cat. no. 186).

As a student Rodin learned to make sculpture by modeling parts of the human figure. He drew from ancient fragments and in his youth acquired plaster casts of broken ancient statuary. When he became affluent, he purchased quantities of ancient torsos, hands, and feet. From the 1870s, if not earlier, it was his practice to reuse favored torsos, such as that of *Adèle* (1879? or 1882; fig. 415). In the Meudon reserve are some small armless figures that from their style predate 1880. Rodin's practice of completing a sculpture by unmaking it derived from accidents and from calculated decisions, as in *Mask of the Man with the Broken Nose* (cat. no. 125) and *The Age of Bronze* (cat. nos. 1–3). In the first sculpture it was accident that shaped the work, and in the second he removed the spear that would have finished it. He would edit figures severely, cutting away without replacing parts of the body he felt were unsuccessfully modeled or enlarged. He even masked with cloth poorly modeled portions of ancient torsos he owned. Occasionally his partial figures had a thematic intent, as in *The Earth* (cat.

no. 176), which evoked life coming into being from raw matter. Rodin's work on *The Gates of Hell* gave the strongest impetus to his reflections on the artistic completeness of a well-made figural part or partial figure. Meditations on ancient fragments convinced him that beauty and perfection could be found in the part, whereas to the ancient Greeks this conception would have been unthinkable. On the basis of his own work and observation of ancient predecessors, he could say to Paul Gsell, "When a good sculptor models a torso, he not only represents muscles, but also the life that moves them. He represents even more than the life; he represents the power that formed them and granted them grace, vigor, amorous charm, or the untamed fire."[1]

By 1889 Rodin was exhibiting partial figures, which he called études, and a large number were included in his 1900 exhibition. In the 1890s he had some of his partial figures, such as *Iris, Messenger of the Gods* (cat. no. 185), enlarged by Henri Lebossé, a decisive indication that he thought they were complete. In the late 1890s he exhibited some of these figures, among them *Headless Seated Nude Bather* (cat. no. 166) and *Meditation without Arms* (cat. no. 62). Such works challenged conventions of sculptural finish by proposing a concept of completeness that would have been recognized by Charles Baudelaire, who had written in his essay "The Salon of 1845": "A work of genius . . . in which every element is well seen, well observed, well understood and well imagined, will always be well executed when it is sufficiently so. Next, that there is a great difference between a work that is complete and a work that is finished; that in general what is complete is not finished, and that a thing that is highly finished need not be complete at all."[2] In 1900 Rodin exhibited the fragmented burgher *Pierre de Wissant* in the portico at the entrance to his retrospective.[3] For Rodin it was complete even if the exhibited *morceau* was without head and hands.

Rainer Maria Rilke wrote in 1903, "the same completeness is conveyed in all the armless statues of Rodin; nothing necessary is lacking. One stands before them as before something whole. The feeling of incompleteness does not arise from the mere aspect of a thing, but from

the assumption of a narrow-minded pedantry, which says that arms are a necessary part of the body and that a body without arms cannot be perfect. . . . With regard to the painter, at least, came the understanding and the belief that an artistic whole need not necessarily coincide with the complete thing, that new values, proportions, and balances may originate within the pictures. In the art of sculpture, also, it is left to the artist to make out of many things one thing, and from the smallest part of a thing an entirety."[4]

In defense of his partial figures Rodin cited the long history of portraiture, and after 1900 he exhibited only portraits and figures enlarged by Lebossé, which were, with the exception of *The Thinker*, partial figures. (Less influential historically and often known to the public through their photographic reproduction were his modeled hands.) An eyewitness to the reactions that followed was Judith Cladel, whose statement strongly suggests exposure to Rodin's own comments:

> The Master has exhibited these *morceaux*, and they have evoked from his critics the rudest criticisms. These critics have never wanted to comprehend that he was not delivering them as works that were properly decorative, but rather for the unique beauty of *métier*, which appears here more striking than in his most finished sculptures. . . . Nothing veils it, neither the interest of the subject nor the expression of sentiment. All that is there is the quality of modeling, the raw result of work. In reality, these are not *Iris, The Earth, The Muse*, but *torsos* that seem to be fragments of a destroyed monument: it is the sum of art, a certificate that the sculptor gives himself, the total of his efforts and of his researches concentrated in plastic formulas. Consequently, of what importance to him is the completion of details, the seductive arrangement? The individual who contemplates these works must

do it with an informed mind before a fragment of nature to be studied, and not with the attitude of a dilettante searching for aesthetic pleasure and the emotion of the subject which does not exist.[5]

Rodin's exhibition of his études and their inspection by visitors to his studios did not always evoke adverse criticism. By 1883 English critics were championing Rodin as the world's greatest master of the sculptural *morceau*. There is no doubt, however, that he was mindful of strong animosity toward his views:

> I am an inventor . . . I deliver the results of my researches in *morceaux*, which are the studies of planes and modeling. I am reproached for not personally showing all the applications which result from them. Let those who follow me occupy themselves with this task. I must content myself with having led the intelligence of the artist of my time into the environment of Michelangelo and the Antique. When [Alessandro] Volta discovered the electric pile, he could not himself give all of its applications, which since have upset all of science. . . . A well-made torso contains all of life. One doesn't add anything by joining arms and legs to it. My *morceaux* are the examples that I propose for artists to study. They are not finished, it is said. And the cathedrals, are they finished?[6]

NOTES

1. Gsell [1911] 1984, 81.
2. Jonathan Mayne, trans. and ed., *Art in Paris, 1845–1862: Salons and Other Exhibitions Reviewed by Charles Baudelaire* (London: Phaidon, 1965), 24.
3. Photograph reproduced in Beausire 1988, 172, fig. 44; Le Normand-Romain 2001, 270–71.
4. Rilke in Elsen 1965a, 123.
5. Cladel 1908, 97.
6. Ibid., 98.

173

Torso of a Man (Study for Saint John the Baptist Preaching) (Torse d'homme [Etude pour Saint Jean-Baptiste préchant]), 1878

- Title variations: *Petit Palais Torso, Small Antique Torso, Torso Study for the Walking Man, First Impression*
- Bronze, Coubertin Foundry, cast 1979, 4/12
- 21 x 10¾ x 15 in. (53.3 x 27.3 x 38.1 cm)
- Signed on back of right thigh: A. Rodin
- Inscribed below signature: No. 4; at lower edge: © Musée Rodin 1979
- Mark inside right thigh, at lower edge: Coubertin seal
- Provenance: Musée Rodin, Paris
- Gift of the B. Gerald. Cantor Collection, 1983.200

Figure 445

*T*he key to understanding Rodin's thinking about the human form is this less-than-life-size torso made presumably in 1878 in connection with his sculpture of *Saint John the Baptist Preaching* (fig. 446).[1] Despite its fragmented form and seemingly battered surface, at this early date Rodin was not interested in simulating the ruin of an ancient sculpture. Later, as he studied ruined antiquities, he must have been struck by their affinity and on one occasion exhibited this torso as *Petit torse antique* (Small antique torso).[2]

Photographs of the model Pignatelli confirm that this torso was modeled after his body (figs. 447–448). By today's standards he had a modest and lean physique, and the pectorals were not highly developed. Lacking body fat, the ribcage is easily seen under the skin—an ideal body from which to model an ascetic who lived in the wilderness and ate grasshoppers.

In the fullest sense of the word, Rodin was making an étude whose purpose was to allow the study of what for him was a new and drastically different type of figural movement. Earlier in the 1870s, while living and working in Brussels, Rodin made several titanic caryatids for architectural decoration and symbolic seated figures as part of a monument to the Belgian burgomaster François Loos. In both there is much strenuous torsion in the bodies but always in terms of the way the body could position itself in one moment. In *Torso of a Man*,

however, Rodin was focusing on the crucial alterable portion of the body between the unalterable areas of the ribcage and pelvis. This seems to be Rodin's first work in which the sternum and pelvis are not aligned or on a straight axis, as in *The Age of Bronze* (cat. nos. 1–3).[3] The photograph of Pignatelli from the front confirms the obvious: he had no dislocation of the navel. The disalignment in the sculpture meant that Rodin could show the body in two successive movements rather than one, with the upper portion starting at the thorax and upper abdomen aimed in one direction and the lower section beginning with the lower abdomen and pelvis directed in another. Close examination of the statue's umbilical area shows that after Rodin had vertically modeled the muscles bordering the dislocated navel, he indicated with a small cut where that feature would normally be, about an inch to the right, and it is on the figure's left framing muscle. All else in the sculpture is simply the means by which to support and frame this crucial area.

That critical focus may be why the back and buttocks are not fully realized. The scapulas (which in the photograph of Pignatelli are not pronounced) have been broadly modeled, and the curvature of the spine midway up and higher matches that of Pignatelli in the photograph showing him from the back (fig. 448) and in the final pose of *Saint John*. The plugged hole just above the right waist and buttock may have been caused by removal of an external armature. The critical area of the lower spine, where Rodin wanted to change the torso's direction, is left rough, probably not out of indecision but perhaps because it was hard to work around the exposed armature. (In the final *Saint John* the spine follows fully that of Pignatelli, and there is no adjustment for the deviation in the torso's front axis.) Rodin also patched clay across and over the partially modeled buttocks and the intervening crease, perhaps because he was not sure of the stance of the legs that would determine not only their position but also, depending on how the weight was carried, which buttock was to be hard and which soft.

In back, there is enough of the right shoulder to show the down and outward position of the future upper arm. In that connection Rodin may have first modeled the full right pectoral with the muscles pulled upward in connection with the arm movement that can be seen in the photograph of Pignatelli from the front, but then, for some reason, such as discontent with what he had done or for positive aesthetic motives, he decided to cut or as Henry Moore observed to the author, to pound that area away.

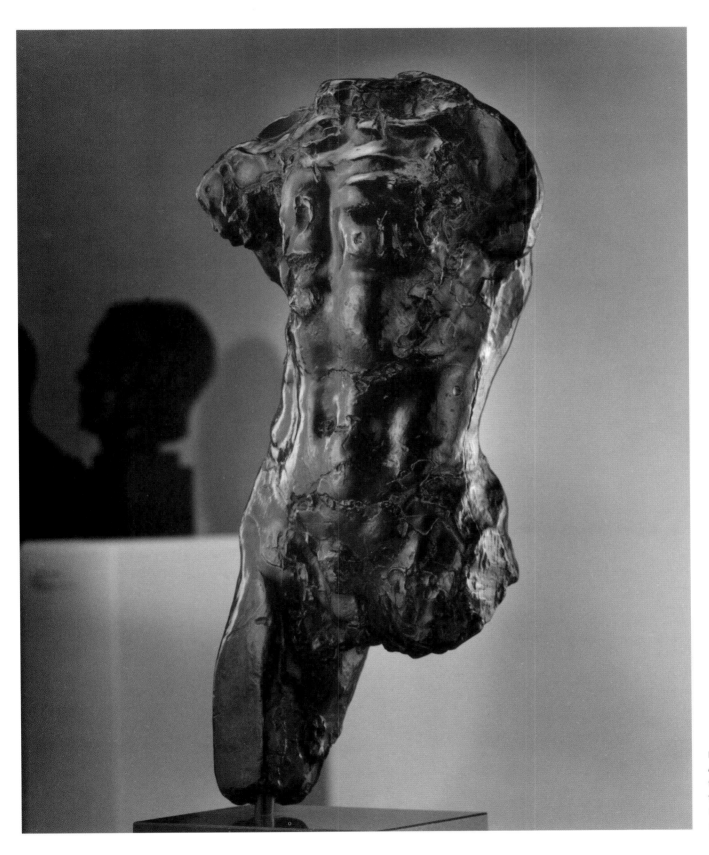

Fig. 445. *Torso of a Man* (Study for Saint John the Baptist Preaching) (cat. no. 173).

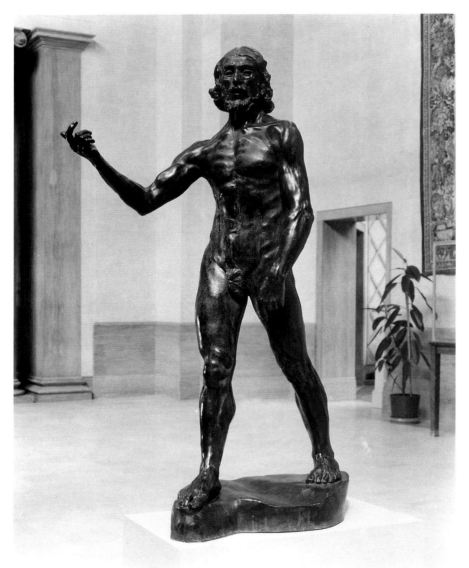

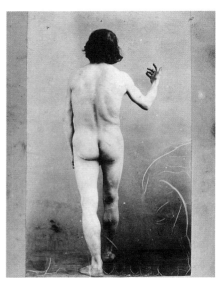

Additionally the crude rather than true terminations of neck and shoulders signal that no head or arms have been removed; the right upper thigh flattened in the front is vertical, and the left nonexistent because the direction of the legs had not been determined. (Pignatelli could have posed the long hours for the torso étude by simply standing up with his legs close together.) The rough, jagged creases running laterally across the upper and lower abdomen are not casting flaws but rather Rodin's own demarcations of this critical nuclear area in which he would show the figure pivoting in time. The challenge was to make artistically plausible what was anatomically impossible in a given moment.

What inspired this change in Rodin's art after *The Age of Bronze*, this new, intense focus on the body's fulcrum of expressive movement? Evidently Rodin wished to get away from the obvious stationary studio posture of his young soldier and to impart more energy and movement to his work. It may have been that Rodin wanted to refute the charge that in *The Age of Bronze* he had made a life cast. (If so accused, unlike the situation in 1877 when his model was in Brussels, it would have been easy for Rodin to show Pignatelli and his normally located navel to skeptical Parisian critics).

While working on *The Age of Bronze* less than three years earlier, Rodin had visited Italy where he studied Michelangelo's art. He may have visited the Casa Buonarroti and there seen and kept in memory wax torsos not unlike his own later works, except for the crucial anatomical liberty he had taken. Possibly from the study of these torsos came Rodin's idea that one could build a figure from the torso outward, rather than from the feet up.

And one of the most important lessons he learned seems to have been that, in Leo Steinberg's words, "Michelangelo's habit is . . . to think the body from center out: power generated at the midriff sends forth equivalent vectors, which we call limbs."[4] Perhaps inspired by this discovery as well as by observation of his models, Rodin's equivalent was to say that "all life surges from a center, then it germinates and spreads from the inside to the outside."[5]

Years ago, while working in the reserve of the Musée Rodin at Meudon, the author found a solid plaster cast of this torso and was able to inspect it with a Stanford colleague, the sculptor Richard Randell. We noticed that there were shallow craters here and there and that the whole looked like a sunburned body from which the skin had peeled off in spots. Randell pointed out that Rodin had applied a thin plaster skin, or what in Rodin's day would have been called a *couche*, that over time could have caused the delamination, or flaking. The beauty of Stanford's lost-wax cast, made by the Coubertin Foundry, is that we have such a precise record of the original surface. The scars left by the lost skin, along with the exposed casting seams, only abet the overall variation in surface treatment and associations with ruined antiquities.

Rodin returned to this torso, which had dried and cracked overtime. He had it cast, photographed, and then reproduced in 1887 at the latest.[6] Rodin had two bronze casts made of this torso in 1889, one is now in the Petit Palais in Paris and the other Rodin gave in friendship to Medardo Rosso several years later.[7] It appears that he exhibited a bronze cast of the torso under the name *Petit torse antique* in his 1900 retrospective, again in Paris (1903) under the name *Première impression* (First impression), and a year later in London as *Torse de Saint Jean* (Torso of Saint John).[8]

The history of this torso includes its being reworked into a one-half life-size, armless but full-length study of *Saint John the Baptist Preaching*[9] and subsequently as part of the final sculpture. It was combined with reworked legs of the *Saint John* in 1900, when it was shown one-half life-size in Rodin's retrospective, representing the first version of *The Walking Man* though still titled *Study for Saint John the Baptist*.[10] Finally, it was enlarged by Henri Lebossé both independently and as part of *The Walking Man* (cat. no. 174) between 1905 and 1907.

NOTES

LITERATURE: Bartlett 1889 in Elsen 1965a, 81; Cladel 1936, 132–33; Elsen 1969, 18–19; Steinberg 1972, 388; Tancock 1976, 360, 363, 369; Elsen 1980, 187; Elsen, 1981, 40; Elsen 1984, 215–17; Miller and Marotta 1986, 134–36, 139; Beausire 1988, 70–71; Goldscheider 1989, 130; Pingeot 1990, 123–24

1. Goldscheider reproduced a very small terra-cotta torso she associated with a roughly two-foot, full-length but armless standing plaster figure she believed to be a study for the *Saint John* (1989, cat. no. 102b-c). The figure's head and body bear no resemblance anatomically to Pignatelli, the model for *Saint John*. Beausire was of the opinion that *Torso of a Man* was not a study for the *Saint John* but used only for *The Walking Man* (1988, 70–71). Beausire did not give any explanation for the disassociation of the torso from the *Saint John*, but the internal evidence of the two torsos, such as the modeling of the ribcages and abdominal areas and relation of the navel to the sternum, does not support his view, nor do the photographs of the naked model (see figs. 447–448). The author is indebted to Ruth Butler for calling attention to the existence of the photographs of Pignatelli which were first published by Hélène Pinet (1990, 26).

2. Leo Steinberg saw the torso thus: "At first sight the torso is a piece of nostalgic neo-antiquity. But it was made by one who sees antique art in two places at once—that is, in its own orbit, invested with native athletic pride; and in our world as a scarred relic" (1972, 388). Truman Bartlett also associated the torso with the antique (in Elsen 1965a, 81).

3. From what photographs tell us of Rodin's Michelangelesque caryatids made in Brussels in 1874 and the seated figures on his *Vase of the Titans* (cat. no. 39), this realignment had not yet taken place. These works were illustrated by Descharnes and Chabrun (1967, 42).

4. Leo Steinberg, "Michelangelo's Florentine Leg Twenty Years After," *Art Bulletin* 71, no. 3 (September 1989): 480–505, especially 495.

5. Author's translation from "Rodin's Artistic Testament," reprinted in Descharnes and Chabrun 1967, 8.

6. Letter from Antoinette Le Normand-Romain to Bernard Barryte, 6 July 2001; Le Normand-Romain 2001, 150.

7. Margaret Scolari Barr, *Medardo Rosso* (New York: Museum of Modern Art, 1963), 43.

8. Beausire 1988, 185, 238, 247. The last title, by which Rodin linked the torso with the sculpture of *Saint John*, contradicts Beausire's view of their not being related.

9. This study was published for the first time in 1979 (see Elsen 1984, 215–16, pl. 207); it was also reproduced and discussed in Elsen 1980, 160–61.

10. Reproduced in Butler 1993, fig. 145.

174

The Walking Man
(*L'homme qui marche*), 1878, and 1899 or 1900

- Title variation: *Large Figure of a Man*
- Bronze, Georges Rudier Foundry, cast 1970, 12/12
- Enlarged 1905–07
- 87⅞ x 29½ x 53⅛ in. (223.2 x 74.9 x 134.9 cm)
- Signed on top of base, between feet: A. Rodin
- Inscribed on back of base, at lower right: Georges Rudier/Fondeur, Paris; on base, left rear corner of base: © by musée Rodin. 1970
- Provenance: Musée Rodin, Paris
- Gift of B. Gerald Cantor. This sculpture is dedicated by Iris Cantor to honor and celebrate Stanford University President Gerhard Casper's leadership and role in rebuilding The Cantor Arts Center. August 31, 2000. 1982.306

Figures 449–450

One morning, someone knocked at the studio door. In came an Italian, with one of his compatriots who had already posed for me. He was a peasant from Abruzzi, arrived the night before from his birthplace, and he had come to me to offer himself as a model. Seeing him, I was seized with admiration: that rough, hairy man, expressing in his bearing and physical strength all the violence, but also all the mystical character of his race.

I thought immediately of a St. John the Baptist; that is, a man of nature, a visionary, a believer, a forerunner come to announce one greater than himself.

The peasant undressed, mounted the model stand as if he had never posed; he planted himself head up, torso straight, at the same time supported on his two legs, opened like a compass. The movement was so right, so determined, and so true that I cried: "But it's a walking man!" I immediately resolved to make what I had seen.[1]

When Rodin made the *Saint John the Baptist Preaching* (see fig. 446) in 1878, he was conscious of violating tradition, of breaking the academic rule that in a moving figure the head should be placed directly over the foot that carries the body's weight. Instead, he was placing the head above air and denying the dictum that the figure should be plumb:

It was customary then, when looking over a model, to tell him to walk, that is, to make him carry the balance of the upright body onto a single leg; it was believed that thus one found movements that were more harmonious, more elegant, "well turned out." The very thought of balancing a figure on both legs seemed like a lack of taste, an outrage to tradition, almost a heresy. I was already willful, stubborn. I thought only that it was absolutely necessary to make something good, for if I didn't transmit my impression exactly as I had received it, my statue would be ridiculous and everyone would make fun of me. . . . I promised myself then to model it with all my might, and to come close to nature, which is to say, to truth.

It was thus that I made "The Walking Man" and "John the Baptist." I only copied the model whom chance had sent me.[2]

The history of *The Walking Man* is complex as it reflects Rodin's practice of making small-size studies of parts of a proposed statue, assembling them in various ways at different times, revising earlier rather than later versions of a figural part, and then enlarging his new synthesis. In 1878 he made a study of a torso, as well as a full figure, from a model named Pignatelli who posed for *Saint John*. Having seen the photographs of Pignatelli naked and in the pose of the *Saint John* (see figs. 447–448), this author believes these sculptures were made directly from life from an inspiring but physically undistinguished model.[3] To counter the unjust charge that he had made a life cast for *The Age of Bronze* (cat. nos. 1–3), Rodin probably asked himself, what if one were to show in a single statue a succession of movements? The answer to this question meant posing Pignatelli with his legs apart, as if in a stride. (As he himself pointed out, Rodin was breaking the rules, but he could have cited François Rude's youthful striding warrior in the center of his *Departure of the Volunteers of 1792* [see fig. 50] as a precedent, albeit in relief.) By itself the torso was thus not originally intended as the emulation of an antique as has sometimes been thought.[4] This torso (cat. no. 173; see also fig. 451), so severe in its editing that the front appears to have been unmade after it was first completed, was then reworked it appears in 1899 or 1900, probably by means of a fresh clay cast, into a one-half life-size, armless but full-length

study of the *Saint John*.[5] That Rodin considered this étude a complete work of art is evident from his having the original torso bronze-cast. It may have been exhibited in 1889 at the Monet-Rodin exhibition and is now in the collection of the Petit Palais.

That joining a new clay cast from the molds of the original torso, which had been kept in plaster and is today at Meudon, to clay casts of the reworked legs from the earlier one-half life-size study of the prophet was more than a simple graft comes through in the account by Judith Cladel, who may well have been an eyewitness to the process she described. "Among the preparatory studies for the *Saint John*, there is one that Rodin had pushed to the limit of his inexorable will. . . . He treated his étude in two parts, the torso as one part, the legs as the other. He had the idea of joining them one day in the future. It was not until twenty years later, around 1900, that he realized this project. . . . Unfortunately, he no longer had the use of the impressive model of 1878 and he had great trouble in achieving a successful joining. Engaging in incessant retouchings, he had a cast made each time of the new state of his figure and was never content with it."[6] The truth of Cladel's observations is brought home to us when we study the juncture of the legs and torso and the many arbitrary or structural decisions Rodin made to conjoin them.

By the end of the century Rodin had no hesitancy about exhibiting in public his *morceaux*, and he had more to reveal about sculpture with this original étude of a torso mounted on reworked legs—*The Walking Man* was exhibited as *Saint John the Baptist* in 1900—than he did with the academically finished *Saint John* (see fig. 446).[7] For many years after the *Balzac* debacle in 1898 and to sympathetic and understanding writers like Camille Mauclair, Rodin made special efforts to explain his aims and principles to the public. The *Balzac* figure had crystallized his thinking; *The Walking Man* stripped Rodin's art to its essentials. We can see how the latter shaped his thought and expression in a famous statement published in 1905: "What . . . is the principle of my figures, and what is it that people like in them? It is the very pivot of art, it is balance; that is to say, the oppositions of volume produced by movement. . . . The human body is like a walking temple, and like a temple it has a central point around which the volumes place and spread themselves."[8]

By 1900 Rodin had pondered his *Saint John* for over 20 years, and he may have felt that the pose was too ambiguous: it could be seen as that of a speaker in a forked but fixed stance or that of a preacher en route. In the new version there would be no ambiguity as Rodin's intent was a purer expression of his ideas on movement. The juncture came after he further elongated the trailing left leg to convey a greater impression of forward motion and after he had changed the base so that by raising its rear section it appeared that the figure was pushing off from the ground more emphatically and explicitly than did *Saint John*.[9] The union of the torso and legs was not made anatomically perfect.

The original torso had not previously been attached to legs, had no buttocks, and was proportionately slightly smaller than the new legs. Rodin effected a rough union of the two: tapering the upper thighs in the front to fit into the torso, and in the back, perhaps due to the absence of Pignatelli, the original model, as Cladel pointed out, not bothering to fashion the massive buttocks in detail but treating broadly their juncture with the legs, as if with a big poultice. This was a decision that in Rodin's mind may have augmented the overall sense of movement of the figure when seen from the back. Rodin made changes to the original legs of his one-half life-size study of *Saint John*. He thickened and tensed the quadriceps of the right thigh to show that the weight had been transferred. The trailing leg had to perform two functions. It presented a problem because from the kneecap down the leg is driving off the foot, but from the kneecap up the weight is being transferred to the right leg, and the left buttock area is soft.[10] Rodin thinned or flattened out the front of the trailing thigh, which has the effect of removing the backward pressure from it and making the transfer of weight to the lead leg more apparent. When seen from the back, however, the trailing leg seems to be an undivided upward thrusting force that is continuous with the back. When you walk around the figure, especially from the sides, you can see the shift in weight.

How would Rodin have described what he had done? From Paul Gsell's conversations with Rodin we have the sculptor's observations on the works of a great writer and of a great sculptor, both of whom must have had considerable influence on the mentality that produced *The Walking Man*. On Dante's treatment of the combat of a man with a serpent, Rodin recalled, "He makes visible the passage of one pose into the other; he indicates how imperceptibly the first glides into the second. In his work, one still detects a part of what was while one discovers in part what will be." In the same conversation Rodin

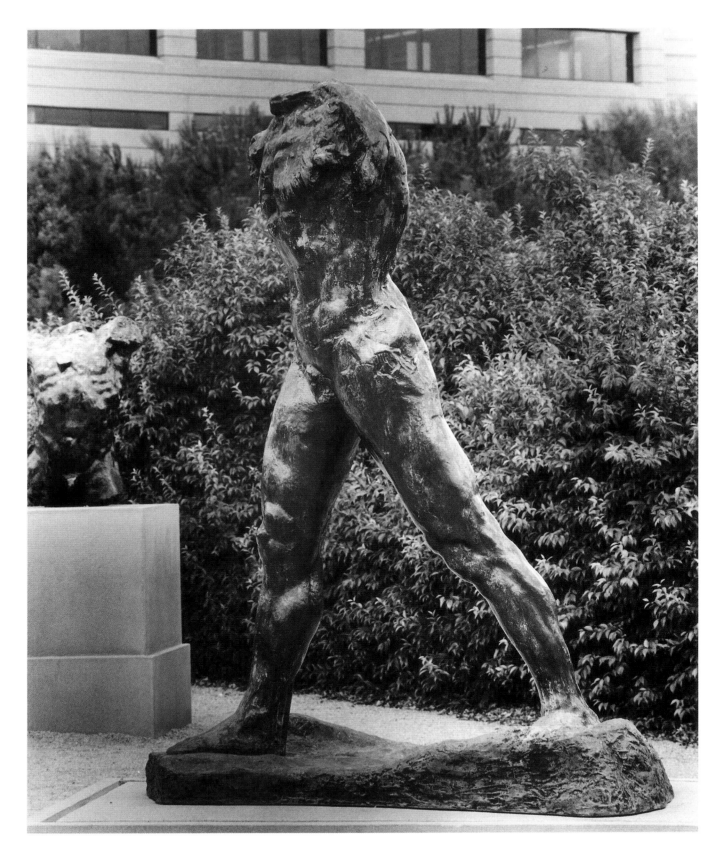

Fig. 449. *The Walking Man* (cat. no. 174) side view.

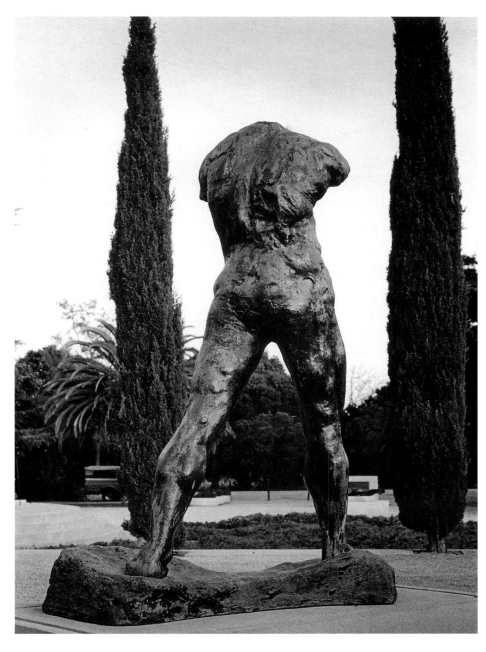

became known as *Saint John of the Column.*) In the next five years however, Rodin exhibited the one-half life-size version, under the name *The Walking Man,* in both plaster and bronze in Venice (1901), Vienna (1901), Mulhouse (1902), Prague (1902), Düsseldorf (1904), Weimar (1904) and Boston (1905).[12]

From the time of its first Paris showing and even before enlargement, *The Walking Man* had a demonstrable influence on a major artist. Shortly after the turn of the century and during a visit to Meudon in about 1902 or 1903, Henri Matisse paid Rodin 1,000 francs for a plaster cast of *The Walking Man.*[13] This was at a time when Matisse was working hundreds of hours on *The Serf* (1903; Baltimore Museum of Art).[14] Rodin had shown sympathy for the younger artist because of the adverse criticism he and his work had received. For Matisse, who was slowly working out answers to questions of expression, finish, and the suggestion of motion in sculpture, Rodin's cast gave him material to think about, build on, and react against. Certainly his decision to amputate *The Serf*'s arms came from his study of Rodin's partial figures.[15]

Fig. 450. *The Walking Man* (cat. no. 174) back view.

discussed Rude's statue *Marshal Ney* (c. 1848–53; Place de l'observatoire, Paris) and how it showed a succession of movements. He referred to this statue's movements as "the metamorphosis of a first attitude . . . into another." Rodin concluded that "The sculptor obliges . . . the spectator to follow the development of an act through one figure."[11]

Possibly in 1899 and definitely in 1900 he exhibited in plaster and on a tall column this one-half life-size sculpture known as *A Study for Saint John the Baptist.* (It

Between 1905 and 1907—and with considerable difficulty—Henri Lebossé enlarged *The Walking Man* to more than life-size, faithfully preserving all the rude passages and "accidents," including the exposed armature strap that serves as the figure's right Achilles tendon. This was no mere mechanical operation. As evidence of the changes Rodin made to the original legs of his *Saint John* and the problems their enlargement involved, Lebossé had to redo his work three times.[16] The trailing left leg gave him the greatest trouble, which suggests that Rodin

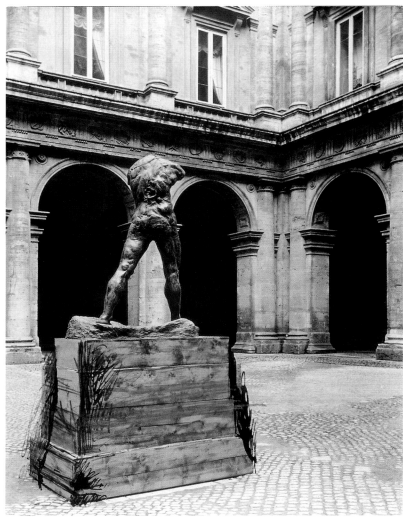

may have introduced changes from the original, smaller model.[17] In its final size *The Walking Man* is about nine inches taller than the final *Saint John*. Because of its increased size and being without arms, the leftward rotation and forward tilt of the torso are more pronounced. From certain views, notably from the back and head on, the enlarged figure seems about to fall on its side or is more off-balance than the original, smaller version. This could not have escaped Rodin's attention. With his *Balzac* (cat. no. 112) and *Spirit of Eternal Repose* (cat. nos. 98–100), he was already challenging gravity and making the figure's involvement with space more explicit while forcing the viewer to experience these sculptures in time from all sides.

In 1907, after its debut in Strasbourg under the name *Grand figure d'homme* (Large figure of a man), the enlarged plaster was renamed *L'homme qui marche* (The Walking Man) and was made the *clou*, or featured sculpture, under the dome of the Grand Palais in the spring salon.[18] Its reception was predictably mixed, with critics complaining that the work was unfinished and that it evoked unpleasant associations with mutilation.[19] It was either an admirable or execrable ébauche (rough sketch) and in the latter case was taking up exhibition space deserved by finished work. The 1907 exhibition of this great sculpture was a major event for young modern sculptors, however. Many were emboldened thereafter to exhibit truncated figures. For Aristide Maillol, Rodin's partial figures liberated him from always showing a full figure, so that he could make and enjoy a torso and be freed (as his model Dina Vierny told the author) from what he called the "calvary" of struggling with modeling a woman's arms. *The Walking Man* in the small version, exhibited along with other fragments in Rodin's 1900 show, inspired Maillol to make his torso, of a striding woman embodying chained action (*Torso of Action in Chains*, 1906; Art Institute of Chicago), by which he argued that the feminine form permitted superior

beauty in sculpture. For Raymond Duchamp-Villon *The Walking Man* was like an emancipation proclamation; it encouraged him to amputate the troublesome arms of his *Adam and Eve, or Pastorale* (1910; Musée national d'art moderne, Paris) as the first step toward redesigning the human form, as seen in his *Torso of a Young Man* (1910; Hirshhorn Museum and Sculpture Garden, Washington, D.C.). The young Wilhelm Lehmbruck showed his first work in Paris in the 1907 exhibition, and his subsequent partial figures are indebted to his experience there, as are those of Constantin Brancusi who worked in Rodin's studio at that time. Alexander Archipenko's *Walking Woman* (1912; private collection), introduced space inside the figure, but as with his other early partial figures it is unthinkable without *The Walking Man* and Rodin's *morceaux*.[20]

Predictably, Rodin ignored the criticisms of *The Walking Man*, and over the next seven years he sent his big figure to Frankfurt (1908), London (1908), Moscow (1908), Munich (1908), Leipzig (1910), Rome (1911), Paris (1913), and Brussels (1914), which helps explain its considerable influence on early modern sculpture.[21] Its importance to Rodin is affirmed by the 20 international exhibitions to which he sent large and small versions of *The Walking Man* prior to the First World War. In a letter to Henri Marcel, who had asked for the loan of sculptures for an exhibition in 1911, Rodin wrote, "As for the most important statue that you would like, I have *L'homme qui marche*, which in my opinion is one of my best works."[22]

In 1911 Rodin sold the first bronze cast of *The Walking Man* to an Austrian collector, Karl Wittgenstein, who intended to give the work to the Museum of Modern Art in Vienna if it did not fit into his apartment. That year, however, Rodin asked Wittgenstein to cancel the transaction as a group of French subscribers had offered to purchase the bronze cast, donate it to the nation, and have it installed in the courtyard of Palazzo Farnese in Rome, which served as the French embassy. Rodin sent the cast to Rome for an exhibition in 1911, after which it was installed on a temporary wooden pedestal in the center of the palace courtyard (fig. 452).[23] A friend of Rodin, Vittorio Pico, perhaps sensing that this location might cause problems, recommended others, to which Rodin replied, "I have known that others have spoken of putting *L'homme qui marche* on the second floor of the Palace or under the arcades, but to my way of thinking and according to the conditions of the offer this bronze must be in the center of the courtyard. The architecture will not crush it because its modeling is powerful enough to fill the space."[24] Rodin told a reporter that he found the juxtaposition of sculpture and site interesting because "the *modelé* approached that of the ancients and the 16th century. It is by this means that the sculpture would be in harmony with the general architecture of the Farnese Palace, which is also of the 16th century."[25] To another writer Rodin explained, "In my sculpture, the shadows are soft, they encircle it without hardness. It is the antique method applied by the artists who constructed the Farnese Palace. There is in the architecture of the palace much force and vigor and as happily my statue does not lack these things, it harmonizes very well."[26]

To the writer Michel Georges-Michel (1883–1985), Rodin observed on the site, "Its 'modelé' goes well with the power of the surrounding architecture. 'Le modelé' is the important dimension. 'Le modelé' is the harmony, the proportion. It is that which gives 'the impression,' as much as the height and largeness. I am very happy that my 'Homme qui marche' is there. It is a demonstration. Because above all I wanted to make a good piece of modeling, a powerful piece of sculpture. All is not there. The head and arms are lacking. But that means little to artists. In commercial art, with statues of 5, 10, or 100 francs, or 2,000 francs, one never forgets to put on the head and the arms . . . sometimes the hair, one by one."[27]

So anxious was Rodin to occupy this famous site that he paid for the travertine for its pedestal and offered to pay for its carving as well as a drainage system around the pedestal. The ambassador came to dislike the sculpture and its location and eventually had it returned to France on the grounds that it obstructed traffic. (His car apparently struck the pedestal while turning in the courtyard.) This caused a great scandal in Rome among the artists who rallied to Rodin's support and drew from the sculptor such comments as "They reproach my statue for not having a head, but, in general, the ambassadors have no more of a head than my *Walking Man*."[28] The cast went to Lyons, where over the years in the courtyard of the Fine Arts Museum it was almost buried under bird droppings. Today it can be seen restored in the Musée d'Orsay in Paris.

While *The Walking Man* was on view in Rome in 1911 and 1912 and widely reproduced in the newspapers and magazines, it is likely that Umberto Boccioni had occasion to study it, and it is clear that his *Technical Manifesto of Futurist Sculpture* of 1912 and the sculpture *Unique*

Forms of Continuity in Space (1913; Museum of Modern Art, New York) show Rodin's influence. In the manifesto Boccioni wrote, "We proclaim that the whole visible world must fall in on us, merging with us and creating a harmony measurable only by the creative imagination; that a leg, an arm, or an object, having no importance except as elements of plastic rhythm, can be abolished, not in order to imitate a Greek or Roman fragment, but to conform to the harmony the artist wishes to create."[29] Like *The Walking Man*, Boccioni's sculpture is of a nude striding figure, bent right leg in advance and trailing left leg, without arms but with a figuration that suggests a head. Boccioni criticized Rodin for having committed the "sins" of Michelangelo but was in turn guilty of artistic grand larceny. His notion of artistic self-sufficiency is unthinkable without Rodin's partial figures.

In 1911 Paul Gsell published his conversations with Rodin, *L'art: Entretiens réunis par Paul Gsell*. It was a great success, underwent several translations, and continues to be republished today.[30] The book's international circulation made available Rodin's views on movement in sculpture, which would have expanded appreciation for *The Walking Man* among artists and the general public. Some reporters writing about the sculpture's placement in Rome quoted passages on movement in sculpture and photography from the volume.[31]

After 1900 Rodin believed he had a far different paradigm to contest: high-speed photography. Rodin was one of the original subscribers to Eadweard Muybridge's portfolio *Animal Locomotion* (1887) and had reflected long on the differences between his art and that of photography. Where younger artists such as the Futurists and Marcel Duchamp were taking inspiration from high-speed photography in their painting, Rodin denied its appropriateness to sculpture on the grounds that it was untruthful.

> Now take my *Saint John*. He is represented with two feet on the ground, but a high-speed photograph of a model moving in the same way would probably show the back foot already raised and moving forward. Or, on the other hand, the forward foot would not yet be on the ground if the back leg in the photograph occupied the same position as in my statue.
>
> For just this reason this photographed model would present the bizarre appearance of a man suddenly struck with paralysis and petrified in his pose. . . .
>
> In high-speed photographs, although figures are caught in full action, they seem suddenly frozen in mid-air. This is because every part of their body is reproduced exactly at the same twentieth or fortieth of a second, and there is not, as in art, the gradual unfolding of a movement. . . .
>
> It is the artist who tells the truth and photography that lies.[32]

Rodin had *The Walking Man* photographed from different views, and one that was reproduced in a periodical, as in the Cesare Faraglia photograph, (fig. 452), showed it from the back, as if Rodin were saying to the viewer, "This is where you begin to experience my sculpture. This is the first act." Rodin's message to younger artists was that well-made sculpture had no front or back. When Rodin had Lebossé scrupulously enlarge the gaping hole under the right shoulder blade (probably a vestige of an external armature, as Henry Moore observed) and all the scars of the original étude, he was saying in effect, "Forget finish!"[33] Despite *The Walking Man*'s evocation of a ruined ancient statue and its frequent comparison with the *Winged Victory of Samothrace*, which had been installed in the Louvre in 1875, Rodin did not trade on this resemblance nor use it as a justification for its scarred form. He did argue that his method of modeling from nature in the round and in depth was like that of the ancients.

Given its descriptive name and the fact that it had replaced his *Saint John* in the artist's favor, we can see that Rodin stripped this sculpture of titles that had literary or historical reference. To Gsell he commented, "When all is said and done, you should not attribute too much importance to the themes you interpret. No doubt they have their value and help to charm the public, but the main concern of the artist should be to fashion living musculatures. The rest matters little."[34] There being no costume or attribute to identify *The Walking Man* with a time and place, a purpose or vocation, the human figure had been divested of culture.[35] Removing the arms meant stripping away rhetorical gestures. As if that were not enough, Rodin showed the world that parts of the figure itself could be dispensed with—a powerful and influential attack on the concept of sculpture as the imitation of nature and devastating to conventions of beauty

and finish. Absence of a head eliminated specific identity and psychological or emotional display, and being without arms as well, the figure totally lacked the means of traditional expression. *The Walking Man* strode into the twentieth century like a newborn. What Rodin had achieved was the strongest and purest expression to that time of the twin themes of art and life: celebrate the act of being alive and let people enjoy the art with which you do it. He had given a modern expressive power to a pedestrian subject through the *overall* character and formation of the figure.

Through the eyes of those who really look at sculpture, we can often learn more about such a complex figure as *The Walking Man*. We are also exposed, however, to their biases about what sculpture should be in the way they read *The Walking Man*. Usually when this work is shown to a sculptor today, he or she tends to look at the figure first from the front and to read only the weight coming down on the right foot. Side views make the figure look stable to them. It takes time, often with guidance, for them to start at the back and to see Rodin's intention of showing a succession of movements starting with the left foot. Three very astute observers, independently of one another, have seen a stationary stance. For Leo Steinberg:

> *L'Homme qui marche* is not really walking. He is staking his claim on as much ground as his great wheeling stride will encompass. Though his body's axis leans forward, his rearward left heel refuses to lift. In fact, to hold both feet down on the ground, Rodin made the left thigh (measured from groin to patella) one-fifth as long again as its right counterpart.
>
> The resultant stance is profoundly unclassical, especially in the digging-in conveyed by the pigeon-toed stride and the rotation of the upper torso. If the pose looks familiar, it is because we have seen news photos of prizefighters in the delivery of a blow. Unlike the balanced, self-possessed classical posture with both feet turned out, Rodin uses the kind of step that brings all power to bear on the moment's work.[36]

For an article on *The Walking Man* written in collaboration with Henry Moore, Moore commented on how the man's feet "clench the earth." Imitating the position of the figure with the right foot turned in, he showed how one could not possibly walk in this manner. The toeing-in was for him the result of the model "striking a pose," which is borne out by Rodin's own recollection that was unknown to Moore when he made the point.[37]

Finally, the sculptor William Tucker wrote, "The great figure sculptures from *John the Baptist* onward are not in general figures in violent movement, rather they are in a state of suspended movement. *The Walking Man* is the type of this kind of sculpture. The perceived illusion of movement is countered by the enormous physical stability of the pose, the spread, straight legs forming that most stable of forms, the isosceles triangle."[38]

During Rodin's last years, a strong reaction set in among early modern sculptors against the representation of figural movement, as part of their turning away from illusion or descriptive sculpture. With few exceptions, this attitude has persisted to the present day among artists and critics. It is not so much that Rodin failed in his intention but that modern sculptors either have forgotten or never learned to look at his sculptures in terms of time and the subtle anatomical changes he employed. Henry Moore expressed this ethos of modern sculpture that he helped form: "Sculpture should not represent actual physical movement . . . sculpture is made out of static, immovable material."[39]

For many years Moore had his cast of Rodin's *Walking Man* near his bed so that it was the first and last thing he saw day and night. The sculpture's qualities that Moore said had influenced him cause us to go back to it and see it in still different ways: " 'I like its springiness, tautness and energy. Every muscle is braced. It all heaves upward. Rodin has put something of the archaic Greek style into it by widening the thighs and calf towards the top. The form diverges upward from the ankle to the knee and from the knee to the top of the thigh. This gives an upward thrust. The leg is not tired and sloppy like a sack. The knees are braced backward and the kneecap is up. . . . I like in Rodin the appearances of pressures from beneath the surface. . . . He certainly knew the architecture of the body. . . . A torso fragment has a condensed meaning. It can stand for an entire figure.' "[40]

The last word on this great sculpture might be Henry Moore's response to a question as to whether he agreed with Matisse that Rodin lost sight of the total effect by concerning himself with details. "Rodin does pay attention to the whole. His own nature gives the figure unity. The unity comes from Rodin's own virility. . . . It is a kind of self-portrait."[41]

NOTES

LITERATURE: Dujardin-Beaumetz 1913 in Elsen 1965a, 165–66; Cladel 1936, 132–33; Grappe 1944, 16–17; Cladel 1948, XVI-XIX; Schmoll 1959, 131; Elsen 1966b; Mirolli (Butler) 1966, 193; Elsen 1967a; Elsen 1969, 19, 26; Steinberg 1972, 349, 363, 370, 388, 393; Tancock 1976, 266, 268, 357, 360, 363, 369; de Caso and Sanders 1977, 78; Elsen 1980, 187; Schmoll 1983, 131–33, 135–36, 139–41, 152, 156–58, 271; Elsen 1984, 215–16; Beausire 1988, 70–71; Goldscheider 1989, 130; Pingeot 1990, 123–26; Butler 1993, 116, 356, 359, 420, 423, 467–70; Butler and Lindsay 2000, 317–20; Le Normand-Romain 2001, 150

1. Dujardin-Beaumetz in Elsen 1965a, 165–66. Rodin told this story many times with variations.
2. Ibid., 166.
3. Previous speculations were offered in the article this author wrote in collaboration with Henry Moore, "Rodin's 'Walking Man' as Seen by Henry Moore" (Elsen 1967a). Comparing the photographs of Pignatelli, who posed exactly as he had for the statue of *Saint John*, for which he became famous in the studios, one is struck by how closely Rodin worked from his figure, even to the curvature of the spine visible in the rear view (see fig. 448). The enlargement of *The Walking Man* and the bronze cast tend to make Pignatelli seem more muscular than he actually was. Rodin was, in fact, faulted for using a poor model when he exhibited *Saint John*. Regarding Pignatelli, see also Butler 1993, 115–16, 525 n. 17
4. One of the first to record its presence in Rodin's studio was Truman Bartlett, who saw it in 1887 and made the association with an antique: "As 'The Broken Nose' was readily taken as a reminder of the antique, so the 'Torso,' of the first sketch of the 'St. John,' would be accepted as a veritable specimen. To all intents and purposes it is, for it represents, so far as it goes, just as fine a note. It is really the half-way point toward the antique" (in Elsen 1965a, 81).
5. Fig. 451 (A91) shows a varient in plaster with extended upper thighs that are sliced straight across and placed on a rough base that allows the torso to remain upright. A bronze cast of this varient is reproduced in Barbier 1987, cat. no. 141. The date of the variant is uncertain. It may date from around 1887, the year Rodin rediscovered the torso made in 1878 (cat. no. 173; letter from Antoinette Le Normand-Romain to Bernard Barryte, 6 July 2001), or from around 1899 when he began developing *The Walking Man*. The full-length study was identified by the author in the Meudon reserve in 1979 (see Elsen 1980, 160 and Elsen 1984, 215–16).
6. Cladel, 1948, xvi-xix. See de Caso and Sanders for a summary of the various views on how and when this new synthesis came about (1977, 79 n. 23). Absent any proof to the contrary, *The Walking Man* was never part of Rodin's studies for *The Burghers of Calais*, as shown by the positions of the figures in the first and second models.

7. The small-scale plaster of *The Walking Man*, mounted on a column, was photographed by Stephen Haweis and Henry Coles (see Butler 1993, fig. 145); a photograph by Eugène Druet is reproduced in Le Normand-Romain 2001, fig. 63
8. Mauclair 1905a, 67–68.
9. In his 1963 essay on Rodin (reprinted in Steinberg 1972), Steinberg first pointed to the greater length of the trailing leg (349). Ruth Mirolli (Butler) later also pointed out that the trailing leg of the *Saint John* was longer than the right (1966, 191). In her study of Rodin's anatomy Joanne Brumbaugh wrote, "The trailing leg left leg is significantly longer than the right. The left foot breadth, length, and heel breadth are all larger than the right. This elongated and enlarged left leg evokes a greater impression of forward movement. In addition Rodin emphasizes the gastronemeus muscles to such a great extent that the man would have to be standing on his toes to get this much contraction in these muscles" ("The Anatomy of the Rodin Sculpture Collection," paper in the author's files, Cantor Arts Center archives.
10. The author owes this observation to Dr. Amy Ladd of the Stanford University School of Medicine.
11. Gsell [1911] 1984, 28–30.
12. Beausire correctly believed that *The Walking Man* was exhibited as *Saint John*, as in 1900, in the large traveling show for the Netherlands (1899) (1988, 85). Rodin had not lost interest in his *Saint John*, as it represented a major step in his career; in all the full figure was exhibited 24 times (368). Beausire 1988, 208, 215, 223, 233, 253, 258, 266, 368. See Le Normand-Romain 2001, 150
13. This information comes from René Chéruy and his unpaginated file in the Musée Rodin archives. *Rodin 1908–12*, 231.
14. Albert E. Elsen, *The Sculpture of Henri Matisse* (New York: Abrams, [1972]), 25–30.
15. Ibid., where this influence is discussed at length. The view that the arms broke off in an accident is too naive to credit, and it ignores the true character of the stumps.
16. Lebossé file, Musée Rodin archives.
17. 25 January 1907, Lebossé file, Musée Rodin archives. "Following your visit of today, I have immediately examined the direction of the left leg of Saint John, and after having compared it by its profile, it is necessary, as you found, to have it make a small movement on the front in order that it be better in its position. . . . The thing is going to be possible. . . . This time you will be completely satisfied."
18. Beausire 1988, 284.
19. Ibid., 286.
20. See Elsen 1969 for a fuller discussion of this subject and for illustrations; see also Pingeot 1990.
21. For exhibitions, see Beausire 1988, 293, 296, 297, 303, 320, 322, 340, 353.
22. *Rodin 1908–12*, 122.
23. In a 1911 letter to the man in charge of the exhibition in Rome to which the sculpture was sent before it went to

the palace, Rodin gave the dimensions for its pedestal as "1m.20 in height, 0.67m wide, 1m.23 in length" (*Rodin 1908–12*, 127.) For the Farnese courtyard pedestal, it would appear from photographs that Rodin increased the height slightly. See also the photographs reproduced in *Rodin 1908–12*, 184, 191.

24. Ibid., 174.

25. *Gazette de Liège*, 24 February 1912.

26. Article by Robert Vaucher, dated February 1912, in the files on *L'homme qui marche*, Musée Rodin archives.

27. Georges-Michel 1942, 266.

28. "A Rome," *Le cri de Paris*, 21 July 1912.

29. Joshua C. Taylor, *Futurism*, exh. cat. (New York: Museum of Modern Art, 1961), 131.

30. For a discussion of the success of this book and background on Paul Gsell, see the introduction by Jacques de Caso to Gsell (1911) 1984, xi-xv.

31. As an example, see *Gazette de Liège*, 24 February 1912.

32. Gsell [1911] 1984, 31–32. Rodin may have known the high-speed photographs by Étienne-Jules Marey and Georges Demenÿ, for example. Their photograph of a walking man from the series *Studies of Athletes*, 1892–94, is reproduced in Marta Braun, "Marey and Demenÿ: The Problems of Cinematic Collaboration and the Construction of the Male Body at the End of the Nineteenth Cen-

tury," in Joyce Delimata, ed., *Actes du colloque: Marey/Muybridge pionniers du cinéma* (Beaune: Conseil régional de Bourgogne, 1995), 80, see also discussion, 72–81.

33. In more than one news article Rodin's friends were quoted as saying that the sculptor was "satisfied with his work as it actually was and fearing to spoil it by finishing it, he preferred to leave it as it is" ("Par ci, par la," *La presse*, 12 February 1912). This was not Rodin's view. He was satisfied, but for the reason that he had achieved the desired effect in modeling. For the observations made by Moore, see Elsen 1967a, 26–31.

34. Gsell [1911] 1984, 75.

35. The figure has also been interpreted in relation to Victor Hugo's range of images for the thinker as intellectual athlete, serving society as its secular prophet, and as a symbol of optimism and action, striding through society and through the centuries; see the discussion of these themes and imagery as they relate to *The Gates of Hell* (cat. no. 37).

36. Reprinted in Steinberg 1972, 349.

37. Elsen 1967a, 29.

38. Tucker 1974, 145.

39. Interview with Alan Bowness in Bowness 1970, 11.

40. Elsen 1967a, 29, 30.

41. Ibid., 29.

175

Torso of a Man (Torse d'homme), c. 1882(?)

- Bronze, Georges Rudier Foundry, cast 1969, 7/12
- 10¼ x 7¼ x 3½ in. (26 x 18.4 x 8.8 cm)
- Signed on left buttock: A. Rodin
- Inscribed on back of right thigh: Georges Rudier./Fondeur.Paris.; below signature: No. 7; on base, left side: © by musée Rodin 1969
- Gift of B. Gerald Cantor and Co., 1982.298

Figure 453

*T*his torso seems to have been originally part of a plaster figure of a standing naked man leaning against a support behind his left leg, a plaster that is in the Musée Rodin Meudon reserve. The plaster was listed as *Etude pour Saint Jean-Baptiste* (*Study for Saint John the Baptist*) and first published in 1989 by Cécile Goldscheider in the first volume of her Rodin catalogue.[1] Goldscheider con-

tended that this naked figure, without arms and lacking the central portion of its left leg, was a study for *Saint John the Baptist Preaching* (see fig. 446) and dated it 1878. Her case rested on what she considered the man's "resolute attitude . . . of the face: The jaw is contracted, the mouth partly open, the look ardent."[2] Rodin's own account of how in 1878 the novice model Pignatelli came to his studio and struck the striding pose instinctively and the fact that the face in the Meudon plaster bears no resemblance to that seen in photographs of Pignatelli undermines Goldscheider's conjecture. In 1992 Nicole Barbier published the catalogue to her important exhibition of Rodin's less well-known works, *Rodin sculpteur: Oeuvres méconnues*, and reproduced the plaster as cast in bronze by the Musée Rodin in 1986 (fig. 454). She gave the figure's name as *Giganti* without any explanation as to her source. She referred in the bibliography to Goldscheider's entry but made no comment.[3] We just do not know the date for the torso and upright partial figure. All that assuredly connects the Stanford torso with *Saint John the Baptist Preaching* is that the torsos in *Giganti* and *Saint John* each had a life separate from the whole figure. We do not know whether the Stanford male torso had a life outside Rodin's studio before the artist's

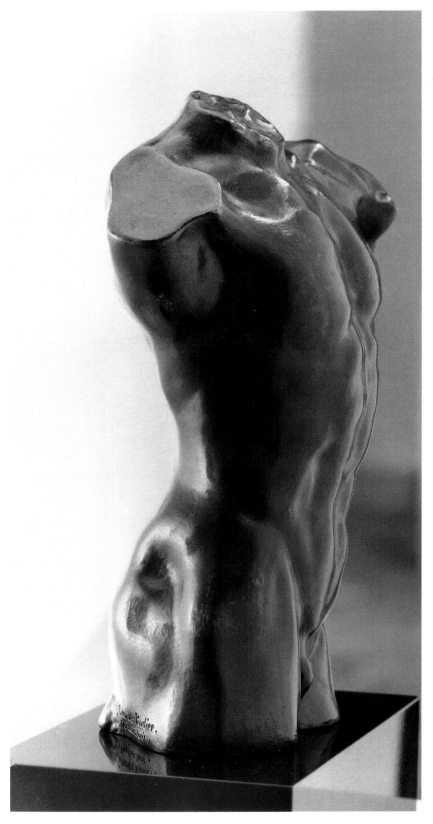

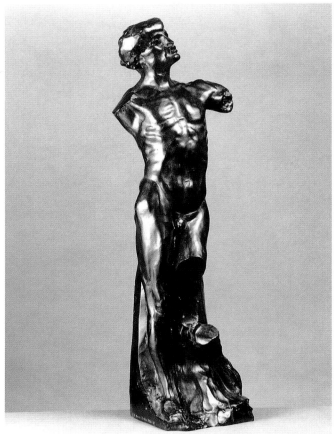

death in 1917. Lacking a title, like *Giganti*, it might have been identified by a writer simply as *étude* or *torse d'homme*. Alain Beausire does not list *Giganti* in *Quand Rodin exposait*, hence there seems no record of its public display under that name.[4]

The handsome, athletic male form enforces the idea that for Rodin the torso was the fulcrum of the body and of his thinking about sculpture. It was the nuclear motif around and on which he would build. The erect body is shown in slight torsion but without tension. The shoulders pivot slightly to the figure's left so that the left shoulder is somewhat higher and in advance of the right. The right shoulder is over the leg on which the weight is carried. This X-relationship of shoulder height to weight disposition in the legs is something Rodin had found in older Western culture. The slight twist of the body gives side view prospects of either the front or the back as well. This was important to Rodin who wanted as much as possible for viewers to experience the firm density of the body in depth. There is also a decided upward swell to the form as if the figure were engaged in an intake of

breath. (It was this kind of antigravitational and upward bodily drive that Henry Moore admired in Rodin's work, which he found shared his own optimism about life.) The finely modeled, lithe body has a surprising range of hollows and projections, including the dimpled right buttock and the depressions in the abdominal area framed by the bones of the ribcage. This is Rodin fully enjoying the architecture of the body for itself alone.

Except for the disposition of the weight, this torso is similar to that of the man in *Orpheus and Eurydice* (1893), the beautiful marble carving that is in the collection of the Metropolitan Museum of Art.[5] Clearly the positioning of Orpheus's arms indicate that they were added after the modeling of the torso. By simply asking him to shift his weight for the second study, Rodin may have made two versions of his handsome model's body.

The truncated neck and arms terminate in rough and smooth passages respectively. The latter is unusual for Rodin, but it influenced the norm for those who showed partial figures in the salons after 1900. The smooth shoulder section might have resulted from Rodin wanting to add an arm. The rough termination of the neck suggests that the head may have been broken off in the clay version, and there is a curious roughening of the area in back of what remains of the neck. The torso is wider at the top due to the position of the shoulders, in which Rodin left enough anatomy to give the viewer a sense of the direction of the absent arms.

That Rodin considered this torso self-sufficient and artistically complete to be admired for itself (rather than for what it might be in the future or might have been in the past) is evidenced by this addition of a small clay ledge under the figure's right buttock so that the whole could stand upright for prolonged contemplation. Of Rodin's many torsos, this one is a very strong candidate for being most like an ancient Greek or Roman bronze fragment. Over his lifetime it was the study of these artifacts that helped convince Rodin that his études of the body were the equal of the finished art of his own age.

NOTES

Literature: Elsen 1969, 23; Tancock 1976, 266, 268

1. Goldscheider 1989, 126, 102c. For the torso in plaster, see Tancock 1976, 266, cat. no. 40.
2. Goldsheider 1989, 126.
3. Barbier 1992, 166.
4. Beausire 1988.
5. Reproduced in Vincent 1981, 12.

OPPOSITE PAGE

Left: Fig. 453. *Torso of a Man* (cat. no. 175).

Right: Fig. 454. *Giganti*, bronze, 24½ x 7⅛ x 6⅜ in. (61.2 x 18.2 x 16.2 cm). Musée Rodin, Paris, S2843.

176

The Earth (La terre), 1884

- Bronze, Georges Rudier Foundry, cast 1965, 8/12
- 8 x 18½ x 6½ in. (20.3 x 47 x 16.5 cm)
- Signed in hollow below torso, right side: A. Rodin
- Inscribed on rocks below legs: Georges Rudier/Fondeur.Paris.; below signature: No. 8; on base, right side, below legs: © by Musée Rodin 1965; interior cachet: A. Rodin and stamp in blue ink, Le Calve No 1588, twice
- Provenance: Paul Kantor Gallery, Malibu
- Gift of the Iris and B. Gerald Cantor Foundation, 1974.34

Figure 455

*R*odin was at his inventive best in this daring expression of the life-force, evoking the source and destiny of human life in matter. *The Earth* is one of his most inspired études. Though made in the 1880s, it has the look of having been made a century later, when sculptors like William Tucker, Anthony Caro, and Alain Kirili returned to rough modeling in clay of abstract and figural forms. Ironically, this may have been one of the rare instances when Rodin made a sculpture without a living model.

Probably modeled from a rectangular block of clay and without an armature, *The Earth*'s profile suggests comparison with a line of hills cresting at the shoulder blades, as in the tradition in older art of imaging the earth in terms of man, seen, for example, as in the paintings of the sixteenth-century Netherlandish painter Joos de Momper. As seen by the undercutting or grooved juncture where the human form and the base come together, the semirecumbent form is rising, not sinking, and is of uncertain gender.[1] *The Earth* was enlarged before 1900. Rodin was to later add to a reduced-scale plaster of *The Earth* the the small *Head of the Man with the Broken Nose* (cat. no. 126; figs. 456, 367).[2] Lacking feet and arms, the

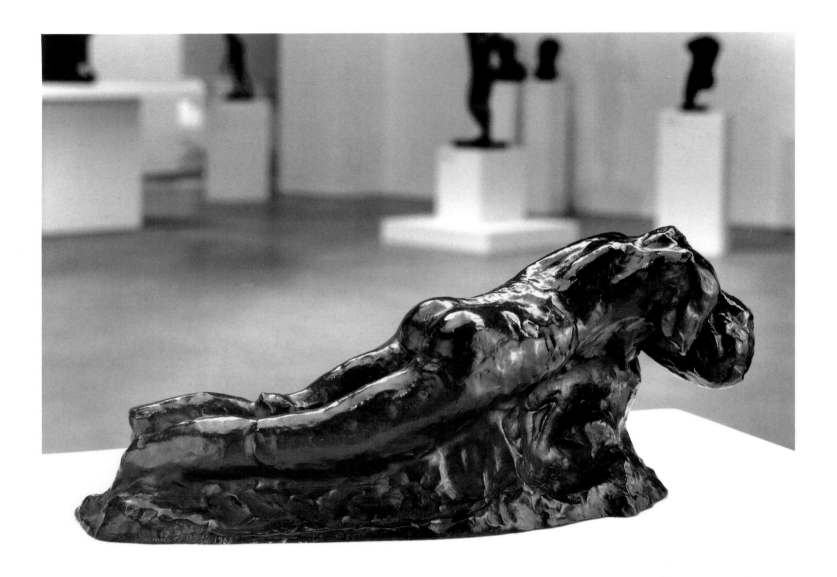

Fig. 455. *The Earth* (cat. no. 176).

head still unformed, and hence with no guiding intelligence, the body seems to be fashioning itself out of the formless matrix of the base. In the absence of extremities and elbows, there is no visible means of leverage. But viewed from above, there is a surprise in the serpentine axis of the body, as if it is in the throes of involuntary movement or willing itself into being. The legs, buttocks, and hips curve to the right, then the upper torso moves to the left, and finally the hanging head is swung to the right along the same axis as the lower legs.

There are two unanatomical interruptions that divide the body in thirds. The first is a crease, like a geological fracture, around the upper abdomen, the second is a

cleft, like a fault line, just below the knees, where Rodin seems to have added a pair of lower legs (possibly from his archive of spare body parts) with no concern for a proper fit. From above, the latter addition makes sense by its prolongation of the curvature of the lower body. The crease may have been the artist's way of demarcating where he might change the position of the upper torso, as he was to do later when he added the upraised *Head of the Man with the Broken Nose.*

The modeling is not uniform; it is as if Rodin were suppressing all his finesse. The head, for example, is almost abstract. The closer the body is to the base, the rougher the modeling, and in some passages, such as the

chest area, it seems faceted like rough cut stone. The top-most surfaces of the body alone approach a smooth fleshiness. That he thought the small version was complete as a work of art was certified by his having it enlarged as exactly as possible.

In reviewing the Salon of 1896, Gustave Geffroy wrote of this work: "It is a body stretched out on its stomach, a powerful piece, which is missing arms and legs, and it is a woman in hovering movement, the legs bent back, the arms extended, the body thrown forward. How can it be that in this last statue with its accentuated movement, its limbs projecting in such a manner, there is no bristling or mangling, but, on the contrary, force and equilibrium? It is because, in fact, all movements, all aspects of life are possible in sculpture and the great truth that matters is the realization of modeling in light."[3]

More than half a century later Leo Steinberg put *The Earth* into another perspective: "It is not enough to observe that no feet are present, for, as the base indicates, no feet were ever intended; nor arms from the deltoid down. And this betrays the novelty of the approach. Unlike the arms of the Venus de Milo, the limbs here are not conceivable as missing or as replaceable in imagination. The hulk of *La terre* allows no fringe forms; it is finished without them because what Rodin represents is not really a human body, but a body's specific gesture, and he retains just so much of the anatomical core as that gesture needs to evolve."[4]

Rodin seems to have waited 12 years before first exhibiting *The Earth* in 1896 in Geneva. Thereafter he showed it several times internationally, and the enlarged plaster was included in his Paris retrospective of 1900.[5]

Fig. 456. *"The Earth" with "Small Head of the Man with the Broken Nose,"* c. 1910, plaster, 11¼ x 20⅞ x 7⅛ in. (29 x 53 x 18 cm). Musée Rodin, Paris, S703.

NOTES

LITERATURE: Grappe 1944, 40; Elsen 1969, 20; Jianou and Goldscheider 1969, 96; Steinberg 1972, 362, 370, 378, 389; Tancock 1976, 474, 479; Elsen 1981, 146, 259, 265; Schmoll 1983, 124, 135, 139, 156, 199–201; Gassier 1984, 73; Lampert 1986, 97–98, 212; Pingeot 1990, 147; Levkoff 1994, 90; Le Normand-Romain 2001, 154

1. Dr. William Fielder of Stanford University Medical School is of the view that the figure is male based on the heavy muscles of the neck and shoulders and proportions of the shoulders to the untapered waist. Laurent saw this figure as deriving from "a feminine figure in the right portion of the cornice of *The Gates of Hell*" (Gassier 1984, 73).
2. Rodin may have added the head during or after 1910, when Lebossé delivered the new size (Elsen 1981, 259).
3. Quoted by JoAnne Paradise in Elsen 1981, 265.
4. Steinberg 1972, 362.
5. For the exhibition history see Beausire 1988, 125, 152, 186, 208, 215, 218, 233, 253.

177

Torso of a Young Woman
(*Torse de jeune femme*), 1886, enlarged 1908–09

- Title variation: *Torso of a Young Woman with an Arched Back*
- Bronze, Georges Rudier Foundry, cast 1960, 10/12
- 33¼ x 19½ x 12½ in. (84.4 x 49.5 x 31.7 cm)
- Signed on top of base, right side, near bottom: A. Rodin

- Inscribed on back of base, left side: Georges Rudier/Fondeur Paris; on base, left side: © by musée Rodin 1960; interior cachet: A. Rodin
- Provenance: Roland, Browse and Delbanco, London
- Gift of the Ahmanson Trust, 1981.323

Figure 457

*T*he source of this life-size torso was in Rodin's small full-figure sculpture named *Psyche*, which Georges Grappe dated from 1886 and which was carved in marble around 1906.[1] The upright figure of *Psyche*, stands, elbows slightly away from the body and hands on her hips. From a plaster of the torso that is only a few inches high and from which the arms but not the hands had been removed, Henri Lebossé greatly enlarged the work

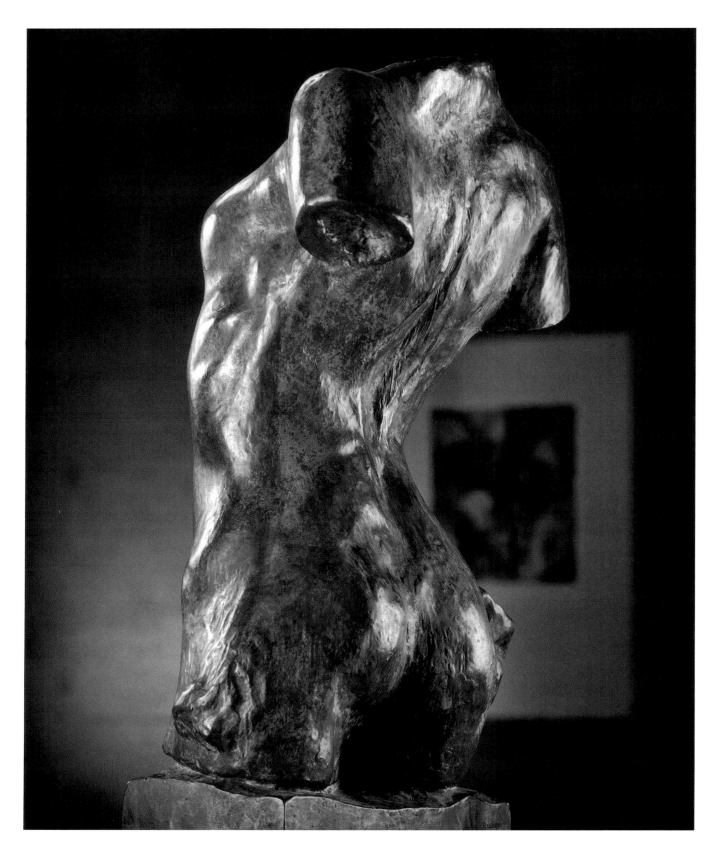

Fig. 457. *Torso of a Young Woman* (cat. no. 177).

in 1908–09 at the same time as *Prayer* (cat. no. 80).[2] The enlarged plaster (fig. 458) was exhibited along with the other torso in the Paris Salon of 1910.[3] Both received considerable praise from the anatomy-minded critic Henri Bidou, who wrote about the salon:

[*The arched torso*] in a contrary design, is thrown back and strongly arched. Here again, the great artist has captured a natural movement. Look at this thorax which rises while lifting the breasts, these ribs which project and swerve. This chest swells with air, as in the last moment of inhaling. The diaphragm lifted, the two flanks become hollow. Look at them, above the iliac crests, encircling the abdomen with their inflected hollows. This abdomen, caught in the movement of the thorax, is itself full and round. The hollow of the navel . . . hardly exists anymore. The large, straight muscles stretch from above to below in the divided girth. All that remains is a living, swelling body, that carries to pure air the rhythm of its life: an admirable piece of analysis. These are not only forms; they are living beings having their interior structure, their organs, their life. The refinement of the most complex fitting together of planes [*modelé*] is combined with the exactitude of a captured momentary movement.[4]

How close Bidou came to Rodin's intention is shown by the sculptor's comments made to Paul Gsell before 1911: "The artist worthy of the name must express the entire truth of nature, not only the truth of the outside, but also, and above all, that of the inside."[5] Rodin could well have had in mind his own *Torso of a Young Woman* when he told Gsell, "Now, there is nothing in nature that has more character than the human body. It evokes through its strength or its grace the most varied images. . . . The human body curved back is like a spring, like a beautiful bow from which Eros aims his invisible arrows."[6]

How different are these readings from that of many artists who admire the sculpture for being so "abstract," particularly in the flow of its surfaces. Such polarized

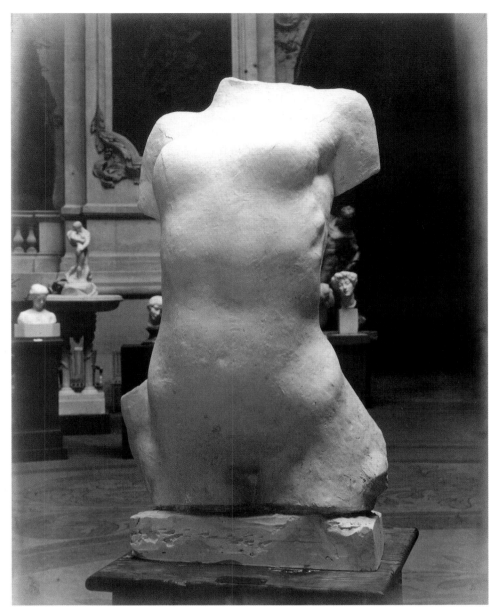

readings are understandable because historically *Torso of a Young Woman* and Rodin's other partial figures, such as *Prayer*, stand as transitions to modern abstract figure sculpture. The latter would be unthinkable without the former.

Rodin's capacity to see his sculptures both as human beings and as abstract forms is most telling in *Torso of a Young Woman*. The extruding, somewhat abstract shapes on the woman's hips resulted from the enlargement of what was originally a very summary treatment of the hands placed at the thighs and clearly visible in the small figure of *Psyche*, which Rodin did not want to be redefined by their enlarger. Perhaps because he did not know the history of this enlarged work, Leo Steinberg read this

differently: "Rodin cultivates carelessness—or admits impatience—even in freeing a plaster cast from its mold, leaving this process, too, incomplete, so that some of his exquisite modeling remains smothered under clods of unshaped plaster. Hence, for instance, the excrescences at the hips of the beautiful *Young Woman's Torso*."[7] Those excrescences are otherwise and more correctly attributable to what Lebossé had to work with in the small model, and he had to painstakingly shape and make them larger with Rodin's approval. They have nothing to do with accidents occurring when the mold of the plaster was removed. Rodin had expert moldmakers, probably the best in the world at that time, and he did not himself remove molds from new plaster casts. As he had a brilliant coterie of assistants, no casting imperfection had to try Rodin's patience. For these reasons, and as Lebossé had to work for months on the enlargement, Rodin's "impatience" was not involved.

Steinberg's hypothesis of "cultivated carelessness" supposed that Rodin did not patiently and thoughtfully consider what he had done, intentionally or not, and what was the result of the sculptural process. While Steinberg may be right in other cases, that this work was enlarged suggests the contrary. As if anticipating such an observation, Rodin commented, "There are certain admirers . . . who attribute to artists completely unforeseen intentions. . . . Be assured that the masters are always fully conscious of what they do."[8] Although speaking of the process of making a sculpture, Rodin's additional comments are apt for their emphasis on hard thought such as would have been called for in judging the results of a Lebossé enlargement: "When a good sculptor models a statue, whatever it represents, he must first conceive the general movement forcefully. Then, until the end of his task, he must keep his idea for the entire composition strongly and clearly in mind. In this way, he can always compare and closely relate the smallest details of his work to it. And this is not done without an enormous amount of thinking."[9] Before sending his two daring torsos to the 1910 Salon, Rodin had ample time and would have pondered at length such details as the area of the hands and the amputations. The creation and retention of these "excrescences" tell us that Rodin could view them abstractly and as contributing to the overall form of his work. Consider, for example, the relation of the "clod"-widened hips to the width of the shoulders and truncated upper arms in terms of overall balance. As with *Prayer*, the editing was not "careless" or capricious,

but thought of in terms of what made the best artistic sense in connecting the edge of the remaining limb to the contour of the torso below. Retention of the casting seams was not negligence, as Rodin could have easily erased them himself or had an assistant do the job. Like the contours on a map, the seams track the topography of the subtly curving bodily planes and show us what the eyes might not see on their own. They are the only vertical projection on the front of the sculpture that would have cast a shadow, and they hold the plane's curvature under strong light.

That Rodin could envision the stunning effect of a small torso greatly enlarged reminds us of his modern sense of scale. Size is the physical dimension of a sculpture. According to Henry Moore, scale is a sculpture's spiritual dimension, the potential for enlargement without loss of power. A small-size sculpture, such as that of the original version of *Psyche*, might be big in scale. (Conversely, as Moore pointed out, something like the Albert Memorial in London's Hyde Park can be big in size, but small in scale.) Because of his innate sense of what made an effective whole, Rodin knew when to suppress detail, such as fingers in the case of *Torso of a Young Woman*, which would have acted against enlarging a form.

Before the First World War several artists, Aristide Maillol and Constantin Brancusi among them, sought to remove shadow as much as possible from sculpture. This effort was linked to the desire to make sculpture a luminous art of joy. If Rodin had set for himself the problem of finding for the body a pose and form that gave its surfaces maximal exposure to natural light, he could not have done better than this torso. Brancusi would solve the problem within a few years by reducing the body to pure cylindrical sections, as in the polished bronze *Torso of a Young Man* (c. 1916; Cleveland Museum of Art).[10] Rodin solved it through his thinking about planes. In explaining his ideas about planes and their simplification to Frederick Lawton, Jacques-Emile Blanche, and an unnamed painter, Rodin said,

"It is the architecture of the statue. . . . It has to do with the relief of the various parts of the statue. . . . Simplifying the *plans* [planes] . . . signifies getting rid of all that would hinder the light from freely glinting over the surface. . . .

"Look!" he went on, taking a piece of board and holding it in front of a statuette. "You see that nearly all, if not quite all of the front of this figure

touches the board on this side. There are no projections that interfere with the sweep of the light across these surfaces and the illuminating of the various reliefs."[11]

It is with his *morceaux* such as *Torso of a Young Woman* that Rodin came as close as he ever would to abstraction. By this time he had determined that expression was to come from the modeling, not physical movement. For Rodin, total abstraction and the forsaking of all detail would have been impossible, as they generalized the logic of forms while emptying them of what for him was life. He valued delicate shadows, for example, those cast by such details as the intervals between the stretched ribs, because they accentuated the projecting planes while affirming the sensuousness of living flesh. As if foreseeing sculpture to come, such as Alexander Archipenko's partial-figure nudes in which stylization deprived the body of animating details, Rodin observed, "If, in seeking simplicity, one neglects to indicate—or even if one suppresses—the details which give the sensation of life . . . the figure will remain stiff. If simplification is obtained through the exact rendering of the contours, the figure will be beautiful; simplicity will result from truth."[12]

Rodin's audacities in the form of the broad, simplified planes of the sculpture were not lost on younger artists who were otherwise critical of his dramatic subjects and use of shadows or holes in the surface for effects of pathos. Replacing Rodin's often tormented surfaces was the ideal of the decorative as seen in the art of Maillol and Matisse, in which descriptive detail and the depiction of feelings were sacrificed for the aesthetic effect of the whole. Expression came through the total arrangement of the work, or what the artist did, rather than the model. Rodin had developed by the age of 40 a personal ideal of the decorative in which the total effect of a composition determined the character, presence, or absence of parts. The final disposition of the sculpture and architecture of *The Gates of Hell* was dependent on Rodin's sense of the decorative. It was from such partial figures as *Torso of a Young Woman* that Maillol, Brancusi, and many others found authority to truncate and otherwise simplify their figures.

How provocative such partial figures as this were for younger artists of very different ambitions can be seen by Jacques Lipchitz's recollection of visiting the new Musée Rodin during or just after the First World War: "My joy was immense, and so was my enthusiasm. . . . I was struck by a certain aspect of some of his sculptures. Probably influenced by the sculptures from his collection of ancient art, he had created what might be called 'torsos.' These figures without arms, heads and legs were endowed with a sense of mystery, and one needed imagination to complete the figure. I did not want to make 'torsos,' but at that moment I understood that a work of art needs the element of mystery. I clearly saw that what Rodin was doing instinctively was not so different than what we, the Cubists, were doing in a more intellectual way, and that at certain points it was even more complex."[13]

NOTES

LITERATURE: Grappe 1944, 127–28; Elsen 1969, 25–26; Jianou and Goldscheider 1969, 100; Steinberg 1972, 393; Schmoll 1983, 75–76, 134; Beausire 1988, 316–17; Pingeot 1990, 149; Barbier 1992, 116

1. Grappe 1944, 55. Perhaps confusing the source of *Torso of a Young Woman* with that of *Prayer*, Grappe said that the full-figure version is found in the upper-right corner of the tympanum of *The Gates of Hell* (ibid., 127–28). Highlighting their relationship, *Psyche* and *Torso of a Young Woman* were reproduced opposite one another in Jianou and Goldscheider 1969, pls. 35–36. For the marble version of *Psyche* see Barbier 1987, 158.
2. In a note to Rodin dated 26 September 1908 Lebossé referred to the "magnificent small torsos" and added, "there is a superiority of the modeling with the beautiful planes that will be a veritable tour de force if I can give you satisfaction (with the difference in height)." Lebossé file, Musée Rodin archives.
3. See Beausire 1988, 316.
4. Henri Bidou, "Les salons de 1910: La sculpture," *Gazette des beaux-arts* 2, no. 27 (July 1910); cited ibid., 317.
5. Gsell [1911] 1984, 81.
6. Ibid., 51–52.
7. Steinberg 1972, 393.
8. Gsell [1911] 1984, 78.
9. Ibid., 69–70.
10. For a version in wood and two bronze casts, see Sidney Geist, *Brancusi: The Sculpture and Drawings* (New York: Harry N. Abrams, 1975), cat. nos. 149–150, 159.
11. Lawton 1906, 164–65.
12. Dujardin-Beaumetz in Elsen 1965a, 173.
13. See Lipchitz in Elsen 1963, 5. The young Lipchitz was in Paris in 1910 and exhibiting in the salons, where he could see such work by Rodin as this. Rodin, in turn, noticed a head by Lipchitz in the 1912 Salon. The irony is that in 1910 Lipchitz was not ready to understand the implications of such torsos as he had yet to become a cubist.

178

Female Torso (*Torse féminin*), n.d.

- Plaster
- 3½ x 1⅞ x 1⅝ in. (8.9 x 4.8 x 4.1 cm)
- Provenance: Charles Feingarten, Los Angeles; Albert E. and Patricia M. Elsen
- Given in honor of Mr. and Mrs. B. Gerald Cantor by Albert E. and Patricia Elsen, 1983.315

Figure 459

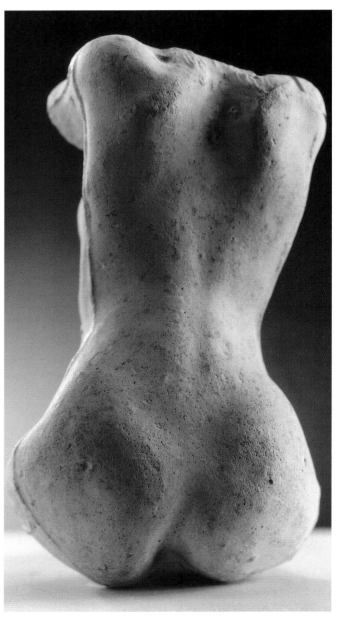

*T*his tiny torso can be found as one of the bodies of *The Sirens* (before 1888) in the left door of *The Gates of Hell* (see fig. 434) and in a work known as *Assemblage of Man and Woman Upside Down* (n.d.).[1] It may also have served as the body of a kneeling woman in a small sculpture called *Bacchantes Embracing* (c. 1900).[2] Somewhat unusual for Rodin's partial figures are the surgically neat stumps of the upper thighs, which may have been desired to facilitate his frequent addition of legs in different positions.

That Rodin admired shapely buttocks was no secret in the Paris art world, and his assistants used to joke about it. Rodin's sexuality was inseparable from his work as a sculptor, and he contributed greatly to the candor we associate with modern sculpture. In this small figural fragment he made it possible to position the plaster in various ways, prone and supine but also upside down, thereby encouraging the viewer to see the work abstractly and also as a human form. Although the torso cannot stand upright unaided, the diagonal rough cut across the neck area (where he may have cut away a rough ball of plaster for a head in the *Assemblage* figure) encourages its inversion. Whether held in the palm of the hand and viewed against the sky or seen against some light, neutral background, the torso has a sense of large scale far beyond its diminutive size. Rainer Maria Rilke recognized this when he wrote about similar plasters, "The small plastic figures of Rodin convey the sense of largeness. By the play of innumerably many surfaces and by the perfect and decisive planes, he creates an effect of magnitude."[3]

Fig. 459. *Female Torso* (cat. no. 178).

OPPOSITE PAGE
Fig. 460. *Male Torso* (cat. no. 179).

NOTES

1. Barbier identified both in her catalogue entry in Lampert 1986, 174, 231. Adapted from the *Gates of Hell*, the *Sirens* had an active afterlife as an independent composition (see fig. 433) and when Rodin integrated them into one of his later designs for the *Apothesis of Victor Hugo*, 1891–94 (see fig. 242 and Butler, Plottel and Roos 1998, 96–97).
2. Regarding the *Bacchantes* pair, see Beausire 1988, 184, and Ambrosini and Facos 1987, 178–79. The *Bacchantes* figures are also used in the trio *The Oceanids* (before 1910), as highlighted by de Caso and Sanders (1977, 113).
3. Rilke in Elsen 1965a, 129.

179

Male Torso (Torse masculin), n.d.

- Bronze, E. Godard Foundry, cast 1980, 3/12
- 9 x 5½ x 3½ in. (23 x 14 x 9 cm)
- Signed on underside of torso: A. Rodin
- Inscribed on top right buttock: E. Godard/Fondr.; lower left torso: © by Musée Rodin 1980; below signature: No 3
- Gift of the Iris and B. Gerald Cantor Art Foundation, 1974.32

Figure 460

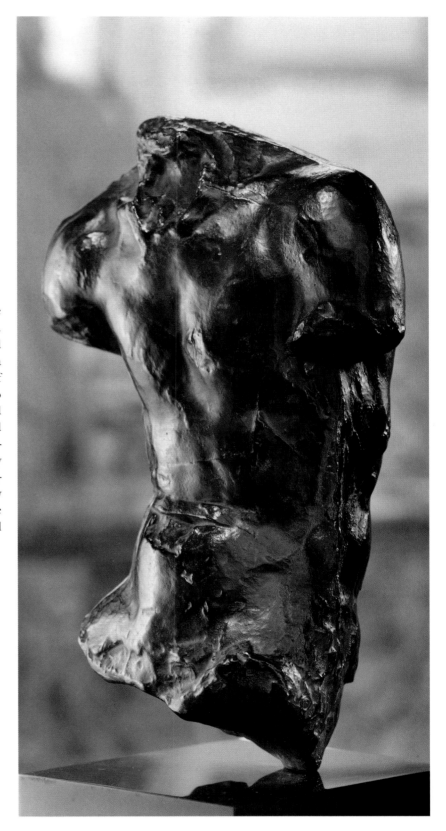

Among the many photographs of Rodin there is one that shows him in the dining room of his Meudon home. He sits sideways on a chair looking out the window and behind him, in the center of the dining table, stands a fragmented classical torso from his vast collection of antiquities.[1] Even while he ate, Rodin made it possible to study art, especially the art he loved most. Rodin learned much from the firsthand study of Greek sculpture, and in turn, he looked at ancient art in terms of his own discoveries from life. The following monologue recorded by Judith Cladel, while intended to open our eyes to fragments of Greek sculpture, tells us much about how Rodin was motivated to make fragments and how he viewed fragmentary work of his own, such as this small male torso:

> Observe any fragments of Greek sculpture: a piece of an arm, a hand. What you call the idea, the subject, no longer exists here, but is not all this debris nonetheless admirably beautiful? In what does this beauty consist? Solely in the modeling. Observe it closely, touch it; do you not feel the precision of this modeling, firm yet elastic, in flux like life itself? It is full, it is like a fruit. All the eloquence of this sculpture comes from that.
>
> What is modeling? The very principle of creation. It is the juxtaposition of the innumerable reliefs and depressions that constitute every fragment of matter, inert or animated. Modeling creates the essential texture, supple, living, embracing every plane. It fills, coordinates, and harmonizes

them. . . . When God created the world, it is of modeling He must have thought first of all.[2]

Rodin's small torso is not in a ruined state, one caused by accident. When he made it, all that interested him is there to be seen: the body not erect but bent forward, forming in profile a crescent shape. Imagining the form within an invisible cube helps to understand what Rodin considered sufficient focus. Flat patches on either side of the spine suggest that he may have placed the clay figure on its back. He showed no interest in the buttocks or thighs, just what he saw from the waist up. There is no navel, as folds of flesh and muscle conceal its location. He modeled the base of a neck but probably made no head. With those who looked to sculpture such as this for a subject, Rodin had no patience, for what he here shared with artists and connoisseurs were the greatest pleasures of his métier, modeling from, hence learning about, how living matter is formed.

NOTES
1. Elsen 1980, 32.
2. Cladel 1917, 222.

180

Study for Galatea
(Etude pour la Galatée), c. 1889 or 1909

- Title variations: *New Study for Galatea, Nude Woman, Young Girl*
- Bronze, E. Godard Foundry, cast 1980, 3/12
- 11 x 7 x 4 in. (27.9 x 17.8 x 10.2 cm)
- Signed below left thigh: A. Rodin
- Inscribed on right side of base, at rear: E. Godard/Fondr; on back of base: © by Musée Rodin 1980; below signature: No 3
- Gift of the Iris and B. Gerald Cantor Collection, 1998.367

Figure 461

*P*ractically ignored in the Rodin literature is this partial figure of a woman—headless and lacking most of her left arm and left leg—who leans on her right arm against a rocky support. The full-figure version of this small study formed part of a composition called *Young Girl Confiding a Secret to a Shade* that was included in Rodin's 1900 retrospective.[1]

The partial figure exists as a plaster in the Musée Rodin and in early editions of his catalogue Grappe identified it as *Study for Galatea*, related to the group *Pygmalion and Galatea*. In this composition Galatea appears in a pose similar to the study, but in reverse, leaning on her left arm. Whereas he had initially dated both the single figure and *Pygmalion and Galatea* to 1889, in the 1944 edition Grappe renamed the partial figure *New Study of Galatea* and re-dated it to 1909, suggesting that Rodin may have recreated the figure in reverse, either for a new version of *Pygmalion and Galatea* or for a separate treatment of the leaning woman.[2]

Related figures include a plaster identical in pose and also lacking a left arm and leg, but with a head. This figure was among the eighteen works given by Rodin to the Metropolitan Museum of Art, New York, which also has one of two marble versions of *Pygmalion and Galatea*.[3] The Rodin Museum in the Philadelphia Museum of Art has a bronze which differs from Stanford's partial figure in specific details: the woman has her head and all her limbs; the pose is reversed, so that she leans on her left arm; her right arm hangs down at her side, rather than being pulled in toward the breast as is suggested by the truncated counterpart mirrored in the Stanford version. In addition the Philadelphia figure's head turns to the left, towards the arm on which she leans, unlike the Metropolitan's plaster in which the woman's head is turned away from her leaning arm and unlike the Stanford bronze in which the rotation of the neck also is away from her leaning arm.[4] The relationships and dating of these figures is complicated by the existence of both left- and right-leaning figures, each with variants. That an intact version of Stanford's partial figure was included in Rodin's 1900 exhibition supports Grappe's revised date of 1909 for the partial figure and the variant with head. To support the partial figure, Rodin fashioned a rough support that evokes a form in nature rather than a piece of studio furniture. In this regard Rodin was traditional, and unlike Edgar Degas on a few occasions and even Jules Dalou in some small genre works, he was not ready to be candid about studio props and preferred to situate his figures in what the viewer would think of as nature.

The area of greater resolution of modeling recommends a more frontal view, but views from the sides are more revealing about the artist's editing and suspension of descriptive definition. The woman's back is unresolved. Seen from her left profile, the shearing off of the back of the right leg and base creates a concave contour that propels the figure upward and pushes it forward. One effect of editing by amputation is to make us see formal similarities between disparate body parts, notably the stump of the woman's left arm and truncated left thigh. The figure's pose is of a modified contrapposto with the legs frontal and the torso turned slightly to its left. The forward projection of the simulated rock support counters the slightly backward tilt of the right shoulder. Rodin's gift of a plaster to the Metropolitan Museum of Art reveals how, late in life, he saw the museum as an extension of the studio and a means of showing artists the importance of the étude.

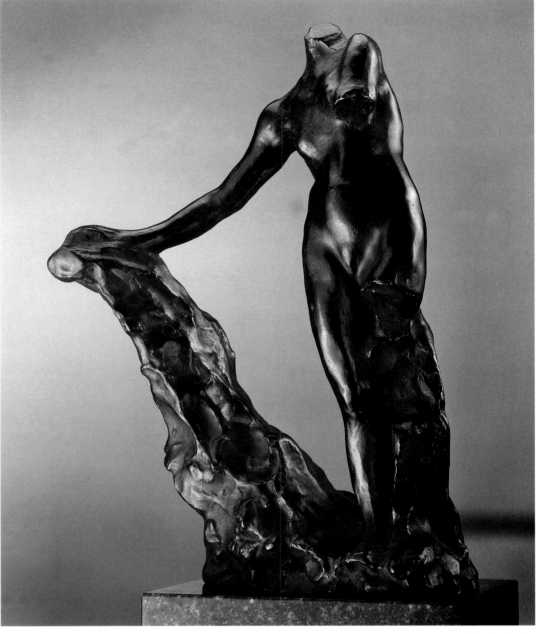

Fig. 461. *Study for Galatea* (cat. no. 180).

NOTES

LITERATURE: Grappe 1944, 127; Tancock 1976, 282, 286; Vincent 1981, 8

1. Beausire 1988, 192, fig. 83; Le Normand-Romain 2001, 236.
2. Grappe 1944, 127. The plaster with the limb detached appears in a 1914 photograph reproduced in Hubert Thiolier, *Jeanne Bardey et Rodin* (Lyon: Beaux-arts, 1990), 153.
3. Vincent (1981) 8–9. A second marble belongs to the Ny Carlsberg Glyptotek, Copenhagen along with a plaster of the left-leaning *Galatea* (1889). See Fonsmark 1988, cat. nos. 25 and 60. Both the New York and Copenhagen marbles are dated before 1910.
4. Tancock 1976, 282–86. Tancock identifies the woman as a "study for Galatea" and, assuming that the sculpture known as *Pygmalion and Galatea* was intended as an illustration of the myth recorded by Ovid, he says Rodin's Galatea "steps hesitantly into life and seems plagued with self-doubt." He further suggests that the theme may have been inspired by the work of Jean-Léon Gérôme (painting: Metropolitan Museum of Art, New York; sculpture: Hearst Memorial, San Simeon, California) and the sculptor Etienne-Maurice Falconet's *Pygmalion and Galatea*, c. 1763 (Louvre, Paris; smaller version, Walters Art Gallery, Baltimore; popularized in Sèvres bisquit porcelain versions). Tancock also stated, on the other hand, that "the marble group . . . was probably assembled from preexisting figures in Rodin's customary manner." In the author's opinion Rodin probably did not have the myth in mind when he made the woman or even when he joined her with a horned, lusting male partner (derived from *Minotaur* [fig. 424] as Rodin explained to Gsell [1911] 1984, 163–64), but rather christened the pair later.

181

Small Torso of a Seated Woman
(*Petit torse féminin assis*), n.d.

- Bronze, Coubertin Foundry, 3/12
- 7½ x 5 x 5⅜ in. (19 x 12.7 x 13.7 cm)
- Signed on left thigh, left side: A. Rodin
- Inscribed on left thigh, beside signature: No. 3; below signature: © by Musée Rodin
- Mark on left thigh, left of copyright: Coubertin foundry seal
- Gift of the Iris and B. Gerald Cantor Collection, 1998.356

Figure 462

*I*ts lack of a base and diminutive size suggest that this beautiful partial figure was modeled in the artist's hand without an armature. There is no evidence of energetic fingering of the clay, and the surface has a continuous smoothness that is accentuated in the beautifully finished Coubertin cast. There is no evidence that the figure was fashioned at any time with all its extremities. The absence of even an indication of a neck commends that thought. In what position the model posed is hard to say. The roundness of the buttocks and undersides of the thighs implies that she was not sitting and may have been bending over. As the sculpture ends just above the knees, it is not possible to know whether she was kneeling.

This figure is sometimes thought to have been derived from the torso of *Cybele* (cat. no. 186), but the position of the thighs with the right higher than the left, the placement of summary indications of the hands on the breasts, and the relaxed back muscles undermine that hypothesis. Until there is a published inventory of the thousands of works at Meudon, we cannot be certain whether this figure exists in a fuller version or whether it had another source in the sculptor's plaster archive.

Probably initiated by the model, as was the artist's custom, the self-compacting pose caught his imagination. Whether the model was covering or squeezing her breasts (as shown in some drawings from the late 1890s), one cannot say, as her hands are not articulated. The mergence of the hand area with the woman's breasts is unusual in Rodin's art. This was probably not due to impatience, as Rodin took the time to etch a crease between the woman's left upper arm and the torso. Moreover, he also had the time to carry the hands to further definition but chose not to do so when he had the sculpture enlarged (cat. no. 182). Why? Rodin always expected us to take in the whole effect of what he had done and that included viewing the form from all sides. Artistically he won a new or further compacting of the form. The view from either side is that of a beautiful, continuous curving form from knee to shoulder with no lateral interruptions, such as fully developed hands over the breasts would have introduced. It is as though Rodin, in order to gain that graceful unity, posed for himself the question, what if the hands were left unarticulated and instead fused with the body?

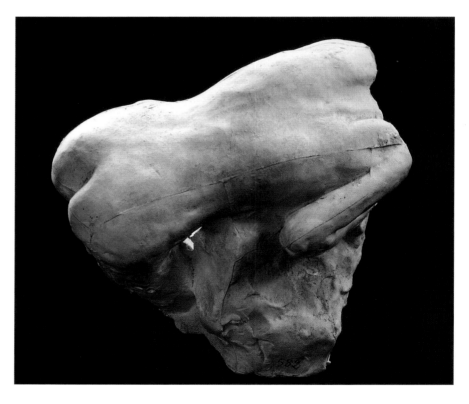

Fig. 463. *Small Torso of a Seated Woman with a Base*, n.d., plaster, 7½ x 6⅝ x 5 in. (19 x 17 x 13 cm). Musée Rodin, Paris, S675.

Judging by one variation having the thighs set into an ancient pot and another variation having a crude, rock-like base added (fig. 463), it would seem that at least in these two occasions Rodin wanted to focus on the beauty of the woman's modeled back rather than on the front of her torso.[1] Rather than providing a narrative element, the addition of these bases indicates that Rodin wanted a means to support and orient at this angle what was most successful and interesting in the sculpture. In addition, the juxtaposition of the woman's body with an ancient form recalls Rodin's admiration for the sensuality of ancient Greek sculpture, which he often cited as an inspiration. Similarly, the juxtaposition of new and old would have pleased him as when he saw his *Walking Man* in the courtyard of Palazzo Farnese (see fig. 452).

NOTES

LITERATURE: Elsen 1981, 140–41, 254–55; Barbier 1992, 46–47

1. The variant with the torso set in a pot was discussed and reproduced in Elsen 1981, 141. For a discussion of this and other assemblages in which Rodin placed feminine torsos in antique vases, see Nicole Barbier's "Vases où poussent les fragments," in Pingeot 1990, 237–39.

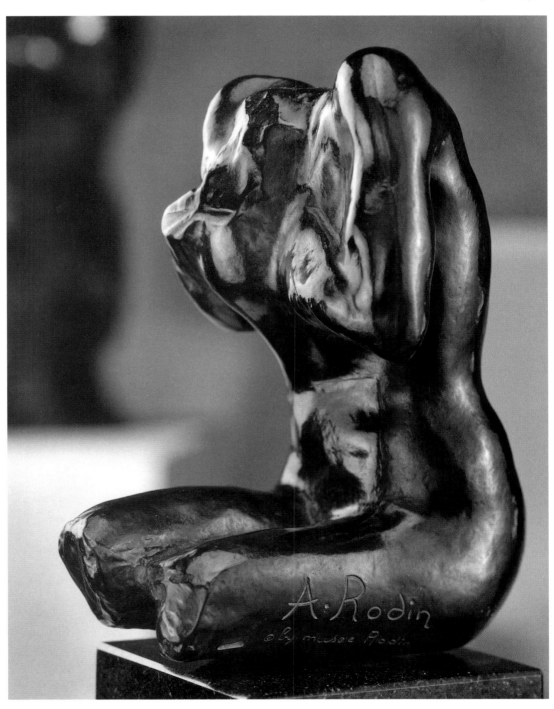

Fig. 462. *Small Torso of a Seated Woman* (cat. no. 181).

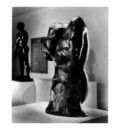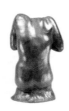

182

Torso of a Seated Woman
(*Torse féminin assis*), n.d., enlarged 1907?

- Title variation: *Victoria and Albert Museum Torso*
- Bronze, Coubertin Foundry, cast 1981, 7/12
- 24¼ x 12 x 8½ in. (61.6 x 30.5 x 21.6 cm)
- Signed on front, at bottom: A. Rodin
- Inscribed on front of base, lower edge, at left: No. 7; on back: © by Musée Rodin 1981
- Mark on back of base, lower edge, at right: Coubertin Foundry seal
- Gift of the Iris and B. Gerald Cantor Collection, 1998.357

Figures 464–65

*D*espite the fact that Rodin gave a bronze cast of this work to the Victoria and Albert Museum in 1914, it remains only briefly discussed and infrequently reproduced.[1] An enlargement of the torso, but not the upper thighs, of a much favored and originally small version (cat. no. 181), it is perhaps Rodin's most abstract work when seen from the back. Thus viewed, the absence of any indication of a neck and the uninterrupted concavity between the shoulders that continues the fluid contours of the torso, for example, creates the impression of a torso by Jean Arp from the early 1930s.[2]

Although thought by some to have been derived from the torso of *Cybele* (cat. no. 186), this is not the case. Not only is the back far less muscular, but the positioning of what remains of the hands placed on the woman's breasts is totally different. When the work was enlarged by Henri Lebossé presumably in 1907, Rodin decided to eliminate the thighs in order to focus on the torso.[3] This presented him with the problem of how to support the body, and he fashioned a roughly modeled, abstract base, on which, from the back, it looks as if the woman is sitting. From the front, however, in the absence of thighs, the base extends into the lower abdomen, which is cosmetically unattractive and which may have sufficiently disturbed viewers and commentators to the extent that the work has been passed over in the literature.[4]

Rodin obviously wanted to compact the torso as much as possible so that the woman's upper arms are held tightly against her sides, merging without any sign of a crease or divide between them. Seen frontally, the placement of the woman's hands vaguely recalls the hieratic frontality of ancient Egyptian figures with arms crossed on the upper body. Rodin chose not to articulate the hands, and from the wrist down they taper into smooth, mittenlike shapes that fuse with the breasts, so that the hands appear to be growing out of the torso. Even the untempered patch above the woman's right breast is made to seem organic.

In the enlargement from the small seated figure, Rodin made the torso more erect. This has the effect of making the vertical form seem more self-sufficient, independent of the leveraging that thighs would have afforded. It also reinforced the emphasis on the back. As compared with the small, more uniformly smooth version, the modeling of the enlarged back shows a discernible pattern of vertical streaking by the fingers (compare figs. 14–15). Lebossé prided himself on being able to reproduce Rodin's "touch," and if he, rather than the sculptor was responsible for this license in the enlargement of exposing the facture, it had to be with Rodin's approval.

The overall effect sought by Rodin in this audacious work seems to be uninterrupted luminous fluidity. To that end he edited and reformed the body by mergence as if it were a single continuous surface, exposing as much of it as possible to light, especially in its dorsal aspect. It was in these years before the First World War that artists such as Aristide Maillol and Constantin Brancusi, who wanted sculpture to impart joy, not anguish, were forming surfaces that brought as much light as possible to their sculptures, partly in reaction to Rodin's use of shadow in his modeling, often for tragic effects. Thus, rather than solely a reaction against Rodin's more expressionistic modeling, the sculpture of Maillol and Brancusi may also be seen as carrying to new conclusions what Rodin did with surfaces and light in such works as the Victoria and Albert Museum *Torso of a Seated Woman*.[5]

There is no record of Rodin's having shown this sculpture in plaster or bronze after its initial exhibitions in London (1914) and Edinburgh (1915), but there can be no doubt about how important he believed it was because of his gift of this work to England. That donation included *The Age of Bronze* (cat. nos. 1–3) from his career's beginning, and this torso told his many friends and admirers in England how far he had come since that time.

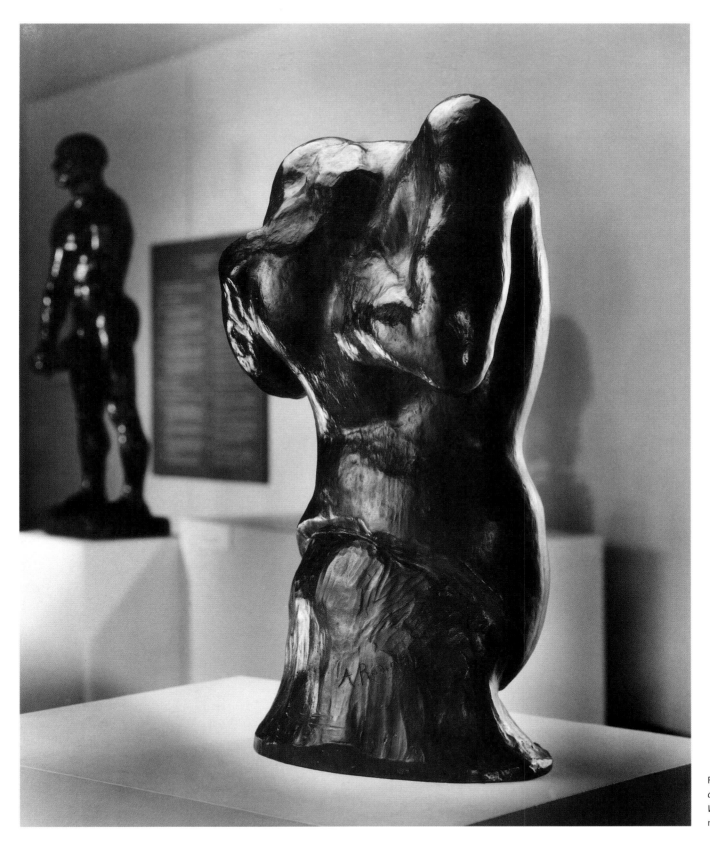

Fig. 464. *Torso of a Seated Woman* (cat. no. 182).

NOTES

LITERATURE: Bowness 1970, 79; Alley 1981, 648; Elsen 1981, 254; Pingeot 1990, 142; Barbier 1992, 47

1. This work and others comprising Rodin's gift to England were exhibited at Grosvenor Gallery and at the Victoria and Albert Museum in London (1914; see E.R.D Maclagan, *Catalogue of Sculpture by Auguste Rodin* [London: Victoria and Albert Museum, 1914] 16), and then in Edinburgh (1915) (Beausire 1988, 354–55, 359). The reproduction in Bowness (1970, 79), shows the plaster pedestal that Rodin provided with the sculpture, perhaps to ensure that it was seen at eye level.

2. Arp's insistence that sculpture not have a front, as there is no front or back to forms in nature such as a tree or rock, could have been influenced by Rodin's "democratic style," which gave parity of expression and beauty to all views of a well-made work of art. It was Arp who in 1950 first alerted this author to the treasure of plaster casts by Rodin at Meudon, not far from his home. The enlargement of Rodin's torso *The Martyr* (cat. nos. 72–73) has a similar treatment between the shoulders of the torso, uninterrupted by any indication of a neck.

3. Lebossé's notes in the Musée Rodin archives (reprinted in Elsen 1981, 258) indicate that in 1907 he enlarged a "*torse.*" Lacking more detailed information we can only surmise that this is the work in question.

4. Since Rodin's death, *Torso of a Seated Woman* usually has been installed so that the front rather than the back is viewed. Seen as a totality, the added base abets the sense of the whole being contained within a cubic form.

5. Brancusi was working in Rodin's studio for several months in 1907, the presumed time at which this enlargement was made (Geist in Elsen 1981, 271–72). Rodin had admired and purchased the work of Maillol before 1907, and it is within the realm of probability that he in turn was influenced by the full volumes and tranquil surfaces of this gifted younger artist.

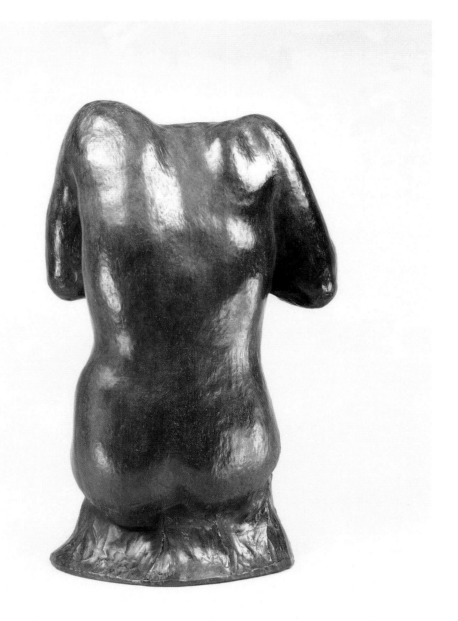

Fig. 465. *Torso of a Seated Woman* (cat. no. 182).

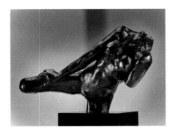

183

Flying Figure (Figure volante), 1890–91

- Bronze, Georges Rudier Foundry, cast 1966, 1/12
- 8½ x 15¾ x 5 in. (21.6 x 40 x 12.7 cm)
- Signed on left side of left thigh: A. Rodin
- Inscribed on left thigh, right of signature: Georges Rudier/Fondeur, Paris; below signature: No 1; back of left thigh: © by Musée Rodin 1966
- Provenance: Musée Rodin, Paris; Private collection, Switzerland
- Museum Purchase Fund, 1970.134

Figure 466

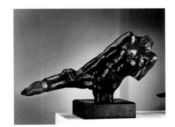

184

Flying Figure (Figure volante), 1890–91, enlarged 1895(?)

- Bronze, Georges Rudier Foundry, cast 1978, 9/12
- 21 x 31 x 12 in. (53.3 x 78.7 x 30.5 cm)
- Signed on front of base, right: A. Rodin
- Inscribed on back of base, lower edge, right: Georges Rudier/Fondeur.Paris.; below signature: No. 9; on base, left side, lower edge, near back: © by musée Rodin 1978; interior cachet: A. Rodin
- Provenance: Musée Rodin, Paris
- Gift of B. Gerald Cantor and Co., 1982.304

Figure 467

*T*he best synoptic analysis of *Flying Figure* was given by Leo Steinberg:

> Touching down only at the stump of a thigh, the other leg (calf-length) trailed like a streamer, the figure's headless trunk ascends at forty-five degrees, while its single arm heaves close to reduce wind resistance. Not the body's shape but its transit determines its stringent economy.

There is a powerful shift here away from traditional ground. Rodin has not so much modeled a body in motion, as clothed a motion in body, and in no more body than it wants to fulfill itself.[1]

No École des beaux-arts model posed for this sculpture, an adaption of the female figure in *Avarice and Lust* (see cat. nos. 66–67). What Rodin wanted was outside the canon of approved postures for studio models. As with *Iris, Messenger of the Gods* (cat. no. 185) and its comparable pose, the model probably came from Montmartre, where she performed the new dances that flouted society's ideals of feminine grace and decorum. Rodin was obviously drawn to the dancer's aggressive assault on space, just as Edgar Degas admired the more elegant balletic postures that extended a dancer's leg at right angles into the air. But Degas never truncated the figure to focus on part of a movement and on a woman's genitals.

Unlike the pose of *Iris, Messenger of the Gods*, that of the *Flying Figure* could have been held by an upright model for intervals long enough to allow Rodin to model his clay in large sections. He did not, however, model his subject in the round. What little modeling he may have done on the back so dissatisfied him that he sawed it off with a wire. As with *Iris*, he treated the *Flying Figure* as if it were a vigorous form seen as a deep relief. The lower part of the woman's right leg moves into depth, away from us, so that from the front we do not see, or miss, the absent foot. He cut the woman's left arm at a point where it formed a strong curve with the contour of the lower part of the torso, a fusion of contours only appreciated from the front. Unusual in Rodin's art is the long, almost straight silhouette made by the woman's left arm seen against its counterpart, interrupted by the curving indentation. He compacted the body to achieve what in life would be an unstable cantilevered form.

Augmenting the sense of motion is Rodin's touch. In études such as this, there is a deliberate withholding of finesse. As he rapidly applied his clay, he spread it out with his thumb to form planes that reflect the limb's curvature and the direction it was moving in. With his sense of *le modelé*, these planes reflect the body seen in depth, rather than flat, and unlike the touches of Degas, they fuse with one another to create greater surface fluidity. (As an example, the woman's right hand rests on and merges with her thigh.) In the études the logic of fitting the planes together rather than joining anatomical parts is more apparent or explicit. This technique is far from

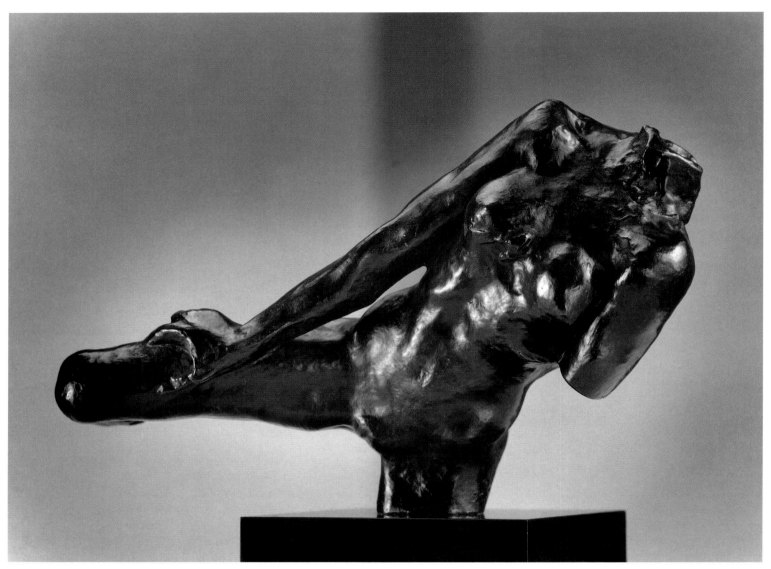

the refined modeling of the final *Burghers*, which Rodin had finished only a year or two before.

 The preservation of the marks and accidents of the process, such as the unmodulated patches of clay on the model's right breast, foretell what Rodin was to do in his spontaneous drawings begun in the second half of the 1890s. In the latter there are no erasures or corrections of errant lines. This artist who otherwise distrusted working in the heat of inspiration, nevertheless, in his études froze the accidental forever. It seems that in Rodin's judgment these accidents encouraged the sense of the form's overall movement and discouraged its interruption by the viewer's serial reading of details. And he saw to it that the enlargement of *Flying Figure* came as close as possible

to all the formed and unformed passages of the original.[2]

 Contemporary reactions of Rodin's peers to this sculpture are lacking. Assuming that the *Figurine, jambe écartée et levée* (Figurine, leg held apart and raised) listed in the catalogue of Rodin's 1900 retrospective is the same as the present *Flying Figure*, it seems this sculpture was exhibited only once, and then it would hardly have been noticed by most visitors who were confronted with more than 160 works by Rodin.[3] Even today, however, people are startled to come upon this sculpture or its enlargement. There is nothing about it that is dated or datable, and that which is so familiar and intimate to the viewer, the human form, is seen totally anew. It is not meant to charm but to challenge. To those who at first see *Flying Figure* as an abstrac-

tion, there is the reminder that Rodin was among the first sculptors both to see the body abstractly and to act accordingly in terms of what could be left out and what constituted a self-sufficient form.

NOTES

LITERATURE: Grappe 1944, 87–88; Elsen 1969, 22, 1981, 257; Jianou and Goldscheider 1969, 103; Steinberg 1972, 338, 362–63, 389; Tancock 1976, 288, 292; Elsen 1981, 257; Gassier 1984, 116; Lampert 1986, 175, 221; Miller and Marotta 1986, 139, 142; Pingeot 1990, 211; Levkoff 1994, 140

1. For his discussion of the figure's movement, see Steinberg 1972, 338, 362–63.
2. For the dating of the enlargement possibly to 1895, see Lebossé's notes, reprinted in Elsen 1981, 257.
3. Beausire 1988, 181. Figurine is identified as *Flying Figure from the Gates of Hell* (1885) in Le Normand-Romain 2001, 94.

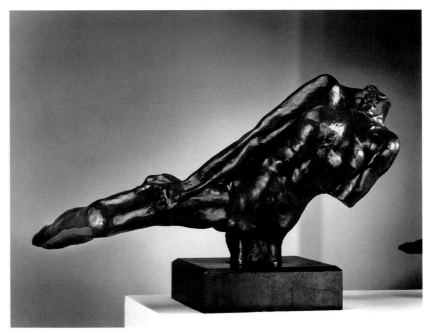

Fig. 467. *Flying Figure* (cat. no. 184).

185

Iris, Messenger of the Gods (with head) (*Iris, messagère des dieux, avec tête*), 1891

- Bronze (solid cast), Susse Foundry, cast 1969, 1/12
- 18 x 16 x 9½ in. (45.7 x 40.6 x 24.1 cm)
- Signed on sole of left foot: A. Rodin
- Inscribed on base, left side: Susse Fondeur/Paris.; below signature: No. 1; on back of base: © by/musée Rodin/1969
- Provenance: Musée Rodin, Paris
- Gift of the Iris and B. Gerald Cantor Foundation, 1974.50

Figure 468

*I*n Rodin's day this work would have been called an étude, made for purposes of study. It was Rodin who in public and Edgar Degas who in private raised the étude to the aesthetic level of the finished work of sculpture. Inspired by uninhibited models, who may also have been Montmartre cancan dancers, Rodin found in the early 1890s new ways to show how the human form could move more freely and occupy space, often defying gravity.[1] In older sculpture, figures could resist gravity if they had wings, but Rodin made this figure appear to resist gravity through a leap, leaving no weight carried by her left foot. Studio visitors reported that, as Druet's photograph shows, Rodin used an iron shaft to support *Iris* (see fig. 469) and the headless version in the Musée Rodin, Paris, is still mounted in this manner.[2]

As Rodin used the étude, he was freed not only from expectations of surface refinement but also from inclusion of the entire body. He had no interest in the back or the totality of the woman's left arm or her face, although he left enough of the former to indicate the beginning of a gesture to counterbalance that of her right arm.[3] Her head is thrown back in the abandon of the dance, or movement, so that from the front the extended neck is emphasized. The torso was established in terms of the planes of its large volumes, but it contains untempered patches on her right breast, a deep indentation below her right breast, and a wide ridgelike navel. What Rodin observed and wanted to portray was that part of a complex and erotic movement that would make a good

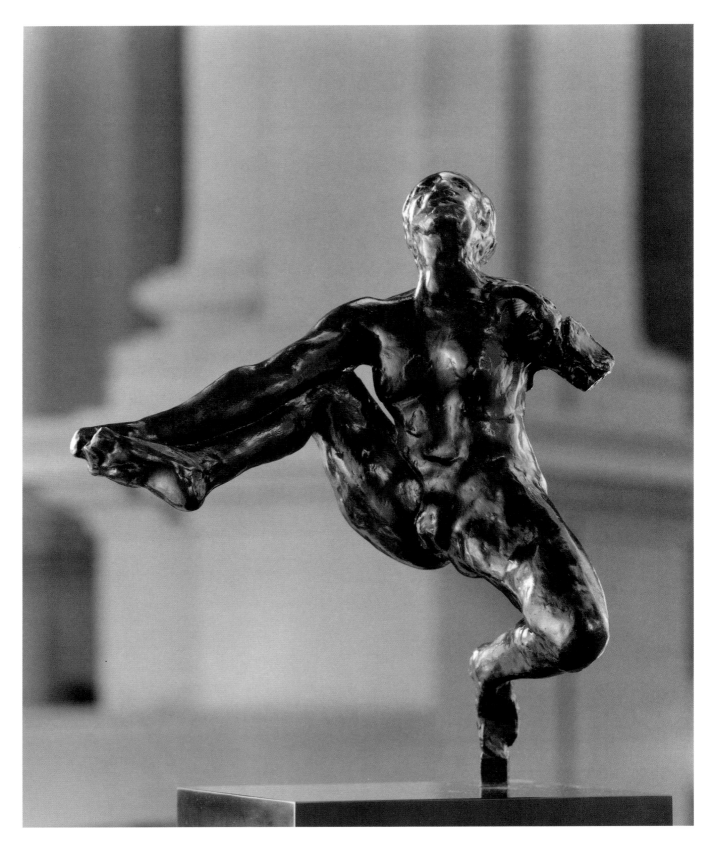

Fig. 468. *Iris, Messenger of the Gods* (cat. no. 185).

sculpture, and no more. That movement had a straight, upright axis, formed by an imagined line running down through the neck, the sternum, and navel and along the inside edge of the ball of the woman's left foot, against which were seen two V-shapes: one in an inverted form made by the woman's raised right leg and one on its side shaped by the woman's bent left leg. Neither the thighs nor the legs move in a parallel plane or direction. Although the torso is oriented to a frontal view, the limbs move vigorously in depth.

What counted in terms of Rodin's detailed anatomical rendering was the way that his stocky, athletic model made two limbs act as one, thereby making the body into a kind of semaphore. He focused on the manner in which she used her right hand to grasp her foot and the relationship of her arm to the right leg, which brought them into unison. The anatomy of her right arm passing in front of and being pushed forward by the right knee is strongly indicated as Rodin wanted to understand the physical mechanics of this part of the movement. Hardly visible, the right hand is reduced to a mittenlike shape.

As stunning as the figure's elevation is, the historically unprecedented aspect of the sculpture is the splayed character of the pose, showing the inside of the woman's thighs and her genitals. (It was sculptures like this that Rodin's assistants would cover with cloths when certain visitors, notably British, came to the studio.) His practice of not using professional art models but enlisting people whose bodies and unselfconscious movement captured his fancy led him naturally to dance hall performers. Rodin seems to have taken his cue from the sexuality of the Paris night world of the early 1890s and the Montmartre models who defied decorum with their spontaneous, gravity-defying, erotic dances. Years later Rodin would make hundreds of drawings focusing on the pubic area, which were taken from more passive, reclining, but similarly uninhibited models. This preoccupation began in sculpture and came naturally with the strenuous pose.

How did Rodin fashion this sculpture to fix such a fugitive moment and difficult pose? It is possible that this sculpture is an enlargement from a still smaller version. Rodin often enlarged his études without a labor of refinement. A smaller version would not have required an armature and could have been quickly worked in the hands. The Stanford bronze can be laid on its back and remain stabile because the dorsal section is rough and flat. It is not impossible that the model also lay on her back reconstituting the pose she had shown Rodin when

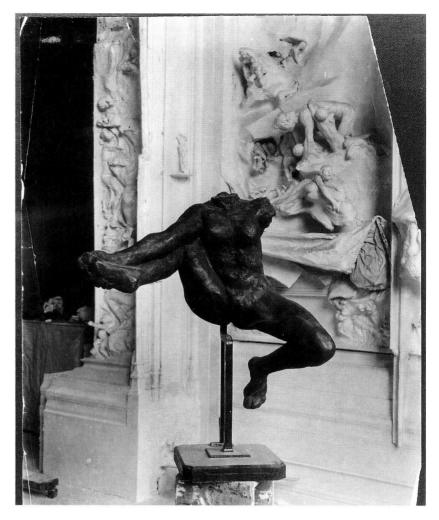

upright. (The rough bottom of her left foot, coupled with the planar back, buttocks, and rear of the head prompt the idea.)[4] Also between the woman's left thigh and buttock is an unanatomical, built-up ridge rather than a smooth transition. This could have resulted from the clay sculpture being made on its back, in which case Rodin's modeling of the thigh would have been interrupted or stopped by the board on which he was working. When he discontinued work, Rodin showed no interest in bringing the big area of the woman's back to further definition.

What did all this signify? Rodin made études that were not always to be seen in the round. Perhaps his later statement, "I have only given my contours a little more movement and much more action within general outlines," applies to works such as this.[5] He was interested in a largeness of effect rather than a close reading of finished details. That effect could mean the sacrifice of body parts if they impeded the movement he wanted. Rodin was to continue editing this figure in other and larger versions.[6]

Fig. 469. Eugène Druet, "Iris, Messenger of the Gods" without Head with "The Gates of Hell" in background, after 1896, gelatin silver print. Musée Rodin, Paris.

As Leo Steinberg aptly put it, "This principle of dispensability determines the limits of fragmentation. An anatomy can be stripped down so long as it yields a clear gesture."[7] Although he protected himself from criticism by associating the energetic eroticism of the sculpture with a mythological character, *Iris* was still another declaration of artistic independence with respect to form and sexuality.[8]

NOTES

LITERATURE: Grappe 1944, 85; Jianou and Goldscheider 1969, 103; Tancock 1976, 288, 291–92; Lampert 1986, 121–23, 220–21; Miller and Marotta 1986, 139; Roos 1986, 654–55; Pingeot 1990, 211–12; Barbier 1992, 156; Levkoff 1994, 136; Butler, Plottel, and Roos 1998, 97, 99–100; Le Normand-Romain 1995B, 67–72, 53; Le Normand-Romain 2001, 186

1. "Rodin was at this time infatuated with the can-can dancers and saved an article in the September 1891 *Gil Blas* on the Chahut dancer Grille d'Egout. He was also fascinated by the 'apache' or hoodlum girls on the rue de Lappe" (Lampert 1986, 121, 123, citing Goldscheider 1963). The apaches are shown in a vintage photograph reproduced by Descharnes and Chabrun 1967, 232.

2. The headless version in the Musée Rodin is mounted upright on an iron shaft, which enters the figure near its right buttock, so that its left foot is in the air. It is not known who made the decision to mount *Iris* the way she is in the Stanford cast. Because the sculpture was intended

to be off the ground, the casting is solid. There was no way to remove the inner core after the cast was made.

3. Lampert wrote, "Intended initially to be a winged muse, the back was left rudimentary" (1986, 221). The unfinished back is better explained by the way the model probably posed.

4. This was observed by Lampert, who had the piece photographed in that orientation and wrote without equivocation, "Conceived from a model who lay obligingly on her back, one leg caught by her hand and the other providing support, even horizontally she is pivoted by her sexual centre. Raised vertical, with the vagina rotated, the orgasmic metaphor becomes obvious" (1986, 121).

5. Dujardin-Beaumetz in Elsen 1965a, 160.

6. Rodin severed the figure's descending leg in a terra-cotta version in the Meudon reserve (reproduced in Pingeot 1990, 212). For studies (c. 1908–09) in which Rodin joined Gwen John, related to the Whistler monument, to *Iris*, see Le Normand-Romain 1995b, 67–72.

7. Steinberg 1972, 363.

8. At one time Rodin tried his audacious étude *Iris* as a winged muse in his project for the *Apotheosis of Victor Hugo* (see Roos 1986, 654–55; Roos in Butler, Plottel, and Roos 1998, 97–100). The gesture of taking the foot in the hand recalls the French expression *se prendre le pied*, which is a vernacular way of saying to have an orgasm (99). The gesture also appears in *Despair* (see cat. nos. 69–71). See Anne M. Wagner, "Rodin's Reputation" in Lynn Hunt, *Eroticism and the Body Politic* (Baltimore: The Johns Hopkins University Press, 1990) 217–23.

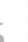
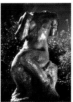

186

Cybele (Cybèle), c. 1889–90, enlarged 1904

- Title variations: *Abruzzezzi Seated, Study of a Seated Woman*
- Bronze, Coubertin Foundry, cast 1981, 2/12
- 63 x 31 x 46 in. (160 x 78.7 x 116.8 cm)
- Signed on front of base: A. Rodin
- Inscribed to right of signature: No. 2; on back of base, lower edge, right: © By Musée Rodin 1981
- Mark on back of base, lower edge: Coubertin Foundry seal
- Gift of the B. Gerald Cantor Collection, 1992.135

Figure 470

*C*ybele began as an étude, a small study of a headless, seated woman with her right hand raised to her shoulder,

dated by Georges Grappe to 1889 and, according to him, destined for *The Gates of Hell*.[1] One doubts that the study was ever intended for the portal, as it has a self-sufficiency in the relatively tranquil pose that would have inhibited its use in combination with other figures, and by itself it does not speak of anguish. The study was used for the marble *Galatea* shown in 1889, a seated nude figure with her right arm raised to her shoulder, and was reused for the body of the seated girl in a group known as *Shame* (or *Absolution*; c. 1889–90).[2] The small version of *Cybele* seems to have been exhibited first in Amsterdam (1899) under the name *Abbruzzezzi*; in Rodin's 1900 retrospective it was identified as *Femme assise* (Seated woman) and shown on a high column.[3] It is an outstanding example of Rodin's gender neutrality with respect to his own art. When shown a second time in the retrospective, adapted for a group composition, the seated woman had joined to it the head of *The Falling Man* (cat. no. 64) and around her legs were grouped figures from *Ugolino and His Sons* (cat. no. 45). The group was titled *Niobe*.[4]

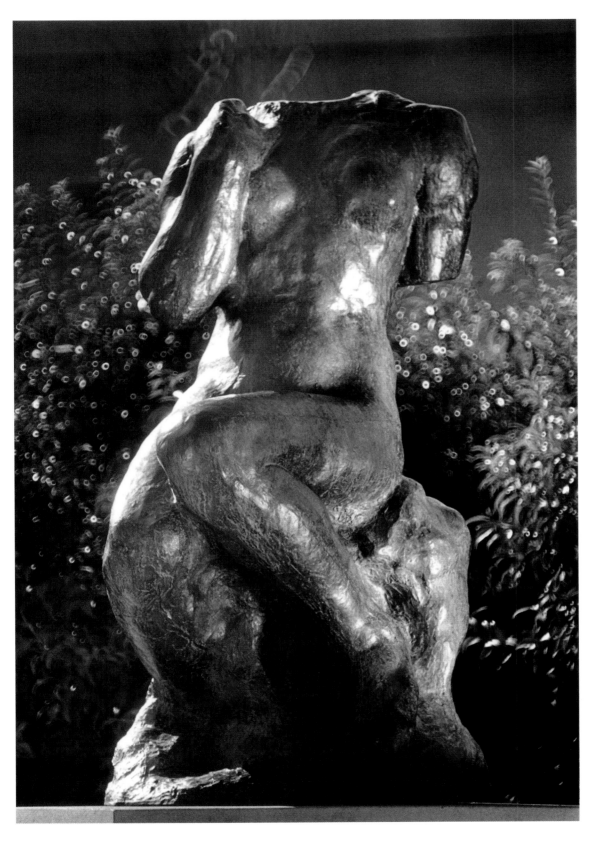

Fig. 470. *Cybele*
(cat. no. 186).

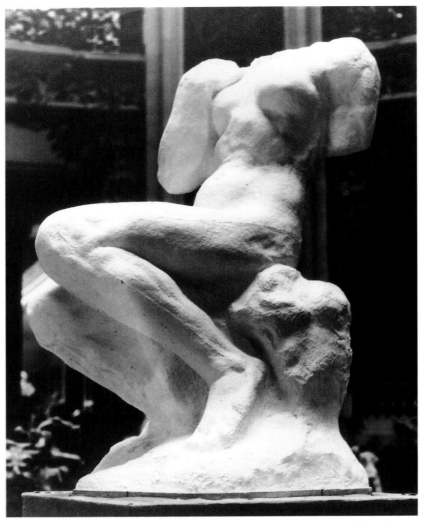

the arts. In antiquity she was shown flanked by lions, crowned and enthroned holding a small drum in her hand, which symbolized her often frenzied rituals.[7] The full, sensuous form of Anna Abruzzesi (b. 1874) as Rodin interpreted her in the sculpture may have inspired a name associated with awesome fertility. Absent the identifying attributes, Rodin relied on the powerful body of the woman to give the name and its associations credibility. The figure evokes the fragments of Greek art that Rodin had pondered on his many visits to the British Museum and to the Louvre. Rodin extolled the sensuousness of Greek art and he learned from ancient fragments a new sense of completeness as opposed to finish. Just how far Rodin was from idealizing the feminine form or working directly from Greek fragments, however, is shown by the fact that his technicians and foundry workers recognized the identity of the model even without the presence of a head.

Rather than being shown bolt upright with her legs primly together and knees directly in front, Rodin found a torsion for the torso and lower limbs, a modified *désinvolture*, a twisting in space, which gives the figure a sense of action in repose. The heels are up, feet braced, one foot drawn back farther than the other as if the figure were about to rise. The upper torso, however, leans slightly backward, rather than forward, indicating that her balance has not been totally shifted forward as would be the case were she about to stand. From just above the navel, the woman turns her body slightly to her left. It is that X-structure used by Rodin in which the paired joints and limbs do not lie in the same vertical planes: one shoulder farther back, the opposite knee farther forward than the other. Thus, this is not a frozen moment of a single action but a suggestion of successive states. The differently poised legs pulling slightly to the woman's right while the torso swivels slightly to its left counter the potential symmetry of the body as a whole and give vigor to an otherwise passive position.

The back of *Cybele* is a shock. Like that of a well-developed man, it gives the impression of great physical strength. Rodin put muscles where they are not, such as those clustered on her right shoulder blade and in the lower back. The indentation of the spinal column and the musculature in general are strongly exaggerated, making the whole back a rugged terrain for light and shadow to play upon. In a similar spirit, the abstracted base of the sculpture, which evokes a rock, is an active element and not neutral in its rapport with the lower sec-

The seated feminine figure was enlarged by Henri Lebossé in 1904 and was exhibited in its enlarged plaster form as *Cybele* in the 1905 Paris Salon (fig. 471).[5] It was there shown with *Ariane* (1890), and the figures were known, respectively, to Rodin's friends and workers as *Abruzzesi Seated* and *Abruzzesi Reclining* because of the identity of the well-known model, who was much liked and used by Rodin. The work was presumably first bronze-cast by the Alexis Rudier Foundry for the Grosvenor Gallery exhibition of contemporary French decorative arts in 1914.[6]

Cybele is a name and not a title. Given to this sculpture after its creation, it tells us more about the sculptor's personal associations inspired by the figure and his mentality shaped by his extensive study of ancient myths than about a priori intentions. A goddess whose cult was imported from Phrygia into Greece and Rome, Cybele was honored as the mother of the gods and mother of nature who saw to the fruitfulness of all creation. The focus of the classical mysteries, she was also mother of

tion of the figure. As with that of *The Thinker* (cat. no. 38), the base of *Cybele* is molded to accommodate the feet, and by its upward taper near the woman's left hip, it abets the vertical thrust of the seated form.

Along with praise, the exhibition of *Cybele* in 1905 drew critical protests that Rodin sadistically "mutilated" his figures.[8] There was also the usual complaint that the artist had no right to exhibit unfinished work in the salon.[9] Perhaps out of concern for such reactions, most of Rodin's contemporaries, such as Jules Dalou who occasionally made fragmentary études, would not exhibit them in the belief that such studies should be reserved for the studio. One of Rodin's breakthroughs with regard to convention was to exhibit in public, without inhibition, what others only showed in private.

Judging from the original, small version as well as its enlargement, the charge of mutilation may have been wrong. There is no evidence in the form of a surviving full figure to support the conjecture that the artist first modeled a neck and head for the original sculpture and then cut them off.[10] From the woman's raised right hand, which appears to be in a gesture of self-address, there issues a flowing shape ending at the base of the neck that evokes the memory of hair, as if Abruzzesi had been absent-mindedly stroking it. (Only the right thumb and forefinger are modeled distinctly, and it is as if the hair covered the rest of the hand.) In any event, when removed from the studio, Rodin intended the sculpture to be seen with the squared-off line of the shoulders, which compacts the upper portion of the form. This would be a dramatic and tangible example of Rodin's thinking about his emerging figures as existing within an imaginary cube. By cutting off the woman's left arm above the elbow, as he did in *Prayer* (cat. no. 80), Rodin opened to view the silhouette of her lower torso. To rectify any possible sense of imbalance, when seen from the front, the implied downward line of the amputated arm is met where Rodin established the edge of the simulated rock base.

Photographs taken of *Cybele* when shown in 1905 reveal that the casting seams on the plaster had not been removed. (Exactly when prior to his 1900 exhibition Rodin began this practice of retaining the marks of the sculptural process in exhibited works is difficult to determine. They are not visible on figures in *The Gates of Hell*, for example.) As evident in the Stanford bronze, there is also a pronounced coarseness to the entire surface of the figure. Both features are explicable when seen under the

brilliant California sun. Rather than allowing the surfaces to go flat under strong light, the seams and textures that cast shadows hold the curvature of the planes. Except for a showing in London, an installation over which he probably had no control, when the bronze was placed near the floor on a thin plinth, it was clear from his use of a column in the 1905 salon and the low angle at which the photographs were taken that Rodin wanted the figure seen from below and at a distance from which the coarse textures would not be strongly apparent. (This accounts for the installation of the sculpture in the B. Gerald Cantor Rodin Sculpture Garden on a high pedestal so that the figure is above eye level.)

Rodin is generally thought of as an artist at his best and most convincing when presenting figures, especially women, in states of distress. Some see this as the artist's limitation and pessimism. *Cybele*, like *Prayer* and *Torso of a Young Woman* (cat. no. 177), shows nothing of the kind but rather the full range of his strengths. Even with the absence of heads, these partial figures clearly display not only dignity but physical health and strength of spirit.

NOTES

LITERATURE: Grappe 1944, 77–78); Jianou and Goldscheider 1969, 222; Tancock 1976, 220, 222; Elsen 1981, 258; Ambrosini and Facos 1987, 149–54; Beausire 1988, 187, 268

1. Grappe (1944, 77–78) gave no source for his date or for his assertion that the work was to have gone in *The Gates*.
2. See Barbier 1987, 144–45; Tancock 1976, 220–24.
3. Beausire 1988, 153, 195; Le Normand-Romain 2001, 132.
4. Beausire properly challenged this author's earlier interpretation of this group as a third version of the Ugolino group (c. 1988, 187) (see Elsen 1980, pl. 29.) He pointed out that it fit the 1900 catalogue description as well as the story of Niobe. Keeping in mind how Rodin often changed the names of his figures and groups, I would only add that this hybrid parent and her distraught offspring still are appropriate for the story of Ugolino and the many early drawings of the seated tragic father.
5. Elsen 1981, 258; Beausire 1988, 268.
6. Beausire 1988, 353–55.
7. John Lemprière, *Lemprière's Classical Dictionary*, 3d. ed. (London: Bracken, 1984), 209.
8. Beausire 1988, 268.
9. Leonce Bénédite, "Les salons de 1905," *La revue de l'art* (1905): 462.
10. Until a comprehensive inventory of the Meudon reserve is published, it is not possible to confirm this conjecture.

187

Blessing Left Hand
(Main gauche bénissante), 1880–84

- Bronze, Alexis Rudier Foundry
- 4½ x 2⅞ x 6 in. (11.4 x 7.3 x 15.2 cm)
- Signed on wrist: A. Rodin
- Inscribed on wrist, left side: Alexis Rudier/Fondeur Paris
- Gift of the Iris and B. Gerald Cantor Foundation, 1974.44

Figure 472

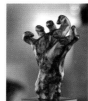

188

Small Clenched Right Hand
(Main crispée droite), 1884–89(?)

- Bronze, Alexis Rudier Foundry
- 5⅜ x 4¹⁄₁₆ x 7¹³⁄₁₆ in. (13.7 x 10.3 x 19.8 cm)
- Signed on inside of wrist: A. Rodin
- Inscribed on back of wrist: Alexis Rudier/Fondeur Paris
- Gift of B. Gerald Cantor, 1978.124

Figure 473

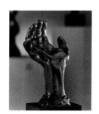

189

Right Hand (Main droite), 1886–89(?)

- Bronze, Georges Rudier Foundry, cast 1968, 10/12
- 11 x 6¼ x 4½ in. (27.9 x 15.9 x 11.4 cm)
- Signed left side of base, on wrist: A. Rodin
- Inscribed on base: Georges Rudier/Fondeur. Paris; below signature: No. 10; on back of base: © by Musée Rodin 1968
- Gift of the Iris and B. Gerald Cantor Foundation, 1974.45

Figure 474

190

Large Clenched Left Hand
(Grande main crispée gauche), 1888

- Bronze, Georges Rudier Foundry, cast 1971, 7/2
- 18¾ x 10¾ x 6 in. (47.6 x 27.3 x 15.2 cm)
- Signed on left side of base: A Rodin
- Inscribed on back of base: Georges Rudier/Fondeur. Paris; below signature: No 7; on left edge of base: © by Musée Rodin 1971; interior cachet: A. Rodin
- Gift of the Iris and B. Gerald Cantor Foundation, 1974.49

Figure 475

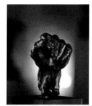

191

Left Hand (Main gauche), c. 1900(?)

- Bronze
- 4¼ x 3˘ x 3¾ in. (10.8 x 8.3 x 9.5 cm)
- Signed on back of wrist: A. Rodin
- Gift of the Iris and B. Gerald Cantor Foundation, 1974.43

Figure 476

192

Large Left Hand (Grande main gauche), 1903(?)

- Bronze, Georges Rudier Foundry, cast 1967, 4/12
- 13 x 6½ x 7 in. (33 x 16.5 x 17.8 cm)
- Signed on wrist, left side: A Rodin
- Inscribed on bottom surface of base: Georges Rudier, Fondeur, Paris; below signature: No 4; under base on left edge: © by Musée Rodin 1967
- Gift of the Iris and B. Gerald Cantor Foundation, 1974.46

Figure 477

See also *Left Hand of Eustache de Saint-Pierre* and *Large Left Hand of Pierre de Wissant* (cat. nos. 14 and 32).

Rodin believed all his life, it seems, that he could make the human hand as expressive as the face. When he sought to prove this by publicly exhibiting a few of his modeled and carved hands, he paid a critical price, as he explained in 1912: "Have not the public and critics who serve the public reproached me enough for exhibiting simple parts of the human body? . . . These people comprehend nothing of sculpture, or what is an étude. Can they not imagine that an artist must apply himself to giving as much expression to a hand or a torso as to a face and that it was logical for an artist to exhibit an arm rather than a bust arbitrarily deprived by tradition of arms, legs, and abdomen? Expression and proportion, the ends are there. The means are modeling. It is by modeling that the flesh lives, vibrates, struggles and suffers."[1]

No previous sculptor is known to have made as many studies of hands, considering them not only in connection with arms but self-sufficient as works of art to be exhibited and sold.[2] The problem of an exact accounting of their number is perplexing. The second curator of the Musée Rodin, Georges Grappe, counted 450 hands in plaster and terra-cotta, but he did not make clear how many of these hands had been used and remained on figures.[3] Even with the publication of a comprehensive inventory of the Meudon reserve, there would be problems and perhaps two sets of numbers: one for those hands used with arms and bodies and a second for hands that had not been attached to figures. These hands range in size from the diminutive to larger than life-size. They include hands of men and women, with the former seemingly predominating, as well as subjects of differing ages and occupations. At times, as shown with the *Small Clenched Right Hand* (fig. 473) and *Large Clenched Left Hand,* (fig. 475), Rodin liked to model both right and left hands in approximately the same attitude.[4] With minimal variations in the placement of the fingers, for example, Rodin might reuse the same expressive hand in more than one sculpture as with the right and left hands of Jacques de Wissant and Pierre de Wissant (cat. nos. 25, 30, 32).[5]

What encouraged Rodin to make so many hand studies was, of course, the large number of figure sculptures he produced, especially for *The Gates of Hell.* As the magnitude of this project developed in his imagination, Rodin must have begun in the early 1880s to build his repertory of hands. This would account for the many less-than-life-size plaster hands. Besides being able to replace parts that suffered studio damage, this reserve allowed him to audition and alter gestures. The shapes and movements of hands were not susceptible to changing relations with gravity. Particularly in his publicly exhibited figures, such as *Saint John the Baptist Preaching* (see fig. 446), *Adam* (cat. no. 40), and *The Burghers of Calais* (see fig. 57), Rodin was working within a tradition of gestural sign language that caused him to give considerable thought to the exact placement and expressiveness of each digit.[6]

Rodin effectively asked himself, why not make and show hands by themselves? History encouraged him to answer in the affirmative. That he was an ardent collector of antiquities, including sculptural fragments of hands from ancient Egypt, must have reinforced his view of how well-made hands could be beautiful and expressive by themselves. In antiquity one can find paintings of hands symbolizing a god and sculptured hands as votive offerings. During the Middle Ages reliquaries were given the form of hands and fingers, and in manuscript painting one can find many images of the hand as a surrogate of God emerging from the heavens.[7] Painters have made studies of hands at least since the Renaissance. Since the sixteenth century, copies of hands made by famous artists, such as Michelangelo, have been available to apprentices and students in studios and art schools. On nineteenth- and twentieth-century gravestones the hands of a man and woman might be seen as isolated but clasped. Rodin would show something similar but less prosaic in his *Hands of Lovers* (before 1909), which reach out to each other.[8] In the nineteenth century, plaster life casts of the hands of famous men, musicians and writers such as Balzac, were made, but these are dry replicas, inexpressive and dormant as they lie on cushions or other bases. Despite the fact it is holding a small sculpture, the life cast of Rodin's hand (cat. no. 194) suffers similarly when compared with those he modeled from living subjects. John Tancock cited two nineteenth-century precedents in focusing on hands: Victor Hugo's drawing of an upward-stretched hand (Rodin's great interest in the writer would have been an incentive to search out his drawings), and perhaps even more important, Eadweard Muybridge's photographic studies of hands in motion, which he made while working for Governor Leland Stanford of California. In 1887 Rodin was a subscriber to Muybridge's publication.[9] Jacques de Caso and Patricia Sanders refer to early nineteenth-cen-

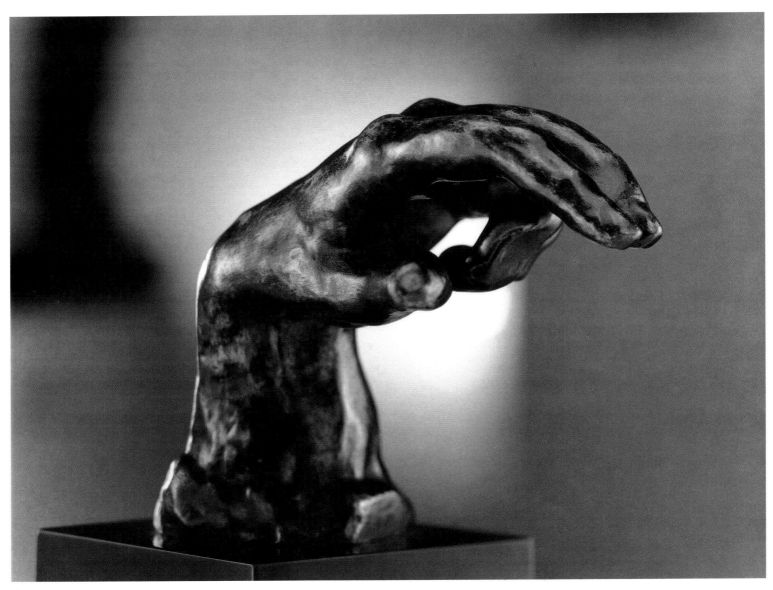

Fig. 472.
Blessing Left Hand (cat. no. 187).

tury literature and descriptions of magical and menacing hands in horror tales as possible influences.[10] Over his lifetime Rodin created an inventory of plaster hands that is amazing in its size and range. We may never know exactly when Rodin began to make separate studies of hands, but probably it dates to his very beginnings as a sculptor. At the Petite école in the mid-1850s he was taught to study figural parts. A photograph taken of his *Saint John* while still in the studio shows the final figure without a right hand.[11]

It was Rodin's practice to have assistants who had a special aptitude, such as Camille Claudel, spend uncounted hours making hands and feet of various sizes, which went into his inventory on shelves and in drawers where they were always within his reach. "Rodin had notably assigned to [Claudel] the modeling of hands, or feet, of many of his personages. At this time [1898] one would find in the rue de l'Université studio, many of these hands, some elegant and svelte, others knotted and clenched, that the master preserves preciously as fragments of the most rare perfection."[12] That the hands vary considerably in modeling may be explained by this division of assignments between the artist and his assistants as well as by Rodin's own evolution. On stylistic grounds, given the smoothness of its finish, anatomical normalcy, and undramatic character, it is possible that Stanford's

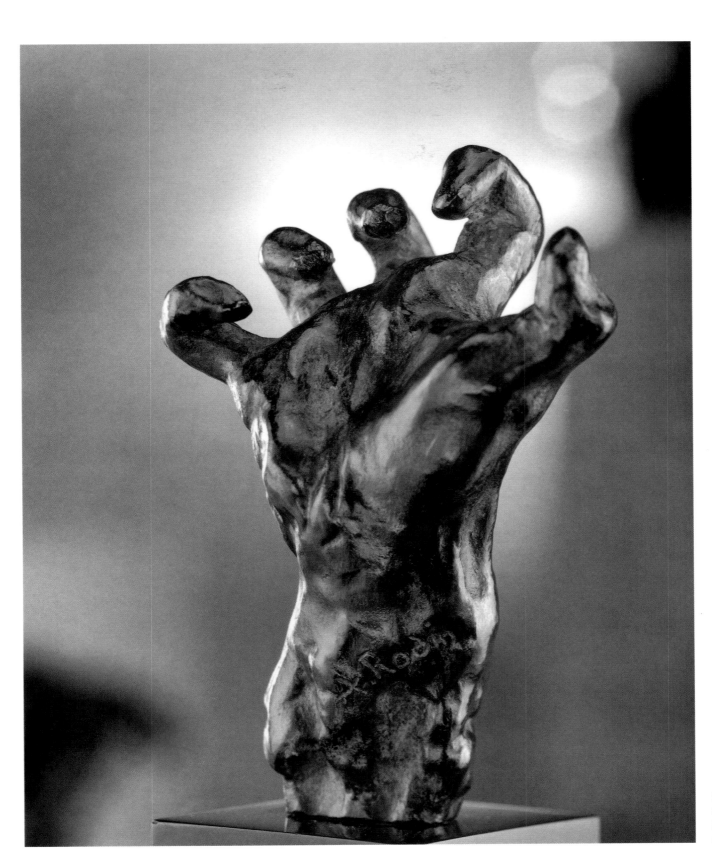

Fig. 473. *Small Clenched Right Hand* (cat. no. 188).

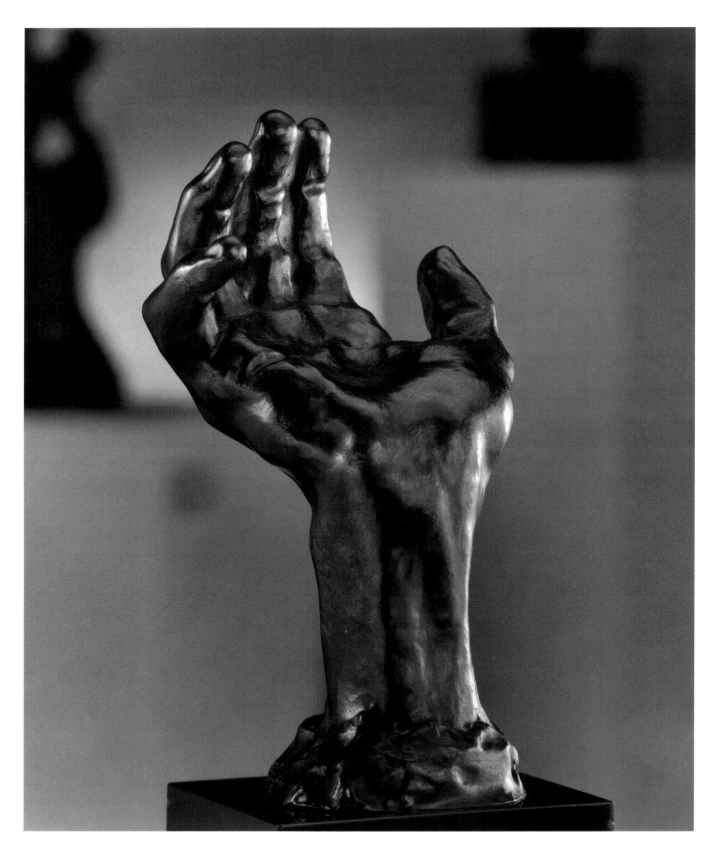

Fig. 474. *Right Hand* (cat. no. 189).

Right Hand (fig. 474) was made by Claudel, perhaps at the time she was working on hands for *The Burghers of Calais*. Rodin was reported to have destroyed many sculptures of hands, but it is probable that they were those that did not please him and that were made by his aides.[13]

Often the hands in terra-cotta or plaster were not mounted and lay on shelves or in drawers like stocks of spare parts (see fig. 10). A major reason for this was that Rodin enjoyed studying them from all angles, and given the way he worked on *The Gates of Hell*, he could not always be sure in what orientation a hand might be seen if attached to a figure. *Left Hand of Eustache de Saint-Pierre* (cat. no. 14), for example, was mounted upright presumably by direction of the Musée Rodin when it was bronze cast, but when affixed to the wrist of the full figure it hangs downward. A photograph in the Stanford collection shows what was probably this study suspended from a string so that Rodin could in a detached and highly focused way test its expressiveness in that orientation and from the angle he told D. Freuler to photograph it (see fig. 78). Rodin flattened the tops of the second and third fingers so that inverted and free of a base the hand could stand by itself. Noticeably flattened for the same purpose were the fingers of the *Large Clenched Left Hand* (fig. 475). Some bronze hands are attached with roughly fashioned, braceletlike bases to wooden or bronze socles so that they can be seen upright. Leo Steinberg put it well, "Now they stand flat-footed on platformed wrists, fingers skyward in prophetic pretentiousness."[14] On bases they are deprived of their expressive potential and are often more eloquent when seen in other positions. An excellent example is the upright left hand displaying a gesture similar to that of a blessing, *Blessing Left Hand* (fig. 472). In *The Gates of Hell* that gesture is inverted and given by a naked woman just behind *The Thinker* so that the gesture cannot be seen from ground level. De Caso and Sanders wrote about this work in its upright stance, associating it with a Black Mass described by Joris-Karl Huysmans: "The blessing gesture, made with the left hand rather than the right, adds a satanic note."[15]

At about the time Rodin was making these hands, probably in the 1880s, the École des beaux-arts textbook by Charles Blanc had this to say on the subject: "That which one calls the extremities, the feet and the hands, are . . . the most individual. . . . The feet and the hands nevertheless have a general character and a normal beauty. For the hands, this beauty consists in a moderate fullness that does not go so far as to produce dimples, but suppresses all dryness in the area where ordinarily the veins come together, and that covers the articulations, while indicating their presence by firm or soft shadows according to the sex, and not by nodes and folds."[16] There is no evidence that from the time of his first exhibited statue, *The Age of Bronze* (cat. nos. 1–3), Rodin idealized or generalized the hands. Stanford's *Large Left Hand* (fig. 477), later used in the marble sculpture *Hand of the Devil* (1903), distances Rodin from Blanc by its stress on the skeletal structure and extreme curvature of the lean thumb and fingertips.[17] Uninterested in such theories as Blanc's, Rodin made hands from life, and their owners seem to have been of different ages (sometimes shown by the finger joints and prominence of the veins) and even states of health. Some suffered from neurological problems (for example, *Left Hand*, fig. 476, with its partially flexed fingers), others from rheumatism, while some had experienced accidents).[18] Some have speculated, without corroborating evidence, that Rodin visited hospitals and there, working with a ball of clay carried in his pocket and without an armature, modeled the hands (and feet) of patients.[19] So thorough was his knowledge of internal as well as external anatomy, so observant and skillful was he in their realization that hand surgeons can identify neurological and other disorders in the hands he made.[20]

The most dramatic examples of Rodin's interest in the deformity of human hands are the *Large Clenched Left Hand* (fig. 475) and *Small Clenched Right Hand* (fig. 473). Discussing the enlarged version of the latter, also known as *The Mighty Hand*, de Caso and Sanders noted the image of convulsive hands in nineteenth-century literature.[21] Both sculptures represent what is known as claw hand, a cosmetically unattractive and psychologically traumatic affliction caused by paralysis of the median and/or cubital nerves in the wrist and scarring of muscles in the forearm.[22] The result is atrophy of the muscles and deformation of the fingers, but as seen in Rodin's hands the thumb's thenar and hypothenar muscles have not atrophied. When Rodin had the *Clenched Left Hand* enlarged to over life-size, the deformations became exaggerated. Neither Hugo's drawings of hands nor French romantic horror stories shaped these hands. Following his practice, Rodin probably did not impose the gesture on his handicapped subject in order to obtain some lurid effect. He observed it and was obviously taken as a sculptor with what happened when the damaged man strained

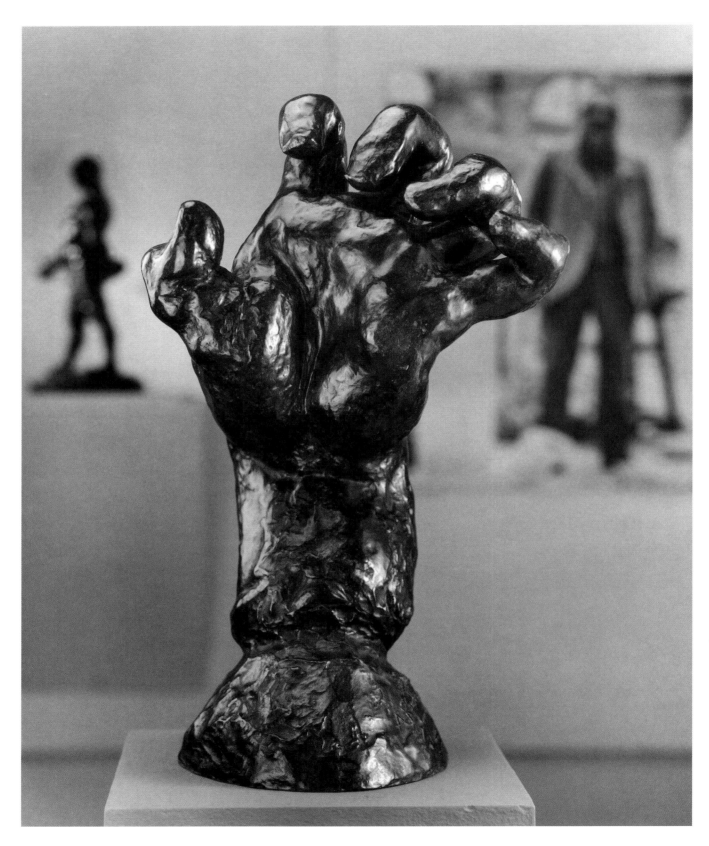

Fig. 475. *Large Clenched Left Hand* (cat. no. 190).

but could not open and extend his fingers.[23] For an artist who had redefined sculpture down to the hole and the lump, this was a challenge demanding the most careful observation: "I have had to work very much in order to attain this maximum of truthful expression in the fitting together of the planes [*le modelé*] of the hand. The study of the human hand is full of difficulties."[24]

When he made *Large Clenched Left Hand* and paired it with *Imploring Woman* to create *Large Clenched Left Hand with Figure* (cat. no. 193, fig. 480) Rodin may have recollected the romantic horror stories, if, in fact, he had read them. Although it has often been suggested that they were a study for one of the burghers of Calais, there is no evidence connecting either of the clenched hands with this project. It may have been in the period 1884–89, however, when working on *The Burghers of Calais* and having to re-create down to their fingertips six life-size male victims that Rodin gave such studies special attention.[25]

The most conclusive evidence of Rodin's conviction that some of his modeled hands were self-sufficient, even when he had used them as part of full figures, lies in their enlargement, notably the *Large Clenched Left Hand*, and their carving in marble, especially *The Hand of God* (c. 1896). Ignoring size discrepancies, Rodin used an enlarged hand as a surrogate in conjunction with a partial figure or with a head to create dramatic encounters such as *Large Clenched Hand with Figure*. His *Hand of God* holding the forms of Adam and Eve is a reminder of Rodin's view that the Creator was a modeler and that the artist like himself could be godlike. Rodin also credited Satan with the same gift, as seen in his *Hand of the Devil* (1903).[26]

Adding to our understanding of Rodin's goal for the hands are Rainer Maria Rilke's observations on the "secret" of Rodin's art: "A piece of arm and leg and body is for him a whole, a unity, because he no longer thinks of arm, leg and body (that would seem to him too thematic, you see, too *literary*, as it were), but only of the *modelé* which is self-contained and which in a certain sense is ready and rounded."[27] It is also from this poet that we have a good sense of Rodin's criterion of completeness: "self-absorption" or having no "movement that does not complete itself within the [sculpture] . . . that which gave distinction to a plastic work of art was its complete self-absorption. It must not demand or expect aught from outside; it should refer to nothing that lay beyond it."[28]

Rodin has often been associated with the symbolist movement, which emerged in France during the 1880s.

He was neither a formal adherent nor in his themes a literary symbolist.[29] Confessing to the occasional addition of an object or name that might broaden a sculpture's reference, Rodin was what might be called an intuitive or natural symbolist, one who believed that treating the specific in nature, like a body movement or hand gesture, would inspire different associations in the beholder's mind as it had in his. The sculptor fervently believed in nature's comparative anatomy. Describing a visit in 1898 to the sculptor's studio, Judith Cladel reported her real or imagined companion's commenting to the artist, "'These hands,' said Claire, in designating a study of hands, clenched, as if to claw and bite, 'these hands resemble the talons of a vulture.' Rodin replied, 'But yes, when one follows nature one obtains everything. Since I have a beautiful body of a woman as a model, the drawings that I take from it give me the images of insects, birds, fish.'"[30]

When Rodin covered its base with a flannel blanket and had the *Small Clenched Right Hand* serially photographed from many angles by Eugène Druet (figs. 478–479), he was illustrating his point about nature's comparative anatomy as well as his belief that his sculptures should be seen from all perspectives.[31] The series was published in the special edition of *La plume* devoted to Rodin in 1900, and some of the photographs accompanied the short article by the symbolist writer Gustave Kahn, who was encouraged by the artist to use them. Kahn's brief appreciation, "Les mains chez Rodin," is like Claire's reaction in Cladel's book and illustrated Rodin's views on the evocative potential of this clenched hand: "Rodin is the sculptor of hands, furious hands, clenched, in revolt, damned. Here is a formidable one that crawls, violent, furrowed with crevasses, with a strained tentacular movement, with a movement like an unnatural beast, crippled, marching toward an invisible enemy on bloody stumps."[32]

Three years later, and in the same vein as Kahn, Rilke published the most poetic and extensive reading of the hands he saw in Rodin's studio, about which he must have conversed with his employer:

There are among the works of Rodin hands, single, small hands which, without belonging to the body, are alive. Hands that rise, irritated and in wrath; hands whose five bristling fingers seem to bark like the five jaws of a dog of Hell. Hands that walk, sleeping hands, and hands that are awakening; criminal hands, tainted with hereditary disease;

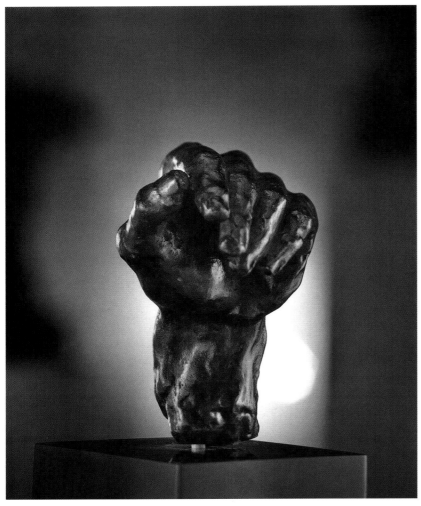

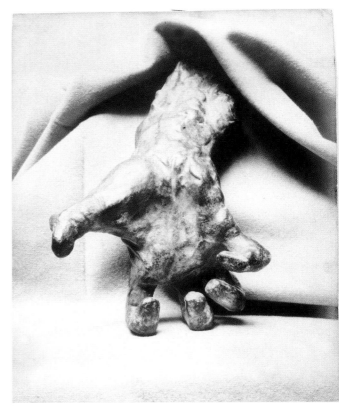

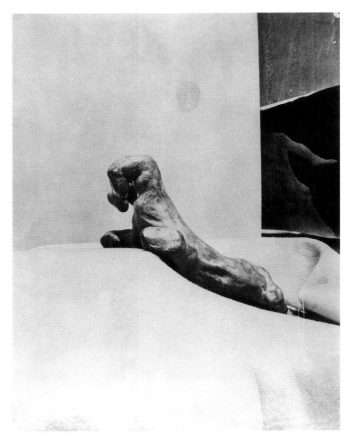

Above: Fig. 476. *Left Hand* (cat. no. 191).

Top right: Fig. 478. Eugène Druet, *Clenched Right Hand Masked with a Blanket* (A129).

Bottom right: Fig. 479. Eugène Druet, *Clenched Right Hand Masked with a Blanket*, c. 1898, gelatin silver print. Musée Rodin, Paris.

and hands that are tired and will do no more, and have lain down in some corner like sick animals that know no one can help them. But hands are a complicated organism, a delta into which many divergent streams of life rush together in order to pour themselves into the great storm of action. There is a history of hands; they have their own culture, their particular beauty; one concedes to them the right of their own development, their own needs, feelings, caprices, and tendernesses. Rodin, knowing through the education which he has given himself that the entire body consists of scenes of life, of a life that may become in every detail individual and great, has the power to give to any part of this vibrating surface the independence of a whole. As the human body is to Rodin an entirety only so long as a common action stirs all its parts and forces, so on the other hand portions of different bodies that cling to one another from an inner necessity merge into one organism. A hand laid on

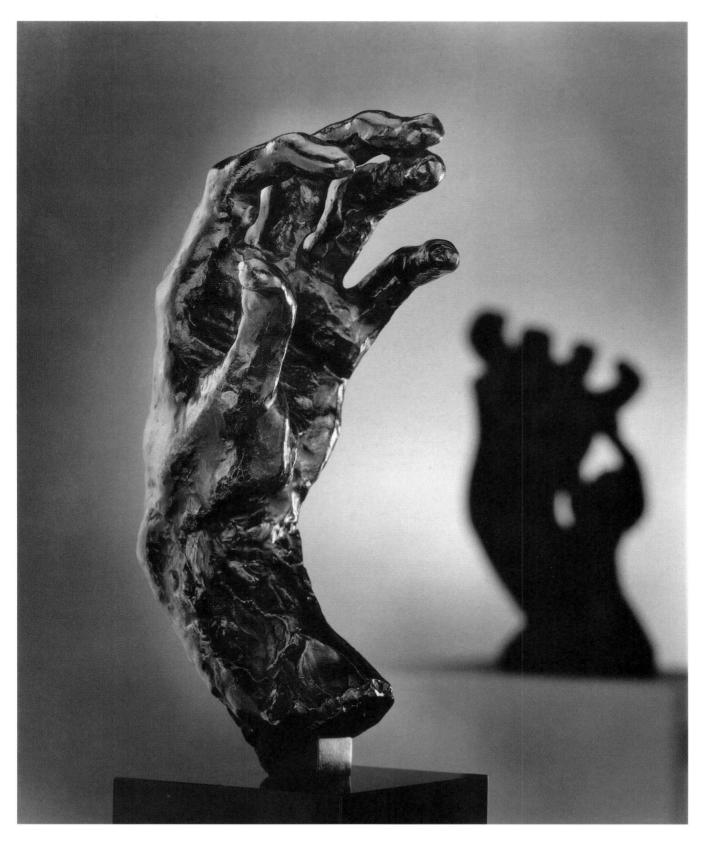

Fig. 477. *Large Left Hand* (cat. no. 192).

another's shoulder or thigh does not any more belong to the body from which it came—from this body and from the object which it touches or seizes something new originates, a new thing that has no name and belongs to no one.[33]

Rodin seems to have first exhibited his partial figures in 1889 in the friendly environs of a private gallery owned by a venturesome and sympathetic dealer, Georges Petit, rather than in the salon. Perhaps he felt freer there to display his études and works from his *Gates of Hell* that were still in progress. The great critical success of this exhibition shared with Claude Monet may have confirmed in Rodin's mind the appropriateness of showing publicly what had been reserved previously for the privacy of the studio and that his études had parity with finished sculptures because the well-made part was an artistic whole.[34] (It was probably not lost on Rodin that Monet's paintings had suffered the criticism of being unfinished by contemporary standards.)

According to Alain Beausire's careful documentary research, Rodin may have begun to exhibit certain hands in 1896, but thereafter he seems to have restricted his choices to only a few. It should be remembered that Rodin had hundreds of other sculptures he was eager to show internationally, and by 1901 his pavilion had become a veritable Musée Rodin for thousands of visitors who could see there numerous hands in vitrines. *The Clenched Hand* in the small and enlarged versions was exhibited at least seven times between 1896 and 1917 in Paris, Prague, Rome, and Munich. *The Hand of God* was the most frequently exhibited, having been shown twelve times between 1896 and 1917. It was displayed in England, New York, and several European cities.[35]

NOTES

LITERATURE: Kahn 1900; Rilke [1903] 1945 in Elsen 1965a, 123–24; Schmoll 1954, 117–39; Spear 1967, 79; Elsen 1969, 20, 24; Steinberg 1972, 338–39; Tancock 1976, 616–20; de Caso and Sanders 1977, 323–25; Judrin, Laurent, and Viéville 1977, 180, 183–86, 199–201; Janson 1981, 289–304; Laurent, Merle, and Gutmann 1983, 61–62, 80, 84–87; Miller and Marotta 1986, 148; Ambrosini and Facos 1987, 137; Pingeot 1990, 171–95; Le Normand-Romain 2001, 118

1. Georges-Michel 1942, 264.
2. On hands in sculpture, see Janson 1981.
3. Laurent, Merle, and Gutmann 1983, 67; Gutmann properly pointed out that this figure does not include casts

destroyed, sold, or given away. In 1962 Leo Steinberg had access to the Meudon reserve and estimated "some 150 small plaster hands, two to five inches long" (1972, 339). In his view "they had no purpose but to be picked up and revolved gingerly between fingers."
4. The gesture of *Blessing Left Hand* (cat. no. 187) is similar to that shown by a right hand illustrated in Laurent, Merle, and Gutmann 1983, fig. 55.
5. Both hands are discussed and reproduced in Judrin, Laurent, and Viéville 1977, 180–86.
6. How he worried over the hands of *Eustache* can be seen in photographs in which the senior burgher's hands have been bandaged or are missing fingers. See figures 77 and 79 and Elsen 1980, pl. 53.
7. This history is summarized in Elsen 1969. See Schmoll 1954 for a historical discussion of the sculptural fragment; and Janson 1981.
8. For a reproduction of this sculpture, see Laurent, Merle, and Gutmann 1983, 106.
9. Tancock 1976, 616–17, 620–21. To this author's knowledge Rodin's copy of Muybridge's book is not in the Musée Rodin library.
10. De Caso and Sanders 1977, 323, 325 n. 1.
11. This photograph was reproduced in Elsen 1980, pl. 9. Matisse later was told by the model who served for *Saint John* and his own *Serf* that Rodin would take the hand off and put it on a peg to study it before reattaching it to the wrist. This was partly the basis of Matisse's misunderstanding that Rodin composed inductively while he worked deductively. Matisse wrote in his "Notes of a Painter" (1907), "I could mention the name of a great sculptor who produces some admirable pieces but for him a composition is nothing but the grouping of fragments and the result is a confusion of expression." Quoted in Alfred Barr, *Matisse: His Art and His Public* (New York: Museum of Modern Art, 1974), 121.
12. Morhardt 1898, 721.
13. De Caso and Sanders (1977) quoted Anita Leslie (*Rodin, Immortal Peasant* [New York: Prentice-Hall, 1937], 219) as saying, Rodin had "modeled 12,000 hands and smashed up 10,000" (315, 317 n. 11). The other sources cited by these authors as witnessing Rodin's willingness to discard unwanted plasters of hands by gift and destruction are more reliable as they are contemporary with the artist.
14. Steinberg 1972, 339.
15. De Caso and Sanders 1977, 327.
16. Charles Blanc, *Grammaire des arts du dessin* (Paris: Renouard; H. Laurens, 1880), 387.
17. For a reproduction of *The Hand of the Devil*, see Laurent, Merle, and Gutmann 1983, 79. Gutmann dated this hand to 1903 on the basis of its proximity to the carved marble of that year (81).
18. Ibid., 61, for a discussion by Michel Merle (Faculty of Medicine, Nancy) of the neurological disorder possibly reflected in *Left Hand*.
19. This reasonable conjecture is repeated by Gutmann, ibid., 67.

20. In fact, a conference of hand surgeons convened at the Musée Rodin in 1983. The excellent catalogue prepared in conjunction with the conference (Laurent, Merle, and Gutmann 1983) contains not only analyses of sculptures showing abnormalities but also explanations demonstrating that certain hands that appear deformed are normal.

21. De Caso and Sanders 1977, 323–25, 325 n.1.

22. The author thanks his colleague Dr. William Fielder, a retired hand surgeon, who tutored him in this subject in front of the sculptures. The median nerve assures the flexibility of the wrist and fingers, while the cubital nerve allows the inclination of the wrist and affects the strength of the fingers to squeeze. There is an informative essay on the anatomy and physiology of the hand by Michel Merle in Laurent, Merle, and Gutmann 1983, 23–29.

23. As part of their therapy, Dr. Robert Chase (retired from Stanford University Medical School) would at times recommend that his patients with claw hand look at Stanford's Rodin collection to see how a great sculptor had made beautiful and powerful art from their affliction.

24. Armand Dayot, "Le Musée Rodin," *L'illustration*, 7 March 1914.

25. De Caso and Sanders saw the *Clenched Right Hand* as probably executed at the same time as the first studies for the door, which would have been in 1880 (1977, 323, 325 n. 2). They made this judgment on "stylistic evidence" and that the mood of pain and suffering in this hand is akin to the atmosphere of *The Gates of Hell*. Absent more evidence, acceptance of this early date is not universal.

26. For further discussion of these hands, see Gutmann in Laurent, Merle, and Gutmann 1983, 72, 79.

27. Rilke to his wife, 1902, quoted in Steinberg 1972, 368.

28. Rilke in Elsen 1965a, 120–21.

29. The best discussion of this subject remains that of Robert Goldwater in *Symbolism* (New York: Harper and Row, 1979), 162ff.

30. Cladel 1903, 91.

31. The dating of these photographs is from Pinet 1985, 56–59. See also Le Normand-Romain 2001, 337–41.

32. Kahn 1900.

33. Rilke in Elsen 1965a, 123–24.

34. De Caso and Sanders wrote, "Acceptance of the fragment was facilitated by the growing philosophical tendency to view life as unfixed and unstable and in a continual process of *becoming*" (1977, 315); they cited Charles Morice's defense (*Rodin* [Paris: H. Floury, 1900], 16–17) of Rodin's fragments as reflecting this influence (316–17 n. 9). The critical enthusiasm and articulate defense of Rodin's *morceaux* came probably not so much from the influence of philosophers but from the access writers such as Morice, Judith Cladel, Gustave Geffroy, and Armand Dayot had to Rodin himself and from his own substantial reflections on finish and observations about how nature was always in a state of becoming. Rodin was neither theoretically inclined nor philosophically educated, and there is no evidence that he had read Schopenhauer, Hegel, and Bergson, who are cited by de Caso and Sanders as having prepared a nourishing climate for Morice's views. On the contrary, Rodin's views could have made writers like Morice, who had access to Rodin, susceptible to the current philosophical ideas. Rodin may have imposed his ideas on critics and public.

35. Beausire 1988, 402. As a catalogue entry might only cite *"Clenched Hand,"* without designation of which hand, it is not always possible to determine which was shown.

193

Large Clenched Left Hand with Figure (Grande main gauche crispée avec figure) c. 1890 or c. 1907

- Title variations: *Large Clenched Hand with Imploring Woman, Mighty Hand with the Torso of Invocation, Supplication*
- Bronze, E. Godard Foundry, cast 1972, 6/12
- 18 x 12 x 10½ in. (45.7 x 30.5 x 26.7 cm)
- Signed on front, lower edge: A. Rodin
- Inscribed on back, lower edge, at right: E. Godard/Fondr. Paris.; below signature: No. 6; on lower edge, left side: © by Musée Rodin 1972
- Provenance: Musée Rodin, Paris

- Gift of the Iris and B. Gerald Cantor Foundation, 1974.47
Figure 480

*I*t was Rodin's fancy at times to join separately made sculptures even though they represented figural parts of different scales, as here in an over-life-size hand and an under-life-size upper portion of a woman. The woman is herself an assemblage of parts from Rodin's repertory and had an alternate history as the upper portion of *The Centauress* (cat. no. 158). In addition, her head, arms, and shoulders, which seem male, were joined to a woman's torso.[1] The woman's hands are rudely indicated, as if bent back rather than extended forward.

For this mix of scales, gender, and finish there was no precedent in nineteenth-century sculpture. There is no evidence that in concocting this duet Rodin had any story as a motive, but knowing his audience, the sculptor must have realized that by establishing a provocative situ-

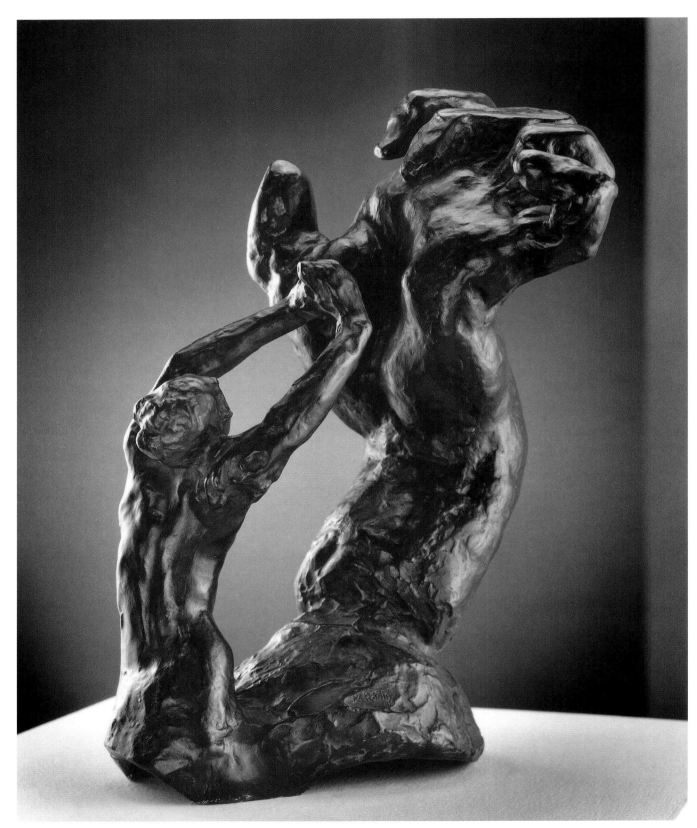

Fig. 480. *Large Clenched Left Hand with Figure* (cat. no. 193).

ation, others would provide their own narrative As one moves around the sculpture, the woman can be seen in differing relationships to the hand, so that from some viewpoints she is totally encompassed, and from others, such as from the sides, it is as if the hand is recoiling before her thrust.

Although he was photographed with this sculpture in plaster in December 1906 (fig. 481), we do not know the exact date of the joining of the hand and the woman's torso.[2] Based on a comparison of the plaster shown in the 1906 photograph with the bronze in the Stanford collection, it would appear not surprisingly that Rodin varied the angle in which the woman would be posed in relation to the large hand.[3] The more upright position of the woman in the Stanford cast makes for a more cubic composition when seen from the sides. The irony in the melodramatic confrontation of what in this context seems the menacing force embodied in the hand and the defenseless woman is that the former is afflicted with paralysis of the median and cubital nerves, which prevents fully opening and extending the fingers.[4] Even more than when seen by itself, in this context Rodin encouraged the beholder to view the hand as a surrogate figure and to view anatomical deformity as sculptural form.

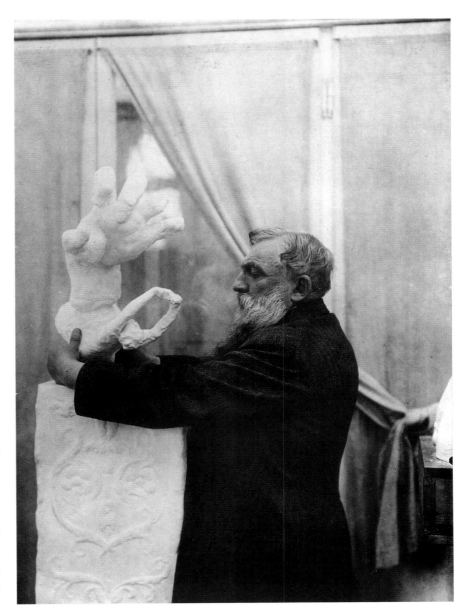

Fig. 481. Photographer unknown, *Rodin Installing "Large Clenched Left Hand with Figure,"* 1906. Musée Rodin, Paris.

NOTES

LITERATURE: Jianou and Goldscheider 1967, 94; Tancock 1976, 620; de Caso and Sanders 1977, 325; Fusco and Janson 1980, 345–46; Laurent, Merle, and Gutmann 1983, 84; Schmoll 1983, 109, 120; Gassier 1984, 116; Pingeot 1990, 243–45; Barbier 1992, 24; Levkoff 1994, 143

1. Barbier observed (in "Assemblages de Rodin," in Pingeot 1990) that the figure's arms were perhaps derived from the *Despairing Adolescent* (c. 1882), 242. See also Butler (in Fusco and Janson 1980, 356) and Laurent (in Gassier 1984, 116), for discussion of the evolution of the entire figure from this source.

2. Monique Laurent stated that the hand was a study for *The Burghers of Calais*, but there is no evidence for this (Laurent, Merle, and Gutmann 1983, 84, citing Laurent's *Auguste Rodin*, exh. cat. [Mexico City: Museo del Palacio de Bellas Artes, 1982], 74).

3. Based on the 1906 photograph, Barbier suggested that the bronze version, with its more vertical figure, was derived from the photographed plaster variant and may date around 1907 ("Assemblages de Rodin," in Pingeot 1990, 243–45).

4. This condition was discussed by Merle (in Laurent, Merle, and Gutmann 1983, 62) in connection with the *Small Clenched Right Hand* (cat. no. 188).

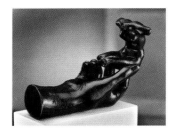

194

Cast of Rodin's Hand with a Small Torso (*Moulage de la main de Rodin tenant un torse*), 1917

Fig. 482. *Cast of Rodin's Hand with a Small Torso* (cat. no. 194).

- Bronze, Georges Rudier Foundry, cast 1973, 8/12
- 7 x 9 x 15½ in. (17.8 x 22.9 x 39.4 cm)
- Signed on right side of wrist: A. Rodin
- Inscribed on wrist, left side: Georges Rudier/Fondeur. Paris; on back of wrist: © by Musée Rodin 1973
- Provenance: Musée Rodin, Paris
- Gift of the Iris and B. Gerald Cantor Foundation, 1974.48

Figure 482

In her moving pages about the end of Rodin's life, Judith Cladel wrote that three weeks before the artist's death, "One afternoon, the moldmaker Paul Cruet, on the order of the absent M. Bénédite [the first curator of the Musée Rodin], took a cast of Rodin's hand. I would have liked for the master himself to direct this small operation; but docile, he let it take place with that sheeplike sweetness that he owed to his illness. Cruet managed with skill."[1]

Taking death masks and casts of the hands of famous artists and writers such as Honoré de Balzac was a long-time practice, but what is unusual in Rodin's case is the presence of the small torso in his hand. Instead of the customary extended empty hand, palm down or up, that of Rodin with its long fingers was positioned to perform a function. Unanswered is the question of whether it was Cruet or Rodin who had the brilliant idea of adding the sculpture that transformed this mundane replica into such a distinct and provocative attribute of a great sculptor? Cladel, who it would seem did not actually witness the event, as she makes no comment about the small torso, was silent on the matter, and one wonders then how she could write that the old artist was docile in the operation. It is obvious from the fingers that Rodin's hand was first placed in a position to hold this exact sculpture before the mold was made.[2]

Writing of his last weeks, Cladel reported that Rodin was denied not only materials for drawing, out of

Bénédite's fear that he would sign a new will offered by one of his relatives, but also tools and clay. Cladel regretted this denial: "Who knows if he would not have been capable of modeling a sketch . . . with his fingers whose skill had become a second instinct." At the end Cladel observed that, despite the severity of his illness, three aspects of his personality continued to manifest themselves: "the sense of art, an affectionate sensibility, and his customary courtesy." Further, Cladel actually witnessed Rodin, deprived of his tools and clay, using a scarf or handkerchief to plug the holes or cavities in his early animated bust of Rose, "to simplify the work of his youth by suppressing an excess of depressions and projections."[3] All this suggests that Rodin, who hated clichés, rather than the good moldmaker Cruet, had the presence of mind to add the torso.

Several commentators have made the felicitous comparison of Rodin's last artistic gesture with his *Hand of God* (c. 1896) and *Hand of the Devil* (1903).[4] In addition to affirming his role as God's rival as a creator, something he had done in his self-portrait in *The Gates of Hell* in the lower-right doorjamb (see fig. 126), there were two other possible motives for the addition of the torso. First, at the end of his life and assuming that his long-term memory was still functioning, Rodin had the chance to prove once and for all that the 1877 charges that he had cast *The Age of Bronze* (cat. nos. 1–3) from the model were false by juxtaposing the dry mechanical record of the life cast with his tiny torso that had so much more animation in it.[5] Second, by choosing and seeming to offer the torso with his extended hand, Rodin was giving future sculptors the lessons of a lifetime in his last artistic will and testament: the beauty of his beloved métier as a modeler, the partial figure and all that it implied. As he put it, "My *morceaux* are the examples that I propose for artists to study."[6]

NOTES

LITERATURE: Cladel 1936, 402–3; Grappe 1944, 139; Elsen 1969, 28; Tancock 1976, 637; Laurent, Merle, and Gutmann 1983, 76; Schmoll 1983, 120; Miller and Marotta 1986, 149–50; Ambrosini and Facos 1987, 141; Pingeot 1990, 174–75; Barbier 1992, 81, 84; Butler and Lindsay 2000, 406–8

1. Cladel 1936, 402.
2. It is also possible that the small sculpture was already in the house, as was his portrait of the youthful Rose. Cruet had not only made molds for Rodin but had "acted as detective in London" in the matter of Rodin forgeries discovered there (Tirel 1925, 213).
3. Cladel 1936, 402.
4. See especially Danièle Gutmann's observations in Laurent, Merle, and Gutmann 1983, 76.
5. Rodin was actually exonerated from the false charge by some sculptors looking into the matter for the undersecretary of fine arts, who had seen him fashioning small figures in his studio.
6. Cladel 1908, 98.

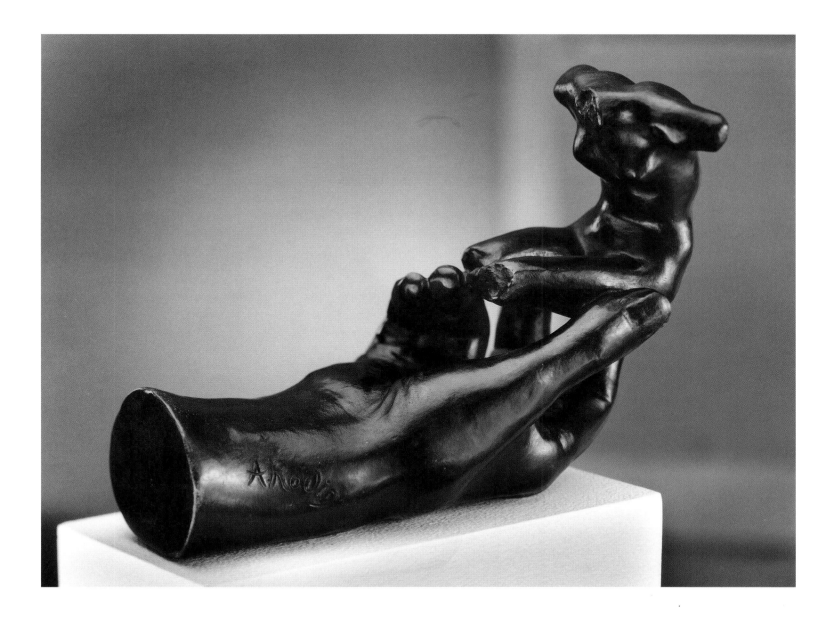

195

Small Torso (Petit torse, type A), n.d.

- Title variations: *Small Seated Torso A; Small Torso A*
- Bronze, Georges Rudier Foundry, cast 1960(?)
- 4 x 3¼ x 3¼ in. (10.2 x 8.3 x 8.3 cm)
- Signed below left thigh: A. Rodin
- Inscribed below right thigh: George[s] Rud[ier]/[Fond]eur Paris; below left thigh: No II/© M[usée] Rodin 1960 [?]
- Bequest of Dr. and Mrs. Harold C. Torbert, 1984.539

Figure 483

A plaster cast of this torso was placed in the life cast of Rodin's hand made shortly before his death (cat. no. 194). It not only identified the hand's owner as a sculptor but served as his offering to sculptors of the future: an artistic testament. It was in this context that Georges Grappe reproduced it, but he did not give us a history of its previous lives in Rodin's art, and until the inventory of plasters at Meudon is available, its biography may not be known.[1] The literature has noted the torso as a fragment possibly related to *The Gates of Hell* and dating from the 1880s.[2]

The figure at first seems to be in a seated posture, and the stumps of the upper arms extend outward and back. There is neither head nor lower legs. The bent pose allowed Rodin fully to realize the woman's curved back. The buttocks are rounded, suggesting that the model was not seated on a support. (Perhaps she

was kneeling.) The hipbones are allowed to protrude, showing Rodin's democratizing of beauty, love of the skeleton, and willingness to mate, rather than minimize, the structure of the body with the work of art. This small sculpture therefore serves as a kind of summation of Rodin's ideas for sculpture at the end of his life. The subject comes not from literature but from life: a supposedly stationary form animated by a natural movement. Artistically the subject is the fitting together of surface planes seen from every angle or profile. Here celebrated are life and modeling. The rough termination of the limbs and neck suggests that there may not have been a full figure,

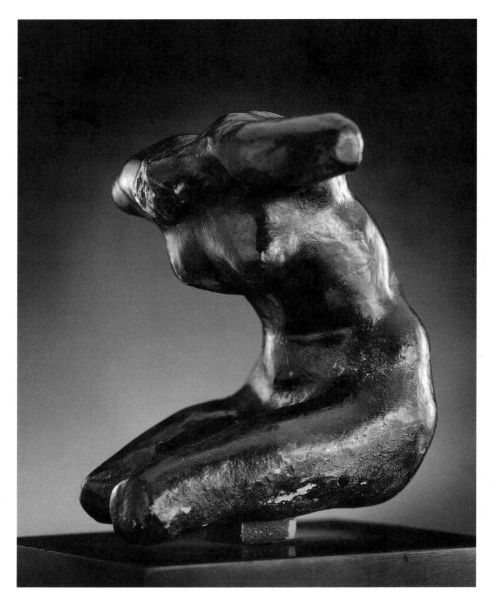

Fig. 483. *Small Torso* (cat. no. 195).

as Rodin anticipated that this bodily core could be self-sufficient as a sculpture. Rodin was laying down the premise that for artistic purposes the human form was infinitely divisible and parts dispensable.

The lesson for sculptors was that with a partial figure proportions and the rhyming of anatomical shapes—breasts, knees, and buttocks—benefited from the absence of the whole body. If held up at eye level and viewed from the rear, for example, the dorsal area hides the truncated neck and it is like an abstract form. Rodin's cubism, using an invisible cubic container to guide his editing, also determined the overall harmony of the piece. Thus reaffirmed by the artist in his last moments is the concept that artistic completeness replaces salon finish. Most important and prophetic, the figure has no modeled base. The sculpture enters the world of objects having lost the special status previously conferred by a base and pedestal. Just as it had been modeled in the artist's hand, with no need of an armature, so when completed its destiny was to be free of gravity and to live its future lives in the beholder's hand or in any orientation its possessor would chose.

NOTES

LITERATURE: Goldscheider 1962, 71; Tancock 1976, 637; Barbier 1992, 81–82, 84–85

1. Grappe 1944, 139. The torso exists in a winged version (Barbier 1992, cat. no. 66; Le Normand-Romain and Marraud 1996, 108).
2. Tancock 1976, 637.

Ceramics

The Stanford collection includes two small ceramic plaques, which serve well to represent Rodin's output in this medium at the Sèvres Porcelain Manufactory. Rodin was among the artists working at Sèvres under the direction of Albert-Ernest Carrier-Belleuse in the last quarter of the century, when France was engaged in revitalizing its traditions of artistic decoration and technical innovation. The plaques reflect the eighteenth-century spirit, style, and techniques of the designs he created for vases.

There are two additional ceramics in the Stanford collection. A stoneware *Bust of Jean d'Aire* (cat. no. 20) is discussed with *The Burghers*, and the *Crying Girl* mask (cat. no. 59) is discussed with *The Gates of Hell*. Rodin's collaborations with ceramist Paul Jeanneney for the bust and Edmond Lachenal for the mask demonstrate his interest in occasionally experimenting with alternative sculptural media, particularly to create replicas of his works.

196

Springtime (Le printemps), c. 1880–82

- Title variations: *Allegory of Spring, Nighttime*
- Glazed porcelain plaque with applied design by Rodin
- 4¼ x 3⅛ in. (10.5 x 8 cm)
- Inscribed in ink on verso: à Sèvres 1880/Auguste Rodin/décembre 1907/à mon amie la/Comtesse Basily/Callimaki; in pencil on verso at right edge: Dessin par Rodin; incised in another hand (?) on verso at left edge: Gris de Platine foncé; in pencil on upper part of verso: un plan/[?]/forme [?]
- Provenance: Countess Eva de Basily-Callimaki; Nicolas de Basily; Lascelle de Basily
- Gift of Mme. Lascelle de Basily, 1974.192.2

Figure 484

*T*he design known as *Springtime* or *Allegory of Spring* is one that Rodin applied to a small rectangular decorative plaque in Sèvres porcelain. It is one of two small plaques (see cat. no. 197) in the Cantor Center's Rodin collection, both similarly inscribed by Rodin, "à mon amie la Comtesse Basily Callimaki" and dated December 1907. This plaque is further inscribed "à Sèvres 1880," suggesting that the design issues from the period when Rodin worked intermittently at the Sèvres Porcelain Manufactory, beginning in June 1879 through the end of 1882.[1] He served as a decorative artist to support himself and his family, designing works that reflect an eighteenth-century sensibility. They include decorative floral motifs, sensual rococo figural types, intimate groups of women and infants often in allegorical guise, and a light-filled ambiance evoking the refined manner of the eighteenth-century sculptor known as Clodion (Claude Michel, 1738–1814), as well as Albert-Ernest Carrier-Belleuse, who became director at Sèvres in 1875.[2] While recalling the small scale and intimacy of rococo groups, the nude woman in Rodin's plaque also betrays the muscular figural types, expressive, simplified contours, and truthful emotions typical of Rodin's sculpture of the early 1880s.

Springtime depicts a standing, frontal nude woman, encircled by putti, some of whom are winged; five float in an arc behind her head. With her right arm, she reaches across her body to support another infant at the center of the arc of putti. The child is propped high on her shoulder and leans toward her face. At the same time the woman touches (or perhaps holds off) with the back of her hand the rightmost infant in the arc. The head and upper body of the woman are thrown back as the infants impinge on her, her expression suggesting a sensuous or enthralled state of communion with them. The putto terminating the left end of the arc stares directly out to the viewer. Beyond this compact, symmetrical group, three additional putti, two fully in shadow, float or fall in arresting poses and provide a dynamic backdrop to the more stable central group. At the upper right an infant in shadow floats diagonally forward with outstretched arms, while below on the right an upright putto in the light-filled foreground floats gently downward. At the left, in deep shadow, yet another infant falls headfirst to the ground.

The motif of a young woman and putti also appears in Rodin's drawings of the period; one of about 1878 shows a woman and two infants and is inscribed "Printemps" (Springtime).[3] Rodin produced allegorical compositions based on the motif of a circle of amours and also that of a nude woman holding a putto or surrounded by several amours. The latter motif is included on two Pompeian-style vases decorated by Rodin in 1880–82 entitled *Le jour* (Day) and *La nuit* (Night), and it is *La nuit*, as highlighted by Roger Marx, that contains the motif seen on the Stanford plaque.[4] The plaque especially invites interpretation with the more complex compositions and iconography of the Pompeian-style vases that, as read by Marx, focus on the themes of Venus and springtime.[5] The same motif appears in reverse (with some modifications) in Rodin's print of the same name made after the plaque (fig. 485). Similar motifs were considered for the base on the first maquette for monument *The Burghers of Calais* (cat. no. 8). Nude and amorous groups are found on *The Gates of Hell* (cat. no. 37) in the low reliefs of mothers and children flanking the tombs, added in 1899. On the right door panel, to the left of the tomb stands a nude, her head concealed under drapery, who reaches across her body to touch one of several putti descending toward her (see fig. 125). The putto's floating pose and position recall the motif on the plaque. Likewise, to the right of the tomb a nude woman reaches across her body with both arms to cradle infants, echoing the gesture of the nude shown in the plaque.[6] Drawings related to the Pompeian-style vases include many at the Musée Rodin that focus on the motif of the nude and putti and include variations in the direction of the nude,

Fig. 484.
Springtime (cat.
no. 196).

in the configuration of the amours, and in the number of amours.[7] These drawings focus on one infant held near the woman's shoulder, its head close to hers, a position closely related to the Venus and infant on the vase *La nuit* and comparable to the pose and emotional texture of the woman and infant on the Stanford plaque.

Rodin noted Sèvres and the date 1880 as part of his inscription of the plaque, and the plaque fits within the Sèvres period thematically, stylistically, and technically. It may derive from a lost drawing, made in connection with the Pompeian-style vases, especially *La nuit*, which Rodin worked on beginning in November 1880 and intermittently through late 1882.[8] Regarding the print, Victoria Thorson suggested a date of 1882 or thereafter (possibly as late as 1888), noting that Rodin may have used a now-lost drawing of the vase or could have copied from the vase when it was presented to him after it became defective in firing.[9] Given what we know of Rodin's method in creating prints by drawing freely on the plate and working from memory or from a preexisting composition, he likely would have made the print after the plaque or a corresponding drawing.[10]

The plaque's poetic allegory and graceful interweaving of figures and infant types also relates to other vases decorated by Rodin at Sèvres, such as *Les éléments* (The Elements) of 1879 and the two vases entitled *Hiver* (Winter; late 1879–early 1880).[11] The plaque recalls the infant types on *Les éléments*, with their firmly outlined, plump bodies and dotted facial features. The plaque's putti are, however, more varied in pose and mood and, therefore, less decorative and more expressive.

The technique Rodin used on this plaque and on *Composition with Putti* (cat. no. 197) is the *pâte-sur-pâte* (paste-on-paste) process, one of the many technical innovations developed at Sèvres from midcentury on (and later used in Germany and England). It was based on traditional techniques—painted and incised decoration of the ceramic paste before firing—but then focused on relief modeling through the superimposition of additional slips of ceramic paste applied in layers to achieve the effect of highlighting and of low relief. This decorating technique, along with the introduction from midcentury on of colored pastes and softer pastes for more fluid incising and modeling, was part of the experimental trend at Sèvres, which accelerated in the last quarter of the century.[12] The pronounced contour lines surrounding both the light and dark figures represent incision through the white slip to expose the dark ground slip or

Fig. 485.
Springtime
(A3).

possibly additional drawing. Rodin contoured the dark figures by building up the surrounding white vaporous areas, producing a range of opaque and diaphanous textures, comparable with the technique used on several vases of late 1879–80.[13]

Both *Springtime* and *Composition with Putti* are illustrated in the monograph on Rodin by Marx and cited as belonging to the collection of Maurice Haquette, a friend of Rodin, through whose family he was introduced to the state official Edmond Turquet, who eventually secured for Rodin the commission for *The Gates of Hell*.[14] Apart from a difference in color between the gray-beige tonalities of Stanford's plaque and the rosy tan and brown tones of the heliotype, the illustration otherwise shows seemingly identical compositional lines and details.[15]

It would be interesting to know the circumstances under which Rodin, as an employee at the Sèvres Manufactory, would have come to have these small plaques or have encountered them at a later point.[16] In comparison with Stanford's other plaque and its simple, three-figure composition, *Springtime* represents a more developed conception, which would have been more suitable to serve by itself as a framed plaque, a format favored by nineteenth-century taste. While *Springtime* as well as the other plaque conceivably may have served as a compositional or technical trial essay, its artistic self-sufficiency suggests that it may represent Rodin's personal artistic exemplar of his subjects, style, and technique at Sèvres.

<div align="right">ROSALYN FRANKEL JAMISON</div>

NOTES

LITERATURE: Marx 1907, 25, pl. XIV; Delteil 1910, 6: cat. no. 4; Thorson 1975, 28, 30; Lajoix 1997, 80

1. Neither plaque is recorded by Grappe (1944) and neither, it appears, is in the Musée Rodin records. Both plaques were noted and reproduced by Marx (1907, 25, 38, pl. XIV), and *Springtime* was cited in Delteil 1910, 6: cat. no. 4, n.p., as a variant of the print by the same title.

2. For works by these artists, see June Hargrove, *The Life and Work of Albert-Ernest Carrier-Belleuse* (New York and London: Garland Publishing, 1977), for example, figs. 145–146, 148–149, 232, and for Clodion, Wend Graf Kalnein and Michael Levey, *Art and Architecture of the Eighteenth Century in France* (Harmondsworth, England: Penguin Books, [1972]), pls. 159–161. For an overview of Clodion's work, see Anne L. Poulet and Guilhem Scherf, *Clodion*, exh. cat. (Paris: Réunion des musées nationaux, 1992). For the historical context of the movement to invigorate French decorative arts, which dates from midcentury and culminated in the 1870s, see Butler 1993, 141–45.

3. Reproduced in Elsen 1963, 158.

4. Marx 1907, pls. XI (left), XV (bottom), and 25 n. 1. The motif of a nude woman holding an infant close and on her shoulder is also seen on another vase, as well as in a variant, where the infant is held to the chest by a faun (pls. VI-VII).

5. Ibid., 26–27.

6. For a close-up view of these motifs in the plaster cast of the portal, see Elsen 1985a, 134.

7. See the preparatory drawing for the vase *La nuit*, discussed and reproduced in Thorson's discussion of the print *Allegory of Spring* (1975, 28, 30–31 [fig. 15; location and dimensions unknown, reproduced from *La plume* 1900, 57]). Other drawings in the Musée Rodin were noted, and some were reproduced, among the related drawings listed in Thorson's discussion (30). They include MR441, 452, 454, 5929, 6329, 6330.

8. The Sèvres records are reproduced in Marx 1907, 43–44; Marx noted that the plaque's subject was used again on the vase *La nuit* (25 n. 1) and indicated that the vase was first listed as *Le songe d'une nuit d'été* (A summer night's dream; 26 n. 2).

9. Thorson 1975, 28; Marx 1907, 26. The print was dated 1883 in Delteil 1910, 6: cat. no. 4.

10. Marx indicated the print was made after the plaque (1907, 25).

11. Reproduced in Marx 1907, pls. I, III-IV.

12. For the background of these trends under the direction of Charles Lauth and his predecessor, see Tamara Préaud, *Sèvres Porcelain*, trans. James B. Davis (Washington, D.C.: Smithsonian Institution Press, 1980), 28–32, and Jeanne Giacomotti, *La céramique* in *Les arts décoratifs* (Paris: Librairie Flammarion, 1935), 3: 50–57. Regarding Rodin's work for Sèvres, see Lajoix 1997, 76–80, and Bumpus 1998, 13–18. Bumpus 1998 includes a comparison of Rodin's technique with those used at Sèvres and with variants used in several private ateliers.

13. See Marx 1907, pls. III-IV, a comparison that accords with the date of 1880 noted by Rodin in his inscription.

14. Regarding the critical importance of Rodin's contact with the Haquette family during his period at Sèvres, see Butler 1993, 145–46.

15. Marx's monograph documenting Haquette's possession of the plaques was published in 1907, the year that Rodin inscribed both of Stanford's plaques to the collector Eva de Basily-Callimaki. The provenance of the plaques following their ownership by Haquette requires clarification.

16. Some work for Sèvres was apparently decorated in Rodin's atelier in Paris, where pieces may have remained; see Lajoix 1997, 78, and Bumpus 1998, 17.

197

Composition with Putti (Enfants), c. 1880–82

- Glazed porcelain plaque with applied design by Rodin
- 3⅛ x 3⅛ in. (7.9 x 7.9 cm)
- Inscribed verso: à mon amie la Comtesse/Basily Callimaki/Auguste/Rodin/en affectueuse sympa/tie. décembre 1907
- Provenance: Countess Eva de Basily-Callimaki; Nicolas de Basily; Lascelle de Basily
- Gift of Mme. Lascelle de Basily, 1974.192.1

Figure 486

*T*his small square porcelain plaque contains a decorative design applied by Rodin, a three-figured composition in a frieze format depicting infants cavorting in a cloudlike ambiance. Like *Springtime* (cat. no. 196), this plaque is inscribed by Rodin and dated December 1907. It also shares with this plaque similar poetic allegories based on infant nudes and the style and technique of Rodin's decorative work at Sèvres. This work included his vase designs *Les éléments* (The Elements, 1879), two vases entitled *L'hiver* (Winter, 1879–80), and the putti depicted on the Pompeian-style vases *Le jour* (Day) and *La nuit* (Night), both 1880–82.[1] Similarly Rodin's first drypoint, *Love Turning the World* (*Les amours conduisant le monde*, 1881), included putti prancing and looking out from clouds.[2]

The two infants depicted are portrayed in a drama of opposition: a winged figure seems to resist a small hoofed satyr, while a third figure, with hands held high, appears to flee from the others. The composition conveys a strong sense of playful drama. Rodin concentrated a surprisingly rich variety of effects achieved by the manipulation of light, contour, and composition, ranging from misty white areas to the delicate detail of the running figure's raised right hand, and from the firmer lines that selectively reinforce contours and points of contact between the pair of figures on the right to the abstract, freer brushwork defining and accenting the dramatically lit putto at the left. This fleeing figure is rendered in a chiaroscuro style highlighting its fleshy anatomy, with half its body in shadow.

The plaque was decorated through a *pâte-sur-pâte* technique (see cat. no. 196). The figures on the plaque are built up in low relief in white slip (or semiliquid porcelain paste) on an olive-gray ground slip over the alabaster clay surface. The ground line beneath them is white, and this cloudlike ambiance continues at the sides of the plaque and above the figures at the right.[3] A third tone, dark brown, reinforces the contour lines and shadow. In his use of the paste-on-paste technique in a combination of incising and modeling—as in the first documented vase he decorated at Sèvres, *Les éléments*—Rodin inscribed his design through a ground slip to reveal the colored body beneath. This was a conventional ceramic decoration technique, sgraffito, and one that, in fact, anticipated Rodin's turn to the medium of drypoint engraving in 1881. In exposing the clay of contrasting color beneath, the incised lines constituted the darker contours and areas of the drawing. In the paste-on-paste technique additional slip was then applied with a brush in delicate touches of varying opacities to achieve highlighting and low-relief modeling. Roger Marx also noted that Rodin's designs were usually premeditated, not improvised, and at times he used pounced tracings to transfer a preexisting drawing.[4]

Fine lines dividing the sections of the bodies and articulating the joints may represent incision into the white paste or simply areas left unpainted. More often, definition and accenting are accomplished through lines painted in dark slip that reinforce selected contours (such as the satyr's head, back, and legs), define contact between figures, or indicate details such as wings and hair. In the fleeing figure the accents of dark slip were brushed on thickly to suggest the figure's volume and the dramatic raking lighting. Rodin was interested, especially around 1880, in relief effects and in enhancing forms painted in white slip with dark slips, which would tend to confirm that the date 1880 inscribed by him on Stanford's other plaque is applicable to this plaque as well. This style emphasizing chiaroscuro effects is related to his gouache-manner drawings of the late 1870s and early 1880s, with their strong contrasts of shadows in dark ink and highlights in gouache, and reflects his interest in the drawing tradition stemming from Leonardo da Vinci, Antonio Correggio, and Pierre-Paul Prud'hon.[5]

Composition with Putti appears as a tailpiece in Marx's 1907 monograph (*Springtime* is illustrated as well). It is listed in the table of illustrations as *Enfants* and identified, as is *Springtime*, as belonging to Maurice Haquette.[6]

Fig. 486.
*Composition
with Putti* (cat.
no. 197).

The inscription on both Stanford plaques refers to Eva de Basily-Callimaki, an art critic, collector, painter, and author, who was born in Paris in 1855, a citizen of Romania, and died in Paris in 1913.[7] According to the inscriptions, she obtained both plaques in 1907, though the circumstances are not known. Her interest in Rodin's designs on porcelain made at Sèvres clearly would have related to her activity as a collector of porcelain and to her monograph published in 1909 on Jean-Baptiste Isabey, who painted several porcelains at the Sèvres factory. Basily-Callimaki corresponded with Rodin around 1898 and continued to do so through the year of her death; her letters mention gratitude for works by Rodin, her activities in Paris on his behalf, and the arrangement of sales between Rodin and several collectors, mostly Russians.[8] When she died, her estate sale included a bust of *The Republic* (*Bellona*, 1878–79), signed by Rodin, which was illustrated in the estate sale catalogue.[9]

Questions remain about the purpose of such porcelain plaques. Five, including the two at Stanford, are found as vignettes and illustrations in the Marx monograph, their compositions ranging from simple two-figure motifs, such as a woman and infant, to compositions based on multiple figures, such as that in Stanford's other plaque.[10] The simplicity of the present three-figure composition, the irregular edge of the square plaque, and especially the crude, uncharacteristic way Rodin rendered the trailing leg of the fleeing putto suggest that *Composition with Putti* may represent a trial piece.[11] It may correspond perhaps to a motif or segment of a frieze dec-orating a vase rather than representing an autonomous decorative composition intended for a framed plaque, a popular nineteenth-century format.[12] (The Sèvres Manufactory, for example, produced many copies of old master paintings intended for setting in furniture or for use as wall decoration.) When given to the Hoover Institution, the two plaques were joined in what is presumably a period frame chosen by Rodin or Basily-Callimaki. They are not included in the Georges Grappe catalogue of the Musée Rodin collection presumably because after Rodin made them, they may have been offered to him by the Sèvres Manufactory or he may have worked on them in his Paris studio, where they may have remained. In any case, they made their way by gift or sale into this private collection.

ROSALYN FRANKEL JAMISON

NOTES

LITERATURE: Marx 1907, 38

1. See Marx 1907, pls. I, III-IV, XIII, XV.
2. See Thorson 1975, 19.
3. The comparable technique was used for rendering infants in a snowy landscape in the vase *L'hiver*; Marx 1907, pl. IV.
4. Ibid., 15–18.
5. For Marx's discussion of Rodin's style and technique, see ibid., 20–26. For further discussion see Lajoix 1997, 76–80, and Bumpus 1998, 13–18.
6. Marx 1907, 38 and "Table des Illustrations," n.p. The provenance of the two plaques following their ownership by Haquette remains to be clarified.
7. Her writings on European art history include a monograph on the French painter Jean-Baptiste Isabey (1767–1855), *Isabey: Sa vie et son temps* (1909). Her collecting interests centered on eighteenth- and nineteenth-century drawings, faience, porcelain pottery, and miniatures. She studied under Théodore Fantin-Latour, who painted two portraits of her. She married a Russian imperial diplomat, Alexander de Basily, in Paris in 1882. They had two sons, Nicolas and Louis, and were divorced in 1899. Nicolas, also a diplomat, (d. 1963), was Russian consul in Paris, where he remained after the Russian Revolution of 1917. His art collection was given to the Hoover Institution in 1966 in his memory by his second wife, an American, Lascelle de Basily. Included in this gift were the two plaques and also a drawing by Rodin (cat. nos. 196–198). Biographical data about her is included in the document prepared by the family dated April 1959: "Data Relating to the Family of Nicolas de Basily" (Hoover Institution, Stanford University). Basily-Callimaki's papers at Hoover include letters, notes, and writings in French regarding French and European art history and papers pertaining to her Isabey book.
8. The author expresses gratitude to Albert Elsen for examining the correspondence between Eva de Basily-Callimaki and Rodin preserved at the Musée Rodin. There seems to be no mention of the plaques in the correspondence nor, it appears, in the papers regarding Basily-Callimaki at the Hoover Institution. In addition, the plaques appear not to be mentioned in the Musée Rodin's records. The author also thanks Alain Beausire for reviewing the files regarding this question.
9. *Succession de Madame de Basily-Callimaki*, Paris, Hôtel Drouot (Nov. 12–13, 1913), Hoover Institution, Stanford University.
10. Some of Rodin's ceramics from the Marx collection were on the Paris art market in 1998.
11. Albert Elsen made this observation about Rodin's drawing style.
12. See also the small ceramic plaque by Rodin, *Young Woman and Child* (c. 1882); this trial piece was discussed and reproduced by Bumpus 1998, 16.

Drawings

Stanford's numerically modest collection of Rodin's works on paper provides a tantalizing insight into his brilliance as a draftsman and the revolution in drawing for which he was responsible. Several early drawings are discussed in other sections of the catalogue and include one for the *Tower of Labor* (cat. no. 33) and one on the Ugolino theme (cat. no. 47). Rodin never relied on his drawing as models for his sculptures. His graphite and wash renderings teach us something of the workings of his imagination during the early years of the making of *The Gates of Hell* (cat. no. 37) and also of his marvelous powers of observation of the living model, often in movement. The continuous drawings, made without looking at the paper and begun in the 1890s, had a demonstrable influence on such important early twentieth-century artists as Henri Matisse and Egon Schiele.

198

Woman Supporting a Globe Encircled by Amours (Femme soutenant un globe entouré par des amours), c. 1880–81

- Pen and ink with gouache over pencil on paper
- 6³/₁₆ x 3³/₁₆ in. (15.7 x 8.1 cm)
- Inscribed recto, left edge: *A Madame de Basily Callimaki/affectueusement Rodin*
- Provenance: Countess Eva de Basily-Callimaki; Nicolas de Basily; Lascelle de Basily
- Gift of Mme. Lascelle de Basily, 1974.193

Figure 487

Fig. 487. *Woman Supporting a Globe Encircled by Amours* (cat. no. 198).

*T*his sketch stems from the period 1879 to 1882, during which Rodin worked at intervals on decorative designs for the Sèvres porcelain factory. The composition depicts a nude woman who twists and arches her back to support a globe encircled by eight putti (a ninth is lightly indicated); her lower body is intertwined with a loosely described larger nude, depicted kneeling with head lowered. Where they appear to be rotating the globe on its axis the putti are clustered on the far side of the globe.

The sketch relates to Rodin's first drypoint, *Love Turning the World*.[1] In the print Rodin focused on the core motif of putti rotating a globe. Although the print's title and theme of love turning the world may have been Rodin's, as Victoria Thorson asserts,[2] the composition clearly has seventeenth-, eighteenth-, and even nineteenth-century precedents. These include *Circle of Amours* (Ronde d'amours) by Jean-Honoré Fragonard (1732–1806)[3] and allegorical compositions by Jean-Baptiste Carpeaux.[4] The motif also appears Rodin's own work for Sèvres (see cat. no. 196, fig. 484), which is instilled with an eighteenth-century spirit.

Most notably, the motif of putti rotating a sphere recalls Clodion's two models, made in 1784–85, for a proposed monument for the Tuileries Gardens to commemorate a famous early Montgolfier balloon ascent from that site on 1 December 1783. In the terra-cotta model at New York's Metropolitan Museum of Art (fig.

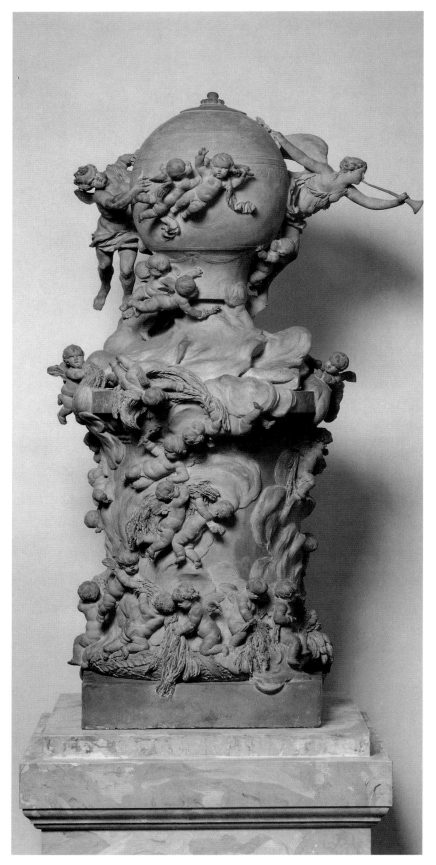

488) two putti, buoyant and free from gravity, are located at the midsection of a large human-scaled balloon that they help rotate.[5]

Rodin's composition presents basic differences from Clodion's complex terra-cotta—the greater number of putti, for example, and their distinct arrangement in a more compelling order. Certain aspects of Rodin's drawing, however, resemble Clodion's model, including the leftmost figure on Rodin's globe recalling the infant of the pair at the center of Clodion's globe. Rodin's close alignment of the infant heads, especially the leftmost pair interrelated both formally and emotively, may also recall the dramatic and emotional texture of the closely placed, often paired infants on the globe and across the base of Clodion's work. Rodin's related print *Love Turning the World* may further indicate his interest in Clodion's model. The crisp definition given by Rodin to the group of putti amassed on the horizontal platform of clouds where they form a wedge at the left underside of the globe may recall the balloon on Clodion's model, which, when viewed from the front, similarly includes a wedge of putti located beneath the globe and toward the left. In addition, the cloud forms in Rodin's print may loosely recall the clouds of smoke and hot air between the globe and large pedestal in Clodion's model.

In *Woman Supporting a Globe* Rodin's articulation of the round volumes of the infants' bodies is much broader and freer than Clodion's detailed naturalism. (Rodin's print depicting amours turning the world shows more precise articulation and a more decorative, Clodion-like spirit, akin to Rodin's other works of the Sèvres period.) In the drawing Rodin stressed the simplicity and rhythm of the circular shapes, highlighted through deep pockets of shadow that may recall the patterns of light and shadow in Clodion's model. In fact, the way Clodion's infants float and tumble across the pedestal in a wavelike motion among the protrusions and crevices of clouds and straw in an otherwise amorphous space may also have flavored Rodin's approach in *The Gates of Hell* (cat. no. 37), begun in the same period. Rodin's conception of figures in an indeterminate space punctuated by curving crevices and ridges and his overall emphasis on a decorative approach to composition in *The Gates* may represent a stylistic inspiration, ironic in its transformation of a subject of eighteenth-century gaiety and optimism into a distinctly somber, pessimistic nineteenth-century theme.

The standing, open-armed, winged torchbearer at the

base of the balloon in Clodion's second model may be recalled by the standing woman in Rodin's drawing, although her vigorous, twisted pose and actual support of the globe represent an aggressive revamping of the weak, didactic gesture of the source. The seated, forward-bent, partially draped, muscular male nude figure of Time located at the rear of Clodion's model may offer a visual source for the curious and unclearly defined kneeling figure intertwined at the feet of the woman in Rodin's drawing. In thrusting his figure of the woman right up to the globe to actually support it and in similarly mining the expressive potential of Clodion's bent and forlorn male nude, Rodin instinctively invigorated the meaning and form of these conventional poses and gestures.[6]

The drawing *Woman Supporting a Globe Encircled by Amours* exemplifies Rodin's early graphic style in its emphasis on energetic but sketchy contours, parallel lines to evoke movement and volume, and chiaroscuro effects in which bold accents of dark ink wash and opaque white gouache clarify and heighten the drama of pose and gesture. Anatomic detail is absent except for the dotted facial features of several putti. Ink-washed shadows convey the emotion of the figures. The kneeling figure's face is entirely in shadow. Whereas hands and faces are only roughly described, the configuration of the woman's straining pose is emphasized. The highlights in gouache reinforce the upward thrust of the composition, leading the eye upward from the kneeling figure's right thigh, along the woman's legs and right arm, to a broad highlight on the globe, culminating in the heads of the putti. In this sketch Rodin focused on the interrelationship of figures and on expressive poses and created a compelling equipoise between the ponderous weight and volume the woman supports and the pyramidal base of her legs and intertwined figure below.

ROSALYN FRANKEL JAMISON

NOTES

LITERATURE: Thorson 1975, 18, 21; Eitner 1982, 29; Eitner, Fryberger, and Osborne 1993, 359–60, no. 426

1. This print is catalogued in Thorson 1975, 18–21.
2. In 1908 Rodin inscribed an almost identical title on one impression of this print (1975, 18).
3. Fragonard's design was the model for an aquatint by Jean-Claude Richard de Saint-Non. (see François Courbon, *La gravure en France des origines à 1900* [Paris: Librairie Delagrave, 1923], 122). On its probable influence on Rodin, see Elsen 1965b, 294.
4. The example, Carpeaux's etching *Geometry of Descartes* (1860), is cited in Thorson 1975, 18, 21 n. 7.
5. See Preston Remington, "A Monument Honoring the Invention of the Balloon," *Metropolitan Museum of Art Bulletin*, n.s.2, 2 (1943–44): 241–48; and Anne L. Poulet and Guilhem Scherf, *Clodion*, exh. cat. (Paris: Réunion des musées nationaux, 1992), 61–62, 410–11 in which the second, more prosaic model is reproduced. Remington noted that the Metropolitan Museum's model was seen by Edmond de Goncourt shortly after 1840 and again at the Exposition of 1867 (as could have Rodin). It was then described by Goncourt in *La maison d'un artiste* (1880). Its whereabouts in Rodin's time are unclear; Clodion's biographer illustrated a drawing of it, indicating that a few years prior the model had been in a private collection (Henri Thirion, *Les Adam et Clodion* [Paris: A. Quantin, 1885], 335–36). As for the location of the alternate model, in the early 1880s through a Baron Ponsard it entered the noted French aeronautical collection of Gaston Tissandier (Remington, "Monument," 246, 248). It was proposed for the Louvre in 1880; its current location is unknown (Poulet and Scherf, *Clodion*, 62).
6. Among drawings and sculptures of putti by Rodin from the 1860s and 1870s, Thorson highlighted two drawings at the Musée Rodin that represent variants of Stanford's drawing, one depicting a globe supported by two putti (MR141) and another, according to Kirk Varnedoe, a drawing on which the first is based, in which the globe is supported by two men (MR67); see Thorson 1975, 18, 21, 21 n.10; see also Judrin 1984–92, 1: 141, 67, and also 69, *Two Putti in a Cartouche*.

OPPOSITE PAGE
Fig. 488.
Clodion (Claude Michel), *Model for a Proposed Monument to Commemorate the Invention of the Hot-Air Balloon in France*, 1784–85, terracotta, height 43½ in. (110.5 cm). Metropolitan Museum of Art, New York, Rogers Fund and Frederic R. Harris gift, 1944

199

Crouching Nude Woman
(Femme nue accroupie), c. 1900–05

- Watercolor over graphite with wash on paper
- 8⅝ x 12½ in. (21.9 x 31.8 cm)
- Signed lower right: A. Rodin
- Inscribed on right side: [unreadable graphite inscription]
- Provenance: Georges Petit collection, Paris; Schoeller, Paris; Palais Galliera, Paris, 16 June 1969, lot 30
- Gift of B. Gerald Cantor, 1969.155

Figure 489

200

Squatting Nude Woman
(Femme nue accroupie), c. 1895–96

- Pen and ink on paper
- 12 x 7⅝ in. (30.5 x 19.4 cm)
- Signed center right: A. Rodin
- Provenance: Mrs. Jules E. Mastbaum, New York and Philadelphia; Mrs. Lawrence Ash; Joy Moos, Montreal
- Committee for Art Acquisition Fund, 1983.26

Figure 490

201

Kneeling Nude Woman
(Femme nue à genoux), c. 1896–1900

- Graphite with wash on paper
- 11½ x 7½ in. (29.2 x 19.1 cm)
- Monogram lower left: R.M. [Roger Marx]
- Signed below figure, lower left: AR; inscribed to the left of the figure: Gros/plus bas
- Provenance: Mrs. Jules E. Mastbaum, New York and Philadelphia; Louise Dixon, Beverly Hills
- Gift of Charles Feingarten, 1970.395

Figure 491

202

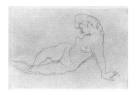

Reclining Nude Woman
(Femme nue étendue), c. 1900

- Graphite tracing on onionskin paper
- 10½ x 15¼ in. (26.5 x 38.5 cm)
- Collector's stamp verso: R.M.
- Provenance: Roger Marx, Paris; Mrs. Jules E. Mastbaum, New York and Philadelphia; Albert E. Elsen
- Gift of Professor and Mrs. Albert E. Elsen in honor of Dr. Kirk T. Varnedoe, 1985.17

Figure 492

203

Standing Pregnant Nude Woman
(Femme nue enceinte, debout), recto, c. 1896–1900

- Verso: *Architectural Study* (*Etude architecturale*) (not illustrated)
- Graphite tracing on onionskin paper
- 15⅛ x 11¼ in. (38.5 x 28.8 cm)
- Inscribed upper right: 385
- Collector's stamp on verso: R.M.
- Provenance: Roger Marx, Paris; Mrs. Jules E. Mastbaum, New York and Philadelphia; Louise Dixon, Beverly Hills
- Gift of Charles Feingarten, 1973.48.1

Figure 493

204

Seated Nude Woman (Femme nue assise), 1898(?)

- Graphite on paper
- 14½ x 10¼ in. (37 x 26.2 cm)
- Verso: *Sketch for "Tower of Labor,"* cat. no. 33.
- Provenance: Mrs. Jules E. Mastbaum, New York and Philadelphia; Louise Dixon, Beverly Hills
- Gift of Charles Feingarten and Gail Wiley Feingarten, 1973.48.2

Figure 494

There are more than 8,000 drawings in the Musée Rodin, all of which have been published by Claudie Judrin.[1] They make Rodin one of the most prolific sculptor-draftsmen in history. Not just their number, but their quality and evidence of revolutionary drawing techniques make this portion of his oeuvre of considerable historical significance. Rodin must be credited with the invention of an important method of drawing, of which Stanford is fortunate in having several excellent examples. This technique might be called continuous drawing or what in his day was called his instantaneous or snapshot works. The exact date of this innovation is not clear, but it seems to been developed around 1895–96.[2] As is true with most inventions, Rodin's did not appear without precedent but depended on traditional training. Rodin studied and made drawings of older drawings, sculptural reliefs, and casts of figures in the round, for which his art school awarded him a medal. He studied anatomy and was also instructed in drawing from the live model. In the Petite école Rodin came under the tutelage of a brilliant teacher, Horace Lecoq de Boisbaudran, who encouraged drawing from life and by memory and of the figure in movement. Rodin had no more influential teacher than this man who succeeded in reforming the teaching of drawing for the École des beaux-arts. In his letter published in the 1913 edition of his mentor's book on drawing, Rodin acknowledged that "the greatest part of what he taught remains with me still."[3]

It was from Lecoq de Boisbaudran that Rodin acquired many of the fundamentals of his art. He was made aware of the importance of a thorough knowledge of anatomy, and he was taught to love working directly from life. In addition, Lecoq de Boisbaudran encouraged an open attitude toward what constituted beauty in nature, the practice of visualizing the emerging figure in a geometric form, allowing the models to wander freely about the studio, and first fixing the great lines of a figure's mass without the use of shadows and details. What then did Rodin add to drawing? It was a case of the pupil building logically on the master's ideas but in ways undreamed of by either at the time the lessons were given. Rodin's genius was to realize novel implications in Lecoq de Boisbaudran's method, to see its logical continuation in a method that would take drawing where it had never been before in terms of the direct observation of nature rendered in a distinctly personal way.

As is known to anyone who has tried drawing from a model, the customary way is not to draw what one actually sees but rather what one remembers having just seen. One looks at the model and then looks away at the paper in order to draw. What Rodin sought consciously in the mid-1890s was a way of capturing a model's total movement, sustaining in the process both the flow of inspiration he received directly from the model and his feelings about the subject. Rather than break visual contact with the model by looking at his paper, Rodin tried to draw without taking his eyes off the model, in effect imagining the tip of the pencil moving on the paper's surface to be a surrogate finger passing along the subject's contours. The result was literally *continuous* drawing. We have three good accounts that give us a clear understanding of why and how Rodin worked in this new manner. The first, published in 1903 by Clément Janin, is from an eyewitness to one of Rodin's continuous drawing sessions:

> In his recent drawings, Rodin uses nothing more than a contour heightened with wash. Here is how he goes about it. Equipped with a sheet of ordinary paper posed on a board, and with a lead pencil—sometimes a pen—he has his model take an essentially unstable pose, then he draws spiritedly, without taking his eyes off the model. The hand goes where it will: often the pencil goes off the page; the drawing is thus decapitated or loses a limb by amputation. . . .
>
> The master has not looked at it once. In less than a minute, this snapshot of movement is caught. It contains naturally, some excessive deformations, unforeseen swellings, but . . . if the relation of proportions is destroyed, on the other hand, each section has its contours and the cursive schematic indication of its modeling. . . . His great preoccupation at this time is to conserve and even to amplify the impression of life he has obtained from the direct sketch. . . . According to him, his secret for fixing the form in the atmosphere is to enlarge it, to give it five quarters instead of four.[4]

Judith Cladel, who in 1898 observed Rodin's new way of drawing, provides another firsthand account:

> Seated before his model he drew a svelte woman with the grace of an Egyptian statue. The artist's eyes never left the lines of her flesh, his hand light and sure traced them on the paper with no other

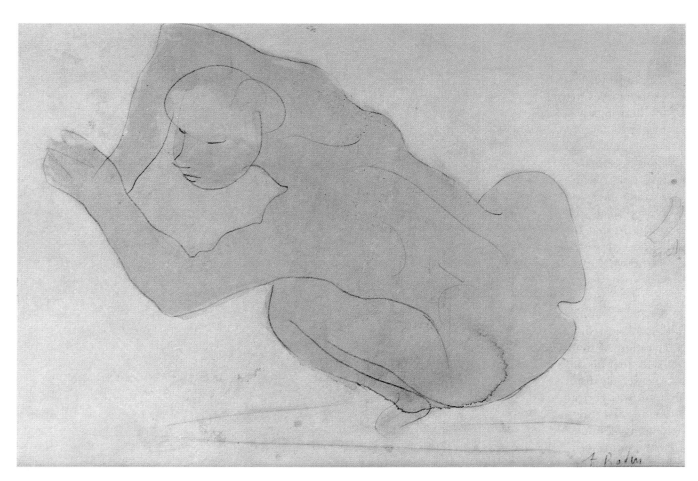

Fig. 489.
Crouching Nude Woman (cat. no. 199).

guide than his brain and that which directly affected him in the image. His hand saw and in three or four minutes or more, the contour and some typical accents were taken. . . . Rodin let the sheet of paper fall to the ground, and slipped another onto his knees, then the slow voluptuous progression of the pencil began again without stopping. He had the woman change the pose, but without indication of any attitude: he awaited nature's eloquence. The woman turned around, twisted her loins, then fell to her knees on the floor, her hands on the ground, her neck bent while glancing toward him to see if this attitude pleased him; doubtlessly finding [the pose] a little conventional he stopped. Then, she rose, rested her hands on her hips, stretched her chest . . . and then she relaxed in order to find another movement, but he said rapidly in a penetrating tone, "Oh! that is beautiful. Don't move. That is beautiful!"[5]

The third account was given by Rodin's secretary Anthony Ludovici, who described coming on the artist and seeing him drawing the model without ever looking away from the model to his pencil, which he did not lift off the paper as he drew. "He always tried to complete his outline of the figure he was drawing in one wavy and continuous sweep. I watched him for some minutes while sheet after sheet was torn away and dropped like rubbish on the floor at his side."[6] Rodin explained his motive and method to Ludovici,

Don't you see that, for my work of modeling, I have not only to possess a complete knowledge of the human form, but also a deep feeling for every aspect of it? I have, as it were, to incorporate the lines of the human body, and they must become part of myself, deeply seated in my instincts. I must feel them at the end of my fingers. All this must flow naturally from my eye to my hand. Only then can I be certain that I understand. Now look! What is this drawing? Not once in describing the shape of that mass did I shift my eyes from the model. Why? Because I wanted to be sure that nothing evaded my grasp of it. Not a thought about the technical problem of representing it on paper could be allowed to arrest the flow of my feelings about it,

from my eyes to my hand. The moment I drop my eyes that flow stops. That is why my drawings are only my way of testing myself. They are my way of proving to myself how far this incorporation of the subtle secrets of the human form has taken place within me. I try to see the figure as a mass, as volume. . . . Occasionally I get effects that are quite interesting, positions that are suggestive and stimulating; but this is by the way. My object is to test to what extent my hands already feel what my eyes see.[7]

What would one make of Rodin's continuous drawings without his explanation and declaration of intentions? That he had lost his skill, that his old hand was shaky, that he was perversely distorting the women's forms, that he was caricaturizing the nude? Consider all that Rodin revealed in the brief statement to Ludovici: his intent is a better understanding of the human form and the coordination of his eye and hand in rendering it. He saw this mode of drawing as crucial to his modeling in sculpture. By the mid-1890s Rodin had assessed his own art and found it lacking in psychological and emotional depth. Continuous drawing became an innovative way of expressing and sustaining the emotions inspired by the model. Rodin had found a new way of possessing the model, sexually and artistically, as suggested by Cladel's emphasis on Rodin's "voluptuous" manner of drawing.

Ludovici and Cladel gave us a sense of how at one sitting Rodin would quickly make a series of drawings from the same model. As the drawings in the Musée Rodin are not arranged chronologically, looking through the inventory volumes produces dispersed examples from these series. Stanford's drawings *Crouching Nude Woman* and *Squatting Nude Woman* (figs. 489–490) have their counterparts drawn a few moments before or after.[8] One is reminded in Rodin's series of drawings of Claude Monet whose series of moments and seasons are the result of painting rapidly the same motif seen from the same spot as the light

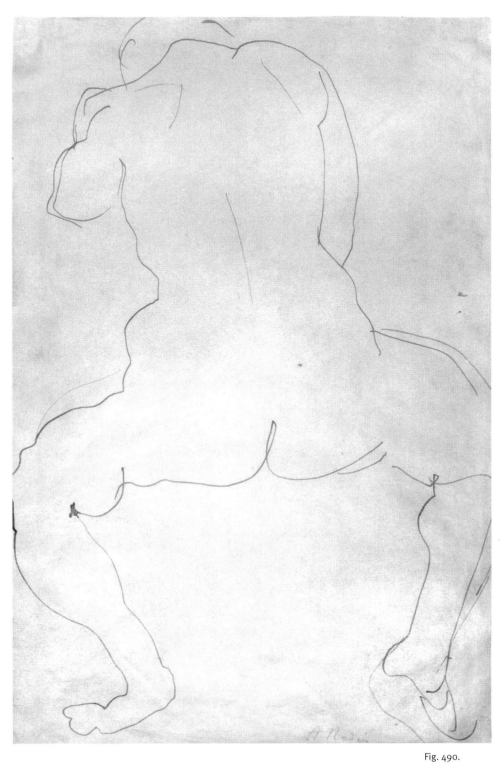

changed. Although Rodin was definitely not an impressionist sculptor or draftsman, Rodin admired Monet, owned one of his paintings, and both shared an insatiable drive to capture in their art nature's abundant subtleties.

One would never date the Stanford drawings before

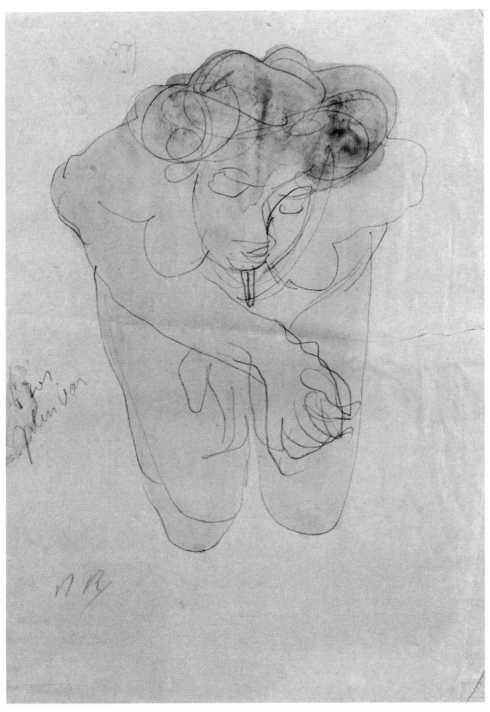

Fig. 491.
Kneeling Nude Woman (cat. no. 201).

stock studio poses, as well as the *poésie* in which the artist was expected to think of the woman as a figure from history, literature, or mythology, standards that generally obtained in the nineteenth century. These are qualities Rodin shares with Degas's work. Unlike Degas, however, Rodin was not interested in the routinized movement (such as those required by personal hygiene) but rather those that were not premeditated. There is no idealization of the figures, and following the distinction emphasized by Kenneth Clark, the women are naked rather than nude.[10]

In these spontaneous sketches, such as *Seated Nude Woman* (fig. 494), there is an occasional piece of furniture to support the model but no setting, unlike the domestic interiors of Degas's drawings, and we see the figures in isolation. The woman is clearly a model. She is no more or less than what she is. Probably because, when a face is shown, Rodin at best treats it synoptically, one is not tempted to look at these women and imagine them as famous heroines or victims of history, for example. Unlike Degas's bathers, Rodin's models often look at him and are aware of his presence, and as Cladel observed, in life they showed a desire to please him.

We know that when he was given the commission for *The Gates of Hell*, Rodin finally had enough money to hire not only many models but more than one at once and that they were free to move about the studio as they liked. "I observe at length my model. I do not ask of her a sought-for pose. I leave her free to come and go in the studio like an escaped horse and transcribe the observations I have made."[11] The results of carrying out Lecoq de Boisbaudran's example of giving models freedom to move naturally, which had been demonstrated to him as a student out of doors, was now enacted in the studio and were seen for more than ten years in Rodin's sculptures before the consequences appeared in his drawings. In this respect the continuous drawings were the beneficiaries of what Rodin had learned in modeling. Rodin told a reporter in 1898 that his recent

the nineteenth century, and they seem essentially modern in every respect. Their nearest counterpart in certain aspects are the pastel drawings of bathers by Edgar Degas of the 1880s and 1890s.[9] Consider the implications of what one can see in these drawings. Rodin established new forms of intimacy between the artist and female model and a novel frankness concerning her identity. Rodin also liberated the model from the *académie*, or

drawings were "the synthesis of his life's work, the outcome of all his labor and knowledge."[12]

That these drawn figures, notably the ink rendering of the squatting woman, are so large within the field of the paper suggests the model's physical proximity to the artist. Even more than those in the work of Degas, the various new angles from which the women are seen, as from above or at the artist's feet, brought fresh perspectives along with new movements into figure drawings, and the familiar became strange. The partial figure in sculpture that Rodin was focusing on by the 1890s now appeared in his drawing as a function of vision and accident and resulted from not looking at the paper rather than from editing. Not only might drawn extremities be amputated by the pencil running off the sheet, but close-up and foreshortened views might show a reclining naked woman with only one arm clearly shown (fig. 492), a squatting figure with legs that seems to emerge from the buttocks (fig. 490), or the frontal view of a kneeling woman who is only head, breasts, hands, and thighs with no torso (fig. 491). There is as a result often a new lack of self-consciousness and a total disregard for decorum on the part of the model with regard to her relationship with the artist and hence the viewer. The ink drawing of the *Squatting Nude Woman*, whose arms and hands one cannot see, invites speculation as to what she is doing to herself in such a posture. The candor that accompanied the making of these drawings had decided erotic implications and led to Rodin's hundreds of drawings emphasizing female genitalia, autoeroticism, and lesbian love-making.

These drawings do not show Rodin deliberately deforming the body but reforming it according to his feelings and the movements of an inspired hand as he rushed to "avoid losing what existed in nature." Looking at the *Standing Pregnant Nude Woman* (fig. 493), for exam-

Fig. 492.
Reclining Nude Woman (cat. no. 202).

Fig. 493.
Standing Pregnant Nude Woman (cat. no. 203).

century after the drawings were done and perhaps because of the abstract art that intervened, one can look at the lines probing the pregnant woman, for instance, as pure rhythms of the hand, as currents of energy, producing surprising configurations, astonishing terminations in mittenlike hands, the contours of a face beyond the fantasies of a caricaturist. As shown by his tracings, Rodin would not correct or beautify hasty and passionate passages that resulted in clawlike hands or grotesque facial profiles. On his frontal view of *Kneeling Nude Woman*, Rodin penciled to one side the words, "Gros/plus bas," telling himself that the figure was too wide and should be lower. It was not unusual for Rodin to exhibit, give, or sell a drawing with similar notations. Symptomatic of his refusal to regard any work as finished, when he sold a marble, he sometimes left his graphite editing marks on the stone, indicating, as with this drawing, how he thought the work could be changed. Critical to his modernity and influence was the fact that Rodin made art free to preserve evidence of the artist's thought processes as well as the marks of the actual making of a sculpture or drawing.

As expressed in his judgment of the final *Balzac*, Rodin came to believe that exaggeration was the moral foundation of being a modern artist. His views about the value of seemingly aberrant passages reveal his audacious aesthetic and were reflected in his statement to Paul Gsell, recorded in *L'art*, concerning similar passages found in Eugène Delacroix's drawings: "One has accused Delacroix of not knowing how to draw. The truth, on the contrary, is that his drawing is marvelously wedded to his color: like the latter, it is jerky, feverish, inspired; it has passages of hastiness, fits of passion; like the color, it is sometimes demented: and it is then that it is most beautiful."[13]

Following the life of a Rodin line produces different reactions. There is the aggressively probing line, like a jabbing finger, which invades the naked pregnant model's physical privacy. There is the caressing line in the *Crouching Nude Woman* (fig. 489), as if Rodin was lightly running his fingertips over the model's contour.

ple, and knowing that Rodin showed many of these drawings in public as in his 1900 retrospective, he clearly dared in drawing to be "ugly" according to contemporary taste. It was probably by 1900 that Rodin became convinced of the importance of his invention. After their initial publication in 1897, Rodin allowed a greater number to be published by Félicien Fagus in *La revue blanche* (15 June 1900), giving international visibility to his invention. One of the Stanford drawings, *Kneeling Nude Woman* (cat. no. 201), was reproduced in a black-and-white wood engraving made by Jules-Léon Perrichon for the magazine.

These drawings helped form a modern aesthetic based on the artist's observation and fidelity to feeling. A

One has the frequent sense of the presence of bone and flesh but also, as when looking at the area of the knees of the pregnant model, there is an inclination to stop at a certain point and see the whole configuration to be reassured that a figure is being described. Such is the case, too, with his drawing *Crouching Nude Woman*, whose contours approach calligraphy in the areas of the buttocks. One can see also how Rodin must have evolved greater manual certainty in making his continuous drawings, which he practiced for at least ten years, for the contours of the *Crouching Nude Woman* vary in pressure but not certitude, and only the interval made by the woman's arms has the look of raveled flesh associated with this mode of drawing. When Rodin claimed that continuous drawing revealed to him nature's secrets, perhaps he had in mind such beautiful contours as the overhead view provided of this woman's buttocks.

Tracings

From eyewitnesses and from the drawings themselves we know that Rodin would often hold a drawing up to the window and make a tracing of it.[14] Stanford has two drawings on onionskin paper, *Reclining Nude Woman* (fig. 492) and *Standing Pregnant Nude Woman* (fig. 493), which were so made. In the tracings the line is drawn with the same pressure and value throughout so that it lacks the nuances of drawings made directly from the model. Tracing was for Rodin like his use of plaster casts in sculpture: they afforded him more than one copy of a work; they permitted changes without destroying the original, such as repositioning a figure within the field, refining or altering what he had done; and they allowed him to give a drawing to a friend while keeping its source.[15] The Stanford tracings also show that Rodin wanted to keep his exaggerations without alteration, much as he would do with his sculptural études of this period. In the case of the drawing of the naked pregnant model, Rodin used a larger sheet of tracing paper with the result that, while the head is still cut off by the top of the paper, one sees the lower legs without feet, which in the original had been cut off by the bottom of the page. The same thing was done with the *Reclining Nude Woman* so that in the tracing there is no obvious reason for the absence of feet.[16] These were Rodin's challenges in drawing to contemporary expectations of correctness, elegance, beauty, finish, and perfection.

Fig. 494. *Seated Nude Woman* (cat. no. 204).

Use of Wash

Rodin's continuous drawings show no interior modeling as he believed his contour lines carried the message of a figure's roundness. He might with three lines indicate shoulder blades and spine in a back or nipples and navel in a torso. Two Stanford drawings, *Crouching Nude Woman* and *Kneeling Nude Woman* (figs. 489 and 491), display Rodin's inventive use of a monochromatic wash applied after the line drawing and in the model's absence. As part of his drive to simplify his art and strive for a personal concept of the essential, he frequently employed a single water-based color to connect the contours, add to the sense of a figure's mass and volume, and open his art further to accident, as with the clotting of the wash in the drawing of the crouching figure. His drawings commissioned in 1899 to accompany Octave Mirbeau's *Jardin des supplices* (*The garden of tortures*; 1902) in the form of transfer lithographs by Auguste Clot (1858–1936) offer a brilliant display of his use of wash and cultivation of accidents in the drying of this liquid medium (see figs. 499–500). As shown in this drawing of the crouching figure with its gray wash, Rodin did not always use color descriptively or to evoke flesh. He anticipated by many years and influenced Henri Matisse's use of contour drawings and monochromatic color in his figure paintings.[17] Rodin's applied color does not usually vary in hue or value.

The Essential

Rodin's continuous drawings belong unquestionably to the late nineteenth-century trend to eliminate perspective and emphasize the surface in painting, a preference associated initially with the Nabis. While he may not have been as self-conscious about the picture plane as such painters as Paul Gauguin and later Matisse, Rodin always thought of rendering the figure in depth. It seems that he came to use wash while thinking about his *Monument to Honoré de Balzac* and the problem of setting a statue against the sky in such a way that it would have an interesting silhouette and not seem like a black cutout. On the contrary, he sought "to obtain above all a drawing of movement in the air. It was to obey the natural principles of sculpture made to be seen in the open air, that is, the search for contour and for what the painters call value. In order to understand this notion exactly, one should think about what one sees of a person standing against the light of the twilight sky: a very precise silhouette, filled by a dark coloration, with indistinct details. The rapport between this dark coloration and the tone of the sky is value, that is to say, that which gives the notion of material substance to the body. . . . All that we see essentially of a statue standing high in place, and all that carries, is its movement, its contour, and its value."[18]

Against Style

Of great importance for artists who followed and attended to what he had done, such as Gustav Klimt, Matisse, and Egon Schiele, was the fact that continuous drawing made the artist totally unselfconscious about not only the technical aspects of rendering but also style. Early in his career Rodin had asked, what if the artist has no style so that he can be more faithful to what he finds in life? Rodin's style in drawing as in sculpture was to have no style, and the last thing that could be said about his continuous drawings is that in any part they result from stylization of the figure. Not the least reason Rodin was not an art nouveau artist was his antipathy to stylization or imposing one's style on nature. These drawings have been Rodin's most potent weapon against the very concept of style and in favor of the artist defying habit and permitting constant self-renewal by working directly from life. When from 1899 to 1900, for less than a year, Rodin, Emile-Antoine Bourdelle, and Jules Desbois, at the behest of a man named Rossi, established the Institut Rodin on the boulevard du Montparnasse, there were no plaster casts in the classrooms and students had to begin drawing by working from life.[19]

NOTES

LITERATURE: **199:** Varnedoe 1970, 3–4; Elsen and Varnedoe 1971, 87; Lampert 1986, 156, 227; Eitner, Fryberger, and Osborne 1993, 360, no. 429; **200:** Elsen 1987, 34; Eitner, Fryberger, and Osborne 1993, 238–39, no. 428; **201:** Elsen and Varnedoe 1971, 87; Eitner, Fryberger, and Osborne 1993, 360, no. 430; **202:** Eitner, Fryberger, and Osborne 1993, 360, no. 432; **203:** Eitner, Fryberger, and Osborne 1993, 361, no. 433; **204:** Eitner, Fryberger, and Osborne 1993, 360, no. 431

1. For this six-volume inventory, see Judrin 1984–92.
2. See Kirk Varnedoe's discussion of this subject, "Rodin as a Draughtsman: A Chronological Perspective," in Elsen and Varnedoe 1971, 69–87. See also Guillemot 1898; Fagus

1900; Cladel 1903, 90–92; Janin 1903; Ludovici 1926, 133–40; Elsen 1963, 155–71; Geissbuhler 1963; Varnedoe 1970, 3–4; Elsen and Varnedoe 1971, 69–87; Elsen 1972; Elsen 1981, 153–56, 179–81; Judrin 1984–92; Güse 1985, 211–68; Lampert 1986, 156–66, 224–28; Elsen 1987; Elsen 1994

3. His method is described in Lecoq de Boisbaudran 1953. For a summary of this method of instruction see Elsen 1963, 160–62.

4. Janin 1903.

5. Cladel 1903, 90. Cladel went on to describe how Rodin's face was filled with a "transparent joy." For the dating of Cladel's witnessing the drawing session see Varnedoe, "Rodin as a Draughtsman," in Elsen and Varnedoe 1971, 116 n. 113.

6. Ludovici 1926, 136.

7. Ibid., 138–39.

8. For that of the first-named drawing see Judrin 1984–92, vol. 2 (1986): 191, no. 2316, and for the second, ibid., vol. 4 (1984): 17, no. 4569. Varnedoe assembled such a series of a figure moving toward the artist; see his essay "Rodin's Drawings," in Elsen 1981, 182–83.

9. For a good, brief comparison between the drawings of Rodin and Degas, see Varnedoe, "Rodin's Drawings," in Elsen 1981, 180.

10. Kenneth Clark, *The Nude: A Study in Ideal Form*, Bollingen series, no. 35 (Princeton: Princeton University Press, 1956), 23–54.

11. Cladel 1903, 29.

12. Varnedoe, "Rodin's Drawings," in Elsen 1981, 181 n. 6, citing Charles Quentin, "Rodin," *Art Journal* (London) 50 (July 1898): 194.

13. Cited by Varnedoe, "Rodin as a Draughtsman," in Elsen and Varnedoe 1971, 118 n. 126; in Gsell [1911] 1984, 45–46.

14. See ibid., 118 n.127.

15. The two Stanford drawings on onionskin paper that came originally from the Roger Marx collection (cat. nos. 202–203) may be examples of the latter. The original version of Stanford's drawing cat. no. 203 is in the Musée Rodin and reproduced in Judrin 1984–92, vol. 1 (1987): 271, no. 1298.

16. See ibid., 1: 151, no. 1210.

17. See Elsen 1987.

18. Mauclair 1898, 597–99.

19. For a discussion of this subject, see Beausire 1988, 165–69. By agreeing to this school, Rodin was anticipating Matisse, who did the same in 1908, in a former convent directly behind Rodin's home in the Hôtel Biron in Paris.

APPENDIX

Among the holdings of the Iris & B. Gerald Cantor Center for Visual Arts are prints and book illustrations by Rodin, as well as historic photographs of the sculptor and of his works. Some prints are mentioned and illustrated in the context of other entries, including *Bellona* (fig. 53) and *Springtime* (fig. 485), and the portraits of Victor Hugo (fig. 240) and Henri Becque (fig. 249). For a discussion of Rodin's prints and book illustrations the reader is referred to Victoria Thorson's 1975 catalogue of Rodin's graphic work. The prints listed below are identified by reference to Thorson and to the earlier catalogue by Loys Delteil (1910).

Prints by Rodin are listed in chronological order. Other works are grouped by artist (anonymous works first) and listed in accession number order. For photographs, the date of the object may be integrated into the title; otherwise the date indicated refers to the date of the photograph (when known) rather than to the date of the sculpture pictured. For intaglio prints and photographs, dimensions refer to plate mark or image; for drawings and lithographs, sheet size is provided.

PRINTS BY AUGUSTE RODIN

A1

Bellona, 1883
Drypoint, 7¹³⁄₁₆ x 3¹⁵⁄₁₆ in. (14.8 x 10 cm)
Signed lower right: A. Rodin
1987.148, gift of Iris and B. Gerald Cantor Foundation
Literature: Delteil 3 iii/iii; Thorson 3 iii/iii
Figure 53

A2

The Round (La ronde), 1883
Drypoint, 9³⁄₁₆ x 7 in. (23.3 x 18 cm)
Signed in pencil, lower right: Aug Rodin
Collector's stamp on verso, lower right: Max Blach, Wien
Provenance: Max Blach, Vienna
1983.76, given in honor of Meyer Schapiro by Professor and Mrs.
 Albert Elsen
Literature: Delteil 5 iii/iii; Thorson 5 ii/iii
Figure 495

A3

Springtime (Le printemps), 1883
From *La gazette des beaux-arts* 27, no. 1 (March 1902): facing 204
Drypoint, 5⅝ x 3⅞ in. (14.2 x 9.9 cm)
1980.107, gift of the Iris and B. Gerald Cantor Foundation,
Literature: Delteil 4; Thorson 4
Figure 485

A4

Henri Becque, 1883-87
From *L'estampe originale* 2 (April-June 1893), pl. 19
Drypoint, 6⁵⁄₁₆ x 8 in. (16 x 20.4 cm)
Signed in pencil, lower right: 22 AR; center left: AR
1963.5.43, gift of Marion E. Fitzhugh and Dr. William M. Fitzhugh, Jr.,
 in memory of their mother, Mary E. Fitzhugh

Fig. 495

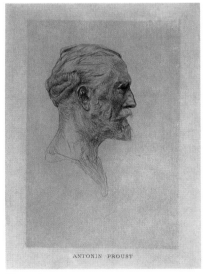

Fig. 496

Fig. 497

Fig. 499

Fig. 498

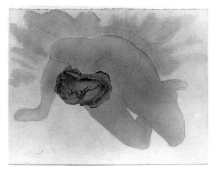

Fig. 500

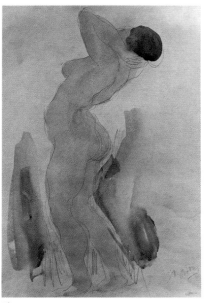

Fig. 501

Literature: Delteil 9 iii/v, edition of 100; Thorson 7 iv/iv; Donna Stein and Donald H. Karshan, *L'Estampe originale: a catalogue raisonné*, exh. cat. New York Cultural Center (New York: Museum of Graphic Art, 1970), cat. no. 72. Not illustrated

A5

Portrait of Henri Becque, 1883-87
Drypoint, 6⁵⁄₁₆ x 8 in. (15.8 x 20.3 cm)
1988.237, gift of the Iris and B. Gerald Cantor Foundation
Literature: Delteil 9 iii or v; Thorson 7 iv/iv (30), Stein and Karshan, as in A4.
Figure 249

A6

Antonin Proust, c. 1884
Drypoint, 7⁷⁄₈ x 5⁵⁄₈ in. (20 x 14.3 cm)
Inscribed below image, center: Antonin Proust
1983.64, gift of Professor and Mrs. Albert Elsen
Literature: Delteil 10 vii/vii; Thorson 10 vii/vii
This image was published in Léon Maillard, *Auguste Rodin* (Paris, 1899) facing p. 110.
Figure 496

A7

Antonin Proust, c. 1884
Drypoint, 9⁷⁄₁₆ x 7¹⁄₁₆ in. (24 x 18 cm)
Inscribed in pencil, lower right (unidentified hand, not Rodin's): Rodin
1988.238, gift of the Iris and B. Gerald Cantor Foundation. Not illustrated

A8

"Victor Hugo," Front View, 1885
Drypoint, 8⁷⁄₈ x 7 in. (22.5 x 17.8 cm)
Signed in ink, below plate mark, lower right: A. Rodin
Inscribed in pencil, lower center: 24/2151
1980.106, gift of the Iris and B. Gerald Cantor Foundation
Literature: Delteil 7 ii/vii; Thorson 9 iii/viii
Figure 240

A9

Souls of Purgatory, 1893
Frontispiece to Gustave Geffroy, *La vie artistique* vol. 2 (Paris, 1893)
Drypoint, 6 x 3¹³⁄₁₆ in. (15.3 x 9.7 cm)
Signed in plate, lower right: Rodin
1963.5.44, gift of Marion E. Fitzhugh and Dr. William M. Fitzhugh, Jr., in memory of their mother, Mary E. Fitzhugh
Literature: Delteil 11 ii/ii; Thorson 12 ii/ii
Figure 497

A10

A Figure (Une figure), c. 1902
Proof for Octave Mirbeau, *Le jardin des supplices* (Paris: Ambroise Vollard, 1902)
Lithograph, 8⁵⁄₈ x 8¼ in. (22 x 21 cm)
Signed in plate, lower right: Aug Rodin
1970.8, gift of B. Gerald Cantor
Literature: Delteil 14; Thorson, 3.123, before tone plates
Figure 498

ILLUSTRATED BOOKS

A11

Emile Bergerat, *Enguerrand, poème dramatique*
Paris: Bibliothèque des deux-mondes. Frinzine, Klein, et Cie., 1884
11 x 8⅞ in. (28 x 22.5 cm)
1976.137, Mortimer C. Leventritt Fund
This volume includes a frontispiece portrait of Octave Mirbeau by
 Henri Lefort and the facsimile reproduction of two drawings by
 Rodin. The illustrations were commissioned in 1884, and Rodin's
 first version of his drawings was completed by 30 July 1884.

A12

Octave Mirbeau, *Le jardin des supplices*
Paris: Ambroise Vollard, 1902
13⁹⁄₁₆ x 10¼ in. (34.4 x 26 cm) unbound, wrappers and box
Inscribed: 1902
1983.156, gift of the Iris and B. Gerald Cantor Foundation
The volume includes 20 transfer lithographs by Rodin, 18 with color.
 They were printed by Auguste Clot.
Literature: Thorson 3, 115 and 126 illustrated; David Becker, *The Artist
 of the Book 1860-1960 in Western Europe and the United States*,
 exh. cat. Museum of Fine Arts Boston (Greenwich, Conn.: New
 York Graphic Society, 1961), 175.
Figures 499–500

A13

Auguste Rodin, *Les cathédrales de France*
Paris: Librairie Armand Colin, 1914
1997.187, bequest of Albert E. Elsen

AUTOGRAPH LETTERS

A14

Letter to Gustav Geffroy with Envelope
Pen and ink
Signed: Rodin
Dated: *21 March 1887*
1984.19a-b, gift of B. Gerald Cantor

A15

Letter to Rose Beuret and Envelope, 1887
Pen and ink
Signed: Auguste Rodin
Dated: 15 August, 1891
1969.212.1, Museum Purchase Fund

A16

Letter to "Chere grande amie"
Pen and ink
Signed: A. Rodin
Dated: June 1914
1986.470, gift of the Iris and B. Gerald Cantor Art Foundation

A17

Letter to Madame Kate Simpson
Pen and ink
Signed: Auguste Rodin
Dated: June 1914
1986.471, gift of the Iris and B. Gerald Cantor Art Foundation

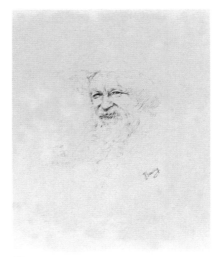

Fig. 502

Fig. 503

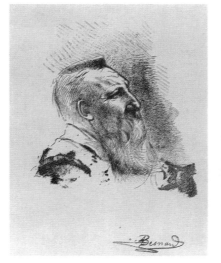

Fig. 504

Fig. 505

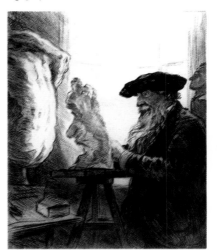

Fig. 506

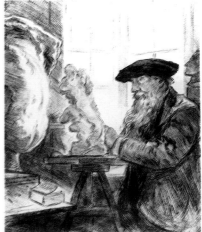

Fig. 507

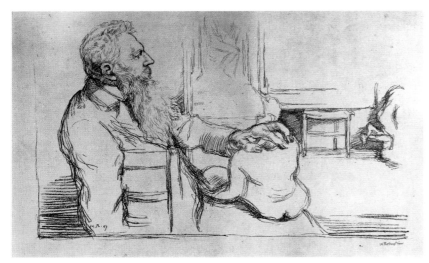

Fig. 508

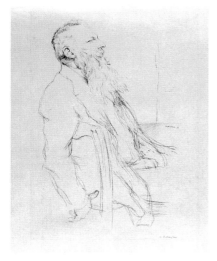

Fig. 509

Fig. 511

Fig. 510

A18

Letter to Gustave Geffroy with Envelope
Pen and ink
Signed: A. Rodin
Dated: February 1896
1988.240.1-2, gift of the Iris and B. Gerald Cantor Art Foundation

A19

Letter to M. Mourey, 1906
Pen and ink
Signed lower right: Rodin
1988.241, gift of the Iris and B. Gerald Cantor Art Foundation

A20

Letter to "Mon cher et vaillant ami"
Pen and ink
Signed: Aug. Rodin
Dated: 16 June 1910
1988.242.1-2, gift of the Iris and B. Gerald Cantor Art Foundation

REPRODUCTIONS AFTER RODIN

A21-31

Eleven-step lost-wax casting process of *The Small Fauness* from *The Gates of Hell*
Plaster, synthetic, clay, wax, ceramic, bronze; prepared by Coubertin Foundry
Each approx. 9½ x 4 x 3¼ in. (24.1 x 10.2 x 8.3 cm)
Final stage is 1/12
1992.188.1-11, gift of the Iris & B. Gerald Cantor Foundation
Figures 28-38

A32

Reproduction of "Torso of Adèle," 1978
Bronze, 17¾ x 6 x 9¼ in. (45 x 15 x 23.5 cm)
Signed, interior cachet: A. Rodin
1982.3004, gift of B. Gerald Cantor Collection
This is a *surmoulage*, a cast made from an authentic bronze, produced by the Nelson Rockefeller Collection (see John Henry, Merryman and Albert Elsen, *Art, Ethics, and the Law*, 2nd ed., 2 vols. (Philadelphia: University of Pennsylvania Press, 1982), 2:543-47.
Figure 415

A33

Photogravure of Drawing "Figure on a Horse," 1906-11
From *Camera Work* 34-35 (1911), 25
Photogravure, 7⁵⁄₁₆ x 5⅞ in. (18.5 x 15 cm)
Signed lower right: Aug. Rodin/1906
1988.261, gift of the Iris and B. Gerald Cantor Foundation
The watercolor, *Horseman*, is in the collection of the Art Institute of Chicago, Alfred Steiglitz Collection. Not illustrated.

FORGERIES — SCULPTURE AND DRAWINGS

A34

Study for "The Thinker"
Anonymous forger of Rodin
Bronze, 6⅞ x 5¹¹⁄₁₆ x 5 in. (17.4 x 14.5 x 12.8 cm)
Falsely signed on left shoulder: *A. Rodin*
1974.238, gift of George Gregson. Not illustrated.

A35

Woman Walking with Hands behind Her Neck
Anonymous forger of Rodin
Pencil and watercolor, 14¹³⁄₁₆ x 10⅞ in. (37.6 ;tx 27.6 cm)
Falsely signed: A Rodin
1969.157, anonymous gift
Figure 501

A36

Two Female Nudes, recto
Two Women, verso:
Pencil and watercolor, 11¹³⁄₁₆ x 9¾ in. (30 x 24.7 cm)
Falsely signed: Aug. Rodin
1974.237, gift of George Gregson. Not illustrated

Attributed to Ernst Durig
Switzerland, 1894-1962

A37

Standing Nude Looking over Shoulder, before 1957
Pencil and watercolor, 15⅞ x 11¹³⁄₁₆ in. (40.4 x 30 cm)
Falsely signed, lower right: A Rodin; [??
Inscribed, 1069]upper right: 6
Provenance: Meltzer Gallery, New York
1997.146, anonymous gift. Not illustrated

A38

Crouching Nude in Profile, before 1957
Pencil and watercolor, 15¹⁵⁄₁₆ x 11⅛ in. (40.5 x 28.2 cm)
Falsely signed, lower right: A Rodin
Inscribed, upper right: 1
Provenance: Meltzer Gallery, New York
1997.147, anonymous gift. Not illustrated

A39

Two Nudes in Profile, before 1957
Pencil and watercolor, 16¾ x 11¾ in. (42.6 x 29.9 cm)
Falsely signed in pencil, lower right: Aug Rodin
Inscribed, upper right: 46
Provenance: Meltzer Gallery, New York
1997.148, anonymous gift. Not illustrated

Attributed to Odilon Roche
France, 1868-1947
A40

Standing Female Nude
Pencil and watercolor, 11 x 6⅞ in. (28 x 17.5 cm)
Falsely signed, lower right: A Rodin
Stamped with false authentication on verso, lower right: Edmond
 Delaye, Lyon
Annotated in ink on verso: certifié dessin original d'Auguste Rodin
1969.156, anonymous gift. Not illustrated

A41

Crouching Nude
Pencil and watercolor, 9¹⁵⁄₁₆ x 8⅝ in. (25.2 x 22 cm)
Falsely signed, lower right: A Rodin
1969.186, gift of B. Gerald Cantor. Not illustrated

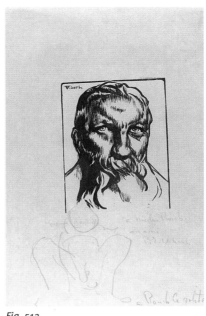

Fig. 512

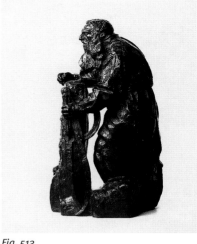

Fig. 513

Fig. 514

Fig. 515

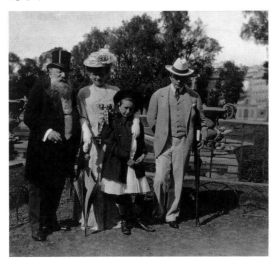

Fig. 516

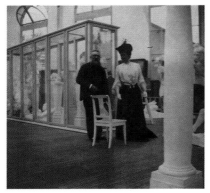

Fig. 517

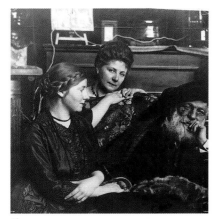

Fig. 519

Fig. 518

Fig. 520

PORTRAITS OF RODIN—PRINTS, DRAWINGS, SCULPTURE, AND PHOTOGRAPHS

Jeanne Bardey
France, 1872–1954

A42

Portrait of the Sculptor Auguste Rodin c. 1912
Lithograph, 14⁵/₁₆ x 10¹³/₁₆ in. (36.4 x 27.5 cm)
Signed in plate, lower right: J. Bardey
1987.116, gift of Margaret and Joel R. Bergquist
Figure 502

A43

Portrait of Auguste Rodin, c. 1912
Lithograph (4/50), 14⁵/₁₆ x 10¹³/₁₆ in. (36.4 x 27.5 cm)
Signed below image, lower right: J. Bardey
Blindstamp, lower right: Galerie/des/Peintres Graveurs/Paris
1988.79, gift of Margaret and Joel R. Bergquist
Figure 503

Paul-Albert Besnard
France, 1849-1932

A44

Portrait of Rodin
Color lithograph, 10⁵/₈ x 8⁵/₁₆ in. (27.1 x 21.1 cm)
Signed in plate, lower right: A. Besnard
Mark below image, lower right: Rodin, par Besnard
1977.77.24, Museum Purchase Fund
Literature: Delteil 130 iii/iii
Figure 504

Eugène Carrière
France, 1849-1906

A45

Rodin Sculpting, 1897
Lithograph, 24¹/₂ x 19¹¹/₁₆ in. (62.2 x 50.1 cm)
Signed in plate, lower left: Eugène Carrière; in pencil below image,
 lower left 97
1972.108, Mortimer C. Leventritt Fund
Literature: Delteil 39
This image appeared on the poster announcing Rodin's retrospective,
 Exposition Rodin, held June to November 1900, Place de l'Alma.
Figure 505

Arthur Paine Garratt
Great Britain, active 1899-1915

A46

Portrait of Rodin
Drypoint, 10¹³/₁₆ x 8¹³/₁₆ in. (27.5 x 22.4 cm)
Signed below plate, lower right: Arthur Garratt
1986.134, gift of James A. Bergquist
Figure 506

A47

Portrait of Rodin
Etching, 19¹/₄ x 15¹⁵/₁₆ in. (49 x 40.5 cm)
1987.115, gift of James A. Bergquist
Figure 507

William Rothenstein
Great Britain, 1872-1945
A48

> *Rodin in His Studio*, 1897
> Lithograph, 13⅜ x 16¾ in. (34 x 42.6 cm)
> Signed in plate, lower left: W.R. 97; in pencil, below image, lower
> right: W. Rothenstein 1979.64, Committee for Art Acquisitions Fund
> This image was published in *Artist-Engraver* (April 1904).
> Literature: William Rothenstein, *Men and Memories 1872-1900, I*
> *(1931)*, ill.pl. 43 William Rothenstein, *Portrait Drawings of William*
> *Rothenstein, 1889-1925, an iconography by John Rothenstein*
> (London: Chapman & Hall, 1926), no. 72.
> *Figure 508*

A49

> *Auguste Rodin*, 1897
> Lithograph, 15⅜ x 11⅜ in. (39.1 x 28.9 cm)
> Signed in plate, right center: Rothenstein 97; in pencil, lower right:
> W. Rothenstein
> Collector's mark on verso, lower right: not in Lugt
> 1981.45, Committee for Art Acquisitions Fund
> Literature: William Rothenstein, *French 500: Auguste Rodin,*
> *Fantin–Latour, and Alphonse Legros*
> *Figure 509*

A50

> *Rodin in His Studio*, 1897
> From "Album of Artists"
> Lithograph, 13⅜ x 16¾ in. (34 x 42.6 cm)
> Signed in plate, lower left: W.R. 97
> Inscribed in pencil, below image, center: à Madame K. Simpson/Paris
> 15 Septembre 1904/Auguste Rodin
> 1987.189, gift of the Iris and B. Gerald Cantor Foundation. Not illustrated

A51

> *George Bernard Shaw Sitting for Rodin*, c. 1906
> Chalk, 11 x 7⁹⁄₁₆ in. (28.2 x 19.2 cm)
> Inscribed in ink, lower right: G.B.S. Sitting for Rodin/for Frances—
> W.R.
> 1988.236, gift of the Iris and B. Gerald Cantor Foundation
> *Figure 510*

John Singer Sargent
United States, active Great Britain, 1856-1925
A52

> *Portrait of Rodin Reading*, 1902
> Pen and ink and wash, 7 x 4⅝ in. (18 x 11.8 cm)
> 1977.19, gift of B. Gerald Cantor
> *Figure 511*

Pierre Eugène Vibert
Switzerland, 1875-1937
A53

> *Rodin*, recto
> Verso: pencil sketch of nude woman
> Woodcut, 11¼ x 7⁹⁄₁₆ in. (28.5 x 19.3 cm)
> Signed on image, upper left: Vibert
> Inscribed in pencil, below image, lower right: à Nicolas Rauch/son
> ami/Pierre Vibert; in pencil, below image, lower left: epreuve
> d'artist
> 1972.183, Mortimer C. Leventritt Fund
> *Figure 512*

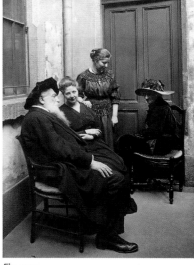

Fig. 521

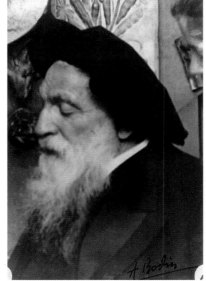

Fig. 522

Fig. 523

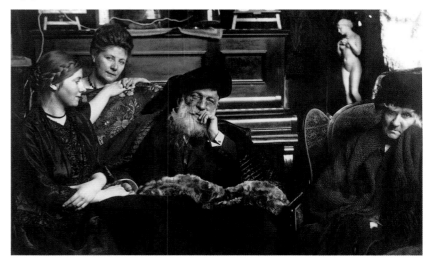

Fig. 524

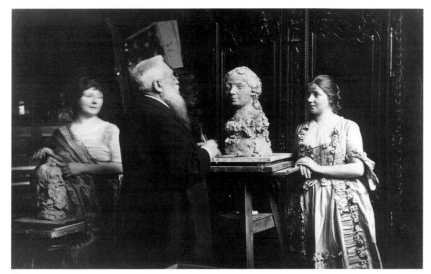

Fig. 525

Fig. 526

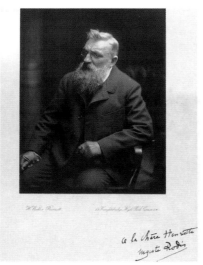

Fig. 527

Fig. 528

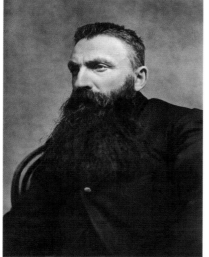

Fig. 529

Emile-Antoine Bourdelle
France, 1861-1929
A54
 Rodin Working on "The Gates of Hell," 1910
 Bronze, Susse Foundry cast (9/10), 27¾ x 10 x 14½ in. (70.6 x 25.4 x 37 cm)
 Inscribed on base, right side: © by Bourdelle / Rodin travaillant/à sa Porte de l'Enfer/Emile Antoine Bourdelle
 1974.112, gift of the Iris and B. Gerald Cantor Foundation
 Figure 513

Séraphin Soudbinine
Russia, active early 1900s
A55
 Bust of Auguste Rodin, 1909
 Bronze, 6 x 4 x 4 in. (15.4 x 10.2 x 10.2 cm)
 1974.113, gift of the Iris and B. Gerald Cantor Foundation
 Figure 514

Prince Paul Troubetskoy
Russia, born Italy, 1866-1938
A56
 Portrait of Rodin, 1905-06
 Bronze, Alexis Rudier foundry cast, 20¼ x 13½ x 14½ in. (51.4 x 34.3 x 36.8 cm)
 Signed on top of base, front: Paul Troubetzkoy
 Inscribed on back of base, left side: Alexis Rudier/Fondeur—Paris
 1974.114, gift of the Iris and B. Gerald Cantor Foundation
 Figure 515

John Tweed
Great Britain (Scotland), 1869-1933
A57
 Profile Portrait of Auguste Rodin, c. 1895
 Plaster, 15¾ x 12½ x 1¾in. (40 x 31.8 x 4.4 cm)
 1982.372, gift of Gail W. Feingarten
 Figure 6

Photographer unknown
A58
 Rodin with Mr. and Mrs. Simpson at Versailles, c. 1908
 Gelatin silver print, 3⅜ x 3⅜ in. (8.8 x 8.8 cm)
 1986.460.1, gift of of the Iris and B. Gerald Cantor Foundation
 Figure 516

A59
 Rodin with Mrs. Robinson at Meudon, c. 1908
 Gelatin silver print, 3¼ x 3¼ in. (8.2 x 8.2 cm)
 1986.460.2, gift of the Iris and B. Gerald Cantor Foundation
 Figure 517
A60
 Auguste Rodin with Jeanne Bardey, Rose Beuret, and Henriette Bardey, 1916
 Gelatin silver print, 15½ x 11¹³⁄₁₆ in. (39.5 x 30 cm)
 Inscribed in ink, lower right: A. Rodin
 1988.243.1, gift of the Iris and B. Gerald Cantor Foundation
 Figure 518

A61

Henriette and Jeanne Bardey with Auguste Rodin, 14 rue Robert, Lyon, 1916
Gelatin silver print, 13 x 11¹³⁄₁₆ in. (33 x 30 cm)
Inscribed in ink, lower right: A. Rodin
1988.243.2, gift of the Iris and B. Gerald Cantor Foundation
This photograph is cropped and enlarged fron A66, fig. 524.
Figure 519

A62

Henriette Bardey, Auguste Rodin, and Jeanne Bardey, 1916
Gelatin silver print, 15⅝ x 5⅝ in. (39.8 x 14.5 cm)
Inscribed in ink, lower right: A. Rodin
1988.243.3, gift of the Iris and B. Gerald Cantor Foundation
Figure 520

A63

Auguste Rodin, Jeanne and Henriette Bardey, and Rose Beuret, 1916
Gelatin silver print, 6⅝ x 4⅝ in. (16.9 x 11.9 cm)
Inscribed on mount, lower right: hommage Mme Bardey A. Rodin
1988.243.4, gift of the Iris and B. Gerald Cantor Foundation
Figure 521

A64

Portrait of Auguste Rodin, 1916
Gelatin silver print, 7 x 4¾ in. (17.9 x 12 cm)
Inscribed in ink, lower right: A. Rodin
1988.243.5, gift of the Iris and B. Gerald Cantor Foundation
Figure 522

A65

Auguste Rodin with Jeanne Bardey, 1916
Gelatin silver print, 9⅜ x 7 in. (24 x 17.8 cm)
Inscribed in ink, lower right: A. Rodin
1988.243.6, gift of the Iris and B. Gerald Cantor Foundation
This photograph is cropped and enlarged from A60, fig. 518.
Figure 523

A66

Henriette and Jeanne Bardey, Auguste Rodin, and Rose Beuret, 19 rue Robert, Lyon, 1916
Gelatin silver print, 4⅛ x 6¼ in. (10.5 x 15.9 cm)
Inscribed in ink, lower right: A. Rodin
1988.243.7, gift of the Iris and B. Gerald Cantor Foundation
Figure 524

A67

Auguste Rodin Sculpting "Bust of Henriette Bardy," with Henriette and Jeanne Bardy, 1916
Gelatin silver print, 4⅜ x 6⅜ in. (10.8 x 16.6 cm)
1988.243.8, gift of the Iris and B. Gerald Cantor Foundation
Figure 525

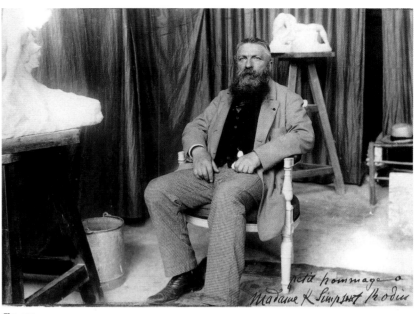

Fig. 531

Fig. 530

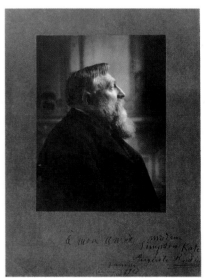

Fig. 533

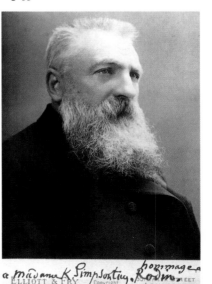

Fig. 532

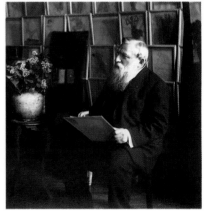

Fig. 534

Fig. 535

Fig. 537

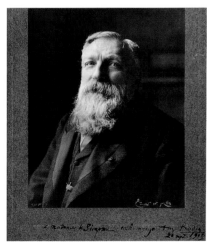

Fig. 539

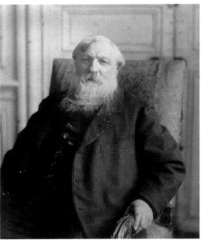

Fig. 536

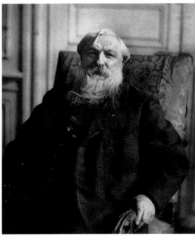

Fig. 538

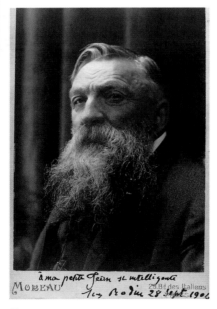

Fig. 540

A68

Rodin Reading a Letter in a Garden, c. 1904
Gelatin silver print, 4¾ x 3½ in. (12 x 9 cm)
Inscribed on verso in pencil, upper center: #1285
1988.245, gift of the Iris and B. Gerald Cantor Foundation,
Figure 526

A69

Auguste Rodin in his boulevard de Vaugirard Studio, posing with
"The Kiss" in marble, c. 1898
Albumen print, 6⅛ x 4⁹⁄₁₆ in. (15.5 x 11.6 cm)
1994.56, gift of Albert E. Elsen
Frontispiece

Henry Walter Barnett
Great Britain, 1862-1934
A70

Portrait of Auguste Rodin with Gloves and Pince-nez, 1904
Photogravure (?), 8¼ x 6¼ in. (20.8 x 16.7)
Inscribed in ink on mount, lower right: chère Henriette/Auguste
 Rodin
Marks printed, lower left: H Walter Barnett; on mount, lower right: 12
 Knightsbridge Hyde Park Corner S.W.
Blind-stamp embossed on image, lower right: W. Walter Barnett
Blind-stamp on image, lower center: copyright
Photographer's copyright seal blind-stamp on mount, lower center
1988.243.9, gift of the Iris and B. Gerald Cantor Foundation
Figure 527

Bertieri Platinotype Studio, Turin
Italy, late 19th-early 20th century
A71

Rodin in Coat and Gloves, c. 1904
Gelatin silver print, 5⅜ x 3¾ in. (13.7 x 9.6 cm)
Inscribed on mat: Madame Kate Simpson/en haute consideration et
 [respectueuse?] sympathie/Aug Rodin
1987.68, gift of the Iris and B. Gerald Cantor Foundation
Figure 528

Etienne Carjat
France, 1829-1906
A72

Portrait of Auguste Rodin, c. 1885
Woodburytype, 8⁹⁄₁₆ x 6⁷⁄₁₆ in. (21.8 x 16.3 cm)
Studio blind-stamp on mount, lower right: Maison A. D. Braun & cie.
1994.55, gift of Albert E. Elsen
Figure 529

Alvin Langdon Coburn
Great Britain, born United States, 1882-1966
A73

Rodin, 1906
From *Camera Work* 21 (January 1908) 11
Photogravure, 8 x 6¼ in. (20.3 x 16 cm)
1973.31, Museum Purchase Fund
Figure 530

Dornac
France, 1844-1896
A74
Portrait of Rodin Seated in His Studio, Dépôt des marbres
Albumen print, 5 x 16⅞ in. (12.8 x 17.5 cm)
Inscribed: petit hommage à/Madame K. Simpson A Rodin
1986.437, gift of the Iris and B. Gerald Cantor Foundation
Figure 531

J. Joseph Elliott and L. Edmund Fry
Great Britain; Elliott: active 1860s to 1890s; Fry: 1835-1903
A75
Portrait of Rodin
Albumen print, 5¹¹⁄₁₆ x 4 in. (14.5 x 10.4 cm)
Inscribed below image, lower left: hommage [sic] Madame K. Simpson. Aug. Rodin.
Marks printed on card, lower left: Elliot & Fry; lower center: copyright; lower right: 55 Baker Street/London. W
1986.440, gift of the Iris and B. Gerald Cantor Foundation
Figure 532

R. Johnson
Great Britain, n.d.
A76
Portrait of Rodin, c. 1911
Gelatin silver print, 7⁷⁄₁₆ x 5⅛ in. (18.8 x 13.2 cm)
Inscribed in ink, lower right: à mon amie Madame / Simpson Kate / Auguste Rodin /[?] janvier 1917
Studio stamp embossed on mount: R. *Johnson/292 Kings Rd SW*
1986.443, gift of the Iris and B. Gerald Cantor Foundation
Figure 533

Gertrude Stanton Käsebier
United States, 1852-1934
A77
Rodin with "Bust of Baron d'Estournelles de Constant," 1905
Gelatin silver print, 5¹¹⁄₁₆ x 4⅝ in. (14.5 x 10.9 cm)
Inscribed in pencil on verso, lower right: *1121*
1988.251, gift of the Iris and B. Gerald Cantor Foundation
Figure 8

Henri Manuel
France, active 1900-1938
A78
Portrait of Rodin, 1911
Gelatin silver print, 5¹³⁄₁₆ x 5⅛ in. (14.8 x 13.1 cm)
Inscribed in ink on mount: *le sculpteur Rodin en hommage à Madame/Kate Simpson novembre 8. 1913*
1986.444, gift of the Iris and B. Gerald Cantor Foundation
Figure 534

A79
Rodin Seated before "Cupid and Psyche" in marble, Hôtel Biron, 1911
Hand colored gelatin silver print, 5¼ x 3¼ in. (13.3 x 8.2 cm)
Signed lower left: H. Manuel/3700
Inscribed recto: Rodin/Voeux bien/affecteux à Madame/Simpson; verso: January 17, 1917
Marks, upper right: A. Rodin; lower right: Croissant/Paris
1986.458, gift of the Iris and B. Gerald Cantor Foundation
Figure 535

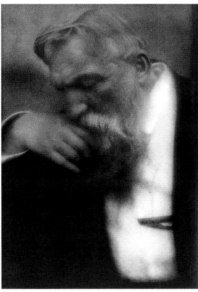

Fig. 541

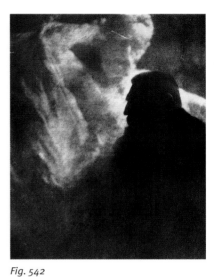

Fig. 542

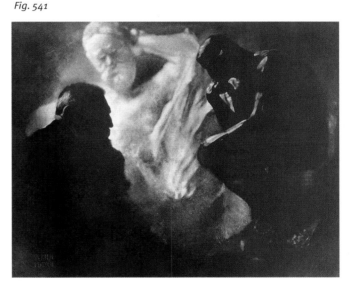

Fig. 543

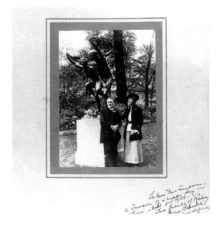

Fig. 5344

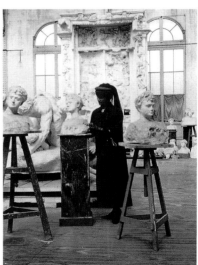

Fig. 545

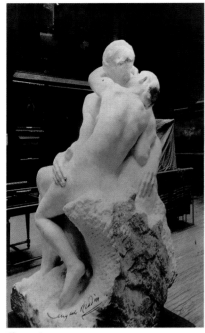

Fig. 546

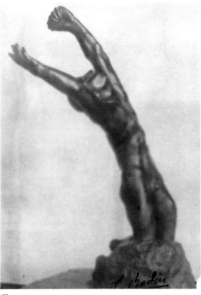

Fig. 547

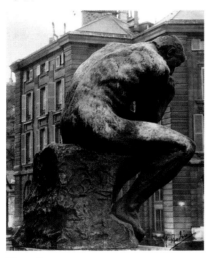

Fig. 548

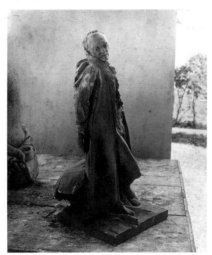

Fig. 549

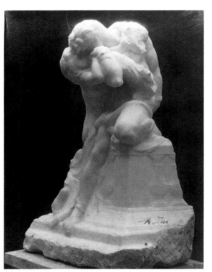

Fig. 550

A80

Auguste Rodin Seated in an Armchair, c. 1911
Gelatin silver print, 8⅛ x 6⅛ in. (20.7 x 15.6 cm)
Inscribed in pencil below blind-stamp: Aug Rodin
Publisher's blind-stamp outlined in pencil on mount, lower right:
 Maison Braun & Cie Paris
1988.243.10, gift of the Iris and B. Gerald Cantor Foundation
This photograph was presumably published by the Braun studio after
 a photograph by Henri Manuel.
Figure 536

A81

Portrait of Auguste Rodin with a Book, Hôtel Biron, 1911
Gelatin silver print, 8¼ x 6¹⁄₁₆ in. (21 x 15.4 cm)
Inscribed below image: Aug. Rodin
Publisher's blind-stamp embossed on mount, lower right: Maison
 Braun & Cie Paris
1988.243.11, gift of the Iris and B. Gerald Cantor Foundation
This photograph was presumably published by the Braun studio after
 a photograph by Henri Manuel.
Figure 537

A82

Rodin Seated in Armchair, 1911
Photogravure, 10¼ x 7½ in. (26 x 19 cm)
Inscribed in pen and ink on mount, lower right: Aug. Rodin 1911; in
 pencil on mount, lower right: à Mrs Simpson/en souvenir de
 grande âme/et de sa visite dans sa maison/qui lui redoit la vie. Le
 11 Mai 1922/Le mort éveillé
Marks printed on plate: Hélio. Braun & Cie; in pencil, verso, upper
 left: #1268
1988.244, gift of the Iris and B. Gerald Cantor Foundation
Figure 538

Ernest Herbert Mills
Great Britain, 1874-1942
A83

Portrait of Rodin, 1905
Gelatin silver print, 7¹¹⁄₁₆ x 5⅞ in. (19.6 x 14.9 cm)
Signed in negative, lower right: Ernest H. Mills
Inscribed in ink on mount: à Madame Simpson en hommage Aug
 Rodin/20 sept 1905
Studio stamp verso, lower left: Ernest H. Mills/at home photogra-
 pher/17 Stanley Gardens/Hampstead NW
1986.463, gift of the Iris and B. Gerald Cantor Foundation
Figure 539

R. Moreau
France, n.d.
A84

Portrait of Rodin, 1906
Gelatin silver print, 5⁹⁄₁₆ x 3⅝ in. (14.2 x 9.3 cm)
Inscribed in ink: à ma petite Jean si intelligente/Aug Rodin 28 sept
 1906
Marks on mount, lower left: Moreau; lower right: 29 Bd des
 Italiens/Paris
1986.436, gift of the Iris and B. Gerald Cantor Foundation
Figure 540

Edward Steichen
United States (born Luxembourg), 1879-1973; worked for Rodin after 1901
A85

> *M. Auguste Rodin*, 1907
> From *Camera Work* 34-35 (April-July, 1911),
> Photogravure, 9⁷⁄₁₆ x 6⁹⁄₁₆ in. (23.9 x 16.5 cm)
> Signed below image, lower left: Steiglitz
> 1974.232, gift of the William Rubin Foundation
> *Figure 541*

A86

> *Rodin and "Monument to Victor Hugo,"* 1902
> From Camera Work 2 (April 1903), 5
> Photogravure, 5¹¹⁄₁₆ x 4⁵⁄₁₆ in. (14.5 x 11 cm)
> Signed in pencil on upper mount, lower center: Steichen/MDCCCCII
> Inscribed in pencil on lower mount, lower right: à Madame Kate
> Simpson/Respectueusement A. Rodin
> 1988.262, gift of the Iris and B. Gerald Cantor Foundation
> *Figure 542*

A87

> *Rodin, "The Thinker," and "Monument to Victor Hugo (Rodin—Le
> Penseur),"* 1902
> From *Camera Work* 11 (July 1905), 35
> Offset lithograph (halftone reproduction), 6⅛ x 7¼ in. (16.5 x 18.4 cm)
> Signed in negative, lower left: Steichen/MDCCCCII
> 1988.263, gift of the Iris and B. Gerald Cantor Foundation
> *Figure 543*

Portraits of Rodin's Circle

Photographer unknown
A88

> *Léonce Bénédite and Malvina Hoffman*, 1919
> Gelatin silver print, 6¼ x 4⅜ in. (16 x 11.1 cm)
> Inscribed in ink on mount, lower right: To dear Mrs. Simpson/a sou-
> venir of a happy day in/Paris-Sept. 27 1919—Two friends of
> Rodin/Leonce Benedite /Malvina Hoffman
> 1986.455, gift of the Iris and B. Gerald Cantor Foundation
> *Figure 544*

A89

> *Mrs. Simpson and Her Portrait Busts, Pavillon de l'Alma, Meudon,
> with "The Gates of Hell" in background*, c. 1903
> Gelatin silver print, 5⅜ x 3⅛ in. (13.6 x 7.9 cm)
> 1987.69, gift of the Iris and B. Gerald Cantor Foundation
> *Figure 545*

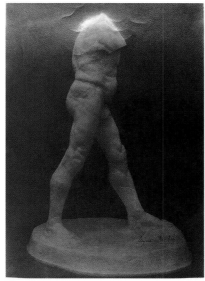

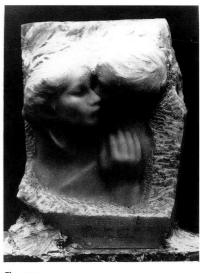

Fig. 551

Fig. 552

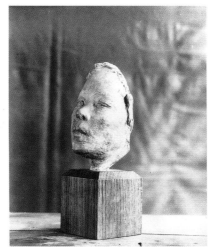

Fig. 553

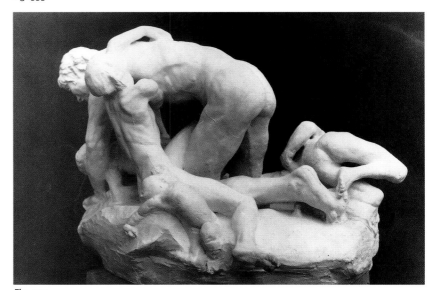

Fig. 554

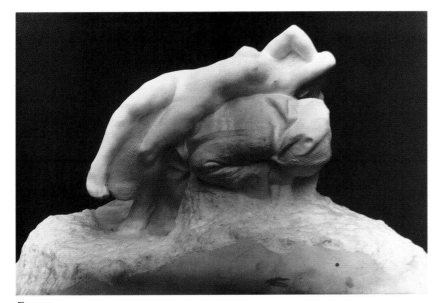

Fig. 555

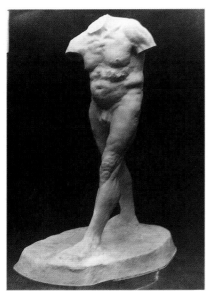

Fig. 556

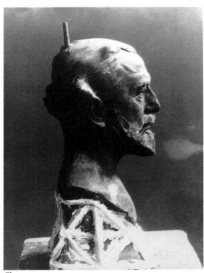

Fig. 557

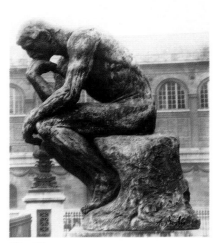

Fig. 558

IMAGES OF RODIN'S WORKS — PHOTOGRAPHS AND DRAWINGS

Photographer unknown

A90

> *The Kiss*
> Gelatin-silver print, 9⁷⁄₁₆ x 7¹⁄₁₆ in. (24 x 18 cm)
> Inscribed on print in ink, lower center: Auguste Rodin; in negative, lower left: 11 R.S.7
> 1978.70.4, gift of the Iris and B. Gerald Cantor Foundation
> *Figure 546*

A91

> *"Torso of a Man" (study for Saint John the Baptiste Preaching),
> c.1887? in plaster, c.1887?*
> Gelatin silver print, 13³⁄₁₆ x 7½ in. (33.5 x 19 cm)1981.273.4, gift of Professor and Mrs. Albert E. Elsen
> *Figure 451*

A92

> *Pedestal of "Monument to Claude Lorrain" c. 1891–92, in marble and
> stone, Nancy, c. 1892*
> Albumen print, 10³⁄₈ x 8³⁄₁₆ in. (26.4 x 20.8 cm)
> Inscribed in negative, in reverse, lower right: 9602
> 1986.442, gift of the Iris and B. Gerald Cantor Foundation
> *Figure 263*

A93

> *"The Prodigal Son" in bronze*
> Gelatin silver print, 7¹⁄₁₆ x 4¹¹⁄₁₆ in. (17.9 x 11.9 cm)
> Inscribed in ink, lower right: A. Rodin
> 1986.462, gift of the Iris and B. Gerald Cantor Foundation
> *Figure 547*

A94

> *The Thinker*
> Gelatin silver print, 11⅛ x 8¹³⁄₁₆ in. (28.3 x 22.4 cm)
> Inscribed in ink, lower right: A. Rodin
> 1988.243.12, gift of the Iris and B. Gerald Cantor Foundation
> *Figure 548*

A95

> *Study for "Monument to Denis Diderot" in plaster, outside Pavillon de
> l'Alma, Meudon, before 1907*
> Gelatin silver print, 6⁹⁄₁₆ x 4⅝ in. (16.7 x 11.8 cm)
> Inscribed in ink, lower right: A. Rodin
> 1988.243.13, gift of the Iris and B. Gerald Cantor Foundation
> *Figure 549*

Charles Berthelomier
France, twentieth century

A96

> *"The Gates of Hell" in plaster in Chaple, Hôtel Biron, 1918*
> Gelatin silver print, 14¼ x 10⅝ in. (36.2 x 27 cm)
> Studio stamp verso, lower center: J. E. B.
> 1987.29, gift of Albert E. and Patricia M. Elsen
> *Figure 128*

Karl-Henri (Charles) Bodmer
France, 1859-after 1893; worked for Rodin, mainly in 1880s
A97

"Shade" with "Fallen Caryatid" in plaster, before 1893
Gelatin silver print, 6½ x 4¹¹⁄₁₆ in. (16.4 x 12.1 cm)
Marks in negative, lower center: No. 5; below image: C. Bodmer phot
1986.421, gift of Albert E. and Patricia M. Elsen
Figure 150

Jacques-Ernst Bulloz
France, 1858-1942; worked for Rodin, 1903-13
A98

Romeo and Juliet
Gelatin silver print, 14⅜ x 10⁷⁄₁₆ in. (36.5 x 26.5 cm)
Inscribed lower right: Rodin
1978.69.1, gift of the Iris and B. Gerald Cantor Foundation
Figure 550

A99

Study for "Monument to Victor Hugo" for the Panthéon, c. 1894–95, in plaster, after 1903
Gelatin silver print, 14¹⁵⁄₁₆ x 10⅞ in. (38 x 26.6 cm)
Inscribed lower right: Auguste Rodin
1978.69.2, gift of the Iris and B. Gerald Cantor Foundation
Figure 551

A100

"The Poet and the Muse" in marble
Gelatin silver print, 14¾ x 10¹³⁄₁₆ in. (37.5 x 27.5 cm)1981.273.3, gift of
Professor and Mrs. Albert E. Elsen and Patricia
Figure 552

A101

"The Muse" for "Monument to Whistler" in plaster, 1908
Gelatin silver print, 10⅞ x 14¾ in. (27.7 x 37.4 cm)1981.275.1, gift of
Professor and Mrs. Albert E. Elsen
Figure 355

A102

"Mask of Hanako" in plaster, c. 1907
Gelatin silver print, 10⁷⁄₁₆ x 8⁹⁄₁₆ in. (26.5 x 21.7 cm)
1981.275.2, gift of Professor and Mrs. Albert E. Elsen
Figure 553

A103

Study for "Apotheosis of Victor Hugo", 1891-94, in plaster
Gelatin silver print, 14⅝ x 11³⁄₁₆ in. (37.1 x 28.4 cm)
Studio stamp verso, lower center: J. E. Bulloz/Editeur Paris.
1981.275.3, gift of Professor and Mrs. Albert E. Elsen
Figure 242

A104

"The Sirens" in marble, after 1889
Gelatin silver print, 13⅞ x 10¼ in. (35.2 x 26.1 cm)
Studio stamp verso, lower center: J. E. B.
1981.275.4, gift of Professor and Mrs. Albert E. Elsen
Figure 433

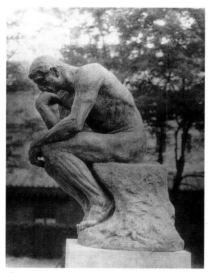

Fig. 559

Fig. 560

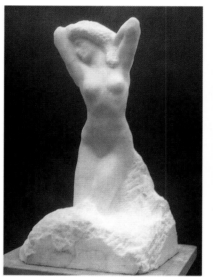

Fig. 561

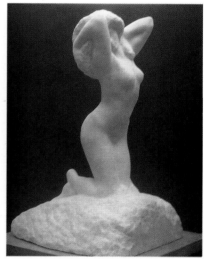

Fig. 562

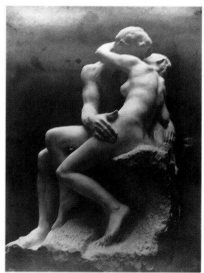

Fig. 563

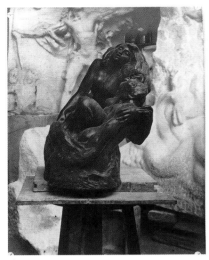

Fig. 564

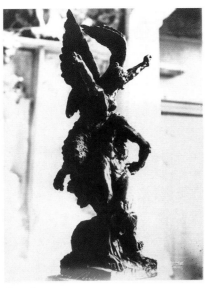

Fig. 565

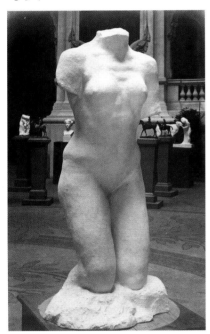

Fig. 567

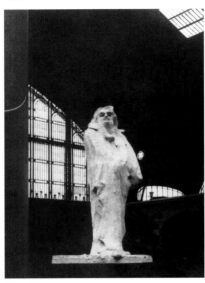

Fig. 566

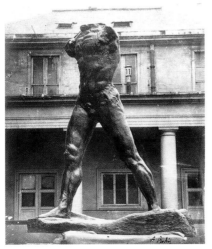

Fig. 568

A105

"Ugolino and His Sons" in plaster
Gelatin silver print, 10¹³⁄₁₆ x 14³⁄₈ in. (27.5 x 36.3 cm)
Studio stamp verso, lower center: J. E. B.
1981.275.5, gift of Professor and Mrs. Albert E. Elsen
Figure 554

A106

"The Temptation of Saint Anthony" in marble, mid-1880s
Gelatin silver print, 10¼ x 14¾ in. (26 x 37.4 cm)
1983.194.1, gift of Professor and Mrs. Albert Elsen
Figure 555

A107

*"Cybele" in plaster, in the Salon de la Société nationale des beaux-
arts, Grand Palais, Paris,* 1905
Gelatin silver print, 13¹⁵⁄₁₆ x 10½ in. (35.4 x 26.6 cm)
Studio stamp verso, lower right: J. E. B.
1983.194.2, gift of Professor and Mrs. Albert E. Elsen
Figure 471

A108

*Study for "Monument to Victor Hugo" for the Pantheon, c. 1894–95,
in plaster,* after 1903
Gelatin silver print, 14 x 9⅝ in. (35.6 x 24.4 cm)
Studio stamp verso, lower center: J. E. B.
1983.194.3, gift of Professor and Mrs. Albert Elsen
Figure 556

A109

"Joan of Arc," 1906, in marble, c. 1906–08
Gelatin silver print, 13⅝ x 10¼ in. (34.6 x 26 cm)
Studio stamp verso, lower right: J. E. B.
1983.194.4, gift of Professor and Mrs. Albert E. Elsen
The sculpture is also entitled *Misery* (La douleur).
Figure 177

A110

"Shade" and "Meditation," 1901–02, in plaster, 1903–04
Gelatin silver print, 15 x 10¾ in. (38.1 x 27.3 cm)
Studio stamp verso, lower right: J. E. B.
1983.194.5, gift of Professor and Mrs. Albert Elsen
Figure 192

A111

"Camille as Thought," 1893–95, in marble, 1903–04
Gelatin silver print, 14½ x 10⁷⁄₁₆ in. (36.8 x 26.6 cm)
Studio stamp verso, lower right: J. E. B.
1983.194.6, gift of Professor and Mrs. Albert E. Elsen
Figure 252

A112

"Bust of Antonin Proust" in wax
Gelatin silver print, 13⁷⁄₁₆ x 9¾ in. (34.2 x 24.7 cm)
Studio stamp verso, lower center: J. E. B.
1983.194.7, gift of Professor and Mrs. Albert Elsen
Figure 557

A113

"Adam" in plaster, 1877-79, Pavillon de l'Alma, Meudon, after 1903
Gelatin silver print, 11⅛ x 8⅝ in. (28.3 x 22 cm)
Inscribed lower right: A. Rodin
1986.445, gift of the Iris and B. Gerald Cantor Foundation
Figure 143

A114

"The Thinker" at the Panthéon, Paris, with Bibliothèque Sainte-
Géneviève in background, after 1906
Gelatin silver print, 11⅛ x 8¾ in. (28.3 x 22.3 cm)
Inscribed lower right: A. Rodin
1986.461, gift of the Iris and B. Gerald Cantor Foundation
This photograph has also been attributed to Laurent Vizzavona.
Figure 558

A115

"The Thinker" in the garden of the Hôtel Biron
Gelatin silver print, 14⅝ x 10⅝ in. (37.1 x 27 cm)
1987.28, gift of Albert E. and Patricia M. Elsen
Figure 559

A116

Marble Bust of Mrs. Simpson, 1904
Gelatin silver print, 13⁷⁄₁₆ x 10⁷⁄₁₆ in. (34.2 x 26.5 cm)
Inscribed lower right [?? 1097] Madame K. Simpson/affectuese-
ment/Aug Rodin/Paris 19 septembre 1904
1987.67, gift of the Iris and B. Gerald Cantor Foundation
Figure 560

A117

"The Prodigal Son," after 1899 in marble, 1903–04
Gelatin silver print, 10⅜ x 7⅝ in. (26.3 x 19.4 cm)
Inscribed in ink, recto, lower right: A. Rodin; in pencil, verso: Auguste
Rodin
1988.243.14, gift of the Iris and B. Gerald Cantor Foundation
Figure 426

A118

"Toilet of Venus" in marble
Gelatin silver print, 13⅝ x 10³⁄₁₆ in. (34.7 x 25.9 cm)
Inscribed in pencil, verso, upper left of mount: #1273/of 2/Toilette de
Venus/Rodin
Studio stamp, embossed in ink, lower right: L'oeuvre de Rodin/J. E.
Bulloz edit, Paris
1988.250.1, gift of the Iris and B. Gerald Cantor Foundation
Figure 561

A119

"Toilet of Venus" in marble
Gelatin silver print, 13½ x 10⅛ in. (34.5 x 25.9 cm)
Inscribed verso, upper left: #1273/of 2/Toilette de Venus/Rodin
Studio stamp, embossed in ink, lower right: L'oeuvre de Rodin/J. E.
Bulloz edit, Paris
1988.250.2, gift of the Iris and B. Gerald Cantor Foundation
Figure 562

A120

"The Kiss" in marble, c. 1905
Gelatin silver print, 14⅛ x 10¹⁄₁₆ in. (35.8 x 25.6 cm)
1994.16, gift of Albert E. Elsen
Figure 563

Fig. 569

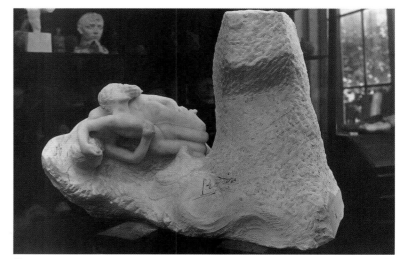

Fig. 570

Fig. 571

Fig. 572

Fig. 573

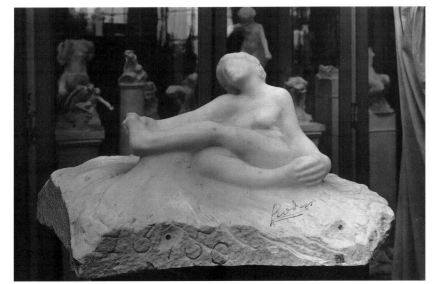

Fig. 574

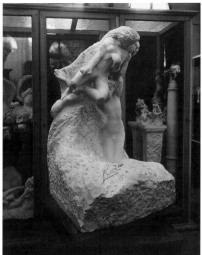

Fig. 575

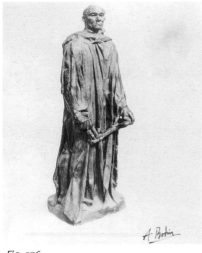

Fig. 576

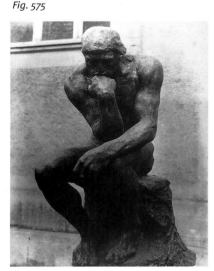

Fig. 577

Fig. 578

Eugène Druet
France, 1868-1916; worked for Rodin 1896-c. 1903 and occasionally thereafter

A121

"The Three Sirens" in bronze, before "Apollo Crushing the Serpent, Python," Dépôt des marbres
Gelatin silver print, 15⁹⁄₁₆ x 11¾ in. (39.6 x 29.8 cm)
Signed in negative, lower right: E. Druet/ph.am
1981.273.1, gift of Professor and Mrs. Albert E. Elsen
Figure 564

A122

"Head of Iris" in bronze, 1898?, Hôtel Biron, c. 1912
Gelatin silver print, 14¹³⁄₁₆ x 10⅜ in. (37.7 x 26.4 cm)
Inscribed in pencil, verso, center: 1942; upper right: Tête de Femme
1981.273.2, gift of Professor and Mrs. Albert E. Elsen
Figure 386

A123

"Head of Pierre Puvis de Chavannes," 1890, in plaster
Gelatin silver print, 14¹⁄₁₆ x 9½ in. (35.8 x 24.1 cm)
Inscribed in negative, lower left: Aug Rodin
1981.273.5, gift of Professor and Mrs. Albert E. Elsen
Figure 269

A124

"Torso of a Young Woman", 1908-09, in plaster in the Salon of 1910, 1910
Gelatin silver print, 15¼ x 11¼ in. (38.7 x 28.5 cm)
Mark in pencil, verso, center: 21925
1983.194.8, gift of Professor and Mrs. Albert E. Elsen
Figure 458

A125

Torso of "The Martyr" in plaster, 1899–1900, Dépôt des marbres
Gelatin silver print, 14¾ x 10¾ in. (37.5 x 27.3 cm)
Inscribed in negative, lower center: Rodin
1983.194.9, gift of Professor and Mrs. Albert E. Elsen
Figure 210

A126

"Call to Arms" in bronze with "The Gates of Hell" in background, 1898
Gelatin silver print, 15 x 10⅜ in. (38.1 x 26.4 cm)
Signed in negative, lower right: [D]ruet
Inscribed in negative, lower center: Aug Rodin
1983.194.10, gift of Professor and Mrs. Albert E. Elsen
Figure 565

A127

"Monument to Honoré de Balzac" in plaster at the Salon of 1898, 1898
Gelatin silver print, 15 3/4 x 11 3/4 in. (40 x 29.8 cm)
Signed in negative, lower right: E. Druet
1983.194.11, gift of Professor and Mrs. Albert E. Elsen
Figure 330

A128

"Monument to Honoré de Balzac" in plaster, Dépôt des marbres, c. 1898
Gelatin silver print, 15 x 10⅞ in. (38.1 x 27.7 cm)
Marks: illegible blind-stamp, lower right; printed numerals, lower right: 109/10
1983.194.12, gift of Professor and Mrs. Albert E. Elsen
Figure 566, p. 352

A129

Clenched Right Hand Masked with a Blanket, c. 1898
Gelatin silver print, 15⅜ x 11¾ in. (39.1 x 29.8 cm)
1983.194.13, gift of Professor and Mrs. Albert E. Elsen
Figure 478

A130

"Prayer, 1909" in plaster in the Salon of 1910, 1910
Gelatin silver print, 14¹³⁄₁₆ x 8 ¹¹⁄₁₆ in. (37.6 x 22 cm)
1983.194.14, gift of Professor and Mrs. Albert Elsen
Figure 567

A131

*"Meditation without Arms" in "Monument to Victor Hugo," in plaster,
as exhibited at the Salon of 1897*, 1897
Gelatin silver print, 9⁵⁄₁₆ x 11 3/4 in. (23.6 x 29.8 cm)
1986.433, gift of Albert E. and Patricia M. Elsen
Figure 191

A132

"Walking Man" in bronze, Courtyard of the Hôtel Biron, c. 1910
Gelatin silver print, 15 x 11⁵⁄₁₆ in. (38.1 x 28.7 cm)
Inscribed lower right: A. Rodin
1986.466, gift of the Iris and B. Gerald Cantor Foundation
Figure 568

A133

*"Thought," 1886, in marble with "The Gates of Hell" in
background*, 1900
Gelatin silver print, 6⅝ x 4⅝ in. (16.9 x 11.7 cm)
1987.164, gift of Albert E. and Patricia M. Elsen
Figure 569

A134

"Call to Arms" in bronze, c. 1898
Gelatin silver print, 15⅝ x 11¾ in. (39.7 x 29.8 cm)
Signed in ink, lower left: E. Druet/[illegible]
Inscribed in ink, lower right: A. Rodin; in pencil, verso, upper left:
#1251
1988.247, gift of the Iris and B. Gerald Cantor Foundation
Figure 570

Harry C. Ellis
United States, active c. 1900
A135

"Seated Male Figure" Supporting "Standing Female Figure," after
1902
Gelatin silver print, 6¹¹⁄₁₆ x 4⁹⁄₁₆ in. (17 x 11.6 cm)
Inscribed lower left: Rodin
Studio stamp verso: American Flashlight Photographer /13, rue Brey,
Paris
1978.68.1, gift of Iris and B. Gerald Cantor Foundation
Figure 571

A136

A Night in May, after 1902
Gelatin silver print, 6¹¹⁄₁₆ x 4⁹⁄₁₆ in. (17 x 11.7 cm)
Inscribed lower center: Rodin
Studio stamp verso: American Flashlight Photographer /13, rue Brey,
Paris
1978.68.2, gift of Iris and B. Gerald Cantor Foundation
Figure 572

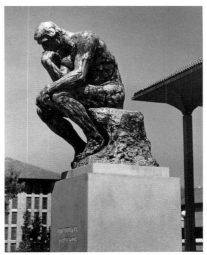

Fig. 579

Fig. 581

Fig. 583

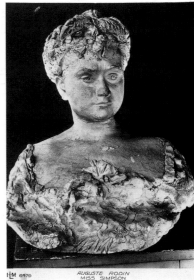

Fig. 580

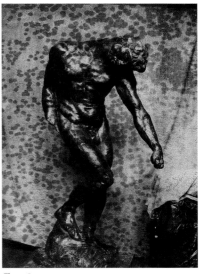

Fig. 582

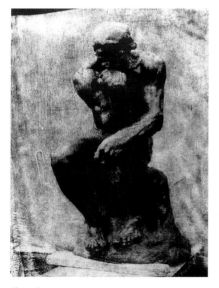

Fig. 584

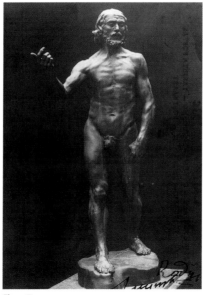

Fig. 585

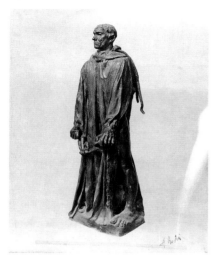

Fig. 586

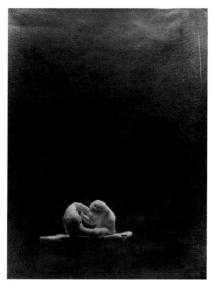

Fig. 587

Fig. 588

A137

Centauress, after 1902
Gelatin silver print, 4⁹⁄₁₆ x 6¾ in. (11.7 x 17.1 cm)
Inscribed center: Rodin
Studio stamp verso: American Flashlight Photographer /13, rue Brey, Paris
1978.68.3, gift of the Iris and B. Gerald Cantor Foundation
Figure 16

A138

"Paolo and Francesca" in marble, after 1902
Gelatin silver print, 6¹⁵⁄₁₆ x 9⁷⁄₁₆ in. (17.7 x 23.9 cm)
Inscribed center: Rodin
Studio stamp on verso: H. C. Ellis/American Flashlight Photographer/13, rue Brey, Paris
1978.68.4, gift of the Iris and B. Gerald Cantor Foundation
Figure 573

A139

"The Shell and the Pearl" in marble, Pavillon de l'Alma, Meudon, after 1902
Gelatin silver print, 6⅞ x 9¼ in. (17.5 x 23.5 cm)
Inscribed lower right: Rodin
Studio stamp verso: H. C. Ellis/American Flashlight Photographer/13, rue Brey, Paris
1978.68.5, gift of the Iris and B. Gerald Cantor Foundation
Figure 574

A140

"Orpheus and the Maenads" in marble, Pavillon de l'Alma, Meudon, after 1902
Gelatin silver print, 9⁵⁄₁₆ x 6¹⁵⁄₁₆ in. (23.6 x 17.7 cm)
Inscribed center: Rodin
Studio stamp verso: H. C. Ellis/American Flashlight Photographer/13, rue Brey, Paris
1978.68.6, gift of the Iris and B. Gerald Cantor Foundation
Figure 575

E. Fiorillo
France, active late 1800s-1900s
A141

Jean d'Aire
Gelatin silver print, 11 5//16 x 8¹⁵⁄₁₆ in. (28.8 x 22.8 cm)
Inscribed in ink, lower right: A. Rodin
Mark printed below image: 6397. Paris—Le Panthéon. Un des Bourgeoise de Calais sous Eustache de Saint Pierre
1986.453, gift of the Iris and B. Gerald Cantor Foundation
Figure 576

A142

"The Thinker" in the courtyard of Dépôt des marbres
Salt print (?), 11¹⁄₁₆ x 8 in. (28.1 x 20.3 cm)
Inscribed in pen and ink, lower right: A. Rodin; printed at bottom edge: 3344—A. Rodin. Le Penseur (E.F. phot Paris)
1988.246, gift of the Iris and B. Gerald Cantor Foundation
Figure 577

D. Freuler
France, lifedates unknown; worked for Rodin c. 1890-1900
A143
> "Meditation without Arms" in plaster, 1895-96, *D*épôt des marbres, c. 1896-97
> Salt print, 9½ x 6¹⁵⁄₁₆ in. (24.1 x 17.7 cm)
> 1986.430, gift of Albert E. and Patricia M. Elsen
> *Figure 190*

A144
> "Monument to Victor Hugo" with "The Gates of Hell" in background, c. 1898
> Salt print, 7¹³⁄₁₆ x 10½ in. (19.9 x 26.1 cm)
> 1986.432, gift of Albert E. and Patricia M. Elsen
> *Figure 246*

A145
> "Suspended Hand of Eustache de Saint-Pierre" in plaster, c. 1896
> Salt print, 4⁷⁄₁₆ x 3⁵⁄₁₆ in. (11.3 x 8.4 cm)
> 1986.434, gift of Albert E. and Patricia M. Elsen
> *Figure 78*

Stephen Haweis and Henry Coles
Haweis: Great Britain, 1878-1969; Coles: Great Britain, born 1875; worked for Rodin, 1903-04
A146
> "Kneeling Nymph" in bronze, 1903-04
> Photogravure, 8⅞ x 6⁷⁄₁₆ in. (22.6 x 16.4 cm)
> 1986.420, gift of Albert E. and Patricia M. Elsen
> *Figure 578*

Leo Holub
United States, born 1916
A147
> "The Thinker" at Stanford University, 1999
> Gelatin silver print, 11¾ x 9 in. (29.8 x 22.9 cm)
> 1999.99, Stanford Museum Collections
> Four other views exist (1999.91-94).
> *Figure 579*

Lapina & Fils
France, n.d.
A148
> Postcard Photograph of "Bust of Miss Simpson"
> Gelatin silver print, 4⅜ x 3 in. (11.1 x 7.6 cm)
> Mark printed lower right: ILM 6479/Musée Rodin/Auguste Rodin/Miss Simpson
> 1986.459, gift of the Iris and B. Gerald Cantor Foundation
> *Figure 580*

Jean-François Limet
France, 1855-1941; worked for Rodin, 1900-1915
A149
> "The Tempest," c. 1903, in marble, after 1903
> Gelatin silver print, 8⅞ x 6⁷⁄₁₆ in. (22.5 x 16.3 cm)
> Inscribed in ink, lower center: Rodin
> 1978.70.1, gift of the Iris and B. Gerald Cantor Foundation
> *Figure 392*

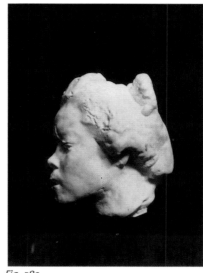
Fig. 589

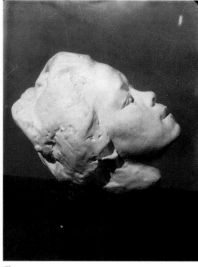
Fig. 590

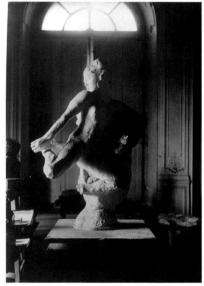
Fig. 591

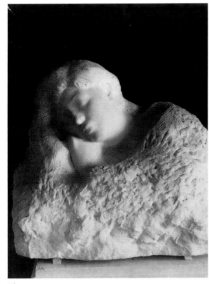

Fig. 592

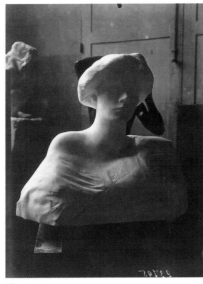

Fig. 593

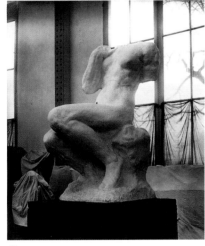

Fig. 594

A150

> *"Mrs. Russell as Athena" in, c. 1896, marble with "Monument to Victor Hugo" in background*, after 1900
> Gelatin silver print, 9⅛ x 6½ in. (23.2 x 16.5 cm)
> Inscribed in ink, lower center: Rodin
> 1978.70.2, gift of the Iris and B. Gerald Cantor Foundation
> *Figure 382*

A151

> *"Orpheus and the Maenads" in plaster in the garden at Meudon*
> Gelatin silver print, 9⅛ x 6½ in. (23.2 x 16.6 cm)
> Inscribed lower center: Rodin
> 1978.70.3, gift of Iris and B. Gerald Cantor Foundation
> *Figure 581*

A152

> *"The Shade," in bronze,* after 1902
> Gum bichromate print, 15¼ x 10⅝ in. (38.8 x 27 cm)
> Inscribed lower right: Rodin
> 1978.71.1, gift of the Iris and B. Gerald Cantor Foundation
> *Figure 582*

A153

> *"Eternal Springtime" in bronze* (recto)
> *Eternal Springtime* (verso)
> Gum bichromate print, 15⅜ x 11⅝ in. (39 x 29.5 cm)
> Inscribed, lower right: A. Rodin
> 1978.71.2a-b, gift of the Iris and B. Gerald Cantor Foundation
> *Figure 583 (recto)*

A154

> *"Spirit of Eternal Repose" on a column in plaster, c. 1900, in the garden at Meudon*, after 1900
> Gelatin silver print, 9⅞ x 7 in. (23.9 x 17.8 cm)
> 1981.273.6, gift of Professor and Mrs. Albert E. Elsen
> *Figure 274*

A155

> *"The Tragic Muse" on a column, in plaster 1890-96, Pavillon de l'Alma, Meudon*, 1902
> Gelatin silver print, 9⁷⁄₁₆ x 7⅛ in. (24.8 x 18 cm)
> 1986.431, gift of Albert E. and Patricia M. Elsen
> *Figure 245*

A156

> *The Thinker*, c. 1895-1900
> Gum bichromate print, 14 x 9¹⁵⁄₁₆ in. (35.6 x 25.3 cm)
> 1987.30, gift of Albert E. and Patricia M. Elsen
> *Figure 584*

Etienne Neurdein (called N.D.)
France, born 1832-active through 1910
A157

Postcard Photograph of "Saint John the Baptist" in bronze
Albumen print, 5½ x 3½ in. (14 x 9 cm)
Inscribed, lower right: Auguste Rodin
Marks, lower left: 77; lower center: Musée du Luxembourg/A.
 Rodin.—Saint Jean-Baptiste; lower right: ND. Phot
1969.212.3, Museum General Gifts
Figure 585

A158

Postcard Photograph of "Honoré de Balzac" in the Salon of 1898,
 1898
Gelatin silver print, 5½ x 3¹⁵⁄₁₆ in. (14 x 10 cm)
Inscribed lower center: Salon de 1898-La Sculpture. Societé
 Nationale des Beaux-Arts. ND Phot
1986.422, gift of Albert E. and Patricia Elsen
Figure 331

A159

Postcard Photograph of "Mme Vicuña," 1888, in marble, 1907
Gelatin silver print, 5 x 3½ in. (12.8 x 8.9 cm)
Inscribed over image: hommage affecteuse/a Madame/Kate Simp-
 son/au Musée du Luxembourg/11 juin 1907
Marks, lower left: 35; lower center: "Musée Luxembourg—A.
 Rodin/Tête de Femme; lower right: ND P
1986.456, gift of the Iris and B. Gerald Cantor Foundation
Figure 377

A160

Jean d'Aire
Gelatin silver print, 11⁷⁄₁₆ x 9¹⁄₁₆ in. (29 x 23 cm)
Inscribed in pen and ink, lower right: A. Rodin
Mark printed at bottom edge: 6396 Paris—Le Panthéon. Un des Bour-
 geois de Calais sous Eustache de Saint Pierre, par A. Rodin. ND
 Phot
1988.248, gift of the Iris and B. Gerald Cantor Foundation
Figure 586

Edward Steichen
United States (born Luxembourg), 1879-1973; worked for Rodin after
1901
A161

Balzac—The Open Sky, 1908
From *Camera Work* 34-35 (April-July 1911): 7
Photogravure, 8³⁄₁₆ x 6¼ in. (20.7 x 15.8 cm)
1974.233.1, gift of the William Rubin Foundation
Figure 333

A162

Balzac—Toward the Light, Midnight, 1908
From *Camera Work* 34-35 (April-July 1911): 9
Photogravure, 6³⁄₁₆ x 8 in. (15.7 x 20.4 cm)
1974.233.2, gift of the William Rubin Foundation
Figure 7

Fig. 595

Fig. 596

Fig. 597

Fig. 598

A163

Balzac—The Silhouette, 4 A.M., 1908
From *Camera Work* 34-35 (April-July 1911): 11
Photogravure, 6⅜ x 8¼ in. (16.1 x 20.6 cm)
1974.233.3, gift of the William Rubin Foundation
Figure 334

A164

Plaster Cast of "A Couple in a Small Urn"
Gelatin silver print, 7⅛ x 5 in. (18.2 x 12.8 cm)
1980.122, gift of Professor Albert E. Elsen
This photograph has also been attributed to Eugène Druet.
Figure 587

A165

Plaster Cast of "A Couple in a Small Urn"
Gelatin silver print, 7⅛ x 5 in. (18.2 x 12.8 cm)
1980.123, gift of Professor Albert E. Elsen
This photograph has also been attributed to Eugène Druet.
Figure 588

A166

Head of Hanako
Two glass negatives, each 4 x 7 in. (10.2 x 17.8 cm)
1991.169.1-2, gifts of Barbara Divver and Theodore Reff in honor of
 Albert Elsen
Figures 589-590

François Antoine Vizzavona
France, 1876-1961; worked for Rodin in the early 1900s
A167

"Leaping Figure" in plaster in Rodin's home, Hôtel de Biron
Gelatin silver print, 6⅝ x 4⅜ in. (16.8 x 11.2 cm)
Inscribed in pencil, verso: 1/4 page Gsell/4646; and scattered
 numerals
Mark verso, center: Vizzavona/95, rue du Bac
1986.423, gift of Albert E. and Patricia M. Elsen
Figure 591

A168

"Sleeping Woman" in marble with pencil editing
Gelatin silver print, 6½ x 4⅝ in. (16.6 x 11.7 cm)
Inscribed verso: 621; and scattered numerals
Studio stamp verso, upper right: La Mention/Cliché Vizzavona/est
 obligatoire
1986.425, gift of Albert E. and Patricia M. Elsen
Figure 592

A169

"Eve Fairfax" in marble, Dépôt des marbres
Gelatin silver print, 7 x 5 in. (17.9 x 12.9 cm)
Inscribed in negative in reverse, lower left: 23795
1986.426, gift of Albert E. and Patricia M. Elsen
Figure 593

A170

"Torso of Whistler's Muse," c. 1906–07, in plaster, Pavillon de l'Alma,
 Meudon, after 1907
Gelatin-silver print, 11¹³⁄₁₆ x 8¹³⁄₁₆ in. (28.4 x 22.4 cm)
Inscribed lower right: *A. Rodin*
1986.446, gift of the Iris and B. Gerald Cantor Foundation
Figure 356

A171

"Cybele," c. 1904, in plaster, Pavillon de l'Alma, Meudon
Gelatin silver print, 11⅛ x 8¹⁵⁄₁₆ in. (28.3 x 22.7 cm)
Inscribed lower right: A. Rodin
1986.447, gift of the Iris and B. Gerald Cantor Foundation
Figure 594

Jane Evelyn Lindsay
Great Britain, 1862-1948
A172

"The Burghers of Calais" under Victoria Tower
Pen and ink with watercolor, 8³⁄₁₆ x 4⁷⁄₁₆ in. (21.5 x 11.3 cm)
Signed verso, upper right (in another hand?): Lady Jane Evelyn Lind-
 say
Inscribed recto, lower right: Rodin's group under Victoria Tower
1983.36, gift of William Drummond
Figure 595

A173

"The Burghers of Calais" under Victoria Tower, 1925
Pen and ink with watercolor, 6¹⁵⁄₁₆ x 9¹⁵⁄₁₆ in. (17.7 x 12.5 cm)
1983.37, gift of William Drummond
Figure 596

A174

A View of "The Burghers of Calais," 1925
Pen and ink with watercolor, 8⅝ x 11⅝ in. (22 x 29.5 cm)
Inscribed verso: 1925; from the Embankment Garden
 Westminster/Burghers of Calais/The Abbey/Victoria Tower; under
 Victoria Tower
1983.75, gift of William Drummond
Figure 597

Miscellaneous
Unknown Photographer
A175

Rodin's Meudon studio with antique sculpture of Hercules, c. 1914
Photographer unknown
Gelatin silver print, 13⅝ x 9¹⁵⁄₁₆ in. (34.7 x 25.2 cm)
1986.468, gift of the Iris and B. Gerald Cantor Foundation
The sculpture *Hercules* is in the collection of the Musée Rodin, Paris,
 S1107.
Figure 598

J. Roseman, life dates unknown
A176

Sculpture Salon in the Grand Palais, Paris, 1900
Gelatin silver print, 11 x 151/4 in. (27.9 x 38.8 cm)
Studio stamp: Photo-Art/R. Roseman/artiste-peintre/8, Rue
 Vercingótrorix, Paris
1981.274, gift of Professor and Mrs. Albert E. Elsen
Figure 599

Fig. 599

SELECTED BIBLIOGRAPHY

The Selected Bibliography consists primarily of sources that were specifically cited or that generally informed the content of the entries and essays. Volumes published after the completion of the manuscript in 1994 and after the author's death in 1995 were selectively added to provide further information regarding specific works. Infrequently cited sources are cited in full form in the notes.

Alexandre 1900
Arsène Alexandre, ed. *Exposition de 1900: L'oeuvre de Rodin.* Paris: Société d'édition artistique, 1900.

Alhadeff 1963
Albert Alhadeff. "Michelangelo and the Early Rodin." *Art Bulletin* 45, no. 4 (December 1963): 363–67.

Alhadeff 1966
Albert Alhadeff, "Rodin: A Self-Portrait in *The Gates of Hell,*" *Art Bulletin* 48, nos. 3–4 (September, December 1966): 393–95.

Alley 1959
Ronald Alley. *Tate Gallery: The Foreign Paintings, Drawings, and Sculptures.* London: Tate Gallery, 1959.

Alley 1981
Ronald Alley. *Catalogue of the Tate Gallery's Collection of Modern Art, other than Works by British Artists.* London: Tate Gallery, 1981.

Ambrosini and Facos 1987
Lynne Ambrosini and Michelle Facos. *Rodin: The Cantor Gift to the Brooklyn Museum.* New York: Brooklyn Museum, 1987.

L'art et les artistes 1914
"Rodin: L'homme et l'oeuvre." *L'art et les artistes* (Paris) 19 (April 1914): 1–112.

Barbier 1987
Nicole Barbier. *Marbres de Rodin: Collection du musée.* Paris: Musée Rodin, 1987.

Barbier 1992
Nicole Barbier. *Rodin sculpteur: Oeuvres méconnues.* Paris: Musée Rodin, 1992.

Bartlett 1887–88
Truman H. Bartlett Papers. Notes, 1887–88. Library of Congress, Washington, D.C.

Bartlett 1889
Truman H. Bartlett. "Auguste Rodin, Sculptor." Reprinted in Albert Elsen, ed., *Auguste Rodin: Readings on His Life and Work* (Englewood Cliffs, N.J.: Prentice-Hall, 1965), 13–109. Elsen compiles Bartlett's serialized text: *American Architect and Building News* (Boston) 25, no. 682 (19 January 1889), 27–29; no. 683 (26 January 1889): 44–45; no. 685 (9 February 1889): 65–66; no. 688 (2 March 1889): 99–101; no. 689 (9 March 1889): 112–14; no. 696 (26 April 1889): 198–200; no. 698 (11 May 1889): 223–35; no. 700 (25 May 1889): 249–51; no. 701 (1 June 1889): 260–63; no. 703 (15 June 1889): 283–85.

Beausire 1988
Alain Beausire. *Quand Rodin exposait.* Paris: Musée Rodin, 1988.

Beausire 1989
Alain Beausire. "Oeuvres de Rodin." In Jacques Vilain, ed. *Claude Monet-Auguste Rodin: Centenaire de l'exposition de 1889.* Exh. cat. Paris: Musée Rodin, 1989.

Bénédite 1926
Léonce Bénédite. *Rodin,* translated by Wilfrid Jackson. London: John Lane, the Bodley Head, 1926.

Beutler 1972
Christian Beutler. "*Les bourgeois de Calais* de Rodin et d'Ary Scheffer." *Gazette des beaux-arts* 79 (January 1972): 39–50.

Boeck 1954
Wilhelm Boeck. "Rodins *Höllenpforte*: Ihre Kunstgeschichtliche Bedeutung." *Wallraf-Richarts Jahrbuch* (Cologne) 16 (1954): 161–95.

Bordeaux 1975
Jean-Luc Bordeaux. "Some Reflections on Rodin's *The Kiss.*" *Gazette des beaux-arts* 86, no. 117 (October 1975): 123–28.

Bothner 1993
Roland Bothner. *Grund und Figur: Die Geschichte des Reliefs und Auguste Rodins Höllentor.* Munich: Wilhelm Fink Verlag, 1993.

Bowness 1970
Alan Bowness. *Rodin: Sculpture and Drawings.* Exh. cat. London: Arts Council of Great Britain, 1970.

Bumpus 1998
Bernard Bumpus. "Auguste Rodin and the Technique of *Pâte-sur-Pâte.*" *Apollo* 147, no. 431 (January 1998): 13–18.

Butler 1980
Ruth Butler, ed. *Rodin in Perspective.* Englewood Cliffs, N.J.: Prentice-Hall, 1980.

Butler 1984
Ruth Butler. "Nationalism, a New Seriousness, and Rodin: Thoughts about French Sculpture in the 1870s." In H. W. Janson, ed. *La scultura nel XIX secolo.* Acts of the XXIV International Congress of the History of Art, 1979. Bologna: Cooperativa Libreria Universitaria Editrice, 1984, 6: 161–67.

Butler 1993
Ruth Butler. *Rodin: The Shape of Genius.* New Haven: Yale University Press, 1993.

Butler and Lindsay 2000
Ruth Butler, Suzanne Glover Lindsay et. al., *European Sculpture of the Nineteenth Century.* The Collections of the National Gallery of Art Sytematic Catalogue. Washington and New York: National Gallery of Art/Oxford University Press, 2000.

Butler, Plottel, and Roos 1998
Ruth Butler, Jeanine Parisier Plottel, and Jane Mayo Roos. *Rodin's Monument to Victor Hugo.* Exh. cat. London: Iris and B. Gerald Cantor Foundation/Merrell Holberton, 1998.

Byvanck 1892
W. G. C. Byvanck. *Un Hollandais à Paris en 1891: Sensations de littérature et d'art.* Paris: Perrin, 1892.

Canetti, Laurent, and Lesberg 1977
Nicolai Canetti, Monique Laurent, and Sandy Lesberg. *The Rodin Museum of Paris.* New York and London: Peebles Press, 1977.

Charpentier 1970
Thérèse Charpentier. "Notes sur le *Claude Gellée* de Rodin à Nancy." *Bulletin de la Société de l'histoire de l'art français* (Paris) (November 1970): 149–58.

Cladel 1903
Judith Cladel. *Auguste Rodin: Pris sur la vie.* Paris: Editions de la plume, 1903.

Cladel 1908
Judith Cladel. *Auguste Rodin: L'oeuvre et l'homme.* Brussels: Van Oest, 1908.

Cladel 1917
Judith Cladel. *Rodin: The Man and His Art with Leaves from His Notebook,* translated by S. K. Star. New York: Century, 1917.

Cladel 1936
Judith Cladel. *Rodin: Sa vie glorieuse, sa vie inconnue.* Paris: Bernard Grasset, 1936.

Cladel 1948
Judith Cladel. *Rodin.* Paris: Editions Terra and Editions Aimery Somogy, 1948.

Coquiot 1917
Gustave Coquiot. *Rodin à l'Hôtel de Biron et à Meudon.* Paris: Librairie Ollendorff, 1917.

Crone and Salzmann 1992
Rainer Crone and Siegfried Salzmann, eds. *Rodin: Eros and Creativity.* Munich: Prestel-Verlag, 1992.

Daix 1988
Pierre Daix. *Rodin.* Paris: Calmann-Lévy, 1988.

Dante 1932
Dante Alighieri. *The "Divine Comedy" of Dante Alighieri: The Carlyle-Wicksteed Translation.* New York: Modern Library, 1932.

de Caso 1964
Jacques de Caso. "Rodin and the Cult of Balzac." *Burlington Magazine* 106 (June 1964): 278–84.

de Caso 1966
Jacques de Caso. "Balzac and Rodin in Rhode Island." *Rhode Island School of Design Bulletin* 52 (May 1966): 1–22.

de Caso and Sanders 1973
Jacques de Caso and Patricia B. Sanders. *Rodin's Thinker: Significant Aspects.* San Francisco: Fine Arts Museums of San Francisco, 1973.

de Caso and Sanders 1977
Jacques de Caso and Patricia B. Sanders. *Rodin's Sculpture: A Critical Study of the Spreckels Collection, California Palace of the Legion of Honor.* San Francisco: Fine Arts Museums of San Francisco, 1977.

Delteil 1910
Loys Delteil. *Rude, Barye, Carpeaux, Rodin: Le peintre-graveur illustré* XIX et XX siècles. Vol. 6. Paris: Delteil, 1910.

Descharnes and Chabrun 1967
Robert Descharnes and Jean-François Chabrun. *Auguste Rodin,* New York: Viking Press, 1967.

Dujardin-Beaumetz 1913
Henri-Charles-Etienne Dujardin-Beaumetz. "Rodin's Reflections on Art." Translated by Ann McGarrell and reprinted in Albert Elsen, ed., *Auguste Rodin: Readings on His Life and Work* (Englewood Cliffs, N.J.: Prentice-Hall, 1965), 145–85. Originally published as *Entretiens avec Rodin* (Paris Dupont, 1913)

Durey 1998
Philippe Durey and Antoinette Le Normand-Romain. "Les métamorphoses de Mme F.: Auguste Rodin, Maurice Fenaille, et Lyon." Exh. cat. *Bulletin des Musée et monuments lyonnais* 2–3 (1998): 6–139.

Eisler 1961
Colin Eisler, "The Athletic of Virtue: The Iconography of Aestheticism," in *De artibus opuscula. 40 Essays in Honor of Erwin Panofsky,* 2 vols., ed. Millard Meiss. New York: New York University Press, I: 82–97.

Eitner 1982
Lorenz Eitner. "From the Hand of the Artist." *The Stanford Magazine* (Winter 1982): 29–30.

Eitner, Fryberger, and Osborne 1993
Lorenz Eitner, Betsy G. Fryberger, and Carol M. Osborne. *Stanford University Museum of Art: The Drawing Collection.* Stanford: Stanford University Museum of Art, 1993.

Elsen 1960
Albert Elsen. *Rodin's "Gates of Hell."* Minneapolis: University of Minnesota Press, 1960.

Elsen 1963
Albert Elsen. *Rodin.* Exh. cat. New York: Museum of Modern Art, 1963.

Elsen 1965a
Albert Elsen, ed. *Auguste Rodin: Readings on His Life and Work.* Englewood Cliffs, N.J.: Prentice-Hall, 1965.

Elsen 1965b
Albert Elsen. "Rodin's *La ronde.*" *Burlington Magazine* 107 (June 1965): 290–99.

Elsen 1966a
Albert Elsen. "Rodin's *Portrait of Baudelaire.*" In *Twenty-five: A Tribute to Henry Radford Hope in Celebration of His Twenty-fifth Year as Chairman of Indiana University's Department of Fine Arts at Bloomington, Indiana.* Exh. cat. Bloomington, 1966.

Elsen 1966b
Albert Elsen. "Rodin's *Walking Man.*" *Massachusetts Review* (Amherst) 7 (spring 1966): 289–320.

Elsen 1967a
Albert Elsen. "Rodin's 'Walking Man' as Seen by Henry Moore." *Studio International* 174 (July-August 1967): 26–31.

Elsen 1967b
Albert Elsen. "Rodin's *Naked Balzac.*" *Burlington Magazine* 109 (November 1967): 606–17.

Elsen 1969
Albert Elsen. *The Partial Figure in Modern Sculpture from Rodin to 1969.* Exh. cat. Baltimore: Baltimore Museum of Art, 1969.

Elsen 1972
Albert Elsen. "Drawings and the True Rodin." *Artforum* 10, no. 6 (February 1972): 64–69.

Elsen 1980
Albert Elsen. *In Rodin's Studio.* Ithaca, N.Y.: Cornell University Press, 1980.

Elsen 1981
Albert Elsen, ed. *Rodin Rediscovered.* Exh. cat. Washington, D.C.: National Gallery of Art, 1981.

Elsen 1984
Albert Elsen. "Recent Rodin Discoveries." In H. W. Janson, ed. *La scultura nel XIX secolo.* Acts of the XXIV International Congress of the History of Art, 1979. Bologna: Cooperativa Libreria Universitaria Editrice, 1984, 6: 215–19

Elsen 1985a
Albert Elsen. *"The Gates of Hell" by Auguste Rodin*. Stanford: Stanford University Press, 1985.

Elsen 1985b
Albert Elsen. *Rodin's "Thinker" and the Dilemmas of Modern Public Sculpture*. New Haven: Yale University Press, 1985.

Elsen 1987
Albert Elsen. "Rodin's Drawings and the Art of Matisse." *Arts Magazine* 61 (March 1987): 32–39.

Elsen 1988
Albert Elsen. *All Masks Fall Off: Rodin's Last Sculpture, the Portrait of Clémentel*, organized by William P. Heidrich. Exh. cat. Memphis: Memphis Brooks Museum of Art, 1988.

Elsen 1994
Albert Elsen. "Drawing and a New Sexual Intimacy: Rodin and Schiele." In Patrick Werkner, ed. *Egon Schiele: Art, Sexuality, and Viennese Modernism*. Palo Alto: Society for the Promotion of Science and Scholarship, 1994, 5–30.

Elsen, McGough, and Wander 1973
Albert Elsen, Stephen C. McGough, and Steven H. Wander. *Rodin and Balzac: Rodin's Sculptural Studies for the Monument to Balzac from the Cantor Fitzgerald Collection*. Exh. cat. Beverly Hills: Cantor Fitzgerald, 1973.

Elsen and Varnedoe 1971
Albert Elsen and J. Kirk T. Varnedoe. *The Drawings of Rodin*. New York: Praeger, 1971.

Fagus 1900
Félicien Fagus. "Discours sur la mission de Rodin." *La revue blanche* 22 (15 June 1900): 241–52.

Fath and Schmoll 1991
Manfred Fath and J. A. Schmoll gen. Eisenwerth, eds. *Auguste Rodin: Das Höllentor-Zeichnungen und Plastik*. Exh. cat. Mannheim Städtische Kunsthalle Mannheim. Munich: Prestel-Verlag, 1991.

Fergonzi 1997
Flavio Fergonzi et al. *Rodin and Michelangelo: A Study in Artistic Inspiration*. Exh. cat. Philadelphia: Philadelphia Museum of Art, 1997.

Fonsmark 1988
Anne-Birgitte Fonsmark. *Rodin: La collection du brasseur Carl Jacobsen à la Glyptothèque—et oeuvres apparentées*. Copenhagen: Ny Carlsberg Glyptotek, 1988.

Fourest 1971
Henri-Pierre Fourest, ed. *L'art de la poterie en France de Rodin à Dufy*. Exh. cat. Sèvres: Musée national de céramique, 1971.

Frisch and Shipley 1939
Victor Frisch and Joseph Shipley. *Auguste Rodin*. New York: Frederick Stokes, 1939.

Fry 1956
Roger Fry. "London Sculptors and Sculptures." In *Transformations: Critical and Speculative Essays on Art*. Garden City, N.Y.: Doubleday Anchor Books, 1956, 183–210.

Fusco and Janson 1980
Peter Fusco and H. W. Janson, eds. *The Romantics to Rodin: French Nineteenth-Century Sculpture from North American Collections*. Exh. cat. Los Angeles County Museum of Art. New York: George Braziller, 1980.

Galantaris 1971
Christian Galantaris. *Les portraits de Balzac connus et inconnus*. Exh. cat. Paris: Maison de Balzac, 1971.

Gassier 1984
Pierre Gassier, ed. *Rodin*. Exh. cat. Martigny, Switzerland: Fondation Pierre Gianadda, 1984.

Geissbuhler 1963
Elisabeth Chase Geissbuhler. *Rodin: Later Drawings*. Boston: Beacon, 1963.

Georges-Michel 1942
Michel Georges-Michel. *Peintres et sculpteurs que j'ai connus, 1900–1942: Picasso, Braque, Claude Monet*. New York: Brentano's, 1942.

Georget and Le Normand-Romain 1997
Luc Georget and Antoinette Le Normand-Romain. *Rodin: "La Voix intérieure."* Exh. cat. Marsailles: Musée des beaux arts, 1997.

Goldscheider 1950
Cécile Goldscheider, *Balzac et Rodin*. Exh. cat. Paris; Musée Rodin, 1950.

Goldscheider 1952
Cécile Goldscheider. "La genèse d'une oeuvre: Le Balzac de Rodin." *La revue des arts* (Paris) 2 (March 1952): 37–42.

Goldscheider 1962
Cécile Goldscheider. *Rodin inconnu*. Exh. cat. Paris: Musée du Louvre, 1962.

Goldscheider 1963
Cécile Goldscheider. "Rodin et la danse." *Art de France* 3 (1963): 321–35.

Goldscheider 1967
Cécile Goldscheider. *Homage to Rodin: The Collection of B. Gerald Cantor*. Exh. cat. Los Angeles: Los Angeles County Museum of Art, 1967.

Goldscheider 1971
Cécile Goldscheider. "La nouvelle salle des *Bourgeois de Calais* au Musée Rodin." *La revue du Louvre* 21, no. 3 (1971): 165–74.

Goldscheider 1985
Cécile Goldscheider. *Auguste Rodin, "La statue de Balzac": Etapes da sa realisation (1891–1898)*. Paris: Palais de l'institut, 1985.

Goldscheider 1989
Cécile Goldscheider. *Auguste Rodin: Catalogue raisonné de l'oeuvre sculpté*. Vol. 1, 1840–86. Lausanne: Wildenstein Institute; Paris: Bibliothèque des Arts, 1989.

Goncourt and Goncourt 1935–36
Edmond de Goncourt and Jules de Goncourt. *Journal: Mémoires de la vie littéraire*. Vol. 7. Paris: E. Flammarion, 1935–36.

Grappe 1929
Georges Grappe. *Catalogue du Musée Rodin. I. Essai de classement chronologique des oeuvres d'Auguste Rodin*. Paris: Musée Rodin, 1929.

Grappe 1944
Georges Grappe. *Catalogue du Musée Rodin. I. Hôtel Biron. Essai de classement chronologique des oeuvres d'Auguste Rodin*. Paris: Musée Rodin, 1944.

Grappe 1947
Georges Grappe. *Le Musée Rodin*. Monaco: Les documents d'art, 1947.

Grunfeld 1987
Frederic V. Grunfeld. *Rodin: A Biography*. New York: Henry Holt, 1987.

Gsell 1907
Paul Gsell. "Chez Rodin." *L'art et les artistes* (Paris) 4 (February 1907): 393–415.

Gsell [1911] 1984
Paul Gsell. *Art: Conversations with Paul Gsell/Auguste Rodin*, translated by Jacques de Caso and Patricia Sanders. Berkeley: University of California Press, 1984. Originally published as *L'art: Entretiens réunis par Paul Gsell/Auguste Rodin* (Paris: Bernard Grasset, 1911).

Gsell 1918
Paul Gsell. "Auguste Rodin." *La revue de Paris* 25 (15 January 1918): 400–417.

Guillemot 1898
Maurice Guillemot. "Au Val-Meudon." *Le journal* (Paris), 17 August 1898, n.p.

Güse 1985
Ernst-Gerhard Güse, ed. *Auguste Rodin: Drawings and Watercolors*, translated by John Gabriel and Michael Taylor. London: Thames and Hudson, 1985.

Hale 1969
William H. Hale. *The World of Rodin*. New York: Time-Life, 1969.

Hare 1984
Marion J. Hare. "The Portraiture of Auguste Rodin." Ph.D. diss., Stanford University, 1984.

Hare 1990
Marion J. Hare. "Autobiographical Notes by Rodin in a Letter to Gaston Schefer, 1883." *Revue d'art canadienne/Canadian Art Review* 17, no. 2 (1990): 158–62.

Herbert 1961
Eugenia W. Herbert. *The Artist and Social Reform: France and Belgium, 1885–1898*. New Haven: Yale University Press, 1961.

Hughes 1990
Robert Hughes. *Nothing If Not Critical: Selected Essays on Art and Artists*. New York: Knopf, 1990.

Hunisak 1981
John Hunisack. "Rodin, Dalou, and the Monument to Labor." In Moshe Baunsch, Lucy Freeman Sandler, and Patricia Egan, eds., *Art, The Ape of Nature: Studies in Honor of H. W. Janson*. New York: Abrams, 1981, 689–705.

Jamison 1986
Rosalyn Frankel Jamison. "Rodin and Hugo: The Nineteenth-Century Theme of Genius in *The Gates* and Related Works." Ph.D. diss., Stanford University, 1986.

Janin 1903
Clément Janin. "Les dessins de Rodin." *Artistes* 8 (15 October 1903): 285–87.

Janson 1968
H. W. Janson. "Rodin and Carrier-Belleuse: The Vase des Titans." *Art Bulletin* 50 (September 1968): 278–80.

Janson 1981
H. W. Janson. "Pars Pro Toto: Hands and Feet as Sculpture Subjects before Rodin." In Giorgio Buccellati and Charles Speroni, eds. *The Shape of the Past: Studies in Honor of Franklin D. Murphy*. Los Angeles: University of California, 1981, 289–304.

Janson 1984
H. W. Janson, ed. *La scultura nel XIX secolo*. Acts of the XXIV International Congress of the History of Art, 1979. Vol. 6. Bologna: Cooperativa Libreria Universitaria Editrice, 1984.

Jianou and Goldscheider 1967
Ionel Jianou and Cécile Goldscheider. *Rodin*. Paris: Arted, 1967.

Jianou and Goldscheider 1969
Ionel Jianou and Cécile Goldscheider. *Rodin*, translated by Kathleen Muston and Geoffrey Skedlind. Paris: Arted, 1969. Originally published as *Rodin* (Paris: Arted, 1967).

Judrin 1976
Claudie Judrin. *Rodin et les écrivains de son temps*. Exh. cat. Paris: Musée Rodin, 1976.

Judrin 1981
Claudie Judrin. *Les centaures*. Exh. cat. Cabinet des dessins, dossier 1. Paris: Musée Rodin, 1981.

Judrin 1982
Claudie Judrin. *Ugolin*. Exh. cat. Cabinet des dessins, dossier 2. Paris: Musée Rodin, 1982.

Judrin 1983
Claudie Judrin, *Dante et Virgil aux Enfers*. Exh. cat. Cabinet des dessin, dossier 3. Paris: Musée Rodin, 1983.

Judrin 1984–92
Claudie Judrin. *Inventaire des dessins de Rodin*. 6 vols. Paris: Musée Rodin, 1984–92.

Judrin and Laurent 1979
Claudie Judrin and Monique Laurent. *Rodin et l'Extrême-Orient*. Exh. cat. Paris: Musée Rodin, 1979.

Judrin, Laurent, and Viéville 1977
Claudie Judrin, Monique Laurent, and Dominique Viéville. *Auguste Rodin: "Le monument des bourgeois de Calais" (1884–95)*. Exh. cat. Paris: Musée Rodin; Calais: Musée des beaux-arts, 1977.

Kahn 1900
Gustave Kahn. "Les mains chez Rodin." *La plume*, nos. 266–71 (15 May-1 August 1900): 28–29.

Kausch 1996
Michael Kausch. *Auguste Rodin: Eros und Leidenshaft*. Exh. cat. Harrach Palace. Vienna: Kunsthistoires Museum, 1996.

Kosinski 1989
Dorothy Kosinski. *Orpheus in Nineteenth-Century Symbolism*. Ann Arbor: UMI Research Press, 1989.

Lajoix 1997
Anne Lajoix. "Auguste Rodin et les arts du feu." *Revue de l'art*, no. 116 (1997): 76–88.

Lami 1914–21
Stanislas Lami. *Dictionnaire des sculpteurs de l'école française au dix-neuvième siècle*. 4 vols. Paris: E. Champion, 1914–21.

Lampert 1986
Catherine Lampert. *Rodin: Sculpture and Drawings*. Exh. cat. London: Arts Council of Great Britain, 1986.

Laurent 1988
Monique Laurent. *Rodin*. Exh. cat. Paris: Editions du Chêne-Hachette, 1988.

Laurent 1990
Monique Laurent. *Rodin*, translated by Emily Read. London: Barrie and Jenkins, 1990. Originally published as *Rodin* (Paris: Editions du Chêne-Hachette, 1988).

Laurent 1992
Monique Laurent. *Guide du Musée Rodin à l'Hôtel Biron*. Paris: Hazan, 1992.

Laurent, Merle, and Gutmann 1983
Monique Laurent, Michel Merle, and Danièle Gutmann. *Rodin: Les mains, les chirurgiens*. Exh. cat. Paris: Musée Rodin, 1983.

Lawton 1906
Frederick Lawton. *The Life and Work of Auguste Rodin*. London: T. Fisher Unwin, 1906.

Lecoq de Boisbaudran 1953
Horace Lecoq de Boisbaudran. *L'éducation de la mémoire pittoresque et la formation de l'artiste*. 1913. Reprint. Paris: Henri Laurens, 1953.

Lecoq de Boisbaudran 1911
Horace Lecoq de Boisbaudran. *The Training of the Memory in Art and the Education of the Artist*, translated by L. D. Luard. London: Macmillan, 1911.

Le Normand-Romain 1995a
Antoinette Le Normand-Romain. *"Le baiser" de Rodin*. Exh. cat. Paris: Musée Rodin, 1995.

Le Normand-Romain 1995b
Antoinette Le Normand-Romain, ed. *Rodin, Whistler, et la Muse*. Exh. cat. Paris: Musée Rodin, 1995.

Le Normand-Romain 1996
Antoinette Le Normand-Romain. "Auguste Rodin: Le buste de *Saint Jean-Baptiste* (1880) acquis par le musée Rodin." *La revue du Louvre*, no. 2 (April 1996): 15.

Le Normand-Romain 1997
Antoinette Le Normand-Romain, ed. *Vers "L'age d'airan": Rodin en Belgique*. Exh. cat. Paris: Musée Rodin, 1997.

Le Normand-Romain 1998
Antoinette Le Normand-Romain, ed. *1898: Le "Balzac" de Rodin*. Exh. cat. Paris: Musée Rodin, 1998.

Le Normand-Romain 1999
Antoinette Le Normand-Romain, ed. *The Gates of Hell*. Exh. cat. Paris: Musée Rodin, 1999.

Le Normand-Romain 2001
Antoinette Le Normand-Romain et al., *Rodin en 1900. L'exposition de l'Alma*. Exh. cat. Paris: Musée du Luxembourg, 2001

Le Normand-Romain and Marraud 1996
Antoinette Le Normand-Romain and Hélène Marraud, *Rodin à Meudon. La Villa des Brillants*. Paris: Musée Rodin, 1996.

Le Nouëne and Pinet 1987
Patrick Le Nouëne and Hélène Pinet. *Auguste Rodin: "Le monument des bourgeois de Calais" and ses photographes*. Exh. cat. Calais: Musée des beaux-arts; Aix-les-Bains: Musée Faure, 1987.

Le Pichon and Lavrillier 1988
Yann Le Pichon and Carol-Marc Lavrillier. *Rodin: "La Porte de l'enfer."* Paris: Pont Royal, 1988.

Levkoff 1994
Mary Levkoff. *Rodin in His Time: The Cantor Gifts to the Los Angeles County Museum of Art*. Los Angeles: Los Angeles County Museum of Art; New York and London: Thames and Hudson, 1994.

Ludovici 1926
Anthony Ludovici. *Personal Reminiscences of Auguste Rodin*. Philadelphia: J. B. Lippincott, 1926.

Maillard 1899
Léon Maillard. *Auguste Rodin, statuaire*. Paris: H. Floury, 1899.

Marx 1907
Roger Marx. *Auguste Rodin, céramiste*. Paris: Société de propagation des livres d'art, 1907.

Mauclair 1898
Camille Mauclair. "L'art de M. Auguste Rodin." *La revue des revues* (Paris) 25 (15 June 1898): 591–610.

Mauclair 1905a
Camille Mauclair. *Auguste Rodin: The Man—His Ideas—His Works*, translated by Clementina Black. London: Duckworth, 1905.

Mauclair 1905b
Camille Mauclair. "Notes sur la technique et la symbolisme de M. Auguste Rodin." *La renaissance latine* (Paris) 4, pt. 2 (15 May 1905): 200–20.

Mauclair 1918
Camille Mauclair. *Auguste Rodin: L'homme et l'oeuvre*. Paris: La renaissance du livre, 1918.

McNamara 1983
McNamara, Mary Jo. "Rodin's Burghers of Calais." Ph.D. diss. Stanford University, 1983.

McNamara and Elsen 1977
Mary Jo McNamara and Albert Elsen. *Rodin's "Burghers of Calais."* Exh. cat. New York: Cantor Fitzgerald Group, 1977.

Miller and Marotta 1986
Joan Vita Miller and Gary Marotta. *Rodin: The B. Gerald Cantor Collection*. Exh. cat. New York: Metropolitan Museum of Art, 1986.

Mirolli (Butler) 1966
Ruth Mirolli (Butler). "The Early Work of Rodin and Its Background." Ph.D. diss., New York University, 1966.

Morhardt 1898
Mathias Morhardt. "Mlle Camille Claudel." *Mercure de France* 25 (March 1898): 709–55.

Morhardt 1934
Mathias Morhardt. "La bataille du Balzac." *Mercure de France* 256, no. 876 (November-December 1934): 463–89.

Nash 1987
Steven A. Nash, ed. *A Century of Modern Sculpture: The Patsy and Raymond Nasher Collection*. New York: Rizzoli, 1987.

Newton and MacDonald 1978
Joy Newton and Margaret MacDonald. "Rodin: *The Whistler Monument*." *Gazette des beaux-arts* 92 (December 1978): 221–32.

Newton and Fol 1985
Joy Newton and Monique Fol. "Correspondance inédite entre Zola et Rodin." *Les cahiers naturalistes*, no. 59 (1985): 187–201.

Pierron 1902
Sander Pierron. "Françoise Rude et Auguste Rodin à Bruxelles." *La grande revue* 24 (October 1902): 138–62.

Pinet 1985
Hélène Pinet. *Rodin sculpteur et les photographes de son temps*. Paris: Philippe Sers, 1985.

Pinet 1990
Hélène Pinet. *Rodin et ses modèles: La portrait photographique*. Exh. cat. Paris: Musée Rodin, 1990.

Pinet 1998
Hélène Pinet. "Montre est la question vital. Rodin and Photography" in Geraldine A. Johnson, ed. *Sculpture and Photography: Envisioning the Third Dimension*. Cambridge: Cambridge University Press, 1998: 68–85.

Pingeot 1986
Anne Pingeot, ed. *La sculpture française au XIXe siècle*. Exh. cat. Paris: Réunion des musées nationaux, 1986.

Pingeot 1988
Anne Pingeot. "*L'age mûr*" de Camille Claudel. Exh. cat. Dossiers du Musée d'Orsay, 25. Paris: Réunion des musées nationaux, 1988.

Pingeot 1990
Anne Pingeot, ed. *Le corps en morceaux*. Exh. cat. Paris: Réunion des musées nationaux, 1990.

Pingeot, Le Normand-Romain, and de Margerie 1986
Anne Pingeot, Antoinette Le Normand-Romain, and Laure de Margerie. *Musée d'Orsay: Catalogue sommaire illustré des sculptures*. Paris: Réunion des musées nationaux, 1986.

Renner 1990
Ursula Renner. "Le penseur et le génie: Hugo von Hofmannsthal und August Rodin." *Neue Zurcher Zeitung* 9–10, no. 131 (June 1990): 67–68.

Rheims 1972
Maurice Rheims. *Nineteenth-Century Sculpture*. Translated by Robert E. Wolfe. New York: Harry N. Abrams, 1977.

Rice 1965
Howard C. Rice. "Glimpses of Rodin." *Princeton University Library Chronicle* 27 (autumn 1965): 33–44.

Rilke [1903] 1945
Originally published as Rainer Maria Rilke. *Rodin*, translated by Jessie Lemont and Hans Trausil. New York: Fine Editions Press, 1945. Reprinted in Albert Elsen, ed., *Auguste Rodin: Readings on His Life and Work* (Englewood Cliffs, N.J.: Prentice-Hall, 1965), 110–44.

Rilke [1903, 1907] 1954
Rainer Maria Rilke. *Selected Works*. Vol. 1, *Prose*. Translated by G. Craig Houston. London: Hogarth Press, 1954. This volume includes *The Rodin-Book, First Part* (1903), 93–135; and *The Rodin-Book: Second Part* (1907), 136–60.

Rodin 1860–99
Auguste Rodin. *Correspondance de Rodin*. Vol. 1, *1860–99*, edited by Alain Beausire and Hélène Pinet. Paris: Musée Rodin, 1985.

Rodin 1900–1907
Auguste Rodin. *Correspondance de Rodin*. Vol. 2, *1900–1907*, edited by Alain Beausire and Florence Cadouot. Paris: Musée Rodin, 1986.

Rodin 1908–12
Auguste Rodin. *Correspondance de Rodin*. Vol. 3, *1908–12*, edited by Alain Beausire and Florence Cadouot. Paris: Musée Rodin, 1987.

Roos 1986
Jane Mayo Roos. "Rodin's *Monument to Victor Hugo*: Art and Politics in the Third Republic." *Art Bulletin* 68 (December 1986): 632–56.

Rosenfeld 1993
Daniel Rosenfeld. "Rodin's Carved Sculpture." Ph.D. diss., Stanford University, 1993.

Rüth and Appel 1997
Uwe Rüth, Thomas Appel et al. *Auguste Rodin: Les Bourgeois de Calais—Postérité et filiations*. Exh. Cat. Musée Royal de Mariemont. Bonn: Gerd Hatje, 1997.

Schmoll 1954
J. A. Schmoll gen. Eisenwerth. *Der Torso als Symbol und Form*. Baden-Baden: Bruno Grimm, 1954.

Schmoll 1959
J. A. Schmoll gen. Eisenwerth. "Zur Genesis des Torso-Motivs und zur Deutung des Torso-Motivs und zur Deutung des fragmentarischen Stils bei Rodin." In J. A. Schmoll gen. Eisenwerth, *Das Unvollendete aus Künstlerische Form*. Bern: Francke, 1959, 117–39.

Schmoll 1972
J. A. Schmoll gen. Eisenwerth. "Denkmäler der Arbeit Entwürfe und Planungen." In Hans-Ernest Mittig and Volker Plagemann, eds., *Denkmäler im. 19. Jahrhundert: Deutung und Kritik*. Munich: Prestel-Verlag, 1972, 253–81.

Schmoll 1983
J. A. Schmoll gen. Eisenwerth. *Rodin-Studien: Persönlichkeit, Werke, Wirkung, Bibliographie*. Munich: Prestel-Verlag, 1983.

Schneider 1975
Mechthild Schneider. "Denkmäler für Künstler in Frankreich: Ein Thema der Auftragsplastik im 19. Jahrhundert." Inaug. diss., Johann-Wolfgang-Goethe Universität, 1975.

Silverman 1989
Debora Silverman. *Art Nouveau in Fin-de-Siècle France: Politics, Psychology, and Style*. Berkeley: University of California Press, 1989.

Sobieszek 1980
Robert A. Sobieszek. "Sculpture as the Sum of Its Profiles: François Willème and Photosculpture in France, 1859–1868." *Art Bulletin* 62 (December 1980): 617–30.

Spear 1964
Athena Tacha Spear. "*The Prodigal Son*: Some New Aspects of Rodin's Sculpture." *Allen Memorial Art Museum Bulletin* 22, no. 1 (fall 1964): 25–36.

Spear 1967
Athena Tacha Spear. *Rodin Sculpture in the Cleveland Museum of Art*. Cleveland: Cleveland Museum of Art, 1967.

Spear 1969
Athena Tacha Spear. "A Note on Rodin's *Prodigal Son* and on the Relationship of Rodin's Marbles and Bronzes." *Allen Memorial Art Museum Bulletin* 27, no. 1 (fall 1969): 25–36.

Spear 1974
Athena Tacha Spear. *A Supplement to Rodin Sculpture in the Cleveland Museum of Art*. Cleveland: Cleveland Museum of Art, 1974.

Steinberg 1972
Leo Steinberg. "Rodin." In *Other Criteria: Confrontations with Twentieth-Century Art*. New York: Oxford University Press, 1972, 322–403. Originally published as the introduction to *Auguste Rodin, 1840–1917: An Exhibition of Sculptures/Drawings*, exh. cat., by Cécile Goldscheider (New York: Charles Slatkin Galleries, 1963), 10–27.

Sutton 1995
Peter C. Sutton. *The William Appleton Coolidge Collection*. Boston: Museum of Fine Arts, 1995.

Tancock 1967
John L. Tancock. "Rodin Is a Rodin Is a Rodin." *Art and Artists* (London) 2 (July 1967): 38–41.

Tancock 1976
John L. Tancock. *The Sculpture of Auguste Rodin: The Collection of the Rodin Museum, Philadelphia*. Philadelphia: Philadelphia Museum of Art, 1976.

Thorson 1975
Victoria Thorson. *Rodin Graphics: A Catalogue Raisonné of Drypoints and Book Illustrations*. San Francisco: Fine Arts Museums of San Francisco, 1975.

Tilanus 1995
Louk Tilanus. "The Monument of *La défense*: Its Significance for Rodin." *Gazette des beaux-arts* 125 (April 1995): 261–76.

Tirel 1923
Marcelle Tirel. *Rodin intime; ou, l'envers d'une gloire*. Paris: Aux éditions du monde nouveau, 1923.

Tirel 1925
Marcelle Tirel. *The Last Years of Rodin*, translated by R. Francis. New York: Robert M. McBride, 1925.

Tucker 1974
William Tucker. *Early Modern Sculpture*. New York: Oxford University Press, 1974.

Tyler 1955
Parker Tyler. "Rodin and Freud: Masters of Ambivalence." *Art News* 54, no. 1 (March 1955): 38–41, 63–64.

Vallon 1928.
Fernand Vallon. *Au Luxembourg et chez Rodin*. Senlis, France: Imprimeries, réunies, 1928.

Varnedoe 1970
Kirk J. Varnedoe. "Two Rodin Drawings." *Committee for Art at Stanford Newsletter* (summer 1970): 3–4.

Varnedoe 1978
Kirk J. Varnedoe. "*Les bourgeois de Calais* at the Musée Rodin, Paris." *Burlington Magazine* 120 (July 1978): 483–86.

Varnedoe 1990
Kirk J. Varnedoe. *A Fine Disregard: What Makes Modern Art Modern*. New York: Harry N. Abrams, 1990.

Vincent 1981
Clare Vincent. "Rodin at the Metropolitan Museum of Art: A History of the Collection." *Metropolitan Museum of Art Bulletin* 38 (spring 1981): 1–48.

Wasserman 1975
Jeanne L. Wasserman, ed. *Metamorphoses in Nineteenth-Century Sculpture*. Exh. cat. Cambridge: Fogg Art Museum, Harvard University, 1975.

INDEX

Numbers in *italics* refer to illustrations.

GENERAL INDEX

PHOTOGRAPHIC CREDITS